Paul Davis
Illustrator/Designer
Page 604

Jody dePew McLeane
Fine Artist
Page 422

Stephen Bentley
Cartoonist
Page 640

Nick Dubrule
Editor
Page 176

1992
Artist's Market

Where & How to Sell
Your Artwork

Edited by
Lauri Miller

Assisted by
Sheila Freeman

Writer's Digest Books

Cincinnati, Ohio

Distributed in Canada by McGraw-Hill,
300 Water Street
Whitby Ontario L1N 9B6.
Also distributed in Australia by Kirby Books, Private Bag No. 19, P.O. Alexandria NSW2015.

Managing Editor, Market Books Department: Constance J. Achabal; Assistant Managing Editor: Glenda Tennant Neff

Artist's Market. *Copyright © 1991 by Writer's Digest Books. Published by F&W Publications, 1507 Dana Ave., Cincinnati, Ohio 45207. Printed and bound in the United States of America. All rights reserved. No part of this book may be reproduced in any manner whatsoever without written permission from the publisher, except by reviewers who may quote brief passages to be printed in a magazine or newspaper.*

International Standard Serial Number
0161-0546
International Standard Book Number
0-89879-473-0

Cover photography by Ron Forth
Close-up portraits by Barbara Kelley

Contents

From the Editor

Vincent Van Gogh is dressed in a Wall Street suit and tie and sits in front of his palette of paints on the computer screen; with chin in hand, he ponders what to do next. If he were to look out the window behind him, he would see *The Starry Night*. This full-color image appears on the *American Showcase* tearsheet freelance illustrator Barbara Kelley sent me last year. Kelley, whose client list includes *The New York Times*, *The Wall Street Journal* and many major corporations, is this year's Close-up illustrator. As I look at her contemporary rendition of Van Gogh again, it seems an appropriate visual introduction to the 1992 *Artist's Market*. Many of you have quandaries similiar to the ones Van Gogh had then—namely how does one both create and survive?

As this late 20th century Van Gogh seems to understand, success in the arts demands—in addition to hard work and talent—a certain amount of professionalism and business acumen.

This year's featured articles have been commissioned with these things in mind. Marketing to Galleries is a step-by-step piece which describes just how one goes about finding the appropriate representation for one's fine art. Designers and illustrators are presented with a practical and informative guide to Setting Your Fees: Being Paid What You're Worth, by Cameron Foote. Rhode Island School of Design professor David Niles explains the essential components of a sample package.

This year's Close-ups, intended both to educate and inspire you, include renowned illustrators Marshall Arisman, Paul Davis and James Endicott and art directors from the advertising agency Rubin Postaer and Associates in Los Angeles, the book publisher Paragon House in New York City, *Omni* magazine and GRP Records. Also featured are medical illustrator Carol Donner, greeting card designer and illustrator Peggy Jo Ackley, Boston-based editorial illustrator Cynthia Carrozza, fine artist Jody dePew McLeane, gallery director Darrell Couturier of Couturier Gallery in Los Angeles and editor at the art publisher Graphique de France, Nick Dubrule. Stephen Bentley, creator of "Herb and Jamaal," is also a Close-up in this edition.

This 1992 edition also features a greater number of illustrations than ever before. They are examples of work submitted to me by freelance artists and art directors in the past year. Hopefully they will give you a better sense of what particular markets are seeking and speak to you visually in a way the listings often cannot.

Lastly, I am happy to announce the *Artist's Market* cover contest, for which the first prize will be $500 and consideration for publication. For information see the *Artist's Market* listing on page 198. I look forward to seeing your submissions and the winning work on the cover of the 1994 edition!

As Van Gogh taught us all, most essential to an artist's productivity is his dogged perseverence and singlemindedness. So stay strong and determined, and good luck with your career in the next year.

Lauri Miller

How to Use Your Artist's Market

Markets in this book are organized according to their professional category, such as book publishers or magazines. However, you have probably found that your talents apply to many categories. For example, if you're a painter who also illustrates, you will find opportunities (for your fine art) not only in the gallery and art publisher sections, but also (for your illustration) in the magazine, book publishing and greeting card sections, for example. Within each section the listed companies have such diverse needs that you will probably find opportunities for your work in almost every section.

Reading the market listings

Listings include information on whom to contact, what type of work is needed, how artists are used, payment method and amount. For an explanation of all the information given in the listings, match the numbered phrases in the sample listing with the corresponding numbers in the copy that follows.

(1)*CAREW DESIGN,, 200 Gate 5 Rd., Sausalito CA 94965. (415)331-8222. (2) President: Jim Carew. (3) Estab. 1975. (4) Specializes in corporate identity, direct mail and package design.
Needs: (5) Works with 15 freelance illustrators and 2-4 freelance designers/year. Prefers local artists only. (6) Works on assignment only. Uses artists for brochure and catalog design and illustration, mechanicals, retouching, airbrushing, direct mail design, lettering, logos and ad illustration.
First Contact & Terms: (7) Send query letter with brochure, resume and tearsheets. (8) Samples are filed. Samples not filed are returned only if requested by artist. (9) Reports back only if interested. (10) Call to schedule an appointment to show a portfolio, (11) which should include roughs and original/final art. (12)Pays for production by the hour, $18-30. Pays for illustration by the project, $100-1,000. (13) Considers complexity of project, client's budget, skill and experience of artist, how work will be used, turnaround time and rights purchased when establishing payment. (14) Buys all rights.
Tips: (15) "The best way for an illustrator and a designer to get an assignment is to show a portfolio."

(1) New listings. An asterisk (*) precedes new listings.

(2) Contact information. Names of contact persons are given in most listings. If not, address your work to the art director or person most appropriate for that field.

(3) Established dates. Dates indicating when the market was established are given in this area of the listings. The risk is sometimes greater when dealing with new companies. So far as we know, all are reputable but some are unable to compete with larger, older companies. Many do survive, however, and become very successful.

(4) Company description. Company descriptions and/or client lists are provided to help you slant your work toward that specific business.

(5) Percentage of freelance work. The number or percentage of jobs assigned to freelance artists or the number of artists a market uses gives you an idea of the size of the market.

(6) Work on assignment. Many firms work on assignment only. Do not expect them to buy the art you send as samples. When your style fills a current need, they will contact you. This section also tells you what type of artwork the company needs.

(7) Submission requirements. Submit materials specified by the listing. If a market instructs you to query, please query. Do not send samples unless that is what they want you to do.

(8) Samples. Many art directors who want samples keep them on file for future reference. If you want your samples returned, include a self-addressed, stamped envelope (SASE) in your mailing package. Include an International Reply Coupon (IRC) if you are mailing to a market outside of your country.

(9) Reporting times. Reporting times vary, and some—such as this listing—will only contact you if interested in your work.

(10) Portfolio presentation. Markets want you to either mail portfolio materials or present them in person. Note whether to call or write for an appointment to show your portfolio.

(11) Portfolio contents. The type of samples you include in your portfolio reflect your understanding of the market; inappropriate samples signify a lack of market research.

(12) Payment terms.

(13) Payment factors. Markets often negotiate payment terms. Therefore, they list the factors they consider when establishing payment.

(14) Rights purchased. Note what rights the market purchases. If several types of rights are listed, it usually means the firm will negotiate. But not always. Be certain you and the art buyer understand exactly what rights you are selling. This design studio buys all rights.

(15) Advice. Read the tips at the end of many listings. They give you personalized advice or a view of general market information.

Call for Entries

Artist's Market *is pleased to announce a first-of-its-kind contest for the cover of its 1994 edition. In addition to the work being considered for publication, the winner will receive $500. Guidelines need to be followed and will be available November 1, 1991. To receive them, please send SASE to Lauri Miller, Cover Contest,* Artist's Market, *1507 Dana Ave., Cincinnati, OH 45207. Entries will be accepted from January 10, 1992 to August 10, 1992. Winners will be announced in December, 1992.*

Setting Your Fees: Being Paid What You're Worth

by Cameron S. Foote

How much is my art worth? That's a question artists have been asking themselves for hundreds of years. In fine or decorative art, the answer has also been pretty much the same for hundreds of years: Whatever the market decides it is worth.

Fortunately in the larger world of commercial art, things are much more predictable. Here there are well established prices, many of which are reported in this edition of *Artist's Market*.

But how, for example, do you know if you can afford to produce an illustration for magazine *X* at the rates quoted in these pages? If art is to be your livelihood, not just a hobby, you can only accept assignments that pay you more than enough to live on.

And how do you go about pricing design assignments, such as brochures for corporate clients? Not only does your price have to be competitive, but chances are the client will also want you to explain how you arrived at it.

So what price is right? Helping you determine what commercial art is worth in today's market is the subject here.

Putting $ in the proper context

Although making money is probably not the reason you chose to be an artist, if you are to be successful in the *business* of commercial art, establishing realistic pricing procedures has to have a high priority. Nothing, your creativity included, is more important.

First off, it is necessary that you kick what I can best describe as the "starving artist syndrome." This is, that true creativity and money making can't coexist. They can. You do *not* have to take vows of poverty to be a freelance artist. Quite the opposite. It *is* possible for you to obtain a comfortable, enjoyable living from your talent.

So many artists accept that art and poverty go hand-in-hand. My experience in talking to thousands of freelance illustrators, graphic designers and art directors across the country has shown me that most underprice their services, especially when they start out or when they have little business experience. Further, low pricing is the primary reason why many artists try freelancing and fail.

At a time when plumbers get from $35 to $65 per hour for their services, I see many highly-talented freelance artists working for a fraction of these fees. Yet at the same time, I also see a few other artists with little or no more talent averaging $100 an hour for their time. Aside from the fact that the higher-priced artists seem happier and continue to freelance year after year, what accounts for the difference?

Primarily, it is their attitude toward pricing. Commercial artists who are successful think, look and act like well paid pros. That is, they dress well when calling upon clients . . . they are not afraid to ask what their talent is worth . . . they turn down any job that doesn't pay

Cameron S. Foote *is the editor of* Creative Business, *"The How-to-Succeed Newsletter for the Freelance and Small Studio," and conducts the seminars, "How to Make it as a Freelance," and "How to Sell Creative Services." Before founding* Creative Business, *he freelanced for ten years. Prior to that he was Creative Director of the Polaroid Corporation.*

enough . . . and they don't haggle, because they realize that whatever price they ask, there will always be another artist who can do it for less.

Successful commercial artists know they are not just providing an illustration or a design to a client, but, rather that they are in the *creative services business*. And that good clients — the ones who provide interesting assignments, pay well and on time, and call again — are actually more concerned about *value* received than about price alone. Given a choice, any smart client would rather overspend his or her budget slightly on good work, delivered on time and without a hassle, than to negotiate a low price from a difficult-to-deal-with commercial artist.

The point is this: Successful commercial artists worry more about their perceived qualifications and attitude than about how their work is priced. It is, of course, true that plum assignments can be lost because of what a client considers to be inappropriate pricing. But it is more often true they are lost because of a perceived lack of experience, ability or attitude.

How to think about pricing

When thinking about pricing their work, too few artists look at the big picture. As indicated above, many assume pricing is the most important factor in success. This orientation often leads to underpricing, a way of trying to assure they will get adequate work. The logic is: "By pricing low and being busier, I'll make up with higher volume what I lose through lower rates." Unfortunately, there are two fatal flaws in this thinking.

First, working harder at lower prices often results in creative burnout. You may be financially successful, but for how long and at what price? Second, a reputation for low-price work attracts smaller, less sophisticated and more demanding clients, while repelling the larger clients with the good assignments. Jobs are often lost, or an individual not even considered, because of the "bargain basement" image low price conveys. And since price is often equated with quality, once an artist gains a reputation for low-price (read low-quality) work, it is exceedingly difficult for him or her to shake that perception and later raise prices.

It should be noted that the following price information presents rates that are realistic for the talented, experienced fulltime freelancer. If you feel you are not yet doing your best work, lack experience, or if freelance commercial art is not your fulltime career, these rates are probably not practical for you. Rather, they may represent what you may want to aspire toward.

Hourly pricing ranges

Larger companies in the business of providing creative services — design firms, ad agencies and such — presently charge in the range of $60 to $150 per hour for creative time. Although it is usually difficult for individuals of equal talent and experience to charge as much, freelance artists should charge about 75 percent of what larger organizations in any given market charge for equal talent.

In other words, if you know that when you worked for a large design shop they were billing your time out at $100 per hour, it is reasonable for you to get $75 an hour freelancing. In any case, it will probably be necessary for you to charge at least $50 per hour if you are to make a comfortable living as a freelance artist.

Also, if you wish to live comfortably in most metropolitan areas of the United States you will need an average gross personal income of $40,000 a year or higher. Those living in a rural area can be successful on less, but they will probably have to work harder because assignments are harder to come by. Thus, if your hourly rate, multiplied by the average hours worked, does not make $40,000 a year possible, your chances of not suffering from creative burnout, continuing in business for many years, and putting away enough for future

security are slim. Most self-supporting, successful freelance artists today charge from $50 to $125 per hour.

Establishing a price structure

Factoring your present salary. Artists beginning to freelance, either full or part-time, often set their hourly rate by multiplying what they presently make by a factor of two. In other words, if their salary is $20 per hour, they use an hourly rate of $40 when estimating or pricing a freelance job. The logic is that twice present pay should be sufficient to cover overhead expenses and non-billable time. (If your pay is based on a yearly salary, hourly rate can be determined by dividing the yearly salary by 2,080, based on a 40-hour week.)

The problem with this method is that it bears no relationship to actual costs of doing business, or realistic expectations for long-term profit. In fact, for most creatives, especially younger, less experienced ones, it sets hourly rates too low to build a viable business.

The costs and profits formula. The best way to establish an hourly fee is to calculate your actual costs and make it the basis for determining the minimum hourly rate you must charge.

To do this, first assign yourself a salary. (If you are already working for yourself and not actually drawing a salary—that is, you simply withdraw money when you need it—add up all those withdrawals.) Then add to this figure all other employment costs—self-employment tax, insurance benefits, etc. You can actually break down these costs, or if you find that too time consuming, simply add a factor of 25 percent.

For illustration purposes, let's say you wish to pay yourself a salary of $35,000. Your annual labor costs are actually $43,750. (Salary of $35,000 + $8,750 benefits [25 percent of $35,000] = $43,750.)

Take this total and divide it by the number of working hours in a year. If you wish to be precise, add up your actual working hours. Or, for simplicity, use 1,920 hours, which assumes 48 working weeks, with 4 non-working weeks for vacations, holidays and sick time. (48 weeks × 5 days × 8 hours = 1,920 hours.)

Also subtract a factor for non-billable hours. Even if you are constantly busy, chances are at least 20 percent of working hours are non-billable. If business is slow, the average can easily grow to 50 percent or more. In our example, we will assume 30 percent of working hours are non-billable, reducing the total number of billable hours to 1,344 (1,920 × .70).

Finally, divide your total labor expenses by the total average billable hours to arrive at your hourly labor expenses. In our example, $43,750 ÷ 1,344 = $32.55 per hour.

Now, having calculated your salary costs, calculate overhead costs. They are all the non-labor expenses of running a business that aren't directly billable to clients. Include here most items for which you will write company checks, as well as daily miscellaneous, or "petty cash" expenses. Don't include pass-along charges such as type or delivery services.

Examples of overhead costs are: office rent, equipment lease fees or amortized purchase prices (computers, fax machines, etc.), taxes, office utilities, automobile ownership (lease fee or amortized purchase price), automobile use, taxis, office and art supplies, postage, telephone charges, and promotional and entertainment expenditures.

Divide this figure by the actual number of hours you work to arrive at the hourly overhead cost. For illustration purposes, we'll assume your yearly overhead costs are $20,000. This amount is then divided by 1,920 yearly business hours to produce the hourly overhead figure $10.42.

By adding this overhead cost figure, $10.42, to your labor cost figure, $32.55, you arrive at your hourly operating cost—$42.97. This is what you must charge for every billable hour.

In looking at this example, note that the $42.97 an hour figure is not based upon an acceptable salary ($35,000 is under the $40,000 required to live comfortably in most metropolitan areas). It also does not provide any provision for capital or equity growth. Moreover, many of the numbers used in the calculations are conservative. Basically, it shows only

what it will take to keep you alive as a freelance artist. It does not show what it will take to make you economically stable and prosperous.

Therefore, once you have a firm fix on what you have to charge every hour (operating cost), you should now go to the next, final step and determine how much you *should* charge. This figure (your hourly rate) should be a combination of your operating cost, plus additional profit margin.

To calculate your hourly rate, add a 10 percent to 20 percent profit margin, depending upon competitive considerations. In our example, 10 percent of $42.97 per hour is $4.30 which, when added to the hourly operating cost, establishes an hourly rate of $47.27 per hour.

Three practices to be wary of

Any pricing method that works consistently well for you is, by definition, good. All three of the methods presented below have their strong proponents. Nonetheless, the experience of most artists around the country is that their problems usually outweigh their benefits. Thus, consider each with considerable caution.

1. Different rates depending upon how busy you are. Considered logically, this makes a lot of sense: when you're busy you charge high rates; when not, you lower your rates to get work. After all, any work is better than no work, right? Probably not.

First off, pricing according to your workload is not terribly professional. It threatens the very image you must cultivate if you are ever to be able to charge realistically high rates. Do you know any other professionals — lawyers, accountants, physicians — who adjust their fees based on busyness?

Secondly, once clients have obtained your services cheap, it is hard to believe they will accept higher rates if you should happen to be busier next time they call.

2. Different rates for different types of clients. When first starting out, one finds he needs to take all the work he can get, both to build one's portfolio and to pay the bills. Thus, he may have to accept lower payment than he would like from some of these initial clients. In the long term though, it is usually bad business to discriminate either for or against any type of organization or company. Treating every client the same is easier for you and fairer for them. Despite this, however, some artists do charge small firms, or start up companies, or "poor" clients such as not-for-profits, lesser fees than larger or more profitable clients.

In most cases, experience shows that such clients are either unaware of, or don't appreciate the generosity. Conversely, other clients who get wind of the practice feel (correctly) that they are being taken advantage of because they are perceived to be "rich."

If you are ever motivated to give a break to a small struggling client or not-for-profit organization, remember this: A viable business (yours) can't be run like a charitable operation. Moreover, every client — not-for-profits included — makes money off your effort. If you feel charitable, the best way to contribute to any worthy cause is to give a tax-deductible *money* gift. That way, everyone — you, the client and society — benefits more.

3. Nickel-and-dime accounting. A way to squeeze the maximum money out of an assignment is to charge for every single expense that can be related to it: every telephone call, every automobile mile, every parking fee, every cab fare, every photocopy, every tube of paint. In other words, to lower your general overhead costs by allocating as many expenses as possible to specific jobs.

Although such practices will, indeed, increase many invoices by another five percent or so, experience shows this to be a rather shortsighted practice. Keeping track of and allocating minor costs is very labor intensive. Even more important, it appears to the client like a conscious effort to squeeze every possible nickel out of his or her organization.

Most clients expect major expenses to be passed along, and even marked-up 25% where appropriate. (Such expenses include: automobile mileage for trips more than 50 miles one

way, meals/tickets/hotel bills, stats, type, photography, long-distance calls, and delivery charges.) They expect minor expenses, such as your supplies, to be part of your overhead.

Reducing surprises

Whenever time-related pricing is used, confidence and trust on behalf of both parties—client and artist—are absolutely necessary. The client must have confidence in your ability to work productively and to provide the creativity desired quickly, without excessive revisions. You must believe the client is basically honest and reasonable. Neither of you can afford to be unpleasantly surprised after a commitment is made.

To reduce pricing surprises, always provide the best written estimate you can. Indicate to the client just how "tight," or not, the estimate is. If additional information is required to properly estimate, it is your obligation to ask for it. Never estimate on incomplete information.

Once you start on a job, it is also your obligation to inform the client periodically of where you stand versus the estimate. (Example: "I'm about half-way through the job and have used approximately half of the estimated time, so my estimate looks okay at this point.") By keeping the client informed as you go along, you allow ample opportunity to make any budget adjustments that may be needed later, or ample time to change the job specifications if necessary to meet a firm budget. In short, you eliminate the end-of-job surprises that are the concerns most clients have with time-related pricing.

Preparing an estimate or proposal

Clients don't necessarily care how much you charge for your time per hour. What they always care about, however, is how much a specific assignment will cost. Therefore, the estimate or proposal you present can be as important as your hourly rate.

When considering a job estimate, first remember that the single largest cause of business litigation is the misunderstandings that naturally arise when one individual works with another. When the subjectivity that's inherent in supplying creative services is added to such a situation, the potential for serious misunderstanding is increased many fold. Handshakes may be a wonderful, genteel way of doing business, but in today's world they are very risky.

On the other hand, providing a detailed, written description of precisely what you will provide, on what schedule and for what cost, is almost impossible for services that are as capriciously, arbitrarily and subjectively evaluated as illustration and design. Moreover, because every job is different, preparation of such a document is quite time-intensive. And supplying too much detail will probably look to the client suspiciously like an effort to justify a padded bill in advance.

Knowing how to respond in each individual circumstance—what is needed on paper and what is not—is one of the ways clients judge the professionalism of their creative suppliers.

Minimal legal protection. You should also keep this thought in mind: Most estimates, proposals and contracts, even ones that are tightly drawn and complete, do not give you any significant legal protection. The reason is that you produce a product—creative execution—that is always unique, hard to define and subjectively evaluated. This results in so many potential "loopholes" that any clients desiring to find one can easily do so, especially if they have legal staff.

In short, if a client wants to violate the terms of an approved esimate, he or she will find a way. Even if you did fight it out later in the courts and ultimately triumph, the victory will probably cost more than it's worth.

So don't spend a lot of time preparing a finely detailed estimate or proposal with the assumption that it will pay off in an iron-clad contract and insurance against client depredations. Likewise, such an estimate or proposal probably isn't going to bolster your case a lot

if you later need to ask for more money or time because the client didn't adhere to his or her end of the bargain. Clients believe what they want to believe. If it is necessary to refer back to the proposal to make your case, chances are you've already lost it.

For these reasons, it is in your interest to minimize the time put on every estimate or proposal. Put enough time on it to explain costs, loosely schedule events, and to make the client comfortable with your professionalism. Anything more is wasted.

The best way to conserve your time, protect your interests and keep clients happy all at once is to make proposals and estimating a two-step process. Think of the first step as a basic definition of the ground rules. Think of the second step as a more detailed application of the rules to a specific situation.

The first step. Prepare a short, no more than two-page, statement of your general working and billing procedures. The primary use of the statement will be as a leave-behind after you make an initial presentation to a potential new client. In addition, it can also be used during the presentation as a way to deflect questions about pricing ("Before I leave, I'll give you a sheet that describes how I price my services."), and as a way to close the presentation ("This sheet summarizes my working and billing procedures. I hope you'll file it and give me a call when appropriate."). Also use the sheet to answer general telephone inquiries about pricing and to screen out undesirable clients.

Such a "How I work" sheet will differentiate you from other artists because few provide clients with *any* advance pricing or working guidelines. And, henceforth, when you get a call from a known client, you'll know the ground rules have already been established. This will make the proposal writing much faster and easier.

The second step. Now we're ready to consider the second step of the process, the proposal or estimate letter itself. My experience indicates that the most effective ones are those that look like they're tailored to the specific circumstances of the job and the needs of the client. The shorter and simpler, the better.

The best ones of all—easiest for you to prepare and easiest for the client to understand—are simple letters of agreement stating what you are going to do, when, and at what cost. Such a letter, accompanied by a brief biographic sketch and list of relevant past clients, is all most clients will want. Further, when countersigned (approved) by the client, it will also give about as much legal protection as a much more complex and time-consuming-to-prepare contract.

Printed forms, whether prepared by you on your computer, provided by an industry organization such as American Institute of Graphic Arts (AIGA), or purchased from a stationery store, are usually too formal, too legal, too potentially off-putting for everyday use. And, as covered above, they don't offer any more protection. They are usually only appropriate for very large projects, such as identity programs for major corporations.

This is not to say that a basic proposal or estimate letter format can't be stored in a computer in a way that allows you to make use of extensive standardized passages ("boilerplate"). Just make sure that the letter you print out has been personalized to reflect the specifics of the job and interest of the client.

Providing firm quotations

Another way of pricing creative services is by firm job quotation. Rather than estimating by hourly or daily fees, some artists simply consider what the client will pay, or what others are charging for similar work. The artist then provides a firm quotation or price. If accepted, he or she is expected to live with it, regardless of how much time the project actually takes. The only exception is if the project specifications later change substantially.

Clients often prefer job quotations because they provide firm figures around which budgets can be developed. They also provide protection against billing surprises. Inasmuch as job quotations are similar to the way most other products and services are bought and sold, for many organizations this is also a more familiar way of working.

For artists, an up-front job quotation assures there will be no after-the-fact discussion about a bill's appropriateness when it lands on the client's desk. Further, it provides an opportunity to price "what the market will bear" when there is little competition or price sensitivity. It allows making an occasional killing on those assignments where working fast and efficiently is possible. Generally, the more routine the assignment is, the easier and safer it is to provide job quotations.

Despite these attractions, experience indicates that providing firm quotations is not appropriate for most artists, except for routine assignments for well-known clients. It is particularly risky for those who are relatively inexperienced or are just starting out in business.

The reason is simply that most assignments are too likely to change, and the way our work is evaluated is simply too subjective. In short, there is just too little precision in our business; too many ways we can be taken advantage of.

The bottom line on job quotations is this: They are only good for those who are experienced and well off enough to be gamblers. For everyone else, the best way to price creative services is to have an hourly rate, to estimate how many hours a given job will take, then to multiply one times the other. The resultant figure can then be modified slightly, if necessary, to accomodate competitive situations. Such a procedure also provides a rational basis from which to defend your charges to a questioning client, as opposed to having a client believing you simply pulled a figure out of your hat.

Use-based pricing

Should the use of creative work affect what is charged for it? If so, how much? These questions have perplexed artists for well over a century. Further, in the past few decades changes and growth in the communications industry have complicated the situation by creating something of a pricing double standard.

For most graphic design assignments, clients simply expect to pay the creator and own the work. Period. Most clients, especially those with concerns about reacting quickly to market conditions and maintaining competitive uniqueness, look askance at any artist desiring a use-based fee. Even those who don't mind will often use such a request as an opportunity to negotiate a lower price.

For many illustration assignments, however, selling one-time rights, pricing according to exposure, and royalty fee arrangements are common, although less so than in the past. In such cases, the practice is to arrive at a base price (usually the time involved in creating, multiplied by hourly rate, plus expenses) and consider it as normal for one-time rights, and/or local exposure in major media or national exposure in minor media. After that, everything is negotiable with the upper limit normally being twice again the base price (100% more). In exceptional circumstances, the original price is sometimes tripled.

Royalty fee arrangements—for children's books illustrators—for example, are an exception to the above inasmuch as everything—initial payment and royalty fee—is negotiable. When negotiating a royalty fee arrangement, most artists try to get as much money up front (the initial payment) as possible. Also, they make sure that the royalty fee is figured on gross receipts (total income), not on net receipts (income after expenses). And they never enter into a royalty arrangement with a firm that does not have a strong reputation for honesty.

Exposure fees arrangements—a base price plus an additional charge based on exposure—is a common practice for certain assignments with high market impact. They are seen, although not common, in logo, corporate identity and package design work. The same considerations as with royalty fee arrangements apply.

How to handle price inquiries

If the query is by phone or mail, provide a "ball-park" figure, a price range, and/or your hourly rate. Never be more specific without detailed job specifications. In other words, provide enough information to qualify the possible client as serious, but no more.

If you are asked about how you charge during a portfolio showing, it's best to say something to the effect of, "I'll cover that completely in just a few minutes." In other words, dodge the issue until you've had a chance to show why the quality of your work makes whatever you charge a bargain.

If asked about the price of a specific job, never be specific. Say something to the effect of, "I can't remember exactly. It seems to me this was in the range of $2,500 to $4,000 (give up to a 100 percent range), but I'll be happy to look it up and get back to you."

At the end of a portfolio showing, briefly and without embarrassment or apology, describe how you charge. For example: "I charge $75 per hour for my time. What this means is that the design of an eight-page brochure normally runs from $2,500 to $4,000 depending upon complexity. Of course, I always give a specific estimate as soon as a job is clearly defined and before I start work."

How to handle price objections

Whenever a client says "you're very expensive," agree. But also say that when price is considered in the context of quality, experience, or service (pick whatever your strengths are), your price is actually quite reasonable. In short, *when value rather than just pure cost is considered, your price is very competitive.*

Under no circumstances apologize for what you charge. No professional ever apologizes for charging an honest fee, and neither should you.

Also, never lower your price to meet an arbitrarily-derived budget. If your price does not fit the client's budget, that's his or her problem, not yours. Whenever you lower a price to match a budget, the client will probably believe your original price was inflated.

What if the client has a legitimate budget problem? Be creative. Offer to work with him or her to find ways in which the job specifications can be modified so that both the budget and your creative fees can be maintained. ("I can give you the same impact by innovative use of two-color, rather than four-color printing.")

It is nearly always best in the long run if you stick to your estimated price, even when it means turning down work you need badly. To do otherwise may make you look like a struggling (read unreliable) artist who needs work; or one whose pricing is not well thought out and is arbitrarily derived; or a pseudo-professional who doesn't have high standards. Besides, almost without exception you'll find that any client who hassles you on price will also hassle you later on procedures, the quality of your work, or the way you schedule the job.

If, even so, you decide that it's in your best interest to negotiate a price that is lower than your initial estimate, always do it on an exceptional basis. And make sure that the client understands that you are making an unusual exception, and why. ("Although your budget is below what I normally charge, I would like to have more [type] work in my portfolio. Therefore, . . .")

What to charge for

In a word, everything. One of the more common mistakes artists make when estimating or billing a job is not considering all the expenses they incur, or services they perform. Sometimes these omissions only cut into short-term profitability, other times they affect long-term viability. To make sure you don't fall into this trap, remember to consider the following when preparing an estimate, or doing your billing.

Time. It's critically important you account for all the time you actually put into a job.

Experience shows that the only way to assure this is strict time recording each and every day.

When estimating a job, always add 10 to 25 percent to the number of estimated work hours to account for unforseen delays and difficulties.

When calling upon prospective clients, limit your free calls to one presentation meeting; after that inform the client you must charge for your time.

Charge for meeting, consultation and creative time at the same rate. If you work on a computer, all your working time is creative time; there is no longer any need to break out "mechanical" or "preparation time." If you still do much mechanical work by hand, bill this at two-thirds your rate for creative time. Otherwise, breaking out different rates only confuses the client and makes bookkeeping more difficult for you.

Travel. Travel time to local clients (within 25 or so miles) is normally considered an overhead expense. Beyond 25 or so miles, travel time is usually billed to the client as work time, except in cases where it might be appropriate to make an exception in order to be competitive with other suppliers located closer.

Other travel billing arrangements: Some artists bill at two-thirds their normal rate; some bill at their normal rate, but make sure they also do client work when sitting on an airplane; some travel in the evening and charge half their normal rate.

All major travel expenses—plane fares, hotel accommodations, airport transporation, meals—should be itemized and billed at cost. Receipts for expenditures over $25 should be submitted with invoices.

It is your option whether or not to break out and bill minor travel expenses. Some artists consider parking fees, automobile mileage, and cabs to meetings to be billable. Others consider accounting for such minor expenses to be too troublesome and consider travel expenses within a certain radius of their office to be part of their non-billable overhead. (See the previous comment on "nickel-and-dime accounting.")

Whichever way you choose to account for local travel expenses, make sure you consider them, and make sure the client understands in advance how they will be covered.

Expenses and markups. As with travel, all major miscellaneous expenses—delivery charges, reference materials, long-distance calls—should be billed. Likewise, it is your judgment whether or not to bill for minor miscellaneous expenses such as special supplies, copies and short long-distance calls.

If you purchase a lot of expensive outside materials and services—such as writing help, type, photography, and printing—you will probably want to mark up these bills before including them in your invoice to the client. The lowest mark up should be 15 percent, the highest 30 percent; the average is 25 percent. Do what is most common in your community. Marking up large expenses is a fair procedure, reflecting your handling of the work and the fact that you must pay the invoice before being paid by the client.

Another option is to have invoices for outside services and supplies sent directly to the client. This eliminates the markup and possibly the profitability that comes with it, but it also eliminates any risk of having to cover large bills if the client is late in paying your invoice. Many cost-conscious clients like it better this way, too.

When working with a printer who will invoice the client directly, you may wish to approach him about a "finder's fee." Many artists feel a fee of up to five percent is appropriate inasmuch as most larger printers pay their salespeople a commission of 10 percent or more. Other artists prefer not to ask for money, instead building-up "good-will credits" that they can cash in when a favor is needed, such as getting their own promotional material printed.

Terms and conditions

Payment in thirds. An increasingly used, if not "standard," pricing and billing procedure for artistic work is one third of the estimate upon acceptance of an assignment, one third upon client approval of the first creative submission, and one third upon satisfactory job

completion. Some artists ask for half (50 percent) up front, especially with unknown clients, or whenever there will be a large cash outlay before getting paid.

Although how strongly you choose to encourage this arrangement depends upon your competitve situation, don't be overly concerned about client sensitivity. It is probably less of a consideration than you believe. If a client should balk at giving you money up front, you can always make "special arrangements."

Keep this thought in mind: *Cash flow is as important to your financial success as how much you charge.*

Net 30. The accepted payment standard for business invoices is, as it has been for decades, 30 days. This is usually expressed as "Net 30." Never let a client tell you that times have changed, that for instance "Net 60" is now normal. This may be the way a particular client chooses to operate (and you may opt to accept it), but it is *not* the business norm.

You should inform each potential client by a clear statement on every proposal, estimate and invoice that "Net 30" is your payment standard. Also make sure "Net 30" appears on the client's purchase order or other internal payment authorization. If not, ask why.

A 45-day collection average. To judge how well your accounts receivable procedures are working, how well you manage your cash flow, simply look at how long it takes, on average, from the time you send an invoice until you receive a check.

If your collection average is 45 days or less, you are doing fine, there's no need for change. If, however, your collection average is 45-60 days, you should be concerned. If it is 60-90 days, you have a problem. And if it is over 90 days, financial disaster is just over the horizon.

Marketing to Galleries

by Victoria + Dodd

All the tips, hints and information in the world won't be of any service to an artist trying to market his work, unless he knows his ultimate goal. Pinning down precisely what this goal is may be the most difficult aspect of a marketing effort, for goals are as numerous and as varied as artists.

For instance, it matters whether you want to be represented by a gallery because you want to be taken seriously or because you want to make a living at your art. In the case of the latter, you need to have some idea of what "making a living" means to you. It could be that a small apartment in a small town with a rented studio space suits you fine. It could be that your aspirations are loftier. You have to know where you want to go before you can map out how to get there. The mapping-out process also involves setting intermediate goals — discovering and/or deciding on the steps that will take you from where you are to where you want to be.

The goal-setting process is most easily begun with you, a pencil, a piece of paper, and nobody else! Nothing interferes more in setting your own personal goals than well-meaning friends and family who have their own ideas about your art and where it, and you, should go. Once you have set your goals, however, the support of your friends and family is invaluable; for you have chosen a difficult path, and knowing that you don't walk it alone can help you get through those particularly difficult times.

Goals

Now you are alone, with pencil and paper, and no distractions. Now what? You begin asking yourself serious questions: What do I want from my art? What do I want from my life? Where do I want my art to be seen? Whom do I want to see my art? How much money do I want to make from my art? (and the corollary question), Do I want to work fulltime at my art or will it be a second income for me? The answers to these questions will be your goals and to a large extent will determine the path you follow to reach them.

Let's say your ultimate goal is to be a recognized artist in your region of the country and to supplement your current income with art sales in the range of $5,000 a year. What do you do next? Your first intermediate goal might be to be represented by one gallery in your area within six months. (Setting deadlines for your goals is very important psychologically. Our goal achieving mechanism is much more impressed by goals with deadlines than by goals with a time frame of "sometime." Napolean Hill's *Think and Grow Rich* gives a good basic background to those unacquainted with basic goal setting principals.) Okay, now find that gallery. You need to find out which ones exist in your area and what kind of work they handle. Gathering this information might take you two months and is your first step in finding your gallery.

You might set yourself a deadline of preparing your presentation to galleries within another two months, leaving you with two months to make presentations to galleries and prepare yourself and your body of work for that wonderful day when a gallery looks at you and your work and says, "We want you!" If you don't have enough work completed to fill a few walls or take up enough floor space to have a one-artist show, you're not as ready as

Victoria + Dodd *are collaborative artists represented by a number of galleries located from Pennsylvania to California to as far away as Japan.*

you should be. So another of your intermediate goals needs to be enough work completed and available to fill the needs of your first gallery.

Before we go on to the details of finding the right galleries for you, we would like to share with you some of the creative possibilities that you may encounter in the process of choosing goals and reaching them. We use the phrase "creative possibilities" to include other phrases like: "goal changing," "pitfalls," "surprises" and "goal reevaluating," which describe the dynamic and creative process of marketing art, in many ways rivaling the creative processes of creating the art itself. For example, you may set yourself a deadline of six months and reach it in three. First of all, congratulate yourself for your success. You deserve it.

Or perhaps you have reached your deadline, but not your goal. This time, too, is a time for reevaluating. What went wrong? Was your time frame realistic? Was your goal one that *you* really wanted? Or was it really someone else's goal? Is it time to change goals? Or is it merely time to give yourself more time?

There are pitfalls in this goal-reaching process, and we're familiar with them because we've spent time in several of them. If you set a goal that you don't really believe you can reach, for example, there's little chance you will reach it. If you believe you could reach it, but don't feel you're worthy of it, you probably won't reach it as well. Your state of mind is very important, so do what you have to do to take good care of it. Don't be discouraged by your setbacks or overly encouraged by mere good luck. Nor should you be discouraged by the seemingly effortless success of others. Just do what you have to do to get where you want to go, and be kind to yourself along the way.

Galleries

Whether you live in a small town or a big city, the easiest galleries to find, and find out about, are going to be the ones closest to you. There's really no substitute for a live visit to a gallery both to see the types of work it handles and to feel the atmosphere it projects. These factors are equally important because the gallery you choose to handle your work is representing *you*, presenting *you* to the public. Just because a gallery deals primarily in watercolor or landscape art doesn't necessarily mean that it's the right place for your watercolors or landscapes.

Hang around awhile and see how the sales staff presents the work, how they sell, or if they sell. Are they friendly? Are they professional? Knowledgeable? Do they seem to know about the artists they handle? Make sure the things that matter to you matter to them. If they don't, find another gallery. There are plenty to pick from and you need to feel comfortable with the people who will be handling your work.

You need to be able to trust the gallery that will represent you. This is not to say that a gallery owner needs to be your best friend, but that person does need to be someone you feel is reliable, responsible and ethical. Such traits are not easily discernible long distance; however phone conversations and letters can tell you a lot about a gallery. This task will prove much easier to a person who trusts his instincts, but here are a few pointers for those of you who haven't exercised your instincts lately.

If your initial call to a gallery receives a cold and hurried response, don't decide that it's not the gallery for you. It could be they're quite busy, or you caught someone on a bad day. If the response was positive, and you were told to send slides of your work, do it. You'll learn more from the next contact the gallery makes with you, both in the attitude they display and in the amount of time it takes them to respond. If the response was a partial negative (they told you they only review at a given time of the year or are too busy right now), try again later. If, however, the response is an outright negative, forget it. When a situation presents you with even a glimmer of hope, go for it. But when someone slams a door in your face, find another door. There are plenty of doors.

But how do you find those doors? Many big cities, such as Philadelphia, Chicago and

Washington DC have gallery guides designed strictly for artists trying to market their works. You can find out from local art associations or a local library if such a publication exists in your area. Likewise, you can contact libraries in other cities to find out what's available there. Most libraries have information centers staffed by delightful people who like to find out things for other people. If your phone demeanor is pleasant, you will find a wealth of information available to you.

In addition, there are books, such as *Artist's Market*, which list galleries and the types of works they carry. There are also the art magazines. Art magazines tend to be focused either on a particular locale or on a particular genre of work. If your interests happen to coincide with one of these magazines, you're fortunate. If, however, your interests have yet to be categorized by a given magazine, then try a magazine with a more general scope, such as *The Artist's Magazine* or *American Artist*, where the focus changes from month to month. And don't forget about *Art in America's Guide to Galleries*, a comprehensive national guide. The really persistent can try telephone directories, obtainable for any city in the country for a price. In a big city, canvassing a telephone directory's yellow pages can be a sizable job. It can also work.

Presentation: Slides

Once you locate a gallery that you've decided to approach, the next step is to present your works to that gallery. Long distance means one thing—slides. In many big cities, a gallery will require you to submit slides even if you are local, for although you will show your work in person, you'll need slides to leave with them.

To say that the quality of your slides has to be good would be a serious understatement. the fact. "Good" may be good enough for your Aunt Selma in Topeka, but what you want for slides that will be representing your work to a gallery is nothing short of excellent.

Photographing art is an art in itself. There are books written on the subject, and you can do it yourself. In fact, there are many benefits to doing it yourself. Chief among them are cost and, particularly for artists who work three-dimensionally, lighting. Also you know that your work is in good hands.

But photographing your own works is time consuming and, if you don't already know how to do it, will involve a large investment of time in learning and acquiring experience. You have to weigh the alternatives and decide how to proceed. One option may be to barter your work with a photographer for his services—a joint promotion may be the result.

What matters most, as far as the slides are concerned, is that they present your work as nearly perfectly as possible. There are few words as unpleasant to hear as, "You know, it looked different on the slide." Choose a photographer with the same care with which you choose a gallery. And make sure you will have a financial agreement if you're not satisfied with the results of a shoot. If the lighting or colors aren't right, do you pay for the film to reshoot? For the time? For anything? Iron out all of the details before the first shoot takes place because when things go wrong, "ironing" can be difficult.

Make sure your photographer or studio understands that you will need to write information on your slides, so they need to be in plain mounts. And check on pricing. Often you can get reduced prices on large numbers of slides, which can be helpful (if you need that many slides).

Slides in hand, the next step is to get them to a gallery. They will need to be labeled with the following information: your name, the title of the work, the copyright date, an arrow or other indicator of the top of the work, the medium, and the size of the work. Use a fine point, black marker. If you make a mistake, remount the slide. Your presentation needs to appear as professional as your work does. Most full-service photography stores carry slide mounts. Simply open the old mount, remove the slide film, and slide it into the new mount. Be careful to keep your fingers off the picture area.

The labeled slides then need to be housed in a slide sheet or presentation mount. For

mailing use a good quality, polyethylene slide sheet. This means one that does not flop over when held in a vertical position.

Slide list

Also include a slide list with your slides, and try to list the slides in the same order in which they appear in the slide sheet. The slide list should have all the information that is on your slides. If pricing information is necessary, the slide list is where that information should appear. Prices do not appear on the slides unless requested. This enables you to adjust prices as necessary without having to repeatedly remount your slides.

The purpose of a slide list is twofold. It allows someone to set up your slides in a projector and view them with the information easily available. It is also handy for the gallery owner to have when clients are reviewing the work. So, even when making a presentation in person, bring a slide list.

Artist's statement

There is no question that excellent slides are essential to a presentation. But there are other things to consider as well. Even if you are making a presentation in person, you will need an Artist's Statement. An Artist's Statement is a brief explanation of why you do what you do. In a presentation that has been mailed, it stands in your place. In a personal presentation, it is something for a gallery owner to refer back to. Just as you want to know what a given gallery is about, so too will a gallery want to know you. And the Artist's Statement can replace your resume if you feel you don't have enough achievements to list.

Resume

A resume for a gallery presentation is really no more than a chronological list of your achievements in the field you have chosen and, when you are just beginning your endeavors, any related fields as well. For instance, this is the place for your educational background and any awards for art that you may have received while in school. Once you have a show or three to your name, you'll probably want to drop the school awards. When you have accumulated enough credits to make a decent showing, the resume can stand on its own, nicely placed on a single page. Till then you may want to add it as a few lines at the bottom of your Artist's Statement, as we did when we were starting out.

Update your resume regularly. As soon as you receive notification that you will be in a given show, you're entitled to list that show on your resume. Perhaps this is a good place to extol the virtues of a word processor. If, and when, you can afford to buy one ... do. Not only does it make resume updates a cinch, it makes the whole task of marketing about 80 percent easier. Once you have written a cover letter, or anything else, you need never do it again. Changes can be made as necessary and with a minimum of bother.

"Self"-promotion

Unlike slides or a resume, a good photograph of yourself is not essential to a marketing effort, but, especially in a mailed presentation, it is highly recommended. People like to have an idea of whom they're dealing with; it's only human to be curious. A black-and-white photograph is fine, but the photograph, like the Artist's Statement, should show you as you wish to be seen, since ultimately it may be used by the gallery for publicity purposes.

When appearing at a gallery in person, remember that first impressions are potent: Be on time and look like you meant to look that way, whatever way that is. There's no substitute for the look of confidence, so you may want to give yourself a little pep talk just prior to your meeting.

Clips

In addition to the other elements in your marketing package, you'll want to include news clips if you have any. A little local news story shows a gallery that the public is interested in you. A review of your work from any type of publication shows that not only are you of interest but that you have experience as well. A couple of clips should do the job; don't overdo it.

More mailing tips

When mailing a presentation, you'll want to tend to a few other details as well. A cover letter is essential. It should introduce you and briefly explain how you came to discover that your work was suitable for that particular gallery. If you spoke to someone at the gallery prior to sending in your presentation package, refer to that contact in the letter. This technique makes your presentation seem like the second time the gallery has dealt with you; it makes you more familiar to them.

Be sure to include the best way to contact you so that, should they be interested in your work, they don't spend fruitless hours trying to call you at a time when you're not usually available. This would definitely not be the best way to begin your working relationship!

Your presentation materials should all be of good quality. If you can't afford to have letterhead printed, just use 20-pound bond. Tyvek envelopes are recommended for both the outgoing package and the self-addressed stamped envelope (SASE). Slide sheets have very rigid edges and can cut through even manila. And don't forget to attach the proper postage to the SASE! It may mean no return of your materials.

To ensure the appearance of the contents of your mailing package, it is best to enclose one piece of board of some sort. It should be clean. Aside from that, the choice is yours. Illustration board looks good but is heavy, increasing postage charges. Corrugated cardboard is lighter but may not be suitable for a more elegant presentation. Foam core takes a bit of a beating and can't usually be used more than once but does an adequate job and is lightweight.

Business card

One thing that every serious artist intent on marketing should have, whether making presentations in person or through the mail, is a business card. Unlike letterhead, there is no substitute for a business card. The minimum amount of information on a business card is your name, address and phone number. Ideally, though, it should remind the reader of the card of what it is you do. Business cards do not have to be expensive. A little creative thought goes a long way in business-card design, and, even if you're graphically brain-dead, most business card outlets have someone on hand who can help you think.

Include a business card in your mailing package; leave a couple behind at galleries you visit; give them to anyone who asks you what you do. Business cards are the cheapest form of advertising.

Recordkeeping

If you've just made a presentation to a gallery, then you've just done a lot of work. Even if you've only been walking into gallery after gallery in your city, you've absorbed a lot of information. You don't want to forget all you've learned, and you certainly don't want to forget what you sent out to what gallery. There's only one solution to these potential quandaries, a solution many creative people don't care for. It's called recordkeeping. But it doesn't have to be a daunting task.

Recordkeeping doesn't have to be more than a verbal sketchbook. For instance, when you go from gallery to gallery, if anything stands out either negatively or positively, make a note of the gallery name, a person's name if necessary, and two or three catch words that

will remind you of what happened. A little spiral notepad and a pen or pencil is all the equipment you'll need.

The same applies to when you send out a mailing package: include the gallery name and person you addressed it to, address, phone number, which slides you sent and when. That's all you need! And how else are you going to remember when to call the gallery if they haven't contacted you? Recordkeeping doesn't need to be complicated. It just needs to be done.

Let's say a gallery really likes your work but would like to see other examples of your work—in other tones. If you can't remember and have to ask them what you sent them slides of, you're going to seem pretty unprofessional. Writing things down can take a few minutes but it pays off in a big way.

Gallery representation

Now that you have some good ideas about how to approach galleries, you need to have a few more about what to do with them once you get them. Galleries are a strange phenomenon. Many gallery owners and directors are artists themselves, or former artists. Most like artists, and not surprisingly, they can be as strange as artists themselves. So be prepared.

If you've struggled to make yourself professional and businesslike in order to find your gallery, it would be most disappointing to discover that your gallery is less than professional in its approach. Galleries that have been in business for several years have established a reputation. Good or bad, find out what the reputation of your gallery is. Get to know the owners and the director. Are you comfortable with them? Do you trust them? Are you willing to trust them with hundreds or thousands of dollars worth of your work?

If the gallery is new, there will be no reputation to work with. In this case it is that much more important to get to know the owners (and the gallery director, if there is one) in order for you to know how to conduct yourself—and to protect yourself if need be.

Contracts

There are two basic ways to work with galleries: with a written contract and without one. For legal advice about contracts, contact your attorney. If you don't have one, your local arts association can probably put you in touch with your local Volunteer Lawyers for the Arts, which has a branch organization in most major cities. A contract presents in writing exactly what the gallery will do for the artist and what the artist will do for the gallery. For example, it could state that the gallery will exhibit the artist's work for a specified period of time, that it will give the artist two one-artist shows during the next two years and will work to generate publicity for the artist. It could also state that the artist would pay the gallery 50 percent commission (a common commission rate in many galleries) on all sales by the gallery, and that the artist will provide photographs, slides, and work to the gallery at the gallery's request.

A gallery may want exclusive rights to represent the artist in a given geographical area. This would mean you could not be represented by other galleries in the area and probably would not be able to sell your own work there either. If a gallery can achieve your sales goals for you, giving them exclusive rights makes sense. But if you need more than one gallery or need to supplement the gallery's sales with your own, you don't want to give up your rights by signing an exclusive contract. The right to sell your work is valuable. Don't treat it lightly.

Should you always have a contract with a gallery? We have worked both with and without one. A written contract protects both parties to some extent, but keep in mind that the legal costs to enforce a contract may be as much as those to enforce your rights without one. If the gallery violates the contract, it may be easier to enforce your rights than it would be without a contract. On the other hand, if you violate the contract, the advantage rests

with the gallery. Each situation is different. Evaluate yours with the help of an attorney, and make as informed a decision as you can. If you have chosen your gallery well, the relationship should be a good one. Just remember, as the number of dollars involved increases, so does the desirability of working with a written contract.

Is your gallery doing its job?

If you have a contract, you can compare what your gallery is doing with the terms of the contract and have a good start in determining its performance. In addition, you can compare its performance in relation to how it is helping you achieve your long and short term goals. If your goals involve sales, is your gallery selling anything? If your goals involve publicity, is your gallery getting you any?

Keep in close contact with your gallery. Make sure they're aware of your new work and whatever publicity you're generating for yourself. Keep them updated with new slides and photographs as they become available. Your gallery probably represents a number of artists besides you. So you need to constantly remind them of you and your work so they have you in mind when they speak to potential buyers. Galleries exist to promote artists and sell work. These purposes probably fit nicely with your goals as an artist. Help the galleries help you. And if they don't help you, find new galleries.

Rejection/acceptance

Unless your experience is very unusual, your work will be rejected more often by galleries than it will be accepted. So what! You're looking for the galleries who want you. Rejections are the marketplace's way of telling you to go onto the next one. Or, to quote the bumper sticker, "You have to kiss a lot of toads before you find a handsome prince!"

Unfortunately, rejections feel about as bad as kissing toads . . . probably worse. Your heart and soul are there for all to see in your art, and it is quite a personal thing when someone says "no" to your heart and soul. But you have chosen the life of an artist, and so you must persevere through the rejections in order to find your galleries. Remember that each gallery is a business with its own customers. In order to stay in business, the gallery has to show work that its customers will buy. The owner or gallery director may love your work, but if she doesn't know to whom she can sell it, she often won't risk showing it.

Take each rejection as just another step on your path to the next acceptance. You must maintain the enthusiasm about your work that brought you to create it and market it in the first place. Allowing rejections to affect your attitude will only stifle your marketing efforts and make your life a lot less fun.

We as artists can have a wonderful life because creating is one of life's luxuries. And bringing our creativity to our audience, where they can share in our creative job, is a privileged activity enjoyed by relatively few. But the pitfalls of the marketplace and the natural disinclination of many artists to apply their creative energy to marketing have left a lot of artists sad and disappointed with the business aspects of art. You must overcome yourself, many times, in order to achieve your goals.

Each of you, as you market your art, will have opportunities to achieve your goals. Anticipate your opportunities and be prepared for them. When you do miss an opportunity, as you most probably will on occasion, learn from your mistake, make the necessary change and keep going.

Our world needs more beautiful things to look at. It needs more culture. It needs more challenging and positive images. It needs more creativity. It needs more art. If you have put your whole self, your heart, and your soul, into your art, then it needs *your* art. And it needs you to put it where the world can see it.

The Business of Art

As a fine or freelance graphic artist, you have many jobs. You're not only expected to be a creative artist, but you're also your own secretary, salesperson, lawyer and accountant. Whether you're a painter, illustrator, graphic designer or cartoonist, you must constantly deal with the business of art. While some artists consider the business side a "necessary evil," every freelancer realizes the benefits good business practices provide. By selling your work in the most effective manner, you build your professional image while fulfilling your creative potential. Good business practices pave a smoother path for your journey to creative success.

This section provides general guidelines to securing and building your business through self-promotion, submitting your work and professional business practices. A special feature on marketing your work through the mail by Rhode Island School of Design professor David A. Niles describes an effective way to put together a sample package.

Who needs self-promotion?

Getting noticed is the most important step in establishing yourself. Your artwork needs to be noticed by the right people. The best way to do this is to plan an effective self-promotion campaign.

Loosely defined, self-promotion is the art of grabbing attention. It is an ongoing process of building name recognition and reputation. By promoting yourself, you let potential clients know who you are, what you do, how well you do it and why hiring you is a smart and profitable decision.

How do you do it? The name of the game is making the right contacts. At first, the best place to start is right in your own backyard. Local contacts are mainly established through word of mouth and referrals. Your friends, relatives and neighbors all have contacts; many might own a business. Volunteer to illustrate posters for local fundraising events. Join organizations, both art-related and community ones, to get acquainted with fellow artists and local business people. Begin to network with local artists, who will let you know which art directors are open to new talent. The more people who know you are available, the better your chances are of getting an assignment.

The next step — making contacts

After you complete a few assignments, the next step in establishing yourself as a professional artist is to develop a list of contacts, both within and out of your local area. Reading the listings in *Artist's Market* will help you determine where you want to sell your work. You can compile a mailing list of names, addresses, phone numbers and contact people of your best prospects. Note if the company wants to be contacted through the mail, by phone or through an agent and also what materials the art director likes to review. Do as much research as you can on the companies which interest you. Comb the resource directories, trade publications and annuals such as *American Illustration*, *The Creative Black Book*, *Print's Regional Design Annual* or *Communication Art's Illustration Annual* to see if their work is featured and to acquire additional names and addresses. Make a master list of your leads. Many artists keep index cards for each potential client. On each card you can note the client's specialty, the name of the art buyer, the firm's address and phone number. Then there is room to note your observations about the client—what type of style is used, a special feature spread or advertisement the company has done that you admire, or if the

client has a certain slant to its work. The few extra minutes you spend in compiling these cards will pay off, because you will be able to send the right materials to potential clients.

You'll either make contact through the mail or by phone. Whether you call or write, be pleasant, clear, succinct and try to sound confident. Explain who you are, what your discipline is and why your style is significant. If you have had many assignments, tell the art director where he may have seen your work and list some of your clients. The best way to use the telephone is in conjunction with an introductory letter mailed a week ahead of the call; then use the call itself to determine interest. Keep in mind that art directors and art buyers are very busy people; oftentimes they find phone calls annoying and may only be able to give you 15 seconds of their time. Make sure you know the name of the art buyer and the correct spelling of the name. Follow up your call by mailing samples of your work. See "Marketing Your Work Through the Mail: The Sample Package" for instruction in this area.

How to present a portfolio

It is important that if the art director has expressed interest in your sample package, or if he has not responded, you should follow-up with a phone call and, if he is interested, request an appointment to show your portfolio to the art director, either through the mail or in person. If the art director suggests you drop off your portfolio, remember that a drop-off is not a turn-down and at many places this is automatic policy. It also may make it easier for you to meet with the art director the next time. If the art director says he is not interested, keep your chin up and call the next one on your list. If he has agreed, now is the chance to display the creative and professional artist you are.

The overall appearance of the portfolio affects your professional presentation. A neat, organized three-ring binder is going to create a better impression than a bulky, time-worn leather case. The most popular portfolios are simulated leather with puncture-proof sides that allow the use of loose samples. The size of the portfolio should be dictated by the size of your work. Avoid the large "student" variety because it is too bulky to spread across an art director's desk. The most popular sizes are between 11×14 and 18×24.

No matter what format you choose for the case, you must follow a few basic principles in presenting its contents. You are showing your portfolio to this art director because, based on the research you have done, you have determined that your work is appropriate for this market. The pieces in your portfolio should be germane to the company. If you're showing your portfolio to an ad agency art buyer, you're not going to bring a lot of greeting card samples. An art director will look for consistency of a particular style or technique. She wants to be sure that your work is solid and will continue to be so. Choose only your best work. Quality is better than quantity.

Select 10 or 12 examples of your best work and bring along 10 extra samples in case the client wants to see more of a particular type of work that you're not showing in your portfolio, interior illustration, for example.

Plan to spend anywhere from 10 to 30 minutes presenting your work. Try to be self-confident and remember that, for the most part, the less said, the better. Usually the art director just wants to see your work and may become irritated if subject to a life story. Allow her to flip the pages while you give a one-line description of each piece. If she has questions about one—the client, the purpose of the assignment, the result, etc., then that's your chance to talk.

If you were called in to talk about a specific job, this is the time to find out about its scope, budget and schedule, along with showing your portfolio. If you are introducing your work to a client for future assignments, make sure you leave behind samples (labelled with your name, address and telephone number) and your business card.

Since the drop-off policy is prevalent, have at least two or three portfolios at hand. One can be left when necessary, another can be used on personal calls, while the third can be

sent to out-of-town prospects. Mini-portfolios are handy for simultaneous submissions. Let it be known that you will retrieve your portfolio either the next morning or the following evening. Most businesses are honorable; you don't have to worry about your case being stolen. However, things do get lost; make sure you've included only duplicates, which can be insured at a reasonable cost. Remember to tag each portfolio with your name and address so you can easily identify it.

Two books which include important information on sample packages and portfolio presentations are *The Professional Designer's Guide to Marketing Your Work*, by Mary Yeung and *The Designer's Commonsense Business Book*, by Barbara Ganim.

Packaging your work

Your primary goal in packaging is to have your samples, portfolio or assigned work arrive undamaged. Before packaging original work, make sure you have a copy (photostat, photocopy, photograph, slide or transparency) in your file at home. If changes are necessary on an assigned job, you can then see on your copy what the art director is discussing over the phone. Most importantly, if your work is lost, you can make a duplicate.

Flat work can be packaged between heavy cardboard or Styrofoam. Cut the material slightly larger than the piece of flatwork and tape it closed. It is wise to include your business card or a piece of paper with your name and address on it on the outside of this packaging material in case the outer wrapper becomes separated from the inner packing. The work at least can then be returned to you.

The outer wrapping, depending on package size and quality of inner wrapping, may be a manila envelope, a foam-padded envelope, a "bubble" package (one with plastic "bubbles" lining the inside), or brown wrapping paper. Use reinforced tape for closures. Make sure one side is clearly addressed.

Check the various types of envelopes and packaging materials available at your local art supply, photography or stationery stores. If you're going to be doing a lot of mailing, buy in bulk quantities. The price is always lower.

Packing original works such as paintings takes several layers of protective coverings. The outer layer protects the work from physical damage, while the inner layer provides a cushion. The outer package must be sturdy, yet easy to open and repack. If you are mailing a flat work that is unframed, consider rolling it into a cardboard tube that can be found at appliance and furniture stores. A cardboard container is adequate for small pieces, but larger works should be protected with a strong outer surface, such as laminated cardboard, masonite or light plywood. Mounted, matted or framed pieces are irregularly shaped and require extra cushioning material such as Styrofoam. When packaging a framed work, wrap it in polyfoam or heavy cloth, cushion the outer container with spacers (any cushioning material that prevents a work from moving), then pack the artwork carefully inside so that it will not move when shipped.

Mailing

The U.S. Post Office mail classifications with which you will be most concerned are First Class and Fourth Class, more commonly called parcel post. First Class mail is the type used every day for letters, etc. If the piece you are mailing is not the usual letter size, make sure to mark it First Class. Fourth Class is used for packages weighing 1 to 70 pounds and not more than 108 inches in length and girth combined.

The greatest disadvantage to using these classes of mail is that you cannot be guaranteed when the package/letter will arrive. If time is of the essence, consider the special services offered by the post office such as Priority Mail, Express Mail Next Day Service and Special Delivery. For overnight delivery, check to see which air freight services are available in your area, the most familiar of which is probably Federal Express.

Certified mail includes a mailing receipt and provides a record of delivery at the ad-

dressee's post office. This type of mail is handled like ordinary mail, but you can request a return receipt on certain types of mail as your proof of delivery.

Cost is determined by weight, size and destination of the package and automatically includes insurance up to $100. You can purchase additional insurance.

UPS does have wrapping restrictions. Packages must be in heavy corrugated cardboard, with no string or paper on the outside, and be sealed with reinforced tape. UPS cannot guarantee how long it will take a package to arrive at its destination but will track lost packages. It also offers Two-Day Blue Label Air Service to any destination in the U.S., and Next Day Service in specific zip code zones.

Greyhound Bus Lines and some commercial airlines also offer same-day or overnight package delivery. Check locally for rates and restrictions.

Finding the right price

Negotiation is the art of reaching a mutual agreement so that both parties feel satisfied with the outcome. When a client describes a project to you, you are hearing the client's needs and wants. She will never know *your* needs unless you speak up.

Each job will present you with a new and different pricing situation. Experience is often the best teacher, but even in the beginning, there are a few rules to follow. First, convey a positive attitude and listen carefully. Try to put yourself in your client's place so you can "hear" what he is really saying. When you speak, do it slowly and distinctly so the art buyer will slow down and listen to you.

So that you will be in a position to quote a price that is fair to both you and the client, you need to develop an hourly rate. After you establish an hourly rate and have completed many jobs, you will be able to quote a fee by knowing how long it usually takes to complete a similar assignment. See the upfront article on pricing by Cameron Foote to find out how to arrive at an hourly rate and set your fees accordingly.

Copyright

According to a report published in the *Graphic Artist's Guild Newsletter*, there are approximately 250,000 artists working in the visual arts. Yet, only about 20% of the works created in a year are registered.

This figure points to a sad lack of knowledge about the copyright law. This section will touch upon the basics of copyright law so that you will be able to enjoy your creative rights.

The copyright law protects the creator of a work when the idea for a work is fixed in tangible form. Copyright protects the *expression* of an idea, not the idea itself. A copyright gives its owner the exclusive rights to reproduce, sell, distribute, display and publish artwork and to make reproductions from it. "Copyright is an exclusive right," says Roger Gilcrest, a patent attorney based in Cincinnati, Ohio. "It excludes other people from copying your work without your permission."

What can you copyright? You can copyright any work that has sprung from your creative efforts and is fixed on paper or any other tangible medium such as canvas or even in computer memory. Reproductions are copyrightable under the category of compilations and derivative works.

What can't be copyrighted? Ideas are not copyrightable. To protect an idea, you must use non-disclosure agreements or apply for a patent. Copyright protects the form but not the mechanical aspects of utilitarian objects. While you can copyright the form of your "Wally the Whale" lamp, you can't stop other people from making lamps. You can also copyright the illustration of Wally painted on the lamp.

How do you get copyright protection? Your work is automatically protected from the date of completion until the date of publication. When your work is published, you should protect your work by placing a copyright notice on it.

What is a copyright notice? A copyright notice consists of the word "Copyright" or its

symbol ©, the year of first publication and the full name of the copyright owner. It must be placed where it can easily be seen, preferably on the front of your work. You can place it on the back of a painting as long as it won't be covered by a backing or a frame. Always place your copyright notice on slides or photographs sent to potential clients or galleries. Affix it on the mounts of slides and on the backs of photographs (preferably on a label).

If you omit the notice, you can still copyright the work if you have registered the work before publication and you make a reasonable effort to add the notice to all copies. If you've omitted the notice from a work that will be published, you can ask in your contract that the notice be placed on all copies.

When is a work "published?" Publication occurs when a work is displayed publicly or made available to public view. Your work is "published" when it is exhibited in a gallery, reproduced in a magazine, on a poster or on your promotional pieces.

How long does copyright protection last? Once registered, copyright protection lasts for the life of the artist plus 50 years. For works created by two or more people, protection lasts for the life of the last survivor plus 50 years. For works created anonymously or under a pseudonym, protection lasts for 100 years after the work is completed or 75 years after publication, whichever is shorter.

How do I register a work? Write to the Copyright Office, Library of Congress, Washington DC 20559. After you receive the form, you can call the Copyright Office information number (202)479-0700 if you need any help. You can also write to the Copyright Office (address your letter to Information and Publications, Section LM-455) for information, forms and circulars. After you fill out the form, return it to the Copyright Office with a check or money order for the required amount, a deposit copy or copies of the work and a cover letter explaining your request. For almost all artistic works, deposits consist of photographs, either transparencies (35mm or 2¼ × 2¼) or prints (preferably 8 × 10). For unpublished works, send one copy; send two copies for published works. You will need a certificate of registration which offers you more in-depth protection than the copyright notice can.

Do I have to register my work? You can register either before or after publication. The only time you must register your work is when you are planning to sue for infringement. However, it is always better to be protected from the start. You will not be entitled to attorney's fees or statutory damages if the infringement occurs before the date of registration (unless, in the case of published work, registration is made within three months after publication).

What is a transfer of copyright? Ownership of all or some of your exclusive rights can be transferred by selling, donating or trading them and signing a document as evidence that the transfer has taken place. When you sign an agreement with a magazine for one-time use of an illustration, you are transferring part of your copyright to the magazine. The transfer is called a license. An exclusive license is a transfer that's usually limited by time, place or form of reproduction, such as first North American serial rights. A nonexclusive license gives several people the right to reproduce your work for specific purposes for a limited amount of time. For example, you can grant a nonexclusive license for your hippopotamus design, originally reproduced on a greeting card, to a manufacturer of plush toys, to an art publisher for posters of the hippopotamus, or to a manufacturer of novelty items for a hippopotamus eraser.

What constitutes an infringement? Anyone who copies a protected work owned by someone else or exercises an exclusive right without authorization is liable for infringement. In an infringement case, you can sue for an injunction, which means you can stop the infringer from reproducing your work; for damages (you must prove how much money you've lost); and to prevent distribution of the infringing material.

For further information on copyright, refer to last year's *Artist's Market* for the article

"The Business of Copyright," *Legal Guide for the Visual Artist*, by Tad Crawford and *Make it Legal*, by Lee Wilson.

Contracts

In simplest terms, a contract is an agreement by which two parties bind themselves to perform certain obligations. Contracts may be written, oral or tacit, but to protect yourself from misunderstandings and faulty memories, make it a practice to have a written contract signed and dated by you and the party you are dealing with.

The items you want specified in your contract will vary according to the assignment and the complexity of the project; but some basic points are: your fee (the basic fee, possibly a kill fee, payment schedule, advances, expense compensation, etc.); what service you are providing for the fee; deadlines; how changes will be handled; and return of original art.

Read carefully any contract or purchase order you are asked to sign. If the terms are complex, or if you do not understand them, seek professional advice before signing. If it is a preprinted or "standard" contract, look for terms which may not be agreeable to you. Because of a 1989 Supreme Court decision, "work for hire" is not as ominous as it once was—when it meant losing all rights to the work created. Now a freelance artist working at someone else's direction will still own rights to the work unless the type of work fits into the law's enumerated categories and the artist agrees in writing to transfer those rights.

Further information on contracts is available in *Business and Legal Forms for Illustrators*, *Business and Legal Forms for Graphic Designers* and *Legal Guide for the Visual Artist*, all by Tad Crawford; *The Artist's Friendly Legal Guide*; *Graphic Artists Guild Handbook of Pricing and Ethical Guidelines*; and *Contracts for Artists* by William Gignilliat.

Recordkeeping

If you haven't kept good business records, all your talent and art skills will mean nothing when it comes time to give an account of your business profitability to the IRS. Recordkeeping is usually considered a drudgery by artists, yet it is an essential part of your business. A freelancer is an independent businessperson and, like any other entreprenuer, must be accountable for financial statements.

You don't have to be an accountant to understand basic recordkeeping principles. Two accounting terms that you'll need to know are "accounting period" and "accounting method." Your accounting period determines the time frame you'll use to report income and claim deductions. Most likely you'll elect a calendar year accounting period, beginning January 1 and ending December 31. An accounting period other than a calendar year is known as a fiscal year.

Once you've selected your accounting period, you'll need to determine which accounting method best suits your business. Your accounting method will determine what income and expenses will be reported during a particular accounting period.

There are two basic accounting methods, the cash method and the accrual method. The cash method, which is used by most individuals, records income when it is received or when a gallery or agent receives it for you. Similarly, expenses are recorded when you pay them. Expenses paid in advance can only be deducted in the year in which they occur. This method typically uses cash receipts and disbursement journals, which record payment when received and monthly paid expenses.

The accrual method is a little more involved. In this method you report income at the time you earn it instead of when you receive it. Also, you deduct expenses at the time you incur them rather than when you pay them. If you use this method, which lists projects as they are invoiced or expenses as they are incurred, you will probably keep accounts receivable and accounts payable journals. The accrual method is best for artists with huge inventories.

You are free to choose any accounting method you wish. However, once you've made

that decision, you may only change your accounting method with the approval of the IRS. In order to request a change of accounting method, you must file Form 3115, Application for Change in Accounting Method, with the Commissioner of the Internal Revenue Service in Washington, D.C. not more than six months after the beginning of the year in which you wish to make a change.

The next step to good recordkeeping is to decide which records to keep. A good rule is to keep any receipt related to your business. It's important to hold on to cancelled checks, sales slips, invoices, cash receipts, cash register tapes, bank statements, bills and receipts for goods and services you have bought. Ask for a receipt with every purchase. If you're entertaining a client at a business dinner, ask the waiter or cashier for a receipt. Keep a record of the date, place, cost, business relationship and the purpose of the meeting. Don't forget to record driving expenses. Keep your business and personal records separate. Also, if you're a painter and an illustrator, keep separate records for each pursuit.

Here are a few tips for setting up an effective recordkeeping system. The first thing you should do is divide your income and expense records into separate headings. Then you should divide each into various subheadings. A handy method is to label your records with the same categories listed on Schedule C of the 1040 tax form. That way you'll be able to transfer figures from your books to the tax form without much hassle. Always make an effort to keep your files in chronological order.

There are various bookkeeping systems at your disposal. A single-entry bookkeeping system records expenses as they are incurred; you add them up at the end of the year. This can be recorded in a journal or diary. A double-entry system is more complicated, involving ledgers and journals in which every item is entered twice—once as a debit and once as a credit—so the books are always in balance.

Taxes

Knowing what income you must report and what deductions you can claim are the two most important factors in computing your taxes. To know these factors, you must first determine whether you are a professional or a hobbyist. You must prove you are a professional in order to claim business-related deductions, which reduce the amount of taxable income you have to report.

Some of the factors which set you apart as a professional are: conducting your activity in a business-like manner (such as keeping accurate records, keeping a business checking account); your expertise and training; the time you devote to your work and whether you have no other substantial source of income; and your history of income or losses. You must show a profit for three out of five years to attain a professional status.

A recent change in federal tax law benefits illustrators, designers and fine artists. This is the revision of the 1986 tax reform bill, The Technical Corrections Act. Under this revision, which became effective on 1988 returns, artists can now deduct any expenses accumulated in the production of images, within the same calendar year in which they were produced. Previously, these expenses had to be spread out over a number of years until the image brought a profit.

Another important related change under the 1986 Act is the development of a new classification for individuals who incorporate as businesses. This is the Personal Service Corporation, or PSC classification. In most cases, individuals who incorporate their businesses in a number of professional areas automatically become classified as PSC's, and they are taxed at a very high rate of 34 percent. It is important to note that design, illustration and fine art are not professions that come under this category. Every year the IRS receives claims from artists who apparently don't know this.

What is deductible?

As a professional who owns an unincorporated business, you must report business expenses and income on Schedule C of Form 1040, Profit (or Loss) from Business or Profession. The following costs of doing business are deductible on Schedule C:

● Advertising expenses. This includes the costs of direct mailings; ads placed or aired on television, radio or in the Yellow Pages; the cost of printing business cards and show invitations.

● Capital expenditures. A capital expenditure is the purchase of a "permanent" fixture such as computer. If you spend less than $10,000 on one item which you use for your business, you may deduct the cost on your Schedule C. If you use the item only to a certain extent for your business, you can deduct that percentage of the item's cost on Schedule C.

● Car and truck expenses. There are two methods of handling this deduction. The IRS allows you to claim 24¢ per mile travelled on business-related trips for up to 15,000 miles, then 11¢ per mile after that. Or you can take a percentage of all auto-related expenses. No matter which method you elect, keep a travel log which notes the date, distance travelled and the reason for the trip. This information will be vital if you are audited.

● Courses and seminars. Courses such as framing and slide photography workshops are deductible because they are related to your profession.

● Depreciation. The costs of business-related items priced over $10,000 can be "capitalized." By capitalizing an item, you deduct a percentage of the cost of the item each year for a certain number of years. The IRS determines the life of the item and the percentages allowed each year.

● Dues and publications. This includes membership fees and subscriptions to art-related magazines and newsletters.

● Freight. This deduction applies only to shipping commissioned works to clients or shipping entries to juried shows.

● Home office. If you use a portion of your home as your studio, you may deduct certain expenses. Refer to the subhead "Home office deduction" in this article for further details.

● Insurance. You can deduct insurance on artwork and your studio.

● Legal and professional expenses. These are deductible if applied to your business.

● Studio rental. This deduction is straightforward, unlike the home office deduction.

● Taxes. Taxes on real and personal property used in your business, and payroll or FICA taxes for your employees are deductible. Federal, state and local business taxes are claimed on Schedule A.

● Travel, meals and entertainment. Only 80 percent of expenses incurred in entertaining clients is deductible.

● Miscellaneous expenses. This includes framing, entry fees and postage, or any expense directly related to running your business.

Estimated tax is the method you use to pay tax on income which is not subject to withholding. You will generally make estimated tax payments if you expect to owe more than $500 at year's end and if the total amount of income tax that will be withheld during the year will be less than 90 percent of the tax shown on the previous year's return. In order to calculate your estimated tax, you must estimate your adjusted gross income, taxable income, taxes and credits for the year. Form 1040ES provides a worksheet which will help you estimate how much you will have to pay. Estimated tax payments are made in four equal installments due on April 15, June 15, September 15 and January 15. For more information, refer to IRS Publication 505, Tax Withholding and Estimated Tax.

The self-employment tax is a social security tax for individuals who are self-employed and therefore cannot have social security tax withheld from their paychecks. In order to be liable for self-employment tax, you must have a net self-employment income of $400 or more. Your net income is the difference between your self-employment income and your allowable business deductions. You will compute the amount of self-employment tax you

owe on Schedule SE, Computation of Social Security Self-Employment Tax. Beginning in 1990, there is a deduction for self-employment tax. The deduction is calculated by multiplying by 7 percent the smaller of: your net income from self employment or $54,256 minus your wages subject to social security tax.

Depending on the level of your business and tax expertise, you may want to have a professional tax advisor to consult with or to complete your tax form. Most IRS offices have walk-in centers open year-round and offer over 90 free IRS publications containing tax information to help in the preparation of your return. The booklet that comes with your tax return forms contains names and addresses of Forms Distribution Centers by region where you can write for further information. The U.S. Small Business Administration offers seminars on taxes, and arts organizations hold many workshops covering business management, often including detailed tax information. Inquire at your arts council, local arts organization or university to see if a workshop is scheduled.

You will be asked to provide your Social Security number or your Employer Identification number (if you are a business) to the person/firm for whom you are doing a freelance project. This information is now necessary in order to make payments.

Home office deduction

A home office deduction allows you to claim a business portion of the expenses incurred for the upkeep and running of your entire home. You may deduct business expenses that apply to a part of your home only if that part is used exclusively on a regular basis as your principal place of business at which you meet or deal with clients, or a separate structure used in your trade or business that is not attached to your residence. Your office must be a space devoted only to your artwork and its business activity.

You may have another business which generates more income than you derive from the sale of your art. For instance, you may have a fulltime job where you have an office at another location. You can still take your home office deduction as long as it's your principal place of business for your secondary source of income.

When a studio is part of the principal residence, deductions are possible on an appropriate portion of mortgage interest, property taxes, rent, repair and utility bills and depreciation.

There are two ways to determine what percentage of your home is used for business purposes. If the rooms in the house are approximately the same size, divide the number of rooms used as your office into the total number of rooms in your house. If your rooms differ in size, divide the square footage of your business area into the total square footage of your house.

Your total office deduction for the business use of your home cannot exceed the gross income that you derive from its business use. In other words, you cannot take a net business loss resulting from a home office deduction.

Rumor has it that anyone who deducts for use of home facilities and equipment automatically runs a higher risk of being audited, especially if the individual is late for filing. So keep a detailed log of business activities taking place in your home office. Record the dates and times the office was used, what was discussed, and all sales and business transacted.

Consult a tax advisor to be certain you meet all of the requirements before attempting to take this deduction, since its requirements and interpretations frequently change.

Sales tax

Check regarding your state's regulations on sales tax. Some states claim that "creativity" is a service rendered and cannot be taxed, while others view it as a product you are selling and therefore taxable. Be certain you understand the sales tax laws to avoid being held

liable for uncollected money at tax time. Write to your state auditor for sales tax information.

If you work on consignment with a shop or gallery, you are not responsible for collecting sales tax since it is the shop or gallery which is making the sale to the consumer. If you sell wholesale, you need not collect sales tax for the same reason. However, you must exchange resale numbers so both parties can show the numbers on their invoices.

In most states, if you are selling to a customer outside of your sales tax area, you do not have to collect sales tax. However, check to see if this holds true for your state. See *The Designer's Commonsense Business Book*, by Barbara Ganim, recently published by North Light Books, for further tax tips.

Insurance

If you are a self-employed artist working out of your home or a separate studio and are not covered by any benefits package, there are two areas of coverage which you need to consider: personal insurance, which includes life, health and disability; and coverage for your business.

Life insurance can be viewed either on a short- or long-term basis. If you want to cover the needs of a specific duration, such as a home mortgage or a bank loan, seek term insurance at the lowest possible rates. Permanent life insurance is a long-term means of accumulating capital; the money which accumulates may be withdrawn, borrowed against or used to pay the premiums on the policy as you grow older.

For health insurance, many freelancers feel it is better to be covered for big problems (such as lengthy hospital stays or long-term nursing care) than for routine medical expenses. You may want to accept a higher total annual deductible—say $2,500 as opposed to $100—in exchange for reducing your premium drastically. Basic coverage protects you for a specified time that pays for most in-hospital costs. Major medical coverage picks up where the basic package stops. Major medical plans cover long-term, catastrophic illnesses; the deductible is usually $1,000 to $1,500 a year.

Disability insurance pays a monthly fee if you are unable to work. This form of protection is normally based on your earnings and your occupation; hazardous jobs require greater protection.

Whether your business is located at home or in an outside office, you should have a small business plan which provides coverage against loss due to fire, theft and liability for the contents of the studio. The more costly your equipment, the greater your coverage should be.

In case an illness prevents you from working, overhead expense protection covers expenses such as rent, electricity, telephone bills and employee salaries. It is available to businesses located outside the home. This short-term plan enables you to resume work after an illness without extra financial pressures.

If there is a condition that needs insuring, there is a policy for it. Compare the policies offered by several companies by sending away for brochures and interviewing agents. Many artists prefer to join a professional organization, such as the American Institute of Graphic Artists or the Graphic Artists Guild, which offers insurance benefits. Coverage under a group plan is significantly less expensive and may offer more comprehensive coverage than individual policies.

The Sample Package: Marketing Your Work Through the Mail

by David A. Niles

For the freelance illustrator or designer, looking for new clients and more challenging opportunities is an ongoing process. In the 90s, the fax machine, fast-delivery systems and related technologies have made it possible for practicing illustrators and designers to live almost anywhere in the country and still service their clients. In addition, establishing new markets—wherever they happen to be—is possible through the simple method of mailing samples of your best work to client prospects.

Mail-marketing is a simple process to organize and takes much less time than perhaps any other method of getting your work before new client prospects. If you compare it to any other method of portfolio presentation, it is the most efficient way to cover not one prospect per call, but many, since any number of "portfolio" packages can be mailed and circulated simultaneously. The function of the mailing package you assemble is to provide answers to a number of questions in the mind of the person receiving the package: Who you are, what you do, where you live, why they should consider using your talent and when and how you can be available to them.

The contents

The specific contents of your mailing package can be easily described:
a) A cover letter
b) Your resume or biographical statement
c) Your business card
d) A promotional card, folder or brochure
e) Samples of your work
f) A reply card
g) SASE for return mailing

● *The Cover Letter.* The purpose of the cover letter is simply to introduce yourself and define the purpose of the enclosed material. This letter should be articulate but precise. You should provide your name, address, phone number and a brief description of the package's contents.

● *The Resume.* Career consultants often disagree about whether resumes help or hinder your fortunes. Some believe that resumes—even the best resumes—are used to screen out people who don't quite match certain criteria, rather than as a device for showing positive strengths. Moreover, it is maintained by some that if as an illustrator or designer you have a considerable track record as a professional, have won some prestigious awards and have

David A. Niles *is Associate Professor of Illustration at the Rhode Island School of Design and a freelance illustrator. He is presently working on a book about professional illustration. It is also an inquiry into the impact of the 90s upon education for illustrators and the professional practice that will result.*

the body of work to match it, a resume is not even necessary. In many cases, a simple biographical sheet or client list that alludes to your professional attainments can be a strong option to a formal resume, and many art directors will agree.

● *Your Business Card.* Along with your portfolio of samples, there is no better way to legitimize your position as a practicing professional than to show a well-designed business card. It is important to include a visual image on your card so the recipient will be able to remember your content and style.

● *A Print Promotion.* This can make a strong contribution to your sample package because it is a designed and printed example of work that amplifies a number of factors that are important to your client's perception of what you do. It indicates the nature of your personal style, how well you can solve a visual communications problem, particularly if your illustrations have a conceptual tone and displays how your work reproduces. An option is to save this promotional piece for a follow-up mailing sent two or three weeks after your sample package.

● *Samples of Your Work.* This is the most important part of your package and should be a well-planned selection of your very best work. If there is any piece that raises the least element of doubt in your mind regarding its quality, leave it out. The same concerns pertain to your marketing package as to your actual portfolio. "When in doubt, leave it out," and "less is more." You must also be sure to include not only samples of work that you know you can do with distinction but also work that you will enjoy doing. Hopefully the two are one in the same.

Inexperienced professionals who are just becoming established in the industry sometimes have an alarming tendency to overload this section of the package with either too many pieces or pieces which lack the singular focus required. Art directors continually lament that too many artists don't succeed in communicating their work through a single voice and only confuse their prospects with too many styles. Obviously, this approach is necessary if a staff job is your goal, but an eclectic approach is rarely appropriate for a portfolio whose main objective is freelance assignments.

Art directors generally like to see a variety of art samples, such as 35mm slide transparencies, C-Print or Cibachrome photographs, photostats of black-and-white work, laser color photocopies and original laminated tearsheets. Remember that things frequently get lost. Try not to part with anything in its original form, which goes for transparencies and photographs as well.

Your slides should be perfectly exposed, and be fitted into a slide sheet of 20. If you have fewer than 20, you can trim back the sheet to accommodate the number needed. C-prints are color prints that are made from original slides of your work and require an internegative, from which the final print is made. The Cibachrome process is another method that does not require an internegative and therefore often provides a more accurate replication of the original.

Your tearsheets, if you have them, are particularly important because they demonstrate that you have worked with clients successfully and have had your work reproduced. If tearsheets are not available, selected pieces can be reproduced at a moderate cost with laser color photocopies, which have become highly successful in providing strong presentation copies of color artwork.

● *A Reply Card.* A simple reply card prepared with your name and address can be included with a brief checklist for your clients to note whether they are interested in your work. Artists who use this system note a consistently high rate of return of reply cards from prospects. If the clients indicate they don't use your type of illustration, you can readily edit their name from your active prospect list. They can then include the completed reply card in the package they return to you.

● *The Self-Addressed, Stamped Envelope.* You *must* include a self-addressed, stamped envelope for the return of any materials to you. If necessary, include in the package instruction

on which materials they can retain for their file, such as color photocopies, photostats or tearsheets.

It is critical that everything included in your sample package be labeled or stamped with your name. If you use a computer, it's very convenient to run off printed labels and fix them to the back of each piece in the package. It is also suggested that a rubber stamp be used to place your name and address on each slide mount so they can easily be identified as your work.

Sending it out

Since mailing regulations tend to change, consult your local post office for rates, as well as suggestions about the best system to use. Generally, a priority mailing system for your mail-marketing program is unnecessary unless there is an urgent need for your prospect to receive the materials by quick delivery.

The contents of your mail-marketing package should also be carefully checked before it is sealed. In most cases a plain manila envelope with a cardboard sandwich for protection is sufficient, but if there is a need to protect any fragile contents, a foam-padded envelope or "bubble" package would be appropriate. To insure careful handling, write "Fragile/Do Not Bend" on the package's cover.

When you initiate a mail-marketing program, keep a log in which you record all pertinent data involving where you mailed each package, the date and specifically what it contained. In addition, after the package has been returned, note the date of return, as well as any information that may have been stated on the reply card.

This highly practical mail-marketing system is a great time-saver for working professionals, who can remain productive in the studio while their sample packages are out in the world, building new clients.

Important Note on the Markets

• *Listings are based on editorial questionnaires and interviews. They are not advertisements (markets do not pay for their listings), nor are listings endorsed by the* Artist's Market *editor.*

• *Listings are verified prior to the publication of this book. If a listing has not changed from last year, then the art director has told us that his needs have not changed — and the previous information still accurately reflects what he buys.*

• *Remember, information in the listings is as current as possible, but art directors come and go; companies and publications move; and art needs fluctuate between the publication of this directory and when you use it.*

• *When looking for a specific market, check the index. A market might not be listed for one of these reasons: 1) It doesn't solicit freelance material, 2) It has gone out of business, 3) It requests not to be listed, 4) It did not respond to our questionnaire, 5) It doesn't pay for art (we have, however, included some nonpaying listings because we feel the final printed artwork could be valuable to the artist's portfolio), 6) We have received complaints about it and it hasn't answered our inquiries satisfactorily.*

• Artist's Market *reserves the right to exclude any listing that does not meet its requirements.*

Key to Symbols and Abbreviations

* New listing
ASAP As soon as possible
b&w Black and white
IRC International Reply Coupon
P-O-P Point-of-purchase display
SASE Self-addressed, stamped envelope
SAE Self-addressed envelope

The Markets

Advertising, Audiovisual & Public Relations Firms

Perhaps the beleaguered advertising industry has suffered long enough. Hit by the country's economic downturn on top of its own three-year-long recession, 1992 may finally bring better days. The most widely followed forecaster of ad spending in the country Robert J. Coen, senior vice president at McCann-Erickson U.S.A., has estimated that ad spending will rise 8.5 percent in 1992, due to the Olympics and the Presidential election—times when consumers are glued to newspapers, radio and TV.

Only time will tell if Coen is right and if so, when it will begin to happen. At the time this book went to press, less advertising was being produced and more creatives were being laid off. Many of them joined the freelance pool. During these highly competitive times, it is paramount that freelance illustrators and designers keep close watch on the look and content of ads, be familiar with the current campaigns of the agency they wish to approach and make sure their portfolios are tailored accordingly.

Print advertising appears to be undergoing a number of changes. In response to economic austerity and the seriousness of this post-war time, the cluttered typographic busyness is being replaced by cleaner and plainer ads. A new simplicity—about direct communication rather than visual allusion—seems to have arrived for the consumer, now more concerned with a product's quality than its image.

While some agree that the recession is causing clients and their agencies to create dull work due to too much precaution, others argue that it is shaking advertising out of its mediocrity and blandness, bringing out the more innovative in creatives, compelling them to give hard thought to the fundamentals of their work. Jay Chiat of Chiat/Day/Mojo and Steven Penchina of Ketchum Advertising are two who have called for a return to the sort of strong emotional content and provocative and memorable ideas indicative of advertising in the 1960's.

Keep abreast of the type of advertising you are interested in by perusing consumer publications, reading graphic art magazines and flipping the channels. Before submitting samples, make sure you understand what the agency does, what freelancers are used for, whether local artists are preferred and the submission procedure required. Don't call if an art director prefers the first inquiry to be via a letter. While some art directors like to see conceptual work (roughs and comprehensives), others want to examine only finished pieces. There are art directors who want to see a variety of work; others expect the freelancer to have done a bit of market research and tailored samples and/or portfolio to their particular needs. Find out what each prefers. As with any query, always have duplicates of everything you send so the agency is free to keep material on file. Also, every submitted piece should be accompanied by a brief description of the project and the instructions you

were given to complete it. Many art directors also like to be told what rate the artist charged and how long it took to do. The listings in this section will give you a bird's eye view of this market and the requirements of each firm.

Payment is either by the hour or by the project. The amount depends upon a variety of factors—the media involved (magazine, local newspaper, etc.), the size of the ad and the company's budget, to name a few factors. Buyouts, one-time use, limited use and arrangements for final ownership of finished art are negotiated with the agency. If research and travel are required, make sure you know upfront who covers the expense.

Public relations firms

Many companies utilize public relations firms to handle publicity and maintain a favorable image for the firm. Freelancers in this area complete a variety of tasks, from logo design to brochure illustration. Remember to send plenty of samples when submitting to these firms. Give the company a clear view of the scope of your work because assignments in this market cover a very broad spectrum. Payment depends on your experience, the project and the company involved.

Audiovisual firms

These firms produce instructional motion pictures, filmstrips, special effects, test commercials and corporate slide presentations for employee training and advertising. Computer graphics and electronic design are gaining in importance as audiovisual vehicles, and there are a growing number of video houses being established as animation specialists. Closely associated with this trend is television art. Many networks and local television stations hire freelancers to design slide shows, news maps, promotional materials and "bumpers" that are squeezed between commercials.

For the names and addresses of additional audiovisual firms, public relations contacts and advertising agencies, check the following sources: the *Standard Directory of Advertising Agencies*, the *Audio Video Market Place*, *O'Dwyer's Directory of Public Relations Firms*, the *Adweek Agency Directory* and the *Redbook*. Weekly publications such as *Advertising Age* and *Adweek* and the daily *The New York Times* business section are helpful for keeping up-to-date on industry news and trends.

Alabama

J.H. LEWIS ADVERTISING AGENCY INC., Suite 220, 1 Chase Corporate Dr., Birmingham AL 35244. (205)733-0024. (205)476-2507. Senior Vice President/Creative Director: Larry D. Norris. Ad agency. Clients: retail, manufacturers, health care and direct mail. Buys 15 illustrations/year.
Needs: Works with illustrators and designers. Uses artists for mechanicals and layout for ads, annual reports, billboards, catalogs, letterheads, packaging, P-O-P displays, posters, TV and trademarks.
First Contact & Terms: Prefers Southern artists. Query. SASE. Reports in 5 days. No originals returned to artist at job's completion. Pays for design by the hour, $30-60. Pays for illustration by the project, $750-1,500. Pays promised fee for unused assigned work.

SPOTTSWOOD VIDEO/FILM STUDIO, 2520 Old Shell Rd., Mobile AL 36607. (205)478-9387. Contact: Manning W. Spottswood. Estab. 1976. AV/film/TV producer. Clients: industry, education, government and advertising. Produces mainly public relations and industrial films and tapes.
Needs: Assigns 5-15 freelance jobs/year. Artists "must live close by and have experience." Uses approximately 1 freelance illustrator/month. Works on assignment only. Uses freelance artists mainly for brochures. Also uses freelance artists for illustrations, maps, charts, decorations, set design, etc.
First Contact & Terms: Send resume or arrange interview by mail. Reports only if interested. Pays for illustration and design by the hour, $35 minimum; by the project, $150 minimum. Considers complexity of project, client's budget, skill and experience of artist, geographic scope of finished project, turnaround time, rights purchased and quality of work when establishing payment.

Arizona

CHARLES DUFF ADVERTISING, Suite 2000, 301 W. Osborn Rd., Phoenix AZ 85013. (602)285-1660. Creative Director: Trish Spencer. Estab. 1948. Ad agency. Full-service multimedia firm. Specializes in agri-marketing promotional materials—literature, audio, video, trade literature. Product specialty animal health. Current clients include: Farnam, Veterinary Products Inc, Bee-Smart Products, Scentry, Inc.
Needs: Approached by 20 freelance artists/month. Works with 1 freelance illustrator/month. Prefers artists with experience in animal illustration: equine primarily and pets. Uses freelance artists mainly for the unusual, beauty and illustration. Also uses freelance artists for brochure, catalog and print ad illustration; retouching; billboards and posters. 35% of work is with print ads.
First Contact & Terms Send query letter with brochure photocopies, SASE, resume, photographs, tearsheets, slides and transparencies. Samples are filed or are returned by SASE only if requested by artist. Reports back within 2 weeks. Reviews portfolios "only by our request." Pays for illustration by the project, $300-600. Buys one-time rights.

FILMS FOR CHRIST ASSOCIATION, 2628 W. Birchwood Circle, Mesa AZ 85202. Contact: Paul S. Taylor. Motion picture producer and book publisher. Audience: educational, religious and secular. Produces motion pictures, videos and books.
Needs: Works with 1-5 illustrators/year. Works on assignment only. Uses artists for books, catalogs and motion pictures. Also uses artists for storyboards, animation, slide illustration and ads. Generally prefers a tight, realistic style, plus some technical illustration.
First Contact & Terms: Send query letter with resume, photocopies, slides, tearsheets or snapshots. Prefers slides as samples. Samples returned by SASE. Reports in 1 month. Provide brochure/flyer, resume and tearsheets to be kept on file for future assignments. No originals returned to artist at job's completion. Considers complexity of project and skill and experience of artist when establishing payment.

***GURLEY ASSOCIATES**, Box 1230, 111 W. Walnut, Rogers AZ 72757. (501)636-4037. FAX: (501)636-9457. Vice President/Senior Art Director: Jim Langford. Estab. 1960. Ad agency. Full-service, multimedia firm. Specializes in packaging and print material. Product specialties are toys and sporting goods.
Needs: Approached by 2-3 freelance artists/month. Works with 1-2 freelance illustrators/month. Prefers artists with experience in toys, automotive, military and space products. Works on assignment only. Uses freelance artists mainly for illustration for packaging. Also uses freelance artists for brochure, catalog and print ad illustration; retouching; and posters. 8-10% of work is with print ads.
First Contact & Terms: Send query letter with brochure, resume, photographs and slides. Samples are filed or are returned by SASE only if requested by artist. Does not report back, in which case the artist should "contact by letter." Call to schedule an appointment to show a portfolio. Portfolio should include "whatever best shows the artist's strengths." Pays for design by the project, $100-3,000. Pays for illustration by the project, $250-7,000. Buys all rights.

PAUL S. KARR PRODUCTIONS, 2949 W. Indian School Rd., Box 11711, Phoenix AZ 85017. (602)266-4198. Contact: Paul Karr. Utah Division: 1024 N. 250 East, Box 1254, Orem UT 84057. (801)226-8209. Contact: Michael Karr. Film and video producer. Clients: industry, business, education, TV and cable.
Needs: Occasionally works with freelancers in motion picture and video projects. Works on assignment only.
First Contact & Terms: Advise of experience, abilities, and funding for project.
Tips: "If you are serious about breaking into the field, there are three avenues: 1) have relatives in the business; 2) be at the right place at the right time; or 3) take upon yourself the marketing of your idea, or develop a film or video idea for a sponsor who will finance the project. Go to a film or video production company, such as ours, and tell them you have a client and the money. Work, and approve the various phases as it is being made. Have your name listed as the producer on the credits."

NORDENSSON LYNN & ASSOCIATES, 1926 E. Ft. Lowell, Tucson AZ 85719. (602)325-7700. Creative Director: Kathryn Polk. Estab. 1963. Ad agency/PR firm. "We are a multi-media, full-service firm strong in print." Specializes in health care, development (real estate), and financial. Current clients include: Intergroup of

The asterisk before a listing indicates that the listing is new in this edition. New markets are often the most receptive to freelance submissions.

Arizona, Tobin Homes, Arizona Commerce Bank and El Dorado Hospital.

Needs: Works with 1 freelance illustrator/month. "We work with local artists (preferably with experience) and artists reps." Uses freelancers mainly for mechanicals and illustrations. Also uses freelance artists for print ad illustration, mechanicals, retouching and lettering. 80% of work is with print ads.

First Contact & Terms: Send query letter with resume, tearsheets, photocopies, slides and SASE. Samples are filed. Samples not filed are returned by SASE only if requested by artist. Reports back to the artist only if interested. Write to schedule an appointment to show a portfolio, include color and b&w samples, or mail original/final art, tearsheets, final reproduction/product, slides. Pays for design by the project, $200-500. Pays for illustration by the project, $75-2,500. Considers complexity of project, client's budget, turnaround time, skill and experience of artist, how work will be used and rights purchased when establishing payment. Rights purchased vary according to project.

Tips: "Get your foot in the door with an initial project, maybe at a lower-priced introductory offer and second project at regular fee."

***PRODUCTION MASTERS INC.**, 834 N. 7th Ave., Phoenix AZ 85007. (602)254-1600. FAX: (602)495-9949. Director Computer Graphics: Michele Kedzior. Estab. 1985. Audiovisual production firm. Full-service, multimedia firm that includes a studio, editing, film, video, audio and computer graphics. Specializes in commercials, industrials and cable. Specialty is consumer. Current clients include: McDonnell Douglas, Evans/PHX, Allied Signal.

Needs: Approached by 4 freelance artists/month. Works with 1 freelance illustrator/month. Prefers artists with experience in medical illustration. Works on assignment only. Uses freelance artists mainly for illustration. Also uses freelance artists for storyboards.

First Contact & Terms: Send query letter with resume. Samples are filed. Does not report back. Call to schedule an appointment to show a portfolio. Portfolio should include thumbnails, roughs, original/final art, b&w and color photostats, tearsheets, photographs, slides, transparencies or demo reel on ¾″ or VHS. Pays for illustration by the project, $50-500. Negotiates rights purchased.

***SWEETWATER SOUND & VIDEO, INC.**, Box 1866, Prescott AZ 86302. (602)445-5050. President: Steve LaVigni. Estab. 1971. Audiovisual firm. Full-service, multimedia firm handling video and audio production for various clients, as well as some print. Specializes in documentaries, educational, cable and direct distribution. Product specialties are educational, nature, old West, entertainment. Current clients include: Ralph Rose Productions, Western Man Productions.

Needs: Approached by 1-2 freelance artists/month. Works with 1-2 freelance illustrators/month. Prefers artists with experience in video, computer graphics, animation on AMIGA. Uses freelance artists mainly for graphics animation. Also uses freelance artists for print ad illustration, storyboards, slide illustration, animation, posters, TV/film graphics, lettering and logos. 20% of work is with print ads.

First Contact & Terms: Send query letter with brochure, photocopies, SASE, resume, photographs, slides, computer disks, ¾″ or VHS videotape. Samples are filed or returned by SASE only if requested by artist. Reports back within 2 weeks. Mail appropriate materials. Portfolio should include photographs, computer disks (AMIGA), video tape VHS ¾″. Payment for design and illustration varies by job and client.

Arkansas

MANGAN RAINS GINNAVEN HOLCOMB, Suite 911, 320 W. Capitol Ave., Little Rock AR 72201. Contact: Steve Mangan. Ad agency. Clients: recreation, financial, consumer, industrial, real estate.

Needs: Works with 5 freelance designers and 5 freelance illustrators/month. Assigns 50 freelance jobs and buys 50 freelance illustrations/year. Uses freelance artists for consumer magazines, stationery design, direct mail, brochures/flyers, trade magazines and newspapers. Also uses freelance artists for illustrations for print materials.

First Contact & Terms: Query with brochure, flyer and business card to be kept on file. Include SASE. Reports in 2 weeks. Call or write to schedule an appointment to show a portfolio, which should include final reproduction/product. Pays for design by the hour, $42 minimum; all fees negotiated.

California

AC&R, ADVERTISING, INC., 2010 Main St., Irvine CA 92714. (714)261-1770. FAX: (714)261-7515. Creative Group Assistant: Denise Pooler. Estab. 1960. Ad agency. Full-service, multimedia firm. Specializes in print, electronic media, outdoor design and collateral. Project specialties are consumer, automotive and retail. Current clients include: KAO Corp., Aaron Bros. Art Marts and Dollar Rent-A-Car.

Needs: Approached by 12 freelance artists/month. Works with 2 freelance illustrators and 1 freelance designer/month. Works mostly with artist reps and prefers artists with experience. Works on assignment only. Uses freelance artists mainly for work that can't be done in-house. Also uses freelance artists for brochure, catalog, print, ad and slide illustration; storyboards; animatics; animation; retouching; TV/film graphics; lettering and logos. Types of illustration needed are editorial, technical and medical. 80% of work is with print ads.

First Contact & Terms: Send query letter with samples that do not need to be returned. Samples are filed and are not returned. Reports back to the artist only if interested. Call or mail appropriate materials: the best examples of the artist's work. Pays for design by the hour, $18-35; by the day, $250-500. Pays for illustration by the hour, by the project or by the day. Buys all rights.

AD VENTURES GROUP, INC., Suite 220, 3100 Lake Center Dr., Santa Ana CA 92704. Executive Vice President: Cathie Underwood. Estab. 1977. Ad agency. Full-service multimedia firm. Specializes in sales promos and retail, including print ads, collateral, direct mail, P-O-P displays, TV and radio broadcast advertising. Current clients include: Pacific Sun Wear, Coleman Spas and Green Foods.

Needs: Approached by 5 freelance artists/month. Works with approximately 2 freelance designers/month. Prefers local artists only with experience in direct mail, fashion, consumer products and services and retail. Works on assignment only. Uses freelance artists for "everything." Also uses freelance artists for brochure, catalog and print ad design and illustration, storyboards, slide illustration, mechanicals, billboards, posters, TV/film graphics, lettering, logos and direct mail design. 50% of work is with print ads.

First Contact & Terms: Send query letter with brochure, photocopies, SASE, resume, photographs, tearsheets, photostats, slides, transparencies or other samples. "Some showing of their work and experience and their fees." Samples are filed or are returned by SASE only if requested by artists. Reports back to the artist only if interested. Write to schedule an appointment to show a portfolio. Mail appropriate materials. Portfolio should include: thumbnails, roughs, original/final art, b&w and color tearsheets, "a good representation of their abilities." Pays for design and illustration by the project. Buys all rights.

***ASAP ADVERTISING**, Suite 207, 29395 W. Agoura Rd., Agoura Hills CA 91301-2500. (818)707-2727. FAX: (818)707-7040. Owner: Brian Dillon. Estab. 1982. Ad agency. Full-service, multimedia firm. Specializes in print advertising, brochures, sales kits, mailers and PR. Product specialties are high tech, OEM and industrial. Current clients include: Aleph International, American Nucleonics Corp., and Diamond "A."

Needs: Approached by 5 freelance artists/month. Works on 2-3 freelance illustration projects/month. Prefers local artists with experience in mechanicals, tight concepts and comps. Works on assignment only. Uses freelance artists for all artwork needs. No staff art dept. Also uses freelance artists for brochure design and illustration, catalog design and illustration, print ad design and illustration, mechanicals, retouching, lettering and logos. 60% of work is with print ads.

First Contact & Terms: Send query letter with resume and photocopies. Samples are filed or are returned by SASE. Reports back within 1 week only if interested. Write to schedule an appointment to show a portfolio. Portfolio should include thumbnails, roughs and b&w samples showing full range of ability (photocopies OK). Pays for design by the project, $40-200; pays for illustration by the project, $100-800. Buys all rights.

B&A DESIGN GROUP, (formerly Anklam Feitz Group), 528 Sonora Ave., Glendale CA 91201-2736. (818)842-5163. Creative Director: Barry Anklam. Full-service advertising and design agency providing ads, brochures, P-O-P displays, posters and menus. Product specialties are food products, electronics, hi-tech, real estate and medical. Clients: high-tech, electronic, photographic accessory companies and restaurants. Current clients include: Denny's Restaurants, CoCo's Restaurants, El Pollo Loco and Pasadena Tournament of Roses.

Needs: Works with 8 freelance artists/year. Assigns 15-20 jobs/year. Uses freelance artists mainly for brochure, newspaper and magazine ad illustration; mechanicals; retouching; direct mail packages; lettering and charts/graphs. Type of illustration needed is editorial, technical and medical.

First Contact & Terms: Contact through artist's agent or send query letter with brochure showing art style. Samples are filed. Reports back only if interested. To show a portfolio, mail color and b&w tearsheets and photographs. Pays for production by the hour, $20-25. Pays for illustration by the project, $600-3,500. Considers complexity of project, client's budget and turnaround time when establishing payment. Rights purchased vary according to project.

ALEON BENNETT & ASSOC., Suite 212, 13455 Ventura Blvd., Van Nuys CA 91423. President: Aleon Bennett. PR firm.

Needs: Works with 2 freelance artists/year. Works on assignment only. Uses freelance artists mainly for work on press releases and advertisements.

First Contact & Terms: Send query letter. Samples are not filed and are not returned. Does not report back.

RALPH BING ADVERTISING CO., 16109 Selva Dr., San Diego CA 92128. (619)487-7444. President: Ralph S. Bing. Ad agency. Product specialties are industrial (metals, steel warehousing, mechanical devices, glass, packaging, stamping tags and labels), political, automotive, food and entertainment.

Needs: Local artists only. Works on assignment only. Uses artists for consumer and trade magazines, brochures, layouts, keylines, illustrations and finished art for newspapers, magazines, direct mail and TV. Prefers pen & ink.

First Contact & Terms: "Call first; arrange an appointment if there is an existing need; bring easy-to-present portfolio. Provide portfolio of photocopies and tearsheets, and client reference as evidence of quality and/or versatility." Reports only if interested. No original work returned to artist at job's completion. Pays by the hour, $5-50 average; by the project, $10 minimum. Considers complexity of project and client's budget when establishing payment.

Tips: "Prefer to see samples of finished work; do not want to see classroom work."

BOSUSTOW VIDEO, 3000 Olympic Blvd., Santa Monica CA 90404. (213)315-4888. Contact: Tee Bosustow. Video production firm. Clients: broadcast series, feature films, commercials, corporate, media promotion and home video.

Needs: Works with varying number of freelance artists depending on projects. Majority of work on in-house computer graphics system. Works on assignment only. Uses freelance artists mainly for titles, maps, graphs and other information illustration.

First Contact & Terms: Hires per job. Send brochure showing art style and resume only to be kept on file. Do not send samples; required only for interview. Reports only if interested. Pays by the project, $50-500. Considers complexity of project, skill and experience of artist, client's budget and turnaround time when establishing payment. Usually buys all rights; varies according to project.

COAKLEY HEAGERTY, 1155 N. First St., San Jose CA 95112-4925. (408)275-9400. Creative Directors: Susann Rivera and J. D. Keser. Art Directors: Thien Do, Tundra Alex, Ray Bauer and Carrie Schiro. Full-service ad agency. Clients: consumer, high-tech, banking/financial, insurance, automotive, real estate, public service. Client list provided upon request.

Needs: Works with 100 freelance artists/year. Assigns 500 freelance jobs/year. Works on assignment only. Uses freelance artists for illustration, retouching, animation, lettering, logos and charts/graphs.

First Contact & Terms: Send query letter with brochure showing art style or resume, slides and photographs. Samples are filed or are returned by SASE. Does not report back. Call to schedule an appointment to show a portfolio. Pays for illustration by the project, $600-5,000.

DIMON CREATIVE COMMUNICATION SERVICES, Box 6489, Burbank CA 91510. (818)845-3748. Art Director: Bobbie Polizzi. Ad agency/printing firm. Serves clients in industry, finance, computers, electronics, health care and pharmaceutical.

First Contact & Terms: Send query letter with tearsheets, original art, photocopies and SASE. Provide brochure, flyer, business card, resume and tearsheets to be kept on file for future assignments. Portfolio should include comps; does not want to see newspaper ads. Pays for design by the hour, $20-50. Pays for illustration by the project, $75 minimum. Considers complexity of project, turnaround time, client's budget and skill and experience of artist when establishing payment.

DOLPHIN MULTI-MEDIA PRODUCTIONS, INC., 1137-D San Antonio Rd., Palo Alto CA 94303. (415)962-8310. FAX: (415)962-8651. Artist Manager: Ellen Coffey. Estab. 1972. AV firm. Full-service multimedia firm. Computer graphics, slides. Specializes in industrial multi-image, speaker support and collaterals. Product specialties are high-tech and biomedical industries, etc. Current clients include: Apple, New Zealand Government, Landor, ACS, J. Walter Thompson, Hills Bros., Levi's, Blue Shield, IBM, Oral B and Pac Bell.

Needs: Prefers artists with experience in computer graphics—Dicomed, Macintosh. Uses freelance artists mainly for computer slide production. Also uses freelance artists for storyboards, slide illustration and animation. 2% of work is with print ads.

First Contact & Terms: Send query letter with resume and slides. Samples are filed. Reports back to the artist only if interested. Mail appropriate materials: 35mm transparencies. Buys all rights.

DUDKOWSKI-LYNCH ASSOCIATES, INC., 150 Shoreline Highway Bldg. E, Mill Valley CA 94941. (415)332-5825. Vice President: Marijane Lynch. "We are a video facility providing Quantel Paintbox images to agencies, producers, corporations and institutions."

Needs: Works with 5 artists/year. "We need airbrush talent, motion graphics, cartoons, and general painting (any medium)." Prefers artists with strong art background and skill, and experience in video or film; best if artist has Quantel Paintbox experience. Uses artists for P-O-P displays, animation, films, video, logos and charts/graphs.

First Contact & Terms: Send resume. Samples are filed. Samples not filed are returned only if requested by artist. Reports back within 1 month. Call to schedule an appointment to show a portfolio, which should include color and b&w final reproduction/product, photographs and video tape. Pays for design by the hour, $15-40 or by the project. Pays for illustration by the image. Considers complexity of project, client's budget, turnaround time and skill and experience of artist when establishing payment. Rights purchased vary according to project.

Tips: "Send resume, follow up call in two weeks. Have samples of work."

EVANS, OGILVIE & PARTNERS INC., Suite 370, 201 Lomas Santa Fe, Solana Beach CA 92075. (619)755-1577. FAX: (619)755-3293. President Creative Director: David Evans. Estab. 1988. Ad agency. Full-service, multimedia firm. Specializes in marketing communications from strategies and planning through implementation in any media. Product specialties are real estate, identities, medical and high-tech. Current clients include: IDM Corp., Eastlake Development Co., Redlands Community Hospital.
Needs: Approached by 3-4 freelance artists/month. Works with 1-2 freelance illustrators and 3-4 freelance designers/month. Works only with artist reps/illustrators. Prefers local artists only with experience in listening, concepts, print and collaterals. Uses freelance artists mainly for comps, design, production and copy. Also uses freelance artists for brochure and print ad design and illustration, storyboards, mechanicals, retouching, billboards, posters, TV/film graphics, lettering and logos. 40% of work is with print ads.
First Contact & Terms: Send query letter with brochure, photocopies, resume and photographs. Samples are filed. Reports back to the artist only if interested. Write to schedule an appointment to show a portfolio or call. Portfolio should include roughs, photostats, tearsheets, transparencies and actual produced pieces. Pays for design by the hour, $30-75; by the project, $150-10,000. Pays for illustration by the project, $75-3,500. Buys first rights, reprint rights or rights purchased vary according to project.

HAYES ORLIE CUNDALL INC., (formerly Orlie, Hill & Cundall, Inc.), 46 Varda Landing, Sausalito CA 94965. (415)332-3625. Contact: Alan Cundall. Ad agency. Current clients include: West Coast Life, Peerless Lighting, Chevron Chemical, Kaiser Health Plan.
Needs: Works with freelance artists when art department is overloaded. Uses freelance artists mainly for work on consumer magazines, stationery design, direct mail, brochures/flyers, trade magazines and newspapers. Also uses artists for layout, paste-up and type specing.
First Contact & Terms: Send query letter and resume to be kept on file for future assignments. No originals returned to artist at job's completion. Pays for design by the hour, $35 minimum, or by the project, fee determined in advance. Considers budget and complexity of project when establishing payment.
Tips: "We're an ad agency with expertise in direct marketing. What I want to see is brilliant selling ideas, magnificently interpreted into ads and other forms of communication."

HAYES ● ROTHWELL, Suite 270, 4699 Old Ironsides Dr., Santa Clara CA 95054. (408)988-3545. FAX: (408)988-3545. Senior Art Director: Daniel Tiburcio. Estab. 1983. Ad agency. Full-service, multimedia firm. Specializes in ads and collateral. Product specialty is high technology. Current clients include: Abekas Video Systems, Cadence and Linear Technology.
Needs: Approached by 5 freelance artists/month. Works with 2-3 freelance illustrators and 2 freelance designers/month. Prefers local artists only. Uses freelance artists mainly for the overload work. Also uses freelance artists for brochure illustration, print ad illustration, mechanicals and lettering. 50% of work is with print ads.
First Contact & Terms: Send query with photocopies and photographs. Samples are filed. Reports back to the artist only if interested or does not report back, in which case the artist should try again! Mail appropriate materials: thumbnails, tearsheets and photographs. Payment for design and illustration is determined by budget. Rights purchased vary according to project.

***THE HITCHINS COMPANY**, 22756 Hartland St., Canoga Park CA 91307. (818)715-0150. President: W.E. Hitchins. Estab. 1985. Advertising agency. Full-service, multimedia firm.
Needs: Approached by 1-2 freelance artists/month. Works with various freelance illustrators and 1 freelance designer/month. Works on assignment only. Uses freelance artists for brochure design and illustration, print ad design and illustration, storyboards, mechanicals, retouching, TV/film graphics, lettering and logo. Needs editorial and technical illustration and animation. 20% of work is with print ads.
First Contact & Terms: Send query letter with photocopies. Samples are filed if interested and are not returned. Reports back to the artist only if interested. Call to schedule an appointment to show a portfolio. Portfolio should include tearsheets. Pays for design and illustration by the project, according to project and client. Rights purchased vary according to project.

DEKE HOULGATE ENTERPRISES, Box 7000-371, Redondo Beach CA 90277. (213)540-5001. Owner: Deke Houlgate. "Our main specialty is publicity; sports promotion; automotive industry provides most of our clientele. We do very little brochure or sales promotion work." Clients: sports and event promotion companies, automotive and specialty products. Client list provided with a SASE.
Needs: Works with 2 freelance artists/year. Assigns 6-12 jobs/year. Uses artists for design, illustration, magazines, retouching and press releases.
First Contact & Terms: Send query letter with brochure. Samples are sometimes filed or are returned by SASE. Reports back within 2 weeks. Write to schedule an appointment to show a portfolio. Pays artist's own rate. "I don't negotiate. Either budget covers artist's rate, or we can't use." Considers client's budget when establishing payment. Rights purchased vary according to project.

HUBBERT-KOVACH MARKETING COMMUNICATIONS, 151 Kalmus, Building B, Costa Mesa CA 92626. (714)751-2160. Senior Art Director: Chris Klopp. Ad agency. Clients: real estate, all product, service.
Needs: Works with 10-20 freelance artists/year. Local artists primarily (southern California). Uses freelance artists mainly for line art/paste-up, b&w and 4-color advertising collateral illustration and layout comps. Especially seeks professionalism (marker skills), efficiency, and deadline awareness.
First Contact & Terms: Send query letter with resume and samples to be kept on file. Accepts any kind of copy that is readable as samples. Samples not filed are returned by SASE. Reports back only if interested. Write for appointment to show portfolio. Pays by the hour, $15-50 average. Pays in 30 days. Considers complexity of the project, client's budget and turnaround time when establishing payment. Rights purchased vary according to project.

DAVID JACKSON PRODUCTIONS (DJP, INC.), 1020 N. Cole St., Hollywood CA 90038. (213)465-3810. FAX: (213)465-1096. President: David Jackson. Estab. 1985. AV firm. Full-service, multimedia firm. Specializes in feature films, television shows, interactive video and records. Current clients include Gendarme and Executive One.
Needs: Approached by 2-3 freelance artists/month. Works with 2-3 freelance illustrators and 2 freelance designers/month. Prefers artists with experience in line drawing and airbrush. Works on assignment only. Uses freelance artists mainly for promo work and jacket art. Also uses freelance artists for brochure design and illustration, storyboards, animation, mechanicals, posters and TV/film graphics. 5% of work is print ads.
First Contact & Terms: Send query letter with resume, SASE and tearsheets. Samples not filed and are returned by SASE. Reports back within 15-30 days. Mail appropriate materials: roughs, original, final art and tearsheets. Pays for design and illustration by the project. Payment is negotiable. Buys all rights.

EDWARD LOZZI & ASSOCIATES, Suite 101, 9348 Civic Center Dr., Beverly Hills CA 90210. FAX: (818)995-3376. Office Manager: Brian Cowan. Estab. 1979. PR firm. Full-service, multimedia firm. Specializes in magazine ads and documentaries. Product specialties are medical, entertainment, books and architectural.
Needs: Approached by 3-5 freelance artists/month. Works with 2-6 freelance illustrators and 2-6 designers/month. Prefers artists with experience in airbrush, pen & ink, washes and line drawing. Also uses freelance artists for brochure design and illustration, print ad design and illustration, storyboards, animation, billboards, posters and logos. 40% of work is with print ads.
First Contact & Terms: Send query letter with brochure, photocopies, SASE, resume, photographs and tearsheets. Samples are filed or are returned by SASE only if requested by artist. Reports back to the artist only if interested. Mail appropriate materials. Pays for design by the hour, $200 minimum; by the project, $500-1,000; by the day, $500 minimum. Pays for illustration by the hour, $150 minimum; by the project, $500-5,000; by the day, $500 minimum. Buys all rights.

LUTAT, BATTEY & ASSOC., INC., Suite 2-A, 910 Campisi Way, Campbell CA 95008. (408)559-3030. Creative Director: Bruce Battey. Estab. 1976. Ad agency. Specializes in print advertising, both consumer and trade; also collaterals. Product specialties are computers and food.
Needs: Approached by 6-10 freelance artists/month. Works with 3 freelance illustrators and 5 freelance designers/month. Prefers artists with experience in high technology, food and fashion. Works on assignment only. Uses freelance artists for all clients. Also uses freelance artists for brochure, catalog and print ad design and illustration, storyboards, slide illustration, mechanicals, retouching, billboards, posters, lettering, logos and desktop publishing. 60% of work is with print ads.
First Contact & Terms: Send query letter with brochure, resume, photographs and tearsheets. Samples are filed or are returned by SASE only if requested by artist. Reports back within days, only if interested. Write to schedule an appointment to show a portfolio. Mail appropriate materials: thumbnails, roughs, original, final art, b&w and color tearsheets, photographs and transparencies. Pays for design and illustration by the project. Rights purchased vary according to project.

LEE MAGID MANAGEMENT AND PRODUCTIONS, Box 532, Malibu CA 90265. (213)463-5998. President: Lee Magid. Estab. 1963. AV and PR firm. "We produce music specials and recordings."
Needs: Works with 4 freelance illustrators/month. Works on assignment only. Uses freelancers mainly for "anything print." Also uses artists for brochure, catalog and print ad design, storyboards, posters, TV/film graphics and logos. 50% of work is with print ads.
First Contact & Terms: Send query letter with brochure, photostats and SASE. Samples are filed or are returned by SASE only if requested by artist. Reports back to the artist only if interested. To show a portfolio, mail photostats; include color and b&w samples. Pays for design and illustration by the project. Considers how work will be used when establishing payment. Buys all rights or reprint rights.
Tips: "Send your work in, but keep originals. Send clear copy of work."

***NEALE-MAY & PARTNERS**, 4920 El Camino Real, Los Altos CA 94022. (415)967-4444. FAX: (415)967-9180. Creative Director: Dino Smalles. Estab. 1986. PR firm. Full-service, multimedia firm. Specializes in promotions, packaging, corporate identity, collateral design, annuals, graphic and ad design. Product special-

ties are food, hi-tech (computers), hospitals and financial. Current clients include: Del Monte Foods, Fujitsu America, Parnell Pharmeceuticals and Sun Microsystems.
Needs: Approached by 20 freelance artists/month. Works with 2-3 freelance illustrators and 2-3 freelance designers/month. Prefers local artists only with experience in all areas of manual and Mac capabilities. Works on assignment only. Uses freelance artists mainly for brochure design and illustration, print ad illustration, mechanicals, retouching, billboards, posters, lettering, logos and cartoons.
First Contact & Terms: Send query letter with "best work samples in area you're best in." Samples are filed. Reports back within 15 days. To show a portfolio, mail thumbnails, roughs, originals, final art and color slides. Pays for design by the hour, $15-25. Pays for illustration by the project, $200. Negotiates rights purchased.

ON-Q PRODUCTIONS, INC., 618 E. Gutierrez St., Santa Barbara CA 93103. President: Vincent Quaranta. AV firm. "We are producers of multi-projector slide presentations. We produce computer-generated slides for business presentations." Clients: banks, ad agencies, R&D firms and hospitals.
Needs: Works with 10 freelance artists/year. Assigns 50 jobs/year. Uses freelance artists mainly for slide presentations. Also uses artists for illustration, retouching, animation and lettering.
First Contact & Terms: Send query letter with brochure or resume and slides. Samples are filed or are returned by SASE. Reports back only if interested. Write to schedule an appointment to show a portfolio, which should include original/final art and slides. Pays for design by the hour, $30 minimum, or by the project, $100 minimum. Pays for illustration by the hour, $25 minimum or by the project, $75 minimum. Considers complexity of project, client's budget, turnaround time and skill and experience of artist when establishing payment.
Tips: "Artist must be *experienced* in computer graphics and on the board. The most common mistake freelancers make are "poor presentation of a portfolio (small pieces fall out, scratches on cover acetate) and they do not know how to price out a job. Know the rates you're going to charge and how quickly you can deliver a job."

PALKO ADVERTISING, INC., Suite 207, 2075 Palos Verdes Dr. N., Lomita CA 90717. (213)530-6800. Art Director: Chuck Waldman. Ad agency. Clients: business-to-business, retail and high-tech.
Needs: Uses artists for layout, illustration, paste-up, mechanicals, copywriting and accurate inking. Produces ads, brochures and collateral material.
First Contact & Terms: Prefers local artists. Send query letter with brochure, resume, business card, "where you saw our address" and samples to be kept on file. Write for appointment to show portfolio. Accepts tearsheets, photographs, photocopies, printed material or slides as samples. Samples not filed returned only if requested. Reports back only if interested. Pays for design by the hour, $15-30. Pays for illustration by the hour, $15-30, or by the project, $50-1,500. Negotiates rights purchased.

REID ADVERTISING AND PUBLIC RELATIONS, 3184-G Airway Ave., Costa Mesa CA 92626. (714)979-7990. FAX: (714)979-1510. President: John Reid. Ad agency and PR firm. Full-service, multimedia firm. Specializes in b&w newspaper and 4-color magazine ads, brochures and collaterals. Product specialty is new homes. Current clients include: Centex Homes and Taylor Woodrow Homes.
Needs: Approached by 2-3 freelance artists/month. Works with 1 freelance illustrator and 1-2 freelance designers/month. Prefers local artist with experience in real estate advertising. Works on assignment only. Uses freelance artists mainly for design and production. Also uses freelance artists for brochure design, print ad design, mechanicals, retouching, billboards, posters and logos. 50% of work is with print ads.
First Contact & Terms: Send query letter with brochure and photocopies. Samples are filed or returned by SASE only if requested by artist. Reports back to the artist only if interested. Mail appropriate materials: roughs and b&w and color photostats. Pays for design by the hour, $15-25 or by the project. Pays for illustration by the project, $250-750. Buys all rights.

RICHARD SIEDLECKI DIRECT MARKETING, Suite C-170, 2674 E. Main St., Ventura CA 93003-2899. (805)658-7000. Direct Marketing Consultant: Richard Siedlecki. Consulting agency. Clients: industrial, publishers, associations, air freight, consumer mail order firms and financial institutions. Client list provided for SASE.
Needs: Assigns 15 freelance jobs/year. Works with 2 freelance designers/month. Works on assignment only. Uses artists for consumer and trade magazines, direct mail packages, brochures, catalogs and newspapers.
First Contact & Terms: Artists should be "experienced in direct response marketing." Send query letter with brochure, resume and business card to be kept on file. Reports only if interested. Pays by the hour, $25 minimum; by the project, $250 minimum. Considers complexity of project and client's budget when establishing payment. "All work automatically becomes the property of our client."
Tips: Artists "must understand (and be able to apply) direct mail/direct response marketing methods to all projects: space ads, direct mail, brochures, catalogs."

***21ST CENTURY VIDEO PRODUCTIONS,** 738 E. Katella, Orange CA 92667. (714)538-8427. FAX: (714)997-0693. Estab. 1986. Audiovisual firm. Full-service, multi-media firm. Specializes in video productions. Current clients include: IBM, Ronald Reagan, CHSOC and Electro-Plasma.

Needs: Approached by 2 freelance artists/month. Works with 1 freelance illustrator and 1 freelance designer/year. Prefers local artists with experience in video productions. Uses freelance artists mainly for animation, TV/film graphics and logos. 10% of work is with print ads.
First Contact & Terms: Send query letter with video. Samples are filed. Reports back to the artist only if interested. To show a portfolio, mail video. Pays for design by the project. Buys all rights.

VIDEO RESOURCES, Box 18642, Irvine CA 92713. (714)261-7266. Producer: Brad Hagen. AV firm. Clients: automotive, banks, restaurants, computer, transportation and energy.
Needs: Works with 8 freelance artists/year. Southern California artists only with minimum 5 years of experience. Works on assignment only. Uses artists for graphics, package comps, animation, etc.
First Contact & Terms: Send query letter with brochure showing art style or resume, business card, photostats and tearsheets to be kept on file. Samples not filed are returned by SASE. Considers complexity of the project and client's budget when establishing payment. Buys all rights.

DANA WHITE PRODUCTIONS, INC., 2623 29th St., Santa Monica CA 90405. (213)450-9101. Owner/Producer: Dana C. White. AV firm. "We are a full-service audiovisual production company, providing multi-image and slide-tape, video and audio presentations for training, marketing, awards, historical, and public relations uses. We have complete inhouse production resources, including slidemaking, soundtrack production, photography, and A/V multi-image programming." Clients: "We serve major industry, such as GTE, Occidental Petroleum; medical, such as Oral Health Services, Whittier Hospital, Florida Hospital; schools, such as University of Southern California, Pepperdine University, and Clairbourne School; and public service efforts, such as fund-raising."
Needs: Works with 4-6 freelance artists/year. Assigns 12-20 freelance jobs/year. Prefers artists local to greater LA, "with timely turnaround, ability to keep elements in accurate registration, neatness, design quality, imagination and price." Uses artists for design, illustration, retouching, animation, lettering and charts.
First Contact & Terms: Send query letter with brochure or tearsheets, Photostats, photocopies, slides and photographs. Samples are filed or are returned only if requested. Reports back within 14 days only if interested. Call or write to schedule an appointment to show a portfolio. Payment negotiable by job.

***WINMILL ENTERTAINMENT,** 813 N. Cordova St., Burbank CA 91505-2924. (818)954-0065. FAX: (818)841-1198. Art Director: George Pomeroy. Estab. 1987. AV firm. Full-service motion picture and music video film production and off-line editing company. Specializes in documentaries, shorts, video long forms, music videos, motion picture development and production. Current clients include: Atlantic Records, A&M Records, Columbia Pictures and Pacific Bell.
Needs: Approached by 1-4 freelance artists/year. Works with 1-2 freelance illustrators and 1-3 freelance designers/year. Works only with artist reps. Prefers artists with experience in motion pictures, television and music. Works on assignment only. Uses freelance artists mainly for storyboards, set stills, film promotion, advertising, set designs, etc. Also uses freelance artists for print ad design, storyboards, mechanicals, retouching, posters, TV/film graphics and logos. 10-25% of work is with print ads, depending on motion picture project.
First Contact & Terms: Contact only through artist rep. Samples are not filed and are returned by SASE. Reports back within 1-3 weeks if interested. Write to schedule an appointment to show a portfolio. Portfolio should include thumbnails, tearsheets and photographs. Pays for design and illustration by the project depending on per project budget allocations. Rights purchased vary according to project.

Los Angeles

THE ADVERTISING CONSORTIUM, 1219 S. La Brea, Los Angeles CA 90019. (213)937-5064. Contact: Kim Miyade or Vicki Screen. Estab. 1985. Ad agency. Full-service, multimedia firm. Specializes in print, collaterals, direct mail, outdoor, broadcast. Current clients include Bernini, Meridian Communications, Tuxedo Center and Murray's Iron Works.
Needs: Approached by 5 freelance artists/month. Works with 1 freelance illustrator and 3 freelance art directors/month. Prefers local artists only. Works on assignment only. Uses freelance artists and art directors for everything (none on staff). Also uses freelance artists for brochure, catalog and print ad design and illustration, mechanicals and logos. 80% of work is with print ads.
First Contact & Terms: Send query letter with brochure, resume, anything that does not have to be returned. Samples are filed. Write to schedule an appointment to show a portfolio. "No phone calls, please." Portfolio should include: original/final art, b&w and color photostats, tearsheets, photographs, slides and transparencies. Pays for design by the hour, $60-75. Pays for illustration by the project, based on budget and scope.

ANCHOR DIRECT MARKETING, Suite 100, 7926 Cowan Ave., Los Angeles CA 90045. (213)216-7855. FAX: (213)215-1655. President: Robert Singer. Estab. 1986. Ad agency. Specializes in direct response.
Needs: Number of freelance artists that approach each month varies. Prefers local artists and artists with experience in direct response and illustration. Works on assignment only. Uses freelance artists mainly for layout.
First Contact & Terms: Call to schedule an appointment to show a portfolio. Portfolio should include "direct response work."

DELLA FEMINA, MCNAMEE WCRS, 5900 Wilshire Blvd., Los Angeles CA 90036. (213)937-8540. FAX: (213)937-7977. Art Buyer: Georgia Nelson. Ad agency. Full-service, multimedia firm. Specializes in magazine ads, collaterals, newspapers and TV. Product specialties are automotive and fast food. Current clients include: Carl's Jr., Isuzu, KSwiss, Magic Mountain, Jiffy Lube and CAL Fed Bank.
Needs: Approached by 10 freelance artists/month. Works with 6 freelance illustrators and a few freelance designers/year. Prefers artists with experience in advertising. Works on assignment only. Uses freelance artists mainly for storyboards/comps. Also uses freelance artists for print ad illustration, storyboards, animatics, animation, mechanicals, retouching, billboards, posters and TV/film graphics. 50% of work is with print ads.
First Contact & Terms: Send query letter with photocopies, resume, photographs, tearsheets, photostats and transparencies. Samples are filed. Reports back within 5 days. Call to schedule an appointment to show a portfolio or mail appropriate materials. Portfolio should include: thumbnails, roughs, b&w and color photostats, tearsheets, photographs and transparencies. Pays for illustration by the hour and by the day. Negotiates rights purchased.

***FOOTE, CONE & BELDING/IMPACT,** 11601 Wilshire Blvd., Los Angeles CA 90025-1772. (213)312-7000. Creative Director: R. Ige. Estab. 1950. Ad agency. Full-service, multimedia firm. "Impact is the design and sales promotion division for Foote, Cone and Belding." Product specialties are package goods, toys, entertainment and retail. Current clients include: Ashton-Tate, Farmers Insurance, Mattel Toys, Orion Pictures, Sunkist Growers, Universal Studios and Walt Disney Publications.
Needs: Approached by 10-15 freelance artists/month. Works with 3-4 freelance illustrators and 2-3 freelance designers/month. Prefers local artists only with experience in design and sales promotion. Must be able to work in-house and have minor computer experience. Works on assignment only. Also uses freelance artists for brochure design and illustration, catalog design and illustration, print ad design and illustration, storyboards, mechanicals, retouching, lettering, logos and computer (Mac). 30% of work is with print ads.
First Contact & Terms: Send query letter with resume, photocopies and tearsheets. Samples are filed. Reports back to the artist only if interested. Write to schedule an appointment to show a portfolio. Portfolio should include roughs and color. Pays for design based on estimate on project from concept to mechanical supervision. Pays for illustration per project. Rights purchased vary according to project.

GARIN AGENCY, Suite 614, 6253 Hollywood Blvd., Los Angeles CA 90028. (213)465-6249. Manager: P. Bogart. Ad agency/PR firm. Clients: real estate, banks.
Needs: Works with 1-2 freelance artists/year. Local artists only. Works on assignment only. Uses artists for "creative work and TV commercials."
First Contact & Terms: Send query letter with photostats or tearsheets to be kept on file for one year. Samples not filed are not returned. Does not report back. Negotiates pay; by the hour. Considers client's budget and turnaround time when establishing payment. Buys all rights.
Tips: "Don't be too pushy and don't overprice yourself."

GUMPERTZ/BENTLEY/FRIED, 5900 Wilshire Blvd., Los Angeles CA 90036. (213)931-6301. Creative Director: John Johnson. Ad agency. Clients: stockbrokers, banks, food companies and visitors' bureaus.
Needs: Works with 3-4 illustrators and photographers/month. Uses freelance artists mainly for illustration. Negotiates pay.
First Contact & Needs: Call to arrange interview to show portfolio.

***LEDUC VIDEO PRODUCTIONS,** 2002 21st St., Los Angeles CA 90404. (213)450-8275. FAX: (213)396-8265. Estab. 1980. Audio and video firm. Full-service, multimedia firm.
Needs: Approached by 1 freelance artist/month. Works with 2 freelance illustrators and 1 freelance designer/month. Prefers artists with experience in video graphics and video cassette cover design. Works on assignment only. Also uses freelance artists for brochure design and illustration, print ad design and illustration, storyboards, animatics, animation, TV/film graphics. 10% of work is with print ads.
First Contact & Terms: Send query letter with SASE. Samples are filed or are returned by SASE only if requested by artist. Reports back to the artist only if interested. To show a portfolio, mail thumbnails, roughs, and videos. Pays for design by the project, $100. Pays for illustration by the project, $50. Rights purchased vary according to project.

Close-up

Annie Ross
Art Services Manager
Rubin Postaer & Associates
Los Angeles, California

Annie Ross makes the lives of the art directors at Rubin Postaer considerably easier than they would be otherwise. As the Art Services Manager, she handles a myriad of responsibilities traditionally theirs, allowing them to spend the majority of their time conceptualizing and creating.

© Barbara Kelley 1991

She is the one who steeps herself in the most current photography, illustration and design via portfolio viewings, sourcebooks, and consumer and trade magazines, pulls what would be appropriate for the agency, and keeps it on file. When the art directors come in and say, "This is the concept and look that I want; who have you seen lately? What do you think would look good?," she is able to quickly interpret their needs and give them visual suggestions.

Rubin Postaer's clients range from heavy-equipment industry to book publishing, from the Disney channel to the American Honda Motor Co., their largest client. Although this is a diverse base requiring a range of illustrative, design and photographic needs, Ross characterizes the agency's overall look as "classic, clean and creative. We're looking to best represent each individual client and product," which means that the work is also "very fresh."

This is why Ross feels compelled to view as many portfolios as she can—usually two to three a day in the presence of the artist or agent, and three to four a day during the summer when there is a drop-off policy. This is the most frenetic time of the year for the agency, since the Honda account is in full swing.

Whether a portfolio contains work with one technique or a variety of them is really immaterial to Ross, as long as it is done well and is adaptable to what they need. She says one type of media is not favored over another, that they are open to just about everything—from woodblock to watercolor, airbrush to gouache. She emphasizes that whatever the technique and medium, it must be really fine, fresh work that is immaculately presented.

When she describes a recent portfolio she found exceptional, it seems there is little else she'd rather behold. "There were varied techniques," she says, as though recounting a pleasurable dream, "looser styles; the colors were exceptional. They were fresh, well put together. It was very neat and beautiful, a real treat to my eyes." She adds, "My eyes love to be treated. There is nothing like a wonderful book!" She finds that some of the most impressive portfolios are done by Art Center College students, books which she feels are highly original and perfectly assembled works of art. Art school, by the way, is something she strongly recommends for illustrators and designers. The majority of those she hires have such schooling.

The current trend in illustration, says Ross, is work that is energetic and well designed. "The old murky avocado green" is out, she says, and fresh, vibrant colors are in. "Styles are a lot more expressionistic, diverse and individual. It's very exciting." She attaches words like "imaginative and whimsical," "sophisticated and savvy" to what she believes is typical of the current "L.A. style." Staying apprised of trends is crucial, Ross believes, to keeping

one's work from appearing dated. Flip through the sourcebooks, she advises; look at the award books; look at *Graphis, Communication Arts* and *Print*. That's what she would do if she were an illustrator, she says.

She would also get some good criticism and analysis, for she sees objectivity as being key to a good portfolio presentation. "It's hard and I can understand it—maybe they've done a piece which touches a cord with them personally, but it's really not up to par—it's a drawing of their nephew, for example. It's not a professional piece." Such an illustration, she says, should be kept at home and enjoyed. She encourages artists to always have another person take a look at their portfolios, either a teacher or someone respected in the business.

While a portfolio does not need to be expensive, she emphasizes that it must be immaculate. "It represents the person as it would if someone came in wearing nice, clean clothes versus someone who's been jogging and comes in looking frayed with their water bottle. Portfolios do sometimes come in looking like that: tattered, the plastic cover sheets are murky, and there are smudge marks on the actual work; they're lackluster, and you know the person hasn't worked the pieces very well or enough. They're not putting their best work forward. Sloppiness," she states adamantly, "is very unappealing, and I wouldn't consider it. I have to be very harsh in my standards because we do really fine work here, and usually we can afford to take the best, and we do. When I recommend a book to the art directors, they know it's going to be top caliber."

In addition to being a resource for the art directors, Ross is also a resource for freelance artists, a rare person in advertising who makes it a point to meet with as many artists and agents as she can, offering feedback if it is asked for, and taking the time to explain to those she has hired the legalese of usage, the copyright law and exactly what is being purchased. "Hopefully my reputation in town is that I'm very fair," she says. "I don't play games. I think if you treat an artist fairly, you're going to get better quality work."

—Lauri Miller

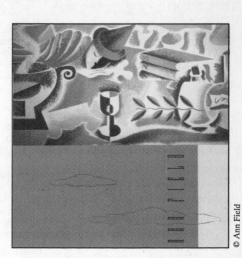

Gladys Perint Palmer, fashion editor of the San Francisco Examiner and freelance illustrator for such publications as Connoisseur and Mirabella, is the creator of this original book on the left. The sensual and Mediterranean-colored self-promotional piece on the right was done by Ann Field. Ross points to both as the dynamic sort of illustration she is after.

LORD, DENTSU & PARTNERS, (formerly HDM), 4751 Wilshire Blvd., 3rd Floor, Los Angeles CA 90010. (213)930-5000. Chairman/Creative Director: Lee Kovel. "We are a general service ad agency." Clients: hotels, ATVs, motorcycle, food, pen and lighter manufacturers. Client list provided upon request.
Needs: Works with 200 freelance artists/year. Assigns 200 freelance jobs/year. Works on assignment only. Uses freelance artists for design, illustration, brochures, catalogs, P-O-P displays, mechanicals, retouching, billboards, posters, direct mail packages, lettering, logos, charts/graphs and advertisements.
First Contact & Terms: Send query letter with brochure showing art style or resume, tearsheets, photostats, photocopies, slides and photographs. Samples are filed. Does not report back. Write to schedule an appointment to show a portfolio, which should include color photostats, photographs, slides and video disks. Pays for design by the day, $300-600. Pays for illustration by the hour, $50-65; by the day, $300-400. Considers complexity of project, client's budget, turnaround time, skill and experience of artist, how work will be used and rights purchased when establishing payment. Negotiates rights purchased; rights purchased vary according to project.

***MILLS MARKETING,** 1000 E. Macy St., Los Angeles CA 90033. (213)223-1178. FAX: (213)223-0648. President: Ezra Millstein. Estab. 1977. Ad agency. Full-service, multimedia firm. Specializes in consumer, cosmetics, housewares, etc. Current clients include: Gemline Frame Co.
Needs: Approached by 3-4 freelance artists/month. Works with 1 freelance illustrator and 1-2 freelance designers/month. Prefers local artists only. Works on assignment only. Uses freelance artists mainly for brochure design and illustration, catalog design, print ad design and illustration, retouching, lettering and logos. 90% of work is with print ads.
First Contact & Terms: Send query letter with brochure and resume. Samples are filed or are not returned. Write to schedule an appointment to show a portfolio. Portfolio should include thumbnails, roughs, original/final art and b&w and color samples. Pays for design by the hour, $25-75; by the project, $200-5,000. Pays for illustration by the project, $200-750. Rights purchased vary according to project.

NATIONAL ADVERTISING AND MARKETING ENTERPRISES, (N.A.M.E.), 7323 N. Figueroa, Los Angeles CA 90041. Contact: J. A. Gatlin. Specializes in brochures and catalogs. Current clients include: William Pitt, American Gem Society and Alexander's Automotive Wholesaler.
Needs: Works on assignment only. Uses artists for graphic design, letterheads and direct mail brochures. Needs technical illustration and product drawings from photographs.
First Contact & Terms: Send query letter with tearsheets, photostats and photographs. Samples not returned. Sometimes buys previously published work. Reports in 4 weeks. To show a portfolio, mail appropriate materials. Pays for design by the hour, $20-100; by the project, $25-1,000. Pays for illustration by the hour, $20-40; by the project, $25-1,200.
Tips: "Submit repros of art, not originals."

RUBIN POSTAER & ASSOCIATES, Suite 900, 11601 Wilshire Blvd., Los Angeles CA 90025. (213)208-5000. Manager, Art Services: Annie Ross. Ad agency. Serves clients in automobile and heavy equipment industries, savings and loans, hotels and cable television.
Needs: Works with about 2 freelance illustrators/month. Uses freelancers for all media.
First Contact & Terms: Contact manager of art services for appointment to show portfolio. Selection based on portfolio review. Negotiates payment.
Tips: Wants to see variety of techniques.

***WILSON SCOTT ASSOCIATES, INC.,** 425 S. Fairfax, Los Angeles CA 90036. (213)934-6150. FAX: (213)934-4726. Executive Vice President: Brien Scott. Estab. 1987. Ad agency. Full-service, multimedia firm. Does work for all product categories. Current clients include: A&M Records, Toyota and Yamaha Musical Instruments.
Needs: Approached by 3-6 freelance artists/month. Works with 5 freelance illustrators and 2 freelance designers/month. Works only with artist reps. Prefers local artists with experience. Works on assignment only. Also uses freelance artists for all types of work. 40% of work is with print ads.
First Contact & Terms: Send query letter with all appropriate samples. Samples are filed or are returned by SASE only if requested by artist. Reports back within 7 days only if interested. To show a portfolio, mail appropriate materials. Pays for design and illustration by the project, $100-3,000. Rights purchased vary according to project.

San Francisco

ANDERSON/ROTHSTEIN, INC., 139 Townsend, San Francisco CA 94107. (415)495-6420. FAX: (415)495-0319. Senior Art Director: Dean Narahara. Estab. 1980. Ad agency. Full-service, multimedia firm. Specializes in magazine ads and collaterals. Product specialty is food service. Current clients include: Dole, Alaska Seafood and Idaho Potatoes.

Needs: Approached by 30 freelance artists/month. Works with 4 freelance illustrators and 3 freelance designers/month. Also uses freelance artists for brochure, catalog and print ad design and illustration, storyboards, mechanicals, retouching, TV/film graphics, lettering and logos. Needs editorial illustration. 70% of work is with print ads.

First Contact & Terms: Send query letter with brochure, photocopies, resume and photographs. Samples are filed. Reports back to the artist only if interested. Call to schedule an appointment to show a portfolio. Portfolio should include: original/final art, b&w and color photostats, photographs and transparencies. Pays for design and illustration by the project. Buys all rights or rights purchased vary according to project.

ARNOLD & ASSOCIATES PRODUCTIONS, 2159 Powell St., San Francisco CA 94133. (415)989-3490. President: John Arnold. AV and video firm. Clients: general.

Needs: Works with 30 freelance artists/year. Prefers local artists (in San Francisco and Los Angeles), award-winning and experienced. "We're an established, national firm." Works on assignment only. Uses artists for multimedia, slide show and staging production.

First Contact & Terms: Send query letter with brochure, tearsheets, slides and photographs to be kept on file. Call to schedule an appointment to show a portfolio, which should include final reproduction/product and color photographs. Pays for design by the hour, $15-50; by the project $500-3,500. Pays for illustration by the project, $500-4,000. Considers complexity of the project, client's budget and skill and experience of artist when establishing payment.

BASS/FRANCIS PRODUCTIONS, 737 Beach St., San Francisco CA 94109. (415)441-4555. Production Manager: Townley Paton. "A multi-media, full-service organization providing corporate communications to a wide range of clients."

Needs: Works with 10 freelance artists/year. Assigns 35 freelance jobs/year. Prefers solid experience in multi-image production. Works on assignment only. Uses freelance artists for mechanicals, lettering, logos, charts/graphs and multi-image designs. Prefers loose or impressionistic style.

First Contact & Terms: Send resume and slides. Samples are filed and are not returned. Reports back within 1 month only if interested. To show a portfolio, mail slides. Pays for design by the project, $100-1,000; by the day, $200-350. Pays for the illustration by the hour, $18-25; by the project, $100-250. Considers turnaround time, skill and experience of artist and how work will be used when establishing payment. Rights purchased vary according to project.

Tips: "Send resume, slides, rates. Highlight multi-media experience. Show slide graphics also."

***LORD & BENTLEY PERSUASIVE MARKETING**, 1800 Cabrillo, San Francisco CA 94121. (415)386-4730. Creative Director: Allan Barsky. Ad and marketing agency.

Needs: Works with 20 freelance artists/year. Prefers experienced local artists only. Works on assignment only. Uses artists for design, illustration, brochures, magazines, newspapers, P-O-P displays, billboards, posters, direct mail packages, logos and advertisements. Artists must "understand reproduction process; the job is to enhance copy strategy."

First Contact & Terms: Send 6 photocopies of published/printed work. Samples not filed are not returned. Does not report back. To show a portfolio, mail appropriate materials, only photocopies of final reproduction/product. Pays for design by the project or hour, $25-100. Pays for illustration by the hour, $50-120. Considers skill and experience of artist when establishing payment. Buys all rights.

MEDIA SERVICES CORP., 10 Aladdin Terrace, San Francisco CA 94133. (415)928-3033. FAX: (415)441-1859. President: Gloria Peterson. Estab. 1974. Ad agency. Specializes in publishing and package design. Product specialties are publishing and consumer. Current clients include: City Life, Eatacup.

Needs: Approached by 3 freelance artists/month. Works with 1-2 freelance illustrators and 2 freelance designers/month. Prefers artists with experience in package design with CAD. Works on assignment only. Uses freelance artists mainly for support. Also uses freelance artists for mechanicals, retouching and lettering. 5% of work is with print ads.

First Contact & Terms: Send query letter with brochure, SASE, resume, photographs or slides and tearsheets or transparencies. Samples are filed or are returned by SASE only if requested by artist. Reports back to the artist only if interested. Mail appropriate materials: original/final art, tearsheets or 5×7 transparencies. Pay for design varies. Pay for illustration varies. Rights purchased vary according to project.

Tips: Wants to see "computer literacy and ownership."

PURDOM PUBLIC RELATIONS, 395 Oyster Point, S. San Francisco, CA 94080. (415)588-5700. FAX: (415)588-1643. President: Paul Purdom. Estab. 1962. PR firm. Full-service, multimedia firm. Product specialties are high-tech and business-to-business. Current clients include Sun Microsystems and Varian Associates.

Needs: Works with 1-2 freelance artists/month and 1-2 freelance designers/month. Works on assignment only. Prefers local artists for work on brochure and catalog design, slide illustration, mechanicals and TV/film graphics.

First Contact & Terms: Samples are not filed and are returned. Call to schedule an appointment to show a portfolio, which should include completed projects. Pays for design by the project and buys all rights.

HAL RINEY & PARTNERS, INC., 735 Battery, San Francisco, CA 94111. (415)981-0950. Contact: Jerry Andelin. Ad agency. Serves clients in beverages, breweries, computers, confections, insurance, restaurants, winery and assorted packaged goods.
Needs: Works with 5-6 freelance illustrators/month. Uses freelancers in all media.
First Contact & Terms: Call one of the art directors for appointment to show portfolio. Selection based on portfolio review. Negotiates payment based on client's budget, amount of creativity required from artist and where work will appear.
Tips: Wants to see a comprehensive rundown in portfolio on what a person does best—"what he's selling"—and enough variety to illustrate freelancer's individual style(s).

EDGAR S. SPIZEL ADVERTISING INC., 1782 Pacific Ave., San Francisco CA 94109. (415)474-5735. President: Edgar S. Spizel. AV producer. Clients: "Consumer-oriented from department stores to symphony orchestras, supermarkets, financial institutions, radio, TV stations, political organizations, hotels, real estate firms, developers and mass transit, such as BART." Works a great deal with major sports stars and TV personalities.
Needs: Uses artists for posters, ad illustrations, brochures and mechanicals.
First Contact & Terms: Send query letter with tearsheets. Provide material to be kept on file for future assignments. No originals returned at job's completion.

UNDERCOVER GRAPHICS, Suite 1-C, 20 San Antonio Place, San Francisco CA 94133. (415)788-6589. Creative Director: Helen Schaefer. AV producer. Clients: musical groups, producers, record companies and book publishers.
Needs: Works with 2-3 freelance illustrators and 2-3 freelance designers/month. Uses artists for billboards, P-O-P displays, corporate identity, multimedia kits, direct mail, TV, brochures/flyers, album covers and books.
First Contact & Terms: Send query letter with brochure or resume, tearsheets, slides, photographs and/or photocopies. Samples returned by SASE. Provide brochures, tearsheets, slides business card and/or resume to be kept on file for future assignments. Reports in 4 weeks only if interested. To show a portfolio, mail roughs, original/final art, tearsheets and photographs. Originals returned to artist at job's completion. Pays $250-5,000, comprehensive layout and production; $10-25/hour, creative services; $25-500, illustration. Considers complexity of project, client's budget, skill and experience of artist and rights purchased when establishing payment. Pays original fee as agreed for unused assigned illustrations.
Tips: Artists interested in working with us should "be creative and persistent. Be different. Set yourself apart from other artists by work that's noticeably outstanding. Don't be content with mediocrity or just 'getting by' or even the 'standards of the profession.' Be *avant-garde*."

Colorado

BROYLES ALLEBAUGH & DAVIS, INC., 8231 E. Prentice Ave., Denver Technological Center, Englewood CO 80111. (303)770-2000. Executive Art Director: Kent Eggleston. Ad agency. Clients: industrial, high-tech, financial, travel and consumer clients; client list provided upon request.
Needs: Works with 12 freelance illustrators/year; occasionally uses freelance designers. Works on assignment only. Uses freelance artists for consumer and trade magazines, direct mail, P-O-P displays, brochures, catalogs, posters, newspapers, TV and AV presentations.
First Contact & Terms: Send business card, brochure/flyer, samples and tearsheets to be kept on file. Samples returned by SASE if requested. Reports only if interested. Arrange interview to show portfolio or contact through artist's agent. Prefers slides or printed pieces as samples. Negotiates payment according to project. Considers complexity of project, client's budget, skill and experience of artist, geographic scope of finished project, turnaround time and rights purchased when establishing payment.

***HAMILTON SWEENEY ADVERTISING,** 707 Sherman St., Denver CO 80203. (303)837-0515. Vice President/Creative Director: Fran Scannell. Estab. 1960. Ad agency. Full-service, multimedia firm. Works in a broad range of media and product categories.
Needs: Approached by 3 freelance illustrators/month. Works with 1 freelance illustrator and 1 freelance designer/month. Prefers artists with experience. Uses freelance artists mainly for illustration. Also uses freelance artists for some brochure design and illustration, print ad illustration, storyboards and mechanicals. 50% of work is with print ads.

First Contact & Terms: Send introductory letter with brochure and photocopies. Samples are filed and not returned. Does not report back, in which case the artist should wait for call. To schedule an appointment to show a portfolio, mail appropriate material. Negotiates payment for design and illustration. Buys all rights.

Connecticut

THE BERNI COMPANY, Marketing Design Consultants, 666 Steamboat Rd., Greenwich CT 06830. (203)661-4747. Contact: Mark Eckstein. Specialties include consumer packaging and corporate identity. Clients: manufacturers and retailers of consumer package goods. Current clients include: Drake Bakeries, Kraft/General Foods, Colgate Palmolive, US Tobacco, Chesebrough Ponds. Buys 50 illustrations/year. Write or call for interview; local professionals only.
Needs: Uses artists for illustration, layout, lettering, paste-up, retouching and type spec for annual reports, catalogs, letterheads, P-O-P displays, packaging, design, production and trademarks. Pays for design by the project, $500 minimum; illustration by the project, $100-2,500. Pays promised fee for unused assigned work.

BRADFORD ADVERTISING & PUBLIC RELATIONS, INC., 140 Ferry Rd., Old Saybrook CT 06475. (203)388-1282. FAX: (203)388-5298. Art Director: Keith Campagna. Creative Director: Wil Bradford. Ad and PR agency. Clients: automotive, industry, bank and sporting goods.
Needs: Works with approximately 10 freelance artists/year. Prefers local artists. Works on assignment only. Uses freelance artists for design, illustration, brochures, catalogs, P-O-P displays, mechanicals, billboards, posters, direct mail packages, press releases, logos and advertisements.
First Contact & Terms: Send brochure. Samples are filed or are returned only if requested. Does not report back. Call to schedule an appointment to show a portfolio, which should include thumbnails, roughs, original/final art, tearsheets and slides. Pays for design by the hour, $25-100; by the project, $250-1,500; by the day, $250-500. Pays for illustration by the hour, $50-300; by the project, $100-1,000; by the day, $250-1,500. Considers complexity of project, client's budget, turnaround time, skill and experience of artist, how work will be used and rights purchased. Negotiates rights purchased; rights purchased vary according to project.
Tips: "When contacting our firm, please send samples of work."

DONAHUE, INC., 227 Lawrence St., Hartford CT 06106. (203)527-1400. FAX: (203)247-9247. Senior Art Director: Kurt Whitmore. Estab. 1979. Ad agency. Full-service, multimedia firm. Specializes in collateral, trade ads. Product specialties are computer, tool and interior design firms.
Needs: Approached by 4-5 freelance artists/month. Works with 1-2 freelance illustrators and 3-4 freelance designers/month. Prefers artists with experience in reproduction, tight comps and mechanicals. Uses freelance artists mainly for "in-house." Also uses freelance artists for brochure design, catalog design and illustration, print ad design, mechanicals, posters, lettering and logos. 40% of work is for print ads.
First Contact & Terms: Send query letter with resume and tearsheets. Samples are filed. Reports back to the artist only if interested. Portfolio should include thumbnails, roughs, original/final art and tearsheets. Pays for design by the hour, $15-25. Pays for illustration by the project, $200-2,000. Rights purchased vary according to project.

ERIC HOLCH/ADVERTISING, 49 Gerrish Lane, New Canaan CT 06840. President: Eric Holch. Product specialties are packaging, machinery and real estate. Current clients include: Raymond Automation, H.L. Thomas and Cotlyn.
Needs: Works with 10 freelance artists/year. Works on assignment only. Uses freelance artists mainly for advertisement and brochure illustration. Prefers food, candy, packages and seascapes as themes for advertising illustrations for brochures, ads, etc. Type of illustration needed is commercial and technical. Pays $100-3,000 average.
First Contact & Terms: Send query letter with brochure showing art style or 8½×11" samples to be kept on file. Write to schedule an appointment to show a portfolio, which should include roughs, photocopies and original/final art. Pays for design and illustration by the project, $100-3,000. Negotiates rights purchased depending on project.

JACOBY/STORM PRODUCTIONS INC., 22 Crescent Rd., Westport CT 06880. (203)227-2220. President: Doris Storm. AV/TV/film producer. Clients: schools, corporations and publishers. Produces filmstrips, motion pictures, slide sets, sound-slide sets and videotapes.
Needs: Assigns 6-8 jobs/year. Uses artists for lettering, illustrations for filmstrips and designing slide show graphics.
First Contact & Terms: Prefers local artists with filmstrip and graphics experience. Query with resume and arrange interview. Include SASE. Reports in 2 weeks. Usually buys all rights. Pays $20-30/frame, lettering; $50-100/frame, illustrations. Pays on acceptance.

LISTENING LIBRARY, INC., 1 Park Ave., Old Greenwich CT 06870-1727. (203)637-3616. Director of Communications: Susan Carnes. Produces books on tape for children and adults.

Needs: Periodically requires illustrators for front covers for 3 catalogs/year. Uses artists for catalog and advertising design, advertising illustration, catalog and advertising layout and direct mail packages.

First Contact & Terms: Local Fairfield County (New York City) and Westchester County artists only. Works on assignment only. Send resume and nonreturnable samples to be kept on file for possible future assignments. "Payment is determined by the size of the job and skill and experience of artist." Buys all rights.

REALLY GOOD COPY CO., 92 Moseley Terrace, Glastonbury CT 06033. (203)659-9487. FAX: (203)633-3238. President: Donna Donovan. Estab. 1982. Ad agency. Full-service, multimedia firm. Specializes in print ads, collateral, direct mail and catalogs. Product specialties are consumer, financial and entertainment products. Current clients include: Levi Strauss & Co., Speidel, CIGNA, Dow Brands, YMCA, NASA and U.S. Postal Service.

Needs: Approached by 3-4 freelance artists/month. Works with 1 freelance illustrator and 1-2 freelance designers/month. Prefers local artists with experience in Macintosh design and production. Works on assignment only. Uses freelance artists for all projects. Needs editorial illustration—line art and cartoon art. There are no on-staff artists. 50% of work is with print ads.

First Contact & Terms: Send query letter with description of background and experience. Samples are filed or are returned by SASE only if requested. Reports back to the artist if interested. Write to schedule an appointment to show a portfolio. Portfolio should include roughs and original/final art. Pays for design by the hour, $25-90. Pays for illustration by the project, $50-600.

Tips: "The most common mistake freelancers make is showing only finished pieces. I want to see roughs and comps, too, to feel confident about exposing my client to the designer and vice versa. Write first with some background to save your time and mine. I screen out 90% of artists before the interview." Because of the recession, "it is more critical that artists be equipped and versatile on the Macintosh to cut project costs."

Delaware

ALOYSIUS, BUTLER, & CLARK, 110 S. Poplar St., Wilmington DE 19801. (302)655-1552. Contact: John Hawkins. Ad agency. Clients: banks, industry, restaurants, real estate, hotels, businesses, transit systems, government offices. Current clients include: Blue Cross, Blue Shield of Delaware and Riddle Memorial Hospital.

Needs: Assigns "many" freelance jobs/year. Works with 3-4 freelance illustrators and 3-4 freelance designers/month. Uses artists for trade magazines, billboards, direct mail packages, brochures, newspapers, stationery, signage and posters.

First Contact & Terms: Local artists only "within reason (Philadelphia, Baltimore)." Send query letter with resume, business card and slides, photos, photostats, photocopies to be kept on file all except work that is "not worthy of consideration." Samples are not kept on file; returned only if requested. Reports only if interested. Works on assignment only. Call for appointment to show portfolio. Pays for design by the hour, $20-50. Pays for illustration by the hour or by the project, $250-1,000.

CUSTOM CRAFT STUDIO, 310 Edgewood St., Bridgeville DE 19933. Audiovisual producer.

Needs: Works with 1 illustrator and 1 designer/month. Works with freelance artists on an assignment basis only. Uses freelance artists mainly for work on filmstrips, slide sets, trade magazines and newspapers. Also uses artists for print finishing, color negative retouching and airbrush work. Prefers pen & ink, airbrush, watercolor and calligraphy.

First Contact & Terms: Send query letter with resume, slides or photographs, brochure/flyer, and tearsheets to be kept on file. Samples returned by SASE. Reports in 2 weeks. No originals returned to artist at job's completion. Pays for design and illustration by the project, $25-100.

PHOTO/ART, INC., Box 1742, Wilmington DE 19899. (302)658-7301. FAX: (302)658-7308. Art Director: Steve Gustasson. Estab. 1935. Ad agency and AV firm. Does graphic design, computer-generated slides and photography. Specializes in collateral, brochures, booklets and slides. Product specialty is industry.

Needs: Works with a varying number of freelance artists and designers/month. Prefers artists with experience in illustration. Works on assignment only. Uses freelance artists mainly for illustration and overload. Also uses freelance artists for brochure and print ad design and illustration, catalog illustration and lettering. 15% of work is with print ads.

First Contact & Terms: Send query letter with brochure, resume and photocopies. "Whatever works best for the artist." Samples are filed or are returned. Reports back to the artist only if interested. Write to schedule an appointment to show a portfolio. Portfolio should include roughs, original/final art and b&w and color samples. Pays for design and illustration by the project. Payment is negotiable. Rights purchased vary according to project.

SHIPLEY ASSOCIATES INC., 1300 Pennsylvania Ave., Wilmington DE 19806. (302)652-3051. Creative Director: Jack Parry. Ad/PR firm. Serves clients in harness racing, industrial and corporate accounts, insurance, real estate and entertainment.
Needs: Works with 2 freelance illustrators and 1 freelance designer/month. Assigns 9 freelance jobs/year. Works with freelance artists on assignment only. Uses artists for annual report illustration, mechanicals, brochure and sign design.
First Contact & Terms: Query with previously published work. Prefers layouts (magazine & newspaper), mechanicals, line drawings and finished pieces as samples. Samples not returned. Reports within 2 weeks. Provide resume, samples and tearsheets to be kept on file for possible future assignments. No originals returned at job's completion. Pays for design by the hour, $8 minimum. Negotiates payment.
Tips: Looks for "versatility and technique, individual style, good production skills."

Florida

COVALT ADVERTISING AGENCY, 12907 N.E. 7th Ave., North Miami FL 33161. (305)891-1543. Creative Director: Fernando Vasquez. Ad agency. Clients: automotive, cosmetic, financial, industrial, banks, restaurants and consumer products.
Needs: Prefers local artists; very seldom uses out-of-town artists. Artists must have minimum of 5 years of experience; accepts less experience only if artist is extremely talented. Works on assignment only. Uses artists for illustration (all kinds and styles), photography, mechanicals, copywriting, retouching (important), rendering and lettering.
First Contact & Terms: Send query letter with brochure, resume, business card, tearsheets, photostats and photocopies to be kept on file. Samples are filed and are not returned. Reports only if interested. Call for appointment to show portfolio, which should include photostats, photographs, slides, original final art or tearsheets. Pays for design by the hour, $35 minimum; by the project, $150 minimum. Pays for illustration by the project, $200 minimum. Considers complexity of project, client's budget, skill and experience of artist, and turnaround time when establishing payment. Buys all rights or reprint rights.
Tips: "If at first you don't succeed, keep in touch. Eventually something will come up due to our diversity of accounts. If I have the person, I might design something with his particular skill in mind."

PRUITT HUMPHRESS POWERS & MUNROE ADVERTISING AGENCY, INC., Suite B, 805 N. Gadsden St., Tallahassee FL 32303. (904)222-1212. Production Manager: Cathy Camp. Ad agency. Clients: business-to-business. Media used includes trade magazines, direct mail, P-O-P displays.
Needs: Uses artists for direct mail, brochures/flyers and trade magazines. "Freelancers used in every aspect of business and given as much freedom as their skill warrants."
First Contact & Terms: Send resume. Provide materials to be kept on file for future assignments. Negotiates payment based on client's budget and amount of creativity required from artist. Pays set fee/job.
Tips: In portfolio, "submit examples of past agency work in clean, orderly, businesslike fashion including written explanations of each work. Ten illustrations or less."

***SHERRY WHEATLEY SACINO INC.**, 235 Central Ave., St. Petersburg FL 33701. (813)894-7273. FAX: (813)823-3895. President: Sherry Sacino. Estab. 1981. PR firm. Handles mostly marketing and writing. Specializes in special events and international marketing. Product specialties are agriculture and food. Current clients include The Columbia Restaurants, JMC Communities, Top-Sail Pro Sailing, and numerous citrus and agricultural accounts.
Needs: Works with 2 freelance illustrators and 3 freelance designers/month. Prefers honest, dependable and fast artists. Works on assignment only. Uses freelance artists mainly for client ads. Also uses freelance artists for brochure design and illustration, print ad design and illustration, retouching, billboards, posters and logos. 10% of work is with print ads.
First Contact & Terms: Send query letter with SASE, photographs and tearsheets. Samples are filed or are returned by SASE only if requested by artist. Reports back to the artist only if interested. To schedule an appointment to show a portfolio, mail appropriate materials. Portfolio should include original/final art and b&w and color tearsheets, photographs and slides. Pays for design by the hour, $15-50; by the project $25-1,500. Pays for illustration by the project. Usually buys all rights.

SANCHEZ & LEVITAN, INC., 1800 SW 27th Ave., Miami FL 33145. (305)442-1586. FAX: (305)442-2598. Art Director: Enrique Duprat. Ad agency and PR firm. Full-service, multimedia firm. Specializes in TV, radio and magazine ads, etc. Product specialty is consumer service firms. Current clients include: Florida Lottery, NCNB National Bank, UpJohn Co.
Needs: Approached by 1 freelance artist/month. Prefers local artists only. Works on assignment only. Uses freelance artists for print ad design, storyboards, slide illustration, mechanicals, TV/film graphics and logos. 35% of work is for print ads.

First Contact & Terms: Send query letter with brochure and resume. Samples are not filed and are returned by SASE only if requested by artist. Reports back to the artist only if interested. Write to schedule an appointment to show a portfolio.

WEST & COMPANY MARKETING & ADVERTISING, Suite 2050, 100 S. Ashley Dr., Tampa FL 33602. (813)224-9378. Senior Art Director: Doug Hardee. Ad agency. "We are a full-service, multimedia firm with in-house art and media departments." Product specialty is food and beverages.
Needs: Works with 3 freelance illustrators and 1 freelance designer/month. Prefers artists with experience in food design. Works on assignment only. Uses freelance artists mainly for newspaper and magazine design. Also uses freelance artists for print ad design and illustration, storyboards, mechanicals, retouching, billboards, posters and lettering. 70% of work is with print ads.
First Contact & Terms: Send query letter with resume. Samples are not filed and are returned. Reports back within 2 weeks. Write to schedule an appointment to show a portfolio. Portfolio should include original/final art, final production/product, color and b&w samples. Pays by the project. Rights purchased vary according to project.

Georgia

CINEVISION CORPORATION, 1771 Tullie Circle, NE, Atlanta GA 30329. (404)321-6333. President: Steve Newton. Estab. 1972. AV firm providing sales service and rental of professional 16mm/35mm/70mm/vistavision motion picture equipment and screening of motion pictures on location and in screening room facility in Atlanta. Current clients include AT&T, Bell South, Paramount Pictures, Columbia Pictures, Universal Pictures, MGM/UA, Warner Bros. and Disney Company.
Needs: Works on assignment only. Uses freelancers for brochure design. 2% of work is with print ads.
First Contact & Terms: Send query letter with brochure. Samples are filed. Reports back within 10 days. To show a portfolio, mail tearsheets. Pays for design and illustration by the project. Considers client's budget when establishing payment.
Tips: "Have experience."

FILMAMERICA, INC., Suite 209, 3177 Peachtree Rd. NE, Atlanta GA 30305. (404)261-3718. President: Avrum M. Fine. AV firm. Clients: corporate and ad agencies.
Needs: Works with 2 freelance artists/year. Works on assignment only. Uses freelance artists for film campaigns. Especially important are illustration and layout skills.
First Contact & Terms: Send query letter with resume and photographs or tearsheets to be kept on file. Samples not filed are returned only if requested. Reports back only if interested. Write for appointment to show portfolio. Pays for design by the project, $1,000-2,000. Pays for illustration by the project, $1,500-2,500. Considers complexity of the project and rights purchased when establishing payment. Rights purchased vary according to project.
Tips: "Be very patient!"

PAUL FRENCH AND PARTNERS, INC., 503 Gabbettville Rd., LaGrange GA 30240. (404)882-5581. Contact: Ms. Gene Ballard. AV firm. Client list provided upon request.
Needs: Works with 3 freelance artists/year. Works on assignment only. Uses artists for illustration.
First Contact & Terms: Send query letter with resume and slides to be kept on file. Samples not filed are returned by SASE. Reports back only if interested. To show a portfolio, mail appropriate materials. Pays for design and illustration by the hour, $25-100 average. Considers client's budget when establishing payment. Buys all rights.
Tips: "Be organized."

GARRETT COMMUNICATIONS, Box 53, Atlanta GA 30301. (404)755-2513. President: Ruby Grant Garrett. Estab. 1979. Production and placement firm for print media. Clients: banks, organizations, products-service consumer. Client list provided for SASE.
Needs: Assigns 24 freelance jobs/year. Works with 2-3 freelance illustrators and 2 freelance designers/year. "Experienced, talented artists only." Works on assignment only. Uses freelance artists for billboards, brochures, signage and posters. 100% of work is with print ads. Prefers loose or realistic style and technical illustration occasionally. Especially needs "help-wanted illustrations that don't look like clip art."
First Contact & Terms: Send query letter with resume and samples to be kept on file. Samples returned by SASE if not kept on file. Reports within 10 days. Write to schedule an appointment to show a portfolio which should include roughs and tearsheets. Pays for design by the hour, $15-35; by the project, $75-1,500. Pays for illustration by the project, $35-2,000. Considers client's budget, skill and experience of artist and turnaround time when establishing payment. Negotiates rights purchased.

Tips: Send "6-12 items that show scope of skills. My best advice to freelancers for an introduction into our company is to send a resume and three samples or copies of work for our files. Do not send samples or copies of fine art or paintings."

GROUPATLANTA, Box 566725, Atlanta GA 30356. (404)442-1100. Creative Director: Ralph Broom. Full service advertising and marketing communications firm employing only freelance artists and writers. Clients: real estate, banks, health care, radio stations, government agencies, child care centers, car dealers.
Needs: Works with 20 freelance artists/year. Assigns 400 freelance jobs/year. Works on assignment only. Uses artists for design, illustration, mechanicals, retouching, animation, posters, direct mail packages, lettering, logos and charts/graphs. Types of illustration needed are editorial, technical and cartoon. Would like to see more good pencil or pen & ink architectural, and CAD computer illustration.
First Contact & Terms: Send query letter with brochure or tearsheets, photostats, photocopies, slides and photographs. Samples are filed and are not returned. Pays for design and illustration by the project. Considers complexity of project, client's budget and turnaround time when establishing payment.
Tips: "Send color, 8½ × 11 photocopied samples with amount you charged on each. Talent is selected based on experience and knowledge of the advertiser's product."

KAUFMANN ASSOCIATES, 1626 Frederica Rd., St. Simons Island GA 31522. (912)638-8678. President: Harry J. Kaufmann. Ad agency. Clients: resort, food processor and bank. Current clients include Sea Island and Pierce and Parker.
Needs: Assigns "very few" freelance jobs/year. Works on assignment only. Works with 1 freelance illustrator/month. Uses artists for brochures.
First Contact & Terms: Send samples to be kept on file. Reports only if interested. Pays for design and illustration by the hour, $35-45; by the project, $100-800. Considers complexity of project, client's budget, and skill and experience of artist when establishing payment. Buys all rights.
Tips: "Organize credentials and samples for a brief but useful review."

MCCANN-ERICKSON, 615 Peachtree St. NE, Atlanta GA 30365. (404)881-3100. FAX: (404)881-3100. Associate Creative Director: David Farmer. Ad agency. Full-service, multimedia firm. Specializes in television and radio broadcast, all forms of print media, collateral and research. Product specialty is consumer. Current clients include: Georgia-Pacific, Coca-Cola USA, Six Flags, American Express Vacations and The *Atlanta Journal & Constitution*.
Needs: Approached by 25 freelance artists/month. Works with 10 freelance illustrators and 2 freelance designers/month. Works on assignment only. Uses freelance artists mainly for illustration, storyboards, comps. Also uses freelance artists for brochure design and illustration, print ad illustration, storyboards, slide illustration, animatics, animation, retouching, TV/film graphics, lettering, logos. 50% of work is print ads.
First Contact & Terms: Send query letter with brochure, photocopies, resume, photographs, tearsheets and transparencies. Samples are filed. Reports back to the artist only if interested. Call to schedule an appointment to show a portfolio. Portfolio should include "anything you feel is important to represent yourself." Pays for design by the hour, $25-75. Pays for illustration by the project, $250 minimum. Buys all rights or negotiates rights purchased.

PRINGLE DIXON PRINGLE, Suite 1500, Marquis One Tower, 245 Peachtree Center Ave., Atlanta GA 30303. (404)688-6720. Creative Director: Jim Pringle. Ad agency. Clients: fashion, financial, fast food and industrial firms; client list provided upon request.
Needs: Works with 2 freelance illustrators/month. Local artists only. Works on assignment basis only. Uses freelance artists for billboards, consumer and trade magazines, direct mail, P-O-P displays, brochures, catalogs, posters, signage, newspapers and AV presentations.
First Contact & Terms: Arrange interview to show portfolio. Payment varies according to job and freelancer.

SAWYER RILEY COMPTON INC., Suite 800, 1100 Abernathy Rd., Atlanta GA 30328. (404)393-9849. FAX: (404)393-9953. Art Director: Tony Messano. Ad agency, AV and PR firm. Specializes in ads, collaterals and scripts. Product specialty is business-to-business exclusively. Current clients include: Hitachi, Gates Energy Products, Komatsu, Baker, Elanco.
Needs: Approached by 2-3 freelance artists/month. Works with 1 freelance illustrator and 2 freelance designers/month. Works on assignment only. Also uses freelance artists for brochure, catalog and print ad design and illustration, storyboards, slide illustration, animatics, animation, mechanicals, retouching, posters, lettering and logos. 70% of work is for print ads.
First Contact & Terms: Send query letter with brochure, photographs, tearsheets, photostats and slides. Samples are filed. Reports back to the artist only if interested. Does not report back, in which case the artist should "follow-up call." Call to schedule an appointment to show a portfolio. Portfolio should include original/final art and photographs. Pays for design by the hour, $35-80. Pays for illustration by the project. Buys all rights.

J. WALTER THOMPSON COMPANY, One Atlanta Plaza, 950 E. Paces Ferry Rd., Atlanta GA 30326. (404)365-7300. Executive Art Director: Bill Tomassi. Executive Creative Director: Mike Lollis. Ad agency. Clients: mainly financial, industrial and consumer. This office does creative work for Atlanta and the southeastern U.S.

Needs: Works with freelance illustrators. Works on assignment only. Uses freelance artists for billboards, consumer and trade magazines and newspapers.

First Contact & Terms: Send slides, original work, stats. Samples returned by SASE. Reports only if interested. No originals returned at job's completion. Call for appointment to show portfolio. Pays by the hour, $20-65 average; by the project, $100-6,000 average; by the day, $150-3,500 average.

Tips: Wants to see samples of work done for different clients. Likes to see work done in different mediums. Likes variety and versatility. Artists interested in working here should "be *professional* and do top grade work." Deals with artists reps only.

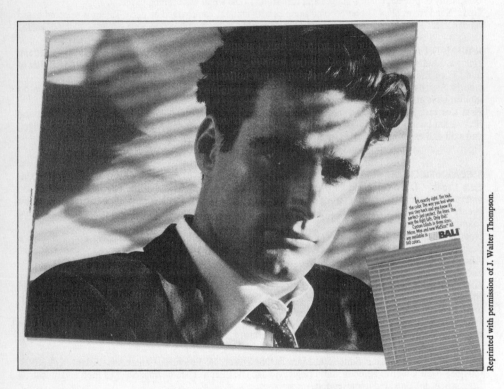

Reprinted with permission of J. Walter Thompson.

Vice president and executive art director of J. Walter Thompson in Atlanta, Georgia, Bill Tomassi, discovered the work of Frank Maresea in the Creative Black Book. "His portfolio was fashion-oriented," Tomassi says, which made Maresea the appropriate freelancer for this promotion of Bali wall coverings. Tomassi says the agency was after "a high-fashion look showing how light passing through the product produces a mood." The piece was successful, says Tomassi, because "in the types of magazines in which this ad ran, visuals like this stand out."

TUCKER WAYNE/LUCKIE & COMPANY, (formerly Tucker Wayne & Co.), Suite 1800, 1100 Peachtree St. NW, Atlanta GA 30309. (404)347-8700. Creative Department Business Manager: Rita Morris. Ad agency. Clients include packaged product, food, utility, transportation and agriculture/pesticide manufacturing.

Needs: A total of 8 art directors occasionally work with freelance illustrators. Uses freelancers for consumer and trade magazines, newspapers and TV.

First Contact & Terms: Call creative secretary for appointment. Selection based on portfolio review. Negotiates payment based on budget, where work will appear, travel expenses, etc.

Tips: Each art director has individual preference.

***EMIL J. WALCEK ASSOCIATES & TRADE PR SERVICE**, Suite D, 1031 Cambridge Square, Alpharetta GA 30201. (404)664-9322. FAX: (404)664-9324. President: Emil Walcek. Estab. 1980. Ad agency. Specializes in magazine ads and collaterals. Product specialty is business-to-business.
Needs: Approached by 3 freelance artists/month. Works with 2 freelance illustrators and 1 designer/month. Prefers local artists only with experience in Mac computer design and illustration, airbrush and type. Works on assignment only. Uses artists for brochure design and illustration, catalog design and illustration, print ad design and illustration, slide illustration, retouching and logos. 50% of work is with print ads.
First Contact & Terms: Send query letter with resume, photostats and slides. Samples are filed or are returned by SASE only if requested by artist. Reports back to the artist only if interested. Write to schedule an appointment to show a portfolio. Portfolio should include thumbnails, roughs, original, final art, tearsheets. Pays for design by the hour or by the project. Pays for illustration by the project. Buys all rights.

Hawaii

MILICI VALENTI GABRIEL DDB NEEDHAM WORLDWIDE, Amfac Bldg., 700 Bishop St., Honolulu HI 96813. (808)536-0881. Executive Assistant: Terry Daguman. Ad agency. Serves clients in food, finance, utilities, entertainment, chemicals and personal care products.
Needs: Works with 3-4 freelance illustrators/month. Artists must be familiar with advertising demands; used to working long distance through the mail; and be familiar with Hawaii. Uses freelance artists mainly for illustration, retouching and lettering for newspapers, multimedia kits, magazines, radio, TV and direct mail.
First Contact & Terms: Provide brochure, flyer and tearsheets to be kept on file for future assignments. No originals returned to artist at job's completion. Pays $200-2,000.

PACIFIC PRODUCTIONS, Box 2881, Honolulu HI 96802. (808)531-1560. Contact: Production Manager. AV producer. Serves clients in industry, government and education. Produces almost all types of AV materials.
Needs: Assigns 2 freelance jobs/year. Works with 3 freelance illustrators, 2 freelance animators and 2 freelance designers/year. Uses freelance artists for all types of projects.
First Contact & Terms: Artists located in Hawaii only. Send query letter and samples (photostats or slides preferred). Samples returned. Provide resume to be kept on file for possible future assignments. Works on assignment only. Reports in 2 weeks. Pays by the project. Payment varies with each client's budget. No originals returned to artist following publication. Negotiates rights purchased.

Idaho

***CIPRA**, 314 E. Curling Dr., Boise ID 83702. (208)344-7770. President: Ed Gellert. Estab. 1979. Ad agency. Full-service, multimedia firm. Specializes in trade magazines, TV and logos.
Needs: Works with freelance illustrators 2-3 times/year. Prefers artists with experience in airbrushing. Works on assignment only. Uses freelance artists mainly for retouching and logos.
First Contact & Terms: Send query letter. Samples are filed. Does not report back unless needed—filed for reference. Mail appropriate materials. Portfolio should include color photocopy. Pays for design and illustration by the project; negotiated for each job. Buys all rights.

I/D/E/A INC., One I/D/E/A Way, Caldwell ID 83605. (208)459-6357. Creative Director: Steve Machado. Ad agency. Product specialties are printed products for the automotive industry. Clients: direct mail. "We have over 30,000 clients in the U.S. auto industry."
Needs: Assigns 12-15 freelance jobs/year. Uses artists for direct mail packages, brochures, airbrush and photographs. Types of illustration needed are editorial ("with a modern and kinetic style") and technical.
First Contact & Terms: Call before sending query letter with brochure, resume and samples to be kept on file. Write for artists' guidelines. Prefers the "most convenient samples for the artist. We would like to see a wide variety of sample work." Samples not kept on file are returned only if requested. Reports only if interested. Works on assignment only. Pays for design and illustration by the project, $150 minimum— "amount varies." Considers complexity of project, client's budget, and skill and experience of artist when establishing payment. Rights purchased vary with project.
Tips: "Most work goes into catalogs or brochures. We do some apparel designs also. At the present, the recession has slowed our need for freelance work to half of normal."

Illinois

ANDREN & ASSOCIATES, INC., 6400 Keating Ave., Lincolnwood IL 60646. (312)267-8500. Contact: Kenneth E. Andren. Clients: beauty product and tool manufacturers, clothing retailers, laboratories, banks, camera

and paper product companies. Clients include Alberto Culver, Barton Brand, Nalco Chemical, Encyclopedia Britannica, Firestone, Reflector Hardware, Rust-O-Leum, Avon Products and National Safety Council. Client list available upon request.

Needs: Approached by 50 freelance artists/year. Works with 6 or more freelance illustrators and 6 or more freelance designers/year. Local artists only. Uses artists for catalogs, direct mail brochures, flyers, packages, P-O-P displays and print media advertising.

First Contact & Terms: Query with samples or arrange interview. Include SASE. Reports in 1-2 weeks. Pays $15 minimum/hour for animation, design, illustration, layout, lettering, mechanicals, paste-up, retouching and type spec.

Tips: "Send in resume prior to calling to schedule appointment to show portfolio."

THE BEST COMPANY, 109 N. Main St., Rockford IL 61101. (815)965-3800. President: Jeffery Best. Ad agency producing radio/TV commercials, brochures, newspaper and magazine ads, logo and corporate identity programs. Clients: mainly consumer accounts. Client list provided upon request.

Needs: Works with 10-20 freelance artists/year. Uses freelance artists mainly for design, illustration, brochures, consumer magazines, retouching, billboards, lettering and logos.

First Contact & Terms: Send query letter with brochure or resume, tearsheets, photostats and slides. Samples are filed or are returned only if requested. Reports back within 2 weeks only if requested. Call or write to schedule an appointment to show a portfolio or mail roughs, original/final art and tearsheets. Pays for design by the hour, $20-45; by the project, $50 minimum. Pays for illustration by the hour, $50 minimum; by the project, $300 minimum. Considers complexity of project, client's budget and skill and experience of artist when establishing payment. Buys all rights; negotiates rights purchased.

Tips: "Do some research on agency and our needs to present portfolio in accordance. Will not see walk-ins."

BRACKER COMMUNICATIONS, Suite 222, 801 Skokie Blvd., Northfield IL 60062-4027. (708)498-6510. President: Richard W. Bracker. Ad agency/PR/publishing firm. Clients: construction, financial, acoustical, contractors, equipment manufacturers, trade associations, household fixtures, pest control products.

Needs: Works with 4-6 freelance artists/year. "Use only artists based in the Chicago area for the most part. We look for ability and have used recent graduates." Works on assignment only. Uses freelance artists for graphic design/key line. Especially important are type specing, design/layout and photo handling. Looking for editorial illustration that is realistic.

First Contact & Terms: Phone or send resume to be kept on file. Reviews any type of sample. Reports within 2 weeks. Write for appointment to show portfolio. Negotiates and/or accepts quotations on specific projects. Considers complexity of project, skill and experience of artist and turnaround time when establishing payment. Buys all rights.

Tips: "We would like to meet graphic designers who have desktop publishing equipment."

BRAGAW PUBLIC RELATIONS SERVICES, 800 E. Northwest Hwy., Palatine IL 60067. (708)934-5580. Principal: Richard S. Bragaw. PR firm. Specializes in newsletters and brochures. Clients: professional service firms, associations and industry. Current clients include: Krengel & Associates, KPT Kaiser Precision Tooling, Inc. and Hykiel-Carlin and Co. Ltd.

Needs: Assigns 12 freelance jobs/year. Local artists only. Works on assignment only. Works with 1 freelance illustrator and 1 freelance designer/month. Uses artists for direct mail packages, brochures, signage, AV presentations and press releases. Type of illustration needed is editorial.

First Contact & Terms: Send query letter with brochure to be kept on file. Reports only if interested. Write to schedule an appointment. Pays by the hour, $25-75 average. Considers complexity of project, skill and experience of artist and turnaround time when establishing payment. Buys all rights.

Tips: "We do not spend much time with portfolios."

CAIN AND COMPANY (ROCKFORD), 6116 Mulford Village Dr., Rockford IL 61107. (815)399-2482. Senior Art Director: Neal Peterson. Ad agency/PR firm. Clients: financial, industrial, retail and service.

Needs: Assigns 6 freelance jobs/year. Uses freelance artists for consumer and trade magazines, billboards, direct mail packages, brochures, catalogs, newspapers, filmstrips, movies, stationery, signage, P-O-P displays, AV presentations, posters and press releases "to some degree."

First Contact & Terms: Send query letter with brochure, resume, business card, samples and tearsheets to be kept on file. Call or write for appointment to show portfolio. Send samples that show best one medium in which work is produced. Samples are not filed and are not returned. Reports only if interested. Works on assignment only. "Rates depend on talent and speed; could be anywhere from $5 to $30 an hour." Considers skill and experience of artist and turnaround time when establishing payment. Buys all rights.

Tips: "Have a good presentation, not just graphics."

JOHN CROWE ADVERTISING AGENCY, INC., 1104 S. 2nd St., Springfield IL 62704. (217)528-1076. President: Bryan J. Crowe. Ad/art agency. Specializes in industries, manufacturers, retailers, banks, publishers, insurance firms, packaging firms, state agencies, aviation and law enforcement agencies. Product specialty is creative advertising. Current clients include: Systems 2000 Ltd., Silhouette American Health Spas.
Needs: Buys 3,000 illustrations/year. Works with 4 freelance illustrators and 3 freelance designers/month. Works on assignment only. Uses artists for color separation, animation, lettering, paste-up and type specing for work with consumer magazines, stationery design, direct mail, slide sets, brochures/flyers, trade magazines and newspapers. Especially needs layout, camera-ready art and photo retouching. Type of illustration needed is technical. Prefers pen & ink, airbrush, watercolor and marker.
First Contact & Terms: "Send a letter to us regarding available work at agency. Tell us about yourself. We will reply if work is needed and request samples of work." Prefers tearsheets, original art, photocopies, brochure, business card and resume to be kept on file. Samples not filed returned by SASE. Reports in 2 weeks. Pays for design by the project, $50-150; pays for illustration by the project, $75-150. No originals returned to artist at job's completion. No payment for unused assigned illustrations.
Tips: "Current works are best. Show your strengths and do away with poor pieces that aren't your stonghold. A portfolio should not be messy and cluttered. There has been a notable slowdown across the board in our use of freelance artists. We pretty much handle our own needs during this recession."

DYNAMIC GRAPHICS, 6000 N. Forest Park Dr., Peoria IL 61614. Art Director: Frank Antal. Graphics firm for general graphic art user.
Needs: Works with 50 freelance artists/year. Works on assignment only. Uses artists for illustrations. Needs artists with "originality, creativity, professionalism."
First Contact & Terms: Send query letter with portfolio showing art style or tearsheets and photocopies. Samples not filed are returned. Reports back within 1 month. To show a portfolio, mail appropriate materials, which should include final reproduction/product or photostats. Pays by the project; "we pay highly competitive rates but prefer not to specify." Considers complexity of project, skill and experience of artist and rights purchased when establishing payment. Buys all rights.
Tips: "Submit styles that are the illustrator's strongest and can be used successfully, consistently."

ELVING JOHNSON ADVERTISING INC., 7804 W. College Dr., Palos Heights IL 60463. (708)361-2850. Art/Creative Director: Michael McNicholas. Ad agency. Serves clients in industrial machinery, construction materials, material handling and finance.
Needs: Works with 2 freelance illustrators/month. Local artists only. Uses freelance artists for direct mail, brochures/flyers, trade magazines and newspapers. Also uses freelance artists for layout, illustration, technical art, paste-up and retouching. Prefers pen & ink, airbrush, watercolor and markers.
First Contact & Terms: Call for interview. Pays for design and illustration by the project, $100 minimum.
Tips: "We find most artists through references and portfolio reviews. We need technical illustration."

LINEAR CYCLE PRODUCTIONS, Box 2827, Carbondale IL 62902-2827. (618)687-3515. Producer: Rich Brown. Estab. 1980. AV firm. "We are an agency specializing in audiovisual sales and marketing programs and also in teleproduction for CATV." Current clients include: Katz, incorporated and McDave and Associates.
Needs: Works with 7-15 freelance illustrators and designers/year. Prefers artists with experience in teleproductions (broadcast/CATV/non-broadcast). Works on assignment only. Uses freelance artists for storyboards, animation, TV/film graphics, lettering and logos. 10% of work is with print ads.
First Contact & Terms: Send query letter with resume, photocopies, photographs, slides, transparencies, video demo reel and SASE. Samples are filed or are returned by SASE only if requested by artist. Reports back to the artist only if interested. To show a portfolio, mail audio/videotapes, photographs and slides; include color and b&w samples. Pays for design and illustration by the project $100 minimum. Considers skill and experience of artist, how work will be used and rights purchased when establishing payment. Negotiates rights purchased.
Tips: "We see a lot of sloppy work and samples, portfolios in fields not requested or wanted, poor photos, photocopies, graphics etc. Make sure that the materials are in a presentable situation."

WALTER P. LUEDKE & ASSOCIATES, INC., Suite 1A, 4223 E. State St., Rockford IL 61108. (815)398-4207. FAX: (815)398-4239. President: W. P. Luedke. Estab. 1959. Ad agency. Full-service multimedia firm. Specializes in magazine ads, brochures, catalogs and consultation. Product specialty is industry.
Needs: Approached by 2 freelance artists/month. Works with 2 freelance illustrators and 2 freelance designers/month. Prefers artists with experience in technical layout. Works on assignment only. Uses freelance artists mainly for artwork, layout, keyline. Also uses freelance artists for brochure, catalog and print ad design and illustration, storyboards, slide illustration, animatics, animation, mechanicals, retouching, billboards, posters, TV/film graphics, lettering and logos. 30% of work is with print ads.
First Contact & Terms: Send query letter with resume, photographs, tearsheets, photostats and slides. Samples are filed and are not returned. Reports back to the artist only if interested. Call to schedule an appointment to show a portfolio. Portfolio should include thumbnails, roughs, original/final art, b&w and

color photostats, tearsheets, photographs, slides or "whatever." Pays for design and illustration by the hour, by the project or by the day (negotiable). Buys all rights.

***MOTIVATION MEDIA, INC.,** 1245 Milwaukee Ave., Glenview IL 60025-2499. (708)297-4740. FAX: (708)297-6829. Contact: Manager, Creative Graphics. Estab. 1969. Audiovisual firm. Specializes in video.
Needs: Works with 1 freelance illustrator and 2-3 freelance designers/month. Prefers artists with experience in multi-image design/production and Forox animation operators. Works on assignment only. Uses freelance artists mainly for multi-image. Also uses freelance artists for storyboards, slide illustration, animation, retouching, TV/film graphics and lettering.
First Contact & Terms: Send query letter with resume and slides. Samples are filed or are returned by SASE only if requested by artist. Reports back only if interested. Write to schedule an appointment to show a portfolio, then follow up with call. Portfolio should include thumbnails and color slides. Pays for design by the hour, $12-25; pays for illustration by the hour, $15-30. Rights purchased vary according to project.

Chicago

ARTFORM COMMUNICATIONS, Suite 300, 325 W. Huron, Chicago IL 60610. (312)664-9402. Creative Director: Elaine Croft. Clients: business, corporate, multi-image and videotapes. Assigns 100 freelance jobs/year.
Needs: Works with 10 freelance illustrators/year. Uses freelance artists for stylized illustrations, human figures and animation. Works with production artists familar with producing film work, cutting rubylith, etc. for Marron Carrel special effects camera.
First Contact & Terms: Query with resume and samples (slides). Include SASE. Reports in 3 weeks. Provide resume and brochures/flyers to be kept on file for possible future assignments. No originals returned to artist at job's completion. Pays for design by the hour, $10-20.50. Pays for illustration by the hour, $10-30.50.
Tips: "Most of our artwork is now computer generated and that limits our use of freelancers." Looking for "work that relates directly to multi-image, logo design , hand lettering and computer graphics experience. We do not want to see mangy, poorly organized portfolios."

AUDITIONS BY SOUNDMASTERS, Box 8135, Chicago IL 60680. (312)224-5612. Executive Vice President: R.C. Hillsman. Produces radio/TV programs, commercials, jingles and records.
Needs: Buys 125-300 designs/year. Uses freelance artists for animation, catalog covers/illustrations, layout, paste-up, multimedia kits and record album design.
First Contact & Terms: Mail 8x10 art. Include SASE. Reports in 3 weeks. Pays $500 minimum, animation; $100-350, record jackets; $50-225, layout; $35-165, paste-up. Material copyrighted.

E. H. BROWN ADVERTISING AGENCY, INC., 20 N. Wacker, Chicago IL 60606. (312)372-9494. Art Director: Arnold G. Pirsoul. Estab. 1920. Ad agency. Specialties include print, television and radio advertising. Clients: insurance, schools, banks, corporations, electronics, high-tech, etc.
Needs: Works with 10 freelance illustrators and 6 freelance designers/year. Works on assignment only. Mainly uses freelancers for creative concept, also uses artists for design, illustration, newspapers, retouching, lettering, charts/graphs and advertisements. 40-50% of work is with print ads.
First Contact & Terms: Send photostats, photocopies and photographs. Samples are filed and are not returned. Reports back only if interested. Call or write to schedule an appointment to show a portfolio, which should include color and b&w roughs and tearsheets. Pays for design by the hour, $35-50, or by the project, $300-1,000. Pays for illustration by the project, $400-1,500. Considers complexity of project, client's budget, turnaround time, skill and experience of artist, how work will be used and rights purchased. Negotiates rights purchased; rights purchased vary according to project.
Tips: "Be precise and efficient about the job to be done. Avoid delays and be on time when the job is contracted. Stick with the estimate. Call us and we will make time to see samples. Show us a range of recent illustrations. Keep your portfolio updated, not heavy. Do not send cartoons or children's book illustrations."

 The asterisk before a listing indicates that the listing is new in this edition. New markets are often the most receptive to freelance submissions.

CLEARVUE, INC., 6465 N. Avondale, Chicago IL 60631. (312)775-9433. Vice President: Matt Newman. AV firm.

Needs: Works with 10-12 freelance artists/year. Works on assignment only. Uses freelance artists mainly for video and filmstrip programs and computer animation. Types of illustration needed are editorial and technical.

First Contact & Terms: Send query letter to be kept on file. Prefers to review proposal and demo tape. Reports back within 10 days. Write for appointment to show portfolio. Pays by the project, $50-2,500, depending on the scope of the work. Average program is 10-20 minutes long. Considers the complexity of the project and budget when establishing payment. Particularly interested in combining existing archival art and video materials with computer animations. Rights negotiable.

Tips: "Have some knowledge of the educational filmstrip and video marketplace. Review our catalogs. Write a proposal that tells how you fill a need in one or more curricular subject areas."

DARBY GRAPHICS, 4015 N. Rockwell, Chicago IL 60618. (312)583-5090. Creative Director: Tony Christian. Estab. 1930. In-house art department in full-service printing company providing audiovisual, design production services. Specializes in benefits, associations publications and hospitals. Current clients include Sears, McDonalds, Hewitt & Assoc., Bank Administration Institute, CECO and The Wyatt Comany.

Needs: Works with 2 freelance illustrators/year and 2 freelance designers/month. Prefers local artist with experience in keyline/production. Uses freelancers mainly for keylining, illustrating and computer/graphic design. Also uses freelance artists for brochure design and illustration, slide illustration, mechanicals and retouching. 10% of work is with print ads.

First Contact & Terms: Send query letter with resume, photocopies and slides. Samples are filed or are returned by SASE only if requested by artist. Reports back to the artist only if interested. Write to schedule an appointment to show a portfolio, which should include roughs and original/final art; include color and b&w samples. Pays for design by the hour, $15-25. Pays for illustration by the project, $100-1,000. Considers skill and experience of artist when establishing payment. Rights purchased vary according to project.

Tips: "Call us a week after writing to schedule an appointment. We do not want to see photocopies, 'fine art' samples from school or too much in a portfolio. Have a variety of the same thing or style. Like to see projects through all the various stages: conception, implementation, layout, paste-up and finished product."

IMAGINE THAT!, Suite 2413, 405 N. Wabash Ave., Chicago IL 60611. (312)670-0234. President: John Beele. Contact: Sheila Dunbar. Ad agency. Clients: broadcast, insurance, University of Illinois sports program, pharmaceuticals, retail furniture stores, real estate and professional rodeo.

Needs: Assigns 25-50 freelance jobs and buys 15 freelance illustrations/year. Uses artists for layout, illustration, mechanicals and photography.

First Contact & Terms: Arrange interview to show portfolio. Pay is negotiable.

McCANN HEALTHCARE ADVERTISING, 625 N. Michigan Ave., Chicago IL 60611. (312)266-9200. Creative Director: Priscilla Kozel. Ad agency. Clients: pharmaceutical and health care companies.

Needs: Work load varies. Works on assignment only. Uses freelance artists mainly for layout and comps. Also uses freelancers for medical trade magazines, journal ads, brochures/flyers and direct mail to physicians. Especially needs sources for tight marker renderings and comp layouts.

First Contact & Terms: Send query letter with resume and samples. Call for appointment to show portfolio, which should include roughs, original/final art, final reproduction/product color and photostats and photographs. Prefers to see original work rather than reproductions, but will review past work used by other ad agencies. Reports within 2 weeks. Pays by the hour, $10-50. Negotiates payment based on client's budget, where work will appear, complexity of project, skill and experience of artist and turnaround time.

Tips: "Rendering with markers very important." Needs good medical illustrators but is looking for the best person—one who can accomplish executions other than anatomical. When showing samples or portfolio "show how you got from A to Z. Show intermediate stages; it shows the thinking process."

MARKETING SUPPORT INC., 303 E. Wacker Dr., Chicago IL 60601. (312)565-0044. Executive Art Director: Robert Becker. Clients: plumbing, heating/cooling equipment, chemicals, hardware, ski equipment, home appliances, crafts and window coverings.

Needs: Assigns 300 freelance jobs/year. Works with 2-3 freelance illustrators/month. Local artists only. Works on assignment only. Uses freelance artists for filmstrips, slide sets, brochures/flyers and trade magazines. Also uses freelance artists for layout, illustration, lettering, type spec, paste-up and retouching for trade magazines and direct mail.

First Contact & Terms: Arrange interview to show portfolio. Samples returned by SASE. Reports back only if interested. Provide business card to be kept on file for future assignments. No originals returned to artist at job's completion. Pays by the hour, $15 minimum. Considers complexity of project, client's budget and skill and experience of artist when establishing payment.

NORTHWEST TELEPRODUCTIONS, 142 E. Ontario, Chicago IL 60611. (312)337-6000. General Manager: Mr. Carmen V. Trombetta. Executive Producer: Debbie Heagy. Estab. 1990. Videotape/film teleproducer. Clients: 40% are major Chicago advertising and PR firms and educational/industrial enterprises and 40% are corporate enterprises, and 20% are broadcast enterprises. Produces multimedia kits, slide sets, videotapes and films.
Needs: Works with 2-3 illustrators/month. Works on assignment only. Assigns 100 jobs/year. Uses artists for videotape teleproduction, television copy art, storyboard animation and computer animation.
First Contact & Terms: Query with resume, business card and slides which may be kept on file. Samples not kept on file are returned by SASE. Reports in 2-3 weeks. Original art returned to artist at job's completion. Pays by the project, $200 minimum.
Tips: "Artists must be familiar with film and videotape. We need more videotape and computer graphics artists. Show some examples of computer graphics."

***S.C. MARKETING, INC.,** 432 N. Clark St., Chicago IL 60610. (312)464-0460. FAX: (312)464-0463. President: Susie Cohn. Estab. 1990. Ad agency, concentrating on print. Specializes in magazine ads, collateral, and miscellaneous print materials. Product specialty is food service. Current clients include: Keebler Co., Bernardi Italian Foods and Original Chili Bowl Co.
Needs: Approached by 1 freelance artist/month. Works with 2 freelance illustrators and 1 freelance designer/month. Prefers artists with experience in food industry. Works on assignment only. Uses freelance artists mainly for layout/creative development, type specing, production coordination, photography supervision. Also uses freelance artists for brochure design and illustration, catalog design and illustration, print ad design and illustration, storyboards, posters, lettering and logos. 40% of work is with print ads.
First Contact & Terms: Send query letter with resume, photocopies, photographs and tearsheets. Samples are filed. Reports back to the artist only if interested. To show a portfolio, mail roughs, original/final art and b&w or color tearsheets and photographs. Pays for design and illustration by the project. Buys all rights.

***WEBER, COHN & RILEY,** 444 N. Michigan Ave., Chicago IL 60611. (312)527-4260. FAX: (312)527-4273. Vice President/Executive Creative Director: C. Welch. Estab. 1960. Ad agency. Full-service, multimedia firm. Specializes in broadcast/print advertising, collateral, direct mail, P-O-P displays.
Needs: Approached by 10 freelance artists/month. Works with 4 freelance illustrators/month. Works on assignment only. Uses freelance artists for storyboards, animatics, mechanicals, retouching and TV/film graphics. 70% of work is with print ads.
First Contact & Terms: Send query letter with photocopies and resume. Samples are filed. Reports back to the artist only if interested. Mail appropriate materials. Portfolio should include tearsheets, photographs and transparencies. Pays for design and illustration by the project. Rights purchased vary according to project.

Indiana

ASHER AGENCY, 511 W. Wayne, Fort Wayne IN 46802. (219)424-3373. Sr. Art Director: Mark Manuszak. Estab. 1974. Ad agency and PR firm. Clients: automotive firms, convention centers, financial/investment firms, area economic development agencies, health care providers and fast food companies.
Needs: Works with 10 freelance artists/year. Assigns 50 freelance jobs/year. Prefers area artists. Works on assignment only. Uses freelance artists mainly for illustration. Also uses freelance artists for design, brochures, catalogs, consumer and trade magazines, retouching, billboards, posters, direct mail packages, logos and advertisements.
First Contact & Terms: Send query letter with brochure showing art style or tearsheets and photocopies. Samples are filed or are returned by SASE. Reports back only if interested. Write to schedule an appointment to show a portfolio, which should include roughs, original/final art, tearsheets and final reproduction/product. Pays for design by the hour, $20 minimum. Pays for illustration by the hour. Considers complexity of project, client's budget, turnaround time and skill and experience of artist when establishing payments. Buys all rights.

BLOOMHORST STORY O'HARA INC., 200 S. Meridian, Indianapolis IN 46225. (317)639-4436. Art Director: Curt Chavalus. Full-service ad agency. Clients: retail.
Needs: Works with 30 artists/year. Uses freelance artists mainly for brochure, catalog, newspaper and magazine ad illustration; P-O-P displays; mechanicals; retouching; animation; films; lettering and charts/graphs.
First Contact & Terms: Send query letter with brochure showing art style or tearsheets, photocopies and slides. Samples are filed or are returned only if requested by artist. Does not report back. Call to schedule an appointment to show a portfolio, which should include color and b&w roughs, photostats, tearsheets, photographs and slides. Pays for illustration by the project, $100-10,000+. Considers complexity of project, client's budget, turnaround time, how work will be used and rights purchased. Rights purchased vary according to project.
Tips: "Please do not leave your phone number asking us to call you back to set up an interview."

C.R.E. INC., 400 Victoria Centre, 22 E. Washington St., Indianapolis IN 46204. (317)631-0260. Creative Director: Mark Gause. Ad agency. Specializes in business-to-business, computer equipment, biochemicals and electronics. Clients: primarily business-to-business.

Needs: Works with 15 freelance artists/year. Works on assignment only. Uses freelance artists for technical line art, color illustrations and airbrushing.

First Contact & Terms: Send query letter with resume, and photocopies to be kept on file. Samples not filed are returned. Reports back only if interested. Call or write to schedule an appointment to show a portfolio, or mail original/final art, final reproduction/product and tearsheets. Pays for design and illustration by the project, $100 minimum. Considers complexity of the project, client's budget, skill and experience of artist and rights purchased when establishing payment. Buys all rights.

Tips: "Show samples of good creative talent."

CALDWELL VAN RIPER, INC. ADVERTISING-PUBLIC RELATIONS, 1314 N. Meridian St., Indianapolis IN 46202. (317)632-6501. Contact: Art Director. Ad agency/PR firm. Clients are a "good mix of consumer (banks, furniture, food, etc.) and industrial (chemicals, real estate, insurance, heavy industry)."

Needs: Assigns 100-200 freelance jobs/year. Works with 10-15 freelance illustrators/month. Works on assignment only. Uses freelance artists for consumer and magazine ads, billboards, direct mail packages, brochures, catalogs, newspaper ads, P-O-P displays, storyboards, AV presentations and posters.

First Contact & Terms: Send query letter with brochure, samples and tearsheets to be kept on file. Call for appointment to show portfolio. Accepts any available samples. Samples not filed are returned by SASE only if requested. Reports only if interested. Pay is negotiated. Considers complexity of project, client's budget, skill and experience of artist and rights purchased when establishing payment. Buys all rights.

Tips: "Send 5 samples of best work (copies acceptable) followed by a phone call."

GRAY, MILLER & MITSCH, Suite 305, 8910 Purdue Rd., Indianapolis IN 46268. (317)875-0580. FAX: (317)872-6023. Creative Director: Larry Mitsch. Estab. 1985. Ad agency. Full-service, multimedia firm. Specializes in magazine ads and collaterals. Product specialty is business-to-business. Current clients include: E-A-R, Mallory, Business Furniture Corp.

Needs: Approached by 1 freelance artist/month. Prefers artists with experience. Uses freelance artists mainly for design assistance. Also uses freelance artists for brochure, catalog and print ad design and illustration, storyboards, slide illustration, animatics, animation, retouching, billboards, posters, TV/film graphics, lettering and logos. 45% of work is for print ads.

First Contact & Terms: Send query letter with brochure, resume, photocopies, photographs and tearsheets. Samples are filed or are returned. Reports back to the artist only if interested. Mail appropriate materials: thumbnails, roughs, original/final art, b&w and color photostats, tearsheets, photographs, slides and 4×5 transparencies. Pays for design by the hour, $25-40; by the project, $25-40; by the day $25-40. Pays for illustration by the project, $150-5,000. Buys one-time rights or rights purchased vary according to project.

***OMNI PRODUCTIONS,** 655 West Carmel Dr., Carmel IN 46032. (317)844-6664. FAX: (317)573-8189. President: Winston Long. Estab. 1984. Audiovisual firm. Full-service, multimedia firm. Specializes in documentaries, educational and training videos. Product specialties: educational, technical, international productions.

Needs: Approached by 3 freelance artists/month. Works with 1 freelance illustrator and 1 freelance designer/month. Prefers artists with experience in graphics and computer automation. Works on assignment only. Uses freelance artists mainly for computer graphics and slides. Also uses freelance artists for storyboards, slide illustration, animation, TV/film grahics and logos. 1% of work is with print ads.

First Contact & Terms: Send query letter with resume. Samples are filed. Reports back to the artist only if interested. Write to schedule an appointment to show a portfolio or mail appropriate materials. Payment for design and illustration varies per project. Rights purchased vary according to project.

BJ THOMPSON ASSOCIATES, INC., 201 S. Main St., Mishawaka IN 46544. (219)255-5000. Creative Director: Tim Elliott. Estab. 1979. "We are a full-service advertising/public relations firm, with much of our work in print-media and collateral." Specializes in RV's, agriculture and home improvement. Current clients include: Jayco, Inc., Reese Products, Leer, Inc. and Champion Motor Coach.

Needs: Works with 6 freelance illustrators and 2 freelance designers/month. Prefers artists with experience in mechanical illustration and airbrush. Works on assignment only. Uses freelancers for all print material. Uses freelance artists for brochure and print ad design and illustration, storyboards, slide illustration, retouching, billboards and posters. 70% of work is with print ads.

First Contact & Terms: Send query letter with resume and slides. Samples are not filed and are returned only if requested by artist. Reports back to the artist only if interested. Write to schedule an appointment to show portfolio, which should include color and b&w photostats, tearsheets, final reproduction/product and slides. Pays for design by the project, $25/hour minimum. Pays for illustration by the project, $50/hour

minimum. Considers complexity of project, client's budget, turnaround time and skill and experience of artist when establishing payment. Buys all rights.

Iowa

***FLEXSTEEL INDUSTRIES INC.**, 3200 Jackson, Dubuque IA 52004-0877. (319)556-7730. FAX: (319)556-8345. Advertising Manager: Tom R. Baldwin or Lance Rygh. Estab. 1893. Full-service, multimedia firm, manufacturer with full-service in-house agency. Specializes in furniture advertising layouts, price lists, etc. Product specialty is consumer—upholstered furniture.
Needs: Approached by 1 freelance artist/month. Works with 4-6 freelance illustrators/month. Prefers artists who can do both wash and line illustration of upholstered furniture. Works on assignment only. Uses freelance artists mainly for line and wash illustrations. Also uses freelance artists for catalog and print ad illustration, retouching, billboards and posters. 25% of work is with print ads.
First Contact & Terms: Send query letter with resume, tearsheets and samples. Samples are filed or are returned by SASE only if requested by artist. Reports back to the artist only if interested. To show a portfolio, mail thumbnails, roughs and b&w tearsheets. Pays for design and illustration by the project. Buys all rights.

Kansas

BRYANT, LAHEY & BARNES, INC., 5300 Foxridge Dr., Mission KS 66202. (913)262-7075. Art Director: Terry Pritchett. Ad agency. Clients: agriculture and veterinary firms.
Needs: Local artists only. Uses artists for illustration and production, including keyline and paste-up; consumer and trade magazines and brochures/flyers.
First Contact & Terms: Query by phone. Send business card and resume to be kept on file for future assignments. Negotiates pay. No originals returned to artist at job's completion.

MARKETAIDE, INC., Box 500, Salina KS 67402-0500. (913)825-7161. Art Director: Rusty Nelson. Full-service ad/marketing/direct mail firm. Clients: financial, agricultural machinery, industrial, some educational, and fast food.
Needs: Prefers artists within one-state distance and possessing professional expertise. Works on assignment only. Uses freelance artists for illustrations, retouching, signage. Type of illustration needed is technical.
First Contact & Terms: Send query letter with resume, business card and samples to be kept on file. Accepts any kind of accurate representation as samples, depending upon medium. Samples not kept on file are returned only if requested. Reports only if interested. Write for appointment to show portfolio. Pays by the hour, $15-75 average; "since projects vary in size we are forced to estimate according to each job's parameters."
Tips: Artists interested in working here "should be highly-polished in technical ability, have a good eye for design and be able to meet all deadline commitments."

MARSHFILM ENTERPRISES, INC., Box 8082, Shawnee Mission KS 66208. (816)523-1059. President: Joan K. Marsh. Estab. 1969. AV firm. Clients: schools.
Needs: Works with 1-2 freelance artists/year. Works on assignment only. Uses freelance artists mainly for illustrating filmstrips, video or teaching guides. Artists must have experience and imagination.
First Contact & Terms: Send query letter, pay scale, resume and slides or actual illustrations to be kept on file "if it is potentially the type of art we would use." Samples not filed are returned. Reports within 1 month. Write for appointment to show portfolio. Pays for illustration by the project. Considers client's budget when establishing payment. Buys all rights.

Kentucky

***MERIDIAN COMMUNICATIONS,** Suite 200, 444 E. Main St., Lexington KY 40507. (606)252-3350. FAX: (606)254-5511. Vice President, Creative Service: Ave Lawyer. Estab. 1975. Ad agency. Full-service, multimedia firm. Specializes in PR, ads (magazine and newspaper), grocery store handbills, TV and radio spots, packaging, newsletters, etc. Current clients include: Toyota, Foodtown, Lexmark, Southern Belle, NAPCOR and Al-tech.
Needs: Approached by 6 freelance artists/month. Works with 2 freelance illustrators and 3 freelance designers/month. Prefers local artists. Works on assignment only. Uses freelance artists for brochure design and illustration, catalog design and illustration, print ad illustration, storyboards, animatics, animation, posters, TV/film graphics, logos. 60% of work is with print ads.

First Contact & Terms: Send query letter with resume, photocopies, photographs and tearsheets. Samples are filed. Reports back within 2 weeks. To show a portfolio, mail original/final art, b&w and color tearsheets and photographs. Pays negotiable rates for design and illustration. Rights purchased vary according to project.

Louisiana

CUNNINGHAM, SLY WADSACK INC., Box 4503, Shreveport LA 71134-0503. (318)861-6660. Creative Director: Harold J. Sly. Ad agency. Current clients include: Schumpert Medical Center, Frymaster Corp., Beairo Industries and Central LA Electric Co.
Needs: Works with 6-10 freelance artists/year. Works on assignment only. Uses artists for layout/design, illustration, photo retouching, mechanical art and airbrushing. Especially looks for mechanical skills. Types of illustration needed are editorial, technical and medical. Editorial illustration should be realistic with varied corporate content.
First Contact & Terms: Send query letter with brochure, resume, business card and samples to be kept on file. Samples not filed are returned only by request. Reports back only if interested. Pays by the hour, $30-75 average. Considers complexity of the project, client's budget and turnaround time when establishing payment. Rights purchased vary according to project.

THE MABYN KEAN AGENCY, 8550 United Plaza Blvd., Baton Rouge LA 70809. (504)925-8278. FAX: (504)922-4422. President: Mabyn Kean Shingleton. Estab. 1977. Ad agency. Full-service, multimedia firm. Specializes in brochures and collaterals. Current clients include: United Companies and Wright & Percy Insurance.
Needs: Approached by 3 freelance artists/month. Works with 3 freelance illustrators and 2 freelance designers/month. Prefers local artists only. Works on assignment only. Uses freelance artists mainly for design and mechanicals. Also uses freelance artists for brochure, catalog and print ad design and illustration, storyboards, animation, mechanicals, retouching, billboards, posters, TV/film graphics and logos. 25% of work is with print ads.
First Contact & Terms: Send query letter with brochure, resume, photographs, tearsheets and slides. Samples are filed and are returned. Reports back to the artist only if interested. Write to schedule an appointment to show a portfolio. Portfolio should include thumbnails, roughs and b&w and color photographs. Pays for design and illustration by the project. Rights purchased vary according to project, but usually all rights.

SACKETT EXECUTIVE CONSULTANTS, 101 Howard Ave., New Orleans LA 70113. (504)522-4040. FAX: 524-8839. Art Director: Mrs. Shawn Nguyen. Estab. 1980. Ad agency and PR firm. Full-service, multimedia firm. Specializes in magazine/newspaper ads, direct mail, audiovisual TV/radio/film productions and political campaigns. Product specialties are retail and political. Current clients include: Canupo, Sound Trek and ABC Insurance.
Needs: Approached by 10 freelance artists/month. Works with 2 freelance illustrators and 1 freelance designer/month. Prefers artists with experience in food illustrations, architectural renderings and technical illustrations. Works on assignment only. Uses freelance artists mainly for illustration and presentation (or crash jobs). Also uses freelance artists for brochure, catalog and print ad design and illustration, animatics, animation, mechanicals, retouching, billboards, posters, TV/film graphics, lettering and logos. 40% of work is for print ads.
First Contact & Terms: Send query letter with brochure, photocopies, resume, tearsheets and photostats. Samples are filed. Samples are not returned. Reports back within 1 week. Call to schedule an appointment to show a portfolio. Portfolio should include original/final art, b&w and color photostats. Pays for design by the hour, $10-50; by the project, $100 minimum; and by the day, $80-400. Pays for illustration by the project, $500-3,000. Buys first rights and all rights.

Maryland

SAMUEL R. BLATE ASSOCIATES, 10331 Watkins Mill Dr., Gaithersburg MD 20879-2935. (301)840-2248. President: Samuel R. Blate. AV and editorial services firm. Clients: business/professional, U.S. government, some private.
Needs: Works with 5 freelance artists/year. Only works with artists in the Washington metro area. Works on assignment only. Uses artists for cartoons (especially for certain types of audiovisual presentations), illustrations (graphs, etc.) for 35mm slides, pamphlet and book design. Especially important are "technical and aesthetic excellence and ability to meet deadlines."
First Contact & Terms: Send query letter with resume and tearsheets, photostats, photocopies, slides and photographs to be kept on file. "No original art, please, and SASE for return." Call or write for appointment to show portfolio, which should include final reproduction/product and color and b&w photographs. Samples

are returned only by SASE. Reports only if interested. Pays by the hour, $20-40. "Payment varies as a function of experience, skills needed, size of project, and anticipated competition, if any." Also considers complexity of the project, client's budget, turnaround time and rights purchased when establishing payment. Rights purchased vary according to project, "but we prefer to purchase first rights only. This is sometimes not possible due to client demand, in which case we attempt to negotiate a financial adjustment for the artist."
Tips: "The demand for technically oriented artwork has increased. At the same time, some clients who have used artists have been satisfied with computer-generated art."

IMAGE DYNAMICS, INC., Suite 1400, 1101 N. Calvert St., Baltimore MD 21202. (301)539-7730. Creative Director: Kelly Andrews. Ad agency/PR firm. Clients: wide mix, specializing in restaurants and hotels, associations, colleges, hospitals and land developers.
Needs: Local artists only. Uses artists for illustration, design and paste-up; frequently buys humorous and cartoon-style illustrations. Prefers various styles in b&w and full-color.
First Contact & Terms: Call to arrange interview to show portfolio; "please do not drop in. Bring lots of b&w and color samples; have printed or produced work to show." Samples are returned. Reports only if interested. Provide business card and samples to be kept on file for possible future assignments. Pays by the project, $100-1,500, depending on project and budget. Considers complexity of project, client's budget, skill and experience of artist and turnaround time when establishing payment.

SHECTER & LEVIN ADVERTISING/PUBLIC RELATIONS, 2645 N. Charles St., Baltimore MD 21218. (301)889-3395. Contact: Roslyn Wills. Ad agency/PR firm. Serves clients in real estate, finance, professional associations, social agencies, retailing, apartments and manufacturing.
Needs: Works with 3-4 illustrators/month. Uses designers for billboards, consumer magazines, stationery design, direct mail, television, brochures/flyers, trade magazines and newspapers. Also uses artists for layouts and mechanicals for brochures, newspaper and magazine ads.
First Contact & Terms: Write for an interview to show portfolio. No originals returned to artist at job's completion. Negotiates pay.

MARC SMITH CO., Box 5005, Severna Park MD 21146. (301)647-2606. Art/Creative Director: Marc Smith. Ad agency. Clients: consumer and industrial products, sales services and PR firms.
Needs: Works with 3 illustrators/month. Local artists only. Uses freelance artists for layout, illustration, lettering, technical art, type specing, paste-up and retouching. Also uses freelance artists for illustration and design of direct mail, slide sets, brochures/flyers, trade magazines and newspapers; design for film strips, stationery, multimedia kits. Occasionally buys humorous and cartoon-style illustrations.
First Contact & Terms: Send query letter with brochure showing art style or tearsheets, photostats, photocopies, slides or photographs. Keeps file on artists; does not return original artwork to artist after completion of assignment. Call or write to schedule an appointment to show a portfolio, which should include color thumbnails, roughs, original/final art, final reproduction/product and tearsheets. Pays by the hour, $25-150, or negotiated.
Tips: "More sophisticated techniques and equipment are being used in art and design. Our use of freelance material has intensified. Project honesty, clarity and patience."

VAN SANT, DUGDALE & COMPANY, INC., The World Trade Center, Baltimore MD 21202. (301)539-5400. Creative Director: Richard Smith. Ad agency. Clients: consumer, corporate, associations, financial, and industrial.
Needs: Number of freelance artists used varies. Works on assignment basis only. Uses freelance artists for consumer and trade magazines, brochures, catalogs, newspapers and AV presentations.
First Contact & Terms: Negotiates payment according to client's budget, amount of creativity required, where work will appear and freelancer's previous experience.

Massachusetts

CORNERSTONE ASSOCIATES, 123 Second Ave., Waltham MA 02154. (617)890-3773. Production Manager: Phil Sheesley. Estab. 1978. "We are an audiovisual company specializing in meetings, multi-media, shows and speaker support slide presentations." Current clients include Reebok, DEC, Prime, and other local clients.
Needs: Works with 2 freelance designers/month. Prefers local artists only with experience in slide mechanicals and design. Also uses artists for storyboards and slide illustration.
First Contact & Terms: Send query letter with resume, slides and SASE. Samples are filed or are returned by SASE. Reports back to the artist only if interested. Call or write to schedule an appointment to show a portfolio, or mail original final art, final reproduction/product, photographs and slides. Considers complexity

of project, client's budget, turnaround time, skill and experience of artist and how work will be used when establishing payment. Rights purchased vary according to project.

Tips: "Have a strong design sense; show you can execute extremely clean mechanicals; have a portfolio that shows these skills."

COSMOPULOS, CROWLEY & DALY, INC., 250 Boylston St., Boston MA 02116. (617)266-5500. Chairman of the Board/Creative Director: Stavros Cosmopulos. Associate Creative Director: Rich Kerstein. Advertising and marketing agency. Clients: banks, restaurants, industry, package goods, food and electronics. Current clients include: Cambridge Savings Bank, Allendale Insurance and Massachusetts Convention Center.

Needs: Works with 6 freelance illustrators and 1 freelance animator/month. Works on assignment only. Uses artists for work on billboards, P-O-P displays, filmstrips, consumer magazines, stationery design, multimedia kits, direct mail, television, slide sets, brochures/flyers, trade magazines and newspapers. Types of illustration needed are technical, medical and advertising.

First Contact & Terms: Send business card, photostats or slides. Samples not filed are returned by SASE. Reports only if interested. Make an appointment to show portfolio. No originals returned to artist at job's completion. Pays for design by the project, $250-2,500. Pays for illustration by the project, $75-4,000. Considers complexity of project, client's budget, geographic scope of finished project, turnaround time and rights purchased when establishing payment.

Tips: "Give a simple presentation of the range of work you can do including printed samples of actual jobs— but not a lot of samples. I look for specific techniques that an artist may have to individualize the art."

FLAGLER ADVERTISING/GRAPHIC DESIGN, Box 1317, Brookline MA 02146. (617)566-6971. President/Creative Director: Sheri Flagler. Specializes in corporate identity, brochure design, fashion and technical illustration. Clients: cable television, finance, real estate, fashion and direct mail agencies.

Needs: Works with 10-20 freelance artists/year. Works on assignment only. Uses artists for illustration, mechanicals, retouching, airbrushing, charts/graphs and lettering.

First Contact & Terms: Send resume, business card, brochures, photocopies or tearsheets to be kept on file. Call or write for appointment to show portfolio. Samples not filed are not returned. Reports back only if interested. Pays for design by the project, $150-1,500 average; for illustration by the project, $150-1,200 average. Considers complexity of project, client's budget and turnaround time when establishing payment.

Tips: "Send a range and variety of styles showing clean, crisp and professional work."

HARPER & COMPANY, INC., 274 Great Rd., Acton MA 01720. (508)263-5331. FAX: (508)635-9558. Creative Partner: Deb Harper. Estab. 1985. Ad agency. Full-service, multimedia firm. Specializes in magazine ads, collaterals, corporate identity and desk-top publishing. Product specialties high-tech and consumer.

Needs: Approached by 2-4 freelance artists/month. Works with 1 freelance illustrator and 2 freelance designers/month. Prefers artists with experience in high technology. Works on assignment only. Uses freelance artists mainly for overflow of design and most production. Also uses freelance artists for brochure design, catalog design and illustration, mechanicals, retouching and logos. 25% of work is with print ads.

First Contact & Terms: Send query letter with photocopies, resume and references. Samples are filed. Reports back within 2 weeks, only if interested. Mail appropriate materials: thumbnails, roughs, original/final art and color photostats. Pays by the project, $50-1,500. Pays for illustration by the project, $25-1,000. Buys all rights.

HELIOTROPE STUDIOS LTD., 21 Erie St., Cambridge MA 02139. (617)868-0171. Production Coordinator: Suzanne Sobert. Estab. 1984. AV firm. "We are a full-service, sophisticated facility for film and video production and post-production." Current projects include NBC-TV "Unsolved Mysteries" series; TWA/The Travel Channel; "Nova"-WGBH-TV, BBC-TV and corporate video projects.

Needs: Works with 6 freelance illustrators and 6 freelance designers/month. Works on assignment only. Uses freelancers mainly for set design and animation. Also uses artists for brochure design and storyboards. Type of illustration needed is technical.

First Contact & Terms: Send query letter with brochure. Samples are filed. Reports back to the artist only if interested. To show a portfolio, mail appropriate materials. Pays for design and illustration by the day, $100-400. Considers client's budget and turnaround time when establishing payment. Rights purchased vary according to project.

Tips: "Have excellent referrals and a solid demo tape of work."

THE PHILIPSON AGENCY, Suite B201, 241 Perkins St., Boston MA 02130. (617)566-3334. FAX: (617)566-3363. President and Creative Director: Joe Philipson. Marketing design firm. Specializes in packaging, collaterals, P.O.P., corporate image, sales presentations, direct mail, business-to-business and high-tech.

Needs: Approached by 3-4 freelance artists/month. Works with 1 freelance illustrator and 3 freelance designers/month. Prefers artists with experience in design, illustration, comps and production. Works on assignment only. Uses freelance artists mainly for overflow and special jobs. Also uses freelance artists for packaging,

brochure, catalog and print ad design and illustration, mechanicals, retouching, posters, lettering and logos. 65% of work is with print ads.

First Contact & Terms: Send query letter with brochure, photocopies, SASE, resume, photographs, tearsheets, photostats, slides and transparencies. Samples are filed or are returned by SASE. Reports back to the artist only if interested. Mail appropriate materials: roughs, original/final art, photostats, tearsheets, photographs and slides. Pays for design by the hour, $15-50; pays for illustration by the hour. Buys all rights.

RAPP COLLINS MARCOA, 40 Broad St., Boston MA 02109-4359. Creative Director: Dom Cimei. Direct marketing ad agency. Clients: industry, financial and publishing firms, utilities, healthcare and software firms. Current clients include: New England Telephone, Bank of Boston and Yankee Gas.

Needs: Number of freelance artists used varies. Usually works with local freelancers. Works on assignment basis only. Uses freelance artists for direct mail, collateral and print.

First Contact & Terms: Arrange interview to show portfolio. "Write, then call." Pays for design by the project, $300 minimum; pays for illustration by the project. Payment varies according to job.

Tips: "Marginal samples lessen the impact of good stuff. Submit samples of work and give an indication of fees."

TR PRODUCTIONS, 1031 Commonwealth Ave., Boston MA 02215. (617)783-0200. Production Manager: Tom Cramer. AV firm. Clients: industry and high-tech.

Needs: Works with 5-10 freelance artists/year. Assigns 20-50 jobs/year. Prefers local artists. Works on assignment generally. Uses artists for slide graphics, layout, mechanical, computer graphics, charts/graphs, advertisements and 2-color and 4-color collateral design. Especially important is clean, accurate board work.

First Contact & Terms: For slide work, artist must have experience in design and mechanicals for slides/multi-image. Send query letter with brochure showing art style, resume and slides to be kept on file. Samples not filed are not returned. Reports only if interested. Call to schedule an appointment to show a portfolio. Pays by the hour, $10-25 average. Considers complexity of project, client's budget, skill and experience of artist and turnaround time when establishing payment. Buys all audiovisual rights.

***TVN-THE VIDEO NETWORK**, 1380 Soldiers Field Rd., Boston MA 02135. (617)782-1618. FAX: (617)782-8860. Producer: Gregg McAllister. Estab. 1986. Audiovisual firm. Full-service multimedia firm. Specialies in video production for business, broadcast and special events. Product specialties cover a broad range of categories. Current clients include: Marriott, Digital, IBM, Rathoen, National Park Service.

Needs: Approached by 1 freelance artist/month. Works with 1 freelance illustrator/month. Prefers artists with experience in Amiga PC, D paint III, 2D and 3D programs. Works on assignment only. Uses freelance artists mainly for video production. Also uses freelance artists for storyboards, animation, TV/film graphics and logos.

First Contact & Terms: Send query letter with videotape and computer disk. Samples are filed or returned. Reports back within 2 weeks. Mail appropriate materials. Portfolio should include videotape and computer disk (Amiga). Pays for design by the hour, $15-30. Buys all rights.

Michigan

WILLIAM R. BIGGS/GILMORE ASSOCIATES, 200 E. Michigan Ave., Kalamazoo MI 49007. (616)349-7711. FAX: (616)349-3051. Creative Department Coordinator: Launa Rogers. Estab. 1973. Ad agency. Full-service, multimedia firm. Specializes in magazine and newspaper ads and collateral. Product specialties are consumer, business-to-business and healthcare.

Needs: Approached by 10 freelance artists/month. Works with 1-3 freelance illustrators and designers/month. Works both with artist reps and directly with artist and prefers artists with experience with client needs. Works on assignment only. Uses freelance artists mainly for completion of projects needing specialties. Also uses freelance artists for brochure, catalog and print ad design and illustration, storyboards, slide illustration, animatics, animation, mechanicals, retouching, billboards, posters, TV/film graphics, lettering and logos.

First Contact & Terms: Send query letter with brochure, photocopies and resume. Samples are filed. Reports back to artists only if interested. Call to schedule an appointment to show a portfolio. Portfolio should include all samples the artist considers appropriate. Pays for design and illustration by the hour and by the project. Rights purchased vary according to project.

LEO J. BRENNAN, INC. Marketing Communications, (formerly Leo J. Brennan Advertising), 2359 Livernois, Troy MI 48083-1692. (313)362-3131. Financial and Administrative Director: Virginia Janusis. Estab. 1969. Ad agency, PR and marketing firm. Clients: mainly industry, automotive, banks and C.P.A.s.

Needs: Works with 10 freelance artists/year. Artist must be well experienced. Uses artists for design, illustration, brochures, catalogs, retouching, lettering, keylining and typesetting. 50% of work is print ads.

First Contact & Terms: Send query letter with resume and samples. Samples not filed are returned only if requested. Reports only if interested. Call to schedule an appointment to show a portfolio, which should include thumbnails, roughs, original/final art, final reproduction/product, color and b&w tearsheets, photostats and photographs. Pay for design and illustration varies. Considers complexity of project, client's budget, skill and experience of artist and turnaround time when establishing payment. Buys all rights.

***CLASSIC ANIMATION,** 2330 Byrd St., Kalamazoo MI 49002. (616)382-0352. FAX: (616)382-3250. Creative Director: David Baker. Estab. 1986. Audiovisual firm. Specializes in animation—computer (PC-Crystal 3.0, Lumena, TIPS, Rio) and traditional. Current clients include: Amway, Upjohn, Armstrong, NBC.

Needs: Approached by 5 freelance artists/month. Works with 3 freelance illustrators and 1 freelance designer/month. Prefers artists with experience in animation. Uses artists mainly for animation and illustration. Also uses freelance artists for storyboards, slide illustration, animatics, animation, TV/film graphics and logos. 10% of work is with print ads.

First Contact & Terms: Send query letter with resume, photocopies and ½ VHS. Samples are filed or are returned by SASE. Reports back within 7 days only if interested. Write to schedule an appointment to show a portfolio. Mail appropriate materials. Portfolio should include slides and ½ VHS. Pays for design and illustration by the project or offers contract. Rights purchased vary according to project.

***MEDIA METHODS,** 24097 N. Shore, Edwardsburg MI 49112. (616)699-7061. President: Jim Meuninck. Estab. 1978. Audiovisual and public relations firm. Full-service, multimedia firm. "We primarily produce botanical videos, vanity videos, and corporate videos." Specialies in videos on botany. Product specialties are health, outdoor and consumer. Current clients include: Indiana University, Divers Alert Network, Boy Scouts of America, Outdoor Life Book Clubs.

Needs: Approached by 1 freelance artist/month. Works with 1 freelance illustrator and 1 freelance designer/month. Prefers artists with experience in pen & ink botanical illustrations. Works on assignment only. Uses freelance artists mainly for video cover boxes, botanical illustrations and some cartoon art. Also uses freelance artists for print ad design and illustration, storyboards, animatics, TV/film graphics, logos, and botanical illustrations. 5% of work is with print ads.

First Contact & Terms: Send query letter with SASE. Samples are filed and photocopied samples. Samples are return by SASE only if requested by artist. Reports back to the artist only if interested. "Timing is important. Could report immediately if there is immediate need." Mail appropriate materials. "Send resume including where you've sold botanical drawings or send samples." Portfolio should include b&w photostats. Pays for design and illustration by the project, $200 minimum. "We always negotiate each contract." Negotiates rights purchased, which vary according to project.

PHOTO COMMUNICATION SERVICES, INC., 6410 Knapp NE, Ada MI 49301. (616)676-1499. Contact: M.L. Jackson. Estab. 1970. AV firm. Full-service, multimedia firm. Product specialties are corporate and industrial products. Current clients include: General Electric and Zondervan Publishing.

Needs: Approached by 2-3 freelance artists/month. Works with 1 freelance illustrator/month. Works on assignment only. Uses freelance artists mainly for animated illustration. Also uses freelance artists for brochure, catalog and print ad design and illustration, storyboards, slide illustration, animation, retouching, lettering and logos. 30% of work is with print ads.

First Contact & Term: Send query with brochure, SASE and tearsheets. Samples are filed or returned by SASE only if requested by artist. Reports back only if interested. Mail appropriate materials: tearsheets and transparencies. Pays for design and illustration by the hour, $25 minimum; by the project, $25 minimum; and by the day, $200 minimum. Rights purchased vary according to project.

SOUND*LIGHT PRODUCTIONS, 1915 Webster, Birmingham MI 48009. (313)642-3502. Producer: Terry Luke. Estab. 1980. "We are an audiovisual service company doing photography, video, print, and multi-image projects and public relations marketing." Current clients include CBS, Westinghouse, Capital Records, Dale Carnegie, Rockwell International and Bridgeport Machine.

Needs: Works with 1 freelance illustrator and 1 freelance designer/month. Prefers local artists only. Uses freelancers mainly for editorial and technical illustration, brochure design and storyboards. Also uses freelance artists for brochure illustration, catalog and print ad design, slide illustration, animation, mechanicals, retouching, posters, TV/film graphics, lettering and logos. 50% of work is with print ads.

First Contact & Terms: Send query letter with brochure, resume, photostats, photocopies, photographs, slides, transparencies and SASE. Samples are filed or are returned only if requested by artist. Reports back to the artist only if interested. Call or write to schedule an appointment to show a portfolio, which should include roughs, original/final art, photostats, final reproduction/product, photographs, slides, and color and b&w samples. Pays for design by the hour, $5-70; by the project, $20 minimum; by the day, $35-75. Pays for illustration by the project, $30 minimum. Considers complexity of project, client's budget, turnaround time,

skill and experience of artist and rights purchased when establishing payment. Negotiates rights purchased; rights purchased vary according to project.
Tips: "The most common mistake freelancers make is having too much work and some is of lower quality. It is best to inquire first and bring samples oriented toward what we do."

THOMPSON ADVERTISING PRODUCTIONS, INC., 31690 W. 12 Mile Rd., Farmington Hills MI 48018. (313)553-4566. Vice President: Clay Thompson. Ad agency. Clients: automotive, marine and industrial. Current clients include Chrysler Corp.
Needs: Works with artists on layout, retouching and creative concept. Artist should have a "strong sense of design communication." Types of illustration needed are editorial and technical. Editorial illustration should be "loose style-fun."
First Contact & Terms: Send resume and samples. Samples not filed are returned only if requested. Call or write to schedule an appointment to show a portfolio, which should include thumbnails, roughs and original/ final art. Pays for design and illustration by the project, $50-5,000. Considers complexity of project, client's budget, and skill and experience of artist. Rights purchased vary according to project.
Tips: Artist should "be prepared to show samples of layout work and demonstrated skills and be prepared to quote a price. Portfolio should include original layouts and artwork. Do not show examples without a concept support."

J. WALTER THOMPSON USA, 600 Renaissance Center, Detroit MI 48243. (313)568-3800. Assistant Art Administrator: Maryann Inson. Ad agency. Clients: automotive, consumer, industry, media and retail-related accounts.
Needs: Deals primarily with established artists' representatives and art/design studios.
First Contact & Terms: Contact only through artist's agent. Assignments awarded on lowest bid. Call to schedule an appointment to show a portfolio, which should include thumbnails, roughs, original/final art, final reproduction/product, color tearsheets, photostats and photographs. Pays for design and illustration by the project.
Tips: Agency deals with proven illustrators from an "approved vendor's list." New vendors are considered for list periodically. "Portfolio should be comprehensive but not too large. Organization of the portfolio is as important as the sample. Mainly, consult professional rep."

Minnesota

ALPINE MARKETING COMMUNICATIONS LTD., 3300 Edinborough Way, Minneapolis MN 55435. (612)832-8242. Account Services Director: Carrie Klauer. Estab. 1973. Ad agency. Full-service, multimedia firm. Specializes in sales support material and business-to-business advertising. Product specialties are real estate, finance and manufacturing.
Needs: Approached by 35 freelance artists/month. Works with 5 freelance illustrators and 6 freelance designers/month. Prefers artists with experience in food illustration and real estate renderings. Works on assignment only. Uses freelance artists for special projects. Also uses freelance artists for brochure design, print ad design and illustration, mechanicals, retouching and logos. 45% of work is with print ads.
First Contact & Terms: Send query letter with brochure, resume, tearsheets and slides. Samples are filed. Reports back only if interested. Mail appropriate materials: roughs, color photostats, photographs and transparencies. Pays for design by the project, $200-10,000. Buys all rights.

BADIYAN PRODUCTIONS INC., 720 W. 94 St., Minneapolis MN 55420. (612)888-5507. President: Fred Badiyan. AV firm. Client list provided upon request.
Needs: Works with 50 freelance artists/year. Works on assignment only. Uses freelance artists for design, brochures, mechanicals, press releases and motion pictures.
First Contact & Terms: Send query letter with brochure or resume, tearsheets, photocopies and slides. Samples are filed or are returned. Write to schedule an appointment to show a portfolio or mail appropriate materials. Pays for design and illustration by the hour or by the project.
Tips: "Send a letter and sample of work."

BUTWIN & ASSOCIATES ADVERTISING, INC., 8700 Westmoreland Lane, Minneapolis MN 55426. (612)546-0203. President: Ron Butwin. Estab. 1977. Ad agency. "We are a full-line ad agency working with both consumer and industrial accounts on advertising, marketing, public relations and meeting planning." Clients: banks, restaurants, clothing stores, food brokerage firms, corporations, full range of retail and service organizations, etc.
Needs: Works with 30-40 freelance illustrators and 20-30 freelance designers/year. Prefers local artists when possible. Uses artists for design, editorial and advertising illustration, brochures, catalogs, newspapers, consumer and trade magazines, P-O-P displays, retouching, animation, direct mail packages, motion pictures

and lettering. 60% of work is with print ads. Prefers realistic pen & ink, airbrush, watercolor, marker, calligraphy and computer illustration.

First Contact & Terms: Send brochure or resume, tearsheets, photostats, photocopies, slides and photographs. Samples are filed or are returned only if SASE is enclosed. Reports back only if interested. Call to schedule an appointment to show a portfolio. Pays for design and illustration by the project; $25-1,500. Considers client's budget, skill and experience of artist and how work will be used when establishing payment. Buys all rights.

Tips: "Portfolios should include layouts and finished project." A problem is that "samples sent are often too weak to arouse enough interest."

FABER SHERVEY ADVERTISING, 160 W. 79th St., Minneapolis MN 55420. (612)881-5111. Creative Director: Paul D. Shervey. Ad agency. Clients: business-to-business, industry and farm-related firms.

Needs: Works with 25 freelance artists/year. Prefers local artists. Uses artists for retouching, line art, keyline and illustration.

First Contact & Terms: Send brochure and business card. Do *not* send samples. Does not report back. Call or write for appointment to show portfolio. Pays by the hour, $20-80 average. Considers complexity of project when establishing payment. Buys all rights.

EDWIN NEUGER & ASSOCIATES, 1221 Nicollet Mall, Minneapolis MN 55403. (612)333-6621. President: Ed Neuger. Estab. 1959. "A full-service public relations firm that specializes in investor relations, media relations and publicity, collateral material development, and special events." Clients: general. Client list provided upon request.

Needs: Works with 10 freelance artists/year. Assigns 25 jobs/year. Prefers local artists because "need close communication and quick turnaround." Uses artists for photography, illustration, design and printing.

First Contact & Terms: Samples are filed and are not returned. Does not report back. Call or write to schedule an appointment to show a portfolio. Pays by the project. Considers complexity of project, client's budget and skill and experience of artist. Buys all rights.

PIERCE THOMPSON & ASSOCIATES, INC., 8100 26th Ave. S., Bloomington MN 55425. (612)854-7131. President: Robert P. Thompson. Vice President: Kim Benike. Estab. 1955. PR firm. Full-service, multimedia firm. Specializes in newspaper and collaterals. Product specialties are telecommunications, insurance, construction, office products, etc.

Needs: Approached by 2 freelance artists/month. Works with 1 freelance illustrator and 1 freelance designer/year. Prefers local artists only. Works on assignment only. Uses freelancers mainly for layout. Also uses freelance artists for brochure, catalog and print ad design and illustration, retouching and logos. 10% of work is with print ads.

First Contact & Terms: Send query letter with brochure, photocopies, resume and photographs. Samples are filed. Reports back to the artists only if interested. Mail appropriate materials, not to be returned. Portfolio should include thumbnails, b&w and color tearsheets. Pays for design by the hour and by the project. Pays for illustration by the project. Buys all rights.

Tips: The most effective way for a freelancer to get started in public relations is "to show quality work, be an on-time performer and be a member of the team!"

RENNER BURNS ADVERTISING, INC., Suite 400, 7600 Parklawn Ave., Edina MN 55435. (612)831-7725. Art Director: Mary Myers. Estab. 1977. Full service ad agency providing finished materials to client (publications, radio or TV stations). Specializes in public utilities. Current clients include Dairyland, Federal Land Co., Waldor Pump Sedgwick Heating & Air Conditioning and American Linen.

Needs: Works with 3 freelance illustrators/month. Prefers local artists. Works on assignment only. Uses freelancers mainly for illustration and photography. Also uses freelance artists for brochure, catalog and print ad illustration, animation, mechanicals, retouching, TV/film graphics, lettering and logos. 40% of work is with print ads.

First Contact & Terms: Send query letter with brochure and photographs. Samples are filed or are returned only if requested by artist. Reports back to the artist only if interested. Call to schedule an appointment to show a portfolio, which should include original, final art, final reproduction/product, photographs, slides; include color and b&w samples. Pays for illustration by the project, $100-2,000. Considers complexity of project, client's budget and turnaround time when establishing payment. Buys all rights.

Tips: "Have a track record and fair rates. Show needed style or talent in portfolio or mailed pieces."

Missouri

BRYAN/DONALD, INC. ADVERTISING, Suite 2712, 2345 Grand, Kansas City MO 64108. (816)471-4866. President: Don Funk. Multimedia, full-service ad agency. Clients: food, fashion, pharmaceutical and real

estate companies.

Needs: Works with 4 freelance artists/year. Assigns 35 jobs/year. Works on assignment only. Uses artists for design, illustration, brochures, catalogs, books, newspapers, consumer and trade magazines, P-O-P display, mechanicals, retouching, animation, billboards, posters, direct mail packages, lettering, logos, charts/graphs and advertisement.

First Contact & Terms: Send samples showing your style. Samples are not filed and are not returned. Reports back only if interested. Call to schedule an appointment to show a portfolio. Considers complexity of project and skill and experience of artist when establishing payment. Buys all rights.

***FBA MARKETING COMMUNICATIONS,** 240 Sovereign Ct., St. Louis MO 63011. (314)256-9400. FAX: (314)256-0943. Art Directors: Mark Ray and Michael Smith. Estab. 1935. Ad agency. Full-service, multimedia firm. Product specialties are business-to-business and consumer services. Current clients include Brown-Forman Co. (Korbel Champagne), Dine-Mor Foods, Star Manufacturing, Carpenter Healthcare.

Needs: Approached by 5-10 freelance artists/month. Works with 2-3 freelance illustrators and 1-3 freelance designers/month. Uses freelance artists for illustration, production and retouching. Also uses freelance artists for brochure illustration, catalog illustration, print ad illustration, storyboards, slide illustration, mechanicals and lettering. 40% of work is with print ads.

First Contact & Terms: Send query letter with resume, photostats, photocopies, and slides. Samples are filed or are returned by SASE only if requested by artist. Reports back to the artist only if interested. Write to schedule an appointment to show a portfolio. Portfolio should include thumbnails, roughs, original/final art and tearsheets. Pays for design by the hour, $30. Pays for illustration by the project, $500. Negotiates rights purchased.

PARKER GROUP, INC., 6900 Delmar, St. Louis MO 63130. (314)737-4000. FAX: (314)727-3034. Director of Graphic Services: Mary Tuttle. Estab. 1979. Ad agency. Full-service, multimedia firm. Specializes in magazines, trade publication and newspaper ads. Product specialties are healthcare, consumer and business. Current clients include: Blue Cross and Blue Shield of Missouri.

Needs: Approached by 20 freelance artists/month. Works with 2 freelance illustrators and designers/month. Works with artist reps. Works on assignment only. Uses freelance artists mainly for illustration and some comp work. Also uses freelance artists for brochure and print ad design and illustration, catalog illustration, storyboards, slide illustration, mechanicals, retouching, billboards, posters, TV/film graphics, lettering and logos. 75% of work is with print ads.

First Contact & Terms: Contact through artist rep or send query letter with photocopies, resume, tearsheets or photostats. Samples are filed and are not returned. Reports back only if interested. Write to schedule an appointment to show a portfolio or mail appropriate material: thumbnails, roughs, original/final art and b&w and color samples of "whatever is available." Pays for design by the hour, $25 minimum; by the project, $150 minimum; by the day, $400 minimum. Pays for illustration by the project, $150 minimum. Rights purchased vary according to project.

PREMIER FILM VIDEO & RECORDING, 3033 Locust St., St. Louis MO 63103. (314)531-3555. Secretary/Treasurer: Grace Dalzell. AV/film/animation/TV producer. Serves clients in business, religion, education and advertising. Produces videotape, motion 35mm, 16mm and Super 8mm, strip films, cassette dupes, 8-tracks and TV and radio spots.

Needs: Assigns 50-60 freelance jobs/year. Works with 8-10 freelance illustrators, "a few" freelance designers/month. Works on assignment only. Uses artists for strip film and slide presentations, TV commercials and motion picture productions.

First Contact & Terms: Send resume to be kept on file. "We do not accept samples; we review them during interviews only." Reporting time varies with available work. Pays by the project; method and amount of payment are negotiated with the individual artist. Pay varies with each client's budget. No originals returned to artist following publication; "copies supplied when possible." Buys all rights, but sometimes negotiates.

Tips: "In developing a brochure, begin by simply stating work capability and area of work most capable of producing, i.e., animation, cartoons, production, direction or editing—whatever you want to do for a living."

Nebraska

MILLER FRIENDT LUDEMANN INC., 1225 L St., Lincoln NE 68508. (402)435-1234. Art Director: Terry Pageler. Ad agency/PR firm. Clients: bank, industry, restaurant, tourist and retail.

Needs: Works on assignment only. Uses artists for consumer and trade magazines, billboards, direct mail packages, brochures, newspapers, stationery, signage, P-O-P displays, AV presentations, posters, press releases, trade show displays and TV graphics. "Freelancing is based on heavy workloads. Most freelancing is paste-up but secondary is illustrator for designed element."

First Contact & Terms: Send query letter with resume and slides to be kept on file. Samples not filed are returned by SASE. Reports back within 10 days. Write for appointment to show portfolio, "if regional/national; call if local." Portfolio should include thumbnails, roughs, original/final art, final reproduction/product, color tearsheets and photostats. Pays by the project, $100-1,500 average. Considers complexity of project, client's budget, skill and experience of artist, turnaround time and rights purchased when establishing payment. Buys all rights.
Tips: "Be prompt and be able to price your project work accurately. Make quality first."

J. GREG SMITH, Suite 102, Burlington Place, 1004 Farnam St., Omaha NE 68102. (402)444-1600. Senior Art Director: Keith Fleming. Senior Art Director/Production: Russ Messerley. Estab. 1974. Ad agency. Clients: financial, banking, associations, agricultural, travel and tourism.
Needs: Works with 3 illustrators and 1 designer/year. Works on assignment only. Mainly uses freelancers for mailers, brochures and projects also uses freelance artists for consumer and trade magazines, catalogs and AV presentations.
First Contact & Terms: Send query letter with brochure showing art style or photocopies. Reports only if interested. To show a portfolio, mail original/final art, final reproduction/product, color and b&w. Pays for design and illustration by the project, $500-5,000. Buys first, reprint or all rights.
Tips: Current trends include a certain "flexibility." Agencies are now able "to use any style or method that best fits the job."

Nevada

DOYLE-MCKENNA & ASSOCIATES, 1175 Harvard Way, Reno NV 89502. (702)323-2181. FAX: (702)329-5899. Senior Art Director: Brian Crane. Estab. 1955. Ad agency. Specializes in newspaper ads, brochures and collaterals. Product specialties are casinos and public utilities.
Needs: Approached by 1-5 freelance artists/month. Works with 2-3 freelance illustrators and 1-2 freelance designers/month. Works on assignment only. Mainly uses freelance talent for illustration, TV production, animation and paste-up. Also uses freelance artists for brochure, print ad and slide illustration, storyboards, animatics, mechanicals, retouching, TV/film graphics, lettering and logos. 70% of work is with print ads.
First Contact & Terms: Send query letter with brochure, photocopies, SASE, resume, photographs, tearsheets, photostats, slides and transparencies. Samples are filed or are returned by SASE only if requested by artist. Reports back within 5 days. Call or write to schedule an appointment to show a portfolio. Portfolio should include roughs, b&w and color photostats, tearsheets, photographs and slides. Pays for design by the hour, $50-100. Pays for illustration by the project, $50-2,000. Negotiates rights purchased.
Tips: "We see a lot of unprofessional presentations."

STUDIOS KAMINSKI PHOTOGRAPHY LTD., 1040 Matley Lane, Reno NV 89502. (702)786-2615. President: T.J. Kaminski. AV/TV/film producer. Clients: education, industry and corporate. Produces filmstrips, motion pictures, multimedia kits, overhead transparencies, slide sets, sound-slide sets and videotapes.
Needs: Works with about 3 illustrators/year. Uses freelance artists mainly as illustrators to paint portraits from photos once in a while. Also uses freelance artists for slide illustration and retouching, catalog design and ad illustration.
First Contact & Terms: Arrange interview to show portfolio. Samples returned by SASE. Reports within 1 week. Works on assignment only. Provide brochure/flyer, resume or tearsheet to be kept on file for possible future assignments. Pays $30-60/hour; $200-500/day.
Tips: Have good samples and be qualified.

New Hampshire

*CHANNELL ONE VIDEO**, Box 1437, Seabrook NH 03874. (603)474-5046. President: Bill Channell. Estab. 1971. Audiovisual firm. Full-service, video firm, but no film. Specializes in corporate work and sports coverage. Product specialties cover a broad range of categories. Current clients include: "Fortune 500 to small 'mom and pops'."
Needs: Approached by 3-4 freelance artists/month. Works with 2-3 freelance illustrators and 2-3 freelance designers/year. Prefers artists with high talent at low cost. Works on assignment only. Uses freelance artists mainly for video support material and video graphics. Also uses freelance artists for brochure design and illustration, print ad design and illustration, animation, posters, TV/film graphics and logos. 10% of work is with print ads.
First Contact & Terms: Send query letter with photocopies, photographs and tearsheets. Samples are filed and not returned. Reports back to the artist only if interested. To schedule an appointment to show a portfolio, call. Portfolio should include whatever shows talents best. Payment for design and illustration

ranges from volunteer to open-ended fee per project. Rights purchased vary according to project.

New Jersey

SOL ABRAMS ASSOCIATES INC., 331 Webster Dr., New Milford NJ 07646. (201)262-4111. President: Sol Abrams. PR firm. Clients: real estate, food, fashion, beauty, entertainment, government, retailing, sports, nonprofit organizations, etc. Media used include billboards, consumer and trade magazines, direct mail, newspapers, P-O-P displays, radio and TV.

Needs: Assigns approximately 6 freelance jobs/year. "For practical purposes, we prefer using artists in New Jersey-New York area." Works on assignment only. Uses artists for consumer magazines, billboards, brochures, catalogs, newspapers, stationery, signage, AV presentation and press releases.

First Contact & Terms: Send query letter with photographs and photostats, which may be kept on file. Samples not kept on file are returned by SASE. Reports only if interested. Pay varies according to client and job. Considers client's budget and skill and experience of artist when establishing payment. Buys all rights.

Tips: "As one who started his career as an artist before deciding to become a public relations consultant, I empathize with young artists. If material interests me and I cannot use it, I might develop leads or refer it to people and firms which may use it. Artists should be honest and sincere. Dedication and integrity are as important as talent."

DAVID H. BLOCK ADVERTISING, INC., 33 S. Fullerton Ave., Montclair NJ 07042 (201)744-6900. Executive Art Director and Vice President: Karen Deluca. Estab. 1939. Clients: finance, industry, consumer, real estate and bio-medical. Buys 100-200 illustrations/year.

Needs: Works with over 12 freelance illustrators and over 15 freelance designers/year. Prefers to work with "artists with at least 3-5 years experience in paste-up and 'on premises' work for mechanicals and design." Uses artists for illustration, layout, lettering, type spec, mechanicals and retouching for ads, annual reports, billboards, catalogs, letterheads, brochures and trademarks.

First Contact & Terms: To schedule an appointment to show portfolio, mail appropriate samples and follow up with a phone call. Include SASE. Reports in 2 weeks. Pays for design by the hour, $15-50. Pays for illustration by the project, $150-5,000.

Tips: "Please send some kind of sample of work. If mechanical artist, line art printed sample. If layout artist, composition of some type and photographs or illustrations. Mail samples first then follow with a phone call."

COOPER COMMUNICATIONS & PRODUCTIONS, INC., 18 S. Orange Ave., South Orange NJ 07079. (201)763-6147. President: Dan Cooper. Office Manager: Valerie Northrup. Full-service ad agency with print, video and multi-image capabilities. Clients: all except retail—specializes in technology communications. Client list provided upon request.

Needs: Works with 4-5 freelance artists/year. Assigns 25 freelance jobs/year. Prefers local artists. Works on assignment only. Uses artists for design, illustration, brochures, catalogs, newspapers, P-O-P displays, mechanicals, animation, posters, direct mail packages, press releases, logos, charts/graphs and ads.

First Contact & Terms: Send query letter with brochure or resume. Samples are filed or are returned only if requested by artists. Reports back only if interested. Call or write to schedule an appointment to show a portfolio. Likes to see work samples and price list. Pays for design and illustration by the hour, $15-20 minimum. Considers complexity of project and turnaround time when establishing payment. Rights purchased vary according to project.

CREATIVE ASSOCIATES, 626 Bloomfield Ave., Verona NJ 07044. (201)857-3444. Producer: Harrison Feather. Estab. 1970. AV firm. "We are a multimedia production facility providing photography, video post-production, slide shows, computer graphics, desktop publishing, scriptwriting services for sales meetings, trade shows, speaker support and entertainment." Clients: high-tech, pharmaceutical, computer, R&D labs, engineering and marine. Client list provided with SASE.

Needs: Works with 5 freelance artists/year. Assigns 10 freelance jobs/year. Works on assignment only. Uses artists for design, illustration, motion pictures and charts/graphs.

First Contact & Terms: Send query letter with brochure or resume and slides. Samples are filed or are returned by SASE. Call to schedule an appointment to show a portfolio, which should include original/final art, slides and video cassette. Pays for design (computer-generated art) by the project, $500 minimum. Pays for illustration by the project, $300 minimum. Considers complexity of project, client's budget, skill and experience of artist and how work will be used when establishing payment. Rights purchased vary according to project.

CREATIVE PRODUCTIONS, INC., 200 Main St., Orange NJ 07050. (201)676-4422. Partner: Gus J. Nichols. Estab. 1955. AV firm. Clients: pharmaceutical firms, manufacturers, chemical and financial firms.
Needs: Works with 30 freelance artists/year. Artists must be within 1 hour travel time to studio with 1 year of experience. Uses freelancers mainly for computer-generated slides and video graphics. Also uses artists for computer-generated charts and graphs. Especially important is "accuracy, neat work and the ability to take direction."
First Contact & Terms: Send resume to be kept on file. Call for appointment to show portfolio. Reports back only if interested. Pays by the hour, $15-25 average. Considers skill and experience of artist when establishing payment.
Tips: Artists "must have computer training/experience with business graphics and be able to create illustrations on computers."

NORMAN DIEGNAN & ASSOCIATES, 343 Martens Rd., Lebanon NJ 08833. (201)832-7951. President: N. Diegnan. Estab. 1977. PR firm. Specializes in magazine ads. Product specialty is industrial.
Needs: Approached by 6 freelance artists/month. Works with 2 freelance illustrators and 2 freelance designers/month. Works on assignment only. Uses freelance artists for brochure design and illustration, catalog design and illustration, print ad design and illustration, storyboards, slide illustration, animatics, animation, mechanicals, retouching and posters. 50% of work is with print ads.
First Contact & Terms: Send query letter with brochure and tearsheets. Samples are filed and are not returned. Reports back within 7 days. To show a portfolio, mail roughs. Pays for design and illustration by the hour. Rights purchased vary according to project.

***INFINITY FOUR VIDEO, INC.**, Suite 205, 846 Riverside Ave., Lyndhurst NJ 07071. (201)507-1227. Producer: John Chow. Estab. 1988. Audiovisual and video production firm. Specializes in TV production for broadcast and corporate. Current clients include: Johnson & Johnson, N.J. Bell, NFL Today and WWOR-TV.
Needs: Approached by 1-2 freelance artists/month. Works with 1 freelance illustrator and 1 freelance designer/month. Prefers artists with experience in 2D-3D electronic graphics and animation. Works on assignment only. Uses freelance artists mainly for video production and graphics animation. Also uses freelance artists for storyboards, animation, TV/film graphics and logos.
First Contact & Terms: Send query letter with resume. Reports back to the artist only if interested. Call to schedule an appointment to show a portfolio. Rights purchased vary according to project.

INSIGHT ASSOCIATES, Bldg. A, 333 Rt. 46 W, Fairfield NJ 07004. (201)575-5521. President: Raymond E. Valente. AV firm. Estab. 1979. "Full-service business communicators: multimedia, videotape, print materials, sales meetings . . . all of the above from concept to completion." Clients: "organizations in need of any audiovisual, audio and/or print." Current clients include: Watco Corp. and Matheson Gas Co. Client list provided upon request.
Needs: Works with 50-100 freelance artists/year. Assigns 50 freelance jobs/year. Works on assignment only. Uses artists for design, technical illustration, brochures, catalogs, P-O-P displays, mechanicals, retouching, animation, direct mail packages, press releases, lettering, logos, charts/graphs and advertisements. 40% of work is with print ads.
First Contact & Terms: Send query letter with brochure or resume. Samples are filed or are returned by SASE. Reports back within 3 weeks only if interested. Write to schedule an appointment to show a portfolio or mail brochure or resume. Pays by the project, amount varies. Considers complexity of project, client's budget, turnaround time and how work will be used when establishing payment. Rights vary according to project.
Tips: "Become acquainted with AV needs, such as video graphics, slide-to-video transfer, etc." Common mistakes in showing a portfolio include "showing photocopies, not being organized and using a hard sell."

JANUARY PRODUCTIONS, INC., 210 6th Ave., Hawthorne NJ 07507. (201)423-4666. Art Director: Karen Neulinger. Estab. 1973. AV producer. Serves clients in education. Produces videos, sound filmstrips and read-along books and cassettes.
Needs: Assigns 1-5 jobs/year. Works with 1-5 freelance illustrators/year. "While not a requirement, an artist living in the same geographic area is a plus." Works on assignment only, "although if someone had a project already put together, we would consider it." Uses freelancers mainly for illustrating children's books. Also uses artists for artwork for filmstrips, sketches for books and layout work.
First Contact & Terms: Send query letter with resume, tearsheets, photocopies and photographs. To show a portfolio, call to schedule an appointment. Portfolio should include original/final art, color and tearsheets. Pays for design and illustration by the project. No originals returned following publication. Buys all rights.
Tips: "Include child-oriented drawings in your portfolio."

J. M. KESSLINGER & ASSOCIATES, 37 Saybrook Place, Newark NJ 07102. (201)623-0007. President: Joe Dietz. Advertising agency. Serves business-to-business clients.
Needs: Uses 1-2 freelance illustrators/month for illustration, mechanicals, direct mail, brochures, flyers, trade magazines and newspapers. Prefers local artists. Works on assignment only.
First Contact & Terms: Phone for appointment. Prefers photostats, tearsheets, slides as samples. Samples returned by SASE only if requested. Reports only if interested. Does not return original artwork to artist unless contracted otherwise. Negotiates pay. Pays by the hour, $15-50 average. Pay range depends on the type of freelance work, i.e. mechanicals vs. creative. Considers complexity of project, client's budget, skill and experience of artist and rights purchased when establishing payment.

***KJD TELEPRODUCTIONS**, 30 Whyte Dr., Voorhees NJ 08043. (609)751-3500. FAX: (609)751-7729. President: Larry Scott. Estab. 1989. Advertising agency, audiovisual firm. Full-service, multimedia firm. Specializes in magazine, radio and television. Current clients include ICI America's and Taylors Nightclub.
Needs: Works with 1-4 freelance illustrators and 1-4 freelance designers/month. Prefers artists with experience in TV. Works on assignment only. Uses freelance artists for brochure design and illustration, print ad design and illustration, storyboards, animatics, animation, TV/film graphics. 70% of work is with print ads.
First Contact & Terms: Send query letter with brochure, resume, photographs, slides and videotape. Samples are filed or are returned by SASE. Reports back to the artist only if interested. To show a portfolio, mail roughs, photographs and slides. Pays for design and illustration by the project. Payment varies. Buys first rights and all rights.

OPTASONICS PRODUCTIONS, 186 8th St., Creskill NJ 07626. (201)871-4192. President: Jim Brown. Specializes in graphics, typesetting, multi-image, audio for AV, displays, and exhibits. Clients: industry and theatre.
Needs: Works with varied number of freelance artists/year. Prefers local artists. Works on assignment only. Uses artists for advertising, brochure and catalog design and illustration, and graphics for multi-image slide shows.
First Contact & Terms: Send query letter with brochure/flyer, business card or resume which will be kept on file. Negotiates payment.

RESULTS, INC., 777 Terrace Ave., Box 822, Hasbrouck Heights NJ 07604. (201)288-7888. Creative Director: D. Green. Art Director: Bob Hosking. Estab.1954. Ad agency. Full-service agency specializing in print, collateral, graphic arts and image campaigns. Specializes in real estate and computer software. Current clients include Hartz Mountain, Alfred Sanzari and SKF.
Needs: Works with 3 freelance illustrators and 3 freelance designers/month. Uses freelancers mainly for (brochure) design. Also uses artists for brochure illustration, print ad design, storyboards and logos. 70% of work is with print ads.
First Contact & Terms: Send query letter with photocopies, photographs and slides. Samples are filed or are returned. Reports back to the artist only if interested. To show a portfolio mail tearsheets and final reproduction/product; include color and b&w samples. Consider complexity of project, client's budget and skill and experience of artist when establishing payment. Rights purchased vary accoring to project.

TECHNICAL ART FOR INDUSTRY, 147 Williamson Ave., Bloomfield NJ 07003. (201)748-4334. Executive Manager/Sales: Douglas Quinn. Estab. 1985. Ad agency. Full-service, multimedia firm. Specializes in business-to-business. Product specialties are health care, heavy industry electronics, aerospace and defense.
Needs: Approached by 10 freelance artists/month. Works with 5-6 freelance illustrators and 2-3 freelance designers/month. Prefers artists with experience in airbrush/retouching, exployed view architectural, tech writers/Japanese translations and German translation. Uses freelance artists for mechanicals/art/copy. Also uses freelance artists for brochure, catalog, print ad and slide illustration, mechanicals and retouching. 85% of work is with print ads.
First Contact & Terms: Send query letter with photocopies, resume and photographs. Samples are filed and are not returned. Does not report back. Call to schedule an appointment to show a portfolio. Portfolio should include original/final art. "Sketches are as important to us as final art." Pays for design by the hour, $10-30; by the project, $100-2,000. Pays for illustration by the hour, $10-30; by the project, $50-2,000. Buys all rights.
Tips: "Don't send too many samples, 10-12 should do it. And work should be clear and portfolios should be a size easy to handle. Always do your very best no matter what the budget is. Always submit sketches or comps which best exhibit your talents. Whether interviewing or delivering your job, always keep in mind: Presentation Presentation Presentation."

TPS VIDEO SERVICES, Box 1233, Edison NJ 08818. (201)287-3626. Contact: R.S. Burks. Video production firm. Clients: industrial, broadcast.
Needs: Works with 50 freelance artists/year. Assigns 200 freelance jobs/year. Works on assignment only. Uses freelance artists for brochure design, P-O-P displays, mechanicals, retouching, animation, posters, lettering, logos and charts/graphs.

First Contact & Terms: Send query letter with resume and any type of sample. "Must have SASE included for return." Samples are filed. Reports back within 1 week only if interested. Write to schedule an appointment to show a portfolio.

VAMCOM ADVERTISING, 202 Johnson Rd., Morris Plains NJ 07950. (201)539-1388. FAX: (201)539-2570. Executive Art Director: Dennis Simmons. Ad agency and PR firm. Full-service, multimedia firm. Specializes in magazine ads and collaterals. Product specialties are technical, medical and financial. Current clients include: AT&T, Employees Federal Credit Union, National Tourism Organization of Malta and Panasonic Industrial Company.
Needs: Approached by 2-3 freelance artists/month. Works with 1 freelance illustrator and 1 freelance designer/month. Works on assignment only. Uses freelance artists mainly for design. Also uses freelance artists for brochure and print ad design and illustration, mechanicals and retouching.
First Contract & Terms: Send query letter with photocopies and tearsheets. Samples are filed. Reports back to the artist only if interested. Call to schedule an appointment to show a portfolio. Portfolio should include thumbnails, roughs and original/final art. Pays for design by the hour, $15-25. Pays for illustration by the project. Rights purchased vary according to project.

ZM SQUARED, 903 Edgewood Lane, Box 2030, Cinnaminson NJ 08077. (609)786-0612. Executive Director: Mr. Pete Zakroff. AV producer. Clients: industry, business, education and unions. Produces slides, filmstrips, videos, overhead transparencies and handbooks.
Needs: Assigns 8 jobs/year. Works with 2 illustrators/month. Prefers artists with previous work experience who specialize. Works on assignment only. Uses artists for cartoons, illustrations and technical art.
First Contact & Terms: Send resume and samples (slides preferred). Samples returned by SASE. Provide samples and brochure/flyer to be kept on file for possible future assignments. Reports in 3 weeks. Pays by the project, $100-2,500. Payment varies with each client's budget. No originals returned to artist following publication. Buys all rights.
Tips: "We look for simplicity in style, facial expressions in cartoons."

New York

ACKERMAN ADVERTISING COMMUNICATIONS INC., 31 Glen Head Rd., Glen Head NY 11545. (516)759-3000. President/Creative Director: Skip Ackerman. Art Director: Fred Appel. Estab. 1973. Serves clients in food, finance and tourism.
Needs: Works with 12 freelance illustrators and 10 freelance designers/year. Local artists only. Uses artists for layout, paste-up, illustration and retouching for newspapers, TV, magazines, transit signage, billboards, collateral, direct mail and P-O-P displays. 85% of work is with print ads.
First Contact & Terms: Arrange interview. No originals returned. Pays by the project.

WALTER F. CAMERON ADVERTISING INC., 275 Broadhollow Rd., Melville NY 11747. (516)752-1515. FAX: (516)752-1525. Director of Creative Services/Senior Art Director: Steven L. Levine. Estab. 1960. Ad agency. Full-service, multimedia firm. Specializes in magazine ads, collaterals and documentaries. Product specialties are automotive, furniture, carpet, retail computer and real estate. Current clients include: G. Fried Carpet, Harrows and Potamkin.
Needs: Approached by 10-20 freelance artists/month. Works with 2 freelance illustrators and 2-4 freelance designers/month. Prefers local artists only with experience in automotive and retail. Uses freelance artists mainly for mechanicals/design comps for presentation. Also uses freelance artists for brochure, catalog and print ad design and illustration, storyboards, animatics, mechanicals, retouching, posters and logos. 90% of work is with print ads.
First Contact & Terms: Send query letter with brochure, photocopies, SASE, resume, photographs, tearsheets, photostats and slides. Samples are filed or are returned by SASE only if requested by artist. Reports back to the artist only if interested. Call, write to schedule an appointment to show a portfolio or mail appropriate materials: thumbnails, roughs, original/final art, b&w and color comps. Pays for design by the hour, $10-25; by the day, $100-150. Pays for illustration by the project, $100-2,500. Buys all rights.

The asterisk before a listing indicates that the listing is new in this edition. New markets are often the most receptive to freelance submissions.

Tips: Looking for "talent, speed and low prices." Due to the recession, "things have slowed; clients pay 1984 prices—this gets passed down."

CHANNEL ONE PRODUCTIONS, INC., 82-03 Utopia Pkwy., Jamaica Estates NY 11432. (718)380-2525. President: Burton M. Putterman. AV firm. "We are a multimedia, film and video production company for broadcast, image enhancement and P-O-P displays." Clients: multi-national corporations, recreational industry and PBS.
Needs: Works with 25 freelance artists/year. Assigns 100 jobs/year. Prefers local artists. Works on assignment only. Uses freelance artists mainly for work on brochures, catalogs, P-O-P displays, animation, direct mail packages, motion pictures, logos and advertisements.
First Contact & Terms: Send query letter with resume, slides and photographs. Samples are not filed and are returned by SASE. Reports back within 2 weeks only if interested. Call to schedule an appointment to show a portfolio, which should include original/final art, final reproduction/product, slides, video disks and videotape. Pays for design by the project, $400 minimum. Considers complexity of project and client's budget when establishing payment. Rights purchased vary according to project.

FASTFORWARD COMMUNICATIONS INC., 401 Columbus Ave., Valhalla NY 10595. (914)741-0555. FAX: (914)741-0597. Vice President: J. Martorano. Estab. 1986. Ad agency and PR firm. Specialties are high technology and entertainment. Current clients include Six Flags, Nynex and AT&T.
Needs: Approached by 6 freelance artists/month. Works with 1 freelance illustrator and 1-2 freelance designers/month. Works on assignment only. Uses freelance artists mainly for Macintosh work. Also uses freelance artists for brochure and catalog design and illustration and TV/film graphics. 90% of work is with printed materials.
First Contact & Terms: Send query letter with samples, rates and resume. Samples are filed or returned by SASE. Reports back to the artist only if interested. Mail appropriate materials: thumbnails and roughs and b&w or color tearsheets. Pays for design and illustration by the project. Buys all rights or rights purchased vary according to project.

***FINE ART PRODUCTIONS,** 67 Maple St., Newburgh NY 12550. (914)561-5866. Contact: Richie Suraci. Estab. 1989. Advertising agency, audiovisual firm and public relations firm. Full-service, multimedia firm. Specializes in film, video, print, magazine, documentaries and collaterals. Product specialties cover a broad range of categories.
Needs: Approached by 24 freelance artists/month. Works with 12 freelance illustrators and 12 freelance designers/month. "Everyone is welcome to submit work for consideration in all media." Works on assignment only. Also uses freelance artists for brochure design and illustration, catalog design and illustration, print ad design and illustration, storyboards, slide illustration, animatics, animation, mechanicals, retouching, billboards, posters, TV/film graphics, lettering and logos. 50% of work is with print ads.
First Contact & Terms: Send query letter with brochure, photocopies, SASE, resume, photographs, tearsheets, photostats, slides and transparencies. Samples are filed or returned by SASE only if requested by artist. Reports back to the artist only if interested. To schedule an appointment to show a portfolio, mail appropriate materials. Portfolio should include thumbnails, roughs, b&w and color photostats, tearsheets, photographs, slides, transparencies. Negotiates payment for design and illustration. Negotiates rights.

HERB GROSS & COMPANY, 18 Harvard St., Rochester NY 14607. (716)244-3711. Producer/Director: Jim Hughes. Ad agency. "We are an ad agency/production company specializing in consumer and retail advertising. We are highly experienced in film, TV, radio and music production." Clients: retail chains, sporting goods, optical, automotive of any kind, office supplies and bedding.
Needs: Works with approximately 6 freelance artists/year; assigns 35 freelance jobs/year. Prefers experienced, flexible artists. Uses artists for brochure, catalog, newspaper and magazine ad illustration, mechanicals, billboards, direct mail packages and lettering.
First Contact & Terms: Send query letter with resume and tearsheets. Samples are filed and are not returned. Reports back only if interested. To show a portfolio, mail final reproduction/product, color and b&w photostats, tearsheets and photographs. Pays for design and illustration by the hour, $25 minimum; or by the project. Considers complexity of project, client's budget, turnaround time, skill and experience of artist and rights purchased when establishing payment. Buys all rights.

ROBERT HABER ASSOCIATES, 40 Catlin Ave., Staten Island NY 10304. (718)780-3191. Director: Robert Haber. Estab. 1980. AV firm. Full-service, multimedia firm. Specializes in exhibition design for museums and industry. Current clients include: Staten Island Children's Museum and Newark Museum.
Needs: Approached by 3-4 freelance artists/month. Works with 1 freelance illustrator and 2 freelance designers/month. Works on assignment only. Also uses freelance artists for brochure and catalog design and illustration, print ad design, slide illustration, mechanicals and posters. 25% of work is with print ads.

First Contact & Terms: Send query letter with brochure, SASE, resume and slides. Samples are filed. Reports back within 2 weeks. Write to schedule an appointment to show a portfolio. Portfolio should include thumbnails, roughs, b&w and color slides. Pays for design by the project, $500-2,000. Pays for illustration by the project, $500-3,000. Rights purchased vary according to project.

Tips: "It is important that initial inquiry be via letter."

***LLOYD S. HOWARD ASSOCIATES INC.**, Box N, Millwood NY 10546. Art/Creative Director: L. Howard. Ad agency. Serves clients in interior furnishings, lighting, swimming pools, recreation and publishing.

Needs: Works with 2 illustrators and up to 5 designers/month. Uses artists for consumer and trade magazines, direct mail, brochures/flyers and newspapers. Also uses artists for mechanicals and finished art for newspapers, magazines, catalogs and direct mail. Especially needs layout/comp artists.

First Contact & Terms: Local or New York-based freelance artists only. Works on assignment only. Call for interview between 9 a.m.-noon. Prefers layouts, dupes, finished samples or photostats as samples. Samples not returned. Reports in 2 weeks. Provide business card and tearsheets to be kept on file for possible future assignments. No originals returned to artist at job's completion. Pays by the project.

Tips: "Show actual comps or roughs."

HUMAN RELATIONS MEDIA, 175 Tompkins Ave., Pleasantville NY 10570. (914)769-7496. Editor-in-Chief: Michael Hardy. AV firm. Clients: junior and senior high schools, colleges, hospitals, personnel departments of business organizations.

Needs: Works with 5 freelance artists/year. Prefers local artists. Uses artists for illustration for videotape. "It is helpful if artists have skills pertaining to science-related topics." Computer graphics preferred for video, science illustration for artwork.

First Contact & Terms: Send query letter with resume and samples to be kept on file. Samples not filed are returned by SASE. Reports back only if interested. Call for appointment to show portfolio, which should include videotape, slides or tearsheets. Pays for illustration by the project, $65-15,000. Considers complexity of the project, number of illustrations in project, client's budget, skill and experience of artist and turnaround time when establishing payment. Rights purchased vary according to project.

Tips: "It is important that samples are seen before face-to-face interviews. We look for a strong, simple graphic style since the image may be on screen only 10 seconds. We require the ability to research and illustrate scientific subjects accurately."

McANDREW ADVERTISING, 2125 St. Raymond Ave., Bronx NY 10462. (212)892-8660. Art/Creative Director: Robert McAndrew. Estab. 1961. Ad agency. Clients: industrial and technical firms. Current clients include: Yula Corp. and Electronic Devices. Assigns 200 jobs and buys 120 illustrations/year.

Needs: Works with 5 freelance illustrators and 2 freelance designers/year. Uses mostly local artists. Uses freelance artists mainly for design, direct mail, brochures/flyers and trade magazine ads. Needs technical illustration. Prefers realistic, precise style. Prefers pen & ink, airbrush and occasionally markers. 50% of work is with print ads.

First Contact & Terms: Query with photocopies, business card and brochure/flyer to be kept on file. Samples not returned. Reports in 1 month. No originals returned to artist at job's completion. Call or write to schedule an appointment to show a portfolio, which should include roughs and final reproduction. Pays for illustration and design by the project, $35-300. Considers complexity of project, client's budget and skill and experience of artist when establishing payment.

Tips: Artist needs an "understanding of a product and the importance of selling it."

McCUE ADVERTISING & PUBLIC RELATIONS INC., 91 Riverside Dr., Binghamton NY 13905. Contact: Donna McCue. Ad/PR firm. Clients: retailers, nonprofit and industry.

Needs: Artists with at least 2 professional assignments only. Uses freelance artists mainly for work on direct mail, television, brochures or flyers, trade magazines, newspapers, mechanicals and logo design.

First Contact & Terms: Send a query letter with resume, brochure, flyer, business card and tearsheets to be kept on file. No originals returned at job's completion. Negotiates payment.

MESSER & SUSSLIN & OTHERS, INC., 264 N. Middletown Rd., Pearl River NY 10965. (914)735-3030. Senior Art Directors: Dan Susslin and Tony Vela. Estab. 1973. Ad agency, "heavy in print." Graphic Design. Current clients include Volvo, Western Union, Catskill OTB, St. Thomas Aquinas College, Materials Research Corp.

Needs: Works with 2 freelance illustrators/month. Prefers local artist only with experience in editorial and advertising illustration. Also uses artists for brochures, print ads and spot illustrations, retouching and lettering. 50% of work is with print ads.

First Contact & Terms: Send query letter with brochure and tear sheets. Samples are filed and are not returned. Reports back to the artist only if interested. Call to schedule an appointment to show a portfolio, which should include tearsheets, final reproduction/product; include color and b&w samples. Pays for illustration by the project, $200-5,000. Considers complexity of project, client's budget, skill and experience of artist and how work will be used when establishing payment. Rights purchased vary according to project.

THE NOTEWORTHY CO., 100 Church St., Amsterdam NY 12010. (518)842-2660. Contact: Carol Constantino. Advertising specialty manufacturer. Clients: advertising specialty jobbers with clients in health fields, real estate, banks, chain stores, state parks and community service groups. Buys 25 illustrations/year.
Needs: Uses artists for catalogs, packaging, litterbags, coloring books and pamphlets.
First Contact & Terms: Query with samples and SASE. Reports in 2 weeks. Provide resume and brochures to be kept on file for future assignments. No originals returned to artist at job's completion. Pays $200 minimum, litterbag design.

RICHARD-LEWIS CORP., Box 598, Scarsdale NY 10583. (914)779-6800. President: R. Byer. Product specialists are: machinery, tools, publishing, office supplies, chemicals, detergent, film and printing supplies.
Needs: Local artists only. Uses artists for illustration, retouching and some ad layout and mechanicals. Prefers airbrush and marker.
First Contact & Terms: Query with resume or arrange interview to show portfolio. Include SASE. Reports in 2-3 weeks. Pays by the hour; negotiates pay.

RONAN, HOWARD, ASSOCIATES, INC., 11 Buena Vista Ave., Spring Valley NY 10977-3040. (914)356-6668. Director: Howard Ronan. Ad/PR firm. Clients: video production products, lighting products, electronic components, book and video publishers and slide and filmstrip lab services.
Needs: Works with 2-3 freelance artists/year. Uses freelance artists mainly for mechanicals, retouching, charts/graphs and AV presentations.
First Contact & Terms: Send query letter. "Samples and/or other material will not be returned. Please do not send unordered material with a demand for return. It is an unwarranted burden on our shipping department." SASE. Reports immediately. Pays $25 minimum for illustrations, layout, lettering, paste-up, retouching and mechanicals for newspapers, magazines, catalogs and P-O-P displays. Pays promised fee for unused assigned illustrations.

***JACK SCHECTERSON ASSOCIATES**, 53/16 251 Place, Little Neck NY 11362. (718)225-3536. FAX: (718)423-3478. Principal: Jack Schecterson. Estab. 1967. Ad agency. Specializes in business-to-business and new product introduction.
Needs: Number artists works with depends upon work on hand. Works only with artist reps. Prefers local artists only. Works on assignment only. Uses freelance artists for brochure design and illustration, catalog design and illustration, print ad design and illustration, retouching, lettering, logos, package and product design.
First Contact & Terms: Send query letter with SASE and whatever best illustrates work. If samples are not filed, they are returned by SASE only if requested by artist. Reports back to the artist only if interested. Write to schedule an appointment to show a portfolio. Mail appropriate materials. Portfolio should include roughs b&w and color best illustrates abilities/work. Pays for design by the project; pay depends on budget. Pays for illustration by the project; depends on budget. Buys all rights.

MICHAEL W. SCHOEN CO., 455 Central Ave., Scarsdale NY 10583. (914)472-4740. FAX: (914)472-4741. Owner: M. Schoen. Ad agency. Full-service, multimedia firm. Specializes in magazine ads and collaterals. Product specialty is industrial.
Needs: Prefers local artists only with experience in airbrush product illustration and ad agency experience. Works on assignment only. Also uses freelance artists for brochure, catalog and print ad design and illustration, mechanicals and retouching.
First Contact & Terms: Send query letter with resume. Samples are not filed and are returned by SASE only if requested by artist. Reports back to the artist only if interested. Call to schedule an appointment to show a portfolio. Pays for design and illustration by the project. Buys all rights.

***STEEN ADVERTISING CORP.**, 1995 Linden Blvd., Elmont NY 11003. (516)285-3900. President: Norman Steen. Estab. 1960. Advertising agency. Full-service, multimedia firm.
Needs: Approached by 3 freelance artists/month. Works with 2 freelance illustrators and 3 freelance designers/month. Prefers local artists only. Works on assignment only. Uses freelance artists mainly for print work. Also uses freelance artists for brochure design and illustration, catalog design and illustration, print ad design and illustration, mechanicals, retouching, TV/film graphics, lettering and logos. 80% of work is with print ads.
First Contact & Terms: Send query letter with brochure, photocopies, photographs and tearsheets. Samples are usually filed and not returned. Reports back to the artist only if interested. Mail appropriate materials. Portfolio should include roughs and tearsheets. Pays for design and illustration by the project. Buys all rights.

TOBOL GROUP, INC., 33 Great Neck Rd., Great Neck NY 11021. (516)466-0414. FAX: (516)466-0776. Estab. 1981. Ad agency. Product specialties are "50/50 business/consumer." Curent clients include: Weight Watchers, Republic Electronics, Mainco, Summit Mfg., Doxon, Inc. and Computer Breakthroughs.

Needs: Approached by 2 freelance artists/month. Works with 1 freelance illustrator and 1 freelance designer/month. Works on assignment only. Also uses freelance artists for brochure, catalog and print ad design and illustration, mechanicals, retouching, billboards, posters, TV/film graphics, lettering and logos. 35% of work is with print ads.

First Contact & Terms: Send query letter with SASE and tearsheets. Samples are filed or are returned by SASE. Reports back within 1 month. Call to schedule an appointment to show a portfolio. Mail appropriate materials: thumbnails, roughs, original/final art, b&w and color tearsheets and transparencies. Pays for design by the hour, $25 minimum; by the project, $100-800. Pays for illustration by the project, $300-1,500. Negotiates rights purchased.

***VISUAL HORIZONS**, 180 Metro Park, Rochester NY 14623. (716)424-5300. FAX: (716)424-5313. Vice President: Reenie Feingold. Estab. 1970. Audiovisual firm. Full-service, multimedia firm. Specializes in presentation products. Current clients include: U.S. Government Agencies, Bermuda Dept. of Tourism.

Needs: Approached by varying number of freelance artists/month. Works on assignment only. Uses freelance artists for brochure design and illustration, catalog design and illustration, print ad design and illustration, slide illustration, mechanicals, posters and logos. A varying percentage of work is with print ads.

First Contact & Terms: Send query letter with resume. Samples are filed. Reports back to the artist only if interested. Write to schedule an appointment to show a portfolio. Pays for design and illustration by the project. Payment is negotiated. Buys all rights.

WALLACK & WALLACK ADVERTISING, INC., 33 Great Neck Rd., Great Neck NY 11021. (516)487-3974. Production Manager: Ron Hollander. Estab. 1982. Ad agency. "We specialize in promotion programs, image through printed materials." Clients: fashion eyewear, entertainment, health and fitness and industrial.

Needs: Works with 6 illustrators/year. Prefers freelance artists with experience in product illustration. Uses freelance artists for mechanicals; brochure, catalog and print ad illustration. Mechanical and print production skills are important. 50% of work is with print ads.

First Contact & Terms: Send query letter with tearsheets and photocopies to be kept on file. Samples returned only if requested. Reports only if interested. To show a portfolio, mail b&w and color roughs, tearsheets and final reproduction/product. Pays for design by the project, $150-1,500. Pays for illustration by the project, $150-5,000. Considers complexity of the project, client's budget, skill and experience of artist, turnaround time, geographic scope for the finished product, and rights purchased when establishing payment. Rights purchased vary according to project.

Tips: "Promote what you're proficient at. Allow potential clients the time to know you and your work (6 to 10 mailings). Follow-ups should be courteous and business like. If you're good, there's work for you. Neatness counts; if your handwriting is bad, type. Show work you're proud of, not work you think will impress."

WINTERKORN LILLIS INC., 400 Euclid Bldg., Midtown Plaza, Rochester NY 14604. (716)454-1010. Executive Vide President, Operations: Wendy Nelson. Ad agency. Specializes in business-to-business/trade. Clients: medical/health care and industrial firms; national level only—few regional accounts. Current clients include: Corning and Kodak.

Needs: Works with 8-10 new illustrators and 6-10 new designers/year. Works on assignment only. Uses freelance artists for technical and medical illustration for trade and consumer magazines, direct mail, P-O-P displays, brochures, posters, AV presentations and literature, coverage for sales promotions and meetings.

First Contact & Terms: Query with samples to be kept on file. Prefers slide carousel or laminated tear sheets as samples. Samples returned only if requested. Reports only if interested. Pays for design and illustration by the project, $700-8,000 average. Considers complexity of project, client's budget, skill and experience of artist, turnaround time and rights purchased when establishing payment.

Tips: "Present only top professional work, 18 pieces maximum, in a very organized manner."

New York City

A.V. MEDIA CRAFTSMAN, INC., Room 600, 110 E. 23rd St., New York NY 10010. (212)228-6644. President: Carolyn Clark. Estab. 1967. AV firm. Full-service, multimedia firm. Specializes in slide shows, training videos and related brochures (educational). Product specialties are consumer and fashion forecasts. Current clients include: J.C. Penney Co., DuPont, Mountain Publishers, and John Wiley & Co.

Needs: Approached by 20 or more freelance artists/month. Works with 2 freelance illustrators and 2 freelance designers/year. Prefers local artists only with experience in mechanicals for both slides or 4-color separations, (Mac Plus-Pagemaker). Works on assignment only. Uses freelance artists for mechanicals—traditional and Mac Pagemaker. Also uses freelance artists for brochure illustration, catalog design and mechanicals.

First Contact & Terms: Send resume, a few photocopied samples of your work and list of clients. Samples are filed or are not returned. Reports back to the artist only if interested. Pays for design by the hour, $10-15 (mechanicals); $18-20 per hour for Pagemaker. Pays for illustration by the project. Rights purchased vary according to project.

Close-up

Carol Donner
Medical Illustrator
Santa Fe, New Mexico

© Barbara Kelley 1991

Carol Donner freelanced as a medical illustrator in New York for 25 years, establishing a solid business. But it was only after getting an agent that she felt she could move to Santa Fe, the area of her choice.

"I figured I had paid my dues," says Donner. In Santa Fe she bought a 100 year-old adobe home and built her own little adobe studio, "the best place I've ever worked." There with its six huge north-facing windows to invite in the light and "good spirits," she works for a number of national clients. She even finds time for her own interests, writing and illustrating children's books and drawing for science fiction publications. ("They tell me I make wonderful monsters.")

Donner's clients are from the three main areas of medical illustrating: magazines, pharmaceutical advertising and medical publishers, all of which involve different styles and skills. "I try to keep the three going at once," she says.

But it's the advertising, she says that she enjoys most because the artwork can be more conceptual, flashier, "wilder." In turn, however, ad work is difficult with its tight deadlines and the constraints and controls of the drug companies—"everything has to be perfect." In editorial, she works for magazines like *Scientific American* and *Hospital Practice Today*. As one of the first medical illustrators to do cover art 20 or so years ago, she notes that now there are dozens of medical magazines hiring cover artists. Magazine work, she says, means less money, but you have more control over your work. And in publishing when you work with doctors on medical books, she says, the work is easier and steadier but much slower.

On style, Donner says, "It's best to have lots of tricks in your bag"—you'll survive better as a freelancer. Donner's "tricks" include: pen and ink, pen and ink with color, airbrush, soft romantic watercolor and oils. Donner recently combined oils and "romance" in a 7 by 11' ethereal mural on fetal development for the National Institute of Health, a two-month project.

It's a challenging profession, Donner admits, but a natural one for her. Even as a child she was fascinated with animals and biology and would store bugs and moles in the refrigerator (to her mother's horror) to study later. Years later she went on to get a fine arts degree, a master's in medical art and a graduate degree in surgical illustrating.

"The best medical illustrators are those who understand *how* things work, rather than just how they look," says Donner. "If you know how your subject works, then your drawing will show just that." That means a solid background in science, physiology and art at accredited schools. The *critical* ingredient for a medical illustrator is to be able to draw.

How well you can draw is the first thing an art director looks for in your portfolio, says Donner. He also checks your color sense—very important—and your style(s) to see if it matches what he is looking for in a particular project. An art director also wants to know if you are a problem solver; that is, can you think of creative solutions for a project?

Starting out, Donner recommends getting a "real job," that is, learning the ropes at a

hospital or medical center, either on staff or freelancing, or working with doctors who publish. Getting a good grounding enables you to freelance in the area of your choice later.

Today, Donner admits, the profession is tighter and more competitive than when she began. Because there is less available federal grant money for hospitals and university medical centers, there are fewer staff jobs—and more artists out there freelancing. She notes that today it is more important to have an agent, especially if you want pharmaceutical ad jobs.

Donner also recommends networking. Join the Association of Medical Illustrators, Donner suggests (AMI Headquarters, Suite 560, 1819 Peachtree St. NE, Atlanta GA 30369). Go to their annual meeting, talk to people in your field, attend workshops, and study the new styles and original work.

Of course, says Donner, it's most important to "practice, practice, practice." And today you must really understand not just science and physiology but the business too. The more you understand about the entire business, "the better you are, and the more fun it is."

—Jean Fredette

"Here are two typical styles of illustration required of medical illustrators," Donner says. *The developing fetus was done in acrylic and oil on paper, while the black-and-white piece was done in pen line on scratchboard.* Reprinted with permission of Carol Donner.

ADELANTE ADVERTISING INC., 386 Park Ave. S, New York NY 10016. (212)696-0855. President/Art Director: Sy Davis. Estab. 1973. Ad agency. Clients: national consumer. Client list available.
Needs: Works with 50 freelance illustrators and 5 freelance designers/year. Seeks experienced professionals. Sometimes works on assignment only. Uses artists for a variety of jobs. 40% of work is with print ads.
First Contact & Terms: Send query letter, brochure, resume and samples to be kept on file. Prefers photographs, slides or tearsheets as samples. Samples not filed are not returned. Reports only if interested. Call for appointment to show portfolio. Pays by the project, $150-5,000. Considers complexity of the project, client's budget, skill and experience of artist, geographic scope for the finished product and turnaround time when establishing payment. Rights purchased vary according to project.
Tips: "Be unique in style."

ANITA HELEN BROOKS ASSOCIATES, PUBLIC RELATIONS, 155 E. 55th St., New York NY 10022. (212)755-4498. President: Anita Helen Brooks. PR firm. Clients: fashion, "society," travel, restaurant, political and diplomatic and publishing. Special events, health and health campaigns.
Needs: Number of freelance jobs assigned/year varies. Works on assignment only. Uses artists for consumer magazines, newspapers and press releases. "We're currently using more abstract designs."
First Contact & Terms: Call for appointment to show portfolio. Reports only if interested. Considers client's budget and skill and experience of artist when establishing payment.
Tips: Artists interested in working with us must provide "rate schedule, partial list of clients and media outlets. We look for graphic appeal when reviewing samples."

CANON & SHEA ASSOCIATES, INC., Suite 1500, 224 W. 35th St., New York NY 10001. (212)564-8822. Art Director: Christine Dorman. Estab. 1978. Ad/PR/marketing firm. Clients: business-to-business and financial services.
Needs: Assigns 20-40 freelance jobs and buys 50-60 freelance illustrations/year. Works with 20-30 freelance illustrators and 2-3 freelance designers/year. Mostly local artists. Mainly uses freelancers for mechanicals and illustrations. 85% of work is with print ads.
First Contact & Terms: Send query letter with brochure showing art style or send resume and tearsheets. To show a portfolio, mail original/final art or write to schedule an appointment. Pays by the hour: $25-35, animation, annual reports, catalogs, trade and consumer magazines; $25-50, packaging; $50-250, corporate identification/graphics; $10-45, layout, lettering and paste-up.
Tips: "Artists should have business-to-business materials as samples and should understand the marketplace. Do not include fashion or liquor ads. Common mistakes in showing a portfolio include showing the wrong materials, not following up and lacking understanding of the audience."

THE CHRISTOPHERS, 12 E. 48th St., New York NY 10017. (212)759-4050. Editor: Stephanie Raha. Estab. 1945. Multimedia public service organization engaging in various publishing and TV ventures.
Needs: Works with 3 freelance artists/year. Prefers local artists with experience in nonprofit field. Works on assignment only. Uses freelance artwork mainly for pamphlets and books. Also uses freelance artists for brochure design and illustration and direct mail packages.
First Contact & Terms: Send query letter with brochure showing art style. Samples are filed or are returned by SASE. Reports back within 1 week. Pays for design and illustration by the project, $150 minimum. Buys all rights.

EFFECTIVE COMMUNICATION ARTS, INC., 221 W. 57th St., New York NY 10019. (212)333-5656. Vice President: W. J. Comcowich. Estab. 1965. AV firm. Produces films, videotapes and interactive videodiscs on science, medicine and technology. Specialize in pharmaceuticals, medical devices and electronics. Current clients include Pfizer, Inc., ICI Pharma, AT&T and Burroughs Wellcome.
Needs: Works with 2 freelance illustrators and 4 freelance designers/month. Prefers artist with experience in science and medicine. Works on assignment only. Uses freelancers mainly for animation. Also uses artists for brochure design, storyboards, slide illustration, mechanicals and TV/film graphics.
First Contact & Terms: Send query letter with resume, photographs and videotape. Samples are filed or are returned only if requested by artist. Reports back to the artist only if interested. Write to schedule an appointment to show a portfolio, which should include original/final art and videotape. Pays for design by the project; by the day, $200-350. Pays for illustration by the project, $150-750. Considers complexity of project, client's budget and skill and experience of artist when establishing payment. Buys all rights.
Tips: "Show good work; have good references."

ELCON COMMUNICATIONS, 38 W. 38th St., New York NY 10018. (212)768-0073. FAX: (212)768-0079. Creative Director: Jay Lazar. Estab. 1988. Ad agency. Full-service, multimedia firm.
Needs: Approached by 5-10 freelance artists/month. Works with 2-5 freelance illustrators and 2-5 freelance designers/month. Prefers local artists only. Works on assignment only. 35% of work is with print ads.
First Contact & Terms: Send query letter with photocopies and samples. Samples are filed and are not returned. Reports back to the artist only if interested. Call or write to schedule an appointment to show a portfolio. Portfolio should include original/final art and tearsheets. Buys all rights or rights purchased vary according to project.

ERICKSEN/BASLOE ADVERTISING, LTD., 12 W. 37th St., New York NY 10018. Director of Creative Services: Catherine M. Reiss. Full-service ad agency providing all promotional materials and commercial services for clients. Produce specialties are promotional, commercial and advertising materials. Current clients include: Turner Home Entertainment, CBS/Fox Home Video and ABC News International.
Needs: Works with 50 freelance artists/year. Assigns 50 jobs/year. Works on assignment only. Uses freelance artists mainly for illustration, advertising, video packaging, brochures, catalogs, trade magazines, P-O-P displays, mechanicals, posters, lettering and logos. "Must be able to render celebrity likenesses." Prefers oils and airbrush.
First Contact & Terms: Contact through artist's agent or send query letter with brochure or tearsheets and slides. Samples are filed and are not returned unless requested; unsolicited samples are not returned. Reports back within 1 week if interested or when artist needed for a particular project. Does not report back to all unsolicited samples. Call or write to schedule an appointment to show a portfolio; "only on request should a portfolio be sent." Pays for illustration by the project, $500-5,000. Considers complexity of project, client's budget, turnaround time, skill and experience of artist, how work will be used and rights purchased when establishing payment. Buys all rights and retains ownership of original.
Tips: "I need to see accurate celebrity likenesses in your portfolio." Has a portfolio-drop off policy.

RICHARD FALK ASSOC., 1472 Broadway, New York NY 10036. (212)221-0043. PR firm. Estab. 1950. Clients: industry, entertainment and Broadway shows.
Needs: Works with 5 freelance artists/year. Uses freelance artists for consumer magazines, brochures/flyers and newspapers; occasionally buys cartoon-style illustrations. 10% of work is with print ads. Prefers pen & ink and collage.
First Contact & Terms: Send resume. Provide flyer and business card to be kept on file for future assignments. No originals returned to artist at job's completion. Pays for illustration and design by the project, $100-1,000.
Tips: "Don't get too complex—make it really simple. Don't send originals."

FLAX ADVERTISING (formerly Flax/DeKrig Advertising), 9 E. 40th St., 10th floor, New York NY 10016. (212)683-3434. Art Director: Linda Ely. Estab. 1962. Clients: women's and children's fashions, men's wear, fabrics and accessories. Assigns 100 freelance jobs and buys around 20 freelance illustrations/year.
Needs: Works with 3-5 freelance illustrators and 5-10 freelance designers/year. Uses artists for mechanicals, comps, illustration, technical art, retouching and lettering for newspapers, magazines, fashion illustration, cartooning and direct mail. 90% of work is with print ads.
First Contact & Terms: Local artists only. Arrange interview to show portfolio. Reports in 1 week. Pays for design and illustration by the project.
Tips: "I would like to see the artists ability, more loose comps and less school projects in a portfolio. Follow up with phone calls. I don't use too many fashion illustrations anymore (mostly photography). Also, I have a drop-off policy on Thursdays. I do review all books and keep cards and samples on file to use at the right time. I use a lot of comp people."

GREY ADVERTISING INC., 777 3rd Ave., New York NY 10017. V.P. Art Buying Manager: Patti Harris.
Needs: Works on assignment only.
First Contact & Terms: Call for an appointment to show a portfolio, which should include original/final art. Pays by the project. Considers client's budget and rights purchased when establishing payment.
Tips: "Most of our advertising is done with photography. We use illustrations on a very limited basis. Treat the work with respect and handle yourself in a businesslike fashion."

HERMAN & ASSOCIATES INC., 488 Madison Ave., New York NY 10022. (212)935-2832. CEO: Paula Herman. Estab. 1966. Serves clients in insurance, electronics/computers, travel and tourism.
Needs: Works with 6-10 freelance illustrators/year. Works with 4 freelance designers/year. Prefers local artists who have worked on at least 2-3 professional assignments previously. Works on assignment only. Uses artists for mechanicals, illustration, retouching for newspapers and magazines. 55% of work is with print ads.
First Contact & Terms: Send brochure showing art style and "whatever best represents artist's work." Samples returned by SASE. Reporting time "depends on clients." Reports back whether to expect possible future assignments. Write to schedule an appointment to show a portfolio. Pays for design by the hour, $25-35; by the project, $250 minimum; by the day, $400-500. Pays for illustration by the project, $300-2,000.
Tips: "The illustrator should be an 'idea' contributor as well. Add to the concept or see another possiblity. Freelancers need to provide 'leave behinds,' reminders of their work. We are using more illustration, especially in the high-tech, electronics and travel-related areas (architecture, buildings, etc.) Send samples that show your versatility."

HILL AND KNOWLTON, INC., 420 Lexington Ave., New York NY 10017. (212)697-5600. Corporate Design Group: Jim Stanton or Lorenzo Ottaviani. Estab. 1989. PR firm. Full-service, multimedia firm. Specializes in annual reports, collaterals, corporate identity, advertisements.

Needs: Works with 4-20 freelance illustrators and 2 freelance designers/month. Works on assignment only. Also uses freelance artists for storyboards, slide illustration, animatics, mechanicals, retouching and lettering. 10% of work is with print ads.
First Contact & Terms: Send query letter with promo and samples. Samples are filed. Does not report back, in which case the artist should "keep in touch by mail – do not call." Call and drop-off only for a portfolio review. Portfolio should include dupe photographs. Pays for illustration by the project, $100-12,000. Negotiates rights purchased.

THE JOHNSTON GROUP, (formerly Jim Johnston Advertising Inc.), 49 W. 27th, 10th floor, New York NY 10176. (212)779-1257. Art/Creative Director: Doug Johnston. Serves publishing, corporate and business-to-business clients.
Needs: Works with 3-4 freelance illustrators/month. Uses artists for consumer magazines, trade magazines and newspapers.
First Contact & Terms: Query with previously published work or samples and SASE, or arrange interview. Reports in 2 weeks. Provide tearsheets to be kept on file for possible future assignments. Payment by job: $250-6,500, annual reports; $250-2,000, billboards; $125-2,500, consumer magazines; $150-5,000, packaging; $250-1,000, P-O-P displays; $150-1,500, posters; $125-600, trade magazines; $100-1,000, letterheads; $200-1,500, trademarks; $300-2,500, newspapers. Payment by hour: $20 minimum, catalogs; $5-20, paste-up. Pays 25% of promised fee for unused assigned illustrations.

CHRISTOPHER LARDAS ADVERTISING, Box 1440, Radio City Station, New York NY 10101. (212)688-5199. President: Christopher Lardas. Estab. 1960. Ad agency. Clients: producers of paper products, safety equipment, chocolate-confectionery, real estate and writing instruments/art materials.
Needs: Works with 3 freelance illustrators and 3 freelance designers/year. Local artists only; must have heavy experience. Works on assignment only. Uses artists for illustration, layout and mechanicals. 75% of work is with print ads.
First Contact & Terms: Send query letter with brochure showing art style or photocopies to be kept on file. Looks for "realistic product illustrations." Samples not filed are returned only if requested. Reports back only if interested. Write for appointment to show portfolio, which should include roughs, original/final art or color and b&w tearsheets. Pays by the hour. Considers client's budget when establishing payment. Buys all rights.
Tips: "Artists generally don't follow-up via mail! After artists make initial phone contact, we request a mail follow-up: e.g. photocopies of samples and business card for future reference. Few comply. Send examples of art you enjoy most."

MANHATTAN VIDEO PRODUCTIONS, INC., 12 W. 27th St., New York NY 10001. (212)683-6565. Production Manager: Alison McBryde. Video production firm serving banks, Fortune 500 companies. Current clients include: Bell Labs, Citibank and Sally Jesse Raphael Show.
Needs: Works with 3-5 freelance artists/year. Works on assignment only. Uses artists for brochures, mechanicals, logos and ads. Currently needs graphics and computer graphics, set designers.
First Contact & Terms: Send query letter with brochure showing art style. Samples not filed are returned by SASE. Reports only if interested. To show a portfolio, mail appropriate materials. Pays for design by the hour, $20 minimum; or by the project, up to $3,000. Pays for illustration by the hour. Considers client's budget, skill and experience of artist and turnaround time when establishing payment. Rights purchased vary according to project.
Tips: "No phone calls.

MARINA MAHER COMMUNICATIONS, 645 Madison Ave., New York NY 10022. (212)759-7543. FAX: (212)355-6318. General Manager: Dale Kuron. Estab. 1983. AV and PR firm. Full-service multimedia firm. Specializes in mailers, A/V, brochures and collaterals. Product specialties are beauty, fashion and lifestyles. Current clients include: Procter & Gamble, Pierre Cardin and Nina Ricci. Prefers local artists only. Also uses freelance artists for brochure and catalog design and illustration, storyboards, slide illustration, mechanicals, retouching, posters, lettering, logos and letterheads.
First Contact & Terms: Send query letter with brochure, photocopies, resume, tearsheets and photostats. Samples are filed. Reports back to the artist only if interested. Call to schedule an appointment to show a portfolio. Portfolio should include "whatever specialty is." Rights purchased vary according to project.

MARTIN/ARNOLD COLOR SYSTEMS, 150 5th Ave., New York NY 10011. (212)675-7270. President: Martin Block. Vice President Marketing: A.D. Gewirtz. AV producer. Produces slides, filmstrips and Vu Graphs, large blow-ups in color and b&w. Clients: industry, education, government and advertising.

Needs: Assigns 20 jobs/year. Works with 2 freelance illustrators and 2 freelance designers/month. Works on assignment only. Uses freelance artists mainly for presentations and display.
First Contact & Terms: Send query letter with resume to be kept on file. Call or write to schedule an appointment to show a portfolio, which should include original/final art and photographs. Pays for design by the project; pays for illustration by the hour, $50 minimum. Original artwork returned to artist after publication. Negotiates rights purchased.
Tips: Artist should have "knowledge of computer graphics."

MARX MYLES GRAPHICS INC., 440 Park Ave. S., New York NY 10016. (212)683-2015. Vice President Sales: Sheldon H. Marx. Estab. 1981. Ad agency/design studio specializing in sales promotion, production and typography.
Needs: Uses freelance artists mainly for paste up ads, brochures, books and magazines. Prefers local artist only with experience in mechanicals and art design.
First Contact & Terms: Send query letter with samples. Samples are filed. Reports back within 1 week. Portfolio should include any appropriate samples. Pays for design by the hour, $10-20. Considers client's budget and skill and experience of artist when establishing payment.

MEDIA DESIGNS, 100 Park Ave., New York NY 10017. (212)818-8913. President/Creative Director: Scott Randall. Estab. 1983. Ad agency and AV firm. "We are a full-service firm providing sales materials, public image presentation, specializing in print and video production." Specializes in broadcast, media and travel.
Needs: Prefers local artists only with experience in design, production and advertising. Uses freelancers mainly for ads and collateral design. Also uses artists for brochure design, print ad design and illustration, storyboards, mechanicals and logos. 50% of work is with print ads.
First Contact & Terms: Send query letter. Samples are filed or are returned only if requested by artist. Reports back to the artist only if interested. Call or write to schedule an appointment to show a portfolio, which should include tearsheets and final reproduction/product. Pays for design by the hour, $20-25. Pays for illustration by the project, $250-750. Considers complexity of project, client's budget and skill and experience of artist when establishing payment. Rights purchased vary according to project.

RUTH MORRISON ASSOCIATES, INC., 19 W. 44th St., New York NY 10036. (212)302-8886. Administrator: Gail Hulbert. Estab. 1972. PR firm. "Other assignments include logo/letterhead design, produces, invitations and product labels." Specializes in food, wine, home funishings, travel, hotel/restaurant, education, non-profit.
Needs: Prefers local artists only with experience in advertising and publishing. Uses freelancers mainly for brochure design, P-O-P materials and direct mail. Also uses artists for catalog and print ad design, mechanicals, posters, lettering and logos. 5% of work is with print ads.
First Contact & Terms: Send query letter with photocopies. Samples "of intent" are filed. Samples not filed are returned only if requested by artist. Does not report back. Considers complexity of project, client's budget, turnaround time, skill and experience of artist and how work will be used when establishing payment. Rights purchased vary according to project.

NEWMARK'S ADVERTISING AGENCY INC., 253 W. 26th St., New York NY 10001. Art/Creative Director: Al Wasserman. Art/ad agency. Clients: manufacturing, industry, banking, leisure activity, consumer, real estate and construction firms.
Needs: Works with 1 freelance designer every 5 months. Uses artists for editorial and technical illustration, or cartoon and photo retouching, billboards, P-O-P display, consumer magazines, slide sets, brochures/flyers and trade magazines. Also uses artists for figure illustration, cartoons, technical art, paste-up, retouching and 3-D model building.
First Contact & Terms: Provide stat samples to be kept on file for future assignments. No originals returned to artist at job's completion. "Send repros first." Pays $8-15/hour, paste-up and $75-3,000 or more/job.

NOSTRADAMUS ADVERTISING, Suite 1128-A, 250 W. 57th St., New York NY 10107. Creative Director: B.N. Sher. Specializes in annual reports, corporate identity, publications, signage, flyers, posters, advertising, direct mail and logos. Clients: ad agencies, book publishers, nonprofit organizations and politicians.
Needs: Works with 5 freelance artists/year. Uses artists for advertising design, illustration and layout; brochure design, mechanicals, posters, direct mail packages, charts/graphs, logos, catalogs, books and magazines.
First Contact & Terms: Send query letter with brochure, resume, business card, samples and tearsheets to be kept on file. Do *not* send slides as samples; will accept "anything else that doesn't have to be returned." Samples not kept on file are not returned. Reports only if interested. Call for appointment to show portfolio. Pays for design, mechanicals and illustration by the hour, $15-25 average. Considers skill and experience of artist when establishing payment.

PHOENIX FILMS, INC., 468 Park Ave. S., New York NY 10016. (212)684-5910. President: Heinz Gelles. Vice President: Barbara Bryant. Clients: libraries, museums, religious institutions, U.S. government, schools, universities, film societies and businesses. Produces and distributes educational films.

Needs: Assigns 20-30 jobs/year. Local artists only. Uses artists for motion picture catalog sheets, direct mail brochures, posters and study guides.
First Contact & Terms: Query with samples (tearsheets and photocopies). Send SASE. Send recent samples of artwork and rates to Renata Stein, Promotion Department. No telephone calls please. Reports in 3 weeks. Buys all rights. Keeps all original art "but will loan to artist for use as a sample." Pays for design and illustration by the hour or project. Rates negotiable. Free catalog upon written request.

RICHARD H. ROFFMAN ASSOCIATES, Suite 6A, 697 West End Ave., New York NY 10025. (212)749-3647. President: Richard R. Roffman. PR firm. Clients: restaurants, art galleries, boutiques, hotels and cabarets, nonprofit organizations, publishers and all professional and business fields.
Needs: Assigns 24 freelance jobs/year. Works with 2 freelance illustrators and 2 freelance designers/month. Uses artists for consumer and trade magazines, brochures, newspapers, stationery, posters and press releases.
First Contact & Terms: Send query letter, SASE (for response) and resume to be kept on file; call or write for appointment to show portfolio. Do not mail samples. Prefers photographs and photostats as samples. Reports only if interested. Pays by the hour, $10-25 average; by the project, $75-250 average; by the day, $150-250 average. Considers complexity of project, client's budget and skill and experience of artist when establishing payment. Buys first rights or one-time rights. Returns material only if SASE enclosed.
Tips: "Realize that affirmative answers cannot always be immediate – do have patience. If you desire an answer in writing please enclose SASE for the reply, thank you."

PETER ROGERS ASSOCIATES, 355 Lexington Ave., New York NY 10017. (212)599-0055. FAX: (212)682-4309. Art Director: Tracy McFarlane. Ad agency. Full-service, multimedia firm. Specializes in magazine ads, TV commercials. Product specialties are beauty, fashion, jewelry and "any other high-end merchandise."
Needs: Approached by 20 freelance artists/month. Works with 1 freelance illustrator and 2 freelance designers/mechanical artists/month. Prefers artists with experience. Uses freelance artists for illustration, storyboards, animatics, retouching, graphics and lettering. 80% of work is with print ads.
First Contact & Terms: Send query letter with any relevant materials, mechanicals, stylists, fashion and still photographs and promo cards. Samples are filed. Call to schedule an appointment to show a portfolio or drop-off and pick-up next day. Pays for design/mechanicals by the hour, $18-30 minimum; or by the project. Pays for illustration by the hour, $25-50 or by the project. Negotiates rights purchased.
Tips: "Avoid unprofessional/sloppy presentations and 'pushiness.' Send samples or drop off book prior to calling. Prefer being contacted by reputable reps/agencies."

PETER ROTHHOLZ ASSOCIATES INC., 380 Lexington Ave., New York NY 10017. (212)687-6565. President: Peter Rothholz. PR firm. Clients: government (tourism and industrial development), publishing, pharmaceuticals (health and beauty products) and business services.
Needs: Works with 2 freelance illustrators and 2 freelance designers/month. Works on assignment only.
First Contact & Terms: Call for appointment to show portfolio, which should include resume or brochure/flyer to be kept on file. Samples returned by SASE. Reports in 2 weeks. Assignments made based on freelancer's experience, cost, style and whether he/she is local. No originals returned to artist at job's completion. Negotiates payment based on client's budget.

JASPER SAMUEL ADVERTISING, 406 W. 31st St., New York NY 10001. (212)239-9544. Art Director: Joseph Samuel. Ad agency. Clients: health centers, travel agencies, hair salons, etc.
Needs: Works with 5-10 freelance artists/year. Works on assignment only. Uses artists for advertising, brochure and catalog design, illustration and layout; product design and illustration on product.
First Contact & Terms: Send query letter with brochure, resume, business card, photographs and tearsheets to be kept on file. Samples not filed are returned. Reports within 1 month. Call or write for appointment to show portfolio. Pays by the project. Considers complexity of project and skill and experience of the artist when establishing payment.

SPACE PRODUCTIONS, 451 West End Ave., New York NY 10024. (212)986-0857. Contact: Producer. "We work in mass communications, using all types of AV materials, film, animation and TV, but the emphasis is on TV." Serves clients in advertising, industry, government and cultural and educational institutions. Produces commercials, information and entertainment programs, sales/marketing, P-O-P display and other types of properties.
Needs: Assigns 20-25 jobs/year. Uses a "dozen or more" illustrators, animators and designers/year. "No geographical restrictions, but artist-applicants should note that we are located in New York City." Uses artists for art direction, graphics, illustration, design/print and TV.
First Contact & Terms: Send resume and samples (copies, any type; subjects that suggest the individual style of an artist's work). Samples not filed are returned by SASE. Provide resume, samples, brochure/flyer, business card or tearsheets – "a small representative sampling" – to be kept on file for possible future assignments. Reports in 2 months. Pays $10-50/hour. Method and amount of payment are negotiated with the individual artist or agent. Payment depends on assignment and varies with each client's budget. Original

artwork sometimes returned to artist following publication. Rights purchased vary.

***STRATEGIC COMMUNICATIONS**, 276 Fifth Ave., New York NY 10001. (212)779-7240. FAX: (212)779-7248. Estab. 1981. PR firm. Specializes in corporate and press materials, VNRs and presentation materials. Specializes in service businesses.
Needs: Approached by 3-4 freelance artists/month. Works with 3 freelance illustrators and 4 freelance designers/month. Prefers local artists only. Works on assignment only. Uses freelance artists for brochure design and illustration, slide illustration, mechanicals, posters, TV/film graphics, lettering, logos, corporate ID programs, annual reports, collateral and press materials.
First Contact & Terms: Send query letter with brochure, resume, photographs and non-returnable samples only. Samples are filed. Does not report back, in which case the artist should send follow-up communication every 6-9 months to keep file active. Portfolio should include original, final art. Pays for design and illustration by the project. Rights purchased vary according to project.

TALCO PRODUCTIONS, 279 E. 44th St., New York NY 10017. (212)697-4015. President: Alan Lawrence. TV/film producer. Clients: nonprofit organizations, industry, associations and PR firms. Produces motion pictures, videotapes and some filmstrips and sound-slide sets.
Needs: Assigns 4-10 jobs/year. Prefers local artists with professional experience.
First Contact & Terms: Send query letter with resume. SASE. Reports only if interested. Portfolio should include roughs, final reproduction/product, color, photostats and photographs. Pay varies according to assignment; on production. On some jobs, originals returned to artist after completion. Buys all rights. Considers complexity of project, client's budget and rights purchased when establishing payment.
Tips: "Do not send anything but a resume!"

VAN VECHTEN & ASSOCIATES PUBLIC RELATIONS, 48 E. 64th St., New York NY 10021. (212)644-8880. President: Jay Van Vechten. PR firm. Clients: medical, consumer products, industry. Client list for SASE.
Needs: Assigns 20+ freelance jobs/year. Works with 2 freelance illustrators and 2 freelance designers/month. Works on assignment only. Uses artists for consumer and trade magazines, brochures, newspapers, stationery, signage, AV presentations and press releases.
First Contact & Terms: Send query letter with brochure, resume, business card, photographs or photostats. Samples not filed are returned by SASE. Reports back only if interested. Write for appointment to show a portfolio. Pays by the hour, $10-25 average. Considers client's budget when establishing payment. Buys all rights.

PETER VANE ADVERTISING, Suite 1200, 250 Park Ave. S., New York NY 10003-1402. (212)679-8260. Executive Vice President/Creative: Penny Vane. Estab. 1978. Ad agency. "We are an advertising agency specializing in direct marketing, providing marketing consultation, creative, production and media services to a wide range of consumer and business-to-business clients." Specializes in publishing, clubs and continuities, financial and trade. Current clients include: Grolier, Highlights for Children, Medical Business Services, Playboy, Meredith, Cowles, Reader's Digest and CBS.
Needs: Prefers artists with experience in direct marketing. Works on assignment only. Uses freelancers mainly for direct mail, space ads and inserts. Also uses artists for brochure and print ad design and illustration, mechanicals and logos. 20% of work is with print ads.
First Contact & Terms: Send query letter with resume and photocopies. Samples are filed "if worthy of future reference" or are returned by SASE. Reports back to the artist only if interested. To show a portfolio, mail roughs, photostats and tearsheets. "Portfolios should show, whenever possible, both original concept (comp) and finished execution (printed piece)." Pays for design by the hour, $25-50. Considers complexity of project, client's budget, turnaround time, skill and experience of artist and how work will be used when establishing payment. Rights purchased vary according to project.
Tips: The most effective way for a freelancer to get started in advertising is to have "referrals, initiative and samples demonstrating transferable skills."

MORTON DENNIS WAX & ASSOCIATES INC., Suite 1210, 1560 Broadway, New York NY 10036. (212)302-5360. FAX: (212)302-5364. President: Morton Wax. Estab. 1956. PR firm. Clients: entertainment, communication arts and corporate.
Needs: Works with 10 freelance designers/year. Artists must have references and minimum 3 years of experience. Works on assignment only. Uses artists for trade magazine ads, brochures and other relevant artwork. 100% of work is with print ads.
First Contact & Terms: Send query letter with resume, photostats or tearsheets to be kept on file. Samples not filed are returned by SASE. Reports only if interested. Write for appointment to show portfolio. "We select and use freelancers on a per project basis, based on specific requirements of clients. Each project

is unique." Considers complexity of project, client's budget, turnaround time and rights purchased when establishing payment. Rights vary according to project.

North Carolina

HEGE, MIDDLETON & NEAL, INC., Box 9437, Greensboro NC 27408. (919)373-0810. President: J.A. Middleton, Jr. Ad agency.
Needs: Assigns 200 freelance jobs/year. Works with 5 freelance illustrators and 5 freelance designers/month. Works on assignment only. Uses artists for consumer and trade magazines, billboards, direct mail packages, brochures, catalogs, newspapers, stationery, signage, P-O-P displays and posters.
First Contact & Terms: Send query letter with brochure, resume, business card, photographs and tearsheets to be kept on file. Samples returned by SASE if requested. Reports only if interested. Write for appointment to show portfolio. Pays by the project, $20-6,000. Considers complexity of project, client's budget, skill and experience of artist, geographic scope of finished project, turnaround time and rights purchased when establishing payment. Buys all rights.

IMAGE ASSOCIATES INC., 4314 Bland Rd., Raleigh NC 27609. (919)876-6400. President: David Churchill. Estab. 1984. AV firm. "Visual communications firm specializing in computer graphics and AV, multi-image, print and photographic applications."
Needs: Works with 1 freelance illustrator and 2 freelance designers/month. Prefers artists with experience in high-tech orientations and computer-graphics. Works on assignment only. Uses freelancers mainly for brochure design and illustration. Also uses freelance artists for print ad design and illustration, slide illustration, animation and retouching. 25% of work is with print ads.
First Contact & Terms: Send query letter with brochure, resume and tearsheets. Samples are filed or are returned by SASE only if requested by artist. Reports back to the artist only if interested. To show a portfolio, mail roughs, original/final art, tearsheets, final reproduction/product and slides. Pays for design and illustration by the hour, $35-75. Consider complexity of project, client's budget and how work will be used when establishing payment. Rights purchased vary according to project.

LEWIS ADVERTISING, INC., 1050 Country Club Ln., Rocky Mount NC 27804. (919)443-5131. Senior Art Director: Scott Brandt. Ad agency. Clients: fast food, communications, convenience stores, financial. Client list provided upon request with SASE.
Needs: Works with 20-25 freelance artists/year. Works on assignment only. Uses artists for illustration and part-time paste-up. Especially looks for "consistently excellent results, on time and on budget."
First Contact & Terms: Send query letter with resume, business card and samples to be kept on file. Call for appointment to show portfolio. Artists should show examples of previous work, price range requirements and previous employers. Samples not filed returned by SASE only if requested. Reports only if interested. Pays by project. Considers complexity of the project, client's budget, turnaround time and ability of artist when establishing payment. Buys all rights.

MORPHIS & FRIENDS, INC., Drawer 5096, 230 Oakwood Dr., Winston-Salem NC 27103. (919)723-2901. Director: Linda Anderson. Art Director: Laura Griffin. Ad agency. Clients: banks, restaurants, clothing, cable, industry and furniture.
Needs: Assigns 20-30 freelance jobs/year. Works on assignment only. Works with approximately 2 freelance illustrators/month. Uses freelance artists for consumer and trade magazines, billboards, direct mail packages, brochures and newspapers.
First Contact & Terms: Send query letter with photocopies to be kept on file. Samples not filed are returned only if requested. Reports only if interested. Call to schedule an appointment to show a portfolio, which should include roughs and final reproduction/product. Pays by the hour, $20 minimum. "Negotiate on job basis." Considers complexity of project, client's budget, skill and experience of artist, geographic scope of finished project, turnaround time and rights purchased when establishing payment. Buys all rights.
Tips: "Send a letter of introduction with a few samples to be followed up by phone call."

THOMPSON AGENCY, Suite M, 1415 South Church St., 112 S. Tyron St., Charlotte NC 28203. (704)333-8821. Contact: Joe Thompson. Ad agency. Clients: banks, resorts and soft drink, utility companies and insurance agencies.
Needs: Assigns approximately 50 freelance jobs/year. Works with 3 freelance illustrators/month. Works on assignment only. Uses freelance artists for consumer and trade magazines, billboards, direct mail packages, brochures, newspapers, signage, P-O-P displays and posters.
First Contact & Terms: Send query letter with brochure showing art style or photocopies to be kept on file. Samples returned by SASE if requested. To show portfolio, mail appropriate materials or write to schedule an appointment; portfolio should include final reproduction/product. Reports only if interested. Pays for

design by the project, $500-7,500; pays for illustration by the project, $350-3,000. Considers complexity of project, client's budget, skill and experience of artist, turnaround time and rights purchased when establishing payment. Buys all rights.

Tips: "In general, we see a bolder use of ideas and techniques. We try to screen all work before appointment. Work must be professional and very creative.

WILLIAMS/SPARLING ADVERTISING, 320 S. Elm St., Greensboro NC 27401. (919)273-9654. FAX: (919)273-1333. Contact: Scott Williams. Estab. 1987. Ad agency. Full-service, multimedia firm. Specializes in print, radio, TV production, collateral, media, special events coordination, promotion and sports/marketing. Product specialty is consumer package goods and corporate identity. Current clients include: Bank of North Carolina and United Arts Council.

Needs: Approached by 10 freelance artists/month. Works with 2 freelance illustrators and 4-6 freelance designers/month. Prefers specialists and artists with experience in all areas and wants top grade work. Uses freelance arts for brochure and print ad design and illustration, storyboards, slide illustration, animatics, animation, posters, TV/film graphics, lettering and logos. 15% of work is with print ads.

First Contact & Terms: Send query letter with brochure, photocopies, SASE and tearsheets. Samples are filed or returned by SASE. Reports back within 30 days. Mail appropriate materials: roughs and b&w and color photostats, tearsheets and transparencies. Pays for design by the hour $20-75; by the project $200-6,000, by the day, $150-400. Pays for illustration by the hour $40-100. Rights purchased vary according to project.

Ohio

BRIGHT LIGHT PRODUCTIONS, INC., Suite 810, 602 Main St., Cincinnati OH 45202. (513)721-2574. President: Linda Spalazzi. Estab. 1976. AV firm. "We are a full-service film/video communications firm producing TV commercials and corporate communications."

Needs: Works on assignment only. Uses freelancers mainly for art/design. Also uses artists for brochure and print ad design, storyboards, slide illustration, animatics, animation, TV/film graphics and logos.

First Contact & Terms: Send query letter with brochure and resume. Samples not filed are returned only if requested by artist. Write to schedule an appointment to show a portfolio, which should include roughs and photographs. Pays for design and illustration by the project. Considers complexity of project, client's budget, turnaround time, skill and experience of artist, how work will be used and rights purchased when establishing payment. Negotiates rights purchased.

Tips: "Don't give up!"

FREEDMAN, GIBSON & WHITE ADVERTISING, (formerly Freedman Advertising), 814 Plum, Cincinnati OH 45202. (513)241-3900. Senior Art Director: Edward Fong. Estab. 1959. Ad agency. Full-service, multimedia firm. Product specialty consumer.

Needs: Approached by 6 freelance artists/month. Works with 2 freelance illustrators/month. Works only with artist reps. Prefers artists with experience in illustration. Works on assignment only. Also uses freelance artists for brochure design and illustration, storyboards, slide illustration, animatics, animation, mechanicals and retouching. 80% of work is with print ads.

First Contact & Terms: Send query letter with brochure and resume. Samples are filed and are not returned. Reports back within 1 week. Call to schedule an appointment to show a portfolio. Portfolio should include: thumbnails, roughs, original/final art and b&w transparencies. Pays for design by the hour, $15-20; by the project. Pays for illustration by the project $300-10,000. Buys all rights.

IMAGEMATRIX, 2 Garfield Pl., Cincinnati OH 45202. (513)381-1380. President: Peter Schwartz. Total communications for business.

Needs: Works with 25 freelance artists/year. Local artists only; must have portfolio of work. Uses freelance artists for paste-up, mechanicals, airbrushing, storyboards, photography, lab work, illustration for AV; buys cartoons 4-5 times/year. Especially important is AV knowledge, computer graphics for video and slides and animation understanding.

First Contact & Terms: Works on assignment only. Artwork buy-out. Send business card and slides to be kept on file. Samples not filed are returned by SASE. Reports within 2 months. Write for appointment to show portfolio. Pays for design by the hour, $8-35; by the project, $90 minimum. Pays for illustration by the hour, $8-15; by the project, $150 minimum. Considers complexity of the project, client's budget, skill and experience of artist and turnaround time when establishing payment. Buys all rights.

Tips: "Specialize your portfolio; show an understanding of working for a 35mm final product. We are using more design for video graphics and computer graphics."

GEORGE C. INNES & ASSOCIATES, Box 1343, 110 Middle Ave., Elyria OH 44036. (216)323-4526. President: George C. Innes. Ad/art agency. Clients: industry and consumer.
Needs: Assigns 25-50 jobs/year. Works with 3-4 freelance illustrators/month. Works on assignment only. Uses freelance illustrators mainly for filmstrips, stationery design, technical illustrations, airbrush, multimedia kits, direct mail, slide sets, brochures/flyers, trade magazines, newspapers and books. Also uses freelance artists for layout and design for reports, catalogs, print ads, direct mail/publicity, brochures, displays, employee handbooks, exhibits, products, technical charts/illustrations, trademarks, logos and company publications. Prefers pen & ink, airbrush, watercolor, acrylics, oils, collage, markers and computer illustration.
First Contact & Terms: Send query letter with brochure showing art style or tearsheets, photostats, photocopies, slides and photographs. Samples not filed are not returned. Reports in 2 weeks. To show a portfolio, a freelance artist should mail appropriate materials. No originals returned to artist at job's completion. Pays for design and illustration by the hour, $5-30.

INSTANT REPLAY, 1349 E. McMillan, Cincinnati OH 45206. (514)861-7065. President: Terry Hamad. Estab. 1977. AV firm. "We are a full-service film production/video production and video post production house with our own sound stage. We also do traditional animation, paintbox animation with Harry, and 3-D computer animation for broadcast groups, corporate entities and ad agencies. We do many corporate identity pieces as well as network affiliate packages, plus car dealership spots and general regional and national advertising for TV market." Current clients include: Procter and Gamble, Merrell-Dow, Whirlpool, G.E. (Jernegine division), NBC, CBS, ABC and FOX affiliates.
Needs: Works with 1 freelance designer/month. Prefers artists with experience in video production. Works on assignment only. Uses freelancers mainly for production. Also uses freelance artists for storyboards, animatics, animation and TV/film graphics. .01% of work is with print ads.
First Contact & Terms: Send query letter with resume, photocopies, slides and videotape. "Interesting samples are filed." Samples not filed are returned only if requested by artist. Reports back to the artist only if interested. Call to schedule an appointment to show a portfolio, which should include slides. Pays by the hour, $25-50; by the project and by the day (negotiated by number of days.) Pays for production by the day, $75-300. Considers complexity of project, client's budget and turnaround time when establishing payment. Buys all rights.

KRAEMER GROUP, 360 Gest St., Cincinnati OH 45203. (513)651-5858. Production Coordinator: Terri Miller. Estab. 1968. AV firm. "We are a full-service film and video production company. Services include scripting, casting, sets, directorial, multi-image shows, and shooting through post production of a project." Current clients include ad agencies, P&G and NCR.
Needs: Works with 2 freelance designers/month. Prefers artists with experience in film and video production. Uses freelancers mainly for production responsibilities (grips; sets, props, lighting, makeup, stylists, graphic designers). Also uses freelance artists for storyboards, animation, TV/film graphics, lettering and logos.
First Contact & Terms: Send query letter with brochure and resume. Samples are filed or are returned only if requested by artist. Reports back within 3-4 weeks. Write to schedule an appointment to show a portfolio, which should include photographs. Pays for design by the day, $175 minimum. Pays for illustration by the project. Considers complexity of project, client's budget, turnaround time, skill and experience of artist and rights purchased when establishing payment. Rights purchased vary according to project.
Tips: "Be willing to start out at entry level to establish one's self; then develop good credentials including reputation, examples of work and references."

LIGGETT-STASHOWER, 1228 Euclid Ave., Cleveland OH 44115. (216)348-8500. FAX: (216)736-8113. Art Buyer: Linda Barberic. Estab. 1940. Advertising agency. Full-service, multimedia firm. Works in all formats. Handles all product categories. Current clients include: Bank, Sear Eye, Babcock and Wilcox.
Needs: Approached by 2 freelance artists/month. Works with 2 freelance illustrators and 1 freelance designer/month. Prefers local artists only. Works on assignment only. Uses freelance artists mainly for brochure design and illustration, catalog design and illustration, print ad design and illustration, storyboards, slide illustration, animatics, animation, mechanicals, retouching, billboards, posters, TV/film graphics, lettering, logos.
First Contact & Terms: Send query letter. Samples are filed. Reports back to the artist only if interested. To schedule an appointment to show a portfolio, mail appropriate materials. Portfolio should include tearsheets and transparencies. Pays for design and illustration by the project. Negotiates rights purchased.

LOHRE & ASSOCIATES, Suite 101, 2330 Victory Parkway, Cincinnati OH 45206. (513)961-1174. Art Director: Charles R. Lohre. Ad agency. Clients: industrial firms.
Needs: Works with 2 illustrators/month. Works on assignment only. Uses freelance artists for trade magazines, direct mail, P-O-P displays, brochures and catalogs.
First Contact & Terms: Send query letter with resume and samples. Pays for design by the hour, $12 minimum; pays for illustration by the hour, $6 minimum.
Tips: Looks for artists who "have experience in chemical and mining industry, and working with metal fabrication. Needs Macintosh-literate artists with own equipment or willing to work at office, during day or evenings."

CHARLES MAYER STUDIOS INC., 168 E. Market St., Akron OH 44308. (216)535-6121. President: C.W. Mayer, Jr. AV producer since 1934. Clients: mostly industrial. Produces film and manufactures visual aids for trade show exhibits.
Needs: Works with 1-2 freelance illustrators/month. Uses illustrators for catalogs, filmstrips, brochures and slides. Also uses artists for brochures/layout, photo retouching and cartooning for charts/visuals. In addition, has a large gallery and accepts paintings, watercolors, etc. on a consignment basis, 33%-40% commissions.
First Contact & Terms: Send slides, photographs, photostats or b&w line drawings or arrange interview to show portfolio. Samples not kept on file are returned. Reports in 1 week. Provide resume and a sample or tearsheet to be kept on file. Originals returned to artist at job's completion. Negotiates pay.

MENDERSON & MAIER, INC., 2260 Park Ave., Cincinnati OH 45206. (513)221-2980. Art Director: Barb Phillips. Estab. 1954. Full-service ad agency in all aspects of media. Product specialties are uniforms, soldering wire and fun-food machines. Current clients include: Felheimer Bros Co., Gold Medal, J.W. Harris and Merit Savings.
Needs: Works with 1 freelance illustrator/month. Prefers local artists only. Uses freelancers mainly for editorial, technical, fashion and general line illustrations and production. Also uses freelance artists for brochure, catalog and print ad design and illustration, slide illustration, mechanicals, retouching and logos. Prefers mostly b&w art, line or wash. 70% of work is with print ads.
First Contact & Terms: Contact only through artist rep; send resume and photocopies. Samples are filed and are not returned. Reports back within 6 days. To show a portfolio, mail photostats, tearsheets, final reproduction/product and photographs; include color and b&w samples. Pays for design by the hour, $10 minimum, or by the project. Pays for illustration by the project. Considers complexity of project and client's budget when establishing payment. Buys all rights.
Tips: The most effective way for a freelancer to get started in advertising is "by any means that builds a sample portfolio."

ART MERIMS COMMUNICATIONS, 750 Prospect Ave., Cleveland OH 44115. (216)664-1113. President: Arthur M. Merims. Ad agency/PR firm. Current clients include: Ohio Pest Control Association, Headquarters Companies, Osborn Engineering and Patrick Douglas, Inc.
Needs: Assigns 10 freelance jobs/year. Prefers local artists. Works on assignment only. Works with 1-2 freelance illustrators and 1-2 freelance designers/month. Uses freelance artists mainly for work on trade magazines, brochures, catalogs, signage and AV presentations.
First Contact & Terms: Send query letter with samples to be kept on file. Call or write for appointment to show portfolio, which should include "copies of any kind" as samples. Pays by the hour, $20-50 or by the project. Considers complexity of project, client's budget and skill and experience of artist when establishing payment.
Tips: When reviewing samples, looks for "creativity and reasonableness of cost."

TELEPRODUCTIONS, C105 Music and Speech Bldg., State Rt. 59, Kent OH 44242. (216)672-2184. Creative Director: Gordon J. Murray. Estab. 1962. "Teleproductions is a university-based PBS television production facility that originates and supports programming for two television stations, a campus cable-network, and also functions as an academic support unit providing instructional television services."
Needs: Works with 2-3 freelance illustrators and 2-3 freelance designers/year. Prefers artists with experience in television, "but not required." Works on assignment only. Uses freelancers mainly for brochure and set design and corollary materials. Also uses freelance artists for catalog and print ad design and illustration, storyboards, slide illustration, animation, mechanicals, posters, TV/film graphics, lettering and logos.
First Contact & Terms: Send query letter with resume and photocopies. Samples are filed. Reports back to the artist only if interested. "We will contact artist about portfolio review." Portfolio should include color and b&w samples, roughs, original/final art, tearsheets, final reproduction/product, photographs, slides. Pays for design and illustration by the project, $25-$350. Considers complexity of project, client's budget, turnaround time, how work will be used and rights purchased when establishing payment. Rights purchased vary according to project.
Tips: "Because of our afilliation with a university with an excellent design program, competition is keen but not exclusive. The diversity of our production often requires the skills of graphic designers, set designers, illustrators, sculptors, cartoonists, paste-up artists and production assistants. We are in the process of building a file of dependable, talented freelancers for future projects."

TRIAD, (Terry Robie Industrial Advertising, Inc.), 7654 W. Bancroft St., Toledo OH 43617-1604. (419)241-5110. Vice President/Creative Director: Janice Robie. Ad agency/graphics/promotions. Clients: industrial, consumer, medical.
Needs: Assigns 30 freelance jobs/year. Works with 1-2 freelance illustrators/month and 2-3 freelance designers/month. Works on assignment only. Uses freelance artists for consumer and trade magazines, brochures, catalogs, newspapers, filmstrips, stationery, signage, P-O-P displays, AV presentations, posters and illustrations (technical and/or creative).

First Contact & Terms: Send query letter with resume and slides, photographs, photostats or printed samples to be kept on file. Samples returned by SASE if not kept on file. Reports only if interested. To show a portfolio, mail appropriate materials or write to schedule an appointment; portfolio should include roughs, original/final art, final reproduction/product and tearsheets. Pays by the hour, $10-60; by the project, $25-2,500. Considers client's budget, and skill and experience of artist when establishing payment. Negotiates rights purchased.
Tips: "We are interested in knowing your specialty."

Oregon

ADFILIATION ADVERTISING & DESIGN, 323 W. 13th Ave., Eugene OR 97401. (503)687-8262. President/Creative Director: Gary Schubert. Media Director/VP: Gwen Schubert. Estab. 1976. Ad agency. "We provide full-service advertising to a wide variety of regional and national accounts. Our specialty is print media, serving predominantly industrial and business-to-business advertisers." Clients: forest products, heavy equipment, software and sporting equipment.
Needs: Works with approximately 4 freelance illustrators and 2 freelance designers/year. Assigns 20-24 jobs/year. Works on assignment only. Uses freelancers mainly for specialty styles. Also uses artists for brochure and magazine ad illustration, retouching, animation, films and lettering. 80% of work is with print ads.
First Contact & Terms: Send query letter, brochure, resume, slides and photographs. Samples are filed or are returned by SASE only if requested. Reports back only if interested. Write to schedule an appointment to show a portfolio. Pays for design by the hour, $25-40. Pays for illustrations by the hour, $25-40; by the project, $400-800. Considers complexity of project, client's budget, turnaround time and skill and experience of artist when establishing payment. Buys first rights, one-time rights, or all rights; rights purchased vary according to project.
Tips: "We're busy. So follow up with reminders of your specialty, utilizing current samples of your work and convenience of dealing with you. We are looking at more electronic illustration lately. Find out what the agency does most often and produce a relative example for indication that you are up for doing the real thing! Follow-up after initial interview of samples. Do not send fine art abstract subjects."

CREATIVE COMPANY, INC., 3276 Commercial St., SE, Salem OR 97302. (503)363-4433. President/Owner: Jennifer Larsen Morrow. Specializes in corporate identity, packaging and P-O-P displays. Clients: local consumer-oriented clients specializing in food products, professionals and trade accounts on a regional and national level.
Needs: Works with 3-4 freelance artists/year. Prefers local artists. Works on assignment only. Uses artists for design, illustration, retouching, airbrushing, posters and lettering. "Clean, fresh designs!"
First Contact & Terms: Send query letter with brochure, resume, business card, photocopies and tearsheets to be kept on file. Samples returned only if requested. Reports only if interested. Call for appointment to show portfolio. "We require a portfolio review. Years of experience not important if portfolio is good. We prefer one-on-one review to discuss individual projects/time/approach." Pays for design and illustration by the hour, $20-50 average. Considers complexity of project and skill and experience of artist when establishing payment.
Tips: Common mistakes freelancers make in presenting samples or portfolios are: "1) poor presentation, samples not mounted or organized, 2) not knowing how long it took them to do a job to provide a budget figure, 3) not demonstrating an understanding of the printing process and how their work will translate into a printed copy, 4) just dropping in without an appointment, 5) not following up periodically to update information or a resume that might be on file."

Pennsylvania

AMERICAN ADVERTISING SERVICE, 121 Chestnut, Philadelphia PA 19106. (215)923-9100. Creative Director: Joseph Ball. Ad agency.
Needs: Uses freelance artists for advertising, billboards, package, graphic and cover design, commercials, exhibits and art renderings.
First Contact & Terms: Prefers personal contact, but mailed art or photocopies OK. Not responsible for art after submission.

COOK ASSOCIATES, INC., 900 Matsonford Rd., West Conshohocken PA 19428. (215)834-1111. FAX: (215)834-1213. Art Director: Robert Nowak. Ad agency. Specializes in sales promotional collaterals, dealer loader brochures and company brochures. Product specialties are health and beauty aids and pharmaceuticals. Current clients include: Smith Kline Beecham, Church & Dwight, Lehn & Fink and Glenbrook Labs.

Needs: Approached by 3-5 freelance artists/month. Works with 2 freelance illustrators and 2 freelance designers/month. Prefers local artists with experience in concept through production. No people just out of school; must have at least 5 years experience. Uses in-house freelance artists mainly for layout and design or production through mechanicals. Also uses freelance artists for brochure and print ad design and illustration, mechanicals, retouching, posters and printed sales brochures. 99% of work is with print material.
First Contact & Terms: Send query letter with photocopies, resume non-returnables. Samples are filed or are returned by SASE only if requested by artist. Reports back to the artist only if interested. "No follow-up calls, please." Portfolio should include thumbnails, roughs, original/final art and b&w and color tearsheets. Pays for design by the hour or day rate. "Salary varies by experience." Pays for illustration/photography by the project. Buys all rights.

EDUCATIONAL COMMUNICATIONS INC., 761 Fifth Ave., King of Prussia PA 19406. Creative Director: Joseph Eagle. Estab. 1969. AV firm. "ECI specializes in training programs for corporate clients. We work in all media but predominately in slides and video." Clients: automotive, pharmaceutical. Current clients include: Dow, Merck, Subaru of America and Mack Trucks.
Needs: Works with 3-4 freelance artists/year. Prefers local artists with experience in A/V , slide art and computer graphics. Uses freelance artists for storyboards, slide illustration, animation and mechanicals. 2% of work is with print ads. Works on assignment only. Especially important are cartoon or technical and medical illustration skills.
First Contact & Terms: Send query letter with resume, tearsheets, photostats, photocopies and slides to be kept on file. Samples are not returned. Does not report back. Write to schedule an appointment to show a portfolio, which should include b&w and color of original/final art, final reproduction/product, roughs, tearsheets and slides. Pays by the day, $100 minimum. Considers complexity of the project, and skill and experience of artist when establishing payment. Buys all rights.
Tips: "Work submitted must be clean, professional, and corporate in nature. Speed, ability to follow directions, and ability to think creatively are important. Ability to meet deadlines essential."

HARDMAN EASTMAN STUDIOS, INC., 1400 E. Carson St., Pittsburgh PA 15203. (412)481-4450. General Manager: Barbara Jost. AV and video production firm. Clients: business and industry.
Needs: Works with 1-2 freelance artists/year. Local artists only. Works on assignment only. Uses artists for design, illustration, mechanicals and charts/graphs. Artists should have the "experience to design art for 35mm slide and TV crop format, also the ability to communicate with clients and translate input into what is required for end use."
First Contact & Terms: Send query letter with resume. Samples not filed are not returned. Reports only if interested. Write to schedule an appointment to show a portfolio, which should include roughs, original/final art, and color photographs. Payment varies. Considers complexity of project, client's budget, skill and experience of artist and turnaround time when establishing payment. Buys all rights.
Tips: "Do not call. Send letter and resume!"

JERRYEND COMMUNICATIONS, INC., Rt. 2, Box 356H, Daniel Boone Rd., Birdsboro PA 19508. (215)689-9118. Vice President: Gerard E. End, Jr. Estab. 1980. Ad/PR firm. Clients: industry, credit unions, technical services, professional societies and automotive aftermarket.
Needs: Works with 5-10 freelance illustrators and 6-12 freelance designers/year. Works "primarily with local artists for time, convenience and accessibility." Works on assignment only. Mainly uses freelance artists for design and layout of ads and newsletters. 20-25% of work is with print ads.
First Contact & Terms: Send query letter with brochure showing art style to be kept on file. Samples not filed returned by SASE. Reports within 2 weeks. Call to schedule an appointment to show a portfolio, which should include roughs, final reproduction/product and tearsheets. Pays for design and illustration by the hour, $25-50 average. Considers complexity of project, client's budget, turnaround time and rights purchased when establishing payment. Buys all rights.
Tips: "Clients are interested in changing graphics and appearances. Call to determine our types of clients and needs. Must be willing to do on-the-spot sketches. If we have nothing for you at the time you call we will suggest other agencies who might have a need."

KINGSWOOD ADVERTISING, INC., 33 Cricket Terrace, Ardmore PA 19003. Senior Vice President/Creative Director: John F. Tucker, Jr. Serves clients in consumer, industrial, electronics, pharmaceuticals, publishing and scientific products and services.
Needs: Works with 3 freelance illustrators, 3 freelance designers/year. Prefers local artists. Works on assignment only. Uses artists mainly for technical and medical illustration and occasional comps from roughs. Also uses artists for technical art, retouching, P-O-P displays, stationery design and newspapers.
First Contact & Terms: Provide business card, brochure/flyer and samples to be kept on file. Prefers roughs through final as samples. Samples returned by SASE. No originals returned to artist at job's completion. Call to schedule an appointment to show a portfolio. Pays for design by the project, $100-700. Pays for illustration by the project, $200-1,000.

Tips: "Learn a little about our clients' products and their current ad and literature style, and possibly suggest an improvement here and there. Also know where your work appeared and what market it addressed."

KRUSE CORPORATE IMAGE, INC., 135 S. 5th. St, Box 78, Reading PA 19603. (215)372-1030. Owner/President: Dan Kruse. Creative Vice President: Joe Reighn. Estab. 1987. AV firm. "We provide multi-image/video production and related print materials for corporate image, product introduction and sales meetings." Clients: manufacturers, financial, medical, chemical, service.

Needs: Works with 2-4 freelance illustrators and 3-6 freelance designers/year. Assigns 10-15 jobs/year. Prefers local or regional artists. Works on assignment only. Uses freelance artists for design, animation and AV programming. Prefers pen & ink, watercolor, markers, and airbrush.

First Contact & Terms: Send query letter with resume. Samples are filed or are returned if requested. Reports back only if interested. Write to schedule an appointment to show a portfolio, which should include tearsheets and slides. Pays for design by the hour, $10-40. Pays for illustration by the hour, $20-50, or by the project. Considers complexity of project, client's budget and turnaround time when establishing payment. Rights purchased vary according to project.

Tips: "I look to see what style(s) artists handle best and how creative their solutions have been while still matching the requirements of the project. They sometimes fail to present materials as solutions to certain communication objectives—as all our projects are. I like to see examples of rough concept sketches through to final design."

LETVEN/DICCICCO ADVERTISING INC., 455 Business Center Dr., Horsham PA 19044. (215)957-0300. Executive Art Director: Ross Winters. Estab. 1967. Full-service, multimedia, business-to-business ad agency. "High Creative." Specializes in food and business-to-business. Current clients include: Hatfield Meats, Primavera, Hallowell and Caulk Dental Supplies.

Needs: Works with 10 freelance illustrators and 25 freelance designers/month. Uses freelance artists mainly for paste-up and mechanicals, illustration, photography and copywriting. Also uses artists for brochure design and illustration, print ad illustration, slide illustration, animatics, animation, retouching, TV/film grapics, lettering and logos. 60% of work is with print ads.

First Contact & Terms: Send query letter with brochure, resume, tearsheets, photostats, photocopies, photographs, slides and SASE. Samples are filed or are returned by SASE only if requested by artist. Reports back to the artist only if interested. Write to schedule an appointment to show a portfolio, which should include roughs, original/final art, tearsheets, final reproduction/product, photographs, slides; include color and b&w samples. Pays for design by the hour, $15-50. Pays for illustration by the project. Considers client's budget, turnaround time, skill and experience of artist and rights purchased when establishing payment. Rights purchased vary according to project.

Tips: "Not everything they've had printed is worth showing—good ideas and good executions are worth more than mediocre work that got printed. Check on agency's client roster in the Red Book—that should tell you what style or look they'll be interested in."

THE NEIMAN GROUP, Harrisburg Transportation Center, Heath and Chesnut St., Harrisburgh PA 17101. (717)232-5554. Art Director: Craig Hunter. Estab. 1978. Full-service ad agency specializing in print collatoral and ad campaigns. Product categories include healthcare, banks, retail, and industry.

Needs: Works with 4 freelance illustrators and 2 freelance designers/month. Prefers local artists with experience in comping and roughs. Works on assignment only. Uses freelancers mainly for illustrations and comps. Also uses freelance artists for brochure design, mechanicals, retouching, lettering and logos. 50% of work is with print ads.

First Contact & Terms: Send query letter with resume, tearsheets, photostats and photographs. Samples are filed. Reports back to the artist only if interested. Write to schedule an appointment to show a portfolio, which should include color and b&w samples, thumbnails, roughs, original/final art, photographs. Pays for design by the hour, $10-35; by the project. Pays for illustration by the hour, $15-40. Buys all rights.

Tips: The most effective way for a freelancer to get started in advertising is to "keep at it, do good work."

NEW YORK COMMUNICATIONS, INC., 207 S. State Rd., Upper Darby PA 19082. Contact: Mike Davis. Estab. 1974. Motion picture/TV/marketing consulting firm. Product specialties are TV commercials and corporate videos. Current clients include: ABC, WABC-TV, KABC-TV and Partnership Group.

Needs: Uses freelance artists for storyboards. Works with 6 freelance illustrators and 3 freelance designers/year. 5% of work is with print ads.

First Contact & Terms: Send query letter with resume and sample storyboards. Works on assignment only. Provide resume, sample storyboards, business card, to be kept on file for future assignments. Samples not kept on file returned by SASE. No originals returned to artist at job's completion. Pays for design by the project, $100-1,200. Pays for illustration by the project, $100-1,200. Considers skill and experience of artist and turnaround time when establishing payment.

Tips: Looks for "the ability to capture people's faces, detail and perspective. Include storyboards in your portfolio or you won't be considered. No page design examples or portraits. Send three samples."

PERCEPTIVE MARKETERS AGENCY LTD., 1100 E. Hector St., Conshohocken PA 19428. (215)825-8710. Creative Director: Bill Middleton. Estab. 1972. Ad agency. Clients: retail furniture, contract furniture, commuter airline, lighting distribution company; several nonprofit organizations for the arts, a publishing firm, air freight company, trade painting products company, etc.
Needs: Works with 10-20 freelance artists/year, mostly local. In order of priority, uses freelance artists for mechanicals, photography, illustration, comps/layout, photo retouching and design/art direction. Concepts, ability to follow instructions/layouts and precision/accuracy are important. 50% of work is with print ads.
First Contact & Terms: Send resume and photostats, photographs and tearsheets to be kept on file. Accepts as samples—"whatever best represents artist's work—but preferably not slides." Samples not filed are returned by SASE only. Reports only if interested. Call for appointment to show portfolio. Pays for design by the hour, $10-25. Pays for illustration by the project, $50-2,500. Considers complexity of the project, client's budget and turnaround time when establishing payment. Buys all rights.
Tips: "Freelance artists should approach us with unique, creative and professional work. And it's especially helpful to follow-up interviews with new samples of work, (i.e., to send a month later a 'reminder' card or sample of current work to keep on file.)"

***THE REICH GROUP**, Suite 200, 1635 Market St., Philadelphia PA 19103. (215)972-1777. FAX: (215)972-1788. Art Director: Tom Scott. Estab. 1978. Ad agency and PR firm. Full-service, multimedia, general advertising, telemarketing, direct mail, design, PR, and video production firm. Specializes in direct mail expertise. Product specialty is insurance. Current clients include: University City Science Center, CIGNA, American Dental Association, and Florida Bar Association.
Needs: Approached by 6 freelance artists/month. Works with 1 freelance illustrator and 2 freelance designers/month. Prefers local artists only with experience in direct mail. Works on assignment only. Uses freelance artists mainly for mechanicals and illustrations. Also uses freelance artists for brochure design and illustration, print ad design and illustration, storyboards, mechanicals, posters, logos. 10% of work is with print ads.
First Contact & Terms: Send query letter with brochure, photocopies, resume and tearsheets. Samples are filed. Reports back to the artist only if interested. Mail thumbnails, roughs and b&w and color tearsheets, then call to schedule an appointment to show a portfolio. Pays for design by the hour, $15-35. Pays for illustration by the project, $250-5,000. Negotiates rights purchased.

SHAPSON GERO & SOMMERS, INC., 260 S. Broad St., Philadelphia PA 19102. (215)545-4300. FAX: (215)546-8510. Creative Director: Bob Eiero. Estab. 1946. Ad agency. Full-service, multimedia firm. Specializes in media advertising and collateral, marketing communications, and PR support. Product specialties are business-to-business, consumer and trade.
Needs: Approached by 20-25 freelance artists/month. Works with 8-10 freelance illustrators/month; 2-3 freelance designers/month. Prefers artists with experience in advertising and corporate projects. Works on assignment only. Uses freelance graphic artists mainly for illustration of ads and brochures. Also uses freelance artists for catalog illustration, storyboards, slide illustration, mechanicals, retouching, billboards, posters, TV/film graphics, lettering, logos, photography. 50% of work is with print ads.
First Contact & Terms: Send query letter with brochure, photocopies, SASE, resume and non-returnable samples. Samples are filed or are returned by SASE *only*. Reports back to the artist only if interested. Write to schedule an appointment to show a portfolio or mail appropriate materials. Portfolio should include thumbnails, roughs, original/final art and b&w and color photostats ortearsheets. Pays for design by the hour or by the project. Pays for illustration by the project. Payment depends on the project. Rights purchased vary according to project.

THE SLIDEING BOARD, INC. a Division of SBI, International, 322 Blvd. of the Allies, Pittsburgh PA 15222. (412)261-6006. General Manager: Rob Dillon. AV and multi-image production firm for sales, marketing, training and capabilities presentations. Clients: consumer, industry, finance and business-to-business.
Needs: Works with 10-15 graphic artists/year. Would like to work with freelance computer graphic artists. (*Not* desk-top publishing.) Assigns 30-50 jobs/year. Prefers local artists only. Uses artists for design, storyboards, mechanicals, lettering, charts/graphs and some illustration and animation.
First Contact & Terms: Call to schedule an appointment to show a portfolio and some slides. Pays for design and illustration by the hour, $5-20, or by the project, depending on complexity, client's budget, turnaround time and skill and experience of artist. Buys all rights.
Tips: Artists must "have knowledge of how to produce art for photography."

Tennessee

CARDEN & CHERRY, INC., 1220 McGavock St., Nashville TN 37203. (615)255-6694. FAX: (615)255-9302. Executive Vice President, Creative Services: Glenn Petach. Estab. 1953. Ad agency. Full-service, multimedia

firm. Specializes in all aspects of print and broadcast. Product specialties are consumer and trade.
Needs: Approached by 10 freelance artists/month. Works with 2 freelance illustrators/month. Uses freelance artists mainly for illustration, retouching and mechanicals. Also uses freelance artists for print ad illustration, mechanicals, retouching and lettering. 40% of work is with print ads.
First Contact & Terms: Send query letter with SASE and anything returnable by SASE. Samples are filed or are returned by SASE. Reports back to the artist only if interested. Call to schedule an appointment to show a portfolio. Portfolio should include "anything, rough or finished." Pays for design by the hour, by the project. Pays for illustration by the project, (negotiable). Negotiates rights purchased.

CASCOM INTERNATIONAL, 806 4th Ave. S., Nashville TN 37210. (615)242-8900. President: Vic Rumore. Estab. 1977. AV firm specializing in graphic and cell animation, special effects. "80% produced on 35mm film, 20% on various computer animation systems." Current clients include 150 TV stations and 65 foreign distributors (TV networks and producers).
Needs: Works with 2 freelance illustrators and 2 freelance designers/month. Prefers artist with experience in film graphics. Works on assignment only. Uses freelancers mainly for print and graphic cell design and layout. Also uses freelance artists for brochure, catalog and print ad design and illustration, storyboards, animation, mechanicals and TV/film graphics. 5% of work is with print ads.
First Contact & Terms: Send query letter with brochure, resume, photographs, slides and transparencies. Samples are filed. Samples not filed are returned only if requested by artist. Reports back within 4 weeks if interested. To show a portfolio mail "anything that shows ability." Negotiates payment. Considers complexity of project, turnaround time and skill and experience of artist when establishing payment. Buys all rights.
Tips: The most effective way for a freelancer to get started in audiovisual is to have "good work, good experience, good attitude and good ideas."

GOOD ADVERTISING, 5050 Poplar Ave., Memphis TN 38157. (901)761-0741. (901)682-2568. Associate Creative Director: Jim Williams, Jr. Estab. 1982. Ad agency. Full-service, multimedia firm. Specializes in print ads, collaterals and TV. Product specialties are consumer and business-to-business. Current clients include: Federal Express, Baptist Hospital and Big Star Supermarkets.
Needs: Approached by 2 freelance artists/month. Works with 2 freelance illustrators and 2 freelance designers/month. Prefers artists with experience in high-quality illustration. Also uses freelance artists for brochure and catalog design and illustration, retouching, lettering and logos. 30% of work is with print ads.
First Contact & Terms: Send query letter with brochure, tearsheets and transparencies. Samples are filed or are not returned. Reports back within 5 days. Mail appropriate materials: original/final art and color photographs. Pays for design by the hour, $25 minimum. Pays for illustration by the project. Buys all rights.

THOMPSON & COMPANY, 65 Union Ave., Memphis TN 38103. Associate Creative Director: Trace Hallowell. Estab. 1981. Full-service ad agency specializing in beauty, financial and automotive. Current clients include: American Electric, Lustrasilk, United Southern Bank, Rotary Lift, Seabrook Wallcoverings, Hayden Inc., and Teledyne.
Needs: Works with various number of freelance illustrators and designers/month. Works on assignment only. Uses freelancers mainly for ads. Also uses freelance artists for brochure design and illustration, print ad and slide illustration, storyboards, animatics, animation, mechanicals, retouching, billboards, posters, TV/film graphics, lettering and logos. 80% of work is with print ads.
First Contact & Terms: Send query letter with samples. Samples are filed or are returned only if requested by artist. Reports back to the artist only if interested. Write to schedule an appointment to show a portfolio, which should include fresh ideas. Considers complexity of project, client's budget, turnaround time, skill and experience of artist, how work will be used and rights purchased when establishing payment. "Always a fair price." Rights purchased vary according to project.

Texas

AUSTIN/TYLER, Suite 104, 3335 Keller Springs Rd., Carrollton TX 75006. (214)931-8617. Creative Director: Flay Mohle. Estab. 1989. Ad agency. Full-service, multimedia firm. Specializes in magazine ads, collaterals, packaging and broadcast. Product specialties are cosmetics, automotive and food/beverage. Current clients include: Berryman Products Inc., Gena Laboratories Inc., The First Intermark and Transmark International.
Needs: Approached by 1-3 freelance artists/month. Works with 0-1 freelance illustrator and 0-1 freelance designer/month. "Accomplished, professional talent with sound business practices. No preference as to areas of experience." Works on assignment only. Uses freelance artists for overflow design and production; short deadline illustration. Also uses freelance artists for brochure, print ad design, print ad illustration, story-

boards, slide illustration, animation, mechanicals, retouching, billboards, TV/film graphics and logos. 85% of work is with print ads.

First Contact & Terms: Send query letter with brochure, resume, photostats and slides. Samples are filed and are not returned. Reports back within 2-3 weeks. Call to schedule an appointment to show a portfolio. Portfolio should include roughs, original/final art and b&w and color tearsheets, photographs and 4×5 transparencies. Pays for design by the project $350-3,500. Pays for illustration by the project, $175-6,000. Negotiates rights purchased or rights purchased vary according to project.

BERNETA COMMUNICATIONS, INC., 701 Park Pl., Amarillo TX 79101. (806)376-7237. Project Manager: Jeanette Moeller. Ad agency and AV firm. "We are a full-service communications and production firm." Clients: banks, automotive firms, museums, various businesses, hotels, motels, jewelry stores and politicians. Client list provided upon request.
Needs: Works with 12 freelance artists/year. Assigns 1,000 freelance jobs/year. Works on assignment only. Uses freelance artists for design, illustration, brochures, catalogs, animation, posters, direct mail packages, lettering, logos, charts/graphs and advertisements.
First Contact & Terms: Send query letter with brochure. Samples are filed. Samples not filed are returned only if requested. Reports back only if interested. To show a portfolio, mail color and b&w thumbnails, roughs, original/final art, photostats, tearsheets, final reproduction/product, photographs, slides and video disks. Pays for design by the project, $100-1,500. Pays for illustration by the project, $100-1,900. Considers complexity of project, client's budget, turnaround time, skill and experience of artist, how work will be used and rights purchased when establishing payment. Rights purchased vary according to project.
Tips: "Be organized. Be able to present yourself in a professional manner."

BOZELL JACOBS KENYON & ECKHARDT, Box 619200, Dallas-Ft. Worth Airport TX 75261-9200. (214)556-1100. Creative Directors: Glen Ashley, Neil Scanlan, Artie McGibbens and Bill Oakley. Ad agency. Clients: all types.
Needs: Works with 4-5 freelance illustrators/month. Works on assignment only. Uses freelancers for billboards, newspapers, P-O-P displays, TV and trade magazines.
First Contact & Terms: Call for appointment to show portfolio. Reports within 3 weeks. Provide business card, brochure/flyer, resume and samples to be kept on file for possible future assignments. Samples not kept on file are returned. Payment is negotiated.
Tips: Wants to see a wide variety including past work used by ad agencies and tear sheets of published art.

***DELTA ADVERTISING,** 2930 Merrell Rd., Dallas TX 75229. (214)351-4821. FAX: (214)350-0635. Desktop Publishing Manager: Fred Mackey. Estab. 1989. Advertising agency. Specializes in magazines—all desktop published with full-color advertising and on-staff writer. Current clients include Auto D-Tail Plus.
Needs: Works with 1 freelance illustrator and 2 freelance designers/month. Uses freelance artists mainly for design. Also uses freelance artists for brochure design and illustration, catalog design, print ad design and illustration.
First Contact & Terms: Send query letter with SASE, photographs and tearsheets. Samples are filed or are returned by SASE only if requested by artist. Write to schedule an appointment to show a portfolio. Portfolio should include all appropriate samples. Pays for design and illustration by the project; other payment methods depend on clients project. Rights purchased vary according to project but usually one-time.

DYKEMAN ASSOCIATES INC., 4115 Rawlins, Dallas TX 75219. (214)528-2991. Contact: Alice Dykeman or Laurie Winters. PR/marketing firm. Clients: business, industry, sports, environmental, energy, health.
Needs: Works with 5 freelance illustrators/designers per month. Assigns 150 jobs/year. "We prefer artists who can both design and illustrate." Local freelance artists only. Uses freelance artists for design of brochures, exhibits, corporate identification, signs, posters, ads, title slides, slide artwork and all design and finished artwork for graphics and printed materials. Prefers tight, realistic style. Prefers pen & ink, charcoal/pencil, colored pencil and computer illustration.
First Contact & Terms: Arrange interview to show portfolio. Provide business card and brochures. No originals returned to artist at job's completion. Pays by the project, $250-3,000 average; "artist makes an estimate; we approve or negotiate." Considers complexity of project, creative compatibility, client's budget,

The asterisk before a listing indicates that the listing is new in this edition. New markets are often the most receptive to freelance submissions.

skill and experience of artist and turnaround time when establishing payment.

Tips: "Be enthusiastic. Present an organized portfolio with a variety of work. Portfolio should reflect all that an artist can do. Don't include examples when you did a small part of the creative work. Have a price structure but be willing to negotiate per project." Finds most artists through portfolio reviews.

***THE EDITING COMPANY**, Suite 107, 8600 Westpark, Houston TX 77063. (713)783-2655. FAX: (713)783-8642. Vice President/Sr. Editor: Terry Moore. Audiovisual firm. Full-service industrial and commercial post production facility. Specializes in broadcast programs, commercials, documentaries and corporate films. Current clients include: Exxon, Shell Oil, Western Atlas Geophysical, Cooper Industries, Ogilvy and Mather and McCann-Erickson.

Needs: Approached by 1-3 freelance artists/month. Works with 1-2 freelance illustrators and 3-4 freelance designers/month. Prefers local artists only with experience in broadcast advertising, 3D animation and television graphics. Works on assignment only. Uses freelance artists mainly for storyboards, animatics, television design and graphics. Also uses freelance artists for slide illustration, animation, TV/film graphics and logos. Less than 5% of work is with print ads.

First Contact & Terms: Send resume, photographs, tearsheets, photostats and slides. Samples are filed or are returned by SASE only if requested by artist. Reports back to the artist only if interested. Write to schedule an appointment to show a portfolio. Portfolio should include b&w and color photostats, tearsheets, photographs and slides. Pays for design by the project, $100 minimum; pays for illustration by the project, $25 minimum. Negotiates rights purchased.

EMERY ADVERTISING, 1519 Montana, El Paso TX 79902. (915)532-3636. Art Director: Henry Martinez. Ad agency. Clients: automotive and architectural firms, banks and restaurants. Current clients include: Accugraph, Ford Dealers Assn., and Talaris.

Needs: Works with 5-6 freelance artists/year. Uses freelance artists mainly for design, illustration and production. Types of illustration needed are technical and cartoons.

First Contact & Terms: Works on assignment only. Send query letter with resume and samples to be kept on file; call for appointment to show portfolio. Prefers tearsheets as samples. Samples not filed returned by SASE. Reports back. Pays for design by the hour, $15-45; by the project, $100-750; by the day, $350-1,000. Pays for illustration by the project, $100-2,500. Considers complexity of project, client's budget and turnaround time when establishing payment. Rights purchased vary according to project.

Tips: Especially looks for "consistency and dependability."

GOODMAN & ASSOCIATES, 3633 W. 7th, Fort Worth TX 76107. (817)735-9333. Production Manager: Cindy Schafer. Ad agency. Clients: financial, fashion, industrial, manufacturing and straight PR accounts.

Needs: Works with 3-6 freelance illustrators/month. Uses freelance artists for billboards, consumer and trade magazines, direct mail, P-O-P displays, brochures, catalogs, posters, signage and AV presentations.

First Contact & Terms: "No phone calls; we respond to written queries promptly." Local artists only. Arrange interview to show portfolio. Works on assignment basis only. Payment is by the project, by the hour or by the day; negotiates according to client's budget.

HEPWORTH ADVERTISING COMPANY, 3403 McKinney Ave., Dallas TX 75204. (214)526-7785. Manager: S.W. Hepworth. Full-service ad agency. Clients: finance, consumer and industrial firms.

Needs: Works with 3-4 freelance artists/year. Uses artists for brochure and newspaper ad design, direct mail packages, magazine ad illustration, mechanicals, billboards and logos.

First Contact & Terms: Send a query letter with tearsheets. Samples are not filed and are returned only if requested by artist. Does not report back. Portfolio should include roughs. Pays for design and illustration by the project. Considers client's budget when establishing payment. Buys all rights.

Tips: Looks for variety in samples or portfolio.

KNOX PUBLIC RELATIONS, Suite A, Guthrie Creek Park, 708 Glencrest, Longview TX 75601. (214)758-6439. President: Donna Mayo Knox. Estab. 1974. PR firm. Clients: civic, social organizations, private schools and businesses.

Needs: Works with 1-3 freelance illustrators/year. Works on assignment only. Uses freelance artists mainly for work on brochures. Also uses freelance artists for billboards, stationery design, multimedia kits, direct mail and flyers. 35% of work is with print ads.

First Contact & Terms: Send query letter with brochure showing art style or resume and samples. Samples returned by SASE. Reports in 3 weeks. Call or write to schedule an appointment to show a portfolio. Originals returned to artist at job's completion. Pays for illustration by the hour.

Tips: "Please query first. We like variety, but don't send too many samples of styles of design."

MARTINEZ/SIBONEY, INC., Suite 1070, 3500 Maple Ave., Dallas TX 75219-3901. (214)521-6060. Senior Art Director: Al Schmidt; Creative Coordinator: Debbie Diaz. Estab. 1985. Ad agency. "We are a full-service Hispanic advertising and marketing agency." Specializes in package goods, transportation and fast food.

Current clients: Frito-Lay, Dallas Area Rapid Transit, McIhenny Tabasco Sauce, Volkswagen of America, Whataburger and Southwestern Bell.

Needs: Works with freelance illustrators and freelance designers. Works only with artist reps. Uses freelance artists for brochure design and illustration, print ad illustration, storyboards, animatics, retouching and logos. 40% of work is with print ads.

First Contact & Terms: Send query letter with photocopies, photographs, slides, transparencies and SASE. Samples are filed or are returned by SASE only if requested by artist. Reports back within 1 week. Call to schedule an appointment to show a portfolio, which should include thumbnails, roughs, original/final art and final reproduction/product. Pays by the project, $500-5,000. Considers complexity of project, client's budget, turnaround time, skill and experience of artist, how work will be used and rights purchased when establishing payment. Buys all rights.

Tips: "Have a good track record. Must have referrals. Don't show everything you've produced since finishing art school."

McCANN-ERICKSON WORLDWIDE, Suite 1900, 1360 Post Oak Blvd., Houston TX 77056. (713)965-0303. Senior Vice President/Creative Director: Jesse Caesar. Ad agency. Clients: all types including consumer, industrial, gasoline, transportation/air, entertainment, computers and high-tech.

Needs: Works with about 20 freelance illustrators/month. Uses freelancers in all media.

First Contact & Terms: Call for appointment to show portfolio. Selection based on portfolio review. Negotiates payment based on client's budget and where work will appear.

Tips: Wants to see full range of work including past work used by other ad agencies and tearsheets of published art in portfolio.

McNEE PHOTO COMMUNICATIONS INC., 9261 Kirby, Houston TX 77006. (713)796-2633. President: Jim McNee. AV/film producer. Serves clients in industry and advertising. Produces slide presentations, videotapes, brochures and films. Also a brokerage for stock photographs.

Needs: Assigns 20 freelance jobs/year. Works with 4 freelance illustrators/month. Prefers local artists with previous work experience. Uses freelance artists for brochures, annual reports and artwork for slides, film and tape.

First Contact & Terms: "Will review samples by appointment only." Provide resume, brochure/flyer and business card to be kept on file for possible future assignments. Works on assignment only. Reports within 1 month. Method of payment is negotiated with the individual artist. Pays by the hour, $30-60 average. Considers client's budget when establishing payment. No originals returned after publication. Buys all rights, but will negotiate.

***THE SENSES BUREAU, INC.**, 1241 W. French Pl., San Antonio TX 78201. (800)383-7856. President: Donnie Meals. Estab. 1991. Audiovisual firm. Full-service, multimedia firm including an audio and music recording studio and recorded music distribution. Specializes in cassettes and CDs by recording artists and distribution. Specializes in rock music and Latin music.

Needs: Approached by 4 freelance artists/month. Works with 1 freelance illustrator and 1 freelance designer/ month. Prefers artists with experience in recorded music industry. Works on assignment only. Uses freelance artists mainly for album art. Also uses freelance artists for brochure design and illustration, catalog design and illustration, print ad design and illustration, storyboards, animation, posters, TV/film graphics, lettering and logos. 60% of work is with print ads.

First Contact & Terms: Send query letter with photocopies, resume and tearsheets. Samples are filed. Reports back within 2 weeks. To schedule an appointment to show a portfolio mail appropriate materials. Portfolio should include roughs, b&w and color tearsheets. Pays for design and illustration by the project, $50-250. Rights purchased vary according to project.

TAYLOR SMITH, Suite 264, 4544 Post Oak Place, Houston TX 77027. (713)877-1220. Contact: Dick Francis. Estab. 1983. Ad agency specializing in TV, radio, print and collateral. Specializes in automotive, oil and gas and utilities company. Current clients include Conoco, Houston Lighting and Power, Hi-lo automotive Parts, Westin Hotels and Chevron.

Needs: Works with 4 freelance illustrators/month. Prefers artists with experience in photography, illustration. Uses freelance artists for brochure and print ad illustration, storyboards, animatics, mechanicals, and retouching. 40% of work is with print ads.

First Contact & Terms: Send query letter with photocopies. Samples are filed. Samples not filed are not returned. Does not report back. Call or write to schedule an appointment to show a portfolio, which should include color and b&w samples, tearsheets, photographs and slides. Pays for design and illustration by the project. Considers complexity of project, client's budget and how work will be used when establishing payment. Negotiates rights purchased.

Tips: The most effective way for a freelancer to get started in advertising is to "call on agencies, show portfolio, send samples and keep in touch."

EVANS WYATT ADVERTISING, 5151 Flynn Pkwy., Corpus Christi TX 78411. (512)854-1661. Creative Director: E. Wyatt. Estab. 1975. Ad agency. Full-service, multimedia firm. Specializes in general and industrial advertising.
Needs: Approached by 2-4 freelance artists/month. Works with 2-3 freelance illustrators and 6-7 freelance designers/month. Works on assignment only. Uses freelance artists mainly for advertising art. Also uses freelance artists for brochure, catalog and print ad design and illustration, storyboards, retouching, billboards, posters, TV/film graphics, lettering, logos and industrial/technical art. 70% of work is with print ads.
First Contact & Terms: Send a query letter with brochure, photocopies, SASE, resume and photographs. Samples are filed and/or are returned by SASE only if requested by artist. Reports back within 10 days. Call to schedule an appointment to show a portfolio. Mail appropriate materials: thumbnails, roughs and b&w and color photostats, tearsheets and photographs. Pays by the hour, by the project, by the day and by arrangement. Buys all rights.

Utah

***BROWNING ADVERTISING**, 6175 N. Cottonwood Rd., Morgan UT 84050. (801)876-2711, ext. 336. FAX: (801)876-3331. Senior Art Director: Brent Evans. Estab. 1878. Distributor, marketer of outdoor sports products, particularly firearms. In-house agency for 3 main clients. In-house divisions include non-gun hunting products, firearms, accessories and fishing.
Needs: Approached by 50 freelance artists/year. Works with 20 freelance illustrators and 20 freelance designers/year. Assigns 150 jobs/year. Prefers artists with experience in outdoor sports—hunting, shooting, fishing. Works on assignment only. Uses freelance artists mainly for design, illustration and production. Also uses freelance artists for advertising design, illustration and layout; brochure design, illustration and layout; catalog illustration; product rendering and design; signage; P-O-P displays; and posters.
First Contact & Terms: Send query letter with resume and the following samples: tearsheets, slides, photographs and transparencies. Samples are not filed or returned. Reports back to the artist only if interested. To schedule an appointment to show a portfolio mail appropriate materials. Portfolio should include photostats, slides, tearsheets, transparencies and photographs. Pays for design by the hour, $30-50; pays for illustration by the hour, $35. Buys all rights and reprint rights.

ALAN FRANK & ASSOCIATES INC., 1524 S. 1100th E., Salt Lake City UT 84105. (801)486-7455. Art Director: Kazuo Shiotani. Serves clients in travel, fast food chains and retailing. Mail art with SASE. Reports within 2 weeks.
Needs: Illustrations, animation and retouching for annual reports, billboards, ads, letterheads, TV and packaging. Minimum payment: $500, animation; $100, illustrations; $200, brochure layout.

SOTER ASSOCIATES, INC., 209 N. 400 W., Provo UT 84601. (801)375-6200. FAX: (801)375-6280. President: N. Gregory Soter. Estab. 1970. Ad agency. Full service, multimedia firm. Specializes in collateral and magazine advertising. Product specialties are computer, banking and health care. Current clients include: Dynix, Deseret Bank, Roberts-Slade, City of Orem, Provo.
Needs: Approached by 2 freelance artists/month. Works with 1 freelance illustrator and 3 freelance designers/month. Works on assignment only. Uses freelance artists for brochure design and illustration, print ad design and illustration, mechanicals, retouching, billboards and logos. 65% of work is with print ads.
First Contact & Terms: Send query letter with resume, photostats, photocopies, tearsheets or "whatever is your preference." Samples are filed. Reports back to the artist only if interested. Write to schedule an appointment to show a portfolio, which should include original/final art and b&w and color photographs. Payment for design and illustration negotiated. Rights purchased vary according to project.

Virginia

CARLTON COMMUNICATIONS, INC., 300 W. Franklin St., Richmond VA 23220. (804)780-1701. Contact: Creative Director. Estab. 1975. Full-service Ad and PR agencies specializing in economic development, hotels, health care, travel, real estate and insurance.
Needs: Works with 2 freelance illustrators and 1 freelance designer/month. Uses freelancers mainly for ads, brochures, direct mail, posters, photography and illustration. Also uses freelance artists for brochure, catalog and print ad design and illustration, storyboards, slide illustration, animatics, animation, mechanicals, retouching, billboards, posters, TV/film graphics, lettering and logos. 50% of work is with print ads.
First Contact & Terms: Send query letter with brochure, resume, tearsheets and photocopies. Samples are filed and are not returned. Reports back to the artist only if interested. Call or write to schedule an appointment to show a portfolio, which should include original/final art. Pays for design by the project, $100 mini-

mum. Pays for illustration by the project, $50 minimum. Consider complexity of project and client's budget when establishing payment.
Tips: "The most common mistakes freelancers make in presenting a portfolio is that there is too much work, causing the book to have an unfocused look."

DEADY ADVERTISING, 17 E. Cary St., Richmond VA 23219. (804)643-4011. President: Jim Deady. Specializes in industrial and financial, manufacturing equipment, medical supplies, real estate and displays and publications. Clients: tobacco, zinc die castings and savings and loans. Current clients include Sterile Concepts, Campbell Atlantic, Jiffy Lube and North American Die Casting Corporation.
Needs: Works with 10-12 freelance artists/year. Local or regional artists only with minimum of 2 years experience with an agency. Works on assignment only. Uses freelance artists for design, illustration, mechanicals, retouching and airbrushing; brochures, magazine and newspaper advertisements, radio and television commercials. Types of illustration needed are technical and medical. Looking for technical and architectural drawing capability.
First Contact & Terms: Send query letter with resume to be kept on file; also send samples. Other samples are returned. Reports back only if interested. Call or write for appointment to show portfolio, which should include photostats. Pays for design by the hour, $30-75 average, or by the project, $250-2,500 average; for illustration by the hour, $30-75; by the project, $275-1,500 average.
Tips: "The recession has slowed business—we find we're taking smaller budget projects and are using freelancers less frequently."

***GOLDMAN & ASSOCIATES**, 408 W. Bute St., Norfolk VA 23510. (804)625-2518. Art Director: Jeffrey Ringer. Ad/PR firm. Current clients include: Storemont/Marriott, DePaul Medical Center and Credit Unions of Virginia.
Needs: Uses freelance artists for work in building and mechanical renderings, airbrushing, animation, TV animation, TV/film production, P-O-P displays, filmstrips, consumer magazines, multimedia kits, slide sets, brochures/flyers and finished work. Types of illustration needed are editorial and medical.
First Contact & Terms: Query with samples of previously published work. SASE. Provide brochures, flyers, resume, tearsheets, samples and 3/4" video tape when possible to be kept on file for future assignments. Originals returned at completion on some jobs. Pays for design by the hour or by the project; for illustration by the project; "payment is as fair as possible."
Tips: Wants to see "spec creative samples that really show you're having fun at what you do."

BERNARD HODES ADVERTISING, Suite 700, 1600 Wilson Blvd., Arlington VA 22209. (703)528-6253. FAX: (703)528-6308. Art Director: Glenn Kimmell. Estab. 1970. Ad agency. Full-service, multimedia firm. Specializes in recruitment advertising on a national level. Current clients include: Martin Marietta, Unysis, USF&G, Computer Sciences Corp. (CSC), Marriott Suites and Hechingers.
Needs: Approached by 20 freelance artists/month. Works with 15 freelance illustrators and 5 freelance designers/month. Prefers artists with experience in airbrush illustration, graphic design and high-tech corporate identity. Works on assignment only. Uses freelance artists for illustration and mechanical key. Also uses freelance artists for brochure and print ad design and illustration, mechanicals, retouching and posters. 90% of work is with print ads.
First Contact & Terms: Send query letter with brochure, photocopies, resume and tearsheets. Samples are filed. Reports back within 5 days only if interested. Write to schedule an appointment to show a portfolio. Portfolio should include thumbnails, roughs, original/final art and b&w and color photostats, tearsheets and 5×7 transparencies. Pays for design by the hour, $12-25; illustration by project $200-5,000. Buys all rights.

***Z-COM, INC.**, 4716A Tulip Rd., Virginia Beach VA 23455. (804)464-2250. FAX: (804)464-3818. Vice President of Production: Judy Ziegler. Estab. 1984. Audiovisual firm. Full-service, multimedia firm. Specializes in video productions for TV, educational purposes and sales. Product specialty is medical. Current clients include: doctors and suppliers of medical equipment.
Needs: Works with 1 freelance illustrator/month. Prefers local artists only with experience in medical, anatomical illustration. Works on assignment only. Uses freelance artists mainly for graphics to be videotaped. Also uses freelance artists for TV/film graphics.
First Contact & Terms: Send query letter with resume, SASE and samples. Samples are filed or are returned by SASE only if requested by artist. Reports back within 2 weeks. To show a portfolio, mail original/final art, b&w and color tearsheets and photographs. Pays for illustration by the project, $25 minimum. Negotiates rights purchased.

Washington

ELGIN SYFERD, 601, 1008 Western Ave., Seattle WA 98104. (206)442-9900. FAX: (206)223-6309. Art Director: Kris Salzer. Estab. 1981. Ad agency. Full-service, multimedia firm. Specializes in magazine ads, collater-

als, documentaries etc. Product specialty is consumers.

Needs: Approached by 20+ freelance artists/month. Works with 1+ freelance illustrator/month. Prefers local artists only. Works on assignment only. Uses freelance artists mainly for collaterals. Also uses freelance artists for brochure illustration, storyboards, retouching and logos.

First Contact & Terms: Send query letter with tearsheets. Samples are filed. Reports back within 3 weeks. Mail appropriate materials: color photostats, tearsheets and 4×5 transparencies. Pays for design by the project. Pays for illustration by the project. Negotiates rights purchased.

KOBASIC, FINE & ASSOCIATES (formerly Fine Advertising), Suite 710, 1110 Third Ave., Seattle WA 98101. (206)623-7725. FAX: (206)623-7723. Creative Director: Bruce Stigler. Estab. 1979. Ad agency. Creative shop. Specializes in radio, TV and print (newspaper, outdoor, magazine). Product specialties are travel, restaurant and real estate. Current clients include: Chalon International, Shuttle Express and Kidder Matthew.

Needs: Approached by 3-5 freelance artists/month. Works with 2-3 freelance illustrators and 1-2 freelance designers/month. Prefers local artists only. Prefers artists with experience in desktop publishing and agency experience. Uses freelance artists for logo design and collateral. Also uses freelance artists for brochure and catalog design and illustration, logos and production. 70% of work is with print ads.

First Contact & Terms: Send query letter with photocopies and resume. Samples are filed. Reports back to the artist only if interested. Write to schedule an appointment to show a portfolio. Portfolio should include b&w and color roughs and original/final art. Pays for design and illustration by the project, $100 minimum. Negotiates rights purchased.

West Virginia

*****FAHLGREN MARTIN,** Box 1628, Parkersburg WV 26102. (304)424-3591. Associate Creative Director: Gary Smith. Estab. 1960. Ad agency. Full-service, multimedia firm.

Needs: Approached by 2-3 freelance artists/month. Works with 2 freelance illustrators/month. Works on assignment only. Uses freelance artists mainly for print ad illustration, mechanicals and retouching. 10% of work is with print ads.

First Contact & Terms: Send query letter with appropriate samples. Samples are not filed and are returned by SASE if requested. Reports back to the artist only if interested. Portfolio should include b&w and color photostats, tearsheets and slides. Pays for illustration by the project. Buys all rights.

GUTMAN ADVERTISING AGENCY, 500 Klos Tower, Wheeling WV 26003-2801. (304)233-4700. President: D. Milton Gutman. Ad agency. Clients: finance, resort, media, industrial supplies (tools, pipes) and furniture.

Needs: Works with 3-4 freelance illustrators/month. Local artists only except for infrequent and special needs. Uses artists for billboards, stationery design, TV, brochures/flyers, trade magazines and newspapers. Also uses artists for retouching work.

First Contact & Terms: Send materials to be kept on file for possible future assignments. Call for an appointment to show a portfolio. No originals returned at job's completion. Negotiates payment.

Canada

*****THE CABER FILM & VIDEO CO. LTD.,** Unit 39, 160 Wilkinson Rd., Brampton ONT L6T 4Z4 Canada. (416)454-5141. FAX: (416)454-5936. Producer: Chuck Scott. Estab. 1988. AV firm. Full-service, multimedia firm. Specializes in television, commercials and corporate videos.

Needs: Approached by 5 freelance artists/month. Works with 2 freelance illustrators and 2 freelance designers/month. Prefers artists with experience in animation, film and video design (graphics). Works on assignment only. Uses freelance artists for storyboards, slide illustration, animation, and TV/film graphics. 5% of work is with print ads.

First Contact & Terms: Send query letter with brochure, resume, photocopies and video reel. Samples are filed or are returned. Reports back within 7 days. Call to schedule an appointment to show a portfolio. Portfolio should include "a representation of your work." Pays for design and illustration by the project. Rights purchased vary according to project.

PULLIN PRODUCTIONS, LTD., 822 Fifth Ave. SW, Calgary, Alberta T2P 0N3 Canada. Creative Director: Art Feinstough. AV firm.

Needs: Works with 4 freelance artists/year. Works on assignment only. Uses freelance artists for design, illustrations, brochures, P-O-P displays, animation, motion pictures, lettering and charts/graphs.

First Contact & Terms: Send query letter with resume and samples. Samples not filed are not returned. Reports only if interested. To show a portfolio, mail appropriate materials. Pays for design by the hour, $10-50. Considers complexity of project, client's budget, skill and experience of artist, how work will be used and turnaround time when establishing payment. Buys all rights.

WARNE MARKETING & COMMUNICATIONS, Suite 810, 111 Avenue Rd., Toronto, Ontario M5R 3J8 Canada. (416)927-0881. Production Associate: Marla Goodman. Current clients include: Raymond Handling Technologies (and dealers), Wellesley Hospital and Johnston Equipment.

Needs: Works with 8 freelance artists/year. Works on assignment only. Uses artists for design, illustrations, brochures, catalogs, P-O-P displays, mechanicals, retouching, billboards, posters, direct mail packages, logos, charts/graphs and advertisements. Artists should have "creative concept thinking." Types of illustration needed are technical and medical. Prefers charcoal/pencil, colored pencil and markers.

First Contact & Terms: Send query letter with resume and photocopies. Samples are not returned. Reports only if interested. Write to schedule an appointment to show a portfolio, which should include roughs and final reproduction/product. Pays for design by the project, $100 minimum. Pays for illustration by the project, $150 minimum. Considers complexity of project, client's budget, and skill and experience of artist when establishing payment. Buys all rights.

Tips: Artist should "send samples (photocopies) and wait for assignment. There is an increasing need for technical illustration."

Other Advertising, Audiovisual and Public Relations Firms

Each year we contact all firms currently listed in *Artist's Market* requesting they give us updated information for our next edition. We also mail listing questionnaires to new and established firms which have not been included in past editions. The following advertising, audiovisual and public relations firms either did not respond to our request to update their listings for 1992 (if they indicated a reason, it is noted in parentheses after their name), or they did not return our questionnaire for a new listing.

Admark Advertising (unable to contact)
Alamo Ad Center Inc. (asked to be deleted)
Arben Design, Inc.
Ted Barkus Co. Inc.
Borders, Perrin & Norrander
Bozell Advertising
The Brady Company
Leo Burnett USA
Butler Learning Systems
Chartmasters
Chiat/Day/Mojo
Cine Design Films
Shimer Von Cantz (unable to contact)
Copy Group Advertising (unable to contact)
Crosby Communications (overstocked)
Data Command, Inc. (asked to be deleted)
DDB Needham
DJC & Associates (unable to contact)
Duke Unlimited, Inc. (asked to be deleted)
Emergency Training Division

of Educational Direction, Inc. (no longer uses freelancers)
Excelvision
Expanding Images
Fallon McElligott
Financial Shares Corporation
Foote, Cone & Belding
Geto & De Milly, Inc. (asked to be deleted)
The Gordon Group, Inc.
The Halsted Organization (overstocked)
Image Innovations, Inc.
Ketchum Advertising
Klock Advertising, Inc.
Letter Graphics
Lewis Broadcasting Corp.
Longendyke/Loreque Inc. (unable to contact)
Lovio-George Inc. (no longer uses outside freelance help)
Lyons, Inc.
Media Forum International
Arthur Meriwether, Inc. (unable to contact)
Muir Cornelius Moore, Inc. (overstocked)

Ogilvy & Mather Public Relations Analysts Inc.
Robert N. Pyle & Associates (asked to be deleted)
Roling, Rav & Davis (unable to contact)
Payne Ross & Associates Advertising Inc.
Saatchi and Saatchi DFS/Pacific
Scali, McCabe, Sloves
Sheehy, Knopf & Shaver Inc. Advertising
Siddall, Matus and Coughter (asked to be deleted)
Starbuck Creative Services (unable to contact)
V. Stefanelli & Associates
E.J. Stewart, Inc.
Sweet Advertising Agency (overstocked)
TAA Inc.
The Tarragano Company
WHAS Television: CBS 11 (asked to be deleted)
Wieden & Kennedy
Young & Rubicam

Market conditions are constantly changing! If you're still using this book and it is 1993 or later, buy the newest edition of Artist's Market *at your favorite bookstore or order directly from* Writer's Digest Books.

Art/Design Studios

Money allocated for design is among the first to be red-lined during economic hard times, and in this past year a slow economy was deepened even more by the war in the Gulf. Currently many designers are finding themselves in a limbo of sorts, surrounded by such questions as whether the client will want a project scaled down, go through with it or cancel it altogether. One thing is for sure—when designers are called upon, it is to do more with less, demanding more of a bare-bones minimalism, a back-to-basics sensibility, a renewed focus on the communication of content.

The variety of freelance opportunities that art/design studios offer matches the diversity of projects studios handle. Studios provide all forms of visual communication for various businesses—corporate identity, product/brand identity, publication design, direct marketing materials, catalogs, annual reports, brochures, exhibits, direct mail pieces and so on.

Art studios are called upon mainly for illustration; your city's airbrush specialists probably call their business an art studio. Design studios offer not only a variety of design specialties but also illustration, layout, mechanicals and retouching.

Studios range in size, scope and purpose. There are one-person studios that generally turn to freelance help when the workload becomes too heavy. Then there are large operations with account executives who turn to outside help for either a fresh approach or for basic mechanical skills such as paste-up.

One design firm might specialize in a particular field, such as display design. Another studio's specialty may be its ability to solve problems for a variety of clients. Some studios specialize in the type of product they design, such as annual reports or packaging. Other studios define themselves by their method of working, such as desktop publishing or other computer technologies.

The health of design and illustration is, overall, contingent on the health of the industry it is done for. Although there are predictions that advertising will pick up in 1992, only time will tell. Still, magazine publishers, for example, understand that illustration creates a more visually attractive, and perhaps more profitable, magazine. Editorial illustrator James Endicott (Close-up, page 494), for example, has not been affected by the recession and feels we are still in an age of illustration.

An area of design that appears to be recession proof is package design. During hard times people tend to cut back on restaurant dining, eat more at home, brown-bag it more often at the office and hence, buy more packaged items at the store. And as more and more non-food producers are cutting back on their media advertising and questioning the success of its promotion, they are exploring other ways to reach the consumer and are looking to make their packages work more actively for them on the shelves. Packages are being revitalized, their aesthetics improved.

Regardless of whether a company has an environmental conscience or is reacting to pressure from the consumer to be "politically correct," increasing numbers of them now have environmental research departments and are exploring the uses of more environmentally friendly materials that have been reduced or recycled or that may be reused by the consumer. The ice cream manufacturer Ben and Jerry's, for example, has integrated its ecological concern into its package design, and the leaf-adorned packages of Rainforest Crunch state that a certain percentage of the profits will go toward ending deforestation.

Computer skills continue to be greatly in demand by design studios. Despite fax machines, many studios still prefer to work with local artists because of the need to meet tight deadlines and to make last-minute changes. In addition to reading the listings of *Artist's Market*, consult your Yellow Pages and Business-to-Business directory to locate studios; follow up by researching studios in the *Design Firm Directory* (names and addresses are noted, but there is no marketing information) for the studio's specialty.

Study the listings in this section to find out what type of work they do, who the art buyers are, what they have done in the past, who their clients are and the size of the studios. Use your skills as a visual communicator to contact studios. Learn as much about prospects as you can before contacting them. Then send samples that match the prospect's needs along with a cover letter asking for a portfolio review. If a studio shows interest, find out what type of work might be available for you, then select appropriate pieces to show in your portfolio.

When showing a portfolio to a studio, bear in mind that what you are basically selling is yourself and what you can do for that studio. First, get to know the art buyer by asking about his current projects. When asked what you do, give an answer that is broadly specific. Rather than saying, "I'm a designer," say, "I specialize in corporate identity." Then mention that you have designed logos and identity systems for companies that are in the same league as your prospect.

Design your portfolio as carefully as you would design another client's project. Present your work in a neat, organized fashion. Show that you know how to pinpoint a client's needs by focusing on the needs of your current prospect. If you are showing your work to a studio that specializes in collateral material, present brochures instead of product designs, for example. Identify what your involvement was in each project, such as designing the logo or lettering the piece. Since many art directors like to see how you conceptualize projects, save space at the end of your presentation to show a complete project from thumbnails to the final product.

Since studios usually bill clients by the hour or by the project, freelancers are similarly paid. Variables in pricing are use of color, turnaround time, rights purchased, complexity of the project and your reputation. When you are first discussing a project, ask whether or not you will retain a copyright and receive credit; some projects call for the company or client to retain all rights.

The most comprehensive directory of design firms is the *Design Firm Directory*. Other sources are award annuals such as those published by *Print* and *Communication Arts*. Consider joining a professional design organization which puts you in touch with a network of designers both in your area and nationally: The Graphic Artists Guild, American Institute of Graphic Arts (AIGA), Society of Publication Designers, American Center for Design, Society of Illustrators and your local art director club. Also, membership in a business organization such as the International Association of Business Communicators provides contacts with businesses which might need your services. Magazines focused on design are *Print*, *HOW*, *Step-by-Step Graphics*, *Communication Arts*, *Metropolis*, *Folio*, *Upper & Lower Case* and *Graphis*.

A.T. ASSOCIATES, 63 Old Rutherford Ave., Charlestown MA 02129. (617)242-6004. FAX: (617)242-0697. Partner: Annette Tecce. Estab. 1976. Specializes in annual reports, industrial, interior, product and graphic design; model making; corporate identity; signage; display; and packaging. Clients: nonprofit companies, corporate clients, small businesses and ad agencies. Client list available upon request.
Needs: Approached by 20-25 freelance artists/year. Works with 3-4 freelance illustrators and 2-3 freelance designers/year. Prefers local artists, some experience necessary. Uses artists for posters, model making, mechanicals, logos, brochures, P-O-P display, charts/graphs and design.
First Contact & Terms: Send resume and nonreturnable samples. Samples are filed or are returned by SASE if requested by artist. Reports back only if interested. Call to schedule an appointment to show a portfolio, which should include a "cross section of your work." Pays for design and illustration by the hour or by the project. Considers complexity of project, client's budget, skill and experience of artist, turnaround time and rights purchased when establishing payment. Rights purchased vary according to project.

AARON, SAUTER, GAINES & ASSOCIATES/DIRECT MARKETING, Suite 230, 320 E. McDowell Rd., Phoenix AZ 85004. (602)265-1933. President: Cameron G. Sauter. Specializes in brand identity, direct marketing, direct response ads, catalogs and P-O-P display for retail stores; banks; and industrial, mail order and service companies.

Needs: Works with 5-10 freelance artists/year. Uses artists for advertising, brochure and catalog design and illustration, mechanicals, retouching and direct mail packages.

First Contact & Terms: Seeks artists with professionalism, speed and experience only. Works on assignment basis. Send query letter with brochure, resume and business card to be kept on file. Prefers original work, photos or slides as samples. Samples returned by SASE if not kept on file. Reports back only if interested. Pays for design by the hour, $15-50 average; by the project, $100-1,000 average; by the day, $50-100 average. Pays for illustration by the hour, $25-75 average; by the project, $100-2,000 average; by the day, $100-150 average. Considers complexity of project, client's budget, skill and experience of artist and turnaround time when establishing payment. "All art is purchased with full rights and no limitations."

***ADVERTISING DESIGNERS, INC.**, 818 N. La Brea Ave., Los Angeles CA 90038. (213)463-8143. President: Tom Ohmer. Estab. 1947. Specializes in annual reports, corporate identity, direct mail, package and publication design and signage. Clients: corporations, museums and PR firms.

Needs: Approached by 50 freelance artists/year. Works with 2-6 freelance illustrators and 10 freelance designers/year. Works on assignment only. Uses freelance illustrators mainly for editorial and annual reports. Uses freelance designers for annual reports. Also uses freelance artists for brochure design and illustration, mechanicals, retouching, airbrushing, lettering, logos and ad design.

First Contact & Terms: Send query letter with resume and photocopies. Samples are filed. Does not report back, in which case the artist should call. Write to schedule an appointment to show a portfolio. For design and illustration, "each project has its own budget." Rights purchased vary according to project.

LEONARD ALBRECHT ASSOCIATES, 15040 Golden W. Circle, Westminster CA 92683. (714)898-0553. Owner: Leonard Albrecht. Specializes in industrial design.

Needs: Works with 2-3 freelance artists/year. Uses artists for design, illustration, mechanicals and model making.

First Contact & Terms: Send query letter with brochure showing art style or resume. Reports within 10 days. Write to schedule an appointment to show a portfolio. Considers skill and experience of artist when establishing payment.

ALEXANDER COMMUNICATIONS, (formerly Macmillan Creative Services Group), Suite 203, 212 W. Superior, Chicago IL 60640. (312)944-5115. Art Director: Jill Fangman. Estab. 1987. Specializes in creative directories and trade publications. "We publish creative directories. Our clients are the advertisers in our publications and the firms that use our publications." Client list not available.

Needs: Approached by 30 freelance artists/year. Works with 20 freelance illustrators and 2-5 freelance designers/year. Works on assignment only. Uses illustrators mainly for editorial and promotional work. Uses designers mainly for promotional work. Also uses artists for lettering, model making and charts/graphs.

First Contact & Terms: Send query letter with brochure, SASE, tearsheets, photographs, photocopies, slides and transparencies. Samples are filed or are returned by SASE if requested by artist. Reports back to the artist only if interested. Call or write to schedule an appointment to show portfolio. Portfolio should include original/final art and b&w or color tearsheets, photographs, slides and transparencies. Trades ad space for design or illustration or when budgeted pays by the project based on use. Rights purchased vary according to project.

***AMBERGER DESIGN GROUP**, 128 River Rd., Lyme NH 03768. (603)795-2645. Creative Director: Michael Amberger. Estab. 1980. Design studio. Full-service, multimedia firm. Specializes in graphic design and photography for advertising. Product specialty is consumer. Current clients include: Dartmouth College, Dartmouth Bookstore, Sunset Motel, Cafe la Fraise and Hanover Park.

Needs: Approached by 2 freelance artists/year. Works with 1 freelance illustrator/month. Prefers artists with experience in the advertising industry and computer graphics. Uses freelance artists for illustration animatics, animation, retouching and TV/film production.

First Contact & Terms: Send query letter with resume and photostats. Samples are filed. Reports back to the artist only if interested. Write to schedule an appointment to show a portfolio. Portfolio should include roughs, original/final art, b&w and color tearsheets. Pays for design and illustration by the hour, $35-75. Buys one-time rights or negotiates rights purchased.

AMBOS COMPANY (formerly Anco/Boston), 47 Lake St., Sherborn MA 01770. (508)650-1148. CEO: Robert Ambos. Book production, art firm. Clients: educational publishers, commercial and industrial companies. Current clients include: Merrill Publishers; Houghton-Mifflin Co., Prentice Hall and Warren, Gorham & Lemont.

We're out to prove...
They don't build downtowns
like this any more.

DOWNTOWN**HANOVER**
MERCHANTS ASSOCIATION

© Amberger Design

According to Michael Amberger, creative director at the Amberger Design Group, this logo for the Hanover Merchants Association shows that Hanover "is a quality town in which to live, shop and dine." For the project freelance designer Edward Epstein of Montpelier, Vermont was told to follow Amberger's tissue layout for position and style. Amberger says "Epstein takes good direction, is mature and professional—with 25 years of experience."

Needs: Approached by over 20 freelance artists/year. Works with approximately 6 freelance illustrators and 1-2 freelance designers/year. Local artists only. Uses artists for books, charts, graphs, technical art and paste-up. Most of the artwork required is one-color line art, much of it computer-rendered.
First Contact & Terms: Send query letter with resume and photocopies. All art becomes the property of Ambos Co. To show portfolio, mail appropriate materials or call to schedule an appointment; send examples of work with resume. Pays for design by the piece, $25 minimum; pays for illustration by the piece, $10 minimum.
Tips: "We are interested only in b&w line art. Our work is for educational materials and is frequently of a technical nature."

***& CO.**, 505 Henry St., Brooklyn NY 11231. (718)834-1843. FAX: (718)596-6530. Contact: Creative Director. Estab. 1983. Specializes in annual reports, direct mail design and brochures. Clients: corporations. Current clients include: Amex, Prudential, Nynex. Client list available upon request.
Needs: Approached by 5-10 freelance artists/year. Works with 2-5 freelance illustrators and 2-5 freelance designers/year. Works only with artist reps. Prefers local artists only. Uses illustrators for various projects. Uses freelance designers for design and mechanicals. Also uses freelance artists for brochure design and illustration, mechanicals and lettering.
First Contact & Terms: Samples are filed. Reports back to the artist only if interested. Mail appropriate materials. Pays for design by the hour, $15-35. Pays for illustration by the project. Buys first rights.

ANDREN & ASSOCIATES INC., 6400 N. Keating Ave., Lincolnwood IL 60646. (312)267-8500. Contact: Kenneth E. Andren. Clients: beauty product and tool manufacturers, clothing retailers, laboratories, banks, camera and paper products. Current clients include: Alberto Culver, Barton Brand, Nalco Chemical, Encyclopedia Britannica, Firestone, Reflector Hardware, Rust-O-Leum, Avon Products, National Safety Council.

***** *The asterisk before a listing indicates that the listing is new in this edition. New markets are often the most receptive to freelance submissions.*

Needs: Assigns 6-7 jobs/month. Local artists only. Uses artists for catalogs, direct mail brochures, flyers, packages, P-O-P displays and print media advertising.
First Contact & Terms: Query with samples or arrange interview. Include SASE. Reports in 1-2 weeks. Pays $15 minimum/hour for animation, design, illustrations, layout, lettering, mechanicals, paste-up, retouching and type specing.

ANTISDEL IMAGE GROUP, INC., 3252 De La Cruz Blvd., Santa Clara CA 95054. (408)988-1010. President: G.C. Antisdel. Estab. 1970. Specializes in annual reports, corporate identity, displays, interior design, packaging, publications, signage and photo illustration. Clients: high technology 80%, energy 10%, and banking 10%. Current clients include IBM. Client list not available.
Needs: Approached by 40 freelance artists/year. Works with 15 freelance illustrators and 5 freelance designers/year. Works on assignment only. Uses artists for illustration, mechanicals, retouching, airbrushing, direct mail packages, model making, charts/graphs, AV materials and lettering.
First Contact & Terms: Send query letter with resume, business card and tearsheets to be kept on file. Reports back only if interested. Call or write to schedule an appointment to show a portfolio, which should include color, tearsheets, photographs and b&w. Pays for design by the hour, $8-50 or by the project $50-18,000. Pays for illustration by the project, $50-10,000. Considers complexity of project, client's budget, skill and experience of artist, how work will be used, turnaround time and rights purchased when establishing payment.
Tips: "Don't send crummy photocopies. Use styles which apply to hi-tech clients."

THE ART WORKS, 4409 Maple Ave., Dallas TX 75219. (214)521-2121. Creative Director: Fred Henley. Estab. 1978. Specializes in illustration, annual reports, brand identity, corporate identity, packaging, publications and signage. Current clients include Southland, Bennetts Printing Co., Boy Scouts and Interstate Batteries. Client list available upon request.
Needs: Approached by 80 freelance artists/year. Works with 30-50 freelance illustrators and 30-50 freelance designers/year. Uses artists for editorial illustration, advertising, brochure, catalog and book design, advertising, brochure and catalog layout; P-O-P displays, mechanicals, retouching, posters, direct mail packages, lettering and logos. "We are currently looking for freelance illustrators and designers to join our group and work in our studio."
First Contact and Terms: Send brochure, business card, slides and original work to be kept on file. Samples returned by SASE only if requested by artist. Reports within 7 days. Call or write for appointment to show portfolio. Pays for design by the hour, $35-45; by the project, $1,000; by the day, $150. Pays for illustration by the hour, $65-100; by the project, up to $5000; by the day, $200. Considers complexity of project, client's budget, skill and experience of artist and turnaround time when establishing payment.
Tips: Common mistakes freelancers make in presenting samples or portfolios are "repetition and showing school work." Advises artists to "send printed samples."

***ASHCRAFT DESIGN**, 11832 West Pico Blvd., Los Angeles CA 90064. (213)479-8330. FAX: (213)473-7051. Art Director: Terry Scott. Estab. 1986. Specializes in corporate identity, display and package design and signage. Client list available upon request.
Needs: Approached by 2 freelance artists/year. Works with 1 freelance illustrator and 2 freelance designers/year. Works on assignment only. Uses freelance illustrators mainly for technical illustration. Uses freelance designers mainly for packaging and production. Also uses freelance artists for mechanicals and model making.
First Contact & Terms: Send query letter with tearsheets, resume and photographs. Samples are filed and are not returned. Reports back to the artist only if interested. To show a portfolio, mail original/final art, tearsheets and 4×5 transparencies. Pays for design and illustration by the project. Rights purchased vary according to project.

***ASSISTANTS IN DESIGN SERVICES**, Suite C, 12730 San Pueblo Ave., San Francisco CA 94805-1303. (415)215-5515. President: Edward Tom. Estab. 1975. Specializes in display design, landscape design, interior design, package design and technical illustration. Clients: corporations/private industrial. Current clients include: Chevron Research Co., PMC, and IBM.
Needs: Approached by 1,000 freelance artists/year. Works with 20 freelance illustrators and 20 freelance designers/year. Prefers local artists only with experience in industrial design. Works on assignment only. Uses freelance illustrators and designers mainly for product design. Also uses freelance artists for brochure design and illustration, catalog design and illustration, mechanicals, retouching, airbrushing, lettering, logos, ad design and illustration, book, magazine and newspaper design, P-O-P design and illustration, poster illustration and design, model making, direct mail design, charts/graphs and audiovisual materials.
First Contact & Terms: Send query letter with brochure, resume, photographs and photocopies. Samples are filed. Reports back within 15 days. Write to schedule an appointment to show a portfolio. Portfolio should include thumbnails, roughs, b&w and color photostats, slides and photographs. Pays for design by the project, $500-5,000. Pays for illustration by the project, $1,000-10,000. Rights purchased vary according to project.

AXION DESIGN INC., 1638 Sherbrooke St. W., Montreal, Quebec H3H 1C9 Canada. (514)935-5409. President: J. Morin. Estab. 1983. Specializes in brand and corporate identity. Clients: Bell Canada, Petro Canada, Royal Bank and Air Canada.
Needs: Approached by 25 freelance artists/year. Works with 4 freelance illustrators and 5 freelance designers/year. Uses artists for brochure design, mechanicals, lettering and logos.
First Contact and Terms: Send resume. Reports back within 14 days. Write to schedule an appointment to show a portfolio. Considers complexity of project and skill and experience of artist when establishing payment. Buys all rights.
Tips: The most common mistakes freelancers make in presenting samples or portfolios is, "They do not understand the communication objectives that their work is meant to meet."

***BACKART DESIGN**, Suite 317, 675 W. Lake St., Oak Park IL 60301. (708)383-0874. FAX: (708)383-9174. Owner: Rudi Backart. Estab. 1980. Corporate identity and package design. Clients: corporations and agencies. Current clients include: Paterano Imports and R.S. Bacon Veneer Co. Client list available upon request.
Needs: Approached by 50 freelance artists/year. Works with 4 freelance illustrators and 1 freelance designer/year. Works on assignment only. Uses illustrators mainly for brochure and packaging. Uses freelance designers mainly for mechanicals and lettering. Also uses freelance artists for brochure illustration, mechanicals, lettering and ad illustration.
First Contact & Terms: Send query letter with tearsheets and photocopies. Samples are filed. Does not report back, in which case the artist should call occassionally. Call to schedule an appointment to show a portfolio. Portfolio should include roughs, original/final art, tearsheets and photographs. Pays for design and illustration by the project, $200-1,500. Rights purchased vary according to project.

BARNSTORM DESIGN/CREATIVE, Suite 201, 2527 W. Colorado Ave., Colorado Springs CO 80904. (719)630-7200. Owner: Douglas D. Blough. Estab. 1975. Specializes in corporate identity, brochure design, multi-image slide presentations and publications. Clients: ad agencies, high-tech corporations, nonprofit fundraising, business-to-business, and restaurants. Current clients include NCR, USOC, Concept Restaurants, ITT Federal Services Corp., National Systems and Research.
Needs: Works with 2-4 freelance artists/year. Works with local, experienced (clean, fast and accurate) artists on assignment. Uses freelancers mainly for paste-up, editorial and technical illustration and layout. Also uses artists for design, mechanicals, retouching, AV materials and calligraphy.
First Contact & Terms: Send query letter with resume and samples to be kept on file. Prefers "good originals or reproductions, professionally presented in any form" as samples. Samples not filed are returned by SASE. Reports only if interested. Call or write for appointment to show portfolio. Pays for design by the hour, $15 minimum. Pays for illustration by the project, $50 minimum, b&w; $200, color. Considers client's budget, skill and experience of artist, and turnaround time when establishing payment.
Tips: "Portfolios should reflect an awareness of current trends. We try to handle as much in-house as we can, but we recognize our own limitations (particularly in illustration). Do not include too many samples in your portfolio."

***BASIC/BEDELL ADVERTISING SELLING IMPROVEMENT CORP.**, Suite H, 600 Ward Dr., Box 30571, Santa Barbara CA 93130. President: C. Barrie Bedell. Specializes in publications, advertisements and direct mail. Clients: national and international newspapers, publishers, direct response marketers, retail stores, hard lines manufacturers and trade associations plus extensive self-promotion.
Needs: Uses artists for publication design, book covers and dust jackets, direct mail layout and pasteup. Especially wants to hear from publishing and "direct response" pros. Negotiates payment by the project. Considers client's budget, and skill and experience of artist when establishing payment.
Tips: "There has been a substantial increase in use of freelance talent and increasing need for true professionals with exceptional skills and responsible performance (delivery as promised and 'on target'). It is very difficult to locate freelance talent with expertise in design of advertising and direct mail with heavy use of type. If work is truly professional and freelancer is business-like, contact with personal letter and photocopy of one or more samples of work that needn't be returned."

BCD INK, LTD. CREATIVE DESIGN SERVICES, 108 E. 16th St., New York NY 10003. (212)420-1222. President: Emma Crawford. Specializes in package, publication and direct mail design. Clients: manufacturers, toy companies, fashion, institutions and corporations. Current clients include: Lancome, Pratt Institute, Tom & Linda Platt, Life-Like/Dard, Hinkle, London Fog® by D. Klein and Son, and Luggage and Leather Goods Manufacturers of America. Client list available upon request.
Needs: Approached by 40-50 freelance artists/year. Works with 5-10 freelance illustrators and 10-20 freelance designers/year. Prefers local artists with design skills and experience in mechanicals and computers (Mac Quark/Adobe Illustrator). Works on assignment only. Uses illustrators mainly for advertising packaging. Also uses artists for brochure design and illustration, catalog design and illustration, mechanicals, lettering, logos, ad design, poster illustration and design and direct mail design.

First Contact & Terms: Send query letter with tearsheets, resume, SASE and photocopies. Samples are filed, or are not returned, or are returned by SASE if requested by artist. Reports back to the artist only if interested. Portfolio should include thumbnails, roughs, original/final art, tearsheets, mechanicals and paste-up. Pays for design by the hour, $10-18. Pays for illustration by the project. Rights purchased vary according to project.

Tips: "Most work is handled by staff artists at this time."

SUZANNE BENNETT AND ASSOCIATES, 33 Ward Ave., Rumson NJ 07760. NJ 07760. (908)530-3796. Contact: Suzanne Bennett. Specializes in direct mail, publications and book design. Clients: PR firms, magazine and book publishers and nonprofit organizations.

Needs: Works with 15 freelance artists/year. Uses artists for mechanicals, retouching, airbrushing and graphs.

First Contact & Terms: Samples not filed are not returned. Does not report back. Write to schedule an appointment to show a portfolio. Considers client's budget, skill and experience of artist, how work will be used and turnaround time when establishing payment. Rights purchased vary according to project.

BARRY DAVID BERGER & ASSOCIATES, INC., 9 East 19th St., New York NY 10003. (212)477-4100. Contact: Amy Patten. Specializes in brand and corporate identity, P-O-P displays, product and interior design, exhibits and shows, corporate capability brochures, advertising graphics, packaging, publications and signage. Clients: manufacturers and distributors of consumer products, office, stationery products, art materials, chemicals, cosmetics. Current clients include: Dennison, Timex, Seiko, Sheaffer and Kodak.

Needs: Works with 10 freelance artists/year. Uses artists for advertising, editorial, medical, technical and fashion illustration, as well as mechanicals, retouching, direct mail package design, model making, charts/graphs, photography, AV presentations and lettering.

First Contact & Terms: Send query letter, then call for appointment. Works on assignment only. Prefers "whatever is necessary to demonstrate competence" as samples including multiple roughs for a few projects. Samples returned if not kept on file. Reports immediately. Provide brochure/flyer, resume, business card, tearsheets and samples to be kept on file for possible future assignments. Pays for design by the hour, $10-25; by the project, $1,000-10,000. Pays for illustration by the project.

J.H. BERMAN AND ASSOCIATES, Suite 550, 1201 Connecticut Ave., Washington DC 20036. (202)775-0892. Office Manager: Sara Greenbaum. Estab. 1974. Specializes in annual reports, corporate identity and signage. Clients: real estate developers, architects, high-technology corporations and financial-oriented firms (banks, investment firms, etc.).

Needs: Works with 10-15 (6 consistently) freelance artists/year. Mainly uses artists for architectural rendering and mechanical/production. Also uses artists for design, illustration, brochures, magazines, books, P-O-P displays, retouching, airbrushing, posters, model making, AV materials, lettering and advertisements.

First Contact & Terms: "Artists should be highly professional, with at least 5 years of experience. Highest quality work required. Restricted to local artists for mechanicals only." Send query letter with brochure, resume, business card and samples to be kept on file. Call or write for appointment to show portfolio or contact through agent. "Samples should be as compact as possible; slides not suggested." Samples not kept on file returned by SASE. Reports only if interested. Pays for design by the hour, $20-50. Pays for illustration by the project, $200 minimum. Considers complexity of project, skill and experience of artist, how work will be used, turnaround time and rights purchased when establishing payment.

Tips: Artists should have a "totally professional approach. The best way for illustrators or designers to break into our field is a phone call followed by a strong portfolio presentation" which should include "original completed pieces."

BINGENHEIMER DESIGN COMMUNICATIONS INC., 126 E. Center College St., Yellow Springs OH 45387. (513)767-2521. President: Bob Bingenheimer. Estab. 1979. Specializes in annual reports, brand identity, corporate identity, display, direct mail, package and publication design; signage and advertising. Clients: corporations, associations and the government. Current clients include NCR, Standard Register. Client list available upon request.

Needs: Approached by 2-10 freelance artists/year. Works with 2-5 freelance illustrators and 1-2 freelance designers/year. Prefers artists with experience in publications. Works on assignment only. Uses illustrators mainly for publications and editorial. Uses designers mainly for collateral. Also uses artists for retouching, airbrushing and ad illustration.

First Contact & Terms: Send query letter with SASE and slides. Samples are filed. Reports back only if interested. To show a portfolio, mail slides. Pays for design by the hour, $30-40. Rights purchased vary according to project.

BOB BOEBERITZ DESIGN, 247 Charlotte St., Asheville NC 28801. (704)258-0316. Owner: Bob Boeberitz. Estab. 1984. Specializes in graphic design. Clients: galleries, retail outlets, restaurants, textile manufacturers, record companies, publishers, universities, hotels and medical service suppliers. Current clients include:

Beacon Manufacturing Co., High Windy Audio, Whitford Press, Holbrook Farm and The Market Place. Client list not available.

Needs: Approached by several freelance artists/year. Works with 3-4 freelance illustrators and 1-2 freelance designers/year. Uses artists primarily for technical illustration, comps and mechanicals. Prefers pen & ink, airbrush and acrylic.

First Contact & Terms: Send query letter with brochure, resume, photostats, photocopies, photographs, business card, slides and tearsheets to be kept on file. "Anything too large to fit in file" is discarded. Reports only if interested. To show a portfolio, write to schedule an appointment or mail color and b&w original/final art, final reproduction/product. Pays for illustration by the hour, $25 minimum, or by the project, $50 minimum. Considers complexity of project, client's budget, skill and experience of artist and turnaround time when establishing payment. Buys all rights.

Tips: "Show sketches. Sketches help indicate how the person thinks. The most common mistake freelancers make in presenting samples or portfolios is not showing how the concept was developed, what your role was in it. I always see the final solution, but never what went into it. In illustration, show both the art and how it was used. Portfolio should focus on what you do best. Portfolios should be neat, clean and flattering to your work. Show only the most memorable work, what you do best. Always have other stuff, but don't show everything. Be brief. Don't just toss a portfolio on my desk; guide me through it. A 'leave-behind' is helpful along with a distinctive looking resume."

BOELTS BROS. DESIGN, INC., 14 E. 2nd St., Tucson AZ 85705-7752. (602)792-1026. FAX: (602)792-9720. President: Eric Boelts. Estab. 1986. Specializes in annual reports, brand identity, corporate identity, display design, direct mail design, package design, publication design and signage. Client list available upon request.

Needs: Approached by 100 freelance artists/year. Works with 10 freelance illustrators and 5-10 freelance designers/year. Works on assignment only. Uses designers and illustrators for brochure, poster, catalog, P-O-P and ad illustration, mechanicals, retouching, airbrushing, charts/graphs and audiovisual materials.

First Contact & Terms: Send query letter with brochure, tearsheets and resume. Samples are filed. Reports back only if interested. Call to schedule an appointment to show portfolio. Portfolio should include roughs, original/final art, slides and transparencies. Pays for design by the hour and by the project. Pays for illustration by the project. Negotiates rights purchased.

Tips: When presenting samples or portfolios, artists "sometimes mistake quantity for quality. Keep it short and show your best work."

***SIDNEY A. BOGUSS & ASSOC., INC.,** 22 Corey St., Melrose MA 02176. (617)662-6660. FAX: (617)662-4879. Design Director: Phil Parisi. Estab. 1957. Specializes in brand identity, corporate identity, display design, package design and collateral materials. Clients: manufacturers, corporations. Client list available upon request.

Needs: Approached by 10 freelance artists/year. Works with 3 freelance illustrators and 6 freelance designers/year. Prefers artists with experience in packaging design and art production. Prefers designers who can work on premises. Works on assignment only. Uses freelance illustrators mainly for instructional drawings and product-in-use drawings. Uses freelance designers mainly for comprehensive mock-ups, mechanical art, refinement and development layouts, line extension layouts. Also uses freelance artists for brochure design and illustration, catalog design, retouching, airbrushing, lettering, logos, catalog illustration and P-O-P design and illustration.

First Contact & Terms: Send query letter with brochure, tearsheets, photostats, resume and photocopies. Samples are filed. Portfolio should include thumbnails, roughs, original/final art, tearsheets and slides. Pays for production by the hour, $12-18. Pay for design determined by complexity of project, skill and experience of individual. Pay for illustration determined by illustration type, complexity, medium and size. Rights purchased vary according to project.

THE BOOKMAKERS, INCORPORATED, 126 S. Franklin St., Wilkes-Barre PA 18701-1189. (717)823-9183. President: John Beck. Specializes in publications and technical illustrations. Clients: mostly book publishers. Clients include Simon and Schuster, South-Western, Allyn and Bacon and Hunter College. Client list available upon request.

Needs: Works with 5-10 freelance illustrators/year. Uses artists for illustrations, brochures, catalogs, retouching, airbrushing, posters and charts/graphs.

First Contact & Terms: Send query letter with resume, tearsheets, photostats, photocopies, slides and photographs. Samples not filed are returned by SASE. Reports only if interested. Write to schedule an appointment to show a portfolio, which should include b&w thumbnails, roughs, original/final art, final reproduction/product, tearsheets and photostats. Pays for design, by the hour, $6-10; by the project, $100-1,200. Pays for illustration by the project, $20-2,500. Considers complexity of project, client's budget, skill and experience of artist, how work will be used and turnaround time when establishing payment. Buys all rights.

Tips: "We are especially interested in versatility. Don't send too much. Send one good flyer or five illustrations of what you do best."

BOOKMAKERS LTD., 25 Sylvan Rd. South,Westport CT 06880. (203)226-4293. President: Gayle Crump. Specializes in publications and related sales promotion and advertising. Clients: trade and educational publishers. Client list not available.

Needs: Approached by 100 freelance artists/year. Works with 20-30 freelance illustrators and 2 freelance designers/year. "We are agents and designers. We represent artists for juvenile through adult markets."

First Contact & Terms: Send query letter with samples showing style (tearsheets, photostats, printed pieces or slides). Samples not filed are returned. Reports within 2 weeks. Considers skill and experience of artist when establishing payment.

Tips: The most comon mistake freelancers make in presenting samples or portfolios is "too much variety— not enough focus. Be clear about what you are looking for and what you can do in relation to the real markets available."

THE BRUBAKER GROUP, 10560 Dolcedo Way, Los Angeles CA 90077. (213)472-4766. Estab. 1968. Specializes in brand identity, display, interior and package design and technical illustration. Clients: aircraft and automobile manufacturers, toy and electronic companies and theme parks. Current clients include: Disney, Mattel, Mazda, Exxon, Lear Jet Corp. and CBS. Client list available upon request.

Needs: Approached by 2-10 freelance artists/year. Works with 2-10 freelance illustrators and designers/year. Prefers artists with experience in product, model construction and consumer product design. Works on assignment only. Uses illustrators mainly for theme park environments and product design. Uses designers mainly for product, environmental and auto design. Also uses artists for brochure design and illustration, poster illustration and design, model making, charts/graphs and audiovisual materials.

First Contact & Terms: Send query letter with tearsheets, photostats, photographs and photocopies. Samples are filed. Samples not filed are not returned. Reports back to the artist only if interested. To show a portfolio, mail b&w photostats and photographs. Pays for design by the hour, $12-60, and by the project. Pays for illustration by the project. Buys all rights.

***BURCHETTE & COMPANY**, 1240 North Pitt St., Suite 200, Alexandria VA 22314. (703)684-6066. FAX: (703)684-6180. Associate Creative Director: Belinda Lee. Estab. 1985. Specializes in corporate identity, display design, package design, publication design and advertising and direct mail. Clients: corporations, associations, government agencies. Current clients include: USGS, DOE, Telesystems Inc.

Needs: Approached by 15 freelance artists/year. Works with 3-4 freelance illustrators/year. Works on assignment only. Uses freelance illustrators mainly for direct mail and ad illustrations. Also uses freelance artists for brochure illustration, retouching, airbrushing and poster illustration.

First Contact & Terms: Send query letter with slides and transparencies. Samples are filed. Reports back to the artist only if interested. Write to schedule an appointment to show a portfolio. Mail appropriate materials. Portfolio should include roughs and slides. Pays for illustration by the project, $400. Rights purchased vary according to project.

BUTLER, 940 N. Highland Ave., Los Angeles CA 90038. (213)469-8128. Vice President/Account Supervisor: Michael Masterson. Estab. 1987. Specializes in corporate identity, displays, direct mail, fashion, packaging and publications. Clients: film companies, fashion, medical and home video distributors.

Needs: Works with 12 freelance artists/year. Works on assignment only. Uses artists for design, brochures, catalogs, books, P-O-P displays, mechanicals, retouching, posters, model making, direct mail packages, lettering and logos.

First Contact & Terms: Send query letter with brochure or resume. Samples are filed. Samples not filed are returned by SASE. Reports back within 1 week only if interested. Pays for design and illustration by the hour, $15. Considers complexity of project, client's budget, skill and experience of artist, how work will be used, turnaround time and rights purchased when establishing payment. Rights purchased vary according to project.

BYRNE DESIGN, 133 W. 19th St., New York NY 10011. (212)807-6671. FAX: (212)633-6194. Creative Director: Pierre Vilmenay. Estab. 1976. Specializes in annual reports and corporate identity. Clients: financial consultants and corporations. Current clients include: Paine Webber, Alliance Capital and Peat Marwick. Client list available upon request.

Needs: Approached by 10 freelance artists/year. Works with 3-4 freelance illustrators and designers/year. Uses freelance illustrators and designers mainly for promotional brochures. Also uses artists for brochure design and illustration, mechanicals, lettering, logos and charts/graphs.

First Contact & Terms: Send query letter with brochure and resume. Samples are filed. Reports back only if interested or need arises. To show a portfolio, mail thumbnails, roughs and tearsheets. Pays for design by the hour, $25-50. Pays for illustration by the project. Rights purchased vary according to project.

CARBONE SMOLAN ASSOCIATES, 170 Fifth Ave., New York NY 10010. (212)807-0011. FAX: (212)807-0870. Senior Designer: Beth Bangor. Estab. 1980. Specializes in corporate identity; display, package, publication and book design; signage and marketing communications. Clients: architects, financial services firms,

museums, publishers, corporations and hoteliers. Clients include American Express, Smith Barney, The Rafael Group, Tiffany's, Deloitte & Touche, Merrill Lynch and The Pierpont Morgan Library. Client list available upon request.

Needs: Approached by hundreds of freelance artists/year. Works with more than 10 freelance illustrators and up to 10 designers/year. "Must follow drop-off policy—portfolios accepted on Wednesday mornings only 8:30-9:00 a.m. Only three accepted (per week)." Uses illustrators for book design and brochures. Uses designers for "all of our work—from architectural signage to graphic design." Also uses artists for brochure design and illustration, catalog and book design and mechanicals.

First Contact & Terms: Send query letter with resume. Samples are filed or are returned by SASE if requested by artist. Reports back within 1-2 weeks. Write to schedule an appointment to show a portfolio. Portfolio should include tearsheets, photographs, slides and transparencies. Pays for design by the hour, $15-25. Pays for illustration by the project, $350-2,000. Buys one-time rights.

CAREW DESIGN, 200 Gate 5 Rd., Sausalito CA 94965. (415)331-8222. President: Jim Carew. Estab. 1975. Specializes in corporate identity, direct mail and package design.

Needs: Works with 15 freelance illustrators and 2-4 freelance designers/year. Prefers local artists only. Works on assignment only. Uses artists for brochure and catalog design and illustration, mechanicals, retouching, airbrushing, direct mail design, lettering, logos and ad illustration.

First Contact and Terms: Send query letter with brochure, resume and tear sheets. Samples are filed. Samples not filed are returned only if requested by artist. Reports back only if interested. Call to schedule an appointment to show a portfolio, which should include roughs and original/final art. Pays for production by the hour, $18-30. Pays for illustration by the project, $100-1,000+. Considers complexity of project, client's budget, skill and experience of artist, how work will be used, turnaround time and rights purchased when establishing payment. Buys all rights.

Tips: "The best way for an illustrator and a designer to get an assignment is to show a portfolio."

***THE CHESTNUT HOUSE GROUP INC.**, 540 N. Lakeshore Dr., Chicago IL 60611. (312)222-9090. Creative Directors: Norman Baugher and Miles Zimmerman. Clients: major educational publishers. Arrange interview.

Needs: Illustration, layout and assembly. Pays by job.

WALLACE CHURCH ASSOCIATES, INC., 330 East 48th St., New York NY 10017. (212)755-2903. FAX: (212)355-6872. Studio Manager: Susan Wiley. Specializes in package design. Clients: Fortune 500 food companies, personal and home product companies and pharmaceutical corporations. Current clients include: Kraft, General Foods, Pillsbury, Gillette and Bristol-Myers. Client list available upon request.

Needs: Approached by 15-20 freelance artists/year. Works with 10-12 freelance illustrators and designers/year. Prefers artists with experience in food and personal care rendering. Works on assignment only. Uses illustrators mainly for package art. Uses designers mainly for graphics, package design and mechanicals. Also uses artists for mechanicals, retouching, airbrushing, lettering, logos and model making.

First Contact & Terms: Send query letter with portfolio. Samples are filed. Reports back only if interested. Portfolio should include "everything." Pays for design by the hour and by the project. Pays for illustration by the hour. Buys all rights.

JANN CHURCH PARTNERS ADVERTISING & GRAPHIC DESIGN, INC., Suite 160, 110 Newport Center Dr., Newport Beach CA 92660. (714)640-6224. FAX: (714)640-1706. President: Jann Church. Estab. 1970. Specializes in annual reports; brand identity; corporate identity; display, interior, direct mail, package and publication design; and signage. Clients: real estate developers, medical/high technology corporations, private and public companies. Current clients include: The Nichols Institute, The Anden Group, Institute for Biological Research & Developement, Fluor Constructors and the Environmental Systems Research Institute. Client list available upon request.

Needs: Approached by 100 freelance artists/year. Works with 3 freelance illustrators and 5 freelance designers/year. Works on assignment only. Uses designers and illustrators for all work.

First Contact & Terms: Send query letter with resume, photographs and photocopies. Samples are filed. Reports back only if interested. Mail appropriate materials. Portfolio should be "as complete as possible." Rights purchased vary according to project.

CLIFF AND ASSOCIATES, 715 Fremont Ave., South Pasadena CA 91030. (818)799-5906. FAX: (818)799-9809. Owner: Greg Cliff. Estab. 1984. Specializes in annual reports, corporate identity, direct mail and publication design and signage. Clients: Fortune 500 corporations and performing arts companies. Current clients include: Arco, Mattel, Yamaha, Times Mirror, Century 21, Avery, Quotron, Union Oil, Northrup and Southern California Edison.

Needs: Approached by 20 freelance artists/year. Works with 15 freelance illustrators and 20 designers/year. Prefers local artists and art center graduates. Uses illustrators and designers mainly for brochures. Also uses artists for mechanicals; lettering; logos; catalog, book and magazine design, P-O-P and poster design and

illustration; and model making. Needs technical and "fresh" editorial illustration.

First Contact & Terms: Send query letter with resume and sample of work. Samples are filed. Does not report back. Call to schedule an appointment to show a portfolio. Portfolio should include thumbnails and b&w photostats and printed samples. Pays for design by the hour, $18-25. Pays for illustration by the project, $200-10,000. Buys one-time rights.

Tips: "Make your resume and samples look like a client presentation. We're very busy, what recession?"

***CONDON NORMAN DESIGN,** 954 W. Washington, Chicago IL 60607. (312)226-3646. Creative Director: Phylane Norman. Estab. 1984. Specializes in display design, direct mail design, package design and publication design. Clients: corporations and manufacturers. Client list not available.

Needs: Approached by 75-100 freelance artists/year. Works with college interns and 10 freelance designers/year. Prefers local artists only. Prefers artists with experience with Macintosh computers. Works on assignment only. Uses freelance illustrators mainly for collateral material, comps and marker rendering. Uses freelance designers mainly for package and publication design. Also uses freelance artists for brochure design and illustration, catalog design, mechanicals, airbrushing, lettering, logos, ad design, P-O-P design and illustration, and direct mail design.

First Contact & Terms: Send query letter with brochure, tearsheets and resume. Samples are filed. Reports back to the artist only if interested. Call to schedule an appointment to show a portfolio. Portfolio should include thumbnails, roughs and original/final art. Pays for design by the hour, project or day. Pays for illustration by the project. Negotiates rights purchased.

CORPORATE GRAPHICS INC., 17th Floor, 655 Third Ave., New York NY 10017. (212)599-1820. Chairman/Art Director: Bennett Robinson. President: Michael Watras. Specializes in annual reports, corporate identity, brochures and other forms of corporate literature. Clients: various and international. Current clients include Bayer USA, Bell Atlantic and Cellular Communications.

Needs: Work with many freelance artists/year. Works on assignment only. Uses artists for illustration, mechanicals, charts, graphs. Portraiture and annual report illustration is also needed for products, maps, situations, etc.

First Contact & Terms: Send resume and tearsheets. Samples are filed or are returned only if requested by artist. Reports back only if interested. Portfolio drop offs: Mondays and Wednesdays, April 15-November 15 only. To show a portfolio, mail b&w and color tearsheets, photostats, photographs. Pays mechanical artists by the hour, $15-20. Considers complexity of a project, client's budget, skill and experience, how work is to be used and turnaround time when establishing payment.

Tips: "We want top notch quality and sophistication of style. Mechanical artists need to know stat camera and color-key skills. Show variety and range. Send mail pieces each 3-6 month as a way of staying in touch. Be persistent—but not by calling on the phone."

COUSINS DESIGN, 599 Broadway, New York NY 10012. (212)431-8222. President: Michael Cousins. Specializes in packaging and product design. Clients: manufacturing companies.

Needs: Works with 10-12 freelance artists/year. Prefers local artists. Works on assignment only. Uses artists for design, illustration, mechanicals, retouching, airbrushing, model making, lettering and logos. Prefers airbrush, colored pencil and marker as media.

First Contact & Terms: Send query letter with brochure or resume, tearsheets and photocopies. Samples are filed and are returned only if requested. Reports back within 2 weeks only if interested. Write to schedule an appointment to show a portfolio, which should include roughs, final reproduction/product and photostats. Pays for design by the hour, $20-40. Pays for illustration by the hour, $20 minimum or a fee. Considers skill and experience of artist when establishing payment. Buys all rights.

CRAYON DESIGN & COMMUNICATION, 6855 Pie IX, Montreal Quebec H1X 2C7 Canada. (514)376-2488. Art Directors: Sol Lang or Mary Bogdan. Estab. 1980. Specializes in annual reports, brand identity, corporate identity, display, direct mail, package and publication design and signage.

Needs: Prefers local artists only with experience in concept and layout, "especially knowledge of type." Prefers latest trends. Also uses artists for brochure and catalog design and illustration, book magazine and newspaper design, P-O-P design and illustration, mechanicals, poster illustration and design, direct mail design, charts/graphs, logos, advertisement design and illustration.

First Contact and Terms: Send query letter with brochure, resume, tearsheets, slides, photographs and transparencies. Samples are filed or are returned by SASE only if requested by artist. Reports back only if interested. To show a portfolio, mail final reproduction/product, b&w and color tearsheets, photographs and transparencies. Pays by the hour, $11-25 (Canadian). Considers skill and experience of artist when establishing payment.

Tips: "Keep sending updated info and samples as career progresses. A phone call of inquiry would clarify if no assignments have been issued."

CREATIVE WORKS, Suite 300, 631 US Highway 1, North Palm Beach FL 33408. (407)863-4900. Graphics Dept. Head (Design, Copywriting, Illustration, Photography): David Wright. Product and Interior Design Department Head: Robert Jahn. Specializes in corporate identity, collateral, signage, product, packaging and sales offices. Clients: ad agencies, PR firms, real estate developers, manufacturers and inventors. Client list not available.

Needs: Approached by 50 freelance artists/year. Works with 12 freelance illustrators and 50 freelance designers/year. Uses local (work in-house), experienced artists. Uses artists for architectural and product illustration, mechanicals, airbrushing, model making and drafting. Especially needs experienced drafting/mechanical people.

First Contact & Terms: Send query letter with resume to be kept on file. Samples not kept on file are returned by SASE only if requested. Reports within 1 week. Write to schedule an appointment to show a portfolio, which should include original/final art and photographs. Pays by the project for drafting and mechanicals. Pays for design and illustration by the project, $100 minimum. Considers complexity of project, client's budget, skill and experience of artist and turnaround time when establishing payment.

Tips: Don't make the mistake of "showing samples that don't accurately represent your capabilities. Send only distinctive graphic or artistic resume that is memorable and request an appointment. Artists usually send resumes with words and no pictures."

JO CULBERTSON DESIGN, INC., 222 Milwaukee St., Denver CO 80206. (303)355-8818. President: Jo Culbertson. Estab. 1976. Specializes in annual reports, corporate identity, direct mail, publication and marketing design and signage. Clients: insurance companies and telecommunications companies, textbook publishers, healthcare providers and professional corporations. Current projects include product literature, food products packaging, annual reports, capablities brochures and book design. Current clients include: Great-West Life Assurance Co., Love Publishing Co., University of Colorado Health Services Center. Client list available upon request.

Needs: Works with 4 freelance illustrators and 2-3 freelance designers/year. Prefers local artists only. Works on assignment only. Uses editorial illustrators mainly for book covers, presentation graphics and general illustration. Uses designers mainly for various print projects. Also uses artists for brochure design and illustration, catalog and P-O-P illustration, mechanicals, lettering and ad illustration.

First Contact and Terms: Send query letter with brochure, resume and samples. Samples are filed or are returned only if requested by artist. Reports back only if interested. Call to schedule an appointment to show a portfolio, which should include roughs, original/final art, final reproduction/product and b&w and color tearsheets and photostats. Pays for design and illustration by the hour, $10-25, or by the project, $250 minimum. Considers complexity of project, client's budget, skill and experience of artist, how work will be used, turnaround time and rights purchased when establishing payment. Rights purchased vary according to project.

Tips: Common mistakes freelancers make in presenting samples are "not checking back periodically and not having an original approach—too much like others. Have persistance, develop personal, individualistic style(s)."

CULTURE & DESIGN STUDIO, 2 E. 37th St., Basement, New York, NY 10016. (212)685-2838. Art Director: David Bruner. Estab. 1974. Specializes in direct mail and publication design. Clients: educational and conference. Clients include American Leadership Conference, CAUSA International and CG&S Advertising. Client list available upon request.

Needs: Approached by 8 freelance artists/year. Works with 5 freelance illustrators and 7 freelance designers/year. Prefers local artists only. "Mac literacy helps for designers." Works on assignment only. Uses illustrators mainly for magazine articles. Uses designers mainly for conference programs. Also uses artists for brochure, book, poster, direct mail and magazine design; mechanicals; AV material; logos; advertisement design and illustration. Needs editorial illustration. Looking for editorial illustration with "realism or understandable abstract."

First Contact & Terms: Pays for design by the hour, $15-30; by the project, $100 minimum. Pays for illustration by the project, $350-670.

Tips: Common mistakes freelancers make in presenting samples or portfolios are "repetition (slides of flat art already presented) and presenting everything they ever did, not discriminating and choosing a hierachy of their work. Keep it simple." Among freelance artists, would like to see "Higher moral standards to produce inspired, life-giving solutions of communication."

CWI INC., 255 Glenville Rd., Greenwich CT 06831. (203)531-0300. Contact: Geoffrey Chaite. Design studio. Specializes in packaging, annual reports, brand identity, corporate identity, P-O-P and collateral material, displays, exhibits and shows. Clients: manufacturers of packaged goods, foods, tools, drugs and tobacco, publishing, banks and sports. Client list not available.

Needs: Works with 5-8 freelance illustrators and 4 freelance designers/year. Minimum 8-10 years of experience. Uses artists for P-O-P displays, stationery design, multimedia kits, direct mail, slide sets, brochures/flyers, trade magazines, newspapers, layout, technical art, type spec, paste-up, retouching and lettering. Especially needs photography, illustration and paste-up.
First Contact & Terms: Send flyers, business card, tearsheets, b&w line drawings, roughs, previously published work, comps and mechanicals to be kept on file for future assignments. May return originals to artist at job's completion. Payment is negotiated.
Tips: "Original comps and art should be shown as much as printed units. Show how you created units in steps, i.e. show roughs, comps, pencils, mechanicals, etc."

D&B GROUP (formerly Donato & Berkley Inc.), 386 Park Ave. S, New York NY 10016. (212)532-3884. FAX (212)532-3921. Contact: Sy Berkley or Steve Sherman. Estab. 1956. Advertising art studio. Specializes in direct mail response advertising, annual reports, brand identity, corporate identity and publications. Clients: ad agencies, PR firms, direct response advertisers and publishers.
Needs: Works with 1-2 freelance illustrators and 1-2 freelance designers/month. Local experienced artists only. Uses freelance artwork mainly for video wraps and promotion. Also uses artists for consumer magazines, direct mail, brochures/flyers, newspapers, layout, technical art, type spec, paste-up, lettering and retouching. Especially needs illustration, retouching and mechanical paste-up. Prefers pen & ink, airbrush, watercolor and oil as media.
First Contact & Terms: Call for interview. Send brochure showing art style, flyers, business card, resume and tearsheets to be kept on file. No originals returned to artist at job's completion. Call to schedule an appointment to show a portfolio, which should include thumbnails, roughs, original/final art and final reproduction/product. Pays for design by the hour, $25-50 or by the project, $75-1,500. Pays for illustration by the project, $75-1,500. Considers complexity of project and client's budget when establishing payment.
Tips: "We foresee a need for direct response art directors and the mushrooming of computer graphics. Clients are much more careful as to price and quality of work. Include 8×10 chromes and original samples in a portfolio. Don't show school samples."

DE NADOR & ASSOCIATES, 14 Yellow Ferry Harbor, Sausalito CA 94965. (415)332-4098. FAX: (415)332-7431. Coordinating Manager: Margaux. Estab. 1977. Specializes in annual reports, brand identity, corporate identity and publication design. Clients: ad agencies and corporations. Current clients include: Brittania Sportswear Ltd., HBR Hotels, Colliers International. Client list available upon request.
Needs: Approached by 60 freelance artists/year. Works with 2-5 freelance illustrators and 5-10 designers/year. Prefers local artists and artists with experience in technical fields. Works on assignment only. Also uses designers and illustrators for brochure design and illustration, mechanicals, ad design and illustration, P-O-P and mail design.
First Contact & Terms: Send query letter with resume, photographs and photocopies. Samples are filed. Reports back only if interested. To show a portfolio, call or mail thumbnails, roughs, photostats, tearsheets, photographs and transparencies. Pays for design by the hour, $10-35. Pays for illustration by the hour, $15-100. Buys all rights or varying according to project.

JOSEPH B. DEL VALLE, Suite 1011, 41 Union Square West, New York NY 10003. Director: Joseph B. Del Valle. Specializes in annual reports, publications, book design. Clients: major publishers and museums. Current clients include: Metropolitan Museum of Art and Philadelphia Museum.
Needs: Works with approximately 6 freelance artists/year. Artists must have experience and be able to work on a job-to-job basis. Uses artists for design and mechanicals.
First Contact & Terms: Send query letter with resume. Reports only if interested. Call or write to schedule an appointment to show a portfolio, which should include final reproduction/product. Pays for design by the hour, $15-25. Considers client's budget and turnaround time when establishing payment.

***DESIGN ASSOCIATES,** 295 Park Ave. South, New York NY 10010. (212)505-1493. FAX: (212)677-3313. Contact: Albert Barry. Estab. 1984. Specializes in package design and graphic design for toy industry. Clients: toy manufacturers. Client list not available.
Needs: Approached by 150 freelance artists/year. Works with 10 freelance illustrators and 15 freelance designers/year. Prefers local artists only. Prefers artists with experience in packaging, cartoon and basic illustration. Works on assignment only. Uses freelance illustrators mainly for packaging and headers. Also uses freelance artists for brochure design, mechanicals, airbrushing, P-O-P design.
First Contact & Terms: Call for appointment or portfolio review. Samples are filed. Reports back to the artist only if interested. Call to schedule an appointment to show a portfolio. Portfolio should include original/final art, tearsheets and comps. Pays for design by the hour, $15-20. Pays for illustration by the hour, $15-20. Buys all rights.

DESIGN CONSULTANT INCORPORATED, Suite 2002, 5445 N. Sheridan Rd., Chicago IL 60640-1932. (312)907-5500. President: Frederic A Roberton. Estab. 1961. Specializes in brand and corporate identity, direct mail, package and publications design and signage. Clients: commercial, industrial and marketing.

Current projects include naming, design identification and new product packaging.
Needs: Works with 3-4 freelance illustrators/year. Works with 10-20 freelance designers/year. Prefers local artists only with experience in technical and products illustration. Works on assignment only. Prefers clean line and color. Uses illustrators mainly for technical and product illustrations. Uses designers mainly for layout, development, comprehensives and art. Also uses artists for brochure and catalog design and illustration, P-O-P design and illustration, mechanicals, model making, charts/graphs, lettering, logos and poster, book, direct mail and ad design.
First Contact & Terms: Send query letter with brochure, resume and photocopies. Samples are filed. Reports back only if interested. To show a portfolio, mail roughs, original/final art, final reproduction/product and photostats and photocopies. Pays by the project, $200-1,500. Considers complexity of project, skill and experience of artist, how work will be used, turnaround time and rights purchased when establishing payment. Rights purchased vary according to project.
Tips: "Send resume and photocopies of range of work. State general cost of such work. We will file in reference and contact is needed. Range of hourly rate charged is also helpful."

DESIGN ELEMENTS, INC., Suite 702, 201 W. Short, Lexington KY 40508. (606)252-4468. President: C. Conde. Estab. 1979. Specializes in corporate identity, package and publication design. "Work directly with end user (commercial accounts)." Client list not available.
Needs: Approached by 6-8 freelance artists/year. Works with 2-3 freelance illustrators and 2-3 freelance designers/year. Works on assignment only. Uses artists for brochure and P-O-P design and illustration, mechanicals, airbrushing, poster design, lettering and logos.
First Contact & Terms: Send query letter with brochure, resume, tearsheets and slides. Samples are filed or are returned only if requested by artist. Reports back only if interested. Call or write to schedule an appointment to show a portfolio. Pays by the hour, $15 minimum. Considers complexity of project, client's budget and skill and experience of artist when establishing payment. Buys all rights.
Tips: "Freelancers need to be more selective about portfolio samples—show items actually done by person presenting, or explain why not. Send resume and samples of work first."

THE DESIGN OFFICE OF STEVE NEUMANN & FRIENDS, Suite 103, 3000 Richmond Ave., Houston TX 77098. (713)629-7501. FAX: (713)520-1171. Associate: Deborah Roe. Specializes in corporate identity and signage. Clients: hospitals.
Needs: Works with 1 freelance designer/year. Artists must be local with computer experience. "We are 100% computerized." Uses artists for production and design. Also uses freelance designers for brochure design, lettering, logos and model making. Prefers pen & ink, colored pencil and calligraphy. Especially needs full-time and/or part-time production person.
First Contact & Terms: Send query letter with resume, references, business card and nonreturnable slides to be kept on file. Call for follow up after 15 days. Pays for design by the hour, $8-12, based on job contract. Considers complexity of project, client's budget, skill and experience of artist, and how work will be used when establishing payment. Rights purchased vary according to project.

ANTHONY DI MARCO, 2948½ Grand Route St. John, New Orleans LA 70119. (504)948-3128. Creative Director: Anthony Di Marco. Estab. 1972. Specializes in brand identity, publications, illustration, sculpture and costume design. Clients: numerous New Orleans Mardi Gras clubs, various churches, printers/agencies. Client list available upon request.
Needs: Approached by 20 or more freelance artists/year. Works with 2-4 freelance illustrators and 2-4 freelance designers/year. Seeks "local artists with ambition. Artists should have substantial portfolios and an understanding of business requirements." Mainly uses artists for fill-in and finish. Also uses artists for design, illustration, mechanicals, retouching, airbrushing, posters, model making, charts/graphs. Prefers highly polished, finished art; pen & ink, airbrush, charcoal/pencil, colored pencil, watercolor, acrylic, oil, pastel, collage and marker.
First Contact & Terms: Send query letter with resume, business card and slides and tearsheets to be kept on file. Samples not kept on file are returned by SASE. Reports back within 1 week if interested. Call or write for appointment to show portfolio. Pays for illustration by the project, $100 minimum.
Tips: "Keep professionalism in mind at all times. Artists should put forth their best effort. Apologizing for imperfect work is a common mistake freelancers make when presenting a portfolio. Include prices for completed works (avoid overpricing). The best way to introduce yourself to us is to call or write for a personal appearance."

DIAMOND ART STUDIO LTD., 11 E. 36th St., New York NY 10016. (212)685-6622. Creative Directors: Gary and Douglas Diamond. Vice President: Douglas Ensign. Art studio. Clients: agencies, corporations, manufacturers and publishers.
Needs: Employs 10 illustrators/month. Assigns 800 jobs/year. Uses artists for comprehensive illustrations, cartoons, charts, graphs, layout, lettering, logo design, paste-up, retouching, technical art and type specing. Prefers pen & ink, airbrush, colored pencil, watercolor, acrylic, pastel and marker.

First Contact & Terms: Send resume, tearsheets and SASE. Samples are filed. Write for interview to show a portfolio. Pays for design by the hour. Pays for illustration by the hour and by project. Considers complexity of project, client's budget, skill and experience of artist, and turnaround time when establishing payment.
Tips: "Leave behind something memorable and well thought out."

EHN GRAPHICS, INC., 244 E. 46th St., New York NY 10017. (212)661-5947. President: Jack Ehn. Specializes in annual reports, book design, corporate identity, direct mail, publications and signage. Current clients include: MacMillan and McGraw Hill. Client list available upon request.
Needs: Approached by 20 freelance artists/year. Works with 10-12 freelance artists/year. Uses artists for illustration, books, mechanicals, retouching and direct mail packages.
First Contact & Terms: Send query letter with samples. Samples not filed are returned only if requested. Reports only if interested. Call or write to schedule an appointment to show a portfolio, which should include original/final art and final reproduction/product. Considers complexity of project, client's budget, and skill and experience of artist when establishing payment.

RAY ENGLE & ASSOCIATES, 626 S. Kenmore, Los Angeles CA 90005. (213)381-5001. President: Ray Engle. Estab. 1963. Specializes in annual reports, corporate identity, displays, interior design, direct mail, packaging, publications and signage. Clients: ad agencies, PR firms, direct clients. Current clients include: IBM, KCET and Hughes. Client list available upon request.
Needs: Approached by 200 freelance artists/year. Works with 4 freelance illustrators and 5 freelance designers/year. Prefers local artists; top quality only. Mainly uses artists for illustration. Also uses freelance artists for brochure and catalog design and illustration, book and magazine design, P-O-P display, mechanicals, retouching, airbrushing, posters, model making, charts/graphs, lettering and logos. Prefers pen & ink, airbrush, colored pencil, marker and calligraphy.
First Contact & Terms: Send query letter with brochure showing art style or resume and tearsheets, photostats, photocopies, slides or photographs. Samples are filed or are returned if accompanied by a SASE. Reports back only if interested. Call to schedule an appointment to show a portfolio. Mail b&w and color thumbnails, roughs, original/final art, final reproduction/product, tearsheets, photostats, photographs. Pays for design by the hour, $25-50; by the project, $100 minimum; by the day, $250 minimum. Pays for illustration by the project, $75 minimum. Rights purchased vary according to project.
Tips: "Think of how you can be of service to us—not how we can be of service to you. Send promotional piece, then follow up with a phone call. Be succinct, businesslike. Respect my time."

ERIKSON/DILLON ART SERVICES, 31 Meadow Rd., Kings Park NY 11754-3812. (516)544-9191. Art Director: Toniann Dillon. Specializes in publications and technical illustration. Clients: book publishers. Current clients include: Lab Aids, Inc., and Global Book Co. Client list not available.
Needs: Approached by 25 freelance artists/year. Works with 8-10 freelance artists/year and 2 freelance designers/year. Local artists only. Uses artists for advertising illustration, book design and illustration, mechanicals, retouching and charts/graphs.
First Contact & Terms: Send query letter with resume and photocopies to be kept on file. Samples not kept on file are not returned. Does not report back. Call to schedule an appointment to show a portfolio, which should include final reproduction/product. Pays for design by the hour, $4.50-20; by the project, $50-1,000; by the day, $40-100. Pays for illustration by the hour, $4.50-$9; by the project, $25-$100; by the day, $40-80. Considers complexity of project and client's budget when establishing payment.
Tips: "Presentation should be at a size that can be accessed in a filing system. Leave copies of samples as reminder. Send updated samples. Call first—show only work relative to my needs."

***STAN EVENSON DESIGN, INC.,** 4445 Overland Ave., Culver City CA 90230. (213)204-1995. FAX: (213)204-4879. Production Manager: Brandi Miles. Estab. 1977. Specializes in annual reports, brand identity, corporate identity, display design, direct mail design, package design and signage. Clients: ad agencies, hospitals, corporations, law firms, record companies, publications, public relations firms. Current clients include: Arco, Architectural Digest, Coldwell Banker, Capitol Records, Word Records, Sealy, Saint Joseph Medical Center, Saint Johns Hospital and Health Center, Mattel Toys.
Needs: Approached by 75-100 freelance artists/year. Works with 20-25 freelance illustrators and 10 freelance designers/year. "We have regular people we work with on regular basis throughout the year." Prefers artists with production experience as well as strong design capabilities. Works on assignment only. Uses illustrators mainly for covers for corporate brochures, as well as various project for all clients. Uses freelance designers mainly for logo design, page layouts, all overflow work. Also uses freelance artists for brochure design and illustration, catalog design, mechanicals, lettering, logos, ad design, catalog illustration, P-O-P design and illustration, poster illustration and design, direct mail design, charts/graphs and ad illustration.
First Contact & Terms: Send query letter with resume. Also has drop-off policy. Samples are filed. Returned by SASE if requested by artist. Reports back to the artist only if interested. Call to schedule an appointment to show a portfolio. Portfolio should include b&w and color photostats and tearsheets, 4×5 or larger transparencies. All work must be printed or fabricated in form of tearsheets, transparencies or actual piece. Pays

for design by the hour, $12.50-25. Pays for illustration, by the project, $100-5,000. Rights purchased vary according to project.

FINN STUDIO LIMITED, 154 E. 64th St., New York NY 10021. (212)838-1212. Creative Director: Finn. Estab. 1970. Clients: theatres, boutiques, magazines, fashion and ad agencies.
Needs: Uses artists for T-shirt designs, illustrations, calligraphy; creative concepts in art for fashion and promotional T-shirts.
First Contact & Terms: Mail slides. SASE. Reports within 4 weeks. Pays $50-500; sometimes also offers royalty.
Tips: "Too often artists bring in the wrong media of art for the product."

FITZPATRICK DESIGN GROUP, Suite 203, 2109 Broadway, New York NY 10023. (212)580-5842. Vice President: Robert Herbert. Retail planning and design firm. Current clients include: Bloomingdale's, Jordan Marsh, Neiman Marcus, British Home Stores, Century 21, Dayton Hudson, Host/Marriott, Jenss. Client list available upon request (for potential clients only).
Needs: Approached by 10-20 freelance artists/year. Works with 2 freelance illustrators and 1 freelance designer/year. Prefers experienced freelancers with references. Works on assignment only. Uses freelance artists for interior design and renderings and design consulting.
First Contact & Terms: Send query letter with brochure showing art style or resume. Samples are filed. Samples not filed are returned by a SASE only if requested. "We usually ask the artist to call after we have had time to review the material." Write to schedule an appointment to show a portfolio, which should include photographs and whatever materials the artist thinks are pertinent. Negotiates payment. Considers complexity of project, skill and experience of artist, turnaround time and client's budget when establishing payment.
Tips: "While it is good to have an overall view of your work, you should also include specifics that relate to what we need done. For example, we primarily specialize in retail stores; we want to see examples of your experience in that area. Never call 'out of the blue.' Never show up without an appointment, and ask if there are specifics that you need to bring with you."

FREELANCE EXPRESS, INC., 111 E. 85th St., New York NY 10028. (212)427-0331. Multi-service company. Estab. 1988.
Needs: Uses artists for cartoons, charts, graphs, illustration, layout, lettering, logo design and mechanicals.
First Contact & Terms: Mail resume and photocopied samples that need not be returned. "Say you saw the listing in *Artist's Market*." Provide materials to be kept on file for future assignments. No originals returned to artist at job's completion.

FREEMAN DESIGN GROUP, 415 Farms Rd., Greenwich CT 06831. (203)968-0026. President: Bill Freeman. Estab. 1972. Specializes in annual reports, corporate identity, package and publication design and signage. Clients: corporations. Current projects include annual reports and company magazines. Current clients include: Pitney Bowes, Continental Grain Co., IBM Credit, Coldwell Banker Commercial. Client list available upon request.
Needs: Approached by 35 freelance artists/year. Works with 5 freelance illustrators and 5 freelance designers/year. Prefers artists with experience in production. Works on assignment only. Uses illustrators for mechanicals, retouching and charts/graphs. Needs editorial and technical. Looking for editorial illustration with "montage, minimal statement."
First Contact & Terms: Send query letter with brochure showing art style, resume and tearsheets. Samples are filed or are returned if accompanied by SASE. "Does not report back." Call to schedule an appointment to show a portfolio or mail original/final art and tearsheets. Pays for design by the hour, $15-25; by the project, $150-3,000.
Tips: "Send us a sample of a promotional piece."

HELENA FROST ASSOCIATES, LTD., Maple Rd., Brewster NY 10509. (914)279-7923; 301 E. 21st St., New York NY 10010. (212)475-6642. President: Helena R. Frost. Estab. 1986. Specializes in packaging, publications and textbooks "at all levels in all disciplines," corporate communications and catalogues. Clients: publishers. Current clients include: Carriage House, Vital and Research Plus.
Needs: Works with over 100 freelance artists/year. Works on assignment only. Prefers realistic style. Uses artists for book design, editorial and technical, mechanicals and charts/graphs.
First Contact & Terms: Send query letter with brochure. Samples are filed or are returned only if requested by artist. Does not report back. Write to schedule an appointment to show a portfolio, which should include roughs, final reproduction/product and tearsheets. Pays for design and illustration by the project. Considers client's budget, turnaround time and rights purchased when establishing payment. Buys one-time rights.

FUNK & ASSOCIATES GRAPHIC COMMUNICATIONS, 1234 Pearl St., Eugene OR 97401. (503)485-1932. President/Creative Director: David Funk. Estab. 1980. Specializes in annual reports, corporate identity, direct mail, package and publication design and signage. Clients: corporations, primarily industrial and high

tech. Current clients include: Spectra Physics, Department of Agriculture City of Eugene, Whittier Wood Producers. Client list available upon request.

Needs: Approached by 50-100 freelance artists/year. Works with 8-12 freelance illustrators and 10 freelance designers/year. "We have a wide variety of clients with diverse needs." Uses illustrators mainly for conceptual and technical illustration. Uses designers mainly for overflow projects and specialized skills. Also uses artists for brochure design, brochure illustration, mechanicals, lettering, P-O-P design, poster and ad illustration.

First Contact & Terms: Send query letter with resume and photocopies. Samples are filed. Reports back only if interested. Write to schedule an appointment to show portfolio. Portfolio should include thumbnails, roughs, original/final art and transparencies. Pays for design by the hour, $15-45, by the project, $200-5,000. Pays for illustration by the hour, $15 minimum. "Payment is usually done by bid." Negotiates rights purchased, and rights purchased vary according to project.

STEVE GALIT ASSOCIATES, INC., 5105 Monroe Rd., Charlotte NC 28205. (704)537-4071. President: Stephen L. Galit. Specializes in annual reports, corporate identity, direct mail, publications and technical illustrations. Clients: ad agencies and corporations.

Needs: Works with 15 freelance artists/year. Looks for "expertise, talent and capability." Uses freelance artists for brochure and catalog illustration, retouching, airbrushing, model making, charts/graphs, lettering.

First Contact & Terms: Send query letter with brochure showing art style or tearsheets, photostats, photocopies, slides or photographs. Samples are filed or are returned if accompanied by a SASE. Reports back only if interested. Call or write to schedule an appointment to show a portfolio. Negotiates payment. Considers client's budget, skill and experience of artist and how work will be used. Rights purchased vary according to project.

***GERALD & CULLEN RAPP, INC.,** 108 E. 35th St., New York NY 10016. (212)889-3337. FAX: (212)889-3341. Associate: Carla Hansen. Estab. 1945. Clients: ad agencies, coporations and magazines. Client list not available.

Needs: Approached by 250 freelance artists/year. Works with 25 freelance illustrators. Works on assignment only. Uses freelance illustrators mainly for advertising illustration. Uses freelance designers mainly for direct mail pieces. Also uses freelance artists for brochure design and illustration, mechanicals, retouching, airbrushing, lettering, logos, ad design, P-O-P illustration, poster illustration and design, direct mail design and ad illustration.

First Contact & Terms: Send query letter with tearsheets and SASE. Samples are filed or returned by SASE if requested by artist. Reports back within 2 weeks. Call or write to schedule an appointment to show a portfolio. Mail appropriate materials. Pays for design by the project, $500-10,000. Pays for illustration by the project, $500-40,000. Negotiates rights purchased.

GILLIAN/CRAIG ASSOCIATES, INC., Suite 301, 165 8th St., San Francisco CA 94103. (415)558-8988. President: Gillian Smith. Estab. 1984. Specializes in annual reports, corporate identity, package and publication design and signage.

Needs: Works with 3-4 freelance illustrators/year. Prefers artists with experience in Macintosh computer design. Works on assignment only. Uses illustrators mainly for annual reports, sometimes brochures or collateral. Uses designers mainly for production, "but almost never" uses designers.

First Contact & Terms: Send query letter with brochure, resume and tearsheets. Samples are filed or are returned if accompanied by a SASE. Reports back only if interested. To show a portfolio, mail appropriate materials or drop off portfolio. Pays by the project, $100-3,500, "depending on nature of project and amount of work." Rights purchased vary according to project.

***ERIC GLUCKMAN COMMUNICATIONS, INC.,** 24 E. Parkway., Scarsdale NY 10583. (914)723-0088. President: Eric Gluckman. Estab. 1973. Specializes in corporate identity, direct mail, publications, industrial advertising and promotion, corporate capability brochures and sales promotion (trade) for mostly industrial accounts. "We are a 'general practice' design firm. We usually deal directly with client." Clients: Brennan Communications, RJG Inc., NDR Industries

Needs: Works with 20 freelance artists/year. Artists should have 3 years of experience minimum. "All rights to art and photography revert to client." Works on assignment only. Uses artists for design, illustration, brochures, mechanicals, retouching, airbrushing, direct mail packages, posters, charts/graphs, lettering, computer generated art, logos and advertisements. Prefers pen & ink and acrylics. Also uses freelance artists for editorial and technical illustration.

First Contact & Terms: Send query letter with resume and samples to be kept on file. No slides as samples. Samples not kept on file returned by SASE. Reports only if interested. Call or write for appointment to show portfolio. Pays for design by the hour, $20-40; by the project, $200-open. Pays for illustration by the project, $100-3,000. Considers complexity of project, client's budget, skill and experience of artist, and turnaround time when establishing payment. Buys all rights.

Tips: "Be professional, make deadlines. Send samples of published artwork, examples of camera ready art and one project from concept to finish (to show thought process). Do not show school projects or material five years old, unless it was an award winner."

***GODAT/JONCZYK DESIGN CONSULTANTS**, 807 S. 4th Ave., Tucson AZ 85701-2701. (602)620-6337. Partners: Ken Godat and Jeff Jonczyk. Estab. 1983. Specializes in annual reports, corporate identity, publication design and signage. Clients: corporations and public institutions. Current clients include Merrill Lynch, Impulse, IBM and Sunquest Information Systems.
Needs: Approached by hundreds of freelance artists/year. Works with 10-12 freelance illustrators/year.
First Contact & Terms: Send query letter with brochure. Samples are filed. Reports back to the artist only if interested. Mail appropriate materials. Pays for design and illustration by the job.

GOLDSMITH YAMASAKI SPECHT INC, Suite 510, 900 N. Franklin, Chicago IL 60610. (312)266-8404. Industrial design consultancy. President: Paul B. Specht. Specializes in corporate identity, packaging, product design and graphics. Clients: industrial firms, institutions, service organizations, ad agencies, government agencies, etc.
Needs: Works with 6-10 freelance artists/year. "We generally use local artists, simply for convenience." Works on assignment only. Uses artists for design (especially graphics), illustration, retouching, model making, lettering and production art. Prefers collage and marker.
First Contact & Terms: Send query letter with resume and samples to be kept on file. Samples not kept on file are returned only if requested. Reports only if interested. Call or write to schedule an appointment to show a portfolio, which should include roughs and final reproduction/product. Pays for design by the hour, $20 minimum. Pays for illustration by the project; payment depends on project. Considers complexity of project, client's budget, skill and experience of artist, how work will be used, turnaround time and rights purchased when establishing payment.
Tips: "If we receive many inquiries, obviously our time commitment may necessarily be short. Please understand. We use very little outside help, but it is increasing (mostly graphic design and production art)."

ALAN GORELICK DESIGN, INC., Marketing Communications, Suite 301, High St. Court, Morristown NJ 07960-6807. (201)898-1991. President/Creative Director: Alan Gorelick. Estab. 1974. Specializes in corporate identity, displays, direct mail, signage, technical illustration and company and product literature. Clients: health care and pharmaceutical corporations, industry, manufacturers. Client list not available.
Needs: Approached by 150 freelance artists/year. Works with 10 freelance illustrators and 20 freelance designers/year. Works with "seasoned professional or extremely talented entry-level" artists only. Uses artists for design, illustration, brochures, mechanicals, retouching, airbrushing, posters, direct mail packages, charts/graphs, logos and advertisements.
First Contact & Terms: Send query letter with brochure, resume, business card, photostats, slides, photocopies and tearsheets to be kept on file. Samples not filed are returned by SASE only if requested. Reports only if interested. Write for appointment to show portfolio, which should include color and b&w thumbnails, roughs, original/final art, final reproduction/product, tearsheets, photostats and photographs. Pays for design by the hour, $20-50. Pays for illustration by the hour, $15-50; by the project, $250-5,000. Considers complexity of project, client's budget, and skill and experience of artist when establishing payment.
Tips: Requires "straight talk, professional work ethic and commitment to assignment." Looking for "neat work, neat appearance, and a broad selection from rough to finish. 'Current' printed pieces."

***GOTTLIEB DESIGN**, 1259 Folsom St., San Francisco CA 94103. (415)552-6565. FAX: (415)552-6565. Contact: Michael Gottlieb. Estab. 1979. Specializes in annual reports, corporate identity, corporate collateral. Clients: corporations. Current clients include Laserscope, Sierra Ventures Management Company, Leon A. Farley Associates. Client list available upon request.
Needs: Approached by 12 freelance artists/year. Works with 2 freelance illustrators and 3 freelance designers/year. Prefers local artists only. Works on assignment only. Uses freelance illustrators mainly for spot illustrations. Also uses freelance artists for brochure design and illustration, mechanicals, airbrushing, logos and computer design.
First Contact & Terms: Send query letter with brochure and resume. Samples are filed. Reports back to the artist only if interested. Call to schedule an appointment to show a portfolio. Portfolio should include thumbnails, roughs, original/final art, color. Pays for design by the hour, $15-25. Pays for illustration by the hour, $15-25; by the project, $200-1,000. Buys one-time rights. Negotiates rights purchased.

TOM GRABOSKI ASSOCIATES, INC., Suite 11, 3315 Rice St., Coconut Grove FL 33133. (305)445-2522. FAX: (305)445-5885. President: Tom Graboski. Estab. 1980. Specializes in exterior/interior signage, environmental graphics, corporate identity, publication design and print graphics. Clients: corporations, museums, a few ad agencies. Current clients include Universal Studios, Florida, Royal Caribbean Cruise Line and The Equity Group.

Needs: Approached by 50-80 freelance artists/year. Works with approximately 4-8 freelance designers/mechanical artists/draftspersons/year. Prefers artists with a background in signage and knowledge of architecture. Freelance artists used in conjunction with signage projects, occasionally miscellaneous print graphics.
First Contact & Terms: Send query letter with resume. "We will contact designer/artist to arrange appointment for portfolio review. Portfolio should be representative of artist's work and skills; presentation should be in a standard portfolio format." Pays by the hour. Rights purchased vary per project.

GRAFICA DESIGN SERVICE, 7053 Owensmouth Ave., Canoga Park CA 91303. (818)712-0071. FAX: (818)348-7582. Designer: Larry Girardi. Estab. 1974. Specializes in corporate identity, package and publication design, signage and technical illustration. Clients: ad agencies, corporations, government, medium size businesses. Current clients include West Oaks Advertising, C.R. Laurence, Windsor Publications. Client list available upon request.
Needs: Approached by 25-50 freelance artists/year. Works with 5-10 freelance illustrators and designers/year. Prefers local artists and artists with experience in airbrush and Apple Macintosh computer graphics. Works on assignment only. Uses illustrators mainly for technical illustration and airbrush illustration. Uses designers mainly for design-layout/thumbnails and comps. Also uses artists for brochure design and illustration, catalog design, mechanicals, retouching, airbrushing, lettering, logos, ad design, catalog illustration, P-O-P illustration, charts/graphs, ad illustration and Mac-computer production.
First Contact & Terms: Send query letter with brochure, resume, SASE, tearsheets, photographs, photocopies, photostats and slides. Samples are filed or are returned by SASE if requested. Reports back only if interested. To show a portfolio, mail thumbnails, roughs, b&w and color photostats, tearsheets, photographs, slides and transparencies. Pays for design by the hour, $15-50; by the project, $100-5,000. Pays for illustration by the hour and by the project. "The payment is based on the complexity of the project, the budget and the experience of the artist." Rights purchased vary according to project.

GRAHAM DESIGN, Suite 210, 1825 K St. NW, Washington DC 20007. (202)833-9657. FAX: (202)466-8500. Contact: Art Director. Estab. 1947. Specializes in annual reports, corporate identity, publication design and signage. Clients: corporations, associations and the government. Current clients include Heritage Foundation and Palmer National Bank. Client list available upon request.
Needs: Approached by "too many" freelance artists/year. Works with 12 freelance illustrators and 12 freelance designers/year. Prefers local artists only. Works on assignment only. Also uses artists for brochure design and illustration, mechanicals, airbrushing and logos.
First Contact & Terms: Send query letter with brochure and resume. Samples are filed. Does not report back, in which case the artist should call. Call or write to schedule an appointment to show a portfolio, which should include b&w and color thumbnails, photostats, slides, roughs, tearsheets, transparencies, original/final art and photographs. Pays for design and illustration by the hour, $30 minimum. Negotiates rights purchased.

GRAPHIC ART RESOURCE ASSOCIATES, 257 West 10th St., New York NY 10014-2508. (212)929-0017. FAX: (212)929-0017. Owner: Robert Lassen. Estab. 1980. Specialties include annual reports, corporate identity, direct mail design, publication design, trade show exhibits, P-O-P signage, print advertising and marketing communications. Clients: corporations and institutions. Current clients include United Mineral and Chemical Corp., Columbia University, Disability Income Services, and Comvest Corp. Client list "is always in flux."
Needs: Approached by 24 freelance artists/year. Works with 1 freelance illustrator/year. Prefers "style compatability with my conceptual approach and professionalism, flexibility and ability to follow instructions." Works on assignment only. Uses illustrators mainly "to provide effects I can't get with photos, including computer graphics." Uses designers mainly "to offer alternatives to my own designs." Also uses artists for retouching, airbrushing, lettering, model making, charts/graphs, ad illustration, computer graphics and mechanicals.
First Contact & Terms: "Send anything you have which shows what you do. Do not send irreplacable originals." Some samples are filed; samples not filed are not returned. Does not report back, in which case artist should wait until he or she is called. Call to schedule an appointment to show portfolio. Portfolio should include whatever artist thinks is appropriate. Pays by the project, $150. Pays for illustration by the project, $150. Rights purchased vary according to project.
Tips: Finds that "many young designers make designs for design's sake and lack awareness of design as a marketing tool. Don't show me fashion. Don't show me proportional distortion except as humor. Don't show me bad typography. We are presently shifting toward high-tech."

***THE GRAPHIC CENTER, INC.**, 60 Madison Ave., New York NY 10010. (212)686-6585. FAX: (212)779-0647. President: Harvey Schlackman. Estab. 1978. Specializes in direct mail design and package design. Clients: corporations. Current clients include Park-Davis, Ciba Giegy, Key Scherring. Client list available upon request.

Needs: Approached by 12+ freelance artists/year. Works with 6-7 freelance illustrators and 2-3 freelance designers/year. Prefers artists with experience in packaging design and construction, pharmaceutical and direct mail concepts. Works on assignment only. Uses freelance artists for brochure design, mechanicals, retouching, lettering, logos, ad design, model making, direct mail design and ad illustration.

First Contact & Terms: Send query letter with brochure, slides and photocopies. Samples are filed or are returned by SASE if requested by artist. Reports back to the artist only if interested. Call to schedule an appointment to show a portfolio. Mail appropriate materials. Portfolio should include roughs and slides. Pays for design and illustration by the project, $100. Buys all rights.

GRAPHIC DATA, 804 Tourmaline St., San Diego CA 92109. (619)274-4511. President: Carl Gerle. Estab. 1971. Specializes in publication design. Clients: industrial and publishing companies. Current clients include IEEE and FBI. Client list available upon request.

Needs: Approached by 20 freelance artists/year. Works with 2 freelance illustrators and 4 freelance designers/year. Prefers local artists and designers with interest in using computer design systems. Works on assignment only. Uses illustrators mainly for architectural, landscape and technical drawing. Uses designers mainly for architectural and publication design. Also uses artists for mechanicals, retouching, airbrushing, book design, poster illustration and design, model making and computer design. Needs technical and cartographic illustration. Looking for editorial illustration that is a thematic cartoon.

First Contact & Terms: Send query letter with brochure, resume and photostats. Samples are filed. Reports back to the artist only if interested. Write to schedule an appointment to show a portfolio. Portfolio should include whatever the artist thinks is appropriate. Pays for design and illustration by the hour, $10 minimum; by the project, $100. Rights purchased vary according to project.

GRAPHIC DESIGN CONCEPTS, 12515 Pacific Ave., Los Angeles CA 90066. (213)397-7153. President: C. Weinstein. Estab. 1980. Specializes in annual reports; corporate identity; displays; direct mail; package, publication and industrial design. "Our clients include public and private corporations, government agencies, international trading companies, ad agencies and PR firms." Current projects include new product development for electronic, hardware, cosmetic, toy and novelty companies.

Needs: Works with 15 freelance illustrators and 25 freelance designers/year. "Looking for highly creative idea people, all levels of experience." All styles considered. Uses illustrators mainly for commercial illustration. Uses designers mainly for product and graphic design. Also uses artists for brochure and catalog design and illustration; book, magazine, and newspaper design; P-O-P design and illustration; mechanicals; retouching; airbrushing; poster illustration and design; model making; direct mail design; charts/graphs; lettering; logos; advertisement design and illustration.

First Contact & Terms: Send query letter with brochure, resume, tearsheets, photostats, photocopies, slides, photographs and transparencies. Samples are filed or are returned if accompanied by SASE. Reports back within 10 days with SASE. Portfolio should include thumbnails, roughs, original/final art, final reproduction/product, tearsheets, transparencies and references from employers. Pays for design and illustration by the hour, $15 minimum. Considers complexity of project, client's budget, skill and experience of artist, how work will be used, turnaround time and rights purchased when establishing payment.

Tips: "Send a resume if available. Send samples of recent work or *high quality* copies. Everything sent to us should have a professional look. After all, it is the first impression we will have of you. Selling artwork is a business. Conduct yourself in a businesslike manner."

GRAPHIC DESIGN INC., 23844 Sherwood, Center Line MI 48015. (313)758-0480. General Manager: Norah Heppard.

Needs: Works on assignment only. Uses artists for brochure design; catalog design, illustration and layout; direct mail packages; advertising design and illustration; and posters.

First Contact & Terms: Send query letter with resume and photocopies. Samples are filed or are returned only if requested. Reports back within 1 week. Write to schedule an appointment to show a portfolio or mail thumbnails, roughs, original/final art, final reproduction/product and color and b&w tearsheets, photostats and photographs. Pays by the project, $50-2,000. Considers complexity of project, available budget, turnaround time and rights purchased when establishing payment. Buys all rights.

Tips: Artists must have the "ability to make deadlines and keep promises."

***APRIL GREIMAN, INC.,** Suite 211, 620 Moulton Ave., Los Angeles CA 90031. (213)227-1222. FAX: (213)227-8651. Production Manager: Elizabeth Bain. Estab. 1980. Specializes in corporate identity, interior design, publication design, signage. Clients: international corporations, museums, retail and universities. Current clients include: Xerox, MCA, MoMA, Vitra, CBS, Letraset. Client list available upon request.

Needs: Approached by 60+ freelance artists/year. Works with 1-4 freelance designers/year. Prefers artists with experience in computers, especially Macintosh. Uses freelance artists for brochure design and illustration, catalog design and illustration, mechanicals, retouching, airbrushing, lettering, logos, ad design and illustration, book, magazine and newspaper design, P-O-P design and illustration, poster illustration and design, model making, direct mail design, charts/graphs, audiovisual materials.

First Contact & Terms: Send query letter with resume and SASE. Samples are filed. Reports back to the artist only if interested. Mail appropriate materials.

GROUP FOUR DESIGN, 147 Simsbury Rd., Avon CT 06001-0717. (203)678-1570. Principal: Frank von Holzhausen. Specializes in corporate communications product design and packaging design. Clients: corporations dealing in consumer and office products.
Needs: Works with 5-10 freelance artists/year. Artists must have at least two years of experience. Uses artists for illustration, mechanicals, airbrushing and model making.
First Contact & Terms: Send query letter with resume and slides. Samples not filed are returned. To show a portfolio, mail roughs and original/final art. Pays mechanical artists by the hour, $12-20; pays for design by the hour, $25 and up. Considers client's budget, and skill and pertinent experience of artist when establishing payment.
Tips: "We look for creativity in all artists seeking employment and expect to see that in their resume and portfolio."

HAMMOND DESIGN ASSOCIATES, INC., 206 W. Main, Lexington KY 40507. (606)259-3639. FAX: (606)259-3697. Vice-President: Kelly Johns. Estab. 1986. Specializes in annual reports; brand identity and corporate identity; display, direct mail, package and publication design and signage. Clients: corporations, universities and colleges. Client list not available.
Needs: Approached by 20-24 freelance artists/year. Works with 7 freelance illustrators/year. Works on assignment only. Uses illustrators mainly for brochures and ad illustration. Also uses illustrators for airbrushing, lettering, P-O-P and poster illustration and charts/graphs.
First Contact & Terms: Send query letter with brochure or resume. Samples are filed or returned by SASE if requested by artist. Reports back only if interested. To show a portfolio, mail thumbnails, roughs, photostats and tearsheets. Pays for design and illustration by the hour, $10-65, by the project, $100-1,000, by the day, $85-250. Buys all rights.

***HARRISON DESIGN GROUP,** 665 Chestnut St., San Francisco CA 94133. (415)928-6100. FAX: (415)673-0243. Estab. 1980. Specializes in annual reports, brand identity, corporate identity, display design, interior design, package design and signage. Clients: corporations and businesses, some nonprofits. Current clients include: Levi Strauss & Co., The Shorenstein Company, Marketel International, Business-Arts Council. Client list available upon request.
Needs: Approached by 75-150 freelance artists/year. Works with 20 freelance illustrators and 5 freelance designers/year. Prefers artists with experience in strong, dramatic images, very sophisticated. Uses freelance illustrators mainly for annual reports and brochures, interior display renderings and computer illustration. Uses freelance designers mainly for project management and design – all projects including identity and packaging. Also uses freelance artists brochure design, lettering, logos, magazine design, charts/graphs and audiovisual material.
First Contact & Terms: Send query letter with resume, tearsheets, photographs and photocopies. Samples are filed. Reports back within 3 weeks. Write to schedule an appointment to show a portfolio. Mail appropriate materials. Portfolio should include thumbnails, roughs, original/final art, b&w or color photostats, tearsheets, photographs, slides or transparencies. Pays for design by the project, $10-25; pays for illustration by the project, $250-4,000. Negotiates rights purchased.

THOMAS HILLMAN DESIGN, 193 Middle St., Portland ME 04101. (207)773-3727. Design Director: Thomas Hillman. Estab. 1984. Specializes in annual reports, corporate identity, direct mail design, package design and publication design. Clients: businesses and corporations.
Needs: Approached by 30-50 freelance artists/year. Works with 6-12 freelance illustrators/year. Prefers local artists and artists with experience in illustration. Works on assignment only. Uses illustrators mainly for collateral. Also uses illustrators for medical, technical and editorial illustration; brochure, catalog and poster design.
First Contact & Terms: Send query letter with tearsheets and photocopies. Samples are filed. Samples not filed are returned by SASE if requested by artist. Reports back only if interested. To show a portfolio, call or mail tearsheets and copies. Pays for illustration by the hour, $20 minimum, or by the project, $75-2,000. Buys all rights, or rights purchased vary according to project.

DAVID HIRSCH DESIGN GROUP, INC., Suite 622, 205 W. Wacker Dr., Chicago IL 60606. (312)329-1500. President: David Hirsch. Specializes in annual reports, corporate identity, publications and promotional literature. Clients: PR, real estate, financial and industrial firms.
Needs: Works with over 30 freelance artists/year. Uses artists for design, illustrations, brochures, retouching, airbrushing, AV materials, lettering, logos and photography. Needs technical and spot illustration.
First Contact & Terms: Send query letter with promotional materials showing art style or samples. Samples not filed are returned by SASE. Reports only if interested. Call to schedule an appointment to show a portfolio, which should include roughs, final reproduction/product, tearsheets and photographs. Pays for

illustration by the project. Considers complexity of project, client's budget and how work will be used when establishing payment.

Tips: "We're always looking for talent at fair prices."

MEL HOLZSAGER/ASSOCIATES, INC., 19-19 Radburn Rd., Fair Lawn NJ 07410. (201)797-3619. FAX: (201)794-7763. Art Director: Mel Holzsager. Specializes in corporate identity, packaging and general graphic design. Clients: publishers, manufacturers.

Needs: Works with occasional freelance artists according to the work load. Prefers local artists. Uses artists for advertising and brochure illustration, mechanicals and retouching.

First Contact & Terms: Send brochure showing art style. Samples are filed and returned only if requested. Call or write to schedule an appointment to show a portfolio, which should include thumbnails, roughs and original/final art. Pays for design and illustration by the project, $50 minimum.

Tips: A mistake artists make is "trying to be too versatile. Specialization would be an advantage."

Los Angeles-based Elliot Hutkin, Inc. specializes in publication design for publishers and corporations. This cover and inside illustration were done for Benchmark, a quarterly magazine for Xerox customers. Robert Eklund, managing editor of the magazine, says the futuristic cover strongly conveys the idea of "looking toward the digital decade." The conceptual illustration by freelance artist Greg Hally poignantly reveals the piece of our private lives we often find ourselves sacrificing to work.

ELLIOT HUTKIN INC., 2253 Linnington Ave., Los Angeles CA 90064. (213)475-3224. Art Director: Elliot Hutkin. Estab. 1982. Specializes in publication design. Clients: corporations and publishers. Current projects: corporate and travel magazines, miscellaneous corporate publications. Current clients include: Xerox Corporation and International Destinations, Inc.

Needs: Works with 10 freelance illustrators and 1 freelance designer/year. Works on assignment only. Uses illustrators mainly for editorial illustration. Also uses artists for retouching, airbrushing, charts/graphs, lettering and logos. Style is eclectic.

First Contact & Terms: Send query letter with tearsheets, photocopies and photographs. Samples are filed or are returned if accompanied by a SASE. Reports back only if interested. Call to schedule an appointment to show a portfolio, which should include roughs, final reproduction/product, b&w and color tearsheets, photographs. Pays for design by the project, $125 minimum. Pays for illustration by the project, $75 minimum.

Tips: "Send samples of work (include *all* styles and black and white). Advertise in *LA Workbook*. Have local (LA) rep." Provide fax number if available.

Close-up

Marshall Arisman
Illustrator
New York, New York

Upon entering Marshall Arisman's Manhattan studio, one
is immediately struck by the power of the heavy, layered oil
paintings on the walls, demanding that one stop and gaze
into their deep and dark emotion. They are works which
speak hard truth in their portrayal of the complexity of the
human condition. Arisman eases into discussions of this
personal work, his life as an illustrator, what he hopes to

© Barbara Kelley 1991

impart to his School of Visual Arts students as the chairperson of the Masters of Fine Arts
program "Illustration as Visual Essay" — all with such fluidity that it is apparent they are
part of an organic whole.

A regular contributor to the Op-Ed page of *The New York Times*, he has a vast client
list: *The Nation, Esquire, Playboy, Omni, Sports Illustrated, Time, The Boston Globe Magazine,
The New York Times Magazine, Mother Jones* and *Rolling Stone*, among others. He has done
both record album and book covers and is presently collaborating on a book with Paul
Theroux. Yet at one point it was very unclear to Arisman where his career was headed.
After graduating from the Pratt Institute in graphic design, he was immediately hired as
an art director at General Motors. It wasn't until he got on the job and had to art direct
everyday that he realized he was never going to care about the work he was doing there
nor be good at it as a result.

Because he had especially disliked the fulltime aspect of the job and wanted more of a
physical and psychological connection to his work, he opted to give freelance illustration
a try, but there was a problem: "I couldn't draw and so I faked it," he says. "My first
portfolio was almost cartoony. I looked at illustrators that I didn't think drew very well and
tried to copy them. My work wasn't changing, wasn't growing. I think Cocteau once said
that in life no one gets to skip steps. It took me until I was 28 to realize that I'd simply
skipped the step of drawing."

He became obsessed with learning. He took classes, copied every page of Leonardo da
Vinci's notebook, and with drawing pad in hand, went to Central Park and the Metropolitan
Museum of Art, where he learned from the masters. Once he could draw, the world seemed
to open up to him. "For example, he says, "everyday for five years I had walked past a
liquor store at nine o'clock in the morning and seen a bunch of guys lined up, waiting for
it to open, and yet I'd never made a picture of it. Once I tapped this resource, I started
drawing these guys, the locks on the door I'd gone through for ten years, things that had
happened to me in Grand Central Station. I thought: This is really amazing."

Guns had been an integral part of his life while growing up in upstate New York; almost
everybody he knew, including his brother, carried one. Already cognizant of the potential
violence within all of us, he only needed to look around to see it further emphasized in
Vietnam, political assassinations and the Watts riots. Arisman felt himself pulled toward
the theme of violence and began a series of drawings on handguns. After a year and a half,
he had 75 drawings addressing violence, 45 of which he paid to have printed into a book
at the School of Visual Arts.

This book served as his portfolio and became the basis for the illustration work he received. With joy in his voice he says, "I suddenly found that I was doing drawings for publication based on pieces I had done for myself." It was a glorious moment for Arisman — to realize that the personal and the professional could merge.

He has no problem with being typecast as someone who does illustration of violent subject matter because he finds that when an editor wants an illustration for drug abuse, wife beating, war or psychosis, the editor usually wants a powerful image conveying a strong emotion. This in turn grants Arisman greater freedom.

Arisman's goal for himself and his students is to bring personal expression to illustration despite hindrances, often resulting from the power being with a magazine's editor instead of the art director. Consequently, he says, there is a "tendency to force the illustration into a kind of exact visualization of the text, which is why, he says, "illustration is presently suffering from a peculiar bastardization of Magritte [the surrealist painter]," and "the image makes no sense at all if you don't read the text."

Thus, the idea behind the program he developed at the School of Visual Arts is to do two things: "to get illustrators back to number one, their own subject matter (for which there is a writing component as well) and have them develop that idea in a series of images." When they leave the program, they will have a book in hand and be able to show art directors what they are interested in and what they do best, just as Arisman did in the mid-60s with his gun book.

Impact, a 40 × 60" oil on paper painting, is one of a series of works Arisman did to explore man's "unlocking of the nuclear Pandora's box," the potential for the annihilation of humanity by nuclear weapons. We should be reminded, Arisman writes, "that technology is only a tool for society to use creatively and responsibly, making it possible to express our humanity more fully. To do this, we must choose to live."

Reprinted with permission of Marshall Arisman.

"The real simple truth," he says, "is that you always get work based on what you show in your portfolio." If you show pieces with none of your content, the only link between the pieces will be your technical craft and you're going to get that kind of work back," he says. But "the moment you introduce content, it's almost impossible for the art director to separate that out."

Arisman finds it encouraging that illustrators can rely on the mail and no longer have to live in New York, the economics of which he says make life very difficult, and feels this is going to lead to more interesting work. When sending your work to an art director, Arisman advises never to send slides. "As much as people may claim they will project them, my experience is they don't. They hold them up, and slides in the business are throwaway items." He recommends at least getting 4 × 5 transparencies of one's work. "At least with a transparency," he says, "you have an accurate description of your work; if you put them in 8 × 10 black mattes, they're quite visible." In addition to your name and phone number, he emphasizes the importance of placing an image of your work on your business card. And he advises, include a short letter with response boxes for them to check. "Make them do something," he says. Leave a line for the person to sign her name, and always include a SASE. Then he says, you can start to develop an index file of art directors interested in your work. "If your work doesn't fit the publication," he says, "take it out of the file and keep going."

He urges the *Artist's Market* reader not to use the book blindly, for example, by mailing one's work to a magazine before becoming familiar with it. The problem with doing that, he says, is "rejection is difficult for everybody, and if you're going to get rejected, you have to get rejected by the right places—places which might use you." But to send your work to publications which publish work very different from yours "is crazy," he says, "because you'll never know that. You'll only get a rejection letter."

—Lauri Miller

———

IMAGE INK STUDIO, INC., 12708 Northup Way, Bellevue WA 98005. (206)885-7696. Creative Director: Dennis Richter. Specializes in annual reports, corporate identity and packaging for manufacturers. Current clients include: Olympic Stain, Weyerhaeuser Paper Company, Attachmate. Client list available.
Needs: Approached by 20 freelance artists/year. Works with 5 freelance illustrators and 15 freelance designers/year. Uses freelance artists for brochure and catalog illustration, mechanicals, retouching and airbrushing. Prefers pen & ink and airbrush.
First Contact & Terms: Send query letter with brochure showing art style or tearsheets. Samples are filed. Reports back only if interested. Call or write to schedule an appointment to show a portfolio, which should include tearsheets. Pays for illustration by the project, $50 minimum. Considers complexity of project, client's budget, skill and experience of artist and how work will be used when establishing payment. Buys one-time rights or all rights.

INDIANA DESIGN CONSORTIUM, INC., 416 Main St., Box 180, Lafayette IN 47902. (317)423-5469. Senior Art Director: Ellen Sprunger. Specializes in corporate identity, display, direct mail, publication, technical illustration and collateral. Clients: agricultural, health care, financial and business-to-business.
Needs: Approached by 5-10 freelance artists/year. Works with 5+ freelance illustrators and 3+ freelance designers/year. Prefers Midwest artists. Uses artists for brochure, catalog, ad, poster and P-O-P illustration; mechanicals; retouching; airbrushing; model making and lettering.
First Contact & Terms: Send resume, tearsheets and photocopies. Samples are filed or are returned by SASE. Reports back only if interested. Call or write to schedule an appointment to show a portfolio, which should include color tearsheets, final reproduction/product and photographs. Pays for design and illustration by the project. Considers complexity of project, client's budget, skill and experience of artist and turnaround time when establishing payment. Negotiates rights purchased.

INNOVATIVE DESIGN & GRAPHICS, Suite 214, 1234 Sherman Ave., Evanston IL 60202-1343. (708)475-7772. Contact: Tim Sonder and Maret Thorpe. Clients: magazine publishers, corporate communication departments, associations.

Needs: Works with 3-15 freelance artists/year. Local artists only. Uses artists for illustration and airbrushing.
First Contact & Terms: To show a portfolio, send query letter with resume or brochure showing art style, tearsheets, photostats, slides and photographs. Reports only if interested. Pays for illustration by the project, $100-700 average. Considers complexity of project, client's budget and turnaround time when establishing payment.
Tips: "Interested in meeting new illustrators, but have a tight schedule. Looking for people who can grasp complex ideas and turn them into high-quality illustrations. Ability to draw people well is a must. Do not call for an appointment to show your portfolio. Send non-returnable tearsheets or self-promos, and we will call you when we have an appropriate project for you."

Leonard's Metal, the company for whom Intelplex designed this logo, is a manufacturer and supplier of sheet metal and parts for commercial and military aircraft. Alan E. Sherman, president of Intelplex, says his design firm was chosen to update Leonard's Metal corporate identity "because of its technical expertise and experience serving the aircraft industry." This new trademark, Sherman says, "symbolizes a set of matched dies typically used to make complex aircraft parts. The color is an industrial metallic that closely resembles the aluminum and stainless materials most commonly used in the firm's work."

© Leonard's Metal

***INTELPLEX,** 12215 Dorsett Rd., Maryland Heights MO 63043. (314)739-9996. Owner: Acaw Sherman. Estab. 1954. Specializes in corporate identity, display design, package design and product design. Clients: manufacturers. Current clients include: Mark Andy Inc., Quickpoint and Key Industries. Client list not available.
Needs: Works with 3 freelance illustrators/year. Prefers local artists with technical knowledge. Works on assignment only. Uses freelance illustrators mainly for product illustration. Most design is done in-house. Also uses freelance artists for mechanicals, retouching, airbrushing and lettering.
First Contact & Terms: Visit if in area. Samples are not filed, and are returned. Reports back within days. Call to schedule an appointment to show a portfolio. Portfolio should include original/final art. Payment for design and illustration varies by project. Buys all rights.

PETER JAMES DESIGN STUDIO, 7520 NW 5th St., Plantation FL 33317. (305)587-2842. FAX: (305)587-2866. Creative Director: Jim Spangler. Estab. 1980. Specializes in business-to-business advertising, package design, direct mail advertising and corporate identity. Clients: manufacturers, corporations and hospitality companies. Client list available upon request.
Needs: Approached by dozens of freelance artists/year. Works with 6 freelance art directors and designers/year. Prefers local artists with 7 years experience minimum in corporate design. Also uses artists for illustration, mechanicals, retouching, airbrushing, lettering and logo design.
First Contact & Terms: Send query letter with samples, tearsheets, photocopies and resume. Samples are filed or returned by SASE if requested by artist. Reports back only if interested. Write to schedule an appointment to show a portfolio or mail tearsheets, comps and print samples. Pays for in-house design by the hour, $15-25. Pays for illustration by the project only. Rights purchased vary according to project.

JMH CORPORATION, 921 E. 66th St., Indianapolis IN 46220. (317)255-3400. President: J. Michael Hayes. Specializes in corporate identity, packaging and publications. Clients: publishers, consumer product manufacturers, corporations and institutions.
Needs: Works with 10 freelance artists/year. Prefers experienced, talented and responsible artists only. Works on assignment only. Uses artists for advertising, brochure and catalog design and illustration; P-O-P displays; mechanicals; retouching; charts/graphs and lettering.

First Contact & Terms: Send query letter with brochure/flyer, resume and slides. Samples returned by SASE, "but we prefer to keep them." Reporting time "depends entirely on our needs." Write for appointment. Pay is by the project for design and illustration. Pays $500-2,000/project average; also negotiates. Considers complexity of project, client's budget, skill and experience of artist, how work will be used, turnaround time and rights purchased when establishing payment.

Tips: "Prepare an outstanding mailing piece and 'leave-behind' that allows work to remain on file."

© JDG Inc. 1990

*These **National Shorthand Reporter** magazine covers were illustrated by two Virginian freelancers: Annie Lunsford and Richard Steadham. Lunsford, who did the hourglass piece, was discovered by Johnson Design Group president and creative director Leonard Johnson via a Washington sourcebook. What attracted him to her work was her "dramatic rendering of lighting." He was impressed with her accommodation to changes and ability to meet deadline. With Steadham, it was the unique style conveyed in his mailed self-promotion that landed him this assignment. He created the acrylic piece from a layout and had two weeks to complete it.*

JOHNSON DESIGN GROUP, INC., Suite 410, 200 Little Falls St., Falls Church VA 22046. (703)533-0550. Art Director: Leonard A. Johnson. Specializes in publications. Clients: corporations, associations and PR firms. Client list not available.

Needs: Approached by 15 freelance artists/year. Works with 15 freelance illustrators and 5 freelance designers/year. Works on assignment only. Uses artists for brochure and book illustration, mechanicals, retouching and lettering. Especially needs line illustration and a realistic handling of human figure in real-life situations.

First Contact & Terms: Send query letter with brochure/flyer and samples (photocopies OK) to be kept on file. Samples are not returned. Negotiates payment by the project.

Tips: The most common mistakes freelancers make in presenting samples or portfolios are "poor quality or subject matter not relevant." Artists should "have a printed 'leave behind' sheet or photocopied samples that can be left in the art director's files."

BRENT A. JONES DESIGN, 328 Hayes St., San Francisco CA 94102. (415)626-8337. Principal: Brent Jones. Estab. 1983. Specializes in corporate identity, brochure design and advertising design. Clients: corporations, museums, book publishers, retail establishments. Current clients include: San Francisco Symphony, Crown Point Press and the California Academy of Sciences. Client list availble upon request.

Needs: Approached by 1-3 freelance artists/year. Works with 2 freelance illustrators and 1 freelance designer/year. Prefers local artists only. Works on assignment only. Uses illustrators mainly for renderings. Uses designers mainly for production. Also uses artists for brochure design and illustration, mechanicals, catalog illustration, charts/graphs and ad design and illustration. "Computer literacy a must."

First Contact & Terms: Send query letter with brochure and tearsheets. Samples are filed and are not returned. Reports back within 2 weeks only if interested. Write to schedule an appointment to show a portfolio, which should include slides, tearsheets and transparencies. Pays for design by the hour, $15-25. Rights purchased vary according to project.

***JSMANDLE & COMPANY, INC.**, Box 1248, Paramus NJ 07652. (201)967-7900. FAX: (201)967-0663. President: James Mandle. Estab. 1983. Specializes in brand identity, corporate identity and package design. Clients: primarily corporations. Current clients include: Warner Lambert, Kraft, FMC, Kiwi Brands, Binney & Smith. Client list available upon request.
Needs: Approached by 10-12 freelance artists/year. Works with 2-3 freelance illustrators and 2-3 freelance designers/year. "We like to establish long-term relationships with a few excellent professionals." Works on assignment only. Uses freelance illustrators and designers mainly for package design and concept development. Also uses freelance artists for retouching, airbrushing, lettering and P-O-P illustration.
First Contact & Terms: Send query letter with brochure, resume, photographs and slides. Samples are filed. Reports back to the artist only if interested. Write to schedule an appointment to show a portfolio. Portfolio should include thumbnails, roughs, original/final art and photographs.

JUNGCLAUS & KREFFEL DESIGN STUDIO (formerly Frederick Jungclaus, Designer/Illustrator), 145 E. 14th St., Indianapolis IN 46202. (317)636-4891. Owners: Fred Jungclaus and Mike Kreffel. Specializes in architectural renderings, illustration, graphic design, cartoons, and display models. Clients: ad agencies, architects, and publishing companies. Current clients include: Indianapolis Motor Speedway, Kahn's Meats, JIST Works, Inc., and Kiwanis International. Client list not available.
Needs: Approached by 3-5 freelance artists/year. Works with 3-5 freelance illustrators and 2 freelance designers/year. Works on assignment only. Uses artists for retouching and airbrushing. Seeks artists capable of illustrating Indy-type race cars or antique cars.
First Contact & Terms: Send samples to be kept on file. Prefers prints or tearsheets as samples. Samples not filed are not returned. Call for appointment to show portfolio. Pays by the project. Considers skill and experience of artist and turnaround time when establishing payment.

AL KAHN GROUP, INC., 301 W. 57th St., New York NY 10024. (212)586-6086. Vice President Marketing: Michele Strub. Estab. 1976. Specializes in ERC (Emotional Response Communications), graphic design, brochures, videos/films, and promotional material. Clients: colleges, universities, nonprofit organizations, medical and high tech. Current clients include: Colorado Tech, Intertec, Synmex and Wilson College. Client list not available.
Needs: Approached by 90 freelance artists/year. Works with 15 photographers and 20 freelance designers/year. Prefers artists with experience in type, layout, grids, mechanicals, comps and creative visual thinking. Works on assignment only. Uses artists for rough comps, presentations, mechanicals, layout and general studio assistance. Also uses artists for model making, charts/graphs, logos, and advertisement, brochure and direct mail design.
First Contact & Terms: Send brochure/flyer or resume, slides, b&w photos and color washes. Samples returned only if requested. To show a portfolio, call to schedule an appointment. Portfolio should include thumbnails, roughs, final reproduction/product and b&w and color tearsheets, photostats, photographs and transparencies. Pays for design by the project, $200-3,000. Pays for illustration by the project, $300-1,500. Considers complexity of project and client's budget when establishing payment. Buys one-time rights.
Tips: "Call, send samples and arrange an interview. Creative thinking and a positive attitude are a plus." The most common mistake freelancers make in presenting samples or portfolios is "work does not match up to the samples they show." Would like to see more roughs and thumbnails.

KEITHLEY & ASSOCIATES, INC., 39 W. 14th St., New York NY 11001. (212)807-8388. Art Director: Monisha Sheth. Specializes in publications. Primary clients: publishing (book and promotion departments); secondary clients: small advertising agencies.
Needs: Works with 3-6 freelance artists/year. "Except for artists doing mechanicals and some design work, all work must be done in our studio. We prefer experienced artists (2 years minimum)." Uses artists for desktop publishing design, brochures, catalogs, books (design and dummy), mechanicals, retouching and charts/graphs.
First Contact & Terms: Call for appointment to show portfolio. Do not send samples. Reports only if interested. Pays for design by the hour, $18-25 average. Pays for mechanicals by the hour, $14-20 average. Considers client's budget, and skill and experience of artist when establishing payment.

KELLY & CO., GRAPHIC DESIGN, INC., 7490 30 Ave. N., St. Petersburg FL 33710. (813)341-1009. Art Director: Ken Kelly. Estab. 1972. Specializes in print media design, logo design, corporate identity, ad campaigns, direct mail, brochures, publications, signage and technical illustrations. Clients: industrial, banking, auto, boating, real estate, accountants, furniture, travel and ad agencies.

Needs: Works with 6 freelance artists/year. Prefers artists with a minimum of 5 years of experience. "Local artists preferred, in my office. Non-smokers. Must be skilled in all areas. Must operate stat camera and have a good working attitude. Must be balanced in all styles." Uses artists for design, illustrations, brochures, catalogs, magazines, newspapers, P-O-P displays, mechanicals, retouching, airbrushing, posters, model making, direct mail packages, charts/graphs, lettering and logos. Needs editoral and technical illustration. Prefers pen & ink, airbrush, colored pencil, watercolor, acrylics and markers.

First Contact & Terms: Send query letter with resume, tear sheets and photocopies, or "copies of work showing versatility." Samples are filed. Reports back only if interested. Write to schedule an appointment to show a portfolio, which should include roughs, tear sheets and b&w photocopies. Pays for design by the hour, $35-55. Pays for illustration by the hour, $65-95; by the day, $90-110. Considers complexity of project, client's budget, skill and experience of artist and turnaround time when establishing payment. Buys all rights.

Tips: "Don't smoke! Be highly talented in all areas with reasonable rates. Must be honest with a high degree of integrity and appreciation. Send clean, quality samples and resume. I prefer to make the contact."

LARRY KERBS STUDIOS INC., 419 Park Ave. S., New York NY 10016. (212)686-9420. Contact: Larry Kerbs or Jim Lincoln. Specializes in sales promotion design, some ad work and placement, annual reports, corporate identity, publications and technical illustration. Clients: industrial, chemical, medical device and insurance companies and travel and PR firms.

Needs: Works with 3 freelance illustrators and 1 freelance designer/month. New York, New Jersey and Connecticut artists only. Uses artists for direct mail, layout, illustration, slide sets, technical art, paste-up and retouching for annual reports, trade magazines, product brochures and direct mail. Especially needs freelance comps through mechanicals; type specification. Needs editorial and technical illustration. Looks for realistic editorial illustration, montages, 2-color and 4 color.

First Contact & Terms: Mail samples or call for interview. Prefers b&w line drawings, roughs, previously published work as samples. Provide brochures, business card and resume to be kept on file for future assignments. No originals returned to artist at job's completion. Pays by the hour, $20-25, paste-up; $25-35, comprehensive layout; $25-35, design; negotiates payment by the project for illustration.

Tips: "Improve hand lettering for comps; strengthen typographic knowledge and application." Freelancers used only for specialties (cartoonists, retouchers, lettering).

DON KLOTZ ASSOCIATES, 298 Millstone Rd., Wilton CT 06897. (203)762-9111. FAX: (203)762-9763. President: Don Klotz. Estab. 1965. Specializes in corporate identity and package design. Clients: corporations and small businesses. Client list available upon request.

Needs: Approached by 23 freelance artists/year. Works with 2 freelance illustrators/year. Prefers artists with experience in packaging and food illustration. Uses illustrators mainly for packaging and trade ads. Also uses artists for brochure design and illustration, mechanicals, airbrushing, book design and model making.

First Contact & Terms: Send query letter with tearsheets and resume. Samples are filed or are returned. Reports back only if interested. Call to schedule an appointment to show portfolio. Portfolio should include thumbnails, b&w roughs and tearsheets. Pays for design and illustration by the hour. Rights purchased vary according to project.

LORNA LACCONE DESIGN, 135 E. 55th St., 4th Floor, New York NY 10022. (212)688-4583. President: Lorna Laccone. Estab. 1975. Specializes in general graphic design of brochures, logos and promotionals for communications firms and major retailers.

Needs: Works with 20 freelance artists/year. Prefers reliable local freelancers to work on premises or off. Uses freelance artists for brochure design, mechanicals and airbrushing. Especially needs neat, clean, fast mechanicals, comps/layouts.

First Contact & Terms: Send query letter with samples. Samples are not filed but returned if accompanied by a SASE. Reports back within 7-10 days. To show a portfolio, mail roughs, original/final art and tearsheets. Pays for design and illustration by the hour or by the project. Considers complexity of project, project's budget and turnaround time when establishing payment.

***L&W DESIGN, INC.**, 4721 Laurel Canyon Blvd., Suite 203, N. Hollywood CA 91607. (818)769-5332. FAX: (818)769-9220. President: Murry Whiteman. Estab. 1981. Specializes in brand identity, coporate identity, display design, package design and publication design. Clients: ad agencies and coporations.

Needs: Approached by 100-200 freelance artists/year. Works with 50 freelance illustrators/year. Uses freelance illustrators mainly for ads. Uses freelance designers mainly for packages. Also uses freelance artists for brochure design and illustration, mechanicals, retouching, aibrushing, lettering and logos.

First Contact & Terms: Contact only through artist rep or send query letter with tearsheets and printed piece. Samples are filed. "If need immediately, will call. If not interested, ask to meet with." Call to schedule an appointment to show a portfolio. Pay for design varies by the project. Pays for illustration by the project, $750-5,000. Rights purchased vary according to project.

LEBOWITZ/GOULD/DESIGN, INC., 7 W. 22nd St., New York NY 10010. (212)645-0550. Associate: Cyndy Travis. Specializes in corporate identity, packaging, signage and product design. Clients: corporations, developers, architects, city and state agencies. Client list not available.

Needs: Approached by 12-15 freelance artists/year. Works with 2-3 freelance freelance illustrators/year. Works on assignment only. Uses freelance artists for mechanicals and drafting for architectural graphics.

First Contact & Terms: Send query letter with resume and slides. Samples are filed or are returned only if requested by artist. Call or write to schedule an appointment to show a portfolio, which should include roughs, final reproduction/product, photostats, photographs and reduced working drawings (where appropriate). Pays for mechanicals and drafting by the hour, $12 minimum. Considers client's budget and turnaround time when establishing payment. Buys all rights.

Tips: "Remember we do not always have free time to interview everyone that calls us—we look for people when we need them. We call you so make your resumes and samples available."

LEKASMILLER, 3210 Old Tunnel Rd., Lafayette CA 94549. (415)934-3971. Production Manager: Maria. Estab. 1979. Specializes in annual reports, corporate identity, direct mail and brochure design. Clients: corporate and retail. Current clients include: Civic Bank of Commerce, Tosco Refining Co., Voicepro and Ortho consumer products.

Needs: Approached by 75 freelance artists/year. Works with 1-3 freelance illustrators/year. Works with 5-10 freelance designers/year. Prefers local artists only with experience in design and production. Works on assignment only. Uses artists for brochure design and illustration, mechanicals, direct mail design, logos, ad design and illustration.

First Contact & Terms: Send resume and photocopies. Samples are filed or are returned if accompanied by a SASE. Reports back only if interested. To show a portfolio, mail thumbnails, roughs, final reproduction/product, tearsheets and transparencies. Pays by the hour, $8-12. Considers skill and experience of artist when establishing payment. Negotiates rights purchased.

Tips: "Mail resume and samples—then follow-up with a phone call."

LEO ART STUDIO, Suite 610, 320 Fifth Ave., New York NY 10001. (212)736-8785. Art Director: Robert Schein. Specializes in textile design for home furnishings. Clients: wallpaper manufacturers/stylists, glassware companies, furniture and upholstery manufacturers. Current clients include: Waverly, Burlington House, Blumenthal Printworks, Columbus Coated, Eisenhart Wallcoverings and Town and Country. Client list available upon request.

Needs: Approached by 35-50 freelance artists/year. Works with 1-2 freelance illustrators and 10-15 freelance designers/year. Prefers artists trained in textile field, not fine arts. Must have a portfolio of original art designs. Should be able to be in NYC on a fairly regular basis. Works both on assignment and speculation. Prefers realistic and traditional styles. Uses artists for design, airbrushing, coloring and repeats. "We are always looking to add full-time artists to our inhouse staff (currently at 7). We will also look at any freelance portfolio to add to our variety of hands."

First Contact & Terms: Send query letter with resume. Do not send slides. "We prefer to see portfolio in person. Contact via a phone is OK—we can set up appointments with a day or two notice." Samples are not filed and are returned. Reports back within 5 days. Call or write to schedule an appointment to show a portfolio, which should include original/final art. Pays for design by the project, $400-800. "Payment is generally two-thirds of what design sells for—slightly less if reference material art material, or studio space is requested." Considers complexity of project, skill and experience of artist and how work will be used when establishing payment. Buys all rights.

Tips: "Do not call if you are not a textile artist. Artists must be able to put design in repeat, do color combinations and be able to draw well on large variety of subjects—florals, Americana, graphics, etc. We will look at student work and advise if it is correct field. We do not do fashion or clothing design."

THE LEPREVOST CORPORATION, Suite 6, 29350 Pacific Coast Hwy., Malibu CA 90265. (213)457-3742. President: John LePrevost. Specializes in corporate identity, television and film design. Current clients include: Public Broadcasting Service (PBS), Pepperdine University.

✳ *The asterisk before a listing indicates that the listing is new in this edition. New markets are often the most receptive to freelance submissions.*

Needs: Approached by 30 freelance artists/year. Works with 10 freelance designers/year. Prefers "talented and professional" artists only. Works on assignment only. Uses artists for animation and film design and illustration; lettering and logo design. Animation and design becoming more sophisticated. Needs storyboards.

First Contact & Terms: Call for appointment. Samples not returned. Provide information to be kept on file for possible future assignments; reports back. Payment by the project for both design and illustration. Considers complexity of project, client's budget, skill and experience of artist, how work will be used, turnaround time and rights purchased when establishing payment.

WES LERDON ASSOCIATES, INDUSTRIAL DESIGN, Box 21204, 2403 Abington Rd., Columbus OH 43221-0204. (614)486-8188. Senior Designer: Mark Schultz. Estab. 1976. Specializes in corporate identity, technical illustration and product design. Clients: manufacturers of electronic, computer and medical products. Current clients include: Westinghouse, AEG, Harris and Gould. Client list not available.

Needs: Approached by 6-8 freelance artists/year. Works with 2 freelance illustrators and designers/year. Prefers artists with experience in product illustration. Uses illustrators mainly for products. Uses designers mainly for products and corporate identity. Also uses artists for mechanicals, logos, model making and product development.

First Contact & Terms: Send query letter with resume and photocopies. Samples and filed or returned. Reports back in 2 weeks. If does not report back, call as a follow-up. Call to schedule an appointment to show portfolio, which should include thumbnails, roughs, original/final art and b&w samples. Pays for design and illustration by the hour, $13-35. Rights purchased vary according to project.

Tips: The most common mistake freelancers make in presenting their work is "too much reliance on slides and not enough original art (slides look better than originals)."

LUCY LESIAK DESIGN, 445 East Illinois St., Chicago IL 60611. (312)836-7850. FAX: (312)836-7851. President: Lucy Lesiak. Estab. 1982. Specializes in corporate identity, publication design, book design and collateral. Clients: corporations, professional associations, non-profits. Current clients include: Scott Foresman and Co., Richard D. Irwin, Inc., and the College of American Pathologists. Client list available upon request.

Needs: Approached by 25-30 freelance artists/year. Works with 4-6 freelance illustrators and 2-3 designers/year. Works on assignment only. Uses editorial and technical illustrators mainly for educational text books. Uses designers mainly for book design. Also uses freelance artists for brochure design, mechanicals, retouching, airbrushing, lettering, poster illustration and charts/graphs.

First Contact & Terms: Send query letter with brochure, tearsheets, photographs, photocopies and slides. Samples are filed. Reports back only if interested. Call to schedule an appointment to show portfolio, which should include original/final art, slides and tearsheets. Pays for design by the hour, $25-40. Pays for illustration by the project, $500-1,500; by usage and size of illustration, $25-1,200. Rights purchased vary.

LESLEY-HILLE, INC., 32 E. 21st St., New York NY 10010. (212)677-7570. President: Valrie Lesley. Specializes in annual reports, corporate identity, publications, advertising and sales promotion. Clients: nonprofit organizations, hotels, restaurants, investment, oil and real estate, financial and fashion firms.

Needs: Works with "many" freelance artists/year. "Experienced and competent" artists. Uses artists for illustration, mechanicals, airbrushing, model making, charts/graphs, AV materials and lettering.

First Contact & Terms: Send query letter with resume, business card and samples to be kept on file. Accepts "whatever best shows work capability" as samples. Samples not filed are returned by SASE. Reports only if interested. Call or write for appointment to show portfolio. Pay varies according to project. Considers complexity of project, client's budget, skill, experience of artist, turnaround time when establishing payment.

Tips: Designers and artists must "be *able to do* what they say they can and agree to do . . . professionally and on time!"

***LIEBER BREWSTER CORPORATE DESIGN**, 324 W. 87 St., New York NY 10024. (212)874-2874. Partner: Anna Lieber. Estab. 1988. Specializes in annual reports, corporate identity, direct mail design, package design, publication design and signage. Clients: corporate, financial, and foodservice. Client list available upon request.

Needs: Approached by 100 freelance artists/year. Works with 10 freelance illustrators and 10 freelance designers/year. Prefers local artists only. Works on assignment only. Uses freelance illustrators mainly for newsletter and computer illustration. Uses freelance designers mainly for mechanicals, computer layout, comprehensives. Also uses freelance artists for brochure design, mechanicals, retouching, airbrushing, lettering, logos, ad design, direct mail design, charts/graphs, audiovisual materials and ad illustration.

First Contact & Terms: Send query letter with resume, tearsheets and photocopies. Samples are filed. Reports back to the artist only if interested. Mail appropriate materials. Portfolio should include b&w and color work. Pays for design by the hour. Pays for illustration by the project. Rights purchased vary according to project.

LORENC DESIGN, INC., Suite 460, 3475 Lenox Rd., Atlanta GA 30326. (404)266-2711. President: Mr. Jan Lorenc. Specializes in corporate identity, display, packaging, publication, architectural signage design and industrial design. Clients: developers, product manufacturers, architects, real estate and institutions. Current clients include: Gerald D. Hines Interests, MCI, City of Raleigh NC, City of Birmingham AL, HOH Associates. Client list available upon request.
Needs: Approached by 25 freelance artists/year. Works with 5 freelance illustrators and 10 freelance designers/year. Local senior designers only. Uses artists for design, illustration, brochures, catalogs, books, P-O-P displays, mechanicals, retouching, airbrushing, posters, direct mail packages, model making, charts/graphs, AV materials, lettering and logos. Needs editorial and technical illustrations. Especially needs architectural signage designers.
First Contact & Terms: Send brochure, resume and samples to be kept on file. Prefers slides as samples. Samples not kept on file are returned. Call or write for appointment to show portfolio, which should include thumbnails, roughs, original/final art, final reproduction/product and color photostats and photographs. Pays for design by the hour, $10-25; by the project, $100-3,000. Considers complexity of project, client's budget, and skill and experience of artist when establishing payment.
Tips: The most common mistake freelancers make in presenting samples or portfolios is "apologizing for problems in portfolios, problems with clients." Looks for "attention to detail."

LUBELL BRODSKY INC., Suite 1806, 21 E. 40th St., New York NY 10016. (212)684-2600. Art Director: Ed Brodsky and Ruth Lubell. Specializes in corporate identity, direct mail, promotion and packaging. Clients: ad agencies and corporations.
Needs: Works with 10 freelance artists/year. Works on assignment only. Uses artists for illustration, mechanicals, retouching, airbrushing, charts/graphs, AV materials and lettering.
First Contact & Terms: Send business card and tearsheets to be kept on file. Reports back only if interested. Considers complexity of project, client's budget, skill and experience of artist and turnaround time when establishing payment.

JACK LUCEY/ART & DESIGN, 84 Crestwood Dr., San Rafael CA 94901. (415)453-3172. Contact: Jack Lucey. Estab. 1960. Art agency. Specializes in annual reports, brand identity, corporate identity, publications, signage, technical illustration and illustrations/cover designs. Clients: businesses, agencies and freelancers. Current clients include U.S. Air Force, TWA Airlines, California Museum of Art & Industry, Lee Books, High Noon Books. Client list available upon request.
Needs: Approached by 12 freelance artists/year. Works with 2 freelance illustrators and designers/year. Uses mostly local artists. Uses artists for illustration and lettering for newspaper work. Especially needs agricultural painting and corporation illustrations. Prefers oil, watercolor and pen & ink. Uses freelancers mainly for type and airbrush.
First Contact & Terms: Query. Prefers photostats and published work as samples. Provide brochures, business card and resume to be kept on file for future assignments. No originals returned to artist at job's completion. Pays for design and illustration by the hour, $50 minimum.
Tips: "We would like to see an upgrade of portfolios." Some common mistakes freelancers make is "a limited variety of subject matter and often the use of only one medium used by artist; also limitation of b&w and no color or color and no b&w. I would like to see more comps and preliminary layouts and roughs along with the finished or camera-ready art work. (Some true idea of time involved to do roughs and complete finished art.) Roughs show thought process involved."

SUDI MCCOLLUM DESIGN, 3244 Cornwall Dr., Glendale CA 91206. (818)243-1345. FAX: (818)956-3347. Contact: Sudi McCollum. Specializes in corporate identity and publication design. Majority of clients are small to mid-size business. "No specialty in any one industry." Clients: corporations and small businesses. Current clients include Babcock & Brown, Miracle Method, Pebble Beach Company, DUX.
Needs: Approached by a few graphic artists/year. Works with a couple of freelance illustrators and a couple of freelance designers/year. Works on assignment only. Uses designers mainly for assistance in production. Also uses artists for retouching, airbrushing, catalog, editorial and technical illustration and charts/graphs.
First Contact & Terms: Send query letter with "whatever you have that's convenient." Samples are filed. Reports back to the artist only if interested. Write or call to schedule an appointment to show a portfolio. Portfolio should include tearsheets and original/final art. Pays for production by the hour, $20-30. Pays for design by the project, $250 minimum. Pays for illustration by the project, $500-3,500.

MCDANIEL ASSOCIATES, 724 Pine St., San Francisco CA 94108. (415)421-3133. Art Director: Jan Stageberg. Estab. 1978. Specializes in corporate identity, direct mail, package and publication design. Clients: Financial institutions, high-tech, toys, food and home products. Current projects include collateral design, brand identity, direct mail campaigns, package design, product support materials, logo and logotype design.
Needs: Approached by 50-75 freelance artists/year. Works with 3-4 freelance illustrators/year. Works with 20 freelance designers/year. Prefers local artists only. Works on assignment only. Prefers promotional and corporate, trendy b&w conservative styles. Uses illustrators mainly for spot illustrations, package design,

airbrush and line art. Uses designers mainly for packaging and collateral design. Also uses artists for brochure design, mechanicals, airbrushing, poster design, model making, direct mail design, charts/graphs, lettering and logos.

First Contact and Terms: Send resume, tearsheets, photostats, photocopies and photographs. Samples are filed or are returned only if requested by artist. Reports back only if interested. Write to schedule an appointment to show a portfolio or mail appropriate materials. Pays for design by the hour, $15-25. Pays for illustration by the project. Considers complexity of project, client's budget and skill and experience of artist when establishing payment. Rights purchased vary according to project.

Tips: "Be responsible to see the job through. Have excellent craftsmanship. Show attention to detail. Be serviceable. Let us know your role in producing the art—show sketches and marker comps if possible."

***MACEY NOYES ASSOCIATES, INC.,** 232 Danbury Rd., Wilton CT 06897. (203)762-9002. FAX: (203)762-2629. Designer: Dee Cavitt. Estab. 1979. Specializes in package design. Clients: corporations (marketing managers, product managers).

Needs: Approached by 25 freelance artists/year. Works with 2-3 freelance illustrators and 5 freelance designers/year. Prefers local artists only. Prefers artists with experience in package comps, Macintosh, and type design. Works on assignment only. Uses freelance illustrators mainly for ad slick, in use technical and front panel product. Uses freelance designers for conceptual layouts and product design. Also uses freelance artists for mechanicals, retouching, aibrushing, lettering, logos and industrial/structural.

First Contact & Terms: Send query letter with resume. Samples are filed or are returned by SASE if requested by artist. Reports back to the artist only if interested. Call to schedule an appointment to show a portfolio. Portfolio should include thumbnails, roughs and transparencies. Pays for design by the hour, project or day. Pays for illustration by the project. Negotiates rights purchased. Rights purchased vary according to project.

***MCGUIRE ASSOCIATES,** 1234 Sherman Ave., Evanston IL 60202. (708)328-4433. Owner: James McGuire. Estab. 1983. Specializes in annual reports, corporate identity, direct mail design, publication design and signage. Clients: ad agencies, direct with clients and marketing firms.

Needs: Works with 5 freelance illustrators/year. Prefers artists with experience in many areas of illustration. Needs editorial, technical and humorous illustration. Works on assignment only. Uses illustrators mainly for brochure, newsletters and ads. Also uses artists for mechanicals.

First Contact & Terms: Send query letter with resume, tearsheet, photostats, slides and photographs. Samples are filed. Samples not filed are returned only if requested by artist. Reports back only if interested. Call or write to schedule an appointment to show a portfolio, which should include b&w and color tearsheets, photostats, photographs and transparencies. Pays for design by the hour, $10-35. Pays for illustration by the project, $100-2,000. Considers complexity of project, client's budget, skill and experience of artist and how work will be used when establishing payment. Rights purchased vary according to project.

Tips: "Send samples of work to keep on file for reference. Do not take too long presenting your portfolio by including too many items."

***MCKENZIE AND COMPANY,** 175 Post Rd. W., Westport CT 06880. (203)454-2443. FAX: (203)454-0416. Specializes in annual reports, corporate identity, direct mail design and publication design.

Needs: Approached by 100 freelance artists/year. Works with 5 freelance designers/year. Uses freelance designers mainly for computer design. Also uses freelance artists for brochure and catalog design.

First Contact & Terms: Send query letter with brochure, resume, photographs and photocopies. Samples are filed or are returned by SASE if requested by artist. Write to schedule an appointment to show a portfolio. Portfolio should include slides. Pays for design by the hour, $15-30. Pays for illustration by the project, $150-3,000. Buys first rights. Rights purchased vary according to project.

TED MADER & ASSOCIATES, Suite 416, 911 Western, Seattle WA 98104. Creative Head: Ted Mader. Specializes in corporate identity, brand identity, displays, direct mail, fashion, packaging, publications and signage. Uses freelance artists for mechanicals, retouching, airbrushing, model making, charts/graphs, AV materials and lettering. Client list available upon request.

First Contact & Terms: Send resume and samples. Samples are filed. Write to schedule an appointment to show a portfolio. Considers skill and experience of artist when establishing payment. Rights purchased vary according to project.

MARKET DIRECT, INC., 301 S. Elmont Dr., Apache Junction AZ 85220-4722. (602)984-3301. President: Lanie Bethka. Estab. 1979. Specializes in brand identity, corporate identity and display, direct mail and package design. Clients: food and transportation companies, manufacturers, financial, medical and real estate firms. Current clients include University of Phoenix, Hi-Health Supermarts, A.S.U. Research Park.

Needs: Approached by 50-100 freelance artists/year. Works with 5 or 6 freelance illustrators and designers/year. Prefers local artists and artists with experience in product illustration, cartooning and direct mail. Works on assignment only. Uses illustrators mainly for product illustrations. Uses designers mainly for direct mail,

display and package design. Also uses brochure design and illustration, catalog design and illustration, airbrushing, P-O-P design and illustration, direct mail design and ad illustration. Types of illustration needed are editorial, medical and technical.

First Contact & Terms: Send query letter with brochure, tearsheets, photostats, resume, photographs, slides, photocopies and transparencies. Samples are filed or are returned. Does not report back, in which case the artist should call. "We contact when the project fits the artist's style or talent." Portfolio should include all that is appropriate. Pays for design by the hour, $55-100; by the project, $100-2,000. Pays for illustration by the hour, $45-100; by the project, $45-2,000. Rights purchased vary according to project.

***MARKETING BY DESIGN,** 2212 K St., Sacramento CA 95816. (916)441-3050. Creative Director: Joel Stinghen. Estab. 1977. Specializes in annual reports; coporate identity; display, direct mail, package and publication design; and signage. Client: associations and corporations. Client list not available.

Needs: Approached by 50 freelance artists/year. Works with 6-7 freelance illustrators and 1-3 freelance designers/year. Works on assignment only. Uses illustrators mainly for editorial. Also uses freelance artists for brochure design and illustration, catalog design and illustration, mechanicals, retouching, lettering, ad design and charts/graphs.

First Contact & Terms: Send query letter with brochure, resume, tearsheets. Samples are filed or are not returned. Does not report back, in which case the artist should call to follow up. To show a portfolio, mail roughs, b&w photostats, color tearsheets, transparencies and photographs. Pays for production by the hour, $7.50-15; by the project, $50-5,000. Pays for illustration by the project, $50-800. Rights purchased vary according to project.

STEVE MEEK INC., Suite 3-C, 743 W. Buena Ave., Chicago IL 60613. President: Steve Meek. Estab. 1986. Specializes in corporate identity and illustration. Clients: Fortune 500 corporations, small businesses, ad agencies, PR firms and art studios. Current clients include: USG, Canteen, Arthur Anderson, GBC and Pathway Financial. Client list not available.

Needs: Approached by 30 freelance artists/year. Works with 12 freelance illustrators/year. Works on assignment only. Prefers rough, loose style. Uses illustrators mainly for brochures and posters. Also uses artists for airbrushing and ad illustration.

First Contact & Terms: Send query letter with tearsheets and photocopies. Samples are filed or are not returned. Reports back within 1 month. Write to schedule an appointment to show portfolio, which should include final reproduction/product. Pays by the project, $500-2,500. Considers client's budget, skill and experience of artist, complexity of illustration and how work will be used when establishing payment. Buys one-time rights.

Tips: "Create your own world. I want to see true avant garde and innovation."

DONYA MELANSON ASSOCIATES, 437 Main St., Boston MA 02129. Contact: Donya Melanson. Art agency. Clients: industries, institutions, associations, publishers, financial and government. Current clients include: Hygienetics, Inc., The Seiler Corp., Cambridge College, American Psychological Association, Commonwealth of Massachusettes, Alliance to Save Energy and American Public Health Association. Client list available upon request.

Needs: Approached by 30 freelance artists/year. Works with 4-5 freelance illustrators/year. Most work is handled by staff, but may occasionally use illustrators and designers. Uses artists for stationery design, direct mail, brochures/flyers, annual reports, charts/graphs and book illustration. Types of illustration needed are editorial and promotional.

First Contact & Terms: Query with brochure, resume, photostats and photocopies. Reports in 1-2 months. Provide materials (no originals) to be kept on file for future assignments. Originals returned to artist after use only when specified in advance. To show a portfolio, call or write to schedule an appointment or mail thumbnails, roughs, original/final art, final reproduction/product and color and b&w tearsheets, photostats and photographs. Pays by the project for cartoons, design, illustration, lettering, retouching, technical art and logo design. Pays by the project for mechanicals. Considers complexity of project, client's budget, skill and experience of artist and how work will be used when establishing payment.

Tips: "Be sure your work reflects concept development. We would like to see more electronic design and illustration capabilities."

BOB MILLER & ASSOCIATES, Suite 100-B, 2012 H Street, Sacramento CA 95814. (916)448-3878. FAX: (916)448-2605. President: Bob Miller. Estab. 1978. Specializes in annual reports; corporate identity; signage; direct mail, package, publication and advertising design. Clients: food processor manufacturers, ad agencies, small manufacturers, museums and retailers. Current clients include: Farmers' Rice Cooperative, Blue Diamond Growers, Crystal Cream & Butter Co. and Mason Paint Co. Client list available upon request.

Needs: Approached by 40-50 freelance artists/year. Works with 1-2 freelance illustrators and designers/year. Prefers artists with experience in design and production. Works on assignment only. Uses illustrators mainly for "styles of illustration that can't be done by our studio." Uses designers mainly for "overflow work or a unique style." Also uses artists for brochure design and illustration; catalog, ad, book, magazine, newspaper,

P-O-P and direct mail design; mechanicals; retouching; airbrushing; lettering; illustration, poster design and illustration; model making and charts/graphs. Looking for editorial illustration that's descriptive.

First Contact & Terms: Send query letter with resume. Samples are filed or are not returned. Does not report back, in which case the artist should "follow up with a phone call." Call to schedule an appointment to show a portfolio. Portfolio should include "anything that will give creditability to portfolio." Pays for design by the hour, $12-15, by the day, $84-105. Pays for illustration by the project, $100-2,000. Rights purchased vary according to project.

Tips: Would like to see "more individualism—portfolios look too much alike."

MIRANDA DESIGNS INC., 745 President St., Brooklyn NY 11215. (718)857-9839. President: Mike Miranda. Estab. 1970. Specializes in "giving new life to old products, creating new markets for existing products, and creating new products to fit existing manufacturing/distribution facilities." Solving marketing problems, annual reports, corporate identity, direct mail, fashion, packaging, publications and signage. Clients: agencies, PR firms, corporate and retail companies. Current clients include: Kings Plaza, Albee Square Mall, Greater New York Savings Bank, Little Things. Client list not available.

Needs: Approached by 30 freelance artists/year. Mainly uses freelancers for mechanicals, editorial, food, fashion and product illustration; and design. Works with 20 freelance illustrators and 5 freelance designers/year. Works with all levels from juniors to seniors in all areas of specialization. Works on assignment only. Uses freelance artists for brochure design and catalog design and illustration, magazine and newspaper design, mechanicals, model making, direct mail packages, charts/graphs and design of advertisements.

First Contact & Terms: Send query letter with resume and photocopies. Samples are filed. Samples not filed are not returned. Does not report back. Call to schedule an appointment to show a portfolio, which should include thumbnails, roughs, original/final art and final reproduction/product. Pays for design and illustration by the hour, $10 minimum,"for juniors to whatever the market demands and budget permits." Considers complexity of project, client's budget and skill and experience of artist when establishing payment. Rights purchased vary according to project.

Tips: "Be professional. Show a variety of subject material and media."

MITCHELL STUDIOS DESIGN CONSULTANTS, 1111 Fordham Ln., Woodmere NY 11598. (516)374-5620. Principal: Steven E. Mitchell. Estab. 1922. Specializes in brand identity, corporate identity, display, direct mail and packaging. Clients: major corporations.

Needs: Works with 20-25 freelance artists/year. "Most work is done in our studio." Uses artists for design, illustration, mechanicals, retouching, airbrushing, model making, lettering and logos.

First Contact & Terms: Send query letter with brochure, resume, business card, photostats, photographs and slides to be kept on file. Reports only if interested. Call or write for appointment to show portfolio, which should include roughs, original/final art, final reproduction/product and color photostats and photographs. Pays for design by the hour, $25 minimum; by the project, $150 minimum. Pays for illustration by the project, $250 minimum. Considers complexity of project, client's budget, skill and experience of artist, how work will be used, turnaround time and rights purchased when establishing payment.

Tips: "Call first. Show actual samples, not only printed samples. Don't show student work."

MIZEREK ADVERTISING, 48 E. 43rd St., New York NY 10017. (212)986-5702. President: Leonard Mizerek. Estab. 1975. Specializes in catalogs, jewelry, fashion and technical illustration. Clients: corporations—various product and service-oriented clientele. Current clients include: Rolex, Leslies Jewelry, World Wildlife, Fortune Magazine and Time Life.

Needs: Approached by 20-30 freelance artists/year. Works with 10 freelance designers/year. Experienced artists only. Works on assignment only. Uses artists for design, illustration, brochures, retouching, airbrushing and logos. Needs technical illustration.

First Contact & Terms: Send query letter with tearsheets and photostats. Reports only if interested. Call to schedule drop off or an appointment to show a portfolio, which should include original/final art and tearsheets. Pays for design and illustration by the project, $500-3,500. Considers client's budget and turnaround time when establishing payment.

Tips: "Let the work speak for itself. Show commercial product work, not only magazine editorial. Keep me on your mailing list! The recession is increasing our use of freelancers."

***MOLLY DESIGN COMPANY,** 425 Riverside Ave., Newport Beach CA 92663. (714)722-0240. FAX: (714)631-8324. Owner: Molly. Estab. 1972. Specializes in corporate identity, signage and automotive graphics. Clients: corporations, ad agencies, PR firms, small companies. Current clients include: Toyota Motor Sales, Buick and Chevy.

Needs: Approached by 6-10 freelance artists/year. Works with 2-3 freelance illustrators and 2-3 freelance designers/year. Prefers artists with experience in the automotive field. Works on assignment only. Uses freelance illustrators mainly for presentations. Uses freelance artists for brochure design, mechanicals, lettering, logos, P-O-P design and illustration and direct mail design.

First Contact & Terms: Send query letter with photographs. Samples are filed or are returned. Reports back within 2 weeks. Call to schedule an appointment to show a portfolio. Portfolio should include thumbnails, roughs, original/final art and photographs. Pays for design and illustration by the project, $100 minimum. Buys all rights. Rights purchased vary according to project.

MOODY GRAPHICS, 143 Second St., San Francisco CA 94105. (415)495-5186. President: Carol Moody. Specializes in annual reports, corporate identity, direct mail, publications and technical illustration. Clients: hotels, banks, small companies—corporate and retail.
Needs: Works with 0-2 freelance illustrators/year. Works with 1-2 freelance designers/year. "Artists work in my studio. They should have mechanical experience and good mechanical abilities; stat camera and Macintosh experience helpful." Works on assignment only. Uses artists for design, illustration, brochures, catalogs, mechanicals, retouching, airbrushing, direct mail packages, charts/graphs, lettering, logos and advertisements. Needs "traditional" editorial and technical illustration.
First Contact & Terms: Call or write for appointment to show portfolio. Samples not kept on file returned by SASE. Reports only if interested. Pays for design and mechanical assembly by the hour, $15-25 average. Pays for illustration and technical drawing by the hour, $15-25 average. Considers skill and experience of artist when establishing payment.
Tips: "Show paste-ups as well as printed samples." The most common mistake freelancers make is showing "too much of the same type of work. They should show 1-3 of best and weed out the rest—like 3 best letterhead designs, 3 best brochures, etc."

SID NAVRATILART, 1305 Clark Bldg., Pittsburgh PA 15222. (412)471-4322. Contact: Sid Navratil. Specializes in annual reports, corporate identity, desk-top publishing, direct mail, publication, signage, technical illustration and 3-dimensional designs. Clients: ad agencies and corporations. Current clients include: PPG Industries, Pittsburgh National Bank, Ketchums Communications. Client list not available.
Needs: Approached by 10 freelance artists/year. Works with 5 freelance illustrators/year. Experienced artists only with a minimum of 5 years of experience; "I prefer artist to work on my premises at least during revision work, if that is possible." Works on assignment only. Uses artists for design, illustration, brochures, mechanicals, retouching, airbrushing, charts/graphs, lettering, logos and advertisements.
First Contact & Terms: Send resume, photocopies and business card to be kept on file. Material not filed is returned only if requested. Reports within 10 days. Write for appointment to show portfolio. Pays for design and illustration by the hour, $20-30 average. Considers complexity of project, client's budget and skill and experience of artist when establishing payment.
Tips: "In illustration, we prefer the daring, innovative approach. The subject is usually industrial in nature, done for corporations such as PPG, USS, Alcoa and Rockwell. 1) Telephone first; 2) Send resume; 3) Follow up with second call and make appointment. Do not send expensive photos and brochures. A brief resume with few photocopies of work is sufficient."

LOUIS NELSON ASSOCIATES INC., 80 University Pl., New York NY 10003. (212)620-9191. Contact: Louis Nelson. Estab. 1980. Specializes in environmental design, brand identity, corporate identity, display, interior design, packaging, publications, signage, product design, exhibitions and marketing. Clients: corporations, associations and governments. Current clients include: Port Authority, California Museum of Science & Industry, MTA, The Statue of Liberty, Bell Labs, Dynacraft, Rocky Mountain Productions, Sarabeth's and Mutual Benefit Life.
Needs: Approached by 25-30 freelance artists/year. Works with 3-5 freelance illustrators and 10 freelance designers/year. Works on assignment only. Uses freelance artwork mainly for specialty graphics and three-dimensional design. Uses artists for design, illustration, mechanicals, model making and charts/graphs.
First Contact & Terms: Considers "quality, point-of-view for project and flexibility." Send query letter with brochure showing art style or tearsheets, slides and photographs. Samples are returned only if requested. Reports within 2 weeks. Write to schedule an appointment to show a portfolio, which should include roughs, color final reproduction/product and photographs. Pays for design by the hour, $8-35 average; by the project, $60-5,000 average. Pays for illustration by the project, $100-500 average. Considers complexity of project, client's budget, skill and experience of artist and rights purchased when establishing payment.
Tips: "I want to see how the person responded to the specific design problem and to see documentation of the process—the stages of development. The artist must be versatile and able to communicate a wide range of ideas. Mostly, I want to see the artist's integrity reflected in his/her work."

TOM NICHOLSON ASSOCIATES, INC., Suite 8, 295 Lafayette St., New York NY 10012. (212)274-0470. Principal: Tom Nicholson. Estab. 1987. Specializes in design of interactive computer programs. Clients: corporations, museums, government agencies. Current clients include: Citibank and IBM. Client list available upon request.
Needs: Approached by "very few" freelance artists/year. Works with 6-10 freelance illustrators and 6 freelance designers/year. Prefers local artists. Uses illustrators mainly for computer illustration and animation. Uses designers mainly for computer screen design and concept development. Also uses artists for mechani-

cals, charts/graphs and AV materials. Needs editorial and technical illustration. Especially needs designers with interest (not necessarily experience) in computer screen design plus a strong interest in information design.

First Contact and Terms: Send query letter with resume; include tearsheets and slides if possible. Samples are filed or are returned. Reports back within 1 week. Write to schedule an appointment to show a portfolio, which should include thumbnails, original/final art and tearsheets. Considers complexity of project, client's budget and skill and experience of artist when establishing payment. Buys one-time or all rights; rights purchased vary according to project.

NORWOOD OLIVER DESIGN ASSOCIATES, 501 American Legionway, Point Pleasant Beach NJ 08742. (201)295-1200. Vice President: Madan P. Vazirani A.I.A. Interior design firm. Clients: department stores, malls, restaurants, hotels, and other commercial and retail clients. Current clients include: Bergdorf Goodman, Bonwit Teller, Hess's and Reynolds. Client list not available.

Needs: Approached by 5 freelance artists/year. Works with 5 freelance illustrators and 2 freelance designers/year. Prefers renderers who have 5-10 years experience and are within driving distance. Works on assignment only. Uses renderers for interior design and renderings, architectural renderings, design consulting, model making and wall hangings. Especially needs perspective renderings of interiors.

First Contact & Terms: Send resume and photocopies. Samples are filed or are not returned. Write to schedule an appointment to show a portfolio, which should include color photostats and photographs. Pays per rendering, $300-500. Considers client's budget, skill and experience of artist, and "whether piece is b&w, color or airbrush" when establishing payment. Buys first rights.

NOTOVITZ DESIGN ASSOCIATES, INC., 47 E. 19 St., New York NY 10003. (212)677-9700. President: Joseph Notovitz. Specializes in corporate design (annual reports, literature, publications), corporate identity and signage. Clients: finance and industry.

Needs: Works with 10 freelance artists/year. Uses artists for brochure, poster, direct mail and booklet illustration; mechanicals; charts/graphs and logo design.

First Contact & Terms: Send resume, slides, printed pieces and tearsheets to be kept on file. Samples not filed are returned by SASE. Reports in 1 week. Call for appointment to show portfolio, which should include roughs, original/final art and final reproduction/product. Pays for design by the hour, $15-50; by the project, $200-1,500. Pays for illustration by the project, $100-5,000; also negotiates.

Tips: "Send pieces which reflect our firm's style and needs. They should do a bit of research in the firm they are contacting. If we never produce book covers, book cover art does not interest us."

TIMOTHY OAKLEY DESIGNS, 3921 Kaualio Pl., Honolulu HI 96816. (808)737-6423. Owner/Senior Art Director: Tim Oakley. Estab. 1980. Specializes in brand identity, corporate identity, direct mail and package design and airbrushing. Clients: agencies, record companies. Current clients include: Sheraton Hotels and Capital Records. Client list available upon request.

Needs: Approached by 10-20 freelance artists/year. Works with 2-5 freelance illustrators and designers/year. Works only with artist reps and prefers local artists only. Works on assignment only. Uses illustrators mainly for national products. Uses designers mainly for local material. Also uses designers and illustrators for brochure design and illustration, lettering, logos, model making, charts/graphs, audiovisual materials and ad illustration.

First Contact & Terms: Call first; then send query letter with brochure, resume, photographs and slides. Samples sometimes filed. Samples not filed are returned by SASE if requested by artist. Reports back only if interested. Write to schedule an appointment to show a portfolio. Portfolio should include thumbnails, photostats, slides, tearsheets and transparencies (2×4 or 4×5). Pays for design by the hour, $35-50; by the project, $250-2,500. Pays for illustration by the hour, $40-100. Buys all rights.

***OBATA DESIGN, INC.**, 1610 Menard St., St. Louis MO 63125. (314)241-1710. FAX: (314)241-8941. Senior Designer: Chris Haller. Estab. 1952. Specializes in annual reports, brand identity, corporate identity, display design, package design, publication design and signage. Clients: Fortune 1,000 corporations. Current clients include: Anheuser-Busch, Emerson Electric. Client list not available.

Needs: Works with 1-2 freelance illustrators/year. Uses freelance illustrators mainly for annual reports. Also uses freelance illustrators for retouching and airbrushing (inhouse).

First Contact & Terms: Send query letter with resume. Samples are not filed and not returned. Reports back to the artist only if interested. Write to schedule an appointment to show a portfolio. Portfolio should include color photographs. Payment varies. Rights purchased vary according to project.

OPTISONICS PRODUCTIONS, 186 8th St., Creskill NJ 07626. (201)871-4192. President: Jim Brown. Specializes in graphics, typesetting, multi-image, audio for AV, displays, exhibits and print media. Clients: industry and theatre.

Needs: Works with varied number of freelance artists/year. Prefers local artists. Works on assignment only. Uses artists for advertising, brochures, catalogs and for graphics for multi-image slide show.
First Contact & Terms: Send query letter with brochure/flyer, business card or resume which will be kept on file. Negotiates payment.

PAPAGALOS AND ASSOCIATES, Suite 222, 5353 N. 7th St., Phoenix AZ 85014. (602)279-2933. Creative Director: Nicholas Papagalos. Specializes in advertising, brochures, annual reports, corporate identity, displays, packaging, publications and signage. Clients: major regional, consumer and business-to-business.
Needs: Works with 10-20 freelance artists/year. Works on assignment only. Uses artists for illustration, retouching, airbrushing, model making, charts/graphs, AV materials and lettering.
First Contact & Terms: Send query letter with brochure or resume and samples. Samples are filed or are returned only if requested. Reports back within 5 days. Call or write to schedule an appointment to show a portfolio, which should include thumbnails, roughs, final reproduction/product, photostats and photographs. Pays for design and illustration by the project, $100 minimum. Considers complexity of project, client's budget, skill and experience of artist, how work will be used, turnaround time and rights purchased when establishing payment. Rights purchased vary according to project.
Tips: In presenting samples or portfolios, "two or three samples of the same type/style are enough."

PERSECHINI & COMPANY, #303, 1575 Westwood Blvd., Los Angeles CA 90024. (213)478-5522. Contact: Suzette Heiman. Estab. 1979. Specializes in annual reports, corporate identity, display, packaging, publications and signage. Clients: healthcare, real estate, hospitality, institutional ad agencies, PR firms and internal communications departments. Current clients in; National Medical Enterprises, UCLA and Mannin Sclvage & Lee. Client list not available.
Needs: Approached by 50-100 freelance artists/year. Works with 5-6 freelance illustrators and 1 freelance designer/year. Works on assignment basis only. Uses artists mainly for design and illustration; also for mechanicals, retouching, airbrushing and lettering. Occasionally uses humorous and cartoon-style illustrations.
First Contact & Terms: Send query letter with brochure, business card and photostats and photocopies to be kept on file. Samples not kept on file are returned by SASE. Reports back only if interested. Pays for design by the hour, $15-25 average. Pays for illustration by the project, $150-5,000 average. Considers complexity of project, client's budget, skill and experience of artist, how work will be used, turnaround time and rights purchased when establishing payment.
Tips: "Most of our accounts need a sophisticated look for their ads, brochures, etc. Occasionally we have a call for humor. Do a lot of mailings of current or new work so we can update files and are always reminded."

PETRO GRAPHIC DESIGN ASSOCIATES, 315 Falmouth Dr., Rocky River OH 44116. (216)356-0429. Principal/Graphic Designer: Nancy Petro. Estab. 1976. Specializes in corporate identity, direct mail and collateral design, design for print communications and ads. "We work directly for clients in diversified areas: builders/developers (including shopping malls); the lawncare industry; and industrial. Client list not available.
Needs: Approached by 20-25 freelance artists/year. Works with 5-8 freelance illustrators/year and 3-5 freelance designers/year. Works on assignment only. Uses illustrators mainly for ads and brochures. Uses designers mainly for back-up when overloaded. Also uses artists for mechanicals, retouching, airbrushing, lettering, ad illustration and fashion illustration.
First Contact & Terms: Send query letter with brochure, resume, tearsheets, photostats and photocopies. Samples are filed. Samples not filed are returned if accompanied by a SASE. Reports back only if interested. Call or write to schedule an appointment to show a portfolio, or mail b&w and color final reproduction/product, tearsheets, photostats and photographs. Pays by the hour, $20-65; by the project, $50-5,000 ("depends on scope of project")." Considers complexity of project, client's budget, skill and experience of artist, how work will be used, turnaround time and rights purchased when establishing payment. Negotiates rights purchased; rights purchased vary according to project. "Show an identifiable, unique product that is of high quality."
Tips: "Don't show weak work. Show work that is of high quality and can be matched (in quality) if you are hired for a job. Please send samples or copies of your work. Your work is your best salesman. Any designer can evaluate the work and know if it fills a need—without undue demands on the designer's time."

PORRAS & LAWLOR ASSOCIATES, 15 Lucille Ave., Salem NH 03079. (603)893-3626. Art Director: Victoria Porras. Estab. 1980. Specializes in corporate identity, direct mail and publications. Clients: banks, high-tech industry and colleges. Client list available on request.
Needs: Approached by 25 freelance artists/year. Works with 3 freelance illustrators and 2 freelance designers/year. Prefers artists living in New England with two years of experience. Uses freelance artists for brochure illustration, mechanicals, airbrushing, AV materials and lettering.
First Contact & Terms: Send query letter with brochure showing art style or samples. Samples are filed. Reports back only if interested. Call or write to schedule an appointment to show a portfolio, which should include thumbnails, original/final art, final reproduction/product or photographs (whatever is applicable to artist). Pays for design by the hour, $15-25. Pays for illustration by the project, $120-3,000. Considers complex-

ity of project, client's budget, skill and experience of artist, turnaround time and rights purchased when establishing payment. Negotiates rights purchased; rights purchased vary according to project.

Tips: "In your portfolio include examples of corporate identity and publications. Don't talk about bad things that happened while you were doing the work."

PRODUCT SYSTEMS INTERNATIONAL INC., 40 N. Cherry St., Lancaster PA 17602. (717)291-9042. Director, Client Development: Nancy B. Rogers. Estab. 1987. Specializes in graphic design, product design/development, package design/packaging, merchandising.

Needs: Works with 20 freelance artists/year. Artists should be within driving distance; "prefer freelancers to work inhouse." Works on assignment only. Uses artists for illustration, brochures, catalogs, mechanicals, model making, charts/graphs, lettering, logos, advertisement and market research. Prefers airbrush, charcoal/pencil and marker.

First Contact & Terms: Send query letter with brochure, resume and business card to be kept on file; slides to be returned. Samples not kept on file are returned. Reports within 30 days. To show a portfolio, write to schedule an appointment and mail thumbnails, roughs, final reproduction/product and photographs. Pays for design by the hour, $10-30; pays for illustration by the hour, $10-$30. Considers complexity of project, and skill and experience of artist when establishing payment.

PRODUCTION INK, 2826 Northeast 19th Dr., Gainesville FL 32609. (904)377-8973. Contact: Terry VanNortwick. Estab. 1979. Specializes in publications, marketing, healthcare, engineering, development and ads.

Needs: Works with 6-10 freelance artists/year. Works on assignment only. Uses artists for brochure illustration, airbrushing and lettering. Needs editorial, medical and technical illustration.

First Contact & Terms: Send resume, samples, tearsheets, photostats, photocopies, slides and photography. Samples are filed or are returned if accompanied by SASE. Reports back only if interested. Call or write to schedule an appointment to show a portfolio, which should include original/final art. Pays for design and illustration by the project, $50-500. Considers complexity of project, client's budget, skill and experience of artist, how work will be used, turnaround time, and rights purchased when establishing payment. Buys reprint rights; rights purchased vary according to project.

Tips: "Send slide samples for our files. Check with us regularly."

THE PUSHPIN GROUP, 215 Park Ave. S., New York NY 10003. (212)674-8080. President: Seymour Chwast. Partner: Phyllis Rich Flood. Specializes in annual reports, brand identity, corporate identity, packaging, publications and signage. Clients: individuals, ad agencies, corporations, PR firms, etc.

Needs: Works with 5-6 freelance artists/year. Generally prefers designers to illustrators. Uses artists for design, illustrations, brochures, books, magazines, mechanicals, retouching, airbrushing, charts/graphs and lettering.

First Contact & Terms: Send query letter with resume, tearsheets, photostats and photocopies. Samples not filed are returned only if requested. Reports only if interested. Call or write to schedule an appointment to show a portfolio, which should include roughs, original/final art, final reproduction/product, color and b&w tearsheets, photostats, photographs and b&w. Pays for design by the hour, $15-20. Considers complexity of project, client's budget, skill and experience of artist, and turnaround time when establishing payment.

***THE Q DESIGN GROUP**, 53 Danbury Rd., Wilton CT 06897. (203)834-1885. FAX: (203)761-1449. Office Manager: Jan Costello. Estab. 1986. Specializes in annual reports, brand identity, corporate identity. Clients: corporations, nonprofit institutions. Client list available upon request.

Needs: Approached by 50 freelance artists/year. Works with 2 freelance illustrators and 5 freelance designers/year. Uses freelance illustrators mainly for feature illustrations. Uses freelance designers mainly for design production. Also uses freelance artists for brochure design and illustration, catalog design, mechanicals, retouching, aibrushing, lettering, logos and ad design and illustration.

First Contact & Terms: Send query letter with resume. Samples are filed. Reports back to the artist only if interested. Mail appropriate materials. Pays for design and illustration by the hour, $10-30; by the project; by the day, $500. Buys all rights.

QUADRANT COMMUNICATIONS CO., INC., Suite 1602, 595 Madison Ave., New York NY 10022. (212)421-0544. FAX: (212)421-0483. President: Robert Eichinger. Estab. 1973. Specializes in annual reports, corporate identity, direct mail design, publication design and technical illustration. Clients: corporations. Current clients include: AT&T, Citibank, NYNEX and Polo/Ralph Lauren. Client list available upon request.

Needs: Approached by 50 freelance artists/year. Works with 12 freelance illustrators and 6 freelance designers/year. Prefers artists with experience in publication production. Works on assignment only. Uses illustrators and designers mainly for publications, trade show collateral and direct mail design. Also uses artists for brochure design and editorial/technical illustration, catalog design, mechanicals, retouching, magazine design, and charts/graphs.

First Contact & Terms: Send query letter with resume. Samples are filed. Reports back only if interested. Call to schedule an appointment to show a portfolio. Portfolio should include tearsheets and photographs. Pays by the hour or by the project, "The payment depends on the nature of the project, the client's budget and the current market rate." Rights purchased vary according to project.

QUALLY & COMPANY INC., Suite 2502, 30 E. Huron, Chicago IL 60611. (312)944-0237. Creative Director: Robert Qually. Specializes in advertising, graphic design and new product development. Clients: major corporations.
Needs: Works with 20-25 freelance artists/year. "Artists must be good and have the right attitude." Works on assignment only. Uses artists for design, illustration, mechanicals, retouching and lettering.
First Contact & Terms: Send query letter with brochure, resume, business card and samples to be kept on file. Samples not kept on file are returned by SASE. Reports back within several days. Call or write for appointment to show portfolio. Considers complexity of project, client's budget, skill and experience of artist, how work will be used, turnaround time and rights purchased when establishing payment.
Tips: Looking for talent, point of view, style, craftsmanship, depth and innovation in portfolio or samples. Sees "too many look-alikes, very little innovation."

THE QUARASAN GROUP, INC., Suite 300, 630 Dundee Rd., Northbrook IL 60062. (708)291-0700. President: Randi S. Brill. Project Managers: Michael Gibson, Kathy Kasper, Jean Lograsso and Jay Skilton. Specializes in books. Clients: book publishers. Client list not available.
Needs: Approached by 400 freelance artists/year. Works with 400-500 freelance illustrators and 8-10 designers/year. Artists with publishing experience only. Uses artists for illustration, books, mechanicals, charts/graphs, lettering and production. Also uses extensive desktop artwork and computer graphics.
First Contact & Terms: Send query letter with brochure or resume and samples addressed to ASD to be circulated and to be kept on file. Prefers "anything that we can retain for our files; photostats, photocopies, tearsheets or dupe slides that do not have to be returned" as samples. Reports only if interested. Pays for production by the hour, $15-25 average; for illustration by the piece/project, $25-2,000 average. Considers complexity of project, client's budget, how work will be used and turnaround time when establishing payment. "For illustration, size and complexity are the key factors."
Tips: Common mistakes freelance artists make are "not identifying work clearly and not submitting samples that can be kept. Follow our procedure as explained by the receptionist; have patience; it really is the best way to showcase your talents with Quarasan."

MIKE QUON DESIGN OFFICE, INC., 568 Broadway, New York NY 10012. (212)226-6024. President: Mike Quon. Specializes in corporate identity, display, direct mail, packaging, publications and technical illustrations. Clients: corporations and ad agencies (e.g. American Express, HBO, IBM, Clairol and AT&T). Client list available upon request.
Needs: Approached by 30-50 graphic artists each year. Works with 5-6 freelance illustrators and 4-5 freelance designers/year. Prefers good/great people "local doesn't matter." Works on assignment only. Prefers graphic style. Uses artists for design, brochures, P-O-P displays, mechanicals, model making, charts/graphs and lettering. Prefers pen & ink. Especially needs computer artists.
First Contact & Terms: Send query letter with resume, tearsheets and photocopies. Samples are filed or are returned if accompanied by a SASE. Reports back only if interested. Write to schedule an appointment to show a portfolio or mail thumbnails, roughs and tearsheets. Pays for design by the hour, $15-35. Pays for illustration by the project, $50-500 and up. Considers complexity of project, client's budget, skill and experience of artist, turnaround time and rights purchased when establishing payment. Buys one-time rights; rights purchased vary according to project.

R.H.GRAPHICS, INC., 23 E. 22nd St., New York NY 10010. (212)505-5070. President: Roy Horton. Vice President: Irving J. Mittleman. Specialized in brand identity, corporate identity, display, direct mail and packaging. Current clients include: Revlon, Clairol, Wallace Lab, World Gold. Client list not available.
Needs: Approached by 25 freelance artists/year. Works with 1-3 freelance illustrators/year. Artists must have ten years of experience. Especially needs mechanicals and ruling. Uses artists for P-O-P displays, mechanicals, retouching, airbrushing and lettering.
First Contract & Terms: Send query letter with brochure showing art style or resume and tearsheets. Reports only if interested. Write to show a portfolio, which should include roughs and original/final art. Pays for design by the hour, $18-25. Pays for illustration by the project, $50-250. Considers client's budget, and skill and experience of artist when establishing payment.
Tips: Wants to see "actual art and variety."

***ROY RITOLA, INC.**, 714 Sansome, San Francisco CA 94111. (415)788-7010. President: Roy Ritola. Specializes in brand identity, corporate identity, displays, direct mail, packaging and signage. Clients: manufacturers.
Needs: Works with 6-10 freelance artists/year. Uses artists for design, illustrations, airbrushing, model making, lettering and logos.
First Contact & Terms: Send query letter with brochure showing art style or resume, tear sheets, slides and photographs. Samples not filed are returned only if requested. Reports only if interested. To show a portfolio, mail final reproduction/product. Pays for design by the hour, $15-50. Considers complexity of project, client's budget, skill and experience of artist, turnaround time and rights purchased when establishing payment.

***RITTA & ASSOCIATES**, 568 Grand Ave., Englewood NJ 07631. (201)567-4400. FAX: (201)567-7330. Art Director: Steven Scheiner. Estab. 1976. Specializes in annual reports; brand and corporate identity; direct mail, package and publication design; automotive. Clients: corporations. Current clients include: AT&T, Bellcore, BMW, Volvo and American Standard.
Needs: Works with 4-6 freelance illustrators and 2-3 freelance designers/year. Prefers artists with publication, editorial and corporate experience. Works on assignment only. Uses freelance illustrators mainly for editorial. Uses freelance designers mainly for corporate and publication. Also uses freelance artists for brochure, catalog, magazine, P-O-P and direct-mail design; and mechanicals, retouching, airbrushing, logos, poster illustration, model making and audiovisual materials.
First Contact & Terms: Send query letter with brochure, tearsheets, resume and photocopies. Samples are filed or are returned by SASE if requested by artist. Reports back to the artist only if interested. To show a portfolio, mail thumbnails, roughs, original/final art, b&w tearsheets and transparencies. Pays for design by the hour, $15-30. Pays a flat fee for illustration. Rights purchased vary according to project.
Tips: "Firm is heavily into Macintosh computers; does use freelancers with knowledge of Quark 3.0, Adobe Illustrator and Photoshop."

Valerie Ritter Paley, creative director of Ritter and Ritter, says that while "the poor bedraggled art director" received no credit at Inwood House's annual meeting, the illustrator of this booklet, Elizabeth Williams, "was directly cited and thanked for a wonderful job done." Ritter first saw Williams' work in the RSVP Directory. "She is a courtroom artist," says Ritter; "she works well getting a fast, imagistic impression down." This made her the perfect illustrator for the booklet's interior, in which people and scenes from within the home are captured.

RITTER & RITTER, INC., 45 W. 10th St., New York NY 10011. (212)505-0241. Creative Director: Valerie Ritter Paley. Estab. 1968. Specializes in annual reports, corporate identity, book covers, brochures, catalogs and promotion for publishers, corporations, nonprofit organizations and hospitals. Client list available.
Needs: Approached by 50 artists/year. Works with 2 freelance illustrators and designers/year according to firm's needs. Does not always work on assignment only; "sometimes we need a freelance on a day-to-day basis." Uses freelance artwork mainly for catalogs and brochures. Uses fine artists for covers, and graphic designers for brochure design, mechanicals, and desktop publishing. Prefers "elegant, understated, sensitive design without self-conscious trendiness."
First Contact & Terms: Prefers experienced artists, although "talented 'self-starters' with design expertise/ education are also considered." Send query letter with brochure, resume and samples to be kept on file. "Follow up within a week of the query letter about the possibility of arranging an appointment for a portfolio review." Prefers printed pieces as samples. Samples not filed are returned by SASE. Pays for mechanicals and desktop publishing by the hour, $10-25. Pays for design by the project, $100-1,000 average; or by the day, $90-150 average. Pays for illustration by the project, $50-500 average. Considers complexity of the project, client's budget, skill and experience of the artist and turnaround time when establishing payment.
Tips: "Don't try to be something for everyone. Most illustrators (with rare exceptions) are not designers and should not think of showing amateurish design attempts. Also be respectful of art directors' time. Know what you'd like to say in advance, rehearse beforehand and have timely dates ready to set up an appointment. Finally, there's no need to diminish the impact of a few good pieces by including less successful ones in an attempt to make a portfolio look more substantial."

DEBORAH RODNEY CREATIVE SERVICES, Suite 205, 1640 5th St., Santa Monica CA 90401. (213)394-0590. Contact: Deborah Rodney. Estab. 1975. Specializes in advertising design and collateral. Clients: ad agencies and direct clients. Current projects include advertising for Kreiss Furniture and The Pritiken Longevity Center.
Needs: Works with 3-5 freelance illustrators/year. Prefers local artists. Uses illustrators mainly for finished art and lettering. Uses designers mainly for logo design. Also uses artists for mechanicals, charts/graphs, advertisement design and illustration. Especially needs "people who do good marker comps, and work on MacIntosh computer."
First Contact & Terms: Send query letter with brochure, resume, tearsheets and photocopies. Call to schedule an appointment to show a portfolio, or mail final reproduction/product and tearsheets or "whatever best shows work." Pays by the hour, $15-20; by the job $100-1,500. Considers complexity of project, client's budget, how work will be used, turnaround time and rights purchased when establishing payment. Negotiates rights purchased.

***ROWE & BALLANTINE,** 8 Galloping Hill Rd., Brookfield CT 06804. (203)775-7887. FAX: (203)775-7881. Partner: Ed Rowe and John Ballantine. Estab. 1988. Specializes in annual reports, corporate identity and publication design. Clients include PR agencies, profit and not-for-profit corporations and individuals.
Needs: Approached by 5 freelance artists/year. Works with 3 freelance designers/year. Prefers artists with experience in mechanicals, desktop publishing. Works on assignment only. Also uses freelance artists for brochure design, mechanicals, lettering, logos, ad design, book design, magazine design and charts/graphs.
First Contact & Terms: Send query letter with resume. Samples are filed. Call or write to schedule an appointment to show a portfolio. Portfolio should include roughs, original/final art, and b&w and color photographs. Pays for design by the hour, $15-20.

***RUBY SHOES STUDIO, INC.,** 124 Watertown St., Watertown MA 02172. (617)923-9769. Creative Director: Susan Tyrrell. Estab. 1984. Specializes in corporate identity, direct mail, package and publication design. Client list available upon request.
Needs: Approached by 150-300 freelance artists/year. Works with 5-10 freelance illustrators and 10-20 free-lance designers/year. Uses freelance illustrators mainly for brochure illustration. Uses freelance designers mainly for ad design and mechanicals. Also uses freelance artists for brochure design and illustration, mechanicals, airbrushing, lettering, logos, P-O-P design and illustration, poster and direct mail design and graphs.
First Contact & Terms: Send query letter with tearsheets, resume and slides. Samples are filed or are returned by SASE. Reports back to the artist only if interested. To show a portfolio, mail roughs, original/ final art, b&w and color tearsheets and slides. Pays for design by the hour, $20-30; by the project, $150-1,500. Pays for illustration by the project. Buys first or one-time rights.

ARNOLD SAKS ASSOCIATES, 350 E. 81st St., New York NY 10028. (212)861-4300. FAX: (212)535-2590. Vice President, Production: Anita Fiorillo. Estab. 1967. Specializes in annual reports and corporate communications. Clients: corporations. Current clients include: Goldman Sachs, Bristol-Myers Squibb, Philip Morris, Peat Marwick, NYNEX and ALCOA. Client list available upon request.

Needs: Approached by 10 freelance artists/year. Works with 1 or 2 freelance mechanical artists and 1 freelance designer/year. "Mechanical artists; accuracy and speed are important. Also a willingness to work late nights and some weekends." Uses illustrators occasionally for annual reports. Uses designers mainly for in-season annual reports. Also uses artists for brochure design and illustration, mechanicals and charts/graphics.
First Contact & Terms: Send query letter with brochure and resume. Samples are filed. Reports back to the artist only if interested. Write to schedule an appointment to show a portfolio. Portfolio should include finished pieces. Payment depends on experience and terms and varies depending upon scope and complication. Rights purchased vary according to project.

JACK SCHECTERSON ASSOCIATES, 53/16 251 Place, Little Neck NY 11362. (718)225-3536. FAX: (718)423-3478. Contact: Jack Schecterson. Estab. 1967. Art/ad agency. Specializes in packaging, product design, brand identity, corporate identity, and P-O-P displays. Clients: manufacturers of consumer/industrial products.
Needs: Uses local artists. Works on assignment only. Uses artists for catalogs, direct mail brochures, exhibits, packaging, industrial design, corporate design, graphics, trademark, logotype design, sales promotion, P-O-P displays and print media advertising. Especially needs package and product designers.
First Contact & Terms: Send query letter with brochure showing design and/or art style or resume and tear sheets, or write for appointment. Samples returned by SASE. Reports "as soon as possible." Pays by the project for design and illustration; negotiates payment. Reproduction rights purchased.
Tips: "Portfolio samples should be printed pieces backed up with felt-tip marker roughs. Due to the recession work has dropped off over 35-50%."

***WILLIAM M. SCHMIDT ASSOCIATES**, 20296 Harper Ave., Harper Woods MI 48225. (313)881-8075. FAX: (313)881-1930. President: John Schmidt. Estab. 1942. Primarily specializes in product design and transportation design, as well as corporate identity, display design, interior design, package design, signage, technical illustration. Clients: companies and agencies. Client list available upon request.
Needs: Approached by 30-40 freelance artists/year. Works with 8-10 freelance illustrators and 12-15 freelance designers/year. Prefers local artists with experience in automotive and product design. Works on assignment only. Also uses freelance artists for brochure design and illustration, mechanicals, airbrushing, logos and model making.
First Contact & Terms: Send query letter with resume, SASE and slides. Samples are not filed and are returned by SASE. Reports back within 1-2 weeks. Mail appropriate materials. Portfolio should include slides, roughs, original/final art and preliminary sketches. Pays for design and illustration by the hour, $15-30 or by the project. Buys all rights.

***R. THOMAS SCHORER & ASSOC. INC.**, 710 Silver Spur Rd., Palos Verdes CA 90274. (213)377-0207. President: Thomas Schorer. Estab. 1971. Specializes in graphic design, environmnental design and architectural design and signage. Client list available upon request.
Needs: Approached by 100+ freelance artists/year. Works with 5 freelance illustrators and 10 freelance designers/year. Works on assignment only. Uses designers for all types of design.
First Contact & Terms: Send query letter with all appropriate samples. Samples are not filed and are returned. Reports back. Write to schedule an appointment to show a portfolio. Portfolio should include all appropriate samples. Payment for design depends on job and talent. Pays for illustration by the project. Buys all rights.

SCHROEDER BURCHETT DESIGN CONCEPTS, 104 Main St., RR 1 Box 5A, Unadilla NY 13849-9703. Designer & Owner: Carla Schroeder Burchett. Estab. 1972. Specializes in packaging, drafting and marketing. Clients: manufacturers.
Needs: Works on assignment only. Uses artists for design, mechanicals, lettering and logos. Type of illustration needed is technical.
First Contact & Terms: Send resume; "if interested, will contact artist or craftsperson and will negotiate." Write for appointment to show portfolio, which should include thumbnails, final reproduction/product and photographs. Pays for design by the project. Pays for illustration by the project, $10-500. "If it is excellent work the person will receive what he asks for!" Considers skill and experience of artist when establishing payment.
Tips: "Creativity depends on each individual. Artists should have a sense of purpose and dependability and must work for long and short range plans."

***SERIGRAPHICS ETC.**, Box 7200, Dallas TX 75209. Contact: Michael Truly. Specializes in packaging, publications and technical illustration, displays and signs. Clients: electronic companies, direct mail catalog industry—wholesale and retail, household appliance manufacturers, architectural firms, decorators, restaurants, clinical psychologists, architects, builders and tax exempt organizations such as Boys and Girls Clubs.
Needs: Works with 1-2 freelance artists/year. Works on assignment. Uses artists for advertising and catalog design, illustration and layout; P-O-P displays, mechanicals, retouching, posters, signs, charts/graphs, logos and architectural models.

First Contact & Terms: Artists must be careful and accurate, and able to interpret rough layouts. Send query letter with brochure, resume and business card to be kept on file. Write for appointment to show portfolio, which should include photographs or photostats. Samples returned only if requested. Reports only if interested. Pays for design and mechanical production work by the hour, $7-8 average. Considers complexity of project, client's budget, skill and experience of artist, how work will be used and turnaround time when establishing payment.

Tips: "Show neat, accurate samples that have been used in publication."

DEBORAH SHAPIRO DESIGNS, 150 Bentley Ave., Jersey City NJ 07304. (201)432-5198. Owner: Deborah Shapiro. Estab. 1979. Specializes in annual reports, brand identity, corporate identity, direct mail, signage and publications. Clients: corporations and manufacturers. Client list available upon request.

Needs: Approached by 50 artists/year. Works with 2-3 freelance artists/year. Works on assignment only. Uses artists for illustration, retouching brochures, catalog illustration, poster illustration, model making and audiovisual materials.

First Contact & Terms: Send query letter with brochure and tearsheets. Samples are filed and are not returned. Reports back only if interested. To show a portfolio, mail original/final art, tearsheets, thumbnails and roughs. Pays for illustration by the project, $100-2,500. Considers complexity of project, client's budget, skill and experience of artist, how work will be used, turnaround time and rights purchased when establishing payment. Buys one-time rights.

Tips: "We do not want to see student works. Do not send too many samples. Send assignment oriented pieces."

***SHERIN & MATEJKA, INC.**, 404 Park Ave. S., New York NY 10016. (212)686-8410. President: Jack Sherin. Estab. 1973. Specializes in corporate communications, publications and sales promotion. Clients: banks, consumer magazines, corporations and ad agencies.

Needs: Approached by 200 freelance artists/year. Works with 20 freelance artists/year. Prefers artists located nearby with solid professional experience. Works on assignment only. Uses freelance artwork mainly for "miscellaneous work." Also uses artists for mechanicals, retouching, airbrushing, lettering, poster and ad illustration.

First Contact & Terms: Send query letter with tearsheets. Samples returned by SASE. Reports back only if interested. Call to schedule an appointment to show a portfolio, which should include tearsheets. Pays $25-55/hour for design. Pays for illustration by the project, $350-10,000. Considers complexity of project, client's budget, skill and experience of artist, and how work will be used when establishing payment.

ROGER SHERMAN PARTNERS, INC., 2532 Monroe St., Dearborn MI 48124. (313)277-8770. Contact: Joy Walker. Interior design and contract purchasing firms providing architectural and interior design for commercial restaurants, stores, hotels, shopping centers, complete furnishing purchasing. Clients: commercial firms.

Needs: Artists with past work experience only, able to provide photos of work and references. Works on assignment only. Uses artists for architectural renderings, furnishings, landscape and graphic design, model making and signage; also for special decor items as focal points for commercial installations, such as paintings, wood carvings, etc.

First Contact & Terms: Send query letter with brochure/flyer or resume and samples to be kept on file. Prefers slides and examples of original work as samples. Samples not returned. Reporting time depends on scope of project. Call or write for appointment. Negotiates payment; varies according to client's budget.

***WILLIAM SKLAROFF DESIGN ASSOCIATES**, 124 Sibley Ave., Ardmore PA 19003. (215)649-6035. FAX: (215)649-6063. Design Director: William Sklaroff. Estab. 1956. Specializes in corporate identity; display, interior, package and publication design; and signage. Clients: contract furniture, manufacturers, health care, corporations. Current clients include: American Leather, Roffman, Subaru of America, Baker, Haleon Corporation, L.V.I. Corporation and Centra State Medical Center. Client list available upon request.

Needs: Approached by 50+ freelance artists/year. Works with 2-3 freelance designers/year. Works on assignment only. Uses freelance designers mainly for assistance on graphic projects. Also uses freelance designers for brochure design and illustration, catalog and ad design, mechanicals and logos.

First Contact & Terms: Send query letter with brochure, resume and slides. Samples are not filed and are returned. Reports back within 3 weeks. To show a portfolio, mail thumbnails, roughs, original/final art and color slides and transparencies. Pays for design by the hour. Rights purchased vary according to project.

SMALLKAPS ASSOCIATION, INC., 21 Beacon Dr., Port Washington NY 11050. (516)944-5530. FAX: (516)944-5618. President: Marla Kaplan. Estab. 1976. Specializes in brand and corporate identity, direct mail and publication design, signage and technical and editorial illustration. Clients: ad agencies, publishers, small and large corporations. Current clients include: McGraw-Hill, American Cancer Society and Oxbridge Communications, Inc.

Needs: Approached by 20 freelance artists/year. Works with 3 freelance illustrators and 5 freelance designers/year. Prefers local artists with experience in mechanicals and comps. Works on assignment only. Also uses artists for brochure design and illustration; catalog, ad, P-O-P and direct mail design; retouching; airbrushing; lettering; logos; P-O-P and direct mail design; charts/graphs and audiovisual materials.
First Contact & Terms: Send query letter with resume, SASE, tearsheets and photocopies. Samples are filed or are returned by SASE if requested by artist. Reports back to the artist only if interested. Call to schedule an appointment to show a portfolio. Portfolio should include thumbnails, roughs, original/final art and photostats. Pays for design by the hour, $10-20; by the day, $80-150. Pays for illustration by the project, $100-1,000. Negotiates rights purchased.

SMITH & DRESS, 432 W. Main St., Huntington NY 11743. (516)427-9333. Contact: A. Dress. Specializes in annual reports, corporate identity, display, direct mail, packaging, publications and signage. Clients: corporations.
Needs: Works with 3-4 freelance artists/year. Local artists only. Works on assignment only. Uses artists for illustration, retouching, airbrushing and lettering.
First Contact & Terms: Send query letter with brochure showing art style or tearsheets to be kept on file (except for works larger than 8½x11). Pays for illustration by the project. Considers client's budget and turnaround time when establishing payment.

SMITH DESIGN ASSSOCIATES, 205 Thomas St., Box 558, Glen Ridge NJ 07028. (201)429-2177. Freelance Artist: Lucille Simonetti, 14 Edgemere Rd., Livingston NJ 07039. Clients: food processors, cosmetics firms, various industries, corporations, life insurance, office consultant. Current clients: Popsicle, Good Humor, Inter-Continental Hotels, Sony and Schering Plough. Client list available upon request.
Needs: Approached by over 100 freelance artists/year. Works with 10-20 freelance illustrators and 2-3 freelance designers/year. Requires quality and dependability. Uses freelance artists for advertising and brochure design, illustration and layout; interior design, P-O-P and design consulting.
First Contact & Terms: Send query letter with brochure showing art style or resume, tearsheets and photostats. Samples are filed or are returned only if requested by artist. Reports back within 1 week. Call to schedule an appointment to show a portfolio, which should include color roughs, original/final art and final reproduction. Pays for design by the hour, $15-30. Pays for illustration by the hour, $25 minimum. Considers complexity of project and client's budget when establishing payment. Buys all rights. Also buys rights for use of existing non-commissioned art.
Tips: "Know who you're presenting to, the type of work we do and the quality we expect."

***SPECTRUM BOSTON CONSULTING, INC.**, 85 Chestnut St., Boston MA 02108. (617)367-1008. FAX: (617)367-5824. President: George Boesel. Estab. 1985. Specializes in brand identity, corporate identity, display design, package design and signage. Clients: consumer, durable manufacturers. Client list not available.
Needs: Approached by 50 freelance artists/year. Works with 10-20 freelance illustrators and 2-3 freelance designers/year. All artists employed on work-for-hire basis. Works on assignment only. Uses freelance illustrators mainly for package and brochure. Also uses freelance artists for brochure design and illustration, mechanicals, logos, P-O-P design and illustration and model making.
First Contact & Terms: Send query letter with brochure, tearsheets, photographs, fees and terms. Samples are filed. Reports back to the artist only if interested. Call or write to schedule an appointment to show a portfolio. Portfolio should include roughs, original/final art and color slides. Pays for design by the hour, $20-40, or by the project, depending on assignment and skill level. Pays for illustration by the project, $50-1,000. Buys all rights.

***SPOT DESIGN**, 775 6th Ave., New York NY 10001. (212)645-8684. Art Director: Drew Hodges. Estab. 1986. Specializes in fashion design and entertainment-based work. Clients: ad agencies and corporations. Current clients include: MTV, Sony Music and Nickelodeon. Client list not available.
Needs: Approached by 5 freelance artists/year. Works with 10 freelance illustrators and 3 freelance designers/year. Works on assignment only. Uses freelance illustrators mainly for entertainment. Uses freelance designers mainly for overflow work. Also uses freelance artists for brochure, catalog and ad design, mechanicals, retouching and airbrushing.
First Contact & Terms: Send query letter with tearsheets and photocopies. Samples are filed. Reports back to the artist only if interested. If does not report back, "keep in contact." Call. Pays for design by the hour, $15, or by the project. Pays for illustration by the project, $500-5,000. Buys one-time rights.

HARRY SPRUYT DESIGN, Box 555, Block Island RI 02807. Specializes in design/invention of product, package and device; design counseling service. Clients: product manufacturers, design firms, consultants, ad agencies, other professionals and individuals. Client list available.
Needs: Works on assignment only. Uses artists/designers for accurate perspective drawings of products, devices (from concepts and sketches), design and material research and model making. Illustrations are an essential and cost effective step of evaluation between our concept sketches and model making." Uses

freelancers for editorial, medical and technical illustrations. Looks for "descriptive line and shade drawings, realistic color illustrations that show how product/object looks and works in simple techniques. Prefers water-color and tempera or other "timeless media."

First Contact & Terms: "Portfolio may include thumbnails and rough sketches, original/final art, final reproduction/product and color photographs/slides of models. I want to see work samples showing the process leading up to these examples, including models or photos if appropriate as well as time estimates. After working relationship is established, we can develop projects by fax, phone and mail." Pays for design by the hour, $15-30; by the day, $100-200; or offers part payment by royalty sharing. Pays for illustrations by the hour, $10-30; by the day, $80-200, or offers part payment by royalty sharing.

Tips: "We want to use our time together effectively by finding out each others needs quickly and communicating efficiently. We look for the ability to understand functioning of three-dimensional object/device/product from perspective sketches and descriptive notes so artist can illustrate accurately and clearly."

MICHAEL STANARD, INC., 996 Main St., Evanston IL 60202. (708)869-9820. FAX: (708)869-9826. Executive Designer: Lisa Fingerhut. Estab. 1978. Specializes in annual reports; brand and corporate identity; display, package and publication design; and signage. Clients: corporations and associations. Current clients include: Kraft, General Foods, City of Evanston, Big Ten Conference and TNT North America. Client list available.

Needs: Approached by numerous freelance artists/year. Works with 5-10 freelance illustrators and 1-2 free-lance designers/year. Works on assignment only. Uses illustrators for a variety of work.

First Contact & Terms: Send query letter with resume. Samples are not filed and are returned by SASE if requested by artist. Reports back to the artist only if interested. To show a portfolio, mail appropriate materials. Pays by the project. Negotiates rights purchased.

***STUDIO GRAPHICS, INC.**, Suite 450, 665 3rd St., San Francisco CA 94107. (415)974-6355. FAX: (415)974-6371. Senior Designer: Nancy Karier. Estab. 1990. Graphic design firm. Specializes in brochures, direct mail, newsletters, annual reports and media ads. Clients: healthcare industry.

Needs: Approached by 20 freelance artists/year. Works with 0-1 freelance illustrators and photographers and 3-10 freelance designers/month. Works on assignment only. Uses freelance designers for production.

First Contact & Terms: Send query letter with resume, photocopies and tearsheets. Samples are filed. Reports back to the artist only if interested. Write to schedule an appointment to show a portfolio. Portfolio should include roughs and original, final art. Pays for design by the hour, $15-25; pays for illustration by the project, $300-1,500. Negotiates rights purchased, which vary according to project.

TESSING DESIGN, INC., 3822 N. Seeley Ave., Chicago IL 60618. (312)525-7704. Principals: Arvid V. Tessing and Louise S. Tessing. Estab. 1975. Specializes in corporate identity, marketing promotions and publications. Clients: publishers, educational institutions and nonprofit groups.

Needs: Works with 8-12 freelance artists/year. Works on assignment only. Uses freelancers mainly for publications. Also uses artists for design, illustrations, books, magazines, mechanicals, retouching, airbrushing, charts/graphs and lettering.

First Contact & Terms: Send query letter with brochure. Samples are filed. Samples not filed are not returned. Reports back only if interested. Call to schedule an appointment to show a portfolio, which should include original/final art, final reproduction/product and photographs. Pays for design by the hour, $35-50. Pays for illustration by the project, $75 minimum. Considers complexity of project, client's budget, skill and experience of artist, how work will be used, turnaround time and rights purchased when establishing payment. Rights purchased vary according to project.

Tips: "We prefer to see original work or slides as samples. Work sent should always relate to the need expressed. Our advice for artists to break into the field is as always; call prospective clients, show works and follow-up."

THARP DID IT, Suite 21, 50 University Ave., Los Gatos CA 95030. (408)354-6726. Art Director/Designer: Rick Tharp. Estab. 1975. Specializes in brand identity, corporate and non-corporate identity, packaging and signage. Clients: direct. Current clients include: BRIO Scanditoy (Sweden), Sebastiani Vineyards, California Cafe Restaurant Corporation, Ernest & Julio Gallo, Mirassou Vineyards and Harmony Foods.

Needs: Approached by 250-350 artists/year. Works with 5-10 freelance illustrators and 1 freelance designer/year. Prefers local artists/designers with experience. Works on assignment only. Uses artists for illustrations.

First Contact & Terms: Send query letter with brochure, resume or printed promotional material. Samples are filed. Samples not filed are returned by SASE. Reports back within 2 years only if interested. To show a portfolio, mail appropriate materials. "No phone calls please. We'll call you." Pays for illustration by the project, $50-10,000. Considers client's budget and how work will be used when establishing payment. Rights purchased vary according to project.

Tips: "In order for a portfolio to be memorable, it should focus on a limited number of styles and techniques. This applies to illustrators. Designers should have a wide variety of very good work. We do not see portfolios unless we initiate the review, after reviewing samples."

***TIMMERMAN DESIGN**, Suite 6, 815 N. 1st Ave., Phoenix AZ 85003-1448. (602)967-7039. Office Manager: Martha Pantera. Estab. 1987. Specializes in annual reports; corporate identity; direct mail, package and publication design. Clients: corporations and marketing consultants.
Needs: Approached by 30-40 freelance artists/year. Works with 2-15 freelance illustrators and 4-7 freelance designers/year. Prefers artists with experience in design and production. Works on assignment only. Uses illustrators mainly for brochure and lettering. Uses freelance designers mainly for ads, brochures, catalogs, logos and mechanicals. Also uses freelance artists for retouching, aibrushing, lettering, P-O-P and poster illustration, model making, charts/graphs and audiovisual materials.
First Contact & Terms: Send query letter with resume, tearsheets, photographs, photocopies, photostats and slides. Samples are filed or are returned by SASE if requested by artist. Reports back to the artist only if interested. To show a portfolio, mail thumbnails, roughs, photostats, tearsheets, slides, transparencies and printed samples of brochures. Pays for design by the hour, $10-25. Pays for illustration by the hour, $15-65. "Payment depends on nature of project, client's budget level of skill and market rate." Rights purchased vary according to project.

TOLLNER DESIGN GROUP, Suite 1020, 111 N. Market St., San Jose CA 95113. (408)293-5300. FAX: (408)293-5389. President: Lisa Tollner. Estab. 1980. Specializes in corporate identity, direct mail design, package design and collateral. Clients: ad agencies and corporations. Current clients include: Cisco Systems, Valid Logi and Valley Fair Shopping Center. Client list available upon request.
Needs: Approached by 50 freelance artists/year. Works with 15 freelance illustrators/year. Prefers local artists only. Works on assignment only. Also uses freelance illustrators for brochure, catalog, P-O-P, poster and ad illustration; retouching; airbrushing; lettering, model making; charts/graphs and audiovisual materials.
First Contact & Terms: Send query letter with tearsheets, photographs, photocopies, photostats, slides and transparencies. Samples are filed. Reports back only if interested. Call or write to schedule an appointment to show portfolio. Portfolio should include tearsheets, photographs, slides and transparencies. Pays for illustration by the project, $150-2,500. Rights purchased vary according to project.

TOTAL DESIGNERS, Box 888, Huffman TX 77336. (713)324-4249. President: Ed Lorts. Specializes in corporate identity, display, signage, technical illustration and exhibit and interior design. Current clients include: Hines Interests, Trammel Crow, Central Park Associates. Client list available upon request.
Needs: Approached by 3 or 4 freelance artists/year. Works with 1 or 2 freelance illustrators and designers/year. Works on assignment only. Uses artists for brochure and catalog illustration, P-O-P displays, mechanicals and logos. Especially needs entry-level artist.
First Contact & Terms: Send query letter with brochure, resume and samples. Samples are filed or are returned. Reports back only if interested. Call or write to schedule an appointment to show portfolio, which should include thumbnails, roughs and original/final art. Pays for design by the project, $100 minimum. Pays for illustration by the project, $250. Considers complexity of project, skill and experience of artist, turnaround time and rights purchased when establishing payment. Buys all rights; rights purchased vary according to project.
Tips: "Bring turnkey projects, thumbnails and roughs through to finished. Don't show old material."

***TRAVER AND ASSOCIATES, INC.**, Suite 203, 424 Riverside, Battle Creek MI 49015. (616)963-7010. FAX: (616)963-5319. Senior Art Director: Stephen Thompson. Estab. 1980. Specializes in brand identity and corporate identity, package design, publication design, advertising, communications, video. Clients: corporations, service industry (food, RV, health care and insurance companies). Current clients include: Kellogg's, Transamerica, Kalsec, Tekonsha, Sealand, Bluewater Marine, Newell Coach and Adventist Health Systems.
Needs: Approached by 12+ freelance artists/year. Works with 6+ freelance illustrators and 6+ freelance designers/year. Works on assignment only. Uses freelance illustrators mainly for packaging and collateral. Also uses freelance artists for brochure design and illustration, retouching, airbrushing, ad design, book design, P-O-P design, model making and ad illustration.
First Contact & Terms: Send query letter with tearsheets, photostats, resume and slides. Samples are filed unless return is requested. Reports back within 2 weeks. Write to schedule an appointment to show a portfolio. Portfolio should include thumbnails, roughs, original/final art and tearsheets. Payment for design and illustration is negotiable. Buys all rights.

CHIP TRAVERS GRAPHIC DESIGN, 2360 E. Broadway, Tucson AZ 85719. (602)792-1018. FAX: (602)884-9825. Specializes in annual reports; corporate identity; display, direct mail and publication design; signage and promotional graphics. Clients: hotels, corporations, hospitals, direct clientele. Current clients include: McCollough, Larson Co. and Magma Copper. Client list available upon request.
Needs: Approached by 50 freelance artists/year. Works with 5-7 freelance illustrators and 10-15 designers/year. Prefers local artists and qualified professionals. Works on assignment only. Uses illustrators mainly for annual reports and posters and covers. Uses designers mainly for ads, publications and logos. Also uses artists for brochure/illustration; mechanicals; retouching; airbrushing; catalog, P-O-P and poster illustration; model making; ad illustration and audiovisual materials.

First Contact & Terms: Send query letter with brochure and resume. Samples are returned. Reports back only if interested. Write to schedule an appointment to show a portfolio. Portfolio should include b&w tearsheets, slides and transparencies (35mm/4×5). Pays for design and illustration by the project. Rights purchased vary according to project.

TRIBOTTI DESIGNS, 22907 Bluebird Dr., Calabasas CA 91302-1832. (818)591-7720. Contact: Robert Tribotti. Estab. 1970. Specializes in graphic design, annual reports, corporate identity, packaging, publications and signage. Clients: PR firms, ad agencies. institutions and corporations. Clients: Southwestern University, LA Daily News, Northrup Corporation, and Grubb& Ellis.
Needs: Works with 2-3 freelance artists/year. Prefers local artists only. Works on assignment only. Mainly uses freelancers for brochure illustration. Also uses artists for catalogs, mechanicals, retouching, airbrushing, charts/graphs, lettering and advertisement. Prefers marker, pen & ink, airbrush, pencil, colored pencil and computer illustration.
First Contact & Terms: Send query letter with brochure. Reports back only if interested. Call to schedule an appointment to show a portfolio, which should include thumbnails, roughs, original/final art, final reproduction/product and b&w and color tearsheets, photostats and photographs. Pays for design and illustration by the project, $100 minimum. Considers complexity of project, client's budget, skill and experience of artist, how work will be used and rights purchased when establishing payment. Buys one-time rights; negotiates rights purchased. Rights purchased vary according to project.
Tips: "We will consider experienced artists only. Must be able to meet deadline. Send printed samples and follow up with a phone call."

***UNICOM**, 4100 W. River Lane, Milwaukee WI 53209. (414)354-5440. FAX: (414)354-7714. Senior Partners: Ken Eichenbaum and Cate Charlton. Executive Art Director: Tom McMahon. Estab. 1974. Specializes in annual reports, brand identity, corporate identity, display design, direct mail design, package design, publication design and signage. Clients: corporations, business-to-business communications, and consumer goods. Client list available upon request.
Needs: Approached by 8-10 freelance artists/year. Works with 3-4 freelance illustrators/year. Works on assignment only. Uses freelance artists for brochure, book, poster, and ad illustration.
First Contact & Terms: Send query letter with brochure. Samples are not filed or returned. Does not report back; the artist should not send samples to be returned. Write to schedule an appointment to show a portfolio. Portfolio should include thumbnails, photostats, slides and tearsheets. Pays for illustration by the project, $200-6,000. Rights purchased vary according to project.

UNIT 1, INC., 1556 Williams St., Denver CO 80218. (303)320-1116. President: Chuck Danford. Estab. 1969. Specializes in annual reports, corporate identity, direct mail, publications and signage. Clients: construction, development and industrial. Current clients include: Saunders Construction Inc., Hazen Research, Analytical Surveys, Inc., Coors Technology Center and Western Mobile Inc. Client list not available.
Needs: Approached by 25 freelance artists/year. Works with 1 or 2 freelance illustrators and 5-10 freelance designers/year.Uses freelancers mainly for design and production. Also uses artists for design, brochures, catalogs, P-O-P displays, mechanicals, posters, direct mail packages, charts/graphs, logos and advertisements.
First Contact & Terms: Send resume and samples to be kept on file. Reports only if interested. Call or write for appointment to show portfolio. Pays for design and production by the project. Considers skill and experience of artist when establishing payment.
Tips: "Show printed pieces whenever possible; don't include fine art. Explain samples, outlining problem and solution. If you are new to the business develop printed pieces as quickly as possible to illustrate practical experience."

UNIVERSAL EXHIBITS, 9517 E. Rush St., South El Monte CA 91733. (213)686-0562. President: M.A. Bell. Estab. 1946. Specializes in display and interior design. Clients: ad agencies, companies and museums. Current clients include: Litton Industries, Yamaha, Hasbro and Lockheed. Client list not available.
Needs: Approached by 5-7 freelance artists/year. Works with 2 freelance illustrators and 6 freelance designers/year. Prefers local artists, up to 40 miles, with sketching abilities. Works on assignment only. Uses artists for design and model making.
First Contact & Terms: Send resume and slides to be kept on file; reviews original art. Samples not kept on file are returned only if requested. Reports back within 5 days. Call for appointment to show portfolio. Pays for design by the hour, $22-35 average. Considers client's budget and turnaround time when establishing payment.
Tips: "Think trade shows and museums."

***URBAN TAYLOR & ASSOCIATES**, 12250 SW 131st Ave., Miami FL 33186. (305)238-3223. FAX: (305)238-1853. Senior Vice President: Terry Stone. Estab. 1976. Specializes in annual reports, corporate identity and communications, and publication design. Clients: corporations. Current clients include: IBM, American Express, Polaroid and Video Jukebox Network. Client list available upon request.

Needs: Works with freelance illustrators on a per need basis. Works with artist reps and local artists. Looking for a variety of illustration styles, freelance designers with experience on Macs. Works on assignment only. Uses freelance illustrators mainly for brochures and publications. Also uses freelance artists for brochure, catalog and P-O-P illustration; retouching; airbrushing; lettering; and charts/graphs.
First Contact & Terms: Send query letter with SASE and appropriate samples. Samples are filed. Reports back to the artist only if interested. "We keep on file for the appropriate project." Call or write to schedule an appointment to show a portfolio, or mail appropriate materials. Pays for illustration by the project, $100 minimum. "Payment depends on project and quantity." Rights purchased vary according to project.

WARHAFTIG ASSOCIATES, INC., 48 W. 25th St., New York NY 10010. (212)645-2220. Production Coordinator: Chik Fung. Estab. 1982. Specializes in collateral, advertising, sales promotion for Fortune 500 companies.
Needs: Works with 20-30 freelance artists/year. Prefers very experienced artists. Uses freelance artwork mainly for mechanicals and illustration. Also uses freelance artists for brochure design and illustration, magazine design, retouching, charts/graphs, AV materials, lettering, logos and design of advertisements.
First Contact & Terms: Send query letter with resume and tearsheets. Samples not filed are returned if accompanied by a SASE. Does not report back. Write to schedule an appointment to show a portfolio, which should provide an adequate representation of style, concepts, work. Pays for design by the hour, $20-40. Pays for illustration by the project. Considers complexity of project, client's budget, skill and experience of artist, how work will be used, turnaround time and rights purchased when establishing payment. Rights purchased vary according to project.
Tips: "Do not show that *one* piece that is not consistent in quality with the rest of your portfolio. Don't throw your work into a portfolio with a zipper that doesn't work. Send material for us to keep on file."

WEYMOUTH DESIGN, INC., 332 Congress St., Boston MA 02210-1217. (617)542-2647. FAX: (617)451-6233. Office Manager: Judith Hildebrandt. Estab. 1973. Specializes in annual reports and corporate collateral. Clients: corporations and small businesses. Client list not available.
Needs: Approached by "tons" of freelance artists/year. Works with 10 freelance illustrators and 5 freelance designers/year. Prefers artists with experience in corporate annual report illustration. Works on assignment only. Uses illustrators mainly for annual reports. Uses designers mainly for mechanicals. Also uses illustrators for brochure and poster illustration.
First Contact & Terms: Send query letter with resume or illustration samples. Samples are filed. Samples not filed are returned by SASE if requested by artist. Reports back within 5 days. For illustration and photography does not report back, in which case the artist should call for a portfolio review in April-June only. Pays for design by the hour, $18-35. Pays for illustration by the project; "artists usually set their own fee to which we do or don't agree." Rights purchased vary according to project.

WHITEFLEET DESIGN INC.,, 440 E. 56th St., New York NY 10022. (212)319-4444. Contact: Ine Wijtvliet. Specializes in annual reports, brand and corporate identity; display, exhibits and shows, packaging, publications, signage and slide shows. Clients: large computer and engineering corporations, retail stores, hospitals, banks, architects and industry.
Needs: Works with 8 freelance artists/year. Uses artists for brochure and catalog layout, mechanicals, retouching, model making, charts/graphs, AV presentations, lettering and logo design. Especially needs good artists for mechanicals for brochures and other print. Prefers Swiss graphic style.
First Contact & Terms: Send brochure/flyer and resume; submit portfolio for review. Prefers actual printed samples or color slides. Samples returned by SASE. Reports within 1 week. Provide brochure/flyer, resume and tearsheets to be kept on file for possible future assignments. Pays $10-15/hour for mechanicals; pays by the project for illustration.

***THE WHOLE WORKS®,** Suite 1804, 1440 Broadway, New York NY 10018-2301. (212)575-0765. Creativity Liaison: Janet Moore. Estab. 1974. Specializes in brand and corporate identity; display, direct mail, package, and publication design; and landscape and interior signage. Clients: ad agencies, manufacturers, foundations and corporations.
Needs: Approached by 20 freelance artists/year. Works with 3 freelance illustrators and 3 freelance designers/year. Prefers artists with experience in traditional skills. Works on assignment only. Uses designers and illustrators for mechanicals, airbrushing, catalog illustration, P-O-P illustration and direct mail design.
First Contact & Terms: Send query letter. Samples are filed or are returned by SASE. Reports back within 3 days. Call to schedule an appointment to show a portfolio. Pays for design by the project or by the day; negotiated. Pays for illustration by the project; negotiated. Buys all rights.

***WILDER●FEARN & ASSOC., INC.,** Suite 416, 644 Linn St., Cincinnati OH 45203. (513)621-5237. FAX: (513)621-4880. President: Gary Fearn. Estab. 1946. Specializes in annual reports; brand and corporate identity; and display, package and publication design. Clients: ad agencies and corporations. Current clients include: Jergens Co., Kenner Toys and Kraft. Client list available upon request.

Needs: Approached by 20 freelance artists/year. Works with 5-10 freelance illustrators and 2-5 freelance designers/year. Prefers artists with experience in packaging and illustration comps. Uses freelance illustrators mainly for comps and finished art on various projects. Uses freelancers for editorial illustration. Uses freelance designers mainly for packaging and brochures. Also uses freelance artists for brochure design and illustration and packaging.

First Contact & Terms: Send query letter with brochure, resume and slides. Samples are filed or are returned by SASE if requested by artist. Reports back to the artist only if interested. Call to schedule an appointment to show a portfolio. Portfolio should include roughs, original/final art and color tearsheets and slides. Payment for design and illustration is based upon talent, client and project. Rights purchased vary according to project.

Tips: "The recession has increased our need for freelance artists."

WISNER ASSOCIATES, Advertising, Marketing & Design, 2237 N.E. Wasco, Portland OR 97232. (503)228-6234. Creative Director: Linda Wisner. Estab. 1979. Specializes in brand identity, corporate identity, direct mail, packaging and publications. Clients: small businesses, manufacturers, restaurants, service businesses and book publishers. Client list not available.

Needs: Approached by 20-30 freelance artists/year. Works with 7-10 freelance artists/year. Prefers experienced artists and "fast clean work." Works on assignment only. Uses artists for illustration, books, mechanicals, airbrushing and lettering.

First Contact & Terms: Send query letter with resume, photostats, photocopies, slides and photographs to be kept on file. Prefers "examples of completed pieces, which show the abilities of the artist to his/her fullest." Samples not kept on file are returned by SASE only if requested. Reports only if interested. To show a portfolio, call to schedule an appointment or mail thumbnails, roughs, original/final art and final reproduction/product. Pays for illustration by the hour, $15-30 average. Pays for paste-up/production by the hour, $10-25. Considers complexity of project, client's budget, skill and experience of artist, how work will be used and turnaround time when establishing payment.

Tips: "Bring a complete portfolio with up-to-date pieces."

MICHAEL WOLK DESIGN ASSOCIATES, 2318 NE 2nd Court, Miami FL 33137. (305)576-2898. President: Michael Wolk. Estab. 1985. Specializes in corporate identity, display and interior design and signage. Clients: Corporate and private. Uses freelance artists for editorial and technical illustration. Client list available.

Needs: Approached by 10 freelance artists/year. Works with 5 freelance illustrators and 5 freelance designers/year. Prefers local artists only. Works on assignment only. Uses illustrators mainly for brochures. Uses designers mainly for interiors and graphics. Also uses artists for brochure design and illustration, mechanicals, logos and catalog illustration. Needs "progressive editorial and technical illustration.

First Contact & Terms: Send query letter with slides. Samples not filed and are returned by SASE. Reports back to the artist only if interested. Mail appropriate materials: slides. Rights purchased vary according to project.

BENEDICT NORBERT WONG MARKETING DESIGN, 333 Broadway, San Francisco CA 94133. (415)781-7590. President/Creative Director: Ben Wong. Specializes in direct mail and marketing design. Clients: financial services companies (banks, savings and loans, insurance companies, stock brokerage houses) and direct mail marketing firms (ad agencies, major corporations).

Needs: Works with 15 freelance artists/year. Uses artists for design, illustration, brochures, catalogs, mechanicals, retouching, posters, direct mail packages, charts/graphs, lettering, logos and advertisements. Especially needs "experienced designers in area of direct mail."

First Contact & Terms: Send query letter with resume, business card and samples to be kept on file. Prefers tearsheets as samples. Reports back if interested. Call for appointment to show portfolio. "Payment depends on experience and portfolio." Considers complexity of project, client's budget, skill and experience of artist, how work will be used, turnaround time and rights purchased when establishing payment.

Tips: "Please show imaginative problem-solving skills which can be applied to clients in direct marketing."

YAMAGUMA & ASSOCIATES, Suite 230, 1570 The Alameda, San Jose CA 95126. (408)279-0500. FAX: (408)293-7819. Production Manager: Gaye Sakakuchi. Estab. 1980. Specializes in corporate identity; display, direct mail and publication design; signage and marketing. Clients: high technology, government and business-to-business. Current clients include the Port of San Francisco, City of San Jose Redevelopment, Intel, A&D Engineering, and SJUSD. Client list available upon request.

Needs: Approached by more than 100 freelance artists/year. Works with 3-4 freelance illustrators and 4-6 designers/year. Works on assignment only. Uses illustrators mainly for 4-color, airbrush and technical work. Uses designers mainly for logos, layout and production. Also uses brochure design and illustration, catalog design, mechanicals, retouching, lettering, logos, ad design, catalog illustration, book design, magazine design, newspaper design, P-O-P design and illustration, poster illustration and design, model making, direct mail design, charts/graphs, audiovisual materials and ad illustration.

© Jennifer Sterling

This project is one of many which Jennifer Sterling worked on for Miami-based Michael Wolk Design Associates. From these projects she says she reaped "the ultimate benefit" — the merging of her freelance business with their firm. Sterling is now a creative director and principal of the firm. This fundraising folder project was done for the Broward Performing Arts Center in Ft. Lauderdale with a very small budget. Sterling says the response has been "phenomenal."

First Contact & Terms: Send query letter with brochure, tearsheets, photostats, resume, photographs, slides, photocopies and transparencies. Samples are filed. Reports back only if interested. To show a portfolio, mail thumbnails, roughs, original/final art, b&w and color photostats, tearsheets, photographs, slides and transparencies. Pays for design by the hour, $15-250. Pays for illustration by the project, $500-2,000. Rights purchased vary according to project.
Tips: Would like to see more McIntosh created illustrations.

***CLARENCE ZIERHUT, INC.,** 2014 Platinum St., Garland TX 75042. (214)276-1722. FAX: (214)272-5570. President: Clarence Zierhut. Estab. 1973. Specializes in brand identity, coporate identity, display and package design, and technical illustration. Clients: corporations.
Needs: Approached by 2 freelance artists/year. Works with 2 freelance illustrators and designers/year. Prefers artists with experience in product illustration. Works on assignment only. Uses illustrators mainly for presentations. Uses freelance designers mainly for product design and layout. Also uses freelance artists for brochure design and illustration, catalog design and illustration, mechanicals, retouching, airbrushing, lettering, logos and model making.
First Contact & Terms: Send query letter with brochure and resume. Samples are filed. Reports back to the artist only if interested. To show a portfolio, mail b&w and color photographs. Pays for design and illustration by the project. Buys all rights.

Other Art/Design Studios

Each year we contact all firms currently listed in *Artist's Market* requesting they give us updated information for our next edition. We also mail listing questionnaires to new and established firms which have not been included in past editions. The following art/design studios either did not respond to our request to update their listings for 1992 (if they indicated a reason, it is noted in parentheses after their name), or they did not return our questionnaire for a new listing.

Primo Angeli Inc.
Ark Andre Richardson King-Architectural Graphic Designers
Battery Graphics (asked to be deleted)
Bass/Yager and Associates
May Bender Design Associates (out of business)
Bright and Associates
CAS Associates
Cathey Associates, Inc.
CN/Design
Woody Coleman Presents, Inc.
Cross Associates
Curry Design
Denton Design Associates (asked to be deleted)
Design & Production Incorporated
Designworks, Inc.
Duffy Design Group
Rod Dyer Group
Falco & Falco Incorporated (no longer uses outside freelance help)
Hans Flink Design Inc.
Freelance Professionals of Chicago, Inc. (unable to contact)
Milton Glaser
Graphicus Corporation
Hornall Anderson Design Works
Huston and Company
Identity Center
Impressions, ABA Industries, Inc.
Inno (asked to be deleted)
Kasom Design
Lee Graphics Design
Little & Co.
Leone Design Group Inc.
M & Co.
Miller + Schwartz
Clement Mok Designs
Morla Design
Mossman Associates (asked to be deleted)
Nichols Graphic Design (unable to contact)
Office of Michael Manwaring
Panographics
Pentagram, SF
Platinum Design, Inc. (asked to be deleted)
Presence
Publishing Services
John Racila Associates (unable to contact)
Read Ink (unable to contact)
Shareff Designs (asked to be deleted)
Sibley, Peteet Design
Strategic Design Group (asked to be deleted)
Gordon Stromberg Design (overstocked)
Studio Graphics
Tokyo Design Center
Waters Design Associates
Vanderbyl Design
Vaughn/Wedeen Creative
Vignelli Associates
Susan B. Wenzel Elements

Market conditions are constantly changing! If you're still using this book and it is 1993 or later, buy the newest edition of Artist's Market *at your favorite bookstore or order directly from Writer's Digest Books.*

Art Publishers

When you sell your work directly to a collector, you know it will be shared with the collector's family and friends. When work hangs in a gallery or at a show, you know many people will see it—art buyers and casual passersby from the nearby community, maybe some tourists and a handful of serious collectors. Yet for maximum exposure, you may want to consider publication.

Art publishers can put your work before art buyers of all incomes, geographic locations, backgrounds and interests. Depending on the type of print or publication, publishing also can maximize your income from the sale of a single image.

Although the terms are sometimes used interchangeably, the difference between prints and reproductions lies in the way they are produced. Prints, also called original graphics or handpulled prints, are copies of original works produced by hand or by nonmechanical means. These may be lithographs, serigraphs, linocuts, engravings, woodcuts or etchings. The artist often is intimately involved in the actual printmaking process.

The nature of the process limits the number of prints that can be made at one time. The quantity is, therefore, limited to the number of impressions possible before the plate or other printing surface wears out. Publishers quite often set limits of 250 or 500 prints in an edition to protect quality and to add value. Because quantity is limited, prints usually command a higher price than reproductions.

In recent years publishers have noted a growth in the interest in original graphics or prints. At the high end of the publishing market, many serious collectors are turning to prints because they are less expensive than original art. At the same time, they hold and even increase their value over time.

Gallery owners have found that collectors who begin by buying fine-art prints will "graduate" to original work as their income increases. Many galleries that would not have considered prints just a few years ago are now adding prints to their collections.

Reproductions are copies produced on an offset press or by photomechanical means. Quantity is limited only by the market. Unlimited reproductions are often called posters. With posters, the image is often enhanced by a border and title type. Special treatments such as gold stamping may also be added.

While some artists choose to publish their own work, this requires a knowledge of printing processes and marketing savvy, as well as the financial means. Art publishers produce prints or reproductions for the artist and may also distribute those published by other companies or by the artists themselves.

Galleries, art dealers, printers and other businesses may be art publishers. Many poster companies sell to wholesale outlets—frame shops, chain poster stores, manufacturers and retail outlets. Publishers of limited edition prints may sell to high-end interior designers, architects, art consultants, corporate collectors and galleries. Some even operate their own print galleries.

Art publishing is market-driven. Trends and popular taste play an important role, especially in the poster market. This year industry experts are predicting brighter, cleaner colors—a move away from the dusty pastels of the 1980s. Deep colors—dark green, sienna and purple—are also making a comeback.

The recent downturn in the economy has also affected the print and poster market. While some publishers report little or no change, others say buyers are being more conservative—opting for more traditional styles and artists who already have a "track record."

If you are interested in submitting work to art publishers, study the market carefully. Visit poster shops, frame stores and galleries. Request publisher catalogs whenever possible. Check recent issues of trade publications such as *Decor* and *Art Business News* or consumer magazines such as *Architectural Digest, Interior Design* and *Metropolitan Home* for features on interior design trends and new ideas in the market. *U.S. Art* does an excellent job of covering the world of realistic art—wildlife, figurative, nature, Western and Americana—for the print buyer.

Other helpful sources include the Pantone Color Institute and the Color Marketing Group. These organizations publish an annual list of popular colors. If possible, attend some trade shows so you can meet designers and publishers. Art Expo and Art Buyers Caravan are large national shows. *Decor* magazine also sponsors a series of eight regional trade fairs.

Some images make better prints than others. Keep in mind most people buy prints or reproductions to hang in their home or office. They look for something they can identify with and live with. Highly experimental work or work that makes a strong but disturbing statement will not have the broad appeal needed to do well in this market. On the other hand, bland or derivative images will not interest most publishers. Publishers look for strong images that are fresh and have universal appeal.

To find a publisher, check who has published the work you admire. Look for ads in trade and consumer magazines, and study the listings presented in this section. Once you've selected a publisher, send a query letter with a brief bio or a list of galleries which have represented your work. Send slides, but be sure to label each one with your name and address. Indicate position, size and media of the original on each slide. Tearsheets can be helpful because they show publishers your work is reproducible. Always include an SASE. If you've published your own work and are interested in distribution only, you can send slides, but at some point you will need to send the actual reproductions.

Most publishers pay on a royalty basis, although a few offer flat fees. Royalties for posters are based on the wholesale price and range from 2.5 to 5 percent. For prints, royalties are based on the retail price and can range from 5 to 20 percent. A number of factors determine price, including the artist's experience and reputation, the quality of the reproduction, printing costs, sales potential and the amount or promotion necessary. Publishers will often hold back royalties on a specific number of prints to pay for printing and promotion. Make sure you clearly understand the arrangement before you make your decision.

Before signing any contract with a publisher, check to see if it indicates exactly how much and what type of promotion you will receive. Find out what rights you are selling. Try to retain the right to reproduce your work in another form while selling the publisher the right to publish your work in a certain type of print for a limited amount of time. Some publishers will purchase additional rights if they also plan to reproduce your work in another format such as notecards or calendars. Other items to look for in your contract include a description of the work, size and type of reproduction, payment, insurance terms, a guarantee of credit line and copyright notice. Always maintain ownership of the original work.

A good publisher will give you approval over the final print, and most will arrange for you to see a press proof. Be realistic in your expectations. The more you know about what can and cannot be done in certain printing processes, the better. It is often very difficult to match colors exactly, for example. Knowing what to expect beforehand can help eliminate surprises and headaches for the printer and publisher, as well as for yourself.

AARON ASHLEY, INC., Suite 1905, 230 5th Ave., New York NY 10001. (212)532-9227. Contact: Philip D. Ginsburg or Budd Wiesenburg. Produces unlimited edition fine quality 4-color offset and hand-colored reproductions for distributors, manufacturers, jobbers, museums, schools and galleries. Current clients include major U.S. and overseas distributors.

Needs: Seeking artwork with decorative appeal for designer market. Considers oil paintings and watercolor. Prefers realistic or representational works. Editions created by working from an existing painting or chrome. Approached by 100+ artists/year. Publishes more than 125 emerging artists/year.
First Contact & Terms: Query, arrange interview or submit slides or photos. Include SASE. "Do not send originals." Reports immediately. Pays royalties or fee. Offers advance. Negotiates rights purchased. Requires exclusive representation for unlimited editions. Provides written contract.

ADVANCE GRAPHICS, 982 Howe Rd., Martinez CA 94553. Photo editor: Steve Henderson. Art publisher handling unlimited edition offset reproductions. Current clients include Sears, Penney's, Macy's and Union Bank. Approached by 100 artists/year. Publishes the work of 50 and distributes the work of 10 emerging artists/year. Publishes and distributes the work of 1-2 mid-career artists/year. Publishes and distributes the work of 1-2 established artists/year. Pays $200-400. "Successful published artists can advance to royalty arrangement. Artists keep originals." Send query letter with photographs, slides and SASE.
Needs: Seeking artwork with creative artistic expression, fashionableness and decorative appeal. Considers oil, acrylic, watercolor, airbrush and mixed media. Prefers "trendy, inspirational and decorative art," Western art and pictures of dogs needed. Artists represented include Sue Dawe, Ron Kimball, A. Sutherland and B. Garcia. Editions created by collaborating with the artist and by working from an existing painting.

AEROPRINT, (AKA SPOFFORD HOUSE), South Shore Rd., Box 154, Spofford NH 03462. (603)363-4713. Owner: R. Westervelt. Estab. 1972. Art publisher/distributor handling limited editions (maximum 250 prints) of offset reproductions and unlimited editions for galleries and collectors. Clients: aviation art collectors. Seeking artwork with creative artistic expression. Publishes/distributes the work of 17 artists/year. Publishes the work of 1 emerging artist/year. Publishes and distributes the work of 12 mid-career artists/year. Publishes and distributes the work of 4 established artists/year. Payment method is negotiated. Offers an advance. Negotiates rights purchased. Does not require exclusive representation. Provides a written contract and shipping from firm. To show a portfolio, mail appropriate materials which should include color or b&w thumbnails, roughs, original/final art, photostats, tearsheets, slides, transparencies or final reproduction/product.
Needs: Considers pen & ink, oil, acrylic, pastel, watercolor, tempera or mixed media. Prefers "aviation subject matter only." Artists represented include Dietz, Corning, Kotula, Willis, Ryan, Deneen and Cohen.
Tips: A common mistake artists make when presenting their work is "incomplete or undeveloped talent, prematurely presented for publishing or introduction to project."

AESTHETIC IMPRESSIONS, 12455 Branford, Arleta CA 91331. (818)897-2259. Manager: David Garcia. Estab. 1980. Art publisher. Publishes and distributes posters and foil prints. Clients: small and large distributors. Current clients include: Western Graphics and Prints Plus.
Needs: Seeking art for the commercial market. Considers lithographs and foil prints. Prefers animal, fantasy themes and landscapes. Artists represented include Kirk Reynart and Carol Hoss. Editions created by collaborating with the artist and by working from an existing painting. Approached by few artists/year. Publishes and distributes the work of 2 established artists/year.
First Contact & Terms: Send query letter with brochure showing art style. Samples are filed. Reports back within 1 week. Call or write to schedule an appointment to show a portfolio. Portfolio should include slides, transparencies and photographs. Payment method is negotiated. Offers an advance. Negotiates rights purchased. Provides a written contract.
Tips: "Prints should deal with animals or landscapes."

AMERICAN ARTS & GRAPHICS, INC., 10315 47th Ave. W., Everett WA 98204-3436. Licensing Director: Shelley Pedersen. Estab. 1948. Publishes posters for a teenage market; minimum 5,000 run. "Our main market is family variety stores, record and tape stores, and discount drug stores." Current clients include Walmart, K-Mart, Fred Meyer, Roses, Longs and Osco.
Needs: Seeking artwork with decorative appeal (popular trends). Prefers 7×11″ sketches; full-size posters are 23×35″. Prefers airbrush, then acrylic and oil. Artists represented include Gail Gastfield, Robert Prokop, Robert Contreras and Gwen Connelly. Editions created by working from an existing painting. Artists represented include Jerry Mooney, Vikki Hart and Jeanne Jablinski. Approached by 100 artists/year. Publishes

The asterisk before a listing indicates that the listing is new in this edition. New markets are often the most receptive to freelance submissions.

and distributes the work of 2-3 emerging, 2-3 mid-career and 3-4 established artists/year. Distributes the work of 60 emerging, mid-career and established artists/year. Artist's guidelines available.

First Contact & Terms: Send query letter with tearsheets, photostats, photocopies and production quality duplicate slides; then submit sketch or photo of art. Include SASE. Reports in 2 weeks. Usually pays royalties of 10¢ per poster sold and an advance of $500-1,000 against future royalties. Payment schedule varies according to how well known the artist is, how complete the work is and the skill level of the artist.

Tips: "Research popular poster trends; request a copy of our guidelines. Our posters are in inexpensive way to decorate so art sales during recession don't show any significant decreases."

© American Graphic Arts/Ted Jeremenko 1990

The austerity of this Ted Jeremenko acrylic painting is representative of all of his work. It was used as a model for the original serigraph "Lighthouse by the Bay," published by American Graphic Arts in Boston. He was paid $6,500 for this piece. Jeremenko has the established reputation and experience with fine-art printers that the art publisher is looking for.

***AMERICAN GRAPHIC ARTS**, 101 Merrimac St., Boston MA 02114. (800)637-9997. FAX: (617)723-6561. President: Jonathan Pollock. Estab. 1986. Art publisher and gallery. Publishes handpulled originals and "unique works." Clients: other galleries, retail art collectors and dealers in the U.S. and Japan.

Needs: Seeking artwork for the commercial market. Considers oil and acrylic. Prefers realistic imagery. Artists represented include Ted Jeremenko and Igor Galanin. Editions created by collaborating with the artist and by working from an existing painting. Approached by 75-100 artists/year. Publishes and distributes the work of 2 established artists/year.

First Contact & Terms: Send query letter with brochure showing art style or resume and the following samples: slides, photographs and transparencies. Samples are filed, if interested or are returned by SASE if requested by artist. Reports back only if interested, otherwise, materials returned. To show a portfolio, mail tearsheets, photographs, slides and transparencies. Payment method is negotiated. Negotiates rights purchased. Requires exclusive representation of artist. Provides in-transit insurance, insurance while work is at firm, promotion, shipping from your firm and a written contract.

Tips: "Prefers artists with established reputations and experience with fine art printers."

AMERICAN MASTERS FOUNDATION, 10688 Haddington, Houston TX 77043. (713)932-6847. FAX: (713)932-7861. Executive Assistant: Allison Sutton. Estab. 1971. Art publisher. Publishes handpulled originals, unlimited and limited editions.

Needs: Seeking artwork with creative artistic expression, fashionableness and decorative appeal for the serious collector, commercial market and designer market. Considers oil, watercolor, acrylic, mixed media, gouache and tempera. Prefers traditional, realist, floral, Victorian, impressionistic styles and landscapes. Artists represented include P. Crowe, L. Dyke, C. Frace, L. Gordon, C.J. Frazier and Pearson. Editions created by collaborating with the artist and by working from an existing painting. Approached by 50-75 artists/year. Publishes the work of 1 artist/year. Publishes the work of 6 mid-career artists/year. Publishes the work of 2 established artists/year.

First Contact & Terms: Send query letter with brochure showing art style or resume, slides and photographs. Samples are not filed and are returned. Reports back within 2 months. Mail appropriate materials: original/final art and photographs. Payment method is negotiated. Offers an advance when appropriate. Buys all rights. Requires exclusive representation of artist. Provides in-transit insurance and shipping from firm.

ANGEL GIFTS INC., Box 530, Fairfield IA 52556. (515)472-5481. Art Director: Donald Schmit. Estab. 1981. Poster art publisher of photographic and graphic images.

Needs: Religious, inspirational, fantasy, florals, animals (zoo, domestic, wildlife) and personalities. Anything with popular appeal; humorous, cute, exceptional pieces. No abstract or surrealism.

First Contact & Terms: Prefers 35mm or larger slides or original artwork. Payment negotiable for poster/card rights.

Tips: "Do not send original work until approved. Send samples/pictures with SASE if needing return."

HERBERT ARNOT, INC., 250 W. 57th St., New York NY 10107. (212)245-8287. President: Peter Arnot. Vice President: Vicki Arnot. Art distributor of original oil paintings. Clients: galleries.

Needs: Seeking artwork with creative artistic expression, decorative appeal for the serious collector and designer market. Considers oil and acrylic paintings. Has wide range of themes and styles — "mostly traditional/impressionistic, not modern." Distributes work for 250 artists/year.

First Contact & Terms: Send query letter with brochure, resume, business card, slides, photographs or original work to be kept on file. Samples are filed or are returned by SASE. Reports within 1 month. Call or write for appointment to show portfolio. Pays flat fee, $100-1,000 average. Provides promotion and shipping to and from distributor.

Tips: "Professional quality, please."

***ART BUYERS CLUB, INC.**, 7 Hemlock Hill Rd., Upper Saddle River NJ 07458. (201)825-2330. FAX: (201)327-5278. President: Al Di Felice. Estab. 1988. Art publisher, distributor and framers. Publishes/distributes posters and limited editions. Clients: galleries, furniture stores, chains, etc.

Needs: Seeking artwork with decorative appeal, art for the serious collector, the commercial market, and the designer market. Media depends on subject matter. Artists represented include Roger Hinjosa, Jack Herlan and Cyrus. Editions created by collaborating with the artist or working from an existing painting.

First Contact & Terms: Send query letter with brochure showing art style or resume and the following samples: tearsheets, photocopies, slides and photographs. Samples are not filed and are returned by SASE. Reports back within 2 weeks. Call to schedule an appointment to show a portfolio. Portfolio should include original/final art, b&w and color slides, transparencies and photographs. Pays royalties or on consignment basis; payment method is negotiated. Offers an advance when appropriate. Buys reprint rights. Requires exclusive representation. Provides promotion and a written contract.

Tips: "Be realistic in analyzing your work. Publishers are primarily interested in top notch work or specialty art."

ART EDITIONS, INC., 352 W. Paxton Ave., Salt Lake City UT 84101. (801)466-6088. Contact: Ruby Reece. Art printer for limited and unlimited editions, offset reproductions, posters and advertising materials. Clients: artists, distributors, galleries, publishers and representatives.

First Contact & Terms: Send photographs, slides, transparencies (size $4 \times 5 - 8 \times 10''$) and/or originals. "Contact offices for specific pricing information. Free information packet available upon request." Samples are filed. Samples not filed are returned by SASE. Reports back within 2 weeks. Provides insurance while work is at firm.

ART IMAGE INC., 1577 Barry Ave., Los Angeles CA 90025. (213)826-9000. President: Allan Fierstein. Publishes and produces unlimited and limited editions that are pencil signed and numbered by the artist. Also distributes etchings, serigraphs, lithographs and watercolor paintings. "Other work we publish and distribute includes handmade paper, cast paper, paper weavings and paper construction." All work sold to galleries, frame shops, framed picture manufacturers, interior decorators and auctioneers. Approached by 36 artists/year. Publishes and distributes the work of 18 emerging artists/year. Publishes and distributes the work of 18 mid-career artists/year. Publishes and distributes the work of 18 established artist/year. Negotiates payment.

Requires exclusive representation. Provides shipping and a written contract. Send query letter with brochure showing art style, tearsheets, slides, photographs and SASE. Reports within 1 week. To show a portfolio, mail appropriate materials or write to schedule an appointment; portfolio should include photographs.

Needs: Seeking artwork with decorative appeal for the designer market. "All subject matter and all media in pairs or series of companion pieces." Prefers contemporary, traditional and transitional artists. Artists represented include Robert White, Peter Wong and Sue Ellen Cooper. Editions created by collaborating with the artist.

Tips: "We are publishing and distributing more and more subject matter from offset limited editions to monoprints, etchings, serigraphs, lithographs and original watercolor paintings."

ART IN MOTION, Suite 150, 800 Fifth Ave, Seattle WA 98104; 1612 Ingleton, Burnaby, BC V5C 5R9 Canada. (604)299-8787. FAX: (604)299-5975. President: Garry Peters. Art publisher and distributor. Publishes and distributes limited editions, original prints, offset reproductions and posters. Clients: galleries, distributors world wide and picture frame manufacturers.

Needs: Seeking artwork with creative artistic expression, fashionableness, decorative appeal and art for the serious collector, commercial and designer market. Considers oil, watercolor, acrylic, and mixed media. Prefers decorative and wildlife. Artists represented include Joyce Kamihura and Luc Raffin. Editions created by collaborating with the artist and by working from an existing painting. Approached by 75 artists/year. Publishes the work of 3-5 emerging, mid-career and established artists/year. Distributes the work of 2-3 emerging and established artists/year.

First Contact & Terms: Send query letter with brochure showing art style or resume and tearsheets, slides, photostats, photography and transparencies. Samples are filed or are returned by SASE if requested by artist. Reports back within 2 weeks only if interested. If does not report back the artist should call. To show a portfolio, call or mail appropriate materials: photostats, slides, tearsheets, transparencies and photographs. Pays royalties of 15%. Payment method is negotiated. "It has to work for both parties. We have artists making $200 a month and some that make $8,000 a month or more." Offers an advance when appropriate. Negotiates rights purchased. Requires exclusive representation of artist. Provides in-transit insurance, insurance while work is at firm, promotion, shipping to and from firm and a written contract.

Tips: "We are looking for a few good artists, make sure you know your goals, and hopefully we can help you accomplish them, along with ours."

ART RESOURCES INTERNATIONAL, LTD., Fields Lane, Brewster NY 10509. (914)277-8888. FAX: (914)277-8602. Vice President: Robin E. Bonnist. Estab. 1980. Art publisher. Publishes unlimited edition offset lithographs and posters. Does not distribute previously published work. Clients: galleries, department stores, distributors, framers throughout the world. Approached by hundreds of artists/year. Publishes the work of 10-20 emerging, 5-10 mid-career and 5-10 established artists each year. Also uses artists for advertising layout and brochure illustration. Pays by royalty (3-10%), or flat fee of $250-1,000. Offers advance in some cases. Requires exclusive representation for prints/posters during period of contract. Provides in-transit insurance, insurance while work is at publisher, shipping to and from firm, promotion and a written contract. Artist owns original work. Send query letter with brochure, tearsheets, slides and photographs to be kept on file or returned only if requested and SASE is included; prefers to see slides or transparencies initially as samples, then reviews originals. Samples not kept on file returned only by SASE. Reports within 1 month. Appointments arranged only after work has been sent with SASE.

Needs: Considers oil and acrylic paintings, pastel, watercolor, mixed media and photography. Prefers pairs or series, triptychs, diptychs. Editions created by collaborating with the artist and by working from an existing painting.

Tips: "Please submit decorative, fine quality artwork. We prefer to work with artists who are creative, professional and open to art direction. Write to the company, including a short bio-date and slides of the work they would like us to publish."

ARTHURIAN ART GALLERY, 4646 Oakton St., Skokie IL 60076-3145. Owner: Art Sahagian. Estab. 1985. Art distributor/gallery handling limited editions, handpulled originals, bronze, watercolor, oil and pastel. Current clients include Gerald Ford, Nancy Reagan, John Budnik and Dave Powers.

Needs: Seeking artwork with creative artistic expression, fashionableness and decorative appeal for the serious and commercial collector. Artists represented include Robert Barnum, Nancy Fortunato, Art Sahagian and Christiana. Editions created by collaborating with the artist. Approached by 25-35 artists/year. Publishes the work of 3-5 and distributes the work of 45-50 emerging artists/year. Publishes the work of 3-6 and distributes the work of 10-20 mid-career artists/year. Publishes the work of 3-6 and distributes the work of 15-25 established artists/year.

First Contact & Terms: Pays flat fee, $100-1,000 average. Rights purchased vary. Provides insurance while work is at firm, promotion and a written contract. Send query letter with brochure showing art style or resume, photocopies, slides and prices. Samples not filed returned by SASE. Reports within 30 days. To show a portfolio, mail appropriate materials or write to schedule an appointment. Portfolio should include

original/final art, final reproduction/product and color photographs. Considers complexity of project, client's budget, and skill and experience of artist when establishing payment.

Tips: "Make your work show good craftsmanship, appeal to the public and provide enough quantity for distribution."

ARTHUR'S INTERNATIONAL, Suite 28-88, 101 S. Rainbow, Las Vegas NV 89128. President: Marvin C. Arthur. Estab. 1959. Art distributor handling original oil paintings primarily. Distributes limited and unlimited edition prints. Approached by many artists/year. Clients: galleries, collectors, etc.

Needs: Seeking artwork with creative artistic expression for the serious collector. Considers all types of original artwork. Artists represented include Wayne Takazono, Wayne Stuart Shilson and Paul J. Lopez, Birdel Eliason, Casimir Gradomski, etc. Editions created by collaborating with the artist or by working from an existing painting. Purchases have been made in pen & ink, charcoal, pencil, tempera, watercolor, acrylic, oil, gouache and pastel. "All paintings should be realistic to view, though may be expressed in various manners."

First Contact & Terms: Send brochure, slides or photographs to be kept on file; no originals unless requested. Artist biographies appreciated. Samples not filed returned by SASE. Reports back normally within 1 week. "We pay a flat fee to purchase the original. Payment made within 5 days. We pay 30% of our net profit made on reproductions. The reproduction royalty is paid after we are paid." Artists may be handled on an exclusive or non-exclusive basis.

Tips: "We like artwork that is realistic. Send photos and/or slides, background info and SASE. Do not send any original paintings unless we have requested it. Having a track record is nice, but it is not a requirement. Being known or unknown is not the important thing; being talented and being able to show it to our taste is what is important."

ARTISTS' ENTERPRIZES, Box 1274, Kaneohe HI 96744. (808)239-8933. FAX: (808)239-9186. Creative Director: Larry LeDoux. Estab. 1978. Distributor, advertising and public relations firm for artists and galleries. "We are publishing and marketing consultants." Distributes handpulled originals, posters, limited editions and offset reproductions. Clients: artists and art galleries. Past clients include Robert Nelson and Shipstore Galleries.

Needs: Seeking artwork with creative artistic expression, fashionableness, decorative appeal and art for the serious collector, commercial and designer market. Considers oil, watercolor, acrylic, pastel, pen and ink and mixed media. Artists represented include David Friedman and Vie Kersting. Editions created by collaborating with the artist and by working from an existing painting. Approached by 15-20 artists/year. Distributes the work of 2-4 emerging artists, 4-6 mid-career artists and 2-4 established artists/year.

First Contact & Terms: Send query letter with brochure showing art style and resume with tearsheets, slides and photographs. Samples are filed or are returned by SASE. Reports back within 90 days if interested. Pays on consignment basis: Firm receives 10% commission. "Artist receives monies from all sales less sales expenses, including telephone, shipping, sales commission (10%) and firm fee (10%)." Artist retains all rights. Provides promotion, a written contract, consulting, marketing, sales, PR and advertising.

Tips: "We specialize in helping artists become better known and in helping them fund a promotional campaign through sales. If you are ready to invest in yourself, we can help you as we have helped the Makk family, Robert Lyn Nelson and Andrea Smith."

ARTISTS' MARKETING SERVICE, 160 Dresser Ave., Prince Frederick MD 20678. President: Jim Chidester. Estab. 1987. Distributor of limited and unlimited editions, offset reproductions and posters. Clients: galleries, frame shops and gift shops.

Needs: Approached by 200-250 artists/year. Publishes the work of 2 and distributes the work of 10-15 emerging artists/year. Distributes the work of 5-10 mid-career and 3-5 established artists/year. Seeking artwork with decorative appeal and art for the commercial collector and designer market. Prefers traditional themes: landscapes, seascapes, nautical, floral, wildlife, Americana, impressionistic and country themes.

First Contact & Terms: Send query letter with brochure, tearsheets and photographs. Samples are filed or returned by SASE only if requested by artist. Reports back within weeks. To show a portfolio, mail tearsheets and slides. Pays on consignment basis (50% commission). Offers an advance when appropriate. Purchases one-time rights. Does not require exclusive representation of artist.

Tips: "We are only interested in seeing work from self-published artists who are interested in distribution of their prints. We are presently *not* reviewing originals for publication."

ARTISTWORKS WHOLESALE INC., 32 S. Lansdowne Ave., Lansdowne PA 19050. (215)626-7770. Art Coordinator: Helen Casale. Estab. 1981. Art publisher. Publishes and distributes posters and cards. Clients: galleries, decorators and distributors worldwide.

Needs: Seeking artwork with creative artistic expression, fashionableness and decorative appeal for the commercial and designer markets. Considers oil, watercolor, acrylic, pastel, mixed media and photography. Prefers contemporary and popular themes, realistic and abstract. Editions created by collaborating with artist and by working from an existing painting. Approached by 100 artists/year. Publishes and distributes the work

of 1-2 emerging artists, 3-4 mid-career artists and 10-15 established artists/year.

First Contact & Terms: Send query letter with brochure showing art style or resume, slides, photographs and transparencies. Samples are not filed and are returned by SASE. Reports back within 1 month. Write to schedule an appointment to show a portfolio or mail appropriate materials: original/final art, photographs and slides. Payment method is negotiated. Offers advance when appropriate. Negotiates rights purchased. Requires exclusive representation of artist. Provides in-transit insurance, insurance while work is at firm, promotion, shipping to and from firm and a written contract.

Tips: "Artistworks is always looking for high quality well-executed work from artists working in a variety of media."

ARTS UNIQ' INC. (formermly Artique Unlimited Association, Inc.), 1710 S. Jefferson, Box 3085, Cookeville TN 38502. (615)526-3491. FAX: (615)528-8904. Contact: Yvette Crouch. Estab. 1985. Art publisher and distributor. Publishes and distributes limited and unlimited editions. Clients: art galleries, gift shops, furniture stores and department stores.

Needs: Seeking artwork with creative artistic expression, decorative appeal and art for the designer market. Considers oil, watercolor and acrylic. Artists represented include Debbie Kingston, D. Morgan, Gary Talbott and Lena Liu. Editions created by collaborating with the artist or by working from an existing painting. Publishes the work of 27 and distributes the work of 22 emerging artists/year.

First Contact & Terms: Send query letter with slides or photographs. Samples are filed and are returned by request. Reports back within 4-8 weeks. Mail appropriate materials. Pays royalties. Does not offer an advance. "Our contract for artists is for a number of years for all printing rights." Requires exclusive representation rights. Provides promotion, shipping from firm and a written contract.

ATLANTIC ARTS, INC., Suite 15, 613 3rd St., Annapolis MD 21403. (301)263-2554. FAX: (301)263-1367. Manager: Cynthia Shinn. Estab. 1982. Art publisher/distributor. Publishes and distributes handpulled originals, limited editions and monotypes. Clients: galleries, art consultants and corporations.

Needs: Seeking artwork with creative expression, fashionableness and decorative appeal, for the commercial and designer market. Considers oil, watercolor, acrylic, pastel, mixed media and works on paper. Prefers contemporary themes and styles. Editions created by collaborating with the artist and by working from an existing painting. Approached by 20-30 artists/year.

First Contact & Terms: Send query letter with brochure showing art style and resume with tearsheets, photostats, slides, photographs and transparencies. Reports back only if interested. Call or write to schedule an appointment to show a portfolio. Portfolio should include original/final art. Payment method is negotiated. Offers an advance when appropriate. Negotiates rights purchased. Sometimes requires exclusive representation of artist.

TAMORA BANE GALLERY, 8025 Melrose Ave., Los Angeles CA 90046. (213)205-0555. FAX: (213)205-0794. Vice President: Tamara Bane. Estab. 1987. Art publisher and gallery. Publishes handpulled originals.

Needs: Seeking art for the serious collector. Considers oil, acrylic, pastel and mixed media. Prefers representational pop, trendy and young styles. Artists represented include Mel Ramos and Eyvind Earle. Editions created by collaborating with the artist and by working from an existing painting. Approached by more than 100 artists/year. Publishes the work of 1 and distributes the work of 6 emerging artists/year. Publishes the work of 6 and distributes the work of 10 mid-career artists/year. Publishes and distributes the work of 3 established artists/year.

First Contact & Terms: Send query letter with brochure or resume and tearsheets, photostats, photocopies, slides, photographs and transparencies. Samples are not filed and are returned. Reports back only if interested. Mail appropriate materials: tearsheets, slides and transparencies. Pays on consignment basis: firm receives 50% commission or payment method is negotiated. Offers an advance when appropriate. Sometimes requires exclusive representation of artist. Provides in-transit insurance, insurance while work is at firm, promotion, shipping to and from firm and a written contract.

Tips: "Please be original. We prefer somewhat established artists. The recession has slowed down sales."

BENTLEY HOUSE LIMITED, Box 5551, Walnut Creek, CA 94596. (415)935-3186. FAX: (415)935-0213. Administrative Assistant: Terri Sher. Estab. 1986. Art publisher. Publishes limited and unlimited editions, offset reproductions, posters and canvas transfers. Clients: framers, galleries, distributors in North America and Europe, and framed picture manufacturers.

Needs: Seeking artwork with decorative appeal for the residential, commercial and designer markets. Considers oil, watercolor, acrylic and mixed media. Prefers traditional styles, realism and impressionism. Artists represented include R. Zolan, C. Valente, A. Gethen, J. Akers and P. Jeannoit. Editions created by collaborating with the artist or by working from an existing painting. Approached by 200 artists/year. Publishes the work of 2 emerging artists, 8 mid-career artists and 18 established artists/year.

First Contact & Terms: Send query letter with brochure showing art style or resume, tearsheets, slides and photographs. Samples are not filed and are returned by SASE if requested by artist. Reports back within 3 months. "We will call artist if we are interested." Pays royalties of 10%; payment method is negotiated or

payment is royalty plus free prints. Does not offer an advance. Buys all reproduction rights. Usually requires exclusive representation of artist. Provides promotion, a written contract, insurance while work is at firm and shipping from firm.

Tips: "Bentley House Limited sells high quality products which can be found in finer retailers worldwide. Our product is too expensive for mass merchandisers like K-Mart. As a result, we look for high quality images produced by experienced artists."

***BERNARD PICTURE COMPANY/HOPE STREET EDITIONS**, Box 4744, Largo Park, Stamford CT 06907. (203)357-7600. FAX: (203)967-9100. Art Coordinator: Susan Murphy. Estab. 1953. Art publisher and distributor. Publishes unlimited editions and posters. Clients: picture frame manufacturers, distributors, manufacturers, galleries and frame shops.

Needs: Seeking artwork with creative artistic expression, fashionableness, decorative appeal, art for the commercial market and for the designer market. Considers oil, watercolor, acrylic, pastel, pen & ink, mixed media and printmaking (all forms). Editions created by collaborating with the artist and by working from an existing painting. Approached by hundreds of artists/year. Publishes and distributes the work of 6-12 emerging artists, 6-12 mid-career artists and 250 established artists/year.

First Contact & Terms: Send query letter with brochure showing art style or resume and the following samples: tearsheets, photostats, photocopies, slides, photographs and transparencies. Samples are returned by SASE. "I will hold potential information only with the artist's permission." Reports back within 2-8 weeks. Call or write to schedule an appointment to show a portfolio. Portfolio should include thumbnails, roughs, original/final art, b&w and color photostats, tearsheets, photographs, slides and transparencies. Pays royalties of 10%. Offers an advance when appropriate. Buys all rights. Usually requires exclusive representation of artist. Provides in-transit insurance, insurance while work is at firm, promotion, shipping from your firm and a written contract.

Tips: "We try to look for subjects with a universal appeal. Some subjects that would be appropriate are landscapes, still lifes, animals in natural settings, religious and florals to name a few. Please send enough examples of your work that we can get a feeling for your style and technique. Considers painting, pastel, collage, printmaking, mixed media, pen & ink line drawing. We are looking for highly skilled artists."

BIG, (Division of the Press Chapeau), Govans Station, Box 4591, Baltimore City MD 21212-4591. (301)433-5379. Director: Philip Callahan. Estab. 1976. Distributor/catalog specifier of original tapestries, sculptures, crafts and paintings to architects, interior designers, facility planners and corporate curators, throughout US. Current clients include Arco Inc., State of NC, Iowa Better Business Bureau. Presentations are done through BIG BOX (slide catalog) and individual presentations to clients. Approached by 50-150 artists/year. Publishes the work of 20 and distributes the work of 200 emerging artists/year. Publishes the work of 10 and distributes the work of 50 mid-career artists/year. Publishes the work of 5 and distributes the work of 30 established artists/year.

Needs: Seeking art for the serious and commercial collector, and the designer market. "What corporate America hangs in its board rooms, highest quality traditional, landscapes, contemporary abstracts; but don't hesitate with unique statements, folk art or regional themes. In other words, we'll consider all categories as long as the craftsmanship is there." Prefers individual works of art. Artists represented include Felicia Simms, James Robe and Billy Toyko. Editions created by collaborating with the artist.

First Contact & Terms: Send query letter with slides. Samples are filed or are returned by SASE. Reports back within 5 days. Call to schedule an appointment to show a portfolio which should include slides. Pays $500-30,000. Payment method is negotiated (artist sets net pricing). Offers an advance. Does not require exclusive representation. Provides in-transit insurance, insurance while work is at firm, promotion, shipping to firm, and a written contract. "All participating artists are included in unique slide catalog, distributed to A+D community throughout US. 100 artists per edition. Only highest quality considered."

Tips: "Use judgement in NET pricing. Remember that in most cases your work is being resold. Don't put yourself out of the marketplace. Selling a quantity of pieces at fair realistic prices is usually more profitable than trying to make a 'killing' on each work. Negotiate pricing with your agents and representatives so as to create a win-win business arrangement."

***BITTAN FINE ART**, Suite 420, 16250 Ventura Blvd., Encino CA 91436. (818)501-4091. FAX: (818)501-5023. Owner: Joshua Bittan. Estab. 1981. Art publisher and gallery. Publishes handpulled originals and limited editions. Clients: galleries and private collectors. Current clients include Tower Galleries and American Design.

Needs: Seeking artwork with creative artistic expression, decorative appeal and art for the serious collector. Considers oil, watercolor, acrylic and mixed media. "I prefer styles that are unique and original and has potential in the marketplace." Artists represented include Guillaume Aroulay and Raphael Abecassis. Editions created by collaborating with the artist. Approached by 50 artists/year. Publishes the work of 1 emerging artist and 3 established artists/year.

First Contact & Terms: Send query letter with brochure showing art style or resume and the following samples: slides and photographs. Samples are filed or are returned by SASE if requested by artist. Reports back only if interested. To show a portfolio, mail original/final art, photographs and transparencies. Payment method is negotiated. Offers an advance when appropriate. Negotiates rights purchased. Requires exclusive representation of artist. Provides in-transit insurance, insurance while work is at firm and promotion.

***BUSCHLEN MOWATT GALLERY,** 111-1445 W. Georgia St., Vancouver BC V6G 2T3 Canada. (604)682-1234. FAX: (604)682-6004. Gallery Director: Ingunn Kemble. Estab. 1979 (gallery opened 1987). Art publisher, distributor and gallery. Publishes and distributes handpulled originals and limited editions. Clients are major international collectors.

Needs: Seeking artwork with creative artistic expression and art for the serious collector. Considers original lithos, etchings and serigraphs. Prefers contemporary art. Artists represented include Gantner, Cathelin, Sawada, Frankenthaler, Olitski, Buffet, Cassigneul. Editions created by collaborating with the artist and by working from an existing painting "as a starting point, not for reproduction." Approached by 500 artists/year. Publishes the work of 4 established artists/year. Distributes the work of 10 emerging artists, 10-20 mid-career artists, and approximately 15 established artists/year.

First Contact & Terms: Send query letter with resume and photographs. Do not contact through agent. Samples are filed or are returned by SASE if requested by artist. Reports back within 3 weeks if interested. Mail appropriate material. Portfolio should include photographs. Pays on consignment basis: firm receives 50-60% commission. Does not offer an advance. Buys all rights. Requires exclusive representation of artist. Provides insurance while work is at firm, promotion and a written contract.

Tips: "Professional presentation is essential. We are not able to take on any new work at this time but might consider something exceptional."

CALIFORNIA FINE ART PUBLISHING CO., 4621 W. Washington Blvd., Los Angeles CA 90016. (213)930-2410. FAX: (213)930-2417. President: Ron Golbus. Estab. 1974. Art publisher and distributor. Publishes and/or distributes handpulled originals, limited and unlimited editions and offset reproductions. Clients: contract interior designers and galleries. Current clients include Hyatt, Hilton and Sheraton.

Needs: Seeking artwork with creative artistic expression, fashionableness and decorative appeal for the commercial and designer market. Considers oil, watercolor, acrylic, pastel, pen & ink and mixed media. Prefers all types of themes and styles. Artists represented include Haskeel and Calero. Editions created by collaborating with the artist and by working from an existing painting. Publishes the work of 5-10 emerging artists/year.

First Contact & Terms: Send query letter with brochure showing art style or resume and tearsheets, photostats, photocopies, slides, photographs and transparencies. Samples are filed or are returned. Reports back within 30 days. To show a portfolio call or mail appropriate materials. Portfolio should include thumbnails, roughs and b&w and color tearsheets, photographs and transparencies. Pays flat fee, royalties, on consignment basis or payment method is negotiated. Offers an advance when appropriate. Buys first rights, all rights or negotiates rights purchased. Requires exclusive representation of artist.

Tips: "We are looking for artists willing to develop 'current market trends.' We are looking for fresh art, new looks and a workable relationship.

CASTLE ARTS, Box 587A, Altamont NY 12009. (518)861-6979. President: Edward A. Breitenbach. Estab. 1983. Distributor handling limited editions, posters, etchings, original oils and sketches for galleries, sub-distributors and gift shops. Clients: galleries and distributors. Distributes the work of one artist/year. Does not require exclusive representation. Provides promotion. "We are only handling one artist at this time. Will consider others in the future."

Needs: Fantasy, novelty, surrealism only. Represents T.E. Breitenbach. Editions created by collaborating with the artist.

CAVANAUGH EDITIONS, 400 Main St., Half Moon Bay, CA 94019. (415)726-7110. Marketing Director: Cheryl Shriver. Estab. 1989. Art publisher. Publishes and/or distributes limited editions. Clients: galleries and puzzle manufacturers.

Needs: Seeking artwork with decorative appeal for the commercial and designer market. Prefers realistic and unique styles. Artists represented include Joanne Case, Todd Leonardo and Bruce Marc Marion. Editions created by collaborating with the artist and by working from an existing painting. Approached by 150 artists/year. Publishes and distributes the work of 1-2 emerging, 2-3 mid-career, and 1-2 established artists/year.

First Contact & Terms: Send query letter with brochure showing art style or resume. Samples are filed. Reports back only if interested. Write to schedule an appointment to show a portfolio, which should include original/final art, photographs, slides or transparencies. Payment method is negotiated. Does not offer an advance. Negotiates rights purchased. Provides insurance while work is at firm and a written contract.

THE CHASEN PORTFOLIO, 6 Sloan St., South Orange NJ 07079. (201)761-1966. President: Andrew Chasen. Director of Marketing: Mark J. Graham. Estab. 1983. Art publisher/distributor of limited editions and originals for galleries, decorators, designers, art consultants, trade professionals and corporate art buyers. Distributes 150 emerging, 100 mid-career and 50 established artists each year.
Needs: Considers oil paintings, acrylic paintings, pastels, watercolor, monoprints, lithographs, serigraphs, etchings and mixed media.
First Contact & Terms: Send query letter with brochure or tear sheets, photographs and slides. Samples are filed. Samples not filed are returned by SASE only if requested. Reports back only if interested. Call or write to schedule an appointment to show a portfolio, which should include original/final art, final reproduction/product and color. Payment method is on consignment basis, firm receives a varying commision. Payment method is negotiated. Negotiates rights purchased. Does not require exclusive representation. Provides in-transit insurance, insurance while work is at firm, promotion, shipping from firm and a written contract.
Tips: "The recession has created a new end-user who is seriously quality conscious."

CIRRUS EDITIONS, 542 S. Alameda St., Los Angeles CA 90013. President: Jean R. Milant. Produces limited edition handpulled originals for museums, galleries and private collectors. Publishes 3-4 artists/year. Send slides of work. Prefers slides as samples. Samples returned by SASE.
Needs: Contemporary paintings and sculpture.

***COLMIN FINE ART,** Suite 1, 250 W. Beaver Creek Rd., Richmond Hill, ONT L4B 1C7 Canada. (416)731-8833. President: George Minarsky. Estab. 1983. Art publisher and distributor. Publishes and/or distributes handpulled originals, limited editions and offset reproductions Clients: galleries, designers and special marketing groups.
Needs: Seeking art for the commercial and designer market. Considers oil, watercolor and acrylic. Represents John Lim, Elizabeth Berry, Bev Hagan and James Groff. Editions created by working from an existing painting. Approached by 50-100 artists/year. Publishes the work of 4-6 and distributes the work of 30+ emerging artists/year. Publishes the work of 2-6 and distributes the work of 30+ mid-career artists/year. Publishes the work of 2-3 and distrubutes the work of 40+ established artists/year.
First Contact & Terms: Send query letter with resume and the following samples: slides, photographs and transparencies. Samples are not filed and are returned by SASE if requested by artist. Reports back within 2 weeks. Mail appropriate materials. Portfolio should include slides, transparencies and photographs. Pays flat fee, $15,000-30,000; royalties of 60%; on consignment basis, firm receives 40% commission; or publishes art in conjunction with artist or distributes handpulled editions. Buys all rights. Requires exclusive representation of artist. Provides insurance while work is at firm, promotion, shipping from your firm and a written contract.

COLONIAL ART CO., THE, 1336 NW 1st St., Oklahoma City OK 73106. (405)232-5233. Estab. 1919. Distributor of offset reproductions for galleries. Clients: Retail and wholesale art. Publishes/distributes the work of "thousands" of artists/year.
Needs: Artists represented include Chagall Dennis Martin, Picasso and Braque. Publishes and distributes the work of 3-4 emerging and established artists/year.
First Contact & Terms: Send sample prints. Samples not filed are returned only if requested by artist. Reports back only if interested. To show a portfolio mail appropriate materials. Payment method is negotiated. Offers an advance when appropriate. Does not require exclusive representation of the artist.

***COLVILLE PUBLISHING,** 1238 Hermosa Ave., Hermosa Beach CA 90254. (213)318-6330. FAX: (213)318-3440. President: Nancy Colville. Estab. 1982. Art publisher. Publishes limited edition serigraphs. Clients: art galleries.
Needs: Seeking artwork with creative artistic expression. Seeking art for the serious collector. Considers oil and pastel. Prefers impressionism and American Realism. Artists represented include John Powell, Henri Plisson, Don Hatfield and Christian Title. Publishes and distributes the work of varying number of emerging artists/year. Publishes and distributes the work of 2 mid-career artists/year. Publishes and distributes the work of 4 established artists/year.
First Contact & Terms: Send query letter with resume, slides, photographs, transparencies, biography and SASE. Samples are not filed. Reports back within 2 weeks. To show a portfolio, mail appropriate materials. Payment method is negotiated. Does not offer an advance. Requires exclusive representation of artist. Provides in-transit insurance, insurance while work is at firm, promotion, shipping to and from firm and a written contract.

CREGO EDITIONS, 3960 Dewey Ave., Rochester NY 14616. (716)621-8803. Owner: Paul Crego Jr. Distributor. Publishes and distributes limited editions and originals.
Needs: Seeking artwork with decorative appeal for the serious collector, the commercial and designer markets. Considers oil, watercolor, acrylic, pen & ink and mixed media. Artists represented include David Kibuuka. Editions created by collaborating with the artist. Approached by 25 artists/year. Publishes and

distributes the work of 1 emerging artist, 1 mid-career artist and 1 established artist/year.
First Contract & Terms: Send query letter with brochure showing art style or resume and photocopies and photographs. Samples are filed or returned by SASE if requested by artist. Reports back only if interested. Mail appropriate materials: original/final art, photographs and slides. Pays flat fee, royalties or payment method is negotiated. Buys first-rights, all rights or negotiates rights purchased. Requires exclusive representation. Provides in-transit insurance, insurance while work is at firm, promotion, shipping to and from firm and a written contract.

CROSS GALLERY, INC., 180 N. Center, Suite 1, Box 4181, Jackson WY 83001. (307)733-2200. Director: Mary Schmidt. Estab. 1982. Art publisher, distributor and gallery. Publishes/distributes limited editions, offset reproductions and handpulled originals; also sells original works. Clients: galleries, frame shops, individuals, retail customers and corporate businesses.
Needs: Seeking artwork with creative artistic expression for the serious collector. Artists represented include Penni Anne Cross, Ken Real Bird, Michael Chee, Andreas Goff and Kevin Smith. Editions created by collaborating with the artist and by working from an existing painting. Considers pen & ink line drawings, oil and acrylic paintings, pastel, watercolor, tempera, and mixed media. Prefers Western Americana with an emphasis on realism as well as contemporary art. Approached by 100 artists/year. Publishes 2 emerging and 1 established artists/year. Distributes 7 emerging and 2 established artists/year.
First Contact & Terms: Send query letter with resume, tearsheets, photostats, photographs, slides and transparencies. Samples are filed. Samples not filed are returned by SASE. Reports back within "a reasonable amount of time." Call to schedule an appointment to show a portfolio or mail color photostats, tearsheets, slides and transparencies. Payment method is negotiated. Offers an advance when appropriate. Requires exclusive area representation of the artist. Provides insurance while work is at firm and shipping from firm.
Tips: "We look for originality. Presentation is very important."

CUPPS OF CHICAGO, INC., 831-837 Oakton St., Elk Grove IL 60007. (312)593-5655. President: Dolores Cupp. Estab. 1964. Distributor of original oil paintings for galleries, frame shops, designers and home shows. Approached by 75-100 artists/year. Distributes the work of "many" emerging, mid-career and established artists/year. Pays flat fee; or royalties of 10%. Offers an advance when appropriate. Negotiates rights purchased. Provides promotion and a written contract. Send query letter with brochure showing art style or resume and photographs. Samples are filed. Samples not filed are returned only if requested. Reports back only if interested. Call or write to schedule an appointment to show a portfolio, which should include original/final art.
Needs: Seeking artwork with creative artistic expression, fashionableness and decorative appeal for the serious collector, commercial collector and designer market. Artists represented include Carlos Cavidad and Sonia Gil Torres. Editions created by collaborating with the artist and by working from an existing painting. Considers oil and acrylic paintings. Considers "almost any style—only criterion is that it must be well done." Prefers individual works of art.
Tips: "Work must look professional. Please send actual artwork or photos—don't like slides."

***DEL BELLO GALLERY**, 363 Queen St. W., Toronto M5V 2A4 Canada. (416)593-0884. Owner: Egidio Del Bello. Art publisher and gallery handling handpulled originals for private buyers, department stores and galleries. Publishes the work of 10 artists/year. Payment method is negotiated. Offers an advance when appropriate. Negotiates rights purchased. Provides promotion. Send query letter with resume, photographs and slides. Samples are filed or are returned by SASE within 2 weeks. Call to schedule an appointment to show a portfolio, which should include original/final art and slides.
Needs: Considers material suitable for lithography. "Interested in all styles." Prefers individual works of art.
Tips: "Also an organizer of the Annual International Exhibition of Miniature Art (in 1988 exhibited the work of 1,500 artists from 60 countries)."

DEVON EDITIONS, 770 Tamalpais Blvd., Corte Madera CA 94925. (415)924-9102. Art Director: Dallas Saunders. Estab. 1989. Art publisher. Publishes and/or distributes posters. Clients: retail stores of all types, decorators, designers, etc.
Needs: Seeking artwork with decorative appeal for the serious collector, commercial and designer markets. Considers oil, watercolor, acrylic, pastel and photography (b&w only). Prefers traditional painting of all styles and b&w photography. Artists represented include Howard Behrens, Max Hayslette, Marco Sassone, Aaron Chang, Arthur Elgort, and artists from the Philadelphia Museum of Art and The Fleischer Museum. Editions created by collaborating with the artist and by working from an existing painting. Approached by hundreds of artists/year. Publishes and distributes the work of 2-3 emerging artists/year. Publishes and distributes the work of 5-7 mid-career artists/year. Publishes the work of 10-15 and distributes the work of over 100 established artists/year.
First Contact & Terms: Send query letter with brochure showing art style or resume and tearsheets, slides, photographs and transparencies. Samples are not filed and are returned by SASE if requested by artist. Reports back within 4-8 weeks. Mail appropriate materials: b&w tearsheets, photographs, slides and trans-

parencies. Payment discussed upon decision to publish only. Requires exclusive representation of artist. Provides in-transit insurance, insurance while work is at firm, promotion, shipping from firm and a written contract. Services are upon acceptance only.

Tips: "Keep portfolio small and show only your best examples in quality 35mm slides for first submission, 4×5″ transparencies also acceptable."

DODO GRAPHICS, INC., Box 585, 145 Cornelia St., Plattsburgh NY 12901. (518)561-7294. FAX (518)561-6720. Manager: Frank How. Art publisher of offset reproductions, posters and etchings for galleries and frame shops. Publishes the work of 5 artists/year. Payment method is negotiated. Offers an advance when appropriate. Buys all rights. Requires exclusive representation of the artist. Provides a written contract. Send query letter with brochure showing art style or photographs and slides. Samples are filed. Samples not filed are returned by SASE. Reports back within 3 months. Write to schedule an appointment to show a portfolio, which should include original/final art and slides.

Needs: Considers pastel, watercolor, tempera, mixed media and airbrush. Prefers contemporary themes and styles. Prefers individual works of art, 16×20″ maximum.

Tips: "Do not send any originals unless agreed upon by publisher."

EDELMAN FINE ARTS, LTD., 386 W. Broadway, 3rd FloorNew York NY 10012. (212)226-1198. Vice President: H. Heather Edelman. Art distributor of original oil paintings. "We now handle watercolors, lithographs, serigraphs and 'work on paper' as well as original oil paintings." Clients: over 900 galleries worldwide. Approached by 75 artists/year. Distributes the work of 25 emerging, 35 mid-career and 75 established artists/year. Pays $50-1,000 flat fee or works on consignment basis (20% commission). Buys all rights. Provides in-transit insurance, insurance while work is at firm, promotion, shipping from firm and written contract. Send query letter with brochure, resume, tearsheets, photographs and "a sample of work on paper or canvas" to be kept on file. Call or write for appointment to show portfolio or mail original/final art and photographs. Reports as soon as possible.

Needs: Seeking artwork with creative artistic expression and decorative appeal for the serious collector and designer market. Works of art on paper. Considers oil and acrylic paintings, watercolor and mixed media. Especially likes Old World and impressionist themes or styles. Artists represented include Rembrandt, Chagall, Miro and Picasso.

Tips: Portfolio should include originals and only best work.

EMPORIUM ENTERPRISES, INC., 235 Preston Royal Center, Dallas TX 75230. (214)987-0055. FAX: (214)357-7770. President/CEO: Fernando Piqué. Estab. 1983. Art publisher/distributor/gallery/frame shop. Publishes/distributes limited editions, offset reproductions and posters. Clients: galleries, frame shops, department stores and gift shops. Publishes/distributes the work of 1-3 artists/year. Payment method is negotiated. Offers an advance when appropriate. Negotiates rights purchased. Requires exclusive representation of the artist. Provides a written contract. Send query letter with brochure. Samples are filed with registration of $5. Reports back only if interested. Call or write to schedule an appointment to show a portfolio or mail appropriate materials.

Needs: Seeking artwork with creative artistic expression. Considers oil, acrylic, pastel, watercolor and mixed media. Prefers individual works of art and unframed series. Editions created by collaborating with the artist.

Tips: "Be patient. We can't represent everyone."

***THE ENTERTAINMENT ART COMPANY,** Suite 312, 400 Main St., Stamford CT 06901. (203)359-6902. FAX: (203)353-9304. President: Bruce Kasanoff. Estab. 1989. Art publisher. Publishes limited editions. "We sell direct to consumers via magazine ads and direct mail."

Needs: Seeking art for the serious special interest collector: comic art collectors, automotive art, etc. Considers "any media we can reproduce via lithography." Artists represented include Walt Kelly ("Pogo") and Rex Lindsey (Archie Comics). Editions created by collaborating with the artist and working from an existing painting. Approached by 10-15 artists/year. Publishes and distributes the work of 1-2 mid-career artists/year. Publishes and distributes the work of established artists/year.

First Contact & Terms: Send query letter with resume and the following samples: tearsheets, slides and photographs. Samples are filed or are returned by SASE if requested by artist. Reports back within 1 week. Call to schedule an appointment or show a portfolio. Portfolio should include original/final art, slides, photographs and transparencies. Pays royalties of 5%. Does not offer an advance. Negotiates rights purchased. Provides insurance while work is at firm, promotion, shipping from your firm and a written contract.

Tips: "We want art that is 'pre-promoted,' that collectors will recognize for the subject matter. Occasionally, we hire artists to create art for our licensed properties from movies and/or comics."

ESSENCE ART, 929-8 Lincoln Ave., Holbrook NY 11741. (516)589-9420. President: Mr. Jan Persson. Estab. 1989. Art publisher and distributor. Publishes and distributes posters, limited editions and offset reproductions. "All are African-American images." Clients: galleries and framers.

Needs: Seeking artwork with creative artistic expression and decorative appeal for the commercial market. Considers all media. Prefers African-American themes and styles. Artists represented include Dane Tilghman, Cal Massey, Brenda Joysmith, Carl Owens and Synthia Saint-James. Editions created by collaborating with artist and by working from an existing painting. Approached by 20 artists/year. Publishes the work of 5-10 and distributes the work of 10-20 emerging artists/year. Publishes the work of 2-4 and distributes the work of 20-30 mid-career artists/year. Publishes the work of 2-5 and distributes the work of 30-40 established artists/year.

First Contact & Terms: Send query letter with slides, photographs and transparencies. Samples are filed or are returned by SASE if requested by artist. Reports back within 2 months. To show a portfolio, mail photographs and transparencies. Pays royalties of 10% and payment method is negotiated. Does not offer an advance. Buys reprint rights. Provides insurance while work is at firm, promotion, shipping from firm and a written contract.

Tips: "We are looking for artwork with good messages."

ELEANOR ETTINGER INCORPORATED, 155 Avenue of the Americas, New York NY 10013. (212)807-7607. FAX: (212)691-3508. President: Eleanor Ettinger. Estab. 1975. Established art publisher of limited edition lithographs, limited edition sculpture, unique works (oil, watercolor, drawings, etc.). Currently distributes the work of 21 artists. "All lithographs are printed on one of our Voirin presses, flat bed lithographic presses hand built in France over 100 years ago." Send query letter with visuals (slides, photographs, etc.), a brief biography, resume (including a list of exhibitions and collections) and SASE for return of the materials. Reports within 14 days.

Needs: Approached by 100-150 artists/year. Prefers American realism. Considers oil, watercolor, acrylic, pastel, mixed media, pen & ink and pencil drawings. "Seeking artwork with creative artistic expression, fashionableness and decorative appeal for the serious collector, commercial collector and designer market. Editions created by collaborating with the artist."

Tips: "The work must be unique and non-derivative. We look for artists who can create 35-50 medium to large scale works per year and who are not already represented in the fine art field."

ATELIER ETTINGER, 155 Avenue of the Americas, New York NY 10013. (212)807-7607. FAX: (212)691-3508. President: Eleanor Ettinger. Estab. 1975. Flatbed limited edition lithographic studio. "All plates are hand drawn, and proofing is completed on our Charles Brand hand presses. The edition is printed on one of our 12-ton, Voirin presses, classic flatbed lithographic presses hand built in France over 100 years ago. Atelier Ettinger is available for contract printing for individual artists, galleries and publishers." Provides insurance while work is on premises. For printing estimate, send good slides or transparencies, finished paper size, and edition size required.

Needs: Artists printed include Rockwell, Warhol, Neel, Kandinsky, Neizvestny, and Sahall. Editions created by collaborating with the artist and by working from an existing painting.

F A ASSOCIATES, Box 691, Cotati CA 94931. (707)664-9003. Business Owner: Linda Fogh. Estab. 1986. Art publisher and distributor. Publishes and distributes handpulled originals, limited editions and offset reproductions. Clients: private collectors, designers and corporate collectors.

Needs: Seeking artwork with creative artistic expression for the serious collector and designer market. Considers all subjects, all media representational. Artists represented include K. Mallary, J. Rideout, L. Brullo, and A. Grendahl-Kuhn. Editions created by collaborating with the artist and by working from an existing painting.

First Contact & Terms: Send query letter with resume and slides, photographs and print samples if available. Samples are filed or are returned by SASE if requested by artist. Reports back within 2 weeks. To show portfolio, mail appropriate materials: photographs, slides and original work if requested. Payment method is negotiated. Does not offer an advance. Negotiates rights purchased. Provides in-transit insurance, shipping from firm and a written contract.

Tips: "Include complete information about each image: size, medium, price, year completed, SASE; without the foregoing no response is made."

FINE ART LTD., 6135F Northbelt Dr., Norcross GA 30071. (404)446-6400 or (800)922-2781. FAX: (404)416-0904. Director: Mr. Emile Valhuerdi. Estab. 1983. Distributor of oil paintings. Clients: designers.

Needs: Seeking artwork with decorative appeal for the designer market. Considers oil only. Prefers traditional and impressionist styles. Artists represented include Candi, Jackson and Torrens. Approached by over 100 artists/year. Distributes the work of 400-500 mostly unknown artists/year.

First Contact & Terms: Send query letter with brochure showing art style or resume and photographs. Samples are not filed and are returned by SASE. Reports back within 2 weeks. Call to schedule an appointment to show a portfolio which should include original/final art and photographs. Payment method is negotiated. Does not offer an advance. Buys all rights. Provides in-transit insurance, insurance while work is at firm and shipping from firm.

Tips: "Send photos."

***THE FINE PRINT,** Box 1, Jackson Hole WY 83001. (307)739-1233. FAX: (307)733-3393. Contact: Russ Garaman. Estab. 1990. Art publisher and gallery. Publishes posters, limited editions and photography. Clients: general public, wholesale to other galleries.
Needs: Seeking artwork with creative artistic expression and decorative appeal for the commercial market. Considers watercolor, mixed media and photographs. Prefers contemporary. Editions created by working from an existing painting. Approached by 10 artists/year. Publishes the work of 2 and distributes the work of 4 emerging artists/year. Publishes and distributes the work of 2 mid-career artists/year.
First Contact & Terms: Send query letter with brochure showing art style or resume and the following samples: tearsheets, photostats, photographs and photocopies. Samples are not filed and are returned by SASE if requested by artist. Reports back only if interested. Mail appropriate materials. Pays royalties of 10%. Offers an advance when appropriate. Buys one-time rights. Provides insurance while work is at firm, promotion and a written contract.
Tips: "We are primarily looking for photographs or other forms of contemporary art of design."

RUSSELL A. FINK GALLERY, Box 250, 9843 Gunston Rd., Lorton VA 22199. (703)550-9699. Contact: Russell A. Fink. Art publisher/dealer. Publishes offset reproductions using five-color offset lithography for galleries, individuals and framers. Publishes and distributes the works of 1 emerging artist and 1 mid-career artist/year. Publishes the work of 2 and distributes the work of 3 established artists/year. Pays 10% royalties to artist or negotiates payment method. Negotiates rights purchased. Provides insurance while work is at publisher and promotion and shipping from publisher. Negotiates ownership of original art. Send query letter with slides or photographs to be kept on file. Call or write for appointment to show portfolio. Samples returned if not kept on file.
Needs: Seeking artwork with creative artistic expression for the serious collector. Considers oil, acrylic and watercolor. Prefers wildlife and sporting themes. Prefers individual works of art; framed. "Submit photos or slides of at least near-professional quality. Include size, price, media and other pertinent data regarding the artwork. Also send personal resume and be courteous enough to include SASE for return of any material sent to me." Artists represented include Manfred Schatz, Ken Carlson, John Loren Head, Robert Abbett and Rod Crossman. Editions created by working from an existing painting.
Tips: "Looks for composition, style and technique in samples. Also how the artist views his own art. Mistakes artists make are arrogance, overpricing, explaining their art and underrating the role of the dealer."

FOXMAN'S OIL PAINTINGS LTD., 1712 S. Wolf Rd., Wheeling IL 60090. (312)679-3804. Secretary/Treasurer: Harold Lederman. Art distributor of limited and unlimited editions, oil paintings and watercolors for galleries, party plans and national chains.
Needs: Considers oil paintings, pastel, airbrush, watercolor, acrylic and collage. Prefers simple themes: children, barns, countrysides; black art and other contemporary themes and styles. Prefers individual works of art. Maximum size $48 \times 60''$. Publishes the work of 4 and distributes work of 115 artists/year.
First Contact & Terms: Send query letter with resume, tearsheets, photographs and slides. Samples are not filed and are returned. Reports back within 2 weeks. Call to schedule an appointment to show a portfolio, which should include original/final art. Payment method is negotiated. Negotiates rights purchased. Requires exclusive representation. Provides promotion, shipping from firm and a written contract.

FRAME HOUSE GALLERY, 10688 Haddington, Houston TX 77043. (713)932-6847. FAX: (713)932-7861. Executive Assistant: Jinx Jenkins. Estab. over 25 years ago. Art publisher. Publishes handpulled originals, unlimited and limited editions.
Needs: Seeking artwork with creative artistic expression, fashionableness and decorative appeal for the serious collector, commercial and designer markets. Considers oil, watercolor, acrylic, mixed media, gouache, tempera. Prefers traditionalism, realism, florals, landscapes, Victorian styles and impressionism. Artists represented include Alan M. Hunt, Lynn Kaatz, James Crow, Christa Kieffer and Jim Harrison. Editions created by collaborating with the artist and by working from an existing painting. Approached by 25-50 artists/year. Publishes the work of 1 emerging artist, 3 mid-career artists and 2 established artists/year.
First Contact & Terms: Send query letter with brochure showing art style or resume and slides and/or photographs. Samples are not filed and are returned. Reports back within 2 months. To show a portfolio, mail original/final art and photographs. Payment method is negotiated. Offers an advance when appropriate. Buys all rights. Provides in-transit insurance and shipping from firm.

***FRAMES 'N GRAPHICS GALLERIES,** 678 Grapevine Hwy., Hurst TX 76054. (817)281-8111. FAX: (817)581-4141. Owner: Lynn Bural. Estab. 1975. Art publisher, distributor and gallery. Publishes and distributes unlimited editions, posters, limited editions, offset reproductions and handmade paper. Clients: distributors, galleries, retail.
Needs: Seeking artwork with decorative appeal. Considers oil, watercolor, acrylic, pastel and mixed media. Prefers popular and accepted themes. Editions created by collaborating with the artist and working from an existing painting. Approached by 50 artists/year. Publishes the work of 2 emerging, 2 mid-career and 2 established artists/year. Distributes the work of 5 emerging, 5 mid-career and 5 established artists/year.

First Contact & Terms: Send query letter with resume and the following samples: slides and photographs. Samples are filed or returned by SASE if requested by artist. Reports back within 2 months. Mail appropriate materials. Portfolio should include slides and photographs. Pays flat fee; payment method is negotiated. Offers an advance when appropriate. Negotiates rights purchased. Provides insurance while work is at firm and a written contract.

FRONT LINE GRAPHICS, INC., 9808 Waples St., San Diego CA 92121. (619)552-0944. Creative Director: Todd Haile. Estab. 1981. Publisher/distributor of posters, prints and limited editions for galleries, decorators, and poster distributors worldwide.
Needs: Seeking artwork with fashionableness and decorative appeal for the commercial collector and designer market. Considers oil, acrylic, pastel, watercolor and mixed media. Prefers contemporary interpretations of landscapes, seascapes, florals and abstracts. Prefers pairs. Minimum size 22 × 30″. Artists represented include Keith Mallett, Neil Loeb and Dale Terbush. Editions created by collaborating with the artist. Publishes the work of 12-18 freelance artists/year. Publishes/distributes the work of 24 artists/year. Approached by 50 artists/year. Publishes the work of 20 emerging artists/year.
First Contact & Terms: Send query letter with slides. Samples not filed are returned only if requested by artist. Reports back within 1 month. Call to schedule an appointment to show a portfolio, which should include original/final art and slides. Payment method is negotiated. Requires exclusive representation of the artist. Provides promotion and a written contract.
Tips: "Front Line Graphics is looking for artists who are flexible and willing to work with us to develop art that meets the specific needs of the print and poster marketplace. Front Line Graphics' standing as a major publisher in the art publishing industry is related to the fresh new art and artists we actively seek out on an on-going basis."

FUTUREVISION, 30 Hicks Ln., Old Westbury NY 11568. (516)334-8688. Vice President: Ted Schiffman. Estab. 1987. Manufacturer. Publishes photographic limited editions and photographic impressionism. Clients: mostly contract—national art distributor, furniture manufacturers reps, graphic designers, interior designers, architects. Current clients include Emporium Enterprises, The Wells Group, Andy Glodstein Graphics.
Needs: Seeking photographic artwork with creative artistic expression and decorative appeal for the commercial and designer market. Considers only color photography. Prefers nature, wildlife, scenic, nautical, Victorian and Americana styles. Artists represented include Karyn Chaune, Sean Cummings, Jim Westphalen and Ted Schiffman. Editions created by collaborating with the artist. Approached by 10 artists/year. Publishes and distributes the work of 3-5 emerging artists, 3-5 mid-career artists and 3 established artists.
First Contact & Terms: Send query letter with photographs. Samples are filed or arc returned by SASE if requested. Reports back within 2-3 weeks. Call or write to schedule an appointment to show a portfolio. Portfolio should include photographs. Payment method is negotiated; firm receives a percentage commission or offers 15% royalty. Offers an advance when appropriate. Negotiates rights purchased. Provides promotion, a written contract, and shipping from their firm.

***G.C.W.A.P. INC.,** 12075 Marina Loop, West Yellowstone MT 59758. (406)646-9551. Executive Vice President: Jack Carter. Estab. 1980. Art publisher. Publishes limited editions. Clients: galleries and direct sales.
Needs: Seeking art for the serious collector. Considers oil. Prefers wildlife and mountain men. Artists represented include Gary Carter C.A.A. Editions created by collaborating with the artist. Approached by 25-30 artists/year. Publishes the work of 1 established artist/year.
First Contact & Terms: Send query letter with brochure showing art style. Samples are not filed. Reports back within 3 weeks. Call to schedule an appointment to show a portfolio. Portfolio should include transparencies. Payment method is negotiated. Does not offer an advance. Buys all rights. Requires exclusive representation of artist. Provides insurance while work is at firm.
Tips: "We only publish western, wildlife and mountain men with historical research. Others need not apply."

GALAXY OF GRAPHICS, LTD., 460 W. 34th St., New York NY 10001. (212)947-8989. President: Reid A. Fader. Estab. 1983. Art publisher. Publishes and distributes unlimited editions. Clients: galleries, distributors, and picture frame manufacturers.
Needs: Seeking artwork with creative artistic expression, fashionableness and decorative appeal for the commerical market. Artists represented include Hal Larsen, Glenna Kurz, Christa Keiffer and Robert Fleming. Editions created by collaborating with the artist and by working from an existing painting. Considers any media. "Any currently popular and generally accepted themes." Approached by several hundred artists/year. Publishes and distributes the work of 12-18 emerging artists, 12-18 mid-career artists, and 25 established artists/year.
First Contact & Terms: Send query letter with resume, tearsheets, slides, photographs, and transparencies. Samples are not filed and are returned by SASE. Reports back within 1-2 weeks. Call to schedule an appointment to show a portfolio. Pays royalties of 10%. Offers an advance. Buys rights only for prints and posters.

Provides insurance while material is in house and in transit from publisher to artist/photographer. Written contract with each artist.

GALLERIE VENDOME, INC., Candlebrook Village, 777 Federal Rd., Box 558, Brookfield CT 06804. (212)254-5555. FAX: (212)420-9315. President: Marc Andre Chiffert. Estab. 1984. Art publisher, distributor and gallery. Publishes and distributes handpulled originals, limited editions, oils and sculpture. Clients: corporate, private collectors, foreign dealers and "yuppie."
Needs: Seeking artwork with creative artistic expression for the serious collector. Considers oil, sculpture and mixed media. Not abstract. Artists represented include Laporte, Gantner, Gaveau Hemeret, Schenck. Editions created by collaborating with artist. Approached by 15-20 artists/year. Publishes the work of 2 emerging, 1 mid-career and 2 established artists/year. Distributes the work of 7 emerging and 10 mid-career and 10 established artists/year.
First Contact & Terms: Send query letter with photos showing art style, tearsheets and slides. Samples are filed or are returned by GVI if requested by artist. Reports back within 2 months. To schedule an appointment to show a portfolio, mail appropriate materials: photographs and slides. Pays: royalties of 20% or on consignment basis, firm receives 35% commission. Offers an advance when appropriate. Buys all rights. Provides in-transit insurance, insurance while work is at firm, promotion, shipping to and from firm.
Tips: "Be considerate and professional." Gallerie Vendome is presently seeking artists on the theme of buildings, construction, and real estate development. The market focuses more on known and 'established' artists, as well as original prints."

GANGO EDITIONS, 205 SW First, Portland OR 97204. (800)852-3662. (503)223-9694. Production Assistant: Elaine Graves. Estab. 1982. Art publisher. Publishes posters. Clients: poster galleries, art galleries and major distributors. Current clients include Bruce McGraw Graphics, Editions Ltd. West, Tunkel Art Source and many overseas distributors.
Needs: Seeking artwork with creative artistic expression and decorative appeal for the commercial and designer markets. Considers oil, watercolor, acrylic, pastel and mixed media. Prefers landscapes and abstract styles. Artists represented include Carol Grigg, Sidonie Caron and Jennifer Winship Mark. Editions created by working from an existing painting. Approached by more than 100 artists/year. Publishes the work of more than 10 and distributes the work of more than 50 emerging artists/year.
First Contact & Terms: Send query letter with slides and photographs. Samples are filed "if we see potential" or are returned by SASE. Reports back within 2 weeks. Write to schedule an appointment to show a portfolio or mail appropriate materials. Portfolio should include slides and photographs. Pays royalties or payment method is negotiated. Offers advance when appropriate. Negotiates rights purchased. Requires exclusive representation of artist. Provides insurance while work is at firm, promotion and a written contract.
Tips: "We are interested in fresh ideas for the poster market rather than reworked old ideas. We are always actively seeking new artists. Artists need to be aware of current fashion colors."

LEN GARON FINE ARTS, 1742 Valley Greene Rd., Paoli PA 19301. (215)296-3481. Director/Owner: Len Garon. Estab. 1976. Art publisher/distributor handling limited and unlimited editions of offset reproductions, posters and handpulled originals. Clients: galleries, frame shops, corporate art consultants and interior designers. Approached by 64-70 artists/year. Distributes the work of 25 emerging artists/year. Publishes the work of 5 and distributes the work of 5 mid-career artists/year. Publishes the work of 10 and distributes the work of 30 established artists/year. Offers an advance when appropriate. Does not require exclusive representation of the artist. Provides promotion and a written contract. Send query letter with brochure, tearsheets and photographs. Samples are filed and are not returned. Reports back within 2 weeks. To show a portfolio, mail tearsheets and transparencies.
Needs: Seeking artwork with creative artistic expression and decorative appeal for the serious collector and the designer market. Considers oil, acrylic, pastel, watercolor and mixed media. Prefers impressionist, original themes "not avant-garde." Prefers unframed series. Maximum size of acceptable work: 24×36". Artists represented include Len Garon, Judy Antonelli, Des Toscano and Kim Johnson. Editions created by collaborating with the artist and by working from an existing painting.
Tips: Sees trend toward "stronger colors, realism, impressionism, less abstract."

***GEME ART INC.**, 209 W. 6th St., Vancouver WA 98660. (206)693-7772. Art Director: Gene Will. Estab. 1966. Publishes fine art prints and reproductions in unlimited and limited editions. Clients: galleries, frame shops, art museums—the general art market.
Needs: Considers oil, acrylic, pastel, watercolor and mixed media. Theme work is open. Prefers "mid America" style. Artists represented include Lois Thayer, Gary Fensky and Susan Scheewe. Works with 40-80 artists/year. Publishes the works of 15-20 artists.
First Contact & Terms: Query with color slides or photos. SASE. Reports only if interested. Call or write for appointment to show portfolio. Simultaneous submissions OK. Payment is negotiated on a royalty basis. Normally purchases all rights. Provides promotion, shipping from publisher and a contract.

GENESIS FINE ARTS, 4808 164th St., SE, Botnell WA 98012. (206)481-1581. Office Manager: Merja Hubbard. Art publisher/distributor/wholesale gallery handling limited editions (maximum 250 prints), handpulled originals and posters for wholesale trade, designers and galleries. Publishes/distributes the work of 7 artists/year. Payment method is negotiated (primarily flat fee per image/print). Offers an advance when appropriate. Negotiates rights purchased. Requires exclusive representation, except locally. Provides promotion and a written contract. Send query letter with brochure showing art style and slides. Samples not filed are returned. Reports back to the artists regarding his query/submission within 1 month. Call or write to schedule an appointment or mail appropriate materials: slides and transparencies.
Needs: Considers pastel, watercolor, mixed media and monoprints. Prefers individual works of art. Maximum size $38 \times 50''$.

GENRE LTD. INC. — ART PUBLISHERS, 415 S. Flower St., Burbank CA 91502. (818)846-1005. President: Mrs. Akiko Morrison. Art publisher of limited editions, offset reproductions, unlimited editions, posters and licensed characters. Clients: catalog/direct mail, corporate, department stores, galleries, chains, high-end. Approached by 30 artists/year. Publishes and distributes the work of 4 or more emerging artists/year. Distributes the work of 1 mid-career artist/year. Publishes and distributes the work of 3 established artists/year; 8 freelance artists/year. "Payment varies according to piece, artist, experience, etc." Payment method is negotiated. Offers an advance when appropriate. Provides a written contract. Send query letter with brochure showing art style or slides and SASE. Samples are filed or are returned only if requested. Reports back within 2 weeks. Call to schedule an appointment to show a portfolio or mail slides. "SASE a must."
Needs: Seeking artwork with decorative appeal for the designer market. Considers children's art, traditional art subjects, original cartoon images, pen & ink line drawings, oil and acrylic paintings and mixed media. "We can create titles." Prefers unframed series.

GERARD GALLERY, 400 Main St., Half Moon Bay, CA 94019. (415)726-0203. Manager: Cheri Marion. Estab. 1990. Gallery. Features original art and private collectors and limited editions. Clients: tourists.
Needs: Seeking artwork with decorative appeal for the serious collector and commercial market. Considers oil, acrylic, pen & ink and mixed media. Prefers landscapes and seascapes, contemporary and realistic styles. Artists represented include Gail Packer, Eda, Woody Jackson, Joanne Case and John Herendeen. Editions created by working from an existing painting. Publishes and distributes the work of 1-2 emerging artists/year. Distributes the work of 4 mid-career and 4-6 established artists/year.
First Contact & Terms: Send query letter with brochure showing art style or resume, tearsheets, slides or photographs. Samples are filed. Reports back only if interested. Write to schedule an appointment to show a portfolio, which should include original/final art, photographs, slides or transparencies. Payment method is negotiated. Does not offer an advance. Provides insurance while work is at firm and a written contract.

GESTATION PERIOD, Box 8280, 1946 N. 4th St., Columbus OH 43201. (614)294-4659. Owner: Bob Richman. Estab. 1971. Distributor. Distributes unlimited editions and posters. Clients: art galleries, framers and bookstores.
Needs: Seeking artwork with creative artistic expression. "We don't publish—we're interested in pre-published works that are available for distribution."
First Contact & Terms: Send query letter with resume, tearsheets and published samples. Samples are filed or returned by SASE. Reports back within 2 months. Negotiates rights purchased. Provides promotion.
Tips: "We are currently seeking published prints for distribution."

GIRARD/STEPHENS FINE ART DEALERS, 4002 28th Ave., Temple Hills MD 20748. (301)423-7563. Creative Director: Yvette Bailey. Estab. 1987. Publishes and distributes handpulled originals and limited editions. Clients: galleries, decorators and framers.
Needs: Seeking artwork with creative artistic expression for the serious collector. Considers oil, watercolor, acrylic and mixed media. Prefers contemporary themes and styles. Artists represented include Jeff Donaldson, Neil Harpe and Stephen Watson. Editions created by working from an existing painting. Approached by 10-12 artists/year. Publishes and distributes the work of 4 emerging artists/year. Distributes the work of 2 mid-career artists and 1 established artist/year.
First Contact & Terms: Send query letter with resume and slides. Samples not filed are returned by SASE. Reports back within 30 days. To show portfolio, mail appropriate materials: slides. Pays 10% royalty. Offers advance when appropriate. Buys one-time rights. Provides insurance while work is at firm, shipping from firm and a written contract.
Tips: "We look for artists that demonstrate technical ability as well as an aesthetic or social philosophy."

GRAPHIQUE DE FRANCE, 46 Waltham St., Boston MA 02118. (617)482-5066. Contact: Nick Dubrule. Estab. 1979. Art publisher and distributor handling offset reproductions, posters, notecards, gift and stationery products and silkscreens. Clients: galleries and foreign distributors. Publishes/distributes the work of 30-40 artists/year. Pays royalties of 10% for posters, 8% for stationery products. Buys reprint rights or product-specific reproduction rights. Provides promotion and written contract. Send slides and transparencies. Sam-

Close-up

Nick Dubrule
Editor
Graphique de France
Boston, Massachusetts

© Barbara Kelley 1991

When selecting work for publication by Graphique de France, Editor Nick Dubrule looks for "a strong image and a strong sense of style." Yet, he says, the key criteria is originality. "We like to break new ground when it comes to the market. We wouldn't do pseudo-impressionistic work or any work that does not stand out in its own idiosyncratic way.

"I know genuine originality is a tall order," he says, "but a lot of what I see is derivative. I see imitations of Matisse, for example. The work may look nice, but we've already got Matisse, so we wouldn't want someone else's version. We want to be able to really believe in the work we publish."

Breaking ground has become a tradition for the company, he explains. When the owners started Graphique de France 12 years ago, their idea was to bring French museum posters to the American market. Not only did they succeed, but the company built a reputation for pioneering the development of the market for museum posters in the U.S. and worldwide, he says.

About one-third of the 50 posters the company publishes each year are museum posters. Another third of the posters are black-and-white photographs. Graphique de France, says Dubrule, was a leader in developing the market for photography posters as well. Strong, contemporary art makes up the remaining third of the company's poster line.

The company is also a distributor of posters published by other, smaller firms. The catalog includes 1,300 posters, says Dubrule, and of these the firm publishes about 35 percent. Smaller posters may sell for about $14, but some go for as high as $75.

Dubrule's training is in fine art, but most recently before coming to the company, he worked in film, producing documentaries on art and photography. This background taught him the impact one image can make. "One thing about film," he says, is that "the image has to be read very quickly . . . so you develop a sense for readability. As in film, posters require an image to make sense quickly. You want a fast, direct image."

While he looks for striking images, Dubrule prefers to see work from artists who have a body of work to present rather than a single image. "And I'm not interested in vitae or resumes or past publication, unless another poster publisher is currently interested in the work. I want to see the work itself. The best way to send me work is to send 5×7 transparencies."

Not all images are suited to the market and some excellent works may not be appropriate, says Dubrule. "We've developed an understanding of people's taste in the poster market. This is how we keep ourselves in check. We try to make sure a good image is also salable."

Once an image is selected, the company adds to the image in ways it deems appropriate, such as special borders, finishes and type treatment. In fact, says Dubrule, Graphique de France also is known for its use of quality paper and printing. The posters are still printed

in France, where, he says, printers and artists work closely together to produce the finest quality silk-screened and offset prints. "One of our benchmarks is that we use very high quality paper—almost as thick as card stock."

In addition to posters, the company added notecards, calendars and other gift stationery items to its line two years ago. "The decision to diversify took time, because it has been so carefully planned," says Dubrule. "Our publishing efforts in the stationery market matches those in the poster field. We wanted to first build confidence in one market, before moving on to another."

Publishing notecards is different than publishing posters, Dubrule admits. For one thing, notecards lend themselves well to promoting a body of work by a single artist, rather than promoting one image. In fact, some artists have been introduced to the public first through the company's notecard line, then select images are presented as posters, he says.

Notecards also differ in the way they are perceived by the audience, he says. "When buying notecards, people are more consciously trying to find images that are meaningful to them. Once you start doing an image as a notecard, people become more sensitive to the meaning behind the poster."

Overall, Dubrule says, today's market for posters, fine-art notecards and related items is better than ever. He sees few distinct trends in the market, however, except a move away from somber or depressing images. "I think there's a growing sophistication on the part of poster buyers. And one reason Graphique de France has been so successful is because we have high expectations of our audience."

—Robin Gee

The graphically energetic and colorful silkscreen by Lepas is both aesthetically interesting and conveys the dynamism of Jazz, the work's title. The prints to the right are part of an "endangered species" series, published both as posters and 9 × 12" prints. They were created by artists from The Graphic Workshop in Boston. Reprinted with permission of Graphique de France.

ples are filed or returned by SASE. Reports back within 6 weeks. To show a portfolio, mail origial/final art, color transparencies or b&w prints.

Needs: Considers oil, pastel and watercolor. "Our catalog is representative of a variety of styles. Preference depends on the work itself." Prefers individual works of art.

Tips: "Put your name on the sample (i.e. slide or transparency, etc.) and address. Include SASE for return. Samples must be seen by GDF before I can schedule a meeting with the artist/agent."

GRAPHIQUE DU JOUR, INC., 2231 Faulkner Rd., Atlanta GA 30324. President: Daniel Deljou. Estab. 1980. Art publisher/distributor handling limited editions (maximum 250 prints), handpulled originals and monoprints/monotypes for designers and architects. Clients: Galleries, designers, corporate buyers and architects. Current clients include Coca Cola, Xerox, Exxon, Marriott Hotels, GE, Charter Hospitals and AT&T.

Needs: Seeking artwork with creative artistic expression and decorative appeal for the serious collector, commercial collector and designer market. Considers oil, acrylic, pastel, watercolor and mixed media. Prefers corporate art and transitional contemporary themes. Prefers individual works of art pairs, or unframed series. Maximum size 30×40″ image of published pieces. Artists represented include Kamy, Lee White, Donna Pinter, Ken Weaver, Michaela Sutillo and Alan Parker. Editions created by collaborating with the artist and by working from an existing painting. Approached by over 100 artists/year. Publishes the work of 10-15 and distributes the work of 10 emerging artists/year. Publishes and distributes the work of 15 mid-career artists/year. Publishes the work of 20 established artists/year.

First Contact & Terms: Send query letter with photographs, slides and transparencies. Samples not filed are returned only if requested by artist. Reports back to the artist regarding his query/submission only if interested. To show a portfolio, mail original/final art. Pays flat fee or royalties; also sells on consignment basis or commission. Payment method is negotiated. Offers an advance when appropriate. Negotiates rights purchased. Requires exclusive representation. Provides promotion, a written contract and shipping from firm.

Tips: "We would like to add a line of traditional art with a contemporary flair. Be original. Don't follow the trend, but hope to start one. We need landscape artists and monoprint artists."

GREGORY EDITIONS, Suite M, 6311 DeSoto Ave., Woodland Hills CA 91367. (818)713-1999. FAX: (818)713-2724. President: Mark Eaker. Estab. 1988. Art publisher and distributor. Publishes and distributes handpulled originals and limited editions. Clients: Retail art galleries. Current clients include R.K. Swahn Fine Art, Atlas Galleries and D. Genaro Galleries.

Needs: Seeking artwork that is contemporary with creative artistic expression. Considers oil and acrylic. Artists represented include Stan Solomon, James Talmadge, Denis Paul Noyer, Mr. Blackwell and sculptures by Ting Shao Kuang. Editions created by working from an existing painting. Publishes and distributes 1 emerging, 3 mid-career and 1 established artists/year.

First Contact & Terms: Send query letter with brochure showing art style. Call to schedule an appointment to show a portfolio, which should include photographs and transparencies. Pays flat signing fee, $5,000-12,000, purchases paintings outright $1,500-3,000. Requires exclusive representation of artist. Provides in-transit insurance, insurance while work is at firm, promotion, shipping from firm and a written contract.

GUILDHALL, INC., 2535 Weisenberger, Fort Worth TX 76107. (817)332-6733; (800)356-6733. President: John M. Thompson III. Art publisher/distributor of limited and unlimited editions, offset reproductions and handpulled originals for galleries, decorators, offices and department stores. Also provides direct mail sales to retail customers. Current clients include over 500 galleries and collectors nationwide.

Needs: Seeking artwork with creative artistic expression for the serious collector, commercial collector and designer market. Considers pen & ink, oil, acrylic, watercolor, and bronze and stone sculptures. Prefers historical Native American, Western, abstract, equine, wildlife, landscapes and religious themes. Prefers individual works of art. Artists represented include Chuck DeHaan, Tom Darro, Wayne Baize, Oleg Stantowsky, Jack Hines, Ralph Wall, Wayne Justus and George Hallmark. Editions created by collaborating with the artist and by working from an existing painting. Approached by 150 artists/year. Publishes the work of 2 and distributes the work of 10 emerging artists/year. Publishes the work of 5 and distributes the work of 12 mid-career artists/year. Publishes the work of 10 and distributes the work of 15 established artists/year.

First Contact & Terms: Send query letter with resume, tearsheets, photographs, slides and 4×5 transparencies. Samples are not filed and are returned only if requested. Reports back within 2 weeks. Call or write to schedule an appointment to show a portfolio, or mail thumbnails, color and b&w tearsheets, slides and 4×5 transparencies. Pays $200-15,000 flat fee; 10-20% royalties; 35% commission on consignment; or payment method is negotiated. Negotiates rights purchased. Requires exclusive representation for contract artists. Provides insurance while work is at firm, promotion, shipping from firm and a written contract.

Tips: "Assure us that you have earned the title of artist."

***HADDAD'S FINE ARTS INC.**, Box 3016 C, Anaheim CA 92803. President: P. Haddad. Produces limited and unlimited edition originals and offset reproductions for galleries, art stores, schools and libraries.
Needs: Unframed individual works and pairs; all media. Publishes 40-70 artists/year.
First Contact & Terms: Submit slides or photos, representative of work for publication consideration. SASE. Reports within 60 days. Buys reproduction rights. Pays royalties. Provides insurance while work is at publisher, shipping from publisher and written contract.

HADLEY HOUSE PUBLISHING, 11001 Hampshire Ave. S., Bloomington MN 55438. (612)943-5205. FAX: (612)943-8098. Vice President Publishing: Joyce A. Olson. Estab. 1974. Art publisher, distributor and gallery. Publishes and distributes handpulled originals, limited and unlimited editions and offset reproductions. Clients: wholesale and retail.
Needs: Seeking artwork with creative artistic expression and decorative appeal for the serious collector. Considers oil, watercolor, acrylic, pastel and mixed media. Prefers wildlife, Western landscapes and Americana themes and styles. Artists represented include Olaf Wieghorst, Kenneth Riley, Steve Hanks, Ted Blaylock, Les Didier, Terry Redllin, Clark Hulings, Bryan Moon and Ozz Franca. Editions created by collaborating with artist and by working from an existing painting. Approached by 200-300 artists/year. Publishes the work of 3-4 and distributes the work of 1 emerging artist/year. Publishes the work of 15 and distributes the work of 2 mid-career artists/year. Publishes the work of 8 established artists/year.
First Contact & Terms: Send query letter with brochure showing art style or resume and tearsheets, slides, photographs and transparencies. Samples are filed or are returned. Reports back within 4-6 weeks. Call to schedule an appointment to show a portfolio, which should include b&w slides, original/final art and transparencies. Pays royalties. Buys one-time rights or reprint rights. Requires exclusive representation of artist. Provides insurance while work is at firm, promotion, shipping from firm, a written contract and advertising through dealer showcase.

***HAR-EL PRINTERS & PUBLISHERS**, Jaffa Port, POB 8053, Jaffa Israel 61081. 972-3-816834/5. FAX: 972-3-813563. Director: Jaacov Har-El. Estab. 1976. Art publisher/distributor/printers handling limited editions (maximum 350 prints), handpulled originals, serigraphs and etchings. Publishes/distributes the work of 6 artists/year. Payment method is negotiated. Offers an advance when appropriate. Negotiates rights purchased. Requires exclusive representation. Provides insurance while work is at firms, promotion, shipping to your firm and a written contract. To show a portfolio mail original/final art and transparencies.
Needs: Considers oils, pastels and watercolor. Prefers contemporary, landscape and seascape themes. Prefers individual works of art.

ICART VENDOR GRAPHICS, 8568 Pico Blvd., Los Angeles CA 90035. (213)653-3190. Director: Sandy Verin Brunton. Estab. 1972. Art publisher/distributor/gallery. Produces limited and unlimited editions of offset reproductions and handpulled original prints for galleries, picture framers, decorators, corporations, collectors.
Needs Considers oil, acrylic, airbrush, watercolor and mixed media, also serigraphy and lithography. Prefers unusual appealing subjects. Prefers Art Deco period styles as well as wildlife and Afro-American art. Prefers individual works of art, pairs, series; 30 × 40" maximum. Artists represented include J.N. Ford, Neely Taugher, Louis Icart and Maxfield Parrish. Publishes the work of 3 emerging, 3+ mid-career and 4+ established artists/year. Distributes the work of numerous artists/year.
First Contact & Terms: Send brochure, photographs, not slides. Samples returned by SASE. Reports back within 1 month. Pays flat fee, $500-1,000; royalties (5-10%) or negotiates payment method. Sometimes offers advance. Buys all rights. Usually requires exclusive representation of the artist. Provides insurance while work is at publisher. Negotiates ownership of original art.
Tips: "Be original with your own ideas. Present clean, neat presentations in original or photographic form (no slides). No abstracts please. Due to the recession business has been reduced by 20-30 percent. Popular styles include impressionism and landscapes."

IMAGE CONSCIOUS, 147 Tenth St., San Francisco CA 94103. (415)626-1555. Creative Director: Joan Folkmann. Estab. 1980. Art publisher/distributor of offset and poster reproductions. Clients: poster galleries, frame shops, department stores, design consultants, interior designers and gift stores. Current clients include Z Gallerie, Deck the Walls and Decor Corporation. Approached by hundreds of artists/year. Publishes the work of 1 and distributes the work of 50 emerging artists/year. Publishes the work of 1 and distributes the work of 200 mid-career artists/year. Publishes the work of 2 and distributes the work of 700 established artists/year. Payment method is negotiated. Negotiates rights purchased. Provides promotion, shipping from firm and a written contract. Send query letter with brochure, resume, tearsheets, photographs, slides and/or transparencies. Samples are filed or are returned by SASE. Reports back within 1 month.
Needs: Seeking artwork with creative artistic expression and decorative appeal for the designer market. Considers oil, acrylic, pastel, watercolor, tempera, mixed media and photography. Prefers individual works of art, pairs or unframed series. Artists represented include Mary Silverwood, Aleah Koury, Doug Keith, Jim

Tanaka, Gary Braasch and Lawrence Goldsmith. Editions created by collaborating with the artist and by working from an existing painting.
Tips: "Research what type of product is currently in poster shops. Note colors, sizes and subject matter trends."

***IMPACT,** 4961 Windplay Dr., El Dorado Hills CA 95630. (916)933-4700. Product Development Director: Sue Gauthier. Estab. 1975. Publishes calendars, postcards, posters and 5×7, 8×10 and 16×20 prints. Clients: distributors, poster stores, framers, plaque companies, tourist businesses, retailers, national parks, history associations and theme parks. "We have international distribution." Publishes/distributes the work of 200 artists/year. Pays flat fee; $100-600; royalties of 7%; payment method is negotiated. Offers an advance when appropriate. Negotiates rights purchased. Does not require exclusive representation of the aritst. Provides insurance while work is at firms, shipping from firm, a written contract and artist credit. Send query letter with brochure, tear sheets, photographs, slides and transparencies. Samples are filed. Reports back within 2 weeks. Call or write to schedule an appointment to show a portfolio, or mail original/final art, tear sheets, slides, transparencies, final reproduction/product, color and b&w.
Needs: Looks for contemporary artwork. Considers acrylics, pastels, watercolors, mixed media and airbrush. Prefers contemporary, original themes, humor, fantasy, autos, animals, children and suitable poster subject matter. Prefers individual works of art. "Interested in licensed subject matter."

***MICHAEL A. JACOBS PUBLISHING CO.,** 911 Greenbay Rd., Winnetka IL 60093. (708)501-5095. FAX: (708)441-9150. Vice President: Michael Bronner. Estab. 1989. Art Publisher. Publishes limited editions. Clients: galleries, print shops, picture framers, museum gift shops, mail order catalogs. Current clients include Spertus Gift and Book Shop, Feldman Gallery.
Needs: Seeking artwork with creative artistic expression for the commercial and designer markets. Considers all media. "Themes preferred vary, but we look for originality." Artists represented include Wolfgang Hutter, Gottfried Kumpf and Otto Zeiller. Editions created by working from an existing painting. Publishes and distributes the work of a varying number of emerging, mid-career and established artists/year.
First Contact & Terms: Send query letter with resume and slides, photographs and transparencies. Samples are filed or are returned by SASE if requested. Reports back within 10 days. Write to schedule an appointment to show a portfolio. Portfolio should include slides, transparencies and photographs. Pays flat fee or royalties of a varying percentage to artist. Offers advance when appropriate. Negotiates rights purchased. Provides promotion, a written contract and shipping from firm.
Tips: "We look for originality combined with quality."

ARTHUR A. KAPLAN CO. INC., 460 W. 34th St., New York NY 10001. (212)947-8989. President: Reid Fader. Estab. 1956. Art publisher of unlimited editions and offset reproduction prints. Clients: picture frame and plaque manufacturers.
Needs: Seeking artwork with decorative appeal. Considers all media and photography. Artists represented include Lena Liu, Charles Murphy and Gloria Eriksen. Editions created by collaborating with artist and by working from an existing painting. Approached by 350 artists/year. Publishes and distributes the work of 12-25 emerging and 12-25 mid-career and 25-50 established artists/year.
First Contact & Terms: Send resume, tearsheets, slides, photographs and original art to be kept on file. Material not filed is returned. Reports within 2-3 weeks. To show a portfolio, mail appropriate materials or call to schedule an appointment. Portfolio should include original/final art, final reproduction/product, color tearsheets and photographs. Pays a royalty of 5-10%. Offers advance. Buys rights for prints and posters only. Provides insurance while work is at firm and in transit from plant to artist.
Tips: "We cater to a mass market and require fine quality art with decorative and appealing subject matter. Don't be afraid to submit work—we'll consider anything and everything."

MARTIN LAWRENCE LIMITED EDITIONS, 16250 Stagg St., Van Nuys CA 91406. (818)988-0630. Contact: Board of Directors. Art publisher. Publishes limited edition graphics, fine art posters and originals by internationally known, up-and-coming and new artists. Publishes and distributes the work of 4 emerging artists/year.
First Contact & Terms: Contact by mail only. Send good quality slides or photographs, pertinent biographical information and SASE. Exclusive representation required.
Needs: Seeking artwork with decorative appeal for the serious and commercial collector. Prefers oil, acrylic, watercolor, serigraphs, lithographs, etchings and sculpture. Artists represented include Pergoca, Yamagata, King, Rios, Warhol, Scharf, Haring and Cutrone. Editions created by collaborating with the artist and by working from an existing painting.

LESLI ART, INC., Box 6693, Woodland Hills CA 91365. (818)999-9228. President: Stan Shevrin. Estab. 1965. Artist agent handling paintings for art galleries and the trade.

Needs Considers oil paintings and acrylic paintings. Prefers realism and impressionism—figures costumed, narrative content, landscapes, still lifes and florals. Maximum size 36×48". Works with 20 artists/year.

First Contact & Terms: Send query letter with photographs and slides. Samples not filed are returned by SASE. Reports back within 1 month. To show a portfolio, mail slides and color photographs. Payment method is negotiated. Offers an advance. Provides national distribution, promotion and written contract.

Tips: "Considers only those artists who are serious about their work being exhibited in important galleries throughout the United States and Europe."

Linda CarterHolman of Scottsdale, Arizona painted "The Jazz Singer" for her own pleasure, hoping for it to "sing—to be emotional in a positive way—with color, form and thought." The piece was acquired by a gallery and then published by Leslie Levy Publishing. Having the piece in poster form, CarterHolman says, "allows me the opportunity to share my view of the world with many people; it [creates] name recognition," and, she adds, she appreciates the money.

The Jazz Singer
Linda Carter Holman Leslie Levy Fine Art

© Linda CarterHolman 1991

LESLIE LEVY FINE ART PUBLISHING, INC., Suite D, 7342 E. Thomas, Scottsdale AZ 85251. (602)945-8491. Director: Gary Massey. Materials to be sent to: Leslie Levy Fine Art Publishing, 7141 E. Main St., Scottsdale AZ 85251. (602)947-0937. Estab. 1976. Art publisher and distributor of limited editions, offset reproductions, unlimited editions, posters and miniature prints. "Our art galleries have a wide mix, mostly out of state. The publishing customers are mainly frame shops, galleries, designers, distributors and department stores. Current clients include Art Somee, Bruce McGraw, Graphique de France, Waterline, Joan Cawley, Mixed Media, Icart, ImageMasters.

Needs Seeking artwork with creative artistic expression, fashionableness and decorative appeal for the serious collector, commercial collector and designer market. "Because we have a large client base for figurative art, we are intending to expand our offering in this area." Current artists include: Steve Hanks, Doug West and Stephen Morath. Editions created by collaborating with the artist and by working from an existing painting. Considers oil, acrylic, pastel, watercolor, tempera, mixed media and photographs. Prefers art with a universal appeal, bright colors. Approached by hundreds of artists/year. Publishes the work of 5-8 emerging, 15 mid-career and 10 established artists/year.

First Contact & Terms: Send query letter with resume, tearsheets, photographs, slides or transparencies— "highest quality of any of the above items." Slides, etc. are returned by SASE. "Portfolio will not be seen unless interest is generated by the materials sent in advance." Pays a percentage of retail each for posters and prints "which are sold quarterly." Pays royalties based on retail and popularity of artist. Sell original art on a consignment basis: firm receives 50% commission. Insists on reprint rights for posters. Requires exclusive publishing of the artist for the type of print/poster being published.

Tips: "First, don't call us before sending materials. After we review your materials, we will contact you whether we are or are not interested. We are known in the industry for our high quality prints and excellent skilled artists. We intend to remain the same. If you feel the representation and/or publication of your art would uphold our reputation, we welcome your submission of materials. We are looking for art unlike what we and other publishers are publishing. Also, we are always looking for artist to represent for their original art in our Scottsdale art galleries."

LOLA LTD./LT'EE, RR 9, Box 458, Shallote NC 28459-9809. (919)754-8002. Owner: Lola Jackson. Art publisher and distributor of limited editions, offset reproductions, unlimited editions and handpulled originals. Clients: art galleries, architects, picture frame shops, interior designers, major furniture and department stores and industry.

Needs Seeking artwork with creative artistic expression and decorative appeal for the commercial collector and designer market. "Handpulled graphics are our main area"; also considers oil, acrylic, pastel, watercolor, tempera or mixed media. Prefers unframed series, 30x40" maximum. Artists represented include Doyle, White, Brent, Jackson, Mohn, Baily, Carlson, Coleman and Woody. Editions created by collaborating with the artist. Approached by 100 artists/year. Publishes the work of 5 emerging and 5 mid-career artists/year. Distributes the work of 40 emerging and 40 mid-career artists/year. Publishes and distributes the work of 5 established artists/year.

First Contact & Terms: Send query letter with brochure showing art style or resume, tearsheets, photostats, photographs, photocopies or transparencies. "Actual sample is best." Samples are filed or are returned only if requested. Reports back within 2 weeks. To show a portfolio, mail original/final art or final reproduction/ product. Payment method is negotiated; offers a flat fee of $20-200, or pays on consignment.. "Our standard commission is 50% less 30-50% off retail." Offers an advance when appropriate. Provides insurance while work is at firm, shipping to firm and a written contract.

Tips: "Send a cover letter, with an actual sample and the price the artist needs. Example: Retail, less 50, less 50. We do not pay for samples. We have sales reps throughout U.S. to sell for you. We are presently looking for more reps."

LONDON CONTEMPORARY ART, 729 Pinecrest, Prospect Heights IL 60070. (708)459-3990. President: Gerard V. Perez. Estab. 1977. Art publisher and distributor. Publishes and distributes handpulled originals and limited editions. Clients: corporate/residential designers, consultants and retail galleries.

Needs: Seeking artwork with creative artistic expression, fashionableness and decorative appeal for the designer market. Considers oil, watercolor, acrylic, pastel and mixed media. Prefers abstract and impressionistic styles and Midwest and Mediterranean landscapes. Artists represented include Dodsworth, Penny and Tarkay. Editions created by collaborating with artist and by working from an existing painting. Approached by 50-75 artists/year. Publishes and distributes the work of 40 artists/year.

First Contact & Terms: Send query letter with slides or photographs. Samples are filed. Does not report back, "in which case the artist should not contact us." Payment method is negotiated. Offers advance when appropriate. Negotiates rights purchased. Requires exclusive representation of artist. Provides insurance while work is at firm, promotion, shipping from firm and a written contract.

Tips: "Send visuals and a bio first."

***LUBLI GRAPHICS/TOUCHSTONE PUBLISHERS**, 95 E. Putnam Ave., Greenwich CT 06830. (203)622-8777. FAX: (203)622-0094. Vice President: Vincent Cassantti. Estab. 1951. Art publisher and gallery. Publishes distributes and exhibits handpulled originals, posters, limited and unlimited editions, offset reproductions and sculpture. Clients: retail and wholesale.

Needs: Seeking artwork with creative artistic expression, art for the serious collector and the commercial market. Considers oil, watercolor, acrylic, pastel, pen & ink, mixed media and sculpture. Artists represented include G. Rodo Boulanger, K. Moti and M. Delacroix. Editions created by collaborating with the artist. Publishes and distributes the work of 2-3 emerging artists and several established artists/year. Distributes the work of several mid-career artists/year.

First Contact & Terms: Send query letter with brochure showing art style or resume and appropriate samples. Samples are not filed. Reports back within days. To show a portfolio, mail photostats, tearsheets, photographs and slides. Payment method is negotiated. Offers an advance when appropriate. Buys all rights or reprint rights. Requires exclusive representation of the artist. Provides in-transit insurance, insurance while work is at firm, promotion, shipping to and from firm, a written contract.

BRUCE MCGAW GRAPHICS, INC., 230 5th Ave., New York NY 10001. (212)679-7823. Acquisitions: Paul Liptak.
First Contact & Terms: Send query letter with brochure showing art style or resume, tearsheets, photostats, photocopies, slides and photographs. Samples not filed are returned by SASE. Reports within weeks. To show a portfolio, mail color tearsheets and photographs. Considers skill and experience of artist, saleability of artwork, client's preferences and rights purchased when establishing contract.

MARIHUBE, LTD., (formerly Marigold Enterprises, Ltd.) 26 E. 64th St., New York NY 10021. (212)759-0777. President: Marilyn Goldberg. Art publisher/distributor/gallery handling limited editions, posters, tapestry and sculpture for galleries, museums and gift boutiques. Current clients include the Boutique/Galeria Picasso in Barcelona Spain and The Hahone Museum in Japan. Approached by 100 artists/year. Publishes the work of 1 emerging, mid-career and established artist/year. Distributes the work of 3 emerging, mid-career and established artists/year. Payment method is negotiated. Offers advance when appropriate. Negotiates rights purchased. Exclusive representation is not required. Provides insurance while work is at firm, shipping to firm and a written contract. Send query letter with resume, slides and transparencies. Samples are filed or returned. Reports within 2 weeks. Call or write to schedule an appointment to show a portfolio or mail slides and transparencies.
Needs: Seeking artwork with decorative appeal for the designer market. Considers oil, acrylic, pastel, water-color and mixed media. Prefers individual works of art, unframed series. Artists represented include Pablo Picasso, Ichiro Isonita. Editions created by collaborating with the artist.
Tips: "We presently have demand for landscapes." Finds that because of the recession, "people are not spending on high priced items (like original oils) but more on posters and art boutique items."

THE MARKS COLLECTION, Suite 308, 1590 N. Roberts Rd., Kennesaw GA 30144-3683. (404)425-7982. President: Jim Marks. Estab. 1981. Art publisher. Publishes unlimited and limited editions. Clients: persons interested in the Civil War; Christian and secular.
Needs: Seeking art for the serious collector. Considers oil, acrylic and mixed media. Prefers Christian, nature and Civil War themes. Artists represented include Michael Gnatek and William Maugham. Editions created by collaborating with the artist. Publishes and distributes the work of 2 established artists/year.
First Contact & Terms: Send query letter with brochure showing art style and slides and photographs. Samples are filed. Reports back only if interested. If does not report back, phone for discussion. Payment depends upon the use and distribution: royalties or flat fee. Offers an advance when appropriate. Provides a written contract.
Tips: "Phone first to give an overview of your style, subject matter, etc."

DAVID MARSHALL, Box 24635, St. Louis MO 63141. (314)997-3003. President: Marshall Gross. Estab. 1972. Art distributor/gallery handling original acrylic paintings, serigraphs, paper construction, cast paper and sculpture. Clients: designer showrooms, architects, designers, galleries, furniture stores and department stores.
Needs: Seeking fashionableness and decorative appeal for the serious collector, commercial collector and designer market. Considers pastel, watercolor and cast paper. Prefers contemporary, impressionist and primitive/original themes and styles. Prefers individual works of art and unframed series; 36 × 40″ maximum. Artists represented include Christine, Mills and Ro. Editions created by collaborating with the artist. Approached by 10-15 artists/year. Distributes the work of 2-4 emerging artists, 4-6 mid-career artists and 4-6 established artists/year.
First Contact & Terms: Send query letter with brochure showing art style or photographs. Samples are not filed and are returned only if requested by artist. Reports within 7 days. Call to schedule an appointment to show a portfolio, which should include roughs, slides and color photos. Distribution items pay flat fee of $15-50 each if artists will reproduce. Pays flat fee; can be negotiated.
Tips: "Glass and mirror designs are given special consideration. Cannot use limited editions or traditional styles. Send samples. We represent all types of shows from professional to street fairs. Current color trend in the Home Furnishings Industry are a must. Artist must be willing to reproduce his or her own work for the duration of our catalog—2-3 years."

 The asterisk before a listing indicates that the listing is new in this edition. New markets are often the most receptive to freelance submissions.

MASTER ART PRESS, INC., Box 8, Getzville NY 14068. (800)777-2044. FAX: (716)691-9548. Contact: Wendy Werner. Art publisher and distributor. Publishes and distributes offset reproductions. Clients: galleries, frameshops and distributors.
Needs: Seeking artwork with creative expression for the serious collector. Considers oil, watercolor and acrylic. Prefers realistic but imaginative themes and styles. Artists represented include Luke Buck, Bill Burkett, Darrell Davis and Margaret M. Martin. Editions created by working from an existing painting. Publishes and distributes the work of 8 established artists/year.
First Contact & Terms: Send query letter with resume, tearsheets, slides and photographs. Samples are not filed and are returned by SASE if requested by artist. Reports back within 3 weeks. Call to schedule an appointment to show a portfolio. Portfolio should include original/final art, photographs and slides. Pays royalty. Requires exclusive representation of artist. Provides in-transit insurance, insurance while work is at firm, promotion, shipping from firm and a written contract.

THE MEISNER GALLERY, 115 Schmitt Blvd., Farmingdale NY 11735. (516)249-0680. FAX: (516)249-0697. Gallery Director: Mitch Meisner. Estab. 1970. Art publisher and gallery. Publishes and distributes limited editions and sculpture. Clients: retail galleries worldwide.
Needs: Seeking art for the serious collector and commercial market. Considers sculpture to be cast in bronze or acrylic. Prefers figurative styles. Artists represented include Michael Wilkinson, Isidore Margulies and Dante Liberi. Approached by more than 100 artists/year. Publishes the work of 3 and distributes the work of 5 emerging artists/year. Publishes the work of 3 and distributes the work of 10 mid-career artists/year. Publishes the work of 6-10 and distributes the work of 30+ established artists/year.
First Contact & Terms: Send query with resume, tearsheets and photographs. Samples are filed. Reports back within 1 month. Call to schedule an appointment to show a portfolio. Portfolio should include b&w and color tearsheets, photographs, slides and transparencies. Payment method is negotiated. Offers advance when appropriate. Negotiates rights purchased. Requires exclusive representation of artist. Provides insurance while work is at firm, promotion and a written contract.
Tips: "We specialize in figurative sculpture but we are open to new and interesting ideas. At this time pieces 12-20″ high are the best size."

***MILITARY GALLERY**, 821-A E. Ojai Ave., Ojai CA 93023. (805)640-0057. FAX: (805)640-0059. Vice President: P. Barnard. Estab. 1986. Art publisher. Publishes unlimited editions, posters and limited editions. Clients: art galleries only. Current clients include: Virginia Bader Fine Arts, Wings Fine Arts, Tamsen-Munger Gallery.
Needs: Seeking artwork with creative artistic expression for the serious collector. Considers oil. "We are looking for artists with new concepts and ideas in aviation art." Artists represented include Robert Taylor and Nicolas Trudgian. Editions created by collaborating with the artist. Approached by 12-15 artists/year.
First Contact & Terms: Send query letter with brochure showing art style or the following samples: slides, photographs and transparencies. Samples are not filed and are returned by SASE if requested by artist. Reports back within 1 month. Mail appropriate materials. Portfolios should only be sent if requested after slides and/or transparencies are sent and approved. Payment is negotiable. Buys all rights. Services provided are negotiable.

***MIXED-MEDIA, LTD.**, Box 15510, Las Vegas NV 89114. (702)796-8282. FAX: (702)796-8282. Estab. 1969. Distributor of posters. Clients: galleries and department stores. Distributes the work of hundreds of artists/year. Payment method is negotiated. Negotiates rights purchased. Does not require exclusive representation. Send finished poster samples. Samples not returned.
Needs: Considers posters only. Distributes the work of over 100 artists. Artists represented include Will Barnet and G.H. Rothe.

MONTMARTRE ART COMPANY, INC., 24 S. Front St., Bergenfield NJ 07621. (201)387-7313 or (800)525-5278. President: Ann B. Sullivan. Estab. 1959. Wholesale art dealer to trade. Clients: galleries, decorators, designers and art consultants.
Needs: Considers oil, acrylic, watercolor and mixed media. Prefers contemporary, traditional themes etc. Prefers unframed series. Distributes the work of 25 freelance artists/year. Publishes and distributes the works of 3 emerging, 10 mid-career and 2 established artists/year. Artists represented include Curran and Laforet.
First Contact & Terms: Send query letter with brochure showing art style or any of the following: resume, tearsheets, photostats, photographs, photocopies, slides and transparencies. Samples not filed are returned by SASE. Reports back within 7-10 days. Call to schedule an appointment to show a portfolio which should include original/final art, slides and transparencies. Payment method is negotiated. Pays flat fee; $50-750 or royalties of 10%. Offers an advance when appropriate. Requires exclusive representation. Provides insurance while work is at firm and shipping from firm.
Tips: "Montmartre buys original artwork, (ie: oil, acrylic etc.) distributes and promotes the work to galleries, designers etc., nationally and internationally. We will work with artists to help make certain works more saleable to our client market. We also help artists get their work published in the print and poster market."

THE NATURE COMPANY, 750 Hearst Ave., Berkeley CA 94710. (415)644-1337. Creative Department: Jean Sanchirico. Art publisher/distributor of unlimited editions. Publishes and distributes work of 7 emerging, 10 mid-career and 20 established artists/year. Artists represented are Joe Holmes, Art Wolfe, Claus Sievert, Ed Lindlof and Larry Duke. Pays flat fee or royalties; wholesale commission. Negotiates rights purchased. Provides in-transit insurance, insurance while work is at firm, promotion, shipping from firm and a written contract. Send query letter with brochure showing art style or tearsheets, photostats, photographs, slides and transparencies. Samples are filed or are returned only if requested. Tries to report within 2 months. To show a portfolio, mail roughs, color and b&w photostats, tearsheets, slides and transparencies.
Needs: Will receive all media. Considers pen & ink line drawings, oil, acrylic, pastel, watercolor, tempera and mixed media. "Must be natural history subjects (i.e, plants, animals, landscapes). Avoid domesticated plants, animals, and people-made objects."

NEW DECO, INC., Suite 3, 6401 E. Rogers Circle, Boca Raton FL 33487. (407)241-3901 or (800)543-3326. President: Brad Morris. Estab. 1984. Art publisher/distributor. Produces limited editions using lithography and silkscreen for galleries, also publishes/distributes unlimited editions.
Needs: Publishes several artists/year. Publishes and distributes the work of 2 emerging, 2 mid-career and 2 established artists/year. Artists represented are Robin Morris, Nico Vrielink, and Yang Ming-Yi. Needs new designs for reproduction.
First Contact & Terms: Send brochure, resume and tearsheets, photostats or photographs to be kept on file. Samples not kept on file are returned. Reports only if interested. Call or write for appointment to show portfolio, which should include tearsheets. Pays flat fee or royalties. Offers advance. Negotiates rights purchased. Provides promotion, shipping and a written contract. Negotiates ownership of original art.
Tips: "We find most of our artists from *Artists's Market*, advertising, trade shows and referrals."

NEW YORK GRAPHIC SOCIETY, Box 1469, Greenwich CT 06836. (203)661-2400. President: Gary H. Stone. Publisher of offset reproductions, limited editions, posters and handpulled originals. Clients: galleries, frame shops, museums and foreign trade. Publishes and distributes the work of numerous emerging artists/year. Pays flat fee or royalty. Offers advance. Buys all print reproduction rights. Provides in-transit insurance from firm to artist, insurance while work is at firm, promotion, shipping from firm and a written contract; provides insurance for art if requested. Send query letter with slides or photographs. Write for artist's guidelines. All submissions returned to artists by SASE after review. Reports within 2 months.
Needs: Considers oil, acrylic, pastel, watercolor, mixed media and colored pencil drawings. Distributes posters only. Publishes/distributes serigraphs, stone lithographs, plate lithographs and woodcuts.
Tips: "We publish a broad variety of styles and themes. However, we do not publish experimental, hard-edge, sexually explicit or suggestive material. Work that is by definition fine art and easy to live with, that which would be considered decorative, is what we are always actively looking for."

NORTH BEACH FINE ARTS, INC., 9025 131st Place N., Largo FL 34643. (813)587-0049. President: James Cournoyer. Art publisher and distributor handling limited edition graphics and posters. Clients: galleries, architects, interior designers and art consultants. Pay negotiable. Negotiates rights purchased. Provides insurance when work is at firm, promotion, written contract and markets expressly-select original handmade editions of a small number of contemporary artists. Send query letter with brochure, resume, tearsheets, photostats, photocopies, slides and photographs to be kept on file. Accepts any sample showing reasonable reproduction. Samples returned by SASE only if requested. Reports back within 2 months. To show a portfolio, mail original/final art, color and b&w tearsheets, photostats and photographs.
Needs: Considers pen & ink line drawings, mixed media serigraphs, stone lithographs, plate lithographs, woodcuts and linocuts. Especially likes contemporary, unusual and original themes or styles. Looking for artists doing own original graphics, high quality prints to distribute.
Tips: Wants "original prints and posters by serious, experienced, career-oriented artists with a well-developed and thought-out style."

***NORTHLAND POSTER COLLECTIVE,** 1613 E. Lake St., Minneapolis MN 55407. (612)721-2273. Manager: Ricardo Levins Morales. Estab. 1979. Art publisher and distributor. Publishes and distributes handpulled originals, unlimited editions, posters and offset reproductions. Clients: mail order customers, teachers, bookstores, galleries, unions.
Needs: "Our posters reflect themes of social justice and cultural affirmation, history, peace." Artists represented include Betty La Duke, Alvin Carter, Lee Hoover, Doug Minkler and Carlos Cortez. Editions created by collaborating with the artist and working from an existing painting.
First Contact & Terms: Send query letter with the following samples: tearsheets, slides and photographs. Samples are filed or are returned by SASE. Reports back within months; if does not report back, the artist should write or call to inquire. Write to schedule an appointment to show a portfolio. Payment method is negotiated. Offers an advance when appropriate. Negotiates rights purchased. Contracts vary but artist always retains ownership of artwork. Provides promotion and a written contract.

Tips: "We distribute work that we publish as well as pieces already printed. We print screen prints in-house and public 1-4 offset posters per year."

PACIFIC EDGE PUBLISHING, INC., Suite 112, 540 S. Coast Hwy., Laguna Beach CA 92651. (714)497-5630. President: Paul C. Jillson Estab. 1988. Art publisher. Publishes handpulled originals.
Needs: Seeking art for the serious collector and commercial market. Considers oil. Prefers representational to semi-abstract styles. Artists represented include Maria Bertran. Editions created by working from an existing painting. Approached by 20 artists/year. Publishes the work of 1 emerging and 1 mid-career artist/year.
First Contact & Terms: Send query letter with brochure showing art style or resume and tearsheets and photographs. Samples not filed are returned by SASE if requested by artist. Reports back within 10 days. Call to schedule an appointment to show a portfolio. Portfolio should include photographs. Pays royalties. Negotiates rights purchased. Requires exclusive representation of artist. Provides in-transit insurance, insurance while work is at firm, promotion, shipping from firm and a written contract.

***PANACHE EDITIONS LTD**, 234 Dennis Lane, Glencoe IL 60022. (312)835-1574. President: Donna MacLeod. Estab. 1981. Art publisher and distributor of offset reproductions and posters for galleries, frame shops, domestic and international distributors. Current clients are mostly individual collectors.
Needs Considers acrylic paintings, pastels, watercolor and mixed media. "Looking for contemporary compositions in soft pastel color palettes, also renderings of children on beach, in park, etc." Prefers individual works of art and unframed series. Publishes and distrubutes work of 1-2 emerging, 2-3 mid-career and 1-2 established artists/year. Artists represented include Bart Forbes, Peter Eastwood and Carolyn Anderson.
First Contact & Terms: Send query letter with brochure showing art style or photographs, photocopies and transparencies. Samples are filed. Reports back only if interested. To show a portfolio, mail roughs, original/final art, final reproduction/product and color. Pays royalties of 10%. Buys reprint rights; negotiates rights purchased. Requires exclusive representation of the artist. Provides in-transit insurance, insurance while work is at firm, promotion, shipping to and from firm and a written contract.
Tips: "We are looking for artists who have not previously been published (in the poster market) with a strong sense of current color palettes. We want to see a range of your style and coloration. We would like to see artists who have a unique and fine art approach to collegiate type events, i.e. Saturday afternoon football games, Founders day celebrations, homecomings, etc. We do not want illustrative work but rather an impressionistic style that captures the tradition and heritage of one's university."

***PORTFOLIO GRAPHICS, INC.**, 4060 S. 5th W. St., Salt Lake City UT 84123. (800)843-0402. FAX: (801)263-1076. Creative Director: Kent Barton. Estab. 1986. Art publisher and distributor. Publishes and distributes limited editions, unlimited editions and posters. Clients: galleries, designers and poster distributors.
Needs: Seeking artwork with creative artistic expression, fashionableness and decorative appeal for the commercial and designer markets. Considers oil, watercolor, acrylic, pastel, mixed media and photography. Artists represented include Dawna Barton, Brooke Morrison and Jodi Jensen. Editions created by working from an existing painting.
First Contact & Terms: Send query letter with resume and biography and the following and samples: slides and photographs. Samples are not filed. Reports back within months. To make an appointment to show a portfolio, mail appropriate materials. Portfolio should include slides, transparencies and photographs. Pays royalties. Offers an advance. Buys reprint rights. Provides promotion and a written contract.

PORTRAITS OF NATURE, Box 217, Youngwood PA 15697. (412)834-2768. Director: Candace E. Crimboli. Estab. 1975. Art publisher handling limited editions for galleries. Publishes/distributes the work of 7 artists/year. Payment method is negotiated. Buys reprint rights. Does not require exclusive representation of the artist. Provides promotion and contract while work is at firm. Send query letter with resume and slides – at least 20 – of most recent work. Samples not filed are returned by SASE only. Reports back within 2 months. Write to schedule an appointment to show a portfolio which should include original/final art.
Needs: Considers oil, acrylic, pastel, watercolor, tempera and mixed media. Prefers contemporary, floral and outdoor themes. Prefers individual works of art.

POSNER GALLERY, 207 N. Milwaukee St., Milwaukee WI 53202. (414)273-3097. President: Judith L. Posner. Estab. 1964. Art publisher/distributor/gallery. Produces limited and unlimited editions of offset reproductions and original serigraphs and lithographs. Current clients include: McGaw Graphics, Edition Limited and Mitchell Beja.
Needs: Seeking creative artistic expression, and decorative appeal, for the serious collector, commercial collector and designer market. Considers all media. Prefers individual works of art. Specializes in contemporary themes. Artists represented include Crane and Peticov. Editions created by collaborating with the artist and by working from an existing painting. Approached by 100 artists/year. Publishes the work of 10 emerging, 10 mid-career and 5 established artists/year. Distributes the work of 30 emerging, 50 mid-career, 100 established artists/year.

First Contact & Terms: Send resume, photographs and slides. Samples are returned by SASE only if requested. Reports within 10 days. Pays 50% royalty, or on consignment (50% commission). Buys all rights. Requires exclusive representation of artist. Provides promotion and shipping from firm.
Tips: "Must be contemporary. No surrealist, space themes or strange subject matter."

POSTERS INTERNATIONAL, 1200 Castlefield Ave., Toronto Ontario M6B-1G2. (416)789-7156. President: Esther Cohen. Estab. 1976. Art publisher/distributor/gallery handling limited editions (maximum 250 prints), handpulled originals and posters for galleries, corporations, wholesalers, restaurants, hotels, designers, and retailers. Current clients include: Bruce McGaw, Editions Limited and The Poster Shoppe.
Needs: Seeking artwork with creative artistic expression, fashionableness and decorative appeal for the commercial collector and designer market. Considers pen & ink, oil, acrylic, pastel, watercolor, tempera and mixed media. Prefers commercial, contemporary, original and trendy themes. Prefers individual works of art, pairs and unframed series. Approached by 100 artists/year. Publishes the work of 4 emerging, 2 mid-career and 2 established artists/year. Distributes the work of 10 emerging, 20 mid-career and 30 established artists/year. Artists represented include Brian Kelly, Friedbert Renbaum, Vita Churchill and Julie McCarroll. Pays flat fee of $200-2,000.
First Contact & Terms: Send query letter with brochure showing art style and tearsheets, photographs, slides and transparencies. Samples are sometimes filed. Samples not filed are returned only if requested by artist. Reports back to the artist within 3 weeks only if interested. To show a portfolio call or mail color and b&w slides and transparencies. "Outside of the shipments should indicate samples have no commercial value. Value at $1." Offers an advance when appropriate. Negotiates rights purchased. Does not require exclusive representation. Provides in-transit insurance, insurance while work is at firm, promotion, shipping from firm and a written contract.
Tips: "Any art that can have mass appeal, we would consider publishing as originals, limited editions, or posters. Must have commercial appeal. The current trend in art publishing is toward rich, deep colors, also back to traditional, i.e. architectural, style."

THE PRESS CHAPEAU, Govans Station, Box 4591, Baltimore City MD 21212-4591. (301)433-5379. Director: Philip Callahan. Estab. 1976. Publishes original prints only, "in our own atelier or from printmaker." Clients: architects, interior designers, corporations, institutions and galleries. Also sells to US government through GSA schedule. Current clients include state of NC and the Iowa Better Business Bureau. Publishes the work of 36 and distributes the work of 135 artists/year. Pays flat fee $100-2,000. Payment method is negotiated. Offers advance. Purchases 51% of edition or right of first refusal. Does not require exclusive representation. Provides insurance, promotion, shipping to and from firm and a written contract. Send query letter with slides. Samples are filed. Samples not filed are returned by SASE. Reports back within 5 days. Write to schedule an appointment to show a portfolio which should include slides.
Needs: Considers original handpulled, etchings, lithographs, woodcuts and serigraphs. Prefers professional, highest museum quality work in any style or theme. Suites of prints are also viewed with enthusiasm. Prefers unframed series.
Tips: "Our clients are interested in investment quality original handpulled prints. Your resume is not as important as the quality and craftsmanship of your work."

PRESTIGE ART GALLERIES, INC., 3909 W. Howard St., Skokie IL 60076. (708)679-2555. President: Louis Schutz. Estab. 1960. Art gallery. Publishes and distributes paintings and mixed media artwork. Clients: retail professionals and designers.
Needs: Seeking art for the serious collector. Considers oil. Prefers realism and French impressionism. Artists represented are Erte, Simbari, Agam and King. Editions created by collaborating with the artist and by working from an existing painting. Approached by 100 artists/year. Publishes 1 emerging, 1 mid-career and 1 established artist/year. Distributes the work of 5 emerging, 7 mid-career and 15 established artists/year.
First Contact & Terms: Send query letter with resume and tearsheets, photostats, photocopies, slides, photographs and transparencies. Samples are not filed and are returned by SASE. Reports back within two weeks. To show portfolio, mail appropriate materials. Pays on consignment; firm receives 50% commission. Offers an advance. Buys all rights. Provides insurance while work is at firm, promotion, shipping from firm and a written contract.
Tips: "Be professional. People are seeking better quality, lower sized editions, less numbers per edition 1/100 instead of 1/750."

PRIMROSE PRESS, Box 302, New Hope PA 18938. (215)862-5518. President: George Knight. Art publisher. Publishes limited edition reproductions for galleries. Clients: galleries, framers, designers, cost consultants, distributors, manufacturers and catalogs.
Needs: Seeks art for the serious collector, commercial collector and the designer market. Considers pen & ink line drawings, oil and acrylic paintings, watercolor and mixed media. Publishes representational themes. Prefers individual works of art; 40×30" maximum. Editions created by working from an existing painting. Approached by 300 artists/year. Publishes the work of 2-4 and distributes the work of 1-2 emerging artists/

year. Publishes the work of 3-5 and distributes the work of 2-3 mid-career artists/year. Publishes the work of 4-6 and distributes the work of 3-5 established artists/year.

First Contact & Terms: Send query letter with tearsheets and slides to be kept on file. Prefers slides as samples. Samples returned by SASE if not kept on file. Reports within 10 days. Pays royalties to artist of 10-20%. Buys one-time rights. Provides in-transit insurance, insurance while work is at publisher, shipping from publisher and a written contract. Artist owns original art.

QUANTUM MECHANICS, Suite B, 14140 Live Oak, Baldwin Park CA 91706. (818)962-6526. FAX: (818)960-7648. Sales Manager: Gene Ashe. Estab. 1986. Art publisher. Publishes and produces PC-generated graphics package. Clients: software companies, ad agencies and distributors.

Needs: Seeking artwork with creative expression for the commercial market. Considers mixed media. Themes and styles are "whatever the client requests." Editions created by collaborating with the artist.

First Contact & Terms: Send query letter with resume and "disk with graphic files." Samples are filed. Reports back within 4 weeks. To show a portfolio, mail "graphic files of work." Pay, rights purchased and services are negotiable. Offers advance when appropriate. Requires exclusive representation.

Tips: "We believe that this marketing idea is so unique that any and all approaches are considered. We only encourage artists who would welcome editing suggestions to their work to make submissions."

R J DESIGN, INC., Box 5359, Plymouth MI 48170. (313)454-0666. President: Robert Rudzik. Estab. 1984. Art publisher and distributor. Publishes and distributes posters. Clients: frame shops and distributors. Current clients include: Image Conscious, Modern Art Editions and the Decor Corp.

Needs: Seeking artwork with decorative appeal. Considers any media. "Prefers popular themes that are unique and entertaining." Artists represented include R. Rudzik. Editions created by collaborating with the artist. Approached by 10 artists/year. Publishes and distributes the work of 1 emerging artist/year.

First Contact & Terms: Send query letter with brochure showing art style. Samples are filed. Reports back only if interested. To show a portfolio, mail color transparencies and photographs. Payment is negotiated. Does not offer an advance. Negotiates rights purchased. Provides insurance while work is at firm, shipping from firm and a written contract.

Tips: "We are looking for artists who are interested in developing images for the poster market."

SALEM GRAPHICS, INC., Box 15134, Winston-Salem NC 27103. (919)727-0659. Contact: Robert C. Baker. Estab. 1981. Art publisher and distributor. Publishes and distributes unlimited editions, limited editions and offset reproductions. Clients: art galleries and frame shops.

Needs: Seeking artwork with creative artistic expression, fashionableness and decorative appeal for the serious collector, commercial and designer markets. Considers oil, watercolor, acrylic and pastel. Artists represented include R.B. Dance, Vivien Weller and Mildred Kratz. Editions created by collaborating with the artist and by working from an existing painting. Approached by 50-100 artists/year. "We publish and/or distribute the work of approximately 15 artists, mostly established."

First Contact & Terms: Send query letter with tearsheets, slides, samples of existing prints and transparencies. Samples are not filed. Reports back ASAP. To show a portfolio, mail color tearsheets, photographs, slides and transparencies. Requires exclusive representation of artist. Provides insurance while work is at firm.

***SAN MARTIN FINE ART**, Box 833, San Martin CA 95046. (408)847-2744. FAX: (408)847-2377. Owner: Radenko Stojakovic. Estab. 1989. Art publisher. Publishes limited editions. Clients: galleries and distributors.

Needs: Seeking artwork for creative artistic expression. Considers oil and watercolor. Prefers figurative and landscape. Artists represented include Anne-Lan and Bernard Verciz. Editions created by working from an existing painting. Approached by 6 artists/year. Publishes the work of 3 emerging artists and 3 established artists/year.

First Contact & Terms: Send query letter with brochure showing art style. Samples are not filed and are returned by SASE. Reports back within 2 weeks. To schedule an appointment for a portfolio review, mail appropriate materials. Portfolio should include photographs. Pays flat fee. Offers an advance. Buys one-time rights. Requires exclusive representation of artist.

SCAFA-TORNABENE ART PUBLISHING CO. INC., 100 Snake Hill Rd., West Nyack NY 10994. (914)358-7600. Director Art and Design: Rosemary Maschak. Produces unlimited edition offset reproductions for framers, commercial art trade and manufacturers worldwide. Approached by 15-200 artists/year. Publishes and distributes the work of 10 emerging, 10 mid-career and 10 established artists/year. "We work constantly with our established artists." Artists represented include: T.C. Chuy, Terry Madden and Carlos Rios. Pays $200-350 flat fee for some accepted pieces. Published artists (successful ones) can advance to royalty arrangements with advance against 5-10% royalty. Buys only reproduction rights (written contract). Artist maintains ownership of original art. Requires exclusive publication rights to all accepted work. Send query letter first with slides or photos and SASE and then arrange interview. Reports in about 2 weeks.

Needs: Seeking artwork with decorative appeal for the commercial collector and designer market. Considers unframed decorative paintings, watercolor, posters, photos and drawings; usually pairs and series. Prefers trendy, inspirational and decorative art. Prefers airbrush, watercolor, acrylic, oil, gouache, collage and mixed media. Artists represented include Carlos Rios, Andres' Orpinas and Anni Moller. Editions created by collaborating with the artist and by working from an existing painting.

Tips: Always looking for something new and different. "Study the market first. See and learn from what stores and galleries display and sell. For trends we follow the furniture market as well as bath, kitchen and all household accessories. Send slides or photos of your work, and call approximately two weeks from contact and please be patient. All inquiries will be answered."

SGL, Suite A, 190 Shepard Ave., Wheeling IL 60090. (708)215-2911. Vice President: Mr. Rami Ron. Estab. 1984. Art publisher/distributor handling art for qualified art galleries.

Needs: Seeking artwork with creative artistic expression for the serious collector. Open to all media. Prefers original themes. Prefers individual works of art. Maximum size no limit. Artists represented include Frederick Hart, Frank Gallo and Felix de Weldon. Editions created by collaborating with artists. Approached by 50 artists/year. Publishes/distributes the work of 3 established artists/year.

First Contact & Terms: Send query letter with resume, tearsheets, photographs, slides and all possible materials defining work. Samples are not filed and are returned. Reports back within 1 month. To show a portfolio, mail color tearsheets and slides. Payment method is negotiated. Negotiates rights purchased. Requires exclusive representation. Provides a written contract.

Tips: "We look for new, exciting ideas. We find most artists through personal recommendations, trade shows and magazines."

***SPRINGDALE GRAPHICS**, 911 Hope St., Box 4816, Springdale CT 06907. (203)356-9510. FAX: (203)967-9100. President: Michael Katz. Estab. 1985. Art publisher and distributor. Publishes and distributes unlimited editions and posters. Clients: galleries, museum shops, distributors, frame shops and design consultants.

Needs: Seeking artwork with creative artistic expression, fashionableness and decorative appeal for the serious collector, commercial market and designer market. Considers oil, watercolor, acrylic, pastel, pen & ink, mixed media and printmaking (all forms). Editions created by collaborating with the artist and working from an existing painting. Approached by hundreds of artists/year.

First Contact & Terms: Send query letter with brochure showing art style or resume and the following samples: tearsheets, slides, photostats, photographs, photocopies and transparencies. Samples are filed or are returned by SASE. Reports back within 2 weeks. Portfolio should include thumbnails, roughs, original/final art, b&w and color photostats, tearsheets, photographs, slides and transparencies. Pays royalties of 10%. Offers an advance when appropriate. Buys all rights. Sometimes requires exclusive representation of the artist. Provides in-transit insurance, insurance while work is at firm, promotion, shipping from your firm and a written contract.

Tips: "We are looking for highly skilled artists with a fresh approach to one or all of the following: painting (all mediums), pastel, collage, printmaking (all forms), mixed media and photography."

***STANTON ARTS, INC.**, 1020 Pine Branch Court, Suite PH, Ft. Lauderdale FL 33326-2839. President: Stan Hoff. Estab. 1978. Art publisher handling unlimited editions of offset reproductions and posters plus figurines. Clients: galleries, framers, department stores and mass merchandisers. Current clients include: Home Shopping Network, Service Merchandise, Downs' Collectors Showcase, Ringling Museum of Art. Publishes the work of 3-5 freelance artists/year. Payment method is negotiated. Offers an advance when appropriate. Negotiates rights purchased. Does not require exclusive representation of the artist. Provides insurance while work is at firm, promotion, shipping from firm, and a written contract. Send query letter with brochure, tear sheets, photographs and slides. Samples are filed. Samples will not be returned. Reports back within 30 days. Call or write to schedule an appointment to show a portfolio, which should include roughs or original/final art, photostats, tearsheets, slides or transparencies.

Needs: Seeking artwork with creative artistic expression, fashionableness and decorative appeal. Considers sculpture, watercolor, oil and acrylic. Prefers children, sports, professions, celebrities, period costumes, clowns/circus and Western subjects. Artists represented include Leighton-Jones, Mary Vickers, David Wenzel, Daniel Lovatt. Editions created by collaborating with the artist. Approached by 200-300 artists/year. Publishes and distributes the work of 2-3 emerging artists and 2 established artists/year. Maximum size 36×48.

***STONINGTON GALLERY**, 2030 1st Ave., Seattle WA 98121. (206)443-1108. FAX: (206)443-6850. Director: Gordon Wood. Estab. 1976. Gallery. Exhibits handpulled originals, limited and unlimited editions and offset reproductions. Clients: "mid to high end." Clients: Nietendo, Key Bank and Nordstrom.

Needs: Seeking artwork with creative artistic expression for the serious collector, commercial market and designer market. Artists represented include Birdsall and Machatanz. Approached by over 50 artists/year. Publishes and distributes the work of 1 established artist/year.

First Contact & Terms: Send query letter with resume or brochure showing art style. Samples are not filed and are returned. Reports back within 1 month. Call to schedule an appointment to show a portfolio. Portfolio should include appropriate samples. Pays on consignment basis. Offers an advance when appropriate. Negotiates rights purchased.

SUMMERFIELD EDITIONS, 2019 E. 3300 S., Salt Lake City UT 84109. (801)484-0700. Owner: Majid Omana. Estab. 1986. Art publisher, distributor and gallery handling offset reproductions, limited editions, posters and art cards. Clients include retail and wholesale galleries, decorators, department stores, card stores and gift shops. Current clients: Kimball Art Center, Evergreen Framing Co & Gallery and Image Conscious. Pays royalties of 10% plus signing fee. Negotiates rights purchased; prefers to buy all rights. Provides a written contract. Send query letter with brochure showing art style or resume, tearsheets, photostats, photocopies, slides and transparencies. Samples are filed. Reports back within 3 months if interested. Call or write to schedule an appointment to show a portfolio, or mail tearsheets, slides and transparencies.
Needs: Seeking artwork with decorative appeal, traditional, from the heart, for the serious collector, commercial collector and designer market. Considers pastel, watercolor and mixed media. Prefers Americana, country, Southwest and contemporary themes. Prefers individual works of art. Artists represented include Karen Christensen, Pat Enk and Ann Argyle. Editions created by working from an existing painting. Publishes and distributes the work of 4 emerging, 4 mid-career and 4 established artists/year.

***JOHN SZOKE GRAPHICS INC.**, 164 Mercer St., New York NY 10012. Director: John Szoke. Produces limited edition handpulled originals for galleries, museums and private collectors.
Needs: Original prints, mostly in middle price range, by upcoming artists. Artists represented include: James Rizzi, Jean Richardson, Masi and Preston. Publishes the work of 10 emerging, 5 mid-career and 2 established artists/year. Distributes 30 emerging, 10 mid-career and 5 established artists/year.
First Contact & Terms: Arrange interview or submit slides with SASE. Reports within 1 week. Charges commission, negotiates royalties or pays flat fee. Provides promotion and written contract.

TEE-MARK LTD., Box 2206, Charlotte NC 28247. (704)588-4038. Vice-President: Harvey Plummer. Estab. 1982. Art publisher/distributor handling limited editions (maximum 950 prints) of offset reproductions and handpulled originals for galleries and golf pro shops. Current clients include: USGA, PGA/World Golf Hall of Fame, TPC, *Golf Magazine*.
Needs Seeking artwork with creative artistic expression and decorative appeal for the serious collector. Considers oil, acrylic, watercolor and mixed media. Tee-Mark specializes in golf artwork. Prefers individual works of art and pairs. Maximum size 40×50″. Artists represented include Ken Reed and Marci Role. Editions created by collaborating with the artist. Approached by 10 artists/year. Distributes the work of 2 emerging artists and 1 mid-career artist/year. Publishes the work of 1 and distributes the work of 5 established artists/year.
First Contact & Terms: Send query letter with brochure showing art style and tearsheets, photographs, photocopies and transparencies. Samples are filed. Reports back within 1 month. Call or write to schedule an appointment to show a portfolio which should include original/final art, tearsheets, slides, transparencies and final reproduction/product. Pays flat fee; $100-1,000, royalties of 10% or on consignment basis: firm receives 35% commission. Payment method is negotiated. Purchases all rights. Requires exclusive representation. Provides in-transit insurance, insurance while work is at firm, promotion, shipping to and from firm and a written contract.

TELE GRAPHICS, 153 E. Lake Brantley Dr., Longwood FL 32779. President: Ron Rybak. Art publisher/distributor handling limited editions, offset reproductions, unlimited editions and handpulled originals. Clients: galleries, picture framers, interior designers and regional distributors. Approached by 30-40 artists/year. Publishes the work of 1-4 emerging artists/year. Negotiates payment method. Offers advance. Negotiates rights purchased. Requires exclusive representation. Provide promotions, shipping from firm and a written contract. Send query letter with resume and samples. Samples not filed returned only if requested. Reports within 30 days. Call or write to schedule an appointment to show a portfolio, which should include original/final art. Pays for design by the project. Considers skill and experience of artist, and rights purchased when establishing payment.
Needs: Seeking artwork with decorative appeal for the serious collector. Artists represented include Beverly Crawford, Diane Lacom and W.E. Coombs. Editions created by collaborating with the artist and by working from an existing painting.

TERRITORIAL ENTERPRISE, INC., Suite 14, 868 Tahoe Blvd., Incline Village NV 89451. (702)832-7400. FAX: (702)333-9406. Art Director: David Delacroix. Estab. 1858. Art publisher and distributor of various paper products and limited editions. Clients: galleries and frame shops. Current clients include Art Attack and other Lake Tahoe galleries.
Needs: Seeking artwork with creative artistic expression. Considers pen & ink. Prefers unique, different fantasy and romantic themes and styles. Artists represented include Muzzio, Ben Intendi and S. Croce. Editions created by working from an existing painting. Approached by 10 artists/year. Publishes the work of

1-3 emerging artists/year. Publishes and distributes the work of 5 mid-career and 1 established artist/year.
First Contact & Terms: Send query letter with brochure showing art style. Samples are filed. Reports back within 2 weeks. Pays flat fee. Offers advance when appropriate. Buys all rights. Provides shipping from firm.

VALLEY COTTAGE GRAPHICS, Box 564, Valley Cottage NY 10989. (914)358-7605 or 358-7606; or (800)431-3741. Distributors: Rosemary Maschak or Ms. Sheila Berkowitz. Publishes "top of the line" unlimited edition posters and prints. Publishes works of 10 emerging, 10 mid-career and 10 established artists/year. Clients: galleries and custom frame shops nationwide. Buys reproduction rights (exclusively) and/or negotiates exclusive distribution rights to "special, innovative, existing fine art publications." Query first; submit slides, photographs of unpublished originals, or samples of published pieces available for exclusive distribution. Reports within 2-3 weeks.
Needs: Prefers large, contemporary "exciting, dynamic" pieces; $18 \times 24''$, $22 \times 28''$, $24 \times 36''$. Artists represented are Linda Bromberg and M.J. Mayer.

VOYAGEUR ART, 2828 Anthony Lane S, Minneapolis MN 55418. President: Lowell Thompson. Estab. 1980. Art publisher of limited editions, posters, unlimited editions and original lithographs. Clients: galleries, frame shops, poster shops, retail catalog companies and corporations.
Needs Considers oil and acrylic paintings, pastel, watercolor, tempera, and mixed media. Prefers traditional works with original themes, and photorealistic works. "Will consider all submissions." Approached by 200 artists/year. Publishes the work of 1-2 emerging, 7-10 mid-career and 10-12 established artists/year.
First Contact & Terms: Send query letter with brochure or resume, tearsheets, photographs, slides or transparencies and SASE. Samples are filed or returned only if requested. Reports back within 2 months. Artists represented include Arnold Alamiz, Linda Roberts and Daniel Smith. Editions created by collaborating with the artist and by working from an existing painting. Payment method is negotiated. Prefers exclusive representation of artist. Provides in-transit insurance, insurance while work is at firm, promotion and a written contract.

WATERLINE PUBLICATIONS, INC., 60 K St, Boston MA 02127. (617)268-8792. Contact: Tom Chiginsky. Estab. 1984. Art publisher and distributor. Publishes limited editions and posters. Clients: 5,000 galleries and framers.
Needs: Seeking artwork with creative artistic expression and decorative appeal. Considers all media, including oil, watercolor, acrylic, pastel and mixed media. Open to all categories of artwork. Currently publishes florals, landscapes, still lifes, marine art, sports, museum editions, animals, environmental, whimsical and decorative. Posters created from original artwork in collaboration with artist. Approached by 150 artists/year. Publishes approximately 12 artists/year.
First Contact & Terms: Send query letter with slides, pictures or transparencies of artwork. Do not send originals unless they are requested. Samples are filed unless otherwise specified. All artwork sent in will be reviewed. Send SASE if you would like samples returned. Reports back within 4 weeks. Pays royalties based on sales. Does not offer an advance. Buys reprint rights. Provides written contract. Promotes all publications through catalog and/or direct mail/advertising.

EDWARD WESTON EDITIONS, 19355 Business Center Dr., Northridge CA 91324. (818)885-1044. Vice President/Secretary: Ann Weston. Art publisher, distributor and gallery handling limited and unlimited editions, offset reproductions and handpulled originals. Approached by hundreds of artists/year. Publishes and distributes the works of 1-2 emerging artists and as many established artists/year as possible. Pays flat fee; royalty of 10% of lowest selling price; or negotiates payment method. Sometimes offers advance. Buys first rights, all rights, reprint rights or negotiates rights purchased. Requires exclusive representation. Provides promotion and written contract. Send brochure and samples to be kept on file. Prefers original work as samples. Samples not filed returned by SASE. "Publisher is not responsible for returning art samples." Reports within 2 months. Write for appointment to show portfolio.
Needs: Seeking artwork with decorative appeal for the serious collector, commercial collector and designer market. Considers all media. Especially likes "new, different, unusual techniques and style." Artists represented include Elke Sommer, Stevel Leal, Charles Bragg and P. Noyer. Editions created by collaborating with the artist and by working from an existing painting.

***WILD APPLE GRAPHICS, LTD.**, HCR 68 Box 131, Woodstock VT 05091. (802)457-3003. FAX: (802)457-3003. Art Director: Laurie Chester. Estab. 1989. Art publisher and distributor. Publishes and distributes unlimited editions. Clients: frame shops, interior designers and furniture companies. Current clients include: Deck the Walls and The Nature Company.
Needs: Seeking artwork with decorative appeal for the commercial and designer markets. Considers oil, watercolor, acrylic and pastel. Artists represented include Lizzie Riches, Richard Humphry, Bernard Carter, Jonathan Phillips and Ginnie Gardiner. Editions created by working from an existing painting. Approached by 100 artists/year. Publishes and distributes the work of 1-4 emerging and mid-career artists/year. Publishes and distributes the work of 6-10 established artists/year.

First Contact & Terms: Send query letter with resume and slides, photographs or transparencies. Samples are returned by SASE. Reports back within 1 month. Payment method is negotiated. Negotiates rights purchased. Provides in-transit insurance, insurance while work is at firm, promotion, shipping to and from your firm and a written contract.

***ZANART PUBLISHING INC.**, Suite 1810, 10920 Wilshire Blvd., Los Angeles CA 90024. (213)824-5002. FAX: (213)208-7110. President: Thomas Zotos. Estab. 1990. Art publisher. Publishes and/or distributes handpulled originals, limited and unlimited editions and posters. Clients: wholesale and retail galleries.
Needs: Seeking artwork with creative artistic expression for the serious collector and the commercial market. Considers oil, watercolor, acrylic, pastel, pen & ink and mixed media. Prefers cartoon art, deco styles and photographs. Editions created by collaborating with artist and working from an existing painting. Approached by 30-40 artists/year. Publishes the work of 6-10 and distributes the work of 1-3 emerging artists/year. Publishes the work of 1-2 mid-career artists and distributes the work of 1 mid-career artist/year. Publishes the work of 5-6 established artists and distributes the work of 1 established artist/year.
First Contact & Terms: Contact only through artist agent. Send query letter with brochure showing art style or resume and the following samples: tearsheets, slides and photographs. Samples are not filed and are returned. Reports back only if interested. Call or write to schedule an appointment to show a portfolio. Mail appropriate materials. Portfolio should include roughs, original/final art or b&w and color tearsheets, photographs if possible, and slides. Pays royalties, on consignment basis, or payment method is negotiated. Does not offer an advance. Buys all rights. Requires exclusive representation of the artist. Provides insurance while work is at firm, promotion and a written contract.

ZOLA FINE ART, 8163 Melrose Ave., Los Angeles CA 90046. (213)655-6060. President: Lisa Zola. Estab. 1986. Art publisher/distributor/gallery. Distributes original artwork in variety of media. Clients: banks, corporations, designers, retail, architects, hotels; also distributes to art consultants. Current clients include: Southern California Gas Company, Bateman Eichler, Hill Richards and Kenneth Leventhal & Company. Approached by 100 artists/year. Distributes the work of 20-30 emerging, 20-30 mid-career and 20-30 established artists/year. Payment method is negotiated. Provides insurance while work is at firm, promotion, return shipping and a written contract. Send query letter with brochure, resume, tearsheets, photographs, slides or transparencies. Samples are returned. Reports back within 1 month. To show a portfolio mail slides, transparencies, bio, price list and SASE.
Needs: Seeking art for the serious collector and designer market. Considers mixed media, gouache, oil acrylic, pastel, watercolor, drawings, sculpture, ceramic and original prints. Prefers contemporary styles and landscapes. Prefers individual works of art and unframed series. Artists represented include Gerald Brommer, Linda Vista and Nick Capaci. Editions created by collaborating with the artist.

Other Art Publishers

Each year we contact all firms currently listed in *Artist's Market* requesting they give us updated information for our next edition. We also mail listing questionnaires to new and established firms which have not been included in past editions. The following art publishers and/or distributors either did not respond to our request to update their listings for 1992 (if they indicated a reason, it is noted in parentheses after their name), or they did not return our questionnaire for a new listing.

All Sales, Inc.
American Quilting Art
Art Spectrum
C.R. Fine Arts Ltd. (moved; no forwarding address)
Caribbean Arts, Inc.
Child Graphics Press (overstocked)
Greg Copeland Inc. (out of business)
Danmar Productions, Inc. (unable to contact)

Gallery Revel
The Golf Shop Collection
Graphicor
William Havu Fine Art
Imcon
Marco Distributors
Metropolitan Editions, Ltd. (unable to contact)
Mitch Morse Gallery Inc. (asked to be deleted)
Rie Munoz Ltd.

George Nock Studios
Petersen Prints
H.W. Rinehart Fine Arts, Inc.
Ted Schwartz Fine Arts
Southeastern Wildlife Exposition
Sugarbrush Prints
Vargas & Associates Art Publishing
James D. Werline Studio
Windy Creek Inc.

Book Publishers

Book publishers used to feel recessions passed them by, that readers craving for the printed word would forever be willing to dig into their pockets, however deep, for new books. This was not the case in the past year when many publishers found sales slowing considerably, coming to a virtual standstill during the Persian Gulf war. At the time this book went to press, some publishers felt their sales were picking up. Others still saw a long road ahead.

A large percentage of books are sold in malls, in stores such as Barnes and Noble and Waldenbooks, and when mall traffic slows, so do book sales. When readers do venture into malls now, it seems they give greater thought to what they purchase and refrain from impulse buys, which books sometimes are. Browsing through a bookstore today, one sees the variety of size, color and style art directors, designers and illustrators are presenting to these hesitant buyers. Jackets have become visually attractive in a quiet, sophisticated, imaginative and eclectic sort of way.

With the proliferation of small presses and independent bookstores (growing 76 percent in the last decade), smaller publishers may be able to offer more opportunity to the free-lancer. Independent bookstores are increasingly relying on computers to track sales and keep inventories down; they are also ordering through a large network of national and regional distributors, rather than the publishers themselves. This means they are able to get a small quantity of books quickly and thus offer a breadth of books (from a variety of publishers) that the large chains don't. With an emphasis on quality, small press books generally use conceptual illustrations that border on fine art.

In addition to decreased book sales and heightened competition, many publishers are feeling the continued effects of mergers, rising production costs (while booksellers warn that increased prices could slow sales further) and very high advances to authors (among the highest is the 3.5 million Random House paid to Marlon Brando for his memoirs and the more than 5 million General Schwarzkopf will gain for his autobiography).

In this milieu staffs have been tightened considerably. Many who were previously art directors or on art staffs are now freelancing. As Susan Newman, art director of Paragon House (Close-up in this section) says, the competition is extremely stiff. To put yourself in good stead, you must understand the unique needs of publishing and the specific needs of the house you approach. Always research your prospective client—thoroughly.

Art directors at publishing houses call on freelance artists to design and illustrate book covers and interiors, as well as catalogs and direct mail pieces. Book design utilizes artists skilled in typography, type specification and layout. The designer may initiate the ideas for text illustration or the suggestion may come from the art director during initial planning stages.

Most assignments for freelance work are for jackets/covers. The cover must represent the contents of the book and attract the consumer. While the cover establishes the relative importance of the author, title and subtitle, it must also identify its market—a romance novel requires a different cover than a scholarly title.

Covers for trade titles (larger format books almost exclusively sold in bookstores) have adopted a looser style of illustration rather than the traditional realistic approach. Many houses are publishing paperback originals, often in series form, skipping the hardcover editions completely. Thus, their covers must convey the book's uniqueness while tying it to a series. The nicely designed trade paperback is the format currently favored for contemporary fiction. Often tagged "quality" paperbacks, their covers show inventive typography and matte-paper jackets.

Mass-market titles (books sold on newsstands as well as in bookstores) especially rely on their covers to catch the consumer's eye. They often employ bright colors and usually focus on one or two of the book's characters or a symbol that summarizes the story.

Certain types of books have held up well through these tough times: children's, religious and scientific books. As well, backlists are being revived, such as Knopf's rerelease of Everyman's Library and Random House's reissue of the Modern Library series.

According to an article in *Publishers Weekly*, as the competition for children's books heightens, art directors are becoming more daring and experimental in creating a new look. They are moving away from ultra-realism and expressing a need for fresh work, more sophisticated graphics and an emphasis on mood and character.

Publishers large and small have turned to computer technologies to streamline production. Computers are also being used for book design, page makeup and for actual artwork. Lisa Torri, of Brooks/Cole Publishing Company in California, says, "There is an extremely strong trend in college textbook publishing toward the use of computers as both an illustration and design tool. We utilize the computer in every aspect of our design department."

Artwork is generally geared to the specific theme of a book. Therefore, art directors call upon a variety of styles to fill their diverse needs. Have your samples on file with as many publishers as possible, so you will be represented when the need arises for your type of work. Write and request a catalog of a publisher's titles to get an idea of the type of books it produces and go to bookstores to get an overview of what is being done.

Art directors generally prefer to receive five to ten samples (never originals) along with a concise cover letter stating what you have to offer. If you are called for a portfolio review, show your best work in the area the art director shows a need. Also include a few pieces that show other specialties in case the art director might also have other interests.

Payment varies according to the project. Fees depend upon the expected sales of the book, the format (hardcover or paperback), the complexity of the project, deadlines and rights purchased. Additional factors involve reuse of the artwork in promotional materials and reprints. Make sure you review all aspects of the assignment with the art buyer.

In this section's listings, we have included the types and approximate number of books published to give you a better understanding of the scope of the house you are considering. We have also broken the listings into subheads to give you as many specifics as possible on the three main job opportunity areas in book publishing—book design, jackets/covers and text illustration.

For further information on this market, refer to *Writer's Market, Novel and Short Story Writer's Market, Children's Writer's and Illustrator's Market, Literary Market Place, Books in Print* and *International Directory of Little Magazines and Small Presses*. The trade magazines *Publishers Weekly* and *Small Press* provide updates on the industry.

A.D. BOOK CO., 6th Floor, 10 E. 39th St., New York NY 10157-0002. (212)889-6500. FAX: (212)889-6504. Art Director: Doris Gordon. Publishes hardcover and paperback originals on advertising design and photography. Publishes 12-15 titles/year. Recent titles include *Borders* and *Logo International 3*.
First Contact & Terms: Works with 3 freelance designers and 3 freelance illustrators/year. Send query letter which can be kept on file, and arrange to show portfolio (4-10 tearsheets). Samples returned by SASE. Buys first rights. Originals returned to artist at job's completion. Free catalog. Advertising design must be contemporary.
Book Design: Pays $100 minimum.
Jackets/Covers: Pays $100 minimum.

ABARIS BOOKS, 42 Memorial Plaza, Pleasantville NY 10570. (914)747-9298. FAX: (914)747-4166. Managing Editor: Elizabeth A. Pratt. Estab. 1973. Book publisher. Publishes hardcover originals and paperback reprints. Types of books include scholarly art and art history books. Specializes in prints and drawings. Publishes 6-8 titles/year. Recent titles include *The Royal Horse and Rider, Woodner Collection of Master Drawings* and several volumes of *The Illustrated Bartsch*. 25% require freelance design. Book catalog free on request.

Needs: Approached by 25-30 freelance designers/year. Works with 2-3 freelance designers/year. Prefers designers with experience in art books and museum catalogs. "We are looking for very specialized experience in this area. It is a prerequisite, not just a preference." Also uses freelance artists for jacket/cover, book, direct mail and catalog design. Works on assignment only.

First Contact & Terms: Send query letter with resume and appropriate samples, slides and photos. Samples are filed. Reports back within 2 months only if interested. Write to schedule an appointment to show a portfolio. Portfolio should include photostats, original/final art and photographs.

Book Design: Assigns 2-3 freelance design jobs/year. Pays by the project.

Jackets/Covers: Assigns 2-3 freelance design jobs/year. Pays by the project.

Tips: Look of design used is "straightforward, clean, simple, elegant—so as not to compete with the works illustrated—(*not* advertising/high-level marketing style). Subdued/understated. Have appropriate experience and recommendations; professional and complete portfolio. Contact by letter first."

ACADIA PUBLISHING CO., Box 170, Bar Harbor ME 04609. (207)288-9025. President: Frank J. Matter. Independent book producer/packager. Estab. 1981. Publishes hardcover originals, trade paperback originals, hardcover reprints and trade paperback reprints. Publishes nonfiction and fiction. Types of books include biography, cookbooks, instructional, juvenile, reference, history, guides, romance, historical, mainstream/contemporary and literary. Specializes in New England subjects. Publishes 8-10 titles/year. 33% require freelance illustration. Recent titles include *The Eloquent Edge*, *The Lost Tales of Horatio Alger* and *My Dear Sarah Anne*. Book catalog available for SASE with 1 first-class stamp.

First Contact & Terms: Approached by 100 freelance artists/year. Works with 3 freelance illustrators and 3 freelance designers/year. Works with freelance artists for jacket/cover illustration and design and text illustration. Works on assignment only. Send query letter with resume, tearsheets and SASE. Samples are filed or returned by SASE if requested. Reports back about queries/submissions within 1 month. Call or write to schedule appointment to show portfolio, which should include slides, SASE, original/final art, tearsheets, final reproduction/product and slides. Considers complexity of project, skill and experience of artist, project's budget and rights purchased when establishing payment.

Jackets/Covers: Assigns 3 freelance design and 3 freelance illustration jobs/year. Pays by the project; rate negotiated.

Text Illustration: Assigns 3 freelance jobs/year. Pays by the project, $100 minimum.

Tips: "We do not want to see a portfolio or original artwork without a query first. Include SASE. New trends include more 4-color art, simplicity, better harmony of text and illustration through research and inspiration of artists and more computer generated art. Book design is leaning toward larger margins and more white space, simple and modern."

***AEGINA PRESS, INC.**, 59 Oak Lane, Spring Valley, Huntington WV 25704. Art Coordinator: Claire Nudd. Estab. 1984. Book publisher. Publishes hardcover and trade paperback originals, and trade paperback reprints. Types of books include contemporary, experimental, mainstream, historical and science fiction, adventure, fantasy, mystery, young adult and travel. Publishes 25 titles/year. Recent titles include *The Power Players*, by Bonnie Huval; and *The Town is Aaron*, by Yereth Knowles. 50% require freelance illustration; 50% require freelance design. Book catalog available for $3 and 9 × 12 SAE with four first-class stamps.

Needs: Approached by 30 freelance artists/year. Works with 15 freelance illustrators each year. Buys 20 freelance illustrations/year. Prefers artists with experience in color separations and graphic layouts. Uses freelance artists mainly for covers and some interior illustrations. Also uses freelance artists for jacket/cover and text illustration, and jacket/cover design. Works on assignment only.

First Contact & Terms: Send query letter with photographs and 8½ × 11 photocopies. Samples are filed and are not returned. Reports back within 2 weeks only if interested. To show a portfolio, mail appropriate materials. Buys one-time rights. Originals are not returned at job's completion.

Jackets/Covers: Assigns 20 freelance design and 5 freelance illustration jobs/year. Pays by the project, $60.

Text Illustration: Assigns 5 freelance jobs/year. Pays by the project, $60. Prefers b&w, pen and ink.

Tips: "Query first with nonreturnable samples. Photocopies are fine."

AIRMONT PUBLISHING CO., INC., 401 Lafayette St., New York NY 10003. (212)598-0222. Vice President/Publisher: Barbara J. Brett. "Airmont Books are all reprints of classics. We are not buying any cover art, but at any time in the future when we may need art, we will consider artists we have worked with on our Avalon Books, published by our Thomas Bouregy Company. See that listing."

***ALFRED PUBLISHING CO., INC.**, 16380 Roscoe Blvd., Box 10003, Van Nuys CA 91410-0003. (818)891-5999. FAX: (818)891-2182. Art Director: Ted Engelbart. Estab. 1922. Book publisher. Publishes trade paperback originals. Types of books include instructional, juvenile, young adult, reference and music. Specializes in music books. Publishes approximately 300 titles/year. Recent titles include *Heavy Metal Lead Guitar*, *Bach: An Introduction to His Keyboard Works*, *Singing with Young Children*. Book catalog free by request.

Needs: Approached by 40-50 freelance artists/year. Works with 20-25 freelance illustrators and 15 freelance designers/year. "We prefer to work directly with artist—local, if possible." Uses freelance artists mainly for cover art, marketing material, book design and production. Also uses freelance artists for jacket/cover and text illustration. Works on assignment only.
First Contact & Terms: Send resume, SASE and tearsheets. "Xerox is fine for line art." Samples are filed. Reports back only if interested. "I appreciate paid reply cards." To show a portfolio, include "whatever shows off your work and is easily viewed." Originals are returned at job's completion.
Book Design: Assigns 10 freelance design jobs/year. Pays by the hour, $20-25, or by the project.
Jackets/Covers: Assigns 20 freelance design jobs and 50 freelance illustration jobs/year. Pays by the project, $150-800. "We generally prefer fairly representational styles for covers, but anything upbeat in nature is considered."
Text Illustration: Assigns 15 freelance illustration jobs/year. Pays by the project, $350-2,500. "We use a lot of line art for b&w text, watercolor or gouache for 4-color text."

ALLYN AND BACON INC., College Division, 160 Gould St., Needham MA 02194. (617)455-1200. Cover Administrator: Linda Knowles Dickinson. Publishes hardcover and paperback textbooks. Publishes over 150 titles/year; 50% require freelance cover designs. Subject areas published include personal selling, business marketing, education, psychology and sociology.
First Contact & Terms: Approached by 80-100 freelance artists/year. Needs artists/designers experienced in preparing art and mechanicals for print production. Designers must be strong in book cover design and contemporary type treatment.
Jackets/Covers: Assigns 100 freelance design jobs/year; assigns 2-3 freelance illustration jobs/year. Pays for design by the project, $300-550. Pays for illustration by the project, $150-500. Prefers sophisticated, abstract style. Prefers pen & ink, airbrush, charcoal/pencil, watercolor, acrylic, oil, collage and calligraphy. "Always looking for good calligraphers."
Tips: "Keep stylistically and technically up to date. Learn *not* to over-design: read instructions, and ask questions. Introductory letter must state experience and include at least photocopies of your work. If I like what I see, and you can stay on budget, you'll probably get an assignment. Being pushy closes the door. We primarily use designers based in the Boston area."

***ALYSON PUBLICATIONS, INC.,** 40 Plympton St., Boston MA 02118. Publisher: Sasha Alyson. Estab. 1977. Book publisher emphasizing gay and lesbian concerns. Publishes 15 titles/year. Recent titles include *Daddy's Roommate* and *Bi Any Other Name*. Circ. 800. Sample copy catalog for 9×12 envelope with 52¢ postage.
First Contact & Terms: Works on assignment only. Send query letter with brochure showing art style or tearsheets, photostats, photocopies and photographs. Samples returned by SASE. Reports only if interested.
Jackets/Covers: Buys 10 cover illustrations/year. Works with artists mainly for book covers. Pays $200-500, b&w, $300-500, color; on acceptance.
Tips: "We are planning six children's books a year aimed at the kids of lesbian and gay parents. Many styles will be needed, from b&w drawings to full-color work. Send samples to be kept on file."

AMERICAN ATHEIST PRESS, 7215 Cameron Rd., Austin TX 78752. (512)458-1244. Editor: R. Murray-O'Hair. Estab. 1963. "The American Atheist Press, a nonprofit, nonpolitical, educational publisher, specializes in the publication of atheist and freethought paperbacks and reprints, as well as criticism of religion. It also publishes a monthly magazine, the *American Atheist*." Publishes 8 titles/year; 40% require freelance illustration. Recent titles include *Atheists: The Last Minority* and *Dial-An-Atheist Greatest Hits*. Books are "simple and uncluttered."
First Contact & Terms: Works with 6 freelance illustrators and 3 freelance designers/year. Send query letter with brochure showing art style; "anything showing style is fine." Samples are filed. Reports back within 3 months on submissions only if interested. Does not report back on queries. Originals returned to artist at job's completion if artist requests. Call or write to schedule an appointment to show a portfolio, which should include roughs, original/final art, photostats, tearsheets or final reproduction/product. Considers complexity of project, skill and experience of artist and project's budget when establishing payment. Negotiates rights purchased.
Book Design: Assigns 3 freelance illustration jobs/year. Pays by the project, $25-500.
Jackets/Covers: Assigns 3-6 freelance design and 3-6 freelance illustration jobs/year. Pays by the project, $25-500.
Text Illustration: Assigns 3 freelance jobs/year. Pays by the project, $25-500.
Tips: "If the artist has a minimum price for his work, he should include that with his basic information; it saves time later on. Often a 'cause' press cannot meet an artist's monetary expectations."

***THE AMERICAN CERAMIC SOCIETY INC.,** 757 Brooksedge Plaza, Westerville OH 43081. (614)890-4700. FAX: (614)899-6109. Manager of Design Production and Manufacturing: Alan L. Hirtle. Estab. 1890. Book and periodicals publisher. Publishes hardcover originals, trade paperback originals and reprints, and textbooks. Types of books include instructional, reference, history and science. Specializes in glass, ceramics and

material science. Publishes 25 titles/year. Recent titles include *Ceramic Transactions* and *Alumina*. 20% require freelance illustration; 10% require freelance design. Book catalog free by request.

Needs: Approached by 8 freelance artists/year. Works with 4 freelance illustrators and 2 freelance designers/year. Buys 300 freelance illustrations/year. Prefers local artists with experience in technical drawing. Uses freelance artists mainly for author figure redraws. Also uses freelance artists for jacket/cover design and illustration, and book, direct mail and catalog design. Works on assignment only.

First Contact & Terms: Send query letter with resume. Samples are not filed. Reports back to the artist only if interested. Write to schedule an appointment to show a portfolio. Portfolio should include roughs and original/final art. Rights purchased vary according to project.

Book Design: Assigns 8 freelance design and 5 freelance illustration jobs/year. Pays by the hour, $12.

Jackets/Covers: Assigns 4 freelance design and 1 freelance illustration jobs/year. Pays by the hour, $12; by the project. Prefers marker comp or PC print.

Text Illustration: Assigns 1 freelance illustration and design job/year. Pays by the hour, $12.

Tips: To get an assignment, show "work that may be at times more technical than purely artistic."

APPLEZABA PRESS, Box 4134, Long Beach CA 90804. (213)591-0015. Publisher: D.H. Lloyd. Estab. 1977. Specializes in poetry and fiction paperbacks. Publishes 2-4 titles/year. 40% require freelance illustration. Recent titles include *Gridlock: Anthology of Poetry about Southern California* and *Horse Medicine & Other Stories*, by Raefel Zepeda.

First Contact & Terms: Approached by 20 freelance artists/year. Works with 2-4 freelance illustrators and 1 freelance designer/year. Mainly uses art for covers. Works on assignment only. Send query letter with brochure, tearsheets and photographs to be kept on file. Samples not filed are returned by SASE. Reports only if interested. Originals returned to artist at job's completion. Portfolio should include 8-10 samples, such as slides or photocopies of b&w work. Considers project's budget and rights purchased when establishing payment. Rights purchased vary according to project.

Jackets/Covers: Assigns 1 freelance design job/year. Prefers pen & ink, collage. Pays by project, $30-100.

Tips: "Usually use cover art that depicts the book title and contents, b&w and one color." The most common mistake illustrators and designers make in presenting their work is "sending samples of art that is inconsistent with our needs, i.e., we receive many fantasy illustration samples and we don't publish fantasy."

APRIL PUBLICATIONS, INC., Box 1000, Staten Island NY 10314. Art Director: Verna Hart. Specializes in paperback nonfiction. Publishes 25 titles/year.

First Contact & Terms: Works with 10 freelance artists/year. Works on assignment only. Send query letter with samples to be kept on file. Prefers photostats as samples. Samples not filed are returned by SASE. Reports only if interested. Considers project's budget and rights purchased when establishing payment. Buys all rights.

ARCsoft PUBLISHERS, Box 132, Woodsboro MD 21798. (301)845-8856. President: A.R. Curtis. Specializes in original paperbacks, especially in space science, computers and miscellaneous high-tech subjects. Publishes 12 titles/year.

First Contact & Terms: Works with 5 freelance artists/year. Works on assignment only. Send query letter with brochure, resume and non-returnable samples. Samples not filed are not returned. Reports back within 3 months only if interested. Original work not returned after job's completion. Considers complexity of project, skill and experience of artist, project's budget and turnaround time when establishing payment. Buys all rights.

Book Design: Assigns 5 freelance illustration jobs/year. Pays by the project.

Jackets/Covers: Assigns 1 freelance design and 5 freelance illustration jobs/year. Pays by the project.

Text Illustration: Assigns 5 freelance jobs/year. Pays by the project.

Tips: "Artists should not send in material they want back. All materials received become the property of ARCsoft Publishers."

ART DIRECTION BOOK CO., 6th Floor, 10 E. 39th St., New York NY 10157-0002. (212)889-6500, FAX: (212)889-6504. Art Director: Doris Gordon. Specializes in hardcover and paperback books on advertising art and design. Publishes 15 titles/year; 50% require freelance design. Recent titles include *Famous 19th Century Faces* and *World Corporate Identity*.

First Contact & Terms: Works with 2 freelance illustrators and 3 freelance designers/year. Professional artists only. Call for appointment. Drop off portfolio. Samples returned by SASE. Originals returned to artist at job's completion. Buys one-time rights.

Book Design: Assigns 10 freelance jobs/year. Uses artists for layout and mechanicals. Pays by the job, $100 minimum.

Jackets/Covers: Assigns 10 freelance design jobs/year. Pays by the job, $100 minimum.

ARTIST'S MARKET, Writer's Digest Books, 1507 Dana Ave., Cincinnati OH 45207. Contact: Lauri Miller. Annual hardcover directory of markets for graphic and fine artists. Send printed piece, photographs or photostats. "Since *Artist's Market* is published only once a year, submissions are kept on file for the next upcoming edition until selections are made. Material is then returned by SASE." Buys one-time rights.
Needs: Buys 50-60 illustrations/year. "I need examples of art that have been sold to or exhibited by one of the listings in *Artist's Market*. Thumb through the book to see the type of art I'm seeking. The art must have been freelanced; it cannot have been done as staff work. Include the name of the listing that purchased or exhibited the work, what the art was used for and, if possible, the payment you received." Pays $25 to holder of reproduction rights and free copy of *Artist's Market* when published. "Please bear in mind that the works are reproduced in black and white. So the higher the contrast, the better."
Tips: "This year we will be holding a contest for the 1994 cover of the *Artist's Market*. For guidelines, please send a SASE. Entries will be accepted from January 10 to August 10, 1992. Winners will be announced in December. The first prize winner's work will be considered for the 1994 cover of *Artist's Market*. The artist will also receive $500."

ARTS END BOOKS, Box 162, Newton MA 02168. Editor and Publisher: Marshall Brooks. Specializes in hardcover and paperback originals and reprints of contemporary literature. Publishes 2 titles/year. Recent titles include *Handbook for Shipwrecked Sailors*. Books have a "seaworthy" look.
First Contact & Terms: Approached by 60 freelance artists/year. Works with 1-2 freelance illustrators/year. Please query. Photocopies are OK.
Book Design: Pays by the project.
Jackets/Covers: Pays by the project, $150 minimum.
Text Illustration: Prefers pen & ink work. Pays by the project.
Tips: "We have more of a fine arts emphasis than not. Mainstream commercial artwork is not suited to the work that we do. Originality is essential. The artwork used is a cross between Pierre Bonnard, Rockwell Kent and Vanessa Bell. Artists should try to familiarize themselves with publications prior to submitting."

ASHLEY BOOKS INC., 4600 W. Commercial Blvd., Tamarac FL 33319. (305)731-2221. President: Billie Young. Estab. 1971. Publishes hardcover originals; controversial, medical and timely fiction and nonfiction. Publishes 50 titles/year; 40% require freelance design or illustration. Recent titles include *Buy Me; Saigon Tea,* by Lewis LeMoyne; and *Hindu Kush,* by Y.L. Harris. Mainly uses artists for book subjects, also uses artists for promotional aids.
First Contact & Terms: Prefers artists experienced with book publishing or record album jackets. Do not send material that needs to be returned. Arrange interview to show portfolio. Buys first rights. Negotiates payment. Free catalog for SASE with 52¢ postage.
Book Design: Assigns 35 jobs/year. Uses artists for layout and paste-up.
Jackets/Covers: Assigns 35 jobs/year. "Cover should catch the eye. A cover should be such that it will sell books and give an idea at a glance what the book is about. A cover should be eye catching so that it draws one to read further."
Tips: "A cover should catch the eye and show at a glance what the book is about so that one is excited and wants to read further. No cartoons, no surrealism."

ASIAN HUMANITIES PRESS, Box 3523, Fremont CA 94539. (415)659-8272. FAX: (415)659-8272. Publisher: M.K. Jain. Estab. 1976. Book publisher. Publishes hardcover originals, trade paperback originals and reprints and textbooks. Types of books include reference and literary fiction books on religion and philosophy. Specializes in Asian literature, religions, languages and philosophies. Publishes 10 titles/year. Recent titles include *New Mahayana: Buddhism for a Post-Modern World* and *Toward a Superconsciousness: Meditational Theory & Practice*. Books are "uncluttered, elegant, using simple yet refined art." 80% require freelance illustration; 100% require freelance design. Book catalog free by request.
Needs: Approached by 10 freelance artists/year. Works with 4 freelance illustrators and designers/year. Buys 8 freelance illustrations/year. Prefers artists with experience in scholarly and literary works relating to Asia. Uses freelance artists mainly for cover/jacket design. Also uses freelance artists for jacket/cover illustration and catalog design.
First Contact & Terms: Send query letter with brochure, resume, tearsheets and photostats. Samples are filed. Reports back to the artist only if interested. To show a portfolio, mail photostats and tearsheets. Rights purchased vary according to project. Originals are not returned at job's completion.
Jackets/Covers: Assigns 10 freelance design and 8 freelance illustration jobs/year. Prefers "camera ready mechanicals with all type in place. "Pays by the project, $250-500.
Tips: "The best way for a freelance graphic artist to get an assignment is to have a great portfolio and relevant referrals. We would like to see more use of Asian and Oriental art, also metaphysical and New Age drawings."

THE ASSOCIATED PUBLISHERS, INC., 1407 14th St. NW, Washington DC 20005-3704. (202)265-1441. FAX: (202)328-8677. Managing Director: W. Leanna Miles. Estab. 1920. Book publisher. Publishes textbooks. Types of books include history and "all materials pertaining to the Black experience." Publishes about 2

titles/year. Recent titles include *The Role of the Black Church* and *The Father of Black History*. 25% require freelance illustration; 50% require freelance design. Book catalog available for $2.

Needs: Approached by 3-5 freelance artists/year. Works with 2 freelance illustrators and designers/year. Prefers artists with experience in the Black experience. Uses freelance artists mainly for annual study kits. Also uses freelance artists for jacket/cover and text illustration; book, direct mail and catalog design. Works on assignment only.

First Contact & Terms: Send query letter with brochure and resume. Samples are filed. Reports back to the artist only if interested. Negotiates rights purchased.

Book Design: Assigns 2-5 freelance design and illustration jobs/year. Pays by the project, $200-1,500.

Jackets/Covers: Assigns 2-5 freelance design and illustration jobs/year. Pays by the project, $200-1,500.

Text Illustration: Assigns 2-5 freelance design and illustration jobs/year. Pays by the project, $200-1,500. Prefers a mixture of media and style.

***ASTARA INC.,** Box 5003, Upland CA 91785. Estab. 1951. Nonprofit religious organization publishing books and materials of interest to those in the metaphysical and philosophical areas. Recent titles include *Forever Young* and *The You Book*. Books have a "New Age" look.

Needs: Works with 2 freelance illustrators and 2 freelance designers/year. Assigns 4-6 jobs/year. Prefers local aritsts only. Works on assignment basis only. Uses freelance artists mainly for book cover design. Also uses artists for advertising and brochure design, illustration and layout.

First Contact & Terms: Send query letter with resume and tearsheets. Reports back within 2 weeks. Call to schedule an appointment to show a portfolio, which should include final reproduction/product and original/final art. Pays for design and illustration by the project, $250-1,500; by the illustration, $80-100. Considers complexity of project, skill and experience of artist and turnaround time when establishing payment. Buys all rights.

AUGSBURG PUBLISHING HOUSE, Box 1209, 426 S. 5th St., Minneapolis MN 55440. (612)330-3300. Contact: Photo-Editor/Design Coordinator. Publishes paperback Protestant/Lutheran books (45 titles/year), religious education materials, audiovisual resources, periodicals. Recent titles include *To Pray & To Love, Theological Ethics of the New Testament* and *A Home for the Homeless*. Also uses artists for catalog cover design; advertising circulars; advertising layout, design and illustration. Negotiates pay, b&w and color.

First Contact & Terms: "Majority, but not all, of the artists are local." Works on assignment only. Call, write, or send slides or photocopies. Reports in 5-8 weeks. Reports back on future assignment possibilities. Provide brochure, flyer, tearsheet, good photocopies and 35mm transparencies; if artist is not willing to have samples retained, they are returned by SASE. Buys all rights on a work-for-hire basis. May require designers to supply overlays on color work.

Book Design: Assigns 45 jobs/year. Uses designers occasionally for inside illustration, text design. Pays by the project, $250-400.

Jackets/Covers: Uses designers primarily for cover design. Pays by the project, $600-900.

Text Illustration: Negotiates pay for 1-, 2-, and 4-color. Generally pays by the project, $25-400.

Tips: The most common mistake illustrators and designers make in presenting their work is "lack of knowledge of company product and the somewhat conservative contemporary Christian market."

AVON BOOKS, 105 Madison Ave., New York NY 10016. (212)481-5665. FAX: (212)532-2172. Contact: Art dept. receptionist for information. Estab. 1941. Book publisher. Publishes trade paperback originals and reprints, and mass market paperback originals and reprints. Publishes contemporary, mainstream, historical and science fiction; fantasy, mystery, juvenile, young adult and self-help. Specializes in historical romance, mystery, trade fiction. Publishes 400 titles/year. Recent titles include *First Man in Rome, Spartina, Warrior's Woman*. 80% require freelance illustration; 10% required freelance design. Book catalog not available.

Needs: Approached by 300 freelance artists/year. Works with 35 freelance illustrators and 5 freelance designers/year. Uses freelance artists mainly for cover illustration and design. Works on assignment only.

First Contact & Terms: Send query letter with SASE and tearsheets. Samples are returned by SASE if requested by artist. Reports back to the artist only if interested. To show a portfolio, mail appropriate materials. Buys one-time or reprint rights. Originals are returned at job's completion.

Book Design: Pays by the project, $500-700.

Jackets/Covers: Pays by the project, $700.

Tips: "A freelance illustrator or designer should have a portfolio or samples showing consistent work of professional quality. We do not schedule any appointments for portfolio review but we have a weekly drop-off policy."

BAEN BOOKS, Box 1403, Riverdale NY 10471. (212)548-3100. Publisher: Jim Baen. Editor: Toni Weisskopf. Estab. 1983. Publishes science fiction and fantasy. Publishes 84-96 titles/year. 75% require freelance illustration; 80% require freelance design. Recent titles include *Generation Warriors* and *Fallen Angels*. Book catalog free for request.

First Contact & Terms: Approached by 1,000 freelance artists/year. Works with 10 freelance illustrators and 4 freelance designers/year. Buys 64 freelance illustrations/year. Send query letter with slides, transparencies (color only) and SASE. Samples are filed. "Happy with artists we are currently using, so not presently reviewing portfolios." Originals returned to artist at job's completion. Considers complexity of project, skill and experience of artist, project's budget, turnaround time and rights purchased when establishing payment. Buys exclusive North American book rights.

Jackets/Covers: Assigns 64 freelance design and 64 freelance illustration jobs/year. Pays by the project, $200 minimum, design; $1,000 minimum, illustration.

Tips: The best way for a freelance illustrator to get an assignment is to show a "good portfolio, high quality samples within science fiction, fantasy genre. Do not send black-and-white illustrations."

BANDANNA BOOKS, 319 Anacapa St., Santa Barbara CA 93101. Publisher: Sasha Newborn. Estab. 1981. Publishes supplementary textbooks, trade paperback originals and reprints. Publishes nonfiction and fiction. Types of books include language, classics and young adult fiction. Specializes in classics and humanism. Publishes 4 titles/year. 50% require freelance illustration. Recent titles include *Sappho, Italian for Opera Lovers, A Humanist Almanac and Datebook for 1991* and Tolstoy's *Little Gospel*.

First Contact & Terms: Approached by 10 freelance artists/year. Buys 5 freelance illustrations/year. Works with illustrators mainly for woodblock or scratchboard art. Also works with artists for cover and text illustration. Send query letter with SASE and samples. Samples are not filed and are returned by SASE only if requested. Reports back about queries/submissions within 6 weeks only if interested. Originals not returned to artist at job's completion. To show a portfolio mail thumbnails and photographs. Considers project's budget when establishing payment.

Book Design: Pays by the project, $50-200.

Jackets/Covers: Prefers b&w scratchboard, woodblock, silhouettes, miniatures. Pays by project, $50-200.

Text Illustration: Pays by the project, $50-200.

Tips: "I need pieces that work very small. Our books are unique—heavy stock paper covers with overhang and deep flaps. Signatures are sewn."

BASCOM COMMUNICATIONS CO., 399 E. 72nd St., New York NY 10021. President: Betsy Ryan. Estab. 1983. Specializes in juvenile and adult hardcover and paperback originals. Publishes 10 titles/year; 50% require freelance illustration. Recent titles include *The Doctor's Guide to Headache Relief* and *Hampstead High* (series).

First Contact & Terms: Approached by 150 freelance artists/year. Works with 3 freelance artists/year. Works on assignment only. Send query letter with brochure showing art style. Samples are filed and are not returned. Does not report back. Originals returned to artist at job's completion. Write to schedule an appointment to show a portfolio, which should include original/final art, tearsheets and final reproduction/product. Considers complexity of project, project's budget and turnaround time when establishing payment.

Book Design: Assigns 5 freelance design, 5 freelance illustration jobs/year. Pays by the hour, $15 minimum.

Jackets/Covers: Assigns 5 freelance design and 5 freelance illustration jobs/year. Pays by the project.

Text Illustration: Assigns 5 freelance jobs/year. Pays by the project.

***BEACON PRESS**, 25 Beacon St., Boston MA 02108. (617)742-2110. FAX: (617)723-3097. Design and Production Manager: Lori Foley. Estab. 1854. Book publisher. Publishes hardcover originals, and trade paperback originals and reprints. Types of books include biography, history and travel. Specializes in feminism, spirituality, contemporary affairs, African American studies, gay & lesbian concerns and the environment. Publishes 60-75 titles/year. Recent titles include *Talking About Death, Biting at the Grave, The Global Ecology Handbook.* 5% require freelance illustration; 100% require freelance design. Book catalog available.

Needs: Approached by 45-50 freelance artists/year. Works with 3-4 freelance illustrators and 20 freelance designers/year. Buys 2-3 freelance illustrations/year. Uses freelance artists mainly for book cover/jacket illustration and design. Also uses freelance artists for text illustration and book design. Works on assignment only.

First Contact & Terms: Send query letter with resume, tearsheets, photocopies and slides. Samples are filed. Reports back within 2-3 weeks. Mail appropriate materials. Portfolio should include tearsheets, transparencies and photographs. Rights purchased vary according to project. Originals are returned at job's completion.

Book Design: Assigns 40 freelance design and 2-3 freelance illustration jobs/year. Pays by the project, $600.

Jackets/Covers: Assigns 40 freelance design and 2-3 freelance illustration jobs/year. Pays by the project.

Text Illustration: Assigns 1-2 freelance illustration jobs/year. Pays by the project. Prefers line art.

Tips: "Must have book industry experience."

***BEDFORD BOOKS OF ST. MARTIN'S PRESS**, 29 Winchester St., Boston MA 02116. (617)426-7440. FAX: (617)426-8582. Advertising and Promo Manager: George Scribner. Estab. 1981. Book publisher. Imprint of St. Martin's Press. Publishes college textbooks. Specializes in English and history. Publishes 12 titles/year. Recent titles include *The Bedford Handbook for Writers, Third Edition; The Winchester Reader;* and *The Bedford Reader, Fourth Edition.* 40% require freelance illustration. 100% require freelance design.

Needs: Approached by 25 freelance artists/year. Works with 4-6 freelance illustrators and 6-10 freelance designers/year. Buys 4-6 freelance illustrations/year. Prefers artists with experience in book publishing. Uses freelance artists for jacket/cover illustration and design, and direct mail and catalog design.

First Contact & Terms: Send query letter with brochure, tearsheets, photostats. Samples are filed or are returned by SASE if requested by artist. Reports back only if interested. Write to schedule an appointment to show a portfolio. Portfolio should include roughs, original/final art, color photostats and tearsheets. Rights purchased vary according to project. Originals returned at job's completion.

Jackets/Covers: Assigns 12 freelance design jobs and 4-6 freelance illustration jobs/year. Pays by the project, $500-1,500.

Tips: "Regarding book cover illustrations, we're usually interested in buying reprint rights for existing works that represent contemporary, multicultural and multiracial scenes. We're looking for local freelancers who have strong portfolios of work done for the publishing industry."

BEHRMAN HOUSE, INC., 235 Watchung Ave., West Orange NJ 07052. (201)669-0447. FAX: (201)669-9769. Projects Editor: Adam Siegel. Estab. 1921. Book publisher. Publishes textbooks. Types of books include preschool, juvenile, young adult, history (all of Jewish subject matter) and Jewish texts and textbooks. Specializes in Jewish books for children and adults. Publishes 7 titles/year. Recent titles include *A Child's Bible, My Jewish World* and *How Do I Decide?* 70% require freelance illustration; 80% require freelance design. Book catalog free by request.

Needs: Approached by 10 freelance artists/year. Works with 4 freelance illustrators and 6 freelance designers/year. Buys 5 freelance illustrations/year. Prefers artists with experience in illustrating for children; "helpful if Jewish background." Uses freelance artists mainly for children's textbooks. Also uses freelance artists for jacket/cover illustration and design, book design and text illustration. Works on assignment only.

First Contact & Terms: Send query letter with brochure, resume, photocopies and photostats. Samples are filed. Reports in 1 month. To show a portfolio, call or mail b&w photostats and original/final art. Rights purchased vary according to project. Originals are returned at the job's completion.

Book Design: Assigns 5 freelance design, 3 freelance illustration jobs/year. Pays by project, $800-1,500.

Jackets/Covers: Assigns 6 freelance design and 4 freelance illustration jobs/year. Pays by the project.

Text Illustration: Assigns 6 freelance design and 4 freelance illustration jobs/year. Pays by the project.

Tips: "Send us a sample of work, and if style and quality of work is appropriate for one of our projects, we will contact artist."

THE BENJAMIN/CUMMINGS PUBLISHING CO., 390 Bridge Pkwy., Redwood City CA 94065. (415)594-4400. Art/Design Manager: Michele Carter. Specializes in college textbooks in biology, chemistry, computer science, mathematics, nursing and allied health. Publishes 40 titles/year; 90% require freelance design and illustration.

First Contact & Terms: Approached by 100 freelance artists/year. Works with 25-75 freelance artists/year. Specializes in 1, 2, and 4-color illustrations-technical, biological and medical. "Heavily illustrated books tying art and text together in market-appropriate and innovative approaches. Our biologic texts require trained bio/med illustrators. Proximity to Bay Area is a plus, but not essential." Works on assignment only. Original artwork not returned to artist at job's completion. Send query letter with resume and samples. Samples returned only if requested. Pays by piece, $20-150 average.

Book Design: Assigns 30 jobs/year. "From manuscript, designer prepares specs and layouts for review. After approval, final specs and layouts are required. On our books, which are dummied, very often the designer is contracted as dummier at a separate per page fee." Pays $3-6.50/page, dummy.

Jackets/Covers: Assigns 40 jobs/year. Pays by the job, $500-2,000.

ROBERT BENTLEY PUBLISHERS, 1000 Massachusetts Ave., Cambridge MA 02138. (617)547-4170. Publisher: Michael Bentley. Book publisher. Publishes hardcover originals and reprints and trade paperback originals. Publishes reference books. Specializes in automotive technology and automotive how-to. Publishes 15-20 titles/year. Recent titles include *Bosch Fuel Injection and Engine Management Including High Performance Tuning.* 50% require freelance illustration; 80% require freelance design. Book catalog for SASE with 75¢ postage.

Needs: Works with 3-5 freelance illustrators and 10-15 freelance designers/year. Buys 1,000+ freelance illustrations/year. Prefers artists with "technical illustration background, although a down-to-earth/user-friendly style is welcome." Also uses freelance artists for jacket/cover illustration and design, text illustration, book design, direct mail and catalog design. Works on assignment only.

First Contact & Terms: Send query letter with resume, SASE, tearsheets and photocopies. Samples are filed. Reports in 3-5 weeks. To show a portfolio, mail thumbnails, roughs and b&w tearsheets and photographs. Buys all rights. Originals are not returned at the job's completion.

Book Design: Assigns 10-15 freelance design and 20-25 freelance illustration projects/year. Pays by the project.

Jackets/Covers: Pays by the project. Media and style preferred depends on marketing requirements.

Text Illustration: Prefers ink on mylar or adobe postscript files.

Tips: "Send us photocopies of your line artwork and resume."

BETTERWAY PUBLICATIONS, INC., Box 219, Crozet VA 22932. (804)823-5661. President and Production Manager: Jackie Hostage. Estab. 1980. Publishes hardcover and trade paperback originals. Publishes nonfiction, instruction, reference, self-help and genealogy. Specializes in home building and remodeling, small business and finance. Publishes 36-40 titles/year. Recent titles include *The Scuba Diving Handbook, Guide to Recycling, Guide to Barrier-Free Housing* and *Cadets at War*. 40% require freelance illustration; 100% freelance design. Book catalog free by request.

First Contact & Terms: Works with 5-6 freelance illustrators and 4-5 freelance designers/year. Buys 80-100 freelance illustrations/year. Works with illustrators mainly for interior line art. Also works with artists for jacket/cover illustration and design, book and catalog design. Works on assignment only. Send query letter with resume, photocopies, SASE and photographs. Samples are filed or are returned by SASE. Reports back only if interested. Originals returned to artist at job's completion. To show a portfolio, mail final reproduction/product. Considers complexity of project, skill and experience of artist and turnaround time when establishing payment. Buys all rights.

Book Design: Assigns 30-35 freelance design and 12-15 freelance illustration jobs/year. Pays by the project, $500-2,000.

Jackets/Covers: Assigns 20-24 freelance design and 10-12 freelance illustration jobs/year. Prefers contemporary, high-tech themes, "computer generated for some titles." Pays by the hour, $12-40; by the project, $350-2,000.

Text Illustration: Assigns 25-30 freelance jobs/year. Prefers line art. Pays by the hour, $12-40; by the project, $50-2,000.

Tips: "Send good samples appropriate to our current needs. Show reliability of turnaround time and willingness to work on a royalty basis for larger projects. Our books have a contemporary but not 'artsy' look. We would like to see more clean basic line art; computer generated line art, maps, graphs, etc."

BLUE BIRD PUBLISHING, Suite 306, 1713 E. Broadway, Tempe AZ 85282. (602)968-4088. Owner/Publisher: Cheryl Gorder. Estab. 1985. Book publisher. Publishes trade paperback originals. Types of books include young adult, reference and general adult nonfiction. Specializes in parenting and home education. Publishes 6 titles/year. Recent title includes: *Green Earth Resource Guide*. 50% require freelance illustration; 25% require freelance design. Book catalog free for SASE with 1 first-class stamp.

Needs: Approached by 12 freelance artists/year. Works with 3 freelance illustrators and 1 freelance designer/year. Buys 20-35 freelance illustrations/year. Uses freelance artists mainly for illustration. Also uses freelance artists for jacket/cover illustration and design, text illustration and catalog design. Works on assignment only.

First Contact & Terms: Send query letter with brochure and photocopies. Samples are filed. Reports in 6 weeks. To show a portfolio, mail b&w samples and color tearsheets. Rights purchased vary according to project. Originals are not returned at the job's completion.

Book Design: Assigns 3 freelance illustration jobs/year. Pays by project, $20-250.

Jackets/Covers: Assigns 1 freelance design and 1 freelance illustration job/year. Pays by the project, $50-200. Prefers "a modern and geometric style and black-and-white, but will consider alternatives."

Text Illustration: Assigns 3 freelance illustration jobs/year. Pays by the project, $20-250. Prefers line art.

BLUE DOLPHIN PUBLISHING, INC., 13386 N. Bloomfield Rd., Nevada City CA 95959. (916)265-6923. FAX: (916)265-0787. President: Paul M. Clemens. Estab. 1985. Publishes hardcover and trade paperback originals. Publishes biography, cookbooks, humor and self-help. Specializes in comparative spiritual traditions, lay psychology and health. Publishes 8 titles/year. Recent titles include *Turning to the Source—An Eastern View of Western Mind* and *Tastes of Tuscany*. Books are "high quality on good paper, with laminated dust jacket and color covers." 10% require freelance illustration; 10% require freelance design. Book catalog $1 with first-class stamp.

First Contact & Terms: Works with 2-4 freelance illustrators and designers/year. Works with illustrators mainly for book covers. Also works with freelance artists for jacket/cover design and text illustration. Works on assignment only. Send query letter with tearsheets. Samples are filed or are returned by SASE only if requested. Reports back about queries/submissions within 4-8 weeks. Originals returned to artist at job's completion. To show a portfolio, mail original/final art and final reproduction/product. Considers project's budget when establishing payment. Negotiates rights purchased.

Book Design: Assigns 1-2 freelance design and 1-2 freelance illustration jobs/year. Pays by the hour, $6-12; by the project, $100-500.

Jackets/Covers: Assigns 1-2 freelance design and 1-2 freelance illustration jobs/year. Pays by the hour, $6-12; by the project, $100-500.

Tips: "Send query letter with brief sample of style of work. We usually use local people."

BOOK DESIGN, Box 193, Moose WY 83012. Art Director: Robin Graham. Specializes in hardcover and paperback originals of nonfiction, natural history. Publishes over 3 titles/year.
First Contact & Terms: Works with 16 freelance artists/year. Works on assignment only. Send query letter with "examples of past work and one piece of original artwork which can be returned." Samples not filed are returned by SASE if requested. Reports back within 20 days. Originals not returned to artist at job's completion. Write to schedule an appointment to show a portfolio. Considers complexity of project, skill and experience of artist, project's budget and turnaround time when establishing payment. Negotiates rights purchased.
Book Design: Assigns 6 freelance design jobs/year. Pays by the project, $50-3,500.
Jackets/Covers: Assigns 2 freelance design and 4 freelance illustration jobs/year. Pays by the project, $50-3,500.
Text Illustration: Assigns 26 freelance jobs/year. Prefers technical pen illustration, maps (using airbrush, overlays etc.), watercolor illustration for children's books, calligraphy and lettering for titles and headings. Pays by the hour, $5-20; by the project, $50-3,500.
Tips: "We are looking for top-notch quality only."

***DON BOSCO MULTIMEDIA**, Box T, 475 North Ave., New Rochelle NY 10802. (914)576-0122. Contact: Production Manager. Specializes in religious hardcover and paperback originals, filmstrips and videotapes. Publishes 20 titles/year; 20% require freelance illustration.
First Contact & Terms: Works with 5 freelance artists/year. Works on assignment only. Send query letter with brochure showing art style. Samples are filed. Reports back within 3 weeks. Call to schedule an appointment to show a portfolio, which should include thumbnails, roughs, original/final art, tearsheets and slides. Considers complexity of project, skill and experience of artist and project's budget. Buys one-time rights.
Jackets/Covers: Assigns 8 freelance design jobs/year. Prefers religious, realistic style. Pays by the project.

THOMAS BOUREGY & CO., INC. (AVALON BOOKS), 401 Lafayette St., New York NY 10003. (212)598-0222. Vice President/Publisher: Barbara J. Brett. Estab. 1950. Book publisher. Publishes hardcover originals. Types of books include adventure, romance and Westerns. Publishes 60 titles/year. Recent titles include *Heart Games*, *Yesterday's Dreams* and *Ghost-Town Gold*. 100% require freelance illustration and design. Book catalog not available. Works with 6 freelance illustrators and 1 freelance designer/year. Buys 60 freelance illustrations/year. Prefers local artists and artists with experience in dust jackets. Uses freelance artists for dust jackets only. Works on assignment only.
First Contact & Terms: Send samples. Samples are filed "if they fit our needs." Samples not filed are returned by SASE if requested. Reports back if interested. Mail appropriate materials. Buys all rights. Originals are not returned at job's completion.
Jackets/Covers: Assigns 60 freelance illustration jobs/year. Pays by the project, $250. Prefers oil or acrylic.

BOWLING GREEN UNIVERSITY POPULAR PRESS, Bowling Green University, Bowling Green OH 43403. (419)372-2981. Managing Editor: Pat Browne. Publishes hardcover and paperback originals on popular culture, folklore, women's studies, science fiction criticism, detective fiction criticism, music and drama. Publishes 15-20 titles and 8 journals/year.
First Contact & Terms: Send previously published work and SASE. Reports in 2 weeks. Buys all rights. Free catalog.
Jackets/Covers: Assigns 20 jobs/year. Pays $50 minimum, color washes, opaque watercolors, gray opaques, b&w line drawings and washes.

BRIARCLIFF PRESS, 11 Wimbledon Court, Jericho NY 11753. (516)681-1505. Editorial/Art Director: Trudy Settel. Estab. 1981. Publishes hardcover and paperback cookbook, decorating, baby care, gardening, sewing, crafts and driving originals and reprints. Publishes 18 titles/year; 50% require freelance design and illustration. Uses artists for color separations, lettering and mechanicals. Assigns 25 jobs/year; pays $5-10/hour. Also assigns 5 advertising jobs/year for catalogs and direct mail brochures; pays $5-10/hour.
First Contact & Terms: Works with 3-5 freelance illustrators and 5-7 freelance designers/year. Send query letter and SASE; no samples until requested. Artists should have worked on a professional basis with other firms of this type. Reports in 3 weeks. Buys all rights. No advance. Pays promised fee for unused assigned work.
Book Design: Assigns 25/year. Pays $6 minimum/hour, layout and type spec.
Jackets/Covers: Buys 24/year. Pays $100-300, b&w; $250-500, color.
Text Illustration: Uses artists for text illustrations and cartoons. Buys 250/year. Pays $10-30, b&w; $25-50, color.
Tips: "Do not send originals,"

BROADMAN PRESS, 127 9th Ave. N., Nashville TN 37234. (615)251-2630. Art Director: Jack Jewell. Estab. 1891. Religious publishing house. 20% of titles require freelance illustration. Recent titles include *The Journey to Amanah*; *Clothed in White* and *The Christian Adventure*. Books have contemporary look. Book catalog free on request.

First Contact & Terms: Works with 15 freelance illustrators and 10 freelance designers/year. Artist must be experienced, professional. Works on assignment only. Send query letter with brochure and samples to be kept on file. Call or write for appointment to show portfolio. Send slides, tearsheets, photostats or photocopies; "samples *cannot* be returned." Reports only if interested. Pays for illustration by the project, $250-1,500. Negotiates rights purchased.
Book Design: Pays by the project, $750-15,000.
Jackets/Covers: Pays by the project, $500-1,500
Text Illustration: Pays by the project, $150-250.
Tips: "We actively search for 'realist' illustrators who can work in a style that looks contemporary." Looks for "the ability to illustrate scenes with multiple figures, to accurately illustrate people of all ages, including young children and babies, and to illustrate detailed scenes described in text. Common mistakes freelancers make is that work is not high enough in quality, or art is obviously copied from clipped photos of celebrities."

***BROOKE-HOUSE PUBLISHING COMPANY,** a division of A.B. Cowles, Inc., Suite 407, 390 5th Ave., New York NY 10018. (212)971-0410. FAX: (212)967-8249. Publisher: Stephen Konopka. Estab. 1986. Independent book producer/packager. Publishes hardcover originals and board books. Types of books include pre-school and juvenile. Specializes in juvenile fiction, board books and "gimmick books for preschoolers." Publishes 20 titles/year. Recent titles include Whiskerville Series and Scholastic Halloween Books. 75% require freelance illustration; 50% require freelance design.
Needs: Approached by 15-20 freelance artists/year. Works with 12 freelance illustrators and 6 freelance designers/year. Buys 240 freelance illustrations/year. Prefers artists with experience in all fields of juvenile interest. Uses freelance artists for text illustration. Works on assignment only.
First Contact & Terms: Send query letter with brochure, tearsheets, photocopies and photostats. Samples are filed. Reports back to the artist only if interested. Call to schedule an appointment to show a portfolio, which should include color tearsheets. Buys all rights. Originals are returned at job's completion.
Book Design: Assigns 20 freelance design and 12 freelance illustration jobs/year. Pays by the project.
Text Illustration: Assigns 20 freelance design and 12 freelance illustration jobs/year. Pays by the project.
Tips: "Show samples of art styles which are conventional and up-market. Board-book art should be gentle, clean, cute and cuddly."

BROOKS/COLE PUBLISHING COMPANY, 511 Forest Lodge Rd., Pacific Grove CA 93950. (408)373-0728. Art Director: Vernon T. Boes. Art Coordinator: Lisa Torri. Estab. 1967. Specializes in hardcover and paperback college textbooks on mathematics, psychology, chemistry, political science, computers, statistics and counseling. Publishes 100 titles/year. 85% require freelance illustration.
First Contact & Terms: Works with 24 freelance illustrators and 25 freelance designers/year. Works with illustrators for technical line art and covers. Works with designers for cover and book design and text illustration. Works on assignment only. Send query letter with brochure, resume, tearsheets, photostats, photographs and SASE. Samples are filed or are returned by SASE. Reports back only if interested. Write to schedule an appointment to show a portfolio, which should include roughs, photostats, tearsheets, final reproduction/product, photographs, slides and transparencies. Considers complexity of project, skill and experience of artist, project's budget and turnaround time. Negotiates rights purchased.
Book Design: Assigns 20 freelance design and many freelance illustration jobs/year. Pays by the project, $250-1,000.
Jackets/Covers: Assigns 20 freelance design and many freelance illustration jobs/year. Pays by the project, $250-900.
Text Illustration: Assigns 85 freelance jobs/year. Prefers ink/Macintosh. Pays by the project, $20-2,000.
Tips: "Provide excellent package in mailing of samples and cost estimates. Follow up with phone call. Don't be pushy. Would like to see more abstract photography/illustration; single strong, bold images. Research our needs and products. The recession has not affected us, though a lot more freelancers are calling us."

WILLIAM C. BROWN PUBLISHERS, 2460 Kerper Blvd., Dubuque IA 52001. (319)588-1451. Vice President and Director, Production and Design: Beverly A. Kolz. Visual/Design Manager: Faye M. Schilling. Estab. 1944. Publishes hardbound and paperback college textbooks. Publishes 200 titles/year; 10% require freelance

The asterisk before a listing indicates that the listing is new in this edition. New markets are often the most receptive to freelance submissions.

An Introduction to
Human Services

Marianne Woodside
Tricia McClam

© Stephanie Workman 1990

When Vernon T. Boes, art director of Brooks/Cole Publishing Co., was considering whom the illustrator should be for a college textbook on human services, she wanted someone who would be able to represent "helping hands, reaching out and caring—in bright, upbeat colors." She gave the assignment to fellow Pacific Grove, California resident Stephanie Workman, whose "contemporary flair, fine craftsmanship and originality" she finds very appealing. Workman was paid $535 for the cover, and the response, Boes says, has been "excellent."

design; 50% require freelance illustration. Also uses artists for advertising. Pays $35-350, b&w and color promotional artwork.

First Contact & Terms: Works with 15-20 freelance illustrators and 5-10 freelance designers/year. Works with artists mainly for illustrations. Works on assignment only. Send query letter with resume, brochure, tearsheets or 8½×11 photocopies or finished 11×14 or smaller (transparencies if larger) art samples or call for interview. Reports back in 1 month. Samples returned by SASE if requested. Reports back on future assignment possibilities. Buys all rights. Pays half contract for unused assigned work.

Book Design: Assigns 50-70 freelance design jobs/year; assigns 75-100 freelance illustration jobs/year. Uses artists for all phases of process. Pays by the project, $400 minimum; varies widely according to complexity. Pays by the hour, mechanicals.

Jackets/Covers: Assigns 70-80 freelance design jobs and 20-30 freelance illustration jobs/year. Pays $100-350 average and negotiates pay for special projects.

Text Illustrations: Assigns 75-100 freelance jobs/year. Considers b&w and color work. Prefers mostly continuous tone, some line drawings; ink preferred for b&w. Pays $25-300.

Tips: "In the field, there is more use of color. There is need for sophisticated color skills—the artist must be knowlegeable about the way color reproduces in the printing process. The designer and illustrator must be prepared to contribute to content as well as style. Tighter production schedules demand an awareness of overall schedules. *Must* be dependable. Prefer black-and-white and color 35 mm slides over photocopies. Send cover letter with emphasis on good portfolio samples. Do not send samples that are not a true representation of your work quality."

***CAPSTONE PRESS, INC.**, Box 669, Mankato MN 56001. (507)387-4992. FAX: (507)625-2748. Publisher: Jean Eick. Estab. 1991. Book publisher. Types of books include pre-school and juvenile. Publishes 48-80 titles/year. Recent titles include *Ripley's Believe It or Not* and *Starshows*. 50% require freelance illustration. 100% require freelance design. Book catalog free by request. Works with 10-12 freelance illustrators and designers/year. "We are always looking for new artists as well as established artists." Uses freelance artists mainly for book illustrations. Also uses freelance artists for jacket/cover and text illustration; jacket/cover, direct mail, book and catalog design; and posters. Works on assignment only.

First Contact & Terms: Send query letter with resume and "samples we can keep in our file." Samples are filed and are not returned. To show a portfolio, mail appropriate materials. Rights purchased vary according to project.

Book Design: Pays by the project.

Jackets/Covers: Assigns 48-80 freelance design and illustration jobs/year. Pays by the project. Media used "vary with each project. We give guidelines with our requests."

Text Illustration: Assigns 48-80 freelance design and illustration jobs/year. Pays by the project.

© Wm. C. Brown Publishers 1990

This acrylic illustration was rendered by Marjorie C. Leggitt of Denver, Colorado for a college textbook published by William C. Brown Publishers. Art manager Janice M. Roerig discovered Leggitt through the Guild of Natural Science Illustrators and assigned her the piece because of her "use of color, attention to detail" and ability to "always meet or exceed expectations of quality and schedules." Roerig feels this is a successful illustration because it is "clear, concise and accurate."

ARISTIDE D. CARATZAS, PUBLISHER, Box 210, 30 Church St., New Rochelle NY 10802. (914)632-8487. Managing Editor: John Emerich. Publishes books about archaeology, art history, natural history and classics for specialists in the above fields in universities, museums, libraries and interested amateurs. Accepts previously published material. Send letter with brochure showing artwork. Samples not filed are returned by SASE. Reports only if interested. To show a portfolio, mail appropriate materials or call or write to schedule an appointment. Buys all rights or negotiates rights purchased.

CAROLINA WREN PRESS, Box 277, Carrboro NC 27510. (919)560-2738. Art Director: Martha Lange. Estab. 1973. Book publisher. Publishes trade paperback originals. Types of books include contemporary fiction, experimental fiction, pre-school and juvenile. Specializes in books for children in a multi-racial and non-sexist manner, and women's and black literature. Publishes 3 titles/year. Recent titles include *Boy Toy* and *Love, or a Reasonable Facsimile.* 50% require freelance illustration. Book catalog free by request.

Needs: Approached by 20 freelance artists/year. Works with 3 freelance illustrators/year. Buys 20 freelance illustrations/year. Prefers artists with experience in children's literature. Also uses freelance artists for jacket/cover and text illustration. Works on assignment only.

First Contact & Terms: Send query letter with resume, tearsheets, photocopies and illustrations; should include children and adults—no cartoons. Samples are filed or are returned by SASE if requested by artist. "No submissions should be made until requested for specific projects." To show a portfolio, mail b&w and color tearsheets. Rights purchased vary according to project. Originals are returned to the artist at the job's completion.

Jacket/Covers: Assigns 3 freelance illustration jobs/year. Pays by the project, $50-150.

Text Illustration: Assigns 3 freelance illustration jobs/year. Payment is 5% of print run-in books.

Tips: "Understand the world of children in the 1990s. Draw sufficiently realistically so racial types are accurately represented and the expressions can be interpreted. Our books have a classical, modern and restrained look."

CHARLESBRIDGE PUBLISHING, 85 Main St., Watertown MA 02172. Managing Editor: Elena Wright. Estab. 1980. "Our trade books are nonfiction nature/science content, so they require very detailed color realism." Recent titles include *A Home in the Rain Forest* and *The Underwater Alphabet Book.* Books are "realistic art picture books."

First Contact & Terms: Works with 4 freelance illustrators/year. Artists should have experience in educational textbooks or children's tradebooks. Works on assignment only. Send resume, tearsheets and photocopies. Samples not filed are returned by SASE. Reports back only if interested. No originals returned to artist at job's completion. Considers complexity of project and project's budget when establishing payment. Buys all rights.
Book Design: Works with 12 freelance designers/year. Pays by the project.
Jackets/Covers: Pays by the project.
Text Illustration: Assigns few jobs/year. Pays by the project.

CHATHAM PRESS, INC., Box A, Old Greenwich CT 06870. (203)531-7807. FAX: (203)622-6688. Contact: R. Salvaggio. Estab. 1971. Book publisher. Publishes hardcover originals and reprints, and trade paperback originals and reprints. Types of books include travel, cookbooks and photography. Specializes in photography, the ocean, beach, coastline and other New England topics. Publishes 6 titles/year. 25% require freelance illustration; 25% require freelance design. Book catalog free for SASE with $1.50 first-class stamps.
Needs: Approached by 40 freelance artists/year. Works with 3 freelance illustrators and 3 freelance designers/year. Uses freelance artists for jacket/cover illustration and design, book design and text illustration. Works on assignment only.
First Contact & Terms: Send query letter with resume, SASE and appropriate samples. Samples are not filed and are returned by SASE if requested by artist. Reports back to the artist only if interested. To show a portfolio, mail appropriate materials. Buys first rights, one-time rights, reprint rights or all rights. Originals are returned at the job's completion. Pays by the project, $100.
Jackets/Covers: Assigns 3 freelance design jobs, 3 freelance illustration jobs/year. Pays by project, $100.
Text Illustration: Assigns 3 freelance design and 3 freelance illustration jobs/year. Pays by project, $100.

CHICAGO REVIEW PRESS, 814 N. Franklin, Chicago IL 60610. (312)337-0747. Editor: Linda Matthews. Specializes in hardcover and paperback originals; trade nonfiction: how-to, travel, cookery, popular science, Midwest regional. Publishes 12 titles/year; 2% require freelance illustration and all require cover jacket design. Recent titles include *The Art of Construction*, *Chicago Tribune Cookbook*, *Chicago with Kids* and *Our Sisters' London, Feminist Walking Tours*.
First Contact & Terms: Approached by 50 freelance artists/year. Works with 5 freelance artists/year. Send query letter with resume and tearsheets or phone. Samples are filed or are returned by SASE. Reports back only if interested. Originals not returned to artist at job's completion "unless there are special circumstances." Call to show a portfolio, which should include tearsheets, final reproduction/product and slides. Considers project's budget when establishing payment. Buys one-time rights.
Book Design: Assigns 2 freelance design jobs/year. Pays by the project, $35-400.
Jackets/Covers: Assigns 10 freelance design and 5 freelance illustration jobs/year. Pays by project, $400.
Tips: "Design and illustration we use is sophisticated, above average, innovative and unusual."

THE CHILD'S WORLD, INC., Box 989, Elgin IL 60121. Editor: Janet McDonnell. Book publisher. Estab. 1968. Publishes nonfiction and fiction. Types of books include juvenile and childrens'. Publishes 50 titles/year; 100% require freelance illustration. Recent titles include The *Dinosaur Series*, The *Discovery World Series* and The *Play With Series*.
First Contact & Terms: Approached by 200-300 freelance artists/year. Works with 15 freelance illustrators/year. Works with illustrators mainly for text illustration of children's books and catalog covers. Also works with freelance artists for cover illustration. Works on assignment only. Send query letter with tearsheets, resume and SASE. Samples are filed or are returned by SASE only if requested. No originals returned to artist at job's completion. Considers complexity of project and skill and experience of artist when establishing payment. Buys all rights.
Text Illustration: Assigns 20-50 freelance jobs/year. Payment varies.
Tips: "Study our market and send appropriate samples (slides are not helpful). Send color samples of work for young children. New trends are leaning toward more sophisticated yet simple design for even the young child." Often sees "samples which show a style much too 'old' looking for our audience; or the subject matter is inappropriate."

***CHINA BOOKS & PERIODICALS,** 2929 24th St., San Francisco CA 94110. (415)282-2994. FAX: (415)282-0994. Art Director: Robbin Henderson. Estab. 1960. Book publisher. Publishes hardcover and trade paperback originals. Types of books include contemporary fiction, instrumental, biography, juvenile, reference, history and travel. Specializes in China-related books. Publishes 7-10 titles/year. Recent titles include *Broken Portraits: China's Unfinished Revolution*; *Chinese Artistic Kites*; and *Lóng is a Dragon: Chinese Writing for Children*. 10% require freelance illustration. 75% require freelance design. Book catalog free by request.
Needs: Approached by 50 freelance artists/year. Works with 5 freelance illustrators and 5 freelance designers/year. Buys 20 freelance illustrations/year. Prefers artists with experience in China and Chinese topics. Uses freelance artists mainly for illustration, graphs and maps.

First Contact & Terms: Send query letter with brochure, resume and SASE. Samples are filed. Reports back within 1 month. Write to schedule an appointment to show a portfolio. Portfolio should include thumbnails, b&w slides and photographs. Originals are returned at job's completion.
Book Design: Assigns 5 freelance design and 5 freelance illustration jobs/year. Pays by the hour, $15-25; by the project, $100-1,000.
Jackets/Covers: Assigns 5 freelance design and 5 freelance illustration jobs/year. Pays by the hour, $15; by the project, $100.
Text Illustration: Assigns 4 freelance design and 2 freelance illustration jobs/year. Pays by the hour, $15-30; by the project, $100-1,000. Prefers line drawings, computer graphics, photos.

CLEIS PRESS, Box 14684, San Francisco CA 94114. (415)864-3385. FAX: (415)864-3385. Production Coordinator: Frédérique Delacoste. Estab. 1980. Publishes trade paperback originals. Types of books include contmporary and experimental fiction. Publishes 6 titles/year. Recent titles include *COSMOPOLIS, Urban Fiction by Women*. 50% require freelance illustration; 100% require freelance design. Book catalog available for SASE and 2 first-class stamps. Approached by 2-3 freelance artists/year. Prefers local artists only. Uses freelance artists for jacket cover illustration and design.
First Contact & Terms: Send query letter with photographs. Samples are filed and are not returned. To show a portfolio, mail appropriate materials. Originals returned at the job's completion.
Book Design: Assigns 5 freelance design jobs/year. Pays by the project, $375 minimum.
Jackets/Covers: Assigns 8 freelance design and 8 freelance illustration jobs/year. Pays by the project, $375 minimum.

CLIFFS NOTES INC., Box 80728, Lincoln NE 68501. Contact: Michele Spence. Publishes educational and trade (Centennial Press) books. Recent titles include *Bluff Your Way in Gourmet Cooking* (Centennial Press), *Cliffs Enhanced ACT Preparation Guide* (Cliff Notes).
First Contact & Terms: Approached by 30 freelance artists/year. Uses artists for educational posters. Works on assignment only. Samples returned by SASE. Reports back on future assignment possibilities. Send brochure, flyer and/or resume. No originals returned to artist at job's completion. Buys all rights. Artist supplies overlays for color art.
Jackets/Covers: Uses artists for covers and jackets.
Text Illustration: Uses technical illustrators for mathematics, science, miscellaneous.

CONARI PRESS, 1339 61st St., Emeryville CA 94608. (415)596-4040. FAX: (415)428-2861. Please call first. Editor: Mary Jane Ryan. Estab. 1987. Book publisher. Publishes hardcover and trade paperback originals. Types of books include self-help, women's issues and general non-fiction guides. Publishes 10 titles/year. Recent titles include *True Love* and *Working with the Ones You Love*. 25% require freelance illustration. Book catalog free for SASE with 1 first-class stamp.
Needs: Approached by 50 freelance artists/year. Uses freelance artists for jacket/cover illustration and design. Works on assignment only.
First Contact & Terms: Send query letter with resume and tearsheets. Samples are filed. Reports back to the artist only if interested. To show a portfolio, mail tearsheets. Rights purchased vary according to project. Originals are returned at job's completion.
Jackets/Covers: Assigns 3-5 freelance design jobs/year. Pays by the project, $500-800.
Text Illustration: Assigns 1-3 freelance jobs/year. Pays by the project, $200-600.
Tips: "To get an assignment with me you should have dynamic designs and reasonable prices."

CONTEMPORARY BOOKS, 180 N. Michigan, Chicago IL 60601. (312)782-9181. Art Director: Georgene Sainati. Book publisher. Publishes hardcover originals and trade paperback originals. Publishes nonfiction and fiction. Types of books include biography, cookbooks, instructional, humor, reference, self-help, romance, historical and mainstream/contemporary. Publishes 140 titles/year. 5% require freelance illustration. Recent titles include *Black Tie Only* (novel), *Arnold* (biography of Arnold Schwarzenegger), and *Greatest Sports Excuses* (humor). Book catalog not available.
First Contact & Terms: Approached by 150 freelance artists/year. Works with 10 freelance illustrators/year. Buys 7-10 freelance illustrations/year. Works with illustrators mainly for covers. Also works with freelance artists for jacket/cover illustration and text illustration. Works on assignment only. Send query letter with brochure and resume. Samples are filed or are not returned. Does not report back. Originals sometimes returned to artist at job's completion when requested. To show a portfolio, mail tearsheets and final reproduction/product. Considers complexity of project, skill and experience of artist and project's budget when establishing payment. Buys reprint rights.
Jackets/Covers: Assigns 7 freelance illustration jobs/year. Pays by the project, $600-1,200.
Text Illustration: Assigns 3 freelance jobs/year. Prefers stipple or line and wash. Pays by the hour, $15-25.
Tips: "Several samples of the same technique aren't really necessary unless they treat vastly different subjects. Plese send samples first, then follow up with a call."

COUNCIL FOR INDIAN EDUCATION, 517 Rimrock Rd., Billings MT 59102. (406)252-7451. Editor: Hap Gilliland. Estab. 1970. Book publisher. Publishes trade paperback originals. Types of books include contemporary fiction, historical fiction, instruction, adventure, biography, pre-school, juvenile, young adult and history. Specializes in Native American life and culture. Recent titles include *Sacajawea: a Native American Heroine* and *Vision of the Spokane Prophet*. 80% require freelance illustration. Book catalog free for SASE with 1 first class stamp.

Needs: Approached by 5 freelance artists/year. Works with 1-3 freelance illustrators/year. Buys 40-100 freelance illustrations/year. Uses freelance artists mainly for illustrating children's books. Works on assignment only.

First Contact & Terms: Send query letter with SASE and photocopies. Samples are filed. Reports back within 2 months. To show a portfolio, mail b&w photostats. Buys one-time rights. Originals are returned at the job's completion.

Book Design: Assigns 4 freelance illustration jobs/year. "We are a small nonprofit organization publishing on a very small budget to aid Indian education. Contact us only if you are interested in illustration for $5 per picture."

Text Illustration: Assigns 4 freelance illustration jobs/year. Prefers realistic pen & ink.

Tips: Look of design used is "realistic/Native American style."

***THE COUNTRYMAN PRESS, INC.**, Box 175, Woodstock VT 05091. (802)457-1049. Production Manager: Clare Innes. Estab. 1976. Book publisher. Publishes hardcover originals and reprints, and trade paperback originals and reprints. Types of books include contemporary and mainstream fiction, mystery, biography, history, travel, humor, cookbooks and recreational guides. Specializes in mysteries, recreational (biking/hiking) guides. Publishes 35 titles/year. Recent titles include *Dream of Darkness, New Hampshire: An Explorer's Guide*; *Fifty Hikes in Connecticut*, and *Twenty-five Mountain Bike Tours in Massachusetts*. 10% require freelance illustration. 100% require freelance cover design. Book catalog free by request.

Needs: Works with 4 freelance illustrators and 7 freelance designers/year. Buys 15 freelance illustrations/year. Uses freelance artists for jacket/cover and book design. Works on assignment only. Prefers working with artists/designers within the New England/New York area.

First Contact & Terms: Send query letter with appropriate samples. Samples are filed. Reports back to the artist only if interested. Mail appropriate materials: best representations of style and subjects. Negotiates rights purchased. Originals are returned at job's completion.

Jackets/Covers: Assigns 20 freelance design jobs/year.

COWLEY PUBLICATIONS, 28 Temple Place, Boston MA 02111. (617)423-2427. Marketing Director: Jeff McArn. Book publisher. Estab. 1980. Publishes trade paperback originals; nonfiction. Types of books include religion. Specializes in contemporary theology, spirituality and books of interest to clergy.

First Contact & Terms: Works with 2 freelance designers/year for jacket/cover design. Works on assignment only. Send query letter with resume and samples. Samples are filed or are returned by SASE only if requested. Reports back about queries/submissions within 1 month. Originals not returned to artist at job's completion. To show a portfolio, mail final reproduction/product. Considers project's budget when establishing payment.

Jackets/Covers: Assigns 2 freelance design jobs/year. Pays by the project, $200-400.

CPI GROUP, 311 E. 51st St., New York NY 10022. (212)753-3800. President: Sherry Olan. Publishes hardcover originals, workbooks and textbooks for ages 4-14. Publishes 40 titles/year; 100% require freelance illustration. Recent titles include *Wonders of Science*.

First Contact & Terms: Approached by 500 freelance artists/year. Uses artists for instructional software, workbooks, textbooks and scientific illustration. Works on assignment only. Send query letter with flyer, tearsheets, photocopies and SASE. Reports back only for future assignment possibilities. Originals are not returned to artist at job's completion. Buys all rights. Free artist's guidelines.

Text Illustration: Assigns 100 freelance jobs/year. "Submit samples of b&w line and color action subjects. In general, realistic and representational art is required." Pays by the project, $35-200, opaque watercolor or any strong color medium except fluorescents.

Tips: "Don't send fine-artsy work, and send a good sampling of work. Most important is b&w work."

CROSSROAD/CONTINUUM, 370 Lexington Ave., New York NY 10017. (212)532-3650. Production Manager: Matt Laughlin. Book publisher. Estab. 1980. Publishes hardcover originals, trade paperback originals, hardcover reprints and trade paperback reprints. Publishes nonfiction. Types of books include biography, reference and religious. Specializes in religion/literary. Publishes 100 titles/year. 5% require freelance illustration; 75% require freelance design. Recent titles include *Beyond the Mirror*, by Nouwan; *Continuum Counseling Series* and *Sex, Race and God*, by Thistlethwaite.

First Contact & Terms: Approached by 20 freelance artists/year. Works with 1 freelance illustrator and 25 freelance designers/year. Buys 5 freelance illustrations/year. Works with illustrators mailny for occasional cover or inside needs. Also works with artist for book design and jacket/cover design. Works on assignment only. Send query letter with brochure, resume and tearsheets. Samples are filed or are returned by SASE

only if requested. Reports back about queries/submissions only if interested. Originals returned to artist at job's completion. Write to schedule an appointment to show a portfolio, which should include original art, tearsheets and final reproduction/product. Considers complexity of project and project's budget when establishing payment. Buys all rights.

Book Design: Assigns 15 freelance design, 1-2 freelance illustration jobs/year. Pays by project, $250-300.

Jackets/Covers: Assigns 80 freelance design jobs/year. Prefers all types of styles with minimal photo research involved. Pays by the project, $400-600.

Text Illustration: Assigns 1-2 freelance jobs/year. Pays by the project; rate varies.

Tips: "Send information that can be kept on hand and follow up with a phone call shortly afterwards. I look at portolios and if an acceptable price is reached and they are in the area, I will give aritsts a chance."

CROSSWAY BOOKS, A Division of Good News Publishers, 1300 Crescent St., Wheaton IL 60187. Contact: Arthur Guye. Nonprofit Christian book publisher. Publishes hardcover and trade paperback originals and reprints. Type of books include fiction (contemporary, mainstream, historical, science fiction, fantasy, adventure, mystery), biography, juvenile, young adult, reference, history, self-help, humor, and books on issues relevant to contemporary Christians. Specializes in Christian fiction. Publishes 30-35 titles/year. 65% require freelance illustration; 35% require freelance design. Recent titles include *Piercing the Darkness, Heart of Stone, In the Midst of Wolves* and *The Francis A. Schaeffer Trilogy.* Book catalog free for (9 × 12) SASE with adequate postage.

First Contact & Terms: Approached by 150-200 freelance artists/year. Works with 15 freelance illustrators and 10 freelance designers/year. Assigns 20 freelance illustration and 30 freelance design projects per year. Uses artists mainly for book cover illustration/design. Also uses artists for advertising, brochure design, related promotional materials, layout, and production. Send query letter with 5-10 nonreturnable samples or quality color photocopies of printed or original art for files. "Please do not send materials that need to be returned." Samples not filed are returned by SASE. Reports back only if interested. Buys "all book and promotional rights." Returns originals to artist. Considers complexity of project, proficiency of artist and projects budget when establishing payment.

Jackets/Covers: Assigns 26 freelance illustration and 14 freelance design jobs/year. Prefers realistic and semi-realistic color illustration in all media. Looks for ability to consistently render the same children or people in various poses and situations (as in series books). Pays by the project, $200-2,000.

Tips: "We are looking for Christian artists who are committed to spreading the Gospel through quality literature. Since we are a nonprofit organization, we may not always be able to afford an artist's 'going rate.' Quality and the ability to meet deadlines are critical. A plus would be a designer who could handle all aspects of a job from illustration to final keyline/mechanical. If an artist is interested in production work (type spec and keylining) please include your hourly rate and a list of references. Also looking for designers who can do imaginative typographic design treatments and exciting calligraphic approaches for covers."

CROWN PUBLISHERS, INC., 201 E. 50th St., New York NY 10022. Design Director: Ken Sansone. Art Director: Jim Davis. Specializes in fiction, nonfiction and illustrated nonfiction. Publishes 250 titles/year. Recent titles include *An Inconvenient Woman,* by Dominick Dunne; *The Plains of Passage,* by Jean M. Auel and *London Fields,* by Martin Amis.

First Contact & Terms: Approached by several hundred freelance artists/year. Works with 50 artists/year. Prefers local artists. Works on assignment only. Send query letter with brochure showing art style. Reports only if interested. Original work returned at job's completion. Considers complexity of project, skill and experience of artist, project's budget, turnaround time and rights purchased when establishing payment. Rights purchased vary according to project.

Book Design: Assigns 20-30 freelance design and very few freelance illustration jobs/year. Pays by the project.

Jackets/Covers: Assigns 100 freelance design and/or illustration jobs/year. Pays by the project.

Text Illustration: Assigns very few jobs/year.

Tips: "No single style, we use different styles depending on nature of the book and its perceived market. Become familiar with the types of books we publish. For example, don't send juvenile or sci-fi."

CUSTOM COMIC SERVICES, Box 726, Glenside PA 19038. Art Director: Scott Deschaine. Estab. 1985. Specializes in educational comic books for promotion and advertising for use by business, education, and government. "Our main product is full-color comic books, 16-32 pages long." Prefers pen & ink, airbrush and watercolor. Publishes 12 titles/year. Recent titles include *McGruff's Surprise Party, The Guiding Hand* and *Let's Talk About It.*

First Contact & Terms: Approached by 150 freelance artists/year. Works with 24 freelance artists/year. "We are looking for artists who can produce finished artwork for educational comic books from layouts provided by the publisher. They should be able to produce consistently high-quality illustrations for mutually agreeable deadlines, with no exceptions." Works on assignment only. Send query letter with business card and nonreturnable samples to be kept on file. Samples should be of finished comic book pages; prefers photostats.

Reports within 6 weeks; must include SASE for reply. Considers complexity of project and skill and experience of artist when establishing payment. Buys all rights.

Text Illustration: Assigns 18 freelance jobs/year. "Finished artwork will be black-and-white, clean, and uncluttered. Artists can have styles ranging from the highly cartoony to the highly realistic." Pays $100-250/comic book page of art.

Tips: A common mistake freelance artists make is "not sending appropriate material—comic book artwork."

DAW BOOKS, INC., 3rd Floor, 375 Hudson St., New York NY 10014-3658. (212)366-2096. Art Director: Betsy Wollheim. Estab. 1971. Publishes hardcover originals and reprints and mass market paperback originals and reprints. Publishes science fiction, fantasy and horror. Publishes 72 titles/year. 50% require freelance illustration. Recent titles include *Sword Breaker*, by Jennifer Roberson and *Stronghold*, by Melanie Rawn. Book catalog free by request.

First Contact & Terms: Works with 12 freelance illustrators and 1 freelance designer/year. Buys over 36 freelance illustrations/year. Works with illustrators for covers. Works on assignment basis only. Send query letter with brochure, resume, tearsheets, slides, transparencies and SASE. Samples are filed or are returned by SASE only if requested. Reports back about queries/submissions within 2-3 days. Originals returned to artist at job's completion. Call to schedule an appointment to show a portfolio which should include original/final art, final reproduction/product and transparencies. Considers complexity of project, skill and experience of artist and project's budget when establishing payment. Buys first rights and reprint rights.

Jacket Covers: Pays by the project, $1,500-8,000. "Our covers illustrate the story."

Tips: We have a drop-off policy for portfolios. We accept them on Tuesdays, Wednesdays and Thursdays and report back within a day or so. Portfolios should contain science fiction, fantasy, and horror color illustrations *only*. We do not want to see anything else."

DELMAR PUBLISHERS INC., Box 15-015, 2 Computer Dr. W., Albany NY 12212. (518)459-1150. Contact: Art Manager. Estab. 1946. Specializes in original hardcovers and paperback textbooks—science, computer, health, mathematics, professions and trades. Publishes 100 titles/year. Recent titles include *Engineering, Drawing and Design* and *Early Childhood Education*.

First Contact & Terms: Approached by 200 freelance artists/year. Works with 40 freelance artists/year. Prefers text illustrators and designers, paste-up artists, technical/medical illustrators and computer graphic/AUTOCAD artists. Works on assignment only. Send query letter with brochure, resume, tearsheets, photostats, photocopies, slides or photographs. Samples not indicated to be returned will be filed for one year. Any material needed back must return via certified mail. Not responsible for loss of unsolicited material. Reports back only if interested. Original work not returned after job's completion. Considers complexity of project, project's budget and turnaround time when establishing payment. Buys all rights.

Book Design: Assigns 15 freelance design jobs/year. Pays by the project, $100-600.

Jacket/Covers: Assigns 60 freelance design jobs/year. Pays by the project, $250-500.

Text Illustration: Assigns up to 15 freelance jobs/year. Prefers ink on mylar or vellum—simplified styles. Two-color application is most common form. Four-color art is needed less frequently but still a requirement. Charts, graphs, technical illustration and general pictorials are common. Pays by the project.

Tips: "Quote prices for samples shown. Quality and meeting deadlines most important. Experience with publishing a benefit." Look of design and illusration used is "basic, clean, conservative, straightforward textbook technical art."

***PAUL M. DEUTSCH PRESS, INC.**, 2211 Hillcrest St., Orlando FL 32803. (407)895-3600. FAX: (407)895-3610. Production Editor: Ann Groom. Managing Editor: Myrene O'Connor. Book publisher. Publishes hardcover and trade paperback originals and textbooks. Types of books include instructional, reference, legal and medical. Specializes in rehabilitation, psychology, life care planning, head injury. Publishes 20-25 titles/year. Recent titles include *Neuropsychology for the Attorney, Innovations in Pain Management, Life Care Planning Series, Guide to Rehabilitation*. 75% require freelance illustration and design. Book catalog not available.

Needs: Approached by 20 freelance artists/year. Works with 15 freelance illustrators and 5 freelance designers/year. Buys 40 freelance illustrations/year. Prefers artists with experience in design and technical illustration. Uses freelance artists mainly for illustration and cover design. Also uses freelance artists for jacket/cover and text illustration. Works on assignment only.

First Contact & Terms: Send query letter with brochure, resume, SASE, tearsheets, photocopies and slides. Samples are filed or returned by SASE if requested by artist. Reports back within 1 month. Write to schedule an appointment to show a portfolio. Portfolio should include thumbnails, roughs, original/final art, b&w and color photostats, tearsheets, photographs, slides, transparencies and dummies. Buys all rights. Originals are not returned at job's completion.

Book Design: Assigns 1-2 freelance design and 20 freelance illustration jobs/year. Pays by the project, $50 minimum; varies with the project.

Jackets/Covers: Assigns 15 freelance design jobs and 15 freelance illustration jobs/year. Pays by the project, $300-1,200. Prefers photographyfi.ne art, and various media and styles.

Text Illustration: Assigns 2 freelance design jobs and 20 freelance illustration jobs/year. Pays by the project, $50 minimum; depends on size of project and difficulty of art needed. Prefers b&w line art, realistic, technical, some photography.

Tips: "Present a professional portfolio, have good references and charge reasonable prices. Also, be experienced with book/jacket design."

DEVONSHIRE PUBLISHING CO., Box 85, Elgin IL 60121. (312)242-3846. Vice President: Don Reynolds. Estab. 1985. Book publisher. Publishes trade paperback originals. Types of books include contemporary, mainstream, historical, and science fiction; instructional, mystery, history and humor. Specializes in fiction. Publishes 2-3 titles/year. Recent titles include *The Making of Bernie Trumble*. 100% require freelance illustration and design. Book catalog free for SASE with 1 first-class stamp.

Needs: Approached by 5 freelance artists/year. Works with 1 freelance designer/year. Buys 2-3 freelance illustrations/year. Uses freelance artists mainly for cover design. Also uses freelance artists for jacket/cover illustration and catalog design. Works on assignment only.

First Contact & Terms: Send query letter with SASE and photocopies. Samples are not filed and are returned by SASE. Reports back within 1 month. To show a portfolio, mail roughs and photostats. Buys one-time rights. Originals are not returned at the job's completion.

Book Design: Assigns 2-3 freelance design and 2-3 freelance illustration jobs/year. Pays by the project, $300-1,500.

Jackets/Covers: Assigns 2-3 freelance design and 2-3 freelance illustration jobs/year. Pays by the project, $300-1,500.

Tips: At deadline *Artist's Market* editors learned that Devonshire is no longer operating at this address and phone.

DIAL BOOKS FOR YOUNG READERS, 375 Hudson St., New York NY 10014. (212)366-2803. Editor: Toby Sherry. Specializes in juvenile and young adult hardcovers. Publishes 40 titles/year. 40% require freelance illustration. Recent titles include *The Talking Eggs*, by Robert Sansoucie.

First Contact & Terms: Approached by 400 freelance artists/year. Works with 20 freelance artists/year. Prefers artists with some book experience. Works on assignment only. Send query letter with brochure, tearsheets, photostats, slides and photographs. Samples are filed and are not returned. Reports back only if interested. Originals returned at job's completion. Call to schedule an appointment to show a portfolio, which should include original/final art and tearsheets. Considers complexity of project, skill and experience of artist and project's budget when establishing payment. Rights purchased vary."

Book Design: Assigns 20 freelance design and 30 freelance illustration jobs/year.

Jackets/Covers: Assigns 2 freelance design and 8 freelance illustration jobs/year.

***DOUBLE B PUBLICATIONS**, 4113 N. Longview, Phoenix AZ 85014. (602)279-6893. Marketing Director: Bruce Fischer. Estab. 1988. Book publisher. Publishes trade paperback originals. Types of books include reference. Specializes in clip art. Publishes 8-10 titles/year. Recent titles include *Rodeos and Western Holidays*. 100% require freelance illustration and design. Book catalog free by request.

Needs: Approached by 10-15 freelance artists/year. Works with 3 freelance illustrators and 3 freelance designers/year. Buys 500+ freelance illustrations/year. Prefers artists with experience in clip art "who can work fast." Uses artists mainly for clip art. Also uses freelance artists for text illustration. Works on assignment only.

First Contact & Terms: Send query letter with resume and examples of work. Samples are filed. Reports back only if interested. Call or write to schedule an appointment to show a portfolio. Portfolio should include thumbnails and original/final art. Buys all rights. Originals are not returned.

DRAMA BOOK PUBLISHERS, 260 5th Ave., New York NY 10001. (212)725-5377. Estab. 1967. Book publisher. Publishes hardcover originals and reprints, trade paperback reprints and textbooks. Types of books include costume, theater and performing arts. Publishes 8 titles/year. 10% require freelance illustration; 25% require freelance design.

Needs: Works with 2-3 freelance designers/year. Prefers local artists only. Uses freelance artists mainly for jackets/covers. Also uses freelance artists for book, direct mail and catalog design and text illustration. Works on assignment only.

First Contact & Terms: Send query letter with brochure and tearsheets. Samples are filed. Reports back to the artist only if interested. Rights purchased vary according to project. Originals are not returned at the job's completion.

Book Design: Pays by the project.

Jackets/Covers: Pays by the project.

ENSLOW PUBLISHERS, Box 777, Bloy St. and Ramsey Ave., Hillside NJ 07205. Production Manager: Brian Enslow. Estab. 1978. Specializes in hardcovers, juvenile young adult nonfiction; science, social issues, biography. Publishes 30 titles/year. 30% require freelance illustration. Book catalog for SASE with 75¢ postage.
First Contact & Terms: Works with 3 freelance artists/year. Works on assignment only. Send query letter with brochure or photocopies. Samples not filed are not returned. Does not report back. Considers skill and experience of artist when establishing payment. Rights purchased vary according to project.
Book Design: Assigns 3 freelance design jobs/year. Pays by the project.
Text Illustration: Assigns 5 freelance jobs/year. Pays by the project.
Tips: "We're interested in b&w india ink work. We keep a file of samples by various artists to remind us of the capabilities of each."

ENTELEK, Ward-Whidden House/The Hill, Box 1303, Portsmouth NH 03802. Editorial Director: Albert E. Hickey. Publishes paperback education originals, specializing in computer books and software. Recent titles include *Sail Training for High Risk Youth*.
First Contact & Terms: Approached by 25 freelance artists/year. Query with samples. Prefers previously published work as samples. Include SASE. Reports in 1 week. Free catalog. Works on assignment only. Provide brochure, flyer and tearsheets to be kept on file for possible future assignments. Pays $300, catalogs and direct mail brochures.
Needs: Works with 1 freelance artist and 1 freelance designer for advertising/year. Especially needs cover and brochure designs.

M. EVANS AND COMPANY, INC., 216 E. 49th St., New York NY 10016. (212)688-2810. Managing Editor: Joseph Mills. Estab. 1956. Book publisher. Publishes hardcover and trade paperback originals. Types of books include contemporary fiction, biography, young adult, history, self-help, cookbooks, westerns and romances. Specializes in westerns, romance and general nonfiction. Publishes 40 titles/year. Recent titles include *Paris 2005*, *Born in Blood* and *Italian Vegetarian Cooking*. 50% require freelance illustration. 50% require freelance design.
Needs: Approached by 25 freelance artists/year. Works with approximately 15 freelance illustrators and designers/year. Buys 20 freelance illustrations/year. Prefers local artists. Uses freelance artists for jacket/cover illustration and design and book design. Works on assignment only.
First Contact & Terms: Send query letter with brochure and resume. Samples are filed. Reports back to the artist only if interested. Call to schedule an appointment to show a portfolio which should include original/final art and photographs. Rights purchased vary according to project. Originals are returned at the job's completion upon request.
Book Design: Assigns 20 freelance design, 20 freelance illustration jobs/year. Pays by project, $375-425.
Jackets/Covers: Assigns 20 freelance design jobs/year. Pays by the project $900-1,500. Media and style preferred depend on subject."

FACTS ON FILE, 460 Park Ave. S., New York NY 10016. (212)683-2244. FAX: (212)683-3633. Art Director: Jo Stein. Estab. 1940. Book and news digest publisher. Publishes hardcover originals and trade paperback reprints. Types of books include instruction, biography, young adult, reference, history, self-help, travel, natural history and humor. Specializes in general reference. Publishes 200 titles/year. Recent titles include *Guinness Book of Records* and *Zoo: The Modern Ark*. 10% require freelance illustration; 50% require freelance design. Book catalog free by request.
Needs: Approached by 100 freelance artists/year. Works with 10 freelance illustrators and 50 freelance designers/year. Buys 10 feelance illustrations. Use freelance artists mainly for jacket and direct mail design. Also use freelance artists for book direct mail design, text illustration and paste-up. Works on assignment only.
First Contact & Terms: Send query letter with SASE, tearsheets and photocopies. Samples are filed. Reports back only if interested. Call to show a portfolio, which should include thumbnails, roughs and color tearsheets, photographs and comps. Rights purchased vary. Originals returned at the job's completion.
Book Design: Assigns 20 freelance illustration jobs/year. Pays by the project, $500-1,000.
Jackets/Covers: Assigns 50 freelance design and 10 freelance illustration jobs/year. Pays by the project $500-1,000. Media and style preferred vary per project.
Text Illustration: Assigns 10 freelance design and 10 freelance illustration jobs/year. Pays $25-50 "per piece, negotiated."
Tips: Our books range from straight black and white to coffee-table type four-color."

FAIRCHILD FASHION & MERCHANDISING GROUP, BOOK DIVISION, 7 W. 34th St., New York NY 10010. (212)630-3852. FAX: (212)630-3868. Production Manager: Juanita Brown. Estab. 1966. Book publisher. Publishes "highly visual and design sensitive" hardcover originals and reprints and textbooks. Types of books include fashion, instruction, reference and history. Specializes in all areas of fashion, textiles and merchandising. Publishes 5-10 titles/year. Recent titles include *Advanced Fashion Sketchbook*, *Creative Pattern Skills* and

90 Years of Fashion. 85% require freelance illustration; 100% require freelance design. Book catalog free by request.

Needs: Works with 3-4 freelance illustrators and 5-6 freelance designers/year. Number of freelance illustrations bought varies. Prefers, but not restricted to, local artists with experience in fashion illustration and design. Uses freelance artists mainly for text and cover design. Also uses freelance artists for jacket/cover illustration and book design.

First Contact & Terms: Send query letter with brochure, photographs and photostats. Samples are filed. Reports back to the artist only if interested. Call to schedule an appointment to show a portfolio, which should include b&w and color tearsheets, slides and photographs. Buys all rights. Originals are not returned at job's completion.

Book Design: Assigns 5-10 freelance design and 2-3 freelance illustration jobs/year. Pays by the project based on budget requirements; negotiated.

Jackets/Covers: Assigns 5-10 freelance design and 1-2 freelance illustration jobs/year. Pays by the project. "Media preferred depends on job halftones, whether it is something from inside text or an illustration."

Text Illustration: Assigns 1-2 freelance design jobs/year.

Tips: "Be punctual; bring portfolio and ask questions about the project. Talk a little about yourself." Would like to see more "fashion illustrations and renditions and drafted art."

FALCON PRESS PUBLISHING CO., INC., 318 N. Last Chance Gulch, Helena MT 59601. (406)442-6597. FAX: (406)442-2995. Editorial Director: Chris Cauble. Estab. 1978. Book publisher. Publishes hardcover originals and reprints, trade paperback originals and reprints, and mass market paperback originals and reprints. Types of books include instruction, pre-school, juvenile, travel and cookbooks. Specializes in recreational guidebooks, high-quality, four-color photo books. Publishes 40 titles/year. Recent titles include *A is for Animals*, *Nature Conservancy Calendar* and *New Mexico On My Mind*. Book catalog free by request.

Needs: Approached by 100 freelance artists/year. Works with 2-5 freelance illustrators/year. Buys 40 freelance illustrations/year. Prefers artists with experience in illustrating children's books. Uses freelance artists mainly for illustrating children's books and map making.

First Contact & Terms: Send query letter with resume, tearsheets, photographs, photocopies and photostats. "Samples should be in the form of one of these options." Samples are not filed and are returned by SASE if requested by artist. Reports back to the artist only if interested. To show a portfolio, mail thumbnails, roughs, original/final art and b&w photostats, slides, dummies, tearsheets, transparencies and photographs. Buys all rights. Originals are returned at the job's completion.

Book Design: "We have inhouse artists."

Jackets/Covers: "Virtually all done inhouse."

Text Illustration: Assigns 3 freelance design and 3 freelance illustrations/year. Pays by the project, $500-1,500. No preferred media or style.

Tips: "Be acquainted with our children's series of books, *Highlights in American History* and *Interpreting the Great Outdoors*; and have a good portfolio. If we do use freelance illustrators, it's to illustrate these two series featuring color illustrations of historical events and natural phenomena, flowers, trees, mountains, animals, etc."

FANTAGRAPHICS BOOKS, INC., 7563 Lake City Way., Seattle WA 98115. (206)524-1967. FAX: (206)524-1967. Publisher: Gary Groth. Estab. 1976. Book publisher. Publishes hardcover originals and reprints and trade paperback originals and reprints. Types of books include contemporary, experimental, mainstream, historical science fiction, young adult and humor. "All our books are comic books or graphic stories." Specializes in fictional comics. Publishes 100 titles/year. Recent titles include *Love and Rockets*, *The Comic Journal*, *Amazing Heroes*, *Hate Magazine* and *Usagi Yojimbo*. 15% require freelance illustration. Book catalog free by request.

Needs: Approached by 500 freelance artists/year. Works with 15 freelance illustrators/year. Must be interested in and willing to do comics. Uses freelance artists mainly for comic book interiors and covers.

First Contact & Terms: Send query letter addressed to Submissions Editor with resume, SASE, photocopies and finished comics work. Samples are not filed and are returned by SASE. Reports back to the artist only if interested. Call or write to schedule an appointment to show a portfolio, which should include original/final art and b&w samples. Buys one-time rights or negotiates rights purchased. Originals are returned at the job's completion.

Book Design: Payment for book design, jackets/covers and text illustration is on a royalty basis.

Tips: "We want to see completed comics stories. We don't make assignments, but instead look for interesting material to publish that is pre-existing. We want cartoonists who have an individual style, who create stories that are personal expressions."

FARRAR, STRAUS & GIROUX, INC., 19 Union Square West, New York NY 10003. (212)741-6900. Art Director: Dorris Janowitz. Book publisher. Estab. 1946. Publishes hardcover and trade paperback originals and trade paperback reprints. Publishes nonfiction and fiction. Types of books include biography, cookbooks,

juvenile, self-help, historical and mainstream/contemporary. Publishes 120 titles/year. 40% require freelance illustration; 40% freelance design.

First Contact & Terms: Works with 12 freelance designers/year. Works with freelance artists for jacket/cover and book design. Send brochure, tear sheets and photostats. Samples are filed and are not returned. Reports back only if interested. Originals returned to artist at job's completion. Call to write to schedule an appointment to show a portfolio, which should include photostats and final reproduction/product. Considers complexity of project and project's budget when establishing payment. Buys one-time rights.

Book Design: Assigns 40 freelance design jobs/year. Pays by the project, $300-450.

Jackets/Covers: Assigns 40 freelance design jobs/year. Pays by the project, $750-1,500.

Tips: The best way for a freelance illustrator to get an assignment is "to have a great portfolio and referrals."

***FIREHOUSE PRESS**, Subsidiary of Nature's Design, Box 255, Davenport CA 95017. (408)426-8205. Publisher: Frank S. Balthis. Estab. 1980. Book publisher. Publishes trade and mass market paperback originals. Types of books include juvenile, young adult, travel and natural history. Specializes in children's guides to national parks. Publishes 1-2 titles/year. Recent titles include *Yellowstone* and *Point Reyes*. 100% required freelance illustration. Book catalog for SASE with 1 first-class stamp. Sample book available for $3.

Needs: Approached by 20 freelance artists/year. Works with 1-2 freelance illustrators/year. Buys 40 freelance illustrations/year. Prefers artists with experience in natural history, parks and children's books. Uses freelance artists mainly for illustration of children's guides. Also uses freelance artists for jacket/cover and text illustration. Works on assignment only.

First Contact & Terms: Send query leter with resume, SASE, tearsheets and photocopies. Samples are filed or are returned by SASE if requested. Reports back only if interested. Call or write to schedule an appointment to show a portfolio, or mail appropriate materials: tearsheets, slides and photocopies. Rights purchased vary according to project.

Jackets/Covers: Assigns 1-2 freelance illustration jobs/year. Pays by the project; may vary with projects. Prefers colored line drawings.

Text Illustration: Assigns 1-2 freelance illustration jobs/year. Pays by the project; may vary with project. Prefers black-and-white line drawings.

Tips: "Develop a comprehensive understanding of the natural history of a park or natural/historical area. Communicate this understanding to children through short text and illustrations. We wish to expand our children's guides to include the national parks. Please refer to our existing titles. Samples are available."

FIVE STAR PUBLICATIONS, Box 3142, Scottsdale AZ 85271-3142. (602)941-0770. Publisher: Linda F. Radke. Estab. 1985. Book publisher. Publishes trade paperback originals. Types of books include juvenile, reference and self-help. Specializes in child care and children's books. Publishes 4 titles/year. Recent titles include *Shakespeare for Children: The Story of Romeo and Juliet*; *Nannies, Maids & More: The Complete Guide for Hiring Household Help*; and *That Hungarian's in My Kitchen: 125 Hungarian/American Recipes*. 25% require freelance illustration; 100% require freelance design. Book catalog available for SASE with 2 first-class stamps.

Needs: Works with 2 freelance illustrators and 1 freelance designer/year. Bought 60 freelance illustrations last year. Prefers artists with experience. Uses freelance artists mainly for book illustration, brochures, cover design. Also uses freelance artists for jacket/cover illustration and text illustration and direct mail design. Works on assignment only.

First Contact & Terms: Send query letter with brochure and resume. Samples are filed. Reports back to the artist only if interested. Rights purchased very according to project.

Book Design: Pays by the project.

Jackets/Covers: Assigns 4 freelance design and 2 freelance illustration jobs/year. Pays by the project. Media and style preferred depend on the assignment.

Text Illustration: Assigns 2 freelance design and 2 freelance illustration jobs/year. Pays by the project. Payment is negotiable. Prefers realism.

Tips: "If artist is to be considered, we require the willingness to do one sample drawing as related to the assignment."

FOREIGN SERVICES RESEARCH INSTITUTE/WHEAT FORDERS, Box 6317, Washington DC 20015-0317. (202)362-1588. Director: John E. Whiteford Boyle. Specializes in paperback originals of modern thought, nonfiction and philosophical poetry.

First Contact & Terms: Works with 2 freelance artists/year. Artist should understand the principles of book jacket design. Works on assignment only. Send query letter to be kept on file. Reports within 15 days. No originals returned. Considers project's budget when establishing payment. Buys first rights or reprint rights.

Book Design: Assigns 1-2 freelance jobs/year. Pays by the hour, $25-35 average.

Jackets/Covers: Assigns 1-2 freelance design jobs/year. Pays by the project, $250 minimum.

Tips: "Submit samples of book jackets designed for and accepted by other clients. Include SASE, please."

THE FREE PRESS, A DIVISION OF MACMILLAN, PUB. CO., 866 Third Ave., New York NY 10022. Manufacturing Director: W.P. Weiss. Specializes in hardcover and paperback originals, concentrating on professional subjects and tradebooks in the social sciences. Publishes 70 titles/year. Recent titles include *Saddam Hussein;* , *Structures of Social Life*; *This People's Navy*; and *Marketing Strategy*. Publishes "conservative and trendy" looking books.
First Contact & Terms: Approached by dozens of freelance artists/year. Works with 2-3 freelance draftsmen/year. Works with 10-12 freelance designers/year. Prefers artists with book publishing experience. Works on assignment only. Send query letter with brochure showing art style or resume and nonreturnable samples. Samples not filed are returned by SASE. Reports only if interested. Original work returned after job's completion. Considers complexity of project, skill and experience of artist, project's budget, turnaround time and rights purchased when establishing payment. Buys all rights.
Book Design: Assigns 70 freelance design jobs/year. Pays by the project, $250-400.
Jackets/Covers: Assigns 70 freelance design jobs/year. Pays by the project, $750-1,500.
Text Illustration: Assigns 35 freelance jobs/year. "It is largely drafting work, not illustration." Pays by the project.
Tips: "Have book industry experience!"

FRIENDSHIP PRESS PUBLISHING CO., 475 Riverside Dr., New York NY 10115. (212)870-2280. Art Director: E. Paul Lansdale (Room 552). Specializes in hardcover and paperback originals, reprints and textbooks; "adult and children's books on social issues from an ecumenical perspective." Publishes over 10 titles/year; many require freelance illustration. Recent titles include *Neighbors: Muslims in North America*; *God is One: The Way of Islam*; and *Haiku, Origami, and More*.
First Contact & Terms: Approached by over 20 freelance artists/year. Works with over 8 freelance artists/year. Works on assignment only. Send brochure showing art style or resume, tearsheets, photostats, slides, photographs and "even black & white photocopies. Send nonreturnable samples." Samples are filed or are not returned. Reports back only if interested. Originals returned to artist at job's completion. To show a portfolio, call or write to schedule an appointment; or mail thumbnails, roughs, original/final art, photostats, tearsheets, final reproduction/product, photographs, slides, transparencies or dummies. Considers skill and experience of artist, project's budget and rights purchased when establishing payment.
Book Design: Pays by the hour, $12-19.
Jackets/Covers: Assigns 10 freelance design and over 5 freelance illustration jobs/year. Pays by the project, $300-400.
Text Illustration: Assigns over 8 freelance jobs/year. Pays by the project, $25-75, b&w.

FUNKY PUNKY AND CHIC, Box 601, Cooper Station, New York NY 10276. (212)533-1772. Creative Director: R. Eugene Watlington. Specializes in paperback originals on poetry, celebrity photos and topics dealing with New Wave, high fashion. Publishes 4 titles/year; 50% require freelance design; 75% require freelance illustration.
First Contact & Terms: Works with 20 freelance artists/year. Send query letter with business card, photographs and slides. Samples not kept on file are returned by SASE. Reports only if interested. Write for appointment to show a portfolio. Originals not returned to artist at job's completion. Considers complexity of project and project's budget when establishing payment. Buys all rights.
Book Design: Assigns 1 freelance job/year. Pays by the project, $125-140.
Jackets/Covers: Assigns 3 freelance illustration jobs/year. Pays by the project, $50 minimum.
Text Illustration: Assigns 2 freelance jobs/year. Pays by the project, $50-100.

C.R. GIBSON, 32 Knight St., Norwalk CT 06856. (203)847-4543. Creative Services Coordinator: Marilyn Schoenleber. Publishes 100 titles/year. 95% require freelance illustration.
First Contact & Terms: Works with approximately 70 freelance artists/year. Works on assignment—"most of the time." Send tearsheets, photostats, slides, photographs, sketches and published work. Samples are filed or are returned by SASE. Reports back within 1 month only if interested. Call to schedule an appointment to show a portfolio or mail tearsheets, slides and published samples. Considers complexity of project, project's budget and rights purchased when establishing payment. Negotiates rights purchased.
Book Design: Assigns at least 65 freelance design jobs/year. Pay by the project, $1,200 minimum.
Jackets/Covers: Assigns 20 freelance design jobs/year. Pays by the project, $500 minimum.
Text Illustration: Assigns 20 freelance jobs/year. Pays by the hour, $15 minimum; by the project, $1500 minimum.
Tips: "Submit by mail a cross-section of your work—slides, printed samples, finished art no larger than a mailing envelope. Enclose SASE in the envelope."

GLENCOE/MCGRAW-HILL, a Macmillan/McGraw-Hill Company, 3008 W. Willow Knolls Rd., Peoria IL 61615. (309)689-3200. Vice President of Art/Design/Production: Donna M. Faull. Specializes in secondary educational materials (hardcover, paperback, filmstrips, software), especially in inudstrial and computer

technology, home economics and family living, social studies, career education, etc. Publishes over 100 titles/year.

First Contact & Terms: Works with over 30 freelance artists/year. Works on assignment only. Send query letter with brochure, resume and "any type of samples." Samples not filed are returned if requested. Reports back in weeks. Original work not returned after job's completion; work-for-hire basis with rights to publisher. Considers complexity of the project, skill and experience of the artist, project's budget, turnaround time and rights purchased when establishing payment. Buys all rights.

Book Design: Assigns over 30 freelance design and over 30 freelance illustration jobs/year. Pays by the hour, $10-40; pays by the project, $300-3,000 and upward (very technical art, lots of volume).

Jackets/Covers: Assigns over 50 freelance design jobs/year. Pays by the project, $200, 1-color; 4,000, complete cover/interiors for textbooks.

Text Illustration: Assigns over 50 freelance jobs/year. Pays by the hour, $10-40.

Tips: "Try not to call and never drop in without an appointment."

GLOBE BOOK COMPANY, 190 Sylvan Ave., 2nd Fl., Englewood Cliffs NJ 07632. (201)592-2640. Art Director: Nancy Sharkey. Specializes in high school level textbooks, social studies, language arts, science and health. Publishes 80 titles/year; 50% require freelance illustration.

First Contact & Terms: Works with 40 freelance artists/year. Works on assignment only. Send query letter with brochure showing art style or tearsheets, photostats or any printed samples. Samples are filed and are not returned. Reports back only if interested. Originals returned to artist at job's completion. Call to schedule an appointment to show a portfolio, or mail original/final art, tearsheets and photographs. Considers complexity of project, project's budget and turnaround time when establishing payment. Buys one-time rights.

Book Design: Assigns several freelance design jobs/year. Pays by the project.

Jackets/Covers: Assigns several freelance design jobs/year. Pays by the project.

Text Illustration: Assigns several freelance jobs/year. Does not want juvenile illustration. Pays by the project.

Tips: "Looking for individuals who can produce four-color, one-color or preseparated work and four-color maps. We need technical and medical illustrators. Also, need freelance dummying and book and cover designers."

GLOBE PEQUOT PRESS, 138 West Main St., Box Q, Chester CT 06412. (203)526-9571. Production manager: Kevin Lynch. Estab. 1947. Publishes hardcover and trade paperback originals and reprints. Publishes biography, cookbooks, instruction, self-help, history and travel. Specializes in regional subjects: New England, Northwest, Southeast bed and board country inn guides. Publishes 70 titles/year. 40% require freelance illustration; 1% require freelance design. Recent titles include *Garden Smarts*, *The Movable Garden* and *American Country Store*. Book catalog free for SASE with 1 first-class stamp.

First Contact & Terms: Works with 10 freelance illustrators and 2 freelance designers/year. Buys 500 freelance illustrations/year. Works with illustrators mainly for b&w pen and ink. Also works with artists for jacket/cover illustration text illustration and direct mail design. Works on assignment only. Send query letter with brochure, resume and photostats. Samples are filed and are not returned. Reports back within 2 weeks only if interested. Originals not returned to artist at job's completion. Call or write to schedule an appointment to show a protfolio which should include roughs, original/final art, photostats, tearsheets and dummies. Considers complexity of project, project's budget and turnaround time when establishing payment. Buys all rights.

Book Design: Assigns 1 freelance design and 28 freelance illustration jobs/year. Pays by the hour, $15-25; by the project, $125-600.

Jackets/Covers: Assigns 25 freelance design and 5 freelance illustration jobs/year. Prefers realistic style. Pays by the hour, $15-30; by the project, $150-700.

Text Illustration: Assigns 28 freelance jobs/year. Prefers b&w pen-and-ink line drawings. Pays by the hour, $10-15; by the project, $10-100.

Tips: "Design and illustration we use is classic/friendly but not corny. In the last year books have appeared more 'artistic', using more unusual illustrations and type styles."

GRAPEVINE PUBLICATIONS, INC., Box 2449, Corvallis OR 97339-2449. (503)754-0583. Managing Editor: Chris Coffin. Estab. 1983. Book publisher. Publishes trade paperback originals and textbooks. Types of books include instruction and self-help. Specializes in instruction in computers, technology, math and science. Publishes 6 titles/year. Recent titles include *Lotus Be Brief, an Easy Course in Using the HP-48SX*. 90% require freelance illustration; 10% require freelance design. Book catalog free by request.

Needs: Approached by 10-20 freelance artists/ycar. Works with 3-5 freelance illustrators and 0-1 freelance designers/year. Buys 20-40 freelance illustrations/year. Uses freelance artists mainly for color cover illustration and pen & ink illustration in text.

First Contact & Terms: Send query letter with brochure, resume, SASE and photographs. Samples are filed or are returned by SASE if requested by artist. Reports back within 1 month. To show a portfolio, mail appropriate materials: b&w and color photographs. Buys all rights. Originals are not returned at the job's completion.

Book Design: Assigns 1-2 freelance design and 10-20 freelance illustration jobs/year. Pays by the project, $200-1,000.
Jackets/Covers: Assigns 10-15 freelance illustration jobs/year. Pays by the project, $500-1,000. Prefers pastel, watercolor or acrylic; original illustrations.
Text Illustration: Assigns 10-20 freelance illustration jobs/year. Pays by the project, $500-5,000. Prefers pen & ink; characters sketched and developed throughout text.
Tips: Looks for a "friendly, human approach to technical instruction, developed watercolor or pen-and-ink cartoon characters."

***GUILT & GARDENIAS PRESS,** Box 318, Fayetteville NC 28302. Director: Carlos Steward. Specializes in hardcover and paperback reprints on any theme, art books and children's books. Publishes 2 titles/year.
First Contact & Terms: Works with 6 freelance artists/year. Prefers freelance artists from NC state or southeast; offers residencies to NC state artists. Send query letter with resume, slides and photographs. Samples are filed. Samples not filed are returned by SASE. Reports back within 3 months. Originals returned to artist at job's completion. To show a portfolio, mail photographs and slides. Considers complexity of project, skill and experience of artist and project's budget when establishing payment. Negotiates rights purchased.
Book Design: Assigns 6 freelance illustration jobs/year. Pays by the hour, $8 minimum; by the project, $50-5,000.
Tips: "Interested in people working residencies programs or workspace programs (materials furnished), and strong black-and-white photographs and artwork. Residencies available in art (all media), crafts, photography, film/video and animation."

HARCOURT BRACE JOVANOVICH, INC., 1250 6th Ave., San Diego CA 92101. (619)699-6568. Art Director, Children's Books: Michael Farmer. Trade Books: Vaughn Andrews. Specializes in hardcover and paperback originals and reprints. Publishes "general books of all subjects (not including text, school or institutional books)." Publishes 250 titles/year. Books contain "high quality art and text." 100% require freelance illustration. Recent titles include *Aida*, *Sky Dogs* and *Who Is the Beast?*.
First Contact & Terms: Approached by 1,500 freelance artists/year. Works with 200 freelance illustrators and 25 freelance designers/year, "experienced artists from all over the world." Works on assignment only. Send query letter with brochure, tearsheets and photostats. Samples are filed or are returned by SASE. Reports back within 8 weeks. Originals returned to artist at job's completion. To show a portfolio, mail photostats, tearsheets, final reproduction/product, photographs and photocopy of book dummy if it's a children's book. Buys all rights.
Book Design: Assigns 50 freelance design, 50 freelance illustration jobs/year. Pays by project, $300-600.
Jackets/Covers: Assigns 250 freelance design and 200 freelance illustration jobs/year. Pays by the project, $750-$1,500.
Text Illustration: Assigns 50 freelance jobs/year. Prefers that all work be rendered on flexible paper. Pays a royalty with advance.
Tips: "Send samples with strong concepts along with a cover letter and background experience. Look at our books before you consider us, to see if your artwork is somewhat appropriate to our style. The recession has not affected our needs at all."

HARVEST HOUSE PUBLISHERS, 1075 Arrowsmith, Eugene OR 97402. (503)343-0123. Production Manager: Fred Renich. Specializes in hardcovers and paperbacks of adult fiction and nonfiction, children's books and youth material. Publishes 55 titles/year.
First Contact & Terms: Works with 5 freelance artists/year. Works on assignment only. Send query letter with brochure or resume, tearsheets and photographs. Samples are filed. Reports back only if interested. Originals sometimes returned to artist at job's completion. Call or write to schedule an appointment to show a portfolio or mail tearsheets and final reproduction/product. Considers complexity of project, skill and experience of artist, project's budget and turnaround time when establishing payment. Buys all rights.
Jackets/Covers: Assigns 50 freelance design and 10 freelance illustration jobs/year.
Text Illustration: Assigns 5 freelance jobs/year. Pays approximately $125/page.
Needs: Uses artists for inside illustrations and cover design. "Must be relevant to textbook subject and grade level." Occasionally uses freelance book designers. "Recent major el/hi series have used thousands of 4-color cartoon-type illustrations, as well as realistic scientific paintings, and a variety of 'story' pictures for reading books; also black line work for workbooks and duplicating masters." Payment is usually by project, and varies greatly, "but is competitive with other textbook publishers."

***HEAVEN BONE PRESS,** Box 486, Chester NY 10918. (914)469-9018. President/Editor: Steve Hirsch. Estab. 1987. Book and magazine publisher. Publishes trade paperback originals. Types of books include contemporary and experimental fiction, and poetry. Publishes 4-6 titles/year. Recent titles include *Dear Empire State Building*, *13 Tales of Sex & Apocalypse in NY* (fiction), and *Walking the Dead: Poems by Lori Anderson*, illustrated by Noel Grunwaldt. 80% require freelance illustration. Book catalog not available.

Needs: Approached by 10-12 freelance artists/year. Works with 3-4 freelance illustrators. Buys 3-15 freelance illustrations/year. Uses freelance artists mainly for illustrations for books and *Heaven Bone* magazine.

First Contact & Terms: Send query letter with brochure, tearsheets, photostats, photographs and slides. Samples are filed or returned by SASE. Reports back within 3 months. Mail appropriate materials: original/final art, photostats, tearsheets, photographs and slides. Rights purchased vary according to project. Originals are returned at job's completion.

Book Design: Assigns 1-2 freelance design jobs/year. Prefers to pay in copies, but have made exceptions.

Jackets/Covers: Prefers to pay in copies, but have made exceptions. Prefers pen & ink, woodcuts and b&w drawings.

Text Illustration: Assigns 1-2 freelance design jobs/year.

Tips: "Know our specific needs, know our magazine and be patient."

T. EMMETT HENDERSON, PUBLISHER, 130 W. Main St., Middletown NY 10940. (914)343-1038. Contact: T. Emmett Henderson. Publishes hardcover and paperback local history, American Indian, archaeology and genealogy originals and reprints. Publishes 2-3 titles/year; 100% require freelance design; 100% require freelance illustration.

First Contact & Terms: Send query letter. No work returned. Reports in 4 weeks. Buys book rights. Originals returned to artist at job's completion. Works on assignment only. Send resume to be kept on file for future assignments. Check for most recent titles in bookstores. Artist supplies overlays for cover artwork. No advance. No pay for unused assigned work. Assigns 5 advertising jobs/year; pays $10 minimum.

Book Design: Assigns 2-4 jobs/year. Uses artists for cover art work, some text illustration. Prefers representational style.

Jackets/Covers: Assigns 2-4 jobs/year. Uses representational art. Pays $20 minimum, b&w line drawings and color-separated work.

Text Illustrations: Pays $10 minimum, b&w. Buys 5-15 cartoons/year. Uses cartoons as chapter headings. Pays $5-12 minimum, b&w.

HERALD PRESS, 616 Walnut Ave., Scottdale PA 15683. (412)887-8500, ext. 244. Art Director: James M. Butti. Specializes in hardcover and paperback originals and reprints of inspirational, historical, juvenile, theological, biographical, fiction and nonfiction books. Publishes 24 titles/year. Recent titles include: *Daniel*; *Earth Keepers*; and *Hard Life of Seymour E. Newton*. Books are "fresh and well illustrated." Estab. 1908. 60% require freelance illustration. Catalog available.

First Contact & Terms: Approached by 75-100 freelance artists each year. Works with 6-7 illustrators/year. Prefers oil, pen & ink, colored pencil, watercolor, and acrylic. Works on assignment only. Send query letter with brochure or resume, tearsheets, photostats, slides and photographs. Samples are not filed and are returned by SASE. Reports back within 2 weeks. Originals not returned to artist at job's completion "except in special arrangements." To show a portfolio, mail original/final art, photostats, tearsheets, final reproduction/product, photographs and slides. "Portfolio should include approximate time different jobs or illustrations had taken." Considers complexity of project, skill and experience of artist and project's budget when establishing payment. Buys all rights.

Jackets/Covers: Assigns 8 freelance design and 8 freelance illustration jobs/year. Pays by the project, $250-600 minimum.

Text Illustration: Assigns 6 freelance jobs/year. Pays by the project, $300-600 (complete project).

Tips: "Design we use is colorful/realistic/religious. When sending samples, show a wide range of styles and subject matter—otherwise you limit yourself."

HOLIDAY HOUSE, 425 Madison, New York NY 10017. (212)688-0085. Design and Production: Tere Lo Prete. Specializes in hardcover children's books. Publishes 45 titles/year; 30% require freelance illustration. Recent titles include: *Hershel and the Hanukkah Goblins* and *The Legend of the Christmas Rose*.

First Contact & Terms: Approached by over 125 freelance artists/year. Works with 10-15 freelance artists/year. Prefers art suitable for children and young adults. Works on assignment only. Samples are filed or are returned by SASE. Reports back only if interested. Originals returned to artist at job's completion. Call to schedule an appointment to show a portfolio, which should include "whatever the artist likes to do and thinks he does well." Considers complexity of project, skill and experience of artist and project's budget when establishing payment. Buys one-time rights.

Book Design: Pays by the hour, $15-20.

Jackets/Covers: Assigns 10-15 freelance illustration jobs/year. Prefers watercolor, then acrylic and charcoal/pencil. Pays by the project, $900.

Text Illustrations: Assigns 5-10 jobs/year. Pays royalty.

Tips: "Show samples of everything you do well and like to do." A common mistake is "not following size specifications."

HOMESTEAD PUBLISHING, Box 193, Moose WY 83012. Art Director: Carl Schreier. Estab. 1980. Specializes in hardcover and paperback originals of nonfiction, natural history, Western art and general Western regional literature. Publishes over 6 titles/year. 75% require freelance illustration. Book catalog free for SASE with 4 first class stamps.

First Contact & Terms: Works with 50 freelance illustrators and 20 freelance designers/year. Works on assignment only. Prefers pen & ink, airbrush, charcoal/pencil and watercolor. Send query letter with samples to be kept on file or write for appointment to show portfolio. Prefers to receive as samples "examples of past work, if available (such as published books or illustrations used in magazines, etc.). For color work, slides are suitable; for b&w technical pen, photostats. And one piece of original artwork which can be returned." Samples not filed are returned by SASE only if requested. Reports within 10 days. No original work returned after job's completion. Considers complexity of project, skill and experience of artist, project's budget and turnaround time when establishing payment. Rights purchased vary according to project.

Book Design: Assigns 6 freelance jobs/year. Pays by the project, $50-3,500 average.

Jackets/Covers: Assigns 2 freelance design and 4 freelance illustration jobs/year. Pays by the project, $50-3,500 average.

Text Illustration: Assigns 26 freelance jobs/year. Prefers technical pen illustration, maps (using airbrush, overlays, etc.), watercolor illustrations for children's books, calligraphy and lettering for titles and headings. Pays by the hour, $5-20 average; by the project, $50-3,500 average.

Tips: "We are using more graphic, contemporary designs. We are looking for the best quality, well-written publications that are available."

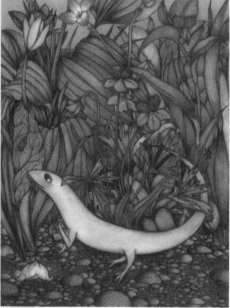

© Humanics Limited 1990

The story **Cambio Chameleon** *was both written and illustrated by Mauro Magellan, also a drummer for the rock band* **The Georgia Satellites.** *Magellan submitted the story and illustrations to Leigh Leitch, art director at Humanics Limited. What impressed Leitch about Magellan's watercolor, pen-and-ink and graphite illustrations was his "rich color, depth, design and characterization of animals." In this book Leitch feels Magellan captures the "magic of nature and draws parallels between nature and the human experience." Magellan was "very involved in the entire production process," she continues, including promotion. For the project he received a ten percent royalty.*

HUMANICS LIMITED, Box 7447, Atlanta GA 30309. (404)874-2176. FAX: (404)874-1976. Acquisitions Editor: Robert Hall. Art Director: Leigh Leitch. Estab. 1976. Book publisher. Publishes hardcover children's, trade paperback originals and educational activity books. Types of books include instruction, pre-school, juvenile, self-help and New Age. Specializes in self-help, psychology, educational resource, nutrition, peace

The asterisk before a listing indicates that the listing is new in this edition. New markets are often the most receptive to freelance submissions.

and environment. Publishes 12 titles/year. Recent titles include *Make the Circle Bigger: We Need Each Other; Tao of Sailing; Cambio, Chameleon* and *Home At Last*. 10% require freelance illustration and design. Book catalog free.

Needs: Approached by 24-30 freelance artists/year. Works with 3 freelance illustrators and 2 freelance designers/year. Buys 60 freelance illustrations/year. Uses freelance artists for text illustration. Works on assignment only.

First Contact & Terms: Send query letter with resume, SASE, photocopies and slides. Samples are filed or are returned by SASE if requested by artist. Reports back to the artist only if interested. Call Leigh Leitch, Art Director to schedule an appointment to show a portfolio or mail appropriate materials. Rights purchased vary according to project. Originals are not returned at the job's completion.

Book Design: Assigns 2 freelance design and 3-5 freelance illustration jobs/year. Pays by the project, $150 minimum, pays royalties.

Jackets/Covers: Assigns 4 freelance illustration jobs/year. Pays by the project, $150 minimum, pays royalties.

Text Illustration: Assigns 2 freelance design and 3 freelance illustration jobs/year.

Tips: "Send examples of your work, preferably related to our subject matter. Follow up with a call. Make appointment for portfolio review if possible."

IDEALS PUBLISHING CORP., Suite 800, 565 Marriott Dr., Nashville TN 37210. (615)885-8270. Children's Book Editor: Peggy Schaefer. Specializes in original children's books.

First Contact & Terms: Works with 10-12 freelance artists/year. Works on assignment only. Send query letter with brochure showing art style, tearsheets, photostats, slides and photographs. Samples are filed or are returned by SASE only if requested. Does not report back. Originals not returned to artist at job's completion. To show a portfolio, mail appropriate materials. Considers skill and experience of artist and project's budget when establishing payment.

IGNATIUS PRESS, Catholic Publisher, 2515 McAllister St., San Francisco CA 94118. Production Editor: Carolyn Lemon. Art Editor: Roxanne Lum. Estab. 1978. Catholic theology and devotional books for lay people, priests and religious readers. Recent titles include *Praying in Time, The Man Born to Be King* and *Do-it-at-Home-Retreat*.

First Contact & Terms: Works with 2-3 freelance illustrators/year. Works on assignment only. Will send art guidelines "if we are interested in the artist's work." Accepts previously published material. Send brochure showing art style or resume and photocopies. Samples not filed are not returned. Reports only if interested. To show a portfolio, mail appropriate materials; "we will contact you if interested." Pays on acceptance.

Jackets/Covers: Buys cover art from freelance artists. Prefers Christian symbols/calligraphy and religious illustrations of Jesus, saints, etc. (used on cover or in text). "Simplicity, clarity, and elegance are the rule. We like calligraphy, occasionally incorporated with Christian symbols. We also do covers with type and photography." Prefers pen & ink, charcoal/pencil. Pays by the project, $300 minimum.

Text Illustration: Pays by the project, $30 minimum.

Tips: "I do not want to see any schmaltzy religious art. Since we are a nonprofit Catholic press, we cannot always afford paying the going rate for freelance art, so we are always appreciative when artists can give us a break on prices and work *ad maiorem Dei gloriam*."

***INNER TRADITIONS INTERNATIONAL**, 1 Park St., Rochester VT 05767. (802)767-3174. FAX: (802)767-3726. Art Dept.: Bonnie Atwater. Estab. 1975. Book publisher. Publishes hardcover originals and trade paperback originals and reprints. Types of books include self-help, cookbooks, esoteric philosophy, alternative medicine, New Age and art books. Publishes 40 titles/year. Recent titles include *Encyclopedia of Erotic Wisdom, The Divine Library*, and *The Life & Art of a Russian Master*. 60% require freelance illustration. 85% require freelance design. Book catalog free by request.

Needs: Works with 8-9 freelance illustrators and 10-15 freelance designers/year. Buys 30 freelance illustrations/year. Uses freelance artists for jacket/cover illustration and design. Works on assignment only.

First Contact & Terms: Send SASE, tearsheets, photographs and slides. Samples filed if interested or are returned by SASE if requested by artist. Reports back to the artist only if interested. To show a portfolio, mail tearsheets, photographs, slides and transparencies. Rights purchased vary according to project. Original art returned at job's completion. Pays by the project.

Jackets/Covers: Assigns 32 freelance design and 26 freelance illustration jobs/year. Pays by the project.

INTERNATIONAL MARINE PUBLISHING CO. Seven Seas Press, Box 220, Camden ME 04843. (207)236-4837. Production Director: Molly Mulhern. Imprint of TAB Books McGraw-Hill. Estab. 1969. Specializes in hardcovers and paperbacks on marine (nautical) topics. Publishes 25 titles/year. 50% require freelance illustration. Book catalog free for request.

First Contact & Terms: Works with 20 freelance illustrators and 20 freelance designers/year. Works with freelance illustrators mainly for interior illustration. Prefers local artists. Works on assignment only. Send resume and tearsheets. Samples are filed. Reports back within 1 month. Originals are not returned to artist

at job's completion. To show a portfolio, mail original/final art and tearsheets. Considers project's budget when establishing payment. Buys one-time rights.

Book Design: Assigns 20 freelance design and 20 freelance illustration jobs/year. Pays by the project, $150-550; by the hour, $12-30.

Jackets/Covers: Assigns 20 freelance design and 3 freelance illustration jobs/year. Pays by the project, $100-300; by the hour, $12-30.

Text Illustration: Assigns 20 freelance jobs/year. Prefers technical drawings. Pays by the hour, $12-30; by the project, $30-80 per piece.

Tips: "Do your research. See if your work fits with what we publish. Write with a resume and sample; then follow with a call; then come by to visit."

***JALMAR PRESS**, Bldg. 2, 45 Hitching Post Dr., Rolling Hill Estates CA 90274. (213)547-1240. President: Bradley L. Winch. Estab. 1971. Books emphasize positive self-esteem. Recent titles include *Imagine That!* and *BecomingWhole (Learning) Through Games*.

First Contact & Terms: Works with 5-7 illustrators and 1-2 designers/year. Mainly uses artwork for cover design, interior layout, and illustration. Works on assignment only. Send query letter with brochure showing art style. Samples not filed are returned by SASE. Reports back only if interested. Considers complexity of project, client's budget and turnaround time when establishing payment. Buys all rights.

Book Design: Pays by the project, $50 minimum if accepted on project.

Jackets/Covers: Pays by the project, $50 minimum if accepted on project.

Text Illustration: Pays by the project, $50 minimum if accepted on project.

Tips: "Portfolio should include samples that show experience. Don't include 27 pages of 'stuff'. We are moving to computer layout, design and even art work. Stay away from the 'cartoonish' look."

***JINNO INTERNATIONAL**, 3 Christine Dr., Chestnut Ridge NY 10977. (914)735-4666. FAX: (914)735-2906. President: Yoh Jinno. Estab. 1989. Book publisher. Publishes hardcover originals. Types of books include graphic design and printing. Publishes 4 titles/year. Recent titles include *Printing Showcase I*. 30% require freelance illustration and design. Book catalog free by request.

Needs: Approached by 50 freelance artists/year. Works with 2-3 freelance illustrators and 2-3 freelance designers/year. Uses freelance artists for jacket/cover illustration and design, book design, text illustration, direct mail and catalog design. Works on assignment only.

First Contact & Terms: Send tearsheets. Some samples are filed; those not filed are not returned. Reports back only if interested. Mail appropriate materials: tearsheets. Rights purchased vary according to project. Originals are returned at job's completion.

Book Design: Assigns 2-3 freelance design projects and 2-3 freelance illustration projects/year (a project contains up to 100 illustrations). Pays by the project.

Jackets/Covers: Assigns 2-3 freelance design projects and 2-3 freelance illustration projects/year. Pays by the project.

Text Illustration: Assigns 2-3 freelance design projects and 2-3 freelance illustration projects/year. Pays by the project.

***KAR-BEN COPIES, INC.**, 6800 Tildenwood Lane, Rockville MD 20852. Editor: Madeline Wikler. Estab. 1975. Specializes in hardcovers and paperbacks on juvenile Judaica. Publishes 10-12 titles/year. Recent titles include *Two by Two: Favorite Bible Stories* and *Daddy's Chair*. 100% require freelance illustration. Book catalog free on request.

First Contact & Terms: Works with 6-8 freelance artists/year. Uses artists for children's storybooks. Send query letter with photostats or tearsheets to be kept on file or returned. Samples not filed are returned by SASE. Reports within 2 weeks only by SASE. Originals returned after job's completion. Considers skill and experience of artist and turnaround time when establishing payment. Buys all rights.

Text Illustration: Assigns 3-5 freelance jobs/year. Pays by the project, $500-3,000 average, or advance plus royalty.

Tips: "Our books include four-color illustrations to appeal to young children."

KITCHEN SINK PRESS, No. 2 Swamp Rd., Princeton WI 54968. (414)295-6922. FAX: (414)295-6878. Editor-in-Chief: David Schreiner. Estab. 1969. Book and comic book publisher. Publishes hardcover originals and reprints and trade paperback originals and reprints. Types of books include science fiction, adventure, fantasy, mystery, humor, graphic novels and comic books. Publishes 24 books and 48 comic books. Recent titles include Al Capp's *Li'l Abner*, Will Eisner's *A Life Force* and Mark Schultz's *Cadillacs & Dinosaurs*. 20% require freelance illustration; 10% require freelance design. Book catalog free by request.

First Contact & Terms: Approached by more than 100 freelance artists/year. Works with 10-20 freelance illustrators and 2-3 freelance designers/year. Buys 300 freelance illustrations/year. Prefers artists with experience in comics. Uses freelance artists mainly for covers, contributions to anthologies and new series. Also uses freelance artists for jacket/cover illustration, comic book covers and text illustration. Works on assignment only although "sometimes a submission is accepted as is." Send query letter with tearsheets, SASE and

photocopies. Samples are filed or are returned by SASE. Reports back within 3-4 weeks. Mail appropriate materials only. "We do not encourage portfolio viewing because of our remote location." Rights purchased vary according to project. Originals are returned at the job's completion.

Book Design: Assigns 2-3 freelance design and many freelance illustration jobs/year. Pays by the project, $600-1,000.

Jackets/Covers: Assigns 6-8 freelance design jobs/year. Pays by the project, $200-400. Prefers line art with color overlays.

Tips: "Dazzle us with your samples."

***KRUZA KALEIDOSCOPIX INC.**, Box 389, Franklin MA 02038. (508)528-6211. Editor: J.A. Kruza. Estab. 1980. Book publisher. Publishes hardcover and mass market paperback originals. Types of books include adventure, biography, juvenile, reference and history. Specializes in children's books for ages 3-10 and regional history for tourists and locals. Publishes 12 titles/year. Recent titles include *Lighthouse Handbook for New England*. 75% require freelance illustration. Book catalog not available.

Needs: Approached by 150 freelance artists/year. Works with 8 freelance illustrators/year. Buys 200+ freelance illustrations/year. Uses freelance artists mainly for illustrating children's books and some magazine editorial. Also uses freelance artists for text illustration. Works on assignment basis only.

First Contact & Terms: Send query letter with brochure, tearsheets, photostats and SASE. Samples are filed or returned by SASE. Reports back to the artist only if interested. To show a portfolio mail above materials. Buys all rights.

Book Design: Pays by the project.

Text Illustration: Assigns 30+ freelance illustration jobs/year. Pays $50-100/illustration. Prefers watercolor, airbrush, pastel, pen & ink.

Tips: "Submit sample color photocopies of your work every 5 or 6 months. We're looking to fit an illustrator together with submitted and accepted manuscripts. Each manuscript calls for different techniques."

LEISURE BOOKS, a division of Dorchester Publishing Co., Inc., Suite 1008, 276 5th Ave., New York NY 10001. (212)725-8811. Managing Editor: Katherine Carlon. Estab. 1970. Specializes in paperback, originals and reprints, especially mass market category fiction—historical romance, western, adventure, horror. Publishes 144 titles/year. 90% require freelance illustration.

First Contact & Terms: Buys from 24 freelance artists/year. "We work with freelance art directors; editorial department views all art initially and refers artists to art directors. We need highly realistic, paperback illustration; oil or acrylic. No graphics, fine art, representational art or photography." Works on assignment only. Send samples by mail—no samples will be returned without SASE. Reports only if samples are appropriate or if SASE is enclosed. Call for appointment to drop off portfolio. Original work returned after job's completion. Considers complexity of project and project's budget when establishing payment. Usually buys first rights, but rights purchased vary according to project.

Jackets/Covers: Pays by the project.

Tips: "Talented new artists are welcome. Be familiar with the kind of artwork we use on our covers. If it's not your style, don't waste your time and ours."

LIBRARIES UNLIMITED, Box 3988 Englewood CO 80155-3988. (303)770-1220. Marketing Director: Shirley Lambert. Estab. 1964. Specializes in hardcover and paperback original reference books concerning library science and school media for librarians, educators and researchers. Publishes 60 titles/year. 2% require freelance illustration. Book catalog free by request.

First Contact & Terms: Works with 4-5 freelance artists/year. Works on assignment only. Send query letter with resume and photocopies. Samples not filed are returned only if requested. Reports within 2 weeks. No originals returned to artist at job's completion. Considers complexity of project, skill and experience of artist, and project's budget when establishing payment. Buys all rights.

Book Design: Assigns 2-4 freelance illustration jobs/year. Pays by the project, $100 minimum.

Jackets/Covers: Assigns 60 freelance design jobs/year. Pays by the project, $250 minimum.

Tips: "We look for the ability to draw or illustrate without overly-loud cartoon techniques. We need the ability to use two-color effectively, with screens and screen builds. We ignore anything sent to us that is in four-color. We also need a good feel for typefaces, and we prefer experience with books."

LITTLE, BROWN AND COMPANY, 34 Beacon St., Boston MA 02106. (617)227-0730. Art Director: Steve Snider. Specializes in trade hardcover and paperback originals and reprints. Publishes 300 titles/year. 50% require freelance illustration.

First Contact & Terms: Works with approximately 50 freelance artists/year. Works on assignment only. Send query letter with brochure, resume, tearsheets, photostats and photographs. Samples are filed. Samples not filed are returned only if requested by artist. Reports back only if interested. Originals returned to artist at job's completion. Call to schedule an appointment to show a portfolio, which should include original/final art, tearsheets, final reproduction/product and photographs. Considers complexity of project, project's budget and turnaround time when establishing payment.

Jackets/Covers: Assigns freelance design and illustration jobs/year. Pays by the project, $700 minimum.

LLEWELLYN PUBLICATIONS, Box 64383, St. Paul MN 55164. Art Director: Terry Buske. Estab. 1901. Book publisher. Imprint of Llewellyn. Publishes hardcover originals, trade paperback originals and reprints, mass market originals and reprints and calendars. Types of books include reference, self-help, metaphysical, occult, mythology, health, women's spirituality and New Age. Publishes 60 titles/year. Recent titles include *Kundalini and Chakra Manual*; *Letting Go*; *Prediction In Astrology*; *Year of Moons*; *Season of Trees*; and *The Magical Almanac*. 60% require freelance illustration. Book catalog available for large SASE and 5 first-class stamps.
First Contact & Terms: Approached by 200 freelance artists/year. Works with 15 freelance illustrators/year. Buys 150 freelance illustrations/year. Prefers artists with experience in book covers, New Age material and realism. Uses freelance artists mainly for book covers and interiors. Works on assignment only. Send query letter with brochure, SASE, tearsheets, photographs and photocopies. Samples are filed or are returned by SASE. Reports back within 1 month, only with SASE. Negotiates rights purchased.
Jackets/Covers: Assigns 40 freelance illustration jobs/year. Pays by the illustration, $150-600. Media and style preferred "are usually realistic, well-researched, airbrush, acrylic, oil, colored pencil. Artist should know our subjects."
Text Illustration: Assigns 15 freelance illustration jobs/year. Pays by the project, or $30-100/illustration. Media and style preferred are pencil and pen & ink, "usually very realistic; there are usually people in the illustrations."
Tips: "Know what we publish and send similar samples. I need artists who are aware of occult themes, knowledgeable in the areas of metaphysics, divination, alternative religions, women's spirituality, and who are professional and able to present very refined and polished finished pieces. Knowledge of history, mythology and ancient civilization are a big plus."

LODESTAR BOOKS, an affiliate of Dutton Children's Books, 375 Hudson St., New York NY 10014. (212)366-2626. Senior Editor: Rosemary Brosnan. Publishes young adult fiction (12-16 years) and nonfiction hardcovers, fiction and nonfiction for ages 9-11 and 10-14, nonfiction and fiction picture books. Publishes 30 titles/year.
First Contact & Terms: Send query letter with samples or drop off portfolio. Especially looks for "knowledge of book requirements, previous jackets, good color, strong design, and ability to draw people and action" when reviewing samples. Prefers to buy all rights.
Jackets/Covers: Assigns approximately 10-12 jackets/year to freelancers. Pays $800 minimum, color.
Tips: In young adult fiction, there is a trend toward "covers that are more realistic with the focus on one or two characters. In nonfiction, strong, simple graphic design, often utilizing a photograph. Three-color jackets are popular for nonfiction; occasionally full-color is used."

LOOMPANICS UNLIMITED, Box 1197, Port Townsend WA 98368. Editorial Director: Steve O'Keefe. Estab. 1975. Book publisher. Publishes trade paperback originals. Types of books include instruction, reference and self-help. Specializes in crime, police science, fake I.D. and underground economy. Publishes 20 titles/year. Recent titles include *Building with Junk* and *SWAT Team Operations*. Books look "masculine, spooky and simple." 50% require freelance illustration. Book catalog available for $3.
First Contact & Terms: Approached by 10 freelance artists/year. Works with 6 freelance illustrators/year. Buys 250 freelance illustrations/year. Prefers artists with "good line drawing skills." Uses freelance artists mainly for how-to illustrations and diagrams. Also uses freelance artists for cover illustration. Works on assignment only. Send query letter with photocopies. Samples are filed. Reports back within 3 weeks. To show a portfolio, mail b&w and color tearsheets. Buys all rights. Originals are not returned at the job's completion.
Jackets/Covers: Assigns 10 freelance illustration jobs/year. Pays by the project, $100-200. Media and style preferred varies.
Text Illustration: Assigns 12 freelance illustration jobs/year. Pays per drawing, $10-20. Prefers "strong line drawings, diagrams and technical illustrations."
Tips: "Send photocopies of good line drawings. We like to see clean technical illustrations. Our pay rate is low, but payment is reliable. We're doing more two-color covers and ask artists to do simple color separation (ruby cutting) more often."

LUCENT BOOKS, Box 289011, San Diego CA 92128-9011. (619)485-7424. Managing Editor: Bonnie Szumski. Estab. 1988. Book publisher. Publishes nonfiction for libraries and classrooms. Specializes in biography, preschool, juvenile and young adult. Specializes in controversial issues and disasters. Publishes 30 titles/year. Recent titles include *Chernobyl: World Disasters*, *Irish Potato Famine* and *The Bhopal Chemical Leak*. 30% require freelance illustration. Book catalog free for SASE.
First Contact & Terms: Approached by 15-20 freelance artists/year. Works with 2-3 freelance illustrators/year. Buys 100-150 freelance illustrations/year. Prefers artists with experience in "young adult books with a realistic style in pen & ink or pencil, able to draw creatively, not from photographs." Uses freelance artists mainly for the *World Disaster* series and technical drawings for the Encyclopedia series. Also uses freelance artists for jacket/cover and text illustration. Works on assignment only. Send query letter with resume, tear-

sheets and photocopies. Samples are filed. Reports back to the artist only if interested. To show a portfolio, mail appropriate materials. Buys all rights. Originals are not returned at the job's completion.

Book Design: Pays by the project.

Jackets/Covers: Pays by the project.

Text Illustration: Assigns 8-10 freelance illustration jobs/year. Pays by the project. Prefers pencil and pen & ink.

Tips: "We have a very specific style in mind and can usually tell immediately from samples whether or not the artist's style suits our needs."

For this biography of George Sanders, Giséle Marie Byrd, vice president, design of Madison Books "wanted a design that would reflect the elegance of the actor, and type that would be from the period when he was at the height of his stardom." Impressed with Richard Rossiter's samples and "handwritten, friendly, casual note," she opted to give the assignment to this Fairfield, Connecticut-based designer. The assignment she says, "couldn't have run smoother." For the piece Rossiter was given the photo and Byrd's comments on the "feel" she was seeking. She praises the fact that Rossiter is "patient in the face of type changes and produces mechanicals that are impeccably prepared."

© Madison Books 1990

MADISON BOOKS, 4720 Boston Wy., Lanham MD 20706. (301)459-5308. FAX: (301)459-2118. Vice President, Design: Gisele Byrd. Estab. 1984. Book publisher. Publishes hardcover and trade paperback originals. Types of books include biography, history, and books about popular culture and current events. Specializes in biography, history and popular culture. Publishes 16 titles/year. Recent titles include *Peace Without Hiroshima, George Sanders: An Exhausted Life* and *Through a Fiery Trial*. 40% require freelance illustration; 100% require freelance jacket design. Book catalog free by request.

First Contact & Terms: Approached by 20 freelance artists/year. Works with 4 freelance illustrators and 12 freelance designers/year. Buys 2 freelance illustrations/year. Prefers artists with experience in book jacket design. Uses freelance artists mainly for book jackets. Also uses freelance artists for book and catalog design. Works on assignment only. Send query letter with tearsheets, photocopies and photostats. Samples are filed or are returned by SASE if requested by artist. Reports back to the artist only if interested. Call to schedule an appointment to show a portfolio which should include roughs, original/final art, tearsheets, photographs, slides and dummies. Buys all rights.

Book Design: Assigns 2 freelance design and 2 freelance illustration jobs/year. Pays by the project, $1,000-2,000.

Jackets/Covers: Assigns 16 freelance design and 2 freelance illustration jobs/year. Pays by the project, $300-5,000. Prefers typographic design, photography and line art.

Text Illustration: Pays by project, $50-300.

Tips: "We are looking for an ability to produce trade-quality designs within a limited budget. Books have large type, clean lines, covers that 'breathe'. If you have not designed jackets for a publishing house but want to break into that area, have at least five 'fake' titles designed to show ability. I would like to see more Eastern European style incorporated into American design. It seems like typography on jackets is becoming more

assertive, as it competes for attention on bookstore shelf. Also, a trend is richer colors, use of metallics."

METAMORPHOUS PRESS INC., 1136 NW Hoyt, Box 10616, Portland OR 97210. (503)228-4972. Publisher: David Balding. Estab. 1982. Specializes in hardcover and paperback originals, general trade books, mostly nonfiction and self-help. "We are a general book publisher for a general audience in North America." Publishes at least 5 titles/year. 1% require freelance illustration. Recent titles include *Self Rescue*; *Sales: The Mind's Side*; *Classroom Magic*; *Beliefs and Magic of NLP Demystified*. Publishes books with "nonfiction trade, mostly text/typograpy, very legible look."

First Contact & Terms: Approached by 200 freelance artists/year. Works with 0-1 freelance designers and 0-1 freelance illustrators/year. "We're interested in what an artist can do for us – not experience with others." Works on assignment only. Send query letter with brochure, business card, photostats, photographs, and tearsheets to be kept on file. Samples are not returned. Reports within a few days usually. Considers complexity of project and project's budget when establishing payment. Rights purchased vary according to project.

Book Design: Rarely assigns freelance jobs. "We negotiate payment on an individual basis according to project."

Jackets/Covers: Will possibly assign 0-1 jobs in both freelance design and freelance illustration this year. Payment would vary as to project and budget.

Text Illustration: Assigns 0-1 freelance jobs/year. Payment varies as to project and budget.

Tips: "We rarely, if ever, use freelance illustrators and would probably use a local artist over others. Amost all art is supplied to us by our authors, or our inhouse graphic designer creates computer generated artwork.

© Sharon Brown

These are two in a series of illustrations for Tokens of Grace, *published by Milkweed Editions. The black-and-white charcoal on grey paper drawings were done by Sharon Brown of Minneapolis and capture "the survival techniques of a young girl growing up within a broken family," says art director R.W. Scholes. During Brown's portfolio showing, Scholes liked the way "her interest in human relationships showed in her work, [the way] her heart, mind and hand were focused on the subject." Brown was instructed to read the book, propose sketches and create the final drawings all within a six-week period.*

MILKWEED EDITIONS, Suite 505, 528 Hennepin, Minneapolis MN 55403. (612)332-3192. Art Director: R.W. Scholes. Estab. 1979. Book publisher. Publishes hardcover and trade paperback originals. Types of books include contemporary and historical fiction, poetry, essays, visual and collaborations. Specializes in contem-

porary subjects. Publishes 10-12 titles/year. Recent titles include *Aquaboogie* and *Agassiz*. 70% require free-lance illustration; 20% require freelance design. Book catalog available for SASE with 75¢ first-class stamps.

First Contact & Terms: Approached by 20 freelance artists/year. Works with 4 freelance illustrators and designers/year. Buys 50 freelance illustrations/year. Prefers artists with experience in book illustration. Uses freelance artists mainly for fiction and poetry jacket/cover illustration and text illustration. Works on assignment only. Send query letter with resume, SASE and tearsheets. Samples are filed or are returned by SASE if requested by artist. Reports back within 4-6 weeks. Call to schedule an appointment to show a portfolio, which should include best possible samples. Rights purchased vary according to project. Originals returned at the job's completion.

Book Design: Assigns 80 freelance illustration jobs/year. Pays by the project, $250 minimum.

Jackets/Covers: Assigns 4 freelance illustration jobs/year. Pays by the project, $50 minimum. "Prefer a range of different media—according to the needs of each book."

Text Illustration: Assigns 20 freelance illustration jobs/year. Pays by the project, $25 minimum. Prefers various mediums and styles.

Tips: "Show quality drawing ability, narrative imaging and interest—call back."

***MODERN CURRICULUM PRESS**, 13900 Prospect Rd., Cleveland OH 44136. (216)238-2222. Art Director: Catherine Wahl. Specializes in supplemental text books, readers and workbooks. Publishes 100 titles/year. Also needs local artists for advertising and mechanicals.

First Contact & Terms: All freelance. Works on assignment only. Send resume and tearsheets of illustrative style to be kept on file; "no slides." Samples not kept on file are returned by SASE. Reports back only if interested. Buys all rights.

Book Design: Pays by the hour, $12 minimum.

Jackets/Covers: Pays by the project, $50 minimum.

Text Illustration: Prefers animated real life themes, "nothing too cartoony; must be accurate." Pays by the project; payment varies.

Tips: Looks for "professional, serious illustrators who know production techniques and can supply comprehensive sketches through final art within deadlines. Books are competing with video—they need to be more visually stimulating. We look for artists with a more original 'style'—creative solutions to size and color restrictions."

MODERN PUBLISHING, 155 E. 55th St., New York NY 10022. (212)826-0850. Art Director: Harriet Sherman. Specializes in children's hardcovers, paperbacks and coloring books. Publishes approximately 100 titles/year. Recent titles include *Reader Teady* and *New Kids on the Block*.

First Contact & Terms: Approached by 10-30 freelance artists/year. Works with 15 freelance artists/year. Works on assignment only. Send query letter with resume and samples. Samples not filed are returned only if requested. Reports only if interested. Original work not returned at job's completion. Considers turnaround time and rights purchased when establishing payment. Buys all rights.

Jackets/Covers: Pays by the project, $100-200 average, cover, "usually 4 books per series."

Text Illustration: Pays by the project, $15-20 average, page (line art), "48-382 pages per book, always 4 books in series."

Tips: "Do not show samples which don't reflect the techniques and styles we use. Reference our books and book stores to know our product line better."

WILLIAM MORROW & CO. INC., (Lothrop, Lee, Shepard Books), 1350 Avenue of the Americas, New York NY 10019. (212)261-6642. Art Director: Cindy Simon. Specializes in hardcover originals and reprint children's books. Publishes 70 titles/year. 100% require freelance illustration. Book catalog free for 8½×11" SASE with 3 first-class stamps.

First Contact & Terms: Works with 30 freelance artists/year. Uses artists mainly for picture books and jackets. Works on assignment only. Send query letter with resume and samples, "followed by call." Samples are filed. Reports back within 3-4 weeks. Originals returned to artist at job's completion. Portfolio should include original/final art and dummies. Considers complexity of project and project's budget when establishing payment. Negotiates rights purchased.

Book Design: "Most design is done on staff." Assigns 1 or 2 freelance design jobs/year. Pays by the project.

Jackets/Covers: Assigns 1 or 2 freelance design jobs/year. Pays by the project.

Text illustration: Assigns 70 freelance jobs/year. Pays by the project.

Tips: "Be familiar with our publications."

MOSAIC PRESS MINIATURE BOOKS, 358 Oliver Rd., Cincinnati OH 45215. (513)761-5977. Publisher: Miriam Irwin. Estab. 1977. Book publisher. Publishes hardcover originals. Types of books include miniature books. Publishes 4 titles/year. Recent titles include *Trees of Minnesota* and *Victorian Christmas*. 100% require freelance illustration. Book catalog free for SASE with 52¢ first-class stamps. "Ask for artists' guide."

First Contact & Terms: Approached by 12 freelance artists/year. Works with 2 freelance illustrators/year. Prefers local artists, but not necessarily. Uses freelance artists mainly for pen & ink drawings. Also uses freelance artists for text illustration. Works on assignment only. Send query letter which includes phone number with SASE and photocopies of pen & ink illustrations under 6″. Samples are not filed and are returned by SASE if requested by artist. Reports back within 2 weeks, if SASE enclosed. Call to schedule an appointment to show portfolio which should include pen & ink only. Buys one-time rights. Originals are sometimes returned at the job's completion.

Book Design: Pays by the project.

Jackets/Covers: Assigns 5 freelance illustration jobs/year. Pays by the project, ($50, 1 copy of the book and 40% discount on all Mosaic Press books). Prefers b&w pen & ink under 6″. "They must reduce well."

Text Illustration: Assigns 10 freelance illustration jobs/year. Pays by the project, $50, 5 copies of the book and 40% discount on all Mosaic Press books. Prefers b&w pen and ink under 6″ tall.

***MOUNTAIN PRESS PUBLISHING CO.,** 2016 Strand Ave., Missoula MT 59801. (406)728-1900. FAX: (406)728-1635. Production Coordinator: John Rimel. Estab. 1948. Book publisher. Publishes hardcover and trade paperback originals and hardcover and trade paperback reprints. Publishes history, travel, natural history, science and geology. Specializes in regional history and regional geology. Publishes 12 titles/year. Recent titles include *Roadside Geology of Texas* and *Birds of the Central Rockies*. 40% require freelance illustration. 25% require freelance design. Book catalog free by request.

Needs: Approached by 25 freelance artists/year. Works with 5 freelance illustrators and 2 freelance designers/ year. Buys up to 5 freelance illustrations/year. Prefers local artists only. Uses freelance artists mainly for cover art and design, some chapter vignettes, maps. Also uses freelance artists for jacket/cover illustration and design and book design. Works on assignment only.

First Contact & Terms: Send query letter with photographs and photocopies. Samples are filed or are returned by SASE if requested by artist. Reports back to the artist only if interested. Write to schedule an appointment to show a portfolio. Portfolio should include thumbnails, b&w photostats and tearsheets. Rights purchased vary according to project. Originals returned at job's completion.

Book Design: Assigns 2-3 freelance design jobs and 4-5 freelance illustration jobs/year. Pays by the project, $50-400.

Jackets/Covers: Assigns 2-3 freelance design jobs and 5-6 freelance illustration jobs/year. Pays by the project, $100-400. Prefers original oil, watercolor or pen & ink painting (transparency of painting) for jacket/cover design and illustration.

Text Illustration: Assigns 0-2 freelance design jobs and 0-5 freelance illustration jobs/year. Pays by the project, $50-1,000. Prefers b&w illustration, computer generated artwork.

JOHN MUIR PUBLICATIONS, Box 613, Santa Fe NM 87504. (505)982-4078. President: Steven Cary. Publishes trade paperback nonfiction. "We specialize in travel books, auto repair manuals, children's books, environmental and parenting books and are always actively looking for new illustrations in these fields." Prefers pen & ink, colored pencil, acrylic and calligraphy. Publishes 50 titles/year. Recent titles include *The Kids' Environment Book*, *Extremely Weird Frogs* and *Teens: A Fresh Look*.

First Contact & Terms: Works with 10-15 freelance illustrators/year and 3-4 freelance designers/year. Prefers local artists. Send query letter with resume and samples to be kept on file. Write for appointment to show portfolio. Accepts any type of sample "as long as it's professionally presented." Samples not filed are returned by SASE. Originals not returned at job's completion. Pays for book design by the hour, $20-25; by the project, $200-$350; or pays $350 for initial design and $15/each additional hour. Pays for jackets/covers by the prjoect, $200-$350. Pays for text illustration by the hour, $20 or offers royalty. Considers complexity of project, skill and experience of artist, project's budget, turnaround time and rights purchased when establishing payment. Buys all rights.

Jackets/Covers: Assigns 25-30 freelance design and freelance illustration jobs/year, mostly 4-color. Pays by the project, $250 minimum.

Text Illustration: Assigns 20 freelance jobs/year. Usually prefers pen & ink. Negotiates payment.

NBM PUBLISHING CO., Suite 1502, 185 Madison Ave., New York NY 11372. (212)545-1223. Publisher: Terry Nantier. Publishes graphic novels including *The Silent Invasion* and *Vic & Blood* for an audience of 18-24 year olds. Genres: adventure, fantasy, mystery, science fiction, horror and social parodies. Themes: science fiction, fantasy, mystery and social commentary. Circ. 5-10,000. Original artwork returned after publication.

Book Design: Approached by 60-70 freelance artists/year. Works with 6 freelance designers/year. Uses freelance artists for lettering, paste-up, layout design and coloring. Prefers pen & ink, watercolor and oil for graphic novels submissions. Send query letter with resume and samples. Samples are filed or are returned by SASE. Reports back within 2 weeks. To show a portfolio, mail photocopies of original pencil or ink art. Pays by the project, $200 minimum.

Tips: "We are interested in submissions for graphic novels. We do not need illustrations or covers only!"

THE NEW ENGLAND PRESS, Box 575, Shelburne VT 05482. (802) 863-2520. Managing Editor: Mark Wanner. Specializes in paperback originals on regional New England subjects, nature. Publishes 12 titles/year; 60% require freelance illustration. Recent titles include *Yankee Wisdom: New England Proverbs*, *Star in the Shed Window* and *Poetry of James Hayford*.
First Contact & Terms: Approached by 20+ freelance artists/year. Works with 6-8 freelance artists/year. Northern New England artists only. Send query letter with brochure showing art style or resume. Samples are filed. Reports back only if interested. Originals not usually returned to artist at job's completion, but negotiable. To show a portfolio, mail "anything that shows talent." Considers complexity of project, skill and experience of artist, project's budget and turnaround time when establishing payment. Negotiates rights purchased.
Book Design: Assigns 8-10 freelance design and 6-8 freelance illustration jobs/year. Payment varies.
Jackets/Covers: Assigns 4-5 freelance illustration jobs/year. Payment varies.
Text Illustration: Assigns 6-8 freelance jobs/year. Payment varies.
Tips: The most common mistake illustrators and designers make in presenting their work is "they never write a query letter—they just send stuff." Design and illustrations are "more folksy than impressionistic."

NEW READERS PRESS, 1320 Jamesville Ave., Syracuse NY 13210. Art Director: Steve Rhodes. Estab. 1960. Publishes trade paperback originals and textbooks. Publishes nonfiction and fiction: instructional, educational history, romance, historical, mainstream/contemporary. Specializes in reading and writing for young adult and adult new readers. Publishes 20-30 titles/year. 20% require freelance illustration; 0-5% freelance design. Book catalog free for request.
First Contact & Terms: Works with 5-10 freelance illustrators and 3-5 freelance designers/year. Buys 50-100 freelance illustrations/year. Works with illustrators mainly for spots and technical illustration. Also uses artists for jacket/cover and text illustration. Works on assignment only. Send query letter with tearsheets, photostats and SASE. Samples are filed or are returned by SASE only if requested. Reports back only if interested. Call or write to schedule an appointment to show a portfolio, which should include roughs, original/final art, photographs and transparencies (2¼″ or 4×5). Considers complexity of project, project's budget and turnaround time when establishing payment. Buys one-time rights; negotiates rights purchased.
Book Design: Assigns 3-5 freelance design and 10-15 freelance illustration jobs/year. Pays by hour, $10-50.
Jackets/Covers: Assigns 3-5 freelance design and 5-10 freelance illustration jobs/year. Prefers contemporary themes. Pays by the hour, $10-50; by the project, $100-500.
Text Illustration: Assigns 10-20 freelance jobs/year. Prefers b&w pen, pencil, watercolor, wash, etc. "Often illustrations include figures of people with a variety of ethnic and cultural backgrounds." Pays by the hour, $10-25; by the project, $10-150.
Tips: Looks for "flexibility in style or medium. We appreciate clean and fresh artwork from artists with little experience to 'seasoned pros.' Send photocopies of artwork. We especially like to work with artists in central New York area due to easier communication and faster turnaround."

NEW WORLD LIBRARY, 58 Paul Dr., San Rafael CA 94903. (415)472-2100. Editor: Katherine Dieter. Book publisher. Types of books include instruction and self-help. Specializes in psychology, philosophy and self-improvement. Publishes 4 titles/year. 25% require freelance illustration; 100% require freelance design. Book catalog free for request.
First Contact & Terms: Works with freelance artists for jacket/cover illustration and design, book and catalog design and text illustration. Works on assignment only. Send query letter with brochure, resume, tearsheets and SASE. Samples are filed or are returned by SASE only if requested. Reports back only if interested. Originals are not returned at job's completion unless requested. Write to schedule an appointment to show a portfolio, which should include original/final art, tearsheets and final reproduction/product. Negotiates rights purchased.
Book Design: Assigns 10 freelance design and 1 freelance illustration jobs/year. Pays by the project, $350 and up.
Jackets/Covers: Assigns 10 freelance design and 1 freelance illustration jobs/year. Pays by the project, $800 and up.
Text Illustration: Assigns 1 freelance job/year. Pays by the hour, $15.

NEWBURY HOUSE, 10 E. 53rd St., New York NY 10022. (212)207-7373. Production Coordinator: Cynthia Funkhouser. Specializes in textbooks emphasizing English as a second language. Publishes 28 titles/year; 50% require freelance illustration. Recent titles include *Grammar in Action: An Illustrated Workbook* and *At Home in Two Lands: Intermediate Reading and Word Study*.
First Contact & Terms: Works with 14 freelance illustrators and 10 freelance designers/year. Works on assignment only. Send query letter with resume and photocopies. Samples are filed and are not returned. Reports back only if interested. Originals not returned at job's completion. Write to schedule an appointment to show a portfolio, which should include roughs, original/final art and final reproduction/product. Considers skill and experience of artists and project's budget when establishing payment. Buys all rights.

Book Design: Assigns 12 freelance design jobs/year. Pays by the project, $200 and up.

Text Illustration: Assigns 14 freelance jobs/year. Prefers line art and ink drawings. Pays per illustration or per project, $20 and up.

Tips: "Designers should have experience in el-hi and/or college book design with samples available to show. Artists should be able to show photocopies of published tearsheets. We use both cartoons and serious illustrations. We seek artists who are able to portray a broad range of ethnic identities in their drawings." A common mistake is that "the look of the illustrations is frequently too juvenile for our books; these books are for adults. Also they should not be confusing or offensive to students from other cultures."

NORTHWOODS PRESS, Box 88, Thomaston ME 04861. Editor: Robert Olmsted. Part of the Conservatory of American Letters. Estab. 1972. Specializes in hardcover and paperback originals of poetry. Publishes approximately 12 titles/year. 10% require freelance illustration. Recent titles include *Dan River Anthology, 1990*; *Looking for the Worm* and *Bound*. Book catalog for SASE.

First Contact & Terms: Approached by 40-50 freelance artists/year. Works with 3-4 freelance illustrators and 3-4 freelance designers/year. Send query letter to be kept on file. Reports within 10 days. Originals returned to artist at job's completion. Considers complexity of project, skill and experience of artist, project's budget, turnaround time and rights purchased when establishing payment. Buys one-time rights and occasionally all rights.

Jackets/Covers: Assigns 4-5 freelance design jobs and 4-5 freelance illustration jobs/year. "The author provides the artwork and payment."

Tips: Portfolio should include "art suitable for book covers—contemporary, usually realistic."

***NORTHWORD PRESS, INC.**, Box 1360, Minocqua WI 54548. (715)356-9800. FAX: (715)356-9762. Art Director: Mary Shafer. Estab. 1984. Book publisher with 3 imprints: Northword (coffee-table books); Heartland (regional); Willow Creek (hunting/fishing). Publishes hardcover originals and reprints and trade paperback originals and reprints. Types of books include juvenile, history, travel, natural histories and nature guides. Specializes in nature, wildlife, hunting/fishing and environmental. Publishes about 40 titles/year. Recent titles include *The Great American Bear, With the Whales* and *Buck Fever*. 20% require freelance illustration. 80% require freelance design. Book catalog free by request.

Needs: Approached by 10-15 freelance artists/year. Works with 1-2 freelance illustrators and 3-4 freelance designers/year. "Several cartoon books are purchased as complete packages; we commission packages of 30-40 illustrations for 1-2 titles/year, possibly a cover here and there. Most books are illustrated with photos. We also use freelancers for design of silkscreened t-shirts and mugs." Prefers artists with experience in wildlife/hunting art. Uses freelance artists mainly for book and advertising design. Also uses freelance artists for jacket/cover illustration and design, book and direct mail design, and text illustration. Works on assignment only.

First Contact & Terms: Send query letter with brochure, SASE, tearsheets, photographs, photocopies, photostats, slides and transparencies. "No originals, and make sure they fit in standard-size folders." Samples are filed or are returned by SASE. Reports back only if interested. "I prefers samples mailed and will call to contact the artist if I want to see a portfolio." Negotiates rights purchased. Originals are returned at job's completion "unless we purchase all rights."

Book Design: Assigns 20-30 freelance design jobs and 1-2 freelance illustration jobs/year. Pays by the project, $1,500-6,000.

Jackets/Covers: Assigns 20-30 freelance design jobs and 1-2 freelance illustration jobs/year. Pays by the project, $50-500. Prefers good type design, usually with provided photos. Cover illustration can be done in any color media that can meet the deadline.

Text Illustration: Assigns 20-30 freelance design jobs and 1-2 freelance illustration jobs/year. Pays by the project, $50-2,000. Prefers pen & ink or wash, some charcoal. "We also do b&w and full-color cartoon books, which should be submitted as full book packages to editor-in-chief."

Tips: "I usually make decisions about who I'm going to work with for books in February and in September/October. Sales materials are assigned throughout the year. I need calligraphers—good, professional ones."

OCTAMERON PRESS, 1900 Mount Vernon Ave., Alexandria VA 22301. Editorial Director: Karen Stokstod. Estab. 1976. Specializes in paperbacks—college financial and college admission guides. Publishes 10-15 titles/year. Recent titles include *College Match* and *Financial Aid Financer*.

First Contact & Terms: Approached by 25 freelance artists/year. Works with 1-2 freelance artists/year. Local artists only. Works on assignment only. Send query letter with brochure showing art style or resume and photocopies. Samples not filed are returned. Reports within 1 week. Original work returned at job's completion. Considers complexity of project and project's budget when establishing payment. Rights purchased vary according to project.

Jackets/Covers: Works with 1-2 freelance designers and illustators/year on 15 different projects. Pays by the project, $300-700.
Text Illustration: Works with variable number of freelance artists/year. Prefers line drawings to photographs. Pays by the project, $35-75.
Tips: "The look of the books we publish is friendly! We prefer humorous illustrations."

ODDO PUBLISHING, INC., Box 68, Fayetteville GA 30214. (404)461-7627. Vice President: Charles W. Oddo. Estab. 1964. Specializes in hardcovers of juvenile fiction. Publishes 6-10 titles/year; 100% require freelance illustration. Recent titles include *Wrongway Santa*. "Our books invite the browser to open them and read." Prefers cartoon and/or realistic work, airbrush, watercolor, acrylic and oil. Book catalog free for SASE with $1.25 first class stamps.
First Contact & Terms: Approached by over 300 freelance artists/year. Works with 3 freelance illustrators and 3 freelance designers/year. Send query letter with brochure, resume, business card or tearsheets to be kept on file. Accepts "whatever is best for artist to present" as samples. Samples not kept on file are returned by SASE only if requested. Reports back only if interested. Works on assignment only. Write for appointment to show portfolio. No originals returned to artist at job's completion. Buys all rights.
Book Design: Assigns 3 freelance jobs/year. Pays for illustration and design combined by the project, $250 minimum.
Text Illustration: Assigns 3 freelance jobs/year. Pays by the project, $250. Artwork purchased includes science fiction/fantasy.
Tips: Portfolio should include "human form to show that artist can illustrate accurately. Chances are if an artist can illustrate people that look real, his or her talents are highly refined. We also look for quality cartoon-illustrating ability. We expect to see various styles to indicate the artist's versatility. Our artwork relates the feeling of the story as if text was not present."

ONCE UPON A PLANET, INC., 65-28 Fresh Meadow Lane, Fresh Meadows NY 11365. Art Director: Alis Jordan. Estab. 1978. Publishes humorous, novelty 32-page-books for the gift and stationery market. Recent titles include *Over 40 Quiz Book* and *Golfer's Prayer Book*. Uses artists for text illustration only.
First Contact & Terms: Approached by 200 freelance artists/year. Send samples showing art style. Works on assignment only. If originals are sent, SASE must be enclosed for return. Reports in 2-4 weeks. Prefers to buy all rights, but will negotiate. Payment is negotiated on an assignment basis.
Text Illustration: Assigns 5-10 freelance jobs/year. Uses b&w line drawings and washes.
Tips: "Samples should include a very small selection of b&w humorous illustrations with or without washes similar to those found in the *New Yorker* magazine. We are not interested in fine art, animals, calligraphy, 'cute' children's books, etc."

ORCHARD BOOKS, 387 Park Ave. S., New York NY 10016. (212)686-7070. Publisher: Norma Jean Sawicki. Book publisher. Division of Franklin Watts. Estab. 1987. Publishes hardcover childrens books only. Specializes in picture books and novels for children and young adults. Also publishes nonfiction for young children. Publishes 50 titles/year. 100% require freelance illustration; 50% freelance design. Book catalog free for SASE with 2 first-class stamps.
First Contact & Terms: Works with 50+ freelance illustrators/year. Works on assignment only. Send query letter with brochure, tearsheets slides and transparencies. Samples are filed or are returned by SASE only if requested. Reports back about queries/submissions only if interested. Originals returned to artist at job's completion. Call or write to schedule an appointment or mail appropriate materials to show a portfolio, which should include thumbnails, tearsheets, final reproduction/product, slides and dummies or whatever artist prefers. Considers complexity of project, skill and experience of artist and project's budget when establishing payment. Buys all rights.
Book Design: Assigns 50 freelance design jobs/year. Pays by the project, $650 minimum.
Jackets/Covers: Assigns 25 freelance deisgn jobs/year. Pays by the project, $650 minimum.
Text Illustration: Assigns 50 freelance jobs/year. Pays by the project, minimum $2,000 advance against royalty.
Tips: Send a "great portfolio."

***OREGON HISTORICAL SOCIETY PRESS**, 1230 SW Park Ave., Portland OR 97205. (503)222-1741. FAX: (503)221-2035. Book Designer: George T. Resch. Production Manager: Susan Applegate. Estab. 1873. A Nonprofit book publisher, part of Oregon Historical Society. Publishes hardcover and trade paperback originals and reprints. Types of books include instructional, biography, juvenile, reference and history. Specializes in history of the Oregon Country (territory) North Pacific Rim. Publishes 15-18 titles/year. Recent titles include *Bering's Search for the Strait* and *Ranald MacDonald, 1824-1894*. 90% require freelance illustration. 5% require freelance design. Book catalog free by request.
Needs: Approached by 15-20 freelance artists/year. Works with 5-8 freelance illustrators/year. Buys 30-60 freelance illustrations/year. Prefers artists with experience in books and maps. Uses freelance artists mainly for maps. Also uses freelance artists for jacket/cover illustration and design, text illustration, maps, jacket/

cover mechanicals, catalog mechanicals and retouching. Works on assignment only.

First Contact & Terms: Send query letter with resume, SASE, tearsheets, photocopies and transparencies. Samples are filed or are returned by SASE. Call to schedule an appointment to show portfolio. Rights purchased vary according to project, but mostly one-time rights. Originals are returned at job's completion.

Book Design: Assigns 1 freelance design job/year. Assigns 20-25 freelance illustration jobs/year. Pays by the hour, $10-30.

Jackets/Covers: Assigns 1 freelance design job and 4-5 freelance illustration jobs/year. Pay by the hour, $10-30; by the project for cover/poster illustration, $800 maximum.

Text Illustration: Assigns 15 freelance illustration jobs/year. Pays by the hour, $10-30; by the project for multiple illustrations, $1,500 maximum.

Tips: "Have book publishing experience, a love of books and a love of history—particularly this region's."

OTTENHEIMER PUBLISHERS, INC., 300 Reisterstown Rd., Baltimore MD 21208. (301)484-2100. Art Director: Bea Jackson. Estab. 1890. Specializes in mass market-oriented hardcover, trade and paperback originals—cookbooks, children's, encyclopedias, dictionaries, novelty and self-help. Publishes 200 titles/year. 80% require freelance illustration.

First Contact & Terms: Works with 25-35 freelance illustrators and 5-10 freelance designers/year. Prefers professional graphic designers and illustrators. Works on assignment only. Send query letter with resume, slides, photostats, photographs, photocopies or tearsheets to be kept on file. Samples not filed are returned by SASE. Reports back only if interested. Call or write for appointment to show portfolio. "I do not want to see unfinished work, sketches, or fine art such as student figure drawings." Original work not returned at job's completion. Considers complexity of project, project's budget and turnaround time when establishing payment. Buys all rights.

Book Design: Assigns 20-40 freelance design jobs/year and over 100 illustration jobs/year. Pays by the project, $200-2,000 average.

Jackets/Covers: Assigns over 25 freelance design and over 25 freelance illustration jobs/year. Pays by the project, $100-1,000 average, depending upon project, time spent and any changes.

Text Illustration: Assigns over 30 jobs/year. Prefers any full color media with a lesser interest in b&w line work. Prefers graphic approaches as well as very illustrative. "We cater more to juvenile market." Pays by the project, $200-4,000 average.

Tips: Prefers "art geared towards children, clean work that will reproduce well. I also look for the artist's ability to render children/people well, which is a problem for some. We use art that is realistic, stylized and whimsical but not cartoony. The more samples, the better."

OXFORD UNIVERSITY PRESS, English Language Teaching (ESL), 9th Floor, 200 Madison Ave., New York NY 10016. Art Buyer: Paula Radding. Estab. 1584. Specializes in textbooks emphasizing English language teaching. Also produces wall charts, picture cards, etc. Recent titles include *Crossroads 1* and *Grover's Orange Book*. Books are fully illustrated contemporary textbooks.

First Contact & Terms: Approached by about 300 freelance artists/year. Works with 75 freelance illustrators and 2 freelance designers/year. Uses artists mainly for editorial illustration. Works on assignment only. Send query letter with brochure, resume, tearsheets, photostats, slides or photographs. Samples are filed. Reports back only if interested. Originals returned to artist at job's completion. Considers complexity of project, skill and experience of artist and project's budget when establishing payment. Artist retains copyright.

Text Illustration: Assigns 75-100 freelance jobs/year. Uses "black line, half-tone and 4-color work in styles ranging from cartoon to realistic. Our greatest need is for natural, contemporary figures from all ethnic groups, in action and interaction." Pays for text illustration by the project, $45/spot, 500 maximum/full page.

Jackets/Covers: Pays by the project, $250-2,000.

Tips: "Please wait for us to call you. You may send new samples to update your file at any time. Do not send wildlife/botanical samples and political cartoons, both of which we never use. Show us people in your illustration samples. We would like to see more natural, contemporary, non-white people from freelance artists."

***PACIFIC PRESS PUBLISHING ASSOCIATION,** 1350 North Kings Rd., Nampa ID 83687. (208)465-2500. FAX: (208)465-2531. Art Coordinator: George Deree. Estab. 1875. Book and magazine publisher. Publishes hardcover and trade paperback originals and textbooks. Types of books include instructional, adventure, mystery, biography, pre-school, juvenile, young adult, reference, history, self-help, cookbooks and religious books. Specializes in Christian lifestyles, Christian outreach. Publishes 35-45 titles/year. Recent titles include *Lindy Chamberlain: The Full Story; Lyrics of Love: God's Top Ten; Jumping off the Retirement Shelf; Saigon: the Final Days.* 70% require freelance illustration. Book catalog available.

Needs: Approached by 150 freelance artists/year. Works with 60 freelance illustrators/year. Buys 550 freelance illustrations/year. Uses freelance artists mainly for illustration for magazines and book covers. Also uses freelance artists for text illustration. Works on assignment basis only.

First Contact & Terms: Send query letter with brochure, tearsheets, photographs and photocopies. Samples are filed or are returned by SASE if requested. Reports back to the artist only if interested. To show a portfolio, mail original/final art and b&w and color tearsheets. Rights purchased vary according to project. Originals are returned at job's completion.

Book Design: Assigns 5 freelance illustration jobs for book interiors/year. Pays by the project, $50-250.

Jackets/Covers: Assigns 40 freelance illustration jobs/year. Pays by the project, $350-700. Preferred media style varies widely.

Text Illustration: Assigns 5 freelance illustration jobs/year. Pays by the project, $50-250. Prefers b&w realism.

Tips: "Demonstrate an illustration style suitable for the project and have access to a fax machine. Then, consistency of style and timeliness of delivery are the best ways to continue receiving projects."

***PALADIN PRESS,** Box 1307, Boulder CO 80306. (303)443-7250. Art Director: Amy Craddock. Estab. 1970. Book publisher. Publishes hardcover originals, and trade paperback originals and reprints. Types of books include instructional, self-help, military, self-defense and revenge. Specializes in knives, self-defense and weapons. Publishes 36 titles/year. Recent titles include *Combat Ammo of the 21st Century, Homemade Grenade Launches, Homemade Semtex, Power of Positive Revenge* and *Master Bladesmith*. 1% require freelance illustration. Book catalog available for $1.

Needs: Approached by 20-30 freelance artists/year. Works with 1 freelance illustrator/year. Buys 5 freelance illustrations/year. Prefers local artists only, with experience in b&w line drawings (ink preferred). Uses freelance artists mainly for spot illustrations. Also uses freelance artists for text illustration. Works on assignment only.

First Contact & Terms: Send query letter with resume, SASE and photocopies. Samples are not filed and are returned by SASE if requested by artist. Reports back within 1 week. Write to schedule an appointment to show a portfolio. Portfolio should include b&w samples and original/final art. Buys all rights. Originals are not returned at job's completion.

Book Design: Assigns 1 freelance illustration job/year. Pays by the illustration, $30-40.

Text Illustration: Assigns 1 freelance illustration job/year. Pays by the illustration, $30-40. Prefers b&w line drawings, preferrably ink.

Tips: "Be located in Boulder, Colorado area, otherwise don't bother to apply."

***PARADIGM PUBLISHING INTERNATIONAL,** 7500 Flying Cloud Dr., Minneapolis MN 55344. (612)941-4111. Production Director: Joan Silver. Estab. 1989. Book publisher. Publishes textbooks. Types of books include instructional, self-help and computer instructional manuals. Specializes in basic computer skills. Publishes 80 titles/year. Recent titles include *MS/PC Dos Made Easy* and *Keyboarding and Applications*. 100% require freelance illustration and design. Book catalog free by request.

Needs: Approached by 50-75 freelance artists/year. Works with 14 freelance illustrators and 20 freelance designers/year. Buys 40 freelance illustrations/year. Uses freelance artists mainly for covers and text design. Works on assignment only.

First Contact & Terms: Send brochure and slides. Samples are filed. Slides are returned. Reports back only if interested. Write to schedule an appointment to show a portfolio or mail appropriate materials: b&w and color transparencies. Rights purchased vary according to project.

Book Design: Assigns 10 freelance design jobs and 30 freelance illustration jobs/year. Pays by the project, $500-1,000.

Jackets/Covers: Assigns 80 freelance design jobs and 30 freelance illustration jobs/year. Pays by the project, $400-1,500.

Text Illustration: Pays $20-75 per illustration.

PARAGON HOUSE, 90 5th Ave., New York NY 10011. (212)620-2820. Art Director: Susan Newman. Estab. 1982. Publishes trade hardcover and softcover originals, textbooks and reprints. Publishes biography, history, New Age, reference, self-help, parenting, technical, collected poems and collected letters. Publishes approximately 100 titles/year. 25-30% require freelance illustration; 50% require freelance design. Recent titles include *Fragments of a Journal, Interpreting Your Child's Handwriting* and *Drawings, Adventures in Arabia*.

First Contact & Terms: Approached by 100+ freelance artists/year. Works with 25+ freelance illustrators and 20+ freelance designers/year. Buys 25+ freelance illustrations/year. Works with illustrators mainly for jacket design and maps. Works on assignment only. Send query letter with tearsheets, slides, photographs, brochure or color photocopies. Samples are filed. Reports back only if interested. Originals returned to artist at job's completion. Call or write to schedule an appointment to show a portfolio, which should include photostats, tearsheets, final reproduction/product, photographs or transparencies. Buys first or one-time rights.

Close-up

Susan Newman
Art Director
Paragon House
New York, New York

© Barbara Kelley 1991

At the time of this interview Susan Newman, the art direc-
tor at Paragon House, had just returned from a week in
Paris. She'd been mesmerized by the great works of art
found there, amazed that she was finally seeing the real
thing. The enthusiasm with which she described the master-
pieces did not wane as she left the discussion of Paris be-
hind and moved into a description of her work as the art
director of Paragon House. Perhaps the transition was made with such ease because there
is a certain similarity for Newman between being an art aficionado in Paris and an art
director in New York. "I get so excited working with those designers and illustrators I
respect, whose work I love," she says. "I get to add to it because I sort of frame it. That's
how I see designing the cover, as though I'm framing a work of art."

Fully intending to be the artist rather than the framer, she studied to be an illustrator
while at the School of Visual Arts. But when she took her portfolio around and received
less than enthusiastic responses, she says she knew she probably would never make it as
an illustrator because she wasn't good enough. "I knew what I wanted my illustration to
look like, but I just couldn't make it look that way," she says. She made up her mind to
switch from illustration to art direction and took as many design courses as she could before
graduating. Having served as an associate art director at Viking Penguin, now at Paragon
House she has the means to match her vision, "to hire this illustrator and that designer
and make everything work."

Paragon's list includes books of biography, contemporary issues, history, literature,
travel, philosophy, New Age, religion, theater and film, allowing the innovative Newman
to create a diversity of covers and to present the work of a broad range of illustrators and
designers. She firmly disbelieves that just because Paragon's list is comprised of nonfiction,
the covers need to carry a photograph or be straight type. Rather, she utilizes a wide range
of style and media—from watercolor and pastel to collage and computer graphics.

She has one staff designer and one part-time assistant to help her with the covers of
about 100 titles each year. The seasonal process begins with weekly cover meetings in which
the editors present new material to Newman, as well as the editor-in-chief, director of the
company and heads of sales and marketing. There they decide upon the titles and discuss
various ideas for the designs of the covers. Afterward, with notes in hand, Newman usually
knows in which direction to head.

As she sees it, her job is first and foremost to insure that the cover reflects the book's
content and the author's style, the "flavor and rhythm" of the work. "It doesn't have to
sum up the book, but it has to evoke the time period, the feeling; it has to draw you in, and
make you want to read it." Thus, Newman reads a portion of every manuscript and expects
her freelance designers and illustrators to read the manuscripts in full.

She feels there are so many excellent designers in New York and tries to spread out the
work as well as she can, matching them to the style and feel of the book. The same is true

of the freelance illustrators she works with, whose personality, knowledge and interests she considers in addition to their work. For example, David Lui, the illustrator who did the cover for *Metaphysics: A Contemporary Introduction*, is "into New Age ideas and metaphysics. So when he read it, he had a complete understanding of it and was able to link a lot of the images he saw when reading it to his own experiences."

Always striving for even more perfect matches between the text and its visual image, Newman keeps abreast of the field by regularly reading magazines such as *Print*, *Graphis* and *Publishers Weekly*. *Rolling Stone* is really important," she says, "because Fred Woodward [art director of the magazine] is such a brilliant designer."

When she finishes a season she goes into bookstores and browses. ("I don't normally do that when I'm in season because I don't want to be influenced by anything," she says.) Then there is the steady stream of self-promotions she receives and the portfolio viewings that oftentimes result. "Some of the promotions," she says, "look just like that of other people I'd hire and so I file it away. Some of it is new and I put it up on the wall. I try to remember them and maybe give them something on the next list if I really like their look."

She can't seem to emphasize the importance of these mailers enough—pieces which show a powerful image, "a great impression of what they do" next to the freelancer's name and phone number. She thinks they should be sent every three to four months and are the essential first step in landing a freelance illustration or design job from a publishing house. She speaks of how competitive it is for freelancers now "because there are fewer publishers than before; they've all bought each other up. There are only one to three art directors per company and they tend to hire those they know." Newman says that because there are fewer individual interviews and more drop-offs, "it's almost more worthwhile for an artist to send a really fantastic mailer—not too big, not a large packet, but with one or two great paintings." Designers, she says, should send a card with six to 12 images on it. "This can make more of an impression on an art director because the mail is opened at one's leisure. Then if she is interested, she will ask to see the portfolio."

These Paragon House covers art directed by Newman are two of her favorites. The one on the left was illustrated by Roberta Ludlow and designed by Newman. Anna Walker designed and illustrated the Claude Santoy cover on the right. Walker is an example of a freelance artist whose self-promotion gained Newman's attention. When this particular book came up, Newman immediately thought of Walker and gave her the project. Reprinted with permission of Paragon House.

Because she also receives a number of items in the mail which are totally inappropriate to her needs, she offers a few suggestions. First, she says, don't send a resume by itself unless you are seeking a staff position. Freelance illustrators and designers, she says, should always include visual images in their inquiries to her, for this is the only way she may ascertain their talents and skills. Second, she stresses the importance of researching Paragon's list and needs before sending samples. Third, don't mail her a whole book expecting that somehow she has the wherewithal to get it published; she is the art director, she says, not the editor-in-chief. And with regard to portfolios, she says, "Sometimes I find that a portfolio will have two or three different styles, and that really bothers me, even though each of those styles may be really good. If they had focused on just one, I may have a better chance of really remembering the work and remembering them. If I have to look at three different styles at once, [the illustrator or designer] walks out my door, and the next day I can't remember what I saw."

— Lauri Miller

Book Design: 50% of freelance design and 10% of freelance illustration is done by freelancers. Pays by the project, $400-600.
Jacket/Covers: 50% of freelance design and 25% of freelance illustration is done by freelancers. Pays by the project, $800-1,500.
Text Illustration: Assigns very few freelance jobs/year. Pays by the project, approximately $100-300.
Tips: "Keep sending material; I love to see new work. When you are looking to get an appointment with an art director, try to make sure they are assigning work for a list, and check if your style is what the company would use. I try to get away from the traditional nonfiction look and design our jackets to be as interesting and varied as possible. I find that design is more complex now, with new options of ink, paper, texture, and artists need to know more about production."

PEACHPIT PRESS, INC., 2414 6th St., Berkeley CA 94710. (415)527-8555. FAX: (415)524-9775. Publisher: Ted Nace. Estab. 1987. Book publisher. Types of books include instruction and computer. Specializes in desktop publishing. Publishes 5-8 titles/year. Recent titles include *Canned Art: Clip Art for the Macintosh* and *Learning PostScript: A Visual Approach*. 100% require freelance design. Book catalog free by request.
Needs: Approached by 2-3 artists/year. Works with 4 freelance designers/year. Prefers local artists with experience in computer book cover design. Uses freelance artists mainly for covers, flyers and brochures. Also uses freelance artists for direct mail and catalog design. Works on assignment only.
First Contact & Terms: Send query letter with resume, photographs and photostats. Samples are filed. Reports back to the artist only if interested. Call to schedule an appointment to show a portfolio which should include original/final art and color samples. Buys all rights. Originals are not returned at job's completion.
Book Design: Payment is negotiable.
Jackets/Covers: Assigns 5-8 freelance design jobs/year. Payment is negotiable.

PEANUT BUTTER PUBLISHING, 200 2nd Ave. W., Seattle WA 98119. (206)281-5965. Contact: Editor. Estab. 1972. Specializes in paperback regional and speciality cookbooks for people who like to dine in restaurants and try the recipes at home. Publishes 30 titles/year. 100% require freelance illustration. Recent titles include *A Wok with Mary Pang, Lentil and Split Pea Cookbook* and *Miss Ruby's Southern Creole and Cajun Cuisine*. Book catalog free for SASE with 1 first class stamp.
First Contact & Terms: Approached by 70 freelance artists/year. Works on assignment only. Send brochure showing art style or tearsheets, photostats and photocopies. Samples not filed are returned only if requested. Reports only if interested. To show a portfolio, mail appropriate materials.
Book Design: Pays by the hour, $15-25; by the project, $200-3,500.
Jackets/Covers: Pays by the hour, $15-25; by the project, $200-3,000.
Text Illustration: Pays by the hour, $15-25; by the project, $200-2,000.
Tips: Books contain pen & ink and 4-color photos. "Don't act as if you know more about the work than we do. Do exactly what is assigned to you."

PELICAN PUBLISHING CO., Box 189, 1101 Monroe St., Gretna LA 70053. (504)368-1175. Production Manager: Dana Bilbray. Publishes hardcover and paperback originals and reprints. Publishes 40-50 titles/year. Types of books include travel guides, cookbooks and childrens' books. Books have a "high quality and detail-oriented" look

First Contact & Terms: Approached by over 200 freelance artists/year. Works with 10-20 freelance illustrators/year. Works on assignment only. Send query letter, 3-4 samples and SASE. Samples are not returned. Reports back on future assignment possibilities. Originals are not returned at job's completion. Buys all rights.
Book Design: Assigns variable number of freelance jobs/year. Pays by the project, $500 minimum.
Jackets/Covers: Assigns variable number of freelance jobs/year. Pays by the project, $150-500.
Text Illustration: Assigns variable number of freelance jobs/year. Pays by the project, $4,500.
Tips: Wants to see "realistic detail, more color samples and knowledge of book design. In the last year there has been a lot more color work, more detail to b&w, more realism."

PHAROS BOOKS/UNITED MEDIA, 200 Park Ave. 6E, New York NY 10166. (212)692-3700. FAX: (212)692-3758. Art Director: Bea Jackson. Book publisher. Imprint of World Almanac, Pharos Books and Topper Books. Publishes hardcover originals and reprints, trade paperback originals and reprints and mass market paperback originals and reprints. Types of books include instruction, biography, juvenile, young adult, reference, history, self-help, travel and humor. Specializes in nonfiction trade. Publishes 50 titles/year. Recent titles include *World Almanac Book of Facts*, *The Kinsey Institute New Report on Sex* and *Miss Manners Guide for the Turn of the Milleneum*. Books have "contemporary trade look." 20% require freelance illustration; 45% require freelance design. Book catalog free by request.
Needs: Approached by 50 artists/year. Works with 10 freelance illustrators and 15 freelance designers/year. Buys 20 freelance illustrations/year. Uses freelance artists mainly for cover design, illustration, maps, etc. Also uses freelance artists for mechanicals, dummies jacket/cover and illustration, book and catalog design and text illustration. Works on assignment only.
First Contact & Terms: Send query letter with brochure, resume, tearsheets and photographs. Samples are filed. Does not report back, in which case the artist should wait to be called (or follow up after 4 weeks). To show a portfolio, mail thumbnails, roughs, original/final art, tearsheets, dummies and printed samples. Originals are returned at job's completion.
Book Design: Assigns 10 freelance design, 20 freelance illustration jobs/year. Pays by project, $300-850.
Jackets/Covers: Assigns 20 freelance design and 10 freelance illustration jobs/year. Pays by the project, $500-1,200. "We look for a solid contemporary trade look that's not too trendy."
Text Illustration: Assigns 8 freelance design and 8 freelance illustration jobs/year. Pays by the project, $150-2,000. Prefers styles appropriate for juveniles and nonfiction trade.
Tips: "Show that you can produce good work, quickly and within budget. I do not re-hire a freelancer when revisions, price negotiations and keeping schedules are a significant problem." Wants to see "work which is appropriate to the list—too many freelancers mail samples blindly without checking what kind of books a company publishes."

PICCADILLY BOOKS, (formerly Polka ● Dot Press), Box 25203, Colorado Springs CO 80936. (719)548-1844. Publisher: Bruce Fife. Estab. 1985. Book publisher. Publishes hardcover and trade paperback originals. Types of books include instruction and humor. Specializes in humor, recreation and performing arts. Publishes 3-8 titles/year. Recent titles include *Strutter's Complete Guide to Clown Makeup*. 80% require freelance illustration and design. Book catalog free for SASE with 2 first class stamps.
Needs: Uses freelance artists mainly for cover design and text illustration. Works on assignment only.
First Contact & Terms: Send query letter with brochure and photocopies. Samples are filed. Reports back to the artist only if interested. To show a portfolio, mail appropriate materials.
Book Design: Pays by the project.
Jackets/Covers: Assigns 6 freelance design jobs/year.
Text Illustration: Assigns 6 freelance illustration jobs/year. Pays by the project.

PLAYERS PRESS, Box 1132, Studio City CA 91604. Associate Editor: Marjorie Clapper. Specializes in children's books.
First Contact & Terms: Buys up to 30 illustrations/year from freelancers. Works on assignment only. Send query letter with brochure showing art style or resume and samples. Samples not filed are returned by SASE. Reports back only if interested. To show a portfolio, mail thumbnails, original/final art, final reproduction/product, tearsheets, photographs and as much information as possible. Buys all rights. Payment varies.

PLYMOUTH MUSIC CO., INC., 170 NE 33rd St., Ft. Lauderdale FL 33334. (305)563-1844. General Manager: Bernard Fisher. Specializes in paperbacks dealing with all types of music. Publishes 60-75 titles/year; 100% require freelance design, 100% require freelance illustrations.
First Contact & Terms: Works with 10 freelance artists/year. Artists "must be within our area." Works on assignment only. Send brochure, resume and samples to be kept on file. Samples not kept on file are returned. Reports back within 1 week. Call for appointment to show a portfolio. Originals not returned to artist at job's completion. Considers complexity of project when establishing payment. Buys all rights.
Jackets/Covers: Assigns 5 freelance design and 5 freelance illustration jobs/year. Pays by the project.

POCKET BOOKS, 1230 6th Ave., New York NY 10020. (212)698-7000. FAX: (212)698-7337. Vice President/ Executive Art Director: Barbara Buck. Estab. 1939. Book publisher. Imprint of Simon and Schuster. Publishes hardcover originals and reprints, trade paperback originals and reprints and mass market paperback originals and reprints. Types of books include contemporary, experimental, mainstream, historical, science fiction, instruction, adventure, mystery, biography, juvenile, young adult, reference, history, self-help, travel, humor and cookbooks. Publishes more than 700 titles/year. 60% require freelance illustration; 50% require freelance design.

Needs: Approached by 100+ freelance artists/year. Works with 100-150 freelance illustrators and 20-30 freelance designers/year. "The work speaks for itself—I don't care where the artist lives." Uses freelance artists mainly for fiction jacket/cover illustration and design. Works on assignment only.

First Contact & Terms: Send query letter with tearsheets, transparencies or color Photocopies. Do not call! Samples are filed and are not returned. "We are not *responsible*." Reports back to the artist only if interested. For a portfolio review do not call. "Drop off any day but Friday—at your own risk." Portfolio should include tearsheets and transparencies (at least 4 × 5). Rights purchased vary according to project. Originals returned at the job's completion. Payment is negotiable, by the project.

Jackets/Covers: Assigns hundreds of freelance design and illustration jobs/year. Payment is negotiable by the project. "I use all styles."

Tips: "Keep me current on your work by dropping off portfolios and leaving new tearsheets behind for my files. Label all tearsheets."

PRAEGER PUBLISHERS, 1 Madison Ave., New York NY 10010. (212)685-6710. Art Director: Carole A. Russo. Publishes textbooks and hardcover and trade paperback originals. Publishes 200 titles/year. Recent titles include *Public Relations Writing*, *Communication Tomorrow* and *Propaganda/A Pluralistic Perspective*.

First Contact & Terms: Approached by 200-250 freelance artists/year. Works with 7 freelance designers/ year, mainly for jacket/cover design. Works on assignment only. Send query letter with tearsheets. Samples are filed and are not returned. Reports back only if interested. Originals not returned at job's completion. Call or write to show a portfolio, which should include original/final art and final reproduction/product. Considers project's budget when establishing payment.

Jackets/Covers: Assigns 35 freelance design jobs/year. Prefers "scholarly" looking design. Pays by the project, $200-500.

Tips: "Want to see type designs mainly; never use illustrations or photographs." Show me what would apply to Praegar, not everything you've ever published. Also, proofread any literature you mail out; especially to a book publisher!

THE PRAIRIE PUBLISHING COMPANY, Box 2997, Winnipeg MB R3C 4B5 Canada. (204)885-6496. Publisher: Ralph E. Watkins. Specializes in paperback juvenile fiction and local history. Publishes 3 titles/year. Recent titles include *The Tale of Johathan Thimblemouse*, *Humour is the Best Sauce* and *The Homeplace*.

First Contact & Terms: Approached by 5 freelance artists/year. Works with 3 freelance illustrators and 1 freelance designer/year. Works on assignment only. Send query letter with resume and tearsheets. Samples are filed or are returned. Reports back within weeks. Originals not returned at job's completion. To show a portfolio, mail roughs. Considers skill and experience of artist and project's budget when establishing payment. Negotiates rights purchased.

Jackets/Covers: Pays by the project, $200-300.

Text Illustration: Prefers line drawings. Pays by the project, $150-200.

Tips: "The work should not appear too complete. What I look for is open-ended art. Artists have to aim at being less dramatic and more focused on the subject. Desktop publishing seems to have brought a number of amateurs into the trade. There is little grasp of using the warm colors on the covers."

BYRON PREISS VISUAL PUBLICATIONS, INC., 24 W. 25th St., New York NY 10010. (212)645-9870. Art Director: Steve Brenniulmeyer. Specializes in hardcover and paperback science fiction, fantasy, animal and nature, young adult and children's. Publishes 100 titles/year; 85% require freelance illustration. Recent titles include *The Dungeon*, *First Contact* and the *Camelot World Series*.

First Contact & Terms: Approached by over 4 freelance artists/week. Works with 50 freelance artists/year. Prefers pen & ink, airbrush, charcoal/pencil, colored pencil, watercolor, acrylic, oil, pastel and computer illustration. Works on assignment only. Send query letter with brochure showing art style or tearsheets, photostats, photographs or "color reproductions of any color art." Samples are filed or are returned by SASE only if requested. Reports back only if interested. Originals returned to artist at job's completion. Call or write to schedule an appointment to show a portfolio, which should include the "best samples possible." Considers complexity of project, skill and experience of artist, project's budget, turnaround time and rights purchased when establishing payment. Negotiates rights purchased.

Book Design: Assigns 10 freelance design and 50 freelance illustration jobs/year. Pay varies per project.
Jackets/Covers: Assigns approximately 20 freelance design and 50 freelance illustration jobs/year. Pay varies per project.
Text Illustration: Assigns 50 freelance jobs/year. Pay varies per project.
Tips: "Please consider subject matter of our books when showing artwork. We use bright colors for children's illustrations. Send one or two color photocopies of best work for our files."

***PRICE STERN SLOAN,** 11150 Olympic Blvd., Los Angeles CA 90064. (213)477-4118. FAX: (213)445-3933. Senior Designer: Rick Penn-Kraus. Estab. 1971. Book publisher. Publishes hardcover originals and reprints, trade paperback originals and reprints, and mass market paperback originals and reprints. Types of books include instruction, pre-school, juvenile, young adult, reference, self-help, humor, cookbooks, photography and automotive. Publishes 90 titles/year. Recent titles include *Complete Murphy's Law*; *Mad Libs*; *Microwave Cookbook*. 30% require freelance illustration. 10% require freelance design. Book catalog free by request.
Needs: Approached by 300 freelance artists/year. Works with 10-40 freelance illustrators and 10-15 freelance designers/year. Prefers artists with experience in book or advertising art. Uses freelance artists mainly for covers and interiors.
First Contact & Terms: Send query letter with brochure, resume and photocopies. Samples are filed or are returned by SASE if requested by artist. Reports within 1 month. Call or write to schedule an appointment to show a portfolio. Portfolio should include b&w and color tearsheets. Rights purchased vary according to project.
Book Design: Assigns 5-10 freelance design jobs and 20-30 freelance illustration jobs/year. Pays by the project.
Jackets/Covers: Assigns 5-10 freelance design jobs and 10-20 freelance illustration jobs/year. Pays by the project, varies.
Tips: "Do not send original art. Become familiar with the types of books we publish. Only send professional, good quality samples for us to hold on to. We have a portfolio drop-off policy Thursday mornings. We are always looking for excellent joke book submissions."

Debi Elfenbein, managing editor at Princeton Book Company, Publishers, was introduced to Eric Fowler when he was a designer at the graphic design firm the publisher used. When he went freelance, Elfenbein saw his portfolio, liked his style and asked him to do this cover. She feels it works well because of its colorful, modern and striking look. She says Fowler is a "very nice guy, easy to work with and makes deadlines."

© Princeton Book Company, Publishers 1989

***PRINCETON BOOK PUBLISHERS, DANCE HORIZONS,** 12 W. Delaware Ave., Pennington NJ 08534. Managing Editor: Debi Elfenbein. Estab. 1975. Dance book publisher and dance video distributor. Publishes hardcover originals, trade paperback originals and reprints, and textbooks. Types of books include instruction, biography and history. Specializes in dance. Publishes 12-15 titles/year. Recent titles include *Anna Sokolow: The Rebellious Spirit* and *The Pointe Book: Shoes, Training & Technique*. 3% require freelance illustration. 97% require freelance design. Book catalog free by request.

Needs: Approached by 3-7 freelance artists/year. Works with 2 freelance illustrators and 3-7 freelance designers/year. Buys 1-3 freelance illustrations/year. Prefers artists with experience in book design and marketing for textbooks and trade books. Uses freelance artists for jacket/cover and book design and dance video covers. Works on assignment only.

First Contact & Terms: Send query letter with resume, photostats and SASE. Samples are filed. Reports back to the artist only if interested. Write to schedule an appointment to show a portfolio. Portfolio should include original/final art and b&w dummies. Rights purchased vary according to project. Originals are returned at job's completion.

Book Design: Assigns 12 freelance design jobs/year. Pays by the project, $375-500.

Jackets/Covers: Assigns 12 freelance design jobs and 3 freelance illustration jobs/year. Pays by the project, $375-500. Uses mostly photos with an occasional watercolor (4-color) or graphic.

Text Illustration: Assigns 3 freelance design jobs and 3 freelance illustration jobs/year. Pays by the hour, $15-30. Prefers pen-and-ink and realistic figures.

Tips: "Have book design experience. Know what my firm specializes in before we talk."

PRUETT PUBLISHING COMPANY, 2928 Pearl St., Boulder CO 80301. (303)449-4919. Project Editor: Jim Pruett. Specializes in hardcover and paperback originals on Western history, outdoor themes, Americana and railroads. Publishes 20 titles/year. Recent titles include *Taming Mighty Alaska*, *Seasonal* and *Ghosts on the Range*. Also uses freelancers for brochure, catalog and advertising design. Assigns 20-25 projects/year. Pays by the project.

First Contact & Terms: Approached by 15-20 freelance artists/year. Works with 4-5 freelance artists/year. Prefers local artists. Works on assignment only. Send query letter with samples showing art style. Samples not filed are returned only if requested with SASE. Considers complexity of project, skill and experience of artist, project's budget and turnaround time when establishing payment. Rights purchased vary according to project.

Book Design: Assigns 20 freelance design and approximately 1 freelance illustration jobs/year. Pays by the project, $150-400.

Jackets/Covers: Assigns 20 freelance design and 5-10 freelance illustration jobs/year. Pays by the project, $200-550.

Text Illustration: Assigns 0-1 freelance jobs/year. Pays by the project, $200-500.

Tips: Looking for "historic illustrations and photographs. Photography is a big part of our design. Do not send cartoons and children's illustrations. It is rare we work with artists from other states as we have a lot of talent here, unless they have a particular style like historic illustration that is hard to find locally."

G.P. PUTNAM'S SONS, (Philomel Books), 200 Madison Ave., New York NY 10016. (212)951-8700. Art Director, Children's Books: Nanette Stevenson. Publishes hardcover and paperback juvenile books. Publishes 100 titles/year.

First Contact & Terms: "We take drop-offs on Tuesday mornings. Please call in advance with the date you want to drop off your portfolio." Originals returned to artist at job's completion. Works on assignment only. Samples returned by SASE. Provide flyer, tearsheet, brochure and photocopy or stat to be kept on file for possible future assignments. Free catalog.

Jackets/Covers: "Uses full-color paintings, tight style."

Text Illustration: "Uses a wide cross section of styles for story and picture books."

RANDOM HOUSE, INC., (Juvenile), 225 Park Ave., New York NY 10003. (212)254-1600. Art Director: Cathy Goldsmith. Specializes in hardcover and paperback originals and reprints. Publishes 150 titles/year. 100% require freelance illustration.

First Contact & Terms: Works with 100-150 freelance artists/year. Works on assignment only. Send query letter with resume, tearsheets and photostats; no originals. Samples are filed or are returned. "No appointment necessary for portfolios. Come in on Wednesdays only, before noon." Considers complexity of project, skill and experience of artist, project's budget, turnaround time and rights purchased when establishing payment. Negotiates rights purchased.

Book Design: Assigns 5 freelance design and 150 freelance illustration jobs/year. Pays by the project.

Text Illustration: Assigns 150 freelance jobs/year. Pays by the project.

READ'N RUN BOOKS, Box 294, Rhododendron OR 97049. (503)622-4798. Publisher: Michael P. Jones. Estab. 1985. Specializes in fiction, history, environment, wildlife for children through adults. "Varies depending upon subject matter. Books for people who do not have time to read lengthy books." Publishes 2-6 titles/year. Recent titles include *Between Two Worlds?* and *The Oregon Trail and Its Pioneers*. "Our books are printed in black and white or sepia, are both hardbound and softbound, and are not slick looking. They are homegrown looking books that people love." Accepts previously published material. Original artwork returned to the artist after publication. Sample copy: $6. Art guidelines for SASE with 1 first-class stamp.

First Contact & Terms: Works with 25-50 freelance illustrators and 12 designers/year. Prefers pen & ink, airbrush, charcoal/pencil, markers, calligraphy and computer illustration. Send query letter with brochure or resume, tearsheets, photostats, photocopies, slides and photographs. Samples not filed are returned by SASE. Reports back within 1-3 months, "depending on workload." To show a portfolio, mail thumbnails, roughs, original/final art, final reproduction/product, color and b&w tearsheets, photostats and photographs. Buys one-time rights. Pays in copies, on publication.

Tips: "We publish books on wildlife, history and nature. We will be publishing short-length cookbooks." In portfolios, "I want to see a lot of illustrations showing a variety of styles. There is little that I actually don't want to see. We have a tremendous need for illustrations on the Oregon Trail (i.e., oxen-drawn covered wagons, pioneers, mountain men, fur trappers, etc.) and illustrations depicting the traditional way of life of Plains Indians and those of the North Pacific Coast and Columbia River with emphasis on mythology and legends."

ROSS BOOKS, Box 4340, Berkeley CA 94704. (415)841-2474. Managing Editor: Brian Kluepfel. Estab. 1977. Book publisher. Publishes trade paperback originals, textbooks and hardcover reprints. Types of books include instruction, young adult, reference, self-help, cookbooks, adult science, holography and computer books. Specializes in holography and computers. Publishes 7 titles/year. Recent titles include *Holography Marketplace 3rd edition* and *B-Trees for BASIC*. 40% require freelance illustration; 40% require freelance design. Book catalog free for SASE with 2 first-class stamps.

Needs: Approached by 100-300 freelance artists/year. Works with 2-4 freelance illustrators and 1-2 freelance designers/year. Number of freelance illustrations purchased each year varies. Prefers artists with experience incomputer generated diagrams and illustration. Also uses freelance artists for jacket/cover illustration, book design, text illustration and direct mail design. Works on assignment only.

First Contact & Terms: Send query letter with resume and photocopies. Samples are filed. Reports back to the artist only if interested and SASE enclosed. Rights purchased vary according to subject. Originals returned at the job's completion.

Book Design: Assigns 2-4 freelance design and 2-4 freelance illustration jobs/year. Pays by the project, $500 maximum.

Text Illustration: Assigns 2-4 freelance design and 2-4 freelance illustration jobs/year. Pays by the project, $500 maximum.

Tips: "Computer illustration ability—especially Macintosh—should be demonstrated."

SCHANES PRODUCTS & SERVICES, 786 Blackthorne Ave., El Cajon CA 92020. (619)698-8183. FAX: (619)698-2253. Art Director: Steven J. Schanes. Specializes in paperback originals and reprints, comic books, signed prints and trade books. Publishes 200 titles/year.

First Contact & Terms: Approached by 50 freelance artists/year. Works with 50 freelance artists/year. "We look for professional standards in the artists we work with." Send query letter with brochure, resume, and samples to be kept on file; originals will be returned. Prefers slides and photostats as samples. Samples not filed are returned. Reports within 3 weeks. Originals returned to artist after job's completion. Considers complexity of the project, skill and experience of artist, project's budget and turnaround time when establishing payment. Rights purchased vary according to project.

Book Design: Assigns 50 freelance jobs/year. Pays by the project, depending on the job, from $50 for a spot illustration to $15,000 for a complete comic book series.

Jackets/Covers: Assigns 15 freelance design and 30 freelance illustration jobs/year. Pays by the hour, $5-40 average; by the project, $50-10,000 average.

Text Illustration: Assigns 15 jobs/year. Prefers pen & ink. Pays by the hour, $5-40 average; by the project, $50-10,000 average.

Tips: Looking for illustration which is "accurate, based on knowledge of human anatomy. Study basic drawing."

SCHIFFER PUBLISHING, LTD., 1469 Morstein Rd., West Chester PA 19380. (215)696-1001. President: P. Schiffer. Specializes in books for collectors and artists.

First Contact & Terms: Approached by over 24 freelance artists/year. Works on assignment only. Send query letter with resume and tearsheets, photostats, photocopies, slides and photographs. Samples not filed are returned by SASE. Reports only if interested. Negotiates rights purchased.

Tips: "Send large, clear examples."

SCHOLASTIC INC., 730 Broadway, New York NY 10003. Art Director: David Tommasino. Specializes in hardcover and paperback originals and reprints of young adult, biography, classics, historical romance and contemporary teen romance. Publishes 250 titles/year; 80% require freelance illustration. Recent titles include *The Baby-sitters Club*; *Friends 4-ever* and *Baker's Dozen*.

First Contact & Terms: Approached by 100 freelance artists/year. Works with 75 freelance artists/year. Prefers local artists with experience. Uses freelance artwork mainly for young adult/romance, historical, classical and biographies. Send query letter with brochure showing art style or tearsheets. Samples are filed

or are returned only if requested. Reports back within 2 weeks only if interested. Originals returned to artist at job's completion. Considers complexity of project and skill and experience of artist when establishing payment. Buys first rights.

Jackets/Covers: Assigns 200 freelance illustration jobs/year. Pays by the project, $1,500-3,500.

Tips: "In your portfolio, show tearsheets or proofs only of printed covers. I want to see oil, acrylic tightly rendered; illustrators should research the publisher. Go into a bookstore and look at the books. Gear what you send according to what you see is being used."

SCOJTIA PUBLISHING CO., 6457 Wilcox Station, Los Angeles CA 90038. Managing Editor: Patrique Quint-ahlen. Estab. 1986. Book publisher. Imprint of Jordan Enterprises Publishing Co. Publishes hardcover and trade paperback originals. Types of books include contemporary, experimental, mainstream, historical, science fiction, instruction, adventure, fantasy, biography, pre-school, juvenile, young adult, reference, history, self-help, travel, humor and cookbooks. Specializes in contemporary, experimental and historical fiction; pre-school; juvenile; young adult; self-help; biography; history and reference. Publishes 2-5 titles/year. Recent titles include *The Boy Who Opened Doors* and *The Strawberry Fox*. Books "reflect classical and contemporary art in design." 80% require freelance illustration; 50% require freelance design. Book catalog not available.

Needs: Approached by 50 freelance artists/year. Works with 5 freelance illustrators and 2 freelance designers/year. Buys 24 freelance illustrations/year. Uses freelance artists mainly for text illustration and book covers. Also uses freelance artists for book design and direct mail design. Works on assignment only.

First Contact & Terms: Send query letter with resume, SASE, tearsheets, photographs, photocopies and photostats. Samples are filed. Reports back with 4 months. To show a portfolio, mail roughs, original/final art and b&w and color photostats, dummies, tearsheets and photographs. Rights purchased vary according to project. Originals are not returned at job's completion unless requested.

Book Design: Assigns 2 freelance design and 2 freelance illustration jobs/year. Pays by the hour, $10-20; by the project, $50-1,500.

Jackets/Covers: Assigns 2 freelance design and 2 frelance illustration jobs/year. Pays by the hour, $5-15; by the project, $50-500. Prefers "painting styles with a Monet, Degas look and color."

Text Illustration: Assigns 2 freelance design and 5 freelance illustration jobs/year. Pays by the hour, $5-15; by the project, $50-500. Prefers line drawings.

Tips: "An artist with a diversity of styles, reflecting an understanding of the natural abstract, curious, forever discovering desire and motivation of children and adults, is most likely to get an assignment with Scojtia. Color, unique characters (animals), realistic drawings that are comfortable with topics of fantasy are the pictures we look for."

***SIERRA CLUB BOOKS**, 100 Bush St., San Francisco CA 94104. Publisher: Jon Beckmann. Editorial Director: Daniel Moses. Design Director: Susan Ristow. Publishes books on natural history, science, ecology, conservation issues and related themes, calendars and guides.

Needs: Uses artists for book design and illustration (maps, juvenile art) and jacket design. Works with 10-15 freelance designers/year.

First Contact & Terms: Send query letter with resume, tearsheets and/or business card to be kept on file. Pays by the project, $600-900 for book design. Pays by the project, $450-1,000 for jacket/cover design; $175-500 for jacket/cover illustration; $1,000-2,000 average for text illustration. Buys U.S. or world rights.

SILVER BURDETT & GINN, 250 James St., Morristown NJ 07960. (201)285-8103. Director Art & Design: Doug Bates. Book publisher. Estab. 1890. Publishes textbooks and nonfiction. Types of books include instruction, technical and history. Specializes in math, science, social studies, English, music and religion. Publishes approx. 75 titles/year. Books look "attractive and functional." 100% require freelance illustration; 20% require freelance design. Recent titles include *Mathematics: Exploring Your World*, *Science Horizons*, *World of Language* and *People in Time and Place*. Book catalog not available.

First Contact & Terms: Approached by 40 freelance artists/year. Works with 50-100 freelance illustrators and 5-10 freelance designers/year. Buys 1,000 freelance illustrations/year. Works with illustrators mainly for illustration of pupils' text. Also works with artists for jacket/cover illustration and design, book design and text illustration. Works on assignment only. Send query letter with resume and tearsheets. Samples are filed or are returned by SASE only if requested. Reports back about queries/submissions only if interested. Originals returned to artist at job's completion. Call to schedule an appointment to show a portfolio, which should include thumbnails, roughs, original/final art, tearsheets and final reproduction/product. Considers complexity of project and skill and experience of artist when establishing payment. Negotiates rights purchased.

Book Design: Assigns approx. 10 freelance design jobs/year. Pays by the hour, $15-25.

Jackets/Covers: Pays by the project, $500-2,000.

Text Illustration: Assigns 1,000 freelance illustrations jobs/year. Pays by the project, $200-1,000.

Tips: The look of design and illustration used is "contemporary, but warm and friendly, inviting; lively, but functional. Work should be appropriate to textbook and educational publishing and be in a current contemporary style that will appeal to the 'MTV' generation."

SIMON AND SCHUSTER BOOKS FOR YOUNG READERS, 1230 Avenue of the Americas, New York NY 10020. (212)698-7000. Contact: Art Director. Specializes in hardcover and paperback juvenile trade books, for ages 3-12. Publishes 50 hardcover and 20 paperbacks/year.
First Contact & Terms: Assigns 50 freelance jobs/year "but only to artists we have previously met and selected. We pay an advance or flat fee."

SINGER MEDIA CORP., 3164 Tyler Ave., Anaheim CA 92801. (714)527-5650. FAX: (214)527-0268. Contact: John J. Kearns. Licenses paperback originals and reprints; mass market, Western, romance, sophisticated romance, mystery, science fiction, nonfiction and biographies. Licenses 200 titles/year through affiliates; 95% require freelance designers for book covers. Also buys 3,000 cartoons/year to be internationally syndicated to newspaper and magazine publishers—also used for topical books. Recent titles include *Silly Corn*, DeGrassi series and Dark Shadows series.
First Contact & Terms: Approached by 50 + freelance illustrators and cartoonists/year. Send query letter with photocopies and tearsheets to be kept on file. Do not send original work. Material not filed is returned by SASE. Reports in 2 weeks. Pays 50% of syndication fee received; books, 15% USA, 20% foreign. Buys first and reprint rights. Originals returned to artist at job's completion. Artist's guidelines $1.
Book Design: Assigns "many" jobs/year. Uses artists for reprints for world market. Prefers clean, clear, uncluttered style.
Jackets/Covers: Popular styles: Western, romance, mystery, science fiction/fantasy, war and gothic. "We are only interested in color transparencies for paperbacks." Duplicates only. Offers advance.
Tips: "Study the market. Study first the best-seller list, the current magazines, the current paperbacks and then come up with something better if possible or something new. We get hundreds of medical cartoons, hundreds of sex cartoons. We are overloaded with cartoons showing inept office girls but seldom get cartoons on credit cards, senior management, aerobics, fitness, romance. We would like more positive and less negative humor. Can always use good travel cartoons around the world. Merged with Media Trans Asia which publishes 32 magazines in Hong Kong, Thailand and India, including inflight magazines for Asian and Mid Eastern Airlines." Also looking for "jacket covers for paperbacks. Young people, sexy but decent."

SOURCEBOOKS, INC., Box 372, Naperville IL 60566. (708)961-2161. Publisher: Dominique Raccah. Publishes hardcover and trade paperback originals. Types of books include reference, business and finance; nonfiction only. "We have 2 divisions—Sourcebooks Trade: business/finance general trade and Financial Sourcebooks: banking/finance/accounting professional books." Recent titles include *Outsmarting the Competition: Practical Approaches to Finding and Using Competitive Information.* 100% require freelance illustration; 100% require freelance design.
Needs: Approached by few freelance artists/year. Works with 3-4 freelance illustrators and 2-3 freelance designers/year. Buys 10-15 freelance illustrations/year. Prefers artists with experience in cover design. Uses freelance artists mainly for cover and book design. Also uses freelance artists for jacket/cover and text illustration, direct mail and catalog design. Works on assignment only.
First Contact & Terms: Send query letter with brochure, resume, tearsheets, photographs and photocopies. Samples are filed and are not returned. Reports back to the artist only if interested. To show a portfolio, mail "whatever best represents the artist's work for our files." Buys all rights. Originals are not returned at job's completion.
Book Design: Assigns 10 freelance design and few freelance illustration jobs/year. Pays by the project.
Jackets/Covers: Assigns 10 freelance design jobs/year. Pays by the project, $400-1,500.
Text Illustration: "Text illustration is rarely done separately."
Tips: "We're currently looking to expand our roster of cover designers. An artist should be very familiar with book cover design to work with us. Strong, dynamic covers are of paramount importance in selling books. To get an assignment, show us some terrific work."

SOUTHERN HISTORICAL PRESS, INC., 275 W. Broad St., Greenville SC 29601. (803)859-2346 or 233-2346. President: The Rev. Silas Emmett Lucas, Jr. Specializes in hardcover and paperback originals and reprints on genealogy and history. Publishes 40 titles/year.
First Contact & Terms: Works with 1 freelance artist/year. Works on assignment only. Send query letter and samples to be kept on file. Call or write for appointment to show portfolio. Prefers tearsheets or photographs as samples. Samples not filed are returned by SASE if requested. Reports back only if interested. Original work not returned after job's completion. Considers complexity of project, skill and experience of artist, project's budget and turnaround time when establishing payment. Buys all rights.
Needs: Assigns 5 freelance book design, cover design and illustration and text illustration jobs/year.

SPINSTERS BOOK COMPANY, Box 410687, San Francisco CA 94141. (415)558-9586. Production Manager: Joan Meyers. Estab. 1978. Book publisher. Publishes hardcover and trade paperback originals and trade paperback reprints. Types of books include contemporary, experimental, historical, fantasy, mystery, biography/"mythography", young adult and self-help. Specializes in lesbian/feminist. Publishes 5-10 titles/year.

Recent titles include *The Thirteen Steps* and *Why Can't Sharon Kowalski Come Home?* 100% require freelance illustration. Book catalog free by request.

Needs: Approached by 40 freelance artists/year. Works with 6 freelance illustrators or artists/year. Buys 5-10 freelance illustrations/year. Prefers artists with experience in lesbian and/or feminist publishing. Uses freelance artists mainly for covers/jackets. Works on assignment only.

First Contact & Terms: Send query letter, resume and color reproductions of work (photographs, photocopies or slides). "Please note if samples are previously published or unpublished." Samples are filed, returned if SASE is enclosed and "we are not able to use material." To show a portfolio, mail original/final art and color slides, tearsheets, transparencies or photographs. Rights purchased according to project. Originals returned at job's completion.

Jackets/Covers: Assigns 5-10 freelance illustration jobs/year. Pays by the project, $150-250. Prefers watercolor, pastel or mixed media.

Text Illustration: Pays by the project, $50-150.

Tips: Because of the recession, "we can no longer pay endless kill fees for sketches and are increasingly seeking out original art that fits the book."

STAR PUBLISHING, Box 68, Belmont CA 94002. Managing Editor: Stuart Hoffman. Specializes in original paperbacks and textbooks on science, art, business. Publishes 12 titles/year. 33% require freelance illustration. Recent title includes *Microbiology Techniques*.

First Contact & Terms: Works with 15 freelance illustrators and 3-4 designers/year. Send query letter with resume, tearsheets and photocopies. Samples not filed are returned only by SASE. Reports back only if interested. Original work not returned after job's completion. Rights purchased vary according to project.

Book Design: Assigns 12 freelance design and 5 freelance illustration jobs/year. Pays by the project.

Jackets/Covers: Assigns 5 freelance design jobs/year. Pays by the project.

Text Illustration: Assigns 6 freelance jobs/year. Pays by the project.

Tips: Freelance artists need to be aware of "increased use of graphic elements, striking color combinations, more use of color illustration."

STEMMER HOUSE PUBLISHERS, INC., 2627 Caves Rd., Owings Mills MD 21117. (301)363-3690. President: Barbara Holdridge. Specializes in hardcover and paperback fiction, nonfiction, art books, juvenile and design resource originals. Publishes 10 titles/year. 10% require freelance design; 75% require freelance illustration.

First Contact & Terms: Approached by over 50 freelance artists/year. Works with 10 freelance artists/year. Works on assignment only. Send brochure/flyer, tearsheets, photocopies or color slides to be kept on file; submission must include SASE. Do not send original work. Material not filed is returned by SASE. Call or write for appointment to show portfolio. Reports in 6 weeks. Works on assignment only. Originals returned to artist at job's completion on request. Negotiates rights purchased.

Book Design: Assigns 1 freelance design, 4 freelance illustration jobs/year. Pays by project, negotiated.

Jackets/Covers: Assigns 4 freelance design jobs/year. Prefers paintings. Pays by the project, $300 minimum.

Text Illustration: Assigns 8 jobs/year. Prefers full-color artwork for text illustrations. Pays by the project on a royalty basis.

Tips: Looks for "draftmanship, flexibility, realism, understanding of the printing process." A common mistake freelancers make in presenting samples or portfolios is "presenting original work only without printed samples and not sending an SASE for material to be returned." Books are "rich in design quality and color, stylized while retaining realism; not airbrushed. 1) Review our books. 2) Propose a strong picture-book manuscript with your illustrations."

STONE WALL PRESS INC., 1241 30th St. NW, Washington DC 20007. Publisher: Henry Wheelwright. Publishes paperback and hardcover originals; environmental, backpacking, fishing, outdoor themes. Publishes 1-4 titles/year; 10% require freelance illustration. Recent titles include *A Sportsman's Guide to Nature*; *Hiking the USA* and *Wildlife Extinction*.

First Contact & Terms: Approached by 20 freelance artists/year. Works with 1 freelance illustrator and 1 freelance designer/year. Prefers artists who are accessible. Works on assignment only. Send query letter with brochure showing art style. Samples returned by SASE. Reports back only if interested. Buys one-time rights. Originals returned to artist at job's completion.

Book Design: Uses artists for composition, layout, jacket design. Prefers realistic style—color or b&w. Artist supplies overlays for cover artwork. Pays cash upon accepted art.

Text Illustration: Buys b&w line drawings.

Tips: Looking for "clean, basic, brief, concise, expendable samples."

TECHNICAL ANALYSIS, INC., 3517 SW Alaska St., Seattle WA 98126-2730. (206)938-0570. Art Director: Christine Morrison. Estab. 1982. Magazine, books and software producer. Publishes trade paperback reprints and magazines. Types of books include instruction, reference, self-help and financial. Specializes in stocks, options, futures and mutual funds. Publishes 3 titles/year. 100% require freelance illustration; 10% require freelance design. Book catalog not available.

Needs: Approached by 100 freelance artists/year. Works with 40 freelance illustrators and 5 freelance designers/year. Buys 100 freelance illustrations/year. Uses freelance artists for magazine article illustration. Also uses freelance artists for text illustration and direct mail design. Works on assignment only.

First Contact & Terms: Send query letter with brochure, resume, SASE, tearsheets, photographs, photocopies, photostats, slides and transparencies. Samples are filed. Reports back within 6-8 weeks. Write to schedule an appointment to show a portfolio or mail tearsheets. Buys first rights or reprint rights. Most originals are returned to artist at job's completion.

Book Design: Assigns 5 freelance design, 100 freelance illustration jobs/year. Pays by project, $30-230.

Jackets/Covers: Assigns 1 freelance design, 15 freelance illustration jobs/year. Pays by project $30-230.

Text Illustration: Assigns 5 freelance design and 100 freelance illustration jobs/year. Pays by the project, $30-230.

TOR BOOKS, 49 W. 24th St., New York NY 10018. Senior Editors: Melissa Ann Singer (general fiction); Patrick Nielsen Hayden (science fiction and fantasy). Specializes in hardcover and paperback originals and reprints: espionage, thrillers, horror, mysteries and science fiction. Publishes 180 titles/year; heavy on science fiction. Recent titles include *The Boat of a Million Years*, by Poul Anderson; *The Eagle and the Raven*, by James Michener and *The Ring of Charon*, by Roger MacBride Allen.

First Contact & Terms: All covers are freelance. Works with 50-100 freelance illustrators and 5-10 freelance designers/year. Works on assignment only. Send query letter with color photographs, slides or tearsheets to be kept on file "unless unsuitable"; call for appointment to show portfolio. Samples not filed are returned by SASE. Reports back only if interested. Original work returned after job's completion. Considers skill and experience of artist, and project's budget when establishing payment. "We buy the right to use art on all editions of book it is commissioned for and in promotion of book."

Book Design: Pays by the project.

Jackets/Covers: Assigns 180 freelance illustration jobs/year. Pays by the project, $500 minimum.

Text Illustration: Pays by the project.

Tips: "We would like to see more technical proficiency. In science fiction, more realistic renditions of machinery, etc.; less wild, cartoony, colorful 'futuristic' stuff."

TRAVEL KEYS BOOKS, Box 160691, Sacramento CA 95816. (916)452-5200. Publisher: Peter B. Manston. Specializes in paperback originals on travel, antiques and home security. Publishes 3-7 titles/year; 100% require freelance illustration. Recent titles include *Manston's Europe 91* (annual) and *Disney World for Kids of All Ages*. Books have an "easy to read and use" look.

First Contact & Terms: Works with 3 freelance artists/year. "We often contract on a work-for-hire basis. Most books include between 15 and 60 illustrations, usually pen-and-ink drawings." Works on assignment only. Send query letter with brochure showing art style or sample tearsheets and photostats. Some samples are filed and retained, but samples not filed are returned. Reports back within 2 months. Originals not returned to artist at job's completion. Considers skill of artist and project's budget when establishing payment. Buys all rights or unlimited rights to reproduction.

Text Illustration: Assigns 4 freelance jobs/year. Prefers representational pen & ink for most projects. Pays by the hour, $20; or by the project, $1,450 maximum.

Tips: "Please query first, request catalog with SASE (3 first-class stamps)." The most common mistakes freelancers make in presenting their work are "failure to include a sample or photocopy of a sample of their work, and failure to include SASE."

TROLL ASSOCIATES, Book Division, 100 Corporate Dr., Mahwah NJ 07430. Vice President: Marian Frances. Specializes in hardcovers and paperbacks for juveniles 3-15 year olds. Publishes over 100 titles/year; 30% require freelance design and illustrations.

First Contact & Terms: Works with 30 freelance artists/year. Prefers artists with 2-3 years of experience. Send query letter with brochure/flyer or resume and tearsheets or photostats. Samples usually returned by SASE only if requested. Reports in 1 month. Works on assignment only. Originals usually not returned to artist at job's completion. Write to schedule an appointment to show a portfolio, or mail original/final art, photostats and tearsheets. Considers complexity of project, skill and experience of artist, project's budget and rights purchased when establishing payment. Buys all rights or negotiates rights purchased.

THE TRUMPET CLUB/DELL PUBLISHING COMPANY, 666 5th Ave., New York NY 10103. Art Director: Ann Hofmann. Estab. 1985. Mail-order school book club specializing in paperbacks and related promotional material. Publishes juvenile fiction and nonfiction. Recent titles include *Camp Funny IIa Ha*; *100 Amazing Americans* and *Poisonous Creatures*. Books look "children-like and lighthearted."

First Contact & Terms: Works with 25 freelance artists/year. Prefers local computer and non-computer designers. Prefers local illustrators, but out-of-towners okay. Send query letter, resume or tearsheets. Samples are filed and are not returned. Reports back only if interested. "We only report if we are interested or you can call for an appointment to show your portfolio. We prefer illustrators with children's book experience, but we will consider others, too." Originals returned after job's completion. Call or write to schedule an

appointment to show a portfolio, which should include photostats, final reproduction/product, slides or transparencies. Considers complexity of project and project's budget when establishing payment.
Book Design: Pays by the hour, $9-25; by the project, $500-3,000.
Jackets/Covers: Pays by the project, $1,200-3,000.
Text Illustration: Pays by the project.
Tips: "We are looking for freelance MacIntosh designers and typesetters familiar with Pagemaker Quark, and Freehand. Non-computer designers are considered as well. May work on or off premises, depending on the complexity of the project. Desingers must be able to carry a job through to production."

TYNDALE HOUSE PUBLISHERS, INC., 351 Executive Dr., Wheaton IL 60189. (708)668-8300. Creative Director: William Paetzold. Specializes in hardcover and paperback originals on "Christian beliefs and their effect on everyday life with a Middle-American look." Publishes 80-100 titles/year; 25% require freelance illustration. Recent titles include *Rise of Babylon*; *Monkey and the Crocodile*; *Calico Bear* and *Christopher Columbus, Natalie Jean* series. Books have "classy, highly-polished design and illustration.
First Contact & Terms: Approached by 40-50 freelance artists/year. Works with 15-20 freelance artists/year. Send query letter, tearsheets and/or slides. Samples are filed or are returned by SASE. Reports back only if interested. Negotiates whether originals returned to artist at job's completion. To arrange to show a portfolio, mail tearsheets, slides and SASE. Considers complexity of project, skill and experience of artist, project's budget and rights purchased. Negotiates rights purchased.
Book Design: Pays by the project, $500-1,000.
Jackets/Covers: Assigns 20 freelance illustration jobs/year. Prefers progressive but friendly style. Pays by the project, $400-5,000.
Text Illustrations: Assigns 20 freelance jobs/year. Prefers progressive but friendly style. Pays by the project, $400-2,000.
Tips: "Only show your best work. We are looking for illustrators who can tell a story with their work and who can draw the human figure in action when appropriate." A common mistake is "neglecting to make follow-up calls. 1) Be able to leave filable sample(s). 2) Be available; by friendly phone reminders, sending occasional samples. 3) Schedule yourself wisely, rather than missing a deadline."

THE UNICORN PUBLISHING HOUSE, INC., 120 American Rd., Morris Plains NJ 07950. (201)292-6852. Contact: Art Director. Specializes in original and reprint hardcovers, especially juvenile and adult classics. Publishes 14 titles/year for ages 4-adult. Recent titles include *The Velveteen Rabbit*, *The Nutcracker* and *The Gift of the Magi*.
First Contact & Terms: Approached by 750 freelance artists/year. Works with 6 freelance artists/year. Send query letter with brochure, resume, tearsheets and photocopies. Samples are not returned. Original work returned after job's completion. Considers complexity of project, skill and experience of artist and project's budget when establishing payment. Negotiates rights purchased.
Book Design: Assigns 6 freelance illustration jobs/year. Pays by the project, $300 minimum.
Text Illustration: Assigns 6 freelance jobs/year. "No preference in medium—art must be detailed and realistic." Pays by the project, "depends on the number of pieces being illustrated."
Tips: "In a portfolio, we're looking for realism in a color and b&w medium. We want to see how artists do people, animals, architecture, natural settings, fantasy creatures; in short, we want to see the range that artists are capable of. We do not want to see original artwork. Usually the biggest problem we have is receiving a group of images which doesn't adequately represent the full range of the artist's capabilities."

UNIVELT INC., Box 28130, San Diego CA 92128. (619)746-4005. Manager: R.H. Jacobs. Publishes hardcover and paperback originals on astronautics and related fields; occasionally publishes veterinary first-aid manuals. Publishes 10 titles/year; all have illustrations. Recent titles include *To Catch a Flying Star—A Scientific Theory of UFOs, Technical Briefing* and *The Case for Mars III*.
First Contact & Terms: Works with 1-2 freelance illustrators and 1-2 freelance designers/year. Prefers local artists. Send query letter with resume, business card and/or flyer to be kept on file. Samples not filed are returned by SASE. Reports in 4 weeks on unsolicited submissions. Buys one-time rights. Originals returned to artist at job's completion. Free catalog.
Jackets/Covers: Assigns 10 freelance jobs/year. Uses artists for covers, title sheets, dividers, occasionally a few illustrations. Pays $50-100 for front cover illustration or frontispiece.
Tips: "Books usually include a front cover illustration and frontispiece. Illustrations have to be space-related. We obtain most of our illustrations from authors and from NASA."

THE UNIVERSITY OF ALABAMA PRESS, Box 870380, Tuscaloosa AL 35487-0380. (205)348-5180. Production Manager: Zig Zeigler. Specializes in hardcover and paperback originals and reprints of academic titles. Publishes 40 titles/year; 10% require freelance design.
First Contact & Terms: Works with 2-3 freelance artists/year. Requires book design experience, preferably with university press work. Works on assignment only. Send query letter with resume, tearsheets and slides. Samples not filed are returned only if requested. Reports back within a few days. Originals not returned to

artist at job's completion. To show a portfolio, mail tearsheets, final reproduction/product and slides. Considers project's budget when establishing payment. Buys all rights.

Book Design: Assigns 2-3 freelance design jobs/year. Pays by the project, $250 minimum.

Jackets/Covers: Assigns 2-3 freelance design jobs/year. Pays by the project, $250 minimum.

THE UNIVERSITY OF CALGARY PRESS, 2500 University Drive NW, Calgary AB T2N 1N4 Canada. (403)220-7578. FAX: (403)282-6837. Production Coordinator: John King. Estab. 1981. Book publisher. Publishes hardcover originals and reprints, trade paperback originals and reprints and textbooks. Types of books include biography, reference, history and scholarly. Publishes 12-14 titles/year. Recent titles include *Sitar Music in Calcutta* and *Alexander Cameron Rutherford: A Gentleman of Strathcona*. Book catalog free by request.

Needs: Approached by 1-2 freelance artists/year. Prefers artists with experience in scholarly book design. Uses freelance artists mainly for covers.Works on assignment only.

First Contact & Terms: Send query letter with resume and photostats. Samples are filed. Reports back within 2-3 weeks. Write to schedule an appointment to show a portfolio, which should include thumbnails, photostats and photographs. Rights purchased vary. Originals returned at job's completion.

Jackets/Covers: Assigns 12 freelance design jobs/year. Pays by the project, $150-300.

VALLEY OF THE SUN PUBLISHING, subsidiary of Sutphen Corp., Box 38, Malibu CA 90265. Art Director: Jason D. McKean. Book publisher. Also publishes audio, video and music cassettes. Estab. 1972. Publishes trade and mass market paperback originals. Subjects include self-help, metaphysical and New Age titles. Publishes 100 titles/year. 50% require freelance illustration. Recent titles include *Atlantis: Healing Temple*; *Pisces Rising*; *Psychic Video Magazine* and *Wisdom Book*.

First Contact & Terms: Approached by 20 freelance artists/year. Buys 50 freelance illustrations/year. Works with illustrators mainly for audio and video package cover art. Also works with artists for jacket/cover illustration. Works on assignment only. Send query letter with slides, transparencies, self-promotion materials and SASE. Samples are filed or are returned by SASE. Reports back only if interested. Originals returned to artists at job's completion. Write to schedule an appointment to show a portfolio, which should include original/final art, tearsheets, photographs, slides and transparencies. Considers project's budget when establishing payment. Buys first rights.

Book Design: Pays by the project, $100 minimum.

Jackets/Covers: Assigns 30-40 freelance illustration jobs/year. Pays by the project, $100 minimum.

Text Illustration: Assigns 10-20 freelance jobs/year. Pays by the project, $100 minimum.

Tips: "We use surrealistic or fantasy illustration, realistic or abstract. I look for eye-catching color. Send black-and-white prints or 35mm or 2¼ × 2¼ transparencies that can be kept on file. Artist can also send self-promotion materials that can be kept on file."

VICTORY PRESS, 543 Lighthouse Ave., Monterey CA 93940-1422. Contact: Eileen Hu. Estab. 1988. Publishes trade paperback originals and children's fiction. Recent titles include *Adventures of Monkey King* and *The Land of Tuppitry*.

First Contact & Terms: Approached by 30 freelance artists/year. Works with 2-4 freelance illustrators/year. Send resume and photocopies. Samples not filed are returned by SASE. Buys all rights.

Book Design: Pay by the project.

Text Illustration: Pays by the project, $100-2,500; pen & ink sketches, $10-20 illustration.

Jackets/Covers: Color, $100-5,000.

Tips: "If possible, include copies of published work. Especially interested in b&w or full-color work relating to children's fairy tales."

J. WESTON WALCH, PUBLISHER, Box 658, Portland ME 04104-0658. (207)772-2846. Managing Editor: Richard Kimball. Specializes in supplemental secondary school materials including books, poster sets, filmstrips and computer software. Publishes 120 titles/year. Recent titles include *Art Projects Around the Calendar* and *The Senses: Connections to Our World*. Books look "practical, open and inviting."

First Contact & Terms: Works with 20 freelance artists/year. Works on assignment only. Send query letter with resume and samples to be kept on file unless the artist requests return. Write for artists' guidelines. Prefers photostats as samples. Samples not filed are returned only by request. Reports within 6 weeks. Original work not returned to the artist after job's completion. Considers project's budget when establishing payment. Rights purchased vary according to project.

Jackets/Covers: Assigns 20 freelance design and illustration jobs/year. Pays by the hour, $12-20 by the project, $100 minimum.

Text Illustration: Assigns 10 freelance jobs/year. Prefers b&w pen & ink. Pays by the hour, $12-20 by the project, $100 minimum.

Tips: Would like to see "realistic depictions of teenagers" from freelance artists.

Jacket Design © Jackie Meyer, Jacket Illustration © Mel Odom 1991

The illustration on this book jacket was done by renowned illustrator Mel Odom to represent an abused woman. Jackie Meyer, the designer of the cover and vice president, creative director of Warner Books, explains that Odom had illustrated the Ruth Rendell books for Louise Fili, former art director of Pantheon Books. "I was asked to redesign the covers for Mysterious Press," Meyer says, "and make them more commercial. I felt Fili had chosen the best illustrator, so I continued to work with him." For the project, Odom read the manuscript and conferred with the author, with whom he is friends. "Our publisher loved the art so much," says Meyer, "that he purchased it for his personal collection."

WARNER BOOKS INC., 666 5th Ave., New York NY 10103. (212)484-3151. Vice President and Creative Director: Jackie Meyer. Publishes mass market paperbacks and adult trade hardcovers. Publishes 350 titles/year; 20% require freelance design; 80% require freelance illustration. Recent titles include *The Gold Coast*, *Scarlet* and *Burden of Proof*. Works with countless freelance artists/year. Buys hundreds of designs and illustrations from freelance artists/year.

First Contact & Terms: Approached by 500 freelance artists/year. Works on assignment only. Send brochure or tearsheets and photocopies. Samples are filed or are returned by SASE. Reports back only if interested. To show a portfolio, mail appropriate materials. Originals returned to artist at job's completion (artist must pick up). Pays $800 and up/design; $1,000 and up/illustration. Negotiates rights purchased. "Check for most recent titles in bookstores."

Jackets/Covers: Uses realistic jacket illustrations. Payment subject to negotiation.

Tips: Industry trends include "more graphics and stylized art. Looks for "photorealistic style with imaginative and original design and use of eye-catching color variations." Artists shouldn't "talk too much. Good design and art should speak for themselves."

***WEEKLY READER CORPORATION**, 245 Long Hill Rd., Middletown CT 06457. (203)638-2757. FAX: (203)638-2609. Graphics Director: Vickey Bolling. Estab. 1928. Children's publisher. Publishes hardcover, trade paperback and mass market paperback reprints. Also publishes children's periodicals. Publishes contemporary, mainstream, historical and science fiction, instructional, adventure, pre-school, juvenile, reference, *Weekly Reader* products. 90% require freelance illustration. 5% require freelance design.

Needs: Approached by 50 freelance artists/year. Works with 200 freelance illustrators and 5 freelance designers/year. Buys 4-5,000 freelance illustrations/year. Uses freelance artists mainly for editorial. Also uses freelance artists for posters, skills books and special projects. Works on assignment only.

First Contact & Terms: Send query letter with tearsheets, SASE, slides and promo pieces. Samples are filed or are returned by SASE. Reports back within 2-3 weeks. Mail appropriate materials: printed samples, b&w tearsheets. Buys first rights. Originals are returned at job's completion.

Posters: Pays by the project, $75-2,000.

Covers: Pays by the project, $250-600. Considers all media.

Text Illustration: Assigns 4-5,000 freelance illustration jobs/year. Pays by the project, $75-6,000. Considers all media.

SAMUEL WEISER INC., Box 612, York Beach ME 03910. (207)363-4393. Vice President: B. Lundsted. Specializes in hardcover and paperback originals, reprints and trade publications on metaphysics/oriental philosophy/esoterica. Recent titles include *Inner Journeys*, by Jay Earley and *Chakras—Roots of Power*, by Werner Bohm. Books have "esoteric study, oriental philosophy" look. Publishes 20 titles/year.

First Contact & Terms: Approached by approximately 15 freelance artists/year. Works with 4 freelance artists/year. Send query letter with resume, slides, book covers and jackets. "We can use art or photos." Samples are filed or are returned by SASE only if requested by artist. Reports back within 1 month only if interested. Originals returned to artist at job's completion. To show a portfolio, mail tearsheets and slides. Considers complexity of project, skill and experience of artist, project's budget, turnaround time and rights purchased when establishing payment. Buys one-time non-exclusive rights. Finds most artists through references/word-of-mouth, portfolio reviews and samples received through the mail.

Jackets/Covers: Assigns 20 freelance design jobs/year. Prefers airbrush, watercolor, acrylic and oil. Pays by the project, $100-500.

Tips: "We're interested in artists with professional experience with cover mechanicals—from inception of design to researching/creating image to type design, color-separated mechanicals to logo in place. It helps if we can see the work. We return samples if the artist requests that we do, but we really like to keep what we think we might be able to use down the road a bit. For example, we have one photo that we just now are using, but I saw it over three years ago for the first time and had nothing to use it on. Don't send us drawings of witches, goblins and demons, for that is not what our field is about. You should know something about us before you send materials. Send SASE for catalog."

WESTERN PRODUCER PRAIRIE BOOKS, Box 2500, Saskartoon SK S7K 2C4 Canada. (306)665-3548. FAX: (306)653-1255. Publishing Director: Jane McHughen. Estab. 1954. Book publisher. Publishes hardcover originals and trade paperback originals and and reprints. Types of books include mainstream fiction, biography, young adult, history and humor. Specializes in natural history. Publishes 22 titles/year. Recent titles include *Julie's Secret*, by Cora Taylor and *Farming in a Nuthouse*, by Aeneas Precht. 25% require freelance illustration; 100% require freelance design. Book catalog free for SASE.

Needs: Approached by 10 freelance artists/year. Works with 6 freelance illustrators and 2 freelance designers/year. Buys 20 freelance illustrations/year. Prefers local artists only with experience in book cover art. Uses freelance artists mainly for cover illustrations. Also uses freelance artists for jacket/cover and book design and text illustration. Works on assignment only.

First Contact & Terms: Send query letter with resume and slides. Samples are filed. Reports back to the artist only if interested. To show a portfolio, mail appropriate materials. Rights purchased vary according to project. Originals are returned at job's completion.

Book Design: Assigns 3 freelance design and 3 freelance illustration jobs/year. Pays by the project.

Jackets: Assigns 22 freelance design and 6 freelance illustration jobs/year. Pays by the project.

Text Illustration: Assigns 6 freelance design and 6 freelance illustration jobs/year. Pays by the project.

WESTPORT PUBLISHERS, INC., 4050 Pennsylvania, Kansas City MO 64111. (816)756-1490. FAX: (816)756-0159. Managing Editor: Terry Faulkner. Estab. 1983. Book publisher. Publishes hardcover and trade paperback originals. Types of books include instruction, biography, juvenile, reference, history, self-help, travel, cookbook, psychology-related and parenting. Publishes 24-30 titles/year. Recent titles include *Little People*, *Making of Two Dakotas*, *Celebrate! Parties for Kids* and *Colorful Kansas City*. 70% require freelance illustration; 80% require freelance design. Book catalog available with SASE.

Needs: Approached by 3-5 freelance artists/year. Works with 3-5 freelance illustrators and 3-5 freelance designers/year. Buys 25-50 freelance illustrations/year. Uses freelance artists mainly for covers, juvenile/self-help titles. Also uses freelance artists for book, direct mail design, text illustration and catalog design. Works on assignment only.

First Contact & Terms: Send query letter with brochure, resume, SASE, tearsheets and photocopies. Samples are filed and considered for each project. To show a portfolio, mail thumbnails, b&w photostats, dummies, roughs and tearsheets. Rights purchased vary according to project. Originals are returned at the job's completion.
Book Design: Assigns 5-10 freelance design and 5-10 freelance illustration jobs/year. Pays by the project, $100 and up.
Jackets/Covers: Assigns 24-30 freelance design and 24-30 freelance illustration jobs/year. Pays by the project.
Text Illustration: Assigns 15 freelance design and 3-5 freelance illustration jobs/year. Pays by the project, $150 and up.
Tips: "Get experience with books similar in subject area to our list."

ALBERT WHITMAN & COMPANY, 6340 Oakton, Morton Grove IL 60053-2723. Editor: Kathleen Tucker. Specializes in hardcover original juvenile fiction and nonfiction—many picture books for young children. Publishes 25 titles/year; 100% require freelance illustration. Recent titles include *Meredith's Mother Takes the Train* and *How the Oxstar Fell from Heaven*. Books need "a young look—we market to preschoolers mostly."
First Contact & Terms: Works with 20 freelance illustrators and 3 freelance designers/year. Prefers working with artists who have experience illustrating juvenile trade books. Works on assignment only. Send brochure/flyer or resume and "a few slides and photocopies of original art and tearsheets that we can keep in our files. Do *not* send original art through the mail." Samples not returned. Reports to an artist if "we have a project that seems right for him. We like to see evidence that an artist can show the same children in a variety of moods, poses and environments." Original work returned to artist at job's completion "if artist holds the copyright." Rights purchased vary.
Cover/Text Illustration: Cover assignment is usually part of illustration assignment. Assigns 18 freelance jobs/year. Prefers realistic and semi-realistic art. Pays by flat fee or royalties.
Tips: Especially looks for "an artist's ability to draw people, especially children and the ability to set an appropriate mood for the story."

WILSHIRE BOOK CO., 12015 Sherman Rd., North Hollywood CA 91605. (818)765-8579. President: Melvin Powers. Publishes paperback reprints; psychology, self-help, inspirational and other types of nonfiction. Publishes 25 titles/year.
First Contact & Terms: Local artists only. Call if interested. Buys first, reprint or one-time rights. Negotiates pay. Free catalog.
Jackets/Covers: Assigns 25 jobs/year. Buys b&w line drawings.

***WINSTON-DEREK, INC.,** Box 90883, Nashville TN 37209. Production: Dawn Kimberley. Book publisher. Estab. 1976. Publishes hardcover originals, trade paperback originals and mass market paperback origials. Publishes biography, juvenile, self-help and poetry also mainstream/contemporary. Specializes in minority concerns. Recent titles include *The Golden Fairy*, by Jill MacKenzie; *The First Frost*, by Janice Schultz; and *A Perfect Christmas for Kate Leary*, by Catherine Gebhardt. Books have "very good graphic art and illustrations with appropriate font styles." Publishes 60-65 titles/year. 30% require freelance illustration.
First Contact & Terms: Works with 6-10 freelance illustrators/year. Buys 75 freelance illustrations/year. Works with illustrators mainly for children's books. Also works with artists for jacket/cover illustration. Works on assignment only. Send query letter with tear sheets and any clear reproduction of work. Samples are filed. Samples not filed are returned by SASE only if requested. Reports back only if interested. Originals not returned to artist at job's completion. To show a portfolio, mail any method of clear reproduction of work. Considers project's budget when establishing payment. Negotitates rights purchased.
Book Design: Assigns 20 freelance design, 25 freelance illustration jobs/year. Pays by project, $150-500.
Jackets/Covers: Assigns 20 freelance illustration jobs/year. Preferred themes usually includes people in a particular setting. Pays by the project, $75-300.
Text Illustration: Assigns 12 freelance jobs/year. Prefers pen and ink, charcoal, acrylic and colored pencil. "Artists medium should be flexible." Pays by the project, $25-75/print.
Tips: Because of the recession, "we are not able to pay as much as we ordinarily would. Also our book production has been cut by five percent."

WOODSONG GRAPHICS INC., Box 304, Lahaska PA 18931-0304. (215)794-8321. President: Ellen Bordner. Specializes in paperback originals covering a wide variety of subjects, "but no textbooks or technical material so far." Publishes 3-6 titles/year. Recent titles include *Dogs & You*, by Doris Phillips and *Snowflake Come Home*, by John Giegling. Books are "usually 5½ × 8½ format, simple text style with 4-color laminated covers and good halftone illustrations accompanying text where appropriate."
First Contact & Terms: Approached by several hundred freelance artists/year. Works with 1-5 freelance illustrators/year depending on projects and schedules; works with "only a couple of freelance designers, but we expect to expand in this area very soon." Works on assignment only. Send query letter with brochure and samples to be kept on file. Any format is acceptable for samples, except originals. Samples not filed are

returned by SASE. Reports only if interested. Originals returned to artist at job's completion. Considers complexity of assignment, skill and experience of artist, project's budget and turnaround time when establishing payment. Rights purchased vary according to project.

Book Design: Assigns 2-3 freelance jobs/year. Pays by the project, $400 minimum.

Jackets/Covers: Assigns 3-6 freelance illustration jobs/year. Pays by the project, $150 minimum.

Text Illustration: Assigns 2-3 freelance jobs/year. Medium and style vary according to job. Pays by the project, $250 minimum.

Tips: Looks for a "realistic style in illustration, generally with an upbeat 'mood.' A willingness to submit some samples specifically created for the project at hand would be tremendously helpful. Our needs are often quite specialized. Animal illustrations are a particular interest here, particularly in formats suitable for covers (4-color reproducible)."

WRITER'S DIGEST BOOKS/NORTH LIGHT, F&W Publishing, 1507 Dana Ave., Cincinnati OH 45207. Art Director: Carol Buchanan. Publishes 25-30 books annually for writers, artists, photographers, plus selected trade titles. Send non-returnable photocopies of printed work to be kept on file. Works on assignment only.

Text Illustration: Uses artists for text illustration and cartoons.

Tips: Uses artists for ad illustration and design, book jacket illustration and design and direct-mail design.

WRITER'S PUBLISHING SERVICE CO., 1512 Western Ave., Box 1273, Seattle WA 98111. (206)284-9954. Publisher: William R. Griffin. Estab. 1976. Book publisher. Publishes hardcover originals and reprints, trade paperback originals and textbooks. Types of books include contemporary, experimental, historical, science fiction, instruction, adventure, fantasy, mystery, biography, pre-school, reference, history, self-help, humor and cookbooks. Specializes in "all subjects; a separate division does only cleaning and maintenance subjects." Publishes 25 titles/year. Recent titles include *Living Through Two World Wars*, by Lehman and *How to Sell and Price Contract Cleaning*, by Davis. 90% require freelance illustration; 50% require freelance design. Book catalog available for $3.

Needs: Approached by 250 freelance artists/year. Works with 50 freelance illustrators and 20 freelance designers/year. Buys over 300 freelance illustrations/year. Prefers artists with experience. Uses freelance artists mainly for illustration, design, covers. Also uses freelance artists for direct mail and catalog design. Works on assignment only.

First Contact & Terms: Send query letter with brochure, resume, tearsheets, photocopies and other samples of work. Samples are filed. Reports back to the artist only if interested. Call or write to schedule an appointment to show a portfolio, which should include roughs, dummies and other samples. Rights purchased vary according to project. Originals returned at job's completion.

Book Design: Assigns 30 freelance design and 20 freelance illustration jobs/year. Pays by the hour, $7-30; by the project, $3-1,500.

Jackets/Covers: Assigns 10 freelance design and 20 freelance illustration jobs/year. Pays by the hour; by the project.

Text Illustration: Assigns 10 freelance design and 20 freelance illustration jobs/year. Pays by the hour or by the project.

Tips: "We are always looking for cleaning and maintenance related art and graphics."

WYRICK & COMPANY, 12 Exchange St., Charleston SC 29401. (803)722-0881. FAX: (803)722-6771. President: C.L. Wyrick, Jr.. Estab. 1986. Book publisher. Publishes hardcover and trade paperback originals and trade paperback reprints. Types of books include contemporary and mainstream fiction, biography, travel, humor, art and photography books. Publishes 6-8 titles/year. Recent titles include *Porgy, Toiling in Soil*. 75% require freelance illustration; 100% require freelance design.

Needs: Approached by 8-12 freelance artists/year. Works with 2-3 freelance illustrators and 2-3 freelance designers/year. Buys 8-20 freelance illustrations/year. Prefers local artists with experience in book design and illustration. Uses freelance artists mainly for book jackets and text illustration. Also uses freelance artists book and catalog design. Works on assignment only.

First Contact & Terms: Send query letter with resume, tearsheets, transparencies and SASE. Samples are filed or are returned by SASE. Reports back within 2-3 months. To show a portfolio, mail tearsheets, photographs, slides and transparencies. Buys one-time rights. Originals are returned at the job's completion.

Book Design: Assigns 6-8 freelance design and 1-3 freelance illustration jobs/year. Pays by the project.

Jackets/Covers: Assigns 6-8 freelance design and 2-4 freelance illustration jobs/year. Pays by the project.

Text Illustration: Assigns 2-3 freelance design and illustration jobs/year. Pays by the project.

Tips: "Send samples of work suitable for book illustrations or cover design—not ads or unrelated work."

YE GALLEON PRESS, Box 25, Fairfield WA 99012. (509)283-2422. Editorial Director: Glen Adams. Estab. 1937. Publishes rare Western history, Indian material, antiquarian shipwreck and old whaling accounts and town and area histories; hardcover and paperback originals and reprints. Publishes 20 titles/year; 10% require freelance illustrators. Book catalog free for SASE.

First Contact & Terms: Works with 2 freelance illustrators/year. Query with samples and SASE. No advance. Pays promised fee for unused assigned work. Buys book rights.

Text Illustration: Buys b&w line drawings, some pen & ink drawings of a historical nature; prefers drawings of groups with facial expressions and some drawings of sailing and whaling vessels. Pays for illustration by the project, $7.50-35.

Tips: " 'Wild' artwork is hardly suited to book illustration for my purposes. Many correspondents wish to sell oil paintings which at this time we do not buy them. It costs too much to print them for short edition work."

ZOLAND BOOKS, INC., 384 Huron Ave., Cambridge MA 02138. (617)864-6252. Design Director: Lori Pease. Estab. 1987. Book publisher. Publishes hardcover originals and reprints and trade paperback originals and reprints. Types of books include contemporary and mainstream fiction, biography, juvenile, travel, poetry, fine art and photography. Specializes in literature. Publishes 6-10 titles/year. Recent titles include *The Earth Shines Secretly—A Book of Days,* by Marge Piercy, art by Nell Blaine; *White Owl and Blue Mouse,* translated by Denise Levertov. Books are "well-designed, well-made, classic with a contemporary element." 10% require freelance illustration; 100% require freelance design. Book catalog free by request.

Needs: Works with 3 freelance illustrators and 5 freelance designers/year. Buys 3 freelance illustrations/year. Uses freelance artists mainly for book and jacket design. Also uses freelance artists for jacket/cover illustration and catalog design. Works on assignment only.

First Contact & Terms: Send query letter with brochure, resume, tearsheets, photocopies and photostats. Samples are filed or are returned by SASE if requested by artist. Reports back to the artist only if interested. To show a portfolio, mail roughs and tearsheets. Rights purchased vary according to project. Originals returned at job's completion.

Book Design: Assigns 6-10 freelance design and 1-3 freelance illustration jobs/year. Pays by the project, $400 minimum.

Jacket/Covers: Assigns 6-10 freelance design and 1-3 freelance illustration jobs/year. Pays by the project, $500 minimum.

Tips: "We love to see all styles and our company is growing, so do send us samples. We would like to see more woodcuts, black & white, children's illustrations and illustrations of books."

Other Book Publishers

Each year we contact all publishers currently listed in *Artist's Market* requesting they give us updated information for our next edition. We also mail listing questionnaires to new and established publishers which have not been included in past editions. The following book publishers either did not respond to our request to update their listings for 1992 (if they indicated a reason, it is noted in parentheses after their name), or they did not return our questionnaire for a new listing.

Airmont Publishing Co., Inc.
Atlantic Monthly Press
Ballantine/Del Rey/Fawcett/Ivy Books
Blue Lantern Studio (unable to contact)
Bantam Books
Berkley Publishing Group
Christian Board of Publication
Chronicle Books
City Lights Books, Inc.
Computer Technology Resource Guide (see Read 'n Run Books)
Craftsman Book Co.
Dillon Press (merged with another company)
Doubleday
Eastview Editions
Exposition Phoenix Press (unable to contact)
Fell Publishers
Gessler Publishing Co., Inc.
Goose Lane Editions Ltd.
Great Commission Publications
Grove Weidenfield
Guernica (no longer uses freelancers)
HarperCollins

Harrison House Publishing
Hemkunt Press
Henry Holt & Co.
Holt, Rinehart & Winston
Houghton Mifflin Co.
Carl Hungness Publishing
Hunter House Publishers
Hurtig Publishers Ltd.
Kaleidoscopix, Inc.
Alfred A. Knopf
Macmillan Publishing Co.
Minnie Ha! Ha!
MIT Press
William Morrow & Co.
Mountain Lion, Inc.
Natural Science Publications (out of business)
New Society Publishers (no longer uses freelancers)
W.W. Norton & Co., Inc.
Padre Productions
Picture Book Studio
The Press of MacDonald & Reinecke
Pulse-Finger Press
Raintree Publishers
Resource Publications, Inc.
Santillana Publishing Co. Inc.
Scarborough House (asked to

be deleted)
Scholium International Inc.
Science Tech Publishers (no longer uses outside freelancers)
Seal Press
Simon and Schuster
Stewart Tabori & Chang
Support Source
Swamp Press
Ten Speed Press
UAHC Press
University of California Press
University of Iowa Press (no longer uses outside freelancers)
University of Nebraska Press (can no longer afford to use freelancers)
University of Pennsylvania Press (asked to be deleted)
University of Texas Press
Urban & Schwarzenberg, Inc.
Viking Penguin Books
Vintage Books
Webb Research Group (late response)
Wisconsin Tales & Trails, Inc.
Woodall Publishing Company

Businesses

There are over 3.5 million businesses in this country, and that adds up to a goldmine of opportunities for freelance artists. Businesses—which range from local supermarkets to multi-million dollar corporations—need artists who can design and illustrate collateral materials, print ads, annual reports and point-of-purchase displays, to name only a few assignments. This section's contents are representative of this hodgepodge of businesses— from architecture firms to IGPC, the largest producer of stamps in the country (and this year's Business Close-up) to Polo/Ralph Lauren for fashion designers and illustrators.

Retail, service and merchandising businesses provide freelance opportunities both locally and nationally. Don't overlook potential clients in your own town. Consult this section and the *Yellow Pages* for businesses in your area. New businesses require artwork for letterheads, brochures and advertisements. Professionals such as doctors may need you to design informational brochures. The grocery store just down the block might need a new approach to its advertisements in the local paper. Keep your name on file by sending samples and a business card to businesses you think might need a graphic facelift or regular contributions. Once you have established a good reputation with one business, word of mouth and referrals will bring extra assignments.

Businesses require a variety of styles to match the diversity of their products and marketing strategies. Realistic work is generally needed for product renderings in catalogs and in print advertising. Collectible manufacturers look for a realistic but fine art approach to plate illustration. Fashion firms call for realism in their catalogs and ads but desire a freer hand for fashion editorial. Familiarity with signage and design of point-of-purchase displays and exhibits increases your chances of working with exhibit, display and sign firms. Architectural, interior and landscape design firms are also included in this section; they usually require that freelancers have good draftsmanship, a knowledge of blueprints and building materials, plus a good sense of perspective.

Do your homework before contacting businesses. Research the company's specialty, its size and its products. Ask for an annual report, which not only documents the financial results of a company's fiscal year but frequently offers a candid perspective on its employees, facilities and marketing plans. Then send samples that match the company's needs.

Find the name of the art buyer during your initial call; then send a sample package. Make appointments in advance to show your portfolio and then select work that reflects the company's specialty. Always leave a reminder behind so that it can be filed for future reference.

Before accepting an assignment, make sure you understand what rights will be purchased. Businesses often buy all rights (called a "buy-out") to artwork because they reuse it. Negotiate your payment so that it reflects the buy-out.

Stay current with economic and business trends by reading the financial pages in newspapers and periodicals; this way you will know what type of businesses are thriving and which ones are in trouble. Attend trade shows to see the latest trends in your field and to make valuable contacts; trade magazines list the dates and locations of upcoming shows. To increase your knowledge of the exhibit, display and sign field, refer to the trade magazine *Visual Merchandising & Store Design*. Read *Women's Wear Daily*, as well as fashion magazines, for trends in the fashion industry. Collectible plate manufacturers are listed in

this section of the book and more names and addresses are listed in *The Bradford Book of Collector's Plates* and in *Plate World*. For additional names and information regarding architecture and interior design firms, consult the directory *Profile* and the magazines *The AIA Journal*, *Architectural Digest* and *Interior Design*.

ABEL LOVE, INC., 20 Lakeshore Dr., Newport News VA 23602. (804)877-2939. Buyer: Abraham Leiss. Estab. 1985. Distributor of books, gifts, hobby, art and craft supplies and drafting material. Clients: retail stores and college bookstores. Current clients include Hampton Hobby House, NASA Visitors Center, For Eustis Transportation Museum, Temple Gift Shops and Hawks Hobby Shop.
Needs: Approached by 100 freelance artists/year. Works with 10 freelance illustrators and 1 freelance designer/year. Uses freelance artists for catalog design, illustration and layout.
First Contact & Terms: Send query letter with slides, photographs and transparencies. Samples are filed. Reports back ASAP. Pays for design and illustration by the project. Rights purchased vary according to project.

ABRACADABRA MAGIC SHOP, 125 Lincoln Blvd., Dept. AM91, Middlesex NJ 08846. (908)805-0200. President: Robert Bokor. Manufacturer/mail order specializing in fun products for men and boys, marketed via mail order.
Needs: Approached by 3-4 freelance artists/year. Works with 2 freelance illustrators and 2 freelance designers/year. Assigns 6 jobs to freelance artists/year. Uses freelance artists mainly for catalogs. Local artists only for design illustration artists anywhere in USA. Works on assignment only. Uses artists for advertising and catalog design, illustration and layout; packaging design and layout. Needs technical illustration.
First Contact & Terms: Send query letter with resume and photocopies. Samples not filed are returned by SASE. Reports back within 1 month. To show a portfolio, mail appropriate materials. Pays for design by the project, $50-1,000; per design. Considers client's budget when establishing payment.
Tips: "We are currently looking for freelance cartoonists to illustrate products for catalogs."

ACADIA CO., INC., 330 7th Ave., New York NY 10001. (212)695-3900. Design Director: Susan P. Cherson. Converter. "Our goods must reflect the national retail market (K-Mart/Walmart/Sears)." Labels: The Acadia Co., Inc.
Needs: Works with 1-2 freelance illustrators and 15 freelance designers/year. Prefers local artists only with experience in repeats, an excellent color sense and a major understanding of home furnishings. Uses freelance artists mainly for creative repeats and colorings. Also uses freelance artists for textile and pattern design, paste-up and mechanicals (for pillow tickings only). No style preferred. Special needs are "room renderings only—someone with an exceptional color sense in home furnishings."
First Contact & Terms: Send query letter with brochure showing art style. Samples are filed or are returned by SASE if requested by artist. Reports back only if interested. Write to schedule an appointment to show a portfolio with enclosed phone number. Portfolio should include color thumbnails. Pays for design by the project, $75-1,000; millwork $300-350 per diem (plus expenses). Pays for illustration by the project, $400-700. Buys all rights.
Tips: The best way for illustrators or designers to introduce themselves to Acadia Co., Inc. is "first by recommendations and then by portfolio review. Have a good, progressive portfolio and be persistent in calling. We are greatly cutting back in giving out artwork. Also, we are asking for smaller colorings and, when possible, repeats—to keep costs down."

ACCENTS, INC., 3208 Factory Dr., Pomona CA 91768. Marketing Manager: Charles Fixa. Estab. 1960. Manufacturer of party paper such as napkins, plates and cups. Clients: grocery and party store trade.
Needs: Approached by 10 freelance artists/year. Works with 1-2 freelance artist/year. Assigns 1-2 jobs/year. Prefers local artists only with experience in party paper industry. Uses freelance artists mainly for design for napkins. Prefers contemporary design. Also uses freelance artists for advertising design, illustration and layout and other design.
First Contact and Terms: Send query letter with brochure and tearsheets. Samples are filed or are returned only if requested by artist. Reports back within 1 month. Call or write to schedule an appointment to show a portfolio, which should include original/final art and final reproduction/product. Pays for design and illustration by the project. Considers complexity of project and client's budget when establishing payment. Negotiates rights purchased.

AERO PRODUCTS RESEARCH INC., 11201 Hindry Ave., Los Angeles CA 90045. (213)641-7242. Director of Public Relations: J. Parr. Aviation training materials producer. Produces line of plastic credit and business cards and advertising specialty items.
Needs: Works with about 4 freelance illustrators and 2 freelance designers/month. Prefers local artists. Uses artists for brochures, catalogs, advertisements, graphs and illustrations.
First Contact & Terms: Send query letter with brochure/flyer and tearsheets to be kept on file. Originals not returned to artist at job's completion. Negotiates pay according to experience and project.

AFRICAN FABRIC PRINTS/AFRICAN GARMENTS INC., Box 91, New York NY 10108. (718)672-5759. Contact: Vince Jordan.
Needs: Uses artists for fashion and textile design and ready-to-wear patterns.
First Contact & Terms: To show a portfolio, mail tearsheets, original art or fashion design ideas. Reports in 5-6 weeks. Pays $50 minimum.

AHPA ENTERPRISES, Box 506, Sheffield AL 35660. Marketing Manager: Allen Turner. Estab. 1976. Media products producer/marketer. Provides illustration, fiction, layout, video production, computer-printed material, etc. Specializes in adult male, special-interest material. Clients: limited-press publishers, authors, private investors, etc.
Needs: Approached by 20 freelance artists/year. Works with about 5 freelance artists/year. Assigns 40-50 jobs to freelance artists/year. Seeking illustrators for illustration of realistic original fiction or concepts. Wants only those artists "who are in a position to work with us on an intermittent but long-term basis." Prefers a tight, realistic style; pen & ink, airbrush, colored pencil and watercolor. Works on assignment only.
First Contact & Terms: Send query letter with resume and photocopies or tearsheets, photostats, photographs and new sketches to be kept on file. Samples not filed are returned by SASE only if requested. Reports back only if interested (within 3-7 days). Pays for illustration by the project, $40-500. Considers complexity of the project and number and type of illustrations ordered when establishing payment. Buys all rights.
Tips: "This is an excellent place for capable amateurs to 'turn pro' on a part-time, open-end basis. We are most inclined to respond to artists whose cover letters indicate a willingness to adapt to our particular market needs. We are not inclined to respond to an illustrator who seems to be 'over-selling' himself."

ALBEE SIGN CO., 561 E. 3rd St., Mt. Vernon NY 10553. (914)668-0201. President: William Lieberman. Produces interior and exterior signs and graphics. Clients are banks and real estate companies.
Needs: Works with 6 freelance artists for sign design, 6 for display fixture design, 6 for P-O-P design and 6 for custom sign illustration. Local artists only. Works on assignment only.
First Contact & Terms: Query with samples (pictures of completed work). Previous experience with other firms preferred. Include SASE. Reports within 2-3 weeks. No samples returned. Reports back as assignment occurs. Provide resume, business card, pictures of work to be kept on file. Pays by job.

ALLBILT/NEW YORK, 38-09 43rd Ave., Long Island City NY 11101. (718)706-1414. FAX: (718)729-3423.Senior Designer: Teresa Bajandas. Manufacturer of custom designed uniforms for the hotel and travel industries. "We work with interior designers and architects in developing a uniform program consistent with the theme and image of each project be it hotel or airline." AllBILT/New York label.
Needs: Works with 2-3 freelance artists/year. Uses freelance artists for accessory design and fashion illustration. Prefers loose figure illustrations and realistic product rendering.
First Contact & Terms: Send query letter with brochure, tearsheets, photostats and photocopies. Samples not filed are returned only if requested by artist. Reports back only if interested. Write to schedule an appointment to show a portfolio, which should include original/final art. Pays for illustration by the project, $100-5,000; by the figure, $50-125. Considers complexity of project when establishing payment.

AMERICAN ARTISTS, Division of Graphics Buying Service, Suite 7, 42 Sherwood Terrace, Lake Bluff IL 60044. (708)295-5355. Manufacturer of limited edition plates, figurines and lithographs. Specializes in horse and cat themes, but considers others. Clients: wholesalers and retailers.
Needs: Approached by 10 freelance artists/year. Works with 5 freelance illustrators and 2 freelance designers/year. Uses artists for plate and figurine design and illustration; brochure design, illustration and layout. Open to most art styles.
First Contact & Terms: Send query letter with resume and samples. Prefers transparencies or slides but will accept photos—color only. Samples not filed are returned only if requested or if unsuitable. Reports within 1 month. Call or write for appointment to show a portfolio. Payment varies and is negotiated. Rights purchased vary. Considers complexity of project, skill and experience of artist, how work will be used and rights purchased when establishing payment.

AMERICAN TRADITIONAL STENCILS, RD 281, Bow St., Northwood NH 03261. (603)942-8100. FAX: (603)942-8919. Owner: Judith Barker. Estab. 1970. Manufacturer of brass and laser cut stencils and 24 karat gold finish charms. Clients: retail craft, art and gift shops. Current clients include Williamsburg Museum, Old Sturbridge and Pfaltzgraph Co., Henry Ford Museum, and some Ben Franklin stores.
Needs: Approached by 1-2 freelance artists/year. Works with 1 freelance illustrator/year. Assigns 2 jobs to freelance artists/year. Prefers artists with experience in graphics. Works on assignment only. Uses freelance artists mainly for stencils. Prefers b&w camera-ready art. Also uses freelance artists for advertising illustration and product design. Send query letter with brochure showing art style and photocopies. Samples are filed or are returned. Reports back in 2 weeks. Call to schedule an appointment to show a portfolio, which should include roughs, original/final art and b&w tearsheets. Pays for design by the hour, $8.50-20, by the project,

$15-150; for illustration by the hour, $6-7.50. Payment is negotiated. Rights purchased vary according to project.

***ANCHOR INDUSTRIES INC.**, 1100 Burch Dr., Box 3477, Evansville IN 47733-3477. (812)867-2421. FAX: (812)867-1429. Advertising and Marketing: Stella Stephens. Estab. 1892. Manufacturer for ages 21 and above. Labels: Made in America.
Needs: Approached by 1-3 freelance artists/year. Works with 1-2 freelance artists/year. Prefers artists who can do simple line art drawings in b&w, preferably pen & ink, from photos as samples. Uses freelance artists mainly for line art for illustrations. Also uses freelance artists for brochure illustration. Prefers hard edge, b&w only.
First Contact & Terms: Send query letter with tearsheets and photocopies. Samples are filed. Reports back only if interested. Portfolio should include b&w, *copies* of final art only. Pays for design and illustration by the project, $100-1,000. Buys all rights.
Tips: "Send media kit with examples of work; sharp photocopies OK."

***ANDOVER TOGS, INC.**, 1 Penn Plaza, New York NY 10119. (212)244-0700. FAX: (212)947-4650. Corp. Art Director: Bob Grubman. Estab. 1940. Manufacturer with inhouse screen printing. Manufactures mass marketed apparel. Boys Toddler-size 18; Girls Toddler-size 14.
Needs: Approached by 40 freelance artists/year. Works with 30 freelance artists/year. Prefers local artists only with experience in screen print design. Uses freelance artists mainly for original concept screen prints. Also uses freelance artists for fashion and textile design, mechanicals and cartoon repeats.
First Contact & Terms: Send query letter with brochure showing art style, resume and appropriate samples. Samples are filed or are returned by SASE if requested by artist. Reports back only if interested. Call or write to schedule an appointment to show a portfolio. Portfolio should include color samples and original/ final art. Pays for design and illustration by the project. Rights purchased vary according to project.

***ANNA-PERENNA INC.**, 71-73 Weyman Ave., New Rochelle NY 10805. Contact: Klaus Vogt. Estab. 1977. Importer, distributor and manufacturer.
Needs: Prefers local artists only. Works on assignment only. Uses artists for advertising design and layout, brochure and catalog design, illustration and layout.
First Contact & Terms: Send query letter with brochure and tearsheets. Reports back within 3 days. To show a portfolio, mail appropriate materials. Considers complexity of project when establishing payment. Buys all rights.

***ANTWERP DIAMOND DIST., INC.**, 587 5th Ave., New York NY 10017. (212)319-3300. FAX: (212)207-8618. Consultant: Leo Lisker. Estab. 1950. Manufacturer/distributor that specializes in diamonds on consignment. Clients: chain and catalog houses.
Needs: Approached by 5 freelance artists/year. Prefers local artists only. Works on assignment only. Uses the work of freelance artists mainly for trademedia. Also uses freelance artists for advertising design, illustration and layout; brochure design, illustration and layout.
First Contact & Terms: Send query letter with brochure showing art style. Samples not filed; they are returned. Reports back within 10 days. Mail appropriate materials. Portfolio should include roughs. Pays by the project, $3,000 minimum. Pays for illustration by the project. Buys all rights.

***APPLAUSE INC.**, 6101 Variel Ave., Woodland Hills CA 91365. (818)595-2852. FAX: (818)595-2990. Director, Design Development: Katie Cahill. Estab. 1965. Manufacturer/a gift company specializing in licensed properties, promotions, seasons and fine collectibles. Clients: "well-known artists. Character licenses." Current clients include Disney, Sesame Street, Looney Tunes, Dolls by Pauline and Robert Raikes.
Needs: Approached by 150-200 freelance artists/year. Works with 30-40 freelance illustrators and designers/ year. Assigns 600 jobs to freelance artists/year. Prefers artists with experience in "character, whimsy and home decor background." Works on assignment only. Uses freelance artists mainly for finish work – tight comps, reflective, inking. Prefers acrylic rendering, inking. Also uses freelance artists for product rendering and design, P-O-P displays, model making and signage.

 The asterisk before a listing indicates that the listing is new in this edition. New markets are often the most receptive to freelance submissions.

First Contact & Terms: Send query letter with resume, tearsheets and slides. Samples are filed or are returned by SASE only if requested by artist. Reports back within 1 month. To show portfolio, mail thumbnails, roughs, original, final art and color samples. Pays for design: by the project, $50-1,200. Pays for illustration: by the project, $75-3,000. Rights purchased vary according to project.

ARCHITECTURE BY SCHLOH, 213 Bean Ave., Los Gatos CA 95030. (408)354-4551. Estab. 1965. Architectural firm providing architectural services for high-end custom homes. Clients: residential.
Needs: Works with 3 freelance illustrators and 2 freelance designers/year. Uses artists mainly for technical drawings. Local artists preferred. Works on assignment only. Uses artists for advertising and brochure design, architectural renderings and model making.
First Contact & Terms: Send query letter with brochure and photocopies. Samples are filed. Reports back within 2 weeks. Write to schedule an appointment to show a portfolio, which should include photographs. Pays for illustration by the hour, $40-50; pays for design by the hour, $20-35. Considers complexity of project and client's budget when establishing payment. Buys first rights.

THE ASHTON-DRAKE GALLERIES, 9200 N. Maryland Ave., Niles IL 60648. (708)966-2770, Artist Relations: Scott Wolff. Estab. 1985. Direct response marketer of limited edition collectibles, such as porcelain dolls, figurines and other uniquely executed artwork sold in thematic continuity series. Clients: collectible consumers mostly women of all age groups.
Needs: Approached by 200 freelance artists/year. Works with 250 freelance doll artists, sculptors, costume designers and illustrators/year. Works on assignment only. Uses artists for concept illustration, collectible design, prototype specifications and sample construction. Prior experience in giftware design, doll design, greeting card and book illustration a plus. Subject matter is children and mothers, animals and nostalgia scenes. Prefers "cute, realistic and naturalistic human features; animated poses."
First Contact & Terms: Send inquiry letter with resume, copies of samples, slides, photographs to be kept on file. Prefers slides, photographs, tearsheets or photostats (in that order) as samples. Samples not filed are returned. Reports within 45 days. Pays for design by the project, $500 minimum. Pays for illustration by the project, $50-200. Concept illustrations are done "on spec" to $200 maximum. Contract for length of series on royalty basis with guaranteed advances. Considers complexity of the project, project's budget, skill and experience of the artist, and rights purchased when establishing payment.
Tips: "Do not send actual products." The most common mistake freelancers make in presenting samples or a portfolio is "sending actual products, ribbons and awards and too many articles on their work. Especially looking for doll artists who work in clay or sculptors and costume designers."

***ASTRO-MECHANICAL DOGS & TRICKS**, 9723 W. 83rd Ave., Arvada CO 80005. Creative Manager: Wally P. Duxsmeg. Estab. 1979. Service-related firm. "We provide technical publications for the computer, laboratory, astro-physical and scientific community."
Needs: Works with 350 freelance artists/year. Assigns 350-500 jobs/year. Prefers artists with experience in technical illustration and graphic design. Works on assignment only. Uses freelance artists for advertising design and layout, brochure and catalog design, illustraiton and layout, product rendering, posters, model making, signage and schematics.
First Contact & Terms: Send query letter with resume, tear sheets, Photostats, slides and photographs. Samples are filed. Samples not filed are not returned. Reports back within 1 month. To show a portfolio, mail thumbnails, roughs, original/final art, final reproduciton/product, tear sheets, Photostats, color and b&w. Pays for designand illustration by the project. Considers complexity of project, client's budget, skilland experience of artist, how work will be used, turnaround time and rights purchased when establishing payment. Negotiates rights purchased.

BAGINDD PRINTS, 2171 Blount Rd., Pompano Beach FL 33069. (305)971-9000. FAX: (305)973-1000. Manager: Arnold S. Reimer. Estab. 1977. Manufacturer of handpainted and silk screened designer wallcovering and fabrics. Clients: interior designers.
Needs: Approached by 10-15 freelance artists/year. Works with 6 freelance designers/year. Prefers local artists with experience in textile design. Uses freelance artists mainly for wallcovering and fabrics. Also uses freelance artists for product design. Send slides and photographs. Samples are not filed and are returned. Reports back in 1 week. Call to schedule an appointment to show a portfolio, which should include original/ final art and photographs. Buys first rights or all rights.

BAIMS, 408 Main, Pine Bluff AR 71601. (501)534-0121. Contact: David A. Shapiro. Estab. 1896. Retailer. Carries Haggar, Van Heusen and other labels.
Needs: Works with 2-3 freelance illustrators and designers/year. Assigns 25-100 jobs/year. Uses artists for ad illustration.
First Contact & Terms: Send a query letter with resume, business card and samples to be kept on file. Reports in 2 weeks. Call or write to arrange an appointment to show a portfolio. Pays $5-20/job.
Tips: "Send non-returnable samples of clothing illustrations."

***BALLOONS ARE EVERYWHERE INC.**, 4658 Airport Blvd., Mobile AL 36608-3124. (205)341-3520. FAX: (205)341-3528. Estab. 1981. Balloons. Manufacturer/Distributor of toy balloons for people ages 18-65.
Needs: Artists work on assignment basis only. Uses freelance artists for P-O-P displays and mechanicals. Will consider all print media.
First Contact & Terms: Produces a seasonal material for all holidays and seasons. Seasonal material should be submitted 6 months before the holiday. Send query letter with resume and roughs. Samples are filed and returned by SASE if requested by artist. Reports back to the artist only if interested. Mail appropriate materials. Buys all rights. Payment is individually negotiated.

BANKERS LIFE & CASUALTY COMPANY, 1000 Sunset Ridge Rd., Northbrook IL 60062. (312)498-1500. Manager-Communications/Graphics: Charles S. Pusateri. Insurance firm.
Needs: Works with 3-5 freelance artists/year. Works on assignment only. Uses freelance artists mainly for sales materials. Also uses artists for advertising and brochure design, illustration and layout; medical illustration; posters and signage. Prefers pen & ink, airbrush, pencil, marker and calligraphy.
First Contact & Terms: Send query letter with resume and printed pieces to be kept on file. Samples returned only if requested. Reports within 2 weeks only if interested. Write to schedule an appointment to show a portfolio, which should include thumbnails, roughs and final reproduction/product. Pays for design by the project, $50-100. Pays for illustration by the project, $25-75. Considers complexity of project, skill and experience of artist and turnaround time when establishing payment. Rights purchased vary according to project.
Tips: "Follow rules but don't give up. Timing is essential. The best way for an artist to break into our field is by sending a letter followed by a phone call."

BASS PRO SHOPS, 1935 S. Campbell, Springfield MO 65898. Art Dept. Manager: Marla Leighton. Distributor. "We specialize in outdoor gear, fishing tackle, hunting, camping and boating for outdoors men and women."
Needs: Approached by 50-60 freelance artists/year. Works with 10-20 freelance illustrators and 20-30 freelance designers/year. Assigns 40-50 jobs to freelance artists/year. Works on assignment only. Uses freelance artists for advertising design and illustration, brochure design and illustration, product design, rendering of product, P-O-P display, display fixture design and signage.
First Contact & Terms: Send query letter with resume, tearsheets, photostats, slides and photographs. Samples are filed and are not returned. Reports back only if interested. Call to schedule an appointment to show a portfolio which should include thumbnails, roughs, final reproduction/product and tearsheets. Pays for design by the hour, $10 minimum, by the project, or by the day, $80 minimum. Pays for illustration by the project. Considers skill and experience of artist and rights purchased when establishing payment. Buys all rights.

***BEALL LADYMON DEPARTMENT STORES**, 1210 Captain Shreve Dr., Shreveport LA 71105. (318)869-3121. FAX: (318)868-3711. Advertising Director: Johnny Walker. Estab. 1951. Retailer specializing in moderate fashion for ages 4-100 years. Labels: hundreds of brand names.
Needs: Approached by 2-3 freelance artists/year. Works with 2-3 freelance artists/year. Prefers artists with experience in fashion illustration. Uses freelance artists mainly for overload projects. Also uses freelance artists for advertising layout, brochure design, catalog design and layout, fashion illustration. Prefers wash art. No special needs.
First Contact & Terms: Send query letter with brochure showing art style. Samples are filed. Reports back only if interested. Mail appropriate materials. Portfolio should include tearsheets and original/final art. Pays for design and illustration by the hour, $15-25; by the project based on estimates/bids. Buys all rights.

***BEISTLE COMPANY**, 1 Beistle Plaza, Box 10, Shippensburg PA 17257. (717)532-2131. FAX: (717)532-7789. Product Manager: C.M. Luhrs-Wiest. Estab. 1900. Manufacturer of paper and plastic decorations and party goods—fanciful illustrations. Clients include general public—home consumers, P-O-P displays, specialty advertising, school market and other party good suppliers.
Needs: Approached by 15-20 freelance artists/year. Prefers artists with experience in designer gouache illustration—fanciful figure work; looks for full-color, camer-ready artwork for seperation and offset reproduction. Works on assignment only. Uses freelance artists mainly for product rendering and brochure design and layout. Prefers designer gouache and airbrush technique for poster style artwork. Also uses freelance artists for brochure design and layout, product rendering and design.
First Contact & Terms: Send query letter with resume and the following samples: tearsheets, photostats, photocopies, slides, photographs, transparencies. Samples are filed and returned by SASE. Reports back within 1 month only if interested. Write to schedule an appointment to show a portfolio. Portfolio should include thumbnails, photostats, slides, roughs, color, tearsheets, transparencies, original, final art and photographs. Pays for illustration by the project, $100 minimum.

BEROL USA, 105 Westpark Dr., Box 2248, Brentwood TN 37024-2248. (615)371-1199. Art Product Group Manager: Terry Butler. Manufactures writing instruments, drawing materials and art supplies (Prismacolor Art Pencils, Art Markers and Art Stix® artist crayons). Current clients include: Alvin Co, Koenig Charrette.
Needs: Approached by 200 freelance artists each year. Works with 5 freelance illustrators and 8 freelance designers each year. Assigns 25 jobs to freelance artists/year. Uses artists for illustration and layout for catalogs, ads, brochures, displays, packages. Artists must use Prismacolor and/or Verithin products only. Uses freelance artists mainly for illustration and finished art. Prefers traditional styles and media.
First Contact & Terms: Query with photographs and slides to be kept on file. Samples returned only by request. Reports within 2 weeks. Call or write to schedule an appointment to show a portfolio; portfolios not necessary. Pays by the project, $300 maximum. Rights purchased vary according to project.
Tips: "Hand-colored photographs (with Prismacolor® Art Pencils) becoming very popular."

***BLUE HAND ALLIANCE**, 210 S. Campbell, Springfield MO 65806. (800)767-9443. FAX: (417)831-7238. Art Director: Ken Boschert. Estab. 1990. Manufacturer of quality screenprinted sportswear. "Our company designs and markets screenprinted T-shirts and sportswear with emphasis on beautifully colored designs." Clients: Kline's dept. stores, Hallmark shops, Silver Dollar City, Dollywood theme park.
Needs: Approached by 2-3 freelance artists/year. Works with 2-3 freelance illustrators and designers/year. Also uses freelance artists for original source of art for screenprints.
First Contact & Terms: Call toll free (1-800-733-8669), describe your artstyle or design then send photocopies or photographs. Samples are filed or returned by SASE if requested by artist. Reports back within 1 day. Call to schedule an appointment to show a portfolio. Pays for design and illustration, 4% commission on sales. Buys reprint rights.

LYNWOOD BROWN AIA AND ASSOCIATES, INC., 1220 Prince St., Alexandria VA 22314. (703)836-5523. FAX: (703)548-7899. President: L. Brown. Architectural firm providing architecture and engineering. Clients: commercial, industrial, institutional and residential.
Needs: Works with 2-3 freelance artists/year. Uses artists for interior design, architectural rendering and model making.
First Contact & Terms: Works on assignment only. Send query letter with brochure; call for appointment to show portfolio. Prefers photos or prints as samples. Samples not filed are returned by SASE only if requested. Reports within 30 days. Pays for design by the hour, $9-20 average; for illustration by the hour, $8-18 average. Considers client's budget, skill and experience of artist and turnaround time when establishing payment.

***L.M. BRUINIER & ASSOC. INC.**,, 1304 SW Bertha Blvd., Portland OR 97219. (503)246-3095. President: Lou Bruinier. Architectural design/residential planner/publisher of plan books. Clients: contractors and individuals.
Needs: Works with 3 freelance artists/year. Uses artists for design and illustration, brochures, catalogs and books. Expecially needs 3-dimensional perspectives (basically residential). Looking for tight and realistic illustration.
First Contact & Terms: Send resume and photostats or photcopies to be kept on file. Material not filed is not returned. Reports only if interested. Pays for design by the project, $60-400; for illustration by hour, $6-10. Considers the complexity of project and the client's budget when establishing payment. Buys all rights.
Tips: "Artists must have experience in inked or pencilled three-dimensional renderings of buildings and homes."

C.J. PRODUCTS, INC., 100 Christmas Pl., Weston WV 26452. (304)269-6111. FAX: (304)269-6115. Technical Director: Jay Hayes. Estab. 1978. Manufacturer of Christmas displays. Clients: national retail chains.
Needs: Approached by 30 freelance artists/year. Works with 6 freelance illustrators and 12 freelance designers/year. Assigns 12 jobs to freelance artists/year. Prefers artists with experience in display, signage, sculpture and photography. Uses freelance artists mainly for special projects. Also uses freelance artists for brochure design, illustration and layout; catalog design, illustration and layout; product rendering and design; model making and P-O-P displays.
First Contact & Terms: Send query letter with brochure showing art style, resume, tearsheets and photocopies. Samples are filed or returned by SASE only if requested by artist. Reports back only if interested. Write to schedule an appointment to show a portfolio or mail thumbnails, roughs, b&w and color photostats, tearsheets, photographs, slides and transparencies. Pays for design and illustration by the hour and by the project. Buys all rights.

CABELA'S, THE WORLD'S FOREMOST OUTFITTER, 812 13th Ave., Sidney NE 69160. (308)254-5505. Catalog Director: Jim Beardsley. Estab. 1960. Direct-mail firm specializing in quality fishing, hunting and outdoor gear.

Needs: Approached by 50-75 freelance artists/year. Works with 15 freelance artists and 6 freelance designers/year. Assigns 35-50 freelance jobs/year. Prefers artists with experience in wildlife and cutaway (4-color). Prefers acrylic. Uses freelance artists mainly for cover design. Also uses freelance artists for catalog illustration and rendering of product.

First Contact & Terms: Send query letter with brochure showing art style, tearsheets, slides and photographs. Samples are filed or are returned. Reports back within 1 week. To show a portfolio, mail roughs, original/final art and color and b&w photographs and slides. Pays for design by the project, $300-500. Pays for illustration by the project, $300-1,500. Considers complexity of project, turnaround time and rights purchased when establishing payment. Buys one-time and all rights.

CAN CREATIONS, INC., Box 8576, Pembroke Pines FL 33084. (305)431-0235. President: Judy Rappoport. Estab. 1984. Manufacturer of decorated plastic pails directed to juvenile market. Clients: balloon and floral designers, party planners and suppliers, department stores, popcorn and candy retailers.

Needs: Approached by 8-10 freelance artists/year. Works with 2-3 freelance designers/year. Assigns 5 freelance jobs/year. Prefers local artists only. Works on assignment only. Uses freelance artists mainly for "design work for plastic containers." Also uses artists for advertising design, illustration and layout; brochure design; posters; signage; magazine illustration and layout.

First Contact & Terms: Send query letter with tearsheets and photostats. Samples are not filed and are returned by SASE only if requested by artist. Reports back within 2 weeks. Call or write to schedule an appointment to show a portfolio, which should include roughs and b&w tearsheets and photostats. Pays for design by the project, $75 minimum. Pays for illustration by the project, $150 minimum. Considers client's budget and how work will be used when establishing payment. Negotiates rights purchased.

Tips: "We are looking for cute and very simple designs, not a lot of detail."

CANTERBURY DESIGNS, INC.. Box 204060, Martinez GA 30917-4060. (800)241-2732 or (404)860-1674. President: Angie A. Newton. Estab. 1977. Publisher and distributor of charted design books; counted cross stitch mainly. Clients: needlework specialty shops, wholesale distributors (craft and needlework), department stores and chain stores.

Needs: Works with 12-20 freelance artists/year. Uses artists mainly for counted cross-stitch design.

First Contact & Terms: Send query letter with samples to be returned. Prefers stitched needlework, paintings, photographs or charts as samples. Samples not filed are returned. Reports within 1 month. Call for appointment to show portfolio. Payment varies. "Some designs purchased outright, some are paid on a royalty basis." Considers complexity of project, salability, customer appeal and rights purchased when establishing payment.

Tips: Would like to see more quality, counted cross stitch designs. "When sending your work for our review, be sure to photocopy it first. This protects you. Also, you have a copy from which to reconstruct your design should it be lost in mail. Send your work by certified mail. You have proof it was actually received by someone."

CAP FERRAT JEANS, Suite 1103, 1411 Broadway, New York NY 10018. (212)869-1808. FAX: (212)869-3442. Senior Vice President: Jack Marine. Estab. 1960. Manufacturer and importer of women's jeans for ages 16-40. Label: Cap Ferrat.

Needs: Approached by 2 freelance artists/year. Works with 1-2 freelance artists/year. Prefers artists with experience in labeling designs, tops and bottoms. Uses freelance artists mainly for new concepts. Also uses freelance artists for advertising, product and fashion design and catalog illustration. No style preferred. Special needs are "development of shirt line to complement jean line—for export program."

First Contact & Terms: Send query letter with brochure showing art style. Samples are not filed and are returned by SASE if requested by artist. Reports back only if interested. Call to schedule an appointment to show a portfolio, which should include roughs. Pays for design and illustration by the project, $50-500. Rights purchased vary according to project.

Tips: Artists should "be sure they understand the denim market."

HUGH DAVID CARTER-ARCHITECT-AIA, Suite 4, 819½ Pacific Ave., Santa Cruz CA 95060. (408)458-1544. Architect: H.D. Carter. Architectural firm specializing in upper-end residential projects, both new and remodeled, some office and interiors.

Needs: Works with 2 freelance artists/year. Works on asignment only. Uses freelance artists for advertising design and illustration, interior rendering, landscape design, architectural rendering, charts, maps and model making.

First Contact & Terms: Send query letter with brochure, resume, tearsheets, photostats, photocopies, slides or photographs. Samples are filed or are returned by SASE. Reports back within 1 month. Call to schedule an appointment to show a portfolio, which should include thumbnails, roughs, original/final art and final reproduction. Pays for design by the hour, $15-50. Pays for illustration by the hour, $15-60; by the project, $150-600. Considers complexity of project, how work will be used and amount of work when establishing payment. Negotiates rights purchased.

THOMAS PAUL CASTRONOVO, ARCHITECT, 1175 Main St., Akron OH 44310. Clients: residential and commercial developers.
Needs: Uses artists for architectural and interior rendering, paintings, sculpture and model building.
First Contact & Terms: Mail slides or b&w photos. Reports in 10 days. Pays for design and illustration by the project.

***CATALINA SWIMWEAR AND SPORTSWEAR,** 6040 Bardini Blvd., Los Angeles CA 90040. (213)726-1262. FAX: (213)726-7579. Art Director: Jaye Pape. Manufacturer specializing in "sporty" clothes for all ages. Labels include: Catalina, Underwets, Allwets, Brazilian Sunset, Bay Club.
Needs: Works with 3-4 freelance artists/year. Prefers local artists with experience in paste up. Also uses freelance artists for paste-up and mechanicals.
First Contact & Terms: Send query letter with resume and photocopies. Samples are filed. Reports back only if interested. Mail appropriate materials. Portfolio should include tearsheets and original/final art. Pays for design by the hour and by the project.

CHICAGO COMPUTER AND LIGHT, INC., 5001 N. Lowell Ave., Chicago IL 60630-2610. (312)283-2749. President: Larry Feit. Estab. 1976. Manufacturer of gift items for upscale gift shops. Clients: gift stores and major public museums.
Needs: Works with 3 freelance artists/year. Assigns 6 jobs/year. Works on assignment only. Uses freelance artists mainly for catalog sheets, package design and letterhead. Also uses freelance artists for advertising, brochure and catalog design, illustration and layout; rendering of product; P-O-P displays; posters; model making and signage.
First Contact and Terms: Send query letter with brochure, resume, tearsheets, photostats and photographs. Samples are filed or are returned by SASE. Reports back within 1 week. Call or write to schedule an appointment to show a portfolio, which should include roughs, original/final art and color and b&w tearsheets, photostats and photographs. Pays for design and illustration by the hour, $10-60. Considers complexity of project and how work will be used when establishing payment. Buys all rights; negotiates rights purchased.
Tips: "Send samples, follow up with a call, then wait."

***CLAIRE'S BOUTIQUES INC.,** 1501 N. Michael, Wood Dale IL 60191. (708)860-6595. FAX: (708)860-3534. Marketing Manager: Linda Oakley. Incorporated 1961. Markets accessories for young people ages 12-24. Labels: Cara Mia, Kids Klub, Designer Collection, Unisex, Romance and Statements.
Needs: Approached by 2 freelance artists/year. Works with 4 freelance artists/year. Prefers local artists only. Uses freelance artists mainly for P-O-P display signage. Also uses freelance artists for advertising design, illustration and layout; brochure design, illustration and layout; and package design.
First Contact & Terms: Send query letter with resume and photographs. Samples are filed. Reports back only if interested. Call to schedule an appointment to show a portfolio that includes roughs, tearsheets and original/final art. Pays for design and illustration by the project. Buys all rights.
Tips: "Call and set an appointment to meet with the marketing department with your portfolio."

***COLLEGIATE CAP AND GOWN,** 1000 N. Market, Champaign IL 61820. (217)351-9500. Director of Advertising: John C. Moore. Estab. 1926. Manufacturer of choir robes, ministerial robes, graduation caps and gowns for ages 17-70. Labels: Collegiate Cap & Gown.
Needs: Approached by 10-15 freelance artists/year. Works with 5-7 freelance artists/year. Prefers local artists only. Uses freelance artists mainly for design of brochures. Also uses freelance artists for advertising design, illustration and layout; brochure design, illustration, and layout; catalog design, illustration and layout; P-O-P displays; calligraphy; paste-up; mechanicals; posters; direct mail and annual reports. Looking for new artists.
First Contact & Terms: Send query letter with tearsheets, photostats, photocopies, slides, photographs, transparencies. Samples are filed. Reports back only if interested. Call to schedule an appointment to show a portfolio, which should include thumbnails, b&w, photostats, slides, roughs, color tearsheets, transparencies, original and final art and photographs. Pays for design and illustration by the project, $250 minimum. Buys all rights.

COMMUNICATIONS ELECTRONICS, Dept. AM, Box 1045, Ann Arbor MI 48106-1045. (313)996-8888. Editor: Ken Ascher. Estab. 1969. Manufacturer, distributor and ad agency (10 company divisions). Clients: electronics, computers.
Needs: Works with approximately 400 freelance illustrators and 100 freelance designers/year. Uses artists for advertising, brochure and catalog design, illustration and layout; product design; illustration on product; P-O-P displays; posters and renderings. Prefers pen & ink, airbrush, charcoal/pencil, watercolor, acrylic, marker and computer illustration.

First Contact & Terms: Send query letter with brochure, resume, business card, samples and tearsheets to be kept on file. Samples not filed are returned by SASE. Reports within 1 month. Call or write for appointment to show portfolio. Pays for design and illustration by the hour, $15-100; by the project, $10-15,000; by the day, $40-800. Considers complexity of project, skill and experience of artist, how work will be used, turnaround time and rights purchased when establishing payment.

***COUNTY SEAT STORES, INC.,** 17950 Preston Rd., Dallas TX 75252. (214)248-5100. FAX: (214)248-5214. Sales Promotion Manager: Cyndi Westin. Estab. 1973. Retailer of casual of jeanswear for men and women. Merchandise directed to ages 16-28. Labels: Nuovo, Levi, Guess, Girbaud.
Needs: Approached by 10 freelance artists/year. Works with 5 freelance artists/year. Prefers local artists only with experience in mechanical and design, complete turnkey. Uses freelance artists mainly for logo and graphic design. Also uses freelance artists for brochure design, illustration and layout; paste-up; mechanicals; posters.
First Contact & Terms: Send query letter with brochure showing art style. Samples are filed. Reports back only if interested. Call to schedule an appointment to show a portfolio, which should include original/final art. Pays for illustration by the project. Buys all rights.
Tips: "Call for appointment or send resume."

CREATIONS BY PHYLLIS CO., 30 NE 125th Place, Portland OR 97230. (503)254-3344. Owner: Phyllis Altman. Estab. 1975. Manufacturer of porcelain music boxes, dolls, carousels, etc. Clients: distributors. Current clients include Show Stoppers.
Needs: Works with 1 freelance illustrator and 1 freelance designer/year. Prefers local artists only with experience in china painting. Uses freelance artists mainly for piece work. Prefers traditional and Victorian. Also uses freelance artists for catalog design and illustration.
First Contact & Terms: Call to find out what needs are. Payment is negotiated. Rights purchased vary according to project.

JERRY CUMMINGS ASSOCIATES INC., Suite 301, 420 Boyd St., Los Angeles CA 90013. (213)621-2756. Contact: Jerry Cummings. Estab. 1970. Landscape architecture firm. Clients: commercial and residential.
Needs: Assigns 20-30 freelance renderings/year. Works on assignment only. Works with artists for landscape architectural rendering. Prefers loose yet realistic landscape illustration. Prefers marker, then pen & ink.
First Contact & Terms: Send query letter with brochure showing art style or resume and photographs. Reports within 2 weeks. Samples returned by SASE. Reports back on future possibilities. Call or write to schedule an appointment to show portfolio, which should include original/final art. Pays for design by the hour, $15-30. Pays for illustration by the hour, $25-35. Considers complexity of project, client's budget and skill and experience of artist when establishing payment.
Tips: "Include landscape renderings in your portfolio. Do not include portraits or abstract art designs. Because of the recession, work is down."

CUSTOM HOUSE OF NEEDLE ARTS, INC., Box 1128, Norwich VT 05055. (802)649-3261. FAX: (802)649-2216. Owner/President: Carolyn Purcell. Manufacturer of traditional crewel embroidery kits. Clients: needle-work shops and catalog shoppers.
Needs: Approached by 2-3 freelance artists/year. Works with a varying number of freelance designers/year. Uses artists for product design. "We hope the artist is a crewel stitcher and can produce sample model. We don't want to see inappropriate designs for traditional crewel embroidery."
First Contact & Terms: Send query letter with samples and any pertinent information to be kept on file. Prefers colored drawings or photos (if good closeup) as samples. Samples not filed are returned by SASE only if requested. Reports within 1 month. Pays royalty on kits sold.
Tips: "We emphasize *traditional* designs; for pictures, pillows, bellpulls, chair seats and clock faces."

CUSTOM STUDIOS INC., 1333 W. Devon Ave., Chicago IL 60660. (312)761-1150. President: Gary Wing. Estab. 1960. Custom T-shirt manufacturer. "We specialize in designing and screen printing custom T-shirts for schools, business promotions, fundraising and for our own line of stock."
Needs: Works with approximately 20 freelance illustrators and 20 freelance designers/year. Assigns 50 free-lance jobs/year. Especially needs b&w illustrations (some original and some from customer's sketch). Uses artists for direct mail and brochures/flyers, but mostly for custom and stock T-shirt designs.
First Contact & Terms: Send query letter with resume, photostats, photocopies or tearsheets; "do not send originals as we will not return them." Reports in 3-4 weeks. Call or write to schedule an appointment to show a portfolio or mail b&w tearsheets or photostats to be kept on file. Pays for design and illustration by the hour, $28-35; by the project, $50-150. Considers turnaround time and rights purchased when establishing payment. For designs submitted to be used as stock T-shirt designs, pays 5-10% royalty. Rights purchased vary according to project.
Tips: "Send 5-10 good copies of your best work. We would like to see more black-and-white, camera-ready illustrations—copies, not originals. Do not get discouraged if your first designs sent are not accepted."

DAMART, 3 Front St., Rollinsford NH 03869. Advertising Manager: Victoria Nevins. Estab. 1970. Manufacturer, mail order, retailer and in-house advertising agency. "At Damart we sell world famous Thermolactyl® underwear, socks, gloves, slippers and many accessories for women and men." Clients: Damart catalogs and advertising.
Needs: Works with 4-8 freelance artists/year. Assigns 10-20 jobs to freelance artists/year. Prefers artists with experience in direct-response advertising. Works on assignment only. Uses freelance artists for all work, including advertising, brochure and catalog design, illustration and layout; posters and signage. "Mac experience a plus."
First Contact & Terms: Send query letter with brochure showing art style or resume, tearsheets, photostats, slides and photographs. Samples are filed and are not returned. Reports back only if interested. Write to schedule a portfolio review. Portfolio should include thumbnails, roughs, original/final art, final reproduction/product. Pays for design and illustration by the project, $100 minimum. Buys all rights or negotiates rights purchased.

DAUPHIN ISLAND ART CENTER, 1406 Cadillac Ave., Box 699, Dauphin Island AL 36528. Owner: Nick Colquitt. Estab. 1984. Distributor and retailer for marine and/or nautical decorative art. Clients: Seasonal vacationers to Dauphin Island
Needs: Approached by 12-14 freelance artists/year. Works with 8-10 freelance artists/year. Prefers local artists only with experience in marine and nautical themes; uses freelance artists mainly for retail items. Also uses artists for advertising, brochure and catalog illustration and wholesale and retail art.
First Contact & Terms: Send query letter with brochure and nautical samples. Samples not filed are returned only if requested by artist. Reports back within 3 weeks. To show a portfolio, mail original/final art and final reproduction/product. Pays for design and illustration by the finished piece price. Considers skill and experience of artist and "retailability" when establishing payment. Negotiates rights purchased.
Tips: "Send samples of marine/nautical decorative art suitable for retail. Willing to place art for sale on consignment."

***DAVIS + GECK**, 1 Casper St., Danbury CT 06810. (203)796-9579. FAX: (203)796-9535. Manager Creative Services: Ray Cauchi. Estab. 1910. Manufacturer of medical devices. "D + G makes surgical devices/sutures—we create support literature." Clients include: surgeons, hospitals, Association of Operating Room Nurses (AORN) and American College of Surgeons (ACS).
Needs: Approached by 12 freelance artists/year. Works with 6 freelance illustrators and 4 designers/year. Assigns 200 jobs to freelance artists/year. Prefers local artists with experience in layout and mechanicals. Works on assignment only. Sales/promotional literature and packaging. Also uses freelance artists for advertising and brochure illustration; catalog design, illustration and layout; product rendering; model making; signage and P-O-P displays.
First Contact & Terms: Send query letter with tearsheets, photostats, photocopies, slides, photographs, transparencies. Samples are filed and not returned. Reports back to the artist only if interested. Call to schedule an appointment to show a portfolio that includes thumbnails, b&w, photostats, slides, roughs, color tearsheets, transparencies, original/final art and photographs. Pays for design by the project, $100-5,000. Pays for illustration by the project, $100-8,000. Buys all rights.

***DEL MAR WINDOW COVERINGS**, 7150 Fenwick Lane, Westminster CA 92683. (714)891-4311. FAX: (714)895-0011. Contact: Marketing Department. Independent since 1988. Manufacturer of merchandise directed to ages 25-50. Label: DelMar.
Needs: Approached by 20-30 freelance artists/year. Works with 2-3 freelance artists/year. Prefers local artists only with experience in home fashions. Uses freelance artists mainly for advertising design and layout; brochure design, illustration and layout; P-O-P displays; calligraphy; paste-up; mechanicals; posters, promotional pieces and direct mail.
First Contact & Terms: Send brochure showing art style, resume, tearsheets and photocopies. Samples are filed. Reports back only if interested. To show portfolio, mail thumbnails, b&w photostats, color tearsheets and photographs. Pays for design/illustration by the hour $50 minimum or by the project. Buys all rights.

***DESIGN & DIRECTION**, Suite 201, 2271 W. 205th St., Torrance CA 90501. (213)320-0822. FAX: (213)320-7080. President: Jay Simpson. Estab. 1978. Service-related firm that specializes in advertising, graphics, printing, color separations. Clients: computers, dental, waterbeds, etc. Current clients include: Learning Tree International, Van R Dental, IEEE Computer Society.
Needs: Approached by 15-20 freelance artists/year. Works with 6 freelance designers/year. Prefers local artists only with experience in production with design sense. Uses freelance artists mainly for illustrations. Also uses freelance artists for advertising design, illustration and layout; brochure design, illustration and layout; catalog design, illustration and layout; product rendering; model making; signage; and P-O-P displays.
First Contact & Terms: Send resume, tearsheets and photocopies. Samples are filed. Reports back to the artist only if interested. Mail appropriate materials. Portfolio should include thumbnails. Pays for design by the hour, $12-18 ("they bid—varies.") Pays for illustration by the project. Buys all rights.

E & B MARINE INC., 201 Meadow Rd., Edison NJ 08818. (201)819-7400. FAX: (201)819-4771. Manager of Creative Services: Barbara Weinstein. Estab. 1947. Specialty retailer of boating equipment with more than 40 locations. Also direct-mail catalogue publisher of boating supplies and accessories.

Needs: Approached by more than 10 freelance artists/year. Works with more than 10 freelance illustrators and more than 50 freelance designers/year. Assigns more than 300 jobs to freelance artists/year. Prefers local artists only with experience in retail and/or catalog. Works on assignment only. Uses freelance artists mainly for paste-up, layout, design and illustration. Prefers line art, some 4-color illustration. Also uses freelance artists for advertising design, illustration and layout; brochure design and layout; catalog design, illustration and layout; signage; P-O-P displays.

First Contact & Terms: Send query letter with resume and tearsheets and photocopies. Samples are filed. Reports back to the artist only if interested. Write to schedule an appointment to show a portfolio, which should include roughs, original/final art and b&w and color tearsheets and photographs. Do not call. Pays for design by the hour, $10-25; by the project. Pays for illustration by the project, $25-1,000. Buys all rights.

EMERSON RADIO CORPORATION, 1 Emerson Lane, North Bergen NJ 07047. (201)854-6600. Director of Advertising and Public Relations: Sharon Fenster; Advertising Assistant: Jill Robbins. Manufacturer.

Needs: Approached by over 100 freelance artists/year. Works with 2 freelance illustrators and 5 freelance designers/year. Prefers New York, New Jersey-area artists. Works on assignment only. Uses freelance artists mainly for brochures and catalogs. Also uses artists for advertising design, illustration and layout.

First Contact & Terms: Send query letter with brochure showing art style. Samples not filed are returned only if requested. Reports back only if interested. Write to schedule an appointment to show a portfolio, which should include final reproduction/product and color samples.

ENESCO CORPORATION, 1 Enesco Plaza, Elk Grove Village IL 60007. (708)593-3979. Contact: Creative Director of Licensed Design Development. Producer and importer of fine giftware and collectibles, such as ceramic, porcelain bisque and earthenware figurines, plates, hanging ornaments, bells, thimbles, musical ornaments, picture frames, magnets, decorative housewares, music boxes, dolls, tins, candles, crystal and brass. Clients: gift stores, card shops and department stores.

Needs: Works with 300 freelance artists/year. Assigns 2,000 freelance jobs/year. Prefers artists with experience in gift product development. Uses freelance artists mainly for licensed product development. Also uses artists for product design and rendering and sculpture.

First Contact & Terms: Send query letter with brochure, resume, tearsheets, photostats and photographs. Samples are filed or are returned. Reports back within 2 weeks. Write to schedule an appointment to show a portfolio, or mail original/final art and photographs.

Tips: "Contact me by mail only. Send samples or portfolio's work for review. It is better to send samples and/ or photo copies of work instead of original art for the first time. All will be reviewed by Sr. Creative Director, V.P., and Licensing Director. If your talent is a good match to Enesco's product development, we will contact you to discuss further arrangements. Everything must be addressed to my attention and will be returned within two weeks. Please do not send slides. Try to have a well thought out concept that relates to giftware product before mailing your submissions."

EVERTHING METAL IMAGINABLE, INC. (E.M.I.), 401 E. Cypress, Visalia CA 93277. (209)732-8126. Executive Vice President: Dru McBride. Estab. 1967. Wholesale manufacturer. "We manufacture lost wax bronze sculpture. We do centrifugal white metal casting; we do resin casting (cold cast bronze, alabaster walnut shell, clear resin etc.)." Clients: wholesalers, premium incentive consumers, retailers.

Needs: Approached by 5 freelance artists/year. Works with 5 freelance designers/year. Assigns 5-10 jobs to freelance artists/year. Prefers artists that understand centrifugal casting, bronze casting and the principles of mold making. Works on assignment only. Uses artists for figurine sculpture and model making. Prefers a tight, realistic style.

First Contact & Terms: Send query letter with brochure or resume, tearsheets, photostats, photocopies and slides. Samples not filed are returned only if requested. Reports back only if interested. Call to show a portfolio, which should include original/final art and photographs "or any samples." Pays for design by the project, $500-10,000. Considers complexity of project, client's budget, how work will be used, turnaround time and rights purchased. Buys all rights.

Tips: "Artists must be conscious of detail in their work, be able to work expediently and under time pressure. Must be able to accept criticism of work from client, and price of program must include completing work to satisfaction of customers."

***EXHIBIT BUILDERS INC.**, 150 Wildwood Rd., Deland FL 32720. (904)734-3196. Contact: J.C. Burkhalter. Produces custom exhibits, displays, scale models, dioramas, sales centers and character costumes. Clients: primarily manufacturers, government agencies, ad agencies and tourist attractions.

Needs: Works on assignment only. Uses artists for exhibit/display design and scale models. Also uses artist for renderings for sales presentations and production art for exhibits.

First Contact & Terms: Provide resume, business card and brochure to be kept on file. Samples returned by SASE. Reports back on future possibilities. Considers complexity of project, skill and experience of artist, how work will be used, turnaround time and rights purchased when establishing payment.

Tips: "Wants to see examples of previous design work for other clients; not interested in seeing school-developed portfolios."

EXPRESSIVE DESIGNS, INC., 2343 W. Stirling Rd., Ft. Lauderdale FL 33312. (305)966-4666. FAX: (305)966-4668. Vice President: Mark Satchell. Estab. 1973. Manufacturer of plastic drinkware and fine collectible porcelain figurines. Current clients include Disney World, J.C. Penney Co. Department Stores and Federated Department Stores.

Needs: Approached by 3-4 freelance artists/year. Works with 1-2 freelance illustrators/year. Assigns 10-12 jobs to freelance artists/year. Works on assignment only. Uses freelance artists mainly for plastic drinkware and figurines. Prefers contemporary beach patterns. Also uses freelance artists for product design and model making.

First Contact & Terms: Send query letter with brochure showing art style. Samples are filed. Reports back in 2 weeks. Call to schedule and appointment to show a portfolio, which should include color samples and photographs. Pays for design by the project, $300-500. Pays for illustration by the project, payment negotiated. Rights purchased vary according to project.

FABIL MFG. CORP, 95 Lorimer St., Brooklyn NY 11206. (212)239-4441. Vice President: Ron Reinisch. Manufacturer and importer of boys' and girls' outerwear and rainwear, boys' sportswear, swimwear and shirts. Label: Members Only.

Needs: Approached by 10 freelance artists/year. Works with 3 freelance illustrators and 4 freelance designers/year. Works with 3 freelance illustrators and 4 freelance designers/year. Local artists only, with experience in children's wear. Also uses artists for catalog design, illustration and layout and fashion design and illustration.

First Contact & Terms: Send query letter with samples. Samples are filed or are returned only if requested. Reports back within 3 weeks, only if interested. Write to schedule an appointment to show a portfolio or mail appropriate materials. Pays for illustration by the project, $50-75. Considers complexity of project, skill and experience of artist and client's budget when establishing payment. Buys all rights.

FAME SHIRTMAKERS LTD., 350 5th Ave., New York NY 10118. (212)947-2815. FAX: (212)629-0091. Vice President: Arthur K. Fried. Estab. 1975. Manufacturer and importer of "young men's high fashion sport clothes," ages 18-35. Labels: Fame, Ziziano and Marc Daniels.

Needs: Approached by 2-3 freelance artists/year. Works with 1-2 freelance artists/year. Prefers artists with experience in men's fashion. Uses freelance artists mainly for fashion ideas and design. Prefers sketches. Special needs include new ideas.

First Contact & Terms: Send query letter with resume. Reports back within 2 weeks. Call to schedule an appointment to show a portfolio, which should include thumbnails and photographs. Pays for design and illustration by the project, $100. Negotiates rights purchased.

Tips: "Shop the market for my product and address my line compared to the market."

FISHMAN & TOBIN, 9th Floor, 34 W. 33rd St., New York NY 10001. Director of Marketing: Lisbeth Kramer. Estab. 1914. Manufacturer of "suits and casual clothing for sizes 2-7, 8-20 and young men, all under one label, TFW, whose image is that of contemporary fashion, well made at very affordable prices."

Needs: Approached by 25 freelance artists/year. Works with a minimum of 5 freelance artists/year. Prefers local artists "with enough experience to have a fairly good portfolio. Recent students are fine if work is good, but prefer those experienced with *deadlines*." Uses freelance artists mainly for ads and direct-mail pieces, P-O-P displays, hangtags and labels.

First Contract & Terms: Send query letter with brochure, tearsheets, photostats, photocopies and slides. Samples are filed or are returned only if requested by artist. Reports back within days only if interested. Write or call to schedule an appointment to show a portfolio, which should include thumbnails, original/final art, final reproduction/product, tearsheets, photostats and photographs. Payment depends on project, experience and "volume of business we can offer." Considers complexity of project, skill and experience of artist, client's budget, how work will be used and turnaround time when establishing payment. Negotiates rights purchased.

Tips: "I seek professionalism as well as talent. I seek artists who are as excited about the particular project as I am. I seek artists looking for new challenges and exposure. I seek artists looking to build a steady clientele."

***FRAMMELWIDGET SYSTEMS**, 920 Disc Dr., Scotts Valley CA 95066. (408)439-2187. Production Director Manager: Sharmy Assad. Estab. 1981. Service-related firm manufacturing electronic fabs/services for such products. Specializes in electronic PCB fabrication, CMOS architecture, hi-density memory chips. Serves Military, Semi-Conductor corps., manufacturers.

Needs: Approached by 3-4 freelance artists/year. Works with 3 freelance illustrators/year and 1 designer/ year. Assigns approximately 150 jobs to freelance artists/year. Prefers local artists with experience in Adobe Illustrator, Corel Draw, PageMaker, Freehand, Frame PC and Mac experience, as well as Sun. Uses freelance artists mainly for illustration, brochure/pamphlet design. Also uses freelance artists for advertising design, illustration; brochure design and illustration; product rendering; posters; and technical illustration.
First Contact & Terms: Send query letter with brochure showing art style, and resume. Samples are filed. Reports back to the artist only if interested. Call to schedule a portfolio review. Mail appropriate materials. Portfolio should include photostats and original, final art. Payment varies. Buys reprint rights.

FRANKLIN ELECTRIC, 400 Spring St., Bluffton IN 46714. (219)824-2900. Manager of Corporate Communications: Mel Haag. Manufacturer of submersible and fractional H.P. motors for original equipment manufacturers and distributors.
Needs: Works with 8 freelance artists/year. "Freelance artists must be proven." Works on assignment only. Uses artists for advertising and brochure design, illustration and layout; catalog design and layout and posters.
First Contact & Terms: Send query letter with brochure showing art style or resume, tearsheets, slides and photographs. Samples not filed are returned only if requested. Reports only if interested. Call to schedule an appointment to show a portfolio, which should include roughs, original/final art, final reproduction/ product and color tearsheets. Pays for design and illustration by the hour, $30 minimum; negotiated.
Tips: "I look for all styles and subjects. I am very interested in new techniques and styles."

FRELINE, INC., Box 889, Hagerstown MD 21740. Art Director: John Burns. Estab. early 1970s. Manufacturer and developer of library promotional aids—posters, mobiles, bookmarks, T-shirt transfers, reading motivators and other products to promote reading, library services and resources. Clients: school and public libraries and classroom teachers.
Needs: Approached by about 50 freelance artists/year. Works with 10-15 freelance illustrators/year. Works on assignment only. Uses freelance artists mainly for posters, bulletin boards, displays, mobiles and T-shirt designs. Also uses artists for graphic design and promotional materials. Prefers pen & ink, airbrush, colored pencil, watercolor, acrylic, pastel, collage and gouache. Most assignments for 4-color process.
First Contact & Terms: Experienced illustrators only. Send query letter with resume and tearsheets to be kept on file. Slides sent for review will be returned. Reports within 15 days. Pays by the project, $85-1,000. Considers complexity of project, skill and experience of artist, turnaround time and rights purchased when establishing payment.
Tips: "Portfolios with an emphasis on illustration suit our needs best. We prefer illustration with bright color, humor and fun. Do not send photocopies of sketches only. Submitting slides is an excellent way of presenting yourself. Our market caters to library usage and education, grade school level up to college."

G.A.I. INCORPORATED, Box 30309, Indianapolis IN 46230. (317)257-7100. President: William S. Gardiner. Licensing agents. "We represent artists to the collectibles and gifts industries. Collectibles include high-quality prints, collector's plates, figurines, bells, etc. There is no up-front fee for our services. We receive a commission from any payment the artist receives as a result of our efforts." Clients: Lenox, Enesco, The Bradford Exchange and The Hamilton Group.
Needs: Approached by 100+ freelance artists/year. Works with 50 freelance illustrators and 5 freelance designers/year. Works on assignment only. "We are not interested in landscapes, still lifes or modern art. A realistic—almost photographic—style seems to sell best to our clients. We are primarily looking for artwork featuring people or animals. Young animals and children usually sell best. Paintings must be well done and should have an emotional appeal to them."
First Contact & Terms: Send query letter with resume and color photographs; do *not* send original work. Samples not kept on file are returned by SASE. Reports in 1-3 months. Payment: "If we are successful in putting together a program for the artist with a manufacturer, the artist is usually paid a royalty on the sale of the product using his art. This varies from 4%-10%." Considers complexity of project, skill and experience of artist, how work will be used and rights purchased when establishing payment; "payment is negotiated individually for each project."
Tips: "We are looking for art with broad emotional appeal."

GARDEN STATE MARKETING SERVICES, INC., Box 343, Oakland NJ 07436. (201)337-3888. President: Jack Doherty. Estab. 1976. Service-related firm providing public relations and advertising services, mailing services and fulfillment. Clients: associations, publishers, manufacturers.
Needs: Approached by 15 freelance artists/year. Works with 4 freelance illustrators and 4 freelance designers/ year. Assigns 10 jobs to freelance artists/year. Works on assignment only. Uses artists for advertising and brochure design, illustration and layout; display fixture design; P-O-P displays and posters. Needs editorial and technical illustrations, realistic style.
First Contact & Terms: Send query letter with resume, business card and copies to be kept on file. Samples not kept on file are returned. Reports only if interested. To show a portfolio, mail thumbnails, original/final art, final reproduction/product, b&w and color tearsheets and photographs. Pays for design by the hour, $25

minimum. Considers complexity of project, skill and experience of artist and how work will be used when establishing payment.

DANIEL E. GELLES ASSOC., INC., Mohonk Rd., High Falls NY 12440. (914)687-7681. Vice President: Robert S. Gelles. Estab. 1956. Interior design firm which also designs and manufactures visual merchandise, display fixtures, etc. "We design custom fixturing for both manufacturers and stores (retailers). We do store floor layouts, plans, etc. We also maintain a stock fixturing line which requires updating consistently." Clients: both large and small, hard and soft goods manufacturers. Current clients include Sears, Roebuck & Co., Bloomingdales, Record World, Koret of California and Calvin Klein."
Needs: Works with 2-3 freelance illustrators/year. Prefers artists with some experience in the field of visual merchandising or P-O-P displays. Uses freelance artists mainly for full-color renderings of store layouts and fixtures. Also uses artists for interior design and rendering and concepts for display ideas.
First Contact & Terms: Send resume and "any clear facsimile that would indicate artist's style and technique." Samples are filed. Call or write to schedule an appointment to show a portfolio, which should include thumbnails, roughs, original/final art, actual renderings (color) and original concepts. Pays for design by the project, $100-500; illustration by the project, $50-300. Considers complexity of project and skill and experience of artist when establishing payment. Negotiates rights purchased.
Tips: "Would like to see color drawings, obliques and freehand illustrations with at least one human figure; prefer anything that gets the concept across *clearly* without abstraction. Do not send scale models, slides or pencil drawings."

GELMART INDUSTRIES, INC., 180 Madison Ave., New York NY 10016. (212)889-7225. Vice President and Head of Design: Ed Adler. Manufacturer of high fashion socks, gloves, headwear, scarves and other knitted accessories. "We are prime manufacturers for many major brands and designer names." Current clients include "major stores."
Needs: Approached by 6 freelance artists/year. Works with 3 freelance designers/year. Uses freelance artists mainly for textile or package design. Also uses artists for fashion accessory design. Prefers pen & ink, colored pencil, watercolor, acrylic, collage and marker.
First Contact & Terms: Call for appointment to show a portfolio. Pays by the project for design, $500-5,000.
Tips: "The best way for designers to introduce themselves is to bring a few sketches of clothing accessories."

GHOTING ASSOCIATES, ARCHITECTS, 8501 Potomac Ave., College Park MD 20740. (301)474-3719. Contact: Vinod M. Ghoting, AIA,. Architectural/interior design/urban design firm providing complete architectural, urban design and interior design services, from shcematic design through construction documents and management. Clients: residential, institutional, medical, commercial and industrial.
Needs: Works with 1 freelance artist/year. Local artists only at this time. Works on assignments only. Uses artists for interior design and renderings.
First Contact & Terms: Send query letter with photographs and photostats to be kept on file. Reports within 15 days. To show a portfolio, mail appropriate materials which should include photostats. Pays for design by the hour, $12-20; pays for illustration by project, $250-500. Considers clients budget, complexity of project, skill and experience of artist when establishing payment.

GIBBONS COLOR LABORATORY INC., 606 N. Almont Dr., Los Angeles CA 90069. (213)2762-3010. Vice President: Alfredo Arozamena. Estab. 1953. "We are a custom lab specializing in film processing, printing and all related matters." Specializes in architectural, portfolio model, interior and landscape representations. Current clients include 20th Century Fox, Lucille Ball Productions and Kenny Rogers Productions.
Needs: Works with 25 freelance designers/month. Uses artists for print ad design, retouching and logos. "We don't use illustration."
First Contact and Terms: Send query letter.
Tips: "A common mistake freelancers make in presenting a portfolio is a lack of good quality photographic prints or design. Many of them do not realize that a good print or design can be the difference between getting a job or not."

GOBÉ OF CA INC., 400 Roosevelt Ave., Montelello CA 90640. (213)721-1300. FAX: (213)721-1509. President: Brian Goldojarb. Estab. 1971. Manufacturer/service-related firm. Contract textile/wallpaper screen printer. Specializes in screen process printing of wallcovering, textile, ceramics, limited edition art. Clients include interior design/garment/fine art. Current clients include Country Life Designs, Disneyland, Amblin Prod., Robert Jensen, OP, Taco Bell, US Air Force.
Needs: Approached by 4-6 freelance artists/year. Works with 2-3 freelance illustrators and 2-3 designers/year. Assigns 4-6 jobs to freelance artists/year. Prefers local artist only with experience in specific field required per job. Works on assignment only. Uses freelance artists mainly for rendition of customers concept. Also uses freelance artists for product rendering, product design, posters and wallcovering/fabric (in repeat).

First Contact & Terms: Send query letter with photocopies and slides. Samples are not filed and are returned. Reports back within 1 week. Write to schedule an appointment to show a portfolio. Portfolio should include slides and photographs. Pays for design by the hour, $15-25. Rights purchsed vary according to project.

GOES LITHOGRAPHING CO., 42 W. 61st St., Chicago IL 60621. Marketing Director: W.J. Goes. Manufacturer of all-year and holiday letterheads. Clients: printers and businesses.
Needs: Uses artists for letterheads.
First Contact & Terms: Send pencil sketches or thumbnail sketches. Samples are returned by SASE. Portfolio should include thumbnail sketches. "No final work should be sent at this time." Considers how work will be used when establishing payment. Buys reprint rights.
Tips: "Listen to what we want and are looking for. Thumbnail work is the first step for use. Call for some of our samples."

GOLDBERGS' MARINE, 201 Meadow Rd., Edison NJ 08818. (908)819-7400. Manager Creative Services: Barbara Weinstein. Produces 18 mail-order catalogs of pleasure boating equipment and water-sport gear for the active family.
Needs: Approached by over 100 freelance artists/year. Works with 20 freelance illustrators and over 25 freelance designers/year. Artists must be "flexible with knowledge of 4-color printing, have a willingness to work with paste-up and printing staff, and exhibit the ability to follow up and take charge." Uses freelance artists mainly for catalog layout, design and illustration. Also uses artists for brochure design, illustration and layout; retail events and signage. "Seasonal freelance work is also available."
First Contact & Terms: Send query letter with brochure, business card, printed material and tearsheets to be kept on file. "Original work (mechanicals) may be required at portfolio showing." Reports only if interested. Write for appointment to show portfolio. Pays by the project. Considers complexity of project, how work will be used and turnaround time when establishing payment.
Tips: "Boating and/or retail experience is helpful and a willingness to do research is sometimes necessary. Long-term relationships usually exist with our company. We have plenty of work for the right people. With so many artists vying for work, you really must stand out of the crowd without being crazy. Approach it from a business standpoint."

THE GRANDOE CORPORATION, 74 Bleeker St. Gloversville NY 12078. (518)725-8641. FAX: (518)725-9088. Designer/Advertising Manager: Doty Hall. Estab. 1890. Design studio, importer and manufacturer of accessories: ski, golf and dress gloves; knit sets and body-glove sportlines for men and women age 16-100. Label: grandoe.
Needs: Approached by 10 freelance artists/year. Works with 2-3 freelance artists/year. Prefers artists with experience in mock-up packaging, graphic art and package design. Uses freelance artists mainly for mock-ups, mechanicals and print-ready work. Also uses freelance artists for advertising, brochure, catalog, fashion, accessory and package design; P-O-P displays; paste-up; mechanicals and direct mail. Prefers "clean and graphic, as opposed to fine art" styles. Special needs are mechanicals, paste-up and package design.
First Contact & Terms: Send query letter with brochure showing art style or resume and photocopies. Samples are filed or are returned. Reports back if interested. Write to schedule and appointment to show a portfolio, which should include original/final art. Pays for design by the hour, $35-50. Pays for illustration by the hour, $25-30. Buys all rights.

GREAT AMERICAN AUDIO CORP., 33 Portman Rd., New Rochelle NY 10801. (914)576-7660. President: Nina Joan Mattikow. Estab. 1976. Audio publishers: products range from old-time radio, self-help, humor, children's, books-on-tape, etc.
Needs: "We do not buy actual work. All artwork is commissioned by us." Works with 5 freelance illustrators/year. Mainly uses freelancers for package illustration. Also uses artists for product and P-O-P design, advertising illustration and layout. Prefers full-color inks or tempera for product illustration. "Art must be customized to suit us. We look for a particular style of work."
First Contact & Terms: Artists must be in New York metropolitan area. Send query letter with brochure and resume to be kept on file. Do not send samples. Write for appointment to show portfolio. Finished original art seen by appointment only. Reports only if interested. Works on assignment only. No originals returned to artist at job's completion. Pays for design by the project, $250-2,000 average. Pays for illustration by the project, $100-2,000. Buys all rights.

***GREEFF FABRICS, INC.**, 150 Midland Ave., Port Chester NY 10573. (914)939-6200. FAX: (914)935-5775. Design Director: Elise Nelson. Estab. 1933. Distributor of high end fabrics, wallcoverings, woven laces. Clients: Interior designers, architects, design shops. Current clients include Pick A Flower, Tradewinds, Bristol Channel.

Needs: Approached by 20 freelance artists/year. Works with 10 designers/year. Assigns 50-75 jobs to freelance artists/year. Prefers local artists with experience in textile design. Works on assignment only. Uses freelance artists mainly for fabric/walcovering design and/or colorings. Prefers traditional styles.

First Contact & Terms: Send resume, tearsheets, photostats, photocopies, photographs, transparencies. Samples are not filed and are returned. "Usually samples are shown only in the presence of artist." Call to schedule a portfolio review. Portfolio should include original, final art, photographs and samples of produced work. Buys all rights or reprint rights.

GREEN & ASSOCIATES, Suite C-26, 115 S. Royal St., Alexandria VA 22314. (703)370-3078. Contact: James F. Green. Interior design firm providing residential and contract interior design and space planning plus custom furniture design. Clients: residential, corporate offices and retail design.

Needs: Number of freelance artists works with/year varies. Prefers local artists; "sometimes we require on-site inspections." Works on assignment only. Uses artists for interior design and interior and architectural rendering.

First Contact & Terms: Send query letter with brochure, resume and photostats or photographs, color preferred, to be kept on file. Reports only if interested. Pays for design and illustration by the project, $250 minimum. "Persons we work with must be able to make themselves available to our clients and staff. We will appreciate good art without regard to reputation of artist, etc." Considers complexity of project, client's budget and skill and experience of artist when establishing payment.

THE HAMILTON COLLECTION, Suite 1000, 9550 Regency Square Blvd., Jacksonville FL 32225. (904)723-6000. SVP Product Development: Melanie Hart; Senior Art and Production Director for commercial art/advertising: Linda Olsen. Direct-marketing firm for collectibles: limited edition art, plates, sculpture and general gifts. Clients: general public, specialized lists of collectible buyers and retail market.

Needs: Approached by 25-30 freelance artists/year. Works with 5 freelance artists in creative department and 15 in product development/year. Assigns 400-500 jobs to freelance artists/year. Only local artists with three years of experience for mechanical work. For illustration and product design, "no restrictions on locality, but must have *quality* work and flexibility regarding changes which are sometimes necessary. Also, a 'name' and notoriety help." Uses artists for advertising mechanicals, brochure illustration and mechanicals, and product design and illustration.

First Contact & Terms: Send query letter with samples to be kept on file, except for fine art, which is to be returned (must include a SASE or appropriate container with sufficient postage). Samples not kept on file are returned only if requested by artist. Reports within 2-4 weeks. Call or write for appointment to show portfolio. Pays for design by the hour, $10-50. Pays for illustration by the project, $50-5,000. Pays for mechanicals by the hour, $20 average. Considers complexity of project, skill and experience of artist, how work will be used and rights purchased when establishing payment.

Tips: Prefers conservative, old fashioned, realistic style. "Attitude and turnaround time important." In presenting portfolio, don't "point out mistakes, tell too much, tell not enough, belittle work or offer unsolicited opinions. Be prepared to offer sketches on speculation."

HAMPSHIRE PEWTER COMPANY, Box 1570, 9 Mill St., Wolfeboro NH 03894-1570. (603)569-4944. Vice President: Jenine Steele. Estab. 1974. Manufacturer of handcast pewter tableware, accessories and Christmas ornaments. Clients: jewelry stores, department stores, executive gift buyers, tabletop and pewter speciality stores, churches, and private consumers.

Needs: Works with 3-4 freelance artists/year. "We prefer New-England based artists for convenience." Works on assignment only. Uses freelancers mainly for illustration and models. Also uses artists for brochure and catalog design, product design, illustration on product and model making.

First Contact & Terms: Send brochure and photographs. Samples are not filed and are returned only if requested. Reports back to the artist within weeks. Call to schedule an appointment to show a portfolio, or mail b&w roughs and photographs. Pays for design and illustration by the hour, $10 minimum. Considers complexity of project, client's budget and rights purchased. Buys all rights.

Tips: "Inform us of your capabilities. We commission work by the project. For artists who are seeking a manufacturing source, we will be happy to bid on manufacturing of designs, under private license to the artists, all of whose design rights are protected. If we commission a project, we intend to have exclusive rights to the designs by contract as defined in the Copyright Law and we intend to protect those rights."

HANSEN LIND MEYER, Suite 1100, 800 N. Magnolia, Orlando FL 32803. (407)422-7061. Director of Design: Charles W. Cole, Jr. Estab. 1963. Architectural/interior design firm providing complete architecture and engineering services. Clients: commercial, health care, justice and government. Current clients include University of Florida Clinics, Arlington County Sheriff's Department and Orange County Courts.

Needs: Approached by 6 freelance artists/year. Works with 10 freelance illustrators/year. Works on assignment only. Uses freelance artists mainly for architectural renderings. Also uses artists for interior and landscape renderings, maps and model making. Prefers watercolor, colored pencil, tempera and marker.

Close-up

Polly Cianciolo
Program Director
IGPC
New York, New York

© Barbara Kelley 1991

Polly Cianciolo, Philatelic Program Director of IGPC, knows a thing or two about stamps. And if that comes as a surprise to you, perhaps that dictionary of yours has spent a bit too much time on the shelf. IGPC is the largest producer of stamps in the United States. But don't run to the local post office to pick up a sample or two. IGPC's clients are foreign governments.

"American stamps are not colorful or topically interesting enough for most of our clients," says Cianciolo. "Foreign governments like more representative art—*beautiful* stamps. And I suspect collectors do too."

IGPC serves as a full-service agency for stamp issuing countries. "We try to provide whatever service they require. Some countries produce their own stamps and we market them internationally. Others have us do everything."

What subjects appeal to foreign governments and collectors? "Keep in mind the purpose of stamps is two-fold," advises Cianciolo, "—to project an image of the respective country to the world and to use as postage for mail delivery. Some subjects may not be of interest outside the country. Others have universal appeal—birds, orchids, mushrooms, ships, railroads, space, or historical events. We have recurring need for art on animals, sports and wildlife. Just about any subject you can think of can be a stamp.

"It's difficult to acquire an artist who can do figures and graphic art. Lots know how to draw or paint, but they don't know design. We don't want to use the same artist and technique for every stamp—we do maybe 500 images a year. The more flexible and versatile an artist is, the more work there is. Some are used one time, others are used 20 or more times.

"Every artist must understand our work is essentially for the client, not for the agency or the artist. We serve a client country, whether or not we agree with its ideas or concepts. Some client countries may not like subtle art. For nature subjects, they prefer representational pieces. There's little need for avant-garde art, but there is a need for good graphic artists whose work will reproduce down to 1½ × 2-inches."

There are preferences when it comes to choosing a medium for stamp art. Some media simply don't reproduce well at a small size. "A stamp is really a miniature poster," Cianciolo says, "and the concept or message must be grasped quickly. Any technique that will fit posters might fit stamps. We don't generally use oil. Watercolor, gouache, pen & ink or something that can be photographed by laser scanner work well. Most stamps are produced by multicolor lithography. We ask for art that can be reproduced in the four-color process. Sometimes a fifth or sixth may be used, but that can be expensive.

"We let our artists pretty much use their own medium, but we don't like them to lacquer their work. Paste overs or multimedia are also difficult to reproduce. Drawings must be loose enough to be reduced; tight drawings can be lost in reproduction. And paint over textured material is difficult to pick up. It's better to simulate texture."

A little research can go a long way in landing an assignment from Cianciolo. "First, know what is currently being done on stamps. Pick up literature, go to a dealer or stamp show. Select art you think is the kind of style or technique that would apply to stamps. You can submit a proposal saying, 'This would make a good issue for X country or X commemoration.' If in New York, call and request an interview and bring along a portfolio of your work that represents your scope and variety. Out-of-towners can send us slides or a printed brochure or samples and offer to do things on spec.

"Once we have an artist, we use that person again and again. It takes a lot of time to train a stamp artist. And we have a lot of need for product."

— *Sheila Freeman*

The variety of realistic images IGPC uses for its stamps is shown here in examples for Palau, the Marshall Islands and Micronesia. In addition to serving as postage, they project to the rest of the world an attractive image of the countries.

Reprinted with permission of IGPC.

First Contact & Terms: Send query letter with resume and samples. Samples not filed are returned only if requested. Reports only if interested. To show a portfolio, mail thumbnails, final reproduction/product and color photographs. Pays for illustration by the project, $750-6,000. Considers complexity of project, client's budget, skill and experience of artist, and turnaround time when establishing payment.

Tips: The most common mistake freelancers make in presenting samples or portfolios is "poor quality reproductions and lack of coordinated professional images. Samples should be representative examples of architectural renderings completed for clients."

***HARK**, 7229 Lydia St., Kansas City MO 64131. (816)361-8138. Owner: J.R. Cromartie. Estab. 1987. Retail manufacturer/distributor. Produces and markets custom and pre-print silk screen T-shirts specializing in religious themes for individuals, groups, businesses and churches. Current clients include: National Metropolitan Spiritual Churches, Inc. and The Gary Club-Gary Unlimited.

Needs: Works with 2-3 freelance illustrators and 2-3 freelance designers/year. Assigns 2-3 jobs to freelance artists/year. Prefers artists with experience in creative camera-ready artwork and computer graphics "who are not afraid to use creativity, color, styles and techniques." Works on assignment only. "No sex, drugs and rock-n-roll (no obscenity)." Also uses freelance artists for advertising, brochure and product design; camera ready film positives.

First Contact & Terms: Send query letter with brochure showing art style, resume, tearsheets, photocopies, photographs and transparencies. Samples are filed. Reports back to the artist only if interested. Mail appropriate materials including tearsheets, photographs, transparencies (8½ × 11"). "No originals please." Pays for design by the project, $25 minimum. Pays for illustration by the project, $15 minimum. Payment is negotiable; complexity of the project will be considered when negotiating payment. Rights purchased vary.

***HARPER INDUSTRIES, INC.**, 350 5th Ave., New York NY 10118. (212)971-9200. FAX: (212)967-7319. Merchandise Manager: Leland Paul Michael. Manufacturer/importer. Merchandise is for men, boys, ladies of all ages. Labels: Mens, Bonjour, Manhattan Ind.

Needs: Approached by 20-30 freelance artists/year. Works with 10 freelance artists/year. Prefers artists with experience in design, boards, sketching. Also uses freelance artists for advertising and fashion illustration; product, fashion, textile and pattern design.

First Contact & Terms: Send query letter with brochure showing art style, resume, tearsheets, photostats, photocopies, photographs. Reports back only if interested. Write to schedule an appointment to show a portfolio. Mail appropriate materials including thumbnails, photostats, roughs, color tearsheets and photographs. Pays for design by the hour, project and day. Buys all rights.

HEP CAT, INC., 2605-A Fessey Park Rd., Nashville TN 37204. (615)386-9705. Owner: Anna Grupke. Estab. 1986. Mail order company selling imprinted sportswear through direct mail; cat designs in particular.

Needs: Works with 5 freelance illustrators and designers/year. Assigns 10-20 jobs to freelance artists/year. Prefers artists with experience in T-shirt design and screen printing. Wants high quality realistic work on whimsical and humorous designs. Works on assignment only. Uses freelance artists mainly for designs imprinted on shirts. Will consider any medium.

First Contact & Terms: Send resume and tearsheets, photostats, photocopies, slides and photographs. "No original art." Samples are filed or are returned by SASE only if requested by artist. Reports back only if interested. To show a portfolio, mail photostats, photographs and slides. Pays for design and illustration by the project, $200-300. Buys all rights.

HERFF JONES, Box 6500, Providence RI 02940-6500. (401)331-1240. Art Director: Fred Spinney. Manufacturer of class ring jewelry; motivation/recognition/emblematic awards—service pins, medals, medallions and trophies. Clients: high-school and college-level students; a variety of companies/firms establishing recognition programs.

Needs: Works with 6 freelance artists/year. "Previous experience in this field helpful but not necessary. Must be strong in illustration work." Works on assignment only. Uses artists for product illustration.

First Contact & Terms: Send query letter with brochure, resume, business card, slides and photos to be kept on file; originals will be returned. Samples not kept on file returned by SASE. Reports only if interested. Write for appointment to show portfolio. Pays by the project, $25-100 average. Considers complexity of project, skill and experience of artist and turnaround time when establishing payment.

Tips: Artists approaching this firm "should be of a professional level. The artist should have a good versatile background in illustrating as well as having some mechanical drawing abilities, such as hand lettering."

IGPC, 10th Floor, 460 W. 34th St., New York NY 10001. (212)869-5588. Contact: Art Department. Agent to foreign governments; "We produce postage stamps and related items on behalf of 40 different foreign governments."

Needs: Approached by 50 freelance artists/year. Works with more than 75-100 freelance illustrators and designers/year. Assigns several hundred jobs to freelance artists/year. Artists must be within metropolitan NY or tri-state area. "No actual experience required except to have good, tight art skills (4-color) and

excellent design skills." Works on assignment only. Uses artists for postage stamp art. Prefers tight, realistic style and technical illustration. Prefers airbrush, watercolor and acrylic.
First Contact & Terms: Send samples. Reports back within 5 weeks. Portfolio should contain "4-color illustrations of realistic, tight flora, fauna, technical subjects, autos or ships. Also include reduced samples of original artwork." Pays by the project. Considers government allowance per project when establishing payment.
Tips: "Artists considering working with IGPC must have excellent 4-color abilities (in general or specific topics, i.e., flora, fauna, transport, famous people, etc.); sufficient design skills to arrange for and position type; the ability to create artwork that will reduce to postage stamp size and still hold up to clarity and perfection. Must be familiar with printing process and print call-outs. All of the work we require is realistic art. In some cases, we supply the basic layout and reference material; however, we appreciate an artist who knows where to find references and can present new and interesting concepts. Initial contact should be made by phone for appointment, (212)629-7979."

***INCOLAY STUDIOS INCORPORATED,** 445 North Fox St., San Fernando CA 91340. Art Director: Shari Bright. Estab. 1966. Manufacturer. "Basically we reproduce antiques in Incolay Stone, all handcrafted here at the studio. There were marvelous sculptors in that era, but we believe we have the talent right here in the USA today and want to reproduce living American artists' work."
Needs: Prefers local artists with experience in carving bas relief. Uses freelance artists mainly for carvings. Also uses artists for product design and model making.
First Contact and Terms: Samples not filed are returned. Reports back within 1 month. Call to schedule an appointment to show a portfolio. Pays for design by the project $100-2,000.Negotiates rights purchased.

INDIANA KNITWEAR CORPORATION, Box 309, 230 E. Osage St., Greenfield IN 46140. (317)462-4413. Merchandise Manager: W. E. Garrison. Estab. 1930. Manufacturer of knit sportswear for young men and boys 8-18, 4-7 and 2-4. Label: Indy Knit.
Needs: Works with 6-8 freelance artists/year. Uses freelance artists mainly for screen print art.
First Contact & Terms: Send query letter with brochure showing art style. Samples not filed are returned only if requested by artist. Reports back within 1 week. Call to schedule an appointment to show a portfolio, which should include roughs, original/final art and final reproduction/product. Pays for design by the project. Pays for illustration by the project, $150-500. Considers complexity of project, skill and experience of artist and turnaround time when establishing payment. Negotiates rights purchased.
Tips: "All artwork we buy must be applicable for screen print on knits. The ideas must be timely."

INFO VIEW CORPORATION, INC., 124 Farmingdale Road, Wethersfield CT 06109. (203)721-0270. President: Larry Bell. Sells desktop computer systems to corporations. Works with graphic artists to create visuals for newsletters, product-sell sheets, promotional materials and trade advertising.
Needs: Works on assignment only. Works with graphic artists in New York and Connecticut. Buys 40+ sketches/year. Looks for unique style. Prefers artists that have a feeling for current trends.
First Contact & Terms: Query with SASE. Reports in 2 weeks. Provide photocopy of recent work to be kept on file for future assignments. Pays by the project.

INTERNATIONAL RESEARCH & EVALUATION, 21098 Ire Control Center., Eagan MN 55121. (612)888-9635. Art Director: Ronald Owon. Estab. 1972. Private, nonpartisan, interdisciplinary research firm that collects, stores and disseminates information on-line, on demand to industry, labor and government on contract/subscription basis."Conducts and produces a wide spectrum of creative exercises for client product introductions and marketing research probes."
Needs: Works with 50-65 freelance illustrators and 31-37 freelance designers/year. Works on assignment only. Uses artists for advertising, brochure and catalog design, illustration and layout; product design and P-O-P display.
First Contact & Terms: Artists should request "Capabilities Analysis" form from firm. Reports only if interested. Pays for design by the project, $125-10,000; pays for illustration by the project, $125-$5,000. Considers how work will be used when establishing payment.

IT FIGURES STUDIO, 302 E. Ayre St., Newport DE 19804. Partners: Ray Daub or Mary Berg. Estab. 1979. Manufacturer/service-related firm. "IFS designs and creates animated (mechanical) figures, animated exhibits and attractions, museum figures (lifecast) and sets, stage sets and props for industrial videos and meetings, and puppet characters for film and video." Clients: department stores, museums, businesses, corporations and film/video producers. Current clients include DuPont Co., The Smithsonian, Lazarus Dept. Stores, Inc. and Dayton Hudson Corp.
Needs: Approached by 20 freelance artists/year. Works with 1-3 freelance illustrators and 1-3 freelance designers/year. Assigns 1-10 jobs to freelance artists/year. Prefers local artists only. Uses freelance artists mainly for sculpture, mold making, set building and conceptual art. Also uses artists for advertising design,

illustration and layout; brochure and catalog design and layout; product design and rendering; model making and make-up.

First Contact and Terms: Send query letter with resume, slides and photographs. Samples are filed or are returned only if requested by artist. Reports back only if interested. Call or write to schedule an appointment to show a portfolio. Pays for design and illustration by the project, $100 minimum. Considers complexity of project, client's budget and skill and experience of artist when establishing payment. Buys all rights.

Tips: "After submitting a resume, artists should attempt to arrange for a meeting providing examples of their strengths and interests. Show overt enthusiasm with the follow-up after one submission of your resume/portfolio."

J.C. PRINTS L.T.D., 444 W. Jericho Turnpike, Huntington NY 11743. (516)692-2900. FAX: (516)692-2755. Contact: Sol Adam. Estab. 1978. Manufacturer of wallpaper.

Needs: Approached by 5-10 freelance artists/year. Works with 1-5 freelance designers/year. Prefers artists with experience in contemporary design.

First Contact & Terms: Send query letter with brochure showing art style that includes photocopies. Samples not filed are returned. Reports back within 1 week. Call to schedule a portfolio review. Portfolio should include original, final art. Payment is negotiable. Buys one-time rights. Negotiates rights purchased.

***JAY JACOBS**, 1530 5th Ave., Seattle WA 98101. (206)622-5400. FAX: (206)682-7045. Art Director: Cari Coyer. Estab. 1941. Retailer that specializes in fun, trendy, fashion forward sportswear for people ages 18-34.

Needs: Approached by few freelance artists/year. Works with 1-2 freelance artists/year. Prefers artists with experience in fashion design, illustration, signage. Also uses freelance artists for brochure design, P-O-P displays, paste-up and mechanicals.

First Contact & Terms: Send query letter with resume, tearsheets, photostats, photocopies and photographs. Samples are filed. Does not report back, in which case the artist should call to follow-up. Call to schedule a portfolio review. Portfolio should include photostats, tearsheets, original/final art, photographs. Method of payment depends on project. Buys all rights or negotiates rights purchased; rights purchased vary according to project.

JBACH DESIGNS, Box 7962, Atlanta GA 30357. Architectural/interior and landscape design/photography/graphics firm. Clients: residential, commercial. Specializes in greeting cards, displays, automobile racing promotion and photography, and package and P-O-P design.

Needs: Works with 10 freelance artists/year. Uses artists for advertising and brochure design, landscape and interior design, architectural and interior rendering, design consulting, furnishings and graphic design.

First Contact & Terms: Send query letter with brochure, resume and business card to be kept on file. Write for appointment to show portfolio; write for artists' guidelines. Reports within days. Pay varies according to assignment. Considers complexity of project, client's budget, skill and experience of artist, how work will be used, turnaround time and rights purchased when establishing payment.

Tips: "The direction for the 1990's for JBACH DESIGNS is more interaction between artist and client to achieve a higher design attitude. JBACH DESIGNS is being structured as a network of designers and artists."

JEWELITE SIGNS, LETTERS & DISPLAYS, INC., 154 Reade St., New York NY 10013. (212)966-0433. Vice President: Bobby Bank. Produces signs, letters, silk screening, murals, hand lettering, displays and graphics. Current clients include Transamerica, Duggal Labs, Steve Morn and MCI.

Needs: Approached by 15+ freelance artists/year. Works with 12 freelance artists/year. Assigns 20+ jobs to freelance artists/year. Works on assignment only. Uses artists for hand-lettering, walls, murals, signs, interior design, architectural renderings, design consulting and model making. Prefers airbrush, lettering and painting.

First Contact & Terms: Call or send query letter. Call to schedule an appointment to show a portfolio, which should include photographs. Pays for design and illustration by the project, $75 and up. Considers complexity of project and skill and experience of artist when establishing payment.

J. JOSEPHSON, INC., 20 Horizon Blvd., S. Hackensack NJ 07606. (201)440-7000. Director of Marketing: Cheryl McPherson. Manufacturer of wallcoverings. "We also provide them to the public in the form of sample books." Serves wallcovering and paint stores, interior designers and architects.

Needs: Approached by 12 freelance artists/year. Works with 2 freelance illustrators and 2 freelance designers/year. Uses freelance artists mainly for developing full collections of wallcovering and book cover designs. Also uses freelance artists P-O-P displays and display fixture design.

First Contact & Terms: Send tearsheets. Samples are filed or are returned only if requested by artist. Reports back only if interested. Call to schedule an appointment to show a portfolio which should include original/final art and final reproduction/product. Pays for design by the project. Considers complexity of project, skill and experience of the artist and rights purchased when establishing payment. Negotiates rights purchased.

***JUDSCOTT LTD.**, 979 3rd Ave., New York NY 10022. (212)838-3280. FAX: (914)347-3192. Vice President: Sally Lefkowitz. Estab. 1960. Manufacturer. Specializes in showroom sales of custom and stock wallpaper and fabrics. Clients: interior designers.
Needs: "We buy designs." Also uses freelance artists for product design.
First Contact & Terms: Reviews "prepared design presentation, then put into our repeat." Reports back with 2 weeks. Call to schedule a portfolio review. Portfolio should include original, final art. Pays for design by the project or negotiates payment. Buys all rights.

***KELCO**, 8355 Aero Dr., San Diego CA 92123. (619)292-4900. FAX: (619)569-3436. Advertising Dept.: John Gamble. Estab. 1929. Manufacturer. Clients serve food industry, oil field, industrial.
Needs: Approached by 0-4 freelance artists/year. Works with 0-4 freelance artists/year and 0-6 designers/year. Assigns 5-20 jobs to freelance artists/year. Prefers artists with experience in oil field illustration. Works on assignment only. Uses freelance artists mainly for ads and collateral. Also uses freelance artists for advertising design, illustration and layout; brochure design, illustration and layout; catalog design and illustration; and signage.
First Contact & Terms: Send query letter with brochure showing art style, resume, tearsheets, photocopies. Samples are filed. Reports back to the artist only if interested. Write to schedule an appointment to show a portfolio, which should include thumbnails, tearsheets, original, final art. Pays for design and illustration by the project. Rights purchased vary according to project.

KELSEY NATIONAL CORP., 3030 S. Bundy, Los Angeles CA 90066. Director of Communications: Billie Sontag. Estab. 1963. Service-related firm providing small group health and life insurance products. Clients: small businesses of under 100 employees nationwide.
Needs: Works with 1-2 freelance artists/year. Assigns 5-10 freelance jobs/year. Prefers local artists. Works on assignment only. Uses artists for advertising mailers; brochure design, illustration and layout; posters and signage. Uses in-house desktop publishing system.
First Contact & Terms: Send query letter. Samples are filed. Reports back only if interested. Call or write to schedule an appointment to show a portfolio, which should include original/final art, final reproduction/product and tearsheets. Pays for illustration by the project. "We ask for an estimate by job and have no specific hourly rate in mind." Considers client's budget, skill and experience of artist and turnaround time when establishing payment. Buys all rights.
Tips: "We need someone to take much information and put it in clear, clean, readable materials. Show me examples of mailers and collaterals done for business-to-business clients in a moderate price range. Don't show consumer advertising or high-end jobs."

***KLINGSPOR ABRASIVES, INC.**, 2555 Tate Blvd. SE, Hickory NC 28602. Marketing Manager: Peter C. Spuller. Estab. 1979. Manufacturer of coated abrasive products (sandpaper) for industrial use. Clients: complete industrial marketplace.
Needs: Prefers local artists only. Works on assignment only. Uses artists for advertising and brochure design, technical illustration and layout, catalog layout, product rendering and posters.
First Contact & Terms: Send query letter with brochure, tear sheets, photographs. Samples are filed. Samples not filed are returned only if requested by artist. Reports back only if interested. Write to schedule an appointment to show a portfolio, or mail roughs, original/final art, final reproduction/product, tear sheets and photographs. Pays for design and illustration by the project. Considers complexity of project, skill and experience of artist, how work will be used and turnaround time when establishing payment. Buys all rights.

KLITZNER IND., INC., 44 Warren St., Providence RI 02901. (401)751-7500, ext. 786. Design Director: Louis Marini. Manufacturer; "four separate divisions that serve uniquely different markets: ad specialty, fraternal, direct mail and retail."
Needs: Works with "several" freelance artists/year. Artists must be "qualified to provide the desired quality of work within our time frame." Works on assignment only. Uses artists for product design, illustration on product and model making. Prefers pen & ink, airbrush, markers and computer illustration.
First Contact & Terms: Send query letter with resume to be kept on file. Reviews photostats, photographs, photocopies, slides or tearsheets; "they must clearly illustrate the quality, detail, etc. of artist's work." Materials not filed are returned by SASE. Reports back only if interested. Write for appointment to show portfolio. Portfolio should include "only professional, commerical samples of work. Do not have need to see school projects." Pays for design by the project, $50 minimum; "a mutually agreed upon figure *before* the project is undertaken." Finds most artists through references/word-of-mouth.
Tips: "Turn-around time on most projects has been virtually cut in half. More competitive market warrants quick, dependable service. This change has created a bigger need for outside assistance during heavy backlog periods."

***KORET OF CALIFORNIA**, 611 Mission, San Francisco CA 94105. (415)957-2000. FAX: (415)957-2207. Art Director: Jeannine Wilson. Estab. 1938. Manufacturer of women's coordinates for 40-70 year olds. Labels: Koret, Impressions and Recreation.

Needs: Approached by 25 freelance artists/year. Works with 20 freelance artists/year. Prefers local artists only. Uses freelance artists mainly for textile and T-shirt design and illustration. Also uses freelance artists for advertising illustration, fashion design and illustration, calligraphy and posters.
First Contact & Terms: Send query letter with brochure showing art style and resume. Samples are filed or are returned by SASE if requested by artist. Reports back within 1 week. Call to schedule a portfolio review. Portfolio should include thumbnails, roughs, original/final art, b&w and color photographs. Pays for design by the hour, $15. Pays for illustration by the project. Buys all rights.

KOZAK AUTO DRYWASH, INC., 6 S. Lyon St., Box 910, Batavia NY 14021. (716)343-8111. President: Ed Harding. Manufacturer and direct marketer of automotive cleaning and polishing cloths and related auto care products distributed by direct mail and retail. Clients: stores with car-care lines, consumers and specialty groups.
Needs: Works with up to 2 freelance artists/year. Uses artists for advertising design and illustration, P-O-P display, packaging design and direct response advertising.
First Contact & Terms: Prefers artist located within a convenient meeting distance with experience in desired areas (P-O-P, packaging, direct response). Works on assignment only. Send query letter with brochure, resume and business card to be kept on file. Material not filed returned only if requested. Reports within 2 weeks. Pays by the project. Considers complexity of project, skill and experience of artist, and how work will be used when establishing payment.

KRISCH HOTELS, INC. KHI Advertising, Inc., Box 14100, Roanoke VA 24022. (703)342-4531. Director of Communications: Julie Becker. Estab. 1985. Service-related firm providing all advertising, in-room and P-O-P pieces for service, wholesale and retail businesses for tourists, meetings, conventions and food service (inhouse department). Clients: hotels/motels, restaurants/lounges, apartment complexes, wholesale businesses and printing firms.
Needs: Approached by 20-30 freelance artists/year. Works with 5-10 freelance illustrators and 2-4 freelance designers/year. Prefers local artists. Works on assignment only. Uses artists for advertising and brochure illustration; inroom pieces; direct mail; illustration product; P-O-P display; posters and signage. Prefers pen & ink, airbrush, charcoal/pencil and computer illustration.
First Contact & Terms: Send query letter with resume and photocopies. Samples not filed are not returned. Reports only if interested. Call or write to schedule an appointment to show a portfolio, which should include roughs, original/final art, tearsheets and photostats. Pays for design and illustration by the hour, $10 minimum; by the project, $25 minimum; by the day, $100 minimum. Considers complexity of project, client's budget, how work will be used, turnaround time, and rights purchased when establishing payment. Finds most artists through references/word-of-mouth.
Tips: "Increased competition in all markets leads to more sophisticated work attitudes on the part of our industry. Artists should know their own abilities and limitations and be able to interact with us to achieve best results. Send a letter of introduction with non-returnable samples (photocopies are okay). *Please* no original art."

KRON-TV, NBC, 1001 Van Ness Ave., San Francisco CA 94119. (415)441-4444. Design Manager: Steve Johnston. TV/film producer. Produces videotapes and still photos.
Needs: Works with 1-2 freelance artists/year for ad illustration, 1-2 for advertising design and 1-5 for product design. Local artists only. Uses artists for design and production of all types of print advertising, direct mail brochures, promotion and sales pieces. Especially needs computer graphic art.
First Contact & Terms: Query. Provide resume and business card to be kept on file for future assignments.
Tips: "We're looking for experienced designers with heavy production knowledge that would enable them to handle a job from design concept through printing."

***KVCR—TV RADIO**, 701 S. Mount Vernon Ave., San Bernardino CA 92410. (714)888-6511 or 825-3103. Station Manager: Lew Warren. Specializes in public and educational radio/TV.
Needs: Assigns 1-10 jobs/year. Uses artists for graphic/set design, set design painting and camera-ready cards.
First Contact & Terms: Query and mail photos or slides. Reports in 2 weeks. Samples returned by SASE. Pays $20-30, camera-ready cards.

L.B.K. CORP., (formerly National Potteries), 7800 Bayberry Rd., Jacksonville FL 32256-6893. (904)737-8500. FAX: (904)737-9526. Art Director: Barbara McDonald. Estab. 1940. "Three companies, NAPCO, INARCO and First Coast Design feed through L.B.K. NAPCO and INARCO are involved with manufacturing/distributing for the wholesale floral industry. First Coast Design produces fine giftware." Clients: wholesale.
Needs: Works with 15 freelance illustrators and designers/year. 50% of work done on a freelance basis. Prefers local artists for mechanicals for sizing decals; no restrictions on artists for design and concept. Works on assignment only. Uses freelance artists mainly for mechanicals and product design. "Background with a seasonal product such as greeting cards is helpful. 75% of our work is very traditional and seasonal. We're

also looking for a higher-end product, an elegant sophistication." Also uses freelance artists for catalog design and layout, product rendering and mechanicals.

First Contact & Terms: Send resume, tearsheets, slides, photostats, photographs, photocopies and transparencies. Samples are filed or returned by SASE only if requested by artist. Reports back in 2 weeks. Portfolio should include samples which show a full range of illustration style. Pays for design by the project. Pays for illustration by the hour, $10-20; pays for mechanicals, $10-15. Buys all rights.

LABUNSKI ASSOCIATES ARCHITECTS, Suite A3, 3301 S. Expressway 83, Harlingen TX 78550. (512)428-4334. President: R.A. Labunski. Architectural firm providing architecture, planning, construction, management, design, space planning, interiors, advertising. Clients: commercial, retail, residential, corporate, banks, hotel/motel/restaurant and schools.

Needs: Approached by 4-5 freelance artists/year. Works with 2-3 freelance illustrators and 2-3 freelance designers/year on assignment only. Uses artists for ad design, illustration and layout; brochure design; interior and architectural rendering; design consulting; furnishings and model making. Prefers textured media.

First Contact & Terms: Desires "affordable, practical" artists with referrals/references. Send query letter with brochure, resume and business card to be kept on file; also send samples. Samples returned by SASE. Reports within 2 weeks. Call or write for appointment to show portfolio. Pays by the project. Considers complexity of project, client's budget, and skill and experience of artist when establishing payment.

LANE & ASSOCIATES, ARCHITECTS, 1318 N., "B," Box 3929, Fort Smith AR 72913. (501)782-4277. Owner: John E. Lane, AIA-ASID. Estab. 1979. Architectural and interior design firm providing architecture and interiors for remodeling and new construction; also art consultant. Clients: residential, religious, commercial, institutional and industrial.

Needs: Approached by 10-20 freelance artists/year. Works with 10-12 freelance artists/year. Works on assignment only. Uses artists occasionally for architectural rendering, charts, graphic design and advertising illustration; selects or commissions art pieces for clients: paintings, drawings, sculpture, photographs, macrame, tapestry (all mediums). Also arranges art exhibits for large local bank—"would like sources of talent for various media: painting, sculpture, photography, drawing, etc." Prefers pen & ink, watercolor, acrylic, oil, pastel and collage.

First Contact & Terms: Prefers to be able to meet in person with artist. Send query letter with brochure showing art style or resume and tearsheets or photographs for file and retention. Payment varies. Considers complexity of project, client's budget, skill and experience of artist, how work will be used, turnaround time, and rights purchased when establishing payment.

EDWARD LAURENCE & CO. DIVISION OF WEBSTER WALLPAPER CO., INC., 2747 Webster Ave., Bronx NY 10458. (212)367-1910. FAX: (212)295-7265. President: E. Nerenberg. Estab. 1950. Manufacturer of silkscreened and hand-printed vinyl wallcovering and fabric. Cilents: wallcovering distributors and showrooms.

Needs: Works with 3-4 freelance illustrators and 2-3 freelance designers/year. Prefers local artists with experience in wallcovering design. Works on assignment only. Uses freelance artists mainly for wallcovering and fabric design. Prefers contemporary styles. Also uses freelance artists for advertising design, illustration and layout; catalog design, illustration and layout; signage; P-O-P displays and posters.

First Contact & Terms: Send resume and samples that best represent the artist's work. Samples are filed or are returned. Reports back only if interested. Call or write to schedule an appointment to show a portfolio or mail appropriate materials. Portfolio should include original/final art. Buys all rights.

LEISURE AND RECREATION CONCEPTS INC., 2151 Fort Worth Ave., Dallas TX 75211. (214)942-4474. FAX: (214)941-5157. President: Michael Jenkins. Designs and builds amusement and theme parks. Clients: developers and entertainment executives.

Needs: Assigns 200 jobs/year. Uses artists for exhibits/displays, sketches of park building sections, bird's eye views of facilities and ground level views.

First Contact & Terms: Query with samples or previously used work and SASE, or arrange interview. Reports in 1 week. Pay for design and illustration by the hour, $10-12; by the project, $1,000-2,500 or by the day.

Tips: Would like to see more "examples of 'turn of the century;' buildings."

***LENOX COLLECTIONS**, 1170 Wheeler Way, Langhorne PA 19047. Produccs collectible figurines, sculptures, functional giftware in porcelain or crystal. Products are sold via direct mail. Themes include fashion figurines, nature and wildlife sculptures and fantasy figurines.

Needs: Works with 20-25 freelance artists/year. Assigns approximately 500 jobs/year. Prefers artists with experience in product design, especially 3-dimensional sculpture design. Works on assignment only. Uses freelance artists mainly for product design. Also uses artists for display fixture design, model making and sculpting/mold making.

First Contact & Terms: Send query letter with resume and photographs. Samples are filed. Samples not filed are returned only if requested by artist. Reports back within a month. Call to schedule an appointment to show a portfolio, which should include original/final art, photographs, slides and color. Pays for design by the hour $15 minimum or by the project, $150 minimum. Considers complexity of project when establishing payment. Buys all rights.

LINE-UP FOR SPORT, 15445-C Red Hill Ave., Tustin CA 92680. Art Director: Karen Heidrick. Estab. 1982. Manufacturer/importer of apparel for the 30-50 year old age group.
Needs: Work with 7-8 freelance artists/year. Prefers local artists. Uses freelance artists for product, fashion and textile design; fashion illustration; window design and paste-up.
First Contact & Terms: Send query letter with brochure showing art style, photostats and slides. Samples are filed and are not returned. Reports back only if interested. To show a portfolio, mail photostats and photographs. Pays for design and illustration by the hour, $10-20; by the project, $100 minimum. When establishing payment, considers complexity of project and skill and experience of artist.

***LONDON INTERNATIONAL U.S. HOLDINGS, INC.,** 8th Floor, 1819 Main St., Sarasota FL 34236. (813)365-1600. FAX: (813)366-3640. Director of Art and Photography: Robert Cashatt. Manufacturer of personal care and hygiene products. Clients: retailers. Current clients: WalMart, K-Mart, Walgreens and Phar Mor.
Needs: Approached by 10 freelance artists/year. Works with 2 freelance illustrators and 4 freelance designers/year. Assigns 50 jobs to freelance artists/year. Prefers local artists only, with experience in Macintosh computer design, package design, and catalog design. Works on assignment only. Uses freelance artists mainly for packaging and collateral. Prefers Macintosh design and marker renderings. Also uses freelance artists for advertising design and layout; brochure design, illustration and layout; catalog design and layout; product rendering; and P-O-P displays.
First Contact & Terms: Send query letter with resume and the following samples: tearsheets and slides. Samples are filed. Reports back to the artist only if interested. Mail appropriate materials. Portfolio should include roughs, original/final art, tearsheets, photographs and transparencies. Pays for design and illustration by the project. Buys all rights.

THE LUCKMAN PARTNERSHIP, INC., 9220 Sunset Blvd., Los Angeles CA 90069. (213)274-7755. Assistant Director of Design: John Janulaw. Architectural firm. Clients: office buildings, hotels, educational facilities, sports facilities, theaters and entertainment centers. Current clients include California State College Los Angeles.
Needs: Approached by 8 freelance artists/year. Works with 3-4 freelance artists/year. Assigns 5 freelance jobs/year. Prefers local artists. Works on assignment only. Uses freelance artists for interior rendering, architectural rendering and model making. Prefers ad marker, airbrush and watercolor.
First Contact & Terms: Send query letter with resume, tearsheets and photocopies. Samples are filed or are returned only if requested by artist. Call to schedule an appointment to show a portfolio, which should include roughs and color photographs. Pays for illustration by the project, $500-20,000. Considers complexity of project, skill and experience of artist, turnaround time, and client's budget when establishing payment. Buys all rights.

MARATHON OIL COMPANY, 539 S. Main St., Findlay OH 45840. (419)422-2121. Graphics Supervisor: Fred J. Sessanna. Estab. 1887. Department specializes in brand and corporate identity, displays, direct mail package and publication design and signage. Clients: corporate customers.
Needs: Works with 4-5 freelance illustrators/year. Prefers local artists only. Works on assignment only. Uses illustrators mainly for publications. Also uses artists for brochure and P-O-P design and illustration, book design, mechanicals, retouching, airbrushing, poster illustration and design, model making, direct mail design, lettering, logos, advertisement design and illustration.
First Contact and Terms: Send query letter with resume and samples. Samples are filed or are returned only if requested by artist. Reports back only if interested. Call or write to schedule an appointment to show a portfolio, which should include roughs, original/final art, final reproduction/product, b&w and color photographs. Pays by the hour, $8-30; by the project. Considers complexity of project, client's budget and skill and experience of artist when establishing payment. Buys all rights.
Tips: "Have your name and samples in our file."

MARBURG WALLCOVERINGS, 1751 N. Central Park Ave., Chicago IL 60647. General Manager: Mike Vukosavich. Manufacturer and distributor which designs, styles and manufactures decorative wall coverings. Clients: wholesale distributors, contractors and architects. Current clients include Carousel Design, Winfield Design, F.G. Anderson, Sancar and Wallquest.
Needs: Approached by 2-4 freelance artists/year. Works with 2-3 freelance artists/year. Uses freelance artists mainly for pattern designs. Prefers bilingual English/German artists. Works on assignment only. Uses artists for product design.

First Contact & Terms: Send query letter with brochure or tearsheets. Samples are filed or are returned only if requested. Reports back only if interested. To show a portfolio, mail thumbnails and color tearsheets. Payment is negotiable. Considers client's budget, and skill and experience of artist when establishing payment. Buys first rights or reprint rights.

ROBERT S. MARTIN & ASSOCIATES REGISTERED ARCHITECTS,422 Franklin St., Reading PA 19602. Contact: Robert S. Martin. Architectural/interior design firm. Clients: commercial and institutional.
Needs: Works with 4 freelance artists/year. Works on assignment only. Uses artists for architectural rendering and furnishings.
First Contact & Terms: Send query letter with resume to be kept on file. Reports back only if interested. Pays for design by the hour, $25-50. Pays for illustration by the project, $500-1,000. Considers complexity and size of project when establishing payment.
Tips: Needs illustrators who are "fast and not expensive." Looks for "strong delineation and color."

MAYFAIR INDUSTRIES INC., Suite 5301, 350 5th Ave., New York NY 10018-0110. President: Robert Postal. Estab. 1935. Manufacturer of T-shirts, sweat shirts and sportswear. Prefers screen printed tops and bottoms (fun tops). Directed towards ages 2-30. Labels: B. J. Frog, Jane Colby Primo, Pilgrim and Rrribbit Rrribbit.
Needs: Works with 10 freelance artists, 2-5 freelance illustrators/year and 5-10 freelance designers/year. Uses artists for pattern design. Adult (female) cartoon style, young look.
First Contact & Terms: Send query letter with brochure showing art style. Samples not filed are returned only if requested. Reports only if interested. To show a portfolio, mail appropriate materials. Pays for illustration by the project, $400-2,500. Considers complexity of project when establishing payment.
Tips: "Understand who you are doing your art for (the consumer). Don't be too general. The recession has increased our need for freelancers."

MEMBERS ONLY, A Division of Europe Craft Imports, 445 5th Ave., New York NY 10016, (212)686-5050. Director of Marketing: Michelle Goldsmith. Estab. 1980. Manufacturer and importer of men's apparel— sportswear and outerwear for a core group of 25-35 year olds. "Themes and styles vary from season to season." Label: Members Only. "We also do sub-labels for each season."
Needs: Works with 2-3 freelance artists/year. "Prefers someone who has graphic experience related to fashion who can handle project from creative to final camera ready art work."
First Contact & Terms: Send query letter with brochure showing art style or slides. Samples are filed or are returned only if requested by artist. Call to schedule an appointment to show a portfolio, which should include appropriate samples. Pays for design and illustration by the project. Buys all rights.

METROPOLITAN WATER DISTRICT OF SOUTHERN CALIFORNIA (MWD), Box 54153, 1111 Sunset Blvd., Los Angeles CA 90054. (213)250-6496. Graphic Arts Designer: Mario Chavez. Supplies water for southern California. "MWD imports water from the Colorado River and northern California through the state water project. It imports about half of all the water used by some 15 million consumers in urban southern California from Ventura to Riverside to San Diego counties. MWD wholesales water to 27 member public agencies which, along with about 130 subagencies, delivers it to homes, businesses and even a few farms in MWD's 5,200-square-mile service area."
Needs: Works with 4-6 freelance artists/year. "Color artwork for publication is separated on scanner, it should be flexible; final agreement (contract) is purchase order, based upon verbal agreement of artist accepting assignment. All artwork is vested in Metropolitan Water District unless agreed upon." Works on assignment only. Uses artists for brochure/publications design, illustration and layout.
First Contact & Terms: Send query letter with brochure showing art style. Samples not filed are returned by SASE. Reports only if interested. Call to schedule an appointment to show a portfolio, which should include b&w roughs, original/final art and tearsheets. Pays for design by the project, $100 minimum. Pays for illustration by the project, $50 minimum.
Tips: "Phone calls should be kept short and to a minimum. Public affairs of MWD is interested in skillful execution of conceptual artwork to illustrate articles for its publication program. Number of projects is limited."

***** *The asterisk before a listing indicates that the listing is new in this edition. New markets are often the most receptive to freelance submissions.*

***MEYER SCHERER AND ROCKCASTLE, LTD.,** 325 2nd Ave. N., Minneapolis MN 55401. Principal: Garth Rockcastle. Architecture/interior and landscape design firm providing design, document preparation and construction supervision. Clients: residential, commercial, institutional and industrial.
Needs: Works with 5-6 freelance artists/year. Works on assignment only. Uses artists for exterior, interior and landscape design; brochure design and layout, design consulting. "We occasionally enter national competitions in partnership with artists of our choosing without reimbursement to the artist unless we are winners. Contact for details. We also collaborate with artists on special projects such as stained glass or building furniture."
First Contact & Terms: Send query letter with resume and slides. Samples not filed are returned by SASE. Reports only if interested. Write to schedule an appointment to show a portfolio, which should include roughs, original/final art and color. Pays for design and illustration by the hour, $15-60; or by the project. Considers complexity of project, client's budget, skill and experience of artist, how work will be used, turnaround time and rights purchased when establishing payment.
Tips: Looks for "innovation and understanding of architecture. Don't ask questions about what we might be particularly interested in."

J. MICHAELS INC., 182 Smith St., Brooklyn NY 11201. (718)852-6100. Advertising Manager: Lance Davis. Estab. 1886. Retailer of furniture and home furnishings for young married couples ages 20-45.
Needs: Works with 5 freelance illustrators/year. Uses artists mainly for mechanicals. Also uses freelance artists for ad illustration, P-O-P display, calligraphy, paste-up and posters. "We use a lot of line ink furniture illustrations." Prefers tight, realistic style, pen & ink line, pencil and washes.
First Contact & Terms: Send query letter with brochure or nonreturnable samples, such as photocopies. Samples are filed and are not returned. Reports back only if interested. "Mail photocopies. If I want to see more, I will call." Pays for illustration by the project, $50 (for items like charts on TV). Considers complexity of project and skill and experience of artist when establishing payment. Buys all rights.
Tips: "We are a furniture retailer. Show me furniture illustrations that can print in newspapers."

MVP CORP. INC., 88 Spence St., Bayshore NY 11706. (516)273-8020 or (800)367-7900. President: Harold Greenberg. Estab. 1975. Manufacturer of imprinted sportswear, T-shirts, jackets and sweatshirts for all ages.
Needs: Works with 3 freelance artists/year. Uses freelance artists mainly for special projects. Also uses artists for fashion illustration.
First Contact & Terms: Send resume. Samples are filed or are returned only if requested by artist. Reports back within 7 days only if interested. Write to schedule an appointment to show a portfolio, which should include roughs. Pays weekly, $500 and up. Considers skill and experience of artist when establishing payment.
Tips: "Looking for full time!"

***NALPAC, LTD.,** 8700 Capital, Oak Park MI 48237. (313)541-1140. FAX: (313)544-9126. President: Ralph Caplan. Estab. 1971. Produces coffee mugs and T-shirts for gift and mass merchandise markets.
Needs: Approached by 10-15 freelance artists/year. Works with 2-3 freelance artists/year. Buys 70 freelance designs and illustrations/year. Works on assignment only. Considers all media.
First Contact & Terms: Send query letter with brochure, resume, SASE, photographs, photocopies, slides and transparencies. Samples are filed or are returned by SASE if requested by artist. Reports back within 1 month. Call to schedule an appointment to show a portfolio. Usually buys all rights, but rights purchased may vary according to project. Pays by the hour, by the project $40-500, or offers royalties of 4%.

NETWORK IND./CLASS KID LTD., 350 5th Ave., New York NY 10118. (212)967-6000. Design Director: Susan Trombetta. Estab. 1978. Importer of men's and boys' sportswear. Labels: Laguna, Pro-Keds, Evenkeel. Clients include Sears, JC Penney and Walmart.
Needs: Approached by 10-15 freelance artists/year. Works with 6-8 freelance illustrators and 2-4 freelance designers/year. Assigns "at least 1-2 jobs to freelance artists every week." Uses artists for fashion, textile and screen print design. Prefers marker, then pen & ink, colored pencil and computer illustration.
First Contact & Terms: Send query letter with resume and photocopies. Samples not filed are not returned. Reports back only if interested. To show a portfolio, mail color roughs (concepts) and original/final art. Pays for design by the hour, $10-20; by the project, $15-100. Pays for illustration by the hour, $90-150; by the project, $10-100. Considers complexity of project and skill and experience of artist when establishing payment.
Tips: "Show flat sketches of garments for illustration. Show cartoon art, textile designs or illustrations to show color sense and skill. Do not show photographs or rough fashion illustrations. If an artist is in the New York area, we can see them immediately. Occasional phone calls are good, because it keeps the artist in our mind. Most of our artists have been recommended by friends."

NIEDERMEYER-AMERICA LTD., Box 4078, Portland OR 97208-4078. Street address: 1818 NE Martin Luther King Blvd. Portland, OR 97210. (503)222-6496. FAX: (503)222-6498. Sales: Jim Niedermeyer. Estab. 1980. Distributor of palm leaf hats,printed casual wear and straw hats for industrial and retail clients.

Needs: Works on assignment only. Uses freelance artists mainly for design and promotion. Also uses freelance artists for advertising design, illustration and layout; brochure design, illustration and layout; and catalog design, illustration and layout.
First Contact & Terms: Send query letter with brochure showing art style. Samples are not returned. Call to schedule an appointment to show a portfolio. Pays for design and illustration by the project. Rights purchased vary according to project.

NOVEL TEE DESIGNS, 1254 23rd St., Newport News VA 23607. Contact: Art Director. Estab. 1985. Manufacturer and distributor of imprinted T-shirts, sweatshirts, aprons and nighshirts for retail shops and tourist-oriented, ski-resort, beach/surf, seasonal and cartoon/humorous designs. Clients: Gift shops, surf shops and department stores.
Needs: Approached by 50-100 freelance artists/year. Works with 50-100 freelance illustrators and 25 freelance designers/year. Assigns 50 jobs to freelance artists/year. Prefers artists with experience in silkscreen printing, art and design. Works on assignment only. Uses freelance artists mainly for T-shirts, sweatshirts, aprons and nightshirts and apparel graphic designs. "We are looking for designs that will appeal to women ages 18-40 and men ages 15-40; also interested in ethnic designs."
First Contact & Terms: Send query letter with brochure showing art style or resume, tearsheets, SASE and photostats. Samples are filed or are returned only if requested by artist. Reports back within 1 month only if interested. To show a portfolio, mail thumbnails, roughs, original/final art, final reproduction/product and tearsheets. Pays for design and illustration by the project, $50-100. Negotiates rights purchased.
Tips: "Artists should have past experience in silkscreening art. Understanding the type of line work needed for silkscreening and originality. We are looking for artists who can create humorous illustrations for a product line of T-shirts. Graphic designs are also welcomed. Have samples of rough through completion."

OBION-DENTON, 34 W. 33rd St., New York NY 10001. (212)563-6070. Art Director: Sandra Von Hagen. Estab. 1865. Manufacturer of children's sleepwear for 0-14 year olds. Labels: Dr. Denton, The Original Dr. Denton and OBION.
Needs: Approached by 50-60 freelance artists/year. Works with 30 freelance artists/year. Prefers artists with experience in screen print and heat transfer design and set-up. Uses freelance artists mainly for screen and transfer print design. Also uses freelance artists for catalog illustration, textile design, paste-up, mechanicals and storyboards. Prefers campy and contemporary styles.
First Contact & Terms: Send query letter with resume and photocopies. Samples are filed. Reports back only if interested. Call to schedule an appointment to show a portfolio, which should include original/final art and photostats. Pays for design by the project, $125-225. Buys all rights.
Tips: "Shop the market and show originality to compete with what is in the stores currently and going forward."

***OCEAN PACIFIC SUNWEAR LTD.,** 2701 Dow Ave., Tustin CA 92680. (714)731-3100. FAX: (714)544-4773. Executive Vice President—Design, Creative Director: Suzi Chauvel. Estab. 1972. Manufacturer and design studio. Creates lifestyle clothing based on surfing and snowboarding, California outdoor activity and lifestyle. Marketed to people 15 to 30 years of age. Labels: Ocean Pacific, OP, OP Pro, OP Tech.
Needs: Works with 5-10 freelance artists/year. Prefers artists with experience in lifestyle market—preferably with interests in surfing and watersports, snowboarding. Uses freelance artists for advertising, brochure and catalog design, illustration and layout; accessory, window, and package design; and P-O-P displays. Prefers artwork that is "cutting edge, young, hip, ireverent and avant garde."
First Contact & Terms: Send query letter with resume and the following samples: tearsheets, photostats, slides and photographs. Samples are filed or returned by SASE if requested by artist. Reports back only if interested. Write to schedule an appointment to show a portfolio after mailing samples of work. Portfolio should include original/final art, photostats, tearsheets, slides and photographs—"anything that shows variety of technique and inventiveness." Pays for design and illustration by the project. Buys all rights.

***ONEITA INDUSTRIES INC.,** Box 24, Andrews SC 29510. (803)264-5225. FAX: (803)264-4262. Vice President of Marketing: Mike Davis. Estab. 1876. Manufacturer currently developing a preprinted T-shirt and sweatshirt program for Europe; directed toward ages 15-30. Labels: Oneita.
Needs: New firm. Prefers artists with experience in European markets. Send query letter with the following samples: tearsheets, slides, photographs and transparencies. Samples are not filed and are returned. Reports back within 2 months.
First Contact & Terms: Mail appropriate materials. Will discuss portfolio after initial review. Pays for design by the project. Buys all rights.

OSSIPOFF, SNYDER & ROWLAND (ARCHITECTS) INC., 1210 Ward Ave., Honolulu HI 96814. President: Sidney E. Snyder, Jr., AIA. Architecture/planning/interior design firm. Clients: commercial (offices), residential, institutional, religious and educational. Current clients include state of Hawaii.

Needs: Approached by 15 freelance artists/year. Works with 2-3 freelance artists/year. Artist should be in Hawaii for this contact. Works on assignment only. Uses artists for interior design, architectural rendering, furnishing, model making and fine art in building projects.

First Contact & Terms: Send query letter with brochure showing art style. Reports back. Write to schedule an appointment to show a portfolio. Payment determined by job.

Tips: "Interested in high quality."

***PARISIAN, INC.,** 750 Lakeshore Pkwy., Birmingham AL 35211. (205)940-4815. FAX: (205)940-4987. Creative Director: Dan Copus. Estab. 1887. Retailer of clothing for children through adults.

Needs: Approached by 10 freelance artists/year. Works with 4 freelance aritst/year. Uses freelance artists mainly for newspaper and direct mail. Also uses freelance artists for advertising illustration and catalog design.

First Contact & Terms: Send query letter with resume and photocopies. "Send a variety of samples." Samples are filed. Reports back only if interested. To show a portfolio, mail b&w and color photostats, tearsheets and photographs. Pays for illustration by the project, $100-1,000. Rights purchased vary according to project.

PATTERN PEOPLE, INC., 10 Floyd Rd., Derry NH 03038. (603)432-7180. Vice President: Michael S. Copeland. Estab. 1988. Design studio servicing various manufacturers. Designs wallcoverings and textiles with "classical elegance and exciting new color themes for all ages."

Needs: Approached by 5-8 freelance artists/year. Works with 10-15 freelance artists/year. Prefers artists with experience in various professional mediums. Uses freelance artists mainly for original finished artwork. Also uses freelance artists for textile and wallcovering design. "We use all styles but they must be professional." Special needs are "floral (both traditional and contemporary); textural (faux finishes, new woven looks, etc.) and geometric (mainly new wave contemporary)."

First Contact & Terms: Send query letter with photocopies, slides and photographs. Samples are filed. Reports back within 1 month. Write to schedule an appointment to show a portfolio, which should include original/final art and color samples. Pays for design by the project, $100-1,000. Buys all rights.

Tips: "The best way to break in is by attending the annual Surtex Design show in New York."

PDT & COMPANY ARCHITECTS/PLANNERS, 8044 Montgomery Rd., Cincinnati OH 45236. (513)891-4605. Project Architect: Mark Browning. Clients: commercial, institutional and multi-family residential.

Needs: Approached by over 10 artists/year. Works with over 7 freelance illustrators and over 5 freelance designers/year. Uses artists for brochure layout, architectural and interior rendering and landscape design. Works on assignment only. Especially needs brick and stone sculptors and renderers. Prefers marker; gouache; mixed media; and stone, bronze and neon sculpture.

First Contact & Terms: Send query letter with brochure showing art style or resume and photographs. Samples are filed or are returned if requested by artist. Reports back in 3 weeks. Call or write to schedule an appointment to show a portfolio or mail photographs. All fees negotiable. Considers skill and experience of artist, client's budget and rights purchased when establishing payment. Negotiates rights purchased.

PEN NOTES, INC., 134 Westside Ave., Freeport NY 11520-5499. (516)868-1966/5753. President: Lorette Konezny. Produces children's learning books and calligraphy kits for children ages 3 and up, teenagers and adults. Clients: Bookstores, toy stores and mothers.

Needs: Prefers New York artists with book or advertising experience. Works on assignment only. Also uses freelance artists for children's illustration, calligraphy, P-O-P display and design and mechanical for catalog sheets for children's books. Prefers knowledge of press proofs on first printing. Prefers pen & ink. Prefers realistic style with true perspective and color.

First Contact & Terms: Send query letter with brochure, photostats and photocopies. Samples are filed or are returned only if requested by artist. Call or write to schedule an appointment to show a portfolio or mail original/final art, final reproduction/product and color and b&w tearsheets and photostats. Original artwork is not returned after job's completion. Pays for design and illustration by the project, $75-6,000. Buys all rights.

Tips: "Work must be clean, neat and registered for reproduction. The style must be geared for children's toys. You must work on deadline schedule set by printing needs."

PENDLETON WOOLEN MILLS, 220 NW Broadway, Box 3030, Portland OR 97208-3030. (503)226-4801. Menswear Communications Manager: Patti McGrath; Womenswear Communications Manager: Pat McKevitt. Manufacturer of men's and women's sportswear, blankets and piece goods.

Needs: Approached by 10 freelance artists/year. Works with 3 freelance illustrators/year. Assigns job to 1 freelance artist/year. Seeks local artist for line art. Uses artists for advertising illustration. Prefers b&w and traditional styles.

First Contact & Terms: Send query letter with samples to be kept on file. Call for appointment to show portfolio. Reports back within 3 weeks. Considers complexity of project, available budget and how work will be used when establishing payment. Pays for illustration by the project, $40 minimum.

PHILADELPHIA T-SHIRT MUSEUM, 235 N 12th St., Philadelphia PA 19107. (215)625-9230. President: Marc Polish. Manufacturer and distributor of imprinted T-shirts and sweatshirts. Clients: retail shops and national mail order firms.
Needs: Uses artists for imprinted sportwear. Prefers humorous illustration.
First Contact & Terms: Send query letter with brochure showing art style or photocopies. Samples not filed are returned. Reports within 1 week. To show a portfolio, mail roughs and photostats. Pays in percent of sales or outright purchase.

PICKARD CHINA, 782 Corona Ave., Antioch IL 60002. (708)395-3800. FAX: (708)395-3827. Director of Marketing: Patti Kral. Estab. 1893. Manufacturer of fine china dinnerware, limited edition plates and collectibles. Clients: upscale stores, department stores, direct mail marketers, consumers and collectors. Current clients include Cartier, Tiffany & Co., Marshall Field's, Bradford Exchange, Hamilton Mint, U.S. Historical Society.
Needs: Assigns 2-3 jobs to freelance artists/year. Uses freelance artists mainly for china patterns and plate art. Prefers designers for china pattern development with experience in home furnishings. Tabletop experience is a plus. Wants painters for plate art who can paint people and animals well— "Rockwellesque" portrayals of life situations. Prefers any medium with a fine art or photographic style. Works on assignment only.
First Contact & Terms: Send query letter with brochure showing art style or resume and color photographs, tearsheets, slides or transparencies. Samples are filed or are returned as requested. Reports back within 3 months. Negotiates fees, royalties and rights purchased.

***PICKHARDT & SIEBERT USA,** 700 Prince Georges Blvd., Upper Marlboro MD 20772. (301)249-7900. Director of Design: Barbara Brower. Estab. 1979. Manufacturer/importer of wallcoverings. "We sell to distributors, who service retail wallcoverings stores."
Needs: Works with about 30 freelance designers/year. Uses artists for product design and styling, and "purchases wallpaper designs from freelancers on an ongoing basis." Uses freelance art mainly for wall coverings.
First Contact & Terms: Send query letter with resume. Samples are filed. Samples not filed are returned only if requested. Reports back only if interested. Write to schedule an appointment to show a portfolio, which should include roughs, original/final art, slides and color. Pays for design and illustration by the project, $200-1,000.
Tips: "Designs need to be right scale and layout to appear in repeat on a wall. Presentation must be professional and clean. Painting must be accurate and exhibit a light hand."

PINEHURST TEXTILES INC., Box 1628, Asheboro NC 27204. (919)625-2153. Contact: Bonna R. Leonard. Estab. 1946. Manufactures ladies' lingerie, sleepwear and leisurewear; nylon tricot, 100% cotton, woven satin, woven polyester/cotton, brushed polyester and fleece; Pinehurst Lingerie label.
Needs: Approached by 5-10 freelance artists/year. Works with 1 freelance illustrator/year. Uses freelance work mainly for catalogs. Seasonal needs: spring and summer due September 1; fall and winter due March 1. Prefers pen & ink, watercolor and acrylic.
First Contact & Terms: Pays for illustration by the project, $75 minimum or by the hour, $25 minimum.
Tips: "Live in this area and do fashion illustration."

PLYMOUTH MILLS, INC., 330 Tompkins Ave., Staten Island NY 10304. (718)447-6707. President: Alan Elenson. Manufacturer of imprinted sportswear: T-shirts, sweatshirts, fashionwear, caps, aprons and bags. Clients: mass merchandisers/retailers.
Needs: Approached by 25 freelance artists/year. Works with 8 freelance illustrators and 8 freelance designers/year. Assigns 100 jobs to freelance artists/year. Uses freelance artists mainly for screenprint designs. Also uses freelance artists for advertising and catalog design, illustration and layout and product design.
First Contact & Terms: Send brochure and resume. Reports back only if interested. Pays for design and illustration by the hour or by the project. Considers complexity of the project and how work will be used when establishing payment.

POLO/RALPH LAUREN CORPORATION, 40 West 55th St., New York NY 10019. (212)603-2710. FAX: (212)977-5137. Coordinator: Bennetta Barrett. Design studio for fashion (men's wear). "The clothing has a very strong Americana feeling for young boys (4-7) to adult men." Labels: Polo and Ralph Lauren.
Needs: Approached by 80-over 100 freelance artists/year. Works with 12 freelance artists/year. Prefers local artists only with experience in realistic fashion illustration and marker—a must. Must work in house only. Uses freelance artists mainly for rendering flats of garments and male figures. Also uses freelance artists for accessory design and fashion illustration. Prefers realistic styles. "Artists with style required, with the ability for fast execution of assignments."

First Contact & Terms: Send query letter with resume and tearsheets and photostats. Samples are not filed and are returned by SASE if requested by artist. Reports back only if interested. To show a portfolio, mail b&w and color photostats and tearsheets. Pays for illustration by the hour, $10-20. Buys all rights.

Tips: "Please be sure the work you are showing is the type or style the firm or studio is looking for. Be completely prepared!"

THE POPCORN FACTORY, 13970 W. Laurel Dr., Lake Forest IL 60045. Vice President and Merchandising: Nancy Hensel. Estab. 1979. Manufacturer of popcorn cans and other gift items sold via catalog for Christmas, Valentine's, Easter and year round gift giving needs.

Needs: Works with 6 freelance artists/year. Assigns up to 20 freelance jobs/year. Prefers local artists only with experience in catalog work. Works on assignment only. Uses freelance artists mainly for cover illustration, flyers and ads. Also uses artists for advertising, brochure and catalog design and illustration.

First Contact & Terms: Send query letter with brochure. Samples are filed. Reports back within 1 month. Write to schedule an appointment to show a portfolio, or mail original/final art and photographs. Pays for design by the project, $500-$2,000. Pays for illustration by the project, $500-$1,500. Considers complexity of project, skill and experience of artist and turnaround time when establishing payment. Buys all rights.

Tips: "Send cartoons, classic illustration, art of a whimsical style, a mix of photography/illustration. Show ads, flyers, inserts, letters and brochures from rough layout through final art."

POURETTE MFG. INC., 6910 Roosevelt Way NE, Seattle WA 98115. (206)525-4488. President: Don Olsen. Estab. 1952. Manufacturer and distributor specializing in candlemaking supplies and soap making supplies. Clients: anyone interested in selling candlemaking supplies or making candles.

PRELUDE DESIGNS, 1 Hayes St., Elmsford NY 10523. (914)592-4300. Art Director: Madalyn Grano. Produces wallpaper, fabric and T-shirts.

Needs: Designs for the juvenile wallpaper/fabric market and both the adult and youth T-shirt markets. Occasionally hires artists for paste-up and color paint-up. Prefers artists experienced in tempera or gouache paints. Patterns submitted for wallcoverings or fabrics should be done to the following dimensions (or fractions thereof): 27W × 25¼L or 27L (6 colors maximum). Designs submitted for T-shirts should be done in the following dimensions: Youth 8W × 9L (or smaller); Adult 13W × 16L (or smaller). Also 6-color maximum and in any medium. Generally looking for fresh designs with an unusual "look." Prefers simple styles and themes dealing with current social trends.

First Contact & Terms: Send query letter with resume and samples of artwork. Include SASE if you wish samples returned. Portfolios may be shown by appointment only, and should include only those designs or patterns that apply to either juvenile wallcoverings/fabrics, or adult or youth T-shirts. Pays royalty of 3-5%. Original artwork returned at completion of project.

Tips: "Many artists don't follow-up with a phone call. In a busy art department, I can't always think to get back to people."

PRESTIGELINE, INC., 5 Inez Dr., Brentwood NY 11717. (516)273-3636. Director of Marketing: Stuart Goldstein. Manufacturer of lighting products.

Needs: Uses artists for advertising and catalog design, illustration and layout and product illustration. Prefers b&w line drawings. Produces seasonal material for Christmas, Mother's Day, Father's Day, Thanksgiving, Easter, back-to-school and graduations; submit work 3-4 months before season.

First Contact & Terms: Send resume, business card and photostats. Call for appointment to show a portfolio. Samples returned by SASE. Reports within 2 weeks. Buys all rights. Payment method is negotiable.

Tips: "There is an increased demand for b&w line art for newspaper advertisements."

PRISS PRINTS, INC., Suite 105, 3960 Broadway Blvd., Garland TX 75043. (800)543-4971; Texas: (214)278-5600. President: Toni Fischer Morath. Estab. 1972. Manufacturer. "We manufacture pressure sensitive wall decorations used primarily in children's rooms." Clients: retail stores selling wallcoverings and/or children's products. Current clients include: Target, Sears, J.C. Penney, Ames, Caldor and Kay-Bee.

Needs: Approached by 25 freelance artists/year. Works with 8 freelance illustrators and 2 freelance designers/year. Assigns 20 jobs to freelance artists/year. Uses freelancers mainly for product design. Also uses artists for advertising and brochure design, illustration and layout; illustration on product and signage.

First Contact & Terms: Send query letter with photostats. Samples are filed or are returned. Reports back only if requested; if not interested, all submissions returned. To show a portfolio, mail photostats. Pays for design and illustration by the project, $100 minimum. Considers complexity of project and interpretation of instructions when establishing payment. Buys all rights.

Tips: "Don't overwhelm me with long letters and too many samples. Don't send any originals unless requested. Send whimsical line art and illustrations."

PULPDENT CORPORATION OF AMERICA, 80 Oakland St., Watertown MA 02172. (617)926-6666. Director of Product Information: Jane Hart Berk. Manufacturer/distributor of dental supplies including instruments, pharmaceuticals, X-ray supplies, sterilizers, needles, articulating paper, etc. Clients: dental-supply dealers and dentists.
Needs: Works with 3-5 freelance artists/year. Works with local artists only. Works on assignment only. Uses artists for advertising, brochure and catalog design, illustration and layout; photography and technical illustration.
First Contact & Terms: Send query letter with business card, photostats and tearsheets. Samples are filed. Reports within 6 weeks. Call or write for appointment to show a portfolio. Pays by the project, $40 minimum. Considers complexity of project and skill and experience of artist when establishing payment; "how much our product is worth determines to some extent the amount we are willing to invest in designing, etc."
Tips: "We prefer simple, not-too-trendy designs aimed at the dental professional."

RAINBOW CREATIONS, INC., 216 Industrial Dr., Ridgeland MS 39157. (601)856-2158. President: Steve Thomas. Estab. 1973. Manufacturer of contract wallcovering: scenics, murals, borders and wallpaper prints. Clients: architects, interior designers and health-care institutions. Current clients include national distribution network.
Needs: Approached by 10 freelance artists/year. Works with 3 freelance illustrators and 2 freelance designers/year. Assigns 10 jobs to freelance artists/year. Prefers artists with experience in pattern design and silk screen. Works on assignment only. Uses freelance artists mainly as a source for new designs. Prefers silk screen and contemporary styles. Also uses freelance artists for product design.
First Contact & Terms: Send query letter with resume, photographs and photocopies. Reports back in 1 month. To show a portfolio, mail photostats, photographs and slides. Pays for design by the project, $100-700. Rights purchased vary according to project.

DARIAN RAITHEL & ASSOCIATES, 8623 Old Perry Hwy., Pittsburgh PA 15237. (412)367-4357. President: Darian Raithel. Estab. 1982. Architectural, interior design and landscape design firm providing total planning and design of retail stores, restaurants, offices and some residences. Current clients include Klay's Cafe, Derby's Deli, Coach Home Men's Stores and Merrill Lynch (now Prudential Preferred Realty).
Needs: Approached by 8-10 freelance artists/year. Works with 5-8 freelance artists/year. Uses freelance artists mainly for presentations. Also uses freelance artists for interior design and rendering, design consulting and furnishings. Especially needs drafting on a freelance basis.
First Contact & Terms: Send brochure showing art style or resume. Samples are filed or filed are returned. Reports back within 2 weeks. Call or write to schedule an appointment to show a portfolio, which should include color thumbnails, roughs and photographs. Pays for design and illustration by the hour, $4-12; by the project, $640-1,970; by the day, $32-96. Considers skill and experience of artist when establishing payment. Buys one-time rights.
Tips: "Show freehand perspective illustrations, detail, specification drawings and plans in your portfolio. Don't oversell yourself. Organize your portfolio and make it neat."

RECO INTERNATIONAL CORPORATION, Collector's Division, Box 951, 138-150 Haven Ave., Port Washington NY 11050. (516)767-2400. Manufacturer/distributor of limited editions, collector's plates, lithographs and figurines. Clients: stores.
Needs: Works with 4 freelance artists/year. Uses artists for plate and figurine design and limited edition fine art prints. Prefers romantic and realistic styles.
First Contact & Terms: Send query letter and brochure to be filed. Write for appointment to show a portfolio. Reports within 3 weeks. Negotiates payment.

RED CALLIOPE AND ASSOCIATES, INC., 13003 Figueroa St., Los Angeles CA 90061. (213)516-6100. FAX: (213)516-7170. Vice President of Design: Bonni Weisman. Estab. 1969. Manufacturer of infant clothing for newborns. Label: Red Calliope.
Needs: Approached by 8-15 freelance artists/year. Works with 7-10 freelance artists/year. Prefers artists with experience in infant and clothing design, juvenile textiles and illustration. Uses freelance artists mainly for complete design. Also uses freelance artists for product, textile and pattern design and displays. Style "must look 'baby.' "
First Contact & Terms: Send query letter with brochure showing art style or resume and photographs, photocopies or "anything appropriate." Samples are not filed and are returned. Reports back within 1 week. Call to schedule an appointment to show a portfolio, which should include appropriate materials. Pays for design by the project, $300-2,500. Pays for illustration by the project, $300-1,000. Rights purchased vary according to project.
Tips: "Prepare a portfolio after doing market research and then call."

RKT&B ARCHITECT (ROTHZEID KAISERMAN THOMSON & BEE, P.C., ARCH & PLANNERS), 30 W. 22nd St., New York NY 10010. (212)807-9500. Partner: Carmi Bee. Architectural firm that designs buildings (new construction, restoration, rehab., medical facilities, retail, housing, offices).

Needs: Works with 3-10 freelance artists/year. Works on assignment only. Uses artists for brochure design and architectural rendering.

First Contact & Terms: Send query letter with brochure showing art style. Samples not filed are returned by SASE. Reports only if interested. To show a portfolio, mail appropriate materials. Payment varies. Considers complexity of project, client's budget, skill and experience of artist, how work will be used, turnaround time and rights purchased when establishing payment.

ROCKY MOUNT UNDERGARMENT, 1536 Boone St., Rocky Mount NC 27801. (919)446-6161. FAX: (919)442-4412. Designer: Sharon Beary. Estab. 1959. Manufacturer of lingerie, undergarments and nightshirts (screen prints) for female children, young ladies and women. Labels: Blossoms, Hang Ten and Capezio.

Needs: Works with up to 5 freelance designers/year. Prefers local artists (not exclusively) with experience in textile design and textile print design. Uses freelance artists mainly for textile print and screen prints. Also uses freelance artists for advertising illustration, textile design and package design. Special needs are textile print design and screen print design.

First Contact & Terms: Send query letter with brochure showing art style or resume and tearsheets, photostats, photocopies and "whatever is available and effective." Don't "send only photocopied black-and-white samples." Samples are filed. Reports back only if interested. Write to schedule an appointment to show a portfolio, which should include original/final art, photostats and actual fabrics. Pays for design by the project, $20-300.

Tips: "We are receptive to all inquiries to textile print design. Be creative in all aspects of your designs from presentation through product. Also keep a balance of professionalism and creativity, but don't bury your creativity."

THE ROSENTHAL JUDAICA COLLECTION, by Rite Lite, 260 47th St., Brooklyn NY 11220. (718)439-6900. President: Alex Rosenthal. Vice President Product Design: Rochelle Stern. Estab. 1948. Manufacturer and distributor of a full range of Judaica ranging from mass-market commercial goods to exclusive numbered pieces. Clients: gift shops, museum shops and jewelry stores.

Needs: Approached by 10 freelance artists/year. Works with 4 freelance designers/year. Works on assignment only. Uses freelance artists mainly for new designs for Judaic giftware. Also uses artists for brochure and catalog design, illustration and layout and product design. Prefers ceramic and brass.

First Contact & Terms: Send query letter with brochure or resume, tearsheets and photographs. Samples are filed. Reports back only if interested. Call to schedule an appointment to show a portfolio, which should include original/final art and color tearsheets, photographs, and slides. Pays for design by the project, $500 minimum. Considers complexity of project, client's budget, skill and experience of artist and turnaround time when establishing payment. Buys all rights. "Works on a royalty basis."

Tips: Do not send originals.

RSVP MARKETING, Suite 5, 450 Plain St., Marshfield MA 02050. (617)837-2804. President: Edward C. Hicks. Direct marketing consultant services—catalogs, direct mail and telemarketing. Clients: insurance, wholesale, manufacturers and equipment distributors.

Needs: Works with 7-8 freelance artists/year. Desires "primarily local artists; must have direct marketing skills." Uses artists for advertising, copy brochure and catalog design, illustration and layout and technical illustration.

First Contact & Terms: Send query letter with resume and finished, printed work to be kept on file. Reports only if interested. Pays for design by the job, $400-5,000. Pays for illustration by the hour, $25-85. Considers skill and experience of artist when establishing payment.

***RUBBERSTAMPEDE,** Box 246, Berkeley CA 94701. (415)843-8910. FAX: (415)843-5906. President: Sam Katzen. Art Director: Kent Lytlen. Estab. 1978. Produces art and novelty rubber stamps, kits, glitter pens, ink pads.

Needs: Approached by 30 freelance artists/year. Works with 10-20 freelance artists/year. Buys 200-300 freelance designs and illustrations/year. Uses freelance artists for calligraphy, P-O-P displays, and original art for rubber stamps. Considers pen & ink. Looks for cute, feminine style. Produces seasonal material: Christmas, Valentine's Day, Easter, Hannukkah, Thanskgiving, Halloween, birthdays and everyday. Submit seasonal material 6 months in advance.

First Contact & Terms: Send query letter with resume, SASE, tearsheets, photographs, photocopies, slides and transparencies. Samples are filed or are returned by SASE if requested by artist. Reports back to the artist only if interested. Write to schedule an appointment to show a portfolio, which should include roughs, original/final art, color tearsheets, photographs and dummies. Pays by the hour, $15-50; by the project, $50-1,000. Rights purchased vary according to project. Originals are not returned.

ST. ARGOS CO., INC., 11040 W. Hondo Pkwy., Temple City CA 91780. (800)648-5655. FAX: (818)579-9133. Manager: Roy Liang. Estab. 1987. Manufacturer and wholesale of calendars, Christmas decorations, gift bags, giftwraps, greeting cards, posters and prints. Clients: gift shops and flower shops.

Needs: Approached by 10 freelance artists/year. Works with 7 freelance illustrators and 2 freelance designers/year. Assigns 2 jobs to freelance artists/year. Prefers artists with experience in illustration for calendars, gift bag, giftwraps, greeting cards and poster prints. Uses freelance artists mainly for design. Prefers Victorian and classic styles.
First Contact & Terms: Send slides and photographs/picture. Samples are filed. Reports back in 1 month. Payment for design and illustration, some deposit then percentage of volume sold or production. Buys all rights.

***SCANDECOR INC.**, 430 Pike Rd., Southampton PA 18966. (215)355-2410. FAX: (215)364-8737. Vice President Operations: Pam Griffin. Estab. 1968. Produces posters. Target market is young people, infants to teens.
Needs: Approached by 50 freelance artists/year. Works with 15-20 freelance artists/year. Buys 50 freelance designs and illustrations/year. Works on assignment only. Uses freelance artists mainly for illustrations. Will consider any media.
First Contact & Terms: Send query letter with photographs, photocopies, slides and transparencies. Samples are filed or are returned. Call to schedule an appointment to show a portfolio, or mail appropriate materials. Rights purchased vary according to project. Originals are returned at job's completion. Payment depends on product.

JANET SCHIRN ASSOCIATES, INC., 401 N. Franklin St., Chicago IL 60610. (312)222-0017. President: Janet Schirn. Interior design firm providing contract and residential interior design. Clients: business, restaurant and mercantile (wholesale).
Needs: Uses artists for graphics and fine art.
First Contact & Terms: Send letter with resume and samples. Pays by the project. Considers client's budget and skill and experience of artist when establishing payment.
Tips: "Better quality work is necessary; there is greater client sophistication. Just show your work—no sales pitch."

SCHMID, 55 Pacella Park Dr., Randolph MA 02368. (617)961-3000. Product Development: Connie Bergh. Estab. 1930. Manufacturer and distributor producing giftware such as music boxes, figurines and picture frames in earthenware and porcelain. Seasonal lines include: Christmas, Valentine's Day, Easter, etc. from a nostalgic to whimsical "look." Other themes include; Mother's Day, wedding, and baby. Clients: gift shops, department stores, jewelry stores and specialty shops.
Needs: Assigns 60-100 freelance jobs/year. Prefers artists with experience in giftware or greeting card design. Works on assignment only. Uses freelance artists mainly for product design. "We assign concept art and freelance artist is responsible for pencil roughs and color once pencil concept is approved."
First Contact & Terms: Send query letter with photocopies and other nonreturnable samples. Samples are filed or are returned by SASE only if requested by artist. Reports back within 1 month only if interested. Write to schedule an appointment to show a portfolio, should include roughs, original/final art, color and b&w tearsheets. Pays for design and illustration by the project. Considers complexity of project and how work will be used when establishing payment. Buys all rights.
Tips: "A 'greeting card style' is a plus. We are looking for illustrators who can portray figures and/or animals."

RICHARD SEIDEN INTERIORS, 238 N. Allen St., Albany NY 12206. (518)482-8600. President: Richard Seiden. Interior design firm. Provides residential and contract interior design. Clients: residential.
Needs: Works with 4 freelance artists/year for graphic design; 3, signage design; 2, model making; 3, murals; 4, wall hangings; 3, landscape design; 2, charts/graphs; and 2, stained glass. Works on assignment only.
First Contact & Terms: Send query letter with resume, tearsheets, photostats and SASE. Reports in 3 weeks. Provide materials to be kept on file for future assignments. Pays $150-1,800, original wall decor; also according to project. To show a portfolio, mail roughs. Pays for design by the hour, $25 minimum. Considers complexity of project, skill and experience of artist and client's budget when establishing payment.
Tips: Prefers to see photos rather than slides, if possible.

SEM PARTNERS, INC., 100 E. Prince St., Drawer Q, Beckley WV 25802. (304)255-6181. Contact: J. Blair Frier, AIA, Principal. Architectural firm offering architectural planning, programming, construction administration and consulting. Clients: commercial, residential, education, state and federal, health care.
Needs: Uses artists for technical illustration, interior design, design consulting and model making.
First Contact & Terms: Works on assignment only. Send brochure and samples to be kept on file. Call for appointment to show portfolio. Samples not filed are returned only if requested. Reports within 1 month. Pays for design by the project, $1,000 minimum; pays for illustration by the project, $00 minimum.. Considers complexity of the project and client's budget when establishing payment.

SHERRY MFG. CO., INC., 3287 NW 65th St., Miami FL 33147. Art Director: Jeff Seldin. Estab. 1948. Manufacturer of silk-screen T-shirts with beach and mountain souvenir themes. Label: Sherry's Best. Current clients include Walt Disney Co., Club Med and Kennedy Space Center.

Needs: Approached by 50 freelance artists/year. Works with 15 freelance designers and illustrators/year. Assigns 350 jobs to freelance artists/year. Prefers artists that know the T-shirt market and understand the technical aspects of T-shirt art. Prefers colorful graphics or highly stippled detail.

First Contact & Terms: Send query letter with brochure showing art style or resume, photostats and photocopies. Samples are not filed and are returned only if requested. Reports back within 2 weeks. Call or write to schedule an appointment to show a portfolio, which should include thumbnails, roughs, original/final art, final reproduction/product and color tearsheets, photostats and photographs. Pays for design and illustration by the project, $150. Considers complexity of project, skill and experience of artist and volume of work given to artist when establishing payment. Buys all rights.

Tips: "Know the souvenir T-shirt market and have previous experience in T-shirt art preparation. Some freelancers do not understand what a souvenir T-shirt design should look like. Send sample copies of work with resume to my attention."

SIEGEL DIAMOND ARCHITECTS, 10780 Santa Monica Blvd., Los Angeles CA 90025. (213)474-3244. Architecture firm providing planning and limited interior design services. Clients: commercial and residential. Buys 6 renderings/year.

Needs: Works with 3 freelance artists for architectural rendering; 3, graphic design; and 2, landscape design. Local artists only. Works on assignment only.

First Contact & Terms: Query with samples and arrange interview to show portfolio; no calls. Samples returned by SASE; reports back on future assignment possibilities. Work must be reproducible in b&w, i.e. line drawing with color added. Provide resume and business card to be kept on file for future assignments. Pays for design and illustration by the project.

TOM SNYDER PRODUCTIONS, INC., 90 Sherman St., Cambridge MA 02140. (617)876-4433. Art Director: Annette Donnelly. Developer of educational computer software for ages 5-adult; develops software, documentation, ancillary materials (music, art, books). Clients: schools, department stores, program stores.

Needs: Approached by over 30 freelance artists/year. Work with 2-3 freelance illustrators and 1 freelance designer/year. Uses artists for b&w and color work; brochure design, illustration and layout; product illustration; package design and computer graphics. Prefers pen & ink, charcoal/pencil, watercolor, oil, computer illustration and woodblock prints.

First Contact & Terms: Works on assignment only. Send query letter with resume and samples to be kept on file. Prefers photocopies as samples. Samples not filed are returned by SASE only if requested. Reports back only if interested. Pays by the hour, $15-25 average. Considers complexity of the project, skill and experience of the artist, how work will be used, and turnaround time when establishing payment.

Tips: "Let your work speak for itself. Just send photocopies and be patient. When an appropriate job comes up and your work is on file, we'll call you. A confident style and ability is important, but creativity is what I really look for in a portfolio."

SPORTAILOR, INC., 6501 NE 2nd Ct., Miami FL 33138. (305)754-3255. FAX: (305)754-6559. Director of Marketing: Stan Rudman. Manufacturer and distributor of men's and boys' apparel (mostly sportswear) for toddlers-mature men. Labels: Sun Country Surfwear, Sun Country active wear, Weekender Relaxwear.

Needs: Works with 3 freelance artists/year. Works on assignment only. Uses artists for advertising design, fashion design and illustration.

First Contact & Terms: Send query letter with brochure showing art style or samples and photocopies. Samples are filed or are returned only if requested. Reports back within 1 week. Call to schedule an appointment to show a portfolio, which should include color roughs and original/final art. "Show all the work you can do." Payment depends on the size of project; "it can be a $25 job or a $200 job." Considers client's budget when establishing payment.

Tips: "We are looking for an artist who can easily sketch from photographs for catalog work as well as a fashion designer who understands the surf market and knows how to come up with a boys' and young men's look."

***SQUEEGEE PRINTERS**, Box 47, Canaan VT 05903. Owner: Pat Beauregard. Estab. 1984. Screen printing providing custom screen printing of wearing apparel, such as pre-printed T-shirts and sweats for the souvenir market and promotional purposes. Clients: stores, hotels, restaurants, resort areas, banks and corporations.

Needs: Works with 3 freelance artists/year. Assigns over 20 jobs/year. Prefers artists with experience in the 4-color process. Works on assignment basis only. Uses freelance artists mainly for producing new stock designs. Also uses artists for advertising illustration and product design.

First Contact and Terms: Send query letter with brochure, resume, photostats and photographs. Samples are filed. Reports back only if interested. To show a portfolio, mail final reproduction/product, tearsheets, photostats, photographs and color. Pays for design by the project, $50 minimum. Considers complexity of project, client's budget, skill and experience of artist and how work will be used when establishing payment. Buys all rights.

Tips: "Send representative samples of work so we can see if it's anything we would be interested in."

***SSI**, 570 S. Miami St., Wabash IN 46992. (219)563-8302. Vice President Product Development: David England. Manufacturer specializing in licensed properties and novelty and sports clothing for juvenile to adult consumers. Labels: SSI, Saturdays Hero.
Needs: Approached by 5-10 freelance artists/year. Works with 7 freelance artists/year. Prefers artists with experience in screen printing, apparel design. Uses freelance artists mainly for concept finished art, hand color separation. Also uses freelance artists for product design, fashion illustration, textile design, pattern design and mechanicals. Looking for wide variety of looks. Specializes in automotive, surfing, humorous themes.
First Contact & Terms: Send query letter with resume and the following samples: tearsheets, photostats, photocopies, slides and photographs. Samples are filed or returned by SASE if requested by artist. Reports back only if interested. Mail appropriate materials. Portfolio should include thumbnails, roughs, original/final art, b&w and color photostats. Pays for concept by the project, $100-200. Pays for illustration by the project, $350-1,000. Rights purchased vary according to project.
Tips: "Send roughs and any printed samples for review."

PAUL STUART, Madison Ave. at 45th St., New York NY 10017. (212)682-0320. P.R. Director/Ad Manager: Julie Oddy. Retailer and designer of updated traditional merchandise for 35-year-olds and older.
Needs: Approached by 10-20 freelance artists/year. Works with 2-3 freelance artists/year. Uses freelance artists mainly for direct mail and postcards. Also uses freelance artists for catalog illustration and layout.
First Contact & Terms: Send query letter with brochure showing art style. Samples are filed. Reports back only if interested. Call to schedule an appointment to show a portfolio, or mail appropriate materials. Payment depends on project. Buys all rights.

STUDIO 38 DESIGN CENTER, 38 William St., Amityville NY 11701. (516)789-4224. Vice President: Andrea Reda. Estab. 1972. Self-contained manufacturer of wallpaper for national clients.
Needs: Approached by 30 freelance artists/year. Works with about 10 freelance designers and 10 freelance illustrators/year. Uses artists for wallpaper. Assigns 80 jobs to freelance artists/year. Prefers pen & ink, airbrush, colored pencil, watercolor, pastel and marker.
First Contact & Terms: Portfolio should include color geometrics and florals; no figures. Pays for design by the project, $50-600.
Tips: "Call and make an appointment."

SUN HILL INDUSTRIES, INC., 48 Union St., Stamford CT 06906. Art Director and Product Development Manager: Nancy Mimoun. Estab. 1977. Manufacturer of Easter egg decorating kits, plastic home-office stationery items, health and beauty aids (organizers and novelties). Clients: discount chain and drug stores and mail-order catalog houses. Clients include K-Mart, Walmart, Walgreens, Caldor and Revco.
Needs: Approached by 10 freelance artists/year. Works with 2-3 freelance illustrators and 1-2 freelance designers/year. Assigns 5-6 freelance jobs/year. Works on assignment only. Uses artists for product and package design, rendering of product and model making. Prefers marker and acrylic.
First Contact & Terms: Send query letter with brochure and resume. Samples are filed or are returned only if requested by artist. Reports back only if interested. Pays for design by the hour, $25 minimum; by the project, $350 minimum. Pays for illustration by the hour, $25 minimum; by the project $350 minimum. Considers complexity of project and turnaround time when establishing payment. Buys all rights.
Tips: "Send all information; don't call; include package designs. Do not send mechanical work."

SUNDBERG, CARLSON AND ASSOCIATES, INC., 914 West Baraga Ave., Marquette MI 49855. (906)228-2333. Designer/Illustrator: Mike Lempinen. Estab. 1980. Architectural/interior design/engineering firm providing architectural , interior and graphic design and illustration; architectural renderings and model making.
Needs: "We are interested in seeing artwork for brochures, advertising, and architectural rendering services, and are especially interested in beginning a file on available art services; freelance, art houses, publication firms, etc." Works with 2-3 freelance illustrators and designers/year. Uses freelance artwork mainly for architectural rendering and promotional materials.
First Contact & Terms: Send query letter with brochure showing art style or resume, tearsheets, photostats and printed pieces. Samples not filed are not returned. Reports only if interested. To show a portfolio, mail appropriate materials. Pays by the hour, $6-15. Considers complexity of project, client's budget, and skill and experience of artist when establishing payment.
Tips: "Please do not send returnable pieces, slides or photos. We can not return unsolicited materials. The best way for freelancers to break in is to try to gain experience through part-time work and volunteering. For our firm, show a strong portfolio."

SUTTON SHIRT CORP., 350 5th Ave., New York NY 10118. (212)239-4880. FAX: (212)629-0041. Merchandise Manager: Irene Mantia. Estab. 1969. Manufacturer of "stylish but moderately priced clothing."
Needs: Approached by 6 freelance artists/year. Works with 6 freelance artists/year. Prefers local artists only. Uses freelance artists mainly for fashion illustration. Also uses freelance artists for package design, paste-up and mechanicals. Prefers "attention to detail with flair."

First Contact & Terms: Send query letter with brochure showing art style. Samples are filed. Reports back only if interested. Call to schedule an appointment to show a portfolio, which should include thumbnails, roughs and original/final art. Pays for illustration by the project, $50.

Tips: "Call and set up a formal interview."

SYLVOR CO., INC., 126 11th Ave., New York NY 10011. (212)929-2728. FAX: (212)691-2319. Owner: Bonnie Sylvor. Estab. 1929. Manufacturer of window displays for department stores and party planners. Clients: department stores, corporate party planners and shops. Current clients include Saks Fifth Ave., Bloomingdales and Elizabeth Arden.

Needs: Approached by 20 freelance artists/year. Works with 5 freelance designers/year. Assigns 8 jobs to freelance artists/year. Prefers local artists only. Works on assignment only. Uses freelance artists mainly for graphic design and overload and rush projects. Prefers high style fashion poster style and flat painting that looks dimensional. Also uses freelance artists for product rendering and design, air brushing, model making and signage.

First Contact & Terms: Send query letter with resume, slides, photographs, transparencies and other samples that do not need to be returned. Resumes are filed; samples are not filed. Does not report back, in which case the artist should call. Call to schedule an appointment to show a portfolio, which should include b&w photostats, slides and photographs. Pays for design by the project by the hour, $8-10; or by the project, $200 maximum. Pays for illustration by the project.

TALICOR, INC., 190 Arovista Circle, Brea CA 92621. (714)255-7900. President: Lew Herndon. Estab. 1971. Manufacturer and distributor of educational and entertainment games and toys. Clients: chain toy stores, department stores, specialty stores and Christian bookstores.

Needs: Works with 4-6 freelance illustrators and 4-6 freelance designers/year. Prefers local artists. Works on assignment only. Mainly uses artists for game design. Also uses artists for advertising, brochure and catalog design, illustration and layout; product design; illustration on product; P-O-P displays; posters and magazine design.

First Contact & Terms: Send query letter with brochure. Samples are not filed and are returned only if requested. Reports back only if interested. Call or write to schedule an appointment to show a portfolio. Pays for design and illustration by the project, $100-5,000. Negotiates rights purchased.

TEACH YOURSELF BY COMPUTER SOFTWARE, INC., Suite 1000, 349 W. Commercial St., East Rochester NY 14445. (716)381-5450. President: Lois B. Bennett. Estab. 1978. Publisher of educational software for microcomputers. Clients: schools, individuals, stores.

Needs: Approached by 10 freelance artists/year. Works with 2 freelance illustrators and 2 freelance designers/year. Local artists only. Works on assignment only. Uses artists for advertising, brochure and catalog design, illustration and layout; and illustration on product.

First Contact & Terms: Send query letter with brochure, resume, photostats, photographs, photocopies, slides or tearsheets to be kept on file. Samples not filed are returned by SASE. Reports back within 6 weeks. Write for appointment to show a portfolio, which should include roughs, photostats and photographs. Pays for design and illustration by the hour or project. Considers complexity of project, skill and experience of artist, how work will be used, turnaround time, and rights purchased when establishing payment. Buys all rights.

Tips: "I like to see a variety of work to see their dimensions. Let your work speak for itself—don't talk too much during a review."

THOG CORPORATION, Box 424, Tallmadge OH 44278. Sales Manager: Don Martin. Provides equipment for the graphic arts industry.

Needs: Approached by 6 freelance artists/year. Works with 2-3 freelance artists/year. Uses freelance artists for advertising, brochure and catalog design, illustration and layout; and product design, technical illustration.

First Contact & Terms: Send query letter. Samples are filed. Reports back only if interested. Write to schedule an appointment to show a portfolio, which should include roughs and photostats. Pays for design and illustration by the project, $25 minimum. Considers complexity of project, client's budget, and rights purchased when establishing payment. Buys all rights.

Tips: "We use a lot of custom line art."

TRIBORO QUILT MFG. CORP., 172 S. Broadway, White Plains NY 10605. (914)428-7551. Sales Manager: Alvin Kaplan. Produces infants' wear and bedding under the Triboro label; for chain and department stores.

Needs: Works with 8 freelancer illustrators/year and 6 freelance designers/year. Works with freelance artists for infants' and childrens' embroidery and fabric designs. Prefers "cute" infant desings.

First Contact & Terms: Call for interview or provide resume, business card and brochure to be kept on file. Reports in 1 week. Samples returned by SASE; reports back on future assignment possibilities. Pays for design and illustration by the project, $100 minimum.

Tips: "Research the market and be persistent. Phone to discuss our design requirements."

UARCO, INC., 121 N. 9th St., Dekalb IL 60115. Advertising Manager: Ed Beckmann. Estab. 1892. Direct mail catalog providing computer supplies and business forms to businesses with computers.
Needs: Works with 4-5 freelance illustrators and 6 designers/year. Works on assignment only. Uses artists for brochure design and layout and cover designs.
First Contact & Terms: Send query letter with resume, tear sheets and photocopies. Samples not filed are returned only if requested. Reports only if interested. To show a portfolio, mail roughs, final reproduction/product and tear sheets. Pays for design by the project, $100 minimum. Considers complexity of project, skill and experience of artist, and turnaround time when establishing payment.

UNIFORMS MANUFACTURING INC., Box 5336, W. Bloomfield MI 48033. (313)332-2700 or (800)222-1474. President: L.P. Tucker. Manufacturer of all types of wearing apparel—smocks, lab coats, shirts, trousers, coveralls, dresses, aprons, cotton gloves, polyester and knits; Uniform label. Catalog available on request.
Needs: Works with 3 freelance artists/year. Works on assignment only. Uses artists for advertising, brochure and catalog design; advertising illustration and direct mail promotions.
First Contact & Terms: Send brochure/flyer and slides as samples. Samples returned by SASE. Reports back as soon as possible. Negotiates payment.

V.M. DESIGNS, INC., 1432 Industrial Way, Gaidnerville NY 89410. (702)782-7330. President: Dennis Buckley. Estab. 1980. Manufacturer of custom decoratives for retail stores. Current clients include major national and regional department and specialty stores.
Needs: Approached by 6-8 freelance artists/year. Works with 3 freelance illustrators and 2 freelance designers/year. Wants dependable quality work. Uses freelance artists mainly for product development. Also uses freelance artists for product rendering and design and model making.
First Contact & Terms: Send query letter with photographs and photocopies. Samples are filed. Reports back in 1 month. Call to schedule an appointment to show a portfolio, which should include thumbnails, roughs and photographs. Pays for design and illustration by the project, a percentage of sale. Buys all rights.

VID AMERICA, 60 Madison Ave., New York NY 10010. Director of Advertising and Promotion: Marylou Bono. Estab. 1978. Manufacturer of pre-recorded home videocassettes. "We work directly with designers etc." Clients: Pre-recorded home videocassette distributors, rack jobbers, direct mail catalog.
Needs: Works with 2 freelance artists/year. Assigns 5 jobs/year. Prefers local artists only artists with experience in video. Works on assignment only. Uses freelance artists mainly for design. Also uses artists for advertising and catalog design and layout, product design and posters.
First Contact & Terms: Send query letter with resume, slides and photographs. Samples are filed and are returned only if requested by artist. Reports back within 1 week. Call to schedule an appointment to show a portfolio, or mail original/final art, tear sheets, slides, color and b&w. Pays for design by the project, $100-1,500. Considers complexity of project skill and experience of artist and turnaround time when establishing payment. Buys all rights.

VISUAL AID/VISAID MARKETING, Box 4502, Inglewood CA 90309. (213)473-0286. Manager: Lee Clapp. Estab. 1961. Distributes sales promotion aids, marketing consultant service,—involved in all phases. Clients: manufacturers, distributors, publishers and graphics firms (printing and promotion) in 23 SIC code areas.
Needs: Approached by 12-15 freelance artists/year. Works with 3-5 freelance artists/year. Assigns 4 jobs to freelance artists/year. Uses artists mainly for printing ads. Also uses artists for advertising, brochure and catalog design, illustration and layout; product design; illustration on product; P-O-P display; display fixture design and posters. Buys some cartoons and humorous and cartoon-style illustrations. Additional media: fiber optics, display/signage, design/fabrication.
First Contact & Terms: Works on assignment only. Send query letter with brochure, resume, business card, photostats, duplicate photographs, photocopies and tearsheets to be kept on file. Originals returned by SASE. Reports back within 2 weeks. Write for appointment to show a portfolio. Pays for design by the hour, $5-75. Pays for illustration by the project, $100-500. Considers complexity of project, skill and experience of artist and turnaround time when establishing payment.
Tips: "Do not say 'I can do anything.' We want to know best media you work in (pen & ink, line drawing, illustration, layout, etc.)."

VISUAL CONCEPTS, 5410 Connecticut Ave., Washington DC 20015. (202)362-1521. Owner: John Jacobin. Estab. 1984. Service-related firm. Specializes in visual presentation, mostly for retail stores. Clients: retail stores, residential and commercial spaces. Current clients include: Up Against the Wall and In Detail.
Needs: Approached by 5-10 freelance artists/year. Works with 3 freelance designers/year. Assigns 10-20 freelance artists/year. Prefers local artists with experience in visual merchandising and 3-D art. Works on assignment only. Uses freelance artists mainly for design and installation. Prefers contemporary or any classic styles. Also uses freelance artists for advertising design and layout, brochure and catalog illustration, signage and P-O-P displays.

First Contact & Terms: Contact through artist rep or send query letter with brochure showing art style or resume and samples. Samples are filed. Reports in 2 weeks. Call to schedule an appointment to show a portfolio, which should include thumbnails, roughs and color photographs or slides. Pays for design by the hour, $6.50-15 and up. Rights purchased vary according to project.

VOGUE PATTERNS, 161 6th Ave., New York NY 10013. (212)620-2733. Associate Art Director: Christine Lipert. Manufacturer of clothing and knitting patterns with the Vogue labels.
Needs: Approached by 50 freelance artists/year. Works with 10-20 freelance illustrators and 1-5 freelance graphic designers/year. Assigns 18 editorial illustration jobs and 100-150 fashion illustration jobs to freelance artists/year. Uses freelance artists mainly for catalog illustration for *Vogue Patterns* catalog book, *Vogue Patterns Magazine* and *Vogue Knitting* magazine. "The nature of catalog illustration is specialized; every button, every piece of top-stitching has to be accurately represented. Editorial illustration assigned for our magazine should have a looser, editorial style. We are open to all media and styles."
First Contact & Terms: Send query letter with resume, tearsheets, slides and photographs. Samples not filed are returned by SASE. Reports back within one month. Call or write to schedule an appointment to show a portfolio, which should include original/final art, final reproduction/product, and color tearsheets. Pays by the project. Considers complexity of the project and turnaround time when establishing payment.
Tips: "Drop off comprehensive portfolio or send a current business card and sample. When a job becomes available, we will call illustrator to view portfolio again."

© Vogue Patterns/Butterick Co. Inc. 1991

New York City-based Bill Donovan created this pencil, charcoal and watercolor fashion illustration for a Vogue Patterns catalog. Donovan has "a sophisticated, modern style and pays [attention to] details and fabric rendering," says Christine Lipert, associate art director of Vogue Patterns/Butterick Co., Inc. Lipert gave the assignment to Donovan following his portfolio drop-off and was pleased with his being "easy to work with, on schedule and willing to make corrections when needed."

WRIGHT'S KNITWEAR CORP., 34 W. 33rd St., New York NY 10001. (212)239-0808. Merchandise Manager: Robert Shields. Estab. 1850. Manufacturer and supplier to major American retailers of printed active and sportswear; mens, boys, juvenile and female printed garments. Labels: Wrights, Laguna, Major Private Label Programs.

Needs: Works with 12 freelance artists and 2 freelance designers/year. Uses freelance artists mainly for screen print graphics and to develop special concepts and characters, particularly in the juvenile area.
First Contact & Terms: Send query letter with brochure, tearsheets, photostats and photocopies. Reports back within 4 weeks only if interested. Call to schedule an appointment to show a portfolio. Pays for design by the project, $300 minimum. Pays for illustration by the piece, $300-350. Considers complexity of project when establishing payment. Buys all rights.
Tips: "We're looking for hot new California beachwear trends, as well as new all over/gament printed techniques. Sloppy mountings and presentations are common mistakes freelancers make. Dress like a responsible business person."

YORK DISPLAY FINISHING CO., INC., 240 Kent Ave., Brooklyn NY 11211. (718)782-0710. President: Stanley Singer. Manufacturer and display firm providing P-O-P advertising displays in vacuum-formed plastic, corrugated cardboard and paper. Clients: display agencies, printers, artists, etc.
Needs: Works with 2 freelance artists/year. Prefers New York City metro area artists, thoroughly experienced in P-O-P design. Uses artists for -P-O-P design and model making.
First Contact & Terms: Send query letter with resume or business card to be kept on file. Reports in 3 weeks. Samples returned by SASE. Pays by the project, $100-1,500 average.

Other Businesses

Each year we contact all firms currently listed in *Artist's Market* requesting they give us updated information for our next edition. We also mail listing questionnaires to new and established firms which have not been included in past editions. The following businesses did not respond to our request to update their listings for 1992 (if they indicated a reason, it is noted in parentheses after their name).

Abbey Press
Adele's Group (unable to contact)
Advance Spectacle Co., Inc.
Alva Museum Replicas
American Bookdealers Exchange
Baxter Hodell Donnelly Preston, Inc. Architects (no longer uses outside freelancers)
Ceramo Studio

Epsilon Data Management, Inc.
The Great Midwestern Ice Cream Company
Hansley Industries, Inc. (unable to contact)
The Image Group
Maruri USA Corp.
Mostad & Christensen
Murphy International Sales Organization
Murray Hill Press

Premier Wallcoverings (unable to contact)
Sea Side Cottage
Serigraphic Productions, Inc. (unable to contact)
Sopp America Inc. (unable to contact)
Spencer Gifts
Stamp Collectors Society of America
Robert J. Sturtcman – Architect

Market conditions are constantly changing! If you're still using this book and it is 1993 or later, buy the newest edition of Artist's Market at your favorite bookstore or order directly from Writer's Digest Books.

Galleries

Galleries have been hit hard by the recession and war. One New York dealer compared the closing of galleries all around him to a virus: "As it spreads," he said, "chances are that it will happen to you." The situation fares no better for nonprofit spaces and museums, many of which are struggling terribly due to cut-backs in government spending. Some have had to close. Yet, many galleries listed in this book responded that the recession was not affecting their sales at all.

This uncertain climate makes it all the more essential that your search for a gallery be practical and professional. This year's upfront article, Marketing to Galleries, offers many helpful tips.

If you have developed your own recognizable style and have established a reputation in your area through shows at a university or fairs, you may be ready to begin your search for a gallery. Although exhibiting in a faraway city may seem more prestigious, you should begin your search close to home. After all, it is the area where you've developed your reputation, and a gallery director may already be familiar with your work. It's also easier to keep an eye on sales and to replace works that have sold. Later, when you are more firmly established in your career, you can extend your range and work with galleries outside your area. You will find they are more willing to work with an artist who is a seasoned professional.

Finding the right gallery

One of your first considerations should be whether a gallery is right for you and your work. If this is your first approach to a gallery, you may find cooperative galleries more open to your work. An artist becomes a member of a cooperative by submitting an application with slides of finished work; the work is juried by a committee of cooperative members. If accepted, the artist may exhibit work in exchange for a fee and a commitment to spend time on such tasks as gallery sitting, housekeeping and maintenance. Some cooperatives take small commissions (20 to 30 percent); others do not charge a commission. When considering a cooperative gallery, decide if you can afford to take time away from your work to fulfill your obligation to the cooperative and whether you are comfortable knowing your work will not be sold by professional salespeople. Sales duties here will be handled by the cooperative members—your fellow artists. Another option is a nonprofit gallery.

There are a growing number of cafes, restaurants and bars, which display the work of local artists. Because these seem like good starting points for an artist desiring to have her work seen, a few such places are included in the listings, such as the Rockridge Cafe in Oakland, California. Also, owners of office buildings have shown an interest in exhibiting artwork in their lobbies in recent years. Perhaps you know of a cafe or restaurant owner or developer in your area who may be interested in showing your work.

In a retail gallery, your work is handled by a professional sales staff—*selling* the work is the gallery's major concern. Your work will either be bought outright or handled on consignment. The benefits to you include knowing your work is being marketed aggressively and being able to devote your full attention to the creative, not the selling side, of your art. In exchange for selling, promoting and publicizing your work, the gallery receives a commission of 40 to 60 percent. If your work sells for $2,500 and the gallery receives a 50 percent commission, you will both receive $1,250 for the sale.

Also, many museums sell work through their own shops, and they often "rent" work for a specified amount of time. You may also wish to consider establishing your own temporary gallery, if you enjoy selling and marketing your work. Some malls will arrange temporary leases of empty store space at a reduced price, but a new long-term tenant can displace you. If this sounds like an approach you would be interested in, check with a mall manager in your area. When considering any kind of gallery space for your work, avoid vanity or subsidy galleries where you pay not only for exhibition space, but for promotion as well.

After you have decided which type of gallery will best suit your needs, do some research to narrow your search to a few galleries in your area. Talk to other artists to see what information they have about galleries. Visit the galleries as though you were a customer and investigate the following aspects:

● How long has the gallery been in business? A newer gallery may be more open to artists, but not as financially stable as a more established gallery.

● Does the gallery feature emerging artists? Ask how many group shows the gallery presents annually — the more group shows, the more artists (including new artists) the gallery works with.

● What are the gallery's hours? A few hours of exhibition time on weekends won't get your work the attention it deserves. In tourist towns, the gallery may be open only during specific seasons.

● Does the gallery have a specialty? If the work featured is not anything like your work in style or subject matter, don't assume it's because no one has submitted similar work. The gallery probably limits the kinds of work it will consider.

● What is the gallery's price range? Do you think it's so high it will discourage the kinds of customers you see buying your work?

● How knowledgeable is the sales staff? If they can answer your questions about other artists' works, your work will probably receive the same kind of attention.

Approaching the gallery

After you select the galleries that interest you, call each gallery director (address him by name, not title) and ask for an appointment to show your work. Never bring a portfolio into a gallery without an appointment. If the gallery isn't reviewing new work, ask if you can send a brochure or sample to be kept on file. If you get an interview, plan your presentation to fit the particular gallery. Bring 15 to 20 professional transparencies or duplicate slides, your leave-behinds (a current brochure, resume, artist's statement and business card) and two or three originals. If you work in several media, show an original in each category, backed up by slides of other works in that media. Choose works appropriate to the gallery and don't drag along everything you have ever done. You will risk confusing and boring the gallery director, and you will have to transport all that work to and from the gallery.

Setting terms

A presentation does not guarantee a gallery will agree to handle your work. Don't be discouraged by a rejection — there are more galleries. Even more importantly, don't be so swept away by an acceptance that you have your work on display before you fully understand the obligations and responsibilities involved. You should know the answers to these questions before agreeing on representation:

● Will your work be sold on consignment? If so, what is the gallery's commission?

● How long will the agreement last? To a new artist, a lifetime deal might sound fantastic — but you will have second thoughts when your career begins to grow.

● What is the extent of the gallery's representation? Is it exclusive? If so, in what area — within 100 miles or in the entire state? Are works sold from your studio included in the agreement?

● Who pays for promotion, insurance and shipping? Generally, the gallery pays for promotional costs and inhouse insurance; shipping costs are often shared.

● Will the gallery provide names and addresses of people who buy your work so you can stay in touch with them? One sale could lead to another. The gallery owner may want to keep this information for himself. If so, ask that names of past buyers be provided; allow the names of prospective buyers to be kept confidential.

● Who sets the retail price? Often, it's a compromise, but you should be consulted.

● How much publicity will the gallery provide? The more the gallery publicizes your work or show, the better your sales will be, and the more your reputation will grow. Be sure your show will be covered in press releases, and that you know how much display time your work will receive.

● Are statements of account provided on a regular basis? If not, how will you know if the gallery is selling your work, and how much it owes you?

● What happens if the gallery folds? You are guaranteed the return of your artwork under the Uniform Commercial Code, but make sure your agreement acknowledges this.

● Will you be able to remove your work during the run of your contract? You might want to enter some of your pieces in a juried show or need to take a piece down to photograph it. Be sure you clarify this point with the gallery director before you sign the contract.

When setting terms, be sure to bring along your own agreement in case the gallery doesn't provide a contract. (North Light Books' *The Artist's Friendly Legal Guide* includes contracts and agreements you can use.) Be sure you have a signed receipt before you leave any work. Before you make a commitment, clear up all the details. All verbal agreements should be confirmed in writing.

Broadening your scope

Because many galleries require they be the exclusive purveyor of an artist within a certain area, once you have had a local gallery show, you are ready to broaden your scope by querying other galleries, first within the same region, then farther away. To develop a sense of which galleries are right for you, look to the myriad of art publications which contain reviews and advertising (the pictures that accompany a gallery's ad can be very illuminating). A few such publications are *ARTnews*, *Art in America*, *The New Art Examiner* and regional publications such as *Artweek* (West Coast), *Southwest Art*, *Artpaper* (based in Minneapolis) and *Art New England*. To find out more about what art magazines cover your area of interest, call the library in that city, and if they don't know, they'll direct you to someone who does. The most complete list of galleries (though it lacks marketing information) is found in *Art in America's Guide to Galleries, Museums and Artists*. Other directories include *Art Now, U.S.A.'s National Art Museum and Gallery Guide*, *The Artist's Guide to Philadelphia Galleries*, and *Washington Art*.

The sample package you send to these galleries will contain the same types of material as before, but it should emphasize your successful shows and sales record. Be sure your slides are of high quality—the lighting even, with no glare; the piece centered; the colors accurate; and the forms perfect. So you have room to label them clearly and neatly, make sure they're set in plain mounts. Label each one with the title of the piece, its size, the medium, your name plus copyright symbol, the date, and an arrow indicating the top of the slide. Be sure you update your file to include your most recent work.

Alabama

***FAYETTE ART MUSEUM**, 530 N. Temple Ave., Fayette AL 35555. (205)932-8727. Director: Jack Black. Museum. Estab. 1969. Represents emerging, mid-career and established artists. Sponsors 6 shows/year. Aver-

age display time is 6 weeks. Open all year. Located downtown Fayette Civic Center; 16,500 sq. ft. 20% of space for special exhibitions.

Media: Considers all media and all types of prints. Most frequently exhibits oil, watercolor and mixed media.

Style: Exhibits expressionism, primitivism, painterly abstraction, minimalism, post-modern works, impressionism, realism and hard-edge geometric abstraction. Genres include landscapes, florals, American, wildlife, portraits and figurative work.

Terms: Shipping costs negotiable. Prefers artwork framed.

Submissions: Send query letter with resume, brochure and photographs. Write to schedule an appointment. Portfolio should include photographs. Replies only if interested within 2 weeks. Files possible future exhibit material.

FINE ARTS MUSEUM OF THE SOUTH, Box 8426, Mobile AL 36689. (205)343-2667. Director: Joe Schenk. Clientele: tourists and general public. Sponsors 6 solo and 12 group shows/year. Average display time 6-8 weeks. Interested in emerging, mid-career and established artists. Overall price range: $100-5,000; most artwork sold at $100-500.

Media: Considers all media and all types of print.

Style: Exhibits all styles and genres. "We are a general fine arts museum seeking a variety of style, media and time periods." Looking for "historical significance."

Terms: Accepts work on consignment (20% commission). Retail price set by artist. Exclusive area representation not required. Gallery provides insurance, promotion, contract; shipping costs are shared. Prefers framed artwork.

Submissions: Send query letter with resume, brochure, business card, slides, photographs, bio and SASE. Write to schedule an appointment to show a portfolio, which should include slides, transparencies and photographs. Replies only if interested within 3 months. Files resumes and slides. All material is returned with SASE if not accepted or under consideration.

Tips: A common mistake artists make in presenting their work is "overestimating the amount of space available." Recent gallery developments are the "prohibitive costs of exhibition—insurance, space, transportation, labor, etc. Our city budget has not kept pace with increased costs."

GADSDEN MUSEUM OF ARTS, 2829 W. Meighan Blvd., Gadsden AL 35904. (205)546-7365. Director: Sherrie Hamil. Museum. Estab. 1965. Clientele: students, adults, and tourists. Sponsors 5 solo and 6 group show/year. Average display time 4 weeks. Interested in emerging and established artists. Overall price range: $50-5,000.

Media: Considers all media. Most frequently exhibits watercolor, oil and photography.

Style: Exhibits impressionism, realism, primitivism, painterly abstraction and conceptualism. Considers all genres. Prefers landscapes, wildlife and portraits. "The Gadsden Museum of Arts displays its permanent collection of artwork (paintings, prints, sculptures and historical memorabilia) and exhibits monthly showings of art groups and individual artists works."

Terms: Accepts work on consignment (30% commission). Retail price set by gallery and artist. Gallery provides insurance, promotion and contract; artist pays for shipping. Prefers framed artwork.

Submissions: Send query letter with resume, slides, photographs and bio. Write to schedule an appointment to show a portfolio, which should include slides. Replies in 1 month. All material is returned if not accepted under consideration.

***LEON LOARD GALLERY OF FINE ARTS,** 2781 Zelda Rd., Montgomery AL 36106. (205)270-9010. (800)345-0538 in Alabama. (800)235-6273 for other US states. Director: Marcia Weber. Retail gallery. Estab. 1988. Represents 250 artists; emerging, mid-career and established. Exhibited artists include Dennis Perrin and Paige Harvey. Sponsors 6 shows/year. Average display time 4-6 months. Open all year (except 2 weeks in December and January). Located in "new shopping area in suburbs; 2700 sq. ft.; light, airy space with pickled pine floors, gallery cloth walls and track lighting." 50% of space for special exhibitions. Clientele: "mid-range to upper income scale." 80% private collectors, 20% corporate collectors. Overall price range: $300-40,000; most work sold at $1,000-2,000.

Media: Considers oil, acrylic, watercolor, sculpture and sculptural ceramics. Considers monotypes—"only original one-of-a-kind works." Most frequently exhibits oil on canvas, watercolor on paper and acrylic on canvas and paper.

Style: Exhibits expressionism, painterly abstraction, impressionism, realism, photorealism and folk art. Genres include landscapes, florals, Americana, figurative work; all genres. Prefers impressionism and expressionism.

Terms: Accepts work on consignment (50% commission) or buys outright for 50% of retail price. Retail price set by the artist. Gallery provides insurance, promotion and contract. Shipping costs are shared. Prefers artwork on canvas unframed.

Submissions: Send resume, slides, bio, brochure, photographs, SASE, business card and reviews. Write to schedule an appointment. Portfolio should include slides. Replies within 6 months. Files biographies, slides and resumes if interested. Returns others promptly.

Tips: "Slide review for new artists takes a lot of time. Consideration often includes having to ask artist for more information, which then takes additional time to act upon. We urge artists to include slides that are of the highest quality and to label them completely—available or sold, size, medium, artist's price (excluding frames) and retail price."

DORIS WAINWRIGHT KENNEDY ART CENTER GALLERY, 900 Arkadelphia Rd., Birmingham AL 35254. (205)226-4928. Assistant Professor of Art: Steve Cole. College art gallery (Birmingham Southern College). Estab. 1965. Represents emerging and mid-career artists. Sponsors 8 shows/year. Average display time 3 weeks. Open September through May. Located in center of campus; 1484 sq ft.; 149 linear feet running wall space. 100% of space for special exhibitions. Clientele: 100% private collectors. Overall price range: $50-3,700; most artwork sold at $400-1,000.

Media: Considers original handpulled prints, woodcuts, wood engravings, linocuts, engravings, mezzotints, etchings, lithographs and serigraphs. Most frequently exhibits drawings, sculpture and paintings.

Style: Exhibits all styles. Genres include all genres.

Terms: "This gallery exists for the benefit of our students and the community. There is no commission on work(s) sold." Gallery provides insurance and promotion; artist pays for shipping. Prefers framed artwork.

Submissions: Send resume, slides and SASE. Replies in 1 month. Files resume.

Alaska

STONINGTON GALLERY, 415 F St., in the Old City Hall, Anchorage AK 99501. (907)272-1489. Manager: Jane Purinton. Retail gallery. Estab. 1984. Clientele: 60% private collectors, 40% corporate clients. Represents 50 artists. Sponsors 9 solo and 15 group shows/year. Average display time 3 weeks. Interested in emerging, mid-career and established artists. Overall price range: $100-5,000; most work sold at $500-1,000.

Media: Considers oil, acrylic, watercolor, pastel, mixed media, collage, works on paper, sculpture, ceramic, craft, fiber, glass and all original handpulled prints. Most frequently exhibited media: oil, mixed media and all types of craft.

Style: Exhibits all styles. "We do not want the Americana, Southwestern, Western and wild, but we have no pre-conceived notions as to what an artist should produce." Prefers landscapes, florals and figurative works. The Stonington Gallery specializes in original works by artists from Alaska and the Pacific Northwest. In addition, we are the only source of high-quality crafts in the state of Alaska. We continue to generate a high percentage of our sales from jewelry and ceramics, small wood boxes and bowls and paper/fiber pieces. Patrons tend to require that metal, clay and wood items be functional, but not so for paper/fiber or mixed media works."

Terms: Accepts work on consignment (40% commission). Retail price set by artist. Exclusive area representation required. Gallery provides insurance, promotion, contract and shipping costs from gallery. Prefers framed artwork.

Submissions: Send letter of introduction with resume, slides, bio and SASE. Write to schedule an appointment to show a portfolio, which should include slides. All material is returned if not accepted or under consideration.

Arizona

***ARIZONA STATE UNIVERSITY ART MUSEUM,** Nelson Fine Arts Center, Arizona State University, Tempe AZ 85287-2911. (602)965-2787. Director: Trudy Turk. Museum. Estab. mid-1950s. Represents emerging, mid-career and established artists. Sponsors 12 shows/year. Average display time 6 weeks. Open all year. Located downtown Tempe. "Gallery features award-winning architecture, designed by Antoine Predock."

***** *The asterisk before a listing indicates that the listing is new in this edition. New markets are often the most receptive to freelance submissions.*

Media: Considers all media. "Greatest interest is in ceramics and other crafts, contemporary and historical."
Submissions: "Interested established artists should submit slides to the director. Most of our shows are of a historical nature."

SUZANNE BROWN GALLERY, 7160 Main St., Scottsdale AZ 85251. (602)945-8475. Director: Ms. Linda Corderman. Retail gallery and art consultancy. Estab. 1962. Located in downtown Scottsdale. "Recently opened a second gallery, specializing in contemporary American Art." Clientele: valley collectors, tourists, international visitors; 70% private collectors; 30% corporate clients. Represents 60 artists. Sponsors 3 solo and 2 group show/year. Average display time 4 weeks. Interested in established artists. Overall price range: $500-20,000; most work sold at $1,000-10,000.
Media: Considers oil, acrylic, watercolor, pastel, drawings, mixed media, collage, sculpture, ceramic, craft, fiber, glass, lithographs, monoprints and serigraphs. Most frequently exhibits oil, acrylic and watercolor.
Style: Exhibits realism, painterly abstration and post modern works; will consider all styles. Genres include landscapes, florals, Southwestern and Western (contemporary) themes. Prefers contemporary Western, Southwestern and contemporary realism. "Contemporary American Art, specializing in art of the New West. Suzanne Brown Gallery and Suzanne Brown Contemporary exhibit realistic and abstract paintings, drawings and sculpture by American artists. Some of these regionally and nationally acclaimed artists are Veloy Vigil, Ed Mell and Patrick Coffaro."
Terms: Accepts work on consignment. Retail price set by gallery and artist. Exclusive area representation required. Gallery provides insurance promotion, contract and shipping costs from gallery. Prefers framed artwork.
Submissions: Send query letter with resume, brochure, slides, photographs, bio and SASE. Replies in 2 weeks. All material is returned if not accepted or under consideration. No appointments are made.
Tips: "Include a complete slide identification list, including availability of works and prices. The most common mistakes artists make is presenting poor reproductions; too much background information, and artists' statements are too wordy."

EL PRESIDIO GALLERY, 120 N. Main Ave., Tucson AZ 85701. (602)884-7379. Director: Henry Rentschler. Retail gallery. Estab. 1981. "Located in historic adobe building with 14' ceilings next to the Tucson Museum of Art." Clientele: locals and tourists; 70% private collectors, 30% corporate clients. Represents 20 artists. Sponsors 3 solo and 4 group shows/year. Average display time 2 months. Accepts artists from mostly the West and Southwest. Interested in emerging and established artists. Overall price range: $500-20,000; most artwork sold at $1,000-5,000.
Media: Considers oil, acrylic, watercolor, mixed media, works on paper, sculpture, ceramic, glass, egg tempera and original handpulled prints. Most frequently exhibited media: oil, watercolor and acrylic.
Style: Exhibits impressionism, expressionism, realism, photorealism and painterly abstraction. Genres include landscapes, Southwestern, Western, wildlife and figurative work. Prefers realism, representational works and abstraction (mostly representational abstracts).
Terms: Accepts work on consignment (50% commission). Retail price set by gallery and artist. Exclusive area representation required. Gallery provides insurance, promotion and contract; artist pays for shipping. Prefers framed artwork.
Submissions: Send query letter with resume, brochure, slides, photographs, bio and SASE. Call or write to schedule an appointment to show a portfolio, which should include originals, slides, transparencies and photographs. Replies in 2 weeks.
Tips: "Have a professional attitude. Be willing to spend money on good frames."

ELEVEN EAST ASHLAND I.A.S., 11 E. Ashland, Phoenix AZ 85004. (602)271-0831. Director: David Cook. Estab. 1986. Located in an old farm house. Sponsors 13 solo and mixed group shows/year. Average display time 3 weeks. Located in "two-story old farm house; central Phoenix, off Central Ave." Interested in emerging, mid-career and established artists. Overall price range: $100-5,000; most artwork sold at $100-800.
Media: Considers all media. Most frequently exhibits photography, painting, mixed media and sculpture.
Style: Exhibits all styles, preferably contemporary. "This is a proposal exhibition space open to all artists excluding Western and Southwest styles (unless contemporary style); not traditional."
Terms: Accepts work on consignment (25% commission); rental fee for space; rental fee covers 1 month. Retail price set by artist. Exclusive area representation not required. Artist pays for shipping.
Submissions: Accepts proposal in person or by mail to schedule shows 6 months at a time. Send query letter with resume, brochure, business card, slides, photographs, bio and SASE. Call or write to schedule an appointment to show a portfolio, which should include slides and photographs. Replies only if interested within 1 month. Files all material. All material is returned if not accepted or under consideration. Deadline: 10/31/91 for shows 6/92-12/92.

ETHERTON/STERN GALLERY, 135 S. 6th Ave., Tucson AZ 85701. (602)624-7370. FAX: (602)792-4569. Contact: Terry Etherton, Michael Stern or Sharon Alexandra. Retail gallery and art consultancy. Estab. 1981. Located "downtown; 3,000 sq. ft.; in historic building—wood floors, 16' ceilings." Represents 50+ emerging,

mid-career and established artists. Exhibited artists include Holly Roberts, Fritz Scholder, James G. Davis and Mark Klett. Sponsors 7 shows/year. Average display time 5 weeks. Open from September to June. 75% of space for special exhibitions; 10% of space for gallery artists. Clientele: 50% private collectors, 25% corporate collectors, 25% museums. Overall price range: $100-50,000; most work sold at $500-2,000.

Media: Considers oil, acrylic, drawing, mixed media, collage, sculpture, ceramic, all types of photography, original handpulled prints, woodcuts, wood engravings, linocuts, engravings, mezzotints, etchings and lithographs. Most frequently exhibits photography, painting and sculpture.

Style: Exhibits expressionism, neo-expressionism, primitivism, post modern works. Genres include landscapes, portraits and figurative work. Prefers expressionism, primitive/folk and post-modern. Interested in seeing work that is "cutting-edge, contemporary, issue-oriented, political."

Terms: Accepts work on consignment (50% commission). Buys outright for 50% of retail price (net 30 days). Retail price set by gallery and artist. Gallery provides insurance and promotion; shipping costs are shared. Prefers framed artwork.

Submissions: Only "cutting-edge contemporary—no decorator art." No "unprepared, incomplete works or too wide a range—not specific enough." Send resume, brochure, slides, photographs, reviews, bio and SASE. Call or write to schedule an appointment to show a portfolio, which should include slides. Replies in 6 weeks only if interested. Files slides, resumes and reviews.

Tips: "Become familiar with the style of our gallery and with contemporary art scene in general."

GALERIA MESA, 155 N. Center, Box 1466, Mesa AZ 85211-1466. (602)644-2242. Visual Arts Supervisor: Susan Hakala. Owned and operated by the city of Mesa. Estab. 1981. Represents emerging, mid-career and established artists. "We only do national geared shows and curated invitationals. We are an exhibition gallery, NOT a commercial sales gallery." Sponsors 9 shows/year. Average display time 4-6 weeks. Open September through July. Located downtown; 3,600 sq. ft., "wood floors, 14' ceilings and monitored security." 100% of space for special exhibitions. Clientele: "cross section of Phoenix metropolitan area." 100% private collectors. "Artists selected only through national juried exhibitions." Overall price range: $100-10,000; most artwork sold at $200-400.

Media: Considers all media. Considers original handpulled prints, woodcuts, engravings, lithographs, wood engravings, mezzotints, monotypes, serigraphs, linocuts and etchings. No media preference.

Style: Exhibits all styles. No genre preferred.

Terms: Artwork is not accepted on consignment. There is a 25% commission. Retail price set by the artist. Gallery provides insurance, promotion, contract and pays for shipping costs from gallery. Requires framed artwork.

Submissions: Send a query letter with a request for a prospectus. "We do not offer a portfolio review. Artwork is selected through national juried exhibitions." Files slides and resumes.

Tips: "Have professional quality slides."

MARY PEACHIN'S ART COMPANY, 3955 E. Speedway, Tucson AZ 85712. (602)881-1311. Retail gallery, wholesale gallery and art consultancy. Estab. 1979. Represents "hundreds" of emerging artists. Exhibited artists include Coffaro, Larry Fodor and Jack Eggman. Open all year. "Two galleries, one in midtown, one in Oro Valley; 3,500 sq. ft. 90% of space for gallery artists. Clientele: 50% private collectors, 50% corporate collectors. Overall price range: $25-2,000; most artwork sold at $100-900.

Media: Considers oil, acrylic, watercolor, pastel, mixed media, collage, works on paper, sculpture, ceramic, fiber, glass, engravings, etchings, lithographs, serigraphs, posters and offset reproductions. Most frequently exhibits monoprints, lithographs and reproductions.

Style: Exhibits painterly abstraction, impressionism, hard-edge geometric abstraction and all styles. Genres include landscapes, florals, Southwestern, Western, figurative work and all genres. Prefers landscapes, figurative work and abstraction.

Terms: Accepts work on consignment (50% commission). Buys outright for 50% of retail price (net 30 days). Retail price set by gallery and artist. Gallery provides insurance and promotion; artist pays for shipping. Prefers framed artwork.

Submissions: Send resume, slides, bio, photographs and SASE. Call to schedule an appointment to show portfolio, which should include photographs. Replies in 1 week; follow up with call. Files all material.

JOANNE RAPP GALLERY/THE HAND AND THE SPIRIT, 4222 North Marshall Way, Scottsdale AZ 85251. (602)949-1262. Owner/Director: Joanne Rapp. Retail gallery. Represents 200 artists/year; emerging, mid-career and established. Exhibited artists include Edward Moulthrop, Peter Shire, Jonathon Bonner and Ann Keister. Sponsors 15 shows/year. Average display time 1 month. Open all year. Located downtown; 2,800 sq. ft.; "clean and contemporary." 80% of space for special exhibitions. Overall price range: $100-up.

Media: Considers mixed media, works on paper, fiber, glass, wood and metal. Most frequently exhibits wearable art, wood, fiber and clay.
Style: Exhibits contemporary craft. Wants to see "innovative styles, not tied to market trends."
Terms: Accepts work on consignment. Retail price set by the artist. Gallery provides promotion and contract. Shipping costs are shared.
Submissions: Jurying is July of each year. Send query letter with resume, slides, descriptive price list, bio and SASE.

SAVAGE GALLERIES, 7112 Main St., Scottsdale, AZ 85251. (602)945-7114. Director: Gwen Meisner. Retail gallery. Estab. 1960. Represents 30 artists; emerging, mid-career and established. Exhibited artists include Charles H. Pabst and George Burrows. Average display time 3 months. Open all year. Located downtown on "Gallery Row"; 2,500 sq. ft.; "large, open gallery with separate viewing room. Artist's works are all hung together." 100% of space for gallery artists. Clientele: "winter visitors, tourists, retired couples, successful young business people, upper middle income." 80% private collectors, 20% corporate clients. Accepts only artists from the U.S. Overall price range: $400-5,000; most artwork sold at $1,000-2,000.
Media: Considers oil, acrylic, watercolor, pastel and sculpture. Most frequently exhibits oil, sculpture and watercolor.
Style: Exhibits impressionism and realism. Genres include landscapes, figurative work, Western and Southwestern. Prefers realism, photorealism and impressionism. Interested in seeing "traditional subjects and styles—Southwest landscapes, Western action."
Terms: Accepts work on consignment (50% commission). Retail price set by the artist. Gallery provides insurance. Artist pays for shipping. Prefers framed artwork.
Submissions: Living American artists only. Send query letter with slides, bio, brochure, photographs and SASE. Write to schedule an appointment to show a portfolio, which should include originals and photographs. Replies only if interested, within 2 weeks. Files brochure and biographies.

UNION GALLERIES, UNIVERSITY OF ARIZONA, Box 10,000, Tucson AZ 85720. Arts Coordinator: Karin Erickson. Nonprofit gallery. Estab. 1982. Clientele: 100% private collectors. Represents 300 artists. Sponsors 3 solo and 10 group shows/year. Average display time is 3 weeks. Interested in emerging, mid-career and established artists. Overall price range: $40-5,000; most artwork sold at $40-300.
Media: Considers oil, acrylic, watercolor, pastel, pen & ink, drawings, mixed media, collage, works on paper, sculpture, ceramic, crafts, fiber, glass, installations, photography, performance and prints. Most frequently exhibits photography, watercolors and clay. "I am interested in exhibiting more installation pieces."
Style: Exhibits hard-edge/geometric abstractions, color field, painterly abstraction, conceptualism, post-modern, surrealism, expressionism, neo-expressionism and realism. Genres include landscapes, figurative and nonobjective work. Prefers painterly abstraction, realism and post-modern works. "We do not cater to any specific style of artwork. We are interested in a well-rounded schedule of exhibitions of art, culture, history and information."
Terms: Accepts work on consignment (25% commission). Retail prices set by artist. Exclusive area representation not required. Gallery provides insurance, promotion and contract; artist pays for shipping.
Submissions: Send query letter and clippings. "Since we jury once a year, artists are notified *when* to send materials. Write to have name put on mailing list to announce annual slide review. Slides are reviewed in the spring. I do not want to have artwork submitted that cannot be exhibited. Not all artwork has to be framed, as long as it can be shown in a professional way. No work in progress."
Tips: "Art sales are down. Realistic watercolors are selling well, and there is a trend toward more installation work."

Arkansas

***HERR-CHAMBLISS FINE ARTS,** 718 Central Ave., Hot Springs National Park AR 71901-5333. (501)624-7188. Director: Malinda Herr-Chambliss. Retail gallery. Estab. 1988. Represents emerging, mid-career and established artists. Sponsors 17 shows/year. Average display time 1 month. Open all year. Located downtown; 3 floors, approximately 5,000-5,500 sq. ft. 50% of space for special exhibitions. Located in a "turn-of-the-century building with art-deco remodeling done in 1950." Prefers painting and sculpture of regional, national and international artists. Overall price range: $50-24,000.
Media: Considers oil, acrylic, watercolor, pastel, pen & ink, drawing, mixed media, sculpture, fiber, glass installation and photography.
Style: Exhibits all styles.
Terms: Negotiation is part of acceptance of work, generally commission is 33%. Gallery provides insurance, promotion and contract (depends on negotiations). Artist pays for shipping. Prefers artwork framed.
Submissions: Send query letter with resume, slides, bio, brochure, photographs, SASE, business card, reviews. Write to schedule an appointment to show a portfolio. Portfolio should include originals, slides, photographs and transparencies. Replies in 2-3 weeks. Files resume and slides if available.

Tips: "On a surprising number of occasions, artists do not label their slides, or they omit important information such as which way is top (slides should include the date, title, medium, size, and directional information). Also, resume should be succinct and show the number of one-person shows, educational background, group shows, list of articles (as well as enclosure of articles). The neater the presentation, the greater chance the dealer can glean important information quickly. Put yourself behind the dealer's desk, and include what you would like to have for review."

INDIAN PAINTBRUSH GALLERY, INC., Highway 412 W., Siloam Springs AR 72761. (501)524-6920. Owner: Nancy Van Poucke. Retail gallery. Estab. 1979. Represents over 50 emerging, mid-career and established artists. Interested in seeing the work of emerging artists. Exhibited artists include Troy Anderson and Bert Seabourn. Sponsors 2-3 shows/year. Average display time 2 weeks. Open all year. Located on bypass; 1,800 sq. ft. 66% of space for special exhibitions. Clientele: Indian art lovers. 80% private collectors, 20% corporate collectors. Overall price range: $5-5,000; most work sold at $5-2,000.
Media: Considers oil, acrylic, watercolor, pastel, pen & ink, drawings, mixed media, works on paper, sculpture, ceramic, woodcuts, lithographs, etchings, posters, serigraphs and offset reproductions. Most frequently exhibits paintings, sculpture, knives, baskets, pottery.
Style: Exhibits Native American. Genres include Americana, Southwestern, Western.
Terms: Accepts work on consignment (60-70% commission). Buys outright for 50% of retail price. Retail price set by gallery. Gallery provides insurance and promotion; artist pays for shipping. Prefers unframed artwork.
Submissions: Send personal information. Call to schedule an appointment to show portfolio, which should include "prints, etc." Replies in 2 weeks.
Tips: The most common mistakes artists make in presenting their work is being "overconfident, pushy and not neat in appearance."

California

ADAMS FINE ARTS GALLERY, 2724 Churn Creek Rd., Redding CA 96002. (916)221-6450. Owner/Director: Susanne Adams. Retail gallery. Estab. 1984. Represents 14 emerging and mid-career artists. Exhibited artists include Susan F. Greaves (featured in *American Artist Magazine*, August 1988) and Janet Turner. Sponsors 4 shows/year. Average display time 3 months. Open all year. Located in a new growth area, 2 blocks from the malls; 1,200 sq. ft.; "known for its quality – good reputation, regular art shows and newly remodeled interior." 50% of space for special exhibitions. Clientele: "Above average income." 70% private collectors, 30% corporate collectors. Overall price range: $100-2,000; most artwork sold at $300-700.
Media: Considers oil, acrylic, watercolor, pastel, mixed media, collage, works on paper, sculpture, craft and fiber. Considers original handpulled prints, woodcuts, engravings, lithographs, wood engravings, mezzotints, serigraphs, linocuts and etchings. Most frequently exhibits oil, watercolor and sculpture.
Style: Exhibits primitivism, painterly abstraction, imagism, impressionism, realism and photorealism. Genres include landscapes, Americana, Southwestern, Western and wildlife. Prefers wildlife, landscapes and Western. "I look for style, color, originality and composition." No "copy-cat styles, vulgarity, nudes that are offensive."
Terms: Artwork is accepted on consignment and there is a 40% commission or "the artist establishes the price they want (wholesale) and the gallery sets the retail price and retains the difference." Retail price set by the gallery. Gallery provides insurance, promotion and contract. Artist pays for shipping. Prefers framed artwork "but must be quality, professionally framed."
Submissions: Send query letter with resume, brochure, business card, slides or photographs and bio. Write to schedule an appointment. Portfolio should include originals and photographs. Replies in 2 weeks. Files "everything. We have extensive art files that are updated regularly and used frequently."
Tips: The recession has affected art sales. I would like to find a new artist with something new and different – fresh – so I can have an edge on my competitors."

ART ATELIER KAFKA, 6069 W. Sunset Blvd., Hollywood CA 90028. (213)464-3938. Consulting Curator: Kristian Von Ritzhoff. Retail gallery and rental gallery. Estab. 1985. Represents 1 emerging and established artist per show and large b&w photography. Exhibited artists include Hans Hostrich. Sponsors 6 shows/year. Average display time 2 months. Open all year. Located in Hollywood; 2,000 sq. ft.; "allows good coverage, nice reception, garden setting, skylights." 80% of space for special exhibitions; 80% for gallery artists. Clientele: movie stars and well-known artists. Overall price range: $1,000-2,100; most artwork sold at $1,400.

Media: Considers oil, acrylic, watercolor, pastel, sculpture, photography, original handpulled prints and lithographs.
Style: Exhibits post modern works, photorealism and hard-edge geometric abstraction. Prefers abstraction, photography and expressionism.
Terms: Accepts work on consignment (10% commission). Retail price set by the gallery and the artist. Gallery provides insurance, promotion and contract. Artist pays for shipping. Prefers unframed artwork.
Submissions: "Prefers eccentric but aesthetic oils and watercolors. For photographs prefer 4′ × 4′ sizes. Send query letter with slides and reviews. Call to schedule an appointment to show a portfolio, which should include slides and photographs. Replies in 3 weeks.

THE ART COLLECTOR, 4151 Taylor St., San Diego CA 92110. (619)299-3232. Curator: Janet Disraeli. Retail gallery. Art consultancy. Estab. 1971. Open all year. Clientele: hotel, health, corporations and residentials. Represents 550 artists. Sponsors 3 solo and 1 group shows/year. Average display time 1 month. Interested in emerging, mid-career and established artists. Overall price range: $200-100,000; most work sold at $700-10,000.
Media: Considers oil, acrylic, watercolor, pastel, mixed media, collage, works on paper, sculpture and ceramic. Most frequently exhibits handmade paper, mixed media and watercolor.
Style: Exhibits realism, photorealism, color field and painterly abstraction. Genres include landscapes, florals and Southwestern themes. Prefers abstraction, realism, ceramic and glass. "We have a large storage space and so we keep a lot of art for our clients. In the 18 years we have gone from a graphic gallery (2 employees) with individual clients to a more varied gallery with clients ranging from interior designers to private and corporate collectors."
Terms: Accepts work on consignment (50% commission). Retail price set by artist. Gallery provides insurance, promotion, contract and shipping costs from gallery.
Submissions: Send query letter, SASE and slides. Include sizes, cost (net or retail) and SASE. Write to schedule an appointment to show a portfolio, which should include originals, slides and transparencies, not larger than 4×5′. Replies in 3 weeks. Files slides.

BARCLAY SIMPSON FINE ARTS, 3669 Mount Diablo Blvd., Lafayette CA 94549. (415)284-7048. Owners: Sharon and Barclay Simpson. Retail gallery. Estab. 1981. Represents 12-15 emerging and mid-career artists/year. Exhibited artists include Joseph Way and Ron Pokrasso. Sponsors 10 shows/year. Average display time 4 weeks. Open all year. Located downtown; 2,500 sq. ft. upper gallery, 1,000 sq. ft. lower gallery. 80% of space for special exhibitions, 20% for gallery artists. Clientele: collectors and corporations. Overall price range: $100-25,000; most artwork sold at $4,500.
Media: Considers oil, acrylic, watercolor, pastel, drawing, mixed media, collage and sculpture, original handpulled prints, woodcuts, engravings, lithographs, mezzotints, linocuts and etchings. Most frequently exhibits painting, prints and sculpture.
Style: Exhibits expressionism, painterly abstraction, minimalism and color field. All genres considered. Prefers abstraction, expressionism and color field.
Terms: Accepts work on consignment (50% commission). "We work with the artist on pricing." Gallery provides promotion and contract (at times). Prefers unframed artwork.
Submissions: Send query letter with resume, slides, bio, SASE and reviews. Replies in 4-6 weeks.
Tips: "We are looking for excellent quality slides and artist's statement regarding work."

BC SPACE GALLERY & PHOTOGRAPHIC ART SERVICES, 235 Forest Ave., Laguna Beach CA 92651. (714)497-1880. Director: Mark Chamberlain. Alternative space and art consultancy. Estab. 1973. Represents emerging and mid-career artists. Has current showings plus previous exhibitors on consultancy or referral basis. Sponsors 7 shows/year. Average display time 6 weeks. Open all year. Located near Main Street; 1,500 sq. ft.; "featuring contemporary photography, innovative and experimental work." Clientele: young, interested in contemporary art and photography. 80% private collectors, 20% corporate collectors. Overall price range: $200-3,000; most work sold at: $300-900.
Media: Considers mixed media, photography and anything photo derived. Considers original handpulled prints and any other type of prints. Most frequently exhibits photography, mixed media, sculptural work.
Style: Exhibits expressionism, surrealism, imagism, conceptualism, post modern works, impressionism, photorealism, sculptural; all styles and genres. Prefers innovative, bold and issue oriented work.
Terms: Artwork is accepted on consignment and there is a 40% commission. Retail price set by the artist. Gallery provides insurance and promotion and artist pays for shipping. Prefers unframed artwork.
Submissions: Send query letter with resume, slides, bio and SASE. Call or write to schedule an appointment to show a portfolio, which should include slides and "whatever is needed to typify work." Replies in 8 weeks. Files slides and bio.
Tips: "We prefer work with a social concern, not just random imagery. Please be patient with our response time." In presenting your work, don't be "sloppy, incomplete or give poor attention to archival processes."

PHILL BERMAN GALLERY, 3820 S. Plaza Dr., Santa Ana CA 92704. (714)754-7485. Retail gallery. Estab. 1987. Represents 11 artists/year; emerging, mid-career and established. Exhibited artists include Marty Bell, Susanna Denton and Aldo Luongo. Sponsors 8 shows/year. Average display time 3-4 months. Open all year. Located "among 7 restaurants in a village in the heart of a major business area"; 609 sq. ft.; "we feature traditional art with warm, comfortable feelings shown in a comfortable setting." 20% of space for special exhibitions, 80% for gallery artists. Clientele: 95% private collectors, 5% corporate collectors.
Media: Considers oil, acrylic, watercolor, pastel, limited editions, offset reproductions, serigraphs and etchings. Most frequently exhibits canvas transfers, oil and watercolor.
Style: Exhibits impressionism and realism. Exhibits landscapes, wildlife and Southwestern.
Terms: Accepts work on consignment (50% commission). Retail price set by the artist. Gallery provides insurance and promotion. Artist pays for shipping. Prefers framed artwork.
Submissions: Not interested in abstract art or high detailed art. Call to schedule an appointment to show portfolio, which should include originals. "Bring in work after 9:30 Monday to Thursday. Pre-call for appointment after 6:30 Tuesday to Friday. Call Phill and request an appointment. I want an artist that I can see and speak with." Files all items received.
Tips: "If you have no plan to grow, don't stop in or call. I want to be part of your growth."

***BINGHAM GALLERY**, 54 W. Santa Clara St., San Jose CA 95113. (408)993-1066 or (800)992-1066. Owners: Susan and Paul Bingham. Retail and wholesale gallery. Also provides art by important living and deceased artists for collectors. Estab. 1974. Represents 8 established artists. Exhibited artists include Keith Ward, Charles Muench, Ray Strong, Mel Fillerup, Ken Baxter and Graydon Foulger. "Nationally known for works by Maynard Dixon." Sponsors 4 shows/year. Average display time 5 weeks. Open all year. Located downtown; 2,500 sq. ft.; high ceiling/great lighting, open space. 60% of space for special exhibitions; 40% for gallery artists. Clientele: serious collectors. 100% private collectors. Overall price range: $1,000-300,000; most work sold at $1,800-5,000.
Media: Considers oil, acrylic, watercolor, pastel, pen & ink, drawing and sculpture; original handpulled prints and woodcut. Most frequently exhibits oil, acrylic and pencil.
Style: Exhibits painterly abstraction, impressionism and realism. Genres include landscapes, florals, southwestern, Western, figurative work and all genres. Prefers California landscapes, Southwestern and impressionism.
Terms: Accepts work on consignment (50% commission), or buys outright for 30% of retail price (net 30 days). Retail price set by the gallery and the artist. Gallery provides insurance, promotion and contract; shipping costs from gallery. Prefers artwork unframed.
Submissions: Prefers artists be referred or present work in person. Call to schedule an appointment to show a portfolio. Portfolio should include originals. Replies in 1 weeks or gives an immediate yes or no on sight of work.
Tips: "Identify yourself immediately on visit." The most common mistake artists make in presenting their work is "failing to understand the market we are seeking."

BIOTA GALLERY, 8500 Melrose Ave., West Hollywood CA 90069. (213)289-0979. FAX: (213)289-0547. Director: Donna M. Kobrin. Co-director: Kira L. Harris. Retail gallery. Estab. 1988. Represents approximately 125 emerging artists. Exhibited artists include Lee Spear Webster and David Shipley. Sponsors 11 shows/year. Average display time 1 month. Open all year. Located in West Hollywood. 90% of space for special exhibitions.
Media: Considers all media and all forms of prints. No photo-mechanically reproduced prints. Most frequently exhibits oil and acrylic.
Style: Exhibits all styles. Considers works which engage issues and concepts concerning the environment. "Impressionistic to neo-abstract, as well as figurative and realist work are exhibited."
Terms: Accepts work on consignment (50% commission). Retail price set by the gallery and the artist.
Submissions: Send query letter with resume, slides, bio, SASE and reviews. Portfolio should include slides, photographs and transparencies. "Please submit a minimum of 8-10 slides, labeled with name of artist, title, dimensions and media, with an arrow indicating top. Include a list of suggested retail prices, current resume, bio and SASE. If there are any supporting materials such as reviews, include. Please do not stop by without an appointment." Replies in 1 month. Files slides.
Tips: "Biota features emerging artists whose work in some way reflects or is informed by the environment. The interaction between art and the environment has unlimited relationships and contexts, including rural, urban, physical and spiritual. A two year agreement to represent requires exclusivity in the Los Angeles area."

J.J. BROOKINGS GALLERY, Mail address: Box 1237, San Jose CA 95108. (408)287-3311. Street address: 330 Commercial St. Director: Timothy Duran. Retail gallery. Estab. 1970. Clientele: 60% private collectors, 10% corporate, 30% trade clients. Represents 20 artists. Sponsors 4 solo and 2 group shows/year. Average display time 2 months. Interested in mid-career and established artists. Overall price range: $200-30,000; most artwork sold at $1,000-5,000.

Media: Considers all media except offset reproductions and posters. Most frequently exhibits photographs, paintings and prints.

Style: Exhibits all styles. Prefers abstraction and realism. "We pride ourselves in presenting a wide range of art not only in price, but in styles, size and recognition of the artist. Quality is the only consideration, though it is doubtful that we will show much politically oriented, social documentary or erotic work."

Terms: Accepts work on consignment (usually 50% commission). Retail price set by gallery and artist. Exclusive area representation not required. Gallery provides insurance, promotion and contract. Prefers framed artwork.

Submissions: Send query letter with resume, brochure, business card, slides, photographs, bio and SASE. Write to schedule an appointment to show a portfolio, which should include slides, transparencies and photographs. Replies in 2-3 weeks. All material is returned if not accepted or under consideration.

Tips: "A professional, well thought-out presentation is a must."

CANDY STICK GALLERY, 381 Main St., Box 55, Ferndale CA 95536. (707)786-4600. Fine Art Director: Deborah Wright or Gallery Director: Carol Lake. Retail and rental gallery. Estab. 1962. Represents 30 emerging, mid-career and established artists. Exhibited artists include Bill McWhorter and Jim McVicker. Sponsors 4 shows/year. Average display time 3 months. Open all year. Located downtown; 3,000 sq. ft.; "built in 1900, 20' Victorian ceilings, white walls." 10% of space for special exhibitions; 70% for gallery artists; and 20% other. Clientele: tourists, locals, mostly upper middle income. 90% private collectors, 10% corporate collectors. Overall price range: $100-7,000; most artwork sold at $200-1,500.

Media: Considers oil, acrylic, drawings, sculpture, glass, watercolor, mixed media, ceramic, pastel, craft, original handpulled prints, wood engravings, etchings, lithographs and serigraphs. Most frequently exhibits oil, watercolor and mixed media.

Style: Exhibits photorealism, color field, painterly abstraction, impressionism, realism and "all styles will be considered." Genres include landscapes, Western, florals and wildlife. Prefers realism, impressionism and photorealism.

Terms: Artwork is accepted on consignment (40% commission). Retail price set by the gallery and the artist and gallery provides promotion. Artist pays for shipping. Prefers framed artwork. "We also have two print racks—one for fine originals, one for prints of unframed, matted work."

Submissions: Call to schedule an appointment to show a portfolio, which should include originals and photographs. Replies in 1 month. Files all material sent, if interested.

Tips: "Allow gallery to contact the artist. Be prepared to accept the decision of the director in a professional manner." Common mistakes artists make are "bringing in work without sending in slides and making an appointment, also poor presentation in framing, etc."

CENTER FOR THE VISUAL ARTS, Suite 100, 1333 Broadway, Oakland CA 94612. (415)451-6300. President, Board of Directors: Tomyé Neal-Madison. Nonprofit gallery. Clientele: gallery owners, consultants, collectors and general public. Exhibits only works by member artists. Interested in seeing the work of emerging, mid-career and established artists. Sponsors 6 solo and 6 group shows/year. Average display time is 6 weeks-2 months. "CVA is a nonprofit artists membership organization. We are not a commercial gallery."

Media: Considers oil, acrylic, watercolor, pastels, pen & ink, drawings, sculpture, ceramic, fiber, photography, craft, mixed media, collage and glass.

Style: Exhibits a wide variety of styles.

Terms: Nonprofit membership fee plus donation of time and referral. Retail price set by artist. Exclusive area representation not required. Gallery provides insurance, promotion and contract; artist pays for shipping.

Submissions: Send query letter.

Tips: Looks for artists with a "professional attitude and professional approach to work."

CENTRAL CALIFORNIA ART LEAGUE, 1402 I St., Modesto CA 95354. (209)529-3369. Gallery Director: Nadene DeMont. Cooperative, nonprofit sales and rental gallery. Estab. 1951. Represents 66 emerging, mid-career and established artists. Exhibited artists include Don Morell, Dolores Longbotham, Barbara Brown, Milda Laukkanen and Dale Laitinen. Sponsors 12 shows/year. Average rental and sales display time 3 months. Open all year. Located downtown; 2,500 sq. ft.; in "a historic building, a former county library, consisting of 2 large gallery rooms, entry, large hallway and two classrooms. (Auditorium shared with historical museum upstairs)." 10% of space for special exhibitions, 90% for gallery artists. Clientele: 75% private collectors, 25% corporate clients. Overall price range: $50-1,300; most artwork sold at $300-800.

Media: Considers oil, pen & ink, works on paper, fiber, acrylic, drawing, sculpture, watercolor, mixed media, ceramic, pastel, collage, photography and original handpulled prints. Most frequently exhibits watercolor, oil and acrylic.

Style: Exhibits mostly impressionism, realism. Will consider all styles and genres. Prefers realism, impressionism and photorealism.

Terms: Artwork is accepted on consignment (30% commission) a Co-op membership fee plus a donation of time (30% commission) and a rental fee for space, which covers 3 months. Retail price set by the artist. Gallery provides insurance. Prefers framed artwork.

Submissions: Call to schedule an appointment to show a portfolio, which should include 5 completed paintings, ready for judging one day a week. Replies in 1 week.

***CESPEDES GALLERY,** 194 S. Palm Canyon Dr., Palm Springs CA 92262. (619)327-1712. Director: Roxanne Wallen. Retail gallery. Estab. 1989. Represents 6 artists; emerging, mid-career and established. Exhibited artists include Encida Cespedes and Amy Coffman. Sponsors 2 shows/year. Average display time 6 months. Open all year. Located downtown; 1800 sq. ft.; presents contemporary art of Native America. 50% of space for special exhibitions. Clientele: collectors and tourists. 50% private collectors, 20% corporate collectors. Overall price range: $7,000-10,000; most work sold at $600-1,000.
Media: Considers acrylic, watercolor, sculpture, ceramic, craft and jewelry, original handpulled prints, serigraph. Most frequently exhibits acrylic, watercolor and sculpture.
Style: Genres include Southwestern and Latin American/Bolivian artists. Prefers Southwestern and abstract.
Terms: Accepts work on consignment (50% commission). Retail price set by the gallery. Gallery provides insurance and promotion. Gallery pays for shipping costs from gallery; artists pays for shipping.
Submissions: Send query letter with photographs or present work in person. Call to schedule an appoinment to show a portfolio. Portfolio should include originals. Replies in 1 week.
Tips: "Artwork or crafts should blend with artwork of Mario Cespedes (owner/artist)."

CLAUDIA CHAPLINE GALLERY, 3445 Shoreline Highway, Box 946, Stinson Beach CA 94970. (415)868-2308. Owner: Claudia Chapline. Retail gallery. Estab. 1987. Represents 12 emerging, mid-career and established artists. Exhibited artists include Whitson Cox, Harold Schwarm, Billy Rose, Bonita Barlow, Marsha Connell, Catherine Gibson, Gary Stephens and Gillian Hodge. Sponsors 12 shows/year. Average display time 5 weeks. Open all year. "Located on Highway One in a coastal resort village; 3,000 sq. ft. plus a sculpture garden; designed by Val Agnoli, architect. The gallery has four exhibition spaces with skylights and a sculpture garden at the foot of Mt. Tamalpais." 50% of space for special exhibitions. Prefers Northern California artists. Overall price range: $50-12,000; most artwork sold at $500-3,000.
Media: Considers oil, acrylic, watercolor, pastel, drawings, mixed media, collage, works on paper, sculpture, unique ceramics and craft, fiber, glass, photography, printmaking, original handpulled prints, woodcuts, engravings, lithographs, wood engravings, mezzotints, serigraphs, linocuts and etchings. Most frequently exhibits paintings, drawings/printmaking and sculpture.
Style: Exhibits painterly abstraction, post modern works and contemporary styles. Prefers contemporary and post modern.
Terms: Artwork is accepted on consignment, and there is usually a 50% commission. Retail price set by the gallery and artist. Gallery provides insurance and promotion and artist pays for shipping. Prefers framed artwork.
Submissions: Send query letter with resume, slides, SASE and reviews. Write to schedule an appointment to show a portfolio. Portfolio should include originals, slides, photographs and transparencies. Replies in 2 months if SASE is provided. Files slides and resumes if interested.
Tips: "Become familiar with the gallery and its approach. Don't show immature, unsaleable and innappropriate work. Include SASE."

COCO BIEN OBJET D'ART, 1442-1444 South Coast, Laguna Beach CA 92657. (714)494-3804. Owner: Colleen Baker-Huber. Retail gallery. Estab. 1986. Represents 50 artists; emerging, mid-career and established. Exhibited artists include Alvaro Rodriguez and Lucian Peytong. Average display time 6 months. Open all year. Located on main state highway at south side of town; 600 sq. ft.; "quaint villa atmosphere and tourist area; black, grey, white decor shows paintings well." 100% of space for gallery artists. Clientele: "mostly tourists looking for local art." 80% private collectors. Overall price range: $75-5,000; most artwork sold at $500-700.
Media: Considers oil, acrylic, watercolor, pastel, mixed media, paper sculpture and original handpulled prints. Most frequently exhibits oil/acrylic paintings, watercolor and sculpture.
Style: Exhibits expressionism, painterly abstraction, impressionism and photorealism. Exhibits all genres. Prefers impressionism, painterly abstraction and photorealism.
Terms: Rental fee for space; covers 1-month or 6-months, agreement plus 15% commission. Retail price set by the gallery. Gallery provides promotion; pays for shipping costs from gallery or shipping costs are shared. Prefers framed artwork.
Submissions: Send query letter with slides, bio and SASE; "if interested, artist will be contacted for private interview and portfolio showing." Replies in 2 weeks. "Only info and slides on artists accepted."
Tips: "Recent trends are that space is at a premium and more display fees are being charged. There are brighter colors in original art, even though pastels are still popular."

COUTURIER GALLERY, 166 N. La Brea Ave., Los Angeles CA 90036. (213)933-5557. Gallery Director: Darrel Couturier. Retail gallery. Estab. 1985. Clientele: major museums, corporate and private; 70% private collectors, 30% corporate clients. Represents 24 artists. Sponsors 6 solo and 2 group shows/year. Average display time 5 weeks. Interested in mid-career and established artists. Overall price range: $500-250,000; most artwork sold at $200-25,000.

Media: Considers oil, watercolor, pastel, pen & ink, drawings, mixed media, sculpture, ceramic, egg tempera, woodcuts, wood engravings, linocuts, engravings, mezzotints, etchings, lithographs, pochoir and serigraphs. Most frequently exhibits painting, sculpture and ceramics.

Style: Exhibits contemporary painting, sculpture and ceramics. The focus of exhibitions is on political and social issues, though not exclusively. Figurative and non-figurative works considered—but only of a high degree of craft and technique.

Terms: Accepts work on consignment or buys outright. Retail price set by gallery and artist. Exclusive area representation required. Gallery provides insurance, promotion and contract; artist pays for shipping and framing. Prefers framed artwork.

Submissions: Send query letter with resume, brochure, business card, slides, photographs, bio and SASE. Call or write to schedule an appointment to show a portfolio, which should include originals, slides, transparencies and photographs. Replies in 2-3 weeks. Files resume and photos. All material returned if not accepted or under consideration.

Tips: Sees trend toward "lots more art by people with little technical skill; hopefully, a new breed of artists trained to handle and incorporate today's technology into their work (e.g., computers, lasers, holograph, new metals and plastics). Am interested in ground-breaking work, not the rehashing of what's already been done (and usually better). Am only seriously considering work of superior quality."

DEPHENA'S FINE ART GALLERY, 2316 J St., Sacramento CA 95816. (916)441-3330. Director: Robert M. Duncan. Retail and rental gallery and art consultancy. Estab. 1984. Represents mid-career artists. Interested in seeing the work of emerging artists. Exhibited artists include A. Wolff, Tasia, Greg Simmons, Bonnie Mae Russell and Jan Miskalen. Sponsors 4 shows/year. Average display time 1 month. Open all year. Located in mid-town, 1,250 sq. ft. 50% for special exhibitions; 100% of space for gallery artists. Clientele: corporate and professional. Overall price range: $200-35,000; most artwork sold at $700-3,000.

Media: Considers oil, pen & ink, paper, acrylic, sculpture, watercolor, mixed media, pastel, original hand-pulled prints, etchings, lithographs, serigraphs and posters.

Style: Exhibits expressionism and realism. Genres include landscapes, florals, Southwestern, Western, wildlife and portraits. Prefers realism and wildlife.

Terms; Artwork is accepted on consignment (50% commission). Retail price is set by the artist. Gallery provides contract. Artist pays for shipping. Prefers framed artwork.

Submissions: Send query letter with resume, brochure, slides, photographs and bio. Write to schedule an appointment to show a portfolio, which should include originals, photographs, slides and transparencies. Replies only if interested within 1 month. Files resume, slides, brochures and photographs.

Tips: "Be cognizant of the director's time."

DONLEE GALLERY OF FINE ART, 1316 Lincoln Ave., Calistoga CA 94515. (707)942-0585. Also has location at 2375 Alamo Pintado Ave., Los Olivos CA 93441, (805)686-1088. Owner: Ms. Lee Love. Retail gallery. Estab. 1985. Represents 28 artists. Interested in mid-career and established artists. Exhibited artists include Ralph Love and James Coleman. Sponsors 3 shows/year. Average display time 2 months. Open all year. Located downtown; 1,200 sq. ft.; "warm Southwest decor, somewhat rustic." 100% of space for gallery artists. Clientele: 100% private collectors. Overall price range: $500-15,000; most artwork sold at $1,000-3,500.

Media: Considers oil, acrylic, watercolor and sculpture. Most frequently exhibits oils, bronzes and alabaster.

Style: Exhibits impressionism and realism. Genres include landscapes, Southwestern, Western and wildlife. Prefers Southwest, landscapes and Western. No abstract art.

Terms: Accepts work on consignment (40% commission). Retail price set by the artist. Gallery provides insurance and promotion. Artist pays for shipping. Prefers framed artwork.

Submissions: Accepts only artists from Western states. Send query letter with resume, brochure, photographs, reviews and bio. Write to schedule an appointment to show a portfolio, which should include photographs. Replies only if interested within 2 weeks. Files "all info."

Tips: "Don't just drop in—make an appointment. No agents."

***DOWNEY MUSEUM OF ART,** 10419 Rives, Downey CA 90241. (213)861-0419. Executive Director: Scott Ward. Museum. Estab. 1957. Interested in seeing the work of emerging artists. Interested in emerging and established artists. Sponsors 6 shows/year. Average display time: 6 weeks. Open all year. Located in a suburban park: 3,000 sq. ft. Clientele: locals and regional art audience. 60% private collectors, 40% corporate collectors. Overall price range: $100-10,000; most work sold at $400-3,000.

Media: Consider oil, acrylic, watercolor, pastel, pen & ink, drawing, mixed media, collage, paper, sculpture, ceramics, crafts, fibers, glass, installation, photography, egg tempera; original handpulled prints, woodcuts, wood engravings, linocuts, engravings, mezzotints, etchings, lithographs, pochoir, serigraphs. Most frequently exhibits painting, drawing, and ceramics.

Style: Exhibits all styles and genres. Prefers California-made art in a wide range of styles.

Terms: Accepts work on consignment (30% commission). Retail price set by artist. Gallery provides insurance and promotion. Artist pays for shipping. Prefers artwork framed.

Submissions: Send query letter with resume, slides and SASE. Replies in 2 months. Files resume and slides.

Close-up

Darrel Couturier
Couturier Gallery
Los Angeles, California

© Barbara Kelley 1991

Darrel Couturier is talking to lightbulbs. He's coaxing wires to cooperate. And in between, he's sharing his wealth of knowledge about the art gallery business.

It is 6:00 on a Thursday evening, and Couturier is preparing lighting for the Friday opening of representational painter E.K. Morris. At an hour when most people are settling down for dinner, the director of Couturier Gallery is settling in for one of his many late nights at the office.

"It's one of the most time-consuming occupations I know of," he says matter-of-factly. "I rarely get time off. It's very hard to separate business and pleasure. There's always art or an artist around."

As director of the four-year-old retail gallery, Couturier's responsibilities include everything from handling correspondence and publicity to designing invitations, setting prices, hanging artwork and writing checks. The gallery sponsors six solo and two group shows per year, so Couturier has a new exhibition to curate every six weeks.

The gallery most frequently exhibits painting, sculpture and ceramic. It generally handles works that are representational/figurative, and is particularly interested in those that offer social or political commentary. "But without question," Couturier says, "the first prerequisite is that the work be exceptional."

Couturier has much to say on the subject of exceptional—and unexceptional—work. He is, he says, "appalled" at some of the submissions he's received; he describes a trend toward sloppy art that shows a lack of technical skill and a limited understanding of the history of art. The fact that such work sometimes sells—even for large sums of money— "does not make it good or great," he says. "The price does not acknowledge the integrity, the level of craftsmanship, or the skill in handling the medium." Couturier wants to see evidence of study from an artist—not necessarily formal education, but an approach that bespeaks constant, thoughtful exposure to others' work. "I've seen some self-taught artists who are pretty terrific," he says.

When evaluating an artist's work, Couturier will first look for superior technique. Then he delves into less-easily-defined qualifications: He has to personally find the work appealing—"it's hard to sell something you don't like"—and he has to believe the work will hold up through some history. "I think there's a lot of art today that people 20 years from now will laugh at." He also pays attention to specifics on a resume, such as how many shows an artist has had and whether he or she has works in public or private collections.

Couturier Gallery represents about 15 artists but has exclusives with very few because, the director says, "the more exposure artists have, the greater their potential for growing and getting recognized." Artists receive 50 percent of their works' selling price, with the gallery receiving the other 50 percent. Sales average in the $1,000 to $7,000 range. Couturier will work with artists to a certain degree on establishing price, but at some point, he says, "they have to trust my judgement if they want to sell the work." The gallery is responsi-

ble for most of the logistical and financial arrangements, although it does ask the artist to share the cost of printing and mailing invitations.

The majority of Couturier's clientele is individual collectors, many of whom are in the movie industry. They tend to buy a piece of work for its own merits—not as an investment, which Couturier describes as an "unhealthy approach" to buying art.

Couturier keeps a continual vigil for artists to handle—traveling to see work, going to exhibitions, obtaining referrals and listening to word of mouth. The one way he won't give an artist consideration is if that artist walks in off the street without an appointment. "It's the nightmare of the business, and it happens constantly," he says. "Try that at a company sometime and see how far you get." Instead, he encourages artists to send him slides, a resume and a self-addressed stamped envelope. The slides need to be well marked with the title, the medium and the size. He says 35mm slides in inexpensive sleeves are fine, adding that "fancy presentations aren't going to make me like the work any better." Artists whose work is not accepted shouldn't expect feedback or criticism, both because Couturier's busy schedule doesn't allow for it and because "I don't think that's the reason the slides were submitted," he says. But with artists I do handle, I tend to offer criticism pretty freely."

His best advice to artists is to try to maintain a level of objectivity about their work—a suggestion he realizes is difficult to live by. "A lot of artists consider their work to be like their children," he says, "but once you send it out, it's like putting mail in a mailbox. It becomes public domain, and it's open to criticism from everywhere. Learn to be your own best critic. It's a hard thing to do, but it can save you a tremendous amount of time and heartache."

—Perri Weinberg-Schenker

Michael Madzo is the creator of this 40 × 30″ mysterious collage painting of paper, acrylic and cotton thread. Madzo is one of the many artists whose work has been exhibited at Couturier Gallery. Reprinted with permission of Couturier Gallery.

***E'DRIES NEWPORT STUDIO**, 1809 ½ W. Bay Ave., Newport Beach CA 92663. (714)673-3883. Retail and wholesale gallery and art consultancy. Estab. 1972. Represents 2 artists; established. Maybe interested in seeing the work of emerging artists in the future. Exhibited artists include Lorraine E'Drie and Paula Hinz. Sponsors 2 shows/year. Average display time 3 weeks. Open all year. Located in Newport Harbor; 1,000 sq. ft. 50% of space for special exhibitions. Clientele: publishers, decorators of homes and offices. 75% private collectors, 25% corporate collectors. Overall price range: $700-20,000 for originals; $25-250 for prints.
Media: Considers oil, acrylic, watercolor, pen & ink, mixed media and collage; originals handpulled prints, lithograph, posters and etching. Most frequently exhibits watercolor, oil and acrylic.
Style: Exhibits painterly abstraction, imagism, impressionism and realism. Genres include landscapes, florals, Americana, Southwestern, wildlife and figurative work. Prefers impressionism, painterly abstraction and imagism.
Terms: Accepts work on consignment (50% commission) or buys outright for 50% of retail price. Retail price set by the artist. Gallery provides promotion and contract. Shipping costs are shared. Prefers artwork framed.
Submissions: Send query letter with slides and bio. Write to schedule and appointment to show a portfolio. Portfolio should include slides. Replies only if interested within 2 weeks.

FRESNO ART MUSEUM, 2233 N. First St., Fresno CA 93703. (209)485-4810. Manager: Jerrie Peters. Nonprofit gallery. Estab. 1957. Clientele: general public and students; 100% sales to private collectors. Sponsors 13 solo and 12 group shows/year. Average display time is 2 months. Interested in emerging and established artists. Overall price range: $250-25,000; most artwork sold at $300-1,000.
Media: Considers all media.
Style: Considers all styles. "Our museum is a forum for new ideas yet attempts to plan exhibitions coinciding within the parameters of the permanent collection."
Terms: Accepts work on consignment (40% commission). Retail price set by gallery and artist. Exclusive area representation not required. Gallery provides insurance, promotion and contract; shipping costs are shared.
Submissions: Send query letter, resume, slides and SASE. All materials are filed.

GALLERY AMERICANA, Box 6146, Carmel CA 93921. (408)624-5071. Director: George Shaffer. Retail gallery. Estab. 1969. Represents 65 emerging, mid-career and established artists. Exhibited artists include Rosemary Miner and Ray Swanson. Sponsors 12 shows/year. Average display time 1 month. Open all year. Located downtown; 7,000 sq. ft.; "large amount of window display area." 15% of space for special exhibitions. Clientele: 90% private collectors, 10% corporate collectors. Overall price range: $1,000-60,000; most artwork sold at $4,000-6,000.
Media: Considers oil, acrylic and sculpture. Prefers oil and acrylic.
Style: Exhibits expressionism, impressionism and realism. Considers all genres.
Terms: Artwork is accepted on consignment (50% commission). Retail price set by the artist. Gallery provides insurance, promotion and contract. Artist pays for shipping. Prefers framed artwork.
Submissions: Send query letter with slides, bio, brochure and photographs. Call to schedule an appointment to show portfolio. Portfolio should include slides, photographs or transparencies. Replies in 1 week. Does not file submissions.

GALLERY 57, 204 N. Harbor Blvd., Fullerton CA 92632. (714)870-9194. Director of Membership: D. Engel. Nonprofit and cooperative gallery. Estab. 1984. Represents 20-30 emerging artists. Sponsors 11 shows/year. Average display time 1 month. Open all year. Located downtown; 1,000 sq. ft., part of "gallery row" in historic downtown area. 100% of space for special exhibitions; 100% for gallery artists. Clientele: wide variety. Because nonprofit, artists handle sales outside gallery. Accepts only artists from southern California able to participate in cooperative activities.
Media: Considers, oil, acrylic, watercolor, pastel, drawings, mixed media, collage, works on paper, sculpture, installation, photography, neon and original handpulled prints. Most frequently exhibits mixed media, painting and sculpture.
Style: Considers all styles. Prefers contemporary works.
Terms: There is a co-op membership fee plus a donation of time. Retail price set by the artist. Gallery provides promotion. Artist pays for shipping. Prefers framed work.
Submissions: Send query letter with resume, or bio and slides. Call or write to schedule an appointment to show a portfolio, which should include slides and 1-2 originals. Replies in 1 month. Does not file material.
Tips: "Slides are reviewed by the membership on the basis of content, focus and professionalism. The gallery requires a commitment toward a supportive cooperative experience in terms of networking and support."

GALLERY WEST, 107 S. Robertson Blvd., Los Angeles CA 90048. (213)271-1145. Director: Roberta Feuerstein. Retail gallery. Estab. 1971. Located near showrooms catering to interior design trade and several restaurants. Represents 25 artists. Sponsors 6 solo and 3 group shows/year. Average display time is 5 weeks.

Interested in emerging, mid-career and established artists. Overall price range: $500-25,000; most artwork sold at $3,500-6,500.

Media: Considers oil, acrylic, watercolor, pastel, mixed media, collage, works on paper, sculpture, ceramic, craft, fiber and limited edition original handpulled prints. Prefers paintings.

Style: Exhibits color field, painterly abstraction, photorealistic and realistic works. Prefers abstract expressionism, trompe l'oeil and realism.

Terms: Accepts work on consignment (50% commission). Retail price set by gallery and artist. Exclusive area representation required. Gallery provides insurance, promotion and contract; shipping costs are shared.

Submissions: Send query letter, resume, slides and SASE. Slides and biography are filed.

GREENLEAF GALLERY, 14414 Oak St., Saratoga CA 95070. (408)867-3277. Owner: Janet Greenleaf. Director: Chris Douglas. Retail gallery and art consultancy. Estab. 1979. Represents 35 to 40 emerging, mid-career and established artists. Exhibited artists include Gregory Deane, Yuriko Takata and Tomi Kobara. Sponsors 7 shows/year. Average display time 3 weeks on wall, 3 months in inventory. Open all year. Located downtown; 2,000 sq. ft.; "featuring a great variety of work in diverse styles and media. We have become a resource center for designers and architects, as we will search to find specific work for all clients." 50% of space for special exhibitions, 50% for gallery artists. Clientele: professionals, collectors and new collectors. 50% private collectors, 50% corporate clients. Prefers very talented emerging or professional fulltime artists—already established. Overall price range: $400-15,000; most artwork sold at $500-4,000.

Media: Considers oil, acrylic, watercolor, pastel, mixed media, collage, works on paper, sculpture, glass, original handpulled prints, lithographs, serigraphs, etchings and monoprints. Most frequently exhibits original oil and acrylic, watercolor and monoprints.

Style: Exhibits expressionism, neo-expressionism, painterly abstraction, minimalism, impressionism, realism or "whatever I think my clients want—it keeps changing." Genres include landscapes, florals, wildlife and figurative work. Prefers all styles of abstract, still lifes (impressionistic), landscapes and florals.

Terms: Artwork is accepted on consignment. "The commission varies." Gallery provides promotion and contract. Artist pays for shipping. Shipping costs are shared. Prefers framed or unframed work, "it depends on work."

Submissions: Send query letter with resume, slides, bio, photographs, SASE, business card, reviews and "any other information you wish—I do not want just slides, always photos as well." Call or write to schedule an appointment for a portfolio review, which should include originals. If does not reply, the artist should phone. Files "everything that is not returned. Usually throw out anything over 2 years old."

Tips: Mistakes artists make in presenting their work are "not setting appointments; new artists seek instant one-person shows, and work is overpriced."

HENLEY'S GALLERY ON THE SEA RANCH, 1000 Annapolis Rd., The Sea Ranch CA 95497. (707)785-2951. Owner: Marion H. Gates. Retail gallery. Estab. 1981. Represents more than 70 artists; emerging, mid-career and established. Exhibited artists include Miguel Dominguez and Duane Gordon. Sponsors 6 shows/year. Average display time 3-4 weeks. Open all year. Located in a commercial area of a second home community; 1,800 sq. ft.; "interesting architecture, incorporates 3 floors." 30% of space for special exhibitions; 65% for gallery artists. Clientele: "medium to upperscale." Overall price range: $200-21,000; most artwork sold at $1,500-3,000.

Media: Considers oil, acrylic, watercolor, pastel, pen & ink, drawings, mixed media, works on paper, sculpture, ceramic, crafts, glass, local photography, original handpulled prints and etchings. Most frequently exhibits watercolor, gouache and oil.

Style: Exhibits realism. Genres include landscapes and figurative work. Prefers landscapes and illustrations.

Terms: Accepts work on consignment (40-50% commission). Retail price set by the artist. Gallery provides insurance, promotion and contract. Artist pays for shipping. Prefers unframed artwork.

Submissions: Send query letter with resume, slides, bio, photographs and SASE. Call or write to schedule an appointment to show a portfolio, which should include originals and slides. Replies in 2 weeks. Files resume.

Tips: Does not want to see "non-loyalty to the gallery and its ongoing efforts." Looks for "a brighter contemporary look."

HOLOS GALLERY, 1241 Lerida Way, Pacifica CA 94044. (415)355-2153. FAX: (415)738-0647. President: Barclay Thompson. Retail and wholesale gallery. Estab. 1979. Represents 20 artists; emerging, mid-career and established. Interested in seeing the work of emerging artists. Exhibited artists include John Kaufman and Lon Moore. Sponsors 4 shows/year. Average display time 3 months. Open all year. Located in a neighborhood shopping area near Golden Gate Park; 600 sq. ft. 50% of space for special exhibitions; 50% for gallery artists. Clientele: 90% private collectors, 10% corporate collectors. Overall price range: $25-5,000; most artwork sold at $50-500.

Media: Considers holograms and holograms with mixed media. Exhibits "just holograms!"
Style: Exhibits surrealism, realism, photorealism and all styles. All genres. Prefers realist, abstract and conceptual styles.
Terms: Accepts work on consignment (50% commission) and bought outright for 50% of retail price (net 30-90 days). Retail price set by the gallery. Gallery provides insurance, promotion and shipping costs to and from gallery. Prefers framed artwork.
Submissions: Send query letter with resume, slides, SASE and reviews. Write to schedule an appointment to show a portfolio, which should include originals. Replies in 2-3 weeks. Files resume and slides.

***L. RON HUBBARD GALLERY,** Suite 400, 7051 Hollywood Blvd., Hollywood CA 90028. (213)466-3310. FAX: (213)466-6474. Contact: Joni Labaqui. Retail gallery. Estab. 1987. Represents 14 established artists. Interested in seeing the work of emerging artists in the future. Exhibited artists include Frank Frazetta and Jim Warren. Average display time is 4 months. Open all year. Located downtown; 6,000 sq. ft.; "marble floors, brass ceilings, lots of glass, state-of-the-art lighting." Clientele: "business-oriented people." 90% private collectors, 10% corporate collectors. Overall price range: $200-15,000; most work sold at $4,000-6,000.
Media: Considers oil and acrylic. "Continuous tone offset lithography is all we exhibit."
Style: Exhibits surrealism and realism. Prefers science fiction, fantasy and Western.
Terms: Artwork is bought outright. Retail price set by the gallery. Prefers artwork framed.
Submissions: Send query letter with resume, slides and photographs. Write or call to schedule an appointment to show a portfolio. Replies in 1 week. Files all material, unless return requested.

INTERNATIONAL GALLERY, 643 G St., San Diego CA 92101. (619)235-8255. Director: Stephen Ross. Retail gallery. Estab. 1980. Clientele: 99% private collectors. Represents over 50 artists. Sponsors 6 solo and 6 group shows/year. Average display time is 2 months. Interested in emerging, mid-career and established artists. Overall price range: $15-10,000; most artwork sold at $25-500.
Media: Considers sculpture, ceramic, craft, fibers, glass and jewelry.
Style: "Gallery specializes in contemporary crafts (traditional and current) folk and primitive art as well as naif art."
Terms: Accepts work on consignment. Retail price is set by gallery and artist. Exclusive area representation not required. Gallery provides insurance, promotion and contract; shipping costs are shared.
Submissions: Send query letter, resume, slides and SASE. Call or write to schedule an appointment to show a portfolio, which should include slides and transparencies. Resumes, work description and sometimes slides are filed.

KURLAND/SUMMERS GALLERY, 8742-A Melrose Ave., Los Angeles CA 90069. (213)659-7098. Director: Ruth T. Summers. Retail gallery. Estab. 1981. Represents 20-25 artists; mid-career and established. Interested in seeing the work of emerging artists. Exhibited artists include Christopher Lee and Colin Reid. Sponsors 8 shows/year. Average display time 5-6 weeks for a major exhibition; 1 month for other work. Open all year. Located 2 blocks east of Beverly Hills; 2,200 sq. ft.; "excellent lighting system, good architecture for showing work both in a home and a gallery setting." 50% of space for special exhibitions. Clientele: 85% private collectors, 15% corporate collectors. Overall price range: $600-60,000; most artwork sold at $2,500-6,500.
Media: Considers wood furniture/ceramic wall reliefs. Most frequently exhibits glass and works on paper by artists working in glass.
Style: Exhibits conceptualism, photorealism and hard-edge geometric abstraction. Prefers sculpture, geometric abstraction and photorealism.
Terms: Accepts work on consignment (50% commission). Retail price set by the artist. Gallery provides insurance, promotion and pays shipping costs from gallery. Artist pays for shipping costs to gallery. Prefers framed artwork.
Submissions: Send query letter with resume, slides, bio, brochure, photographs, SASE, business card, reviews and cover letter. Call or write to schedule an appointment to show a portfolio, which should include slides, photographs, transparencies, reviews, articles and photographs of installation. Replies in 2-3 weeks. Files bio, slides and cover letter.
Tips: "Be sure that your work is compatible with what we show, we specialize in contemporary non-functional glass, often incorporating non-glass elements." A developing trend seems to be that "more sophisticated artwork and work from Eastern Europe is coming into forefront."

***LITE RAIL GALLERY,** 918 12th St., Sacramento CA 95814. (916)441-1013. Director: Michael Xepoleas. Artistic Advisor: Robert Jean-Ray. Retail gallery. Estab. 1989. Represents 24 mid-career artists. Interested in seeing the work of emerging artists. Exhibited artists include Mickael Scott Jones. Sponsors 16 shows/year. Average display time 6 weeks. Open all year. Located downtown in old Masonic temple, 2 blocks from state capitol; 10,000 sq. ft., 4 separate gallery spaces; "1911 architectural design, 22 ft. high ceiling; 5,000 sq. ft. unique basement gallery." 50% of space for special exhibitions. Overall price range: $100-75,000; most work sold at $500-2,500.

Media: Considers oil, pen & ink, paper, acrylic, sculpture, watercolor, mixed media, ceramic, installation, pastel and photographs, original handpulled prints, woodcuts, wood engravings, linocuts, mezzotints and etchings. Most frequently exhibits ceramics, oil and pencil.

Style: Exhibits expressionism, post-modern works, realism and photorealism. Genres include landscapes, Americana, portraits – all genres.

Terms: Rental fee for space; covers 6 weeks. Retail price set by the gallery and the artist. Gallery provides insurance, promotion and contract, shipping costs from gallery.

Submissions: Call, then send query letter with resume, slides, bio, photographs and reviews. "Wait for response and then visit at any time." Call to schedule an appointment to show a portfolio, which should include originals, photographs and slides. Replies in 2 weeks. Files all material.

LOS ANGELES MUNICIPAL ART GALLERY, Barnsdall Art Park, 4804 Hollywood Blvd., Los Angeles CA 90027. (213)485-4581. Director: Edward Leffingwell, Curator: Noel Korten. Nonprofit gallery. Estab. 1971. Sponsors 6 solo and group shows/year. Average display time is 6 weeks, 10,000 sq. ft. Accepts primarily Los Angeles artists. Interested in emerging, mid-career and established artists.

Media: Considers oil, acrylic, watercolor, pastel, pen & ink, drawings, sculpture, ceramic, fibers, photography, craft, mixed media, performance art, collage, glass, installation, original handpulled prints and offset reproductions.

Style: Exhibits contemporary works. "The Los Angeles Municipal Art Gallery organizes and presents exhibitions which primarily illustrate the significant developments and achievements of living Southern California artists. The gallery strives to present works of the highest quality in a broad range of media and styles. We seek to provide a national and international forum for Los Angeles artists by participating in exchange and travelling shows. Programs reflect the diversity of cultural activities in the visual arts in Los Angeles."

Terms: Gallery provides insurance, promotion and contract.

Submissions: Send query letter, resume, brochure, slides and photographs. Slides and resumes are filed.

MAYHEW WILDLIFE GALLERY, 400 Kasten St., Mendocino CA 95460. (707)937-0453. Owner: Meridith Carine. Retail gallery. Estab. 1980. Represents a broad scope of artists from Northern California: emerging, mid-career, and established. Exhibited artists include George Sumner and James D. Mayhew. Sponsors 2 major shows/year. Display time varies. Open all year. Located in the village of Mendocino, an art community with small shops; "modern interior quaint New England architecture in a coastal town." 30% of space for special exhibitions; 70% for gallery artists. Clientele: "locals and tourists who enjoy wildlife and are environmentally aware." 10% private collectors. Overall price range: $25-10,000; most work sold at $25-500.

Media: Considers oil, acrylic, watercolor, pastel, pen & ink, drawings, mixed media, works on paper, sculpture, glass, original handpulled prints, offset reproductions, woodcuts, wood engravings, linocuts, engravings, mezzotints, etchings, lithographs, posters and serigraphs. Most frequently exhibits bronze, watercolor and etchings.

Style: Exhibits impressionism (environmental), realism, photorealism and abstract sculpture. Genres include landscapes, florals and wildlife. Prefers wildlife, florals and landscapes.

Terms: Accepts work on consignment (60% commission). Retail price set by the artist. Gallery provides insurance and promotion; shipping costs are shared. Prefers framed artwork.

Submissions: Send query letter with resume, slides, bio, brochure and photographs. "We prefer being contacted for appointments first." Portfolio should include originals. Replies only if interested with 3 months. Files brochures or catalogs.

Tips: "Please contact us by phone to express your interest as a first step."

MERRITT GALLERY, 1109 S. Mooney Blvd., Visalia CA 93277. (209)627-1109. Director: Luci Merritt. Retail gallery. Estab. 1983. Represents 25-30 mid-career and established artists. Exhibited artists include Melanie Taylon Kent. Sponsors 2-4 shows/year. Average display time 4 months. Open all year. Located in strip center, main thoroughfare; 700 sq. ft. 25% of space for special exhibitions.

Terms: Accepts work on consignment (40% commission). Retail price set by artist. Gallery provides insurance and promotion; artist pays for shipping. Prefers framed artwork.

Submissions: Send resume, bio and slides or photographs. Write to schedule an appointment to show portfolio, which should include photographs or slides and bio. Replies in 2 weeks. Files current artist's inventory.

Tips: "Do not bring originals unless requested; present professional portfolio and frame to professional standards. Artists are sometimes poorly prepared or have no portfolio and little or no understanding of how the presented work will fit into the gallery." There is a trend "away from the Southwestern fad, toward higher end contemporary graphics and traditional work. Quality work whether multiple or unique will always have a market."

MONTEREY PENINSULA MUSEUM OF ART, 559 Pacific St., Monterey CA 93940. (408) 372-5477. Director: Jo Farb Hernandez. Nonprofit museum. Estab. 1959. Represents emerging, mid-career and established artists. Features 9 galleries. Sponsors approximately 18-20 exhibitions/year. Average display time is 4-12 weeks.

Media: Considers all media.

Style: Exhibits contemporary, abstract, impressionistic, figurative, landscape, primitive, non-representational, photorealistic, Western, realist, neo-expressionistic and post-pop works. "Our mission as an educational institution is to present a broad range of all types of works. Do not submit trendy, faddish derivative commercial work."

Terms: No sales. Museum provides insurance, promotion and contract; shipping costs are shared.

Submissions: Send query letter, resume, slides and SASE. Resume and cover letters are filed.

Tips: The most common mistake artists make is "trying to second-guess what we want to see—tailoring the work to us. We'd rather see a serious commitment to their chosen field, technical proficiency and serious explorations into their aesthetic direction."

***MUSEUM OF NEON ART**, 704 Traction Ave., Los Angeles CA 90013. (213)617-0274. Curator: Mary Carter. Museum. Estab. 1981. Sponsors 3 solo and 3 group shows/year. Average display time: 3 months. Interested in emerging, mid-career and established artists.

Media: Considers neon, electric and kinetic art.

Style: Exhibits all styles and all genres. "The museum of neon art is a nonprofit, cultural and educational public benefit foundation created to exhibit, document and preserve works of neon, electric and kinetic art."

Terms: Retail price set by artist. Artist pays for shipping.

Submissions: Send query letter with slides and SASE. Do not submit material in person. Portfolio should include slides and transparencies. Replies in 3 months.

Tips: "We're interested in artists who can express ideas and emotions visually. The most common mistakes artists make in presenting their work is bringing in photos—or the works themselves—and asking for an evaluation on the spot."

NORTH VALLEY ART LEAGUE GALLERY, 1126 Parkview Ave., Redding CA 96002. (916)243-1023. President: George Schilens. Nonprofit gallery. Estab. 1983. Represents 170 emerging, mid-career and established artists. Exhibited artists include Susan Greaves and George Nagel. Sponsors 17 shows/year. Average display time 1 month. Open all year. Located mid-town; 2,530 sq. ft.; 1930 vintage cottage. Clientele: mainly average income. 95% private collectors, 5% corporate clients. Overall price range: $50-1,500; most artwork sold at $150-200.

Media: Considers oil, acrylic, watercolor, pastel, pen & ink, drawings, mixed media, collage, works on paper, sculpture, ceramic, fiber, glass, photography, original handpulled prints, woodcuts, engravings, lithographs, pochoir, wood engravings, mezzotints, serigraphs, linocuts and etchings. Most frequently exhibits watercolor, oil and acrylic.

Style: Exhibits all styles and genres. Prefers landscapes, florals and Western.

Terms: Artwork is accepted on consignment (20% commission). Retail price is set by the artist. Gallery provides promotion. Artist pays for shipping. Prefers framed artwork.

Submissions: "All artists are encouraged. All members may show."

Tips: "We are a non-juried gallery except for special shows. We encourage all levels to participate in our general gallery exhibits."

OLD CHURCH GALLERY, 990 Meadow Gate Rd., Box 608, Meadow Vista CA 95722. (916)878-1758. Gallery Directress: Donna Mae Halsted. Retail gallery; alternative space; art consultancy; frame shop; offers art classes/workshops/seminars; cultural center for literary, musical and children's entertainment. Estab. 1987. Represents 11 emerging, mid-career and established artists. Exhibited artists include Pamela Cushman and Margot Seymour Schulzke, P.S.A. Sponsors 6 1-or 2-person shows/year. Average display time 6 weeks. Open all year. Located down "town" in a small but rapidly growing village in the foothills of the Sierra Mountains; 3,000 sq. ft. "In October we hold the annual Mountains & Meadows Conservation Fine Arts Festival." 60% of space for special exhibitions. Clientele: 95% private collectors, 5% corporate clients. "We represent only local artists in all media. However, we do consider out of area artists for invitational shows, classes, workshops and seminars." Overall price range: $150-3,000; most work sold at $150-1,000.

Media: Considers most media and types of prints. Most frequently exhibits watercolor, pastel and oil.

Style: Exhibits painterly abstraction, impressionism, realism and photorealism. "Any style well planned and professionally executed is accepted when in good moral taste." Genres include landscapes, florals, Americana, Southwestern, Western, wildlife, portraits and figurative work. Prefers realism, impressionism and abstraction.

Terms: Artwork is accepted on consignment (40% commission). The gallery and the artist set the price together. Gallery provides insurance, promotion and contracts. "Works are usually hand delivered. In the case of our national open show the artist pays for shipping and insurance." Prefers framed artwork. "We ask the artist to use archival-quality framing."

Submissions: Send query letter with resume, bio, photographs, reviews, slides, SASE, business card, tearsheets, history of exhibitions and awards, collections in which your art appears, list of other galleries exhibiting your work, list of writings you have done in the art field and education in art. Call or write to schedule an appointment to show a portfolio, which should include originals, photographs, slides and transparencies.

Replies in 3-6 weeks. Files resume and bio, 3-6 samples of the artist's work, news releases and significant articles about the artist and/or work.
Tips: The most common mistake artists make is "not making an appointment—they just stop by with a car full of paintings and make a disorganized presentation."

***OLIVER ART CENTER—CALIFORNIA COLLEGE OF ARTS & CRAFTS**, 5212 Broadway, Oakland CA 94618. (415)653-8118, ext. 198. FAX: (415)655-3541. Director: Dyana Chadwick. Nonprofit gallery. Estab. 1989. Represents emerging, mid-career and established artists. Sponsors 5-8 shows/year. Average display time 6-8 weeks. Located on the campus of the California College of Arts & Crafts; 3,500 sq. ft. of space for special exhibitions.
Media: Considers all media and all forms of prints.
Style: Exhibits contemporary works of various genres and styles.
Terms: Gallery provides insurance and promotion, pays for shipping costs to gallery. Prefers artwork framed.
Submissions: Send query letter with resume, slides, statement, brochure, photographs, SASE, business card and reviews. Replies in 3 weeks. Files resume, bio, reviews, 1 slide per artist for slide registry.
Tips: "Proposals for collaborative works or special installations/projects should be accompanied by a complete write-up, including descriptions, costs, rationale, and drawings/slides as available."

ORLANDO GALLERY, 14553 Ventura Blvd., Sherman Oaks CA 91403. Co-Director: Robert Gino. Retail gallery. Estab. 1958. Represents 30 artists. Sponsors 22 solo shows/year. Average display time is 4 weeks. Accepts only Los Angeles artists. Interested in emerging, mid-career and established artists. Overall price range: up to $35,000; most artwork sold at $2,500.
Media: Considers oil, acrylic, watercolor, pastel, pen & ink, drawings, mixed media, collage, works on paper, sculpture, ceramic and photography. Most frequently exhibits oil, watercolor and acrylic.
Style: Exhibits painterly abstract, conceptual, primitive, impressionism, photo-realism, expressionism, neo-expressionism, realism and surrealism. Genres include landscapes, florals, Americana, figurative work and fantasy illustration. Prefers impressionism, surrealism and realism. Does not want to see decorative art.
Terms: Accepts work on consignment. Retail price is set by artist. Exclusive area representation required. Gallery provides insurance and promotion; artist pays for shipping.
Submissions: Send query letter, resume and slides. Portfolio should include slides and transparencies.

PALO ALTO CULTURAL CENTER, 1313 Newell Rd., Palo Alto CA 94303. (415)329-2366. Curator: Signe Mayfield. Nonprofit gallery. Estab. 1971. Exhibits the work of regional and nationally known artists in group and solo exhibitions. Interested in established or emerging, mid-career artists who have worked for at least 3 years in their medium. Overall price range: $150-10,000; most artwork sold at $200-3,000.
Media: Considers oil, acrylic, watercolor, pastel, pen & ink, drawings, sculpture, ceramic, fiber, photography, mixed media, collage, glass, installations, decorative art (i.e., furniture, hand-crafted textiles etc.) and original handpulled prints. "All works on paper must be suitably framed and behind plexiglass." Most frequently exhibits ceramics, painting, photography and fine arts and crafts.
Style: Our gallery specializes in contemporary and historic art.
Terms: Accepts work on consignment (10-30% commission). Retail price is set by gallery and artist. Exclusive area representation not required. Gallery provides insurance, promotion and contract; artist pays for shipping.
Submissions: Send query letter, resume, slides, business card and SASE.

THE JOHN PENCE GALLERY, 750 Post St., San Francisco CA 94109. (415)441-1138. Proprietor/Director: John Pence. Retail gallery or art consultancy. Estab. 1975. Clientele: collectors, designers, businesses and tourists, 85% private collectors, 15% corporate clients. Represents 16 artists. Sponsors 7 solo and 2 group shows/year. Average display time is 4 weeks. Interested in emerging, mid-career and established artists. Overall price range: $450-65,000; most artwork sold at $4,500-8,500.
Media: Primarily considers oil and pastel. Will occasionally consider watercolor and bronze.
Style: Exhibits painterly abstraction, impressionism, realism and academic realism. Genres include landscapes, florals, Americana, portraits, figurative work and still life. "We deal eclectically. Thus we may accept someone who is the best of a field or someone who could become that. We are *actively involved* with the artist, not merely reps." Looks for "consistency, interesting subjects, ability to do large works."
Terms: Accepts work on consignment (50% commission) or buys outright (33% markup). Retail price is set by gallery and artist. Exclusive area representation required. Gallery provides insurance and promotion.
Submissions: Send query letter, resume and slides. "No appointments. Send for application/instructions." Resumes are filed.

***NANCY PHELPS GALLERY**, 2880-A Grand Ave., Los Olivos CA 93441-0864. (805)686-1142. Partner: Judy McDonald. Retail gallery. Estab. 1987. Represents 30 artists; mid-career and established. Exhibited artists include Nancy Phelps and Lori Quarton. Sponsors 4 shows/year. Average display time 6 months. Open all year. Located downtown; 1700 sq. ft.; "the gallery is light and airy, with a woman's touch." 20% of space for

special exhibitions. Clientele: homeowners, decorators. Overall price range: $100-5,000; most work sold at $800-3,500.

Media: Considers oil, acrylic, watercolor, pastel, sculpture, ceramic, fiber, original handpulled prints, offset reproductions, lithographs and etching. Most frequently exhibits watercolor, oil and acrylic.

Style: Exhibits impressionism and realism. Genres include landscapes, florals, Southwestern, portraits and figurative work. Prefers figurative work, florals and landscapes.

Terms: Accepts work on consignment (40% commission). Retail price set by the artist. Gallery provides insurance and promotion. Artist pays for shipping. Prefers artwork framed.

Submissions: Send query letter with bio, brochure, photographs, business card and reviews. Call to schedule an appointment to show a portfolio. Portfolio should include photographs. Replies in 2 weeks. Files bio, brochure and business card.

Tips: "Be sure the work submitted is in keeping with the nature of our gallery."

***MICHAEL REIF FINE ART**, Box 2037, Mill Valley CA 94942. (415)381-2400. FAX: (415)381-2490. Director: Michael Reif. Retail and wholesale gallery. Estab. 1985. Represents 20-30 artists. Exhibited artists include Jais Nillsen and Emil Bisttram. Sponsors 1-2 shows/year. Average display time 18 months. Open all year. Located in a suburb of San Francisco; 2,000 sq. ft.; "I deal in 20th century modernism out of my 'gallery,' which is also my home." 50% of space for special exhibitions Clientele: "galleries worldwide and wealthy individuals." 70% private collectors. Overall price range: $3,000-250,000; most work sold at $20,000-75,000.

Media: Considers oil, pen & ink, acrylic, drawing, sculpture, watercolor, mixed media, pastel, collage and photography. Most frequently exhibits oil on canvas or board, tempera or watercolor on paper.

Style: Exhibits expressionism, painterly abstraction, surrealism, hard-edge geometric abstraction and modernism. Genres include cubism, futurism and surrealism.

Terms: Buys outright for 50% of retail price (net 30-90 days). "I own almost all the art that I show." Retail price set by the gallery. Gallery pays for shipping costs. Prefers artwork framed "well."

Submissions: Prefers only "original paintings, drawings, and sculpture by artists that worked between 1910 and 1970 – the earlier the better." Send query letter with slides and bio. Call to schedule an appointment to show a portfolio, which should include photographs, transparencies and all possible historical information. Replies in 1-2 weeks.

Tips: "I am interested in older artists that worked between 1920 and 1960, works considered modernist or avant-garde."

ROCKRIDGE CAFÉ, 5492 College Ave., Oakland CA 94618. (415)653-6806. Manager: Tom Hile. Café gallery. Estab. 1983. Exhibits emerging artists. Membership varies. Exhibited artists include Jerry Doty, photographer and Sandy Diamond, calligraphy designer. Sponsors 20 shows/year. Average display time 6 weeks. Open all year. Located in a commercial/residential area; "we have space for 2 shows (group or one-person) per 6-week span of time. We do not 'represent' any artists; we have 2 large, airy dining rooms with natural light." Clientele: urban professional dining room clientele, 500-1,000 people daily. 100% private collectors. No sculpture. Overall price range: $50-1,000; most artwork sold at $100-300.

Media: Considers oil, acrylic, watercolor, pastel, pen & ink, drawings, mixed media, collage, works on paper, ceramic (flat), craft (flat), fiber, glass (flat), photography. "Will consider any 2-D media." Considers all types of prints. Most frequently exhibits photography, paintings of all types and mixed media.

Style: Exhibits all styles and genres. "We'll consider any genre or subject matter that would be appropriate to the dining room clientele, by which we mean that we cannot consider subject matter that would be very disturbing or offensive to someone who is eating."

Terms: Artwork is accepted on consignment (no commission). Artist sets retail price. Gallery provides basic promotion. Artist pays for shipping. Prefers framed artwork.

Submissions: Send query letter with resume, slides or photographs and SASE or call for information. Call to schedule an appointment to show a portfolio, which should include slides or photographs. Replies in 3 weeks.

Tips: "Samples should include work you would like to have shown, not a representative sampling. Show us 8-15 pieces."

SAN FRANCISCO ART INSTITUTE, WALTER/McBEAN GALLERY, 800 Chestnut St., San Francisco CA 94133. (415)771-7020: Director: Jean-Edith Weiffenbach. Nonprofit gallery. Estab. 1968. Clientele: audience of general art community, artists, teachers and students. Exhibits work in 8 shows/year of between 2 and 8 artists/show. Interested in emerging and mid-career artists. Average display time is 5 weeks. "We exhibit work by artists of any nationality, creed and gender. We do not offer works for sale."

Media: Considers all media.

Style: Exhibits contemporary, abstract and figurative works. "We exhibit all media and styles, including performance, installation, painting, sculpture, video and photography."

Terms: Retail price is set by artist. Exclusive area representation not required. Gallery provides insurance, shipping, promotion and contract.

Submissions: Send query letter, resume and slides. Work is reviewed for general curatorial interest, although it is not generally selected for exhibition through submissions or a slide jurying process.

Tips: Sees trend toward "world art from culturally specific and diverse communities, plus the emergence of new technologies in art; art that has a social concern; art that does not function in the current art market and has no commodity value."

***SAN FRANCISCO CRAFT & FOLK ART MUSEUM,** Bldg. A, Fort Mason Center, San Francisco CA 94123. (415)775-0990. Curator: Carole Austin. Estab. 1983. Represents emerging and mid-career artists. Average display time 8 weeks. Open all year. Located in a cultural center in a national park; 1,500 sq. ft.; "amidst 4 other museums and many theaters and nonprofits." 100% of space for special exhibitions and museum shop. 100% private collectors. Overall price range: $100-3,000. "We are basically a museum and sell only occasionally, so we do not keep statistics on prices."

Media: Considers mixed media, collage, paper, sculpture, ceramics, crafts, fiber, glass, installation. Most frequently exhibits textile, ceramics and paper.

Style: Exhibits primitivism, folk art and contemporary fine craft.

Terms: Museum shop. Accepts work on consignment (25% commission). Retail price set by the artist.

Submissions: Send query letter with resume, slides, bio, brochure, photographs and SASE. Write to schedule an appointment. Portfolio should include photographs, slides and transparencies. Replies in 8 weeks if SASE included. Does not file material.

THE SAN FRANCISCO MUSEUM OF MODERN ART RENTAL GALLERY, Bldg. A, Fort Mason Center, San Francisco CA 94123. (415)441-4777. Director: Marian Parmenter. Nonprofit gallery and art consultancy. Estab. 1978. Amount of exhibition space 1,500 sq. ft. Clientele: Corporations and private collectors; 40% private collectors, 60% corporate clients. Shows the work of 800 artists. Sponsors 11 exhibitions/year. "All work is stored, not really 'displayed' in racks except sculpture and the exhibiting artists." Interested in emerging, mid-career and established artists. Overall price range: $100-15,000; most artwork sold at $1,000-5,000.

Media: Considers oil, acrylic, watercolor, pastel, drawings, mixed media, collage, sculpture, installation, photography and original handpulled prints. Most frequently exhibited media: painting, sculpture and photography. Does not want to see fiber and clay.

Style: Exhibits hard-edge/geometric abstraction, painterly abstraction, minimalism, post-modern, pattern painting, surrealism, primitivism, photorealism, expressionism, neo-expressionism and realism. Genres include landscapes and figurative work. "Work chosen to be exhibited is chosen for quality, not style or theme."

Terms: Accepts work on consignment (40% commission). Retail price is set by gallery. Exclusive area representation not required. Gallery provides insurance, promotion and contract; artist pays for shipping.

Submissions: Send query letter, resume, slides and SASE.

***SAN GABRIEL FINE ARTS GALLERY,** 343 S. Mission Dr., San Gabriel CA 91776. (818)282-1448. Fine Arts Chairman: Don Miles. Nonprofit gallery. Estab. 1965. Represents emerging, mid-career and established artists. Approximately 400 members. Exhibited artists include John Bohnenberger and Don Miles. Sponsors 1 show/month, plus 2 juried shows annually. Average display time 1 month. Open all year. Located in San Gabriel Old Town area, near historic San Gabriel Mission. "Our gallery is odd shaped—it has four large walls, plus three walls in window area and can accommodate as many as 60 paintings, depending on size; Spanish style architecture, located on a corner." 50% of space for special exhibitions. "Members fill balance of gallery. In months when there is no featured artist, members fill entire gallery." Clientele: art lovers. 90% private collectors; 10% corporate collectors. Overall price range: $150-2,500; most work sold at $150-750.

Media: Considers oil, acrylic, watercolor, pastel, pen & ink, drawings, mixed media, collage, sculpture, ceramics. Considers prints. Most frequently exhibits oil, watercolor, pastel and sculpture.

Style: Exhibits impressionism and realism. All genres. Prefers landscapes, portrait, still life.

Terms: There is a rental fee for space; covers 1 month. "Potential buyers are put in touch with artist re-sale arrangements. Artists then donate 25% of sale to Gallery." Retail price set by artist. Gallery provides insurance and promotion. Artist pays for shipping. Prefers artwork framed. "Items are not generally displayed, unless framed. Can be held in bins for sale if unframed."

Submissions: Send query letter with resume, brochure, photographs and SASE. Write to schedule an appointment to show a portfolio. Portfolio should include originals and photographs. Replies within 1 to 3 months. Files brochures.

Tips: "Since we are nonprofit, we are restricted in what we can do. Primarily, we provide exhibit space for artist, and personnel to greet visitors to the gallery, plus putting potential buyers in touch with artists regarding sales. We are primarily a traditional arts gallery, but have shown some contemporary work—subject to approval by our fine arts standards committee."

***DANIEL SAXON GALLERY,** (formerly Saxon-Lee Gallery), 7525 Beverly Blvd., Los Angeles CA 90036. (213)933-5282. Principal: Daniel Saxon. Retail gallery. Estab. 1986. Clientele: 85% private collectors, 15% corporate clients. Represents 15 artists. Sponsors 8 solo and 6 group shows/year. Average display time is 1 month. Interested in emerging and established artists. Overall price range: $2,000-70,000; most artwork sold at $10,000.
Media: Considers oils, acrylics, watercolor, pastels, drawings, mixed media, collage, sculpture and performance. Most frequently exhibited media: oils, acrylics and sculpture.
Style: Exhibits representational, figurative and conceptual works.
Terms: Accepts work on consignment (50% commission) or buys outright (50% markup). Retail price is set by gallery and artist. Gallery provides insurance, shipping, promotion and contract.
Submissions: Send resume and slides. Slides are filed.
Tips: Common mistakes include "poor slide identification, badly written letters (should be typed) neglecting to include return postage on return envelope—and walk in expecting an audience right then and there."

SUNBIRD GALLERY, 243 Main St., Los Altos CA 94022. (415)941-1561. FAX: (415)941-9071. Director: Carolyn Duque. Retail gallery. Estab. 1983. Represents 20-25 artists; emerging, mid-career and established. Exhibited artists include Veloy Vigil and Frank Howell. Sponsors 5-6 shows/year. Open all year. Located in downtown Los Altos; 2,500 sq. ft.; "a very large open space, good for viewing a variety of work." 50% of space for special exhibitions; 100% for gallery artists. Clientele: 99% private collectors, 1% corporate collectors. Overall price range: $80-16,500; most work sold at $2,000-4,000.
Media: Considers oil, acrylic, watercolor, pastel, drawings, mixed media, collage, works on paper, sculpture, ceramic, original handpulled prints, woodcuts, engravings, etchings, lithographs and serigraphs. Most frequently exhibits oil, lithographs, acrylic and watercolor.
Style: Exhibits expressionism, primitivism, painterly abstraction, impressionism and realism. Genres include landscapes, florals and Southwestern. Prefers contemporary, realism and expressionism.
Terms: Accepts work on consignment (40-50% commission). Retail price set by the gallery and the artist. Gallery provides insurance, promotion and contract; shipping cost from gallery. Prefers framed artwork.
Submissions: Send query letter with resume, slides, bio, brochure and SASE. Write to schedule an appointment to show a portfolio, which should include slides and photographs. Replies in 3 weeks. If does not reply, the artist should "call and request slides back in SASE." Files slides or photos and bios.

***TARBOX GALLERY,** 1202 Kettner Blvd., San Diego CA 92101. (619)234-5020. Owner-Director: Ruth R. Tarbox. Retail gallery. Estab. 1969. Represents and exhibits work of emerging, mid-career and established artists. Clientele: 60% collectors, 40% corporate clients. Represents 75 artists. Sponsors 5 or 6 solo and group shows alternately/year. Average display time is 3 weeks."For the past 6 years we have had a gallery in a building with a center built as an open atrium (glass enclosed) beside two award winning restaurants. Our walls are moveable." Overall price range: posters to $6,000; average sale $1,000.
Media: Considers oils, acrylics, watercolors, pastels, mixed media, collage, sculpture and ceramics. Most frequently exhibited media: watercolors, oils, acrylics, pastels and airbrush.
Style: Exhibits painterly abstraction, primitivism, impressionism and realism. Genres include landscapes, florals, Southwestern, and figurative work. Prefers landscapes. "Our gallery already has some excellent watercolorists, and we would like to augment these artists in oil working in contemporary themes."
Terms: Accepts work on consignment (50% commission). Retail price is set by gallery and artist. Exclusive area representation required within 10-mile radius. Gallery provides insurance, promotion and contract; shipping costs are shared.
Submissions: Send query letter, resume and slides, signed, sized and described first. From these the gallery can determine if this work will find a ready market in this area. Indicate pricing. Call or write to schedule an appointment to show a portfolio, which should include originals (at least 1) and slides. Resumes of promising artists are filed. Slides are returned.
Tips: "There is more interest in landscapes and pleasing colors and effects than there was a year ago."

TOPAZ UNIVERSAL, 4632 W. Magnolia Blvd., Burbank CA 91505. (818)766-8660. Director: Diane Binder. Retail gallery. Estab. 1982. Located in the center of movie studio and metro media area. Clientele: 60% private collectors. Represents 8 artists. Sponsors 2 solo and 4 group shows/year. Average display time is 3 months. Interested in established artists. Overall price range: $2,000-100,000; most work sold at $6,000-25,000.

Media: Considers oil, acrylic, watercolor, pastel, pen & ink, drawings, sculpture, mixed media, performance and original handpulled prints.
Style: Exhibits contemporary, impressionistic, figurative and neo-expressionistic works. Specializes in contemporary, figurative and expressionistic works.
Terms: Accepts work on consignment (50% commission). Buys outright. Retail price is set by gallery and artist. Exclusive area representation not required. Gallery provides insurance, promotion and contract; shipping costs are shared.
Submissions: Send query letter with resume and brochure.
Tips: "Common mistakes artists make is presenting naive, handwritten resume; being very unprofessional. Works must be more serious—not just decorative or dated."

***SHARON TRUAX FINE ART,** 1625 Electric Ave., Venice CA 90291. (213)396-3162. FAX: (213)396-3162. Contact: Sharon Truax. Private dealer and curator with gallery viewing space. Estab. 1987. Represents 20 emerging, mid-career and established artists. Exhibited artists include Nancy Day, Peter Lodato, Mike Berg, Laddie John Dill and Kiki Sammarcelli. Sponsors 8-10 shows/year. Average display time 5-6 weeks. Open all year by appointment. 1,200 sq. ft. warehouse; "clean viewing space with 30 ft. ceiling, and intimate salon-viewing area opening to garden." 60% of space for special exhibitions. 70% private collectors, 30% corporate collectors. Overall price range: $1,000-125,000; most work sold at $3,000-5,000.
Media: Considers all media. Most frequently exhibits oil on wood panel, canvas, mixed media and paper. Most frequently exhibits oil on wood panel canvas, mixed media and paper.
Style: Exhibits painterly abstraction, minimalism and constructivism. Genres include landscape, "styles for eclectic tastes."
Terms: Accepts work on consignment (50% commission). Retail price set by the gallery and the artist. Gallery provides insurance and promotion; shipping costs are shared. Prefers artwork framed.
Submissions: "Open to unique projects." Send query letter with resume, slides, and SASE. Write to schedule an appointment to show a portfolio, which should include slides and transparencies. Replies in 1 month. Files resume.

WESTERN VISIONS, 408 Broad St., Nevada City CA 95959. (916)265-6239. Owner: John Soga. Retail and wholesale gallery. Estab. 1983. Represents 20 emerging, mid-career and established artists. Exhibited artists include Bev Doolittle and Judy Larson. Sponsors 7 shows/year. Average display time 1 month. Open all year. Located in the New York Hotel; 800 sq. ft. 50% of space for special exhibits. Clientele: "upper middle class." 90% private collectors, 10% corporate collectors. Overall price range: $200-7,000; most artwork sold at $1,200.
Media: Considers acrylic, watercolor, pastel, pen & ink, mixed media, offset reproductions, lithographs, posters and serigraphs. Most frequently exhibits offset reproductions, serigraphs and lithographs.
Style: Exhibits imagism, impressionism and realism. Genres include landscapes, florals, Americana, Southwestern, Western and wildlife. Prefers Western, wildlife and camouflage.
Terms: Artwork is accepted on consignment (40% commission) or bought outright (50% of retail; net 30 days). Retail price is set by the gallery and artist. Gallery provides insurance, promotion and contract. Artist pays for shipping. Prefers unframed artwork.
Submissions: Send query letter with slides, bio, brochure and photographs. Call or write to schedule an appointment to show a portfolio, which should include slides and photographs. Replies only if interested within 1 week.
Tips: "We are looking for good artists who do Western and wildlife, especially camouflage art of any kind."

WINDWALKER GALLERY, Suite E, 28601 Front St., Temecula CA 92390. (714)699-1039. Director: Gwen Anderson. Retail gallery. Estab. 1988. Represents 15 emerging, mid-career and established artists. Exhibited artists include Robert Freeman and Cat Corcilius. Sponsors 2 shows/year. Average display time 3 months. Open all year. Located in Old Town, 1,400 sq. ft., "located in 'Old West' type building. Interior architecture is Southwest with arches and movable display walls and art stands." 25% of space for special exhibitions. Clientele: 100% private collectors. Accepts only artists from New Mexico, Arizona, Colorado, Oklahoma and California. Prefers only Native American and Southwest styles. Original art only. Overall price range: $400-4,000; most artwork sold at $700-2,000.

 The asterisk before a listing indicates that the listing is new in this edition. New markets are often the most receptive to freelance submissions.

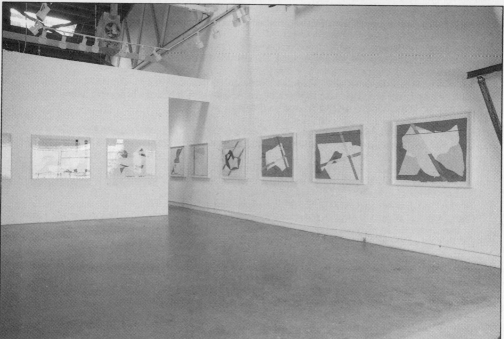

© Nancy Kay 1990

Sharon Truax Fine Art is shown here with a solo exhibit of Nancy Kay's acrylic on handmade-paper constructions. Both the gallery and the artist's residence are in Venice, California, where there is a large artist community. Owner Sharon Truax says she is open to showing such unique projects as this in her gallery, which has a "clean viewing space, with 30' ceilings, warehouse loft space, and an intimate salon-viewing area which opens to a garden."

Media: Considers oil, acrylic, watercolor, pastel, mixed media, sculpture, ceramic and fiber. Most frequently exhibits paintings, sculpture and ceramics.
Style: Exhibits painterly abstraction, conceptualism, impressionism and realism. Genres include landscapes, Southwestern, Western, portraits and figurative work. Most frequently exhibits Southwestern, landscapes and Western.
Terms: Artwork is accepted on consignment (50% commission). Retail price set by the gallery and the artist. Gallery provides insurance and promotion. Artist pays for shipping. Prefers framed artwork.
Submissions: Send query letter with resume, slides, bio, brochure, photographs and SASE. Portfolio should include originals. Replies in 3 weeks. Files "photos/slides of work that interests me and that I may want to display at a later date. All other is returned with SASE."
Tips: "Please visit the gallery to see what type of work is displayed. NEVER walk into the gallery with an armload of originals without an appointment. We notice a trend of 'younger,' average income collectors seeking quality works by new, unknown artists. Established and newer collectors are looking for lower priced pieces by emerging artists banking on having made a good investment purchase."

THE WING GALLERY, 13734 Riverside Dr., Sherman Oaks CA 91423. (818)981-9464. FAX: (818)981-ARTS. Director: Robin Wing. Retail gallery. Estab. 1974. Represents 100+ artists; emerging, mid-career, established. Exhibited artists include Doolittle and Wysocki. Sponsors 6 shows/year. Average display time 2 weeks-3 months. Open all year. Located in suburban-retail area; 3,500 sq. ft. 80% of space for special exhibitions. Clientele: 90% private collectors, 10% corporate collectors. Overall price range: $50-50,000; most work sold at $150-5,000.
Media: Considers oil, acrylic, watercolor, pen & ink, drawings, sculpture, ceramic, craft, glass, original handpulled prints, offset reproductions, engravings, lithographs, monoprints and serigraphs. Most frequently exhibits offset reproductions, watercolor and sculpture.

Style: Exhibits primitivism, impressionism, realism and photorealism. Genres include landscapes, Americana, Southwestern, Western, wildlife. Prefers wildlife, Western and landscapes/Americana.
Terms: Accepts work on consignment (40-50% commission). Retail price set by the gallery and the artist. Gallery provides insurance, promotion and contract; shipping costs are shared. Prefers unframed artwork.
Submissions: Send query letter with resume, slides, bio, brochure, photographs, SASE, reviews and price list. Call or write to schedule an appointment to show a portfolio, which should include slides, photographs and transparencies. Replies in 1-2 months. Files current information and slides.

Colorado

BOULDER ART CENTER, 1750 13th St., Boulder CO 80302. (303)443-2122. BAC Board of Directors: Exhibitions Committee. Nonprofit gallery. Estab. 1972. Exhibits the work of 300 individuals and 10 groups/year. Sponsors 4 solo and 8 group shows/year. Average display time is 6 weeks. "Emphasis is on Colorado artists." Interested in emerging and established artists. Overall price range: $200-17,000; most artwork sold at $850-2,500.
Media: Considers all media.
Style: Exhibits contemporary, abstract, figurative, non-representational, photo-realistic, realistic and neo-expressionistic works.
Terms: Accepts work by invitation only. Retail price is set by artist. Exclusive area representation not required. Gallery provides insurance, promotion and contract; artist pays for shipping and travel.
Submissions: Send query letter, artist statement, resume, approximately 20 slides and SASE. Reports within 6 months. Press and promotional material, slides and BAC history are filed.

***SANDY CARSON GALLERY**, 1734 Wazee St., Denver CO 80202. (303)297-8585. Director: Jodi Carson. Retail gallery and art consultancy. Estab. 1974. Clientele: individuals and corporations; 20% private collectors, 80% corporate clients. Represents 200 artists. Sponsors 6-8 group and solo shows/year. Average display time is 6 weeks. "We have relocated to a more retail location and formed a gallery district in lower downtown Denver. Many other galleries have followed. We maintain the same amount of square footage and have more of a New York or Chicago look gallery." Interested in emerging and mid-career artists. Overall price range: $125-10,000; most work sold at $2,000.
Media: Considers oils, acrylics, watercolor, pastels, drawings, mixed media, paper, sculpture, ceramics, fibers, glass, photography and original handpulled prints.
Style: Exhibits hard-edge geometric abstraction, color field, painterly abstraction, minimalism, conceptual, post-modern, pattern painting, primitivism, impressionism, photorealism, expressionism, neo-expressionism and realism. "We carry contemporary serious artwork. It can be abstract to landscape oriented. We tend to stay away from figurative imagery. We have the capability of carrying large scale pieces."
Terms: Accepts work on consignment (50% commission). Retail price is set by gallery and artist. Exclusive area representation required. Gallery provides insurance, promotion and contract; artist pays for shipping.
Submissions: Send query letter, resume and slides. Call or write to schedule an appointment to show a portfolio, which should include: originals, slides and transparencies. Resumes are filed.
Tips: "I do not want to see commercialized art or copied imagery."

***COGSWELL GALLERY**, 223 Gore Creek Dr., Vail CO 81657. (303)476-1769. Pres./Director: John Cogswell. Retail gallery. Estab. 1980. Represents 40 emerging, mid-career and established artists. Exhibited artists include Clyde Aspevig and Jean Richardson. Sponsors 8-10 shows/year. Average display time 3 weeks. Open all year. Located in Creekside Building in Vail; 1500 sq. ft. 50% of space for special exhibitions. Clientele: American and international, young and active. 80% private collectors, 20% corporate collectors. Overall price range: $100-50,000; most work sold at $1,000-5,000.
Media: Considers oil, acrylic, sculpture, watercolor, ceramic, photography and bronze; lithographs and serigraphs. Most frequently exhibits bronze, oil and watercolor.
Style: Exhibits painterly abstraction, impressionism and realism. Genres include landscapes, Southwestern and Western.
Terms: Accepts work on consignment (50% commission). Retail price set by the artist. Gallery provides insurance and promotion; shipping costs from gallery. Prefers artwork framed.
Submissions: Send query letter with resume, slides and bio. Call to schedule an appointment to show a portfolio, which should include slides. Replies only if interested within 1 month.

***CORE NEW ART SPACE**, 1412 Wazee St., Denver CO 80202. (303)571-4831. Secretary: Joyce W. Hoffer. Cooperative alternative and nonprofit gallery. Estab. 1981. Represents emerging and mid-career artists. Clientele: 90% private collectors; 10% corporate clients. 30 members. Sponsors 30 solo and 6-10 group shows/year. Average display time: 2 weeks. Accepts mostly artists from front range Colorado. Overall price range: $75-600; most work sold at $100-300.

Media: Considers oils, acrylics, watercolors, pastels, pen & ink, drawings, mixed media, collages, glass, paper, sculpture, ceramics, installations, photography, egg tempera, woodcuts, wood engravings, linocuts, engravings, mezzotints, etchings, monoprints and serigraphs. Specializes in avant-garde.

Style: Exhibits expressionism, neo-expressionism, painterly abstraction, conceptualism; considers all styles and genres.

Terms: Co-op membership fee plus donation of time. Retail price set by artist. Exclusive area representation not required.

Submissions: Send query letter with personal contact. Quarterly auditions to show a portfolio, which should include originals, slides and photographs. Request membership or Associate Membership application. "Our gallery is a cooperative which gives an opportunity for emerging artists in the metro-Denver area to show their work. We run four to six open shows a year which are juried by members of the art community. We accept work in all media, and prefer contemporary treatments of subject matter. There is an entry fee charged, but no commission is taken on any work sold. The member artists exhibit in a one-person show once a year. Member artists generally work in more avant-garde formats, and the gallery encourages experimentation. Members are chosen by slide review and personal interviews. Due to time commitments we require that they live and work in the area. An Associate Membership is also available."

Tips: "Stay away from traditional work with boring subject matter. In the Denver area there has been an expansion into the more contemporary art forms. We are in a recession. Galleries seem to be doing better in the past year or so. Nationally, art seems to be in a greater demand, and contemporary pieces are gaining wider acceptance."

EMMANUEL GALLERY & AURARIA LIBRARY GALLERY, Campus Box 173361, Denver CO 80217-3361. (303)556-8337. FAX: (303)556-3447. Director: Carol Keller. Nonprofit gallery and university gallery. Estab. 1976. Represents emerging, mid-career and established artists. Members are from 3 colleges. Sponsors 24 shows/year. Average display time 3-4 weeks. Open during semesters all year. Located on the downtown campus; about 1,000 sq. ft.; "the oldest standing church structure in Denver, a historical building built in 1876." 100% of space for special exhibitions. Clientele: private collectors or consultants. Wide price range.

Media: Considers all media and all types of prints. Most frequently exhibits painting, photography and sculpture.

Style: Exhibits neo-expressionism, conceptualism, minimalism, color field, post modern works, realism, photorealism, installations and all styles and genres.

Terms: It is a nonprofit gallery and there is a consignment during exhibit. A 25% commission donation is accepted. Retail price set by the artist. Gallery provides insurance and promotion. Shipping costs are negotiated.

Submissions: Send query letter with resume, slides, SASE and reviews. Call or write to schedule an appointment to show a portfolio, which should include slides and resume. Replies ASAP.

EMPIRE ART GALLERY, 5 E. U.S. 40, Empire CO 80438. (303)569-2365. Owner: Dorothy Boyd. Retail gallery. Estab. 1976. Represents 25 artists; emerging, mid-career and established. Exhibited artists include Gregory Perillo and Jim Faulkner. Sponsors 4 shows/year. Average display time 6 months. Open all year. Located downtown; 1,200 sq. ft.; restored 1860 mining building. 20% of space for special exhibitions; 80% for gallery artists. Clientele: investors and art collectors. 95% private collectors, 5% corporate collectors. Overall price range: $50-13,000; most artwork sold at $500-1,000.

Media: Considers oil, acrylic, watercolor, pastel, pen & ink, drawings, mixed media, works on paper, sculpture, ceramic and craft, original handpulled prints, offset reproductions, engravings, lithographs, serigraphs and posters. Most frequently exhibits oil, pastel and watercolor.

Style: Exhibits expressionism, primitivism, impressionism, realism and photorealism. No abstract work. All genres. Prefers portraits, wildlife and landscapes.

Terms: Accepts work on consignment (40% commission). Retail price set by the artist. Gallery provides insurance, promotion and contract; shipping costs from gallery. Prefers framed artwork.

Submissions: Send query letter with resume and photographs. Call or write to schedule an appointment to show a portfolio, which should include originals and photographs. Replies in 2 months. Files resumes and photos.

Tips: "We prefer to see original work. We like work professionally presented."

HAYDEN HAYS GALLERY, Broadmoor Hotel, Colorado Springs CO 80906. (719)577-5744. President: Elizabeth Kane. Retail gallery. Estab. 1979. Represents 20 artists; emerging, mid-career and established. Exhibited artists include William Hook and Jacqueline Rochester. Sponsors 2-3 shows/year. Open all year. 1,400 sq. ft. 100% of space for gallery artists. Clientele: "all types and out-of-town visitors." 90% private collectors, 10% corporate collectors. Overall price range: $25-10,000; most artwork sold at $550-2,500.

Media: Considers oil, acrylic, watercolor, pastel, pen & ink, drawings, mixed media, collage, sculpture, engravings, mezzotints, etchings, lithographs and serigraphs. Most frequently exhibits oil, acrylic, and watercolor.

Style: Exhibits expressionism, primitivism, impressionism and realism. Genres include landscapes, florals, Southwestern and figurative work. Prefers figurative, landscapes and Southwestern.

Terms: Prefers work on consignment (60% commission). Retail price set by the artist. Gallery provides insurance and promotion; shipping costs are shared. Prefers framed artwork.

Submissions: Send query letter with slides and bio. Call to schedule an appointment to show a portfolio, which should include slides. Replies only if interested within 1 month. Files "bio, 1-2 slides (to keep)."

INKFISH GALLERY, 949 Broadway, Denver CO 80203. (303)825-6727. Gallery Director: Paul Hughes. Retail gallery and art consultancy. Estab. 1975. Clientele: 60% local, 30% out of state, 10% tourist. 80% private collectors, 20% corporate clients. Represents 25 artists. Sponsors 6 solo and 6 group shows/year. Average display time 3 weeks. Centrally located with 3 other galleries; 2,500 sq. ft. Interested in emerging, mid-career and established artists. Overall price range: $100-50,000; most artwork sold at $500-5,000.

Media: Considers oil, acrylic, watercolor, pastel, pen & ink, drawings, mixed media, collage, works on paper, sculpture, ceramic, glass, installations, woodcuts, wood engravings, linocuts, engravings, mezzotints, etchings and lithographs. Most frequently exhibits paintings, works on paper and sculpture.

Style: Exhibits neo-expressionism, surrealism, minimalism, primitivism, color field, painterly abstraction, conceptualism, post modern works and hard-edge geometric abstraction. Considers all genres. No "Cowboy and Indian" art. Prefers non-representational work. "Inkfish Gallery specializes in contemporary art with a focus on Colorado artists. We have been in business 15 years and are seeing a much better understanding and acceptance of contemporary art."

Terms: Accepts work on consignment (50% commission). Retail price set by gallery and artist. Exclusive area representation not required. Gallery provides insurance, promotion and shipping costs from gallery. Prefers framed artwork.

Submissions: Send query letter with resume, brochure, slides, photographs and bio. Call to schedule an appointment to show a portfolio, which should include originals, slides, transparencies and photographs. Replies in 2-3 weeks. Files bios and slides. All material is returned if not accepted or under consideration.

MOYERS GALLERY AND FRAMING, 214½ N. Tejon St., Colorado Springs CO 80903. (719)633-2255. Retail gallery and custom framing facility. Estab. 1982. Represents 10-12 artists; emerging, mid-career and established. Exhibited artists include Lora Coley and Marilyn Kikman. Sponsors 2 shows/year. Average display time 1 month. Open all year. Located "downtown; 2,700 sq. ft.; unique frames and mouldings." 40% of space for special exhibitions. Clientele: businessmen and women. 80% private collectors. Overall price range: $2,000-2,500; most work sold at $400-500.

Media: Considers oil, acrylic, watercolor, pastel, pen & ink, drawings, collage, photography, etchings, lithographs, serigraphs and posters. Most frequently exhibits oil, watercolor and pastel.

Style: Exhibits expressionism, primitivism, impressionism and realism. Genres include landscapes, florals, Americana, Southwestern, wildlife and portraits. Prefers impressionism and realism.

Terms: Accepts work on consignment (40-60% commission). Buys outright for 50% of retail price (net 30 days). Retail price set by the gallery. Gallery provides promotion; shipping costs are shared. Prefers unframed artwork.

Submissions: Send query letter with slides, bio, photographs. Write to schedule an appointment to show a portfolio, which should include originals and photographs. Replies only if interested within 2 weeks. Files slides, letters and photographs.

REISS GALLERY, 429 Acoma St., Denver CO 80204. (303)778-6924. Director: Rhoda Reiss. Retail gallery. Estab. 1978. Represents 160 artists; emerging, mid-career and established. Exhibited artists include Sica, Nancy Hannum and Jim Foster. Sponsors 3-4 shows/year. Average display time 6-8 weeks. Open all year. Located just 6 blocks south of downtown; 2,100 sq. ft.; "in an old Victorian house." 40% of space for special exhibitions. Clientele: "corporate and interior designers." 30% private collectors, 70% corporate collectors. Overall price range: $100-12,000; most artwork sold at $600-1,000.

Media: Considers oil, acrylic, watercolor, pastel, mixed media, collage, works on paper, sculpture, ceramic, fiber glass, original handpulled prints, offset reproductions, woodcuts, engravings, lithographs, posters, wood engravings, mezzotints, serigraphs, linocuts and etchings. Most frequently exhibits oil, prints and handmade paper.

Style: Exhibits painterly abstraction, color field, impressionism. Genres include landscapes, Southwestern and Western. Prefers abstract, landscape and Southwestern. Does not want to see "figurative work or traditional oil paintings."

Terms: Accepts work on consignment (50% commission). Retail price set by the artist. Gallery provides insurance and promotion; artist pays for shipping. Prefers unframed artwork.

Submissions: Send query letter with resume, slides, bio, brochure, photographs, SASE and reviews. Call to schedule an appointment to show a portfolio, which should include originals, photographs and slides. Replies in 2-4 weeks. Files bios, slides and photos.

Tips: Suggests "that artist send work in large scale. Small pieces do not work in corporate spaces. Contemporary work shows best in our gallery. I look at craftsmanship of work, composition and salability of subject matter. Don't send poor slides, poorly framed work."

***SANGRE DE CRISTO ARTS AND CONFERENCE CENTER,** 210 N. Santa Fe Ave., Pueblo CO 81003. (719)543-0130. Curator of Visual Arts: Barbara Racker. Nonprofit gallery. Estab. 1972. Represents emerging, mid-career and established artists. Exhibited artists include Eliot Porter and James Balog. Sponsors 25-30 shows/year. Average display time 6 weeks. Open all year. Located "very downtown, right off Interstate I-25"; 7,500 sq. ft.; four galleries, one showing a permanent collection of Western art; changing exhibits are shown in the other three. Clientele: "We serve a 19-county region and attract 200,000 visitors yearly. Most art exhibits are not for sale, however, when they are for sale, anyone can buy." Overall price range: $50-100,000; most work sold at $50-13,000.
Media: Considers all media, but craft. Considers original handpulled prints, woodcuts, wood engravings, linocuts, mezzotints, etchings, lithographs and posters. Most frequently exhibits watercolor, oil on canvas and sculpture.
Style: Exhibits all styles. Genres include Southwestern.
Terms: Accepts work on consignment (30% commission). Retail price set by the artist. Gallery provides insurance, promotion and contract; shipping costs. Prefers artwork framed.
Submissions: "There are no restrictions, but our exhibits are booked into 1993 right now." Send query letter with slides. Write to schedule an appointment to show a portfolio, which should include slides. Replies in 2 weeks.

TAOS CONNECTIONS OF DENVER, 162 Adams St., Denver CO 80206. (303)393-8267. Owner: Robert J. Covlin. Retail gallery. Estab. 1983. Clientele: 80% private collectors, 20% corporate clients. Represents 20 artists. Sponsors 6 solo shows/year. Average display time is 3 months. Accepts only regional artists (Southwest contemporary). Interested in emerging and established artists. Overall price range: $150-8,000; most artwork sold at $500-1,000.
Media: Considers oil, acrylic, watercolor, pastel, drawings, mixed media, sculpture and original handpulled prints. Most frequently exhibits oil, watercolor and mixed media.
Style: Exhibits impressionistic, expressionistic and realistic works. Genres exhibited include landscapes, architectural interpretations, florals and figurative work. "Taos Connections of Denver features Southwestern contemporary art for the art collector's home, office or gift-giving pleasures; including oil, watercolor and other media, metal and stone sculpture, hand-painted furniture, pottery and glassware. Art by respected regional and Southwestern artists."
Terms: Accepts work on consignment (40% commission). Retail price is set by gallery and artist. Exclusive area representation required. Gallery provides insurance and promotion; shipping costs are shared.
Submissions: Send query letter, resume and photographs. All received material is filed.
Tips: "We look for good, solid work with a Southwest feeling."

3RD AVE. GALLERY, (formerly Peter Heineman Fine Arts), 2424 E. 3rd Ave., Denver CO 80206. (303)321-6992. Owner: Diane Patterson. Retail gallery. Estab. 1987. Clientele: 98% private collectors; 2% corporate clients. Represents 4 artists. Sponsors 10 solo and 5 group shows/year. Average display time: 2 weeks. Interested in emerging and established artists. Overall price range: $0-3,000; most work sold at $400-700.
Media: Considers oil, acrylic, watercolor, pastel, pen & ink, drawings, mixed media, collage, works on paper, egg tempera, woodcuts, wood engravings, linocuts, engravings, mezzotints, etchings, lithographs, pochoir and serigraphs. Most frequently exhibits oil, watercolor and etchings/engravings.
Style: Exhibits all styles and all genres. "I have concentrated on collecting quality oil paintings, mostly by unknown artists, which can be sold at moderate price levels for average consumers. Usually a very large eclectic collection here defying any specific theme or concept."
Terms: Accepts work on consignment (40% commission). Retail price set by gallery and artist. Exclusive area representation not required. Gallery provides insurance, promotion, contract; artist pays for shipping. Prefers framed artwork.
Submissions: Send query letter with resume, brochure, slides, photographs, bio and SASE. Write to schedule an appointment to show a portfolio, which should include originals. Replies only if interested within 1 week.
Tips: "Keep your prices down to where people can afford them."

TURNER ART GALLERY, 301 University Blvd., Denver CO 80206. (303)355-1828. Owner: Kent Lewis. Retail gallery. Estab. 1929. Represents 12 emerging, mid-career and established artists. Exhibited artists include Scott Switzer and Charles Fritz. Sponsors 6 shows/year. Open all year. Located in Cherry Creek North; 4,200 sq. ft. 50% of space for special exhibitions. Clientele: 90% private collectors. Overall price range: $1,000-10,000.

Media: Oil, acrylic, watercolor, pastel, sculpture and antique prints. Most frequently exhibits oil, watercolor and sculpture.

Style: Exhibits traditional and/or representational. All genres.

Terms: Retail price set by the gallery and the artist. Gallery provides insurance, promotion, contract and shipping costs from gallery.

Submissions: Call or send slides and bio. Replies in 1 week. Files work of accepted artists.

***THE WESTERN COLORADO CENTER FOR THE ARTS**, 1803 North 7th St., Grand Junction CO 81501. (303)243-7337. Director: David M. Davis. Nonprofit community art center. Represents emerging, mid-career and established artists. Estab. 1954. Sponsors various numbers of shows/year. Average display time is 1 month.

Media: Considers oils, acrylics, watercolor, pastels, pen & ink, drawings, mixed media, collage, paper, sculpture, ceramics, crafts, fibers, glass, installations, photography, performance and original handpulled prints.

Style: Exhibits hard-edge geometric abstraction, color field, painterly abstraction, minimalism, conceptual, post-modern, pattern painting, feminist/political, primitivism, impressionistic, photorealistic, expressionistic, neo-expressionistic, realistic and surrealistic works. Genres exhibited include landscapes, florals, Americana, Western, portraits, figurative work and fantasy illustration. Specializes in realism and impressionism. "We are completely unlimited."

Terms: Accepts work on consignment (25% commission). Retail price is set by artist. Exclusive area representation not required. Gallery provides insurance, promotion and contract; artist pays for shipping.

Submissions: Send query letter, resume, brochure, business card, slides, photographs and SASE. Call or write to schedule an appointment to show a portfolio, which should include slides and transparencies. "Slides are returned, all other material is copied, and copies are filed."

Connecticut

MONA BERMAN FINE ARTS, 78 Lyon St., New Haven CT 06511. (203)562-4720. Director: Mona Berman. Art consultancy. Estab. 1979. Represents over 50 emerging, mid-career and established artists. Exhibited artists include Tom Hricko and Juliet Holland. Sponsors 1 show/year. Open all year. Located near downtown; 1,000 sq. ft. 5% private collectors, 95% coporate collectors. Overall price range: $200-20,000; most artwork sold at $3,500-5,000.

Media: Considers all media except installation. Considers all types of prints except posters. Most frequently exhibits work on paper, painting and relief.

Style: Exhibits all styles. Prefers abstract, landscape and transitional.

Terms: Accepts work on consignment (50% commission) or buys outright for 50% of retail price (net 30 days). Retail price is set by gallery and artist. Gallery provides insurance; artist pays for shipping. Prefers artwork unframed.

Submissions: Send query letter, resume, slides, bio, SASE, reviews and "price list — indicate retail or wholesale." Portfolios are reviewed only after slide submission. Replies in 1 month. Slides and reply returned only if SASE is included.

***BROOKFIELD CRAFT CENTER GALLERY**, Route 25, Brookfield CT 06804. (203)775-4526. Retail Manager: Judith Russell. Nonprofit gallery. Estab. 1954. Represents 200+ emerging, mid-career and established artists. Sponsors 6 shows/year. Average display time 6 months. Open all year. Located in suburban area; 1,000 sq. ft.; "housed in restored 1780 grist mill (Connecticut state landmark)." 50% of space for special exhibitions. Clientele: upscale and corporate. 10% private collectors, 5% corporate collectors. Overall price range: $5-5,000; most work sold at $25-100.

Media: Considers paper, fiber, glass, ceramic and craft. Does not consider prints. Most frequently exhibits jewelry, glass and ceramics.

Style: Exhibits all contemporary styles and genres.

Terms: Accepts work on consignment (40% commission) or buys outright for 50% of retail price (net 30 days). Retail price set by the artist. Gallery provides insurance, promotion and contract; shipping costs are shared. Prefer artwork framed.

Submissions: Send query letter with resume, slides, brochure and bio. Call or write to schedule an appointment to show a portfolio, which should include originals, slides, photographs and transparencies. Replies in 2 weeks.

ARLENE MCDANIEL GALLERIES, 10 Phelps Lane, Simsbury CT 06070. (203)658-1231 or 658-9761. President: Arlene McDaniel. Retail gallery. Estab. 1972. Clientele: 50% private collectors; 50% corporate clients. Represents 20 artists. Sponsors 5 group shows/year. Interested in emerging and established artists. Overall price range: $2,500-5,000; most work sold at $500-10,000.

Media: Considers oil, acrylic, watercolor, pastel, pen & ink, drawings, mixed media, collage, sculpture, woodcuts, wood engravings, linocuts, engravings, mezzotints, etchings and lithographs. Prefers oil, watercolor and acrylic.

Style: Exhibits impressionism, realism, color field, painterly abstraction and post modern works. Genres include landscapes, florals and figurative work. Prefers landscapes and abstraction. "We don't feel that we are representing any specific 'ism' in the art produced today, but rather intuitively seek individuals who are striving for a high level of quality in their form of expression. Thus, the mediums overlap the styles which overlap philosphies."

Terms: Accepts work on consignment (50% commission). Buys outright (50% retail price; 30 net days). Exclusive area representation required. Gallery provides insurance; shipping costs are shared. Prefers framed artwork.

Submissions: Send query letter with resume, brochure, slides, photographs and bio. Call or write to schedule an appointment to show a portfolio, which should include originals, slides, transparencies and photographs. Replies only if interested within 1 week. Files slides and bios.

WILDLIFE GALLERY, 172 Bedford St., Stamford CT 06901. (203)324-6483. FAX: (203)324-6483. Director: Patrick R. Dugan. Retail gallery. Represents 72 artists; emerging, mid-career and established. Exhibited artists include R. Bateman and R.T. Peterson. Sponsors 4 shows/year. Average display time 6 months. Open all year. Located downtown; 1,200 sq. ft. 30% of space for special exhibitions, 25% for gallery artists. Clientele: 20% private collectors, 10% corporate collectors. Overall price range: $300-10,000; most artwork sold at $500-3,000.

Media: Considers oil, acrylic, watercolor, pastel, original handpulled prints, woodcuts, wood engravings, engravings, lithographs and serigraphs. Most frequently exhibits acrylic, oil and watercolor.

Style: Exhibits realism. Genres include landscapes, florals, Americana, Western, wildlife and sporting art. Prefers realism. Does not want to see "impressionism, over-priced for the quality of the art."

Terms: Accepts work on consignment (50% commission). Retail price set by the gallery. Gallery provides promotion and contract; shipping costs are shared. Prefers unframed artwork.

Submissions: Send query letter with photographs, bio and SASE. Write to schedule an appointment to show a portfolio, which should include originals and photographs. Replies only if interested within 2 weeks. Files "all material, if qualified."

Tips: "Must be work done within last six months." Does not want "art that is old that artists have not been able to sell." Sees trend toward "more country scenes, back to 18th-century English art."

Delaware

DELAWARE CENTER FOR THE CONTEMPORARY ARTS, 103 E. 16th St., Wilmington DE 19801. (302)656-6466. Director: Steve Lanier. Nonprofit gallery. Estab. 1979. Clientele: Mostly middle- to upper-middle class locals; 100% private collectors. Represents 250 artists. Sponsors 9 solo/group shows/year. Average display time is 4 weeks. Interested in emerging and established artists. "Lean toward emerging artists." Overall price range: $50-4,000; most artwork sold at $500.

Media: Considers all media.

Style: Exhibits contemporary, abstracts, impressionism, figurative, landscape, non-representational, photorealism, realism and neo-expressionism. Prefers regional contemporary works.

Terms: Accepts work on consignment (35% commission). Retail price is set by gallery and artist. Exclusive area representation not required. Gallery provides insurance and promotion; shipping costs are shared.

Submissions: Send query letter, resume, slides and photographs. Write to schedule an appointment to show a portfolio. Slides are filed.

UNIVERSITY GALLERY, UNIVERSITY OF DELAWARE, 301 Old College, Newark DE 19716. (302)451-8242. FAX: (302)451-8000. Director/Curator: Belena S. Chapp. University affiliated gallery. Estab. 1978. Represents emerging, mid-career and established artists. Sponsors 8-12 shows/year. Average display time is 6 weeks to 2 months. Open all year. Located in heart of downtown Newark, DE; 2,500 sq. ft. in main gallery, 900 in West gallery; 1832 Greek Revival structure with 27-foot high ceilings. 100% of space for special exhibitions. 100% private collectors. Broad price range from student to established collectors.

Media: Considers all media and all types of prints. Most frequently exhibits works on paper, installation and sculpture.

Style: Considers all styles.

Submissions: "Our terms are in the process of review. Previously the university gallery took no commission." Retail price set by the artist. Gallery provides insurance, promotion and contract; shipping costs are shared. Prefers artwork framed or unframed (depends on exhibition).

District of Columbia

AARON GALLERY, 1717 Connecticut Ave. NW, Washington DC 20009. (202)234-3311. Manager: Annette Aaron. Retail gallery and art consultancy. Estab. 1970. Represents 35 artists, emerging, mid-career and established. Sponsors 18 shows/year. Average display time is 3-6 weeks. Open all year. Located on Dupont Circle. 2,000 sq. ft. Clients are private collectors and corporations. Overall price range: $500 and up; most artwork sold at $2,000-10,000.
Media: Considers oil, acrylic, watercolor, mixed media, collage, paper, sculpture, ceramic and installation. Most frequently exhibits sculpture, paintings and works on paper.
Style: Exhibits expressionism, painterly abstraction, imagism, color field, post-modern works, impressionism, realism and photorealism. Genres include florals. Most frequently exhibits abstract expressionism, figurative expressionism and post-modern works.
Terms: Accepts work on consignment (50% commission). Retail price is set by gallery and artist. Exclusive area representation required. Gallery provides promotion and contract; artist pays for shipping.
Submissions: Send query letter, resume, slides or photographs, reviews and SASE. Slides and photos should be labeled with complete information – dimensions, title, media, address, name and phone number. Write to schedule an appointment to show a portfolio, which should include originals and photographs. Slides, resume and brochure are filed.

AMERICAN WEST GALLERY, 1630 Connecticut Ave. NW, Washington DC 20009. (202)265-1630. Contact: Owner. Retail gallery. Estab. 1985. Open year round. Clientele: local collectors and tourists. Represents 25-30 artists. Accepts only artists from the Western U.S. Interested in emerging and established artists. Overall price range: $100-52,000.
Media: Considers oil, acrylic, watercolor, pastel, pen & ink, drawings, mixed media, collage, works on paper, sculpture, ceramic, woodcuts, wood engravings, engravings, mezzotints, etchings, lithographs and serigraphs.
Style: Exhibits impressionism, expressionism, realism, photorealism, surrealism, minimalism and primitivism. Genres include landscapes, wildlife, portraits and figurative work also Americana, Southwestern and Western themes. "We want to bring East the best of what's happening in the West: paintings, sculpture and ceramics mostly. We are quite diverse in style and theme."
Terms: Accepts work on consignment (50% commission). Retail price set by gallery and artist. Exclusive area representation required. Artist pays for shipping.
Submissions: Send query letter with resume, slides, SASE, photographs and bio. To show a portfolio mail slides, transparencies and photographs. Label each with media, size, title and price." Replies in 2 months.
Tips: "Be concise. Don't be too pushy, defensive or sensitive."

ARTEMIS, Suite M-003, 1120 20th St. NW, Washington DC 20036. (202)775-0916. Owner: Sandra Tropper. Retail and wholesale dealership and art consultancy. Clientele: 40% private collectors, 60% corporate clients. Represents more than 100 artists. Small office space with large spaces in the building complex for exhibition; no shows." 50% of total space devoted to hanging the work of gallery artists. Interested in emerging and mid-career artists. Overall price range: $100-10,000; most artwork sold at $500-1,500.
Media: Considers oil, acrylic, watercolor, mixed media, collage, works on paper, sculpture, ceramic, craft, fiber, glass, installations, woodcuts, engravings, mezzotints, etchings, lithographs, pochoir, serigraphs and offset reproductions. Most frequently exhibits prints, contemporary canvases and paper/collage.
Style: Exhibits impressionism, expressionism, realism, minimalism, color field, painterly abstraction, conceptualism and imagism. Genres include landscapes, florals and figurative work. "I want to bring together clients (buyers) with art they appreciate and can afford. For this reason I am interested in working with many artists."
Terms: Accepts work on consignment (50% commission). Retail price set by dealer and artist. Exclusive area representation not required. Gallery provides insurance and contract; shipping costs are shared. Prefers unframed artwork.
Submissions: Send query letter with resume, slides, photographs and SASE. Write to schedule an appointment to show a portfolio, which should include originals, slides, transparencies and photographs. Replies only if interested within 1 month. Files slides, photos, resumes and promo material. All material is returned if not accepted or under consideration.
Tips: "Everything is starting to look alike!"

ATLANTIC GALLERY OF GEORGETOWN, 1055 Thomas Jefferson St. NW, Washington DC 20007. (202)337-2299. FAX: (202)944-5471. Director: Virginia Smith. Retail gallery. Estab. 1976. Represents 10 artists. Sponsors 5 solo shows/year. Average display time is 2 weeks. Interested in mid-career and established artists. Exhibited artists include John Stobart and Alan Maley. Open all year. Located downtown; 700 sq. ft. Clients include corporate and individual collectors. Clientele: 70% private collectors, 30% corporate clients. Overall price range: $100-20,000; most artwork sold at $300-5,000.

Media: Considers oil, watercolor and limited edition prints. Most frequently exhibits oils, watercolor and limited edition prints.

Style: Exhibits realism and impressionism. Prefers realistic marine art, florals, landscapes and historic narrative leads.

Terms: Accepts work on consignment (40% commission). Retail price is set by gallery and artist. Exclusive area representation required. Gallery provides insurance, promotion and contract; artist pays for shipping.

Submissions: Send query letter, resume and slides. Portfolio should include originals and slides.

***BIRD-IN-HAND BOOKSTORE & GALLERY,** 323 7th St. SE, Box 15258, Washington DC 20003. (202)543-0744. Director: Christopher Ackerman. Retail gallery. Estab. 1987. Represents 76 emerging artists. Exhibited artists include Jane Wallace, Betty Ann MacDonald. Sponsors 16 shows/year. Average display time 3½ weeks. Located on Capitol Hill at Eastern Market Metro; 300 sq. ft.; space includes small bookstore, art and architecture. "Most of our customers live in the neighborhood." 100% private collectors. Overall price range: $75-1,650; most work sold at $75-350.

Media: Considers oil, pen & ink, paper, acrylic, drawing, sculpture, watercolor, mixed media, pastel, collage and photography; original handpulled prints, woodcuts, wood engravings, linocuts, engravings, etchings. Prefers small paintings, prints and photography. Also place sculpture for clients' home, office and garden.

Terms: Accepts work on consignment (40% commission). Retail price set by the gallery. Gallery provides insurance, promotion and contract; shipping costs are shared.

Submissions: Send query letter with resume, slides and SASE. Write to schedule an appointment to show a portfolio, which should include originals and slides. Replies in 1 month. Files resume; slides of accepted artists.

Tips: "We suggest a visit to the gallery before submitting slides. We show framed and unframed work of our artists throughout the year as well as at time of individual exhibition. Work is moderately priced."

***FOUNDRY GALLERY,** 9 Hillyer Court, Washington DC 20008. (202)387-0203. Membership Director: Randy Michenor. Cooperative gallery. Estab. 1975. Clientele: 80% private collectors; 20% corporate clients. Sponsors 10-20 solo and 2-3 group shows/year. Average display time 3 weeks. Interested in emerging artists. Overall price range: $100-2,000; most work sold at $100-1,000.

Media: Considers oil, acrylic, watercolor, pastel, pen & ink, drawings, mixed media, collage, paper, sculpture, ceramics, fiber, glass, installations and photography; also woodcuts, engravings, mezzotints, etchings, pochoir and serigraphs. Most frequently exhibits oil, acrylic, sculpture, paper and photography.

Style: Exhibits expressionism, painterly abstraction, conceptualism and hard-edge geometric abstraction. Prefers non-objective, expressionism and neo-geometric. "Foundry Gallery is an artist-run, self-supporting, alternative-space gallery. It was founded to encourage and promote Washington area artists and to foster friendship with artists and arts groups outside the Washington area. The Foundry Gallery is known in the Washington area for its promotion of contemporary/experimental works of art; therefore, the gallery is mainly interested in representing artists working with non-traditional ideas and media."

Terms: Co-op membership fee plus donation of time; 30% commission. Retail price set by artist. Exclusive area representation not required. Gallery provides insurance and a promotion contract. Prefers framed artwork.

Submissions: Send query letter with resume, slides, and SASE. "Local artists drop off actual work." Call or write to schedule an appointment to drop off a portfolio. Replies in 1 month.

Tips: "All works must be delivered by artist."

FOXHALL GALLERY, 3301 New Mexico Ave. NW, Washington DC 20016. (202)966-7144. Director: Jerry Eisley. Retail gallery. Sponsors 6 solo and 6 group shows/year. Average display time is 3 months. Interested in emerging and established artists. Overall price range: $500-20,000; most artwork sold at $1,500-6,000.

Media: Considers oil, acrylic, watercolor, pastel, sculpture, mixed media, collage and original handpulled prints (small editions).

Style: Exhibits contemporary, abstract, impressionistic, figurative, photorealistic and realistic works and landscapes.

Terms: Accepts work on consignment (50% commission). Retail price is set by gallery and artist. Exclusive area representation required. Gallery provides insurance.

Submissions: Send resume, brochure, slides, photographs and SASE. Call or write to schedule an appointment to show a portfolio.

GATEHOUSE GALLERY, Mount Vernon College, 2100 Foxhall Rd. NW, Washington DC 20007. (202)331-3416 or 3448. Associate Professor and Gatehouse Gallery/Director: James Burford. Nonprofit gallery. Estab. 1978. Clientele: college students and professors. Sponsors 7 solo and 2-3 group shows/year. Average display time: 3 weeks. Interested in emerging artists.

Media: Considers all media. Most frequently exhibits photography, drawings, prints and paintings.

Style: Exhibits all styles and all genres. "The exhibitions are organized to the particular type of art classes being offered."

Terms: Accepts work on consignment (20% commission). Retail price set by artist. Exclusive area representation not required. Gallery provides promotion and contract; artist pays for shipping.

Submissions: Send query letter with resume, brochure, slides or photographs. All material is returned if not accepted or under consideration.

GILPIN GALLERY, INC., 655 15th St. NW, Washington DC 20005. (202)393-2112. President: Maryanne Kowalesky. Retail gallery. Estab. 1982. Clientele: 80% private collectors, 20% corporate clients from Washington DC area. Represents 25 artists. Sponsors 4 solo shows/year. 90% of total space devoted to special exhibitions. Interested in emerging and established artists.

Media: Considers paintings, drawings, wearable prints and sculpture.

Style: Exhibits representational, impressionist, expressionist and abstract works.

Terms: Accepts work on consignment (50% commission). Buys outright (50% retail price). Retail price set by gallery and artist. Exclusive area representation not required. Gallery provides insurance, some promotion, contract and shipping from gallery. Prefers artwork framed.

Submissions: Send query letter with brochure and bio. Call or write to schedule an appointment to show a portfolio, which should include originals and photographs. Replies only if interested within 1 month. Files all material. All material is returned if not accepted or under consideration.

Tips: "Do not approach us on weekends or holidays. We prefer appointments."

***JANE HASLEM GALLERY/SALON,** Haslem Fine Arts, Inc., 2025 Hillyer Place NW, Washington DC 20009. (202)232-4644. President: Jane N. Haslem. Retail gallery. Estab. 1960. Open year round. Built in 1886-interior is Victorian and neo-classic. Clientele: collectors, institutions, museums etc., 60% private collectors; 40% corporate clients. Represents 50-75 artists. Sponsors 8 solo and 4 group shows/year. Average display time: 4 weeks. Interested in emerging and established artists. Overall price range: $500-25,000; most work sold at $500-5,000.

Media: Considers oils, acrylics, watercolors, pastels, pen & ink, drawings, mixed media, collages, paper and egg tempera, also woodcuts, wood engravings, linocuts, engravings, mezzotints, etchings, lithographs, pochoir and serigraphs. Specializes in paintings, prints and works on paper, recognizable and abstract imagery, all American artists.

Style: Exhibits realism, painterly abstraction and hard-edge geometric abstraction. Genres include landscapes, florals and figurative work.

Terms: Accepts work on consignment. Buys outright. Retail price set by gallery and artist. Exclusive area representation required. Gallery provides promotion and contract. Artist pays for shipping.

Submissions: Send query letter with resume, slides and SASE. To show a portfolio always send slides first, appointments arranged later. Replies in 6-12 month. Files only letters when we have asked for artist to make an appointment.

Tips: "Looks for professionalism, quality in work and determination."

THE INTERNATIONAL SCULPTURE CENTER, 1050 Potomac St. NW, Washington DC 20007. (202)965-6066. FAX: (206)965-7318. Curator of Exhibitions: David Furchgott. Nonprofit gallery. Represents emerging artists. Sponsors 4 shows/year. Average display time 3 months. Open all year. Located in Georgetown; "exhibition space is throughout office space; on three floors and in garden." 100% of space for special exhibitions. Clientele: architects, landscape architects, designers, art consultants and practicing artists. Overall price range: $300-5,000.

Media: Considers oil, acrylic, watercolor, pastel, pen & ink, drawings, mixed media, collage, works on paper, indoor (free-standing and pedestal) and outdoor sculpture, ceramic, craft, fiber, glass and photography. Most frequently exhibits sculpture, painting and photography.

Style: All styles. Prefers contemporary sculpture, conceptualism and contemporary figurative.

Terms: Retail price set by the artist. Gallery provides insurance. Artist provides transportation. Prefers framed artwork.

Submissions: Send query letter with resume, slides, bio and SASE. Write to schedule an appointment to show a portfolio, which should include slides and transparencies. Replies in 3 weeks to 2 months. "Files all artists that would be considered unless the artist requests immediate return. Slides also sent to Sculpture Source at artist's request."

OSUNA GALLERY, 1919 Q St. NW, Washington DC 20009. (202)296-1963. FAX: (202)296-1965. Director: Andrew Cullinan. Retail gallery. Estab. 1969. Represents 20 emerging, mid-career and established artists. Exhibited artists include Carlos Alfonzo and Anne Truitt. Sponsors 10 shows/year. Average display time 1 month. Open all year. 1,500 sq. ft. 100% of space for gallery artists. Clientele: 80% private collectors, 20% corporate collectors. Overall price range: $1,000-20,000; most artwork sold at $5,000-8,000.

Media: Considers oil, acrylic, watercolor, pastel, pen & ink, drawings, mixed media, collage, works on paper and sculpture. Most frequently exhibits oil, acrylic, sculpture.
Style: Exhibits painterly abstraction, color field and realism.
Terms: Accepts work on consignment (50% commission). Gallery provides insurance and promotion; gallery pays for shipping costs from gallery. Prefers framed artwork.
Submissions: Send resume, slides, bio and SASE. Write to schedule an appointment to show a portfolio, which should include slides and transparencies. Replies in 3 weeks. Files slides and resume.

HOLLY ROSS GALLERY, 516 C St. NE, Washington DC 20002. (202)544-0400. Art Consultant: Sheryl Ameen. Retail gallery and art consultancy. Estab. 1981. Located in capitol hill. Clientele: 60% private collectors, 40% corporate clients. Represents 700 artists. Interested in emerging, mid-career and established artists. Overall price range: $75-10,000; most artwork sold at $900-3,500.
Media: Considers all media. Most frequently exhibits paintings, prints and sculpture.
Style: Exhibits impressionism, expressionism, realism, photorealism and painterly abstraction. Genres include landscapes, Americana, Southwestern, Western and figurative work. Prefers abstraction, photorealism and realism. "Our businesss is based in the service-oriented consulting field. Most of our sales are through our consultants. Working with a client to help them find that perfect piece is what our business is all about. We also do museum picture-quality framing and canvas/paper conservation work."
Terms: Accepts work on consignment (40% commission). Retail price set by artist. Exclusive area representation not required. Gallery provides insurance, contract and shipping costs from gallery negotiable.
Submissions: Send query letter with resume, slides and price information. Call or write to schedule an appointment to show a portfolio, which should include originals and slides. Replies in 2-4 weeks. Files bio, slides and some original work. All material is returned if not accepted or under consideration.

ANDREA RUGGIERI GALLERY, 2030 R St., Washington DC 20009. (202)265-6191. Owner: Andrea F. Ruggieri. Retail gallery. Estab. 1986. Clientele: 40% private collectors, 60% corporate clients. Represents 10 artists. Sponsors 8 solo and 2 group shows/year. Average display time is 1 month. Interested in emerging and established artists. Overall price range: $300-100,000.
Media: Considers oil, watercolor, pastel, pen & ink, drawings, mixed media, sculpture and prints.
Style: Exhibits representational works and abstraction. "We specialize in contemporary painting, works on paper and sculpture."
Terms: Accepts work on consignment (50% commission). Retail price is set by gallery and artist. Exclusive area representation required. Gallery provides all promotion and contract; artist pays for 50% of shipping.
Submissions: Send letter, resume, brochure, slides and SASE. "Slides of artists we are interested in are given consideration over a period of 1 month."

SCULPTURE PLACEMENT, LTD., Box 9709, Washington DC 20016. (202)362-9310. Curator: Paula A. Stoeke. Art management business. Estab. 1980. Clientele: 50% private collectors; 50% corporate clients. Sponsors 20 solo and 4-5 group shows/year. Average display time: 6 weeks. Considers only large outdoor sculpture. Interested in emerging and established artists. Overall price range: $60,000-180,000; most work sold at $80,000.
Media: Considers sculpture, especially bronze sculpture, cast metal and stone.
Style: Exhibits realistic and abstract sculpture. "We arrange exhibitions of travelling sculpture for corporate locations, museums, sculpture gardens and private estates. We are exclusive agents for the American realist, bronze sculptor J. Seward Johnson, Jr."
Submissions: Send query letter with slides, photographs and SASE. "Do not contact us by phone." Replies only if interested within 3 months.
Tips: "Simply send a couple of slides with letter. We keep slide bank. Please do not contact by phone." Wants to see "fine craftsmanship (no pedestal pieces, please)".

SPECTRUM GALLERY, 1132 29th St. NW, Washington DC 20007. (202)333-0954. Director: Anna G. Proctor. Retail/cooperative gallery. Estab. 1966. Located in Georgetown. Open year round. Clientele: 80% private collectors, 20% corporate clients. Represents 29 artists. Sponsors 10 solo and 3 group shows/year. Average display time: 4 weeks. Accepts only artists from Washington area. Interested in mid-career artists. Overall price range: $50-5,000; most artwork sold at $450-900.
Media: Considers oil, acrylic, watercolor, pastel, pen & ink, drawings, mixed media, collage, works on paper, sculpture, ceramic, fiber, woodcuts, mezzotints, etchings, lithographs and serigraphs. Most frequently exhibits acrylic, watercolor and oil.
Style: Exhibits impressionism, realism, minimalism, painterly abstraction, pattern painting and hard-edge geometric abstraction. Genres include landscapes, florals, Americana, portraits and figurative work. "Spectrum Gallery, one of the first cooperative galleries organized and operated in the Washington area, was established to offer local artists an alternative to the restrictive representation many galleries were then providing. Each artist at Spectrum is actively involved in the shaping of Gallery policy as well as the maintenance and operation of the Gallery. The traditional, the abstract, the representational and the experimental

can all be found here. Shows are changed every four weeks and each artist is represented at all times. Presently there are 29 members of the Gallery."

Terms: Co-op membership fee plus donation of time; 35% commission. Retail price set by artist. Exclusive area representation not required. Gallery provides promotion and contract.

Submissions: Bring actual painting at jurying; application forms needed to apply.

Tips: "Artists must live in the Washington area because of the cooperative aspect of the gallery. A common mistake artists make in presenting their work is not knowing we are a cooperative gallery."

TAGGART & JORGENSEN GALLERY, 3241 P St. NW, Washington DC 20007. (202)298-7676. Gallery Manager: Lauren Rabb. Retail gallery. Estab. 1978. Located in Georgetown. Clientele: 80% private collectors, 10% corporate clients. Represents 2 living artists. Interested in seeing the work of emerging, mid-career and established artists. Sponsors 2 group shows/year. Average display time: 1 month. "Interested only in artists working in a traditional, 19th century-style." Overall price range: $1,000-1,000,000; most artwork sold at $20,000-500,000.

Media: Considers oil, watercolor, pastel, pen & ink and drawings.

Style: Exhibits impressionism and realism. Genres include landscapes, florals and figurative work. Prefers figurative work, landscapes and still lifes. "We specialize in 19th and early 20th century American and European paintings, with an emphasis on American Impressionism. We are interested only in contemporary artists who paint in a traditional style, using the traditional techniques. As we plan to handle very few contemporary artists, the quality must be superb."

Terms: Buys outright (50% retail price; immediate payment). Retail price set by gallery and artist. Exclusive area representation required. Gallery provides insurance, promotion, contract and shipping costs to and from gallery. Prefers unframed artwork.

Submissions: "Please call first; unsolicited query letters are not preferred. Looks for technical competence. We do *not* want to see anything done in acrylic!"

Tips: "Collectors are more and more interested in seeing traditional subjects handled in classical ways. Works should demonstrate excellent draughtsmanship and quality."

TOUCHSTONE GALLERY, 2009 R St. NW, Washington DC 20009. (202)797-7278. Director: Mary Sawchenko. Cooperative gallery. Estab. 1977. Clientele: 80% private collectors, 20% corporate clients. Represents 40 artists. Sponsors 9 solo and 4 group shows/year. Average display time 3 weeks. Interested in emerging, mid-career and established artists. Overall price range: $200-5,000; most artwork sold at $600-2,000.

Media: Considers all media. Most frequently exhibits paintings, sculpture and prints.

Style: Exhibits all styles and all genres. "We show mostly contemporary art from the Washington DC area."

Terms: Co-op membership fee plus donation of time; 40% commission. Retail price set by artist. Exclusive area representation not required. Prefers framed artwork.

Submissions: Send query letter with SASE. Portfolio should include originals and slides. All material is returned if not accepted or under consideration. The most common mistake artists make in presenting their work is "showing work from each of many varied periods in their careers."

***WASHINGTON PRINTMAKERS GALLERY,** 2106 R St. NW, Washington DC 20008. (202)337-7757. Director: Mark Ouellette. Cooperative gallery. Estab. 1985. Represents 35 established artists/year. Interested in seeing the work of emerging artists. Exhibited artists include George Chung and Barbara Barrett Caples. Sponsors 12 exhibitions/year. Average display time 1 month. Open all year. Located "in town area, on a gallery row"; 1,500 sq. ft.; "English basement setting with back garden area." 33% of space for special exhibitions. Clientele: varied. 75% private collectors, 25% corporate collectors. Overall price range: $95-850; most work sold at $125-450.

Media: Considers paper; all types of prints. Most frequently exhibits etchings, lithographs and monotypes.

Style: Considers all styles and genres.

Terms: Co-op membership free plus donation of time (6% commission). Retail price set by the artist. Gallery provides insurance, promotion and contract; shipping costs from gallery. Prefers artwork framed.

Submissions: Send query letter with resume, slides and bio. Call to schedule an appointment to show a portfolio, which should include originals, slides and transparencies. Replies in 2 weeks.

Tips: "There is a yearly jury in April for prospective new members."

WASHINGTON PROJECT FOR THE ARTS, 400 7th St. NW, Washington DC 20004. (202)347-4813. Contact: Program Review Committee. Alternative space. Estab. 1975. Interested in seeing the work of and representing emerging and mid-career artists. Has 1,200 members. Sponsors 12 shows/year. Average display time 8-10 weeks. Open all year. Located downtown, near the Mall, 7,500 sq. ft.; artist-designed bookstore, stairway, bathrooms, apartment and media facilities. 100% of space for special exhibitions. Clientele: young, 25-35, well-educated professionals. No sales.

Media: Considers all types, including video, performance and book art. Most frequently exhibits painting, sculpture, print and video media and photography.
Style: Contemporary.
Terms: Artists are paid an honorarium or commission for their work. Gallery provides insurance and promotion. Gallery pays for shipping costs to and from gallery. Prefers framed artwork.
Submissions: Send resume, slides, bio, brochure, photographs, SASE, business card and reviews; as much information as possible. Write to schedule an appointment to show a portfolio. Replies in 3 months. Will file all materials.
Tips: Looks for artists who have "the ability to ask difficult questions in their work, thereby stimulating discussion on the important issues of our times." Trends include "multi-culturalism in exhibitions; artists of various ethnic and religious backgrounds who explore community issues and address social and political issues."

Florida

ALBERTSON-PETERSON GALLERY, 329 S. Park Ave., Winter Park FL 32789. (407)628-1258. FAX: (407)628-0596. Owner: Louise Peterson. Director: Judy Albertson. Retail gallery and art consultancy. Estab. 1984. Represents 15-20 artists; emerging, mid-career and established. Sponsors 4-6 shows/year. Average display time 3½ weeks. Open all year. Located downtown; 3,000 sq. ft.; "on a prominent street, a lot of glass, good exposure." 75% of space for special exhibitions, 75% for gallery artists. Clientele: 50% private collectors, 50% corporate collectors. Overall price range: $5,000-12,000; most work sold at $100-3,000.
Media: Considers oil, acrylic, watercolor, pastel, mixed media, collage, works on paper, sculpture, ceramic, craft, glass, photography, woodcuts, wood engravings, engravings, lithographs, etchings. Most frequently exhibits paintings, sculptures, glass and clay.
Style: Exhibits painterly abstraction, imagism, color field, pattern painting and all contemporary work.
Terms: Accepts work on consignment (50% commission). Retail price set by the gallery. Gallery provides insurance, promotion and contract; shipping costs are shared. "We want canvas-stretched works on paper not framed works."
Submissions: Send query letter with resume, slides, bio, photographs, SASE and reviews. Call or write to schedule an appointment to show a portfolio, which should include slides, bio, resume and statement. Replies in 1 month. "We always give some answer." Files bios and reviews.
Tips: "Know our gallery and the kind of work we like to exhibit – i.e. quality and contemporary feeling."

BACARDI ART GALLERY, 2100 Biscayne Blvd., Miami FL 33137. (305)573-8511. Contact: Director. Nonprofit gallery. Estab. 1963. Sponsors 4 solo and 6 group shows/year. Average display time is 5 weeks. Interested in emerging and established artists.
Media: Considers all media.
Style: Considers all styles. "As a community service in the visual arts, we seek to bring important artists or collections to our community, as well as present notable examples of either from our own resources in South Florida."
Terms: "We do not charge fee, commission or buy works." Gallery provides insurance, promotion and contract.
Submissions: Send query letter with resume, slides and SASE. Resume and slides are filed "if given permission to retain them."
Tips: "Looks for quality and professional standards."

CIRCLE GALLERIE MARTIN, (formerly Gallerie Martin), 417 Town Center Mall, Boca Raton FL 33431 (407)395-3050. All artwork purchased through Circle Fine Art Corp, 303 E. Wacker Dr., Chicago IL 60611. (312)616-1300. Retail gallery. Estab. 1968. Clientele: 85% private collectors; 15% corporate clients. Represents 75 artists. Sponsors 4 solo and 8 group shows/year. Average display time: 3 weeks. Accepts only artists that are exclusively ours. Interested in emerging and established artists. Overall price range: $1,500-30,000; most work sold at $900-7,500.
Media: Considers oil, acrylic, watercolor, mixed media, sculpture, lithographs and serigraphs. Most frequently exhibits oil, acrylic and sculpture.
Style: Exhibits impressionism, expressionism, primitivism, painterly abstraction and pattern painting. Genres include landscapes, figurative work; considers all genres. Prefers impressionism, expressionism and abstraction. Looks for "new concepts of art that are pleasing to the eye."
Terms: Buys outright (50% retail price; net 30 days). Retail price set by gallery and artist. Exclusive area representation required. Gallery provides insurance and promotion; shipping costs are shared.
Submissions: Send query letter with resume and slides. Call or write to schedule an appointment to show a porfolio, which should include originals. Replies only if interested within 2 weeks.
Tips: "Professionalism is a must."

CLAYTON GALLERIES, INC., 4105 S. MacDill Ave., Tampa FL 33611. (813)831-3753. Director: Cathleen Clayton. Retail Gallery. Estab. 1986. Represent 28 emerging and mid-career artists. Exhibited artists include Billie Hightower and Craig Rubadoux. Sponsors 7 shows/year. Average display time 5-6 weeks. Open all year. Located in the southside of Tampa 1 block from the bay; 1,400 sq. ft.; "post modern interior with glass bricked windows, movable walls, center tiled platform." 30% of space for special exhibitions. Clientele: 40% private collectors, 60% corporate collectors. Prefers Florida or Southeastern artists with M.F.A.s. Overall price range: $100-15,000; most artwork sold at $500-2,000.
Media: Considers oil, pen and ink, paper, fiber, acrylic, sculpture, glass, watercolor, mixed media, ceramic, pastel, craft, photography, original handpulled prints, woodcut, wood engraving, engraving, mezzotint, etching, lithograph, collagraphs and serigraph. Prefers oil, metal sculpture and mixed media.
Style: Considers neo-expressionism, painterly abstraction, post-modern works, realism and hard-edge geometric abstraction. Genres include landscapes and figurative work. Prefers figurative, abstraction and realism—"realistic, dealing with Florida, in some way figurative."
Terms: Accepts work on consignment (50% commission). Retail price set by gallery and the artist. Gallery provides insurance, promotion and contract; artist pays for shipping. Prefers unframed artwork.
Submissions: Prefers Florida artists. Send resume, slides, bio, SASE and reviews. Write to schedule an appointment to show a portfolio, which should include photographs and slides. Replies in 6 month. Files slides and bio, if interested.
Tips: Looking for artist with "professional background i.e., B.A. or M.F.A. in art, awards, media coverage, reviews, collections, etc." A mistake artists make in presenting their work is being "not professional, i.e., no letter of introduction, poor or unlabeled slides, no, or incomplete, resume."

THE DE LAND MUSEUM OF ART INC., 600 N. Woodland Blvd., De Land FL 32720. (904)734-4371. Executive Director: Harry Messersmith. Museum. Represents emerging, mid-career and established artists. Sponsors 6-8 shows/year. Open all year. Located "downtown; 5,100 sq. ft.; in The Cultural Arts Center. Clientele: 95% private collectors, 5% corporate collectors. Overall price range: $100-30,000; most work sold at $300-5,000.
Media: Considers oil, acrylic, watercolor, pastel, works on paper, sculpture, ceramic, woodcuts, wood engravings, engravings and lithographs. Most frequently exhibits paintings, sculpture, photographs and prints.
Style: Exhibits expressionism, surrealism, imagism, impressionism, realism and photorealism; all genres. Looks for quality, innovation, skill, craftsmanship, content, concept at the foundation—any style or content meeting these requirements considered.
Terms: Accepts work on consignment (30% commission), for exhibition period only. Retail price set by artist. Gallery provides insurance, promotion and contract; shipping costs may be shared.
Submissions: Send resume, slides, bio, brohcure, SASE and reviews. Write to schedule an appointment to show a portfolio, which should include slides. Replies in 1 month. Files slides and resume.
Tips: "Artists should have a developed body of artwork and an exhibition history that reflects the artists commitment to the fine arts. Museum contracts 2-3 years in advance."

***PETER DREW GALLERY**, The Crocker Center, Suite 247, 5050 Town Center Circle, Boca Raton FL 33486. (407)391-4348 or (407)734-4099. Director: Linda Fleetwood. Retail gallery. Estab. 1982. Clientele: 90% private collectors; 10% corporate clients. Represents 34 artists. Sponsors 9 two-person and 16 group shows/year. Interested in emerging and established artists. Overall price range: $300-25,000; most work sold at $3,000-15,000.
Media: Oils, acrylics, watercolors, mixed media, collages, sculpture, ceramics, installations and photography; also original handpulled mono prints. Most frequently exhibits mixed media, sculpture, acrylic painting and oil painting.
Style: Exhibits hyper-surrealism, photorealism, painterly abstraction, and abstract illusionist. All style and genres are reviewed and considered, but must be "strictly contemporary—*no* abstract expressionist." Prefers photorealism, painterly abstraction and realism.
Terms: Terms and representation negotiated upon acceptance. Retail price set by gallery and artist. Exclusive area representation required. Gallery provides contract. Prefers artwork framed.
Submissions: Call to schedule an appointment to show a portfolio, which should include transparencies and photographs. Replies in 6-9 months.
Tips: "Last year we decided to narrow down our exhibits to primarily notable regional artists. We will view works of all mediums, however Florida artists have best opportunity of exhibiting." Walk-ins are discouraged. "Although galleries are often quiet, this does not mean that business is at a standstill, most sales and outside exhibitions are handled through correspondence."

EDISON COMMUNITY COLLEGE, GALLERY OF FINE ART, Box 6210, 8099 College Pky., Ft. Myers FL 33906. (813)489-9313. Curator: James H. Williams. Nonprofit gallery, college gallery. Estab. 1979. Has about 200 members. Sponsors 14-15 shows/year. Average display time 1 month. Open all year. Located on college campus; 4,500 sq. ft. 100% of space for special exhibitions. Clientele: general public. Most work sold at $50-1,000.

Media: Considers all fine art media; no offset lithographs except some signed posters. Most frequently exhibits painting, sculpture, ethnic and folk art.

Style: Exhibits all styles and genres "except wildlife and Americana."

Terms: Artists accepted for exhibition may sell art objects on view. Retail price set by artist. Gallery provides insurance and promotion; gallery pays for shipping costs "usually one way, sometimes both ways for major artists." Prefers framed artwork.

Submissions: Send resume and slides. Write to schedule an appointment to show a portfolio, which should include slides or transparencies. Replies in 3 months. Files resumes.

Tips: "Slides and resumes should reflect actual work and collections/exhibition record, with references."

FLORIDA STATE UNIVERSITY GALLERY & MUSEUM, Copeland & W. Tennessee St., Tallahassee FL 32306-2037. (904)644-6836. Gallery Director: Allys Palladino-Craig. University gallery and museum. Estab. 1970. Represents over 100 artists; emerging, mid-career and established. Sponsors 12-22 shows/year. Average display time 3-4 weeks. Located on the university campus; 16,000 sq. ft. 50% of space for special exhibitions.

Media: Considers all media, including electronic imaging and performance art. Most frequently exhibits painting, sculpture and photography.

Style: Exhibits all styles "but portraiture, Western, wildlife and florals have not figured in an exhibition in recent memory." Prefers contemporary figurative and non-objective painting, sculpture, print making.

Terms: "Sales are almost unheard of; the gallery takes no commission." Retail price set by the artist. Gallery provides insurance and promotion; gallery pays for shipping costs to and from gallery for invited artists.

Submissions: Send query letter with resume, slides, bio, brochure, photographs, reviews and SASE. Write to schedule an appointment to show a portfolio, which should include slides. Replies in 1½-2 months from faculty and steering committee.

Tips: "Almost no solo shows are granted; artists are encouraged to enter our competition – the FL National (annual deadline for two-slide entries is Halloween); show is in the spring; curators use national show to search for talent."

FOSTER HARMON GALLERIES OF AMERICAN ART, 1415 Main St., Sarasota FL 34236. (813)955-1002. Owner/Director: Foster Harmon. Retail gallery. Naples gallery estab. 1964, Sarasota galleries estab. 1980. Represents over 100 established artists. Exhibited artists include Milton Avery and Will Barnet. Sponsors 24 shows/year (in 3 galleries). Average display time 3-4 weeks. Closed September and half of October. Located downtown, 3,500 sq. ft.; built as an art sales gallery. "A handsome, modern facility." 100% of space for special exhibitions. Clientele: all kinds. 90% private collectors, 10% corporate collectors. Overall price range: $300-350,000; most work sold at $2,000-20,000.

Media: Considers oil, pen & ink, paper, acrylic, drawing, sculpture, glass, watercolor, mixed media, pastel and collage. Most frequently exhibits paintings, sculpture and drawings.

Style: Exhibits all styles. Genres include landscapes, florals, Americana, portraits, abstract.

Terms: Accepts work on consignment (40-50% commission). Retail price set by artist. Exclusive area representation required. Gallery provides insurance and promotion; artist pays for shipping. Prefers framed artwork.

Submissions: Send query letter with resume, brochure, slides and SASE. Call or write to schedule an appointment to show a portfolio, which should include originals; "this is after previous step." Replies in weeks. Materials are not filed.

Tips: Artist "should already be represented in museums and other public collections."

GALLERY CAMINO REAL, 608 Banyan Trail, Boca Raton FL 33431. (407)241-1606 or 1607. Associate Director: William Biety. Retail gallery. Estab. 1971. Represents 25 emerging, mid-career and established artists. Interested in seeing the work of emerging artists. Exhibited artists include Jules Olitski and Robert Lowe. Sponsors 10 shows/year. Average display time 3 weeks. Open all year. Located in central Boca Raton; 3,500 sq. ft.; "high-tech industrial spaces; a center with five galleries." 40% of space for special exhibitions. Clientele: collectors, designers, corporations. 60% private collectors. "We only review work submitted through the mail." Overall price range: $500-500,000; most artwork sold at $4,000-30,000.

Media: Considers oil, acrylic, watercolor, pastel, drawings, mixed media, collage, works on paper, sculpture, ceramic, fiber, original handpulled prints, woodcuts, wood engravings, linocuts, engravings, mezzotints, etchings, lithographs and serigraphs. Most frequently exhibits paintings, sculpture and clay.

Style: Exhibits expressionism, neo-expressionism, painterly abstraction, minimalism, color field and photorealism. Prefers painterly abstract, figurative and color field works.

Terms: Accepts work on consignment (50% commission). Retail price set by artist. Gallery provides insurance and promotion; shipping costs are shared. Prefers framed artwork.

Submissions: "We only review work submitted through the mail." Send resume, slides, bio and reviews. Write to schedule an appointment to show a portfolio, which should include slides and transparencies. Replies in 2 weeks. Files "only resumes of artists of interest."

Tips: "Include return postage-paid envelope for return of materials; be as familiar as possible with the gallery and the work exhibited there."

CAROL GETZ GALLERY, Suite 15-F, 2843 S. Bayshore Dr., Coconut Grove FL 33133. (305)448-3243. Director/Owner: Carol Getz. Retail gallery. Estab. 1987. Represents 12 mid-career and established artists. Interested in seeing the work of emerging artists. Exhibited artists include Michelle Spark, Judith Glantzman, Steve Miller, Marilyn Minter and Michael Mogavero. Sponsors 8 shows/year. Average display time 6 weeks. Open fall and spring. Located in center of Coconut Grove; 900 sq. ft.; "glass walls, so the work can be seen even when gallery is closed." 100% of space for special exhibitions. Clientele: all ages—mostly upper middle class. 85% private collectors, 15% corporate collectors. Overall price range: $400-15,000; most artwork sold at $4,000-6,000.

Media: Considers oil, acrylic, watercolor, pastel, pen & ink, drawings, mixed media, collage, works on paper, woodcuts, linocuts, engravings, mezzotints, etchings, lithographs, pochoir and serigraphs. Most frequently exhibits paintings, prints and drawings.

Style: Exhibits expressionism, neo-expressionism, primitivism, painterly abstraction, conceptualism, minimalism and realism. Prefers new image (combination of object and abstraction) and figurative abstraction.

Terms: Accepts work on consignment (40-50% commission). Retail price set by gallery and artist. Gallery provides insurance and promotion; gallery pays for shipping costs to and from gallery. Prefers unframed artwork.

Submissions: Accepts only artists from New York area (NJ, CT, etc.). Prefers only paintings, drawings and prints. "Artist must have shown before at reputable galleries and have a comprehensive resume." Send resume, slides and bio. Call to schedule an appointment to show a portfolio. Replies in 1 month.

Tips: "Send slides and resumes first with SASE."

GREENE GALLERY, 1090 Kanc Concourse, Miami FL 33154. (305)865-6408. President: Barbara Greene. Retail gallery/art consultancy. Open all year. Clientele: 75% private collectors; 25% corporate clients. Sponsors 8-10 group shows/year. Average display time: 4 weeks. Interested in emerging and established artists.

Media: Considers oil, acrylic, watercolor, pastel, pen & ink, drawings, mixed media, collage, works on paper, sculpture, ceramic, woodcuts, wood engravings, linocuts, engravings, etchings, lithographs, pochoir and serigraphs. Most frequently exhibits paintings, prints and sculptures.

Style: Exhibits very little realism—mostly contemporary art, minimalism, color field, painterly abstraction, conceptualism, post modern works and hard-edge geometric abstraction. Genres include landscapes, florals and figurative work. Prefers abstraction, geometric and post modernism. "The gallery handles paintings and prints by leading and emerging artists. Geometric and abstact art is the gallery's main interest. The gallery is also interested in new image work of high quality."

Terms: Exclusive area representation required.

Submissions: Send query letter with resume, slides, SASE, photographs and bio. Call or write to schedule an appointment to show a portfolio, which should include originals, slides, transparencies and photographs. Replies in 1 weeks. Files slides, photo, bio and reviews.

THE HANG-UP, INC., 45 S. Palm Ave., Sarasota FL 34236. (813)953-5757. President: F. Troncale. Retail gallery. Estab. 1971. Represents 25 emerging, mid-career and established artists. Sponsor 6 shows/year. Average display time 1 month. Open all year. Located in arts and theater district downtown;" 1,700 sq. ft. "High tech, 10 ft. ceilings with street exposure in restored hotel." 50% of space for special exhibitions; 50% of space for gallery artists. Clientele: 75% private collectors, 25% corporate collectors. Overall price range: $1,000-5,000; most artwork sold at $500-1,000.

Media: Considers oil, acrylic, watercolor, mixed media, collage, works on paper, sculpture, original hand-pulled prints, lithographs, etchings, serigraphs, posters and offset reproductions. Most frequently exhibits paintings, graphics and sculpture.

Style: Exhibits expressionism, painterly abstraction, surrealism, impressionism, realism and hard-edge geometric abstraction. Genres include landscape and all other genres but prefers abstraction, impressionism and surrealism.

Terms: Accepts artwork on consignment (40% commission) or buys outright for 50% of the retail price (net 30 days). Retail price set by gallery. Gallery provides insurance, promotion and contract; shipping costs are shared. Prefers unframed work.

Submissions: Send resume, brochure, slides, bio and SASE. Write to schedule an appointment to show a portfolio which should include originals and photographs. Replies in 1 week.

IRVING GALLERIES, 332 Worth Ave., Palm Beach FL 33480. (407)659-6221. FAX: (407)659-0567. Director: Holden Luntz. Retail gallery. Estab. 1959. Represents 15 artists; established. Not interested in seeing the work of emerging artists. Exhibited artists include Botero, Frankenthaler, Motherwell, Stella and Pomodovo. Closed for August. Located on main shopping street in town; 2,600 sq. ft. 100% of space for gallery artists. Clientele: "major 20th century collectors." 85% private collectors, 15% corporate collectors. Overall price range: $2,000 and up; most work sold at $20,000 and up.

Media: Considers oil, acrylic, watercolor, pastel, pen & ink, drawings, mixed media, works on paper and sculpture. Most frequently exhibits acrylic, oil, and bronze.
Style: Exhibits expressionism, painterly abstraction, color field, post modern works and realism. Genres include landscapes, florals and Americana.
Terms: Prefers framed artwork.
Submissions: Send query letter with resume, slides and bio. Call or write to schedule an appointment to show a portfolio, which should include slides and transparencies. Replies in 3 weeks.

J. LAWRENCE GALLERY, 1010 E. New Haven Ave., Melbourne FL 32901. (407)728-7051. Director/Owner: Joseph L. Conneen. Retail gallery. Estab. 1980. Represents 180 emerging, mid-career and established artists. Interested in seeing work of emerging artists. Exhibited artists include Kiraly and Mari Conneen. Sponsors 10 shows/year. Average display time 3 weeks. Open all year. Located downtown; 6,500 sq. ft. 50% of space for special exhibitions. Clientele: 80% private collectors, 20% corporate collectors. Overall price range: $2,000-150,000; most work sold at $2,000-15,000.
Media: Considers oil, acrylic, watercolor, pastel, sculpture, ceramic, glass, original handpulled prints, mezzotints, lithographs and serigraphs. Most frequently exhibits oil, watercolor and silkscreen.
Style: Exhibits expressionism, painterly abstraction, impressionism, realism, photorealism and hard-edge geometric abstraction; all genres. Prefers realism, abstract and hard-edge works.
Terms: Accepts work on consignment (40% commission). Retail price set by gallery. Gallery provides insurance and promotion; artist pays for shipping.
Submissions: Prefers resumes from established artists. Send resume, slides and SASE. Write to schedule an appointment to show a portfolio, which should include originals and slides.

NAPLES ART GALLERY, 275 Broad Ave. S., Naples FL 33940. (813)262-4551. Owners: Warren C. Nelson and William R. Spink. Retail gallery. Estab. 1965. Clientele: 95% private collectors, 5% corporate clients. Represents 63 artists. Sponsors 13 solo and 20 group shows/year. Average display time is 3 weeks. Interested in emerging and established artists. Overall price range: $2,000-30,000; most artwork sold at $2,000-15,000.
Media: Considers oil, acrylic, watercolor, drawings, mixed media, collage, works on paper, sculpture and glass. Most frequently exhibits oils, acrylics and glass. Currently looking for glass and paintings.
Style: Exhibits primitivism, impressionism, photorealism, expressionism and realism. Genres include landscapes, florals, Americana, figurative work and fantasy. Most frequently exhibits realism, impressionism and abstract. Currently seeking abstract.
Terms: Accepts work on consignment. Retail price is set by artist. Exclusive area representation required. Gallery provides insurance, promotion and agreement; shipping costs are shared.
Submissions: Send query letter with resume and slides. Write to schedule an appointment to show a portfolio, which should include slides and transparencies.

NORTON GALLERY OF ART, 1451 S Olive Ave., West Palm Beach FL 33401. (407)832-5194. Director: Christina Orr-Cahall. Curator of Collections: David Setford. Museum. Estab. 1940. Open year round. Closed Mondays. Clientele: 50% residents, 50% tourists. Sponsors 2 solo and 4 group shows/year. Average display time for a temporary exhibit 6 weeks. Interested in emerging and established artists.
Submissions: Send query letter with resume, slides, photographs and bio. Call or write to schedule an appointment to show a portfolio, which should include slides, transparencies and photographs. Replies in 2 weeks. Files slides and resumes.

NUANCE GALLERIES, 720 S. Dale Mabry, Tampa FL 33609. (813)875-0511. Owner: Robert A. Rowen. Retail gallery. Estab. 1981. Represents 50 artists; mid-career and established. Exhibited artists include Mary Alice Braukman and Alvar. Sponsors 3 shows/year. Open all year. 3,000 sq. ft.
Terms: Accepts work on consignment (50% commission). Retail price set by the gallery and the artist. Gallery provides insurance and contract; shipping costs are shared.
Submissions: Send query leter with slides and bio. Replies in 1-2 weeks.
Tips: "Be professional; set prices (retail) and stick with them."

PARK SHORE GALLERY, 3333 Tami Ami Trail N., Naples FL 33940. (813)434-0833. Artistic Director: Evan J. Obrentz. Retail gallery. Estab. 1984, renamed and relocated in 1987. Clientele: upscale tourists, winter residents and locals; 60% private collectors, 10% corporate clients. Represents 66 artists. Sponsors 6 solo and 7-8 group shows/year. Average display time for exhibitions 2½ weeks; for gallery artists 2-3 months. Interested in established artists. Overall price range: $300-35,000; most artwork sold at $2,000-12,000.
Media: Considers oil, acrylic, watercolor, mixed media, collage, sculpture, ceramic, glass, etchings, lithographs and serigraphs. Prefers paintings, bronze sculptures and fine prints.
Style: Exhibits impressionism, expressionism, neo-expressionism, realism, surrealism, painterly abstraction and post modern works. Genres include landscapes, florals, Southwestern and figurative work. Prefers impressionism, realism and figurative work. "Quality is our overall measure of acceptance; professionalism is desired."

Terms: Accepts work on consignment (50% commission). Retail price set by gallery and artist. Exclusive area representation required. Gallery provides insurance, promotion, contract and shipping costs from gallery. Prefers framed artwork.

Submissions: Send query letter with resume, brochure, slides, photographs, bio and SASE. Write to schedule an appointment to show a portfolio, which should include originals, slides, photographs and suggested retail price list. Replies only if interested within 4 weeks. Files resume, bio and brochures. All material is returned if not accepted or under consideration.

PENSACOLA MUSEUM OF ART, 407 S. Jefferson, Pensacola FL 32501. (904)432-6247. Director: Kevin J. O'Brien. Nonprofit gallery/museum. Estab. 1954. Open year round. Located in the historic district. Renovated 1906 old city jail. Clientele: 90% private collectors; 10% corporate clients. Sponsors 3 solo and 19 group shows/year. Average display time: 6-8 weeks. Interested in emerging and established artists. Overall price range: $200-20,000; most work sold at $500-3,000.

Media: Considers all media. Most frequently exhibits painting, sculpture, photography and new-tech (i.e. holography, video art, computer art etc.).

Style: Exhibits neo-expressionism, realism, photorealism, surrealism, minimalism, primitivism, color field, post modern works, imagism; all styles and genres.

Terms: Retail price set by gallery and artist. Exclusive area representation not required. Gallery provides insurance, promotion and shipping costs.

Submissions: Send query letter with resume, slides, SASE and video tape. Call or write to schedule an appointment to show a portfolio, which should include originals, slides, transparencies and video tape. Replies in 2 weeks. Files guides and resume.

Tips: "Grow a long mustache and act like Leroy Nieman."

***SOUTH CAMPUS ART GALLERY, MIAMI-DADE COMMUNITY COLLEGE,** 11011 Southwest 104 St., Miami FL 33176-3393. (305)347-2322. FAX: (305)347-2658. Director: Robert J. Sindelir. College gallery. Estab. 1970. Represents emerging, mid-career and established artists. Exhibited artists include Komar and Melamid. Sponsors 10 shows/year. Average display time 3 weeks. Open all year except for 2 weeks at Christmas and 3 weeks in August. Located in suburban area, southwest of Miami; 3,000 sq. ft.; "space is anonymous, totally adaptable to any exhibition." 100% of space for special exhibitions. Clientele: students, faculty, community and tourists. "Gallery is not for sales, but sales have frequently resulted."

Media: Considers all media, all original types of prints. "No preferred style or media. Selections are made on merit only."

Style: Exhibits all styles and genres.

Terms: "Purchases are made for permanent collection; buyers are directed to artist." Retail price set by the artist. Gallery provides insurance and promotion; arrangements for shipping costs may vary. Prefers artwork framed.

Submissions: Send query letter with resume, slides, bio, brochure, SASE, and reviews. Write to schedule an appointment to show a portfolio, which should include slides. Replies in 2 weeks. Files resumes and slides (if required for future review).

Tips: "Present good quality slides of works which are representative of what will be available for exhibition."

THE SUWANNEE TRIANGLE G, Dock St., Box 341, Cedar Key FL 32625. (904)543-5744. Manager: Clair Teetor. Retail gallery. Estab. 1983. Represents 25 emerging and mid-career artists. Full-time exhibited artists include Connie Nelson and Kevin Hipe. Open all year. Located in the historic district; 400 sq. ft.; "directly on the Gulf of Mexico." 25% space for special exhibitions. 100% private collectors. Interested in seeing the work of emerging artists. Overall price range: $50-500; most artwork sold at $150-1,200.

Media: Considers oil, watercolor, pastel, ceramic, craft, jewelry, glass, offset reproductions, posters, serigraphs and etchings. Most frequently exhibits watercolor, oil and craft.

Style: Exhibits contemporary crafts and jewelry, painterly abstraction and imagism.

Terms: Artwork is bought outright for 50% of the retail price (net 30 days). Retail price set by the gallery. Gallery provides promotion and contract. Shipping costs are shared. Prefers framed artwork.

Submissions: Send query letter with resume, slides, bio, SASE and reviews. Call to schedule an appointment to show a portfolio. What portfolio should include is up to the discretion of artist. Replies only if interested within 3 weeks. Files material of future interest.

Tips: "Be prepared with well thought-out presentation. Do not monopolize time with frequent phone calls."

THE THOMAS CENTER GALLERY, 302 NE 6th Ave., Box 490, Gainesville FL 32602. (904)334-2197. Visual Arts Coordinator: Mallory McCane O'Connor. Nonprofit gallery. Estab. 1980. Clientele: "serves the community as a cultural center." Sponsors 3 solo and 8 group shows/year. Average display time is 1 month. "We concentrate on regional artists." Interested in emerging, mid-career and established artists.

Media: Considers all media.

Style: Considers all styles. "We have to be careful about anything that is too controversial or that deals with explicit sex or violence. This doesn't mean that the work must be bland and boring, however."

Terms: Accepts work on consignment (20% commission). Retail price is set by artist. Exclusive area representation not required. Gallery provides insurance, promotion and contract; shipping costs may be shared.

Submissions: Send query letter with resume, brochure, slides and SASE. Write to schedule an appointment to show a portfolio. Resume and 2 slides are filed.

VALENCIA COMMUNITY COLLEGE ART GALLERIES, 701 N. Econlockhatchee Trail, Orlando FL 32825. (305)299-5000. Gallery Curator: Judith Page. Nonprofit gallery. Estab. 1982. Clientele: 100% private collectors. Sponsors 1 solo and 5 group shows/year. Average display time is 6 weeks. Interested in emerging, mid-career and established artists.

Media: Considers all media. Most frequently exhibits sculpture, paintings and drawings.

Style: Considers all styles. Looks for "individuality, passion." Does not want to see commercial work.

Terms: Accepts work on consignment (no commission). Retail price is set by artist. Exclusive area representation not required. Gallery provides insurance, shipping costs, promotion and contract.

Submissions: Send query letter with resume, slides, photographs and SASE. Write to schedule an appointment to show a portfolio, which should include slides and transparencies. Resumes and other biographical material are filed.

FRANCES WOLFSON ART GALLERY, 300 NE 2nd Ave., Miami FL 33132. (305)347-3278. Galleries Administrator: Roland Barrero-Chang. One of three associated nonprofit galleries. Others are Sentry Gallery (Suite 1365, 300 NE 2nd Ave., Miami FL 33132) and InterAmerican Art Gallery (6207 SW 27th Ave., Miami FL 33135). Estab. 1976. Represents emerging, mid-career and established artists. Sponsors 14 shows/year. Average display time 6 weeks. Open winter, fall and spring. Located downtown; 3,500 sq. ft. 100% of space for special exhibitions. Overall price range: $100-100,000.

Media: Consider oil, acrylic, watercolor, pastel, pen & ink, drawings, mixed media, works on paper, sculpture, ceramic, fiber, installation, photography, original handpulled prints, woodcuts, wood engravings, linocuts, engravings, mezzotints, etchings, lithographs, pochoir and serigraphs. Most frequently exhibits paintings, work on paper and sculpture.

Style: Exhibits all styles and genres.

Terms: Retail price set by the artist. Gallery provides insurance and promotion; gallery pays for shipping costs. Prefers framed artwork.

Submissions: Send query letter with resume, slides, bio and reviews. Write to schedule an appointment to show a portfolio, which should include slides. Replies in 2-3 weeks. Files correspondence and resume.

Georgia

ALIAS GALLERY, Suite F-2, 75 Bennett St., Atlanta GA 30309. President: Sarah A. Hatch. (404)352-3532. Retail gallery and custom/archival framing. Estab. 1985. Clientele: all great art appreciators—artist to upper middle class; 90% private collectors. Sponsors 1 solo and 1 group show/year. Average display time is 4-10 weeks. "My standards for quality work are very high." 350 sq. ft. Gallery sapce is in TULA fine art center. Interested in emerging and mid-career artists. Overall price range: $50-3,500; most artwork sold at $50-1,000.

Media: Considers oil, acrylic, watercolor, pastel, mixed media, installations, photography and unique handpulled prints. Most frequently exhibits paintings and pastels.

Style: Exhibits conceptual and expressionistic work. "The ideal work is the true vital expression of the artist and his or her ability to create a work which stands on its own merits. It has a 'life' of its own. Am always looking for a new idea, technique or style."

Terms: Central gallery space is booked with thematic shows. 30-40% commission. Retail price is set by artist. Gallery provides insurance, promotion and contract.

Submissions: Send SASE for prospectus about upcoming shows.

Tips: "I lean toward bright color, but I have seen dark works with their own special kind of brightness. I do not want to see commercial or decorative art." Send SASE for current gallery prospectus.

THE ATLANTA COLLEGE OF ART GALLERY, 1280 Peachtree Street NE, Atlanta GA 30309. (404)898-1157. Director: Lisa Tuttle. Nonprofit gallery. Estab. 1984. Clientele: general public and art students. Sponsors 10 group shows/year. Average display time is 5 weeks. Interested in emerging, mid-career and established artists.

Media: Considers all media. Most frequently exhibits paintings, drawings, sculpture, prints, photography and installations.

Style: Considers all styles. "We primarily sponsor group exhibitions which are organized in a variety of ways: curated, juried, invitational, rentals, etc." Interested in seeing interdisciplinary, new genre, installation, site work and video sculpture.

Terms: Accepts work on consignment (30% commission). Retail price is set by artist. Exclusive area representation not required. Gallery provides insurance, promotion and contract; shipping costs are shared.

Submissions: Send query letter with resume, slides and SASE. Write to schedule an appointment to show a portfolio, which should include slides.

Tips: "We are a nonprofit exhibition space and do *not* 'represent' artists per se." Due to the recession, "we are all experienceing budget cuts from funding agencies, requiring us to be more resourceful and strategic about the ways we spend our programming funds."

FAY GOLD GALLERY, 247 Buckhead Ave., Atlanta GA 30305. (404)233-3843. Owner: Fay Gold. Retail gallery. Estab. 1980. Open year round. Clientele: 50% private collectors; 50% corporate clients. Represents 25 artists. Sponsors 18 solo and 4 group show/year. Average display time 4 weeks. Interested in emerging and established artists. Overall price range: $200-350,000; Most work sold at $2,000-20,000.

Style: Exhibits all styles. Genres include landscapes, Americana and figurative work. Prefers abstracts, landscapes and figurative works. "We specialize in contemporary art of all mediums."

Terms: Accepts work on consignment (50% commission). Retail price set by gallery and artist. Exclusive area representation required. Gallery provides insurance and promotion.

Submissions: Send query letter with resume, slides and SASE. Limited review of material. "We contact artists for a portfolio review if we are interested." Replies in 1 month. All material is returned if not accepted or under consideration.

ANN JACOB GALLERY, 3500 Peachtree Rd. NE, Atlanta GA 30326. (404)262-3399. Director: Yvonne M. Jacob. Ann Jacob America, 756 Madison Ave., New York NY 10021. (212)988-5143. Director: J. Dance. Retail gallery and art consultancy. Estab. 1968. Represents 75 emerging, mid-career and established artists. Exhibited artists include Ben Smith and Mario Glushankoff. Sponsors 4 shows/year. "We always show our stable of artists even if there is a show at the same time." Open all year. Clientele: 75% private collectors, 25% corporate collectors.

Media: Considers oil, acrylic, watercolor, drawing, mixed media, collage, works on paper, sculpture, ceramic, craft, fiber, glass, woodcuts, wood engravings, engravings, mezzotints, etchings, lithographs and serigraphs. Most frequently exhibits acrylic on canvas, bronze sculpture and art glass. Ann Jacob America specializes in folk art.

Style: Exhibits all styles and genres. Prefers painterly abstraction, expressionism and realism.

Terms: Accepts work on consignment (50% commission). Retail price set by gallery and artist. Gallery provides promotion and contract; gallery pays for shipping from gallery. Prefers framed artwork.

Submissions: Send resume, slides, bio, photographs and SASE. Call or write to schedule an appointment to show a portfolio, which should include slides, photographs and resume. Replies in 2 weeks.

Tips: "Please send information, including slides; then, if interested we will be in touch."

EVE MANNES GALLERY, Suite A, 116 Bennett St., Atlanta GA 30309. (404)351-6651. Retail gallery and art advisory. Estab. 1980. Clientele: major corporate and private clients; 40% private collectors, 60% corporate clients. Represents 25 artists. Sponsors 4 solo and 6 group shows/year. Average display time is 4-6 weeks. Interested in emerging, mid-career and established artists. Overall price range: $500-20,000 plus larger commission prices; most artwork sold at $500-3,000.

Media: Considers oil, acrylic, watercolor, pastel, paper, sculpture, ceramic, fiber, glass, photography and mono prints. Most frequently exhibits pastel, oil or acrylic on canvas, sculpture (metal, wood), ceramic or glass. Currently looking for oil or acrylic on canvas.

Style: Exhibits hard-edge geometric abstraction, painterly abstraction, pattern painting, expressionism and realism. Genres include landscapes and figurative abstract. Most frequently exhibits color abstract, sculpture and landscapes. Currently seeking landscape realism. Seeks "challenging, vital work in both abstract and representational style. We welcome artists with strong, individual visions who explore personal and universal themes."

 The asterisk before a listing indicates that the listing is new in this edition. New markets are often the most receptive to freelance submissions.

Terms: Accepts work on consignment (50% commission). Retail price is set by gallery or artist. Exclusive area representation required. Gallery provides insurance, promotion and contract; shipping costs are shared.
Submissions: Send query letter with resume, brochure and slides. Write to schedule an appointment to show a portfolio, which should include originals and slides. Slides, bio, postcards and catalogs are filed.
Tips: Looking for "consistency in artwork and images, confidence, friendliness, responsibility and commitment to gallery and self." Does not want to see "arrogant self-centered persons unwilling to work with gallery to help in sales." Current trend seems to be that "artists and galleries are having to work together more often in processing sales (possibly splitting discounts to established clientele)."

PEACHTREE GALLERY, LTD., 2277 Peachtree Rd. NE, Atlanta GA 30309. (404)355-0511. Manager: Gladys G. Lippincott. Retail gallery. Estab. 1983. Interested in established artists and posthumous works. Location: Buckhead area of Atlanta (in city limits) where there are other art and antiques specialists. Clientele: 80% private collectors, 20% corporate clients. Overall price range: $250-15,000; most artwork sold at $500-3,000.
Media: Considers oil, watercolor, pastel, pen & ink, drawings, mixed media, woodcuts, wood engravings, linocuts, engravings, mezzotints, etchings and lithographs. Most frequently exhibits oil, watercolor and lithographs.
Style: Exhibits impressionism, expressionism and realism. Prefers landscapes, florals, Americana, wildlife, figurative work and all genres. "Peachtree Gallery, Ltd., deals primarily in oil, watercolor and works on paper by listed American artists of the late 19th and early 20th centuries. The gallery's collection includes some English and French pieces. Scenes of the South and works by Southern artists are featured."
Terms: Accepts artwork on consignment or buys outright. Retail price set by gallery. Gallery provides promotion. Artist pays for shipping. Prefers framed artwork.
Submissions: Call to schedule an appointment to show a portfolio. Files bio, resume and brochure. Gallery does not handle contemporary artists. We are happy to see work by contemporary artists so that we can refer to it when we receive inquiries. We keep info on file.
Tips: "We see a growing interest in works by women artists and by both male and female artists of the WPA period and later."

Hawaii

HALE O KULA GOLDSMITH GALLERY, Box 416, Holualoa HI 96725. (808)324-1688. Owner: Sam Rosen. Retail gallery. Estab. 1981. Clientele: tourist and local trade; 100% private collectors. Interested in seeing the work of mid-career and established artists. Specializes in miniature art. Overall price range: $100-3,000; most artwork sold at $100-1,000.
Media: Considers sculpture, craft and mixed media.
Style: Exhibits contemporary, abstract, impressionism, floral, realism and neo-expressionism.
Terms: Accepts work on consignment (40% commission). Retail price is set by artist. Exclusive area representation not required. Gallery provides promotion and contract; shipping costs are shared.
Submissions: Send query letter accompanied by resume and slides. Write to schedule an appointment to show your portfolio.

INTERNATIONAL CONNOISSEURS, Box 1274, Kaneohe HI 96744. (808)239-8933. Owner: Larry LeDoux. Art consultancy. Estab. 1978. Clientele: 60% private collectors, 40% corporate clients. Represents 6 artists. Sponsors 2-4 solo shows/year. Interested in emerging, mid-career and established artists. Overall price range: $15-20,000; most artwork sold at $30-6,000.
Media: Considers oil, acrylic, watercolor, pastel, pen & ink, drawings, mixed media, collage, woodcuts, wood engravings, linocuts, engravings, mezzotints, etchings, lithographs and serigraphs. Most frequently exhibits oils and acrylics, reproductions and serigraphs.
Style: Exhibits realism, impressionism, expressionism and surrealism. Genres include landscapes and wildlife. Prefers surrealism and impressionism. "We are basically an artist's agency specializing in the marketing of artists through national media campaigns supported by mail-order sales, mailings and telemarketing. Our purpose is to create a national identity through exposure and retail sales, and generate continuing wholesale income through establishment of a network of galleries."
Terms: Accepts work on consignment. Retail price set by gallery and artist. Exclusive area representation not required.
Submissions: Send query letter with resume, brochure, slides, photographs, bio and SASE. Replies in 3 weeks. Files brochures. Most material is returned if not accepted or under consideration.
Tips: "We are looking for artists who want to invest in themselves whatever is necessary to create a national identity and following." Strong interest continues in impressionism and expressionism, not realistic treatment, but recognizable subjects.

QUEEN EMMA GALLERY, 1301 Punchbowl St., Honolulu HI 96813. (808)547-4397. Director: Masa Morioka Taira. Nonprofit gallery located in the main lobby of The Queen's Medical Center. Estab. 1977. Clientele: M.D.s, staff personnel, hospital visitors, community-at-large; 90% private collectors. Sponsors 8 solo and 4 group shows/year. Average display time is 3-3½ weeks. Interested in emerging, mid-career and established artists. Overall price range: $50-1,000; most artwork sold at $100-300.

Media: Considers all media.

Style: Exhibits contemporary, abstract, impressionism, figurative, primitive, non-representational, photorealism, realism neo-expressionism, landscapes and florals. Specializes in humanities-oriented interpretive, literary, cross-cultural and cross-disciplinary works. Interested in folk art, miniature works and ethnic works. "Our goal is to offer a variety of visual expressions by regional artists, including emergent and thesis shows by honors students and MFA candidates."

Terms: Accepts work on consignment (30% commission). Retail price is set by artist. Exclusive area representation not required. Gallery provides promotion and contract.

Submissions: Send query letter with resume, brochure, business card, slides, photographs and SASE. "Prefer brief proposal or statement or proposed body of works." Preference given to local artists.

Tips: "The best introduction to us is to submit your proposal with a dozen slides of works created with intent to show. Show professionalism, honesty, integrity, experimentation, new direction and readiness to show." Sees trend toward "global, environmental concerns, the use of non-traditional materials, expression and presentations and new technologies."

THE VILLAGE GALLERY, 120 Dickenson St., Lahaina HI 96761. (808)661-4402. Owner/Manager: Linda Shue. Retail gallery. Estab. 1970. Clientele: tourists, return visitors, those with a second home in Hawaii, 85% private collectors, 15% corporate clients. Represents 100 artists. Sponsors 10 solo and 4 group shows/year. Average display time varies. Interested in emerging and established artists. Overall price range: $10-10,000; most work sold at $800-3,000.

Media: Considers oil, acrylic, watercolor, pastel, pen & ink, drawings, mixed media, collage, works on paper, sculpture, ceramic, fiber and glass. Most frequently exhibits oil, watercolor and mixed media.

Style: Exhibits impressionism, realism, color field and painterly abstraction. Genres include landscapes, florals, figurative work; considers all genres. Prefers impressionism, painterly abstraction and realism.

Terms: Accepts work on consignment (50% commission). Retail price set by gallery and artist. Exclusive area representation required. Shipping costs are shared. Prefers artwork framed.

Submissions: Send query letter with resume, slides, and photographs. Write to schedule an appointment to show a portfolio, which should include originals, slides and photographs. Replies in 2 weeks. All material is returned if not accepted or under consideration.

Idaho

OCHI GALLERY, 1322 Main St., Boise ID 83702. (208)342-1314. Owners: Denis or Roberta Ochi. Retail gallery and art consultancy. Estab. 1974. Sponsors 4 solo and 2 group shows/year. Average display time is 4-6 weeks. Interested in emerging and established artists. Overall price range: $500-100,000.

Media: Considers all media.

Style: Considers all styles. Most frequently exhibited styles: contemporary and realism. "We are always looking for good art regardless of style."

Terms: Accepts work on consignment. Retail price is set by gallery or artist. Exclusive area representation required.

Submissions: Send query letter with resume, slides and photographs. Write to schedule an appointment to show a portfolio, which should include originals, slides and transparencies. Slides, transparencies and "any pertinent information on artist's career" are filed.

Illinois

ARTEMISIA GALLERY, 700 N. Carpenter, Chicago IL 60622. (312)226-7323. President: Fern Shaffer. Cooperative and nonprofit gallery/alternative space. Estab. 1973. 18 members. Sponsors 60 solo shows/year. Average display time 4 weeks. Interested in emerging and established artists. Overall price range: $150-10,000; most work sold at $600-2,500.

Media: Considers oil, acrylic, watercolor, pastel, pen & ink, drawings, mixed media, collage, works on paper, sculpture, ceramic, craft, fiber, glass, installation, photography, egg tempera, woodcuts, wood engravings, linocuts, engravings, mezzotints, etchings, lithographs, pochoir and serigraphs. Prefers paintings, sculpture and installation. "Artemisia is a cooperative art gallery run by artists. We try and promote women artists."

Terms: Co-op membership fee plus donation of time; rental fee for space; rental fee covers 1 month. Retail price set by artist. Exclusive area representation not required. Gallery provides insurance; artist pays for shipping.
Submissions: Send query letter with resume, slides and SASE. Write to schedule an appointment to show a portfolio, which should include slides. Replies in 6 weeks. All material is returned if not accepted or under consideration.
Tips: "Send clear, readable slides, labeled and marked 'top' or with red dot in lower left corner."

CAIN GALLERY, 1016 North Blvd., Oak Park IL 60301. (708)383-9393. Owners: Priscilla and John Cain. Retail gallery. Estab. 1973. Open all year. Clientele: 80% private collectors, 20% corporate clients. Represents 75 artists. Sponsors 3 solo shows/year. Average display time for a work 6 months. Interested in emerging and established artists. Overall price range: $100-6,000; most artwork sold at $300-600.
Media: Considers oil, acrylic, watercolor, mixed media, collage, sculpture, ceramic, woodcuts, engravings, mezzotints, etchings, lithographs and serigraphs. Most frequently exhibits acrylic, watercolor and serigraphs.
Style: Exhibits impressionism, realism, surrealism, painterly abstraction, imagism and all styles. Genres include landscapes, florals, figurative work and all genres. Prefers impressionism, abstraction and realism. "Our gallery is a showcase for living American artists—mostly from the Midwest, but we do not rule out artists from other parts of the country who attract our interest. We have a second gallery in Saugatuck, Michigan, which is open during the summer season. The Saugatuck gallery attracts buyers from all over the country."
Terms: Accepts artwork on consignment. Retail price set by artist. Exclusive area representation required. Gallery provides insurance, promotion, contract and shipping costs from gallery. Prefers framed artwork.
Submissions: Send query letter with resume and slides. Call or write to schedule an appointment to show a portfolio, which should include originals and slides. Replies in 2 weeks.

CHIAROSCURO, 750 N. Orleans, Chicago IL 60610. (312)988-9253. Proprietors: Ronna Isaacs or Peggy Wolf. Contemporary retail gallery. Estab. 1987. Located in Chicago's River North Gallery District. Clientele: 95% private collectors; 5% corporate clients. Represents over 200 artists. Average display time 1 month. Overall price range: $30-2,000; most work sold at $50-1,000.
Media: All 2-dimensional work—mixed media, oil, acrylic; ceramics (both functional and decorative works); sculpture, art furniture, jewelry.
Style: "On the average the gallery exhibits bright contemporary works. Paintings are usually figurative works either traditional oil on canvas or to the very non-traditional layers of mixed-media built on wood frames. Other works are representative of works being done by today's leading contemporary artists. We specialize in affordable art for the beginning collector."
Terms: Accepts work on consignment (50% commission). Retail price set by gallery and artist. Exclusive area representation required in River North Gallery District. Gallery provides insurance; shipping costs are shared.
Submissions: Send query letter with resume, slides, photographs, bio and SASE. Call or write to schedule an appointment to show a portfolio, which should include originals, slides and photographs. Replies in 3 weeks. Files resumes and slides. All material is returned if not accepted or under consideration.
Tips: "Include bio and price list with all slides and SASE. It is also important to have good quality photo documentation otherwise the gallery doesn't understand what they're supposed to looking at."

CONTEMPORARY ART WORKSHOP, 542 W. Grant Pl., Chicago IL 60614. (312)472-4004. Administrative Director: Lynn Kearney. Nonprofit gallery. Estab. 1949. Clientele: art-conscious public, well informed on art; 75% private collectors, 25% corporate clients. Average display time is 3½ weeks "if it's a show, otherwise we can show the work for an indefinite period of time." Interested in emerging and mid-career artists. Overall price range: $300-5,000; most artwork sold at $1,500.
Media: Considers oil, acrylic, watercolor, mixed media, works on paper, sculpture, and original handpulled prints. Most frequently exhibits paintings, sculpture and works on paper.
Style: "Any good work" is considered.
Terms: Accepts work on consignment (⅓ commission). Retail price is set by gallery or artist. Exclusive area representation not required. Gallery provides insurance and promotion.
Submissions: Send query letter with resume, slides and SASE. Slides and resume are filed.
Tips: "Looks for a professional approach, fine art school degree (or higher), and high quality work in whatever medium. Artists a long distance from Chicago will probably not be considered." The most common mistake artists make in presenting their work is "showing bad slides, too wide a range of styles, years of their work, or badly framed work."

***THE CURTIS, ALLEN, TURNER GALLERY,** Suite 3-D, 6854 S. East End, Chicago IL 60649. (312)288-6509, (312)929-1824. Director/Curator: Phillip J. Turner. Private gallery. Estab. 1940. Clientele: 70% private collectors. Represents 10-12 artists. Sponsors 6 solo and 1 group show/year. Average display time 1 month. "Our

gallery has approximately 500 sq. ft., with natural and interior lighting." Interested in emerging artists. Overall price range: $200-8,000; most work sold at $500-1,000.

Media: Considers all printmaking media, all painting media, drawings and works on paper. Most frequently exhibited media: prints, drawings and paintings.

Style: Genres include figurative and abstract work. "Our gallery is dedicated to showing the artwork of young, emerging artists from Chicago and its vicinity. We prefer to exhibit prints, paintings and drawings that deal with a visionary theme. This is our 51st year in existence."

Terms: Accepts work on consignment (30% commission). Retail price set by gallery and artist. Exclusive area representation not required. Gallery provides promotion and contract; shipping costs are shared. Prefers artwork framed.

Submissions: Send query letter with resume, slides, business card, bio and SASE. Call or write to schedule an appointment to show a portfolio, which should include originals, slides, transparencies and photographs. Slides must be labeled and work properly mounted or matted. Replies only if interested within 1 month. Files slides, bio and resume. All material is returned if not accepted or under consideration.

Tips: "Please call ahead of time to schedule an appointment. We look for self-motivated artists that are driven to communicating their personal message. Works are still large in scale, which appeals to corporate interests. While there is still a lot of work that appears more commercial in interest, there seems to be a trend toward art that is more spiritual."

***DEBOUVER FINE ARTS**, Suite 15-109 Merchandise Mart, Chicago IL 60654. (312)527-0021. President: Ronald V. DeBouver. Wholesale gallery and art consultancy. Estab. 1981. Clientele: interior designers and wholesale trade only. Represents over 200 emerging, mid-career and established artists. Overall price range: $50-8,000; most artwork sold at $500.

Media: Considers oils, acrylics, watercolor, drawings, mixed media, collage, paper and posters. Most frequently exhibits oils, watercolors, graphics.

Style: Exhibits abstraction, color field, painterly abstraction, impressionistic, photorealistic and realism. Genres include landscapes, florals, Americana, English and French school and figurative work. Most frequently exhibits: impressionistic, landscapes and floral. Currently seeking impressionistic, realism and abstract work.

Terms: Accepts work on consignment (⅓ to ½ commission). Retail price is set by gallery or artist. Exclusive area representation not required.

Submissions: Send resume, slides, photographs, prices and sizes. Call to schedule an appointment to show a portfolio, which should include originals, slides and transparencies. Resume and photos are filed.

***EVANSTON ART CENTER**, 2603 Sheridan Rd., Evanston IL 60201. (708)475-5300. Director: Michele Rowe-Shields. Nonprofit gallery, contemporary art gallery and school. Estab. 1929. Represents emerging, mid-career and established artists. "All exhibitions are temporary—we do not represent specific artists." 1,200 members. Exhibited artists include Donald Lipski, Jin Soo Kim and Paul Sierra. Sponsors 6-8 shows/year. Average display time 6 weeks. Open all year. Located on lakefront property just north of Northwestern University campus; 3,000 sq. ft.; housed in a converted 1927 lakefront mansion; the exhibition space still maintains the charm of the original home." 100% of space for special exhibitions. Clientele: private collectors, professional artists, students and children. 80% private collectors, 20% coporate collectors. "Sales are not the primary focus of the Art Center." Overall price range: $500-20,000; most work sold at $500-5,000.

Media: Considers all media and all types of prints. Most frequently exhibits installations, paintings, sculpture and video.

Style: Exhibits all styles and genres. "The Evanston Art Center remains sensitive to the currents and trends present in today's art and reflects them in its exhibition program."

Terms: Accepts work on consignment (20% commission). Retail price set by the artist. Gallery provides insurance, promotion and contract. Arrangements for shipping depend upon the exhibition. Prefers artwork framed.

Submissions: Send query letter with resume, slides, bio and SASE. Write to schedule an appointment to show a portfolio, which should include slides. "Our exhibition committee meets bimonthly to review slides and make recommendations for future exhibitions." Replies in 6 weeks. Files resume and bio for future contact.

Tips: "Artists should be familiar with the Art Center and its exhibition program. Professional quality slides are of the utmost importance in order to represent the work accurately. Many of our exhibitions are thematic, so artists are encouraged to submit accordingly."

FREEPORT ART MUSEUM AND CULTURAL CENTER, 121 N. Harlem Ave., Freeport IL 61032. (815)235-9755. Contact: Director. Estab. 1975. Clientele: 30% tourists; 60% local; 10% students. Sponsors 2 solo and 10 group shows/year. Average display time 5 weeks. Interested in emerging, mid-career and established artists.

Media: Considers oil, acrylic, watercolor, pastel, pen & ink, drawings, mixed media, collage, works on paper, sculpture, ceramic, craft, fiber, glass, installation, photography, egg tempera, original handpulled prints, woodcuts, wood engravings, linocuts, engravings, mezzotints, etchings, lithographs, pochoir and serigraphs.
Style: Exhibits all styles and genres. "We are a regional museum serving Northwest Illinois, Southern Wisconsin and Eastern Iowa. We have extensive permanent collections and 12-15 special exhibits per year representing the broadest possible range of regional and national artistic trends."
Terms: Gallery provides insurance and promotion. Shipping costs are shared. Prefers artwork framed.
Submissions: Send query letter with resume, slides, SASE, brochure, photographs and bio. Write to schedule an appointment to show a portfolio, which should include originals, slides and photographs. Replies in 1-2 months. Files resumes.
Tips: "Send information in December or January."

GALERIE AMERICANA, Suite 308, 320 W. Illinois, Chicago IL 60610. (312)337-2670. Director: Derrick Beard. Retail and wholesale gallery/alternative space/art consultancy. Estab. 1985. Clientele: tourists, private collectors and walk-ins. 80% private collectors; 10% corporate clients. Represents 50 artists. Sponsors 3 solo and 3 group shows/year. Average display time 6 weeks. Accepts only artists from U.S., Carribbean and Latin America. Interested in established artists. Overall price range: $200-10,000; most work sold at $1,000-3,000.
Media: Considers oil, acrylic, watercolor, pastel, pen & ink, drawings, mixed media, collage, works on paper, sculpture, craft, photography, egg tempera, woodcuts, wood engravings, linocuts, engravings, etchings, lithographs, serigraphs, offset reproductions and posters. Most frequently exhibits oil, prints and sculpture.
Styles: Exhibits all styles and genres. Prefers post-modernism, social realism and primitivism. "Our gallery is based on the belief that we should serve those minorities who have a social theme and/or a sensitivity to developments in society. We look for older artists who express a social statement and who were active during the '30s, '40s, '50s."
Terms: Accepts artwork on consignment (50% commission) or buys outright (35% retail price; net 60 days.) Retail price set by gallery and artist. Exclusive area representation required. Gallery provides insurance, promotion and contract; shipping costs are shared. Prefers framed artwork.
Submissions: Send query letter with resume, brochure, business card, slides, photographs, bio and SASE. Write to schedule an appointment to show a portfolio, which should include slides, transparencies and photographs. Replies in 4 weeks. Files resume, slides/photographs. All material is returned if not accepted or under consideration.
Tips: "Please write, do not call. By appointment only! Include *best* examples of work."

GALLERY TEN, 514 E. State St., Rockford IL 61104. (815)964-1743. Contact: Jean Apgar Retail gallery. Estab. 1986. "We are a downtown gallery representing visual artists in all media." Clientele: 50% private collectors, 50% corporate clients. Represents 400 artists. Interested in emerging, mid-career and established artists. Average display time 6 weeks. Overall price range: $4-10,000; most artwork sold at $50-300.
Media: Considers all media.
Style: Exhibits fresh and contemporary styles and all genres. "Partners organize continually rotating shows with themes such as figurative, holiday, the fine art of craft, architecture, fiber and handmade paper in the main gallery. Sponsors national juried exhibits along with shows of individual artists and groups. We also have sales gallery for handcrafted and innovative objects and jewelry. All work must be for sale and ready to hang."
Terms: Retail price set by artists (40% commission). Exclusive area representation not required. Gallery provides promotion. Prefers framed artwork.
Submissions: Send query letter with slides, photographs and SASE. Replies in 2 weeks. All material is returned if not accepted or under consideration.
Tips: Looks for "creative viewpoint—professional presentation and craftsmanship. Common mistakes artists make in their submissions include sloppy presentation, poor quality slides, poor quality paper and/or photocopying of materials, errors in spelling and grammar in letters, statements and resumes."

GROVE ST. GALLERY, 919 Grove St., Evanston IL 60201. (708)866-7341. Gallery Director: Chris or George. Retail gallery. Estab. 1889. Clientele: 60% private collectors; 40% corporate clients. Represents 15 artists. Sponsors 6 solo and 5 group shows/year. Average display time 4 weeks. Interested in emerging and established artists. Overall price range: $500-25,000; most work sold at $2,500-10,000.
Media: Considers oil, acrylic, watercolor, pastel, glass and serigraphs. Most frequently exhibits oil.
Style: Exhibits impressionism. Genres include landscapes, florals, Southwestern and Western themes and figurative work. Prefers Mediterranean landscapes, florals and Southwestern/Western works.
Terms: Accepts artwork on consignment. Retail price set by artist. Exclusive area representation required. Gallery provides partial insurance and promotion; shipping costs are shared. Prefers artwork framed.
Submissions: Send query letter with resume, slides, brochure, photographs and bio. Call or write to schedule an appointment to show a portfolio, which should include originals, slides, transparencies and photographs. Replies in 3 weeks. Files photographs or slides. All material is returned if not accepted or under consideration.

GWENDA JAY GALLERY, 2nd Floor, 301 W. Superior, Chicago IL 60610. (312)664-3406. Assistant Director: Emily Britton. Retail gallery. Estab. 1988. Represents 23 artists; mid-career artists mainly, but emerging and established, too. Exhibited artists include Paul Sierra and Eric Shultis. Sponsors 11 shows/year. Average display time 4 weeks. Open all year. Located in River North area; 2,200 sq. ft.; "we have a view of the Hancock building and are level with the El (elevated trains of Chicago)." 85% of space for 1-2 person exhibitions, 15% for gallery artists. Clientele: "all types—budding collectors to corporate art collections." Overall price range: $500-12,000; most artwork sold at $1,000-6,000.

Media: Considers oil, acrylic, mixed media and sculpture. "If there is an architectural theme, we may consider prints of limited editions only."

Style: Exhibits "eclectic styles and a personal vision." Genres include landscapes and some figurative work.

Terms: Accepts work on consignment (50% commission). Retail price set by the gallery. Gallery provides insurance, promotion and contract; shipping costs are shared.

Submissions: Send query letter with resume, slides, bio and SASE. Write to schedule an appointment. "We contact once slides have been reviewed." Replies in 2-4 weeks.

Tips: "Please send slides with resume and an SASE first. We will reply and schedule an appointment if we wish to see more. Please be familiar with the gallery's style—for example, we don't typically carry abstract art. And no photography." Looking for "consistent style and dedication to career. No original works until we've seen slides. There is no need to have work framed excessively. The work should stand well on its own, initially."

CARL HAMMER GALLERY, 200 W. Superior St., Chicago IL 60610. (312)266-8512. Director: Carl Hammer. Retail gallery. Estab. 1980. Open all year. Clientele: collectors, students, artists and visitors. Represents 20 artists. Sponsors 5 solo and 5 group shows/year. Average display time 4-5 weeks. Accepts only on aesthetic basis. Interested in emerging and established artists. Overall price range: $350-20,000; most artwork sold at $2,500-7,000.

Media: Considers oil, acrylic, watercolor, pastel, drawings, mixed media, collage, sculpture and fiber. Most frequently exhibits sculptures, paintings and mixed media.

Style: Exhibits works by self-taught and outsider artists, both historical and contemporary. "Works include paintings, drawings, textiles (Afro-American, Amish, American vintage and contemporary), eccentric furniture, architectural features, circus banners, assemblage and unique objects from American material culture. Work is accepted on aesthetic basis only, and is not based on inclusion in a certain category. Contemporary artists with academic backgrounds are exhibited as well (4-5 shows per year)."

Terms: Accepts artwork on consignment (commission varies) or buys outright (retail price varies). Retail price set by gallery. Exclusive area representation usually required. Gallery provides insurance, promotion and contract.

Submissions: Send query letter with slides, SASE and photographs. Replies in up to 2 months.

Tips: "Artists should be very familiar with the gallery focus and direction. We rarely choose work from submitted slides."

HYDE PARK ART CENTER, 1701 E. 53rd St., Chicago IL. (312)324-5520. Executive Director: Eileen M. Murray. Nonprofit gallery. Estab. 1939. Represents emerging artists. Clientele: general public. Sponsors 1 solo and 7 group shows/year. Average display time is 4-6 weeks. Located in the historic Del Prado building, the gallery is in a former ballroom. "Restricted to Illinois artists not currently affiliated with a retail gallery." Overall price range: $100-10,000.

Media: Considers all media. Interested in seeing "innovative, 'cutting edge' work by young artists; also interested in proposals from curators, groups of artists."

Terms: Accepts work "for exhibition only." Retail price is set by artist. Exclusive area representation not required. Gallery provides insurance and contract.

Submissions: Send query letter with resume, slides and SASE. Will not consider poor slides.

ILLINOIS ARTISANS SHOP, State of Illinois Center, 100 W. Randolph St., Chicago IL 60601. (312)814-5321. Director: Ellen Gantner. Retail gallery operated by the nonprofit Illinois State Museum Society. Estab. 1985. Clientele: tourists, conventioneers, business people, Chicagoans. Represents 800 artists. Interested in emerging, mid-career and established artists. Average display time is 6 months. "Accepts only juried artists living in Illinois." Overall price range: $10-5,000; most artwork sold at $250.

Media: Considers all media. "The finest examples in all mediums by Illinois artists."

Style: Considers all styles. "Seeks contemporary, traditional, folk and ethnic arts from all regions of Illinois. 'Cute' crafts are not welcome in our shop."

Terms: Accepts work on consignment (50% commission), retail price is set by gallery and artist. Exclusive area representation not required. Gallery provides promotion and contract.

Submissions: Send resume and slides. Accepted works are selected by a jury. Resume and slides are filed. "The finest work can be rejected if slides are not good enough to assess."

***LAKEVIEW MUSEUM SALES/RENTAL GALLERY,** 1125 W. Lake Ave., Peoria IL 61614. (309)686-7000. Museum Shop & Gallery Manager: Sally Stone. Retail and rental gallery and art consultancy. Estab. 1965. Clientele: the community of Peoria; 40% private collectors, 60% corporate clients. Represents 100 artists; emerging, mid-career and established. Sponsors 3 group shows/year. Average display time is 12 weeks. Accepts only midwest artists. Overall price range: $50-3,000; most artwork sold at $300.
Media: Considers all media except performance art. Most frequently exhibits watercolor, oil and acrylic. Currently looking for glass and jewelry.
Style: Exhibits painterly abstract, impressionistic, photo-realistic, expressionistic, neo-expressionistic and realist styles. Genres include landscapes, florals, Americana and figurative work. Most frequently exhibits impressionism, realism and expressionism.
Terms: Accepts work on consignment (35% commission). Retail price is set by artist. Exclusive area representation not required. Gallery provides promotion and contract.
Submissions: Send query letter with resume and slides. Call or write to schedule an appointment to show a portfolio, which should include slides. Contract, resume, slides are filed. Common mistakes artists make in their submissions include "submitting poorly framed work, out-of-date resumes and improperly labeling their work."
Tips: Looks for seriousness of intent in artists. "We want them to be professional artist and not 'hobbiests.' " The best way for artists to introduce themselves to this gallery is through slides at the jurying process.

***R.H. LOVE GALLERIES, INC.,** 100 E. Ohio St., Chicago IL 60611, and 400 S. Financial Pl., Chicago IL 60611. (312)664-9620. FAX: (312)951-5267. Retail gallery. "R.H. Love Galleries includes two contemporary galleries, as well as a third gallery specializing in paintings by eighteenth and nineteenth century American artists." Estab. 1966. Represents about 20 emerging, mid-career and established artists. Exhibited artists include Robert Goodnough and Darby Bannard. Sponsors 20 shows/year. Average display time for contemporary galleries ranges from a few days to 2 years. Open all year. 18,000 square feet; contemporary works, featuring modern and post modern work, is in a suitably contemporary setting. 100% of space for special exhibitions. Clientele: wealthy individuals. 80% private collectors, 5% corporate collectors, 15% to museums. Overall price range: $2,000-2,000,000; most work sold at $25,000 range.
Media: Considers oil, pen & ink, paper, fiber, acrylic, drawing, sculpture, glass, watercolor, mixed media, ceramic, installation, pastel, collage, craft and photography. No multiple images. Most frequently exhibits oil, watercolor and sculpture.
Style: Exhibits all styles.
Terms: Contemporary artwork is accepted on consignment (50% commission). Retail price set by the gallery and the artist. Gallery provides full service; pays shipping costs from gallery. Prefers artwork unframed.
Submissions: Send query letter with resume, slides, bio, brochure, photographs, SASE, business card and reviews. Write to schedule an appointment to show a portfolio, which should include photographs, slides or transparencies. Replies in a few weeks. Resumes—"we keep a file on every artist."

***PETER MILLER GALLERY,** 401 W. Superior St., Chicago IL 60610. (312)951-0252. Co-Director: Natalie R. Domchenko. Retail gallery. Estab. 1979. Clientele: 80% private collectors, 20% corporate clients. Represents 15 artists. Sponsors 9 solo and 3 group shows/year. Average display time is 1 month. Interested in emerging and established artists. Overall price range: $500-20,000; most artwork sold at $5,000 and up.
Media: Considers oil, acrylic, mixed media, collage, sculpture, installations and photography. Most frequently exhibits oil on canvas, acrylic on canvas and mixed media.
Style: Exhibits painterly abstraction, conceptual, post-modern, expressionistic, realism and surrealism.
Terms: Accepts work on consignment (50% commission). Retail price is set by gallery or artist. Exclusive area representation not required. Gallery provides insurance, promotion and contract; "if requested."
Submissions: Send slides and SASE. Slides, show card are filed.
Tips: Looks for "classical skills underlying whatever personal vision artists express. Send a sheet of twenty slides of work done in the past eighteen months with a SASE."

N.A.M.E., 700 N. Carpenter, Chicago IL 60622. (312)226-0671. Director: Irene Tsatsos. Nonprofit gallery. Estab. 1973. Represents emerging, mid-career and established artists. Has 75 members. Sponsors 8 shows/year. Average display time 5 weeks. Open all year. At River West; 2,000 sq. ft.
Media: Considers all media.
Style: Exhibits new work and new genres.
Terms: Retail price set by the artist. Gallery takes no commission. Gallery provides promotion; shipping costs are shared.
Submissions: "No portfolio reviews." Call gallery for proposal guidelines.
Tips: "There are 3 deadlines a year—1/15, 5/15, 9/15. Proposals are acknowledged immediately and decided upon within three months after review deadline."

ISOBEL NEAL GALLERY, LTD., Suite 200, 200 Superior St., Chicago IL 60610. (312)944-1570. President: Isobel Neal. Retail gallery. Estab. 1986. Clientele: 90% private collectors, 10% corporate clients. Represents about 12 artists. Sponsors 2 solo and 5 group shows/year. Average display time 6 weeks. Features African-American artists. Interested in emerging, mid-career and established artists. Overall price range: $300-12,000; most artwork sold at $500-3,000.

Media: Considers oil, acrylic, watercolor, pastel, pen & ink, drawings, mixed media, collage, works on paper, sculpture, ceramic, fiber, photography, egg tempera, woodcuts, wood engravings, linocuts, engravings, mezzotints, etchings, lithographs and serigraphs. Most frequently exhibits oil, acrylic and sculpture.

Style: Exhibits impressionism, expressionism, realism, color field, painterly abstraction and hard-edge geometric abstraction; considers all styles. Genres include landscapes and figurative work. "The Isobel Neal gallery was founded to provide an opportunity for African-American artists to showcase their work and to enhance their visibility in the mainstream gallery system and in the community. The work ranges from figurative to abstract, sometimes with black imagery, but often not."

Terms: Accepts work on consignment (50% commission). Retail price set by gallery and artist. Exclusive area representation required. Gallery provides insurance, promotion and contract. "Under certain circumstances, the gallery will share shipping cost." Prefers framed artwork.

Submissions: Send query letter with resume, slides, bio and SASE. Call or write to schedule an appointment to show a portfolio. Replies in several months. Files slides, bio, resume and articles. All material is returned if not accepted or under consideration.

Tips: "Slides should be labeled properly and should be of good viewing quality." Common mistakes artists make in submitting work are "submitting photos instead of slides, not including a slide listing, not fully labeling slides, not cropping slides well, no SASE and submitting all of their work and not just their best. If at all possible, visit the gallery to see what we show."

NEVILLE-SARGENT GALLERY, 708 N. Wells and 311 W. Superior, Chicago IL 60610. (312)664-2787. Director: Jane Neville. Retail gallery and art consultancy. Estab. 1974. Converted from industrial warehouse. Clientele: 50% private collectors; 50% corporate clients. Represents 30 artists. Sponsors 5 solo and 7 group shows/year. Average display time 3 weeks. Interested in emerging and established artists. Overall price range: $400-20,000; most work sold at $800-3,500.

Media: Will consider oils, acrylics, watercolors, pastels, mixed media, collage, works on paper, sculptures and monotypes. Most frequently exhibits oil/acrylic canvases, steel/bronze sculptures and mixed media/handmade paper.

Style: Exhibits expressionism, neo-expressionism, realism, photorealism, primitivism and painterly abstraction. Genres include city scenes, landscapes and figurative work. Prefers painterly abstraction, realism and expressionism. "Neville-Sargent does not limit itself to a particular category of art. In an effort to satisfy our clients, who have a broad range of interests within the arts, we carry local and international artists, abstract and realist works in a variety of price ranges. Our philosophy is to embrace diversity and quality. The collection is eclectic. Though there is an increasing emphasis on sculpture, we are however open to significant work in the mediums stated above."

Terms: Accepts work on consignment (100% commission). Retail price set by gallery and artist. Exclusive area representation required. Gallery provides insurance, promotion and contract; shipping costs are shared.

Submissions: Send query letter with resume, slides and SASE. Call to schedule an appointment to show a portfolio, which should include originals. Reports within 1 month. Files "material that interests us." All material is returned if not accepted or under consideration.

Tips: "Quality of slides and presentation of slides is essential. Always enclose SASE."

NIU ART MUSEUM, Northern Illinois University, DeKalb IL 60115. (815)753-1936. FAX: (815)753-0198. Museum Director: Lynda Martin. University museum. Estab. 1970. Shows emerging, mid-career and established artists. Exhibited artists include Miriam Schapiro and Faith Ringgold. Sponsors 20 shows/year. Average display time 6 weeks. Open all year. Located in DeKalb, Illinois and Chicago; space varies by gallery; "one is located in a renovated 1895 auditorium." 50% of space for special exhibitions.

Media: Considers all media and all types of prints.

Style: Exhibits all styles and all genres.

Terms: "All sales are referred to the artist." Retail price set by the artist. Museum provides insurance and promotion; shipping costs to and from gallery are shared.

Submissions: Send query letter with resume and slides. Replies in 6 months. Files "maybes."

NORTHERN ILLINOIS UNIVERSITY ART GALLERY IN CHICAGO, 212 W. Superior, Chicago IL 60610. (312)642-6010. Director: Peggy Doherty. Nonprofit university gallery. Estab. 1984. Represents emerging, mid-career and established artists. Sponsors 6 shows/year. Average display time 6-7 weeks. Open all year. Located in Chicago gallery area (near downtown); 1,656 sq. ft. 100% of space for special exhibitions. Overall price range: $100-50,000.

Media: Considers all media.
Style: Exhibits all styles and genres.
Terms: "No charge to artist and no commission." Retail price set by the artist. Gallery provides insurance and promotion; shipping costs are shared, depending on costs. Prefers framed artwork.
Submissions: Send query letter with resume, slides, SASE, reviews and statement. Replies in 3-4 weeks. Files resumes, bios, statements and paperwork.
Tips: "Always include SASE. Artists often expect too much: critiques of their work and immediate exhibitions. Work for exhibition is rarely selected at the first viewing."

NINA OWEN, LTD., 212 W. Superior St., Chicago IL 60610. (312)664-0474. Director: Audrey Owen. Gallery and art consultancy. Estab. 1985. Clientele: professionals—designers, architects, developers; 33% private collectors, 67% corporate clients. Represents 100 artists. Sponsors 3 solo and 3 group shows/year. Average display time is 2 months. Accepts sculptors only. Overall price range: $3,000-25,000. Most artwork sold at $4,500-5,000.
Media: Considers sculpture—metal, wood—mixed media, ceramic, fiber and glass. Most frequently exhibits steel, glass and wood sculptures. Currently looking for glass sculpture.
Style: Prefers "finely-executed abstract sculpture."
Terms: Accepts work on consignment. Retail price is set by gallery and artist. Exclusive area representation not required. Gallery provides insurance, promotion and contract; shipping costs are shared.
Submissions: Send query letter with resume, slides and SASE. Call or write to schedule an appointment to show a portfolio, which should include originals, slides or maquette (optional). Files slides and printed material of sculptors in our slide registry (approximately 50 artists not exhibited in gallery, but submitted for commissions).

THE PEORIA ART GUILD, 1831 N. Knoxville Ave., Peoria IL 61603. (309)685-7522. Director: Duffy Armstrong. Retail gallery for a nonprofit organization. Also has rental program. Estab. 1888. Clientele: 50% private collectors; 50% corporate clients. Represents 400 artists. Sponsors 7 solo and 3 group shows/year. Average display time 6 weeks. Interested in emerging mid-career and established artists. Overall price range: $25-3,000; most work sold at $125-500.
Media: Considers oil, acrylic, watercolor, pastel, mixed media, collage, works on paper, sculpture, ceramic, jewelry, fiber, glass, photography, woodcuts, wood engravings, linocuts, engravings, mezzotints, etchings, lithographs and serigraphs. Most frequenly exhibits acrylic/oil, watercolor and etchings/lithographs.
Style: Exhibits all styles. Genres include landscapes, florals and figurative work. Prefers landscapes, realism and painterly abstraction. "The Peoria Art Guild has a large and varied consignment gallery that supplies all the two-dimensional work to our extensive art rental program. Realistic watercolors, acrylics and oils work into this program easily with painterly abstractions and color field work always a possibility. The main gallery primarily exhibits newly emerging and established Midwestern artists with no restriction to style."
Terms: Accepts work on consignment (40% commission). Retail price set by artist. Gallery provides insurance, promotion and contract. Prefers artwork framed.
Submissions: Send query letter with resume, slides and SASE. Call to schedule an appointment to show a portfolio, which should include originals. Replies in 2 months. Files resume, slides and statement. All material is returned if not accepted or under consideration.

RANDOLPH STREET GALLERY, 756 N. Milwaukee, Chicago IL 60622. (312)666-7737. Contact: Exhibition Committee or Time Arts Committee. Nonprofit gallery. Estab. 1979. Sponsors 10 group shows/year. Average display time is 1 month. Interested in emerging, mid-career and established artists.
Media: Considers all media. Most frequently exhibits mixed media and performance.
Style: Exhibits hard-edge geometric abstraction, painterly abstraction, minimalism, conceptual, post-modern, feminist/political, primitivism, photorealism, expressionism and neo-expressionism. "We curate exhibitions which include work of diverse styles, concepts and issues, with an emphasis on works relating to social and critical concerns."
Terms: Accepts work on consignment (20% commission). Retail price is set by artist. Exclusive area representation not required. Gallery provides shipping costs, promotion, contract and honorarium.
Submissions: Send resume, brochure, slides, photographs and SASE. "Live events and exhibitions are curated by a committee which meets monthly." Resumes, slides and other supplementary material are filed.
Tips: Sees trend toward "a greater commitment to the community—art is no longer an 'ivory-tower' phenomenon."

***J. ROSENTHAL FINE ARTS, LTD.**, 230 W. Superior, Chicago IL 60610. (312)642-2966. FAX: (312)642-5169. Director: R.M. Kramer. Retail and wholesale gallery. Estab. 1980. Represents 12 emerging, mid-career and established artists. Exhibited artists include Martha Erlebacher and John Deom. Average display time 6 weeks. Open all year. Located in River North Gallery district; 4,500 sq. ft.; 75% of space for special exhibitions. Clientele: 50% private collectors, 50% corporate collectors. Overall price range: $500-500,000; most work sold at $5,000-25,000.

Media: Considers oil, acrylic, watercolor, pastel, pen & ink, drawing, mixed media, collage, paper, sculpture and installation; original handpulled prints, engravings, etchings, lithographs and serigraphs. Most frequently exhibits paintings, drawings and prints.
Style: Minimalism, color field, post modern works, realism and photorealism. Genres include landscapes and figurative work. Prefers photorealism, realism and post-modernism.
Terms: Accepts work on consignment (50% commission). Gallery provides insurance, promotion. Prefers artwork framed.
Submissions: Send query letter with resume, slides, bio, photographs, SASE and reviews. Write to schedule an appointment to show a portfolio, which should include originals, photographs, slides and transparencies. "Please label slides with all relevant information." Replies in 2 months. Files material interested in.

ESTHER SAKS GALLERY, 311 W. Superior, Chicago IL 60610. (312)751-0911. Director: Esther Saks. Assistant Director: Jane Saks. Retail gallery. Estab. 1983. Clientele: 75% private collectors, 10% corporate clients. Represents 25 artists. Sponsors 9 solo and 3 group shows/year. Average display time 4 weeks. Interested in emerging, mid-career and established artists. Overall price range: $250-14,000; most work sold at $1,000-4,000.
Media: Considers oil, acrylic, watercolor, drawings, mixed media, collage, works on paper, sculpture, ceramic, fiber, glass and original handpulled prints. Most frequently exhibits ceramic, works on paper and paintings.
Style: Exhibits neo-expressionism, surrealism and painterly abstraction. Genres include figurative work. "The Esther Saks Gallery offers contemporary artworks in a variety of media with a strong focus on ceramic sculpture. The gallery has a continuing commitment to work that affirms idea and image over technique and materials, while still revealing the hand and sensibility of the artist."
Terms: Accepts work on consignment (50% commission). Retail price set by gallery and artist. Exclusive area representation required. Gallery provides insurance, promotion, contract and shipping costs from gallery.
Submissions: Send query letter with resume, slides and SASE. Portfolio should include slides. "Include older pieces as well as new." Replies in 2 months. Follow your submissions with a phone call about a month after submitting."

***LAURA A. SPRAGUE ART GALLERY,** Joliet Junior College, 1216 Houbolt Ave., Joliet IL 60436. (815)729-9020. Gallery Director: Joe B. Milosevich. Nonprofit gallery. Estab. 1978. Sponsors 6 to 8 solo and group shows/year. Average display time is 3-4 weeks. Interested in emerging and established artists.
Media: Considers all media except performance. Most frequently exhibits painting, drawing and sculpture (all mediums).
Style: Considers all styles.
Terms: Gallery provides insurance and promotion.
Submissions: Send query letter with resume, brochure, slides, photographs and SASE. Call or write to schedule an appointment to show a portfolio, which should include originals and slides. Query letters and resumes are filed.

STATE OF ILLINOIS ART GALLERY, Suite 2-100, 100 W. Randolph, Chicago IL 60601. (312)814-5322. Administrator: Debora Duez Donato. Museum. Estab. 1985. Represents emerging, mid-career and established artists. Sponsors 6-7 shows/year. Average display time 7-8 weeks. Open all year. Located "in the Chicago loop; in the State of Illinois Center designed by Helmut Jahn." 100% of space for special exhibitions.
Media: All media considered, including installations.
Style: Exhibits all styles and genres, including contemporary and historical work.
Terms: "We exhibit work, do not handle sales." Gallery provides insurance and promotion; artist pays for shipping. Prefers framed artwork.
Submissions: Accepts only artists from Illinois. Send resume, slides, bio and SASE. Write to schedule an appointment to show a portfolio, which should include slides. Replies in 2 months.

UNIVERSITY OF ILLINOIS AT CHICAGO—CAMPUS PROGRAMS, 750 S. Halsted, M/C118, Chicago IL 60607. (312)413-5070. FAX: (312)413-5043. Director: Booker Suggs. Nonprofit gallery. Estab. 1965. Represents emerging, mid-career and established artists. Exhibited artists include Ken Thurlbeck, Wallace Kirkland, Paula Henderson and Karl Kuehn. Sponsors 18 shows/year. Average display time 3 weeks. Open September-May. Located near downtown Chicago, Mongomery Ward Gallery: 1,131 sq. ft.; The Chicago Gallery: 2,906 sq. ft.; and The Art Lounge 720 sq. ft. Clientele: University community, students, staff and faculty. Work must fit within university guidelines. Overall price range: $150-8,000.
Media: "We consider all media as long as it can fit through the door." Considers all types of prints.
Style: Exhibits all styles and all genres.
Terms: The gallery receives 20% of all sales. Retail price set by the artist. Gallery provides insurance and promotion. Artist pays for shipping. Prefers framed artwork.
Submissions: Send query letter with resume, slides, SASE and statement. Write to schedule an appointment to show a portfolio, which should include originals and slides. Replies in 4 months. Files none of material received.

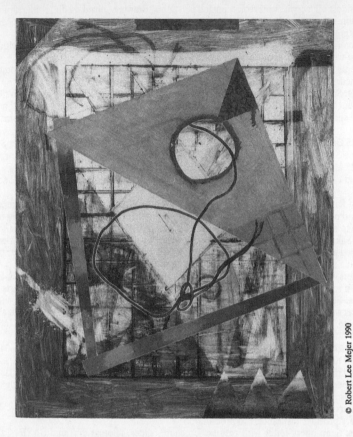

© Robert Lee Mejer 1990

Synergism, a watercolor monotype by artist/professor Robert Lee Mejer of Quincy, Illinois evokes, he says, "playfulness, [a sense of] illusional space and inner-outer world, and elicits emotions through color." While participating in a workshop, Mejer made contact with the director of the Laura A. Sprague Art Gallery at Joliet Junior College, and this resulted in a show. The exhibit gave Mejer the "opportunity to share [his] work with a new audience and provide students with exposure to new and unusual methods of printmaking."

Tips: "Work is chosen by committee which is why UIC has no style preference. We have three exhibition spaces: A Montgomery Ward gallery, the Chicago gallery and the Art Lounge."

RUTH VOLID GALLERY, LTD., 225 W. Illinois St., Chicago IL 60610. (312)644-3180. FAX: (312)644-3210. President: Ruth Volid. Retail gallery and art consultancy. Estab. 1970. Represents 103 emerging, mid-career and established artists. Exhibited artists include Barbara Wells and Ginger Mongiello. Sponsors 5 shows/year. Average display time 6 weeks. Open all year. Located near the loop "River North"; 4,000 sq. ft.; "we work with architects and design firms." 80% of space for special exhibitions. Clientele: 25% private collectors, 75% corporate collectors. Overall price range: $250-20,000; most work sold at $750-3,000.
Media: Considers all media; original handpulled prints, engravings, mezzotints, lithographs, pochoir and serigraphs. Most frequently exhibits paintings, watercolors and sculpture.
Style: Exhibits all styles. Genres include landscapes, florals, Americana, Southwestern, Western and wildlife. Prefers landscape and contemporary.
Terms: Accepts work on consignment (50% commission). Retail price set by the gallery and the artist. Gallery provides insurance, promotion and contract; shipping costs are shared.
Submissions: Send query letter with resume, slides, bio and reviews. Call or write to schedule an appointment to show a portfolio, which should include slides. Replies in 1 month. Files slides, if accepted.
Tips: "Send slides and resume. Include artists price."

***WEDGE PUBLIC CULTURAL CENTER FOR THE ARTS**, 110 S. LaSalle St., Box 1331, Aurora IL 60507. (708)897-2757. Director: Dan Tutor. Nonprofit alternative space. Estab. 1986. "Wedge is a nonprofit, tax exempt, cultural organization open to a wide variety of visual media concepts integrated with music, dance, theater, poetry and film. Six artists have formed the initial nucleus from which its driving force has evolved. The center is promoting art exhibits and cultural events in the Fox River Valley. It is a space where professional artists can display their work and share ideas with their peers and art patrons." Open all year. 4,000 sq. ft.; "first floor has natural burlap walls, natural wood floor. Renovation of second and third floors of building underway. Basement unfinished, but available. No physical size limitations. Track lighting. No direct sunlight. No sales commission. All sales are between the artist and patron. $10 donation required for artist's membership to exhibit. Artist may make extra donations."
Media: Considers all media, plus music, dance, film and poetry.
Terms: "Wedge handles all publicity. The center promotes the artist and art as a service to the community. Newspapers, radio, magazines, public-service announcements. Wedge pays for all openings, announcements, postage and advertising. No insurance. Not responsible for loss or damage. Someone sits with show during exhibition hours. Artist supplies necessary display hardware. All work must be professionally framed. Pedestals are limited. Wedge hangs all work."

ZAKS GALLERY, 620 N. Michigan Ave., Chicago IL 60611. (312)943-8440. Director: Sonia Zaks. Retail gallery. Represents 25 artists. Sponsors 10 solo and 1 group shows/year. Average display time is 1 month. Interested in emerging, mid-career and established artists. Overall price range: $500-15,000, "sculpture commissions higher prices."
Media: Considers oil, acrylic, watercolor, pastel, pen & ink, drawings, sculpture and mixed media.
Style: Specializes in contemporary paintings, works on paper and sculpture.
Terms: Accepts work on consignment. Retail price is set by gallery and artist. Exclusive area representation required. Gallery provides insurance and contract.
Submissions: Send query letter accompanied by resume and slides. Write to schedule an appointment to show your portfolio.
Tips: "A common mistake some artists make is presenting badly taken and unmarked slides. Artists should write to the gallery and enclose a resume and about one dozen slides."

Indiana

ARTLINK, 1030 Broadway, Fort Wayne IN 46802. (219)424-7195. Artistic Director: Betty Fishman. Nonprofit gallery. Estab. 1979. Represents emerging and mid-career artists. Membership 400 (not all artists). Sponsors 8 shows/year. Average display time 5-6 weeks. Open all year. Located 5 blocks from central downtown; 1,600 sq. ft. 100% of space for special exhibitions. Clientele: "upper middle class." Overall price range: $100-500; most artwork sold at $100.
Media: Considers all media, including prints. Prefers work for annual print show and annual photo show, sculpture and painting.
Style: Exhibits expressionism, neo-expressionism, painterly abstraction, conceptualism, color field, post modern works, photorealism, hard-edge geometric abstraction, all styles and all genres. Prefers imagism, abstraction and realism. "Interested in a merging of craft/fine arts resulting in art as fantasy in the form of furniture, bas relief, photo/books, (all experimental media in non-traditional form.)"
Terms: Accepts work on consignment (35% commission). Retail price set by the artist. Gallery provides insurance, promotion and contract; shipping costs from gallery or shipping costs are shared. Prefers framed artwork.
Submissions: Send query letter with resume, slides and SASE. Reviewed by 14 member panel. Replies in 2-4 weeks. "Jurying takes place four times per year unless it is for a specific call for entry. A telephone call will give the artist an idea of the next jurying date."
Tips: Common mistakes artists make in presenting work are "bad slides and sending more than requested—large packages of painted material. Printed catalogues of artist's work without slides are useless." Developing trends seem to be "higher prices, more 'crafts' in fine arts galleries, joint efforts by artists and gallery making higher demands on professionalism of the artist."

EDITIONS LIMITED GALLERY, 2727 E. 86th St., Indianapolis IN 46240. (317)253-7800. Director: John Mallon. Retail gallery. Represents emerging, mid-career and established artists. Sponsors 4 shows/year. Average display time 1 month. Open all year. Located "north side of Indianapolis; track lighting, exposed ceiling, white walls." Clientele: 60% private collectors, 40% corporate collectors. Overall price range: $100-8,500; most artwork sold at $500-750.
Media: Considers oil, acrylic, watercolor, pastel, pen & ink, drawings, mixed media, collage, works on paper, sculpture, ceramic, craft, fiber, glass, photography, original handpulled prints, woodcuts, engravings, mezzotints, etchings, lithographs, pochoir and serigraphs. Most frequently exhibits mixed media, acrylic and pastel.

Style: Exhibits all styles and genres. Prefers abstract, landscapes and still lifes.

Terms: Accepts work on consignment (50% commission). Retail price set by the gallery. "I do discuss the prices with artist before I set a retail price." Gallery provides insurance, promotion and contract; shipping costs are shared. Prefers unframed artwork.

Submissions: Send query letter with slides and bio. Portfolio should include originals, slides, resume and bio. Replies in 1 month. Files bios, reviews, slides and photos.

Tips: Does not want to see "hobby art." Please send "a large enough body of work."

WILLIAM ENGLE GALLERY, 415 Massachusetts Ave., Indianapolis IN 46204. (317)632-1391. President: William E. Engle. Retail gallery. Estab. 1981. Represents 50 mid-career and established artists; interested in seeing the work of emerging artists. Exhibited artists include Lilian Fendig and Hirokazu Yamaguchi. Sponsors 4-5 shows/year. Open all year. Located downtown in the gallery area, 1,100 sq. ft.; "high ceilings, long walls." 100% of space for special exhibitions. Clientele: 70% private collectors, 30% corporate clients. Overall price range: $100-10,000; most artwork sold at $400.

Media: Considers oil, acrylic, watercolor, pastel, pen & ink, drawings, mixed media, collage, works on paper, sculpture, ceramic, craft, fiber, glass, photography, original handpulled prints, woodcuts, lithographs, serigraphs, linocuts and etchings. Most frequently exhibits ceramic, painting and watercolor.

Style: Exhibits expressionism, painterly abstraction, conceptualism, post modern works, impressionism, realism and hard-edge geometric abstraction. All genres. Prefers figurative work, landscapes and Western.

Terms: Artwork is accepted on consignment (50% commission). Retail price set by the artist. Gallery provides promotion and contract. Gallery pays for shipping costs from gallery. Prefers framed artwork.

Submissions: Send query letter with resume, slides, bio, brochure, photographs, SASE, business card and reviews. Write to schedule an appointment to show a portfolio, which should include slides and photographs. Replies in 2 weeks.

Tips: "Be imaginative."

THE FORT WAYNE MUSEUM OF ART SALES AND RENTAL GALLERY, 311 E. Main St., Ft. Wayne IN 46802. (219)424-1461. Gallery Manager: Ron Myers. Retail and rental gallery. Estab. 1983. Clientele: 90% private collectors, 10% corporate clients. Represents artists who reside within a 150 mile radius of Fort Wayne. Interested in emerging, mid-career and established artists. Overall price range: $75-4,500; most artwork sold at $250-650.

Media: Considers oil, acrylic, watercolor, pastel, pen & ink, sculpture, photography, mixed media, collage and original handpulled prints and computer generated art.

Style: "We try to show the best regional artists available. We jury by quality, not salability." Exhibits impressionism, expressionism, realism, photorealism and painterly abstraction. Genres include landscapes, florals, Americana, Southwestern, Western and wildlife. Prefers landscapes, abstractions and florals. "We do not do well with works that are predominantly figures or still life."

Terms: Accepts work on consignment (35% commission). Retail price is set by artist. Exclusive area representation not required. Gallery provides insurance, promotion and contract. Artist pays for shipping. Prefers framed artwork.

Submissions: Send query letter with resume, brochure, slides, photographs, bio and SASE. Slides and resumes are filed.

Tips: Common mistakes artists make in presenting their work are "poor framing, some send very poor slides. Size is a limitation. Work must not be too large for one person to handle."

GALLERY 614, 0350 C.R., N. Coronna IN 46730. (219)281-2752. Vice President: Mary Green. Retail gallery. Estab. 1973. Represents 4 artists; emerging and mid-career. Exhibited artists include R. Green and M. Viles. Sponsors 2 shows/year. Average display time 6 months. Open by appointment all year. Located in a rural area; 1,600 sq. ft.; "with track lighting, wooden and slate floors—plush." 50% of space for special exhibitions, 50% for gallery artists. Clientele: doctors, lawyers and businesspeople. 100% private collectors. Overall price range: $750-3,000; most artwork sold at $750-1,000.

Media: Considers oil, watercolor, pastel, photography, carbro and carbon printing. Most frequently exhibits carbro and carbon prints.

Style: Exhibits painterly abstraction and impressionism. Genres include landscapes, florals, portraits and figurative work. Prefers portraits, landscapes and still lifes.

Terms: Accepts work on consignment (30% commission). Retail price set by the gallery and the artist. Gallery provides insurance and promotion; shipping costs are shared. Prefers framed artwork.

Submissions: Send query letter with resume, slides and bio. Call to schedule an appointment to show a portfolio, which should include originals, photographs and slides. Replies only if interested within 2 weeks. Files all inquiries.

***GREATER LAFAYETTE MUSEUM OF ART,** 101 South 9th St., Lafayette IN 47901. (317)742-1128. Executive Director: Sharon Theobald. Museum. Estab. 1909. Represents 100 emerging, mid-career and established artists. Members: 1,340. Exhibited artists include Warrington Colescott and Rick Paul. Sponsors 14 shows/

year. Average display time 10 weeks. Closed in August. Located 6 blocks from city center; 3,318 sq. ft.—4 galleries. 100% of space for special exhibitions. Clientele: audience includes Purdue University faculty, students and residents of Lafayette/West Lafayette and 9 county area. 50% private collectors, 50% corporate collectors. Overall price range: $150-15,000; most work sold at $500-1,000.

Media: Considers all media; woodcuts, wood engravings, linocuts, engravings, mezzotints, etchings, lithographs and serigraphs. Most frequently exhibits paintings, prints and sculpture. Most frequently exhibits paintings, prints and sculpture.

Style: Exhibits all styles. Genres include landscapes, florals, Americana, portraits and figurative work. Prefers non-objective, representational (landscape) and representational (figurative).

Terms: Accepts work on consignment (35% commission). Retail price set by the artist. Gallery provides insurance, promotion and contract; artist pays for shipping. Prefers artwork framed.

Submissions: Send query letter with resume, slides, artists statement and letter of intent. Write to schedule an appointment to show a portfolio, which should include slides. Replies in 1 month. Files artists statement, resume. Slides are returned to artists.

PATRICK KING CONTEMPORARY ART, 427 Massachusetts Ave., Indianapolis IN 46204. (317)634-4101. Director: Patrick King. Retail gallery. Estab. 1981. Clientele: private, corporate and museum. Represents 30 artists. Interested in mid-career and established artists. Sponsors 4 solo and 5 group shows/year. Average display time is 5 weeks. 1,100 sq. ft. studio and furniture maker gallery. "Gallery consigns works from exhibition to inventory for sales and presentations." Accepts only artists with 5-8 years of professional experience. Overall price range: $300 and up; most artwork sold at $600-3,500.

Media: Considers oil, acrylic, pastel, sculpture, ceramic, fiber, craft, mixed media and installation. Specializes in painting, sculpture and textile.

Style: Exhibits contemporary, abstract, figurative, non-representational, realist works and landscapes. Would like to see handcrafted or studio produced furniture.

Terms: Accepts work on consignment (50% commission). Retail price is set by gallery. Exclusive area representation required. Gallery provides promotion; shipping costs are shared.

Submissions: Send query letter with resume, slides, photographs and SASE. Files "correspondence, resumes, slides and photographs of all artists accepted for representation. All other portfolios returned provided artist sends SASE with initial query."

NEW HARMONY GALLERY OF CONTEMPORARY ART, 506 Main St., New Harmony IN 47631. (812)682-3156. Director: Connie Weinzapfel. Nonprofit gallery. Estab. 1975. Clientele: 80% private collectors, 20% corporate clients. Represents approximately 130 artists. Interested in emerging, mid-career and established artists. Sponsors 3 solo and 7 group shows/year. Average display time is 6 weeks. Overall price range: $50-5,000; most artwork sold at $100-500.

Media: Considers all media and original handpulled prints. Most frequently exhibits paintings (oil and acrylic), mixed media and sculpture.

Style: Considers all contemporary styles.

Terms: Accepts work on consignment (35% commission). Retail price is set by artist. Exclusive area representation not required. Gallery provides insurance, promotion and contract.

Submissions: Send query letter, resume, brochure, slides and SASE. Call to schedule an appointment to show a portfolio, which should include originals. Slides and resumes are filed or returned, and reviewed quarterly.

Tips: Accepts only Midwest artists. A common mistake artists make in presenting their work is showing "poor quality slides and haphazard resume." We are always looking for fresh innovative talent.

Iowa

ART GUILD OF BURLINGTON, INC., Box 5, 7th and Washington, Burlington IA 52601. (319)754-8069. Director: Lois Rigdon. Nonprofit gallery and museum sales shop. Estab. 1978. Represents emerging, mid-career and established artists. Has over 400 members. Exhibited artists include Connie Bieber and Jim Spring. Sponsors 12 shows/year. Average display time 3 weeks. Open all year. Located in historic Heritage Hill area; 2,400 sq. ft. "circa 1876 German Methodist Church restored and adapted to use as gallery, gift shop and classrooms." 35% of space for special exhibitions. Clientele: 75% private collectors, 25% corporate collectors. Price range: $25-1,000; most artwork sold at $75-500.

Media: Considers oil, acrylic, watercolor, pastel, pen & ink, drawings, mixed media, collage, works on paper, sculpture, fiber, glass, photography, original handpulled prints, woodcuts, wood engravings, linocuts, engravings, mezzotints, etchings, lithographs and serigraphs. Most frequently exhibits watercolor, prints and pottery.

Style: Exhibits surrealism, realism, photorealism and all styles. Genres include landscapes, florals, Southwestern, wildlife, portraits and figurative work.

Terms: Work accepted on consignment (20% commission). Retail price set by artist. Gallery provides insurance and promotion; artist pays for shipping. Prefers framed artwork.

Submissions: Send resume, slides, bio, brochure, SASE and business card. Call or write to schedule an appointment to show a portfolio, which should include originals and slides. Replies in 1 month. Files resume and slides.

BLANDEN MEMORIAL ART MUSEUM, 920 3rd Ave. S., Fort Dodge IA 50501. (515)573-2316. Director: Philip A. LaDouceur. Nonprofit municipal museum. Estab. 1930. Clientele: schoolchildren, senior citizens, tourists. 75% private collectors, 25% corporate clients. Sponsors 8 solo and 6 group shows/year. Average display time is 2 months. Interested in emerging, mid-career and established artists.

Media: Paintings, drawing, prints, photography, sculpture in various media.

Style: Exhibits painterly abstraction. Genres include landscapes and florals.

Submissions: Send query letter with resume, brochure, slides and SASE. Write to schedule an appointment to show a portfolio, which should include originals and slides. Slides, resumes and brochures are filed.

Tips: Looking for artists with a "unique view, excellence in vision and creativity." Does not want to see "copycat artists."

BRUNNIER GALLERY AND MUSEUM, Iowa State University, 290 Scheman Bldg., Ames IA 50011. (515)294-3342. Museum Store Manager: Jan Rathke. Estab. 1989. Clientele: university, community, and conventioneers. "The store will not sponsor shows, only the museum." Average display time 2 months. Interested in emerging and mid-career artists.

Media: Considers works on paper, sculpture, ceramic, fiber, glass, enamel and porcelain. Most frequently exhibits glass, ceramic and porcelain.

Style: "The museum store will be used as an educational tool to expose our community to affordable decorative arts and artists as well as various art forms and techniques."

Terms: Accepts artwork on consignment (30% commission) or buys outright (50% retail price; net 30 days). Retail price set by gallery and artist. Exclusive area representation not required. Gallery provides insurance and promotion.

Submissions: Send query letter with resume, brochure, slides and photographs. Call or write to schedule an appointment to show a portfolio, which should include originals and slides.

Tips: "We have a small space and have to work with limited areas." Sees trend toward "more collecting; glass unusual jewelry are popular."

CORNERHOUSE GALLERY, 2753 1st Ave. SE, Cedar Rapids IA 52402. (319)365-4348. Director: Janelle McClain. Retail gallery. Estab. 1976. Represents 75 emerging and mid-career artists. Exhibited artists include John Preston, Grant Wood and Stephen Metcalf. Sponsors 2 shows/year. Average display time 6 months. Open all year. 3,000 sq. ft.; "converted 1907 house with 3000 sq. ft. matching addition devoted to framing, gold leafing and gallery." 15% of space for special exhibitions. Clientele: "residential/commercial, growing collectors." 60% private collectors. Overall price range: $10-75,000; most artwork sold at $400-1,500.

Media: Considers oil, acrylic, watercolor, pastel, drawings, mixed media, collage, works on paper, sculpture, ceramic, fiber, glass, original handpulled prints, woodcuts, wood engravings, linocuts, engravings, mezzotints, jewelry, etchings, lithographs and serigraphs. Most frequently exhibits oil, acrylic, original prints and ceramic works.

Style: Exhibits painterly abstraction, conceptualism, color field, post modern works and impressionism. Exhibits all genres. Prefers abstraction, impressionism and post modern.

Terms: Accepts work on consignment (40% commission). Retail price set by artist/gallery. Gallery provides insurance and promotion; gallery pays for shipping costs from gallery. Prefers unframed artwork.

Submissions: Send resume, brochure, photographs and bio. Write to schedule an appointment to show a portfolio, which should include originals and photographs. Replies in 1 month. Files bio and samples.

Tips: Do not "stop in unannounced." Common mistakes artists make is "not working enough at it, i.e., thinking they can paint two or three works and be ready to sell and to charge the same prices as established artists who have paid their dues."

PERCIVAL GALLERIES, INC., Walnut at 6th, Valley National Bank Building, Des Moines IA 50309. (515)243-4893. Director: Bonnie Percival. Retail gallery. Estab. 1969. Represents 100 emerging, mid-career and established artists. Exhibited artists include Mauricio Lasansky and Karen Strohbeen. Sponsors 8 shows/year. Average display time is 3 weeks. Open all year. Located in downtown Des Moines; 3,000 sq. ft. 50-75% of space for special exhibitions.

Terms: Accepts work on consignment (50% commission) Retail price set by the gallery. Gallery provides insurance and promotion.
Submissions: Send query letter with resume, slides, photographs, bio and SASE. Call or write to schedule an appointment to show a portfolio, which should include originals, photographs and slides. Replies in 1 month. Files only items of future interest.

Kansas

***CLAYTON STAPLES GALLERY,** The Wichita State University School of Art and Design, Box 67, Wichita KS 67208. (316)689-3555, ext. 44. Director: D.T. Lincoln. Nonprofit gallery. Estab. 1970. Represents emerging, mid-career and established artists. Sponsors approx. 12-15 shows/year. Average display time 3 weeks. Closed during summer. Located on university campus; 600 sq. ft.; "well designed, small gallery." 20% of space for special exhibitions. Clientele: all types. 50% private collectors, 50% corporate collectors. Overall price range: $100-10,000. Most work sold at $500.
Media: Considers all media. Most frequently exhibits painting/drawing, sculpture, mixed.
Style: Exhibits all styles and all genres (if they are of quality).
Terms: Accepts work on consignment (20% commission). Retail price set by the artist. Gallery provides promotion and contract; artist pays for shipping. Prefers artwork framed.
Submissions: Send query letter with resume, slides, bio, brochure and SASE. Write to schedule an appointment to show a portfolio, which should include slides and photographs. Replies only if interested in 1 month. Files catalogs, resumes, and exhibit info.
Tips: No expectations other than high quality work.

GALLERY ELLINGTON, 350 N. Rock Rd., Wichita KS 67206. (316)682-9051. FAX: (316)682-8384. Owner: Howard Ellington. Retail gallery. Estab. 1978. Represents 10 mid-career and established artists. Exhibited artists include Birger Sandzer and Todd Matson. Sponsors 1 show/year. Average display time 6 months. Open all year. Located on the East Side; 250 sq. ft. 100% of space for special exhibitions. Clientele: "upper class." 80% private collectors, 20% corporate collectors. Overall price range: $50-25,000; most artwork sold at $500.
Media: Considers oil, watercolor, woodcuts, engravings, etchings, lithographs and serigraphs. Most frequently exhibits oils, lithographs and block prints.
Style: Exhibits impressionism. Genres include landscapes and Southwestern. Prefers Southwestern and impressionism.
Terms: Accepts work on consignment (30 or 40% commission). Retail price set by artist; shipping costs are shared. Prefers framed artwork.
Submissions: Accepts only artists from Southwest/prairie printmakers. Send resume and photographs. Call to schedule an appointment to show a portfolio, which should include originals. Replies only if interested.

GALLERY OF FINE ARTS TOPEKA PUBLIC LIBRARY, 1515 W. 10th, Topeka KS 66604. Gallery Director: Larry Peters. Nonprofit gallery and museum. Estab. 1973. Represents emerging, mid-career and established artists. Sponsors 8 shows/year. Average display time 1 month. Open all year. Located "1 mile west of downtown; 1,200 sq. ft., clean and attractive interior, security, professional installation and cases for small or fragile works." 100% of space for special exhibitions.
Media: Considers all media, woodcuts, woods engravings, mezzotints, etchings and lithographs. Most frequently exhibits 3D arts, paintings and drawings.
Style: Exhibits neo-expressionism, painterly abstraction, post modern works, realism and photorealism. Genres include landscapes, Southwestern and figurative work.
Terms: "If work is chosen for exhibition, there is no commission." Retail price set by artist. Gallery provides insurance; artist pays for shipping. Prefer framed artwork.
Submissions: Prefers only Nebraska, Kansas, Missouri, and Oklahoma artists—will accept others. "Size and weight are of importance: two people must easily handle all works." Send resume, slides and reviews. Call or write to schedule an appointment to show portfolio, which should include slides. Replies in 3 weeks. Files resume. "May be booked 1-2 years in advance."
Tips: "I want work to jump out and get my attention. (A good, quiet work may do this as well as a vibrant, exciting work)." Doesn't want to see "poor slides or photo prints, not enough work presented or no resume— Don't tell me more than I wish to know. I prefer a slide portfolio that I may view at my leisure without the artist being present. I see it becoming more competitive to get shows. Artists are going to really have to be into marketing to make a living."

WICHITA ART MUSEUM SALES/RENTAL GALLERY, 619 Stackman Dr., Wichita KS 67203. (316)268-4921. Chairperson: Barbara Rensner. Nonprofit retail and rental gallery. Estab. 1963. Clientele: tourists, residents of city, students; 99% private collectors, 1% corporate clients. Represents 119 artists. Sponsors 2 group shows/year. Average display time is 6 months. Accepts only artists from expanded regional areas. Interested

in emerging and established artists. Overall price range: $5-1,800; most artwork sold at $5-500.

Media: Considers oil, acrylic, watercolor, pastel, mixed media, collage, works on paper, sculpture, ceramic, fiber, glass and original handpulled prints.

Style: Exhibits hard-edge/geometric abstraction, impressionism, photorealism, expressionism and realism. Genres include landscapes, florals, portraits and figurative work. Most frequently exhibits photorealism and impressionism.

Terms: Accepts work on consignment (40% commission). Retail price is set by artist. Exclusive area representation not required. Gallery provides insurance and contract.

Submissions: Send query letter with resume. Resumes and brochures are filed.

THE WICHITA GALLERY OF FINE ART, Fourth Financial Center, 100 N. Broadway Wichita KS 67202. (316)267-0243. Co-owner: Robert M. Riegle. Retail gallery. Estab. 1977. Clientele: affluent business professionals; 80% private collectors, 20% corporate clients. Represents 25 emerging, mid-career and established artists. Sponsors 3 group shows/year. Average display time 6 months. Overall price range: $100-10,000; most artwork sold at $500-1,500.

Media: Considers oil, acrylic, watercolor, pastel, sculpture and original handpulled prints. Most frequently exhibits oil, watercolor and sculpture. Currently looking for watercolor.

Style: Exhibits impressionistic, expressionistic and realist styles. Genres include landscapes, florals and figurative work. Most frequently exhibited styles: impressionism, realism and expressionism. "Style is secondary to quality." Does not want to see "trite or faddish work."

Terms: Accepts work on consignment (40% commission). Retail price is set by gallery or artist. Exclusive area representation required. Gallery provides insurance, promotion and contract; shipping costs are shared.

Submissions: Send query letter with resume, brochure, slides, photographs and SASE. Call or write to schedule an appointment to show a portfolio, which should include originals. Letters are filed.

Tips: Seeking "full-time professional artists, producing consistently high quality art, adhering to ethical standards. Show prints rather than slides and have a good resume of education and background."

Kentucky

***THE GALLERY AT CENTRAL BANK,** Kincaid Towers, Vine St., Lexington KY 40507. (606)253-6135. FAX: (606)253-3381. Curator: John Irvin. Museum. Estab. 1988. Represents emerging, mid-career and established artists. Currently showing "a sister cities high school show." Sponsors 11-12 shows/year. Average display time 3 weeks. Open all year. Located downtown; 2,000 sq. ft. Overall price range: $75-5,000. Most work sold below $1,000.

Media: Considers all media. Most frequently exhibits watercolor, oil and fiber.

Style: Exhibits all styles and genres.

Terms: Artist receives 100% of the sales price. Retail price set by the artist. Gallery provides insurance, promotion, reception and cost of hanging; artist pays for shipping. Prefers artwork framed.

Submissions: Accepts only artists from Kentucky. No nudes. Call to schedule an appointment to show a portfolio, which should include originals. Replies immediately. Files names, addresses and phone numbers.

Tips: "Don't be shy, call me. We pay 100% of the costs involved once the work is delivered."

KENTUCKY ART & CRAFT GALLERY, 609 W. Main St., Louisville KY 40202. (502)589-0102. Director of Marketing: Sue Rosen. Retail gallery operated by the private nonprofit Kentucky Art & Craft Foundation, Inc. Estab. 1984. Represents more than 400 emerging, mid-career and established artists. Exhibited artists include Arturo Sandoval and Sarah Frederick. Sponsors 12 shows/year. Open all year. Located downtown in the historic Main Street district; 3,000 sq. ft.; the gallery is "a Kentucky tourist attraction located in a 120-year-old cast iron building." 33% of space for special exhibitions. Clientele: tourists, the art-viewing public and schoolchildren. 10% private collectors, 5% corporate clients. Overall price range: $3-20,000; most artwork sold at $25-500.

Media: Considers mixed media, works on paper, sculpture, ceramic, craft, fiber and glass. Most frequently exhibits ceramics, fiber and wood.

Terms: Artwork is accepted on consignment (40% commission). Retail price set by the artist. Gallery provides insurance, promotion, contract and shipping costs from gallery.

Submissions: Contact gallery for jury application and guidelines first then send query letter with resume and 5 slides. Replies in 2-3 weeks. "If accepted, we file resume, slides, signed contract, promotional materials, PR about the artist and inventory pricing."

Tips: "The artist must live or work in a studio within the state of Kentucky."

PARK GALLERY, 174 N. Hurstbourne Lane, Louisville KY 40222-5108. (502)896-4029. Owners: Ellen Guthrie and Martha Juckett. Retail gallery. Estab. 1973. Clientele: 80% private collectors. Represents 20 artists. Sponsors 6 solo and 1 group shows/year. Average display time is 1 month. Interested in emerging, mid-career

and established artists. Overall price range: $100-3,000; most artwork sold at $300-1,000.

Media: Considers oil, acrylic, watercolor, pastel, sculpture, ceramic, fiber, craft, mixed media, glass, limited-edition original handpulled prints and handmade jewelry.

Style: Exhibits contemporary, landscape, floral and primitive works. Specializes in eclectic, affordable art.

Terms: Accepts work on consignment (40% commission) or buys outright (net 30 days). Retail price is set by gallery or artist. Gallery provides insurance, promotion and contract; shipping costs are shared.

Submissions: Send query letter with resume, brochure, slides and photographs. Call or write to schedule an appointment to show a portfolio. All materials are filed.

Tips: Looks for "quality and originality or uniqueness. No repetition, commercialism or mass-produced items."

***TWO STREET STUDIO**, 126 S. 2nd St., Paducah KY 42001. (502)443-2582. Director: S. Roush. Retail gallery. Estab. 1988. Represents 20 artists, emerging and mid-career. Exhibited artists include Warren Farr and H. Cline. Sponsors 9 shows/year. Average display time 6 weeks. Open all year. Located downtown, next to art center; 2,000 sq. ft.; "big city gallery in small town." 60% of space for special exhibitions. 10-20% private collectors, 30-40% corporate collectors. Overall price range: $200-10,000; most work sold at $200-5,000.

Media: Considers oil, acrylic, watercolor, pastel, pen & ink, drawing, mixed media, collage, paper, sculpture, ceramic, fiber, glass, installation and photography; original handpulled prints, including woodcuts, wood engravings, linocuts, engravings, mezzotints, etchings, lithographs and pochoir. Most frequently exhibits oil paintings, drawings and sculpture.

Style: Exhibits all styles. Prefers all styles, "no clichés."

Terms: Accepts work on consignment (40% commission) or buys outright for 50% of the retail price (net 30 days). Retail price set by the gallery and the artist. Gallery provides insurance, promotion and contract; shipping costs are shared. Prefers artwork framed.

Submissions: Prefers only Midwest artists with exhibition records and possibly a MFA. Send query letter with resume, slides, bio, brochure, photographs, SASE, business card and reviews. Write to schedule an appointment to show a portfolio, which should include originals, photographs and transparencies. Replies in 1 week. "I only file material on artists I represent."

Tips: "Be organized, have previous experience, and look at the gallery first to be sure your work is appropriate."

YEISER ART CENTER INC., (formerly Paducah Art Guild, Inc.), 200 Broadway, Paducah KY 42001. (502)442-2453. Executive Director: Dan Carver. Nonprofit gallery. Estab. 1957. Represents emerging, mid-career and established artists. Has 450 members. Sponsors 8 shows/year. Average display time 6-8 weeks. Open all year. Located downtown; 1,800 sq. ft.; "in historic building that was farmer's market." 90% of space for special exhibitions. Clientele: professionals and collectors. 90% private collectors. Overall price range: $200-8,000; most artwork sold at $200-1,000.

Media: Considers oil, acrylic, watercolor, pastel, pen & ink, drawings, mixed media, collage, works on paper, sculpture, ceramic, craft, fiber, glass, photography, original handpulled prints, woodcuts, wood engravings, linocuts, mezzotints, etchings, lithographs and serigraphs. Most frequently exhibits oil, acrylic and mixed media.

Style: Exhibits all styles. Genres include landscapes, florals, Americana and figurative work. Prefers realism, impressionism and abstraction.

Terms: Accepts work on consignment (25% commission). Retail price set by artist. Gallery provides insurance and promotion; shipping costs are shared. Prefers framed artwork.

Submissions: Send resume, slides, bio, SASE and reviews. Replies in 1 month.

Tips: "Do not call. Send submissions—see above. Must have large body of work."

***ZEPHYR GALLERY**, 637 W. Main St., Louisville KY 40202. (502)585-5646. Contact: Recruitment. Cooperative gallery and art consultancy with regional expertise. Estab. 1988. Represents 18 artists; emerging, mid-career and established. Exhibited artists include Suzanne Mitchell and Billy Hertz. Sponsors 12 shows/year. Average display time 1 month. Open all year. Located downtown; approximately 3,000 sq. ft.; "cast-iron facade, main exhibition space and 'Riverview Gallery'—special exhibits." 20% of space for special exhibitions. Clientele: 25% private collectors, 75% corporate collectors. Most work sold at $200-7,000.

Media: Considers all media. Considers only small edition print work by the artist. Most frequently exhibits painting, photography and sculpture.

Style: Exhibits individual styles.

Terms: Co-op membership fee plus donation of time (25% commission); outside the Louisville metropolitan area (50% consignment). Retail price set by the artist. Gallery provides insurance, promotion and contract; artist pays for shipping. Prefers artwork framed.

Submissions: No functional art (jewelry, etc.). Send query letter with resume and slides. Call to schedule an appointment to show a portfolio, which should include slides; may request original after slide viewing. Replies in 1 month. Files slides, resumes and reviews (if accepted).

Tips: "Most decisions, especially membership, are made democratically among the current members. We are looking for a diverse mixture of mature fine artists."

Louisiana

CASELL GALLERY, 818 Royal St., New Orleans LA 70116. (504)524-0671. Vice President: Janice Bezverkov. Retail gallery. Estab. 1970. Represents 10 artists; mid-career. Sponsors 6+ shows/year. Average display time 1 month. Open all year. Located in Virux Carre (historical sector); 500 sq. ft. 80% of space for special exhibitions. Clientele: locals and visitors to New Orleans (national and international). 20% private collectors, 10% corporate collectors. Overall price range: $500; most work sold at $200.
Media: Considers watercolor, pastel, pen & ink, drawing, paper; original handpulled prints, woodcuts, wood engravings, linocuts, engravings, etchings, lithographs, silk screen, pochoir, posters and serigraphs. Most frequently exhibits pastels, serigraphs and etchings.
Style: Exhibits expressionism, neo-expressionism, primitivism, impressionism and realism. Genres include landscapes, wildlife and figurative work. Prefers impressionism, expressionism and primitivism.
Terms: Accepts work on consignment (40% commission) or buys outright for 50% of retail price (net 30 days). Retail price set by the gallery and the artist. Gallery provides insurance. Prefers artwork unframed.
Submissions: Accepts only artists from New Orleans area. Send query letter with photographs, business card and reviews; visit. Call to schedule an appointment to show a portfolio, which should include photographs. Replies only if interested in 1 week.

LE MIEUX GALLERIES, 332 Julia St., New Orleans LA 70130. (504)565-5354. President: Denise Berthiaume. Retail gallery and art consultancy. Estab. 1983. Clientele: 75% private collectors; 25% corporate clients. Represents 18 artists. Sponsors 4 solo and 5 group shows/year. Accepts only artists from the Southeast. Interested in established artists.
Media: Considers oil, acrylic, watercolor, pastel, drawings, mixed media, works on paper, sculpture, ceramic, glass and egg tempera. Most frequently exhibits oil, watercolor and drawing.
Style: Exhibits impressionism, neo-expressionism, realism and hard-edge geometric abstraction. Genres include landscapes, florals, wildlife and figurative work. Prefers landscapes, florals and paintings of birds.
Terms: Accepts work on consignment (50% commission). Retail price set by gallery and artist. Exclusive area representation required. Gallery provides insurance, promotion and contract; artist pays for shipping. Prefers artwork unframed.
Submissions: Send query letter with resume, slides and photographs. Write to schedule an appointment to show a portfolio, which should include slides and photographs. Replies in 3 months. All material is returned if not accepted or under consideration.
Tips: "Give me the time and space I need to view your work and make a decision; you cannot sell me on liking or accepting it; that I decide on my own."

STONER ARTS CENTER, 516 Stoner Ave., Shreveport LA 71101. (318)222-1780. Director: Danny J. Williams. Nonprofit gallery. Estab. 1972. Sponsors 7 solo or 2-person shows/year. Average display time is 6 weeks. Interested in emerging and established artists. Most artwork sold at $300-3,000 for large paintings; $100 or less for craft items in sales gallery.
Media: Considers oil, acrylic, watercolor, pen & ink, drawings, mixed media, collage, works on paper, sculpture, ceramic, fiber, glass, installation, photography and original handpulled prints. Most frequently exhibits oil, acrylic, mixed media and sculpture.
Style: Exhibits painterly abstraction, minimalism, conceptualism, surrealism, primitivism, impressionism and neo-expressionism. "The Stoner Arts Center is a contemporary gallery and exhibits varied styles and media. We do not exhibit realistic, sentimental work but will consider all media. We exhibit the works of reputable artists who have shown on a regional and national level, but we are always open to new and promising talent."

 The asterisk before a listing indicates that the listing is new in this edition. New markets are often the most receptive to freelance submissions.

Terms: Accepts work on consignment (40% commission) in sales gallery. Retail price is set by artist. Exclusive area representation not required. Gallery provides insurance, promotion and contract.
Submissions: Send query letter with resume, slides and SASE.
Tips: "Visit the gallery first to see if your work would fit in. Then send slides, resume and statement; show a professional attitude. Artists often assume that they can schedule a show immediately."

Maine

***UNIVERSITY OF MAINE MUSEUM OF ART**, 109 Carnegie Hall, Orono ME 04469. (207)581-3255. FAX: (207)581-1604. Director: Charles Shepard. Museum. Estab. 1946. Exhibits emerging, mid-career and established artists. Sponsors 18 shows/year. Average display time 4-6 weeks. Open all year. Located on a rural university campus; 2,750 sq. ft. (500 linear feet of display space); museum is located in 1904 original granite library building. 100% of space for special exhibitions.
Media: Considers all media and all types of prints.
Style: Exhibits all styles and genres.
Terms: Accepts donated artwork for exhibition. Gallery provides insurance and promotion; shipping costs are shared. Prefers artwork framed.
Submissions: Send query letter with resume, slides, bio and reviews. Write to schedule an appointment to show a portfolio, which should include originals and slides. Replies in 1 month. Files bio, slides, if requested, and resume.

Maryland

ARTISTS CIRCLE, LTD., 11544 Spring Ridge Rd., Potomac MD 20854. (301)921-0572. Contact: Gallery Manager. Art consultancy. Estab. 1972. "No exhibitions. Gallery art shown by appointment to designers, architects and clients." Located in suburb. Clientele: 5% private collectors; 95% corporate clients. Represents 1,000 artists. Interested in emerging and established artists. Overall price range: $300-500,000; most work sold at $500-6,000.
Media: Considers oil, acrylic, watercolor, pastel, drawings, mixed media, collage, works on paper, sculpture, ceramic, fiber, glass, photography, egg tempera, woodcuts, wood engravings, engravings, mezzotints, etchings, lithographs, pochoir, serigraphs and offset reproductions.
Style: Exhibits impressionism, expressionism, neo-expressionism, realism, color field, painterly abstraction, post modern works, pattern painting and hard-edge geometric abstraction. Considers all styles. Genres include landscapes, Americana and subjects regional to Washington DC, Maryland or Virginia. Prefers abstracts and landscapes. "We are committed to placing the highest quality fine art in the corporate and business community. As the first art consultant in the Washington DC metropolitan area, we have a long standing professional relationship with the business and development community as well as the hundreds of artists throughout the country we represent. Because the corporate needs and market are so broad, we sell and show a wide range of media and styles. We often work closely with the developer and space planner when we are placing art. Unlike most art consultants, we maintain a 2,000 sq. foot gallery/office space, a large inventory of samples and existing pieces and have a full-time staff of 5 people."
Terms: Accepts work on consignment (50-40% commission) or buys outright (50% retail price; net 30 days). Retail price set by artist. "We reserve the right to advise an artists on prices if warranted." Gallery provides insurance and contract (if needed or for commissions); client pays shipping. Prefers artwork unframed.
Submissions: Send query letter with resume, brochure, slides and bio. Call to schedule an appointment to show a portfolio. Replies in 1-2 weeks. Files slides and artist info. All material is returned if not accepted or under consideration.
Tips: One trend is "the use, as well as acceptance, of professional art consultants as a viable source for corporate fine art, rather than galleries, also a greater use of signature sculpture by developers. It is interesting how many galleries now contact us in hopes of showing their artists to the corporate and business market. This did not happen in the past."

819 GALLERY, 817 S. Broadway, Fells Point, Baltimore MD 21231. (301)732-4488. Director: Stephen Salny. Retail gallery. Estab. 1986. Represents 12 emerging artists. Sponsors 6 solo shows/year. Average display time 7 weeks-2 months. Open February through December. Located on the waterfront in historic Fells Point. 1,200 sq. ft. 50% of space devoted to special exhibitions; 50% to work of gallery artists. Gallery housed in renovated historic townhouse. Clientele: locals, tourists from Washington DC, Philadelphia and Virginia. 100% private collectors. Overall price range: $500-3,000; most work sold at $1,000-2,000.

Media: Considers oil, acrylic, watercolor, pastel, drawing, mixed media, collage, works on paper, ceramic and glass. Considers monotypes. Most frequently exhibits original works on paper.

Style: Exhibits painterly abstraction, color field, realism and photorealism. Genres include landscapes and florals. Prefers abstraction and realistic landscapes.

Terms: Accepts work on consignment (50% commission). Retail price set by artist. Exclusive area representation required. Gallery provides some promotion and contract; artist pays for shipping. Prefers archival-quality framed artwork.

Submissions: Send query letter with resume, business card, slides, bio, brochure, photographs and SASE. Replies in 2 months; "if no response, call to remind." All material is returned if not accepted or under consideration.

Tips: "Looks for good organization in addition to reliability, professionalism and accuracy. Follow submission rules." Common mistakes artists make in presenting their work are that "they do not listen to the gallery requirements. They stop by unannounced, usually at a busy time for the gallery."

THE GALLERY AT ST. MARY'S COLLEGE OF MARYLAND, St. Mary's City MD 20686. (301)862-0246. Director: Jonathan Ingersoll. Nonprofit gallery. Estab. 1971. Represents artists; emerging, mid-career and established. Sponsors 10 shows/year. Average display time 1 month. Open all year. Rural location; 1,600 sq. ft. 100% of space for special exhibitions.

Media: Considers "anything."

Style: Exhibits all styles and genres. No barns or fishing boats.

Terms: Gallery provides insurance and shipping costs. Prefers framed artwork, but will shrink wrap.

Submissions: Send letter, bio and examples.

Tips: "The best way for artists to be introduced to our gallery is to have someone respected in the art world introduce them. Otherwise a good letter with resume and good examples of the work."

HOLTZMAN ART GALLERY, Towson State University, Towson MD 21204. (301)830-2476/2333. Director: Christopher Bartlett. Nonprofit gallery. Estab. 1973. Clientele: students, Baltimore general public and private collectors. Sponsors 2 solo and 5 group shows/year. Average display time is 3 weeks. Interested in established artists. Overall price range: $50-10,000; most artwork sold at $100-1,000.

Media: Considers oil, acrylic, watercolor, pastel, pen & ink, drawings, mixed media, collage, works on paper, sculpture, ceramic, craft, fiber, glass, installation, photography, performance art, original handpulled prints and silkscreens. Most frequently exhibits paintings, watercolor and sculpture.

Style: Considers all styles and genres. "We exhibit a broad range of contemporary styles and media which also encompass diverse subject matter or themes as an educational resource to students and as displays of both traditional and avant-garde contemporary work."

Terms: Retail price is set by artist. Exclusive area representation not required. Gallery provides insurance, promotion and contract.

Submissions: Send query letter and resume. Resumes are filed. Slides are requested after initial contact.

***IMAGES INTERNATIONAL ART GALLERY,** 4600 E. West Highway, Bethesda MD 20814. (301)654-2321. FAX: (301)907-0216. President: Beverley Hill. Retail gallery. Estab. 1985. Represents 25 artists; emerging, mid-career and established. Exhibited artists include H. Otsuka and Warren Allin. Sponsors 6 shows/year. Average display time 6 weeks. Open all year. Located in downtown Bethesda; 1,100 sq. ft.; "interior moveable walls, with storage." 80% of space for special exhibitions. Clientele: upper and moderate income. 90% private collectors, 10% corporate collectors. Overall price range: $500-10,000; most work sold at $500-2,500.

Media: Considers oil, acrylic, watercolor, mixed media, paper and sculpture; original handpulled prints, mezzotints, etchings, and serigraphs. Most frequently exhibits oil, mixed media and watercolor.

Style: Exhibits expressionism, surrealism, color field, impressionism, realism and hard-edge geometric abstraction. Genres include landscapes, florals, Americana, wildlife and figurative work. Prefers landscapes, Americana and figurative.

Terms: Accepts work on consignment (50% commission); or buys outright for 30% of retail price (net 30 days). Retail price set by the artist. Gallery provides insurance, promotion and contract; shipping costs are shared. Prefers artwork framed.

Submissions: Accepts only artists from the Northeast and mid-Atlantic. Prefers only oil and acrylic. Should be contemporary and "gallery compatible." Send query letter with resume, slides, brochure, photographs, business card and reviews. Write to schedule an appointment to show a portfolio, which should include photographs and slides. Replies in 2 weeks. Files resume, brochure, reviews and photos.

***MARLBORO GALLERY,** 301 Largo Rd., Largo MD 20772. (301)322-0965-7. Coordinator: John Krumrein. Nonprofit gallery. Estab. 1976. Seasons for exhibition: September-May. Clientele: 100% private collectors. Sponsors 4 solo and 4 group shows/year. Average display time 3 weeks. 2,100 sq. ft. with 10 ft. ceilings and 25 ft. clear story over 50% of space—track lighting (incandecent) and day light. Interested in emerging, mid-career and established artists. Overall price range: $200-16,000; most work sold at $500-700.

Media: Considers all media and all types of prints. Most frequently exhibits acrylics, oils and welded steel.
Style: Exhibits expressionism, neo-expressionism, realism, photorealism, minimalism, primitivism, painterly abstraction, conceptualism and imagism. Genres include landscapes, Southwestern, Western and figurative work. Prefers expressionism and minimalism. "We are open to all serious artists and all media. We will consider all proposals without prejudice."
Terms: Accepts artwork on consignment. Retail price set by artist. Exclusive area representation not required. Gallery provides insurance. Artist pays for shipping. Prefers artwork ready for display.
Submissions: Send query letter with resume, slides, SASE, photographs and bio. Call or write to schedule an appointment to show a portfolio, which should include slides and photographs. Replies in 1 month. Files resume, bio and slides.
Tips: "Indicate if you prefer solo shows or will accept inclusion in group show chosen by gallery."

MEREDITH GALLERY, 805 N. Charles St., Baltimore MD 21201. (301)837-3575. President: Judith Lippman. Retail gallery. Estab. 1977. Clientele: commercial and residential. Exhibits the work of 4-6 individuals and 5-7 groups/year. Sponsors 5 solo and 5 group shows/year. Average display time is 2 months. Interested in emerging and established artists. Overall price range: $200-5,000; most artwork sold under $2,000.
Media: Considers watercolor, ceramic, fiber, craft, glass, artist-designed furniture and original handpulled prints.
Style: Exhibits contemporary, abstract, figurative, realistic works and landscapes. Specializes in contemporary American crafts and artist-designed furniture.
Terms: Accepts work on consignment. Retail price is set by gallery and artist. Exclusive area representation required. Gallery provides insurance, promotion and contract; shipping costs are shared.
Submissions: Send query letter, resume, slides, SASE and price list. "Slides, resume and price list are filed if we are interested."
Tips: "Looks for excellent craftsmanship, innovative design and quality in your field."

TOWN CENTER GALLERY, INC., 250 Hungerford Dr., Rockville MD 20850. (301)424-7313. Manager: Connie Woolard. Cooperative gallery. Estab. 1972. Clientele: 90% private collectors; 10% corporate clients. Represents 22 artists. "Gallery offers space to non-members. Gallery members feature show hangs for 1 month, 12 times/year, if no special shows are scheduled." 1,500 st. ft. in 'Metrocenter,' direct access from metro stop. Interested in emerging, mid-career and established artists. Overall price range: $50-2,500; most artwork sold at $50-500.
Media: Considers oil, acrylic, watercolor, pastel, pen & ink, drawings, mixed media, collage, works on paper, sculpture, ceramic, egg tempera, woodcuts, wood engravings, linocuts, engravings, mezzotints, etchings, lithographs, serigraphs and offset reproductions. Most frequently exhibits watercolors or acrylics, oils and prints. Also carries computer art.
Style: Exhibits impressionism, expressionism and realism. Genres include landscapes, florals, Americana, wildlife and figurative work. Prefers landscapes, florals and still-lifes.
Terms: Co-op donation of time; 35% commission. Rental fee for space; rental fee for non-members covers 1 month. Retail price set by artist. Exclusive area representation not required. Prefers framed artwork.
Submissions: Send query letter with resume, business card, slides, bio and SASE. Call or write to schedule an appointment to show a portfolio, which should include originals, slides, transparencies and photographs. Replies in 3 weeks.
Tips: "A special show might be best consideration for anyone living outside the immediate area, as members are required to give working time, etc., since we are a co-operative gallery. Special non-member shows offered three times a year. The other months are group shows with one large wall for featuring a member each month or if a *special show* (non-member) has been requested, that space is used instead for 'special' (non-member) show." Sees trend toward "a real increased interest in original art; many beginning collectors."

Massachusetts

A.K.A SKYLIGHT GALLERY OF BEACON HILL, 43 Charles St., Boston MA 02114. (617)720-2855. FAX: (617)723-7683. Director: John Chiltick. Rental gallery. Estab. 1986. Represents 18 artists; emerging, mid-career and established. Exhibited artists include Ricky Leacock and Anthony Nordoff. Sponsors 12 shows/year. Average display time 1 month. Open all year. Located "downtown, in prestigious Beacon Hill"; 650 sq. ft.; "tremendous skylights, loft gallery, high white brick walls." Clientele: professionals. 80% private collectors, 20% corporate collectors. Overall price range: $300-1,500.

Media: Considers oil, acrylic, watercolor, pastel, pen & ink, drawing, mixed media, collage and paper. "We need flat art—cannot handle 3D works." Most frequently exhibits oil, acrylic and other.

Style: Exhibits expressionism, impressionism, realism, photorealism and hard-edge geometric abstraction. All genres.

Terms: Accepts work on consignment (10% commission); rental fee for space (covers 1 month). Exclusive area representation is not required. Gallery handles all promotion. Artist receives 90% commissions with exception of first piece sold at 50-50 split). Retail price set by the artist. Gallery provides insurance, promotion and contract; artist pays for shipping. Prefers framed artwork or acid-free matted.

Submissions: Send query letter with resume, slides and photographs. Write to schedule an appointment to show a portfolio, which should include photographs, slides and transparencies. Replies in 2½ weeks. Files resumes, etc.

Tips: "It's an excellent space for artist interested in selling at prices artist sets. Please call for our free prospectus. It explains our procedures."

ALPHA GALLERY, 121 Newbury St., Boston MA 02116. (617)536-4465. Directors: Joanna E. Fink and Alan Fink. Estab. 1967. Clientele: 70% private collectors, 25% corporate clients. Represents 15 artists. Sponsors 8-9 solo and 1-3 group shows/year. Average display time is 3½ weeks. Interested in emerging and established artists. Price range: $500-500,000; most artwork sold at $1,000-10,000.

Media: Considers oil, acrylic, watercolor, pastel, pen & ink, drawings, mixed media, sculpture and original handpulled prints. Most frequently exhibits oil on canvas, prints and works on paper.

Style: Exhibits painterly abstraction, expressionistic and realism. Genres include landscapes and figurative work. Most frequently exhibits figurative and new image works, expressionism. Prefers "strong, figurative, non-decorative oils, in which the paint itself is as important as what is portrayed."

Terms: Accepts work on consignment (50% commission). Retail price is set by gallery and artist. Exclusive area representation required. Gallery provides insurance, promotion mailing costs; shipping costs are shared.

Submissions: Send query letter with resume, slides and SASE.

AMHERST GALLERY OF FINE ART, (formerly Fauve Gallery) 26 Main St., Amherst MA 01002. (413)256-0321. Contact: Gabrielle Jazwiecki. Retail gallery, art consultancy and framer. Estab. 1974. Represents 12-15 artists; emerging, mid-career and established. Exhibited artists include John Grillo and Leonel Góngora. Sponsors 10 shows/year. Average display time 1 month. Open all year. Located on the commons—downtown; 900 sq. ft.; classic Victorian setting. 90% of space for special exhibitions. Clientele: corporate to walk-in. 50% private collectors, 50% corporate collectors. Overall price range: $100-5,000; most artwork sold at $100-1,200.

Media: Considers oil, acrylic, watercolor, pastel, pen & ink, drawings, mixed media, collage, works on paper, sculpture, ceramic, craft, fiber, glass, photography, original handpulled prints, woodcuts, wood engravings, engravings, mezzotints, etchings, lithographs, pochoir, serigraphs and posters. Most frequently exhibits oil, acrylic and mixed media.

Style: Exhibits expressionism, painterly abstraction, impressionism, realism, photorealism and all genres.

Terms: Accepts work on consignment (50% commission). Area exclusivity for 12 months. Retail price set by the gallery. Gallery provides insurance and contract; artist pays shipping. Prefers framed artwork. "But we will frame at 20% off materials."

Submissions: Prefers artists from all areas. Send query letter with resume, slides, bio, brochure, photographs, SASE and reviews. Write to schedule an appointment to show a portfolio, which should include originals, photographs, slides and transparencies. Replies in 6 weeks. Files all material.

Tips: "Only send the best work with good quality slides." Because of the recession, "would like to see lower prices and more flexibility in payment."

***ARTISTS FOUNDATION GALLERY,** 8 Park Plaza, Boston MA 02116. (617)227-2787. Director: Catherine Mayes. Nonprofit gallery. Estab. 1986. Represents emerging and mid-career artists. Sponsors 8 shows/year. Average display time 2 months. Open all year. Located in downtown Boston; 2,500 sq. ft.; "We are located in the State Transportation building." 100% private collectors. Overall price range: $150-20,000; most work sold at $3,000.

Media: Considers all media and types of handpulled prints. Most frequently exhibits prints, photographs, crafts, paints and sculpture.

Style: Exhibits all styles.

Terms: Accepts work on consignment (30% commission). Retail price set by the artist. Gallery provides insurance and promotion; artist pays for shipping.

Submissions: Accepts only artists from Massachusetts. Send query letter with resume, slides and bio. Write to schedule an appointment to show a portfolio. Portfolio samples should be appropriate for medium. Replies in 1 month.

CAPE MUSEUM OF FINE ARTS, Box 2034, 60 Hope Lane, Dennis MA 02638. (508)385-4477. Director: Suzanne M. Packer. Museum. Estab. 1981, opened to public in 1985. Represents 75 artists. Sponsors 1 solo and 5 group shows/year. Average display time 6 weeks-2 months. Accepts only artists from region or associated with Cape Cod. Interested in emerging and established artists.

Media: "We accept all media." No offset reproductions or posters. Most frequently exhibits oil, sculpture, watercolor and prints.

Style: Exhibits all styles and all genres. "The CMFA provides a year-round schedule of art-related activities and programs for the Cape community: exhibitions, Cinema Club, lectures, bus trips and specially planned events for all ages. The permanent collection focuses on art created by Cape artists from the 1900 to the present date."

Submissions: Send query letter with resume and slides. Write to schedule an appointment to show a portfolio, which should include originals. All material is returned if not accepted or under consideration.

Tips: "We encourage artist to leave with the Museum their resume and slides so that we can file it in our archives." Wants to see works by "innovators, creators . . . leaders. Museum quality works. Artist should be organized. Present samples that best represent your abilities and accomplishments."

CLARK GALLERY, INC., Box 339, Lincoln Station, Lincoln MA 01773. (617)259-8303. Assistant Director: Jennifer Atkinson. Retail gallery. Estab. 1976. Represents 30 artists; emerging and mid-career. Exhibited artists include Robert Freeman and Peter Sullivan. Sponsors 10 shows/year. Average display time is 1 month. Closed August. Located in a suburb of Boston; 1,600 sq. ft.; space is large enough for 2 solo exhibitions. 8 shows per year are devoted to gallery artists; 2 shows per year include other artists—1 show devoted exclusively to artists not affiliated with the gallery. Clients are young to established collectors from greater Boston area and craft collectors from across U.S. 90% private collectors, 10% corporate collectors. Overall price range: $400-30,000; most work sold at $500-5,000.

Media: Considers oil, acrylic, drawing, mixed media, collage, works on paper, sculpture, ceramic, craft and glass; original handpulled prints. Most frequently exhibits paintings, furniture and ceramics.

Style: Exhibits painterly abstraction, realism, photorealism and folk art. Genres include landscapes and figurative work. "We are very eclectic, showing two and three-dimensional works in all styles, ranging from abstract to realistic and everything in between."

Terms: Accepts work on consignment (50% commission). Retail price is set by gallery. Gallery provides insurance, promotion and contract (sometimes); shipping costs are shared. Artwork may be framed or unframed.

Submissions: "Shows mostly Boston area artists, but others are welcome to submit." Send query letter with resume, slides and SASE. "Appointment to see original work will be set up only after slide review." Replies in 2 weeks. Files resumes.

***FULLER MUSEUM OF ART,** 455 Oak St., Brockton MA 02401-1399. (508)588-6000. Curator: Peter Baldaia. Museum. Estab. 1969. Represents emerging, mid-career and established artists. Sponsors 6-8 shows/year. Average display time 2-3 months. Open all year. Located on the west side of Brockton, adjacent to DW Field Park; 5,000 sq. ft.; "award-winning architectural structure nestled on 22 wooded acres bordering a pond." 75% of space for special exhibitions. Clientele: community-based and extending into greater Boston area.

Media: Considers all media and all types of prints. Most frequently exhibits painting, sculpture and crafts.

Style: Exhibits all styles. Genres include landscapes, florals, American, portraits, and figurative work. Prefers painterly abstraction, realism and post modern works.

Terms: Work is considered and accepted for display by curator. Gallery provides insurance and promotion; shipping costs are shared. Prefers artwork framed.

Submissions: Prefers artists living and working in New England with solid track record of exhibitions. Send query letter with resume, slides, bio and SASE "limit of 12 slides please. We contact artists after reviewing their submissions." Replies in 1-2 months. Files material of potential interest for future group/solo shows.

THE GALLERY AT CORNERSTONE, 62 1st Ave., Waltham MA 02154. (617)890-3773. FAX: (617)890-8049. Gallery Coordinator: Robert Zinck. Estab. 1984. Represents emerging and mid-career artists. Sponsors 8 shows/year. Average display time 6 weeks. Open all year. 150 sq. ft. 100% of space for special exhibitions. Most work sold at $200-1,000.

Media: Considers photography.

Style: Exhibits all genres.

Terms: Retail price set by the artist. Gallery provides promotion; artist pays for shipping, ½ of postcard cost, ½ of food and beverages for reception.

Submissions: Send query letter, resume, slides and bio. Call and write to schedule an appointment to show a portfolio, which should include originals. Replies only if interested in 1 month. Files "everything that could be of future use."

GALLERY EAST, THE ART INSTITUTE OF BOSTON, 700 Beacon St., Boston MA 02215. (617)262-1223. Exhibitions Directors: Bonnell Robinson. Nonprofit gallery. Estab. 1911. Clientele: students and private individuals. Sponsors 1 solo and 6 group shows/year. Average display time 1 month. Interested in emerging and established artists.

Media: Considers oil, acrylic, watercolor, pastel, pen & ink, drawings, mixed media, collage, works on paper, sculpture, ceramic, installation, photography and original handpulled prints. Most frequently exhibits photography, oil/acrylic and graphic design.
Style: Exhibits landscapes, portraits and figurative work. "The AIB is *not* a commercial gallery. It is an educational nonprofit gallery."
Terms: Accepts work on consignment (33% commission). Retail price is set by gallery and artist. Gallery provides insurance, promotion and contract; shipping costs are shared.
Submissions: Send query letter, resume, brochure, slides and SASE. Portfolio should include slides and transparencies. Resumes are filed.

GALLERY ON THE GREEN, 1837 Massachusetts Ave., Lexington MA 02173. (617)861-6044. Director: Patricia L. Heard. Retail gallery and art consultancy. Estab. 1980. Represents 30 artists. Sponsors 5 solo and 2 group shows/year. Average display time 6 weeks. Interested in mid-career and established artists.
Media: Considers oil, acrylic, watercolor, pastel, pen & ink, drawings, mixed media, collage, works on paper, sculpture, ceramic, fiber, glass, egg tempera and original handpulled prints. Most frequently exhibits oil, acrylic and watercolor.
Style: Exhibits impressionism, expressionism, realism, painterly abstraction and imagism. Genres include landscapes, florals, wildlife, portraits and figurative work. Prefers landscapes. "Carefully limited eclecticism."
Terms: Accepts work on consignment (50% commission). Retail price set by gallery and artist. Exclusive area representation required during exhibition. Gallery provides insurance, promotion, contract and shipping costs from gallery. Prefers framed artwork.
Submissions: Send query letter with resume, slides and SASE. Call to schedule an appointment to show a portfolio, which should include slides and transparencies. Replies in 3 weeks. Files slides and resumes. All material is returned if not accepted or under consideration.
Tips: "In corporate work there is a great need for large scale, realistic or semi-realistic work at reasonable prices." Sees trend toward "interest in fine crafts; work reflecting care for the environment."

***GROHE GLASS GALLERY**, Dock Square, Boston MA 02109. (617)227-4885. Retail gallery. Estab. 1988. Represents 50 artists; mid-career and established. Interested in seeing the work of emerging artists. Exhibited artists include Tom Patti and Paul Stankard. Sponsors 10 shows/year. Average display time 1 month. Open all year. Located downtown; 500 sq. ft. 75% of space for special exhibitions. Clientele: glass collectors. 90% private collectors, 10% corporate collectors. Overall price range: $1,500-35,000.
Media: Considers glass.
Terms: Accepts work on consignment (50% commission). Retail price set by the artist. Gallery provides insurance, promotion and contract; shipping costs are shared.
Submissions: Prefers only glass artists. Send query letter with resume, slides, bio, photographs and SASE. Write to schedule an appointment to show a portfolio. Replies in 2 weeks.

***THE HOPKINS GALLERY**, Main St., Wellfleet MA 02667. (508)349-7246. Manager: Marla Freedman. Retail gallery. Estab. 1983. Represents 50 artists; emerging, mid-career and established. Exhibited artists include Peter Watts and Ellen LeBow. Sponsors 5 shows/year. Average display time 3 weeks to 4 months. Open spring and summer. Located in Cape Cod; 1,000 sq. ft.; "contemporary and evocative art." 60% of space for special exhibitions. Clientele: "wealthy and up-and-coming." 20% private collectors, 10% corporate collectors. Overall price range: $200-3,000; most work sold at $200-800.
Media: Considers oil, acrylic, watercolor, pastel, pen & ink, drawing, collage, paper, sculpture, ceramic, craft, glass, installation and photography. Most frequently exhibits oil, pastel and photography.
Style: Exhibits expressionism, painterly abstraction, impressionism and hard-edge geometric abstraction; all genres.
Terms: Accepts work on consignment (45% commission). Retail price set by the artist. Gallery provides insurance, promotion and contract; artist pays for shipping. Prefers artwork framed.
Submissions: Send query letter with resume, slides, bio, brochure, photographs, SASE, business card and reviews. Write to schedule an appointment to show a portfolio, which should include originals, slides, photographs and transparencies. Replies in 2 months.

R. MICHELSON GALLERIES, 132 Main St., Northampton MA 01060 and 25 S. Pleasant St., Amherst MA 01002. (413)586-3964 and (413)253-2500. Owner: R. Michelson. Retail gallery. Estab. 1976. Represents 25 artists/year; emerging, mid-career and established. Exhibited artists include Barry Moser and Leonard Baskin. Sponsors 10 shows/year. Average display time 1 month. Open all year. Located downtown; the Northampton gallery has 1,500 sq. ft.; the Amherst gallery has 1,800 sq. ft. 50% of space for special exhibitions, 50% for gallery artists. Clientele: 85% private collectors, 15% corporate collectors. Overall price range: $50-25,000; most artwork sold at $300-3,000.
Media: Considers oil, acrylic, watercolor, pastel, pen & ink, drawings, works on paper, original handpulled prints, woodcuts, wood engravings, linocuts, engravings, mezzotints, lithographs, pochoir, serigraphs and posters. Most frequently exhibits works on paper and paintings.

Style: Exhibits expressionism, neo-expressionism, imagism, realism, photorealism and figurative works. All genres. Prefers realism, photorealism and expressionism.
Terms: Accepts work on consignment (50% commission) and buys outright. Retail price set by the gallery and the artist. Framed or unframed artwork accepted.
Submissions: Send query letter with resume, slides, bio, brochure, SASE and reviews. Replies in 1 month. Files slides.

***MILLS GALLERY/BOSTON CENTER FOR THE ARTS,** 549 Tremont St., Boston MA 02116. (617)426-8835. Gallery Manager: Sarah Grimm. Nonprofit gallery. Estab. 1974. Represents emerging artists. Sponsors 10 shows/year. Average display time 1 month. Open in fall, winter and spring. Located in Boston's south end; 1,250 sq. ft.; "part of the Boston Center for the Arts, an art center with over 50 artists in residence." 100% of space for special exhibitions. 100% private collectors. Overall price range: $100-10,000; most work sold at $100-1,000.
Media: Considers all media including performance. Also considers original handpulled prints. Most frequently exhibits painting, sculpture and mixed media.
Style: Exhibits all styles and genres.
Terms: Accepts work on consignment (40% commission). Retail price set by gallery and artist. Gallery provides insurance, promotion and contract. Artist pays for shipping. Prefers artwork framed.
Submissions: Send query letter with resume, slides, SASE and reviews. Write to schedule an appointment to show a portfolio, which should include slides. Replies in 2 months. Files slides.

PUCKER SAFRAI GALLERY, INC., 171 Newbury St., Boston MA 02116. (617)267-9473. FAX: (617)424-9759. Director: Bernard Pucker. Retail gallery. Estab. 1967. Represents 30 artists; emerging, mid-career and established artists. Exhibited artists include modern masters such as Picasso, Chagall, Boraque, and Samuel Bak and Brother Thomas. Sponsors 8 shows/year. Average display time 4-5 weeks. Open all year. Located in the downtown retail district. 5% of space for special exhibitions, 95% for gallery artists. Clientele: private clients from Boston, all over the US and Canada. 90% private collectors, 10% corporate clients. Overall price range: $20-200,000; most artwork sold at $5,000-20,000.
Media: Considers oil, acrylic, watercolor, pastel, pen & ink, drawings, mixed media, sculpture, ceramic, photography, woodcuts, engravings, lithographs, wood engravings, mezzotints, serigraphs, linocuts and etchings. Most frequently exhibits paintings, prints and sculpture.
Style: Exhibits all styles. Genres include landscapes and figurative work.
Terms: Terms of representation vary by artist, usually it is consignment. Retail price set by the gallery. Gallery provides promotion. Artist pays shipping. Prefers unframed artwork.
Submissions: Send query letter with resume, slides, bio and SASE. Write to schedule an appointment to show a portfolio, which should include originals and slides. Replies in 3 weeks. Files resumes.

SMITH COLLEGE MUSEUM OF ART, Elm St. at Bedford Terrace, Northampton MA 01063. (413)585-2770. FAX: (413)585-2075. Associate Curator of Painting and Sculpture: Linda Muehlig. Museum. Estab. 1879. Interested in seeing the work of emerging artists. Sponsors 8-10 shows/year. Average display time 2 months. Open all year. Located "on Smith College campus; 17,500 sq. ft.; exterior sculpture courtyard."
Media: Considers all media, including all types of prints except reproductions.
Style: Exhibits works of all periods and styles.
Terms: Acquisitions are made by purchase or gift. Gallery pays for shipping costs to and from gallery.
Submissions: Send query letter with whatever is available. Write to schedule an appointment to show a portfolio, which should include appropriate materials. Replies in about 1 month. Files letter, resume, photos and reviews.

TENNYSON GALLERY, 237 Commercial St., Provincetown MA 02657. (508)487-2460. Owner: Linda Tennyson. Retail gallery. Estab. 1985. Clientele: 95% private collectors, 5% corporate clients. Represents 30-35 artists. Sponsors 7 group shows/year. Average display time 3 weeks. Interested in emerging and established artists. Overall price range: $250-6,000; most artwork sold at $350-950.
Media: Considers all media, including original handpulled prints. Considers woodcuts, wood engravings, linocuts, engravings, mezzotints, etchings, lithographs and serigraphs. Most frequently exhibits oil/acrylic, pastel, glass and sculpture.
Style: Exhibits impressionism, realism and painterly abstraction. Genres include landscapes, florals, wildlife, portraits and figurative work. Prefers impressionism, realism and painterly abstraction. "Metamorphosis, our jewelry store, has been in business for 14 years, while Tennyson Gallery continues in its 5th year. We look for artists who strive for excellence in their work."
Terms: Accepts artwork on consignment (50% commission). Retail price set by artist. Exclusive area representation required. Artist pays for shipping. Prefers framed artwork.
Submissions: Send query letter with resume, slides, SASE, brochure, photographs and bio. Write to schedule an appointment to show a portfolio, which should include originals, slides, transparencies and photographs. Replies in 1 month. Files resumes, slides, photographs and transparencies.

TOWNE GALLERY, 28 Walker St., Lenox MA 01240. (413)637-0053. Owner: James Terry. Retail gallery. Estab. 1977. Clientele: 95% private collectors, 5% corporate clients. Represents 25 artists. Sponsors 1 solo and 2 group shows/year. Average display time 4 weeks. Interested in emerging, mid-career and established artists. Overall price range: $100-3,500; most artwork sold at $350-650.
Media: Considers oil, acrylic, watercolor, pastel, mixed media, collage, paper, sculpture, ceramic, craft, fiber, glass, mezzotints, etchings, lithographs and serigraphs. Most frequently exhibits serigraphs, collagraphs and ceramics.
Style: Exhibits color field, painterly abstraction and landscapes. "The gallery specializes in contemporary abstracts for the most part. We also show large ceramics as an addition to the fine arts." No political statements.
Terms: Accepts work on consignment (60% commission). Retail price set by gallery and artist. Exclusive area representation required. Gallery provides insurance, promotion and contract; artist pays for shipping. Prefers framed artwork.
Submissions: Send query letter with resume, brochure, slides, photographs, bio and SASE. Write to schedule an appointment to show a portfolio, which should include originals, "after query letter is responded to." Replies only if interested within 6 months. Files bios and slides. All material is returned if not accepted or under consideration.
Tips: "Use professional slides."

***HOWARD YEZERSKI GALLERY,** 186 South St., Boston MA 02111. (617)426-8085. Owner: Howard Yezerski. Retail gallery. Estab. 1988. Represents 15-20 artists; emerging, mid-career and established. Exhibited artists include Paul Shakespear and Richard Jacobs. Sponsors 10 shows/year. Average display time 4½ weeks. Open all year. Located downtown; 2,500 sq. ft.; converted leather warehouse. 60% of space for special exhibitions. Clientele: corporate, individual, established and new collectors and museums. 80% private collectors, 20% corporate collectors. Overall price range: $1,000-100,000; most work sold at $5,000-10,000.
Media: Considers oil, acrylic, mixed media, collage, sculpture, ceramic, installation and photography; original handpulled prints. Most frequently exhibits painting, photographs and sculpture/installation.
Style: Exhibits painterly abstraction, conceptualism and "quirky realism. We do not exhibit genre art."
Terms: Accepts work on consignment (50% commission). Retail price set by the gallery. Gallery provides insurance and promotion; shipping costs are shared. Prefers artwork framed.
Submissions: Accepts only artists from New York and New England. Send query letter with resume, slides, bio, SASE, business card, reviews and artist's statement. Write to schedule an appointment to show a portfolio, which should include originals, slides and transparencies. Replies in 6 months. Files cover letter, bio and statement.
Tips: "Find out about us first. Do not send work that is inappropriate for the viewpoint of this gallery."

Michigan

***ART CENTER OF BATTLE CREEK,** 265 E. Emmett St., Battle Creek MI 49017. (616)962-9511. Director: A.W. Concannon. Estab. 1948. Clientele: individuals, businesses and corporations; 90% private collectors, 10% corporate clients. Represents 150 artists. Exhibition program offered in galleries, usually 6-8 solo shows each year, two artists competitions, and a number of theme shows. Also offers Michigan Artworks Shop featuring work for sale or rent. Average display time for shows: 1 month. "Four galleries, including Central gallery, converted from church—handsome high vaulted ceiling, arches lead into galleries on either side. Welcoming, open atmosphere." Interested in emerging and established artists. Overall price range: $5-1,000; most artwork sold at $5-300.
Media: Considers oils, acrylics, watercolor, pastels, pen & ink, drawings, mixed media, collage, paper, sculpture, ceramics, crafts, fibers, glass, photography and original handpulled prints.
Style: Exhibits painterly abstraction, minimalism, impressionistic, photorealistic, expressionistic, neo-expressionistic and realistic works. Genres include landscapes, florals, Americana, portraits and figurative work. Prefers "work by Michigan artists."
Terms: Accepts work on consignment (33⅓% commission). Retail price is set by artist. Exclusive area representation not required. Gallery provides insurance, promotion and contract; artist pays for shipping.
Submissions: Send query letter, resume, brochure, slides and SASE. All material is filed "except slides which are returned. Michigan artists receive preference."
Tips: "Looks for original work that is well presented."

ART TREE SALES GALLERY, 461 E. Mitchell, Petoskey MI 49770. (616)347-4337. Manager: Anne Thurston. Retail gallery of a nonprofit arts council. Estab. 1982. Clientele: heavy summer tourism; 99% private collectors, 1% corporate clients. Represents 150 artists. Sponsors 2 week one person exhibits November through May, 1 week one person exhibits June through October. Prefers Michigan artists. Interested in emerging, mid-career and established artists. Overall price range: $6-2,000; most artwork sold at $20-300.

Media: Considers oil, acrylic, watercolor, pastel, mixed media, collage, works on paper, sculpture, ceramic, wood, fiber, glass, original handpulled prints, offset reproductions and posters.
Style: Exhibits painterly abstraction, impressionism, photorealism, expressionism and realism. Genres include landscapes, florals, Americana and figurative work.
Terms: Accepts work on consignment (20% commission in gallery, 33⅓% commission in gift shop). Retail price is set by gallery and artist. Exclusive area representation not required. All work is accepted by jury. Gallery provides insurance and promotion; artist pays for shipping.
Submissions: Send query letter, resume, brochure, photographs and SASE. Write to schedule an appointment to show a portfolio, which should include originals, slides or photos.
Tips: We especially concentrate on theme shows or single-medium shows, or small solo exhibitions. Our audience tends to be conservative, but we enjoy stretching that tendency from time to time. We exhibit the work of Michigan artists who show and sell on a consignment basis." Common mistakes artists make in presenting their work are not having it ready for presentation: not framed, matted, titled, ready for display and protected from public contact; slides or photos poorly taken."

JESSE BESSER MUSEUM, 491 Johnson St., Alpena MI 49707. (517)356-2202. Director: Dennis R. Bodem. Chief of Resources: Robert E. Haltiner. Nonprofit gallery. Estab. 1962. Clientele: 80% private collectors, 20% corporate clients. Sponsors 5 solo and 16 group shows/year. Average display time is 1 month. Prefers northern Michigan artists, but not limited. Interested in emerging and established artists. Overall price range: $10-2,000; most artwork sold at $50-150.
Media: Considers oil, acrylic, watercolor, pastel, pen & ink, drawings, mixed media, collage, works on paper, sculpture, ceramic, craft, fiber, glass, installations, photography, original handpulled prints and posters. Most frequently exhibits prints, watercolor and acrylic.
Style: Exhibits hard-edge geometric abstraction, color field, painterly abstraction, pattern painting, primitivism, impressionism, photorealism, expressionism, neo-expressionism, realism and surrealism. Genres include landscapes, florals, Americana, portraits, figurative work and fantasy illustration.
Terms: Accepts work on consignment (25% commission). Retail price is set by gallery and artist. Exclusive area representation not required. Gallery provides insurance, promotion and contract.
Submissions: Send query letter, resume, brochure, slides and photographs to Robert E. Haltiner. Write to schedule an appointment to show a portfolio, which should include slides. Letter of inquiry and brochure are filed.

GALLERY YAKIR, 26232 Pembroke, Huntington Woods MI 48070. (313)548-4300. Director: Joanna Abramson. Retail gallery and wholesaler. "We also broker art, finding art for clients." Estab. 1985. Clientele: 95% private collectors, 5% corporate clients. Represents 26 artists. Sponsors 1 solo and 2 group shows/year. Average display time 6 weeks. Interested in mid-career artists. Overall price range: $100-15,000; most artwork sold at $300-3,500.
Media: Considers oil, watercolor, pastel, pen & ink, mixed media, collage, works on paper, sculpture, glass, woodcuts, wood engravings, linocuts, etchings, lithographs and posters. Most frequently exhibits sculpture, prints and watercolor.
Style: Exhibits abstract, impressionism, minimalism and painterly abstraction; considers all styles. Genres include landscapes, portraits and figurative work; considers all genres. Specializes in Israeli art.
Terms: Accepts work on consignment (40% commission). Retail price set by gallery and artist. Exclusive area representation required. Gallery provides insurance, promotion and contract; shipping costs are shared. Prefers framed artwork.
Submissions: Send query letter with resume, brochure, slides or photographs and bio. Call to schedule an appointment to show a portfolio, which should include slides or transparencies or photographs. Replies in 3 weeks. Files "everything I might be interested in." All material is returned if not accepted or under consideration.
Tips: "Send bio, photos/slides and any articles written about your work." Sees trend toward "tougher competition, softening prices."

LINDA HAYMAN GALLERY, 32500 Northwestern Hwy., Farmington Hills MI 48334. (213)932-0080. FAX: (313)932-0861. Owner: Linda Hayman. Retail gallery with locations in Michigan and Florida. Estab. 1979. Clientele: banks, doctor's offices, general offices. Represents emerging, mid-career and established artists.
Style: Prefers contemporary styles, original themes and photorealism.
Terms: Accepts work on consignment (50% commission).
Submissions: Send query letter with brochure, slides and photographs. Call or write to schedule an appointment to show a portfolio, which should include slides and photographs. Replies in 2 weeks.
Tips: Notices that "traditional is coming back, even in real contemporary rooms."

KALAMAZOO INSTITUTE OF ARTS, 314 South Park St., Kalamazoo MI 49007. (616)349-7775. FAX: (616)349-9313. Director of Collections and Exhibitions: Helen Sheridan. Museum. Estab. 1924. Represents mid-career and established artists. Sponsors 30 shows/year. Average display time 1 month. Closed for two

weeks at the end of August. Located in downtown Kalamazoo adjacent to Bronson Park. Features contemporary space designed by Skidmore, Owings & Merrill. 100% of space for special exhibitions. Overall price range: $200-10,000; most work sold at $200-1,500.

Media: Considers all media; original handpulled prints, woodcuts, wood engravings, linocuts, engravings, mezzotints, etchings, lithographs, pochoir and serigraphs. Most frequently exhibits paintings, oils, watercolors and lithographs.

Style: Exhibits expressionism, neo-exoexpressionism, painterly abstraction, photorealism, realism, imagism and impressionism. All genres. Prefers realism, impressionism and expressionism.

Terms: Retail price is set by artist. Gallery provides insurance; shipping costs are shared. Prefers artwork framed.

Submissions: Send query letter, resume, slides, reviews, bio and SASE. Write to schedule an appointment to show a portfolio, which should include material appropriate for medium. Replies in 6 weeks. Files bios, resumes and reviews.

Tips: "Apply by the first of the month for review that month; replies may be delayed in July and August."

ROBERT L. KIDD GALLERY, 107 Townsend St., Birmingham MI 48009. (313)642-3909. Associate Director: Sally Parsons. Retail gallery and ad consultancy. Estab. 1976. Clientele: 50% private collectors; 50% corporate clients. Represents approximately 125 artists. Sponsors 8 solo and 3 group shows/year. Average display time is 4 weeks. Interested in emerging and established artists. Overall price range: $200-18,000; most artwork sold at $800-5,000.

Media: Considers oil, acrylic, watercolor, pastel, mixed media, works on paper, sculpture, ceramic, fiber and glass. Most frequently exhibits acrylic, oil and sculpture.

Style: Exhibits color field, painterly abstraction, photorealism and realism. Genres include landscapes. "We specialize in original contemporary paintings, sculpture, fiber, glass, clay and handmade paper by Americans and Canadians."

Terms: Accepts work on consignment. Retail price is set by gallery and artist. Exclusive area representation required. Gallery provides insurance and promotion; shipping costs are shared.

Submissions: Send query letter, resume, slides and SASE.

Tips: Looks for "high quality technical expertise and a unique and personal conceptual concept. Understand the direction we pursue and contact us with appropriate work."

***KRASL ART CENTER,** 707 Lake Blvd., St. Joseph MI 49085. (616)983-0271. Director: Dar Davis. Retail gallery of a nonprofit arts center. Estab. 1980. Clientele: community residents and summer tourists. Sponsors 30 solo and group shows/year. Average display time is 1 month. Interested in emerging and established artists. Most artwork sold at $100-500.

Media: Considers oils, acrylics, watercolor, pastels, pen & ink, drawings, mixed media, collage, paper, sculpture, ceramics, crafts, fibers, glass, installations, photography and performance.

Style: Exhibits all styles. "The works we select for exhibitions reflect what's happening in the art world. We display works of local artists as well as major traveling shows. We sponsor all annual Michigan competitions and construct significant holiday shows each December."

Terms: Accepts work on consignment (25% commission or 50% markup). Retail price is set by artist. Exclusive area representation required. Gallery provides insurance, promotion, shipping and contract.

Submissions: Send query letter, resume, slides, and SASE. Call to schedule an appointment to show a portfolio, which should include originals.

KRESGE ART MUSEUM, Michigan State University, E. Lansing MI 48824. Director: Susan Bandes. Museum. Estab. 1959. Represents emerging, mid-career and established artists. Gallery is closed August. Located on the MSU campus; 4,000 sq. ft. 70% of space for special exhibitions. Clientele: the local community. 100% private collectors. Overall price range: $200-20,000; most artwork sold at $200-5,000.

Media: Considers oil, acrylic, watercolor, pastel, pen & ink, drawings, mixed media, works on paper, sculpture, ceramic, glass, photography, original handpulled prints, woodcuts, wood engravings, linocuts, engravings, mezzotints, etchings, lithographs, pochoir, serigraphs and posters. Most frequently exhibits prints, paintings and photographs.

Style: Exhibits all styles and genres. Prefers contemporary styles.

Terms: 10-20% commission added to price. Retail price set by the artist. Gallery provides insurance; sometimes shipping costs and sometimes artist pays for shipping. Prefers framed artwork.

Submissions: Send query letter with resume, slides and bio. Write to schedule an appointment to show a portfolio, which should include slides and transparencies. Replies in 1 month. Files resume.

Tips: "We tend to do group shows of specific media or themes rather than solo exhibits. We are seeing a decline in funding for exhibitions. Artists can help by working with museums and public spaces to educate the public to their work."

***MICHIGAN GUILD GALLERY,** 118 N. 4th Ave., Ann Arbor MI 48104-1402. (313)662-ARTS. MGAA Executive Director: Mary Strope. Nonprofit gallery. "We do not sell artwork. We exhibit." Estab. 1986. Represents emerging, mid-career and established artists. 2000 national members. Average display time 3-4 weeks. Open August-July. Located downtown; 1,000 sq. ft.; "unique interior design and use of space." 100% of space for special exhibitions.
Media: Considers oil, acrylic, watercolor, pastel, pen & ink, drawing, mixed media, collage, paper, sculpture, ceramic, craft, fiber, glass, installation, photography and jewelry. Also, original handpulled prints; woodcut, wood engraving, linocut, engraving, mezzotint, etching and lithograph. Exhibits all styles and genres.
Terms: Gallery provides insurance and promotion. Artist pays for shipping. Prefers artwork framed.
Submissions: Artists must be members of the Michigan Guild of Artists and Artisans. "Send a written proposal describing the show and a fact sheet about each participating artist. Each artist must be a Guild member. Include SASE with 10 slides that represent the style and quality of the work to be exhibited. The Gallery Committee may ask to see samples of your work." Reports within 2 months. "Sales are not permitted on the premises. All work is for exhibition only. No commissions are collected or paid."

***MIDLAND ART COUNCIL GALLERIES OF THE MIDLAND CENTER FOR THE ARTS,** 1801 W. St. Andrews, Midland MI 48640. (517)631-3250. Director: Hilary Bassett. Nonprofit gallery and museum. Estab. 1956. Exhibits emerging, mid-career and established artists. "We exhibit artists, we do not represent them." Sponsors 10 shows/year. Average display time 5-6 weeks. Open all year, seven days a week, 1:00-5:00 pm. Located in a cultural center; "an Alden B. Dow design." 100% of space for special exhibitions.
Media: Considers all media and all types of prints.
Style: Exhibits all styles and genres.
Terms: "Exhibited art may be for sale" (20% commission). Retail price set by the artist. Gallery provides insurance, promotion and contract; shipping costs are shared. Artwork must be exhibition ready.
Submissions: Send query letter with resume, slides, bio, SASE and proposal. Write to schedule an appointment to show a portfolio, which should include slides, photographs and transparencies. Replies only if interested as appropriate. Files resume, bio and proposal.

MUSKEGON MUSEUM OF ART, 296 W. Webster, Muskegon MI 49440. (616)722-2600. FAX: (616)726-5567. Curator: Henry Matthews. Museum. Estab. 1912. Represents emerging, mid-career and established artists. Sponsors 22 shows/year. Average display time 6 weeks. Open all year. Located downtown; 13,000 sq. ft. "Through the process of selection we offer 6-10 one-artist shows a year, as well as opportunity to show in the regional competition."
Media: Considers oil, acrylic, watercolor, pastel, pen & ink, drawings, mixed media, collage, works on paper, sculpture, ceramic, craft, fiber, glass, installation, photography, original handpulled prints, woodcuts, wood engravings, linocuts, engravings, mezzotints, etchings, lithographs, serigraphs and posters.
Style: Exhibits expressionism, neo-expressionism, primitivism, painterly abstraction, surrealism, imagism, conceptualism, minimalism, color field, post modern works, impressionism, realism, photorealism, pattern painting, hard-edge geometric abstraction; all styles and genres.
Terms: Accepts work on consignment (25% commission) "in our gift shop." Retail price set by the artist. Gallery provides insurance, promotion and contract. Prefers framed artwork.
Submissions: Most one-artist shows have a Michigan base. Send query letter with resume, slides, bio, SASE and reviews. Write to schedule an appointment to show a portfolio, which should include originals, photographs, slides, transparencies or any combination thereof. Replies in 1 month. Files "those that we feel might have the possibility of a show."

JOYCE PETTER GALLERY, 134 Butler, Saugatuck MI 49453. (616)857-7861. Owner: Joyce Petter. Retail gallery. Estab. 1973. Represents 50 artists; emerging, mid-career and established. Exhibited artists include Harold Larsen and Fran Larsen. Sponsors 9 shows/year. Average display time 2 weeks. Open all year. Located downtown on a main street; 4,000 sq. ft.; "a restored Victorian in community known for art." 50% of space for special exhibitions, 50% for gallery artists. Clientele: 80% private collectors, 20% corporate collectors. Overall price range: $100-8,000; most artwork sold at $700-2,000.
Media: Considers oil, acrylic, watercolor, pastel, pen & ink, drawings, mixed media, collage, works on paper, sculpture, ceramic, craft, glass, original handpulled prints, woodcuts, wood engravings, linocuts, engravings, etchings, lithographs and serigraphs, "anything not mechanically reproduced." Most frequently exhibits oil, watercolor and pastel/acrylic.
Style: Exhibits painterly abstraction, surrealism, impressionism, realism, hard-edge geometric abstraction and all styles and genres. Prefers landscapes, abstracts, and "art of timeless quality."
Terms: Accepts work on consignment (50% commission). Retail price set by the artist. Gallery provides insurance, promotion and contract; shipping costs from gallery. Prefers framed artwork.
Submissions: Send query letter with resume and photographs. Call or write to schedule an appointment to show a portfolio, which should include originals and photographs. Replies in 1 month. Files only material of gallery artists.
Tips: "Art is judged on its timeless quality. We are not interested in the 'cutting edge.' "

THE PRINT GALLERY, INC., 29203 Northwestern Hwy., Southfield MI 49034. (313)356-5454. President: Diane Shipley. Retail gallery and art consultancy. Estab. 1979. Clientele: white collar, professional and tourists; 60% private collectors; 40% corporate clients. Sponsors 4 solo and 4 group shows/year. Average display time is 2 months. Interested in emerging, mid-career and established artists. Overall price range: $100-3,000; most artwork sold at $200.
Media: Considers oils, acrylics, watercolor, pastels, mixed media, original serigraphs, lithographs and sculpture.
Style: Exhibits painterly abstraction, post-modern, primitivism, impressionism, photorealism, expressionism and realism. Genres include landscapes, florals, Americana, Western, portraits and figurative work.
Terms: Accepts work on consignment (50% commission). Retail price is set by gallery and artist. Gallery provides insurance, shipping and contract.
Submissions: Send query letter and slides. Call or write to schedule an appointment to show a portfolio, which should include originals, slides and transparencies.

RUBINER GALLERY, Suite 430-A, 7001 Orchard Lake, West Bloomfield MI 48322. (313)626-3111. President: Allen Rubiner. Retail gallery. Estab. 1964. Clientele: 60% private collectors; 40% corporate clients. Represents 25 artists. Sponsors 5 solo and 3 group shows/year. Interested in emerging, mid-career and established artists. Overall price range: $600-12,000; most artwork sold at $1,000-6,000.
Media: Considers oil, acrylic, watercolor, pastel, mixed media, collage, works on paper, sculpture and original handpulled prints.
Style: Exhibits painterly abstraction, impressionism and realism. Genres include landscapes, florals and figurative work. Prefers realism and abstraction.
Terms: Accepts work on consignment (50% commission). Retail price is set by gallery and artist. Exclusive area representation required. Gallery provides insurance and promotion; shipping costs are shared.
Submissions: Send query letter, slides and photographs. Call or write to schedule an appointment to show a portfolio, which should include originals. Resumes and slides are filed.

***SAPER GALLERIES**, 433 Albert Ave., East Lansing MI 48823. (517)351-0815. FAX: (517)351-0815. Director: Roy C. Saper. Retail gallery. Estab. in 1978 as 20th Century Fine Arts; in 1986 acquired new location and name. Displays the work of 60+ artists; emerging, mid-career and established. Exhibited artists include H. Altman and J. Isaac. Sponsors 3-4 shows/year. Average display time 6 weeks. Open all year. Located downtown; 3,700 sq. ft.; "We were awarded *Decor* magazine's Award of Excellence for gallery design. Everything is in perfect condition, efficient, and of unusually high quality." 30% of space for special exhibitions. Clientele: students, professionals, experienced and new collectors. 80% private collectors, 20% corporate collectors. Overall price range: $30-140,000; most work sold at $400-4,000.
Media: Considers oil, acrylic, watercolor, pastel, drawing, mixed media, collage, paper, sculpture, ceramic, craft and glass; original handpulled prints. Considers all types of prints, except offset reproductions. Most frequently exhibits intaglio, serigraphy and sculpture.
Style: Exhibits expressionism, painterly abstraction, surrealism, post modern works, impressionism, realism, photorealism and hard-edge geometric abstraction. Genres include landscapes, florals, Southwestern and figurative work. Prefers abstract, landscapes and figurative.
Terms: Accepts work on consignment (negotiable commission); or buys outright for negotiated percentage of retail price. Retail price set by the gallery and the artist. Gallery provides insurance, promotion and contract; shipping costs are shared. Prefers artwork unframed (gallery frames).
Submissions: Send query letter with resume, brochure and slides or photographs, bio, and SASE. Call to schedule an appointment to show a portfolio, which should include originals or photos of any type. Replies in 1 week. Files any material (photos, etc.) the artist does not need returned.
Tips: "Artists must know the nature of works displayed already, and work must be of the highest quality and therefore, marketable. Aesthetics is extremely important."

Minnesota

***GROVELAND GALLERY**, 25 Groveland Terrace, Minneapolis MN 55403. (612)377-7800. Director: Sally Johnson. Retail gallery. Estab. 1973. Represents 26 artists; mid-career and established. Sponsors 7 shows/year. Average display time 6 weeks. Open all year. Located on the edge of downtown Minneapolis; 1,300 sq. ft.; gallery is located on the first floor of a restored 1890s mansion. 75% of space for special exhibitions. Clientele: corporate, museum and private collectors. 75% private collectors, 25% corporate collectors. Overall price range: $500-20,000; most work sold at $800-2,000.
Media: Considers oil, acrylic, watercolor, pastel, pen & ink and drawing; original handpulled prints, woodcuts, wood engravings, engravings and lithographs. Most frequently exhibits oils and acrylics; watercolor and gouache; pastels and other drawings.

Style: Exhibits expressionism, painterly abstraction, realism and photorealism. Genres include landscapes and figurative work. Prefers landscapes, still life and figurative. "The gallery specializes in representational paintings and drawings by regional artists. This includes a wide range of painting styles from photorealist to expressionist and a variety of subjects from landscapes to interiors and figurative. We also represent a small number of abstract painters."
Terms: Accepts work on consignment (50% commission). Retail price set by the gallery. Gallery provides insurance and promotion; artist pays for shipping or shipping costs are shared. Prefers artwork framed.
Submissions: Accepts mostly Midwestern artists. Send query letter with resume, slides, SASE, and any statements or reviews that support slides. Call to schedule an appointment to show a portfolio, which should include photographs, slides or transparencies. Replies in 2-4 weeks.

MCGALLERY, 400 1st Ave., Minneapolis MN 55401. (612)339-1480. Gallery Director: M.C. Anderson. Retail gallery. Estab. 1984. Clientele: collectors and art consultants; 60% private collectors, 40% corporate clients. Represents 30 artists. Sponsors 8 two-person shows/year. Average display time is 6 weeks. Interested in emerging, mid-career and established artists. Overall price range: $800-11,000; most artwork sold at $1,500.
Media: Considers oil, acrylic, pastel, drawings, mixed media, collage, works on paper, art glass, ceramic, photography and original handpulled monotypes. Most frequently exhibits works on paper, art glass, ceramic and sculpture.
Style: Exhibits painterly abstraction, post modern, expressionism and neo-expressionism. Prefers "artists that deal with art in a new perspective and approach art emotionally. They usually have an excellent color sense and mastery of skill."
Terms: Accepts work on consignment (50% commission). Retail price is set by artist. Exclusive area representation required. Gallery provides promotion and contract; artist pays for shipping.
Submissions: Send query letter, resume, slides and photographs. Call or write to schedule an appointment to show a portfolio, which should include originals, slides and/or transparencies.

MINNESOTA MUSEUM OF ART, Landmark Center, 5th & Market, St. Paul MN 55102-1486. (612)292-4355. Curator of Exhibition: Katherine Van Tassell. Museum. Estab. 1927. Clientele: tourists. Sponsors 1-2 solo and 8-12 group shows/year. Average display time: 3 months. Accepts only artists from upper-Midwest. Interested in emerging artists.
Media: Considers all media but offset reproductions and posters. Most frequently exhibits paintings, prints, drawings and photographs.
Style: Exhibits all styles and genres. "Our museum specializes in American art primarily from 1850-1950. We are also committed to displaying the works of contemporary, emerging Midwestern artists. In addition we have a collection of non-western art and present exhibitions from this collection."
Terms: "We mostly show the work of artists in two month exhibitions for coverage only, no particular terms. We take 10% of commission if an artist should (which is rare) sell a work from our show." Retail price set by artist. Gallery provides insurance, promotion, contract and shipping costs to and from gallery. Prefers artwork framed.
Submissions: Send query letter with resume, slides, bio and SASE. Write to schedule an appointment to show a portfolio. "We prefer not to schedule appointments until after we have seen slides and resume." Replies in 1 month. Files slides and resume.
Tips: "Our contemporary artists must be from Midwest region. It would help if they've seen our galleries and have some idea of our programs."

NORMANDALE COLLEGE CENTER GALLERY, 9700 France Ave, So. Bloomington MN 55431. (612)832-6340. FAX: (612)896-4571. Director of Student Life: Gail Anderson Cywinski. College gallery. Estab. 1975. Represents 6 artists/year; emerging, mid-career and established. Sponsors 6 shows/year. Average display time 2 months. Open all year. Suburban location; 30 running feet of exhibition space. 100% of space for special exhibitions. Clientele: students, staff and community. Overall price range: $25-750; most artwork sold at $100-200.
Media: Considers oil, acrylic, watercolor, pastel, pen & ink, drawings, mixed media, collage, works on paper, sculpture, ceramic, craft, fiber, glass, photography, original handpulled prints, offset reproductions, woodcuts, wood engravings, linocuts, engravings, mezzotints, etchings, lithographs, pochoir, serigraphs and posters. Most frequently exhibits watercolor, photography and prints.
Style: Exhibits all styles and genres.
Terms: "We collect 10% as donation to our foundation." Retail price set by the artist. Gallery provides insurance, promotion and contract; artist pays for shipping. Prefers framed artwork.
Submissions: "Send query letter; we will send application and info." Portfolio should include slides. Replies in 2 months. Files "our application/resume."

THE RAVEN GALLERY, 3827 W. 50th St., Minneapolis MN 55410. (612)925-4474. Owner/Director: Jerry Riach. Retail gallery. Estab. 1972. Represents many artists; emerging, mid-career and established. Exhibited artists include Tsonakwa and Amy Cordova. Sponsors 12-15 shows/year. Average display time 3-4 weeks.

Open all year. Located at the southwest corner of the city of Minneapolis; 2,000 sq. ft.; "the gallery is located in a unique shopping area of numerous privately owned specialty shops; its interior is divided into 2 bays, one of which is used for feature display while the other is used to display rotating stock." 40% of space for special exhibitions. Clientele: 95% private collectors, 5% corporate collectors. Overall price range: $50-10,000; most artwork sold at $500-1,500.

Media: Considers acrylic, watercolor, pastel, drawings, mixed media, sculpture, ceramic, craft, photography, original handpulled prints, woodcuts, lithographs, serigraphs and etchings. Most frequently exhibits original handpulled prints, sculpture and original painting.

Style: Exhibits art of native people of North America. Genres include landscapes, Southwestern, wildlife, portraits and figurative work. Prefers wildlife, figurative work and landscapes.

Terms: Accepts work on consignment (50% commission). Buys outright for 40% of retail price (net 30 days). Retail price set by the gallery and the artist. Gallery provides insurance and promotion; pays for shipping costs from gallery. Prefers unframed artwork.

Submissions: Accepts only tribal artists from North America. Send query letter with resume, slides, bio and photographs. Call or write to schedule an appointment to show a portfolio, which should include originals, photographs, slides and background information on the artist and the art. Replies in 1 month. Files biographical and cultural information.

Tips: "We always look for new artists, particularly during recession. Common mistakes: Artists sometimes come in unprepared—no bio info; small amount of work and no photos or slides, don't make appointment."

STEPPINGSTONE GALLERY, 50 Main St., Hutchinson MN 55350. (612)587-4688. Owner/Manager: Linda. Retail gallery. Estab. 1983. Represents 6-8 artists; emerging and mid-career. Exhibited artists include T. Soucek, B. Hillman and B. Haas. Sponsors 2 shows/year. Average display time 1-2 months. Open all year. Located downtown; 1,000 sq. ft.; "remodeled building, brick walls." 95% private collectors, 5% corporate clients. Overall price range: $25-200; $25-100.

Media: Considers oil, acrylic, watercolor, pastel, pen & ink, mixed media, works on paper, ceramic, original handpulled prints, woodcuts, engravings, lithographs, etchings and offset reproductions. Most frequently exhibits watercolor and etchings.

Style: Exhibits all styles and genres. Prefers impressionism, realism and abstraction.

Terms: Accepts work on consignment (40% commission). Retail price set by the artist. Gallery provides promotion; artist pays for shipping. Prefers framed artwork.

Submissions: Send query letter with brochure, photographs and reviews. Write to schedule an appointment to show a portfolio, which should include originals and photographs. Replies only if interested within 1-2 weeks.

***VERMILLION**, 2919 Como Ave. SE, Minneapolis MN 55414. (612)379-7281. FAX: (612)379-7284. Contact: Steve Andersen. Retail and wholesale gallery. Estab. 1977. Represents 35 artists; emerging, mid-career and established. Exhibited artists include Nicholas Africano and Duncan Hannah. Sponsors 8 shows/year. Average display time 1 month. Open all year. Located 5 minutes from downtown. "We are a limited edition fine art print publisher. The gallery is part of the business." Clientele: private, corporate, museums and universities. 60% private collectors, 40% corporate collectors. Overall price range: $1,200-95,000; most work sold at $5,000-20,000.

Media: Considers sculpture; original handpulled prints, woodcuts, wood engravings, linocuts, mezzotints, etchings, lithographs and monotypes. Most frequently exhibits monotypes, limited edition lithographs and multiples.

Style: Exhibits expressionism, painterly abstraction, minimalism and post modern works.

Terms: "Artists are invited to the studio on the merits of their original work to produce an edition or a portfolio of monotypes, etc. The proceeds from the sale of the work are split between the publisher and artist. We are also open to other negotiated deals." Retail price set by the gallery. Gallery provides insurance, promotion and contract; shipping costs are shared.

Submissions: Send query letter with resume, slides, bio, SASE and reviews. Write to schedule an appointment to show a portfolio, which should include slides. Replies only if interested within 1 month. Files resumes and reviews.

Mississippi

MERIDIAN MUSEUM OF ART, 628 25th Ave., Box 5773, Meridian MS 39302. (601)693-1501. Contact: John Marshall. Nonprofit gallery. Estab. 1970. Sponsors solo and group shows. Average display time is 4-6 weeks. Interested in emerging and established artists.

Media: Considers oil, acrylic, watercolor, pastel, pen & ink, drawings, mixed media, collage, works on paper, sculpture, ceramic, fiber, glass, installations, photography, performance and original handpulled prints. Most frequently exhibits painting, drawing, sculpture, oil, pencil and wood.

Style: Exhibits color field, painterly abstraction, post modern, neo-expressionism, realism and surrealism. Genres include landscapes, figurative work and fantasy illustration.

Terms: "We no longer accept works for sale at the Meridian Museum of Art." Exclusive area representation not required. Gallery provides insurance, promotion and contract; artist pays for shipping.

Submissions: Send query letter, resume, brochure, slides, photographs and SASE. Write to schedule an appointment to show a portfolio, which should include originals and slides. Biographical and object-related material are filed.

***MISSISSIPPI CRAFTS CENTER,** Box 69, Ridgeland MS 39158. (601)856-7546. Director: Martha Garrott. Retail and nonprofit gallery. Estab. 1975. 200 members. Represents 70 artists; guild members only. Interested in seeing the work of emerging artists. Exhibited artists include Susan Denson and Wortman Pottery. Open all year. Located in a national park, near the state capitol of Jackson; 30 × 40 ft.; a traditional dogtrot log cabin. Clientele: travelers and local patrons. 99% private collectors. Overall price range: $2-900; most work sold at $10-60.

Media: Considers paper, sculpture, ceramic, craft, fiber and glass. Most frequently exhibits clay, basketry and metals.

Style: Exhibits all styles. Crafts media only.

Terms: Accepts work on consignment (40% commission), first order; buys outright for 50% of retail price (net 30 days), subsequent orders. Retail price set by the gallery and the artist. Gallery provides promotion and shipping costs to gallery.

Submissions: Accepts only artists from the Southeast. Artists must be juried members of the Craftsmen's Guild of Mississippi. Ask for standards review application form. Call or write to schedule an appointment to show a portfolio, which should include slides. Replies in 1 week.

MISSISSIPPI MUSEUM OF ART, 201 E. Pascagoula St., Jackson MS 39201. (601)960-1515. Chief Curator: Elise Smith. Nonprofit museum. Estab. 1911. Clientele: all walks of life/diverse.

Media: Considers oil, acrylic, watercolor, pastel, pen & ink, drawings, mixed media, collage, works on paper, sculpture, ceramic, craft, fiber, glass, installation, photography, performance art and original handpulled prints. Most frequently exhibits paintings, watercolor and photography.

Style: Exhibits all styles and genres.

Submissions: Send query letter, resume, slides and SASE. Slides and resumes are filed.

Missouri

BARUCCI'S ORIGINAL GALLERIES, 8121 Maryland Ave., St Louis MO 63105. (314)727-2020. President: Shirley Schwartz. Retail gallery and art consultancy. Estab. 1977. Clientele: affluent young area; 70% private collectors, 30% corporate clients. Represents 40 artists. Sponsors 3-4 solo and 4 group shows/year. Average display time is 2 months. Gallery is located in "affluent county, a charming area; Williamsburg exterior/ contemporary interior." Soft focus. Interested in emerging and established artists. Overall price range: $500-5,000.

Media: Considers oil, acrylic, watercolor, pastel, collage and works on paper. Most frequently exhibits watercolor, oil, acrylic and hand blown glass.

Style: Exhibits painterly abstraction, primitivist and impressionistic works. Genres include landscapes and florals. Currently seeking impressionistic landscapes — large works — 40 × 60'.

Terms: Accepts work on consignment (50% commission). Retail price is set by gallery or artist. Gallery provides a contract.

Submissions: Send query letter with resume, slides and SASE. Write to schedule an appointment to show a portfolio, which should include originals and slides. Slides, bios and brochures are filed.

Tips: Common mistakes artists make in presenting their work is "not marking slides, not including pricing information."

BOODY FINE ARTS, INC., 10701 Trenton Ave., St. Louis MO 63132. (314)423-2255. Retail gallery and art consultancy. "Gallery territory includes 15 Midwest/South Central states. Staff travels on a continual basis, to develop collections within the region." Estab. 1978. Clientele: 30% private collectors, 70% corporate clients. Represents 100 artists. Sponsors 6 group shows/year. Interested in mid-career and established artists. Overall price range: $500-200,000.

Media: Considers oil, acrylic, watercolor, pastel, drawings, mixed media, collage, sculpture, ceramic, fiber, glass, works on handmade paper, neon and original handpulled prints.

Style: Exhibits color field, painterly abstraction, minimalism, impressionism and photorealism. Prefers non-objective, figurative work and landscapes.

Terms: Accepts work on consignment or buys outright. Retail price is set by gallery and artist. Exclusive area representation required. Gallery provides insurance, promotion and contract; shipping costs are shared.

Submissions: Send query letter, resume and slides. Write to schedule an appointment to show a portfolio, which should include originals, slides and transparencies. All material is filed.

Tips: "Organize your slides."

CHARLOTTE CROSBY KEMPER/KANSAS CITY ART INSTITUTE, 4415 Warwick, Kansas City MO 64111. (816)561-4852. Exhibitions Director: Sherry Cromwell-Lacy. Nonprofit gallery. Clientele: collectors, students, faculty, general public. Sponsors 8-10 shows/year. Average display time is 4-6 weeks. Interested in emerging and established artists.

Media: All types of artwork are considered.

Submissions: Send query letter.

***RICK JONES MODERN AND CONTEMPORARY ART,** 3915 Fairview, St. Louis MO 63116. (314)776-4556. FAX: (314)776-0698. Director: Rick Jones. Art consultancy and print publisher. Estab. 1986. Represents 10-15 arists; emerging, mid-career and established. Exhibited artists include José Maria Sicilia and John Hennessy. Open all year. Located in an urban area near downtown. Clientele: private collectors, other dealers and galleries. 50% private collectors. Overall price range: $100-100,000; most work sold at $2,000-15,000.

Media: Considers oil, acrylic, watercolor, pen & ink, drawing, mixed media, sculpture and photography; original handpulled prints, woodcuts, wood engravings, linocuts, engravings, mezzotints, etchings, lithographs and serigraphs. Most frequently exhibits paintings, drawings and prints.

Style: Exhibits expressionism, neo-expressionism, painterly abstraction, conceptualism, minimalism, color field and hard-edge geometric abstraction. Prefers abstract expressionism, minimalism and hard-edge abstraction.

Terms: Accepts work on consignment (50% commission). Retail price set by the gallery and the artist. "We help advise artists on prices." Gallery provides promotion; artist pays for shipping. Prefers artwork framed.

Submissions: Prefers only painters, sculptors and photographers. Send query letter with resume, slides, bio, photographs, SASE and reviews. Call to schedule an appointment to show a portfolio, which should include slides, photographs and transparencies. Replies only if interested in 2 months. Files all material.

Tips: "Work must be mature and accomplished. Do not approach if work is decorative or craftsy."

LEEDY-VOULKOS GALLERY, 1919 Wyandotte, Kansas City MO 64108. (816)474-1919. Director: Sherry Leedy. Retail gallery. Estab. 1985. Clientele: 50% private collectors, 50% corporate clients. Represents 25-30 artists. Sponsors 6 two-person, 1 group and 2 solo shows/year. Average display time is 6 weeks. Interested in emerging, mid-career and established artists. Price range: $500-25,000; most artwork sold at $5,000.

Media: Considers oil, acrylic, watercolor, works on paper, mixed media, sculpture, ceramic, glass, installation, photography and original handpulled prints. Most frequently exhibits painting and clay sculpture.

Style: Exhibits abstraction, expressionism and realism. "I am interested in quality work in all media. While we exhibit work in all media our expertise in contemporary ceramics makes our gallery unique."

Terms: Accepts work on consignment (50% commission). Retail price is set by gallery and artist. Exclusive area representation required. Gallery provides insurance, promotion and contract; shipping costs are shared.

Submissions: Send query letter, resume, slides, prices and SASE. Call or write to schedule an appointment to show a portfolio, which should include originals, slides and transparencies. Bio, vita, slides, articles, etc. are filed.

Tips: "Have an idea of what our gallery represents and show professionalism. If the artist expects us to devote time to previewing their work, they should devote some time to exploring our gallery and have some idea of what we do. We have added a second location, 2012 Baltimore, where we have an additional 5,000 sq. ft. of exhibition space. Exhibitions run concurrently with the L-V Gallery."

MORTON J. MAY FOUNDATION GALLERY, Maryville College, 13550 Conway, St. Louis MO 63141. (314)576-9300. Director: Nancy N. Rice. Nonprofit gallery. Represents 6 emerging, mid-career and established artists/year. Sponsors 10 shows/year. Average display time 1 month. Open all year. Located on college campus. 10% of space for special exhibitions. Clientele: college community. Overall price range: $100-4,000.

Media: Considers oil, acrylic, watercolor, pastel, pen & ink, drawings, mixed media, collage, works on paper, sculpture, ceramic, fiber, installation, photography, original handpulled prints, woodcuts, engravings, lithographs, wood engravings, mezzotints, linocuts and etchings. Most frequently exhibits oil, watercolor and prismacolor.

Style: Exhibits expressionism, primitivism, painterly abstraction, realism, photorealism and hard-edge geometric abstraction. Considers all genres.

Terms: Artist receives all proceeds from sales. Retail price set by the artist. Gallery provides insurance and promotion; artist pays for shipping. Prefers framed artwork.

Submissions: Prefers St. Louis area artists. Send query letter with resume, slides, bio, brochure and SASE. Call to schedule an appointment to show a portfolio, which should include slides, photographs and transparencies. Replies only if interested within 3 months.

Tips: Does not want to see "hobbyists'/crafts fair art."

PRO-ART, 1214 Washington Ave., St. Louis MO 63103. (314)231-5848. Artistic Director: Michael Holohan. Retail gallery and art consultancy. Estab. 1985. Represents 25-30 artists; emerging and mid-career. Exhibited artists include Mark Pharis and Chris Gustin. Sponsors 10 shows/year. Average display time 1 month. Open all year. Located in St. Louis' Central West End; 2,000 sq. ft. Clientele: private collectors, corporate clients. Overall price range: $200-10,000; most artwork sold at $1,000.

Media: Considers drawing, sculpture and ceramic. Most frequently exhibits ceramic.

Style: Prefers ceramic vessels and sculpture.

Terms: Accepts work on consignment (50% commission). Gallery provides insurance, promotion and contract; shipping costs are shared.

Submissions: Prefers "mostly ceramics. Some drawings, but rarely." Send query letter with resume, slides, bio and SASE. Call to schedule an appointment to show a portfolio, which should include photographs. Replies in 2 months. Files resumes.

Tips: "Come visit or find out about the kind of work and artists we represent."

Montana

CUSTER COUNTY ART CENTER, Box 1284, Pumping Plant Rd., Miles City MT 59301. (406)232-0635. Executive Director: Susan McDaniel. Nonprofit gallery. Estab. 1977. Clientele: 90% private collectors, 10% corporate clients. Sponsors 8 group shows/year. Average display time is 6 weeks. Interested in emerging and established artists. Overall price range: $200-10,000; most artwork sold at $300-500.

Media: Considers oil, acrylic, watercolor, pastel, pen & ink, drawings, mixed media, collage, works on paper, sculpture, ceramics, fibers, glass, installations, photography and original handpulled prints. Most frequently exhibits paintings, sculpture and photography.

Style: Exhibits painterly abstraction, conceptualism, primitivism, impressionism, expressionism, neo-expressionism and realism. Genres include landscapes, Western, portraits and figurative work. "Our gallery is seeking artists working with traditional and non-traditional Western subjects in new, contemporary ways." Specializes in Western, contemporary and traditional painting and sculpture.

Terms: Accepts work on consignment (30% commission). Retail price is set by gallery and artist. Exclusive area representation not required. Gallery provides insurance, promotion and contract; shipping expenses are shared.

Submissions: Send query letter, resume, brochure, slides, photographs and SASE. Write to schedule an appointment to show a portfolio, which should include originals, "a statement of why the artist does what he/she does" and slides. Slides and resumes are filed.

GALLERY 16, 608 Central, Great Falls MT 59404. (406)453-6103. Advertising Director: Judy Ericksen. Retail and cooperative gallery. Estab. 1969. Represents 100 artists; emerging, mid-career, established. Has 15 members. Exhibited artists include Jean Souders and Jeff Wilson. Sponsors 10 shows/year. Average display time 3 months. Open all year. Located downtown; 600 sq. ft.; "wide open space with good light, movable center section that can be altered easily to make a dramatic change in the interior space." 25% of space for exhibited artists. The balance for members and cosignors. Space devoted to showing the work of gallery artists varies. Clientele: "wide variety, due to the variety of shows; all ages, mainly leaning toward contemporary taste." 85% private collectors, 15% corporate collectors. Overall price range: $10-9,000; most work sold at $10-800.

Media: Considers oil, acrylic, watercolor, pastel, pen & ink, drawings, mixed media, collage, works on paper, sculpture, ceramic, fiber, glass, installation, photography, hand-made garments and jewelry, original handpulled prints, woodcuts, engravings, lithographs, wood engravings, serigraphs, linocuts and etchings. "We accept some commercially prepared prints if we also have originals by the artist." Most frequently exhibits ceramic, watercolor and jewelry.

Style: "We are open to almost any style if the quality is there. We lean toward contemporary material. There are many other opportunities for the display of Western art in this area."

Terms: Accepts work on consignment (35% commission). Retail price set by the artist. Gallery provides insurance, promotion and contract. Artist pays for shipping. Framed and unframed artwork accepted.

Submissions: Prefers contemporary work in all media. Send query letter with resume, slides, bio and SASE. Call to schedule an appointment to show a portfolio, which should include slides. Files materials of artists whose work is accepted.

Tips: "Montana is remote. Unless work can be easily shipped or artist can make delivery, it is best to check to see if shipping would be prohibitive." Common mistakes artists make is presenting "poorly matted and framed work and some slides are not the best quality."

GLACIER GALLERY, 1498 Old Scenic Highway, 2 East, Kalispell MT 59901. (406)752-4742. Contact: Gallery. Retail gallery and art consultancy. Estab. 1969. Clientele: 95% private collectors, 5% corporate clients. Number of exhibitions vary each year. Average display time is 4 weeks. Interested in emerging, mid-career and established artists. Overall price range: $100-150,000; most artwork sold in excess of $10,000.
Media: Considers all media and original handpulled prints. Most frequently exhibits oil, bronze and etchings.
Style: Genres include landscapes, Americana and Western works and wildlife. Looking for "variety within the artists' works."
Terms: Accepts work on consignment (33-40% commission) or buys outright. Retail price is set by gallery and artist. Exclusive area representation not required. Gallery provides insurance ("to a limit"), promotion and contract; artist pays for shipping.
Submissions: Send query letter, resume, brochure, slides and photography. Write to schedule an appointment to show a portfolio. Various material is filed.
Tips: Feels the "contemporary art market is slow."

HARRIETTE'S GALLERY OF ART, 510 1st Ave. N., Great Falls MT 59405. (406)761-0881. Owner: Harriette Stewart. Retail gallery. Estab. 1970. Represents 20 mid-career artists. Exhibited artists include King Kuka and Lorraine Kuehntopp. Sponsors 1 show/year. Average display time 6 months. Open all year. Located downtown; 1,000 sq. ft. 100% of space for special exhibitions. Clientele: 90% private collectors, 10% corporate collectors. Overall price range: $100-10,000; most artwork sold at $200-750.
Media: Considers oil, acrylic, watercolor, pastel, pen & ink, mixed media, sculpture, original handpulled prints, lithographs and etchings. Most frequently exhibits watercolor, oil and pastel.
Style: Exhibits expressionism. Genres include landscape, floral and Western.
Terms: Accepts work on consignment (33⅓% commission). Buys outright for 50% of retail price. Retail price set by the gallery and the artist. Gallery provides promotion; "buyer pays for shipping costs." Prefers framed artwork.
Submissions: Send query letter with resume, slides, brochure and photographs. Write to schedule an appointment to show a portfolio, which should include originals. Replies only if interested within 1 week. Have Montana Room in largest Western Auction in U.S.—The "Charles Russell Auction," in March every year—looking for new artists to display.

HAYNES FINE ARTS GALLERY, Hayes Hall, Montana State University, Bozeman MT 59717. (406)994-2562. Director: John Anacker. University gallery. Estab. 1974. Interested in seeing the work of emerging artists. Sponsors 15 shows/year. Average display time 1 month. Open all year. Located at the University; 1,500 sq. ft. 100% of space for special exhibitions. Clientele: students and community members.
Media: Considers all media and all types of prints.
Style: Exhibits all contemporary styles.
Terms: Retail price set by the artist. Gallery provides insurance; artist pays for shipping. Prefers artwork framed.
Submissions: Send query letter, resume, slides and SASE. Write to schedule an appointment to show a portfolio, which should include slides. Replies in 1 month. Files resumes.

HOLE IN THE WALL GALLERY, 123 E. Main St., Ennis MT 59729. (1-800)992-9981. FAX: (406)682-7440. Manager: Kathy Spositer. Retail gallery. Estab. 1978. Represents 60 emerging, mid-career and established artists. Exhibited artists include Gary Carter and Lee Stroncek. Average display time 2 weeks. Open all year. Located downtown on Main Street; 2,000 sq. ft. 25% of space for special exhibitions, 75% for gallery artists. Clientele: wealthy collectors. 75% private collectors, 25% corporate collectors. Overall price range: $100-30,000.
Media: Considers oil, acrylic, watercolor, pastel, pen & ink, mixed media, sculpture and lithographs. Most frequently exhibits oil, watercolor and bronze.
Terms: Accepts work on consignment (commission). Retail price set by the artist. Gallery provides promotion. Gallery pays for shipping costs from gallery, artist pays for shipping to gallery. Prefers framed artwork.
Submissions: Send query letter with resume, slides, bio, brochure, photographs, SASE, business card and reviews. Call to schedule an appointment to show a portfolio, which should include originals, photographs, slides and transparencies. Replies in 2 weeks. Files resume, brochure and bio.
Tips: "Artists must do Western, wildlife work, be professional and established."

***LEWISTOWN ART CENTER**, 801 W. Broadway, Lewistown MT 59457. (406)538-8278. Executive Director: Nancy Robertson. Wholesale and nonprofit gallery and signature gift shop. Estab. 1971. Represents emerging, mid-career and established artists. Exhibited artists include Don Greytak. Sponsors 24 shows/year. Average display time 4 weeks. Open all year. Located in Courthouse Square, Main Street; 1,075 sq. ft.; (2 separate

galleries: 400 sq. ft in one, 425 in other. Plus a reception area that is used as overflow, approximately 250 sq. ft.); historical stone bunk house—1897 and historical carriage house same era. 50% of space for special exhibitions. Clientele: business/professional to farmers-ranchers. 75% private collectors, 25% corporate collectors. Overall price range: $45-1,200; most work sold at $200-400.

Media: Considers oil, acrylic, watercolor, pastel, pen & ink, drawing, mixed media, sculpture, ceramic, fiber and glass; all types of prints on consignment only. Most frequently exhibits oil/acrylic, watercolor and bronze.

Style: Exhibits expressionism, primitivism, conceptualism, post modern works, impressionism and realism. All genres. Styles exhibited most frequently vary from year to year.

Terms: Accepts work on consignment (30% commission). Retail price set by the gallery and the artist. Gallery provides insurance, promotion and contract; artist pays for shipping. Prefers artwork framed.

Submissions: First send query letter with slides and bio. Then later send brochure and reviews. Replies in 2 weeks.

Tips: "Located in the center of Montana, between Great Falls and Billings, the LAC serves Montanans within a 100-mile radius. The LAC takes pride in exhibiting established artists as well as emerging."

Nebraska

GALLERY 72, 2709 Leavenworth, Omaha NE 68105. (402)345-3347. Director: Robert D. Rogers. Retail gallery and art consultancy. Estab. 1972. Clientele: individuals, museums and corporations. 75% private collectors, 25% corporate clients. Represents 10 artists. Sponsors 4 solo and 4 group shows/year. Average display time is 3 weeks. Interested in emerging, mid-career and established artists. Overall price range: $750 and up.

Media: Considers oil, acrylic, watercolor, pastel, pen & ink, drawings, mixed media, collage, sculpture, ceramic, installation, photography, original handpulled prints and posters. Most frequently exhibits paintings, prints and sculpture.

Style: Exhibits hard-edge geometric abstraction, color field, minimalism, impressionism and realism. Genres include landscapes and figurative work. Most frequently exhibits color field/geometric, impressionism and realism.

Terms: Accepts work on consignment (commission varies), or buys outright. Retail price is set by gallery or artist. Gallery provides insurance and promotion; shipping costs are shared.

Submissions: Send query letter with resume, slides and photographs. Call to schedule an appointment to show a portfolio, which should include originals, slides and transparencies. Vitae and slides are filed.

***GERI'S ART AND SCULPTURE GALLERY**, 7101 Cass St., Omaha NE 68132. (402)558-3030. President: Geri. Retail gallery and art consultancy featuring restrike etchings and tapestry. Estab. 1978. Exhibited artists include Agam and Calder. Open all year. Located in midtown Omaha. Clientele: collectors, designers, residential and corporate. 50% private collectors, 50% corporate collectors. Overall price range: $35-10,000; most work sold at $500-1,000.

Media: Considers watercolor, mixed media, collage, paper, sculpture, ceramic and photography. Considers all types of prints, especially lithographs, serigraphs and monoprints.

Style: Considers all styles and genres. "We carry mostly graphics."

Terms: Artwork is bought outright or leased.

HAYMARKET ART GALLERY, 119 S. 9th St., Lincoln NE 68508. (402)475-1061. Director: Louise Holt. Nonprofit gallery. Estab. 1968. Represents 150 emerging artists. 175 members. Exhibited artists include Barry Monohon and Gary John Martin. Sponsors 9 shows/year (some are group exhibitions). Average display time is minimum of 3 months (If mutually agreeable this is extended or work exchanged). Open all year. Located downtown, near historic Haymarket District; 3093 sq. ft.; "renovated 100-year-old building near Historic Haymarket District." 25% of space for special exhibitions. Clientele: private collectors, interior designers and decorators. 90% private collectors, 10% corporate collectors. Overall price range: $100-2,500; most work sold at $200-750.

Media: Considers oil, acrylic, watercolor, pastel, pen & ink, drawing, mixed media, collage, paper, sculpture, ceramic, fiber, glass and photography; original handpulled prints, woodcuts, wood engravings, linocuts, engravings, mezzotints, etchings, lithographs and serigraphs. Most frequently exhibits oil, watercolor and mixed media.

Style: Exhibits expressionism, neo-expressionism, impressionism, realism, photorealism. Genres include landscapes, florals, Americana, wildlife and figurative work. Prefers realism, expressionism, and photorealism.

Terms: Accepts work on consignment (40% commission). Retail price set by the artist (pricing is sometimes done in conference with director). Gallery provides promotion and contract; artist pays for shipping. Prefers artwork framed.

Submissions: Send query letter with resume, slides, bio, SASE; label slides concerning size, medium, price, top, etc. Submit at least 6-8 slides. Reviews submissions monthly. Replies in 3-4 weeks. Files resume, bio and slides of work by accepted artists (unless artist requests return of slides). All materials are returned to artists whose work is declined.

Tips: "Be familiar with the kind of work the gallery exhibits and submit work that will relate to needs and directions of the gallery's programs. The gallery's principal aim has been to exhibit, promote and sell the work of regional artists."

Nevada

THE BURK GAL'RY, 1229 Arizona St., Box 246, Boulder City NV 89005. (702)293-4514. Owner: Cindy Miller. Retail gallery. Estab. 1972. Open year round. "Gallery feartures old structure (1932), off-white walls, ceiling spots and moveable walls to accommodate a variety of art." Clientele: 98% private collectors; .02% corporate clients. Represents 30 artists. Sponsors 6 solo and 2 group shows/year. Average display time: 3 months. Accepts only artists from Southwestern U.S. Interested in emerging and established artists. Overall price range: $100-10,000; most work sold at $100-1,500.

Media: Considers oil, acrylic, watercolor, pastel, pen & ink, drawings, mixed media, collage, sculpture, ceramic, engravings, lithographs, etchings, serigraphs and offset reproductions. Most frequently exhibits watercolor, oil and bronze.

Style: Exhibits realism, photorealism and primitivism. Genres include landscapes, Southwestern, Western, wildlife and portraits. Prefers Southwestern themes, wildlife and landscapes. "Our gallery specializes in watercolors dealing with the Southwest and contemporary themes."

Terms: Accepts work on consignment (40% commission). Retail price set by artist. Exclusive area representation required.

Submissions: Send query letter with resume, slides and SASE.

***MOIRA JAMES GALLERY,** 2801 Athenian Dr., Henderson NV 89014. (702)454-4800. FAX: (702)454-2787. Retail gallery, primarily craft. Estab. 1989. Represents 150 artists; emerging, mid-career and established artists. Exhibited artists include Tom Mann, jewelry and Tom Coleman, ceramics. Sponsors 7 shows/year. Average display time 6 weeks. Open all year. Located in suburban Las Vegas; 5,000 sq. ft.; "contemporary architecture with extensive bookstore and cafe as part of complex." 50% of space for special exhibitions. Clientele: 80% private collectors, 20% corporate collectors. Overall price range: $75-3,000; most work sold at $300.

Media: Considers glass, ceramic, craft, jewelry in mixed metals, contemporary furniture and glass. Most frequently exhibits ceramics, jewelry and glass.

Terms: Accepts work on consignment (50% commission); or buys outright for 50% of retail price (net 30 days). Retail price set by the artist. Gallery provides insurance, promotion and contract; shipping costs from gallery.

Submissions: Interested in contemporary crafts only. Send query letter with resume, slides, bio and reviews. Write to schedule an appointment to show a portfolio, which should include originals, photographs, slides and transparencies. Replies in 2 weeks. Files material of possible exhibits.

MINOTAUR GALLERY, 3200 Las Vegas Blvd. S., Las Vegas NV 89109. (702)737-1400. President: R.C. Perry. Retail gallery and art consultancy. Estab. 1980. Clientele: 95% private collectors, 5% corporate clients. Represents 2,000 artists on a rotating basis. Sponsors 5 solo and 3 group shows/year. Interested in emerging and established artists. Overall price range: $1,000-100,000; most artwork sold at $2,000-10,000.

Media: Considers oil, acrylic, watercolor, pastel, pen & ink, drawings, mixed media, works on paper, sculpture, ceramic, craft, glass and original handpulled prints. Most frequently exhibits prints, paintings and sculpture.

Style: Exhibits painterly abstraction, impressionism, expressionism, realism and surrealism. Genres include landscapes, florals, Americana and Western styles, portraits, figurative work and fantasy illustration. "We are a department store of fine art covering a wide range of styles and taste levels."

Terms: Accepts work on consignment or buys outright. Retail price is set by gallery and artist. Exclusive area representation required. Gallery provides insurance, shipping, promotion and contract.

Submissions: Send query letter, resume, brochure, slides and photographs.

The asterisk before a listing indicates that the listing is new in this edition. New markets are often the most receptive to freelance submissions.

NEVADA MUSEUM OF ART, 160 W. Liberty St., Reno NV 89501. (702)329-3333. Curator: Roy Herrick. Museum. Estab. 1931. Located downtown in business district. Sponsors 18 solo shows/year. Average display time: 4-6 weeks. Interested in emerging and established artists.
Style: "NMA is a nonprofit private art museum with a separate facility, E.L. Wiegand Museum, a new contemporary museum with 8,000+ square feet for all media and format. Museum curates individual and group exhibitions for emerging as well as established artists. Museum has active acquisition policy for West/ Great Basin artists."

***XS GALLERY**, Western Nevada Community College, 2201 West Nye Lane, Carson City NV 89703. (702)887-3108. Director: Sharon Rosse. College gallery. Estab. 1984. Sponsors 12 shows/year. Average display time 1 month. Open all year. Located on community college campus as well as having gallery space in Nevada's legislature building.
Style: Exhibits innovative, experimental contemporary artwork.
Terms: All artists receive honoraria to visit the area to present lectures within the community.

New Hampshire

***THE ENGLISH GALLERY**, 6 Old Street Rd., Peterborough NH 03458. (603)924-9044. Manager: Kelley Schofield. Estab. 1974. Represents emerging, mid-career and established artists. Exhibited artists include sculptors William Kieffer and Ann Feeley and painters Sascha Burland and David Green. Sponsors 9-10 shows/year. Average display time 5½ weeks. Open all year. Located in residential area on outskirts of town on main highway; 546 sq. ft.; "it is intimate and comfortable – an atmostphere whereby the art can be easily transferred in clients' mind to their own home." 95% of space for gallery artists. Clientele: middle to upper class professionals. 95% private collectors. Overall price range: $100-5,000; most work sold at $250-800.
Media: Considers oil, acrylic, watercolor, pastel, pen & ink, drawing, mixed media, collage, paper, sculpture and photography; original handpulled prints, woodcuts, engravings, linocuts, mezzotints, etchings, lithographs. Most frequently exhibits watercolor, oils and sculpture.
Style: Exhibits primitivism, minimalism, post modern works, impressionism, realism, photorealism and pattern painting. Genres include landscapes, florals, Americana, wildlife, portraits and figurative work. "Open to all quality work."
Terms: Accepts work on consignment (40% commission). Rental fee for space (covers 5½ weeks). Retail price set by the aritst. Gallery provides insurance and promotion; artist pays for shipping. Prefers framed or unframed; artist assumes the cost.
Submissions: Send query letter with resume, slides, bio, photographs, SASE, business card and reviews. Write to schedule an appointment to show a portfolio, which should include originals, photographs and slides. Replies in 1 month. Files resume, slides, bio, reviews and business card.
Tips: "Want to see artists with honest and sincere commitment to their work."

MCGOWAN FINE ART, INC., 10 Hills Ave., Concord NH 03301. (603)225-2515. Owner/Art Consultant: Mary McGowan. Gallery Director: Dorothy Glendinning. Retail gallery and art consultancy. Estab. 1980. Represents emerging, mid-career and established artists. Sponsors 4 shows/year. Average display time 1 month. Located just off Main Street. 75-100% of space for special exhibitions. Clientele: residential and corporate. Most work sold at $125-1,000.
Media: Considers oil, acrylic, watercolor, pastel, mixed media, collage, works on paper, sculpture, original handpulled prints, woodcuts, wood engravings, linocuts, engravings, mezzotints, etchings, lithographs and serigraphs. Most frequently exhibits limited edition prints, monoprints and oil/acrylic.
Style: Exhibits painterly abstraction and all styles. Genres include landscapes.
Terms: Accepts work on consignment (40% commission). Retail price set by the artist. Gallery provides insurance and promotion. Gallery pays for shipping costs from gallery, or artist pays for shipping. Prefers unframed artwork.
Submissions: Send query letter with resume, slides and bio. Replies in 1 month. Files "bio, reviews, slides if possible."

New Jersey

***ALJIRA, A CENTER FOR CONTEMPORARY ART**, 2 Washington Pl., Newark NJ 07102. (201)643-6877. Artistic Director: Carl Hazelwood. Alternative space. Estab. 1984. Represents 200 members; emerging, mid-career and established. Sponsors 8 shows/year. Average display time 6-8 weeks. Open all year. Located in downtown Newark at the corner of Broad Street; 2,000 sq. ft. 70% of space for special exhibitions. Clientele: community and regional. 99% private collectors, 1% corporate collectors. Overall price range: $200-1,500; most work sold at $200-500.

Media: Considers all media and all types of prints. Most frequently exhibits painting, sculpture and mixed.
Style: Exhibits expressionism, neo-expressionism, primitivism, painterly abstraction, imagism, conceptualism, minimalism, color field, post modern works, realism, photorealism, pattern painting and hard-edge geometric abstraction. All genres.
Terms: Recommends contribution of 30% of sales. Retail price set by the artist. Gallery provides insurance, promotion and contract; shipping costs are shared. Prefers artwork framed.
Submissions: Send query letter with resume, slides, bio, photographs, SASE and reviews. Call or write to schedule an appointment to show a portfolio, which should include slides and transparencies. Replies in 1 month. Files slides and resumes.

ARC-EN-CIEL, 64 Naughright Rd., Long Valley NJ 07853. (201)876-9671. Owner: Ruth Reed. Retail gallery and art consultancy. Estab. 1980. Clientele: 50% private collectors, 50% corporate clients. Represents many artists. Sponsors 3 group shows/year. Average display time is 6 weeks-3 months. Interested in emerging, mid-career and established artists. Overall price range: $50-8,000; most artwork sold at $250-1,500.
Media: Considers oil, acrylic, papier mache, sculpture. Most frequently exhibits acrylic, painted iron, oil.
Style: Exhibits surrealism, primitivism and impressionism. "I exhibit country-style paintings, naif art from around the world. The art can be on wood, iron or canvas. I also have some papier mache."
Terms: Accepts work on consignment or buys outright (50% markup). Retail price is set by gallery and artist. Exclusive area representation required. Gallery provides insurance; shipping costs are shared.
Submissions: Send query letter, resume, photographs, slides and SASE. Call or write to schedule an appointment to show a portfolio. Photographs are filed.
Tips: Looks for "originality and talent. No over-priced, over-sized *hokey*, commercial art."

ART FORMS, 16 Monmouth St., Red Bank NJ 07701. (201)530-4330. Director: Charlotte T. Scherer. Retail gallery. Estab. 1984. Represents 12 artists; emerging, mid-career and established. Exhibited artists include Paul Bennett Hirsch and Sica. Sponsors 7 exhibitions/year. Average display time 1 month. Open all year. Located in downtown area; 1,200 sq. ft.; 60% of space devoted to special exhibitions; 30% to work of gallery artists. "gallery has art deco entranceway, tin ceiling, SoHo appeal." 50% of space for special exhibitions. Clientele: 60% private collectors, 40% corporate collectors. Overall price range: $250-70,000; most artwork sold at $1,200-4,500.
Media: Considers all media, including wearable art. Considers original handpulled prints, woodcuts, wood engravings, linocuts, engravings, mezzotints, etchings, lithographs, pochoir and serigraphs. Most frequently exhibits mixed media, oil and lithographs.
Style: Exhibits neo-expressionism expressionism, painterly abstraction. Prefers neo-expressionism, painterly, expression.
Terms: Accepts work on consignment (50% commission). Retail price set by the artist. Gallery provides insurance, promotion and contract, and pays shipping costs from gallery. Prefers unframed artwork.
Submissions: Send query letter with resume, slides, bio and SASE. Write to schedule an appointment to show a portfolio, which should include originals and slides. Replies in 1 month. Files resume and slides.

BARRON ARTS CENTER, 582 Rahway Ave., Woodbridge NJ 07095. (201)634-0413. Acting Director: Nancy Casteras. Nonprofit gallery. Estab. 1977. Clientele: culturally minded individuals mainly from the central New Jersey region, 80% private collectors, 20% corporate clients. Interested in mid-career and established artists. Sponsors several solo and group shows/year. Average display time is 1 month. Interested in emerging and established artists. Overall price range: $200-5,000.
Media: Considers oil, acrylic, watercolor, pastel, pen & ink, drawings, mixed media, collage, works on paper, sculpture, ceramic, craft, fiber, glass, installation, photography, performance and original handpulled prints. Most frequently exhibits acrylic, photography and mixed media.
Style: Exhibits painterly abstraction, impressionism, photorealism, realism and surrealism. Genres include landscapes and figurative work. Prefers painterly abstraction, photorealism and realism.
Terms: Accepts work on consignment. Retail price is set by artist. Exclusive area representation not required. Gallery provides insurance, promotion and contract; artists responsible for shipping.
Submissions: Send query letter, resume and slides. Call to schedule an appointment to show a portfolio. Resumes and slides are filed.
Tips: Most common mistakes artists make in presenting their work are "improper matting and framing and poor quality slides. There's a trend toward exhibtion of more affordable pieces—pieces in the lower end of price range."

***BERGEN MUSEUM OF ART & SCIENCE**, Ridgewood and Farview Aves., Paramus NJ 07652. (201)265-1248. Director: David Messer. Museum. Estab. 1956. Represents emerging, mid-career and established artists. Exhibited artists include Norman Lundine and Beverly Hallam. Sponsors 10 shows/year. Average display time 2 months. Open all year. Located across from Bergen Pines Hospital in Paramus, NJ; 8,000 sq. ft. 65% of space for special exhibitions.

Terms: Payment/consignment terms arranged by case. Retail price set by the artist. Gallery provides promotion; artist pays for shipping. Prefers artwork framed.
Submissions: Send query letter with resume, bio and photographs. Write to schedule an appointment to show a portfolio, which should include originals, photographs and transparencies. Replies only if interested within 4 weeks.
Tips: Prefers "upbeat art of quality."

MARY H. DANA WOMEN ARTISTS SERIES–DOUGLASS COLLEGE LIBRARY, Rutgers University, New Brunswick NJ 08903. (201)932-7739. FAX: (201)932-6743. Curator: Beryl K. Smith. Alternative space, located in a college library. Estab. 1970-71. Represents 6-8 artists/year; emerging, mid-career and established. Interested in emerging artists, "but not students." Sponsors 6 shows/year. Open during the academic year, September-June. Located on the college campus, 1 mile from downtown; "a library space with long hours, heavily trafficked by the University community as well as the New Brunswick area community. Spots available for lighting, but walls may not be changed (i.e. painted). Work is not noted for sale, although interested persons are put in touch with the artist directly."
Media: Considers oil, acrylic, watercolor, pastel, pen & ink, drawings, mixed media, collage, works on paper, sculpture, photography, and original handpulled prints. "We are most interested in showing work that is innovative and well done."
Terms: "Work is decided upon by jury composed of art historians and studio art faculty." Gallery provides insurance and promotion (press releases and card mailings). Artist pays for shipping (except in New York/Philadelphia corridor). Prefers framed artwork.
Submissions: Send query letter with resume, 6 slides and SASE. "Jury meets in February to plan for next academic year." Replies only if interested within 4 weeks. SASE must be enclosed for return of slides. If no reply the artist should make a phone inquiry. Files resumes of all submissions; for chosen artists, retain the slides, resume and photos requested.
Tips: "Send 4-6 slides of work representing what is to be shown, in good condition, labelled clearly with size, medium and name of artist. Slides should not show the vast range of which artist is capable, but rather show development within the style, or continuity. Catalogue is produced each year that includes all exhibiting artists for that season."

HOLMAN HALL ART GALLERY, Hillwood Lakes, CN 4700, Trenton NJ 08650-4700. (609 771-2189. Chairman, Art Department: Dr. Howard Goldstein. Nonprofit gallery and art consultancy. Estab. 1973. Clientele: students, educators, friends and the general public. Represents 125 artists. Sponsors 7 solo and group shows. Average display time is 5 weeks. Interested in emerging and established artists. Overall price range: $100-5,000.
Media: Considers all media, original handpulled prints and offset reproductions. Most frequently exhibits photography, mixed media, sculpture, prints, paintings and drawings.
Style: Exhibits hard-edge geometric abstraction, painterly abstraction, conceptualism, photorealism and expressionism. Genres include landscapes, Americana and figurative work. "Our gallery specializes in any type, style or concept that will best represent that type, style or concept. Being on a college campus we strive not only to entertain but to educate as well."
Terms: Retail price is set by artist. Exclusive area representation not required. Gallery provides insurance, promotion and contract; artist pays for shipping.
Submissions: Exhibitions are arranged by invitation only. Open exhibitions are juried. Includes national drawing, national printmaking and county photography exhibitions.

***JENTRA FINE ART GALLERY**, Hwy. 33 and Millburst Rd., Freehold NJ 07728. (908)431-0838. Directress: Judy Borell. Retail gallery and art consultancy. Estab. 1968. Represents emerging, mid-career and established. Sponsors 2-3 shows/year. Average display time 2 months. Open all year. Located on a major highway; 1,600 sq. ft. 60% of space for special exhibitions. Clientele: "wide variety." 70% private collectors, 30% corporate collectors.
Media: Considers oil, acrylic, watercolor, pastel, pen & ink, drawing, mixed media, collage, paper, sculpture, ceramic, craft, fiber and glass; engravings, linocuts, mezzotints, etchings, lithographs, serigraphs and posters.
Style: Exhibits all styles and genres.
Terms: Accepts work on consignment. Retail price set by the gallery and the artist. Gallery provides insurance and promotion; shipping costs are shared. Prefers artwork unframed.
Submissions: Send query letter with resume, slides, bio, photographs, and reviews. "Call before sending anything you expect back." Call to schedule an appointment to show a portfolio. Replies only if interested within 3 weeks.

THE KORBY GALLERY, 479 Pompton Ave., Cedar Grove NJ 07009. (201)239-6789. Owner: Alfred Korby. Retail gallery. Estab. 1958. Clientele: upper income private buyers, upper-end designers; 70% private collectors. Represents 15 artists. Sponsors 18 solo and 4 group shows/year. Average display time 4 weeks-2 months. Interested in emerging and established artists. Overall price range: $200-2,500; most artwork sold at $1,500.

Media: Considers oil, acrylic, watercolor, sculpture, ceramic, fiber, collage, glass and color original hand-pulled prints. Specializes in lithographs, serigraphs and etchings. Currently looking for oils.
Style: Exhibits contemporary, abstract, landscape, floral, primitive and miniature works. Specializes in contemporary; currently seeking realism.
Terms: Accepts work on consignment (40% commission). Retail price is set by gallery and artist. Exclusive area representation required.
Submissions: Send query letter with resume, slides, photographs and SASE. Call or write to schedule an appointment to show a portfolio.
Tips: Sees a "return to romance and realism."

***NABISCO BRANDS**, River Rd., E. Hanover NJ 07936. (201)503-3238. Nonprofit corporate gallery. Estab. 1975. Sponsors 8 group shows/year. Average display time 6 weeks. Limited to artists in N.Y. metropolitan area. Interested in emerging, mid-career and established artists. Overall price range $200-25,000.
Media: Exhibits original prints, oil, acrylic and watercolor paintings and sculptures, photography, crafts.
Style: Exhibits all styles. Includes all genres. "The Nabisco Gallery organizes 8 exhibitions per year in its spacious lobby area. A variety of media, style and subject matter is the goal in arranging each year's schedule. Nabisco accepts slides and resumes from artists which it keeps on file. These files are then utilized in putting together various shows."
Terms: Retail price set by artist. Exclusive area representation not required. Gallery provides insurance and some promotion. Shipping costs are shared. Artwork must be framed.
Submissions: Send query letter with resume and slides. "We do not review portfolios." Replies only if interested. Files all material sent.
Tips: "Send five slides and any relevant published material."

PELICAN ART PRINTS, 1 Nasturtium Ave., Glenwood NJ 07418. (914)986-8113 or (201)764-7149. Owner: Tom Prendergast. Art Director: Sean Prendergast. Art consultancy. "Brokers prints, at various locations—restaurants, automobile dealers, galleries, dentist offices, frame shops and banks." Estab. 1986. Represents emerging and established artists. Exhibited artists include Doolittle and Bateman. Sponsors 2 shows/year. Average display time 2 months. Open all year. Clientele: 50% private collectors, 40% other galleries, 10% corporate clients. Overall price range: $150-1,500; most artwork sold at $350-500.
Media: Considers watercolor and pen & ink, woodcuts, lithographs, serigraphs and etchings. Most frequently exhibits original prints and serigraphs. Interested in "portrait art—mostly of famous people."
Style: Exhibits imagism and realism. Genres include landscapes, Americana, Southwestern, Western, marine, aviation and wildlife. Prefers wildlife, western and Americana.
Terms: Accepts work on consignment (20% commission). Retail price set by the artist. Gallery provides promotion; artist pays for shipping. Prefers unframed artwork.
Submissions: Send query letter with resume and brochure. Call to schedule an appointment to show a portfolio, which should include originals. Replies in 1 week.
Tips: "Have work that shows professional art."

SIDNEY ROTHMAN-THE GALLERY, 21st on Central Ave., Barnegat Light NJ 08006. (609)494-2070. Director-Owner: S. Rothman. Retail gallery. Estab. 1958. Represents 50 artists; emerging, mid-career and established artists. Exhibited artists include John Gable and Gregorio Prestopino. Sponsors 1 show/year. Average display time 3 months. Open June-Sept. Located in the seashore resort area; 256 sq. ft.; located on the street floor of owner's home. 100% of space for gallery artists. Clientele: 100% private collectors. Overall price range: $100-20,000.
Media: Considers all media and handpulled prints. No photography or offset reproductions. Most frequently exhibits watercolor, acrylic and hand-pulled prints.
Style: Exhibits all styles and genres.
Terms: Accepts work on consignment (33% commission). Retail price set by the gallery and the artist. Gallery provides promotion; shipping costs from gallery.
Submissions: Send query letter with resume, slides and SASE. Call or write to schedule an appointment to show a portfolio, which should include originals and slides. Replies in 1 month.

SCHERER GALLERY, 93 School Rd. W., Marlboro NJ 07746. (201)536-9465. Owner: Marty Scherer. Retail gallery. Estab. 1968. Clientele: 80% private collectors, 20% corporate clients. Represents over 40 artists. Sponsors 4 solo and 3 group shows/year. Average display time is 2 months. Interested in mid-career and established artists. Overall price range: $200-25,000; most artwork sold at $1,000-10,000.
Media: Considers oil, acrylic, watercolor, pen & ink, drawings, mixed media, collage, works on paper, sculpture, glass and original handpulled prints. Most frequently exhibits paintings, original graphics and sculpture.
Style: Exhibits hard-edge geometric abstraction, color field, painterly abstraction, minimalism, conceptualism, surrealism, impressionism, expressionism and realism. "Scherer Gallery is looking for artists who employ creative handling of a given medium(s) in a contemporary manner." Specializes in handpulled graphics

(lithographs, serigraphs, monotypes, woodcuts, etc.). "Would like to be more involved with original oils and acrylic paintings."

Terms: Accepts work on consignment (50% commission). Retail price is set by gallery and artist. Exclusive area representation required. Gallery provides insurance, promotion and contract; shipping costs are shared.
Submissions: Send query letter, resume, brochure, slides and photographs. Call or write to schedule an appointment to show a portfolio, which should include originals, slides and transparencies.
Tips: Considers "originality and quality of handling the medium."

SERAPHIM FINE ARTS GALLERY, 32 N. Dean St., Englewood NJ 07631. (201)568-4432. Contact: Director. Retail gallery. Clientele: 90% private collectors, 10% corporate clients. Represents 150 artists; emerging, mid-career and established. Sponsors 6 solo and 3 group shows/year. Overall price range: $700-17,000; most artwork sold at $4,000-7,000.
Media: Considers oil, acrylic, watercolor, drawings, collage, sculpture and ceramic. Most frequently exhibits oil, acrylic and sculpture.
Style: Exhibits impressionism, realism, photorealism, painterly abstraction and conceptualism. Considers all genres. Prefers impressionism, abstraction and photorealism. "We are located in New Jersey, but we function as a New York gallery. We put together shows of artists which are unique. We represent fine contemporary artists and sculptors."
Terms: Accepts work on consignment. Retail price set by gallery and artist. Exclusive area representation required. Gallery provides insurance and promotion. Prefers framed artwork.
Submissions: Send query letter with resume, slides and photographs. Portfolio should include originals, slides and photographs. Replies in 2-4 weeks. Files slides and bios.
Tips: Looking for "artistic integrity, creativity and an artistic ability to express self." Notices a "return to interest in figurative work."

BEN SHAHN GALLERIES, William Paterson College, 300 Pompton Rd, Wayne NJ 07470. (201)595-2654. Director: Nancy Eireinhofer. Nonprofit gallery. Estab. 1968. Clientele: college, local and New Jersey metropolitan-area community. Sponsors 5 solo and 10 group shows/year. Average display time is 6 weeks. Interested in emerging and established artists.
Media: Considers all media.
Style: Specializes in contemporary and historic styles, but will consider all styles.
Terms: Accepts work for exhibition only. Gallery provides insurance, promotion and contract; shipping costs are shared.
Submissions: Send query letter with resume, brochure, slides, photographs and SASE. Write to schedule an appointment to show a portfolio.

WYCKOFF GALLERY, 210 Everett Ave., Wyckoff NJ 07481. (201)891-7436. Director: Sherry Cosloy. Retail gallery. Estab. 1980. Clientele: collectors, art lovers, interior decorators and businesses; 75% private collectors, 25% corporate clients. Sponsors 1-2 solo and 8-10 group shows/year. Average display time is 1 month. Interested in emerging, mid-career and established artists. Overall price range: $250-10,000; most artwork sold at $500-3,000.
Media: Considers oil, acrylic, watercolor, pastel, pen & ink, pencil, mixed media, sculpture, ceramic, collage and limited edition prints. Most frequently exhibits oil, watercolor and pastel.
Style: Exhibits contemporary, abstract, traditional, impressionistic, figurative, landscape, floral, realistic and neo-expressionistic works.
Terms: Accepts work on consignment. Retail price is set by gallery or artist. Gallery provides insurance and promotion.
Submissions: Send query letter with resume, slides and SASE. Resume and biography are filed.
Tips: Sees trend toward "renewed interest in traditionalism and realism."

New Mexico

THE ALBUQUERQUE MUSEUM, 2000 Mountain Rd. NW, Albuquerque NM 87104. (505)243-7255. Curator of Art: Ellen Landis. Nonprofit museum. Estab. 1967. Location: Old Town (near downtown). Sponsors mostly group shows. Average display time is 3-6 months. Interested in emerging, mid-career and established artists.
Media: Considers all media.
Style: Exhibits all styles. Genres include landscapes, florals, Americana, Western, portraits, figurative and nonobjective work. "Our shows are from our permanent collection or are special traveling exhibitions originated by our staff. We also host special traveling exhibitions originated by other museums or exhibition services."

Submissions: Send query letter, resume, slides, photographs and SASE. Call or write to schedule an appointment to show a portfolio.
Tips: "Artists should leave slides and biographical information in order to give us a reference point for future work or to consider their work in the future."

ALBUQUERQUE UNITED ARTISTS, INC., Box 1808, Albuquerque NM 87103. (505)243-0531. Nonprofit arts organization. Estab. 1978. Represents over 400 artists. Sponsors 8 group shows/year. Sponsors statewide juried exhibits and performances. Average display time is 4 weeks. Accepts only New Mexico artists. "Has no permanent gallery—we rent various locations in the city." Interested in emerging and mid-career artists. Overall price range: $150-2,500; most artwork sold under $500.
Media: Considers oil, acrylic, watercolor, pastel, pen & ink, drawings, mixed media, collage, works on paper, sculpture, ceramic, craft, fiber, glass, installation, photography and original handpulled prints. Most frequently exhibits mixed media, acrylic and ceramics.
Style: Exhibits hard-edge geometric abstraction, color field, painterly abstraction, conceptual works, postmodern, photorealism and expressionism. Genres include landscapes and florals. "Albuquerque United Artists does not specialize in any specific concept as long as the artwork is contemporary."
Terms: Accepts work "only for shows" on consignment (30% commission) or membership fee plus donation of time. Retail price is set by artist. Exclusive area representation not required. AUA provides insurance and contract; shipping costs are shared.
Submissions: Request membership information.
Tips: "We make a special effort to include emerging artists. Part of our mission is to educate and train young and emerging artists. We will look at everything and try to direct artists to the appropriate persons or places where their work is most likely to be shown. Too often artists send slides not labeled properly, works are delivered without wires or otherwise unsuitably prepared for exhibition, miss deadlines, application forms incomplete, fail to follow instructions." Sees trend "in Albuquerque toward more acceptance of contemporary art (non-traditional Southwest). Many new artists moving to this area with fresh ideas."

***PHILIP BAREISS CONTEMPORARY EXHIBITIONS**, 15 Taos Ski Valley, Box 2739, Taos NM 87571. (505)776-2284. Associate Director: Susan Strong. Retail gallery and 3 acre sculpture park. Estab. 1989 at current location "but in business over 10 years in Taos." Represents 21 artists; emerging, mid-career and established. Exhibited artists include Gray Mercer and Patricia Sanford. Sponsors 8 shows/year. Average display time 2 months. Open all year. Located in the countryside, close to town; 4,000 sq. ft.; "gallery is unique metal building with sculptural qualities." 99% private collectors, 1% corporate collectors. Overall price range: $250-65,000.
Media: Most frequently exhibits outdoor sculpture, paintings and monotypes.
Styles: Exhibits all styles and genres, including abstract.
Terms: Accepts work on consignment (varying commission). Gallery provides contract; artist pays for shipping.
Submissions: Currently interested in outdoor sculpture. Send query letter with photographs. Write to schedule an appointment to show a portfolio, which should include photographs. Replies only if interested. Files "resumes and photos if not returned to the artist—kept only if interested."
Tips: "Do not send material unless your query results in a request for submission. The amount of material a gallery receives from artists can be overwhelming."

BENT GALLERY AND MUSEUM, Box 153, 117 Bent St., Taos NM 87571. (505)758-2376. Owner: O.T. Noeding. Retail gallery and museum. Estab. 1961. Represents 15 established artists. Interested in emerging artists. Exhibited artists include Leal Mack. Open all year. Located 1 block off of the Plaza; "housed in the home of Charles Bent, the first territorial governor of New Mexico." 95% private collectors, 5% corporate collectors. Overall price range: $100-10,000; most work sold at $500-1,000.
Media: Considers oil, acrylic, watercolor, pastel, pen & ink, drawings, sculpture, original handpulled prints, woodcuts, engravings and lithographs.
Style: Exhibits impressionism and realism. Genres include landscapes, florals, Southwestern and Western. Prefers impressionism, landscapes and Western works.
Terms: Accepts work on consignment (33½-50% commission). Retail price set by the gallery and the artist. Artist pays for shipping. Prefers framed artwork.
Submissions: Send query letter with brochure and photographs. Write to schedule an appointment to show a portfolio, which should include originals and photographs. Replies if applicable.
Tips: "It is best if the artist comes in person with exampes of his or her work."

BRUSH FIRE GALLERY, Calle De Parian, Mesilla NM 88046. (505)527-2685. Owner: Pati Bates. Retail gallery. Estab. 1987. Represents 25 artists; emerging, mid-career and established. Exhibited artists include Pati Bates and Steve Hanks. Sponsors 4 shows/year. Average display time 90 days-1 year. Open all year. Located in Old Town Mesilla, a tourist area; 500 sq. ft.; "an old, historical adobe structure." 20% of space for special

exhibitions, 80% for gallery artists. Clientele: mostly tourists and local buyers collectors. Overall price range: $3,500-10,000; most artwork sold at $900-1,500.

Media: Considers all media, etchings, offset reproductions and serigraphs. Most frequently exhibits watercolor, pencil and oil.

Style: Exhibits expressionism, painterly abstraction, surrealism, color field, realism, photorealism and all styles. Genres include Southwestern, wildlife, figurative work and all genres. Prefers figurative work and wildlife. Interested in seeing Southwest and contemporary work, technically sound and of good quality.

Terms: Accepts work on consignment (30% commission) or buys work outright for 50% of retail price (net 30 days). Retail price set by the artist. Gallery provides insurance and promotion. Artist pays for shipping. Framed and unframed artwork accepted.

Submissions: Send query letter with resume, slides, brochure and SASE. Call or write to schedule an appointment to show a portfolio, which should include slides. Replies in 3 weeks only if interested. Files slides. The most common mistakes artist make in presenting their work includes "no appointment made — just dropping in; no cards; work not framed or presentation folder disorganized or dirty; not respecting my time — staying too long while I have customers."

Tips: "Expenses to operate are increasing due to overrated value of rental space in tourist areas."

BRYANS GALLERY, 121 C. N. Plaza, Taos NM 87571. (505)758-9407. Director: Michael McCormick. Retail gallery. Estab. 1983. "Located in old county courthouse where movie 'Easy Rider' was filmed." Clientele: 90% private collectors; 10% corporate clients. Represents 35 artists. Sponsors 3 solo and 1 group show/year. Average display time: 2-3 weeks. Interested in emerging and established artists. Overall price range: $1,500-85,000; most work sold at $3,500-10,000.

Media: Considers oil, acrylic, watercolor, pastel, pen & ink, drawings, mixed media, collage, works on paper, sculpture, ceramic, craft, photography, woodcuts, wood engravings, linocuts, engravings, mezzotints, etchings, lithographs, pochoir, serigraphs offset reproductions and posters. Most frequently exhibits oil, pottery and sculpture/stone.

Style: Exhibits impressionism, neo-expressionism, surrealism, primitivism, painterly abstraction, conceptualism and post modern works. Genres include landscapes and figurative work. Interested in work that is "classically, romantically, poetically, musically modern." Prefers figurative work, lyrical impressionism and abstraction.

Terms: Accepts work on consignment (50% commission). Retail price set by gallery and artist. Exclusive area representation required. Gallery provides promotion and contract; artist pays for shipping. Prefers artwork framed.

Submissions: Send query letter with resume, brochure, slides, photographs, bio and SASE. Write to schedule an appointment to show a portfolio. Replies in 4-7 weeks.

Tips: "Send a brief, concise introduction with several color photos."

EL TALLER TAOS GALLERY, 119A Kit Carson Rd., Taos NM 87571. (505)758-4887. Director: Mary Alice Renison. Retail gallery. Estab. 1983. Represents 25 artists; mid-career and established. Exhibited artists include Amado Pena and Katalin Ehling. Sponsors 3 shows/year. Average display time up to 6 months. Open all year. Located downtown; 4,000 sq. ft. 100% of space for gallery artists. Clientele: 80% private collectors, 20% corporate collectors. Overall price range: $35-15,000; most artwork sold at $500-4,000.

Media: Considers oil, acrylic, watercolor, pastel, drawings, mixed media, collage, works on paper, sculpture, ceramic, fiber, glass, original handpulled prints, woodcuts, engravings, lithographs, etchings and serigraphs. Most frequently exhibits paintings, limited edition original graphics and sculpture.

Style: Exhibits primitivism, painterly abstraction, impressionism and realism. Genres include landscapes, Southwestern, Western and figurative work.

Terms: Accepts work on consignment (50% commission). Retail price set by the gallery and the artist. Gallery provides insurance and promotion; artist pays for shipping. Prefers framed artwork.

Submissions: Prefers only Southwestern subjects. Send query letter with resume, bio, brochure, photographs, SASE, business card and reviews. Call or write to schedule an appointment to show a portfolio, which should include originals, photographs and transparencies. Replies in 2-3 weeks. Files bio and cover letter.

FULLER LODGE ART CENTER, Box 790, 2132 Central, Los Alamos NM 87544. (505)662-9331. Director: Patricia Chavez. Retail gallery, nonprofit gallery, museum and rental gallery for members. Estab. 1977. Represents over 50 artists; emerging, mid-career and established. Has 280 members. Sponsors 11 shows/year. Average display time 1 month. Open all year. Located downtown; 1,300 sq. ft.; "gallery housed in the original log building from the Boys School that preceded the town." 98% of space for special exhibitions. Clientele: local, regional and international visitors. 99% private collectors, 1% corporate collectors. Overall price range: $50-1,200; most artwork sold at $200-300.

Media: Considers oil, acrylic, watercolor, pastel, pen & ink, drawings, mixed media, collage, works on paper, sculpture, ceramic, craft, fiber, glass, installation, photography, original handpulled prints, woodcuts, engravings, lithographs, wood engravings, mezzotints, serigraphs, linocuts and etchings.

© Bill Rane 1990

Director of Bryan's Gallery, Michael Mc-Cormick, was introduced to artist Bill Rane through a friend of Rane's. It was the beginning of a strong relationship, for Rane's work has now been exhibited for eight consecutive years in the gallery. In fact, says McCormick, "we established the gallery around his work." This piece The Night the Horse Got Loose *is representative of what McCormick calls his "lyrical sense of mythology, music and poetry."*

Style: Exhibits all styles and genres.

Terms: Accepts work on consignment (30% commission). Retail price set by the artist. Gallery provides insurance and promotion; artist pays for shipping. Prefers "exhibition ready" artwork.

Submissions: "Prefer the unique. Not 'Santa Fe' style." Send query letter with resume, slides, bio, brochure, photographs, SASE and reviews. Call to schedule an appointment to show a portfolio, which should include originals, photographs (if a photographer) and slides. Replies in 2 weeks. Files "resumes, etc., slides returned if SASE."

Tips: "Be aware that we never do one person shows—artists will be used as they fit in to scheduled shows." Should show "impeccable craftsmanship. Work should be in exhibition form (ready to hang)."

GALLERY A, 105 Kit Carson, Taos NM 87571. (505)758-2343. Director: Mary L. Sanchez. Retail gallery. Estab. 1960. Represents 70 artists; emerging, mid-career and established. Exhibited artists include Gene Kloss and Carlos Hall. Sponsors 1 show/year. Average display time 2 months. Open all year. Located one block from the plaza; over 3,500 sq. ft; "Southwestern interior decor." 50% of space for special exhibitions, 100% for gallery artists. Clientele: "from all walks of life." 98% private collectors. Overall price range: $100-12,000; most artwork sold at $500-5,000.

Media: Considers oil, acrylic, watercolor, pastel, original handpulled prints, serigraphs and etchings. Most frequently exhibits oil, watercolor and acrylic.

Style: Exhibits expressionism, impressionism and realism. Genres include landscapes, florals, Southwestern and Western works. Prefers impressionism, realism and expressionism.

Terms: Accepts work on consignment (40% commission). Retail price set by the artist. Gallery provides promotion; artist pays for shipping. Prefers framed artwork.

Submissions: Send query letter with bio and photographs. Call or write to schedule an appointment to show a portfolio, which should include photographs. Replies only if interested within 1 week. Files bios.

EDITH LAMBERT GALLERY, 707 Canyon Rd., Santa Fe NM 87501. (505)984-2783. Contact: Director. Retail gallery. Estab. 1986. Represents 30 artists; emerging and mid-career. Exhibited artists include Carol Hoy and Margaret Nes. Sponsors 4 shows/year. Average display time 3 weeks. Open all year. Located in "historic 'art colony' area; 1,500 sq. ft.; historic adobe, Southwestern architecture, lush garden compound." 20% of space for special exhibitions. Clientele: 95% private collectors. Overall price range: $100-4,500; most artwork sold at $500-2,600.

Media: Considers oil, acrylic, watercolor, pastel, mixed media, collage, works on paper, ceramic, craft and glass. Most frequently exhibits watercolor/casein, pastel and oil.

Style: Exhibits expressionism, neo-expressionism and painterly abstraction. Genres include landscapes, Southwestern and figurative work. Prefers expressionism and painterly abstraction. No portraits or "animal" paintings.

Terms: Accepts work on consignment (50% commission). Exclusive area representation required. Retail price set by the gallery. Provides insurance, promotion and contract; shipping costs are shared. Prefers framed artwork.

Submissions: Send query letter with resume, slides, bio, SASE and reviews. Call to schedule an appointment to show a portfolio, which should include originals and slides. Replies only if interested within 1 month.

Tips: Looks for "consistency, continuity in the work; artists with ability to interact well with collectors and have a commitment to their career."

MAGIC MOUNTAIN GALLERY, INC., Box 1267, Taos NM 87571. (505)758-9604. Owner: Kay Decker. Retail gallery. Estab. 1980. Represents 25 artists; mid-career and established. Exhibited artists include Malcolm Furlow and James Roybal. Shows 1 show/year. Average display time 1 month. Open all year. Located in historic Taos Plaza; 1,200 sq. ft. 50% of space for special exhibitions. 90% private collectors, 10% corporate collectors. Overall price range: up to $16,000; most work sold at $1,000-5,000.

Media: Considers oil, acrylic, watercolor, pastel, sculpture and ceramic; original handpulled prints, lithographs and serigraphs. Most frequently exhibits sculpture, paintings (oils) and ceramics (clay art).

Style: Exhibits expressionism, color field and impressionism. Genres include landscapes and Southwestern. Prefers impressionism, colorfield and expressionism.

Terms: Accepts work on consignment (50% commission). Retail price set by the artist. Gallery provides insurance, promotion and contract; shipping costs are shared. Prefers artwork framed.

Submissions: Send query letter with resume, slides, bio, and photographs. Call or write to schedule an appointment to show a portfolio which should include originals and photographs. Replies in 1 month. Files bio and photos.

QUAST GALLERIES, TAOS, 229 Kit Carson Rd., Box 1528, Taos NM 87571. (505)758-7160. Director: C. Whitehouse. Retail gallery. Estab. 1986. Represents 26 artists; emerging, mid-career and established. Exhibited artists include Holis Williford and Steve Kestrel. Sponsors 6 shows/year. Average display time 6 months. Open all year. Located a quarter mile east of the town plaza; 1,600 sq. ft.; "old adobe home set under ancient cottonwoods with an outdoor sculpture garden." 100% of space for special exhibitions, 100% for gallery artists. Clientele: collectors from across the country. 80% private collectors, 20% corporate collectors. Overall price range: $500-150,000; most artwork sold at $2,000-15,000.

Media: Considers oil, watercolor, pastel, drawings and sculpture with an emphasis on bronze. Most frequently exhibits bronze, oil and watercolor.

Style: Exhibits impressionism and representational work. Genres include landscapes, florals, Southwestern, Western, wildlife, portraits and figurative work. Prefers wildlife, landscape and Western.

Terms: Accepts work on consignment (50% commission). Buys outright for 40% of retail price. Retail price set by the artist. Gallery provides insurance, promotion and contract; artist pays for shipping. Prefers framed artwork.

Submissions: Send query letter with bio, brochure, photographs, SASE, business card, reviews and prices. Write to schedule an appointment to show a portfolio, which should include originals, slides and photographs. Replies in 6 weeks or within 2 weeks only if interested.

Tips: "Have technical skills and a professional approach to work." Sees trend toward galleries being "more involved in the education and awareness of quality art."

RUTGERS BARCLAY GALLERY, 325 W. San Francisco St., Santa Fe NM 87501. (505)986-1400. Director/Owner: Rutgers Barclay. Assistant Director: Laurie B. Innes. Retail gallery. Estab. 1988. Clientele: 40% private collectors. Represents 3 or more artists. Sponsors 3-7 solo and 1-2 group shows/year. Average display time 4 weeks. Interested in emerging, mid-career and established artists. Overall price range: $2,000-85,000 and up; most work sold at $3,000-30,000.

Media: Considers oil, acrylic, watercolor, pastel, pen & ink, drawings, mixed media, works on paper, sculpture, ceramic, egg tempera and original handpulled prints. Most frequently exhibits oils, watercolors and monoprints.

Style: Exhibits impressionism, expressionism, neo-expressionism, realism, photorealism, color field and painterly abstraction; considers all styles. Genres include landscapes, florals, wildlife, portraits and figurative work; considers all genres except Southwestern art. Prefers contemporary works, realism and abstraction.

Terms: Accepts work on consignment (50% commission). Retail price set by gallery and artist. Exclusive area representation not required. Gallery provides insurance, promotion and contract; shipping costs are shared. Prefers framed artwork.

Submissions: Send query letter with resume, slides, photographs, bio and SASE. Call to schedule an appointment to show a portfolio, which should include slides, transparencies, photographs and bio. Does not want to see "other people representing them showing their portfolios—prefer to meet with artists themselves whenever possible. Also do not want to see portfolios of *everything* they have *ever* done. Most galleries prefer to see a limited selection of materials, i.e. 20 slides, 3-4 articles, resume/biography." Replies only if interested within 2 weeks. All material is returned if not accepted or under consideration.

SANTA FE EAST GALLERY, 200 Old Santa Fe Trail, Santa Fe NM 87501. Sales Director: Ron Cahill. Retail gallery. Estab. 1980. Clientele: 98% private collectors, 2% corporate clients. Represents 100 artists. Sponsors 4 solo and 4 group shows/year. Average exhibition length is 1 month. Interested in emerging, mid-career and established artists. Overall price range: $150-35,000; most artwork sold at $900-3,500.
Media: Considers oil, acrylic, watercolor, pastel, mixed media, collage, sculpture and jewelry. Most frequently exhibits oil, sculpture and jewelry.
Style: Exhibits impressionism, expressionism and realism. Genres include landscapes and figurative work. Prefers American impressionism and contemporary realism. "We feature museum quality exhibitions of large nineteenth and early twentieth century American art, contemporary Southwest artists and one-of-a-kind designer jewelry."
Terms: Accepts work on consignment (40-50% commission). Retail price is set by gallery and artist. Exclusive area representation required. Gallery provides insurance, promotion and contract; artist pays for shipping and supplies professional quality photographs.
Submissions: Send query letter, resume, slides, photographs, price information and SASE. Write to schedule an appointment to show a portfolio, which should include originals, slides and resume. Letters and resumes are filed. "Gallery also sponsors juried exhibitions of art and jewelry. Write for information."
Tips: The most common mistakes artists mare are "dropping in without appointments and not including pricing information."

UNIVERSITY ART GALLERY, NEW MEXICO STATE UNIVERSITY, Williams Hall, University Ave. E. of Solano, Las Cruces NM 88003. (505)646-2545. Director: Karen Mobley. Estab. 1972. Represents emerging, mid-career and established artists. Sponsors 8 shows/year. Average display time 1 month. Open all year. Located at university; 4,000 sq. ft. 100% of space for special exhibitions.
Media: Considers all media and all types of prints.
Style: Exhibits all styles and genres.
Terms: Shipping costs are shared. Prefers artwork framed.
Submissions: Send query letter with resume, slides, bio, SASE, brochure, photographs, business card and reviews. Write to schedule an appointment to show a portfolio, which should include originals, photographs, transparencies and slides. Replies in 2 months. Files resumes.
Tips: A common mistake artist make is "not considering the space or concept of our program. We do almost no one person shows."

New York

ADAMS ART GALLERY, 600 Central, Dunkirk NY 14048. (716)366-7450. Curator: Marvin Bjurlin. Nonprofit gallery. Estab. 1975. Represents 12-16 artists/year in both solos and duos; emerging and mid-career. Sponsors 12 shows/year. Average display time 3 weeks. Open all year. Located near downtown; "a renovated classic revival Unitarian church, 18' ceilings, track lights." 100% of space for special exhibitions. Clientele: general public. "There are very few sales." Overall price range: $500-5,000.
Media: Considers oil, acrylic, watercolor, pastel, pen & ink, drawings, mixed media, collage, works on paper, sculpture, ceramic, craft, fiber, glass, installation and photography. No media preferred.
Style: Exhibits all styles and genres. No style preferred. Does not want to see "decorative 'office' art."
Terms: Accepts work on consignment (25% commission). Retail price set by the artist. Gallery provides insurance and promotion; shipping costs are shared. Prefers framed artwork.
Submissions: "Artist's work must represent a strong personal statement." Send query letter with resume, slides and bio. Write to schedule an appointment to show a portfolio, which should include slides.
Tips: "While we have no regional limits, it is hard for us to deal with large artwork which is shipped (limited storage area). Most artists deliver and pick up work. We help with costs." Sees trend toward "diversification of media, more multimedia."

BURCHFIELD ART CENTER, State University College, 1300 Elmwood Ave., Buffalo NY 14222. (716)878-6012. Director: Anthony Bannon. Nonprofit gallery. Estab. 1966. Clientele: urban and suburban adults, college students, corporate clients, all ages in touring groups. Sponsors solo and group shows. Average display time is 4-8 weeks. Interested in emerging, mid-career and established artists who have lived in western New York State.

Media: Considers oil, acrylic, watercolor, pastel, pen & ink, drawings, sculpture, ceramic, fiber, photography, craft, mixed media, performance art, collage, glass, installation and original handpulled prints.

Style: Exhibits contemporary, abstract, impressionistic, figurative, landscape, floral, primitive, non-representational, photorealistic, realistic, neo-expressionistic and post-pop works. "We show both contemporary and historical work by western New York artists, Charles Burchfield and his contemporaries. The museum is not oriented toward sales."

Terms: Accepts work on craft consignment for gallery shop (50% commission). Retail price is set by gallery and artist. Exclusive area representation not required. Gallery provides insurance, promotion and contract; shipping costs are shared.

Submissions: Send query letter, resume, slides and photographs. Call or write to schedule an appointment to show a portfolio. Biographical and didactic materials about artist and work, slides, photos, etc. are filed.

Tips: Sees trend toward "diversity and political ideology."

CEPA GALLERY, 4th Floor, 700 Main St., Buffalo NY 14202. (716)856-2717. Executive Director: Gail Nicholson. Alternative space and nonprofit gallery. Open fall, winter and spring. Clientele: artists, students, photographers and filmmakers. Interested in emerging, mid-career and established artists. Sponsors 10 solo and 6 group shows/year. Average display time 4-6 weeks. Prefers photographically related work.

Media: Installation, photography, film, mixed media, computer imaging and digital photography.

Style: Contemporary photography. "CEPA provides a context for understanding the aesthetic, cultural and political intersections of photo-related art as it is produced in our diverse society."

Submissions: Send query letter with resume, slides, SASE, brochure, photographs, bio and artist statement. Call or write to schedule an appointment to show a portfolio, which should include slides and photographs. Replies in 6 months.

Tips: "It is a policy to keep slides and information in our Artist File for indefinite periods. Grant writing procedures require us to project one and two years into the future. Call first regarding suitability for this gallery. CEPA does not sell photographs or take comissions. Always provide a good artist statement about the work."

CHAPMAN ART CENTER GALLERY, Cazenovia College, Cazenovia NY 13035. (315)655-9446. Chairman, Center for Art and Design Studies: John Aistars. Nonprofit gallery. Estab. 1978. Clientele: the greater Syracuse community. Sponsors 3 solo and 4 group shows/year. Average display time is 3 weeks. Interested in emerging, mid-career and established artists. Overall price range: $50-3,000; most artwork sold at $100-200.

Media: Considers oil, acrylic, watercolor, pastel, pen & ink, drawings, sculpture, ceramic, fiber, photography, craft, mixed media, collage, glass and prints.

Style: Exhibits all styles. "Exhibitions at the Chapman Art Center Gallery are scheduled for a whole academic year at once. The selection of artists is made by a committee of the art faculty in early spring. The criteria in the selection process is to schedule a variety of exhibitions every year to represent different media and different stylistic approaches; other than that our primary concern is quality. Any artist interested in exhibiting at the gallery is asked to submit to the committee by March 1 a set of slides or photographs and a resume listing exhibitions and other professional activity."

Terms: Retail price is set by artist. Exclusive area representation not required. Gallery provides insurance and promotion; works are usually not shipped.

Submissions: Send query letter, resume, 10-12 slides or photographs.

Tips: A common mistake artists make in presenting their work is that the "overall quality is diluted by showing too many pieces. Call or write and we will mail you a statement of our gallery profiles."

DARUMA GALLERIES, 554 Central Ave., Cedarhurst NY 11516. (516)569-5221. Owner: Linda. Retail gallery. Estab. 1980. Represents about 15 artists; emerging and mid-career. Interested in seeing the work of emerging artists. Exhibited artists include Christine Amarger and Eng Tay. Sponsors 2-3 shows/year. Average display time 1 month. Open all year. Located on the main street; 1,000 sq. ft. 100% private collectors. Overall price range: $150-5,000; most work sold at $250-1,000.

Media: Considers watercolor, pastel, pen & ink, drawings, mixed media, collage, woodcuts, linocuts, engravings, mezzotints, etchings, lithographs and serigraphs. Most frequently exhibits etchings, lithographs and woodcuts.

Style: Exhibits all styles and genres. Prefers scenic (not necessarily landscapes), figurative and Japanese woodblock prints.

Terms: 33⅓% commission for originals; 50% for paper editions. Retail price set by the gallery (with input from the artist). Artist pays for shipping. Prefers unframed artwork.

Submissions: Send query letter with resume, bio and photographs. Call to schedule an appointment to show a portfolio, which should include originals and photographs. Replies quickly. Files bios and photo examples.

Tips: "Bring good samples of your work and be prepare to be flexible with the time needed to develop new talent. Have a competent bio, presented in a professional way."

DAWSON GALLERY, 349 East Ave., Rochester NY 14604. (716)454-6609. Exhibition Director: Shirley Dawson. Retail gallery. Estab. 1982. Represents mid-career and established artists. Exhibited artists include Bill Stewart. Sponsors 11 shows/year. Open all year. Located downtown, on street level in a cultural district; 1,600 sq. ft.; high-tech design with walk-in space located in the heart of Rochester's cultural district, within walking distance to major museums and a performance center. 80% of space for special exhibitions. 90% private collectors, 10% corporate collectors. Overall price range: $300-30,000; most artwork sold at $1,500-4,000.
Media: Considers sculpture from almost any media—oil, mixed media, sculpture, ceramic, fiber and glass. Most frequently exhibits metal, wood and clay.
Style: Exhibits neo-expressionism, primitivism and surrealism. Prefers decorative arts (functional sculpture).
Terms: Accepts work on consignment (50% commission). Retail price set by the artist (with gallery guidance when necessary). Gallery provides insurance, promotion, contract and shipping costs from gallery. Prefers artwork framed.
Submissions: No prints or photography. Send query letter with resume, slides, bio, brochure, photographs, SASE, reviews. Call or write to schedule an appointment to show a portfolio, which should include slides. Replies as quickly as possible. Files slides and resumes if interested.

© Leonard Urso 1990

Dancers, by Leonard Urso of Scottsville, New York, stands 6'5" in copper. It was exhibited in the Dawson Gallery of Rochester, New York, and according to the artist, "it conveys subtle movement in color, pattern and form. The characters are strong, but elegant." Urso was introduced to the gallery's directors during a "casual meeting" and now has a friendship, as well as a business relationship with them.

EAST END ARTS COUNCIL, 133 E. Main St., Riverhead NY 11901. (516)727-0900. Visual Arts Coordinator: Patricia Berman. Nonprofit gallery. Estab. 1971. Represents and exhibits emerging, mid-career and established artists. Clientele: 100% private collectors. Exhibits the work of 30 individuals and 7 groups/year. Sponsors 30 solo and 7 group shows/year. Average display time is 6 weeks. Prefers regional artists. Overall price range: $10-10,000; most artwork sold at under $200.

Media: Considers all media and prints.

Style: Exhibits contemporary, abstract, Americana, figurative, landscapes, florals, primitive, non-representational, photorealistic, Western, realistic and post-pop works. "Being an organization relying strongly on community support, we walk a fine line between serving the artistic needs of our constituency and exposing them to current innovative trends within the art world. Therefore, there is not a particular area of specialization. We show photography, fine craft and all art media."

Terms: Accepts work on consignment (30% commission). Retail price is set by gallery and artist. Exclusive area representation not required. Gallery provides insurance, promotion and contract; artist pays for shipping.

Submissions: Send query letter, resume and slides. "All materials will be returned."

Tips: When making a presentation "don't start with 'My slides really are not very good.' Slides should be great or don't use them."

FOCAL POINT GALLERY, 321 City Island, Bronx NY 10464. (212)885-1403. Artist/Director: Ron Terner. Retail gallery and alternative space. Estab. 1974. Clientele: locals and tourists. Interested in emerging artists. Sponsors 7 solo and 1 group show/year. Average display time 3-4 weeks. Overall price range: $175-750; most artwork sold at $300-500.

Media: Most frequently exhibits photography, painting and etching.

Style: Exhibits all styles and genres. Prefers figurative work, landscapes, portraits and abstracts. Open to any use of photography.

Terms: Accepts work on consignment (30% commission). Exclusive area representation required. Gallery provides promotion. Prefers framed artwork.

Submissions: "Artist should please call for information."

Tips: "Do not include resumes. The work should stand by itself."

GALLERY NORTH, 90 North Country Rd., Setauket NY 11733. (516)751-2676. Director: Elizabeth Goldberg. Nonprofit gallery. Estab. 1965. Represents emerging, mid-career and established artists mainly from the New York metropolitan area. Has about 200 members. Sponsors 9 shows/year. Average display time 4-5 weeks. Open all year. (Suburban location) Located near the state university at Stony Brook; approximately 750 sq. ft.; "in a renovated Victorian house." 85% of space for special exhibitions. Clientele: university faculty and staff, Long Island collectors and tourists. 95% private collectors. Overall price range: $100-50,000; most work sold at $5-5,000.

Media: Considers oil, acrylic, watercolor, pastel, pen & ink, drawings, mixed media, collage, works on paper, sculpture, ceramic, craft, fiber, glass, photography, original handpulled prints, woodcuts, wood engravings, linocuts, engravings, mezzotints, etchings, lithographs and serigraphs. Most frequently exhibits paintings, prints and crafts, especially jewelry and ceramics.

Style: Exhibits all styles. Prefers realism, abstraction and expressionism.

Terms: Accepts work on consignment (40% commission). Retail price set by the gallery and artist. Gallery provides insurance, promotion and contract; shipping costs are shared.

Submissions: Send query letter with resume, slides, bio, SASE and reviews. Call to schedule an appointment to show a portfolio, which should include originals, slides or photographs. Replies in 2-4 weeks. Files slides and resumes when considering work for exhibition.

Tips: "If possible the artist should visit to determine whether he would feel comfortable exhibiting here. A common mistake artists make is that slides are not fully labelled as to size medium, which end is up."

THE GRAPHIC EYE GALLERY of Long Island, 301 Main St., Port Washington NY 11050. (516)883-9668. President: Olga Poloukhine. Cooperative gallery. Estab. 1974. Represents 25 artists. Sponsors 2 solo and 4 group shows/year. Average display time: 1 month. Interested in emerging and established artists. Overall price range: $35-7,500; most artwork sold at $500-800.

Media: Considers mixed media, collage, works on paper, woodcuts, wood engravings, linocuts, engravings, mezzotints, etchings, lithographs and serigraphs. Most frequently exhibits etchings, mixed graphics and monoprints.

Style: Exhibits impressionism, expressionism, realism, primitivism and painterly abstraction. Genres include figurative works. Considers all genres. Prefers realism, abstraction and figurative work.

Terms: Co-op membership fee plus donation of time. Retail price set by artist. Exclusive area representation not required. Shipping costs are shared. Prefers framed artwork.

Submissions: Send query letter with resume, slides and bio. Portfolio should include originals and slides. Files historical material.

Tips: "Artists must produce their *own* work and be actively involved. We plan to have a competative juried art exhibit in the near future (1991). Open to all artists who are print makers."

HILLWOOD ART MUSEUM, Long Island University, C.W. Post Campus, Brookville NY 11548. (516)299-2788. Director: Judy Collischan Van Wagner. Assistant Director: Mary Ann Wadden. Nonprofit gallery. Estab. 1974. Clientele: Long Island residents and university students. Interested in seeing the work of emerg-

ing and mid-career artists. Sponsors 1-2 solo and 6-7 group shows/year. Average display time is 4-6 weeks. "We prefer metropolitan area artists because of transportation costs." Overall price range: $2,000-80,000.
Media: Considers oil, acrylic, watercolor, pastel, pen & ink, drawings, mixed media, collage, works on paper, sculpture, ceramic, fiber, photography, performance and limited edition prints. Most frequently exhibits sculpture, paintings, drawing and photography.
Style: "Our gallery specializes in work representing the original ideas of artists dedicated to perceiving their world and experiences in a unique and individual manner. Interested in seeing risk-taking, provocative work."
Terms: Accepts work "in the context of invitational/exhibition." Retail price is set by artist. Gallery provides insurance, promotion and contract; shipping costs are shared.
Submissions: Send query letter, resume and slides. Selected slides and resumes are filed.

ISIS GALLERY LTD., 609 Plandome Rd., Manhasset NY 11030. (516)365-8353. President: Dr. Thelma Stevens; Vice President: Dr. Diane Chichura. Retail gallery and art consultancy. Estab. 1982. Clientele: collectors and corporate decorators. Represents 75 artists. Interested in seeing the work of emerging, mid-career and established artists. Sponsors 24 solo shows/year. Average display time 2-6 weeks. Overall price range: $500-10,000; most artwork sold at $2,000.
Media: Considers oil, acrylic, mixed media, sculpture, fiber, glass, lithographs and serigraphs. Most frequently exhibits oil, acrylic and mixed media.
Style: Exhibits impressionism, expressionism, realism, photorealism, surrealism, painterly abstraction and hard-edge geometric abstraction. Genres include landscapes, florals, Americana, portraits and figurative work. Prefers florals, landscapes and abstracts. "Isis Gallery Ltd. is the North Shore's alternative to the art galleries of the Hamptons and Manhattan. It provides the sophisticated consumer with a source for the finest available art at attractive prices to meet the needs of all art buyers." Interested in seeing romantic, modern, impressionistic, realistic artwork.
Terms: Accepts work on consignment (50% commission). Buys outright (50% retail price; net 30 days). Rental fee for space; rental fee covers 2 weeks. Retail price set by gallery and artist. Exclusive area representation not required. Gallery provides insurance, promotion and contract; artist pays for shipping. Prefers framed artwork.
Submissions: Send query letter with resume, brochure, business card, slides, photographs, bio and SASE. Replies in 3 weeks.
Tips: "In your resume show your achievements, exhibits, prizes, reviews and collections your work is in. Do not include rambling personal statements, or commercial or decorative art. Often artists show too many styles and media without a logical transition and without showing growth. We could use more realistically priced, lower priced American artists. A very small percentage of our clientele will pay prices over $1,000. Lower priced paintings are in demand because of paintings coming in from Europe and Far East."

ISLIP ART MUSEUM, 50 Irish Ln., East Islip NY 11730. (516)224-5402. Director: Madeleine Burnside. Nonprofit museum gallery. Estab. 1973. Clientele: contemporary artists from Long Island, New York City and abroad. Sponsors 8 group shows/year. Average display time is 6 weeks. Interested in emerging, mid-career and established artists.
Media: Considers oil, acrylic, watercolor, pastel, pen & ink, drawings, mixed media, collage, works on paper, sculpture, ceramic, craft, fiber, glass, installation, photography, performance and original handpulled prints. Most frequently exhibits installation, oil and sculpture.
Style: Exhibits all styles. Genres include landscapes, Americana, portraits, figurative work and fantasy illustration. "We consider many forms of modern work by artists from Long Island, New York City and abroad when organizing exhibitions. Our shows are based on themes, and we only present group exhibits. Museum expansion within the next two years will allow for one and two person exhibits to occur simultaneously with the ongoing group shows."
Terms: Retail price is set by artist. Exclusive area representation not required. Gallery provides insurance, promotion, contract and shipping.
Submissions: Send resume, brochure, slides and SASE. Slides, resumes, photos and press information are filed. The most common mistake artists make in presenting their work is that "they provide little or no information on the slides they have sent to the museum for consideration."

KIRKLAND ART CENTER, East Park Row, Box 213 Clinton NY 13323-0213. (315)853-8871. Director: Dare Thompson. Nonprofit gallery. Estab. 1960. Clientele: general public and art lovers; 99% private collectors, 1% corporate clients. Sponsors 6 solo and 6 group shows/year. Average display time is 3-4 weeks. Interested in emerging, mid-career and established artists. Overall price range: $60-4,000; most artwork sold at $200-1,200.
Media: Considers oil, acrylic, watercolor, pastel, pen & ink, drawings, mixed media, collage, works on paper, sculpture, ceramic, craft, fiber, glass, installation, photography, performance art and original handpulled prints. Most frequently exhibits watercolor, oil/acrylic, prints, sculpture, drawings, photography and fine crafts.

Style: Exhibits painterly abstraction, conceptualism, impressionism, photorealism, expressionism, realism and surrealism. Genres include landscapes, florals and figurative work.

Terms: Accepts work on consignment (25% commission). Retail price is set by artist. Exclusive area representation not required. Gallery provides insurance, promotion and contract; artist pays for shipping.

Submissions: Send query letter, resume, slides, slide list and SASE or write to schedule an appointment to show a portfolio.

Tips: Common mistakes artists make are "including slides of all their work, rather than concentrating on what would make a cohesive show. Shows are getting very competitive—artists should send us slides of their most challenging work, not just what is most saleable. It is best to call or write for instructions and more information."

THE LORING GALLERY, 661 Central Ave., Cedarhurst NY 11516. (516)294-1919. President: Rosemary or Arthur Uffner. Retail gallery. Estab. 1952. Represents 9 artists. Sponsors 3 solo shows/year. Average display time is months. Interested in mid-career and established artists. Overall price range: $100-10,000; most artwork sold at $1,500-7,000.

Media: Considers oil, acrylic, watercolor, pastel, drawings, mixed media, collage, works on paper and original handpulled prints. Most frequently exhibits oil, pastel and sculpture.

Style: Exhibits color field, painterly abstraction, primitivism, impressionism, photorealism, realism and surrealism. Genres include landscapes, Americana and figurative work. "We handle works from the turn of the century to the present. All must be in the realm of time cut. Wonderful imagery is most important."

Terms: Accepts work on consignment (50% commission) or buys outright. Retail price is set by gallery and artist. Exclusive area representation required. Gallery provides promotion; shipping and insurance costs are shared.

Submissions: Send query letter, resume and slides. Write to schedule an appointment to show a portfolio, which should include originals, slides and transparencies.

MARI GALLERIES OF WESTCHESTER, LTD., 133 E. Prospect Ave., Mamaroneck NY 10543. (914)698-0008. Owner/Director: Carla Reuben. Retail gallery. Estab. 1966. Located in a 200-year-old red barn. Exhibits the work of 30-35 artists/show. Sponsors 8 solo shows/year. Average display time is 4-5 weeks. Interested in emerging artists.

Media: Considers all media and prints.

Style: Exhibits all contemporary styles.

Terms: Accepts work on consignment (40-50% commission). Retail price is set by gallery and artist. Exclusive area representation required. Gallery provides insurance and promotion; shipping costs are paid by artist to and from gallery.

Submissions: Send query letter with resume, brochure, slides and SASE. Write to schedule an appointment to show a portfolio. "I keep a file on all my artists."

***NORTHPORT/BJ SPOKE GALLERY,** 299 Main St., Huntington NY 11743. (516)549-5102. President: Helen Burros. Membership Director: Rita Calumet. Cooperative and nonprofit gallery. Estab. 1978. Represents 27 members; emerging, mid-career and established artists. Exhibited artists include Ed Kimmel and Abby Rust. Sponsors 12 group shows and nine 1-2 person shows/year. Average display time 1 month. Open all year. Located in center of town; 1,400 sq. ft.; flexible use of space—3 separate gallery spaces; 1 space: group show when 2 person show, national juried, or special exhibitions are in other 2 areas. 66% of space for special exhibitions; 33% of space for gallery artists 9 times a year; 100% to gallery artists 3 times a year. Overall price range: $100-10,000; most work sold at $900-1,600. Eligible for a 2 person show every 18 months.

Media: Considers all media except crafts, all types of printmaking. Most frequently exhibits paintings, prints and sculpture.

Style: Exhibits all styles and genres. Prefers painterly abstraction, realism and expressionism.

Terms: Co-op membership fee plus a donation of time (25% commission); rental fee for space (covers 1 month). Retail price set by the artist. Gallery provides promotion; artist pays for shipping. Prefers artwork framed; large format, artwork can be tacked.

Submissions: For membership, send query letter with resume, slides, bio, SASE and reviews. For national juried show send SASE for prostectus or deadline. Call or write to schedule an appointment to show a portfolio, which should include originals and slides. Files resumes; may retain slides for awhile if needed for upcoming exhibition.

Tips: "Send slides that represent depth and breadth in the exploration of a theme, subject or concept. They should represent a cohesive body of work."

PETRUCCI GALLERY, 25 Garden Circle at Rt. 9W, Saugerties NY 12477. (914)246-9100. Owner: W.F. Petrucci. Retail gallery. Estab. 1975. Clientele: 98% private collectors, 2% corporate clients. Represents 75 artists. Sponsors 12 solo shows/year. Average display time is 4 weeks. Interested in mid-career and established artists. Overall price range: $1,000-25,000.

Media: Considers all media and original handpulled prints.

Style: Exhibits all styles.

Terms: "Terms are discussed with artist after acceptance." Price set by gallery and artist. Exclusive area representation required. Gallery provides promotion and contract; artist pays for shipping.

Submissions: Send query letter with resume and photographs. Call to schedule an appointment to show a portfolio, which should include originals and slides. Resumes and photographs are filed.

***PRINT CLUB OF ALBANY**, Box 6578, 140 N. Pearl St., Albany NY 12206. (518)432-9514. President: Dr. Charles Semowich. Nonprofit gallery and museum. Estab. 1934. Represents 40+ artists; emerging, mid-career and established. Sponsors 2 shows/year. Average display time 6 weeks. Open all year. Located in downtown arts district. "We currently have a small space and hold exhibitions in other locations." Clientele varies. 80% private collectors, 20% corporate collectors.

Media: Considers original handpulled prints, woodcuts, wood engravings, linocuts, engravings, mezzotints, etchings, lithographs and serigraphs.

Style: Exhibits all styles and genres.

Terms: Accepts work on consignment from members. Membership is open nationwide; also accepts donations to the permanent collection. Retail price set by the artist. Artist pays for shipping. Prefers artwork framed.

Submissions: Prefers only prints. Send query letter.

Tips: "We are a nonprofit organization of artists, collectors and others. Artist members exhibit without jury. We hold members shows, national open competitive show, and we commission an artist for an annual print each year. Our shows are held in various locations. We are now planning for a museum and building."

QUEENS COLLEGE ART CENTER, Benjamin S. Rosenthal Library, Queens College, CUNY, Flushing NY 11367. (718)997-3770. FAX: (718)793-8049. Curator: Suzanna Simor. Nonprofit university gallery. Estab. 1955. Represents emerging, mid-career and established artists. Sponsors 10 shows/year. Average display time 1 month. Open all year. Located in borough of Queens; 1,000 sq. ft. 100% of space for special exhibitions. Clientele: "college and community, some commuters." 100% private collectors. Overall price range: up to $10,000; most artwork sold at $200.

Media: Considers oil, acrylic, watercolor, pastel, pen & ink, drawings, mixed media, collage, works on paper, sculpture, ceramic, craft, fiber, glass, installation, photography, original handpulled prints, woodcuts, wood engravings, linocuts, engravings, mezzotints, etchings, lithographs, pochoir, serigraphs and posters. Most frequently exhibits paintings, prints, drawings and photographs.

Style: Prefers all genres.

Terms: Accepts work on consignment (30% commission). Retail price set by the artist (in consultation with the gallery). Gallery provides promotion; artist pays for shipping.

Submissions: Cannot exhibit large 3d objects. Send query letter with resume, slides, bio, brochure, photographs, SASE and reviews. Write to schedule an appointment to show a portfolio, which should include slides, photographs or transparencies; "originals if presented in person." Replies in 2-3 weeks. Files "resume/bio, publicity materials, photos, etc. if available (any documentation)."

ROCKLAND CENTER FOR THE ARTS, 27 So. Greenbush Rd., West Nyack NY 10994. (914)358-0877. Executive Director: J. Ramos. Nonprofit gallery. Estab. 1972. Represents emerging, mid-career and established artists. Has 1,500 members. Sponsors 6 shows/year. Average display time 5 weeks. Open September-May. Located in suburban area; 2,000 sq. ft.; "contemporary space." 100% of space for special exhibitions. Clientele: 100% private collectors. Overall price range: $500-50,000; most artwork sold at $1,000-5,000.

Media: Considers oil, acrylic, watercolor, pastel, pen & ink, mixed media, sculpture, ceramic, fiber, glass and installation. Most frequently exhibits painting, sculpture and craft.

Style: Exhibits all styles and genres.

Terms: Accepts work on consignment (33% commission). Retail price set by the artist. Gallery provides insurance, promotion and shipping costs to and from gallery. Prefers framed artwork.

Submissions: "Proposals accepted from curators only. No one person shows. Artists should not apply directly." Replies in 2 weeks.

Tips: "Artist may propose a curated show of 3 or more artists: curator may not exhibit. Request curatorial guidelines. Unfortunately for artists, the trend is toward very high commissions in commercial galleries. Nonprofits like us will continue to hold the line."

SCHWEINFURTH ART CENTER, Box 916, 205 Genesee St., Auburn NY 13021. (315)255-1553. Director: Lisa Pennella. Nonprofit gallery. Estab. 1981. Clientele: local and regional children and adults, specialized audiences for fine art, architecture, photography and folk art. Sponsors 6 solo and 6 group shows/year. Average display time is 2 months. Interested in emerging and established artists. Overall price range: $25-7,500; most artwork sold at $100-500.

"I am fascinated with the timelessness and energy of particular objects, shapes and phenomena, the communicative power of petroglyphs and bone carvings, the solemnity of vertical form, the power of inexplicability," says Karen Erla, creator of this monoprint Jazz at Marty's. The White Plains, New York-based artist says this work engages "concerns of environment, technology and destiny." It was exhibited at the Queens College Art Center and is owned by the Metropolitan Museum of Art.

Media: Considers oil, acrylic, watercolor, pastel, pen & ink, drawings, sculpture, ceramic, fiber, photography, craft, installations, original handpulled prints and posters.
Style: Exhibits contemporary realism and abstract art.
Terms: Accepts work on consignment (20% commission). Retail price is set by artist. Exclusive area representation not required. Gallery provides insurance, promotion and contract; shipping costs are shared.
Submissions: Send query letter, resume, brochure, slides, photographs and SASE. Call to schedule an appointment to show a portfolio. "Slides, resumes, reviews and promotional materials for past exhibitions, all correspondence and notes" are filed.

STATEN ISLAND INSTITUTE OF ARTS AND SCIENCES, 75 Stuyvesant Pl., Staten Island NY 10301. (718)727-1135. Exhibitions Manager: Carol Glurceo. CEO/President: Hedy A. Hartman. Museum. Estab. 1881. Clientele: school groups, locals and tourists. Normally sponsors 10-12 shows/year. Average display time 2-6 weeks. Interested in emerging, mid-career and established artists.
Media: Considers all media. Most frequently exhibits oil, mixed media and photography.
Style: Exhibits all styles and all genres. "The art collections span 3,500 years of art history and contain more than 250 paintings, 900 drawings, prints, watercolors, and more than 3,800 examples of sculpture, the decorative arts, antiquities, costumes and textiles. It is the mission of the institute to collect, preserve, exhibit and interpret objects of artistic, scientific and historical interest that constitute an important part of the human heritage, especially with reference to Staten Island."
Terms: Exclusive area representation not required. Gallery provides insurance, promotion and contract. Prefers framed artwork.
Submissions: Send query letter with resume, brochure, photographs and bio. Write to schedule an appointment to show a portfolio, which should include slides. Replies in 1 month. Files query letter, resume and photographs.
Tips: "Artists should not call before introducing themselves through correspondence."

***WESTCHESTER GALLERY**, County Center, White Plains NY 10606. (914)684-0094. FAX: (914)684-0608. Gallery Coordinator: Jonathan G. Vazquez-Haight. Nonprofit gallery. Represents 40+ artists; emerging, mid-career and established. Exhibited artists include Alice Laoziak (ceramics) and Carla Rae Johnson (sculpture). Sponsors 6 shows/year. Average display time 3½-4 weeks. Closed holidays and August. Located at county center and county seat. 400+ sq. ft. gallery proper; 300 sq. ft. glass enclosed cabinets; housed in landmark art deco building. 80% of space for special exhibitions. 70% private collectors, 30% corporate collectors. Overall price range: $100-160,000; most work sold at $100-3,000.
Media: Considers all media (including video and performance) and all types of prints. Most frequently exhibits paintings, sculpture and photos.
Style: Exhibits all styles and genres. Prefers landscapes, still life and figurative.
Terms: Accepts work on consignment (33⅓% commission). Retail price set by the artist. Gallery provides insurance, promotion and contract; artist pays for shipping. Will consider art framed or unframed, depending on work.
Submissions: Send query letter with resume, slides, bio, brochure, photographs, SASE or actual work. Write to schedule an appointment to show a portfolio, which should include originals, slides, photographs and transparencies. Replies in 2-3 months.

***WIESNER GALLERY**, 730 57 St., #4D, Brooklyn NY 11220. (718)492-6123. Director: Nikola Vizner. Retail gallery and art consultancy. Estab. 1985. Clientele: 50% private collectors, 50% corporate clients. Represents 30 artists. Sponsors 5 solo and 5 group shows/year. Average display time is 4 weeks. Interested in emerging and established artists. Overall price range: $200-15,000; most artwork sold at $1,200.
Media: Considers oils, acrylics, watercolor, pastels, pen & ink, drawings, mixed media, collage, paper, sculpture, installations, photography and limited edition prints. Most frequently exhibited media: oils, acrylics and photography.
Style: Exhibits color field, painterly abstraction, minimalism, conceptual, post-modern, feminist/political, neo-expressionism, realism and surrealism. Genres include landscapes, Americana and figurative work. Seeks "strong contemporary works regardless of medium, with artist's statement about his/her viewpoint, philosophy, personal or universal message."
Terms: Accepts work on consignment (50% commission). Retail price is set by the gallery and artist. Exclusive area representation not required. Gallery provides insurance and promotion; artist pays for shipping.
Submissions: Send resume, slides and SASE. Write to schedule an appointment to show a portfolio, which should include slides and transparencies. Resumes, slides, photographs, brochures and transparencies are filed.
Tips: "Looks for high artistic knowledge and intelligence."

New York City

A.I.R. GALLERY, 63 Crosby St., New York NY 10012. (212)966-0799. Administrator: Sarah Savidge. Cooperative and nonprofit gallery, alternative space. Estab. 1972. Represents 35 artists; emerging and mid-career. Exhibited artists include Jane Haskell. Sponsors 13 shows/year. Average display time 3 weeks. Open September-June. Located in SoHo; 1,700 sq. ft. 75% of space for special exhibitions. Clientele: include private collectors and art consultants. 80% private collectors, 20% corporate collectors. Overall price range: $200-10,000; most artwork sold at $500-5,000.
Media: Considers oil, acrylic, drawing, mixed media, collage, works on paper, sculpture, installation and photography. Most frequently exhibits paintings, sculpture and mixed media.
Style: Exhibits primitivism, painterly abstraction, minimalism and hard-edge geometric abstraction. Prefers painterly abstraction, minimalism and primitivism.
Terms: Co-op membership fee plus donation of time (15% commission). Retail price set by the artist. Gallery provides promotion; artist pays for shipping. Prefers framed artwork.
Submissions: Accepts only artits from NYC for full membership; U.S.A. for affiliate membership. Women artists only. "We don't review portfolios, only slide submissions." Replies in 2 months. All materials are returned.
Tips: "A.I.R. was the first cooperative of women artists in the U.S., founded to give women artists a place to show their work. Please call gallery for further information."

ACTUAL ART FOUNDATION, 7 Worth St., New York NY 10013. (212)226-3109. Director: Valerie Shakespeare. Nonprofit foundation. Estab. 1981. Represents 10 artists; emerging and mid-career. Sponsors 2 shows/year. Average display time 3 months. Open all year. Located downtown. Clientele: "community business."

Media: Considers all media.

Style: Exhibits "actual" art. Does not want to see representational art, old-fashioned art or any style of art already established.

Terms: "We arrange for, curate and sponsor exhibitions in off-site spaces." Retail price set by the artist. Gallery provides insurance, promotion and contract; foundation pays for shipping costs to and from site.

Submissions: "Prefers actual artists dealing with effects of time in work." Send query letter with slides, bio and SASE. Call or write to schedule an appointment to show a portfolio, which should include slides. Replies in 1 month. Files "only material requested or interested in."

Tips: "Work should involve effects of time on materials of the work in some way." Sees trends toward "new concerns with time, with questions of conservation, with awareness among artists."

ARTISTS SPACE, 223 W. Broadway, New York NY 10013. (212)226-3970. FAX: (212)966-1434. Curator: Connie Butler. Alternative space and nonprofit gallery. Estab. 1973. Represents emerging artists. Sponsors 5 visual arts, 5 video and 5 one-person projects/year. Average display time 6 weeks. Open September-June. Located in downtown Manhattan, Tribeca; approximately 5,000 sq. ft.; "a very large space for a Manhattan gallery." 70% of space for special exhibitions. Audience of artists and gallery goers. "We have a very small percentage of sales because we're noncommercial." Overall price range: usually under $10,000.

Media: Considers all media; though deemphasizes craft. Usually does not exhibit prints. Most frequently exhibits installation/video, sculpture and painting.

Style: Exhibits all styles, with emphasis on installation.

Terms: "There is no acquisition or representation. We exhibit artists." Retail price set by the artist. Gallery provides insurance, promotion (in keeping with exhibition) and shipping costs to and from gallery.

Submissions: Exhibits work in all media from all regions. Send letter with resume, slides and SASE. Replies in 6-8 weeks. Files work of New York and New Jersey state artists.

Tips: "Please be familiar with type of work gallery shows; gallery does not represent artists—exhibits work only." Don't send "too much material—visual and/or written. Please include a SASE for return of slides. Notices new emphasis on alternative organizations and more political work."

BOWERY GALLERY, 121 Wooster St., New York NY 10012. (212)226-9543. Contact: Director. Cooperative gallery. Estab. 1969. Represents 32 emerging, mid-career and established artists. Sponsors 12 shows/year. Average display time 3 weeks. Open September-July. Located in Soho; approximately 1,200 sq. ft. 100% of space for gallery artists. 95% private collectors, 5% corporate collectors. Overall price range: $100-10,000.

Media: Considers oil, acrylic, watercolor, pastel, pen & ink, drawings, sculpture, original handpulled prints. Most frequently exhibits paintings, sculpture and drawings.

Style: Exhibits expressionism, painterly abstraction and realism. All genres. Interested in seeing figurative and abstract painting and drawing.

Terms: Co-op membership fee plus donation of time. Retail price set by the artist. Artist pays for shipping. Prefers framed artwork.

Submissions: Accepts only artists from New York region. Send query letter with resume. Call to schedule an appointment to show a portfolio, which should include originals and slides. Replies in 2 months. Files resumes.

BROADWAY WINDOWS, New York University, 80 Washington Square East, New York NY 10003. Viewing address: Broadway at E. 10th St. (212)998-5751. Director or Assistant Director: Marilynn Karp or Ruth D. Newman. Nonprofit gallery. Estab. 1984. Clientele: the metropolitan public. On view to vehicular and pedestrian traffic 24 hours a day. "We do not formally represent any artists. We are operated by New York University as a nonprofit exhibition space whose sole purpose is to showcase artwork and present it to a new ever-growing art interested public." Sponsors 9 solo shows/year. Average display time is 5 weeks. Interested in emerging and established artists.

Media: Considers all media. "We are particularly interested in site specific installations."

Terms: Accepts work on consignment (20% commission). Retail price is set by artist. Exclusive area representation not required. Gallery provides insurance, promotion and contract; artist pays for shipping.

Submissions: Send query letter, resume, slides, photographs and SASE. "Proposals are evaluated once annually in response to an ad calling for proposals. Jurors look for proposals that make the best use of the 24 hour space."

Tips: "Often artists do not provide the visual evidence that they could produce the large scale artwork the Windows' physical structure dictates. And, in general their installation proposals lack details of scale and substance."

***CFM**, 138 W. 17th St., New York NY 10011. (212)929-4001. FAX: (212)691-5453. President: Neil Zukerman. Retail gallery. Estab. 1988. Represents emerging, mid-career and established artists. Exhibited artists include Michael Parkes and Leonor Fini. Sponsors 3 shows/year. Average display time 2 months. Open all year by appointment. Located in Chelsea; 1,000 sq. ft.; gallery features antique furniture, Persian carpets, fireplace and views. Percentage of space devoted to special exhibitions and work of gallery artists varies. 80% private

collectors, 20% corporate collectors. Overall price range: $35-200,000; most work sold at $2,500-15,000.

Media: Considers oil, acrylic, watercolor, pen & ink, drawing and sculpture; original handpulled prints. Most frequently exhibits oil and original graphics.

Style: Exhibits surrealism and realism. Genres include figurative and representational work. Prefers figurative, representational and surrealism.

Terms: Buys artwork outright for 50% of retail price. Retail price set by the artist. Gallery provides insurance and shipping costs.

Submissions: Send query letter with photographs and SASE. Write to schedule an appointment to show a portfolio, which should include originals and photographs. Replies in 1 week. Files photographs and resumes.

CIRCLE GALLERY, 468 W. Broadway, New York NY 10012. (212)677-5100. Contact: Circle Fine Art Corp, Suite 3160, 875 N. Michigan Ave., Chicago IL 60611. Retail gallery. Estab. 1974. Open year round. Clientele: 90% private collectors; 10% corporate clients. Represents 100 established artists. Sponsors 3 solo and 5 group shows/year. Average display time 2 weeks. Overall price range: $35-80,000; most artwork sold at $1,500-5,000.

Media: Considers almost all media except photography; also considers woodcuts, wood engravings, linocuts, engravings, mezzotints, etchings, lithographs and serigraphs. Most frequently exhibits graphics, paintings and sculpture.

Style: Exhibits all contemporary styles and genres.

Terms: Buys outright.

Tips: Common mistakes artists make are "poor presentations and submissions, inappropriate styles."

CITY GALLERY, New York City Department of Cultural Affairs, 2 Columbus Circle, New York NY 10019. (212)974-1150. Director: Elyse Reissman. Nonprofit gallery. Estab. 1980. Sponsors 8 group shows/year. Average display time is 4 weeks. Prefers New York City artists. Interested in emerging, mid-career and established artists.

Media: Considers all media.

Style: Considers all styles and genres. "City Gallery is the official gallery of the City of New York. It presents exhibits that highlight the cultural diversity of New York City's many artistic and ethnic communities. Proposals for group shows from nonprofit arts organizations are reviewed twice each year and selected by a panel of artists and arts administrators."

Terms: Gallery provides promotion security and other in-kind services.

Submissions: Send proposal, resume, slides and SASE. "Call and request a copy of application guidelines."

DYANSEN GALLERY, 122 Spring St., New York NY 10012. (212)627-6414. Production Development: Dennis Rae. Retail gallery. Clientele: 95% private collectors. Represents 20 artists. Average display time is 4 weeks. Interested in emerging and established artists. Overall price range: $1,500-20,000; most artwork sold at $4,000.

Media: Considers oil, acrylic and sculpture, mostly bronze.

Style: Exhibits color field, impressionism and realism. Genres include landscapes, figurative work and fantasy illustration. "Our galleries specialize in beautiful appealing figurative and landscape, architectural imagery."

Terms: Accepts work on consignment (60% commission) or buys outright. Retail price is set by gallery. Exclusive area representation required. Gallery provides insurance, promotion and contract; shipping costs are shared.

Submissions: Send query letter, resume, brochure, slides, photographs and SASE. Resume and brochure are filed.

FORUM GALLERY, 1018 Madison Ave., New York NY 10021. (212)772-7666. FAX: (212)772-7669. Director: Bella Fishko. Retail gallery. Estab. 1960. Represents 20 artists; emerging, mid-career and established. Exhibited artists include Max Weber and Gregory Gillespie. Sponsors 11 shows/year. Average display time 1 month. Open all year. Located in upper east side; 16,000 sq. ft.; "terrace sculpture garden." 90% of space for special exhibitions, 10% for gallery artists. Clientele: 80% private collectors, 5% corporate clients. Price range: $1,000-250,000; most artwork sold at $20,000-75,000.

Media: Considers oil, acrylic, watercolor, pastel, pen & ink, drawings, mixed media, collage, works on paper, sculpture, ceramic, fiber, glass, original handpulled prints, woodcuts, linocuts, engravings, mezzotints, etchings and lithographs. Most frequently exhibits oil on canvas, bronze and watercolor.

Style: Exhibits all styles. Genres include landscapes, florals, portraits and figurative work. Prefers American Representational and American Modernism.

Terms: Retail price set by the gallery. Gallery provides insurance, promotion and contract. Prefers framed artwork.

Submissions: Accepts only American artists. Send query letter with resume, slides, bio, photographs, SASE and reviews. Replies in 1 month.

Tips: "Only write, do not call first—and be familiar with the type of work we handle."

GALLERY HENOCH, 80 Wooster, New York NY 10012. (212)966-6360. Director: George Henoch Shechtman. Retail gallery. Estab. 1983. Represents 40 artists; emerging and mid-career. Exhibited artists include Jay Kelly and Max Ferguson. Sponsors 10 shows/year. Average display time 3 weeks. Closed August. Located in SoHo; 4,000 sq. ft. 50% of space for special exhibitions, 50% for gallery artists. Clientele: 90% private collectors, 10% corporate clients. Overall price range: $3,000-40,000; most artwork sold at $10,000-20,000.

Media: Considers oil, acrylic, watercolor, pastel, pen & ink, drawing, and sculpture. Most frequently exhibits painting, sculpture, drawing and watercolor.

Style: Exhibits photorealism and realism. Genres include landscapes, figurative work and all genres. Prefers landscapes, cityscapes and still lifes.

Terms: Accepts work on consignment (50% commission). Retail price set by the gallery. Gallery provides insurance and promotion. Shipping costs are shared. Prefers framed artwork.

Submissions: Send query letter with slides, bio and SASE. Portfolio should include slides and transparencies. Replies in 3 weeks.

Tips: "We suggest the artist be familiar with the kind of work we show and be sure their work fits in with our styles." The recession has made it "more difficult to introduce new artists."

GALLERY INTERNATIONAL 57, 888 Seventh Ave., New York NY 10016. (212)582-2200. Director: Kazuko Hillyer. Retail gallery. Estab. 1987. Seasons for exhibition: September-June. "This gallery features international contemporary artists." Represents 12 artists. Sponsors 5 solo shows/year. Average display time 4 weeks. Interested in established artists. Overall price range: $2,000-10,000.

Media: Considers oil, acrylic, watercolor, and mixed media. Prefers only original oils.

Terms: Accepts artwork on consignment (40% commission). Retail price set by gallery and/or artist. Exclusive area representation not required but preferred. Gallery provides insurance and a contract. Prefers artwork framed.

Submissions: Send query letter with slides and photographs. Replies in 1-2 months only if interested.

Tips: "Please do *not* call or come in. Send in material with SASE."

STEPHEN GILL GALLERY, 122 E. 57th St., New York NY 10022. (212)832-0800. President: Stephen Gill. Retail gallery. Estab. 1986. Represents 10 artists; emerging and established. Exhibited artists include Peter Max and Robert Rauchenberg. Sponsors 2-3 shows/year. Average display time 1-3 months. Closed July. Located on upper east side; 715 sq. ft. 50% of space for special exhibitions. Clientele: 50% private collectors, 50% corporate collectors. Overall price range: $300-10,000; most artwork sold at $1,000-2,000.

Media: Considers oil, acrylic, mixed media, collage, sculpture (small), photography and original handpulled prints only. Most frequently exhibits acrylic, oil and collage.

Style: Exhibits conceptualism. Looking for "original ideas—conceptual, new ideas, the bizarre."

Terms: Accepts work on consignment (50% commission) or buys outright—"names only." New artists must donate 1 piece to gallery if selected ("We have selected 2 new artists in the past years.") Retail price set by the gallery and artist. Gallery provides promotion and contract; artist pays for shipping.

Submissions: Prefers only "paintings on canvas. No watercolor." Send query letter with resume, slides, bio and SASE. Write to schedule an appointment to show a portfolio or send slides and SASE. Portfolio should include slides and transparencies. Replies only if interested within 2 months.

Tips: The most common mistake artists make in presenting their work is "calling me! All I want is SASE with slides. They also submit landscapes, abstracts, still-lifes, etc. that do not fit into our format."

***BILL GOFF, INC.,** Box 508, New York NY 10028-0005. (212)794-1414. FAX: (212)794-1738. President: Bill Goff. Estab. 1977. Publishes baseball art. 95% private collectors, 5% corporate collectors.

Media: Baseball subjects for prints. Realism and photorealism. Represents 10 artists; emerging, mid-career and established. Exhibited artists include Andy Jurinko and William Feldman.

Terms: Accepts work on consignment (50% commission) or buys outright for 50% of retail price. Overall price range: $95-30,000; most work sold at $125-220. Retail price set by the gallery. Gallery provides insurance and promotion; shipping costs are shared. Prefers artwork unframed.

Submissions: Send query letter with bio and photographs. Write to schedule an appointment to show a portfolio, which should include photographs. Replies only if interested within 2 months. Files photos and bios.

Tips: "Do not waste our time or your own by sending non-baseball items."

FOSTER GOLDSTROM GALLERY, Suite 303, 560 Broadway, New York NY 10012 (212)941-9175. Owner: Foster Goldstrom. Retail gallery. Estab. 1970. Located in SoHo. Clientele: 90% private collectors, 10% corporate clients. Represents 8 artists. Sponsors 8 solo and 2 group shows/year. Average display time 3-4 weeks. Interested in emerging and established artists. Overall price range: $650-40,000.

Media: Considers oil, acrylic, drawings, mixed media, collage, works on paper, sculpture, ceramic and photography.

Style: Exhibits all styles and genres. Prefers abstracts.

Terms: Accepts work on consignment (50% commission). Buys outright (50% retail price). Retail price set by gallery and artist. Exclusive area representation not required.

Submissions: Send query letter with slides and SASE. Replies in 2 weeks. All material is returned if not accepted or under consideration.

Tips: "Please come into gallery, look at our stable of artists work, and see first if your work is of our aesthetic."

JOHN GOOD GALLERY, 532 Broadway, New York NY 10012. (212)941-8066. FAX: (212)274-0124. Director: Carol A. Greene. Retail gallery. Estab. 1984. Represents 10 emerging and mid-career artists. Exhibited artists include James Hyde and Jacqueline Humphries. Sponsors 8 shows/year. Average display time 4 weeks. Open all year; summer, by appointment only. Located in SoHo; 3,000 sq. ft. 75-100% of space for special exhibitions, 75-100% for gallery artists. Clientele: private collectors. 80% private collectors, 20% corporate clients. Other clients: museums and art consultants. Overall price range: $500-30,000; most artwork sold at $5,000-15,000.

Media: Considers oil, acrylic, watercolor, pastel, pen & ink, drawings, mixed media, collage, works on paper, sculpture, installation and photography. Does not consider prints. Most frequently exhibits paintings.

Style: Exhibits new abstract painting.

Terms: Accepts work on consignment (50% commission). Retail price set by the gallery and the artist. Gallery provides insurance, promotion and shipping costs to and from gallery. Prefers unframed artwork.

Tips: "We are not accepting work for review."

GRAND CENTRAL ART GALLERIES, 24 W. 57th St., New York NY 10019. (212)867-3344. Director: John Evans. Retail gallery. Estab. 1922. Clientele: private, museum, corporate and industrial; 80% private collectors, 10% corporate clients. Represents 60 artists. Sponsors 5 solo and 5 group shows/year. Interested in emerging and established artists. Overall price range: $1,000-1,000,000; most artwork sold at $10-40,000.

Media: Considers oil, watercolor and pastel.

Style: Exhibits impressionism and realism. Genres include landscapes, portraits and figurative work. "Grand Central Art Galleries exhibits a mix of contemporary realism (oil, watercolor, sculpture) and late 19th- and early 20th-century works." Does not want to see non-representational paintings.

Terms: Accepts work on consignment (40% commission). Retail price is set by gallery and artist. Exclusive area representation required. Gallery provides promotion and contract; shipping costs are shared.

Submissions: Send resume, slides and SASE. Common mistakes artists make are "sending fifty or more slides to view, rather than 10-15 slides and bringing paintings to the gallery without an appointment."

Tips: A trend seems to be "more interest in impressionist painting."

O.K. HARRIS WORKS OF ART, 383 W. Broadway, New York NY 10012. Director: Ivan C. Karp. Commercial exhibition gallery. Estab. 1969. Open fall, winter, spring and early summer. "Four separate galleries for four separate one-person exhibitions and the back room features selected gallery artists which also changes each month." Clientele: 80% private collectors, 20% corporate clients. Represents 65 artists. Sponsors 40 solo shows/year. Average display time 3 weeks. Interested in emerging, mid-career and established artists. Overall price range: $50-$250,000; most artwork sold at $12,500-100,000.

Media: Considers all media. Most frequently exhibits paintings, sculpture and photography.

Style: Exhibits realism, photorealism, minimalism, abstraction, conceptualism, photography and geometric abstraction. Genres include landscapes, Americana and figurative work. "The gallery's main concern is to show the most significant artwork of our time. In its choice of works to be exhibited it demonstrates no prejudice as to style or materials employed. Its criteria demands innovation of concept and maturity of technique. It believes that its exhibitions over the years have proven the soundness of its judgment in identifying important artists and its pertinent contribution to the visual arts culture."

 The asterisk before a listing indicates that the listing is new in this edition. New markets are often the most receptive to freelance submissions.

Terms: Accepts work on consignment (50% commission). Retail price set by gallery. Exclusive area representation required. Gallery provides insurance and promotion. Prefers framed artwork.

Submissions: Send query letter with slides "labeled concerning size, medium, top, etc." and SASE. Replies in 1 week.

Tips: "We strongly suggest the artist be familiar with the gallery's exhibitions, i.e. the kind of work we show and be sure their work fits in with our aesthetic. No agonized figure or animal paintings. See the exhibitions. Always include SASE." Common mistakes artists make in presenting their work are: "poor quality photos, unmarked photos (size, material, etc.), submissions without return envelope, utterly unappropriate work. We affiliate one out of 10,000 applicants, maybe."

HELIO GALLERIES, 588 Broadway, New York NY 10012. Director: Joseph Sipos. Retail gallery and art consultancy. Estab. 1984. Represents 16 emerging artists. Exhibited artists include Joan Griswold and Glen Hansen. Sponsors 12 shows/year. Average display time 3 weeks. Open all year. Located in SoHo. 25% of space for special exhibitions. Gallery features discreet lighting fixtures accepted by natural light. 75% private collectors, 25% corporate collectors. Overall price range: $200-20,000; most work sold at $2,000-6,000.

Media: Considers all media; original handpulled prints, woodcuts, wood engravings, linocuts, engravings, mezzotints, etchings, lithographs and stencil. Most frequently exhibits oil on canvas, pastel and watercolor.

Style: Exhibits expressionism, neo-expressionism, painterly abstraction, surrealism, impressionism, realism and photorealism. All genres. Prefers painterly realism.

Terms: Retail price set by the gallery. Gallery provides promotion and contract; shipping costs are shared. Prefers artwork framed.

Submissions: Send query letter with resume, slides, bio, SASE and reviews. Call to schedule an appointment to show a portfolio, which should include originals and slides. Replies only if interested in 1 week. Files slides, resume and bio.

Tips: "Please be patient. For review, be aware of recent exhibitions and the direction of gallery."

HUDSON GUILD ART GALLERY, 441 W. 26th St., New York NY 10001. (212)760-9805. Director: Haim Mendelson. Nonprofit gallery. Estab. 1948. Represents emerging, mid-career and established artists. Sponsors 6 shows/year. Average display time 1 month. Open October through June. Located in West Chelsea; 1,200 sq. ft.; a community center gallery in a New York City neighborhood. 100% of space for special exhibitions. 100% private collectors.

Media: Considers oil, acrylic, watercolor, pastel, pen & ink, drawings, mixed media, collage, paper and sculpture; original handpulled prints, woodcuts, wood engravings, linocuts, engravings, mezzotints, etchings, lithographs, pochoir and serigraphs. Most frequently exhibits paintings, sculpture and graphics.

Style: Exhibits all styles and genres.

Terms: Accepts work on consignment (20% commission). Retail price is set by artist. Gallery provides insurance; artist pays for shipping. Prefers artwork framed.

Submissions: Send query letter, resume, slides, bio and SASE. Portfolio should include photographs and slides. Replies in 1 month.

MICHAEL INGBAR GALLERY, 578 Broadway, New York NY 10012. (212)334-1100. Director: Michael Ingbar. Retail gallery and art consultancy. Estab. 1977. Clientele: 30% private collectors, 70% corporate clients. Represents 27 artists. Sponsors 2 solo and 9 group shows a year on a co-op basis with the artists. Average display time is 1 month. Interested in emerging, mid-career and established artists. Overall price range: $600-12,000; most artwork sold at $2,000-8,000.

Media: Considers oil, acrylic, works on paper, fiber, original handpulled prints and sculpture.

Style: Exhibits hard-edge geometric abstraction, impressionism and realism. Genres include landscapes and figurative work. "We feel that we are one of the few solo galleries that show 'pleasing and pretty' works that have a soothing or uplifting effect on the viewer. All works should communicate to the general public we sell to, which is primarily corporations looking for art to be decorative as well as of a high quality." Does not want to see small works.

Terms: Accepts work on consignment (50% commission). Retail price is set by gallery and artist. Exclusive area representation not required.

Submissions: Send query letter and SASE. Slides are filed.

Tips: The most common mistakes artists make in presenting their work are "coming in person, constantly calling, poor slide quality (or unmarked slides)." Sees trend toward "more upbeat art."

JADITE GALLERIES, 415 W. 50th St., New York NY 10019. (212)315-2740. Director: Roland Sainz. Retail gallery. Estab. 1985. Clientele: 80% private collectors, 20% corporate clients. Represents 25 artists. Sponsors 10 solo and 2 group shows/year. Average display time is 2 weeks. Interested in emerging and established, national and international artists. Overall price range: $500-8,000; most artwork sold at $1,000-3,000.

Media: Considers oil, acrylic, watercolor, pastel, pen & ink, drawings, mixed media, collage, sculpture and original handpulled prints. Most frequently exhibited media: oils, acrylics, pastels and sculptures.
Style: Exhibits minimalism, post modern, impressionism, neo-expressionism, realism and surrealism. Genres include landscapes, florals, portraits, Western collages and figurative work. Features "national and international emerging artists dealing with contemporary works."
Terms: Accepts work on consignment (40% commission). Retail price is set by gallery and artist. Exclusive area representation not required. Gallery provides insurance, promotion and contract; exhibition costs are shared.
Submissions: Send query letter, resume, brochure, slides, photographs and SASE. Call or write to schedule an appointment to show a portfolio, which should include originals, slides or photos. Resume, photographs or slides are filed.

LA MAMA LA GALLERIA, 6 E. 1st St., New York NY 10003. (212)505-2476. Director: Lawry Smith. Nonprofit gallery. Estab. 1981. Represents emerging, mid-career and established artists. Sponsors 14 shows/year. Average display time 3 weeks. Open September-June. Located in East Village; 2,500 sq. ft.; "very large and versatile space." 100% of space for special exhibitions. Clientele: 20% private collectors, 20% corporate clients. Overall price range: $1,000-5,000; most artwork sold at $1,000.
Media: Considers oil, acrylic, watercolor, pastel, pen & ink, drawings, mixed media, collage, sculpture, ceramic, craft, installation, photography, original handpulled prints, woodcuts, engraving and lithograph. Most frequently exhibits oil, installation and collage. No performance art.
Style: Exhibits expressionism, neo-expressionism, primitivism, painterly abstraction, imagism, conceptualism, minimalism, post modern works, impressionism, photorealism and hard-edge geometric abstraction.
Terms: Accepts work on consignment (20% commission). Retail price set by the gallery. Gallery provides promotion; artist pays for shipping or shipping costs are shared. Prefers framed artwork.
Submissions: Send query letter with resume, slides and bio. Write to schedule an appointment to show a portfolio, which should include originals, slides, photographs or transparencies. Replies in 3 weeks. Files slides and resumes.

***LEWIS LEHR, INC.,** Box 1008, New York NY 10028-0007. (212)288-6765. Director: Lewis Lehr. Retail gallery. Estab. 1984. Represents 20+ artists; established. Interested in seeing the work of emerging artists. Exhibited artists include FSA and O'Sullivan. Sponsors 6 shows/year. Average display time 8 weeks. Open all year by appointment. Located midtown; 300 sq. ft.; "friendly gallery." 90% private collectors, 10% corporate collectors. Overall price range: $300-5,000; most work sold at $1,000.
Media: Considers photography.
Style: Exhibits surrealism and realism. Genres include Americana and portraits.
Terms: Accepts work on consignment or buys outright. Retail price set by the gallery. Gallery provides promotion; artist pays for shipping. Prefers artwork unframed.
Submissions: Send query letter with resume and brochure. Write to schedule an appointment to show a portfolio, which should include originals. Replies in 1 week. Doesn't file any material.

MARKEL/SEARS FINE ARTS, 40 E. 88th, New York NY 10128. (212)996-7124. President: Kathryn Markel. Private art consultancy. Estab. 1985. Represents 40 artists/year; emerging, mid-career and established. Exhibited artists include Steve Aimone and Madge Willner. Sponsors no exhibitions. Open all year by appointment. Located in Manhattan. 80% corporate clients. Overall price range: $700-5,000.
Media: Considers all original work, unique works on paper. Most frequently sells pastel, watercolor and collage.
Style: Exhibits all styles.
Terms: Accepts work on consignment (50% commission). Retail price set by the gallery and the artist. Gallery provides insurance. Artist pays for shipping. Prefers unframed artwork.
Submissions: Send query letter with slides and SASE. Portfolio should include slides. Replies in 2 weeks.
Tips: "Send 10-15 slides of recent work with SASE."

MIDTOWN PAYSON GALLERIES (formerly Midtown Galleries), 745 5th Ave., 4th Floor, New York NY 10151. (212)758-1900. Director: Bridget Moore. Retail gallery. Estab. 1932. Sponsors 6 solo and 4 group shows/year.
Media: Considers painting and sculpture.
Style: Features 20th-century and contemporary American artists.
Terms: Retail price is set by gallery and artist. Exclusive area representation required.
Submissions: Send query letter, resume, brochure, slides, photographs and SASE.

MORNINGSTAR GALLERY, 164 Mercer St., New York NY 10012. (212)334-9330. Director: Jack Krumholz. Retail gallery. Estab. 1979. Represents approximately 20 artists; emerging, mid-career and established. Exhibited artists include Will Barnet and Judith Shahn. Sponsors primarily ongoing group exhibitions. Average display time 1-2 months. Open all year. Located in SoHo section of NYC; 550 sq. ft. 100% of space for gallery

artists. Clientele: "retail, decorators, corporations, professionals." 80% private collectors, 20% corporate clients. Overall price range: $50-10,000; most artwork sold at $200-1,000.

Media: Considers oil, acrylic, watercolor, pastel, pen & ink, drawings "preferably on paper," original hand-pulled prints, woodcuts, wood engravings, linocuts, engravings, mezzotints, etchings, lithographs, serigraphs and all limited edition original graphics. Most frequently exhibits etchings/aquatints, serigraphs and lithographs.

Style: Exhibits expressionism, neo-expressionism, surrealism and realism. Considers all genres. Prefers cityscapes, landscapes and still lifes (florals). Interested in seeing work that is "not too somber."

Terms: Accepts work on consignment (50% commission). "Gallery may be rented for one- or two-person shows for a period of approximately 3 weeks." Retail price set by the gallery and the artist. Gallery provides insurance and promotion; artist pays for shipping. Prefers unframed artwork, framed for one-person shows.

Submissions: Send query letter with resume, slides, bio, photographs and SASE. Write to schedule an appointment to show a portfolio, which should include originals, slides and photographs. Replies only if interested in 1-2 weeks.

Tips: "Always enclose SASE for return of slides." Sees trend toward "galleries specializing more: media, style, images, etc."

MUSEUM OF HOLOGRAPHY, 11 Mercer St., New York NY 10013. (212)925-0581. Curator: Sydney Dinsmore. Nonprofit museum. Estab. 1976. Clientele: 95% private collectors, 5% corporate clients. Sponsors 4 group/theme shows per year and several one-person shows. Average display time is 3-4 months. Galleries include new video room, front entrance/gallery shop and expanded educational area. Accepts only holography. Interested in emerging, mid-career and established artists. Overall price range: $15-7,000; most artwork sold at $60-200.

Media: Considers only holograms.

Style: "Our museum specializes in all forms of holography, artistic, technical, scientific and its applications. Style is not a consideration with our institution."

Terms: Accepts work on consignment. Retail price is set by gallery and artist. Exclusive area representation not required. Gallery provides insurance and promotion; shipping costs are shared.

Submissions: Send query letter, resume and slides. Write to schedule an appointment to show a portfolio, which should include originals and slides. Resume and slides are filed.

Tips: "Works are considered for exhibition purposes only. We do not want to represent holographers commercially."

NAHAN GALLERIES, 381 W. Broadway, New York NY 10013. (212)966-9313. Contact: Kenneth Nahan. Retail gallery. Estab. 1960. Represents 15 established artists. Sponsors 8-10 solo shows/year. Average display time 3 weeks. 15,000 sq. ft. Overall price range: $500 up.

Media: Considers most media.

Style: Interested in seeing school of Paris, modern art and estates of established artists.

Terms: Buys outright. Retail price set by gallery. Exclusive representation only. Gallery provides insurance, promotion and contract.

Submissions: Send query letter with slides. Replies in a few months. All material is returned if not accepted or under consideration.

NOVO ARTS, 57 E. 11th St., New York NY 10003. (212)674-3093. Fine Art Consultant: Lynda Deppe. Fine arts consultants for private collectors and corporations. Sponsors 5 group shows/year. Average display time is 2 months. Interested in emerging, mid-career established artists. Overall price range: $200 and up. Also sells photography and sculpture by international artists.

Media: Considers all media.

Style: Exhibits all styles. Interested in seeing abstract and representational art.

Terms: Accepts work on consignment. Retail price is set by gallery and artist. Exclusive area representation not required.

Submissions: Send query letter, resume, slides, price the artist would like to receive and SASE. Call or write to schedule an appointment to show a portfolio, which should include originals and slides. Slides, resume and price list are filed.

OUTER SPACE, INC., 2710 Broadway, New York NY 10025. (212)874-7142. Director: Ernest Acker. Nonprofit gallery and alternative space. Estab. 1984. Represents 20 artists/year; emerging and mid-career. Exhibited artists include Xanda McCagg, Kenneth Agnello, Carol Mahtab, Jim Hutchinson, Virginia Tillyard, Tehran Wilson, Tom Laidman and Raphael Collazo. Sponsors 10 shows/year. Average display time 3 weeks. Closed Christmas (2 weeks) and July and August. Located on the upper upper west side in Manhattan; 625 sq. ft.; "in an art deco building on the entire third floor, including two other galleries: Steve Bush Exhibit Room and The Wall Gallery." 20% of space for special exhibitions, 80% for gallery artists. Clientele: 100% private collectors. Prefers contemporary work. Overall price range: $50-5,000; most artwork sold at $50-500.

Media: Considers oil, acrylic, watercolor, pastel, mixed media, collage, works on paper, sculpture, fiber, glass, installation and photography. "Steve Bush exhibits prints, graphics and photographs." Considers original handpulled prints, offset reproductions, woodcuts, wood engravings, linocuts, engravings, mezzotints, etchings, lithographs, pochoir and serigraphs. Most frequently exhibits oil, acrylic and assemblage/collage.
Style: Exhibits expressionism, neo-expressionism, painterly abstraction, surrealism, post modern works, realism, photorealism. Genres include landscapes, Americana, Southwestern, figurative work and abstraction. Prefers abstract expressionism, neo-expressionism and post modern works.
Terms: Accepts work on consignment (15% commission). Co-op membership fee plus donation of time (15% commission). "Shares are sold and stock certificates issued." Retail price set by the gallery. Gallery provides promotion and contract. Artist pays for shipping. Prefers framed artwork.
Submissions: Prefers only contemporary work. Send query letter with slides. Call or write to schedule an appointment to show a portfolio, which should include originals, slides, photographs and transparencies. Replies in 3 weeks. If interested replies within 3 months. Files member artists' slides.

THE PHOENIX GALLERY, Suite 607, 568 Broadway, New York NY 10012. (212)226-8711. Director: Linda Handler. Nonprofit gallery. Estab. 1958. Represents 28 artists; emerging, mid-career and established. Has 28 members. Exhibited artists include David Raymond and Margaret Pomfret. Sponsors 10-12 shows/year. Average display time 4 weeks. Open fall, winter and spring. Located in SoHo; 180 linear ft.; "We are in a landmark building in SoHo, the oldest co-op in New York. We have a movable wall which can divide the gallery into two large spaces." 100% of space for special exhibitions, 100% for gallery artists. Clientele: 75% private collectors, 25% corporate clients. Other clients: art consultants. Overall price range: $50-20,000; most artwork sold at $300-10,000.
Media: Considers oil, acrylic, watercolor, pastel, pen & ink, drawings, mixed media, collage, works on paper, sculpture, ceramic, photography, original handpulled prints, woodcuts, engravings, wood engravings, linocuts and etchings. Most frequently exhibits oil, acrylic and watercolor.
Style: Exhibits painterly abstraction, minimalism, realism, photorealism, hard-edge geometric abstraction and all styles. Prefers painterly abstraction, hard-edge geometric abstraction and sculpture.
Terms: Co-op membership fee plus donation of time (25% commission). Retail price set by the gallery. Gallery provides insurance, promotion and contract; artist pays for shipping. Prefers framed artwork.
Submissions: Send query letter with resume, slides and SASE. Call to schedule an appointment to show a portfolio, which should include slides. Replies in 1 month. Only files material of accepted artists. The most common mistakes artists make in presenting their work are "incomplete resumes, unlabeled slides, an application that is not filled out properly."
Tips: "Come and see the gallery—meet the director."

PRINTED MATTER BOOKSTORE AT DIA, 77 Wooster St., New York NY 10012. (212)925-0325. FAX: (212)925-0464. Director: John Goodwin. Nonprofit bookstore. Estab. 1976. Clientele: international. Represents 2,500 artists. Interested in emerging and established artists. Overall price range: 50 cents-$3,500; most artwork sold at $20.
Media: Considers only artwork in book form in multiple editions.
Terms: Accepts work on consignment (50% commission). Retail price is set by artist. Exclusive area representation not required. Gallery provides promotion and contract; artist pays for shipping.
Submissions: Send query letter and review copy of book.

***PUCHONG GALLERY,** 36A 3rd Ave., New York NY 10003. Director: Melvin Dennis. Retail gallery. Estab. 1983. Represents 12 artists. Sponsors 12 shows/year. Average display time 1 month. Open all year. Located in a storefront on a busy street; 40 sq. ft. 100% of space for special exhibits. Overall price range: $200-3,000; most work sold at $400-500. Exhibited artist include Anita Chernewski and Bill Costa.
Media: Considers photography. Most frequently exhibits silver/gelatin prints, type "C" prints, and cibachrome prints.
Style: Exhibits expressionism and surrealism. Genres include landscapes and figurative work. Prefers experimental, figure and landscape.
Terms: Accepts work on consignment (50% commission). Retail price set by gallery and artist. Prefers artwork framed.
Submissions: Send query letter with resume and photographs. Call or write to schedule an appointment which should include originals. Files slides and resumes. All material is returned if not accepted.
Tips: "Schedule a portfolio review. The gallery is eclectic, showing high quality work in a range of styles. Avant-garde, experimental work is favored somewhat."

RAYDON GALLERY, 1091 Madison Ave., New York NY 10028. (212)288-3555. Director: Alexander R. Raydon. Retail gallery. Estab. 1962. Represents established artists. Clientele: tri-state collectors and institutions (museums). Sponsors 12 group shows/year. Overall price range: $100-100,000; most artwork sold at $1,800-4,800.

Media: Considers all media. Most frequently exhibits oil, prints and watercolor.

Style: Exhibits all styles and all genres. "We show fine works of arts in all media, periods and schools from the Renaissance to the present with emphasis on American paintings, prints and sculpture."

Terms: Accepts work on consignment or buys outright.

Tips: "Artists should present themselves in person with background back-up material (bios, catalogues, exhibit records and original work, slides or photos). Artist's ought to join local, regional and national art groups and associations for grants exposure, review, criticism and devlopment of peers and collectors."

***THE REECE GALLERIES, INC.**, 24 W. 57th St., New York NY 10019. (212)333-5830. FAX: (212)333-7366. Co-Director: Leon Reece. Retail and wholesale gallery and art consultancy. Estab. 1974. Represents 40 artists; emerging and mid-career. Exhibited artists include Tsugio Hattori-Sica. Sponsors 5-6 shows/year. Average display time 1 month. Open all year. Located in mid-town; 1,500 sq. ft.; the gallery is broken up into 3 show areas. 90% of space for special exhibitions. Clientele: corporate, private, architect, and consultant. 50% private collectors, 50% corporate collectors. Overall price range: $300-30,000; most work sold at $1,000-15,000.

Media: Considers oil, acrylic, watercolor, pastel, mixed media, collage and paper; original handpulled prints, engravings, mezzotints, etchings, lithographs, pochoir and serigraphs.

Style: Exhibits expressionism, painterly abstraction, color field and impressionism.

Terms: Accepts work on consignment (50% commission). Retail price set by the gallery and the artist. Gallery provides insurance; artist pays for shipping. Prefers artwork unframed.

Submissions: Prefers only work on canvas and prints. Send query letter with resume, slides, bio, SASE and prices. Call or write to schedule an appointment to show a portfolio, which should include slides and photographs with sizes and prices. Replies in 2 weeks.

Tips: "A visit to the gallery (when possible) to view what we show would be helpful for you in presenting your work—to make sure the work is compatible with our aesthetics."

***ROSS-CONSTANTINE**, 65 Prince St., New York NY 10012. (212)226-0391. Owner: Stewart Ross. Retail gallery. Estab. 1989. Represents 100 artists; established. Average display time 1 year. Open all year. Located in SoHo; 1,200 sq. ft.; Specializes in early 20th century art—1920s to 1950s. 100% of space for work of gallery artists. 65% private collectors. Overall price range: $500-10,000; most work sold at $1,500-5,000.

Media: Considers oil.

Style: Exhibits post modern works, realism and hard-edge geometric abstraction. Prefers abstract and social realism.

Terms: Accepts work on consignment (50% commission); or buys outright. Retail price set by the gallery. Gallery provides insurance and contract; artist pays for shipping. Prefers artwork framed.

Submissions: Send query letter with slides and bio or call to schedule an appointment to show a portfolio, which should include originals and slides. Replies only if interested within 1 week.

Tips: "Artists must have work that was done in the 1950s or before."

NATHAN SILBERBERG FINE ARTS, 301 E. 63rd St., New York NY 10021. (212)752-6160. Owner: N. Silberberg. Retail and wholesale gallery. Estab. 1973. Represents 10 artists; established. Interested in seeing the work of emerging artists. Exhibited artists include Joan Miro and Henry Moore. Sponsors 4 shows/year. Average display time 1 month. Open March-July. 2,000 sq. ft. 75% of space for special exhibitions. Overall price range: $50,000; most work sold at $4,000.

Media: Considers oil, acrylic and watercolor; original handpulled prints, lithographs, pochoir, serigraphs and etchings.

Style: Exhibits surrealism and conceptualism.

Terms: Accepts work on consignment (40-60% commission). Retail price set by the gallery. Gallery provides insurance and promotion; shipping costs are shared. Prefers framed artwork.

Submissions: Send query letter with resume, slides and SASE. Write to schedule an appointment to show a portfolio, which should include originals, slides and transparencies. Replies in 1 month.

Tips: "First see my gallery and the artwork we show."

SOHO CENTER FOR VISUAL ARTISTS, 114 Prince St., New York NY 10012. (212)226-1995. Director: Bruce Wall. Nonprofit gallery. Estab. 1973. Clientele: 75% private collectors, 25% corporate clients. "We offer one-time group shows to emerging artists." Sponsors 7 group shows/year. Average display time is 5 weeks. Overall price range: $1,000-3,000.

Media: All media.

Style: "The SoHo Center for Visual Artists is a nonprofit exhibition gallery sponsored by the Aldrich Museum of Contemporary Art. Established in 1973, the Center sponsors group exhibitions of emerging artists who are not represented by commercial galleries in New York City."

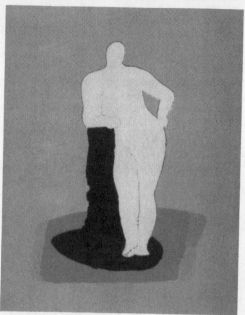

Nathan Silberberg Galleries, Ltd. 1990

Nathan Silberberg, of Nathan Silberberg Galleries Ltd. in New York City, regularly shows the work of Sandro Chia, the creator of this piece. The Column, a 35½ × 27½" work in black, white and hues of orange is an etching, aquatint with carborundum. It has been sold to a private collector.

Terms: Accepts work on consignment (no commission). Retail price is set by artist. Exclusive area representation not required. Gallery provides promotion and contract; artist pays for shipping.

Submissions: Send 20 slides of recent work, resume and SASE. "Contact the Center for times for slide review."

DOROTHY SOLOMON & ASSOCIATES, INC., (formerly The Art Collaborative), 12 White St., New York NY 10013. (212)925-4780. Wholesale gallery and art consultancy. Also has rental gallery. Estab. 1984. Clientele: primarily architects, designers, corporate, some government, 5% private collectors; 95% corporate clients. Represents 300 artists. Sponsors 4 solo and 8 group shows/year. "No erotic, political or religious art." Interested in emerging and established artists. Overall price range: $4,500-20,000; most work sold at $500-5,000.

Media: Considers all media, but no offset reproductions.

Style: "The Art Collaborative was founded on the philosophy that the corporate community was so varied in their art requirements and that artists need someone to market their work effectively to this vast art market. Our role is 'matchmaker' between the two; by interpreting our client's needs correctly as to aesthetic, budget and environmental factors, we make recommendations for artists' works which match those requirements."

Terms: Accepts work on consignment (50% commission). Rental fee for space; rental fee covers 2 weeks-1 month (storefront space only). Retail price set by gallery and artist. Exclusive area representation sometimes required. Gallery provides insurance, promotion and shipping costs from gallery. "Most works on paper, including prints, we prefer unframed; they are either on site or transported to client's space in large portfolio case."

Submissions: Send query letter with slides, brochure, 8 × 10 photographs, bio, price list that relates to visuals sent and SASE. Drop-off policy for portfolios; weekly review. Replies in 3 weeks.

Tips: "Be as professional in your presentation as possible, including all material requested. Pricing info is extremely important! Slides or photos should be top-quality dupes. No originals please. Installation shots are also important for site-specific pieces."

STUX GALLERY, 155 Spring St., New York NY 10012. (212)219-0010. Director: Kim Heirston. Retail gallery. Clientele: 80% private collectors, 20% corporate clients. Represents 10 artists. Sponsors 10 solo and 2 group shows/year. Average display time is 3½ weeks. Interested in emerging and established artists. Overall price range: $1,000-50,000; most artwork sold at $2,500-10,000.

Media: Considers oil, acrylic, mixed media, sculpture, photographs and prints.
Terms: Accepts work on consignment (50% commission). Retail price is set by gallery and artist. Exclusive representation required. Gallery provides insurance, promotion and contract.
Submissions: "The Director/Owner views materials with the artist present by appointment. Portfolio should include slides and transparencies. For artist unable to view materials with Director/Owner, send resume, slides, transparencies etc. and SASE."

JOHN SZOKE GRAPHICS, INC., 164 Mercer St., New York NY 10012. (212)219-8300. FAX: (212)966-3064. President: John Szoke. Director: Susan Jaffe. Retail gallery and art publisher. Estab. 1974. Represents 30 artists; emerging, mid-career and established. Exhibited artists include Christo and Dine. Open all year. Located downtown in SoHo; 1,500 sq. ft.; "gallery has a skylight." 50% of space for special exhibitions, 50% for gallery artists. Clientele: other dealers and collectors. 20% private collectors, 20% corporate collectors. Overall price range: $1,000-22,000.
Media: Considers works on paper, sculpture, silkscreen, woodcuts, engravings, lithographs, pochoir, mezzotints, serigraphs, linocuts and etchings. Most frequently exhibits etchings and lithographs.
Style: Exhibits surrealism, minimalism and realism. All genres.
Terms: Buys artwork outright. Retail price set by the gallery. Gallery provides insurance and promotion; artist pays for shipping. Prefers unframed artwork.
Submissions: Send query letter with slides and SASE. Write to schedule an appointment to show a portfolio, which should include slides. Replies in 1 week. Files letter, resume, all correspondence and slides unless SASE is enclosed.

TATYANA GALLERY, 6th Floor, 145 E. 27th St., New York NY 10016. (212)683-2387. Contact: Director. Retail gallery. Estab. 1980. Represents and exhibits work of established artists. Open fall, winter, spring and summer. Clientele: 50% private collectors. Sponsors 2 solo and 2 group shows/year. Overall price range: $200-150,000; most artwork sold at $400-16,000.
Media: Considers oil, watercolor, pastel, pen & ink, drawings, mixed media and works on paper. Most frequently exhibits oil, watercolor and drawings.
Style: Exhibits impressionism and realism. Prefers landscapes, figurative work and portraits. "Our gallery specializes in Russian and Soviet Realist Art and impressionsm."
Tips: Looking for "the best Russian Realist paintings I can find in the USA."

***TIBOR DE NAGY GALLERY,** 41 W. 57th St., New York NY 10019. (212)421-3780. Director: Steven B. Beer. Retail gallery. Estab. 1950. Represents 18 artists; emerging and mid-career. Exhibited artists include Harold Gregor and Larry Cohen. Sponsors 12 shows/year. Average display time 1 month. Closed August. Located midtown; 3,500 sq. ft. 100% of space for work of gallery artists. 60% private collectors, 40% corporate collectors. Overall price range: $800-30,000; most work sold at $5,000-15,000.
Media: Considers oil, pen & ink, paper, acrylic, drawing, sculpture, watercolor, mixed media, pastel and collage; original handpulled prints, woodcuts, linocuts, engravings, mezzotints, etchings, and lithographs. Most frequently exhibits oil/acrylic paintings, watercolor and sculpture.
Style: Exhibits painterly abstraction, conceptualism, color field, post modern works, realism and hard-edge geometric abstraction. Genres include landscapes and figurative work. Prefers abstract, painterly realism and realism.
Terms: Accepts work on consignment (50% commission). Retail price set by the gallery and the artist. Gallery provides insurance, promotion and contract; artist pays for shipping. Prefers artwork framed.
Submissions: Send query letter with resume, slides, bio, brochure, photographs, SASE and reviews. Call to schedule an appointment to show a portfolio, which should include photographs and slides. Replies in 2 weeks. Files resume and bio.

JACK TILTON GALLERY, 24 W. 57th St., New York NY 10019. (212)247-7480. Director: Janine Cirincione. Retail gallery. Estab. 1983. Represents 12 artists. Sponsors 6 solo and 5 group shows/year. Average display time 4 weeks. Interested in emerging and established artists.
Media: Considers oil, acrylic, watercolor, pastel, pen & ink, drawings, mixed media, collage, works on paper, sculpture, installation, photography and egg tempera. Most frequently exhibits paintings and sculpture.
Style: Exhibits painterly abstraction, conceptualism, post modern works, hard-edge geometric abstraction and all styles. Prefers abstraction. "Our gallery specializes in contemporary abstract painting and sculpture."
Terms: Accepts artwork on consignment (50% commission). Retail price set by gallery and/or artist. Exclusive area representation not required.
Submissions: Send query letter with slides and SASE. Call or write to schedule an appointment to show a portfolio, which should include slides and small portable works. All material is returned if not accepted or under consideration.

ALTHEA VIAFORA GALLERY, 568 Broadway, New York NY 10012. (212)925-4422. Director: Althea Viafora. Retail gallery. Estab. 1981. Clientele: 75% private collectors, 25% corporate clients. Represents 10 artists. Sponsors 8 solo and 3 group shows/year. Average display time is 1 month. Interested in emerging and

established artists. Overall price range: $2,500-25,000; most artwork sold at $3,000-10,000.

Media: Considers oil, acrylic, watercolor, pastel, pen & ink, drawings, mixed media, collage, works on paper, sculpture, installation, photography and original handpulled prints. Most frequently exhibits acrylic on canvas, oil on canvas and photography.

Style: Exhibits painterly abstraction, conceptualism, surrealism and expressionism. Genres include landscapes and figurative work.

Terms: Accepts work on consignment. Retail price is set by gallery and artist. Gallery provides insurance and promotion.

VIRIDIAN GALLERY, 52 W. 57 St., New York NY 10019. (212)245-2882. Director: Paul Cohen. Cooperative gallery. Estab. 1970. Clientele: consultants, corporations, private collectors; 50% private collectors, 50% corporate clients. Represents 31 artists. Sponsors 13 solo and 2 group shows/year. Average display time is 3 weeks. Interested in emerging, mid-career and established artists. Overall price range: $1,000-15,000; most artwork sold at $2,000-8,000.

Media: Considers oil, acrylic, watercolor, pastel, pen & ink, drawings, mixed media, collage, works on paper, sculpture, installation, photography and limited edition prints. Most frequently exhibits oil, sculpture and mixed media.

Style: Exhibits hard-edge geometric abstraction, color field, painterly abstraction, conceptualism, post modern, primitivism, impressionism, photorealism, expressionism, neo-expressionism and realism. Genres include landscapes, florals, portraits and figurative work. "Eclecticism is Viridian's policy. The only unifying factor is quality. Work must be of the highest technical and aesthetic standards."

Terms: Accepts work on consignment (20% commission). Retail price is set by gallery and artist. Exclusive area representation not required. Gallery provides insurance, shipping, promotion and contract.

Submissions: Send query letter and SASE.

***WARD-NASSE GALLERY INC.,** 178 Prince St., New York NY 10012. (212)925-6951. Director: Margot Norton. A nonprofit artist-run gallery. Estab. 1978. Represents 100 members; emerging. Exhibited artists include Brian Carleton and Julia Balk. Sponsors 17 shows/year. Average display time 3 weeks. Open all year. Located in SoHo; 2,000 sq. ft.; "The ground floor of the gallery is prime SoHo-area space; with 14 ft. ceilings. It's good for all media. The building was constructed around 1915." 100% of space for special exhibitions. There are 5-6 special exhibits per year; every exhibition generally has whole gallery space. Clientele: young collectors, artists, tourists, some corporate, major collectors. 80% private collectors, 20% corporate collectors. Overall price range: $100-10,000; most work sold at $400-1,500.

Media: Considers all media except craft, including installation, performance, video, window installation and work using text. Most frequently exhibits painting, sculpture and photography.

Style: Exhibits all styles. Genres include landscapes, portraits and figurative work. Prefers painterly abstraction, expressionism and impressionism.

Terms: Co-op membership fee plus a donation of time (15% commission). Retail price set by the artist. Gallery provides insurance, promotion and contract; artist pays for shipping. Accepts both framed and unframed artwork, whatever is most appropriate for the piece.

Submissions: "Artists should be seriously committed to artmaking; not part-time artsts." Send query letter with SASE. Reviews slide first, then possibly portfolio, which should include slides. Slide reviews held quarterly and provide specific questions or information. Replies in 3 weeks.

Tips: "We file any material on artist(s) or exhibitions, literary events, performances, films, or topical exhibitions that might be appropriate for this gallery—we are committed to exhibiting. Please send SASE for membership application before sending any other material. We will be happy to send additional material on the gallery and past exhibitions, history and other events, if the artist so requests. We do not look at portfolios brought into the gallery. Slide reviews are done by the membership in general, not by the director of gallery. Artists should not come to the gallery with their portfolios or actual work for review."

***WILLOUGHBY SHARP GALLERY,** 8 Spring St., New York NY 10012. (212)966-5888. Director: Lisa Metcalf. Retail gallery. Estab. 1988. Represents 28 emerging artists. Exhibited artists include Dennis Oppenheim, Robin Winters and Buster Cleveland. Sponsors 11 shows/year. Average display time 3 weeks. Open all year. Located in SoHo; 500 sq. ft. 100% of space for gallery artists. Clientele: other SoHo art dealers, collectors. 90% private collectors; 10% corporate collectors. Overall price range: $500-100,000; most work sold at $1,000-9,000.

Media: Considers oil, acrylic, watercolor, pastel, pen & ink, drawing, mixed media, collage, paper, sculpture, ceramic, glass, installation and photography; original handpulled prints: woodcut, wood engraving, linocut, engraving, mezzotint, etching, lithograph, seriagraph and offset reproductions. Most frequently exhibits sculpture, painting and photography. Specializes in bronze sculpture.

Style: Exhibits expressionism, surrealism, conceptualism, minimalism, post-modern works. Prefers expressionism, minimalism and conceptualism. Interested in seeing "cutting-edge, contemporary work of almost any style."

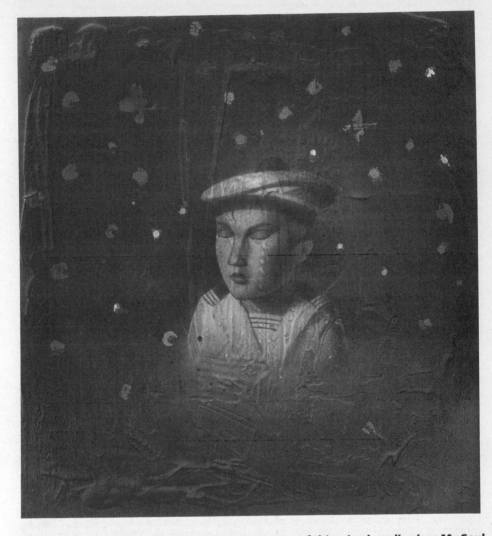

© Sherry Kerlin 1991

Artist Sherry Kerlin of New York City is the creator of this mixed-media piece My Soul is a Sailor. *It was featured in a solo show at the Willoughby Sharp Gallery. The owner, Willoughby Sharp, first met Kerlin "when she walked into the gallery," he says. The response to this work was "excellent, and the gallery is proud," says Sharp, "to represent Kerlin. We will have another solo show of her work next season."*

Terms: Accepts work on consignment (50% commission). Retail price set by artist. Gallery provides insurance and promotion. Shipping costs are shared. Prefers artwork framed.
Submissions: Send query letter with resume, slides, bio, SASE and reviews. Replies in 2 weeks.
Tips: "Call first after having visited the gallery and knowing the kind of work it represents."

YESHIVA UNIVERSITY MUSEUM, 2520 Amsterdam Ave., New York NY 10033. (212)960-5390. Director: Sylvia A. Herskowitz. Nonprofit museum. Estab. 1973. Clientele: New Yorkers and tourists. Sponsors 5-7 solo shows/year. Average display time is 3 months. Interested in emerging, mid-career and established artists. Museum works can be sold through museum shop.

Media: Considers oil, acrylic, watercolor, pastel, pen & ink, drawings, mixed media, collage, works on paper, sculpture, ceramic, craft, fiber, glass, installation, photography and original handpulled prints.

Style: Exhibits post-modernism, surrealism, photorealism and realism. Genres include landscapes, florals, Americana, portraits and figurative work. "We only exhibit works of Jewish theme or subject matter but are willing to consider any style or medium."

Terms: Accepts work for exhibition purposes only, no fee. Pieces should be framed. Retail price is set by gallery and artist. Gallery provides insurance, promotion and contract; artist pays for shipping and framing.

Submissions: Send query letter, resume, brochure, slides, photographs and statement about your art. Write to schedule an appointment to show a portfolio, which should include originals. Resumes, slides or photographs are filed "only by special arrangement with artist."

Tips: Mistakes artist make are sending "slides that are not identified, nor in a slide sheet." Notices "more interest in mixed media and more crafts on display."

North Carolina

CASE ART GALLERY, Barton College, Lee St., Wilson NC 27893. (919)237-3161, ext. 365. Gallery Director: Edward Brown. Nonprofit gallery. Estab. 1965. Clientele: students, faculty, townspeople and area visitors. Sponsors 3 solo and 4 group shows/year. Average display time is 3½ weeks. "We have added a 15 × 50' second gallery adjacent to our existing Case Art Gallery. It is a general purpose exhibition space, well-lighted, carpeted, high ceilings, etc." Interested in mid-career artists. Most artwork sold at $350.

Media: Considers oil, acrylic, watercolor, pastel, pen & ink, drawings, mixed media, collage, works on paper, sculpture, ceramic, craft, fiber, glass, installation, photography and original handpulled prints. Most frequently exhibits fiber, pottery and paintings.

Style: Considers all styles. Genres include landscapes, Americana, figurative work and fantasy illustration. Most frequently exhibits abstraction and photorealism. Looks for "good craftsmanship, professionally presented, strong design, originality and a variety of styles and subjects."

Terms: "We take no commission on possible sales." Retail price is set by artist. Gallery provides insurance, promotion and contract; shipping costs are shared.

Submissions: Send query letter with resume. Write to schedule an appointment to show a portfolio, which should include slides. Resumes are filed.

Tips: "Looks for good design, craftsmanship and exhibition record. We are moving away, somewhat, from showing young artists without exhibition records."

***GALLERY C,** 432 Daniel St., Raleigh NC 27605. (919)828-3165. Director: Charlene Newsom. Retail gallery. Estab. 1985. Represents 20 artists; emerging, mid-career and established. Exhibited artists include Norma Murphy and Louis St. Lewis. Sponsors 8 shows/year. Average display time 6 weeks. Open all year. Located in "a historic shopping area; 2,000 sq. ft.; shares a lobby with an upscale gardening specialty store which features original artwork for outdoors." 60% of space for special exhibitions, 40% for work of gallery artists. 70% private collectors, 30% corporate collectors. Overall price range: $15-20,000; most work sold at $300-1,000.

Media: Considers oi, acrylic, watercolor, pastel, pen & ink, drawing, mixed media, collage, paper, sculpture, ceramic, craft, fiber, glass and installation; original handpulled prints, woodcuts, wood engravings, linocuts, engravings, mezzotints, etchings, lithographs, pochoir, posters and serigraphs. Most frequently exhibits oil, watercolor and mixed media.

Style: Exhibits all styles. Genres include landscapes, florals and figurative work.

Terms: Accepts work on consignment (40-50% commission). Retail price set by the artist. Gallery provides insurance, promotion and contract; shipping costs are shared. Prefers artwork framed.

Submissions: Send query letter with resume, slides, bio, brochure, photographs, SASE, business card and reviews. Call to schedule an appointment to show a portfolio, which should include originals. "We view original work after looking at slides or photos." Replies in 1 month.

Tips: "Call first. We will be happy to explain our procedure."

WELLINGTON B. GRAY GALLERY, EAST CAROLINA UNIVERSITY, Jenkins Fine Art Center, Greenville NC 27858. (919)757-6336. Director: Charles M. Lovell. Nonprofit university gallery. Estab. 1977. Represents emerging, mid-career and established artists. Sponsors 12 shows/year. Average display time 5-6 weeks. Open year round. Located downtown, in the university; 5,500 sq. ft.; "auditorium for lectures, sculpture garden." 100% of space for special exhibitions. Clientele: 25% private collectors, 10% corporate clients, 50% students, 15% general public. Overall price range: $1,000-10,000.

Media: Considers all media plus environmental design, architecture, crafts and commercial art, original prints, relief, intaglio, planography, stencil and offset reproductions. Most frequently exhibits paintings, printmaking and sculpture.

Style: Exhibits all styles and genres. Interested in seeing contemporary art in a variety of media.
Terms: There is a 20% suggested donation on sales. Retail price set by the artist. Gallery provides insurance and promotion. Shipping costs are shared. Prefers framed artwork.
Submissions: Send query letter with resume, slides, brochure and SASE. Write to schedule an appointment to show a portfolio, which should include originals, slides, photographs and transparencies. Replies in 2-6 months. Files "all mailed information for interesting artists. The rest is returned."

LITTLE ART GALLERY, North Hills Mall, Raleigh NC 27615. (919)787-6317. President: Ruth Green. Retail gallery. Estab. 1968. Represents 50 artists; mid-career and established. Exhibited artists include Fritzi Huber, Boulanger and Paul Landry. Sponsors 4 shows/year. Average display time 1 month. Open all year. Located in a suburban mall; 2,000 sq. ft.; small balcony for mini-shows. 20% of space for special exhibitions. Clientele: 90% private collectors, 10% corporate clients. Overall price range: $200-2,000; most artwork sold at $500-1,000.
Media: Considers oil, acrylic, watercolor, mixed media, collage, ceramic and all types of original handpulled prints. Most frequently exhibits watercolor, oil and original prints.
Style: Exhibits painterly abstraction, realism and abstracted realism. Genres include landscapes and figurative work. Prefers realism and abstracted realism.
Terms: Accepts work on consignment (50% commission). "Will buy outright in certain circumstances." Retail price set by the artist. Gallery provides insurance and promotion. Prefers unframed artwork.
Submissions: Send query letter with photographs. Call or write to schedule an appointment to show a portfolio. Replies in 1 week. Files bios and 1 photo.
Tips: Most common mistake artists make is "presenting the whole range of work they have done instead of concentrating on what they are currently doing and are interested in."

PINEHURST GALLERIES, Magnolia Rd., Pinehurst NC 28374. (919)295-6177. Vice President: Vivien Weller. Retail gallery. Estab. 1990. Represents 100 artists; established. Interested in seeing the work of emerging and mid-career artists. Exhibited artists include Ray Ellis and T.M. Nicholas. Sponsors 5 shows/year. Average display time 6 months. Open all year. Located downtown, in the main village; 4,000 sq. ft.; "the gallery is old Southern brick, covered in colorful flowers." 25% of space for special exhibitions, 75% for gallery artists. 50% private collectors, 50% corporate collectors. Price range: $300-10,000.
Media: Considers oil, acrylic, watercolor, pastel, pen & ink, drawings, mixed media, collage, works on paper, high end crafts, jewelry, sculpture, ceramic, craft, fiber, glass, installation, photography, original handpulled prints, woodcuts, engravings, lithographs, posters and etchings. Most frequently exhibits oil, ceramic and sculpture.
Style: Exhibits painterly abstraction, impressionism, realism and all styles. Genres include landscapes, florals, portraits and figurative work.
Terms: Accepts work on consignment (40% commission). Retail price set by the artist. Gallery provides insurance, promotion and contract; artist pays for shipping. Prefers framed artwork.
Submissions: Send query letter with resume, slides, bio and reviews. Write to schedule an appointment to show a portfolio, which should include slides. Replies in 2 weeks. Files resumes, correspondence and slides.

***SOMERHILL GALLERY**, 3 Eastgate E. Franklin St., Chapel Hill NC 27514. (919)968-8868. FAX: (919)967-1879. Director: Joseph Rowand. Retail gallery. Estab. 1972. Represents emerging, mid-career and established artists. Sponsors 10 major shows/year, plus a varied number of smaller shows. Open all year. 10,000 sq. ft.; Gallery features "architecturally significant spaces, pine floor, 18' ceiling, 6 separate gallery spaces, stable, photo, glass." 50% of space for special exhibitions.
Media: Considers oil, pen & ink, paper, fiber, acrylic, drawing, sculpture, glass, watercolor, mixed media, ceramic, pastel, collage, craft and photography; woodcuts, wood engravings, linocuts, engravings, mezzotints, etchings, lithographs and serigraphs. Most frequently exhibits paintings, sculpture and glass.
Style: Exhibits all styles and genres.
Submissions: Focus is on Southeastern contemporary of The United States; however artists from all over the world are exhibited. Send query letter with resume, slides, bio, SASE and any relevant materials. Replies in 6-8 weeks. Files slides and biographical information of artists.

WILKES ART GALLERY, 800 Elizabeth St., N. Wilkesboro NC 28659. (919)667-2841. Manager: Ginger Edmiston. Nonprofit gallery. Estab. 1962. Clientele: middle-class. 75% private collectors, 25% corporate clients. Sponsors solo and group shows. Average display time is 3-4 weeks. Interested in emerging and established artists. Overall price range: $200-9,000; most artwork sold at $500-1,500.
Media: Considers all media. Most frequently exhibits paintings, sculpture and photography.
Style: Exhibits conceptual, primitive, impressionistic, photorealistic, expressionistic, realist and surrealist works. Genres include landscapes and figurative work. Most frequently exhibits impressionism, realism and abstraction. Currently seeking impressionism.

Terms: "Exhibition committee meets in January each year to schedule exhibits." Exclusive area representation not required. Gallery provides insurance, promotion and contract; shipping costs are shared.
Submissions: Send query letter with resume, statement, slides and SASE. Resumes are filed.

North Dakota

ARTMAIN, 13 S. Main, Minot ND 58701. (701)838-4747. Partners/Owners: Beth Kjelson and Becky Piehl. Retail gallery. Estab. 1981. Represents 12-15 artists. Sponsors 6 solo and 2 group shows/year. Average display time is 4-6 weeks. Interested in emerging artists. Overall price range: $100-500; most work sold at $100-300.
Media: Considers oil, acrylic, watercolor, pastel, pen & ink, drawings, ceramic, fiber, photography, craft, mixed media, collage, original handpulled prints and posters.
Style: Exhibits contemporary, abstract, Americana, impressionistic, landscapes, primitive, non-representational and realistic works. "We specialize in Native American works and would like to see more contemporary artwork."
Terms: Accepts work on consignment (30% commission). Retail price is set by gallery and artist. Exclusive area representation required. Gallery provides insurance, promotion and contract; shipping costs are shared.
Submissions: Send query letter, resume and slides or photographs. May call to schedule an appointment to show a portfolio.
Tips: "Because galleries and artists are having a difficult time of making it, galleries are going into smaller and and less expensive works."

THE ARTS CENTER, Box 363, 115 2nd St. SW, Jamestown ND 58402. (701)251-2496. Director: Joan Curtis. Nonprofit gallery. Estab. 1981. Sponsors 8 solo and 4 group shows/year. Average display time is 1 month. Interested in emerging artists. Overall price range: $50-600; most artwork sold at $50-350.
Style: Exhibits contemporary, abstract, Americana, impressionistic, figurative, primitive, photorealistic and realistic work; landscapes and florals.
Terms: 20% commission on sales from regularly scheduled exhibitions. Retail price is set by artist. Gallery provides insurance, promotion and contract; shipping costs are shared.
Submissions: Send query letter, resume, brochure, slides, photograph and SASE. Write to schedule an appointment to show a portfolio. Invitation to have an exhibition is extended by Arts Center curator, Kris Storbeck.
Tips: Wants to see "innovative art, but not too avant-garde."

BROWNING ARTS, 22 N. 4th St., Grand Forks ND 58201. (701)746-5090. Director: Mark Browning. Retail gallery. Estab. 1981. Open all year. Clientele: 80% private collectors, 20% corporate clients. Represents 25 artists. Average display time 3 months. Accepts only artists within 200 mile radius. Interested in emerging, mid-career and established artists. Overall price range: $100-2,000; most artwork sold at $200-500.
Media: Considers all media and original prints.
Style: Exhibits all styles and genres. "Our gallery provides a 'showcase' and sales outlet for all media and styles (done within a 200 mile radius generally) by artists consistently producing a professional quality of work."
Terms: Accepts work on consignment (33% commission). Retail price set by artist. Exclusive area representation not required. Gallery provides insurance and promotion.
Submissions: Send query letter with resume, slides, SASE and bio. Call or write to schedule an appointment to show a portfolio, which should include resume, slides, SASE and bio. Replies in 2 weeks.
Tips: Artists should show "A serious dedication to their involvement with their art form; at least one year experience; and only artworks following (not completed during) art instruction. Don't submit old works/ slides, art school projects/MFA, etc. To introduce yourself, set up an interview time, appear in person with works or slides and history/bio, then explain current directions/interests."

HUGHES FINE ART CENTER ART GALLERY, Department of Visual Arts University of North Dakota, Grand Forks ND 58202-8134. (701)777-2257. Director: Brian Paulsen. Nonprofit gallery. Estab. 1979. Represents emerging, mid-career and established artists. Sponsors 5 shows/year. Average display time 3 weeks. Open all year. Located on campus; 96 running ft. 100% of space for special exhibitions.
Media: Considers all media. Most frequently exhibits painting, photographs and jewelry/metal work.
Style: Exhibits all styles and genres.
Terms: Retail price set by the artist. Gallery provides "space to exhibit work and some limited contact with the public and the local newspaper." Gallery pays for shipping costs to and from gallery. Prefers framed artwork.
Submissions: Send query letter with slides. Portfolio should include slides. Replies in 1 week. Files "duplicate slides, resumes."
Tips: "Send slides, and approximate shipping costs."

MIND'S EYE GALLERY, Dickinson State University, Dickinson ND 58601. (701)227-2312. Professor of Art, Director: Katrina Callahan-Dolcater. Nonprofit gallery. Estab. 1972. Clientele: 100% private collectors. Sponsors 5 solo and 6 group shows/year. Average display time is 3 weeks. Interested in emerging and established artists. Overall price range: $10-3,000; most artwork sold at $10-150.
Media: Considers oil, acrylic, watercolor, pastel, pen & ink, drawings, mixed media, collage, works on paper, sculpture, ceramic, craft, fiber, photography and original handpulled prints. Most frequently exhibits oil, watercolor and prints.
Style: Exhibits hard-edge/geometric abstraction, color field, painterly abstraction, post-modernism, surrealism, impressionism, photorealism, expressionism, neo-expressionism and realism. Genres include landscapes, florals, Americana, Western, portraits and figurative work. "We sponsor a biennial 'Emerging Artists National Art Invitational' in which we welcome the opportunity to review slides and professional resumes of any interested artists. 10-15 artists are invited for this group show. Slides are returned within six months of submission and invitations are extended year-round."
Terms: Retail price is set by artist. Exclusive area representation not required. Gallery provides insurance, promotion and contract; shipping costs are shared.
Submissions: Send query letter, resume, brochure, business card and slides. Write to schedule an appointment to show a portfolio, which should include originals and slides. Artist's names and resumes are filed; slides returned.
Tips: Looks for "sophisticated, intelligent images by experienced artists; excellent technique, meaningful images; *curious* images. It is best to start with slides first!"

MINOT ART GALLERY, Box 325, Minot ND 58702. (701)838-4445. Director: Judith Allen. Nonprofit gallery. Estab. 1970. Represents emerging, mid-career and established artists. Sponsors 24 shows/year. Average display time 1 month. Open all year. Located at North Dakota state fairgrounds; 1,600 sq. ft.; "2-story turn-of-the-century house." 100% of space for special exhibitions. Clientele: 100% private collectors. Overall price range: $50-2,000; most artwork sold at $100-400.
Media: Considers oil, acrylic, watercolor, pastel, pen & ink, drawings, mixed media, collage, works on paper, sculpture, ceramic, fiber, glass, photograpy, woodcuts, engravings, lithographs, serigraphs, linocuts and etchings. Most frequently exhibits watercolor, acrylic and mixed media.
Style: Exhibits all styles and genres. Prefers figurative, Americana and landscapes. No "commercial style work."
Terms: Accepts work on consignment (30% commission). Retail price set by the artist. Gallery provides insurance, promotion and contract; shipping costs from gallery or shipping costs are shared. Prefer framed artwork.
Submissions: Send query letter with resume and slides. Write to schedule an appointment to show a portfolio, which should include photographs and slides. Replies in 1 month. Files material interested in.
Tips: "Send letter with slides/resume. Do not call for appointment. We are seeing many more photographers wanting to exhibit."

Ohio

ALAN GALLERY, 61 W. Bridge St., Berea OH 44017. (216)243-7794. President: Alan Boesger. Retail gallery and arts consultancy. Estab. 1983. Clientele: 20% private collectors, 80% corporate clients. Represents 25-30 artists. Sponsors 4 solo shows/year. Average display time is 6-8 weeks. Interested in emerging, mid-career and established artists. Overall price range: $700-6,000; most artwork sold at $1,500-2,000.
Media: Considers all media and limited edition prints. Most frequently exhibits watercolor, works on paper and mixed media.
Style: Exhibits color field, painterly abstraction and surrealism. Genres include landscapes, florals, Western and figurative work.
Terms: Accepts work on consignment (40% commission). Retail price is set by gallery and artist. Exclusive area representation not required. Gallery provides insurance, promotion and contract; shipping costs are shared.
Submissions: Send resume, slides and SASE. Call or write to schedule an appointment to show a portfolio, which should include originals and slides. All material is filed.

TONI BIRCKHEAD GALLERY, 324 W. 4th St., Cincinnati OH 45202. (513)241-0212. Director: Toni Birckhead. Retail gallery and arts consultancy. Estab. 1979. Clientele: 25% private collectors, 75% corporate clients. Represents 40 artists. Sponsors 4 solo and 2 group shows/year. Average display time is 6-7 weeks. Interested in emerging, mid-career and established artists. Overall price range: $500-5,000; most artwork sold at $500-1,000.
Media: Considers oil, acrylic, watercolor, pastel, pen & ink, drawings, mixed media, collage, works on paper, sculpture, ceramic, installation, photography and original handpulled prints. Most frequently exhibits painting, sculpture and works on paper.

Style: Exhibits hard-edge geometric abstraction, color field, painterly abstraction, minimalism, conceptual post-modernism, neo-expressionism and realism.

Terms: Accepts work on consignment (50% commission). Retail price is set by gallery and artist. Exclusive area representation required. Gallery provides insurance, promotion and contract; shipping expenses are shared.

Submissions: Send query letter, resume, slides and SASE. Call or write to schedule an appointment to show a portfolio, which should include originals and slides. Slides, resumes and reviews are filed.

C.A.G.E., 344 W. 4th St., Cincinnati OH 45202. (513)381-2437. Contact: Programming Committee. Nonprofit gallery. Estab. 1978. Clientele: 99.9% private collectors, .1% corporate clients. Sponsors 7-12 group shows/year. Average display time is 1 month. Interested in emerging and mid-career artists. Overall price range: $100-5,000; most artwork sold at $100-500.

Media: Considers all media. Most frequently exhibits paintings, mixed media and installation/video/performance.

Style: Considers all styles; "experimental, conceptual, political, media/time art, public art and artists' projects encouraged." Most frequently exhibits figurative, photographic and expressionist. "Proposals from artists are accepted and reviewed in January (deadline December 15) for exhibition 9-20 months from deadline. A panel of peer artists and curators selects the exhibitions."

Terms: Retail price is set by artist. Exclusive area representation not required. Gallery provides insurance, promotion and contract.

Submissions: Send query letter with 10 slides and SASE.

THE CANTON ART INSTITUTE, 1001 Market Ave. N., Canton OH 44702. (216)453-7666. Executive Director: M. Joseph Albacete. Nonprofit gallery. Estab. 1935. Sponsors 25 solo and 5 group shows/year. Represents emerging, mid-career and established artists. Average display time is 6 weeks. Overall price range: $50-3,000; few sales above $300-500.

Media: Considers all media. Most frequently exhibits oil, watercolor and photography.

Style: Considers all styles. Most frequently exhibits painterly abstraction, post-modernism and realism.

Terms: "While every effort is made to publicize and promote works, we cannot guarantee sales, although from time to time sales are made, at which time a 25% charge is applied." One of the most common mistakes in presenting portfolios is "sending too many materials. Send only a few slides or photos, a brief bio and an SASE."

Tips: There seems to be "a move back to realism, conservatism and support of regional artists."

THE A.B. CLOSSON JR. CO., 401 Race St., Cincinnati OH 45202. (513)762-5564. Director: Phyllis Weston. Retail gallery. Estab. 1866. Clientele: general. Represents emerging, mid-career and established artists. Average display time is 3 weeks. Overall price range: $600-75,000.

Media: Considers oil, watercolor, pastel, mixed media, sculpture, original handpulled prints and limited offset reproductions.

Style: Exhibits all styles and genres.

Terms: Accepts work on consignment or buys outright. Retail price is set by gallery and artist. Exclusive area representation required. Gallery provides insurance and promotion; shipping costs are shared. Portfolio should include originals.

***EMILY DAVIS GALLERY,** School of Art, University of Akron, Akron OH 44325. (216)972-5950. Director: Michael Jones. Nonprofit gallery. Estab. 1974. Clientele: persons interested in contemporary/avant-garde art. Sponsors 8 solo and 4 group shows/year. Average display time is 3½ weeks. Interested in emerging and established artists. Overall price range: $100-65,000; "no substantial sales."

Media: Considers all media.

Style: Exhibits contemporary, abstract, figurative, non-representational, photorealistic, realistic and neo-expressionistic works.

Terms: Retail price is set by artist. Exclusive area representation not required. Gallery provides insurance, shipping costs, promotion and contract.

Submissions: Send query letter with resume, brochure, slides, photographs and SASE. Write for an appointment to show a portfolio. Resumes are filed.

EASTON LIMITED GALLERY, 311 Conant, Maumee OH 43537. (419)893-6203. Partner: M.L. Wagener. Retail gallery. Estab. 1984. Represents emerging, mid-career and established artists. Exhibited artists include Heiner Hertling. Sponsors 4 shows/year. Open all year. Located downtown near Main St.; 4,200 sq. ft.; "in a historical section of town." 50% of space for special exhibitions. Clientele: professionals and local businesses. 50% private collectors, 10% corporate clients. Overall price range: $200-3,500.

Media: Considers oil, acrylic, watercolor, pastel and wood carvings. Most frequently exhibits original oils and original watercolors.

Style: Exhibits landscapes and wildlife works.

Terms: Artwork is accepted on consignment (33% commission). Gallery and artist set the retail price. Gallery provides promotion; shipping costs are shared.

Submissions: Write to schedule an appointment to show a portfolio, which should include originals and prints.

CHARLES FOLEY GALLERY, 973 E. Broad St., Columbus OH 43205. (614)253-7921. Director: Charles Foley. Retail gallery. Estab. 1982. Represents established artists. Interested in seeing the work of emerging artists. Exhibited artists include Tom Wesselmann and Richard Anuszkiewicz. Sponsors 2 shows/year. Average display time 8 weeks. Open all year. Located east of the Columbus Museum of Art; 5,000 sq. ft.; "housed in a turn-of-the-century house, specializing in 20th-century masters." 50% of space for special exhibitions, 50% for gallery artists. Clientele: 90% private collectors, 10% corporate clients. Overall price range: $30-150,000; most artwork sold at $2,500-20,000.

Media: Considers oil, acrylic, watercolor, pen & ink, drawings, mixed media, collage, works on paper, sculpture, ceramic, original handpulled prints, woodcuts, linocuts, engravings, etchings, lithographs, serigraphs and posters. Most frequently exhibits paintings, etchings and drawings.

Style: Exhibits expressionism, color field and hard-edge geometric abstraction. Prefers pop art, op art and expressionism.

Terms: Accepts work on consignment (30% commission). Retail price set by the gallery and the artist. Gallery provides promotion. Gallery pays for shipping costs. Prefers framed artwork.

Submissions: Send query letter with SASE. Call to schedule an appointment to show portfolio, which should include originals and transparencies.

IMAGES GALLERY, 3154 Markway Rd., Toledo OH 43606. (419)537-1400. Owner: Frederick D. Cohn. Retail gallery. Estab. 1970. Represents 75 artists; emerging, mid-career and established. Exhibited artists include Carol Summers and Larry Zox. Sponsors 8-10 shows/year. Average display time 1 month. Open all year. Located in a small suburban mall; 4,500 sq. ft.; gallery is 2 stories with a balcony and brilliant white space. 50% of space for special exhibitions. 50% private collectors, 25% corporate clients. Overall price range: $300-20,000; most work sold at $1,000-1,500.

Media: Considers oil, acrylic, watercolor, pastel, pen & ink, drawings, mixed media, collage, works on paper, sculpture, glass and photography; original handpulled prints, woodcuts, wood engravings, engravings, mezzotints, lithographs, pochoir and serigraphs. Most frequently exhibits original print and acrylics on canvas.

Style: Exhibits expressionism, painterly abstraction, color field, post modern works, realism and photorealism. Genres include landscapes, florals and Americana.

Terms: Accepts work on consignment (50% commission). Retail price set by the gallery and the artist. Gallery provides promotion; shipping costs from gallery. Unframed work only.

Submissions: Send query letter with resume, slides, bio, brochure, photographs and reviews. Call or write to schedule an appointment to show a portfolio, which should include slides. Replies in 1-4 weeks.

LICKING COUNTY ART GALLERY, 391 Hudson, Newark OH 43055. (614)349-8031. Exhibition Coordinator: H. Schneider. Nonprofit gallery. Estab. 1959. Represents 30 artists; emerging, mid-career and established. Exhibited artists include Roger Williams, Ralph Williams and Gary Ross. Sponsors 12 shows/year. Average display time 1 month. Located 6 blocks north of downtown; 784 sq. ft.; in a Victorian brick building. 70% of space for special exhibitions. Clientele: 90% private collectors, 10% corporate clients. Overall price range: $30-6,000; most work sold at $100-500.

Media: Considers oil, acrylic, watercolor, pastel, pen & ink, drawings, mixed media, collage, works on paper, sculpture, ceramic, fiber, glass, installation, photography, original handpulled prints, woodcuts, engravings, lithographs, wood engravings, serigraphs and etchings. Most frequently exhibits watercolor, oil/acrylic and photography.

Style: Exhibits conceptualism, color field, impressionism, realism, photorealism and pattern painting. Genres include landscapes, florals, wildlife, portraits and all genres. Prefers landscape, portraits and floral.

Terms: Artwork is accepted on consignment (30% commission.) Retail price set by artist. Gallery provides insurance, promotion and contract; artist pays for shipping. Prefers framed artwork.

Submissions: Send query letter with resume, brochure and photographs. Write to schedule an appointment to show a portfolio, which should include originals and slides. Replies only if interested within 6 weeks.

THE MIDDLETOWN FINE ARTS CENTER, 130 N. Verity Pkwy., Middletown OH 45042. (513)424-2416. Contact: Director. Nonprofit gallery. Estab. 1975. Clientele: tourists, students, community; 95% private collectors, 5% corporate clients. Sponsors 5 solo and/or group shows/year. Average display time 3 weeks. Overall price range: $100-1,000; most work sold at $150-500.

Media: Considers all media except prints. Most frequently exhibits watercolor, oil, acrylic and drawings.

Style: Exhibits all styles and all genres. Prefers realism, impressionism and photorealism. "Our gallery does not specialize in any one style or genre. We offer an opportunity for artists to exhibit and hopefully sell their work. This also is an important educational experience for the community. Selections are chosen two years in advance by a committee which meets one time a year.

Terms: Accepts work on consignment (30% commission). Retail price set by artist. Exclusive area representation not required. Gallery provides insurance and promotion; artist pays for shipping. Prefers artwork framed and wired.

Submissions: Send query letter with resume, brochure, slides, photographs and bio. Write to schedule an appointment to show a portfolio, which should include originals, slides or photographs. Replies in 3 weeks-3 months (depends when exhibit committee meets.). Files resume or other printed material. All material is returned if not accepted or under consideration.

Tips: "Decisions are made by a committee of volunteers, and time may not permit an on-the-spot interview with the director."

MILLER GALLERY, 2715 Erie Ave., Cincinnati OH 45208. (513)871-4420. Co-Directors: Barbara and Norman Miller. Retail gallery. Estab. 1960. Located in affluent suburb. Clientele: 80% private collectors, 20% corporate clients. Represents about 50 artists. Sponsors 4 solo and 3 group shows/year with display time 1 month. Interested in emerging, mid-career and established artists. Overall price range: $100-25,000; most artwork sold at $300-10,000.

Media: Considers, oil, acrylic, mixed media, collage, works on paper, ceramic, fiber, glass and original handpulled prints. Most frequently exhibits oil or acrylic, original prints, blown glass and ceramics.

Style: Exhibits painterly abstraction, impressionism and realism. Genres include landscapes, interior scenes and still lifes. "The ideal artworks for us are those executed in a sure, authoritative technique, not overworked, and not trite. We especially seek both fine realism and nonsubjective paintings; the realism must not include covered bridges or sentiment. Landscapes preferred and must have depth, substance and fine technique. Nonsubjective works must be handled with assurance and not be overworked or busy. We prefer medium to large paintings."

Terms: Accepts artwork on consignment (50% commission); buys outright when appropriate (40% of retail). Retail price set by artist and gallery. Exclusive area representation is required. Gallery provides insurance, promotion and contract; shipping and show costs are shared.

Submissions: Send query letter with resume, brochure, slides or photographs with sizes, wholesale (artist) and selling price and SASE. "All material is filed if we're interested, none if not."

Tips: "Artists often either completely omit pricing info or mention a price without identifying their percentages or selling price."

SPACES, 2220 Superior Viaduct, Cleveland OH 44113. (216)621-2314. Alternative space. Estab. 1978. Represents emerging artists. Has 300 members. Sponsors 10 shows/year. Average display time 1 month. Open all year. Located downtown Cleveland; 6,000 sq. ft.; "loft space with row of columns." 100% private collectors.

Media: Considers all media. Most frequently exhibits installation, painting and sculpture.

Style: Exhibits all styles.

Terms: 20% commission. Retail price set by the artist. Gallery provides insurance, promotion and contract.

Submissions: Send query letter with resume, slides and SASE. Annual deadline in spring for submissions.

Oklahoma

DAPHNE ART & FRAME GALLERY, INC., 16 W. 2nd St., Sand Springs OK 74063. (918)245-8005. President: Bill Loyd. Retail gallery. Estab. 1969. Represents 100 established artists. Interested in seeing the work of emerging artists. Exhibited artists include G. Harvey and Troy Anderson. Sponsors 2 shows/year. Average display time 3 months. Open all year. Located downtown; 800 sq. ft.; gallery has "plenty of light and wonderful customer relations." 75% of space for special exhibitions. 5% private collectors. Overall price range: $50-1,000; most work sold at $200.

Media: Considers oil, acrylic, watercolor, pastel; etchings, lithographs, serigraphs and posters.

Style: Exhibits expressionism, neo-expressionism, surrealism, post modern works and realism. Genres include landscapes, florals, Americana, Southwestern, Western and wildlife. Prefers landscapes, florals and Western/Indian.

Terms: Accepts work on consignment (40% commission); or buys outright for 50% of the retail price. Retail price set by the gallery. Gallery provides insurance and promotion; shipping costs are shared. Prefers artwork unframed.

Submissions: Send query letter with resume, slides or photographs. Write to schedule an appointment to show a portfolio, which should include slides or photographs. Replies in 3 weeks. Files letters and resumes.

Tips: "Don't just walk in—make an appointment."

THE FRAMESMITH GALLERY, 6528-E East 101st St., Tulsa OK 74133. (918)299-6863. Owner: Bob D. McDaniel. Retail gallery, wholesale gallery, art consultancy and consignment gallery. Estab. 1983. Represents 30 emerging, mid-career and established artists. Exhibited artists include S.S. Burris and Troy Anderson. Sponsors 4 shows/year. Average display time 6 months. Open all year. Located in suburbs; 1,500 sq. ft. 33% of space for special exhibitions. Clientele: commercial/walk-in. 2% private collectors, 10% corporate clients. Overall price range: $400-10,000.

Media: Considers oil, acrylic, watercolor, pastel, pen & ink, drawings, mixed media, works on paper, sculpture, glass, installation and photography. Prefers watercolor, oil and pen & ink.

Style: Exhibits all styles. Genres include landscapes, florals, Americana, Southwestern, Western, wildlife, portraits and figurative work. Prefers landscapes, figurative works and western/wildlife.

Terms: Artwork is accepted on consignment and there is a 33% commission. Retail price set by the artist. Gallery provides insurance and promotion. Artist pays for shipping. Prefers framed artwork.

Submissions: Send query letter with resume, slides and photographs. Call or write to schedule an appointment to show a portfolio. Portfolio should include originals, slides and photographs. Replies only if interested within 1 month.

Tips: "Class 'A' neighborhood ($50,000 and up) and very, very conservative." Notices a "return to classical and impressionistic styles."

GUSTAFSON GALLERY, 9606 N. May, Oklahoma City OK 73120. (405)751-8466. President: Diane. Retail gallery. Estab. 1973. Represents 10 mid-career artists. Exhibited artists include D. Norris Moses and Downey Burns. Sponsors 1 show/year. Average display time 2 months. Open all year. Located in a suburban mall; 1,700 sq. ft. 100% of space for special exhibitions. Clientele: upper and middle income. 60% private collectors, 40% corporate collectors. Prefers contemporary Southwestern art. Overall price range: $4,000 minimum.

Media: Considers oil, acrylic, pastel, mixed media, collage, works on paper, sculpture, ceramic and fiber. Considers offset reproductions, lithographs, posters and serigraphs. Most frequently exhibits acrylic, pastel and serigraphs.

Style: Exhibits primitivism and painterly abstraction. Genres include landscapes, Southwestern and Western.

Terms: Artwork is accepted on consignment (40% commission); or buys outright for 50% of the retail price; net 30 days. Retail price set by the the artist. Gallery provides promotion. Shipping costs are shared.

Submissions: Send query letter with resume, brochure, photographs, business card and reviews. Call to schedule an appointment to show a portfolio, which should include originals and photographs. Replies in 1 month.

PLAINS INDIANS & PIONEERS MUSEUM, 2009 Williams Ave., Woodward OK 73801. (405)256-6136. Director: Frankie Herzer. Museum. Estab. 1966. Represents 4 artists. Sponsors 10 shows/year. Average display time 1 month. Open all year. Located on Highway 270 across from post office; 5,000 sq. ft. 75% of space for special exhibitions.

Terms: Accepts work on consignment (20% commission). Retail price set by the artist. Gallery provides promotion; artist pays for shipping. Prefers artwork framed.

Submissions: Send query letter with resume and slides. Call or write to schedule an appointment to show a portfolio, which should include photographs. Replies in 2 weeks. Files resumes.

Tips: "Call for an appointment for originals or slides to be considered by director."

THE UNIVERSITY OF OKLAHOMA MUSEUM OF ART, 410 W. Boyd St., Norman OK 73019-0525. (405)325-3272. Director: Tom Toperzer. Museum. Estab. 1936. Represents 10 emerging, mid-career and established artists/year. Exhibited artists include Carolyn Brady and Joseph Glasco. Sponsors 10 shows/year. Average display time 4-6 weeks. Open all year. Located on campus; 13,600 sq. ft.

Media: Considers oil, acrylic, watercolor, pastel, pen & ink, drawings, mixed media, collage, works on paper, sculpture, ceramic, craft, fiber, glass, installation, photography, original handpulled prints, woodcuts, engravings, lithographs, pochoir, posters, wood engravings, mezzotints, serigraphs, linocuts and etchings. Most frequently exhibits paintings, drawings/prints and photographs.

Style: Exhibits all styles and genres.

Terms: Gallery provides insurance and promotion. Prefers framed artwork.

Submissions: Send query letter with resume, slides and bio. Files slides and bio.

THE WINDMILL GALLERY, Suite 103, 3750 W. Robinson, Norman OK 73072. (405)321-7900. Director: Pam Jacene. Retail gallery. Estab. 1987. Represents 20 emerging, mid-career and established artists. Exhibited artists include Rance Hood and Doc Tate Neuaquaya. Sponsors 4 shows/year. Average display time 1 month. Open all year. Located in northwest Norman (Brookhaven area); 900 sq. ft.; interior decorated Santa Fe style: striped aspen, adobe brick, etc. 30% of space for special exhibitions. Clientele: "middle-class to upper middle-class professionals/housewives." 100% private collectors. Overall price range $50-15,000; most artwork sold at $100-2,000.

Media: Considers oil, acrylic, watercolor, pastel, pen & ink, drawings, mixed media, works on paper, sculpture and craft. Considers original handpulled prints, offset reproductions, lithographs, posters, cast-paper and serigraphs. Most frequently exhibits watercolor, tempera and acrylic.
Style: Exhibits primitivism and realism. Genres include landscapes, Southwestern, Western, wildlife and portraits. Prefers Native American scenes, portraits and Western-Southwestern and desert subjects.
Terms: Artwork is accepted on consignment (40% commission). Retail price set by the artist. Gallery provides insurance and promotion. Shipping costs are shared. Prefers framed artwork.
Submissions: Send query letter with slides, bio, brochure, photographs, SASE, business card and reviews. Call to schedule an appointment to show a portfolio. Portfolio should include "whatever best shows their works." Replies only if interested within 1 month. Files brochures, slides, photos, etc.
Tips: Accepts artists from Oklahoma area; Indian art done by Indians only; Western and Southwestern art can be done by Anglo artists. "Call, tell me about yourself, try to set up appointment to view works or to hang your works as featured artist. Fairly casual—but must have bios and photos of works or works themselves! Please, no drop-ins!"

Oregon

BLACKFISH GALLERY, 420 NW 9th Ave., Portland OR 97209. (503)224-2634. Director: Cheryl Snow. Retail cooperative gallery. Estab. 1979. Represents 24 artists; emerging and mid-career. Exhibited artists include Barry Pelzner and Helen Issifu. Sponsors 12 shows/year. Open all year. Located downtown, in the "Northwest Pearl District; 2,500 sq. ft.; street-level, 'garage-type' overhead wide door, long, open space (100' deep)." 70% of space for feature exhibits, 15-20% for gallery artists. Clientele: 80% private collectors, 20% corporate clients. Overall price range: $250-12,000; most artwork sold at $900-1,400.
Media: Considers oil, acrylic, watercolor, pastel, pen & ink, drawings, mixed media, collage, sculpture, ceramic, photography, original handpulled prints, woodcuts, wood engravings, linocuts, engravings, mezzotints, etchings, lithographs, pochoir and serigraphs. Most frequently exhibits paintings, sculpture and prints.
Style: Exhibits expressionism, neo-expressionism, painterly abstraction, surrealism, conceptualism, minimalism, color field, post modern works, impressionism and realism. Prefers neo-expressionism, conceptualism and painterly abstraction.
Terms: Accepts work on consignment from invited artists (50% commission); co-op membership includes monthly dues fee plus donation of time (40% commission on sales). Retail price set by the artist, with assistance from gallery on request. Gallery provides insurance, promotion, contract and shipping costs from gallery. Prefers framed artwork.
Submissions: Accepts only artists from northwest Oregon and southwest Washington ("unique exceptions possible"); "must be willing to be an active cooperative member—write for details." Send query letter with resume, slides, SASE, reviews and statement of intent. Write to schedule an appointment to show a portfolio, which should include photographs and slides. "We review 4 times/year." Replies in 1 month. Files material only if exhibit invitation extended.
Tips: "Research first—know who you're approaching!"

WILSON W. CLARK MEMORIAL LIBRARY GALLERY, 5000 N. Willamette Blvd., Portland OR 97203-5798. (503)283-7111. Director: Joseph P. Browne. Nonprofit gallery. Estab. 1959. Clientele: students and faculty. Sponsors 7 solo and 4 group shows/year. Average display time is 1 month. Interested in emerging and established artists. Overall price range: $75-750.
Media: Considers oil, acrylic, watercolor, pastel, pen & ink, drawings, mixed media, collage, photography and prints. Most frequently exhibits watercolor, acrylics and mixed media.
Style: Exhibits all styles and genres. "We are strictly an adjunct to the university library and have sold only one work in the past eight or ten years."
Terms: Accepts work on consignment (10% commission). Retail price is set by artist. Exclusive area representation not required. Gallery provides insurance and promotion.
Submissions: Send query letter, resume, brochure and photographs. Write for an appointment to show a portfolio, which should include photographs.

COGLEY ART CENTER, 4035 S. 6th St., Klamath Falls OR 97603. (503)884-8699. Owner/Manager: Sue Cogley. Retail gallery. Estab. 1985. Represents 17 artists; emerging and mid-career. Exhibited artists include Katheryn Davis, Guy Pederson and Stacy Smith Rowe. Sponsors 10-12 shows/year. Average display time 1 month. Open all year. Located in a suburban area on the main business street; 800 sq. ft.; "contemporary in feeling—all wall space (no windows), movable panels and track lighting." 25% of space for special exhibitions, 75% for gallery artists. Clientele: middle to upper end. 100% private collectors. Overall price range: $150-1,500; most artwork sold at $300-800.
Media: Considers oil, acrylic, watercolor, pastel, pen & ink, drawings, mixed media, collage, works on paper, sculpture, ceramic, fiber, glass, mosaic, original handpulled prints, woodcuts, etchings and serigraphs. Most frequently exhibits watercolor, oil, monotype and glass.

Style: Exhibits all styles, "leaning toward contemporary." Prefers impressionism, painterly abstraction and realism.

Terms: Accepts work on consignment (40% commission). Retail price set by the artist. Gallery provides insurance, promotion and contract. Gallery pays for shipping costs from gallery; artist pays for shipping to gallery. Prefers framed artwork, "but we can work with unframed."

Submissions: Prefers Oregon and Northwest artists. Send query letter with current bio and photographs or slides (a minimum of 3 pieces) and SASE. Call to schedule an appointment to show a portfolio, which should include originals and slides. Replies in 1-2 weeks. Files bio and photos of artists "which we may be interested in in the future."

LANE COMMUNITY COLLEGE ART GALLERY, 4000 E. 30th Ave., Eugene OR 97405. (503)747-4501. Gallery Director: Harold Hoy. Nonprofit gallery. Estab. 1970. Sponsors 7 solo and 2 group shows/year. Average display time is 3 weeks. Interested in emerging, mid-career and established artists. Most artwork sold at $100-1,500.

Media: Considers all media.

Style: Exhibits contemporary works.

Terms: Retail price is set by artist. Exclusive area representation not required. Gallery provides insurance, promotion and contract; shipping costs are shared. "We retain 25% of the retail price on works sold."

Submissions: Send query letter, resume and slides with SASE. Resumes are filed.

LAWRENCE GALLERY, Box 187, Sheridan OR 97378. (503)843-3633. Director: Anna Eason. Retail gallery and art consultancy. Estab. 1977. Clientele: tourists, Portland and Salem residents; 80% private collectors, 20% corporate clients. Represents 150 artists. Sponsors 7 two-person and 1 group shows/year. "We are developing a landscaped sculpture garden adjacent to the gallery building." Interested in emerging, mid-career and established artists. Overall price range: $10-10,000; most artwork sold at $250-1,500.

Media: Considers oil, acrylic, watercolor, pastel, pen & ink, drawings, mixed media, collage, sculpture, ceramic, fiber, glass, jewelry and original handpulled prints. Most frequently exhibits oil, watercolor, metal sculpture and ceramic.

Style: Exhibits painterly abstraction, impressionism, photorealism and realism. Genres include landscapes, florals and Americana. "Our gallery features beautiful art-pieces that celebrate life."

Terms: Accepts work on consignment (50% commission). Retail price is set by artist. Exclusive area representation required. Gallery provides insurance, promotion and contract; artist pays for shipping.

Submissions: Send query letter, resume, brochure, slides and photographs. Write for an appointment to show a portfolio. Resumes, photos of work, newspaper articles, other informative pieces and artist's statement about his work are filed.

Tips: "Do not bring work without an appointment. Do not want to see colored mattes and elaborate frames on paintings."

LITTMAN GALLERY, Box 751, Portland OR 97207-0751. (503)725-4452. Contact: Gallery Director. Nonprofit gallery. Estab. 1968. Represents emerging, mid-career and established artists. Sponsors 7 shows/year. Average display time 1 month. Not open all year. Located downtown; 1,500 sq. ft.; wood floors, 18 ft. 11 in. running window space. 100% of space for special exhibitions. Overall price range: $300-15,000; most work sold at $300-600.

Media: Considers all media and performance art; all types of prints. Most frequently exhibits mixed media, oil and sculpture.

Style: Exhibits all styles and genres. Prefers abstraction, surrealism and conceptualism.

Terms: Retail price set by the artist. Gallery provides insurance and promotion; shipping costs are shared. Prefers artwork framed.

Submissions: Send query letter, resume, slides and bio. Write to schedule an appointment to show a portfolio, which should include originals, slides and photographs. Replies in 1 month. Files all information.

Tips: "We are a nonprofit university gallery which looks specifically for educational and innovative work."

MAVEETY GALLERY, Suite 508, 1314 NW Irving Ave., Portland OR 97209. (503)224-9442. Director: Billye Turner. Retail gallery and art consultancy. Estab. 1982. Clientele: corporate, tourists and collectors; 50% private collectors, 50% corporate clients. Represents 75 artists. Interested in seeing the work of emerging, mid-career and established artists. Sponsors 11 solo and 1 group shows/year. Average display time is 1 month. "Special shows monthly, always revolving work." Overall price range: $200-10,000; most artwork sold at $1,000-3,000.

Media: Considers oil, acrylic, watercolor, pastel, pen & ink, drawings, mixed media, collage, works on paper, sculpture, ceramic, fiber, glass, photography and original handpulled prints. Most frequently exhibits oils, acrylics, ceramics and glass.

Style: Exhibits painterly abstraction, impressionism and photorealism. Genres include landscapes and figurative work.
Terms: Accepts work on consignment (50% commission). Retail price is set by gallery and artist. Exclusive area representation required. Gallery provides insurance, promotion and contract; artist pays for shipping.
Submissions: Send query letter, slides and photographs. Call to schedule an appointment to show a portfolio, which should include originals, slides and transparencies. All material is filed.
Tips: Feels there is a "movement toward more representative work."

NORTHVIEW GALLERY, 12000 SW 49th, Portland OR 97219. (503)244-6111. Director: Hugh Webb. Nonprofit gallery. Sponsors 6-8 shows/year. Average display time 4 weeks. Interested in emerging and established artists. Overall price range: $100-3,000; most artwork sold at $100-600.
Media: Considers oil, acrylic, watercolor, pastel, pen & ink, drawings, mixed media, collage, sculpture, ceramic, craft, fiber, glass, installation, photography, color and b&w original handpulled prints and posters.
Style: Exhibits all styles and genres. Does not want to see "work done under supervision—calligraphy."
Terms: Accepts work on consignment; no commission. Retail price is set by artist. Exclusive area representation not required. Gallery provides insurance, promotion and contract; shipping costs are shared.
Submissions: Send query letter with resume, slides, photograph and SASE by April 1. Selections for next academic year made in May.
Tips: Looks for a "strong sense of individual direction."

***QUARTERSAW GALLERY,** 528 NW 12th Ave., Portland OR 97209. (503)223-2264. Partner/Director: Victoria Frey. Retail gallery. Estab. 1984. Represents 20 artists; emerging and mid-career. Exhibited artists include Mary Josephson and Thomas Prochaska. Sponsors 12 shows/year. Open all year. Located north of downtown arts district—the "Pearl District"; 2,500 sq. ft. 5-15% of space for special exhibitions. 85-90% private collectors, 10-15% corporate collectors.
Media: Considers oil, pen & ink, paper, acrylic, drawing, sculpture, watercolor, mixed media, pastel, collage and photography. Most frequently exhibits acrylic/oil painting, monoprints and sculpture.
Style: Exhibits expressionism, neo-expressionism and painterly abstraction. Prefers figurative abstract and expressive abstract.
Terms: Accepts work on consignment (50% commission). Retail price set by the gallery and the artist. Gallery provides insurance, promotion and contract; artist pays for shipping. Prefers artwork framed or unframed.
Submissions: Send query letter with resume, slides and SASE. Replies in 2-5 weeks.

ROGUE GALLERY, 40 S. Bartlett, Medford OR 97501. (503)772-8118. Director: D. Elizabeth Withers. Assistant Director: Louise Abel Curtis. Nonprofit sales and rental gallery. Estab. 1960. Clientele: valley residents and tourists; 95% private collectors, 5% corporate clients. Represents 375 artists. Main gallery sponsors 12 exhibits/year; "rental gallery changes bimonthly." Average display time is 3 months. Interested in emerging, mid-career and established artists. Overall price range in rental shop: $50-1,200; most work sold at $300-600.
Media: Considers all media and original handpulled prints.
Style: Exhibits all styles and genres, "especially cutting-edge work."
Terms: Accepts work on consignment (35% commission) in rental gallery. Retail price is set by artist. Exclusive area representation not required. Gallery provides insurance and promotion; artist pays for shipping.
Submissions: Send resume and slides. Call or write to schedule an appointment to show a portfolio, which should include originals, slides and transparencies. Resumes are filed; slides are returned.
Tips: Likes to see a "wide variety of techniques, styles, etc." Sees trend toward "monotypes Southwest, regional and figurative" work. A mistake artists commonly make is "poor matting and framing."

Pennsylvania

ALBER GALLERIES, Suite 5111, 3300 Darby Rd., Harverford PA 19041. (215)732-0474. Owner: Howard Alber. Wholesale gallery/art consultancy. Clientele: 20% private collectors, 80% corporate clients. Represents 30 artists. Interested in emerging, mid-career and established artists. Overall price range: $25-10,000; most artwork sold at $150-800.
Media: Considers oil, acrylic, watercolor, pastel, pen & ink, drawings, mixed media, collage, works on paper, sculpture, fiber, photography, woodcuts, wood engravings, linocuts, engravings, mezzotints, etchings, lithographs and serigraphs.
Style: Exhibits impressionism, realism, photorealism, minimalism, color field, painterly abstraction, conceptualism. Considers all styles. Genres include landscapes, Americana and figurative work. Prefers sculpture, illustration, print editions or photographs for the slide registry. "Today, we're a major contributor to the sales and rental gallery of the Philadelphia Museum of Art."

Terms: Accepts work on consignment (40% commission). Retail price set by gallery and artist. Exclusive area representation not required. Gallery provides some insurance and some promotion. Shipping costs are shared.

Submissions: Send query letter with resume, slides, SASE, brochure, price and bio. Replies in 3 weeks.

ART INSTITUTE OF PHILADELPHIA, 1622 Chestnut St., Philadelphia PA 19103. (215)567-7080. Gallery Coordinator: Sandra L. Kelly. School gallery. Estab. 1981. Clientele: 50% private collectors, 50% corporate clients. Sponsors 2 solo and 10 group shows/year. Average display time 1 month. Interested in established artists. "We would like artwork to be educational and of interest for our students." Overall price range: $200-1,500.

Media: Considers oil, acrylic, watercolor, pastel, pen & ink, drawings, mixed media, collage, works on paper, photography and lithographs. Most frequently exhibits watercolor, graphics, photography and illustration.

Style: Exhibits impressionism, realism, photorealism and photography. Genres include landscapes, florals, wildlife and portraits. Prefers landscapes, graphics, and illustration. "Our gallery was established as an educational tool for our students. We also are concerned with the community at large. We hope to bring them informative and enlightening exhibits. We deal in many Philadelphia organizations such as the Philadelphia Watercolor Club, Art Alliance, American Institute of Graphic Arts, Interior Design Council, Color Print Society, etc."

Terms: Retail price set by artist. Exclusive area representation not required. Gallery provides insurance. Prefers artwork framed.

Submissions: Send query letter with slides, brochure, and photographs. Schedule a meeting if possible. Artists should call to schedule an appointment to show a portfolio, which should include slides and photographs. Replies in 2 weeks.

Tips: "Artists need to call six months to one year in advance."

***JOY BERMAN GALLERIES,** 2201 Pennsylvania Ave., Philadelphia PA 19130. (215)854-8166. President: Joy Berman. Retail gallery and art consultancy. Estab. 1985. Represents 80 artists; emerging, mid-career and established. Sponsors 7 shows/year. Average display time 6 weeks. Open all year. Located in art museum area; 2,500 sq. ft. 60% of space for special exhibitions. Includes 2 separate galleries, the main gallery in Suite 901 and a lobby level gallery. Clientele: corporate and residential. 50% private collectors, 50% corporate collectors. Overall price range: $500-10,000; most work sold at $1,500-4,000.

Media: Considers oil, pen & ink, acrylic, drawing, sculpture, watercolor, mixed media, ceramic, pastel and collage; original handpulled prints, woodcuts, wood engravings, linocuts, engravings, mezzotints, etchings, lithographs and serigraphs. Most frequently exhibits oil, acrylic and pastel.

Style: Exhibits expressionism, painterly abstraction, surrealism, conceptualism, impressionism, realism and hard-edge geometric abstraction. All genres. Prefers landscapes, abstract and Philadelphia cityscapes and landscapes.

Terms: Accepts work on consignment (50% commission). Retail price set by the gallery. Gallery provides insurance and promotion; artist pays for shipping. Prefers artwork framed.

Submissions: Send query letter with resume, slides, bio and SASE. Write to schedule an appointment to show a portfolio, which should include originals and transparencies. Replies in 1 month. Files resumes.

Tips: "All slides must be labeled with size and title, and send a retail/artist price list—we're looking for artists with commitment."

CIRCLE GALLERY, 5416 Walnut St., Pittsburgh PA 15232. (412)687-1336. Director: Kelly Thompson. Retail gallery. Estab. 1972. Located on a village shopping street. Clientele: 70% private collectors, 30% corporate clients. Represents 250 artists. Sponsors 8-10 solo and 1-2 group shows/year. Average display time 2 weeks. Interested in established artists. Overall price range: $150-125,000; most artwork sold at $700-1,500.

Media: Considers oil, watercolor, pastel, pen & ink, drawings, collage, works on paper, sculpture, fiber, glass, woodcuts, wood engravings, engravings, etchings, lithographs and serigraphs. Most frequently exhibits lithographs, oil paintings and sculpture.

Style: Exhibits impressionism, expressionism, primitivism, painterly abstraction, conceptualism and hard-edge geometric abstraction. Genres include landscapes, florals, portraits and figurative work. Prefers figurative work, landscapes and conceptualism. "We represent established artists—artists whose work we have at some time published usually, e.g. Rockwell, Erté and Vasarely. We contract with artists such as Calman Shemi and Marcel Salinas to represent them in the States and so we carry their originals and lithographs (if applicable)."

Terms: Accepts work on consignment (1% commission). Retail price set by gallery. Exclusive area representation required. Gallery provides promotion, contract and shipping costs from gallery. Prefers framed artwork.

Submissions: "Contact Jack Solomon, chairman, Circle Fine Art Corporation, Suite 3160, 875 N. Michigan Avenue, Chicago IL 60611."

Close-up

Jody dePew McLeane
Artist
Eden Prairie, Minnesota

"If you're interested in working with a gallery," warns artist Jody dePew McLeane, "you must first educate yourself about it and then carefully scrutinize the gallery." Take the time, she says, to visit the gallery and ask a lot of questions. "One disadvantage to working with a gallery, especially one not in your own community, is you have very little control over what happens to your work once you leave."

© Barbara Kelley 1991

McLeane has had her share of bad experiences and has heard several horror stories from other artists. "Unfortunately, bad experiences with galleries are not that unusual. Although you should be paid on the spot, some galleries can hold onto checks for several months. I've even heard of artists whose work was sold and weren't told about it until they asked where a painting was."

By all means, ask around, she says. "You can be bombarded with requests from galleries, and you have no idea of their professional reputation." Ask for a list of artists represented, and feel free to contact them about their experience with the gallery, she says. Most artists, she feels, are willing to give you an assessment of the treatment they've received. MacLeane believes word-of-mouth is an important source of inside information on galleries.

Visit and talk to the people working there. But don't just look at the work hanging on the walls, she advises. What is currently exhibited may not be truly representative of the gallery's philosophy. "This can be misleading. For example, most of my work is done in a traditional style, but the work I exhibit in a gallery show might be much different." It's better, she says, to look at the *quality* of the work presented rather than the style.

Get to know the gallery staff, says McLeane. "The way I see it, each piece of work I do is a part of *me*, and I like to know just who is representing this. Having a personal relationship with the gallery is as important as it is in anything else—if they know you, they'll have a better feel for you and your work. Don't badger them, but do make yourself known."

Despite her caution, McLeane says finding and working with a really good gallery can do a lot of wonderful things for you. Following her own advice, she selected and has been with the Katie Gingrass Gallery in Milwaukee and Walnut Creek, California for seven years. "She (Katie Gingrass) is the most professional person I've worked with. She's put my work in front of a lot of notable collectors. I recently got a wonderful commission through the gallery. Stouffers commissioned me to do several works for their restaurants in Chicago and other areas. This is the type of thing a good gallery can do for you. The marketing to large, important clients would be very hard to do on my own." McLeane is also working with a gallery in Bethesda, Maryland and is considering one in Tulsa, Oklahoma.

McLeane has been showing and selling her work for 22 years. She works in pastels and has developed a painterly effect by layering very soft French- or German-made pastels. "Because of the nature of the pastels, my work has changed so much over the years. My work used to be very drawing-like. You could see each individual stroke. The softer pastels diffuse into each other, making the work highly textured and much softer."

She used to do landscapes, but now much of her work is either of people or interiors. McLeane does not work from models but instead takes her camera wherever she goes. "I take candid shots with a zoom lens. It serves as a shorthand to help me capture and remember images. It's very personal work, not really very corporate-oriented. That's why I like working with juried shows." Unlike galleries, shows allow you to meet your buyers and get instant—and personal—feedback, she explains.

Although she sold only through galleries at the beginning of her career, McLeane now sells about half her work through shows. She limits her participation to "top-drawer, high-quality shows" and finds the overall level of quality going up each year.

Shows require a time commitment, says McLeane, and in coming years she may cut down on the number of shows she does each year. Yet she plans to continue working everyday in her studio. "I can't think of anything else I'd rather be doing. I've always drawn and I can't go a long time without working."

With a degree in art, McLeane had planned to teach, but she is "forever grateful" to the head of her art department who told her she should "just draw." She began working seriously on her art after her oldest daughter turned two but moved into her own studio only about five years ago. "Since I've been in my studio I've been more productive. When the work is going well, I feel so good, so enthusiastic. When things are not coming as fast, I can always work on matting or on paperwork. I find I get a lot more done in my own space.

"I love the freedom," she says. To other artists, she says "you can make a living without selling out. You can keep your integrity and be your own boss. It takes a little hard work, but you can do it."

—Robin Gee

The way in which McLeane's quick, bold pastel strokes create a painterly appearance is shown in Two Waiters/Sun. McLeane exaggerates colors and values and only suggests details because she is more interested in creating mood than realistic rendition.
Reprinted with permission of Jody dePew McLeane.

CONCEPT ART GALLERY, 1031 S. Braddock Ave., Pittsburgh PA 15218. (412)242-9200. Director: Sam Berkovitz. Retail gallery. Estab. 1972. Clientele: 50% private collectors, 50% corporate clients. Represents 40 artists. Sponsors 4 solo and 4 group shows/year. Average display time is 1 month. Interested in established artists. Overall price range: $50-25,000; most artwork sold at $300-1,000.
Media: Considers oil, acrylic, watercolor, pastel, pen & ink, drawings, mixed media, collage, works on paper, sculpture, ceramic, craft, fiber, glass and limited edition original handpulled prints. Most frequently exhibits watercolor, prints and paintings.
Style: Exhibits geometric abstraction, color field, painterly abstraction, impressionistic, photorealistic, expressionistic and neo-expressionistic works. Genres include landscapes and florals, 19th century European and American paintings.
Terms: Accepts work on consignment (25-50% commission) or buys outright. Retail price is set by gallery. Exclusive area representation required. Gallery provides insurance and promotion; shipping costs are shared.
Submissions: Send query letter with resume, brochure, slides, photographs and SASE. Slides and biographies are filed.

DREXEL UNIVERSITY DESIGN ARTS GALLERY, Dept. of Interiors and Graphic Design, Philadelphia PA 19104. (215)895-2390. Gallery Coordinators: Lydia Hunn and Roberta Gruber. Nonprofit gallery. Clientele: students, artists and Philadelphia community. Sponsors 7 solo and 2 group shows/year. Display time 1 month.
Media: Considers oil, acrylic, watercolor, pastel, pen & ink, drawings, mixed media, collage, works on paper, sculpture, ceramic, craft, fiber, glass, installation and photography.
Style: Exhibits all styles and genres. Prefers narrative, political and design oriented work. "Our gallery is a teaching tool for a design arts gallery whose students are instructed in visual communication. Our shows are designed to be the best examples of these categories."
Terms: Exclusive area representation not required. Gallery provides insurance and promotion. Prefers artwork framed.
Submissions: Send query letter with resume, brochure, slides and SASE. Write to schedule an appointment to show a portfolio, which should include slides. Replies only if interested within 1 month. Files resumes. All material is returned if not accepted or under consideration.

PEARL FOX GALLERY, 103 Windsor Ave., Melrose Park PA 19126. (215)635-4586. Owner: Pearl Fox. Retail gallery. Estab. 1948. Clientele: individuals, schools, builders and other corporations. Represents 22 artists. Sponsors 3 solo and 3 group shows/year. Average display time is 2 weeks. Interested in emerging, mid-career and "principally" established artists.
Media: Considers oil, acrylic, watercolor, pastel, pen & ink, drawings, mixed media, collage, works on paper, sculpture, ceramic, craft, fiber, glass and jewelry. Most frequently exhibits oil, polymer tempera and watercolor.
Style: Exhibits hard-edge geometric abstraction, painterly abstraction, primitivism, impressionism, realism and surrealism. Genres include landscapes, florals, portraits, figurative work and fantasy illustration. Most frequently exhibits realism, surrealism and abstraction. Wants museum-quality work.
Terms: Accepts work on consignment (40% commission). Retail price is set by gallery or artist. Exclusive area representation required. Gallery provides insurance, promotion and contract; shipping costs are shared.
Submissions: Send query letter with resume, photographs and SASE. Call to schedule an appointment to show a portfolio, which should include originals. Resumes, catalogs, reviews and photographs are filed.

GALLERY G, 211 9th St., Pittsburgh PA 15222. (412)562-0912. Director: Carol Siegel. Retail gallery and "art resource for design trade." Estab. 1974. Clientele: corporate and commercial, 25% private collectors, 75% corporate clients. Represents 83 artists. Sponsors 2 solo and 2 group shows/year. Interested in mid-career and established artists. Overall price range: $90-10,000; most artwork sold at $500-800.
Media: Considers oil, acrylic, watercolor, pastel, drawings, mixed media, collage, works on paper, sculpture, ceramic, craft, fiber, glass, egg tempera, woodcuts, wood engravings, linocuts, engravings, mezzotints, etchings, lithographs, serigraphs, offset reproductions and posters. Most frequently exhibits oil/acrylic painting, sculpture and handmade paper.
Style: Exhibits impressionism, expressionism, neo-expressionism, realism, photorealism, minimalism, primitivism, color field, painterly abstraction, conceptualism, post modern works, imagism, pattern painting and hard-edge geometric abstraction; considers all styles. Genres include landscapes, florals, Americana, wildlife and figurative work; considers all genres. Prefers realism, impressionism and color field.
Terms: Accepts work on consignment (40% commission) or buys outright (50% retail price; net 30 days). Retail price set by artist. Exclusive area representation required, 150 mile radius. Gallery provides insurance, promotion, contract and shipping from gallery. Prefers framed artwork.
Submissions: Send query letter with resume, brochure, slides, photographs, bio and SASE. Write to schedule an appointment to show a portfolio, which should include complete slide portfolio, transparencies, photographs, "bio and other info." Replies in 3 months. Files materials only of artists accepted for representation. All material is returned if not accepted or under consideration.

Tips: "We are a resource for the design/contract design industry. We are located in the cultural district in the heart of downtown. We show mainly work of established, well-known artists."

***THE GALLERY SHOP AT ABINGTON ART CENTER**, 515 Meetinghouse Rd., Jenkintown PA 19046. (215)887-4882. Gallery Shop Coordinator: Marian Emery. Retail store. Exhibits 100-200 artists; emerging, mid-career and established. Exhibited artists include Robin Desmond Brown, Wolf Dosch. Average display time 3 months. Open all year. 20×30′. Clientele: students of AAC and residents of town.
Media: Considers ceramic, contemporary craft and glass. Most frequently exhibits jewelry and pottery.
Terms: Accepts work on consignment (40% commission) or buys outright for 50% of retail price. Retail price set by the artist. Shipping costs are shared on consignment work.
Submissions: Send query letter with resume, slides, bio, photographs, SASE and business card. Call or write to schedule an appointment to show a portfolio. Portfolio should include photographs and slides. Replies only if interested.

LEN GARON ART STUDIOS, 1742 Valley Greene Rd., Paoli PA 19301. (215)296-3481. Director of Marketing: Phil Hahn. Wholesale gallery. Estab. 1982. Represents 21 emerging, mid-career and established artists. Exhibited artists include Len Garon and Anna Chen. "I sell previously published prints, lithographs, etchings, etc., plus test market original paintings prior to printing the image to press image." Clientele: galleries, frameshops, designers and furniture stores. Most artwork sold at $50-3,500.
Media: Considers original handpulled prints, offset reproductions, woodcuts, lithographs, posters, mezzotints, serigraphs and etchings and original paintings.
Style: Exhibits, expressionism, painterly abstraction, impressionism and realism. Genres include landscapes, florals, Americana, Southwestern, Western, wildlife and figurative work. Prefers landscapes, florals and Americana. Not interested in avante-garde.
Terms: "I sell from samples, then purchase outright." Retail price set by the artist. Gallery pays for shipping costs from gallery. Prefers unframed but matted artwork.
Submissions: Send query letter with photographs, SASE, reviews and samples of prints. Write to schedule an appointment to show a portfolio. Portfolio should include slides, photographs and samples of prints. Replies in 2 weeks.
Tips: "Send prints that are most commercially salable. Painting with the color trends helps sell work to the 3 markets: corporate art, home interior art (decorative) and investor and collectable art."

GROSS MCCLEAF GALLERY, 127 S. 16th St., Philadelphia PA 19102. (215)665-8138. President: Estelle Gross. Retail gallery. Estab. 1969. Represents 40 artists; established. Interested in seeing the work of emerging artists. Sponsors 9 shows/year. Average display time 3 weeks. Open all year. Located in downtown Philadelphia: 1,400 sq. ft. Clientele: 50% private collectors, 50% corporate clients. Overall price range: $300-10,000; most artwork sold at $2,000.
Media: Considers oil, acrylic, watercolor, pastel, mixed media, collage, and sculpture. No photography.
Style: Prefers painterly realism.
Terms: Accepts work on consignment (50% commission). Retail price set by gallery and artist. Gallery provides insurance, promotion and contract. Artist pays for shipping. Prefers framed artwork.
Submissions: Send query letter with resume, slides, bio and SASE. Write to schedule an appointment to show a portfolio, which should include originals. Replies immediately. Files "slides and resumes in which we have an interest."
Tips: "Visit the gallery first!"

***THE HAHN GALLERY**, 8439 Germantown Ave., Philadelphia PA 19118. (215)247-8439. Director: Roslyn Hahn. Retail gallery. Estab. 1975. Represents 50 artists; emerging, mid-career and established. Sponsors 19-22 shows/year. Average display time 3 weeks. Open all year. Located on main suburban street; 1800 sq. ft. 90% of space for special exhibitions. 80% private collectors. Overall price range: $500-3,500; most work sold at $1,000 or under.
Media: Considers oil, acrylic, watercolor, pastel, mixed media, collage, paper, sculpture, ceramic, craft, fiber, glass and photography; original handpulled prints, woodcuts, engravings, lithographs, pochoir, wood engravings, linocuts, mezzotints, etchings and serigraphs. Most frequently exhibits oil, watercolor and lithographs.
Style: Exhibits painterly abstraction, impressionism and realism. Genres include landscapes, florals and figurative work.
Terms: Accepts work on consignment (50% commission). Retail price set by the gallery and the artist. Gallery provides insurance and promotion. Shipping costs are shared.
Submissions: Send query letter with resume, slides or photographs. Call or write to schedule an appointment to show a portfolio. Portfolio should include originals, photographs and slides. Replies as soon as possible.
Tips: "Visit our gallery first, if possible, to see what we feature."

***INTERNATIONAL IMAGES, LTD.**, The Flatiron Building, 514 Beaver St., Sewickley PA 15143. (412)741-3036. Retail gallery. Estab. 1978. Clientele: 90% private collectors; 10% corporate clients. Represents 100 artists, emerging, mid-career and established; primarily Soviet. Sponsors 8 solo shows/year. Average display time: 4-6 weeks. Overall price range: $150-150,000; most work sold at $10,000-65,000.

Media: Considers oils, watercolors, pastels, pen & ink, drawings and original handpulled prints. Most frequently exhibits oils, watercolors and works on paper.

Style: Exhibits all styles. Genres include landscapes, florals and portraits. Prefers abstraction, realism and figurative works. "International Images was founded in 1978 by Elena Kornetchuk. She was the first gallery to import Soviet Art, with an exclusive contract with the U.S.S.R. In 1986, she began to import Bulgarian art as well and has expanded to handle several countries in Europe and South America as well as the basic emphasis on Eastern block countries. She travels 2-6 times/year to Eastern Europe. International Images sponsors numerous shows each year throughout the country in galleries, museums, universities and conferences, as well as featuring our own shows every four to six weeks."

Terms: Accepts work on consignment. Retail price set by gallery. Exclusive area representation required. Shipping costs are shared.

Submissions: Send query letter with resume and slides. Portfolio should include slides. Replies in 4 weeks. All material is returned if not accepted or under consideration.

Tips: "Looks for Soviet, Bulgarian and International art styles."

DENE M. LOUCHHEIM GALLERIES, FLEISHER ART MEMORIAL, 709-721 Catharine St., Philadelphia PA 19147. (215)922-3456. Gallery Coordinator: Lanny Bergner. Nonprofit gallery. Sponsors Challenge Exhibitions, 5 juried exhibits per year. Challenge Estab. 1978. Clientele: art collectors, curators, dealers, artists. Sponsors 8 shows/year. Average display time is 3 weeks. Accepts regional artists only (50 mile radius of Philadelphia). Interested in emerging artists. Price range: $500-5,000.

Media: Considers oil, acrylic, watercolor, pastel, pen & ink, drawings, mixed media, collage, works on paper, sculpture, ceramic, fiber, glass, installation, photography, performance art and limited edition handpulled prints. Most frequently exhibits painting, sculpture and photography. No video.

Style: Considers all styles. "The work should seek to explore the boundaries of art, not the established norms. Fleisher is an excellent place to show installation sculpture and work that receives little commercial exposure."

Terms: Accepts work on consignment (20% commission). Retail price is set by artist. Exclusive area representation not required. Gallery provides insurance, promotion and contract.

Submissions: Send query letter. "Challenge Exhibitions juried shows brochure sent in January to artists telling how to apply."

MAIN LINE CENTER OF THE ARTS, Old Buck Rd. and Lancaster Ave., Haverford PA 19041. (215)525-0272. Director: Judy Herman. Nonprofit gallery. Clientele: 100% private collectors. Average display time 4 weeks. Accepts only artists from tri-state area (Pennsylvania, New Jersey, Delaware). Interested in emerging artists. Overall price range: $20-3,000; most artwork sold at $40-300.

Media: Considers oil, acrylic, watercolor, pastel, pen & ink, drawings, mixed media, collage, works on paper, sculpture, ceramic, craft, fiber, glass and original handpulled prints. Most frequently exhibits works on paper, paintings and sculpture.

Style: Exhibits all styles and all genres. "Main Line Center of the Arts has a varied exhibition schedule to complement its educational mission to serve Montgomery and Delaware counties with classes and a wide range of arts activities as well as to create an active forum for artists in this community. Our annual schedule includes a juried painting and sculpture exhibition, a juried works on paper exhibition, a juried craft exhibition, a faculty exhibition, student and professional members' exhibitions and exhibitions of public school artwork."

Terms: Accepts work on consignment (30% commission). Retail price set by artist. Exclusive area representation not required. Gallery provides promotion and contract; artist pays for shipping.

Submissions: Send query letter with resume, slides and SASE. Call or write to schedule an appointment to show a portfolio, which should include originals and slides. Files resumes. All material is returned if not accepted or under consideration.

Tips: "Nonprofit spaces are gaining status and filling an important vacuum."

THE MORE GALLERY, 1630 Walnut St., Philadelphia PA 19103. (215)735-1827. President: Charles N. More. Retail gallery. Estab. 1980. Represents 20 artists; emerging, mid-career and established. Exhibited artists include Sidney Goodman and Paul George. Sponsors 8 shows/year. Average display time 1 month. Open all year. Located in center of the city; 1,800 sq. ft. 80% of space for special exhibitions. 60% private collectors, 40% corporate collectors. Overall price range: $1,000-20,000; most work sold at $5-10,000.

Media: Considers oil, pen & ink, acrylic, drawing, sculpture, watercolor, mixed media, installation, pastel, collage and photography; woodcuts, wood engravings, linocuts, engravings, mezzotints, etchings, lithographs, pochoir and serigraphs. Most frequently exhibits oil and sculpture.

Style: Exhibits expressionism, neo-expressionism and painterly abstraction. Interested in all genres. Prefers figurative work.

Terms: Accepts work on consignment (50% commission). Retail price set by the gallery and the artist. Gallery provides insurance and promotion; shipping costs are shared. Prefers artwork framed.

Submissions: Send query letter with resume, slides, bio, photographs and SASE. Write to schedule an appointment to show a portfolio, which should include slides and transparencies. Replies only if interested within 1 month.

Tips: "Visit first."

MUSE GALLERY, 60 N. 20th St., Philadelphia PA 19106. (215)627-5310. Director: Sissy Pizzollo. Cooperative and nonprofit gallery. Represents 17 artists. Sponsors 8 solo and 4 group shows/year. Average display time 1 month. Accepts only artists form the tri-state areas. Interested in emerging and established artists. Overall price range: $200-3,000; most work sold at $1,000-1,500.

Media: Considers oil, acrylic, watercolor, pastel, pen & ink, drawings, mixed media, collage, works on paper, sculpture, ceramic, fiber, glass, installation, photography, egg tempera, woodcuts, wood engravings, linocuts, engravings, mezzotints, etchings, lithographs, pochoir, serigraphs and offset reproductions. Most frequently exhibits paintings, sculpture and photography.

Style: Exhibits all styles and genres. Prefers figurative, post-modern and surrealist works. "The Muse Gallery was founded as a women's cooperative to give appropriate opportunities to professional women artists to show their work. We specialize in a diversity of contemporary art pieces."

Terms: Co-op membership fee plus donation of time; 10% commission. Retail price set by artist. Exclusive area representation not required. Prefers artwork framed.

Submissions: Send query letter with resume, 5-21 slides, photographs, bios and SASE. Write to schedule an appointment to show a portfolio, which should include slides. Replies in 1 week. All material is returned if not accepted or under consideration.

Tips: "Send quality slides and show consistency in subject and medium."

NEWMAN GALLERIES, 1625 Walnut St., Philadelphia PA 19103; 850 W. Lancaster Ave., Bryn Mawr PA 19010, Rt. 113 and Cross Rd., Lederach PA 19450. (215)563-1779. Vice President: W. Andrews Newman III. Retail gallery. Estab. 1865. Open all year. Located in Center City and in suburbs. "Largest and oldest gallery in Philadelphia." Clientele: 90% private collectors, 10% corporate clients. Represents over 100 artists. Sponsors 8 solo shows/year. Average display time 4 weeks. Interested in emerging and established artists. Overall price range: $250-100,000; most artwork sold at $2,500-25,000.

Media: Considers oil, acrylic, watercolor, pastel, pen & ink, drawings, mixed media, egg tempera, woodcuts, wood engravings, linocuts, engravings, mezzotints, etchings, lithographs and serigraphs. Most frequently exhibits watercolor and oil/acrylic paintings and etchings.

Style: Exhibits impressionism and realism. Genres include landscapes, florals, Americana, wildlife and figurative work. Prefers landscapes, Americana and wildlife/floral works . "We handle many artists, most of whom work in a very traditional or representational style. Our center city gallery specializes in 19th- and early 20th-century American and European painting. We hold our special exhibitions for contemporary American artists at our suburban gallery. Large exhibitions are held at our center city gallery and are promoted."

Terms: Accepts work on consignment (33-40% commission). Retail price set by gallery and artist. Exclusive area representation required. Gallery provides insurance and promotion; shipping costs are shared.

Submissions: Send query letter with resume, slides, SASE, brochure and photographs. Call to schedule an appointment to show a portfolio, which should include originals, slides, transparencies and photographs. Replies in 1 month. All material is returned if not accepted or under consideration.

OLIN FINE ARTS GALLERY, Washington and Jefferson College, Washington PA 15301. (412)223-6110. Gallery Chairman: P. Edwards. Nonprofit gallery. Estab. 1982. Represents emerging, mid-career and established artists. Exhibited artists include Mary Hamilton and Jack Cayton. Sponsors 9 shows/year. Average display time 3 weeks. Open all year. Located near downtown (on campus); 1,925 sq. ft.; modern, air-conditioned, flexible walls, secure. 100% of space for special exhibitions. Clientele: mostly area collectors and students. 95% private collectors, 5% corporate collectors. Most work sold at $300-500.

The asterisk before a listing indicates that the listing is new in this edition. New markets are often the most receptive to freelance submissions.

Media: Considers all media, except installation, offset reproductions and pochoir. Most frequently exhibits oil, acrylic and watercolor.

Style: Exhibits all styles and genres. Prefers realism/figure, landscapes and abstract.

Terms: Accepts work on consignment (20% commission). Retail price set by the artist. Gallery provides insurance and promotion; artist pays for shipping. Prefers artwork framed.

Submissions: Send query letter with resume, slides, bio and SASE. Call to schedule an appointment to show a portfolio, which should include originals and slides. Replies in 2-4 weeks.

THE STATE MUSEUM OF PENNSYLVANIA, 3rd and North St., Box 1026, Harrisburg PA 17108-1026. (717)787-4980. Contact: Curator of Fine Arts. Museum. Estab. 1905. Sponsors 9-12 shows/year. Average display time 6 months. Accepts only artists from Pennsylvania. Interested in established artists.

Media: Considers oil, acrylic, watercolor, pastel, pen & ink, drawings, mixed media, collage, works on paper, sculpture, ceramic, craft, fiber, glass, egg tempera, woodcuts, wood engravings, linocuts, engravings, mezzotints, etchings and lithographs.

Style: Exhibits all styles and genres. "The State Museum of Pennsylvania is the official museum of the Commonwealth, which collects, preserves and exhibits Pennsylvania history, culture and natural heritage. The Museum maintains the Pennsylvania Collection of Fine Arts, representing all periods and styles of fine art from the founding of the state to the present. The Museum is also responsible for exhibitions at the Governor's Residence and for limited displays of art work in the State Capitol offices of senior officials. The Museum maintains a research file of information on all known Pennsylvania artists."

Submissions: Send query letter with resume, slides and bio. Replies in 1-3 months. Files resume, bio, exhibit history and photos. All material is returned if not accepted or under consideration.

Rhode Island

ARNOLD ART, 210 Thames, Newport RI 02840. (401)847-2273. President: Bill Rommel. Retail gallery. Estab. 1870. Clientele: tourists and Newport collectors; 95% private collectors, 5% corporate clients. Represents 30-40 artists; mid-career and established. Sponsors 6-8 solo or group shows/year. Average display time 2 weeks. Overall price range: $150-12,000; most artwork sold at $150-750.

Media: Considers oil, acrylic, watercolor, pastel, pen & ink, drawings, mixed media, limited edition offset reproductions, color prints and posters. Most frequently exhibits oil, acrylic and watercolor.

Style: Exhibits painterly abstraction, primitivism, photorealism and realism. Genres include landscapes and florals. Specializes in marine art and local landscapes.

Terms: Accepts work on consignment. Retail price is set by gallery or artist. Exclusive area representation not required. Gallery provides insurance, promotion and contract.

Submissions: Send query letter with resume and slides. Call for an appointment to show a portfolio, which should include originals. Resume and slides are filed.

***BANNISTER GALLERY/RHODE ISLAND COLLEGE ART CENTER,** 600 Mt. Pleasant Ave., Providence RI 02908. (401)456-9765 or 8054. Gallery Director: Dennis O'Malley. Nonprofit gallery. Estab. 1978. Represents emerging, mid-career and established artists. Sponsors 9 shows/year. Average display time 3 weeks. Open September through May. Located on college campus; 1,600 sq. ft.; "features spacious, well-lit gallery space with off-white walls, gloss black tile floor; two sections plus one with a 9' ceiling and one with a 12' ceiling." 100% of space for special exhibitions. Clientele: students and public.

Media: Considers all media and all types of original prints. Most frequently exhibits painting, photography and sculpture.

Style: Exhibits all styles.

Terms: Artwork is exhibited for educational purposes—gallery offers no commission. Retail price set by the artist. Gallery provides insurance and promotion; shipping costs from gallery. Prefers artwork framed.

Submissions: Send query letter with resume, slides, bio, brochure, SASE and reviews. Files addresses, catalogs and resumes.

LENORE GRAY GALLERY, INC., 15 Meeting St., Providence RI 02903. (401)274-3900. Director: Lenore Gray. Retail gallery. Estab. about 1970. Sponsors 6 solo and 6 group shows/year. Average display varies. Interested in emerging, mid-career and established artists.

Media: Considers oil, acrylic, watercolor, pastel, drawings, sculpture, photography, mixed media, glass, installation and color and b&w original handpulled prints.
Style: Exhibits contemporary, abstract, Americana, impressionistic, figurative, landscape, primitive, non-representational, photo-realistic, realistic, neo-expressionisitic and post-pop works.
Terms: Accepts work on consignment. Retail price is set by gallery or artist. Exclusive area representation required. Gallery provides insurance.
Submissions: Send query letter with resume, slides, photographs or SASE. Write for an appointment to show a portfolio.

South Carolina

ANDERSON COUNTY ARTS COUNCIL, 405 N. Main St., Anderson SC 29621. (803)224-8811. Executive Director: Diane B. Lee. Program Director: Kimberly Spears. Nonprofit gallery of county art center. Estab. 1972. Clientele: community and tourists. Sponsors about 9 shows/year; local, regional and national. Average display time 4-6 weeks. Interested in emerging and established artists. Overall price range: $100-5,000; most work sold at $100-1,500.
Media: Considers all media. Most frequently exhibits watercolor and 3-dimensional works.
Style: Exhibits all styles and genres. Prefers realism and abstraction. "The Anderson County Arts Council is composed of individuals and organizations interested in the promotion of the visual and performing arts and those wishing to preserve Anderson County cultural growth."
Terms: Accepts work on consignment (30% commission). Retail price set by artist. Gallery provides insurance and promotion; artist pays for shipping.
Submissions: Send query letter with resume, slides and bio. Call or write to schedule an appointment to show a portfolio, which should include originals and slides. Replies in 3 months. All material is returned if not accepted or under consideration.

***ART GALLERY-HORACE C. SMITH BUILDING,** 800 University Way, University of South Carolina-Spartanburg, Spartanburg SC 29303. (803)599-2256. Associate Professor of Art: John R. Caputo. Nonprofit gallery. Estab. 1989. Represents emerging, mid-career and established artists. "We are an educational institute. We do not have members. We do not actively pursue sales." Sponsors 6 shows/year. Average display time 1 month. Open Sept.-May. Located "on campus; rural area off of interstate; 900 sq. ft., 70 ft. of wallspace; neutral carpeted walls, ties in visually with Performing Arts Center." 100% of space for special exhibitions. Clientele: university and community. Overall price range: $500-3,000; most work sold at $500.
Media: Considers oil, acrylic, drawing, mixed media, collage, paper, sculpture, ceramic and photography; woodcuts, linocuts, etchings, lithographs and serigraphs. Most frequently exhibits paintings, drawings and prints.
Style: Exhibits expressionism, neo-expressionism, primitivisim, painterly abstraction, minuimalism, color field, post modern works, pattern painting, hard-edge geometric abstraction. "We do not show genre art. We have no preference on style. All judgements are made on the quality of the work."
Terms: "Artwork is exhibited for a fixed period. No percentage of commission is taken." Retail price set by the artist. Gallery provides insurance, promotion and contract; "$100 is provided to assist the shipping costs." Prefers artwork framed.
Submissions: Send query letter with resume, slides, bio, SASE and reviews. Write to schedule an appointment to show a portfolio, which should include photographs and transparencies. Replies in 1-2 months. Files resumes and photographs.

CECELIA COKER BELL GALLERY, College Ave., Hartsville, SC 29550. (803)332-1381. Director: Kim Chalmers. "The Cecelia Coker Bell Gallery is a campus-located teaching gallery which exhibits a great diversity of media and style to the advantage of exposing students and the community to the breadth of possibility for expression in art. Primarily exhibiting regional artists with an emphasis on quality. Features international shows of emerging artists and sponsors competitions." Estab. 1984. Sponsors 8 solo and 2 group shows/year. Average display time is 3 weeks. Gallery is 30×40′, located in art department; grey carpeted walls, track lighting. Interested in emerging artists.
Media: Considers oil, acrylic, drawings, mixed media, collage, works on paper, sculpture, installation, photography, performance art, graphic design and printmaking. Most frequently exhibits painting, sculpture/installation and mixed media.
Style: Considers all styles. Not interested in conservative/commercial art.
Terms: Retail price is set by artist. Exclusive area representation not required. Gallery provides insurance, promotion and contract; shipping costs are shared.
Submissions: Send query letter with resume, slides and SASE. Write for an appointment to show a portfolio, which should include slides. Resumes are filed.

BROOKGREEN GARDENS, US 17 South, Murrells Inlet SC 29576. (803)237-4218. Director: Gurdon L. Tarbox, Jr. Museum. Estab. 1931. Outdoor garden. Clientele: tourists and local residents. Represents 205 artists. Places permanent installations. Accepts only sculpture by American citizens. Interested in emerging, mid-career and established artists.
Style: Exhibits realism and figurative work. Prefers figurative and wildlife. Gallery shows work by "American sculptor by birth or naturalization; figurative sculpture in permanent materials such as non-ferrous metals or hardstone such as marble, limestone or granite. We suggest you obtain a copy of "A Century of American Sculpture: Treasures from Brookgreen Gardens."
Terms: Buys outright. Retail price set by artist.
Submissions: Send query letter with resume, brochure, slides and photographs. Write to schedule an appointment to show a portfolio, which should include originals, slides, transparencies and photographs. Replies in 6 months. Files all material. All material is returned if requested, if not accepted or under consideration.
Tips: Artists seem to "think Brookgreen Gardens is wealthy. It is not!"

***CONVERSE COLLEGE MILLIKEN GALLERY**, 580 E. Main St., Spartanburg SC 29302. (803)596-9177. Gallery Director: Mac Boggs. Estab. 1971. College gallery. Represents emerging, mid-career and established artists. Exhibited artists include Teresa Prater. Sponsors 9 shows/year. Average display time 1 month. Open during fall, winter and spring. Located on campus; 1,800 sq. ft.; gallery has glass walls for sculpture exhibits. 100% of space for special exhibitions. Clientele: students and community. Overall price range: $50-5,000; most work sold at $50-500.
Media: Considers all media and all types of prints. Most frequently exhibits painting, sculpture and prints/photography.
Style: Exhibits all styles.
Terms: No commission. Retail price set by the artist. Gallery provides insurance and promotion; shipping costs are shared. Prefers artwork framed.
Submissions: Send query letter with resume, slides, brochure, photographs, SASE and reviews. Portfolio should include slides and photographs. Replies only if interested within months. Files resumes.

***PICKENS COUNTY ART MUSEUM**, Pendelton and Johnson, Pickens SC 29671. (803)878-7818. Director: Olivia G. Fowler. Nonprofit museum located in old county jail. Estab. 1976. Clientele: artists and public. Sponsors 12 solo shows/year. Average display time is 1 month. Interested in emerging, mid-career and established artists. Overall price range: $200-700; most artwork sold at $200.
Media: Considers oil, acrylic, watercolor, pastel, pen & ink, drawings, sculpture, ceramics, fiber, photography, crafts, mixed media, collage and glass.
Style: Exhibits contemporary, abstract, landscape, floral, primitive, non-representational, photo-realistic and realism.
Terms: Accepts work on consignment (20% commission). Retail price is set by artist. Exclusive area representation not required. Gallery provides insurance, promotion and contract.
Submissions: Send query letter with resume, photograph and SASE.

***PORTFOLIO ART GALLERY**, 2007 Devine St., Columbia SC 29205. (803)256-2434. Owner: Judith Roberts. Retail gallery and art consultancy. Estab. 1980. Represents 25-35 artists; emerging, mid-career and established. Exhibited artists include Sigmund Abeles and Joan Ward Elliott. Sponsors 3-4 shows/year. Average display time 3 months. Open all year. Located in a 1930s shopping village, 1 mile from downtown; 500 sq. ft. plus 1,100 sq. ft.; Features 12' ceilings. 100% of space for work of gallery artists. "We have satellite location for exhibitions only." Clients are professionals, corporations and collectors. 40% private collectors, 40% corporate collectors. Overall price range: $150-12,500; most work sold at $200-1,500.
Media: Considers oil, acrylic, watercolor, pastel, mixed media, collage, paper, sculpture, ceramic, craft, fiber, glass and photography; original handpulled prints, woodcuts, wood engravings, linocuts, engravings, mezzotints, etchings, lithographs and serigraphs. Most frequently exhibits watercolor, oil and monotypes.
Style: Exhibits neo-expressionism, painterly abstraction, imagism, minimalism, color field, impressionism, realism, photorealism and pattern painting. Genres include landscapes and figurative work. Prefers landscapes/seascapes, painterly abstraction and figurative work.
Terms: Accepts work on consignment (40% commission). Retail price set by the gallery and the artist. Gallery provides insurance, promotion and contract; artist pays for shipping. Artwork may be framed or unframed.
Submissions: Send query letter with slides, bio, brochure, photographs, SASE and reviews. Write to schedule an appointment to show a portfolio, which should include originals, slides, photographs and transparencies. Replies only if interested within 1 month. Files tearsheets, brochures and slides.
Tips: "Bring examples of best work—unframed, originals (no copies)—to portfolio reviews."

South Dakota

THE HERITAGE CENTER, INC., Red Cloud Indian School, Pine Ridge SD 57770. (605)867-5491. Director: Brother Simon. Nonprofit gallery. Estab. 1984. Clientele: 80% private collectors. Sponsors 6 group shows/year. Represents emerging, mid-career and established artists. Average display time is 10 weeks. Accepts only Native Americans. Price range: $50-1,500; most artwork sold at $100-400.
Media: Considers oil, acrylic, watercolor, pastel, pen & ink, drawings, sculpture and original handpulled prints.
Style: Exhibits contemporary, impressionistic, primitive, Western and realistic works. Specializes in Native American art (works by Native Americans).
Terms: Accepts work on consignment (20% commission). Retail price is set by artist. Exclusive area representation not required. Gallery provides insurance and promotion; artist pays for shipping.
Submissions: Send query letter, resume, brochure and photographs Wants to see "fresh work and new concepts, quality work done in a professional manner."
Tips: "Show art properly matted or framed. Don't present commercial prints as handpulled prints. Good work priced right always sell. Young artists sometimes tend to overprice their work. Write for information about annual Red Cloud Indian Art Show."

Tennessee

CUMBERLAND GALLERY, 4107 Hillsboro Circle, Nashville TN 37215. (615)297-0296. Director: Carol Stein. Retail gallery. Estab. 1980. Clientele: 60% private collectors; 40% corporate clients. Represents 35 artists. Sponsors 6 solo and 2 group shows/year. Average display time 5 weeks. Interested in emerging and established artists. Overall price range: $450-15,000; most work sold at $1,000-5,000.
Media: Considers oil, acrylic, watercolor, pastel, mixed media, collage, works on paper, sculpture, photography, woodcuts, wood engravings, linocuts, engravings, mezzotints and etchings. Most frequently exhibits paintings, drawings and sculpture.
Style: Exhibits realism, photorealism, minimalism, painterly abstraction, post modernism and hard-edge geometric abstraction. Prefers landscapes, abstraction, realism and minimalism. "Since its inception, the gallery has focused on contemporary art forms including paintings, works on paper, sculpture and multiples. Approximately fifty percent of the artists represented have national reputations and fifty percent are strongly emerging artists. These individuals are geographically dispersed, about half reside in the Southeast."
Tips: "I would hope that an artist would visit the gallery and participate on the mailing list so that he/she has a sense of what we are doing. It would be helpful for the artist to request information with regard to how Cumberland Gallery prefers work to be considered for inclusion. I suggest slides, resume, recent articles and a SASE for return of slides."

EATON GALLERY, 968 June Rd., Memphis TN 38119. (901)767-0690. FAX: (901)767-0690. Owner/Director: Sandra Saunders. Retail gallery. Estab. 1984. Represents 25 emerging, mid-career and established artists. Exhibited artists include Charles Inzer. Sponsors 10 shows in Gallery I/10 in Gallery II. Average display time 1 month. Open all year. Closed in August for 2 weeks. Located in east Memphis; 2,500 sq. ft.; "the interior is contemporary." 800 sq. ft. of space for special exhibitions. Clientele: 80% private collectors, 20% corporate clients. Overall price range: $350-10,000; most artwork sold at $1,500-4,500.
Media: Considers oil, acrylic, watercolor, pastel, drawings, mixed media, works on paper and sculpture. Considers original handpulled prints, woodcuts, engravings, lithographs, mezzotints, serigraphs and etchings. Most frequently exhibits oil, acrylic and watercolor.
Style: Exhibits expressionism, painterly abstraction, color field, impressionism and realism. Genres include landscapes, florals, Americana, Southwestern, portraits and figurative work. Prefers impressionism, expressionism and realism.
Terms: Artwork is accepted on consignment and there is a 50% commission. Retail price set by the artist or both the gallery and the artist. Gallery provides insurance, promotion and contract. Artist pays for shipping. Prefers framed artwork.
Submissions: Send query letter with resume, bio, photographs and reviews. Write to schedule an appointment to show a portfolio. Portfolio should include originals and photographs. Replies in 1 week. Files photos and "anything else the artists will give us."
Tips: "Just contact us—we are here for you."

***PAUL EDELSTEIN GALLERY**, 4976 Summer Ave., Memphis TN 38122. (901)682-7724. FAX: (901)682-0013. Owner/Director: Paul Edelstein. Retail gallery. Estab. 1985. Represents 30 artists; emerging, mid-career and established. Exhibited artists include Walter Anderson and Carroll Cloar. Sponsors 1-2 shows/year. Average display time 6 weeks. Open all year. Located in East Memphis; 2,800 sq. ft. 80% of space for special exhibitions. 95% private collectors, 5% corporate collectors. Overall price range: $500-140,000; most work sold at $300-800.

Media: Considers oil, acrylic, watercolor, pastel, pen & ink, drawing, mixed media, collage, paper and photography; woodcuts, wood engravings, linocuts, etchings, lithographs and serigraphs. Most frequently exhibits oil, acrylic and watercolor.

Style: Exhibits primitivism, painterly abstraction and color field. Prefers contemporary and established artists from the 1950s.

Terms: Accepts work on consignment (40% commission). Retail price set by the gallery. Gallery provides insurance, promotion and contract; artist pays for shipping. Prefers artwork unframed.

Submissions: Send query letter with resume, slides, bio, brochure, photographs, SASE and business card. Write to schedule an appointment to show a portfolio, which should include originals, photographs, slides and transparencies. Replies in 2 months. Files all material.

EDELSTEIN/DATTEL ART INVESTMENTS, 4134 Hedge Hills Ave., Memphis TN 38117. (901)767-0425. Owner/Director: Paul R. Edelstein. Retail gallery. Estab. 1985. Represents 30+ emerging, mid-career and established artists. Clientele: 80% private collectors, 20% corporate clients. Sponsors 2 solo and 2 group shows/year. Average display time is 1 month. 2,500 sq. ft. Price range: $300-4,800.

Media: Considers oil, acrylic, watercolor, pastel, pen & ink, drawings, mixed media, collage, works on paper, sculpture, ceramic, fiber, glass, photography and limited edition prints. Most frequently exhibits oil, watercolor and drawings.

Style: Exhibits hard-edge geometric abstraction, color field, painterly abstraction, minimalism, post modern feminist/political works, primitivism, photorealism, expressionism and neo-expressionism. Genres include landscapes, florals, Americana, portraits and figurative work. Most frequently exhibits primitive, painterly abstraction and expressionism. "Especially seeks new folk artists and N.Y. SoHo undiscovered artists." Specializes in contemporary and black folk art, Southern regionalism, modern contemporary abstract and WPA 1930's modernism.

Terms: Accepts work on consignment (40% commission) or buys outright. Retail price is set by gallery. Exclusive area representation required. Gallery provides insurance, promotion and contract.

Submissions: Send query letter with resume, brochure, business card, slides, photographs and SASE. Call or write to schedule an appointment to show a portfolio, which should include originals, slides or transparencies. Biographies and resumes of artists are slides are filed. "Most artists do not present enough slides or their biographies are incomplete. Professional artists need to be more organized when presenting their work."

Tips: "Meet me in person with your original works."

***OATES GALLERY**, 2775 Lombardy Ave., Memphis TN 38111. (901)452-9986. Director: Rena Dewey. Estab. 1973. Retail gallery. Represents 20+ established artists. Interested in seeing the work of emerging artists. Exhibited artists include Jay H. Connaway. Sponsors 2 shows/year. Average display time 2 months. Open all year. Located midtown in central location; 2,500 sq. ft. 100% of wall space for work of gallery artists. Clientele: collectors. 90% private collectors, 10% corporate collectors. Overall price range: $300-10,000; most work sold at $10,000 and up.

Media: Considers oil; original handpulled prints and all name artists.

Style: Exhibits impressionism and realism. All genres. Prefers Americana, landscapes and florals.

Terms: Buys artwork outright. Retail price set by the gallery. Gallery provides insurance, promotion and contract; pays for shipping costs. Prefers artwork framed.

Submissions: Send query letter with photographs. Call to schedule an appointment to show a portfolio, which should include photographs and transparencies. Replies in 2 weeks.

THE PARTHENON, Centennial Park, Nashville TN 37201. (615)862-8431. Museum Director: Miss Wesley Paine. Nonprofit gallery in a full-size replica of the Greek Parthenon. Estab. 1931. Clientele: general public, tourists; 50% private collectors, 50% corporate clients. Sponsors 8 solo and 6 group shows/year. Average display time is 6 weeks. Interested in emerging, mid-career and established artists. Overall price range: $300-1,000; most artwork sold at $750.

Media: Considers "nearly all" media.

Style: Exhibits contemporary works, impressionism and American expressionism. Currently seeking contemporary works.

Terms: Accepts work on consignment (20% commission). Retail price is set by artist. Exclusive area representation not required. Gallery provides a contract and limited promotion.

Submissions: Send query letter with resume and slides that show work to best advantage.

SLOCUMB GALLERY, East Tennessee State University, Department of Art, Box 23740A, Johnson City, TN 37614-0002. (615)929-4247. Director: Ann Ropp Curtis. Nonprofit university gallery. Estab. 1960. Sponsors 2-3 solo and 5 group shows/year. Average display time is 1 month. Interested in emerging, mid-career and established artists. Price range: $100-5,000; most artwork sold at $500.

Media: Considers all media.
Style: Exhibits contemporary, abstract, figurative, primitive, non-representational, photorealistic, realistic, neo-expressionistic and post-pop styles and landscapes.
Submissions: Send query letter with resume and slides. Call or write to schedule an appointment to show a portfolio. Slides and resumes are filed.

***ZIMMERMAN/SATURN GALLERY,** 131 2nd Ave. N., Nashville TN 37201. (615)255-8895. Owner/Director: Alice Zimmerman. Retail gallery. Estab. 1985. Represents 60 artists; emerging, mid-career and established. Exhibited artists include John Baeder and Emma Amos. Sponsors 10 shows/year. Average display time 1 month. Open all year. Located downtown in historic district; 3,000 sq. ft.; "the building is on the historic register, has high ceilings and an art deco interior." 66% of space for special exhibitions. 75% private collectors, 25% corporate collectors. Overall price range: $10-6,000; most work sold at $1,200-1,500.
Media: Considers oil, acrylic, watercolor, pastel, pen & ink, drawing, mixed media, collage, paper, sculpture, ceramic, craft, glass and photography; original handpulled prints, woodcuts, engravings, etchings, lithographs, serigraphs and posters. Most frequently exhibits works on canvas and paper, and craft sculpture.
Style: Exhibits primitivism, painterly abstraction, surrealism, post modern works, realism, photorealism and hard-edge geometric abstraction. Genres include landscapes and figurative work. Prefers realism, gentle abstraction and landscapes.
Terms: Accepts work on consignment (50% commission). Retail price set by the gallery. Gallery provides insurance and promotion; shipping costs are shared. Prefers artwork unframed.
Submissions: Send query letter with resume, slides, bio, SASE and reviews. Call to schedule an appointment to show a portfolio, which should include slides and transparencies. Replies in 1 week. Files material from artists gallery intends to represent.
Tips: "Send expected prices of work."

Texas

ARCHWAY GALLERY, 2600 Monterose, Houston TX 77006. (713)522-2409. Director: Pat Moberley Moore. Cooperative gallery. Estab. 1978. Clientele: 70% private collectors, 30% corporate clients. Represents 14 artists. Sponsors 9 solo and 3 group shows/year. Average display time 4 weeks. Accepts only artists from the Houston area. Interested in emerging artists. Overall price range: $150-4,000; most work sold at $150-1,000.
Media: Considers oil, acrylic, watercolor, pastel, pen & ink, drawings, mixed media, collage, works on paper, sculpture, ceramic, fiber, photography and egg tempera.
Style: Exhibits impressionism, expressionism, realism, surrealism, minimalism, painterly abstraction and constructions/collage. Genres include landscapes, florals and Southwestern works. "Since 1976 this cooperative has shown the works of many regional artists of both local and national acclaim. For the artist Archway provides artistic freedom, individual control of quality and content and a stepping stone on career path. Archway is an active member of the Houston Art Dealers Association."
Terms: Co-op membership fee plus donation of time; (5% commission). Rental fee for space; rental fee per month. Retail price set by artist. Exclusive area representation not required. Gallery provides promotion and contract. Prefers artwork framed.
Submissions: Send query letter with resume, brochure, slides, photographs and SASE. Write to schedule an appointment to show a portfolio, which should include originals, slides and photographs. Replies in 4 weeks. Files resume, brochure and slides. All material is returned if not accepted or under consideration.
Tips: "Don't show poor-quality slides."

ART LEAGUE OF HOUSTON, 1953 Montrose Blvd., Houston TX 77006. (713)523-9530. Executive Director: Barbara Oenbrink. Nonprofit gallery. Estab. 1948. Clientele: general; 60% artists. Sponsors 12 individual/group shows/year. Average display time is 4-5 weeks. Located in a new contemporary metal building with 1,300 sq. ft. of exhibition space. Interested in emerging, mid-career and established artists. Overall price range: $10-5,000; most artwork sold at $100-2,500.
Media: Considers all media.
Style: Exhibits contemporary work. Features "high-quality artwork reflecting serious aesthetic investigation and innovation. The work should additionally have a sense of personal vision."
Terms: Accepts work on consignment (20% commission). Retail price is set by artist. Exclusive area representation not required. Gallery provides insurance, promotion and contract; shipping costs are assumed by artists.
Submissions: Send query letter, resume and slides. Submissions reviewed once a year in mid-April and exhibition agenda determined for upcoming year. Open only to artists living within a 50-mile radius of Houston.

***BENTELER-MORGAN GALLERIES**, 4100 Montrose Blvd., Houston TX 77006. (713)522-8228. FAX: (713)522-6098. Director: Susan Morgan. Retail gallery. Estab. 1980. Represents 30 artists; emerging, mid-career and established. Sponsors 8-10 shows/year here and elsewhere. Average display time 6-8 weeks. Open by appointment only in August. Located in museum district; 1,300 sq. ft. Overall price range: $200-125,000.
Media: Considers photography.
Style: Broad range of styles.
Terms: Vary. Retail price set by the gallery and the artist. Gallery provides insurance, promotion and contract; shipping costs are shared with gallery artists only.
Submissions: Send query letter with resume, slides, bio, brochure and SASE. "One-on-one reviews are few." Portfolio should include originals and slides.
Tips: "Portfolios are dropped off and picked up later if presenting portfolios."

***BRENT GALLERY**, Box 66034., Houston TX 77266-6034. (713)522-5013. Director: Kevin Mercier. Retail gallery. Estab. 1986. Clientele: collectors and museums, 80% private collectors; 20% corporate clients. Represents 16 artists. Sponsors 4 shows/year. Average display time: 12 weeks. Interested in emerging artists. Overall price range: $250-11,000; most work sold at $750-5,000.
Media: Considers oils, acrylics, drawings, mixed media, collages, paper, sculpture, installations and photography. Most frequently exhibits paintings, drawings and photography.
Style: Exhibits progressive styles. "I am interested in showing highly selective work by serious artists preferably living in the U.S. or Latin America."
Terms: Accepts work on consignment (50% commission). Retail price set by gallery and artist. Exclusive area representation required in the Southwest. Gallery provides insurance and promotion; shipping costs are negotiable.
Submissions: Send query letter with resume, slides and SASE. Replies in 5 weeks. Files letters. All material is returned if not accepted or under consideration.
Tips: "Seeks artists who are honest, energetic, intelligent, aggressive, humble, sensitive, interesting, organized, sincere and confident."

CONTEMPORARY GALLERY, 4152 Shady Bend Dr., Dallas TX 75244. (214)247-5246. Director: Patsy C. Kahn. Private dealer. Estab. 1964. Clientele: collectors and retail. Interested in emerging and established artists.
Media: Considers oil, acrylic, drawings, sculpture, mixed media and original handpulled prints.
Style: Contemporary, 20th-century art—paintings, graphics and sculpture.
Terms: Accepts work on consignment or buys outright. Retail price is set by gallery and artist. Gallery provides insurance, promotion and contract; shipping costs are shared.
Submissions: Send query letter, resume, slides and photographs. Write for an appointment to show a portfolio.

D-ART VISUAL ART CENTER, 2917 Swiss Ave., Dallas TX 75204. (214)821-2522. Manager: Katherine Wagner. Nonprofit gallery. Estab. 1981. Represents emerging, mid-career and established artists. Has 300 members. Sponsors 20 shows/year. Average display time 3 weeks. Open all year. Located "downtown; 24,000 sq. ft.; renovated warehouse."
Media: Considers all media.
Style: Exhibits all styles and genres.
Terms: Rental fee for space. Retail price set by the artist. Gallery provides promotion. Artists pays for shipping. Prefers framed artwork.
Submissions: Supports Dallas area artists. Send query letter with resume, slides, bio and SASE. Call to schedule an appointment to show a portfolio, which should include originals and slides. Files "artist's name, type of work, etc."

***DIVERSEWORKS ARTSPACE**, 1117-1119 E. Freeway, Houston TX 77002. (713)223-8346. FAX: (713)223-4608. Gallery Administrator: Patty Shepherd. Nonprofit gallery/performance space. Estab. 1982. Represents 1,400 members; emerging and mid-career artists. Sponsors 10-12 shows/year. Average display time 6 weeks. Open all year. Located just north of downtown (warehouse district). Has 4,000 sq. ft. for exhibition, 3,000 sq. ft. for performance. "We are located in the warehouse district of Houston. The complex houses five artists's studios (20 artists), and a conservator/frame shop." 75% of space for special exhibition.
Style: Exhibits all contemporary styles and all genres.
Terms: "DiverseWorks does not sell artwork. If someone is interested in purchasing artwork in an exhibit we have, the artist contacts them." Gallery provides insurance and promotion; shipping costs. Accepts artwork framed or unframed, depending on the exhibit and artwork.
Submissions: All proposals are put before an advisory board made up of local artists. Send query letter with resume, slides and reviews. Call or write to schedule an appointment to show a portfolio, which should include originals and slides. Replies in 3 months. "We maintain an artists slide registry."
Tips: "Call first for proposal guidelines."

***EMPORIUM ART AND FRAMES – YOU NAME IT – WE FRAME IT,** Emporium Enterprises, Inc., 235 Preston Royal Center, Dallas TX 75230. (214)987-0055. FAX: (214)987-0056. Director: Shelly Hoffman. Retail gallery, industry suppliers and art wholesale/brokerage. Estab. 1983. Represents over 150 artists; emerging, mid-career and established. Sponsors 4 shows/year. Average display time 1 month. Open all year. Located in north Dallas; 4,200 sq. ft.; gallery is "hi-tech yet very inviting: marble, glass, track lighting." 20% of space for special exhibitions. Clients are "very 'upper-end' – they like the new and different." 90% private collectors, 10% corporate collectors.

Media: Considers all media, including wall sculpture, jewelry, 3-D gift items and all types of prints. Most frequently exhibits serigraphs/lithographs, originals and etchings.

Style: Exhibits expressionism, primitivism, post modern works, impressionism, realism, animation and all other styles. All genres. Prefers contemporary, impressionistic and traditional.

Terms: Buys work outright for 50-80% of retail price (net 30 days). There is a nonrefundable $5 filing fee. Retail price set by the gallery. Gallery provides insurance, promotion and contract; shipping costs are shared. Prefers artwork unframed.

Submissions: Send query letter with resume, slides, bio, brochure, photographs, SASE, business card and reviews. Write to schedule an appointment to show a portfolio, which should include slides and net prices. Replies in 1 month. Files all material – "all of it is ours to keep."

***500X GALLERY,** 500 Exposition Ave., Dallas TX 75226. (214)828-1111. President: Vance Wingate. Cooperative gallery. Estab. 1977. Represents and exhibits 15 emerging artists. Clientele: young professionals; 90% private collectors, 10% corporate clients. Sponsors 9 group shows/year. Average display time is 12 days. Accepts only Dallas-Ft. Worth area artists.

Media: Considers all media and prints. Most frequently exhibited media: oil paintings, sculpture, installations and constructions.

Style: Exhibits contemporary, figurative, landscapes, non-representational, photorealistic, realistic, neo-expressionistic and post-pop works. "500X Gallery exists to give emerging contemporary artists from Texas exposure in the Dallas/Ft. Worth area. 500X exists to expand the envelope of the visual art experience. Interested in seeing raw, disturbing, provocative, finished work."

Terms: Co-op membership fee plus donation of time. Retail price is set by artist. Overall price range: $500-5,000; most artwork sold at $750-2,000. Exclusive area representation not required. Gallery provides promotion.

Submissions: Send query letter, resume, slides and SASE.

Tips: "Looks for strong individualist work with a bit of an edge. Be aware of the type of work we show."

***FLORENCE ART GALLERY,** 2500 Cedar Springs, Dallas TX 75201. (214)754-7070. Director: Estelle Shwiff. Retail gallery. Estab. 1975. Represents 10-15 artists; emerging, mid-career, and established. Exhibited artists include Simbari, H. Claude Pissarro. Sponsors 2 shows/year. Average display time 2 months. Open all year. Located 5 minutes from downtown/arts antique area; "five big rooms – 30 ft. ceilings, on major street corner." 20% of space for special exhibitions. Clientele: international, US, local. 90% private collector; 10% corporate collector.

Media: Considers oil, acrylic, watercolor, pastel, pen & ink, mixed media, collage, paper, sculpture, bronze; original handpulled prints, woodcuts, etchings, lithographs, serigraphs. Most frequently exhibits oils, bronzes and graphics.

Style: Exhibits all styles and genres. Prefers figurative, landscapes and abstract.

Terms: Accepts work on consignment. Retail price set by gallery and artist. Gallery provides insurance, promotion and contract. Shipping costs are shared. Prefers artwork framed.

Submissions: Send query letter with slides, bio and photographs. Call to schedule an appointment to show a portfolio. Portfolio should include photographs. Replies in 2 weeks. Files artists accepted in gallery.

Tips: "Have a complete body of representative work."

GALLERY 1114, 1114 North Big Spring, Midland TX 79701. (915)685-9944. President: Travis Beckham. Cooperative gallery and alternative space. Estab. 1983. Represents 12-15 artists; emerging, mid-career and established. 10 members. Sponsors 8 shows/year. Average display time is 6 weeks. Closed during August. Located at edge of downtown; 900-950 sq. ft.; special features include one large space for featured shows, smaller galleries for members and consignment – "simple, elegant exhibit space," wood floors, and white walls. 60% of space for special exhibitions. Has a "younger" clientele. Almost 100% private collectors. Overall price range: $10-8,000; most artwork sold at $50-350.

Media: Considers all media. Interested in all original print media. Most frequently exhibits painting, ceramics and drawing.

Style: Exhibits all styles and all genres—"in a contemporary sense, but we are not interested in genre work in the promotion sense."

Terms: Accepts work on consignment (40% commission). Retail price set by gallery. Gallery provides promotion; shipping costs from gallery. Prefers artwork framed.

Submissions: Send query letter, resume, slides, bio, reviews and SASE. Call or write for an appointment to show a portfolio, which should include slides. Replies in 3-6 weeks. Files all material of interest. "We schedule up to 2-3 years in advance. It helps us to keep material. We do not file promotional material."

Tips: "Make a neat, sincere, consistent presentation with labeled slides and SASE. We are interested in serious work, not promotion. We are an alternative space primarily for the central U.S. We are here to give shows to artists working in a true contemporary or modernist context: artists with a strong concern for formal strength and originality and an awareness of process and statement."

W.A. GRAHAM GALLERY, 1431 W. Alabama, Houston TX 77006. (713)528-4957. Director: William Graham. Retail gallery. Estab. 1981. Clientele: 70% private collectors, 30% corporate clients. Represents 18 artists. Sponsors 9 solo and 2 group shows/year. Average display time is 1 month. Interested in emerging, mid-career and established artists. Overall price range: $100-15,000; most artwork sold at $500-15,000.

Media: Considers oil, acrylic, watercolor, pastel, pen & ink, drawings, mixed media, collage, works on paper, sculpture, ceramic, craft, fiber, glass, installation, photography and original handpulled prints. Most frequently exhibits oils, photos, sculpture and drawings.

Terms: Accepts work on consignment (50% commission). Retail price is set by gallery and artist. Exclusive area representation required. Gallery provides insurance and promotion.

HUMMINGBIRD ORIGINALS, INC., 4319-B Camp Bowie Blvd., Ft. Worth TX 76107. (817)732-1549. President: Carole Alford. Retail gallery. Estab. 1983. Represents 50 artists; emerging, mid-career and established. Exhibited artists include Gale Johnson and Mary Ann White. Sponsors 2-5 shows/year. Open all year. Located 2 miles west of downtown in the cultural district; 1,600 sq. ft. 20% of space for special exhibitions, 80% for gallery artists. Clientele: 80% private collectors, 20% corporate collectors. "There is an increasing focus in this area." Price range: $50-10,000; most work sold at $300-700.

Media: Considers oil, acrylic, watercolor, pastel, drawings, mixed media, collage, works on paper, sculpture, ceramic, craft, fiber, glass and original prints. Most frequently exhibits watercolor, oil and acrylic.

Style: Exhibits painterly abstraction, surrealism, conceptualism, minimalism, impressionism, realism and all styles. Genres include landscapes, florals, Americana, Southwestern, Western and wildlife. Prefers impressionism, abstraction and realism.

Terms: Accepts work on consignment (40-50% commission). Retail price set by the gallery and the artist. Gallery provides insurance, promotion and contract; shipping costs are shared. Prefers unframed artwork.

Submissions: Send query letter with resume, slides, bio, brochure, photographs, SASE, business card and reviews. Call or write to schedule an appointment to show a portfolio, which should include originals, slides, photographs and transparencies. Replies only if interested within 2 weeks. Files material useful to clients and future exhibit needs.

Tips: "Be prepared. Know if your work sells well, what response you are getting. Know what your prices are. Also understand a gallery, its role as an agent and its needs."

LAGUNA GLORIA ART MUSEUM, 3809 W. 35th St., Austin TX 78703; Box 5568, Austin TX 78763. (512)458-8191. Curator: Peter Mears. Museum. Estab. 1961. Clientele: tourists and Austin citizens. Sponsors 2-3 solo and 6 group shows/year. Average display time: 1½ months. Interested in emerging, mid-career and established artists.

Media: Currently exhibit 20th-Century American art with an emphasis on two-dimensional and three-dimensional contemporary artwork to include experimental video, mixed media and site-specific installations.

Style: Exhibits all styles and all genres. No commercial clichéd art.

Terms: Retail price set by artist. Gallery provides insurance and contract; shipping costs are shared.

Submissions: Send query letter with resume, slides and SASE. Write to schedule an appointment to show a portfolio, which should include slides, transparencies and photographs. Replies only if interested within 2-4 weeks. Files slides, resume and bio. All material is returned if not accepted or under consideration. Common mistakes artists make are "not enough information—poor slide quality, too much work covering too many changes in their development."

***LONGVIEW MUSEUM & ARTS CENTER,** 102 W. College St., Longview TX 75601. (903)753-8103. Director: Millicent Canter. Museum. Estab. 1960. Represents mid-career and established artists. Sponsors 8 shows/year. Average display time 6 weeks. Open all year. Located downtown in a converted home. 75% of space for special exhibitions. Clientele: general public and schools.

Media: Considers all media.

Style: Exhibits all styles and genres.

Terms: Accepts work on consignment (30% commission). Retail price set by the artist. Gallery provides insurance and promotion; artist pays for shipping. Prefers artwork framed.

Submissions: Send query letter with slides, bio, brochure, photographs and reviews. Write to schedule an appointment to show a portfolio, which should include originals and slides. Does not reply, in which case the artist should call in 2 weeks. Files photographs, bio and reviews.

***MCMURTREY GALLERY**, 3508 Lake St., Houston TX 77098. (713)523-8238. Owner: Eleanor McMurtrey. Retail gallery. Estab. 1981. Represents 20 artists; emerging and mid-career. Exhibited artists include Ibsen Espada and Jenn Wetta. Sponsors 10 shows/year. Average display time 1 month. Open all year. Located near downtown; 2,600 sq. ft. Clientele: corporations and mid-career individual lawyers. 75% private collectors, 25% corporate collectors. Overall price range: $400-17,000; most work sold at $1,800-6,000.

Media: Considers oil, acrylic, pastel, drawing, mixed media, collage, paper and sculpture. Most frequently exhibits mixed media, acrylic and oil.

Style: Exhibits primitivism, painterly abstraction and realism. Prefers abstract, realism and narrative.

Terms: Accepts work on consignment (50% commission). Retail price set by the gallery and the artist. Gallery pays for shipping costs from gallery. Prefers artwork framed.

Submissions: Send query letter with resume, slides and SASE. Call to schedule an appointment to show a portfolio, which should include originals and slides.

Tips: "Be aware of the work the gallery exhibits and act accordingly."

ROBINSON GALLERIES, Suite 7, 3733 Westheimer, Houston TX 77027. (913)961-5229. Director: Thomas V. Robinson. Retail and wholesale gallery. Estab. 1969. Clientele: 90% private collectors, 10% corporate clients. Represents 10 artists. Sponsors 4 solo and 6 group shows/year. Average display time 5 weeks. Interested in emerging, mid-career and established artists. Overall price range: $100-100,000; most work sold at $1,000-25,000.

Media: Considers oil, acrylic, watercolor, pastel, pen & ink, drawings, mixed media, collages, works on paper, sculpture, ceramic, craft, fiber, glass, installation, photography, egg tempera, woodcuts, wood engravings, linocuts, engravings, mezzotints, etchings, lithographs and serigraphs. Most frequently exhibits oil/acrylic paintings, works on paper, wood and bronze.

Style: Exhibits expressionism, realism, photorealism, surrealism, primitivism and conceptualism. Genres include landscapes, Americana and figurative work. Prefers figurative and Americana work and social commentary. "I am interested in artists that are making a statement about the human condition."

Terms: Accepts work on consignment (50% commission). Buys outright (50% retail price, net 10 days). Retail price set by gallery and artist. Exclusive area representation required. Gallery provides insurance, promotion and shipping costs from gallery. Prefers framed artwork.

Submissions: Send query letter with resume, brochure, slides, photographs, bio and SASE. Write to schedule an appointment to show a portfolio, which should include originals, slides, transparencies and photographs. Replies in 1 week. Files resume and slides. All material is returned if not accepted or under consideration.

Tips: The most common mistake artists make is that "they do not know, nor do they seem to be concerned with the direction of the prospective gallery. Artists should do their homework and pre-determine if the gallery and the work it shows and promotes is compatible with the work and career objectives of the artist."

SAN ANTONIO ART INSTITUTE, 6000 N. New Braunfels, San Antonio TX 78209. (512)824-7224. FAX: (512)824-6622. President: Russell A. Cargo. Chair/Gallery Committee: Louis Turner. Nonprofit gallery. Estab. 1939. Represents emerging, mid-career and established artists. Exhibited artists include Larry Bell and Carl Embrey. Sponsors 7 shows/year. Average display time 5 weeks-1½ months. Open all year. Located in northeast San Antonio; 3,008 sq. ft.; "high ceiling, unique lighting; location adjacent to McNay Art Museum; beautiful grounds." 65% of space for special exhibitions. Clientele: college fine arts students, tourists, upscale community. Clientele: 90% private collectors, 10% corporate clients. Overall price range: $25-50,000.

Media: Considers all media.

Style: Exhibits all styles and genres.

Terms: "We follow NEA and Mid-America Arts Alliance guidelines." Retail price set by the artist. Gallery provides insurance, promotion, contract and shipping costs to and from gallery. Prefers framed artwork.

Submissions: NEA guidelines followed. Send query letter with resume and bio. No unsolicited slides. Call or write to schedule an appointment to show a portfolio, which should include slides, photographs and transparencies. Replies in 2 months. Files resume and bio.

Tips: "Send complete information, including social security number. No wildlife art or traditional Western art."

***SUSANNA SHEFFIELD GALLERY,** 512 Sul Ross, Houston TX 77006. (713)526-2431. Director: Susanna Sheffield. Retail gallery. Estab. 1987. Clientele: 60% private collectors; 40% corporate clients. Represents 10 artists. Sponsors 4 solo and 3 group shows/year. Average display time: 1 month. Interested in emerging and established artists. Overall price range: $400-10,000; most work sold at $2,000-5,000.

Media: Considers oils, acrylics, pen & ink, drawings, mixed media, collages, paper and sculpture. Most frequently exhibits paintings, sculpture and mixed media.

Style: Exhibits all styles and all genres. Prefers abstraction and surrealism. "I specialize in no particular genre or style and show only the work I passionately like. I like highly individualistic substantive, authentic work—serious, not decorative. The gallery is small and I plan to keep it that way."

Terms: Accepts work on consignment (50% commission). Retail price set by gallery and artist. Exclusive area representation not required. Gallery provides insurance and promotion; shipping costs are shared. Prefers artwork framed.

Submissions: Send query letter with resume, slides and SASE. Write to schedule an appointment to show a portfolio, which should include originals and slides. Replies in 2 weeks. Files resumes and slides. All material is returned if not accepted or under consideration.

Tips: A common mistake artists make is "incomplete information on slides—leaving out media and/or dimensions."

***EVELYN SIEGEL GALLERY,** 3612 W. 7th, Fort Worth TX 76107. (817)731-6412. Owner: E. Siegel. Retail gallery. Estab. 1983. Represents about 25 artists; emerging, mid-career and established. Interested in seeing the work of emerging artists. Exhibited artists include Judy Pelt and Jill Bush. Sponsors 9 shows/year. Average display time 1 month. Located in museum area; 2500 sq. ft.; Diversity of the material and artist mix. "The gallery is warm and inviting; a reading area is provided with many art books and publications." 25% of space for special exhibitions. Clientele: middle to upper income. 80% private collectors.

Media: Considers oil, acrylic, watercolor, pastel, mixed media, collage, sculpture, ceramic; original hand-pulled prints; woodcuts, wood engravings, linocuts, engravings, mezzotints, etchings, lithographs, serigraphs and posters (limited number). Most frequently exhibits oil, pastel and watercolor.

Style: Exhibits expressionism, neo-expressionism, painterly abstraction, impressionism, realism and hard-edge geometric abstraction. Genres include landscapes, florals, Southwestern and figurative work. Prefers landscape and figurative.

Terms: Accepts work on consignment (40% commission), or is sometimes bought outright. Retail price set by gallery and artist. Gallery provides insurance, promotion and contract. Artist pays for shipping. Prefers artwork framed.

Submissions: Send query letter with resume, slides and bio. Call or write to schedule an appointment to show a portfolio. Artist's portfolio should include two of the following: originals, photographs, slides and transparencies.

Tips: Artists must have an appointment.

JUDY YOUENS GALLERY, 2631 Colquitt St., Houston TX 77098-2117. (713)527-0303. Cotact: Director. Retail gallery. Estab. 1981. Clientele 75% private collectors, 25% corporate clients. Represents approximately 30 artists. Sponsors 10 solo and 5 group shows/year. Average display time 5 weeks. Interested in emerging artists. Price range $2,000-20,000; most artwork sold at $2,000-12,000.

Media: Considers oil, acrylic, mixed media, collage, sculpture, glass and installation. Most frequently exhibits paintings and sculpture; predominantly exhibits glass.

Style: Exhibits expressionism, neo-expressionism, realism, surrealism, minimalism and painterly abstraction.

Terms: Accepts work on consignment. Retail price set by gallery and artist. Exclusive area representation generally not required. Gallery provides insurance, promotion and contract. Prefers unframed artwork.

Submissions: Send query letter with slides, photographs and bio. Write to schedule an appointment to show a portfolio, which should include slides and transparencies. Replies in 3-4 weeks. Files only the work that we accept. All material is returned if not accepted or under consideration.

Tips: "Have good slides that are well marked."

Utah

APPLE YARD ART, 3096 S. Highland Ave., Salt Lake City UT 84106. (801)467-3621. Manager: Sue Valentine. Retail gallery. Estab. 1981. Clientele: 80% private collectors, 20% corporate clients. Represents 10 artists. Interested in seeing the work of emerging, mid-career and established artists. Sponsors 3 solo shows/year. Average display time is 6 weeks. "We have added European pine antiques and home accessories to compliment our art." Overall price range: $50-2,000; most artwork sold at $300.

Media: Most frequently exhibits watercolor, serigraphs and handmade paper.

Style: Exhibits impressionisim. Genres include landscapes and florals. Prefers impressionistic watercolors.

Terms: Accepts work on consignment (40% commission). Retail price is set by artist. Exclusive area representation required. Gallery provides insurance, promotion and contract; artist pays for shipping.

Submissions: Send query letter, resume and slides. Write for an appointment to show a portfolio, which should include originals.

Tips: Looks for "fresh, spontaneous subjects, no plagiarism." Most common mistakes artists make in presenting their work are "poorly framed artwork and not knowing a price—wanting me to decide. The public wants more original artwork or limited edition prints—not unlimited prints that can be found in every discount store catalog, etc."

BRAITHWAITE FINE ARTS GALLERY, 351 West Center, Cedar City UT 84720. (801)586-5432. Director: Valerie Kidrick. Nonprofit gallery. Estab. 1976. Represents emerging, mid-career and established artists. Has "100 friends (donors)." Exhibited artists include Jim Jones and Milford Zornes. Sponsors 17 shows/year. Average display time 3-4 weeks. Open all year. Located on "college campus; 1,500 sq. ft. (275 running wall); historic—but renovated—building." 100% of space for special exhibitions. Clientele: local citizens; visitors for Shakespeare festival during summer. Clientele: 100% private collectors. Overall price range: $100-8,000; most work sold at $100-500.

Media: Considers oil, acrylic, watercolor, pastel, pen & ink, drawings, mixed media, collage, works on paper, sculpture, ceramic, fiber, glass, installation, photography, original handpulled prints, woodcuts, wood engravings, linocuts, engravings, mezzotints, etchings, lithographs, serigraphs. Most frequently exhibits oil, watercolor and ceramic.

Style: Exhibits realism and all styles and genres. Prefers realism (usually landscape), painterly abstraction and surrealism.

Terms: Accepts work on consignment (25% commission). Retail price set by the artist. Gallery provides insurance, promotion and contract (duration of exhibit only); shipping costs are shared. Prefers framed artwork.

Submissions: Send query letter with resume, slides, bio and SASE. Write to schedule an appointment to show a portfolio, which should include slides and transparencies. Replies in 3-4 weeks. Files bios, slides, resume (only for 2 years).

Tips: "Know our audience! Generally conservative; during summer (Shakespeare festival) usually loosens up. We look for broad stylistic vision and content. Artists often send no slides, no bio, no artist statement. They also can be too demanding."

***DOLORES CHASE FINE ART,** 260 S. 200 W. St., Salt Lake City UT 84101. (801)328-2787. Contact: Dolores Chase. Retail gallery. Estab. 1985. Represents 15 artists; emerging and mid-career. Exhibited artists include Edie Roberson and Lee Deffebach. Sponsors 4-6 shows/year. Average display time 6-8 weeks. Open all year. Located in downtown Salt Lake City; 2,000 sq. ft.; gallery features a diagonal exhibit wall through large room, with smaller side galleries. 35% of space for special exhibitions. Clientele: skiers and other visitors from out of town, locals, business people and collectors. 70% private collectors, 30% corporate collectors. Overall price range: $500-5,000; most work sold at $700-2,000.

Media: Considers oil, acrylic, pastel, watercolor, mixed media, sculpture, ceramic and glass. No prints. Most frequently exhibits acrylic, oil and mixed media.

Style: Exhibits expressionism, painterly abstraction, surrealism, color field and realism. All genres. Prefers contemporary art: abstraction, surrealism and realism.

Terms: Accepts work on consignment (50% commission). Retail price set by the gallery and the artist. Gallery provides insurance and contract; shipping costs from gallery.

Submissions: Send query letter with resume, slides, bio, SASE, reviews and price list. Prefers art under $2,000. Write to schedule an appointment to show a portfolio, which should include slides. Replies in 3-5 weeks.

MARBLE HOUSE GALLERY, 44 Exchange Pl. Salt Lake City UT 84111. (801)532-7338. Owner: Dolores Kohler. Retail gallery and art consultancy. Estab. 1987. Clientele 70% private collectors; 30% corporate clients. Represents 20 artists; emerging, mid-career and established. Sponsors 6 solo or 2-person shows and 2 group shows/year. Average display time 1 month. Located in the historic financial district; modern interior facade; well lit; 6,000 sq. ft. Overall price range $100-10,000; most work sold at $200-5,000.

Media: Considers oil, acrylic, watercolor, pastel, pen & ink, mixed media, collage, sculpture, ceramic, photography, egg tempera, woodcuts, wood engravings, linocuts, engravings, mezzotints, etchings, lithographs, pochoir and serigraphs. Most frequently exhibits oil, watercolor and sculpture.

Style: Exhibits impressionism, expressionism, realism, surrealism, painterly abstraction and post modern works. Genres include landscapes, florals, Americana Southwestern, Western, portraits, still lifes and figurative work. Prefers abstraction, landscapes and florals.

Terms: Accepts work on consignment (50% commission); buys outright (net 30 days.) Retail price set by gallery and artist. Exclusive area representation required. Gallery provides promotion and contract; shipping costs are shared. Prefers artwork framed or unframed.

Submissions: Send query letter with resume, slides, photographs, bio and SASE. Call or write to schedule an appointment to show a portfolio, which should include originals, slides, transparencies, and photographs. Replies in 2 weeks. Files slides, resume and price list. All material is returned if not accepted or under consideration.

Tips: "No crude, suggestive subjects. Looks for professionalism and steady productions in artists. This year we are having a Gallery Stroll on the third Friday of each month. About 15 galleries participate."

Vermont

COTTONBROOK GALLERY, RR1, Box 440, Stowe VT 05672. (802)253-8121. Owner: Vera Beckerhoff. Retail gallery and custom frame shop. Estab. 1981. Clientele: upscale second homeowners. Average display time 3 weeks. Prefers New England artists, but will accept work from Northern (West and Canada) artists. Interested in emerging and established artists. Overall price range: $50-3,000; most artwork sold at $100-200.

Media: Considers oil, watercolor, pastel, pen & ink, drawings, mixed media, sculpture, original handpulled prints, limited edition offset reproductions, posters. Most frequently exhibits etchings, watercolor, oil.

Style: Exhibits painterly abstraction, primitivism and impressionism. Genres include landscapes, Americana and figurative work. Most frequently exhibits New England landscapes and winter watercolors.

Terms: Rental fee for space. Retail price is set by gallery or artist. Exclusive area representation not required. Gallery provides promotion and contract; shipping costs are shared.

Submissions: Send query letter with resume, slides and SASE. Write for an appointment to show a portfolio, which should include originals.

***LA PETITE GALERIE**, 150 Dorset St., Suite 237, S. Burlington VT 05407-2010. (802)658-9323. FAX: (802)862-2899. Director: Jean Johnson. Retail gallery with some co-op. Estab. 1990. Represents 35 artists (11 of the 35 are co-op); emerging and established. Exhibited artists include Michael Escoffery and Idaherma Williams. Sponsors 11 shows/year. Closed in August. Moving to the Marketplace downtown in August '91; 900 sq. ft.; interior is country French. Clientele: tourists (Canada). 30% private collectors, 70% corporate collectors. Overall price range: $300-10,000; most work sold at $1,000.

Media: Considers oil, pen & ink, acrylic, drawing, sculpture, watercolor, mixed media, ceramic sculptures on wheel and pastel; original handpulled prints, woodcuts, engravings and etchings. Most frequently exhibits bronze sculpture, acrylics (framed), wood and ceramic sculptures.

Style: Exhibits painterly abstraction, impressionism, realism, photorealism, pattern painting, and hard-edge geometric abstraction. Genres include landscapes, florals, Southwestern, wildlife and figurative work. Prefers figurative, abstract and impressionistic.

Terms: Accepts work on consignment (40% commission); co-op membership fee plus a donation of time (20% commission); rental fee for space (covers 1 month up to 1 year). 10 members are co-op, 25 on 40% consignment. Retail price set by the artist. Gallery provides promotion. Artist pays for shipping. Prefers artwork framed.

Submissions: Send query letter with resume, brochure, business card, slides, photographs, reviews, bio, SASE and video if possible, and price list. Write to schedule an appointment to show a portfolio, which should include originals, photographs and transparencies. Replies in 1 week. Files slides, photos and bio.

Tips: "Artists should send all materials at one time, i.e. slides, a minimum of ten (a sleeve preferred) and an Artist's Statement."

PARADE GALLERY, Box 245, Warren VT 05674. (802)496-5445. Owner: Jeffrey S. Burnett. Retail gallery. Estab. 1982. Clientele: tourist and upper middle class second home owners; 98% private collectors. Represents 15-20 artists. Interested in emerging, mid-career and established artists. Overall price range: $20-2,500; most artwork sold at $50-300.

Media: Considers oil, acrylic, watercolor, pastel, mixed media, collage, works on paper, sculpture and original handpulled prints. Most frequently exhibits etchings, silkscreen and watercolor. Currently looking for oil/acrylic and watercolor.

Style: Exhibits primitivism, impressionistic and realism. "Parade Gallery deals primarily with representational works with country subject matter. The gallery is interested in unique contemporary pieces to a limited degree." Does not want to see "cutesy or very abstract art."

Terms: Accepts work on consignment (⅓ commission) or occasionally buys outright (net 30 days). Retail price is set by gallery or artist. Exclusive area representation required. Gallery provides insurance and promotion.

Submissions: Send query letter with resume, slides and photographs. Write for an appointment to show a portfolio, which should include originals or slides. Biographies and background are filed.

WOODSTOCK GALLERY OF ART, Gallery Place, Route 4 E., Woodstock VT 05091. (802)457-1900. Assistant Director: Samantha McCue. Retail gallery. Estab. 1972. Represents 70+ artists; mid-career and established. Interested in seeing the work of emerging artists. Exhibited artists include Cynthia Price and Jerome Corielle. Sponsors 8-10 shows/year. Average display time is 1 month. Open all year. Located 1 mile east of town; 1,600 sq. ft.; gallery features large wall space, cathedral ceilings, wooden staircase. 50-75% of space for special exhibitions. 75% private collectors, 25% corporate collectors. Overall price range: $100-8,000.

Media: Considers all media; wood engravings, engravings, lithographs and offset reproductions. Most frequently exhibits acrylic/oil paintings, photo/etching and sculpture.

Style: Exhibits expressionism, neo-expressionism, surrealism, painterly abstraction, impressionism, realism and photorealism. Will consider all styles. All genres. Prefers expressionism, painterly abstract and impressionism.

Terms: Accepts work on consignment (50% commission). Retail price is set by gallery and artist. Gallery provides insurance, promotion and contract; artist pays for shipping. Prefers artwork framed.

Submissions: Accepts only artists from New England. Send query letter with resume, brochure, slides, photographs, business card, reviews, bio and SASE. Write to schedule an appointment to show a portfolio, which should include originals. Replies in 2 weeks. Files resumes and bio sheets.

Tips: "Send an organized packet including items listed above under submissions. Artists with honesty and commitment, please apply."

Virginia

***ALLEGHANY HIGHLANDS ARTS AND CRAFTS CENTER**, 439 Ridgeway St., Box 273, Clifton Forge VA 24422. (703)862-4447. Chairman, Exhibition Committee: Bess Caton. Retail and nonprofit gallery. Estab. 1984. Represents 86 artists and 227 craftspeople; emerging, mid-career and established. 389 members. Exhibited artists include Jeanne Shepherd and Geneva Welch. Sponsors 12 shows/year. Average display time 1 month. Open all year. Located downtown; 428 sq. ft. in one gallery, 397 sq. ft in second adjoining space—"can be used together. Also 59 running feet in shop area; spacious, well lit, comfortable to children and adults, handicapped accessibility." 55% of space for special exhibitions. Clientele: tourists from all 50 states and several foreign counties annually, as well as regional visitors. 99% private collectors, 1% corporate collectors. Overall price range: $25-500; most work sold at $125-250.

Media: Considers all media; original handpulled prints, woodcuts, wood engravings, linocuts, engravings, mezzotints, etchings, lithographs and serigraphs. Most frequently exhibits oil and watercolor, drawings/prints and sculpture.

Style: Exhibits expressionism, primitivism, painterly abstraction, post modern works, impressionism, realism. All genres. Prefers realism, impressionism and painterly abstraction. "Our only real preference is for quality work."

Terms: Accepts work on consignment (30% commission). Retail price set by the artist. Gallery provides insurance and promotion; artist pays for shipping. Prefers artwork framed. "While we prefer framed work, we have some space for matted shrink wrapped pieces."

Submissions: "We focus on artists from the region (150 mile radius)." Send query letter with resume, slides, bio, SASE and "brief reviews, please." Write to schedule an appointment to show a portfolio, which should include originals and slides. Replies in 2 months. Files resumes, representations of work and brief reviews.

Tips: "We work to present all media and styles as the Center is an educational facility. We also see many tourists, particularly from May-December. While we will look at slides, final decisions are made by reviewing actual work, either as a submission or if seen in another facility, so we may be quite sure of what to expect."

***ART AND AUTHORS GALLERY**, 202 Clarke Ct., Fredericksburg VA 22407. (703)898-0869. FAX: (703)898-0869. Owner/Curator/Artist: Anne Brauer. Retail gallery. Estab. 1989. Represents 10 artists; emerging, mid-career and established. Exhibited artists include Anne Brauer and Bert Gonce. Closed February and August. Located in commercial area just out of city limits; 576 sq. ft.; "one-story garden gallery with skylights, divided into two galleries for openness." 50% of space for special exhibitions. Clientele: professionals, collectors and the general public. 90% private collectors. Overall price range: $50-650; most work sold at $150-300.

Media: Considers oil, acrylic, watercolor, pen & ink, mixed media, collage and sculpture. Most frequently exhibits oil, watercolor and mixed media.

Style: Exhibits expressionism, primitivism, painterly abstraction, impressionism and realism. Genres include landscapes, florals, Americana and portraits.

Terms: Accept work on consignment (30% commission). Retail price set by the artist. Gallery provides promotion. Artist pays for shipping. Artwork must be framed.

Submissions: Accepts only artists from local area, within 30-mile area. Send query letter with resume, slides, photographs and SASE. Call to schedule an appointment to show a portfolio, which should include originals and photographs. Replies in 2 weeks. Files photographs of work.

Tips: "Be sure you feel your work is salable. The curator has final word in accepting any art to be displayed."

THE ART LEAGUE, INC., 105 N. Union St., Alexandria VA 22314. (703)683-1780. Gallery Director: Katy Svoboda. Cooperative gallery. Estab. 1953. Clientele: 75% private collectors, 25% corporate clients. Has 1,000-1,100 members. Sponsors 10 solo and 16 group shows/year. Average display time is 1 month. Located in The Torpedo Factory—the largest gallery on the first floor. Accepts artists from metropolitan Washington area, Northern Virginia and Maryland. Interested in emerging, mid-career and established artists. Overall price range: $50-4,000; most artwork sold at $150-500.
Media: Considers oil, acrylic, watercolor, pastel, pen & ink, drawings, mixed media, collage, works on paper, sculpture, ceramic, fiber, glass, photography and original handpulled prints. Most frequently exhibits watercolor, all print making and oil/acrylic.
Style: Exhibits all styles and genres. Prefers impressionism, painted abstraction and realism. "The Art League is a membership organization open to anyone interested."
Terms: Accepts work on consignment (33⅓% commission) and co-op membership fee plus donation of time. Retail price is set by artist. Exclusive area representation not required.
Tips: A common mistake artists make is "framing that either overwhelms the work or is done in a nonprofessional way with dirty, poorly fitting mattes, etc."

HERNDON OLD TOWN GALLERY, 720 Lynn St., Herndon VA 22070. (703)435-1888. Membership chairman: Lassie Corbett. Cooperative gallery. Estab. 1984. Clientele: 90% private collectors, 10% corporate clients. Represents 5 member artists and 5 associate artists. Sponsors 4 solo and 8 group shows/year. Average display time 2 months. Interested in emerging artists. Overall price range: $25-1,000; most work sold at $150-350.
Media: Considers oil, acrylic, watercolor, pastel, pen & ink, drawings, mixed media, collage, photography, egg tempera, original handpulled prints and offset reproductions. Most frequently exhibits watercolor, acrylic, oil and drawings.
Style: Exhibits impressionism, realism and oriental brush; considers all styles. Genres include landscapes, florals, Americana, wildlife, figurative work; considers all genres. Prefers impressionism, realism (local scenes) and oriental brush.
Terms: 10% commission. Rental fee for space for artists on consignment; rental fee covers 6 months. Retail price set by artist. Exclusive area representation not required. Gallery provides promotion; artist pays for shipping. Prefers framed artwork.
Submissions: Send query letter with resume, slides and SASE. Call or write to schedule an appointment to show a portfolio, which should include originals, slides or photographs. Replies in 1 week. All material is returned if not accepted or under consideration. Contact for guidelines.

***MARSH GALLERY**, University of Richmond, Richmond VA 23173. (804)289-8276. Director Richard Waller. Museum. Estab. 1967. Represents emerging, mid-career and established artists. Sponsors 8 shows/year. Average display time 1 month. Open September through May. Located on university campus; 1,800 sq. ft. 100% of space for special exhibitions.
Media: Considers all media and all types of prints. Most frequently exhibits painting, sculpture and drawing.
Style: Exhibits all styles and genres. Prefers realism and abstraction.
Terms: Work accepted on loan for duration of special exhibition. Retail price set by the artist. Gallery provides insurance, promotion and contract; shipping costs to and from gallery. Prefer artwork framed.
Submissions: Send query letter with resume, slides, brochure, SASE, reviews and printed material if available. Write to schedule an appointment to show a portfolio, which should include photographs, slides, transparencies or "whatever is appropriate to understanding the artist's work." Replies in 1 month. Files resume and other materials the artist does not want returned (printed material, reviews, etc.).

THE PRINCE ROYAL GALLERY, 204 South Royal St., Alexandria VA 22314. (703)548-5151. Director: John Byers. Retail gallery. Estab. 1977. Located in middle of Old Town Alexandria. "Gallery is the ballroom and adjacent rooms of historic hotel." Clientele: primarily Virginia, Maryland & Washington DC residents; 95% private collectors, 5% corporate clients. Sponsors 6 solo and 1 group shows/year. Average display time 3-4 weeks. Interested in emerging, mid-career and established artists. Overall price range: $75-8,000; most artwork sold at $700-1,200.
Media: Considers oil, acrylic, watercolor, pastel, mixed media, sculpture, egg tempera, engravings, etchings and lithographs. Most frequently exhibits oil, watercolor and bronze.
Style: Exhibits impressionism, expressionism, realism, primitivism and painterly abstraction. Genres include landscapes, florals, portraits and figurative work. "The gallery deals primarily in original, representational art. Abstracts are occasionally accepted but are hard to sell in Northern Virginia. Limited edition prints are accepted only if the gallery carries the artist's original work."
Terms: Accepts work on consignment (40% commission). Retail price set by artist. Exclusive area representation required. Gallery provides insurance, promotion and contract. Prefers framed artwork.
Submissions: Send query letter with resume, brochure, slides and SASE. Call or write to schedule an appointment to show a portfolio, which should include originals, slides and transparencies. Replies in 1 week. Files resumes and brochures. All material is returned if requested.

Tips: "Write or call for an appointment before coming. Have at least six pieces ready to consign if accepted. Can't speak for the world, but in Northern Virginia collectors are slowing down. Lower-priced items continue OK, but sales over $3,000 are becoming rare. More people are buying representational rather than abstract art. Impressionist art is increasing."

RESTON ART GALLERY, 11400 Washington Plaza W., Reston VA 22090. (703)481-8156. Publicity: JoAnn Morris-Scott. Nonprofit gallery. Estab. 1988. Clientele: 75% private collectors, 25% corporate clients. Represents 13 artists. Sponsors 10 solo and 2 group shows/year. Average display time 1 month. Interested in emerging artists. Overall price range: $25-1,750; most work sold at $150-350.
Media: Considers all media and prints. Most frequently exhibits oil, acrylic, watercolor, photos and graphics.
Style: Exhibits all styles and genres. Prefers realism and painterly abstraction. The gallery's purpose is to "promote local artist and to educate the public. Gallery sitting and attendance at meetings is required."
Terms: Co-op membership fee plus donation of time; 20% commission. Retail price set by artist. Exclusive area representation not required. Gallery provides promotion; artist pays for shipping. Prefers artwork unframed.
Submissions: Send query letter with resume, slides, photographs, bio and SASE. Call or write to schedule an appointment to show a portfolio, which should include originals, slides and photographs. Replies in 1 week. All material is returned if not accepted or under consideration.

Washington

***MIA GALLERY,** 314 Occidental Ave. S., Seattle WA 98104. (206)467-8283. Owner: Mia McEldowney. Retail gallery. Represents 65 artists; emerging, mid-career and established. Exhibited artists include Joe Max Emmilger and Kiff Slemmons. Sponsors 12 shows/year. Average display time 1 month. Open all year. Located in Pioneer Square; 1,500 sq. ft. 85% of space for special exhibitions. Clients are primarily private collectors. 85-90% private collectors, 10-15% corporate collectors. Overall price range: $250-10,000; most work sold at $350-2,500.
Media: Considers oil, acrylic, watercolor, pastel, pen & ink, drawing, mixed media, collage, paper, sculpture, ceramic, craft and jewelry; original handpulled prints, woodcuts, wood engravings, linocuts, engravings, mezzotints, etchings, lithographs, serigraphs and clay prints.
Style: Exhibits primitivism, outsider and narrative. Genres include figurative work.
Terms: Accepts work on consignment (50% commission). Retail price set by the artist. Gallery provides insurance, promotion and contract; shipping costs from gallery. Prefers artwork framed.
Submissions: Accepts only artists from the Northwest. Prefers only abstract art. Send query letter with resume, slides, bio and SASE. When slides are approved the gallery will contact the artist. Replies in 2 weeks. Files material only on accepted artists.
Tips: "Make sure your work is appropriate to the style of the gallery. Send slides showing consistency in work. Include complete information on media, size, title and basic retail value."

Wisconsin

***CROSSMAN GALLERY,** Center for the Arts, UW-Whitewater, 800 W. Main St., Whitewater WI 53704. (414)472-5708. Director: Susan Walsh. Nonprofit university gallery. Estab. 1979. Represents emerging, mid-career and established artists. Exhibited artists include Sam Gilliam and Sue Coe. Sponsors 1 and 2 person shows, invitations, student exhibitions. Sponsors 6-7 shows/year, separate from student shows. Average display time 2-3 weeks. Open all year. Located on the edge of campus, 70 miles from Milwaukee, 100 miles from Chicago; 2,600 sq. ft.; open exhibition space is available in atrium for large works such as bronze sculpture or suspended fibers. 30% of space for special exhibitions. Clientele: alumni.
Media: Considers all media and original handpulled prints. Most frequently exhibits painting, sculpture and mixed media/new technology.
Style: Exhibits all styles. Genres include landscapes and Americana. Prefers imagism, naturalism and new technology (surrealism).
Terms: "Will put artist in contact with interested parties in terms of sales." Gallery provides insurance and promotion; shipping costs from gallery for smaller works; shipping costs are shared for large sculpture especially. Prefers artwork framed.
Submissions: Send query letter with resume, slides, bio, photographs, SASE and reviews. Portfolio should include photographs, slides and transparencies. Replies in 1-2 months. Files resumes, sample slides and photos.
Tips: "Grant money helpful from artist to foot certain expenses (audio equipment, etc.)."

FOSTER GALLERY, 121 Water St., Eau Claire WI 54702. (715)836-2328. Director: Eugene Hood. University gallery. Estab. 1970. Represents emerging, mid-career and established artists. Exhibited artists include Richard Long, Sidney Goodman, Roger Essely, Dorit Cypus and Bruce Charlesworth. Sponsors 9 shows/year. Average display time 3 weeks. Open from September-May. Located on the university campus; 3,250 sq. ft.; "two connected spaces, one with 13' ceiling and marbelized floor." 95% of space for special exhibitions. Clientele: 75% private collectors, 25% corporate collectors. Overall price range: $35-10,000; most work sold at $200-750.
Media: Considers oil, acrylic, watercolor, pastel, pen & ink, drawings, mixed media, collage, works on paper, sculpture, ceramic, fiber, glass, installation, photography, video, computer and performance art, original handpulled prints, woodcuts, wood engravings, engravings, mezzotints, etchings, lithographs and serigraphs. Most frequently exhibits fiber, drawings and paintings.
Style: Exhibits all styles and genres. Prefers realism, painterly abstraction, conceptualism and photography.
Terms: Accepts work on consignment (10% commission). Retail price set by the artist. Gallery provides insurance and promotion; shipping costs to gallery. Prefers framed artwork.
Submissions: Send query letter with resume, slides, bio, SASE and reviews. "Present an idea of a theme or group show." Portfolio should include slides. Replies only if interested within 2 months.
Tips: Wants to see "quality, works undergraduate students will be inspired by, but can also relate to." Does not want to see "pseudo-naive work, intuitive no-skill work." Notices a "return to skill or craft aesthetic; exhibits that use gallery space not just its walls, to create a total environment."

THE FANNY GARVER GALLERY, 230 State St., Madison WI 53703. (608)256-6755. President: Fanny Garver. Retail gallery and art consultancy. Estab. 1972. Clientele: 80% private collectors, 20% corporate clients. Represents 100 artists. Sponsors 8 solo and 4 group shows/year. Average display time 1 month. Space includes display cases for glass and jewelry. Interested in emerging, mid-career and established artists. Overall price range: $40-10,000; most artwork sold at $60-500.
Media: Considers oil, acrylic, watercolor, pastel, pen & ink, drawings, mixed media, collage, works on paper, sculpture, ceramic, craft, fiber, glass, woodcuts, wood engravings, linocuts, engravings, mezzotints, etchings and lithographs. Most frequently exhibits watercolor, oil and pastel. Does not want to see photography.
Style: Exhibits all styles. Genres include landscapes, florals, Americana and portraits.
Terms: Accepts work on consignment or buys outright. Retail price set by gallery and artist. Exclusive area representation required. Gallery provides insurance, promotion and contract; shipping costs are shared.
Submissions: Send query letter with resume, slides, bio and SASE. Call or write to schedule an appointment to show a portfolio, which should include originals and slides. Replies in 2 weeks. Files resume and bio. All material is returned if not accepted or under consideration.
Tips: "Never contact us on Saturday, the busiest day, or during December. Send a SASE if you want slides back." Looking for "direction, maturity, original expression, reliability, consistency of quality, reasonable expectations in pricing, commitment to creating a continuing body of work and a willingness to discuss prices and other marketing strategies with us." As trend sees "interest in emerging artists whose work is still reasonably priced."

KATIE GINGRASS GALLERY, Milwaukee, 241 N. Broadway, Milwaukee WI 53202. (414)289-0855. Director: Pat Brophy or Elaine Hoth. Retail gallery. Estab. 1984. Clientele: 45% private collectors, 55% corporate clients. Represents 150 artists. Sponsors 6-8 group shows/year. Average display time 6 weeks. Interested in emerging and established artists. Overall price range: $50-10,000; most artwork sold at $100-3,000.
Media: Considers oil, acrylic, watercolor, pastel, drawings, mixed media, collage, works on paper, sculpture, ceramic, craft, fiber, glass, photography, egg tempera, woodcuts, wood engravings, linocuts, engravings, mezzotints, etchings, lithographs, pochoir and serigraphs. Most frequently exhibits paintings, pastel and craft.
Style: Exhibits impressionism, expressionism, realism, photorealism, color field, painterly abstraction, post modern works and imagism. Genres include landscapes, florals and figurative work. Prefers realism, abstraction and impressionism. Specializes in contemporary American paintings, sculptures, drawings and fine crafts.
Terms: Accepts work on consignment (50% commission). Retail price set by gallery and artist. Exclusive area representation required. Gallery provides insurance, promotion, contract and shipping costs from gallery.
Submissions: Send query letter with resume, slides, photographs, bio and SASE. Write to schedule an appointment to show a portfolio, which should include originals, slides and prices. Replies in 2 months. Files resumes, biographies and sildes. All material is returned if not accepted or under consideration.
Tips: Looks for "individualistic and unique thinking in realistic, abstract and craft work."

***HAGGERTY MUSEUM OF ART**, Marquette University, 13th and Clybourn, Milwaukee WI 53202. (414)288-1669. FAX: (414)288-5415. Curator: Jane Goldsmith. Museum. Exhibits emerging, mid-career and established artists. Sponsors 10 shows/year. Average display time 2 months. Open all year. Located downtown university campus; 8,000 sq. ft.; contemporary architecture. 70% of space for special exhibitions.
Media: Considers oil, acrylic, watercolor, pastel, pen & ink, drawing, mixed media, collage, paper, installation and photography; original handpulled prints, woodcuts, engravings, mezzotints, lithographs and serigraphs. Most frequently exhibits paintings, prints and photographs.

Style: Exhibits all styles and genres. Prefers surrealism, conceptualism, color field, post modern works and realism.

Terms: Accepts work on consignment (40% commission). Only works accepted for exhibitions are eligible for sale. The museum will process sales but does not actively promote sale of art. Retail price set by the artist. Gallery provides insurance and promotion. Gallery pays shipping costs.

Submissions: Send query letter with resume, slides and reviews. Write to schedule an appointment to show a portfolio. Portfolio should include slides and transparencies. Replies in 2 months. Files only information of interest to exhibitions.

Tips: "Only work of national/international quality is considered."

***JOHN MICHAEL KOHLER ARTS CENTER**, 608 New York Ave., Box 489, Sheboygan WI 53082-0489. (414)458-6144. Exhibitions Dept.: Suzanne Ford. Nonprofit gallery/arts center. Estab. 1967. Represents emerging artists. "We feature the work of emerging American (primarily) artists." Sponsors 15 shows/year. Average display time 2 months. Open all year. Located downtown; 8,525 sq. ft.; "The Center is located in one of the city's most famous old houses, is an impressive Italianate villa built in 1882. An addition, which opened in 1970, provided a theatre, large studio-classrooms, and spacious new galleries. Five galleries present 14 to 18 unusual, though-provoking, and often amusing exhibitions per year of contemporary American art; Artspace, an off-site gallery, provides additional temporary and ongoing exhibition space for contemporary American artists; and Flying Colors serves as a creative learning shop and exhibitions space geared towards children." 80-100% of space for special exhibitions.

Media: Considers all media. Most frequently exhibits ceramic, art, unconventional photography and installation.

Style: Exhibits primitivism, surrealism, conceptualism, post modern works and photorealism. "Our focus is on the crafts, ceramic arts, unconventional photograph installations and the art of naives and visionaries."

Terms: "Artists exhibited receive an honorarium. They may offer works for sale if they wish. We retain 25% of price of works sold in our galleries. A publication in the form of a check list with essay or a catalog accompanies most exhibitions." Retail price set by the aritst. Gallery provides insurance and promotion; approved shipping costs to and from gallery. Prefers artwork framed or unframed. "Depending upon the work and where it's going."

Submissions: Send query letter with resume, slides, bio, brochure, photographs, SASE, business cards and reviews. Call to schedule an appointment to show a portfolio, which should include photographs, slides and tarnsparencies. Replies in 1 week as to receipt of materials. Replies only if interested within months as to exhibition possibilities—"we schedule 2-3 years in advance." Files slides, bios and supporting materials.

Tips: "Be prepared to leave materials. We return materials upon request but prefer to keep them on file. In addition to regular exhibitions, the center offers a wide range of classes, workshops and residencies. It also holds the outdoor Arts Festival in July and conducts an Arts/Industry program in which 12 to 17 artists per year spend two to six months working in the Kohler Co. Pottery, Iron and Brass Foundries, and Enamel Shop. A collaboration between art and industry, this program makes industrial material, technologies and facilities available to the artists so they may further their artistic explorations."

***NEW VISIONS GALLERY, INC.**, at Marshfield Clinic, 1000 N. Oak Ave., Marshfield WI 54449. Executive Director: Ann Waisbrot. Nonprofit educational gallery. Runs museum and art center program for community. Open all year. 1,500 sq. ft. Organizes a variety of group and thematic shows (10 per year), very few one person shows, sponsors Marshfield Art Fair. Annual invitational exhibit of art with agricultural themes. Show of art masks being developed. Does not represents artists on a continuing basis. Average display time 6 weeks. Price range varies with exhibit. Small gift shop with original jewelry, notecards and crafts at $10-100.

Media: Considers all media.

Style: Exhibits all styles and genres.

Terms: Accepts work on consignment (35% commission). Retail price set by artist. Gallery provides insurance and promotion. Prefers artwork framed.

Submissions: Send query letter with resume, slides and SASE. Label slides with size, title, media. Replies in 1 month. Files resume. Will retain some slides if interested, otherwise they are returned.

Tips: "Do not drop in without an appointment. We may not be able to meet with you. If you are in our area and wish to show a portfolio, call for an appointment."

***POSNER GALLERY**, 207 N. Milwaukee St., Milwaukee WI 53202. (414)273-3097. Director: Judith Posner. Retail gallery. Estab. 1974. Represents 200 artists; emerging, mid-career and established artists. Exhibited artists include Hockney and Wesselmann. Sponsors 4 shows/year. Sponsors 4 shows/year. Average display time 6 weeks. Open all year. Located downtown; 8,000 sq. ft. 50% of space for special exhibitions. Gallery features unique decor. 50% private collectors, 50% corporate collectors. Overall price range: $50-50,000; most work sold at $1,000-10,000.

Media: Considers oil, acrylic, watercolor, pastel, pen & ink, drawing, mixed media, collage, works on paper, sculpture; original handpulled prints, linocuts, engravings, etchings, lithographs, pochoir, posters and serigraphs. Most frequently exhibits lithographs, serigraphs and paintings (acrylic).

© Clair Colquitt 1987

For a quarter "Misty" of Misty and the Pinboys, with limbs of Boeing control struts, breasts of Kenmore vacuum cleaner cowlings, eyes of croquet balls and clothing of polka-dotted polyster, will sing you a song. The installation, which stands 90×144×144", was exhibited at the John Michael Kohler Arts Center in Sheboygan, Wisconsin in the show "Eccentric Machines." It was created by Clair Colquitt of Seattle, Washington and is the result of three months of hard labor, two years of computer study and a 20-year art career.

Style: Exhibits painterly abstraction, minimalism, impressionism, realism, photorealism, pattern painting and hard-edge geometric abstraction. All genres. Prefers landscapes, florals and abstract.

Terms: Accepts work on consignment (50% commission). Retail price set by the gallery and the artist. Gallery provides insurance and promotion; artist pays for shipping. Prefers artwork unframed.

Submissions: Send query letter with slides, bio and SASE. Portfolio should include slides. Replies in weeks.

VALPERINE GALLERY, 1719 Monroe St., Madison WI 53711. (608)256-4040. Director: Valerie Kazamias. Retail gallery. Estab. 1982. Represents 75 artists; emerging, mid-career and established. Exhibited artists include Sarah Aslakson and Peggy Zalucka. Sponsors 5 shows/year. Average display time 3 weeks. Open all year. Located in neighborhood shopping area; 3,000 sq. ft. 50% of space for special exhibitions. Gallery is "spacious, with excellent wall space and lighting—built to be a gallery, not remodeled to be one." 25% private collectors, 75% corporate collectors. Overall price range: $100-7,000; most work sold at $500-1,500.

Media: Considers oil, acrylic, watercolor, pastel, mixed media, collage, paper, sculpture, ceramic, fiber and glass; original handpulled prints, woodcuts, engravings, lithographs, posters, linocuts, etchings and serigraphs. Most frequently exhibits watercolor, oil and acrylic.

Style: Exhibits expressionism, painterly abstraction, impressionism, realism and photorealism. Genres include landscapes and florals. Prefers landscapes, florals and abstract.

Terms: Accepts work on consignment (40% commission). Retail price set by the artist. Gallery provides insurance, promotion and contract; artist pays for shipping. Prefers artwork framed.

Submissions: Send query letter with resume, slides, bio, brochure and reviews. Call or write to schedule an appointment to show a portfolio, which should include originals, slides and photographs. Replies in 1 month. Files resume and, if possible, slides and photos.

CHARLES A. WUSTUM MUSEUM OF FINE ARTS, 2519 Northwestern Ave., Racine WI 53404. (414)636-9177. Associate Curator: Caren Heft. Museum. Estab. 1941. Represents about 200 artists; emerging, mid-career and established. Sponsors 16-18 shows/year. Average display time 6 weeks. Open all year. Located northwest of downtown Racine; 3,000 sq. ft.; "an 1856 Italianate farmhouse on 13 acres of parks and gardens." 100% of space for special exhibitions. Clientele: "private collectors from a tri-state area between Chicago and Milwaukee, as well as corporate collectors." Clientele: 75% private collectors, 25% corporate collectors. Overall price range: $100-10,000; most artwork sold at $300-1,000.

Media: "We show all media, including video, but specialize in 20th-century works on paper, craft and artists' books." Considers original handpulled prints, woodcuts, wood engravings, linocuts, engravings, mezzotints, etchings, lithographs and pochoir. Most frequently exhibits works on paper, ceramics, fibers.

Style: Exhibits all styles and genres. Most frequently exhibits abstraction, realism and surrealism.

Terms: Accepts work on consignment (30% commission). Retail price set by the artist. Gallery provides insurance, promotion and contract; shipping costs from gallery (for group); artist pays for shipping (for solo). Prefers artwork framed.

Submissions: "Artists must send letter, note or postcard of interest. Museum reviews slides once annually each February, to consider for solo and small group shows. Other juried competitions are advertised. We notify artists in November, jury in February-March and notify in April." Files resume and correspondence.

Tips: "Be patient. There are a lot of artists applying for few exhibition slots."

Wyoming

BIG RED GALLERY, 2836 U.S. Highway 14-16 East, Clearmont WY 82835. (307)737-2291. Gallery Program Director: Elizabeth Guheen. Nonprofit gallery. Estab. 1983. Open year round. A renovated barn from 1882 on historical register tour. Gallery also houses 4 artist-in-resident studios and a gallery office as well as conference facilities upstairs. Sponsors 1 solo and 7 group shows/year. Average display time 6 weeks. Prefers regional work but not exclusively. Interested in emerging and established artists.

Media: Considers all media and all types of prints. Most frequently exhibits oil/acrylic, clay and bronze.

Style: Exhibits expressionism, realism, post modern works and contemporary art and crafts; all genres. "Our gallery specializes in art produced by, for and about Wyoming and the Rocky Mountin region. We include very contemporary work as well as more traditional treatments. Expanding awareness of all the arts in rural Wyoming is one of our missions."

Terms: Accepts work on consignment (35% commission). Retail price set by artist. Exclusive area representation not required. Gallery provides insurance, promotion, contract and shipping costs to gallery. Prefers artwork framed.

Submissions: Send query letter with resume, slides and SASE. Write to schedule an appointment to show a portfolio, which should include relevant materials. Replies in 2 months.

Tips: "Have patience—Selection Committee meets about 5 times a year. We schedule shows 2 years in advance."

FOUR SEASONS GALLERY, Pink Garter Plaza, Box 2174, Jackson WY 83001. (307)733-4049. Owner: Phillip Shaffer. Retail gallery. Estab. 1970. Clientele: 100% private collectors. Represents 11 emerging, mid-career and established artists. Sponsors 1 solo and 1 group shows/year. Average display time is 6 months. Overall price range: $150-5,000.

Media: Considers oil, acrylic, watercolor, pastel, pen & ink, drawings, sculpture and print. Most frequently exhibits oil, watercolor and pencil.

Style: Genres include landscapes, Westerns and portraits. "Our gallery specializes in Western art of all kinds and Teton landscapes." Does not want to see "abstracts of any kind, run-of-the-mill compositions, poor paint handling."

Terms: Accepts work on consignment (40% commission). Retail price is set by artist. Exclusive area representation required. Gallery provides insurance, promotion and shipping.

Submissions: Send query letter, brochure, slides, photographs and SASE.

Tips: "Looks for quality realism with good paint quality, color and composition. Fewer people with disposable income, so fewer sales."

NICOLAYSEN ART MUSEUM, 400 E. Collins Dr., Casper WY 82601. (307)235-5247. Director: Sam Gappmayer. Museum. Estab. 1967. Open all year. Clientele: 90% private collectors, 10% corporate clients. Sponsors 10 solo and 10 group shows/year. Average display time 2 months. Interested in emerging, mid-career and established artists.

Media: Considers all media.
Style: Exhibits contemporary styles. Does not want to see "wildlife art, cowboy romanticism."
Terms: Accepts work on consignment (30% commission). Retail price set by artist. Exclusive area representation not required. Gallery provides insurance, promotion and shipping costs from gallery.
Submissions: Send query letter with slides. Write to schedule an appointment to show a portfolio, which should include originals or slides. Replies in 2 months.

Canada

OPEN SPACE, 510 Fort St., Victoria B.C. V8W 1E6 Canada. (604)383-8833. Director: Sue Donaldson. Alternative space and nonprofit gallery. Estab. 1971. Represents emerging, mid-career and established artists. Has 311 members. Sponsors 8-10 shows/year. Average display time 2½ weeks. Open all year. Located downtown; 1,500 sq. ft.; "multi-disciplinary exhibition venue." 100% of space for gallery artists. Overall price range: $300-8,000.
Media: Considers oil, acrylic, watercolor, pastel, pen & ink, drawing, mixed media, collage, works on paper, sculpture, ceramic, installation, photography, video, performance art, original handpulled prints, woodcuts, wood engravings, linocuts, engravings, mezzotints and etchings.
Style: Exhibits all styles. All contemporary genres.
Terms: "No acquisition. Artists selected are paid exhibition fees for the right to exhibit their work." Retail price set by the artist. Gallery provides insurance, promotion, contract and fees; shipping costs are shared. Prefers artwork "ready for exhibition."
Submissions: "Non-Canadian artists must submit by September 30 in order to be considered for visiting foreign artists' fees." Submit by February 28 or September 30. Send query letter with resume, 10-20 slides, bio, SASE, reviews and proposal outline. "No photos or original work." Replies in 1 month.
Tips: Artists should be aware of the trend of "de-funding by governments at all levels."

WOODLAND NATIVE ART GALLERY, 1 Woodland Dr., Cutler, Ontario P0P 1B0. (705)844-2132. FAX: (705)844-2281. Manager: Tom Duncan. Retail gallery. Estab. 1974. Represents 40-60 artists: emerging, mid-career and established. Exhibited artists include Donald Vann, Leland Bell and J. Gordon Fiddler. Sponsors 4 shows/year. Average display time 1 year. Open all year. Located on the Trans Canada Highway; 1,600 sq. ft. 10% of space for special exhibitions. "Our gallery is cluttered because of the 400 paintings displayed (we want to show as much as possible)." Clientele: 95% private collectors, 5% corporate clients.
Media: Considers oil, acrylic, deer and moosehide acrylic, watercolor, pastel, pen & ink, drawings, mixed media, sculpture, original handpulled prints, lithographs, etchings, serigraphs, offset reproductions and posters. Most frequently exhibits acrylic, stone lithographs and offset reproductions.
Style: Exhibits conceptualism, primitivism, surrealism, realism and paintings depicting legends. Genres include wildlife and "native."
Terms: Artwork is bought outright for 20-60% of retail price. Retail price set by gallery and artist. Gallery provides promotion; shipping costs are shared. Prefers unframed artwork.
Submissions: Send query letter with resume, bio and slides. Replies only if interested in 1 month. If does not reply, artist should re-write. Files most material.

Other Galleries

Each year we contact all firms currently listed in *Artist's Market* requesting they give us updated information for our next edition. We also mail listing questionnaires to new and established firms which have not been included in past editions. The following galleries did not respond to our request to update their listings for 1992 (if they indicated a reason, it is noted in parentheses after their name).

Adams-Middleton Gallery
Alder Gallery
Art in the Atrium
Artbanque Gallery
Artframes . . . Bungalo Gallery
Artist Associates, Inc.
The Artists Gallery (unable to contact)
Artpark Stores
Artphase I, Inc. (out of business)
Kenneth Bernstein Gallery (unable to contact)
The Blue Sky Gallery, Inc.
Capital Gallery of Contemporary Art
Carnegie Mellon Art Gallery (out of business)
Frank Caro Gallery (only interested in Chinese art)
Corporate Art Source Inc.
Dimensions, Inc.
Dolan/Maxwell Gallery (asked to be deleted)
Olga Dollar Gallery (not accepting new artists)
Echo Press
El Prado Galleries, Inc.
Fine Arts Center for New River Valley
Doris Fordham Gallery, Inc. (unable to contact)
Francis Ellman Gallery
Fisher Gallery at the Farmington Valley Arts Center

Galeria Botello Inc.
Galesburg Civic Art Center
Galleria Renata
Gallery G (unable to contact)
Gallery 912½
The Gallery Shop/Ann Arbor Art Association
Gallery 10
Genest Gallery
Glen Echo Gallery
Husberg Fine Arts Galleries (not accepting new artists)
Image Gallery (unable to contact)
Jack Gallery (out of business)
The Judge Gallery (unable to contact)
The Ledoux Gallery (unable to contact)
Lizardi/Harp Gallery
Louisville Visual Art Association
Sue Malinski Gallery
Mayans Galleries, Ltd.
J. Michael Galleries
Alexander F. Milliken Inc. (out of business)
Moreau Galleries
Museum of Contemporary Hispanic Art (unable to contact)
NAB Gallery
Newspace, Los Angeles
Off the Wall Gallery
Open Space a Cooperative Gal-

lery (unable to contact)
Partners Gallery, Ltd. (out of business)
Philadelphia Art Alliance (not accepting new artists)
Red River Gallery
Rezac Gallery
Saint Joseph's University Gallery
Shellfish Collection Studio and Gallery
Shipmans Place Gallery & Gifts
Sioux City Art Center – The Shop
Small Space Gallery
South Shore Art Center
Southport Gallery
Stein Gallery
Swan Coach House Art Gallery
Theatre Art Galleries (not accepting new artists)
JB Tollett Gallery (unable to contact)
Union County Public Library
The Upham Gallery (not accepting new artists)
Arie Van Harwegen Den Breems – fine art
Viewpoints Art Gallery
Virginia Inn
The White Hart Gallery
Philip Williams Posters
Wolff Gallery (out of business)
The Women's Art Registry of Minnesota

Greeting Cards
and Paper Products

In this fast-paced society, in which we often live hundreds of miles away from families and close friends, the greeting card is often our quickest and easiest way of staying in touch. Hence, it continues to be a strong, solid market for freelance artwork. According to the Greeting Card Association, $4.7 billion will have been spent this year on greeting cards, meaning that 7.3 billion cards will have been sold. Even though the market remains steady, the industry continues to change as it responds to changes in public taste.

One change in the market, however, comes from the nature of the industry itself. Of the roughly 1,000 greeting card firms in the United States, most are small operations run by writers and artists. The industry is slowly beginning to reflect this by becoming more sensitive to freelancers' needs, especially in payment policies and terms. Only a few years ago, most card companies bought artwork outright—for all rights. This is now changing; more and more firms are willing to negotiate for rights.

More changes

Larger firms, long associated with traditional and rather conservative cards, have now developed their own lines of upbeat, irreverent, humorous cards. The term "studio" had been used to describe slightly off-color, cartoonish vertical cards. Today humorous and risqué cards can be found with other cards, no longer banished to racks at the end of the aisle. The lines between traditional, studio and alternative cards have become so blurred, cards are now described simply as occasion or nonoccasion cards. It is nonoccasion cards that are now the fastest growing segment, accounting for 10 to 15 percent of the total sales of the companies that have entered this market.

There are nonoccasion cards for children: "You're perfectly wonderful. It's your room that's a mess," reads one; "You've been hitting the books, and does it show," reads another. Even a larger market is the collection of cards for adults conveying a variety of contemporary situations. These range from cards for people recovering from drug addiction to those for people who have lost their jobs to cards for things people find too difficult to say. One begins, "It isn't easy for me to bring this up, but I think we need to talk about our past relationships."

Another large area of growth is in ethnic cards, which are designed to appeal to African-Americans, Hispanics and other cultural and ethnic groups; they are meant to speak to the culture. According to one study, the number of Hispanics in this country has risen by one third, nearly five times faster than the rest of the population. Cards reflect this culture with bright colors, gold foil, bold graphics and sentimental and religious verse. With the unification of Europe in 1992, many in the industry foresee a global increase in their foreign language cards. This has led to a surge in the number of new companies producing these cards and the number of new lines under development by larger firms.

Senior citizens continue to be a strong consumer group. Greeting card companies are attempting to cater to this group by offering an array of cards, from lively to sentimental, such as cards for ruby and golden wedding anniversaries, retirement, grandchildren and travel.

Both greeting cards and calendars reflect the nation's deep concern for the environment. Many are printed on recycled paper and/or support an environmental or social cause, such as a new card line by C.R. Gibson, which donates two percent of the proceeds to Save the Children.

"Unquestionably, the strongest trend in calendars is the growing concern for our environment," says Jenna Nelson, calendar product manager of Argus Communications. "This will manifest itself in calendars featuring the preservation of our planet and its wildlife, especially its endangered species." She continues, "We also will see a resurgence in patriotism, which will draw buyers to themes featuring the scenic beauty of America and, most notably, its national parks."

Stationery firms and giftwrap companies are also undergoing changes. Fashion-oriented elegant florals and sophisticated scenes are most popular for giftwrap and colorful gift bags.

Study the market

Research the market carefully before approaching greeting card firms. Small companies are all different. Each has carved out its own specific niche in the field, and it is important to be familiar—to know which suits your style and approach. Larger firms may handle a variety of lines, but they are very market-driven and will expand or develop lines according to market research.

One way to research card or stationery firms is, of course, to visit your local card or gift shop. Some firms offer artist guidelines, sample cards or a catalog—usually for a SASE. If you have the opportunity, a visit to one of the regional or national card and stationery shows may be very educational—and a way to meet card editors and publishers.

Once you've chosen a firm, contact the art director or creative director. Since most greeting card work is colorful, send color slides, photos, tearsheets or final reproductions. If you have an idea for a card that requires pop-ups, die cuts or special folds, you may want to include a model card. Note, too, that most greeting card designs are still vertical, so most of your samples should also be vertical.

Most card firms buy illustration and verse separately, but if you are a good writer, verse may help sell the idea—and you will be compensated accordingly. Even if you are not a writer, go ahead and include suggested copy, if you have an idea.

Speaking of ideas, think in terms of card lines and related gift items. Many greeting card artists also work with licensing agents to market their ideas to giftware firms. Licensing agents are more interested in ideas or concepts for a line, rather than individual illustrations.

Payment rates for greeting card illustration and design can be as high as for magazine or book illustration. Some card companies also pay for design and concept ideas and for roughs. Although many still pay for all rights, some are willing to negotiate for other arrangements, such as greeting card rights only. This often depends on whether the firm has other plans for the illustration or design, such as use on calendars, stationery, party supplies or even toys. If other uses are anticipated, make sure you are compensated for these in some way up front.

One other change in the industry is worth special mention. The Greeting Card Creative Network (GCCN) is an organization designed to help writers and artists in the greeting card field. The group provides access to a network of industry professionals, including publishers and licensing agents and acts as a clearinghouse for information on design and marketing trends, and legal and financial concerns within the industry. Membership fees in GCCN range from $30 (student) to $50 (professional artist) per year. For more information, contact GCCN, Suite 615, 1350 New York Ave. NW, Washington DC 20005. (202)393-1780.

For more information on the illustration and design of greeting cards, see *The Complete*

Guide to Greeting Card Design and Illustration, by Eva Szela. Magazines such as *HOW*, *Step-by-Step Graphics* and *The Artist's Magazine* also include information on greeting card illustration. Industry magazines such as *Greetings* and *Giftware News* are a good source of information on marketing trends and also provide information on upcoming shows. For lists of stationery firms, see *Party & Paper Retailer* and the *Thomas Register of Manufacturers*.

ACME GRAPHICS, INC., 201 3rd Ave. SW, Box 1348, Cedar Rapids IA 52406. (319)364-0233. President: Stan Richardson. Estab. 1913. Produces printed merchandise used by funeral directors, such as acknowledgments, register books and prayer cards.
Needs: Approached by 30 freelance artists/year. Considers pen & ink, watercolor and acrylic; religious, church window, floral and nature art.
First Contact & Terms: Send brochure. Samples not filed are returned by SASE. Reports back within 10 days. Call or write to schedule an appointment to show a portfolio, which should include roughs. Original artwork is not returned to the artist after job's completion. Pays by the project. Payment varies. Buys all rights.
Tips: "Send samples or prints of work from other companies. Do not want to see modern art or art with figures. Some designs are too expensive to print."

ADVANCE CELLOCARD CO., INC., 1259 N. Wood St., Chicago IL 60622. (312)235-3403. President: Ron Ward. Estab. 1953. Produces greeting cards.
Needs: Considers watercolor, acrylic, oil and colored pencil. Produces material for Valentine's Day, Mother's Day, Father's Day, Easter, graduation, birthdays and everyday.
First Contact & Terms: Send query letter with brochure. Samples not filed are returned by SASE. Reports back within weeks. To show a portfolio, mail original/final art. Original artwork is not returned to the artist after job's completion. Pays average flat fee of $75-150/design. Buys all rights.
Tips: "Make a phone call and follow up with samples or a letter of introduction including photostats or samples of artwork."

AFRICA CARD CO. INC., Box 91, New York NY 10108. (718)672-5759. President: Vince Jordan. Publishes greeting cards and posters.
Needs: Buys 25 freelance designs/year.
First Contact & Terms: To show a portfolio, mail art or arrange interview. Include SASE. Reports in 6 weeks. Pays $50 minimum, greeting cards and posters. Buys all rights.

ALASKA MOMMA, INC., 303 5th Ave., New York NY 10016. (212)679-4404. President: Shirley Henschel. "We are a licensing company representing artists, illustrators, designers and cartoon characters. We ourselves do not buy artwork. We act as a licensing agent for the artist. We license artwork and design concepts to toy, clothing, giftware, stationery and housewares manufacturers and publishers."
Needs: Approached by 100 or more freelance artists/year. Needs illustrators. "An artist must have a distinctive and unique style that a manufacturer can't get from his own art department. We need art that can be applied to products such as posters, cards, puzzles."
First Contact & Terms: "Artists may submit work in any way they choose, as long as it is a fair representation of their style." Henschel prefers to see several multiple color samples in a mailable size. No originals. "We are interested in artists whose work is suitable for a licensing program. We do not want to see b&w art drawings. What we need to see are slides or color photographs or color photocopies of finished art. We need to see a consistent style in a fairly extensive package of art. Otherwise, we don't really have a feeling for what the artist can do. The artist should think about products—and determine if the submitted material is suitable for product. Please send SASE so the samples can be returned. We work on royalties that run from 5-10% from our licensees. We require an advance against royalties from all customers. Earned royalties depend on whether the products sell."
Tips: "Publishers of greeting cards and paper products have become interested in more traditional and conservative styles. There is less of a market for novelty and cartoon art. We need freelance artists more than ever (during this recession) as we especially need fresh talent in a difficult market."

AMBER LOTUS, 1241 21st. St., Oakland CA 94607. (415)839-3931. Product Manager: Winfried Emerson. Estab. 1984. Specializes in calendars, journals and cards. Publishes 12 calendars, 9 journals, and 9 card series.
Needs: Works on assignment only. Works with 2-6 freelance artists/year. Buys 30-50 illustrations/year from freelance artists. Buys artwork mainly for calendars and greeting cards. Prefers local artists, but not necessary. Prefers airbrush, watercolor, acrylic, pastel, calligraphy and computer illustration. Buys approximately 12 computer illustrations from freelancers/year.
First Contact & Terms: Send query letter with brochure or small sampling. Samples are filed or are returned by SASE. Reports back within 6 weeks only if interested. Originals returned to artist at job's completion. Considers skill and experience of artist, project's budget and rights purchased when establishing payment.

Tips: "Show something distinctive, innovative and classy that can be used as a series of images. We are especially looking for work that has not been already over exposed in print. No pets or cartoons."

AMBERLEY GREETING CARD CO., 11510 Goldcoast Dr., Cincinnati OH 45249-1695. (513)489-2775. FAX: (513)489-2857. Vice President: Ned Stern. Estab. 1966. Produces greeting cards. "We are a multi-line company directed toward all ages. Our cards are conventional and humorous."
Needs: Approached by 20 freelance artists/year. Works with 10 freelance artists/year. Buys 200 designs/illustrations/year. Local artists only. Works on assignment only. Uses freelance artists mainly for humorous cards. Considers any media. Looking for humorous styles.
First Contact & Terms: Samples are not filed and are returned by SASE if requested by artist. Reports back to artist only if interested. Call to schedule an appointment to show a portfolio which should include original/final art. Buys all rights. Original artwork is not returned at the job's completion. Pays by the project, $60.

***AMCAL**, 1050 Shary Ct., Concord CA 94518. (415)689-9930. Publishes calendars, advent calendars, gift bags, ornaments and greeting cards. "Markets to better gift, book and department stores throughout U.S. Some sales to Europe, Canada and Japan. Rapidly expanding company looking for distinctive card and gift ideas for growing market demand. We look for illustration and design that can be used many ways—a card, gift bag, address book and more so we can develop a collection. We buy art that appeals to a widely female audience and some juvenile. No gag humor or cartoons."
Needs: Prefers work in 5×7 vertical card format. Send photos, slides or published work.
First Contact & Terms: Responds within 2 weeks. Send samples or call for appointment to show a portfolio. Pay for illustration by the project, advance against royalty.
Tips: "Know the market. Go to gift shows and visit lots of stationery stores. Read all the trade magazines. Talk to store owners to find out what's selling and what isn't."

AMERICAN GREETINGS CORPORATION, 10500 American Rd., Cleveland OH 44144. (216)252-7300. Director of Creative Resources and Development: Lynne Shlonsky. Estab. 1906. Produces greeting cards, stationery, calendars, paper tableware products, giftwrap and ornaments—"a complete line of social expressions products."
Needs: Prefers artists with experience in illustration, decorative design and calligraphy.
First Contact & Terms: Send query letter with resume. "Send no samples."

***AMSCAN INC.**, Box 587, Harrison NY 10528. (914)835-4333. FAX: (914)835-4502. Creative Art Director: Keith A. Spaar. Estab. 1954. Produces paper tableware products, giftwrap and party decorations. Produces "complete party theme items for all ages, all seasons and all holidays."
Needs: Approached by 10-20 freelance artists/year. Buys a varying number of designs and illustrations/year. Prefers artists with experience in party goods. Uses freelance artists mainly for ensemble design. Also uses freelance artists for paste-up and mechanicals done on the Mac. In terms of media, limited color preferred. For final art, ensemble design, 10″ circle; all other illustrations, any rectangular shape. Produces material for all holidays and seasons, including birthdays, baby and wedding showers and general entertaining.
First Contact & Terms: Send query letter with resume and non-returnable samples—photocopies (color or b&w). Samples are filed. Reports back only if interested. Portfolio should include original/final art, b&w and color photographs and printed samples. Rights purchased vary according to project. Originals are not returned at job's completion. Payment negotiable.

***ATHENA INTERNATIONAL**, Box 918, Edinburgh Way, Harlow Essex CM20 2DU England. Group Publishing Director: Mr. Roger Watt. Produces greeting cards, postcards, posters, prints, pop and personality products and calendars.
Needs: Works with numerous freelance artists/year. Also uses freelance artists for P-O-P displays, paste-up and mechanicals. Produces material for everyday, special occasions, Christmas, Valentine's, Mother's Days, Father's Day, and Easter, plus quality artwork for prints and posters.
First Contact & Terms: Send query letter with brochure, photostats, photocopies, and slides. Samples not filed are returned. Reports back within 30 days. To show a portfolio, mail roughs, photostats and photographs. Original artwork is returned to artist after job's completion. Negotiates rights purchased.

 The asterisk before a listing indicates that the listing is new in this edition. New markets are often the most receptive to freelance submissions.

THE AVALON HILL GAME CO., 4517 Harford Rd., Baltimore MD 21214. (301)254-9200. FAX: (301)254-0991. Art Director: Jean Baer. Estab. 1958. Produces games for adults. "Primarily produces strategy and sports games, also family, roleplaying and computer games."

Needs: Approached by 30 freelance artists/year. Works with 10 freelance artists/year. Buys 30-50 designs and illustrations from freelance artists/year. Prefers artists with experience in military and/or fantasy art. Works on assignment only. Uses freelance artists mainly for cover and interior art. Also uses freelance artists for fantasy illustration. Considers any media. "The styles we are looking for vary from realistic to photographic, but are sometimes fantasy. We like quality."

First Contact & Terms: Send query letter with tearsheets, slides, SASE and photocopies. Samples are filed or are returned by SASE if requested by artist. Reports back within 2-3 weeks. If does not report back, the artist should "wait. We will contact the artist if we have an applicable assignment." Call to schedule an appointment to show a portfolio or mail appropriate materials. Portfolio should include original/final art and b&w and color photostats and tearsheets. Buys all rights. Original artwork is not returned at the job's completion. Pays by the project, $500 average.

BARNSTABLE ORIGINALS, 50 Harden Ave., Camden ME 04843. (207)236-8162. Art Director: Marsha Smith. Produces greeting cards, posters and paper sculpture cards. Directed toward tourists traveling in New England and sailors or outdoors people—"nature and wildlife lovers."

Needs: Approached by 250 freelance artists/year. Buys 50 designs and illustrations from artists/year. Prefers 5×7 cards, vertical or horizontal. Prefers traditional style; watercolor, acrylic, oil. "No cutesy" art.

First Contact & Terms: Send query letter with brochure, photocopies, slides or photographs showing art style. Samples not filed are returned by SASE. Reports back within 1 month. No originals returned to artist at job's completion. Pays $100 minimum flat fee per design/illustration. Pays on acceptance. Buys all rights. Finds most artists through samples received through the mail.

Tips: "We're looking for quality artwork—any creative and fresh ideas. Please enclose postage for return of materials or send something we can keep for our files."

BARTON-COTTON INC., 1405 Parker Rd., Baltimore MD 21227. (301)247-4800. Contact: Creative/Art Department. Produces religious greeting cards, commercial Christmas cards, wildlife designs and spring note cards. Free guidelines and sample cards; specify area of interest: religious, Christmas, spring, etc.

Needs: Buys 150-200 illustrations from freelancers/year. Submit seasonal work "any time of the year."

First Contact & Terms: Send query letter with resume, tearsheets, photocopies, photostats, slides and photographs. Previously published work and simultaneous submissions accepted. Reports in 4 weeks. To show a portfolio, mail original/final art, final reproduction/product, and color tearsheets. Submit full-color work only (watercolor, gouache, pastel, oil and acrylic); pays $150-500/illustration; on acceptance.

Tips: "Good draftsmanship is a must, particularly with figures and faces. Spend some time studying market trends in the greeting card industry to determine current market trends. There is an increased need for creative ways to paint traditional Christmas scenes with up-to-date styles and techniques."

BEACH PRODUCTS, 1 Paper Pl., Kalamazoo MI 49001. (616)349-2626. Creative Director: Mark Sokolowski. Publishes paper-tableware products; general and seasonal, birthday, special occasion, invitations, announcements, stationery, wrappings and thank-you notes for children and adults.

Needs: Approached by 200 freelance artists/year. Uses artists for product design and illustration. Sometimes buys humorous and cartoon-style illustrations. Prefers flat 4-color designs; 5¼ wide × 5½ high for luncheon napkins. Produces seasonal material for Christmas, Mother's Day, Thanksgiving, Easter, Valentine's Day, St. Patrick's Day, Halloween and New Year's Day. Submit seasonal material before June 1; everyday (not holiday) material before March.

First Contact & Terms: Send query letter with 9×12 SASE so catalog can be sent with response. Disclosure form must be completed and returned before work will be viewed. Call or write to schedule an appointment to show a portfolio, which should include original/final art and final reproduction/product. Previously published work OK. Originals not returned to artist at job's completion; "all artwork purchased becomes the property of Beach Products. Items not purchased are returned." Pays average flat fee of $300 for illustration/design; royalties of 5%. Considers product use when establishing payment.

Tips: "Artwork should have a clean, professional appearance and be the specified size for submissions, as well as a maximum of four flat colors." Trends include "French and Spanish influences in florals, bright graphics (color is everything)."

ANITA BECK CARDS, 3409 W. 44th St., Minneapolis MN 55410. President: Cynthia Anderson. "We manufacture and distribute greeting cards, note cards, Christmas cards and related stationery products through a wholesale and direct mail market." Clients: wholesale and direct mail.

Needs: Uses freelance artists mainly for card designs; note that photographs are not used.

First Contact & Terms: Send query letter with brochure and photographs. Samples are filed or are returned only if requested by artist. Reports back within a month. Call or write to schedule an appointment to show a portfolio. Pays for design by the project, $50 minimum. Buys all rights.

Tips: "Submit design ideas for cards."

© Anita Beck Cards

This Christmas card is one of four created by Maria Vaci of Albany, New York for Anita Beck Cards of Minneapolis. It "is graphic, with bold colors and strong, understated design," says the president, Cynthia Anderson. "It aptly conveys the holiday greeting message," says Anderson, "and the response has been good."

FREDERICK BECK ORIGINALS, 1329 Marster Rd., Burlingame CA 94010. (415)348-1510. FAX: (415)343-1247. Owner: David Bisson. Estab. 1953. Produces greeting cards: silk screen printed Christmas cards, traditional to contemporary.

Needs: Approached by 6 freelance artists/year. Works with 10 freelance artists/year. Buys 25 designs/illustrations/year. Prefers artists with experience in silk screen printing. Uses freelance artists mainly for silk screen Christmas card designs. Considers silk screen printing only. Looking for "artwork compatible with existing line; shape and color are important design elements." Prefers 5⅜ × 7⅞. Produces material for Christmas. Submit 12 months before holiday.

First Contact & Terms: Send query letter with simple sketches. Samples are filed. Reports back within 2 weeks. Portfolio should include thumbnails. Rights purchased vary according to project. Original artwork is not returned at job's completion "but could be." Pays by the project, $150-200.

bePUZZLED, A DIVISION OF LOMBARD MARKETING, INC., 45 Wintonbury Ave., Bloomfield CT 06002. (203)286-4222. FAX: (203)286-4229. New Product Development.: Luci Seccareccia. Estab. 1987. Produces games and puzzles for children and adults. "bePUZZLED mystery jigsaw games challenge players to solve an original whodunit thriller by matching clues in the mystery with visual clues revealed in the puzzle."

Needs: Works with 4-10 freelance artists/year. Buys 15-30 designs and illustrations from freelancers/year. Prefers local artists with experience in children's book and adult book illustration. Uses freelance artists mainly for box cover art, puzzle images and character portraits. All illustrations are done to spec. Considers acrylic, watercolor and b&w. Prefers art 10 × 12 and 18 × 18.

First Contact & Terms: Send query letter with brochure, resume, SASE, tearsheets, photographs and transparencies. Samples are filed. Reports back within 60 days. Will call to schedule an appointment to show a portfolio, which should include original/final art and photographs. Original artwork is returned at the job's completion. Pays by the project, $50-2,000.

Tips: Prefers that artists not "ask that all material be returned. I like to keep a visual in my files for future reference."

***BERGQUIST IMPORTS, INC.,** 1412 Hwy. 33 S., Cloquet MN 55720. (218)879-3343. FAX: (218)879-0010. President: Barry Bergquist. Estab. 1948. Produces paper tableware products, mugs, plates, dinnerware and tile.

Needs: Approached by 5 freelance artists/year. Works with 5 freelance artists/year. Buys 50 freelance design and illustrations/year. Prefers artists with experience in Scandinavian designs. Works on assignment only. Uses freelance artists for calligraphy. Produces material for Christmas, Valentine's Day and everyday. Submit 6-8 months before holiday.

First Contact & Terms: Send query letter with brochure, tearsheets and photographs. Samples are not filed and are returned. Reports back within 2 months. To show a portfolio, mail roughs, color tearsheets and photographs. Rights purchased vary according to project. Originals are returned at job's completion. Pays by the project, $50-300 or royalties of 5%.

***BLUE SKY,** 10600 Markison, Dallas TX 75238. (214)553-8686. FAX: (214)343-8816. President: Van Walker. Estab. 1984. Distributor of giftwrap, gift bags and totes for women.

Needs: Approached by approximately 3 freelance artists/year. Prefers "artistic simplicity." Works on assignment only. Uses freelance artists mainly for design, including product designs. Produces material for birthdays and everyday.

First Contact & Terms: Send query letter with photographs and photocopies. Samples are returned. Reports back to the artist only if interested. Call to schedule an appointment to show a portfolio. Buys all rights. Pays negotiable rates, by the project.

BRAZEN IMAGES INC., 269 Chatterton Parkway, White Plains NY 10606. (914)949-2605. FAX: (914)683-7927. Art Director: Kurt Abraham. Produces greeting cards "for anyone over 18; we make sexually oriented adult cards."

Needs: Approached by 200 freelance artists/year. Works with 5-10 freelance artists/year. Buys 20-50 illustrations from freelance artists/year. Prefers airbrush; but "we like a wide range of styles." Artwork must be proportional to a 5×7 greeting card with extra for trim. Both vertical and horizontal are OK. Photorealistic airbrush illustration. Produces material for Christmas, Halloween, Valentine's Day, birthdays and weddings. "We look for material all year long—we store it up until press time. If it doesn't make it in one year's printing, it'll make it the next."

First Contact & Terms: Send query letter with brochure, slides, SASE and any clear copy of nonpublished work plus SASE. Samples are filed or are returned by SASE only if requested by artists. Reports back within 1 month. Call or mail original/final art and b&w slides and photographs. Original artwork is "in most cases" returned to the artist after job's completion. Pays average flat fee of $200-300/illustration; by the project, $200-300 average. Buys one-time rights.

Tips: "As our name implies, we expect work to be brazen and very upfront sexually. Subtlety is not for us! Due to the recession, buyers are ordering much more tightly, taking less chances on the untried and sticking with best-sellers. We are always overloaded with images—more than we can use so the submission really has to be a killer to bump something else!"

BRICKHOUSE PRODUCTIONS, Box 8305, Universal City CA 91608. President/Founder: Michael Houbrick. Estab. 1985. Produces greeting cards. "Publishes hip greeting cards featuring Mr. Brick and other well-known characters. Most cards are geared for the thirty-something crowd."

Needs: Approached by 50 freelance artists/year. Works with 2-5 freelance artists/year. Buys 2-5 designs and illustrations from freelancers/year. Prefers artists with experience in watercolor and cartooning. Works on assignment only. Considers pen & ink and watercolor only. Produces material for all holidays and seasons. Submit 12 months before holiday.

First Contact & Terms: Send query letter with brochure, resume and tearsheets. Samples are filed or are not returned. Reports back *only* if interested. Original artwork is not returned to the artist after job's completion. Pays average flat fee of $100/design; $200/illustration. Buys all rights.

Tips: "Environmental issues are big in the 1990s. This means big focus now is on 1992 presidential campaign. "Red, white and blue—all my energy for the next year will be toward the election.""

BRILLIANT ENTERPRISES, 117 W. Valerio St., Santa Barbara CA 93101. Art Director: Ashleigh Brilliant. Publishes postcards.

Needs: Buys up to 300 designs from freelancers/year. Artists may submit designs for word-and-picture postcards, illustrated with line drawings.

First Contact & Terms: Submit 5½ × 3½ horizontal b&w line drawings and SASE. Reports in 2 weeks. Buys all rights. "Since our approach is very offbeat, it is essential that freelancers first study our line. Ashleigh Brilliant's books include *I May Not Be Totally Perfect, But Parts of Me Are Excellent* and *Appreciate Me Now and Avoid the Rush*. We supply a catalog and sample set of cards for $2." Pays $40 minimum, depending on "the going rate" for camera-ready word-and-picture design.

Tips: "Since our product is highly unusual, freelancers should familiarize themselves with it by sending for our catalog ($2 plus SASE). Otherwise, they will just be wasting our time and theirs."

BURGOYNE, INC., 2030 E. Byberry Rd., Philadelphia PA 19116. (215)677-8000. Art Director: Jon Harding. Publishes greeting cards and calendars; Christmas, winter and religious themes.

Needs: Buys 75-100 designs/year. Prefers artists experienced in greeting card design. Uses freelance artists for product design and illustration and calligraphy. "Traditional but with a flair—high style as opposed to contemporary." Will review any media; prefers art proportional to 5¼ × 7⅛. Produces seasonal material for Christmas; will review new work at any time.

First Contact & Terms: Send query letter with original art, published work or actual work. Samples returned by SASE. Simultaneous submissions OK. Reports in 2 weeks. No originals returned to artist at job's completion. To show a portfolio, mail appropriate materials or call to schedule an appointment; portfolio should include original/final art and final reproduction/product. Pays for design by the project, $100-300. Buys all rights; on acceptance.

Tips: "Familiarize yourself with greeting card field. Spend time in card stores." Sees trend toward "more emphasis on recycled papers."

CAPE SHORE, INC., 42 N. Elm St., Box 1020, Yarmouth ME 04096. Art Director: Joan Jordan. Produces notes, stationery products and giftware for year-round and Christmas markets. Nautical plus inland in theme. Directs products to gift and stationery stores and shops.

Needs: Buys 25-50 designs and illustrations/year from freelance artists. Prefers watercolor, acrylic, cut paper or gouache. June deadline for finished artwork.

First Contact & Terms: "Please send sample artwork so we can judge if style is compatible. All samples and reports will be returned within several weeks." Pays by the project, $25-200. Pays average flat fee of $125 for illustration/design. Prefers to buy all rights. Originals returned to artist if not purchased.

Tips: "We do not use black-and-white artwork, greeting cards or photography. Submit samples to see if styles are compatible. We look for realistic detail, good technique, bright colors, tight designs of traditional themes."

***JOHN C.W. CARROLL/CREATIVE DIRECTION**, 45 Wayside Lane, Redding CT 06896. (203)938-8007. Owner: John Carroll. Estab. 1990. Produces greeting cards, stationery, calendars and collectibles. "My company is an independent creative resource, operating under contract on behalf of a range of gift and stationery trade clients. A team-tailored approach provides complete product development services: planning, design/art/editorial, and production."

Needs: Approached by 100+ freelance artists/year. Works with 20-25 freelance artists/year. Buys 75-100 freelance designs and illustrations/year. Works on assignment only. Uses freelance artists mainly for design and illustration. Also uses freelance artists for calligraphy. Considers all media. "No fluorescents. Our needs list is updated periodically." Produces material for all holidays and seasons, birthdays and everyday. Submit seasonal material 18 months in advance.

First Contact & Terms: Send query letter with SASE. Samples are filed or are returned by SASE. Reports back within 4 weeks. Call or write to schedule an appointment to show a portfolio. Portfolio should include roughs, tearsheets, photographs and slides. No original art. Rights purchased vary according to project. Originals are returned to artist at job's completion. Pays by the project, $200-2,500 or 5% royalties.

CASE STATIONERY CO., INC., 179 Saw Mill River Rd., Yonkers NY 10701. (914)965-5100. President: Jerome Sudwow. Vice President: Joyce Blackwood. Estab. 1954. Produces stationery, notes, memo pads and tins for mass merchandisers in stationery and housewares departments.

Needs: Approached by 10 freelance artists/year. Buys 50 designs from freelance artists/year. Works on assignment only. Buys design and/or illustration mainly for stationery products. Uses artists for mechanicals and ideas. Produces materials for Christmas; submit 6 months in advance. Likes to see youthful and traditional styles, as well as English and French country themes.

First Contact & Terms: Send query letter with resume and tearsheets, photostats, photocopies, slides and photographs. Samples not filed are returned. Reports back. Call or write to schedule an appointment to show a portfolio. Original artwork is not returned. Pays by the project. Buys first rights or one-time rights.

Tips: "Get to know us. We're people who are creative and who know how to sell a product."

H. GEORGE CASPARI, INC., 35 E. 21st St., New York NY 10010. (212)995-5710. President: Douglas H. Stevens. Publishes greeting cards, Christmas cards, invitations, giftwrap and paper napkins. The line maintains a very traditional theme.

Needs: Buys 80-100 illustrations/year from freelance artists. Prefers watercolor and other color media. Produces seasonal material for Christmas, Mother's Day, Father's Day, Easter and Valentine's Day.

First Contact & Terms: Arrange an appointment with Lucille Andriola to review portfolio. Prefers unpublished original illustrations as samples. Reports within 4 weeks. Negotiates payment on acceptance; pays for design by the project, $300 minimum.

Tips: "Caspari and many other small companies rely on freelance artists to give the line a fresh, overall style rather than relying on one artist. We feel this is a strong point of our company. Please do not send verses."

***COMSTOCK CARDS, INC.,** Suite 15, 600 S. Rock Blvd., Reno NV 89502. (702)333-9400. FAX: (702)333-9406. Art Director: David Delacroix. Estab. 1986. Produces greeting cards, giftwrap, giftbags, notepads and magnets. Styles include "alternative, Victorian, adult and outrageous products for females ages 25-55."

Needs: Approached by 200-250 freelance artists/year. Works with 50 freelance artists/year. Buys 200 freelance illustrations and designs/year. Prefers artists with experience in "outrageous cartoons." Uses freelance artists mainly for cartoon cards. Also uses freelance artists for calligraphy and mechanicals. "No verse or prose. Gaglines must be short and sweet." Prefers 5 × 7" final art. Produces material for Halloween, Christmas, Easter, Birthdays, Valentine's Day, Hanukkah, Thanksgiving, Mother's Day and everyday. Submit 9 months before holiday.

First Contact & Terms: Send query letter with SASE, tearsheets and photographs. Samples are not filed and are returned by SASE if requested. Reports back within 2 weeks. To show a portfolio, mail roughs and dummies. Buys all rights. Originals are not returned. Pays royalties of 5% or flat fee of $75/cartoon and gag.

***CONTENOVA GIFTS, INC.,** Box 69130, Station K, Vancouver, B.C. V5K 4W4 Canada. (604)253-4444. FAX: (604)253-4014. Creative Director: Jeff Sinclair. Estab. 1965. Produces greeting cards, impulse products, ceramic greeting mugs.

Needs: Approached by varying number of freelance artists/year. Buys 150+ freelance designs and illustrations/year. Prefers artists with experience in full-color work with fax capabilities. Works on assignment only. Uses freelance artists mainly for greeting cards and mugs. Considers airbrush, marker, watercolor. Looking for "humorous cartoon work, cute animals and characters." Prefers 4 × 9" final art. Produces material for Father's Day, Christmas, Easter, birthdays, Valentine's Day, Mother's Day and everyday. Submit 6 months before holiday.

First Contact & Terms: Send query letter with brochure, tearsheets, SASE and photocopies. Samples are not filed and are returned by SASE. Reports back within 1 week. To show a portfolio, mail roughs, photostats, slides, color tearsheets and dummies. Buys all rights. Pays $75/card design; mugs negotiable.

CPS CORPORATION, 1715 Columbia Ave., Franklin TN 37065. (615)794-8000. Art Directors: Francis Huffman and Sherry Murphy. Manufacturer producing Christmas and all-occasion giftwrap.

Needs: Approached by 75 freelance artists/year. Assigns 75-100 freelance jobs/year. Uses freelance artists mainly for giftwrap design.

First Contact & Terms: Send query letter with resume, tearsheets, photostats and slides. Samples are filed or are returned by SASE. Reports back only if interested. Call or write to schedule an appointment to show a portfolio, which should include roughs, original/final art, final reproduction/product, tearsheets and photostats. Pays average flat fee of $400 for illustration/design. Considers complexity of project and skill and experience of artist when establishing payment. Negotiates rights purchased.

Tips: "Designs should be appropriate for one or more of the following categories: Christmas, wedding, baby shower, birthday, masculine/feminine and abstracts." Sees trend toward "giftwrap becoming more high fashion, photography and illustration becoming a larger niche of market."

CREATE-A-CRAFT, Box 330008, Fort Worth TX 76163-0008. (817)292-1855. Editor: Mitchell Lee. Estab. 1967. Produces greeting cards, giftwrap, games, calendars, posters, stationery and paper tableware products for all ages.

Needs: Approached by 500 freelance artists/year. Works with 3 freelance artists/year. Buys 3-5 designs and illustrations from freelance artists/year. Prefers artists with experience in cartooning. Works on assignment only. Buys freelance design and illustration mainly for greetings cards and T-shirts. Also uses freelance artists for calligraphy, P-O-P display, paste-up and mechanicals. Considers pen & ink, watercolor, acrylic and colored pencil. Prefers humor and "cartoons that will appeal to families. Must be cute, appealing, etc. No religious, sexual implications or offbeat humor." Produces material for all holidays and seasons; submit 6 months before holiday.

First Contact & Terms: Contact only through artist's agent. Samples are filed and are not returned. Reports back only if interested. Write to schedule an appointment to show a portfolio, which should include original/final art, final reproduction/product and color and b&w slides and tearsheets. Original artwork is not returned

to the artist after job's completion. "Payment depends upon the assignment, amount of work involved, production costs, etc. involved in the project." Buys all rights.

Tips: "Demonstrate an ability to follow directions exactly. Too many submit artwork that has no relationship to what we produce. Sample greeting cards are available for $2.50 and a SASE. Demonstrate an ability to follow directions exactly. Write, do not call. We cannot tell what the artwork looks like from a phone call."

CREATIF LICENSING, 31 Old Town Crossing, Mount Kisco NY 10549. President: Stan Cohen. Licensing Manager. "Creatif is a licensing agency that represents artists and concept people."

Needs: Creatif Licensing is looking for unique art styles and/or concepts that are applicable to multiple products. The art can range from fine art to cartooning."

First Contact & Terms: "If you have a style that you feel fits our qualifications please send photocopies or slides of your work with SASE. If we are interested in representing you, we would present your work to the appropriate manufacturers in the clothing, gift, publishing, home furnishings, paper products (cards/giftwrap/party goods, etc.) areas with the intent of procuring a license. We try to obtain advances and/or guarantees against a royalty percentage of the firm's sales. We will negotiate and handle the contracts for these arrangements, show at several trade shows to promote the artist's style and oversee payments to insure that the requirements of our contracts are honored. The artists are responsible for providing us with materials for our meetings and presentations and for copyrights, trademarks and protecting their ownership (which is discretionary). For our services, as indicated above, we receive 50% of all the deals we negotiate as well as renewals. There are no fees if we are not productive."

Tips: Common mistakes illustrators make in presenting samples or portfolios are "sending oversized samples mounted on heavy board; not sending in appropriate material; sending washed out slides."

CREATIVE PAPERS BY C.R. GIBSON, The C.R. Gibson Co., Knight St., Norwalk CT 06856. (203)847-4543. Vice President Creative Papers: Steven P. Mack. Publishes stationery, note paper, invitations and giftwrap. Interested in material for stationery collections or individual notes and invitations. "Two to three designs are sufficient to get across a collection concept. We don't use too many regional designs. Stationery themes are up to date, fashion oriented. Designs should be somewhat sophisticated without being limiting. Classic designs and current material from the giftware business do well."

Needs: Buys 100-200 freelance designs/year. Especially needs new 4-color art for note line and invitations; "we need designs that relate to current fashion trends as well as a wide variety of illustrations suitable for boxed note cards. We constantly update our invitation line and can use a diverse selection of ideas." Uses some humorous illustrations but only for invitation line. "We buy a broad range of artwork with assorted themes. The only thing we don't buy is very contemporary or avant-garde." Prefers gouache, watercolor, acrylic, oil and collage. Speculation art has no size limitations. Finished size of notes is $4 \times 5\frac{1}{2}$ and $3\frac{3}{4} \times 5$; folded invitations, $3\frac{3}{4} \times 5$; card style invitations, $4\frac{3}{8} \times 6$; and giftwrap repeat, 9×9 minimum.

First Contact & Terms: Send query letter with brochure showing art style or resume, photocopies, slides and SASE. Prefers 4-6 samples (slides or chromes of work or originals), published or unpublished. Previously published, photocopied and simultaneous submissions OK, if they have not been published as cards and the artist has previous publishers' permissions. Reports in 6 weeks. Call or write to schedule an appointment to show a portfolio, which should include thumbnails, roughs, original/final art and tearsheets. Pays $35-50 for rough sketch. Pays average flat fee of $200-250, design; $200-250, illustration; by the hour, $20-25 average; royalties of 5-6%. Negotiates payment. Usually buys all rights; sometimes buys limited rights.

Tips: "Almost all of the artists we work with or have worked with are professional in that they have a background of other professional assignments and exhibits as well as a good art education. We have been fortunate to make a few 'discoveries,' but even these people have been at it for a number of years and have a very distinctive style with complete understanding of printing specifications and mechanicals. More artists are asking for royalties and are trying to develop licensed characters. Most of the work is not worthy of a royalty, and people don't understand what it takes to make a 'character' sell. Keep your presentation neat and don't send very large pieces of art. Keep the submission as varied as possible. I am not particularly interested in pen & ink drawings. Everything we print is in full color."

THE CROCKETT COLLECTION, Rt. 7, Box 1428, Manchester Center VT 05255. (802)362-2913. FAX: (802)362-5590. President: Sharon Scheirer. Estab. 1929. Publishes mostly traditional, some contemporary, humorous and whimsical Christmas and everyday greeting cards, postcards, note cards and bordered stationery. Christmas themes geared to sophisticated, upper-income individuals. Artist's guidelines for SASE.

Needs: Approached by 225 freelance artists/year. Buys 25-75 designs/year from freelance artists. Produces products by silk screen method exclusively. Considers gouache, poster paint, cut and pasted paper and acrylic.

First Contact & Terms: Send query letter with SASE. Request guidelines which are mailed out once a year in January, 1 year in advance of printing. Submit unpublished, original designs only. Art should be in finished form. Art not purchased returned by SASE. Buys all rights. Pays $90-140 per design.

Tips: "Designs must be suitable for silk screen process. Airbrush and watercolor techniques are not amenable to this process. Bold, well-defined designs only. We are seeing more demand for religious themes on Christmas cards. Our look is traditional, mostly realistic and graphic. Request guidelines and submit work according to our instructions."

DECORAL INC., 165 Marine St., Farmingdale NY 11735. (516)752-0076; (800)645-9868. President: Walt Harris. Produces decorative, instant stained glass, plus sports and wildlife decals.
Needs: Buys 50 designs and illustrations from freelance artists/year. Uses artists mainly for greeting cards and decals; also uses artists for P-O-P displays. Prefers watercolor.
First Contact & Terms: Send query letter with brochure showing art style or resume and samples. Samples not filed are returned. Reports back within 30 days. To show a portfolio, call or write to schedule an appointment or mail original/final art, final reproduction/product and photostats. Original artwork is not returned. Pays average flat fee, $200 minimum, illustration or design. Buys all rights.

***DEL REY GRAPHICS**, 3580 Haven Ave., Redwood City CA 94070. (415)369-3800. FAX: (415)365-8450. Art Director: Joy. Estab. 1982. Produces greeting cards, stationery and boxes.
Needs: Approached by 3-4 freelance artists/year. Works with 1-2 freelance artists/year. Works on assignment only. Uses freelance artists for paste-up and mechanicals. Produces material for all holidays and seasons. Submit 8 months before holiday.
First Contact & Terms: Send query letter with samples. Samples are filed or returned. Reports back only if interested. Write to schedule an appointment to show a portfolio, or mail appropriate materials. Rights purchased vary according to project. Originals sometimes returned to artist at job's completion. Pays by the project.

DESIGNER GREETINGS, INC., Box 140729, Staten Island NY 10314. (718)981-7700. Art Director: Fern Gimbelman. Produces greeting cards and invitations, and general, informal, inspirational, contemporary, juvenile, soft-line and studio cards.
Needs: Works with 16 freelance artists/year. Buys 100-150 designs and illustrations from freelance artists/year. Works on assignment only. Also uses artists for calligraphy, P-O-P displays and airbrushing. Prefers pen & ink and airbrush. No specific size required. Produces material for all seasons; submit 6 months before holiday.
First Contact & Terms: Send query letter with brochure or tearsheets, photostats or photocopies. Samples are filed or are returned only if requested. Reports back within 3-4 weeks. Call or write to schedule an appointment to show a portfolio, which should include original/final art, final reproduction/product, tearsheets and photostats. Original artwork is not returned after job's completion. Pays average flat fee. Buys all rights.
Tips: "We are willing to look at any work through the mail, (photocopies, etc.). Appointments are given after I personally speak with the artist (by phone)."

DIEBOLD DESIGNS, Box 236, High Bridge Rd., Lyme NH 03768. (603)795-4592. FAX: (603)795-4222. Principle: Peter Diebold. Estab. 1978. Produces greeting cards. "We produce special cards for special interests and greeting cards for businesses, primarily Christmas."
Needs: Approached by more than 20 freelance artists/year. Works with 5-10 freelance artists/year. Buys 10-20 designs and illustrations/year from freelance artists. Prefers professional caliber artists. Works on assignment only. Uses freelance artists mainly for greeting card design, calligraphy and mechanicals. Also uses freelance artists for paste-up. Considers all media. "We market cards designed to appeal to individual's specific interest—golf, tennis, etc." Looking for an upscale look. "Our cards are all 5×7." Produces material for Christmas and special cards for business people. Submit 6-9 months before holiday.
First Contact & Terms: Send query letter with SASE and brief samples of work. Samples are filed or are returned by SASE. Reports back to artist only if interested. To show a portfolio, mail appropriate materials. "Portfolio should be kept simple." Rights purchased vary according to project. Return of originals at the job's completion is negotiable. Pays by the project, $100 minimum.

***DIFFERENT LOOKS**, 80 E. Ridgewood Ave., Paramus NJ 07652. (201)265-7710. FAX: (201)262-9171. V.P. Marketing and Creative: Pat Corcoran. Estab. 1986. Produces "upscale gift wrap and gift totes, bows and ribbons, gift tissue and tags."
Needs: Approached by 50-60 freelance artists/year. Works with 10 freelance artists/year. Buys 30 freelance illustrations and designs/year. Prefers artists with experience in the giftwrap industry. Uses freelance artists mainly for design of wrap and totes. Also uses freelance artists for illustration and graphics. Will consider any media. Prefers an "upscale, modern, bright look." Produces material for Christmas, graduation, birthdays, Valentine's Day, Hanukkah, everyday, baby, wedding, shower, anniversary. "Birthday is big." Submit seasonal material any time—"we look all year."

First Contact & Terms: Send query letter with resume and SASE. Samples are filed or returned by SASE if requested. Reports back within 6 weeks. To show a portfolio, mail previous work, new ideas. Negotiates rights purchased, according to project. Whether originals are returned to artist depends on rights purchased. Pays by the project, $500 minimum; offers royalties of 3-5%, or sometimes buys, sometimes licenses (big names only).

DREAMSCAPE PRESS, Box 389, Northport AL 35476. (205)349-4629. Publisher: Cynthia McConnell. Estab. 1986. Produces greeting cards. "We publish alternative greeting cards, which are primarily watercolor, but not limited as such."
Needs: Approached by 10-15 freelance artists/year. Works with 5 freelance artists/year. Works on assignment only. Also uses freelance artists for original artwork. Considers any media. "We are seeking dreamy, archetypal, somewhat surreal styles. Considers humorous work." Prefers art no larger than 10×14. Produces material for Christmas, birthdays and everyday. Submit 6 months before holiday.
First Contact & Terms: Send query letter with brochure, SASE, photographs, photocopies and slides. Samples are filed. Reports back to the artist only if interested. Rights purchased vary according to project. Original artwork is returned at the job's completion. Pays royalties, which vary.

EARTH CARE PAPER INC., Box 14140, Madison WI 53714. (608)277-2920. Art Director: Barbara Budig. Estab. 1983. Produces greeting cards, giftwrap, note cards and stationery. "All of our products are printed on recycled paper and are targeted toward nature enthusiasts and environmentalists."
Needs: Buys 50-75 illustrations from freelance artists/year. Uses artists for greeting cards, giftwrap, note cards, stationery and postcards. Considers all media. Produces Christmas cards; seasonal material should be submitted 12 months before the holiday.
First Contact & Terms: "For initial contact, artists should submit samples which we can keep on file." Reports back within 2 months. Original artwork is usually returned after publication. Pays 3-5% royalties plus a cash advance on royalties or a flat fee, $100 minimum. Buys reprint rights.
Tips: "We primarily use nature themes. We consider graphic, realistic or abstract designs. We would like to develop a humor line based on environmental and social issues. We are primarily mail order. This year we would like to see art depicting biomes such as rainforests and old growth forests. Submit samples we can keep on file."

***EASY ACES**, 387 Charles St., Providence RI 02504. (401)272-1500. FAX: (401)272-1503. President: Fred Roses. Estab. 1978. Produces children's seasonal and everyday "impulse" goods – games, toys and novelties.
Needs: Approached by 20 freelance artists/year. Works with 5 freelance artists/year. Uses freelance artists mainly for concept, finished art, packaging. Also uses freelance artists for P-O-P displays. Considers all media. Produces material for Halloween, Christmas, Easter, birthdays, Valentine's Day.
First Contact & Terms: Send query letter with brochure, tearsheets, photostats, photographs, slides, SASE, photocopies and transparencies. Samples are filed or returned by SASE if requested by artist. Reports back only if interested. To show a portfolio, mail thumbnails, roughs, original/final art, b&w and color photostats, tearsheets, photographs, slides and dummies. Negotiates rights purchased. Originals are returned at job's completion. Pays by the project or offers royalties of 5%.

ELEGANT GREETINGS, INC., (formerly Rainbow Zoo Designs), Suite 102-2, 3611 Motor Ave., Los Angeles CA 90034. (213)842-9690. FAX: (213)842-7645. President: S. Steier. Estab. 1981. Produces greeting cards, stationery and children's novelties; a traditional and contemporary mix geared toward children 8-18, as well as schoolteachers and young adults 18-35.
Needs: Approached by 15 freelance artists/year. Works with 3 freelance artists/year. Buys varying number of designs and illustrations/year. Prefers local artists only. Sometimes works on assignment basis only. Uses freelance artists mainly for new designs, new concepts and new mediums. Also uses freelance artists for P-O-P displays, paste-up and mechanicals. Looking for "contemporary, trendy, bright, crisp colors." Produces material for all holidays and seasons. Submit 12 months before holiday.
First Contact & Terms: Send query letter with any and all types of samples. Samples are not filed and are returned. Reports back within 1 month. To show a portfolio, mail appropriate materials. Rights purchased vary according to project. Original artwork returned at the request of the artist. Pays royalties of 3-10%.

***KRISTIN ELLIOTT, INC.**, 6 Opportunity Way, Newburyport MA 01950. (508)465-1899. Contact: Charles F. Elliott, Jr. or Barbara Elliott. Produces invitations and announcements, boxed notes and hang-ups, correspondence cards for everyday and Christmas, Christmas cards, everyday giftwrap and all-occasion greeting cards. "Most products printed on recycled paper. All products produced in U.S. and are directed more toward fine art and conservation market (greeting card lines)."
Needs: Works with freelance artists on speculation and assignment basis. Prefers watercolor "with clear, bright colors"; other media accepted. Designs range from traditional florals to contemporary graphics. Greeting card designs should include copy. Complimentary artist samples provided.

First Contact & Terms: Send query letter with samples. Samples are returned by SASE. Reports back within 2 weeks. Call or write to schedule an appointment to show a portfolio, which should include original art, final reproductions or slides; or send facsimile by mail. Color is preferred. Original artwork is returned at artist's request after job's completion. Pays average flat fee of $135/design. Buys reprint or all rights.

Tips: Common mistakes freelance artists make are presenting submissions in b&w or using "muddied" colors.

ENCORE STUDIOS, INC., 150 River Rd., Edgewater NJ 07020. (201)943-0824. FAX: (201)943-1299. Art Director: Ceil Benjamin. Estab. 1979. Produces personalized wedding, bar-bat mitzvah, party invitations, birth announcements, stationery, Christmas cards and party accessory items. "We have a sophisticated, graphic contemporary style."

Needs: Approached by 50-75 freelance artists/year. Works with 20 freelance artists/year. Prefers artists with experience in designing for holiday cards, invitations, announcements and stationery. "We are interested in designs for any category in our line. Interested in unique type layouts, monograms for stationery and weddings, holiday logos, flowers for our wedding line, Hebrew monograms for our bar-bat mitzvah line." Also uses freelance artists for calligraphy, paste-up and mechanicals. Considers b&w or full-color art. Looking for "high class, graphic, contemporary designs." Produces material for Christmas, Hanukkah, Rosh Hashanah and New Year. Submit all year.

First Contact & Terms: Send query letter with brochure, resume, SASE, tearsheets, photographs, photocopies or slides. Samples are filed or are returned by SASE if requested by artist. Reports back within 2 weeks only if interested. Write to schedule an appointment to show a portfolio. Mail appropriate materials. Portfolio should include roughs, original/final art, b&w photographs, slides and dummies. Negotiates rights purchased. Negotiates return of originals to the artist. Pays $100-500, by the project.

***EQUINE PRODUCTS, LTD.,** Box 23567, Pittsburgh PA 15222. (412)232-4500. FAX: (412)232-4550. Creative Director: M.A. Polyak. Estab. 1985. Produces greeting cards, stationery, giftwrap and gifts. "We sell wholesale to retail stores throughout the country, which specialize in items related to horses (approx. 900 stores). Clients include Kentucky Derby Museum, Cowboy Hall of Fame, Arabian Nights and Museum of Racing."

Needs: Approached by 10-20 freelance artists/year. Works with 14 freelance artists/year. Prefers artists with experience in illustrating horses and animals. Uses freelance artists mainly for greeting cards, brochures and catalogs. Also uses freelance artists for P-O-P displays, mechanicals, retouching, airbrushing, logos, ad and direct-mail design, stationery and giftwrap.

First Contact & Terms: Send query letter with photostats, photographs, slides, SASE, photocopies and transparencies. Samples are filed or returned by SASE if requested by artist. Reports back within 60 days. To show a portfolio, mail thumbnails, roughs, b&w photostats, photographs and slides. Rights purchased vary according to project. Pays for design by the project, $50-500. Pays for illustration by the project, $100-2,500.

THE EVERGREEN PRESS, INC., 3380 Vincent Rd., Pleasant Hill CA 94523. (415)933-9700. Art Director: Malcolm K. Nielsen. Publishes greeting cards, giftwrap, stationery, quality art reproductions, Christmas cards and postcards.

Needs: Approached by 750-1,000 freelance artists/year. Buys 200 designs/year from freelance artists. Buys design and/or illustration mainly for greeting cards, Christmas cards and giftwrap and product design. Uses only full-color artwork in any media in unusual designs, sophisticated art and humor or series with a common theme. No super-sentimental Christmas themes, single greeting card designs with no relation to each other, or single color pen or pencil sketches. Roughs may be in any size to get an idea of work; final art must meet size specifications. Would like to see nostalgia, ecology, fine-arts-oriented themes. Produces seasonal material for Christmas, Easter and Valentine's Day; "we examine artwork at any time of the year to be published for the next following holiday."

First Contact & Terms: Send query letter with brochure showing art style or slides and actual work; write for art guidelines. Samples returned by SASE. Reports within 2 weeks. To show a portfolio, mail roughs and original/final art. Originals returned at job's completion. Negotiates rights purchased. "We usually make a cash down payment against royalties; royalty to be negotiated. Pays on publication.

Tips: Sees "trend toward using recycled paper for cards and envelopes and subject matter involving endangered species, the environment and ecology. Spend some time in greeting card stores and become familiar with the 'hot' cards of the moment. Try to find some designs that have been published by the company you approach."

GORDON FRASER GALLERY, 173 S. Main St., New Town CT 06470. (203)426-8174. FAX: (203)426-3367. Creative Director: Kathryn White. Estab. 1962. Produces greeting cards, stationery, paper tableware products, giftware and totes. "Our products have realistic designs, are museum reproductions and Victorian.

Needs: Approached by 40 freelance artists/year. Works with 15 freelance artists/year. Buys 150 designs and illustrations/year from freelance artists. Uses freelance artists for all product areas. Produces material for all holidays and seasons: Halloween, Easter, Valentine's Day, Hanukkah, Thanksgiving, Mother's Day, New Year, graduation, birthdays and everyday. Submit 6 months before holiday.

First Contact & Terms: Send query letter with slides. Samples are filed or are returned by SASE if requested by artist. Reports back within 5 days. Call to schedule an appointment to show a portfolio which should include original/final art and slides. Rights purchased vary according to project. Original artwork is not returned at the job's completion unless specifically requested. Pays by the project, $300 minimum.

FREEDOM GREETINGS, Box 715, Bristol PA 19007. (215)945-3300. President: Jay Levitt. Estab. 1969. Produces greeting cards featuring flowers and scenery.
Needs: Approached by over 100 freelance artists/year. Buys 200 designs from freelance artists/year. Works on assignment only. Considers watercolor, acrylic, etc. Prefers novelty. Call for size specifications. Produces material for all seasons and holidays; submit 14 months in advance.
First Contact & Terms: Send query letter with resume and samples. Samples are returned by SASE. Reports within 10 days. To show a portfolio, mail roughs and original/final art. Originals returned to artist at job's completion. Pays average flat fee of $150-275, illustration/design. Buys all greeting and stationery rights.

***FULLMOON CREATIONS, INC.**, 74 S. Hamilton St., Philadelphia PA 18901. (215)345-1233. FAX: (215)348-5378. Art Director: Frederic Lelev. Estab. 1986. Produces greeting cards and stationery—"colorful graphic design for 90s manufacturers."
Needs: Approached by 70 freelance artists/year. Works with 10 freelance artists/year. Buys 10 freelance designs and illustrations/year. Prefers local artists only. Works on assignment only. Uses freelance artists mainly for illustrations. Looking for all styles. Produces material for Christmas, birthdays and New Year. Submit 4 months before holiday.
First Contact & Terms: Send query letter with brochure, resume, photographs and photocopies. Samples are filed. Reports back only if interested. To show a portfolio, mail b&w roughs. Buys one-time rights. Originals are returned at job's completion. Pays by the project, $150; royalties of 5%.

GALLANT GREETING CORP., 2654 W. Medill Ave., Chicago IL 60647. (312)489-2000. Creative Director: John Fenwick. Estab. 1965. Produces greeting cards and stationery. Produces everyday and seasonal cards. "Looking for contemporary illustration and graphics with humorous and traditional themes."
Needs: Works with 40 freelance artists/year. Buys 500 designs and illustrations/year. Also uses freelance artists for calligraphy and paste-up. Considers all media. Produces material for all holidays and seasons; submit 9 months before holiday.
First Contact & Terms: Send query letter with photocopies. Samples are filed or are returned only if requested by artist. Reports back within 14 days. Call to schedule an appointment to show a portfolio. Original artwork is sometimes returned to the artist after job's completion. Pays average flat fee of $100-300, illustration. Buys exclusive greeting card rights worldwide.

THE C.R. GIBSON CO., Creative Papers Greeting Cards, 32 Knight St., Norwalk CT 06856. (203)847-4543. Product Manager: Robert Pantelone. Estab. 1870. Produces greeting cards, photo albums, social books and stationery.
Needs: Approached by over 200 freelance artists/year. Buys 100-200 designs and illustrations from freelance artists/year, mainly for greeting cards, but also for albums, stationery, wrap, gifts, books, baby and wedding collections. Considers most media except collage. Scale work to a minimum of 4 ⅞×6 ¾. Prefers vertical image. Submissions reviewed year-round; submit seasonal material 12 months before the holiday. Will send guidelines on request.
First Contact & Terms: Send query letter and samples showing art style and/or resume and tearsheets, photostats, photocopies, slides, photographs and other materials. Prefers samples, not originals. Samples not filed are returned by SASE. Reports in 2 months. Call or write for appointment to show portfolio, which should include final reproduction/product, tearsheets, photographs and transparencies along with representative originals. Original artwork returned at job's completion. Pays $200 minimum per illustration or design. Negotiates rights purchased.
Tips: "Please consider the appropriateness of an image for an occasion—its 'sendability.' Also, we're happy to consider an artist's suggestions for verse/text. Don't show too many pieces and apologize about some of them; I'd rather see one piece the artist loves than to see ten pieces he or she has to qualify. Our orientation is toward fashion, and "Pretty" as a category has become tremendously important; it includes florals and general styling of a line, by illustration and design. Of particular interest will be work that embodies deluxe production techniques, such as embossing, die-cutting and foil stamping. Our line has grown more traditional, because this is what our customers perceive as appropriate coming from C.R. Gibson/Creative Papers."

GLITTERWRAP, INC., 40 Carver Ave., Westwood NJ 07675. (201)666-9700. FAX: (201)666-5444. President: Melinda Scott. Estab. 1987. Produces giftwrap for contemporary mylar and iridescent wraps and totes.
Needs: Approached by 25 freelance artists/year. Works with 15 freelance artists/year. Buys more than 50 designs/illustrations/year from freelance artists. Uses freelance artists mainly for giftwrap and totebags. Also uses freelance artists for paste-up and mechanicals. Considers designs on acetate. Looking for a contemporary graphic and upscale look. Produces material for all holidays and seasons. Submit 10 months before holiday.

First Contact & Terms: Send query letter with brochure, resume, tearsheets, photostats, photographs, slides, photocopies and transparencies. Samples are not filed and are returned by SASE if requested by artist. Reports back within 2 weeks. To show portfolio, mail thumbnails, roughs and original/final art. Negotiates rights purchased, vary according to project. Original artwork is not returned at the job's completion. Pays by the project, $250-600; royalties of 5%.

GRAND RAPIDS CALENDAR CO., 906 S. Division Ave., Grand Rapids MI 49507. (616)243-1732. Art Director: Rob Van Sledright. Publishes calendars; pharmacy, medical and family themes.
Needs: Buys approximately 15 designs/year. Uses artists for advertising art and line drawings.
First Contact & Terms: Send query letter and SASE for information sheet. Reports in 2 weeks. Previously published, photocopied and simultaneous submissions OK. Pays $10 minimum.

GREETWELL, D-23, M.I.D.C., Satpur, Nasik 422 007 India. Chief Executive: H.L. Sanghavi. Produces greeting cards, calendars and posters.
Needs: Approached by 50-60 freelance artists/year. Buys 50 designs from freelance artists/year. Buys freelance designs/illustrations mainly for greeting cards and calendars. Prefers flowers, landscapes, wildlife and general themes.
First Contact & Terms: Send color photos and samples to be kept on file. Samples not filed are returned only if requested. Reports within 4 weeks. Original art returned after reproduction. Pays flat fee of $50/design. Buys reprint rights.

***HURLIMANN ARMSTRONG STUDIOS**, Box 1246, Menlo Park CA 94026. (415)325-1177. owner: Mary Ann Hurlimann. Estab. 1987. Produces greeting cards (museum style fine art notes) and enclosures.
Needs: Approached by 10+ freelance artists/year. Works with 3 freelance artists/year. "We have just begun to use other artists." Buys 16 freelance designs/year. Considers watercolor, oil, acrylic—no photography. Prefers rich color, clear images, no abstracts. Prefers 9×12″ final art.
First Contact & Terms: Send query letter with slides. Samples are not filed and are returned by SASE if requested by artist. Reports back within 1 month. To show a portfolio, mail slides. Buys all rights. Originals are returned at job's completion. Pays royalties of 8%.

INTERCONTINENTAL GREETINGS LTD., 176 Madison Ave., New York NY 10016. (212)683-5830. Creative Marketing Director: Robin Lipner. Sells reproduction rights on a per country per product basis. Licenses and syndicates to 4,500-5,000 publishers and manufacturers in 50 different countries. Industries include greeting cards, calendars, prints, posters, stationery, books, textiles, heat transfers, giftware, china, plastics, toys and allied industries, scholastic items and giftwrap.
Needs: Approached by 500-700 freelance artists/year. Assigns 400-500 jobs and 1,500 designs and illustrations/year from freelance artists. Buys illustration/design mainly for greeting cards and paper products. Also buys illustration for giftwrap, calendars, giftware and scholastic products. Uses traditional as well as humorous and cartoon-style illustrations. Prefers airbrush and watercolor, then colored pencil, acrylic, pastel, marker and computer illustration. Prefers "clean work in series format; all card subjects are considered."
First Contact & Terms: Send query letter and/or resume, tearsheets, slides, photographs and SASE. To show a portfolio, mail appropriate materials or call or write to schedule an appointment; portfolio should include original/final art and color tearsheets and photographs. Pays negotiable rates by the project for design and illustration. Pays 20% royalties upon sale of reproduction rights on all selected designs. Contractual agreements made with artists and licensing representatives; will negotiate reasonable terms. Provides worldwide promotion, portfolio samples (upon sale of art) and worldwide trade show display.
Tips: "More and more of our clients need work submitted in series form, so we have to ask artists for work in a series or possibly reject the odd single designs submitted. Make as neat and concise a presentation as possible with commerical application in mind. Artists often send too few samples or sloppy, poor quality reproductions. Show us color examples of at least one finished piece as well as roughs." Sees trend towards "humorous characters."

***THE INTERMARKETING GROUP**, 29 Holt Rd., Amherst NH 03031. (603)672-0499. President: Linda L. Gerson. Estab. 1985. Licensing agent for greeting cards, stationery, calendars, posters, paper tableware products, giftwrap, eurobags, giftware, toys, needle crafts. The Intermarketing Group is a full-service merchandise licensing agency representing artist's works for licensing with companies in the greeting card, giftware, toy, housewares, needlecraft and apparel industries.
Needs: Approached by 35 freelance artists/year. Works with 10 freelance artists/year. Licenses works as developed by clients. Prefers artists with experience in full-color illustration. Uses freelance artists mainly for cards, giftware, calendars, paper tableware, toys, bookmarks, needlecraft, apparel, housewares. Will consider all media forms. "My firm generally represents highly illustrated works, characters and humorous illustrations for direct product applications. All works are themed." Prefers 5×7 or 8×10 final art. Produces material for all holidays and seasons, Halloween, Christmas, Birthdays, Valentine's Day, Mother's Day, everyday. Submit seasonal material 6 months in advance.

© Hurlimann Armstrong Studios 1991

"Spiral" was painted in watercolor by Greg Mort and was one of four of his paintings chosen for reproduction by Hurlimann Armstrong Studios of Menlo Park, California. General partner Mary Ann Hurlimann says they had known of the artist, whose work is in the Smithsonian Institution's Air and Space Museum and "were attracted to the clarity and intensity" of his creations. The card conveys quality, says Hurlimann. "It is dramatic, with a timeless appeal. Everyone has, at some time in their life, stood in awe of a beautiful night sky; this piece captures that instinctive response."

First Contact & Terms: Send query letter with brochure, tearsheets, photostats, resume, photographs, slides, SASE, photocopies and transparencies. Samples are not filed and are returned by SASE. Reports back within 3 weeks. To show a portfolio, mail appropriate materials. Portfolio should include original/final art, b&w and color, tearsheets, photographs, slides and dummies. Buys all rights. Original artwork returned to artist after job's completion. Pays royalties of 3-8%.

Tips: "A common mistake freelance artists make in presenting samples is not providing color reference." Sees trend toward "themes which are more traditional and less alternative."

JILLSON & ROBERTS, INC., 5 Watson Ave., Irvine CA 92718. (714)859-8781. Art Director: Lisa Henry. Estab. 1974. Produces giftwrap. "We produce giftwrap and gift bags for adults, teenagers and children. Colorful graphic designs as well as humorous or sophisticated designs are what we are looking for."

Needs: Approached by several freelance artists/year. Works with 10 freelance artists/year. Prefers artists with experience in giftwrap. Buys freelance design and illustration mainly for giftwrap. Also uses freelance artists for paste-up. Considers all media. Prefers elegant, humorous, sophisticated, contemporary styles. Produces material for Christmas, Valentine's Day, Hanukkah, Halloween, graduation, birthdays, baby announcements and everyday. Submit 1 year before holiday.

First Contact & Terms: Send query letter with brochure showing art style, tearsheets and slides. Samples are filed and are returned. Reports back within 3 weeks. To show a portfolio, mail thumbnails, roughs, original/final art, final reproduction/product, color slides and photographs. Original artwork is not returned to the artist after job's completion. Pays by the project. Buys all rights.

JOLI GREETING CARD CO., 1881 Industrial Dr., Libertyville IL 60048. (708)367-8600. Art Director: Holly Woelffer. Produces greeting cards and stationery.

Needs: Number of designs and illustrations bought/year varies. Artists must not have worked for Joli's immediate competition. Uses artists for P-O-P displays. Considers airbrush for product illustration. Prefers finished art of 4×9 for studio cards and 5×7. Publishes seasonal material for Christmas, St. Valentine's Day,

Mother's Day, Father's Day. Looking for illustrations of animals and scenery.
First Contact & Terms: Send query letter with samples to be kept on file. Accepts "whatever is available" as samples. Samples not filed are returned by SASE. Reports within 1 month. Sometimes returns original art after reproduction. Pays flat fee, $150. Buys all rights.
Tips: "We have moved into more traditional cards utilizing more embossing and stamping."

***KEM PLASTIC PLAYING CARDS, INC.**, Box 137, Scranton PA 18504. (717)343-4783 or (800)233-4173. Vice President: Mark D. McAleese. Estab. 1937. Produces plastic playing cards. Manufactures high-quality durable cards and markets them worldwide to people of all ages, ethnic backgrounds, etc. Special interest is young people.
Needs: Buys 1-3 designs/illustrations/year. Prefers "artists who know composition and colors." Buys freelance design/illustrations mainly for playing cards. Also uses artists for calligraphy. Considers watercolor, oil and acrylics. Seeks "good composition with vivid, bouncing colors and color contrasts, always in good taste." Prefers 5½ × 7. Produces material for all holidays and seasons.
First Contact & Terms: Send query letter with brochure and slides. Samples are not filed. Samples not filed are returned. Reports back within 1 week. To show a portfolio, mail roughs, final reproduction/product, slides, tearsheets, photostats and color. Original artwork is returned to the artist after job's completion. Pays $500-1,000/illustration. Buys first or one-time rights; negotiates rights purchased.

KOGLE CARDS, INC., Suite 212, 5575 S. Sycamore St., Littleton CO 80120. President: Patty Koller. Estab. 1982. Produces greeting cards.
Needs: Approached by 300 freelance artists/year. Buys 250 designs and 250 illustrations from freelance artists/year. Works on assignment only. Considers all media for illustration. Prefers 5 × 7 for final art. Produces material for Christmas and all major holidays plus birthdays; material accepted year-round.
First Contact & Terms: Send slides. Samples not filed are returned by SASE. "No SASE, no return." Reports back within 2 weeks. To show a portfolio, mail original/final art, color and b&w photostats and photographs. Original artwork is not returned. Pays royalties of 8%. Buys all rights.

LOVE GREETING CARDS, INC., 1717 Opa Locka Blvd., Opa Locka FL 33054-4221. (305)685-5683. Vice President: Norman Drittel. Estab. 1984. Produces greeting cards, posters and stationery. "We produce cards for the 40-60 market, complete lines and photography posters."
Needs: Works with 2 freelance artists/year. Buys 60 designs and illustrations/year from freelance artists. Prefers artists with experience in greeting cards and posters. Also buys illustrations for high-tech shopping bags. Uses freelance artwork mainly for greeting cards. Considers pen & ink, watercolor, acrylic, oil and colored pencil. Seeks a contemporary/traditional look. Prefers 5 × 7 size. Produces material for Hanukkah, Passover, Rosh Hashanah, New Year, birthdays and everyday.
First Contact & Terms: Send query letter, brochure, resume and slides. Samples are filed or are returned. Reports back within 10 days. Call or write to schedule an appointment to show a portfolio, which should include roughs and color slides. Original artwork is not returned to the artist after job's completion. Pays average flat fee of $75/design. Buys first or one-time rights; negotiates rights purchased.

***LUCY & COMPANY**, 7711 Lake Ballinger Way NE, Edmonds WA 98026. (206)775-8826. FAX: (206)672-0280. Manager: Diane Roger. Estab. 1977. Produces greeting cards, stationery, paper tableware products, calendars, giftwrap and posters. "The main emphasis of the line is on Lucy Rigg's bears, also a nostalgic, playful Victorian theme—florals, hearts and laces for young and older adults and female interest."
Needs: Approached by a few freelance artists/year. Works with 2-3 freelance artists/year. Uses freelance artists mainly for special projects. Also uses freelance artists for P-O-P displays, paste-up and mechanicals. Considers watercolor, gouache, oils, acrylic, pen & ink. Prefers 5 × 7" for final art. Produces material for Christmas, birthdays, Valentine's Day, everyday, Mother's Day.
First Contact & Terms: Send query letter with SASE, photographs, slides and photocopies. Samples are filed or are returned by SASE. Reports back within 3 weeks only if interested. To show a portfolio, mail appropriate materials. Rights purchased vary according to project. Pays by the hour, $50-30, or royalties of 5%.

***MAGIC MOMENTS GREETING CARDS**, 10 Connor Lane, Deer Park NY 11729. (516)595-2300. FAX: (516)254-3922. Contact: David Braunstein. Estab. 1938. Produces greeting cards.
Needs: Approached by 20 freelance artists/year. Works with 10 freelance artists/year. Buys 450+ freelance designs and illustrations/year. Prefers artists with experience in greeting cards. Works on assignment basis only. Uses freelance artists for calligraphy. Considers all media. Produces material for all holidays and seasons. Submit 9 months before holiday.
First Contact & Terms: Send query letter with photostats, photographs, slides and photocopies. Samples are not filed and are returned by SASE. Reports back only if interested. To show a portfolio, mail color photographs. Buys all rights. Originals are not returned at job's completion. Pays by the project, $100-125/design.

MAID IN THE SHADE, Church Street Station, Box 341, New York NY 10008-0341. (201)659-1269. Art Director: Laird Ehlert. Estab. 1984. Produces greeting cards and postcards. "We are part of the alternative card market. Our largest customer groups are college age, young professional or gay. We are known for sophisticated humor."
Needs: Approached by 20-50 freelance artists/year. Works with 1-20 freelance artists/year. Buys approximately 50 designs and illustrations/from freelance artists/year. Prefers artists with experience in greeting cards and graphic design. Uses freelance artists mainly for greeting cards and postcards; usually finished (concept, artwork, mechanicals); "although our in-house production staff can do mechanical paste-up if necessary." Considers anything that can be reproduced by the usual printing methods, b&w or color. "We are completely open; however, bear in mind that it should be eye-catching on the display rack." Prefers art for 5×7 folding cards or 4¼×6 postcards, "which is 100% reproduction size, or else it should be proportional." Produces material for Christmas, birthdays and general. Submit 9-12 months before holiday.
First Contact & Terms: Send query letter with photocopies. Samples are filed or are returned by SASE if requested by artist. Reports back within 2 months. To show a portfolio, mail photocopies. Buys all rights or negotiates rights purchased. Original artwork is not returned at the job's completion. Pays average flat fee of $150 for illustration/design.
Tips: "We'd love to see illustration that doesn't look like another company's! We're real big on dated-looking clip art (1930s-1950s), old advertising, 20th-century Americana, but leave it open to high impact graphics. It seems that many artists completely ignore our needs and guidelines for submissions."

***A MAJOR PRODUCTION,** 5161 River Rd., Bethesda MD 20816. (301)951-3722. FAX: (301)907-6930. President and Art Director: Edward Garfinkle. Estab. 1981. Produces greeting cards, buttons, magnets, key rings, stickers. Products feature "witty and humorous one-liners, selling to all age groups—with an emphasis on the 18-50 age group."
Needs: Approached by 50 freelance artists/year. Works with 10 freelance designs and illustrations/year. Buys 40 freelance designs and illustrations/year. Prefers artists with experience in cartooning. Works on assignment only. Uses freelance artists mainly for buttons and stickers. Also uses freelance artists for P-O-P displays. Looking for sophisticated cartoons. Produces seasonal material for Halloween, Christmas, Valentine's Day, birthdays and everyday. Submit 6 months before holiday.
First Contact & Terms: Send query letter with resume, photographs and slides. Some samples are filed; others are returned. Reports back within 2 weeks. To show a portfolio, mail thumbnails, roughs and b&w and color. Rights purchased vary according to project. Pays by the project, $25 minimum.

MARCEL SCHURMAN CO. INC., 2500 N. Watney Way, Fairfield CA 94533. (707)428-0200. Art Director: Sandra McMillan. Produces greeting cards, giftwrap and stationery. Specializes in "very fine artwork with many different looks: traditional, humorous, graphic, photography, juvenile, etc."
Needs: Buys 800-1000 designs/year from freelance artists. Prefers final art sizes proportionate to 5×7, 4×6; Produces seasonal material for Valentine's Day, Easter, Mother's Day, Father's Day, graduation, Halloween, Christmas, Hanukkah and Thanksgiving. Submit art by January for Valentine's Day and Easter, May for Mother's and Father's Day, graduation; June for Christmas, Halloween, Thanksgiving and Hanukkah. Interested in all-occasion cards also.
First Contact & Terms: Send query letter with slides, printed material or photographs showing a variety of styles. "No bios, news clippings or original art, please." Reports within 1 month. Returns original art after reproduction. Pays average flat fee of $300/illustration; royalites of 5%.

DAVID MEKELBURG & FRIENDS, 1222 N. Fair Oaks Ave., Pasadena CA 91103. (818)798-3633. FAX: (818)798-7385. Sales Manager: Richard Crawford. President: Susan Kinney. Estab. 1988. Produces greeting cards, stationery, calendars, posters and giftwrap.
Needs: Approached by 10 freelance artists/year. Works with 2 freelance artists/year. Prefers local artists only. Works on assignment only. Uses freelance artists mainly for design. Produces material for all holidays and seasons, birthdays and everyday. Submit 12 months before holiday.
First Contact & Terms: Send query letter with resume and color photocopies. Samples are filed and are not returned. Reports back only if interested. Write to schedule an appointment to show a portfolio, which should include original/final art, photographs and product renderings. Rights purchased vary according to project. Original artwork returned after publication. Pays royalties of 5%.

MIRAGE IMAGES INC., 69 Moss Agate Rd., Douglas WY 82633. (307)358-5000. President: Caroline Selden. Estab. 1982. Produces postcards and children's books.
Needs: Works on assignment only. Buys freelance designs/illustrations mainly for books. Also uses freelance artists for calligraphy, paste-up and mechanicals. Considers pen & ink, watercolor, colored pencil and photography—camera-ready art.
First Contact & Terms: Send query letter with brochure, resume, tearsheets and slides. Samples are not filed and are returned only if requested by artist. Reports back within 2 months. To show a portfolio, mail roughs, original/final art, final reproduction/product, color and b&w slides, tearsheets, photostats and photo-

graphs. Original artwork is sometimes returned to the artist after job's completion. Buys all rights.
Tips: "Have a good portfolio and professional approach to our business; be punctual on all deadline dates."
Would like to see renditions of animals and nature.

MUSEUM GRAPHICS/NEW HEIGHTS, Box 2368, Menlo Park CA 94025. President: Alison Mayhew. Estab.
1952. Produces greeting cards and stationery. "We publish greeting cards from high-quality photographs. We
are looking for fun, contemporary and humorous photos to add to our existing line. We are willing to look
at other types of art, such as silk screens, monoprints and collages."
Needs: Works with freelance artists. Looks for contemporary styles. Prefers 8 × 10 photos. Produces material
for all holidays and seasons; submit 6 months before holiday.
First Contact & Terms: Send query letter with brochure showing art style, photostats, slides and SASE.
Samples are not filed and are returned by SASE. Reports back regarding query/submission within 1 month.
To show a portfolio, mail color and b&w original/final art, final reproduction/product, slides, tearsheets,
photostats and photographs. Original artwork is returned to the artist after job's completion. Pays royalties
of 10%.

NATIONAL ANNOUNCEMENTS INC., 34-24 Collins Place., Flushing NY 11354. (718)353-4002. Vice Presi-
dent: David Rosner. Estab. 1960. Produces wedding invitations (blank stock, ready for printing) for women
ages 18 up.
Needs: Prefers local artists with greeting card background. Buys illustrations mainly for wedding invitations.
Prefers half-tone florals.
First Contact & Terms: Send query letter with brochure. Samples are not filed and are returned only if
requested by artist. Reports back only if interested. Call or write to schedule an appointment to show a
portfolio, which should include final reproduction/product. Original artwork is not returned to the artist after
job's completion. Pays average flat fee of $50-250. Buys all rights.
Tips: "Greeting card experience is necessary, plus it's helpful to understand the graphic arts process."

NEW DECO, INC., 6401 E. Rogers Circle, Boca Raton FL 33487. (407)241-3901. President: Brad Hugh
Morris. Estab. 1984. Produces greeting cards, posters, fine art prints and original paintings.
Needs: Approached by 10-20 freelance artists/year. Works with 5-10 freelance artists/year. Buys 8-10 designs
and 5-10 illustrations from freelance artists/year. Buys artwork for greeting cards, giftwrap, calendars, paper
tableware, poster prints, etc.
First Contact & Terms: Send query letter with brochure, resume, tearsheets, slides and SASE. Samples not
filed are returned by SASE. Reports back within 10 days only if interested. To show a portfolio, mail color
slides. Original artwork is returned after job's completion. Pays royalties of 10%. Negotiates rights purchased.
Tips: "Do not send original art at first."

NEW ENGLAND CARD CO., Box 228, Route 41, West Ossipee NH 03890. (603)539-5200. Manager: Harold
Cook. Estab. 1980. Produces greeting cards and prints of New England scenes.
Needs: Approached by 75 freelance artists/year. Works with 10 freelance artists/year. Buys more than 24
designs and illustrations/year. Prefers artists with experience in New England art. Considers oil, acrylic and
watercolor. Looking for realistic styles. Prefers art in multiples of 5 × 7. Produces material for all holidays
and seasons. Submit all year.
First Contact & Terms: Send query letter with photographs, slides and transparencies. Samples are filed or
are returned. Reports back within 2 months. Call or write to schedule an appointment to show a portfolio
or mail appropriate materials: original/final art, photographs and slides. Rights purchased vary according to
project; but "we prefer to purchase all rights." Payment negotiable.

NOVA GREETINGS, INC., Box 517, St. Clair MI 48079. (519)451-9600. Vice President: Doug Bryant. Estab.
1988. Produces greeting cards. "We produce a diverse group of cards from risqué photos to high-end art-
work."
Needs: Approached by more than 100 freelance artists/year. Works with 40 freelance artists/year. Buys 300-
400 designs/illustrations/year. Uses freelance artists mainly for greeting cards. Considers any media. Looking
for "cute to serious detailed artwork for all occasions." Prefers 7½ × 10½ with ¼ bleed. Produces material
for all holidays and seasons. Submit 9 months before holiday.
First Contact & Terms: Send query letter with brochure, resume, SASE, photocopies and slides. Samples
are not filed and are returned. Reports back within 4 weeks. Call to schedule an appointment to show a
portfolio, which should include roughs, color tearsheets and slides. Negotiates rights purchased. Original
artwork returned after publication. Pays by the project, $250-500; will negotiate.

OATMEAL STUDIOS, Box 138, Rochester VT 05767. (802)767-3171. FAX: (802)767-9890. Creative Director:
Helene Lehrer. Estab. 1979. Publishes humorous greeting cards and notepads, creative ideas for everyday
cards and holidays.

Needs: Approached by approximately 300 freelance artists/year. Buys 100-150 designs/illustrations/year from freelance artists. Uses artists for greeting card design and illustration. Considers all media; prefers 5 × 7, 6 × 8½, vertical composition. Produces seasonal material for Christmas, Mother's Day, Father's Day, Easter, Valentine's Day and Hanukkah. Submit art in May for Christmas and Hanukkah, in January for other holidays.

First Contact & Terms: Send query letter with slides, roughs, printed pieces and brochure/flyer to be kept on file; write for artists' guidelines. "If brochure/flyer is not available, we ask to keep one slide or printed piece." Samples returned by SASE. Reports in 3-6 weeks. "We do not hold portfolio reviews." Negotiates payment arrangement with artist.

Tips: "We're looking for exciting and creative humorous (not cutesy) illustrations. If you can write copy and have a humorous cartoon style all your own, send us your ideas! We do accept work without copy too. Our seasonal card line includes traditional illustrations, so we do have a need for non-humorous illustrations as well."

OUTREACH PUBLICATIONS, Box 1010, Siloam Springs AR 72761. (501)524-9381. Creative Director: Darrell Hill. Produces greeting cards, calendars and stationery. Produces announcements, invitations; general, informal, inspirational, contemporary, soft line and studio.

Needs: Works with 60 freelance artists/year. Buys 150 designs from freelance artists/year. Works on assignment only. Also uses artists for calligraphy. Prefers designers' gouache colors and watercolor. "Greeting card sizes range from 4½ × 6½ to 5½ × 8½; prefer same size, but not more than 200% size." Produces material for Valentine's, Easter, Mother's Day, Father's Day, Confirmation, graduation, Thanksgiving, Christmas; submit 1 year before holiday.

First Contact & Terms: Send query letter with brochure or photocopies, slides and SASE. Samples are not filed and are returned by SASE. Reports back within 6 weeks. To show a portfolio, mail color original/final art, final reproduction/product, slides and photographs. Original artwork is not returned after job's completion. Pays average flat fee of $100-350/design. Buys all rights.

Tips: "Outreach Publications produces Dayspring Greeting cards, a Christian card line. Suggest interested artists request our guidelines for freelance artists. Experienced greeting cards artists preferred. Submissions should include no more than 12 selections."

P.S. GREETINGS, INC., 4459 W. Division St., Chicago IL 60651. Art Director: Kevin Lahvic. Manufacturer of boxed greeting and counter cards.

Needs: Receives submissions from 300-400 freelance artists/year. Works with 20-25 artists on greeting card designs. Prefers illustrations be 5 × 7 cropped. Publishes greeting cards for everyday and Christmas.

First Contact & Terms: Send query letter requesting artist's guidelines. All requests as well as submissions must be accompanied by SASE. Reports within 2 months. Pays $100-200. Buys exclusive worldwide rights for greeting cards only.

Tips: "Include your name and address on each piece. Our needs are varied: florals, roses, feminine, masculine, pets (dogs and cats), photos. Also, ideas for foil stamping and embossing images. We also print Christmas cards with various types of treatments."

PAPEL/FREELANCE, INC., Box 7094, North Hollywood CA 91609. (818)765-1100. Art Department Manager: Helen Scheffler. Estab. 1955. Produces souvenir and seasonal ceramic giftware items: mugs, photo frames, also paper items (memo pads, stationery) and moulded jewelry.

Needs: Approached by about 125 freelance artists/year. Buys 250 illustrations from freelance artists/year. Artists with minimum 3 years of experience in greeting cards and giftware. Uses artists for product and P-O-P design, illustrations on product, calligraphy, paste-up and mechanicals. "Very graphic, easy to interpret, bold colors, both contemporary and traditional looks." Produces material for Christmas, Valentine's Day, Easter, St. Patrick's Day, Mother's and Father's Day and everyday.

First Contact & Terms: Send query letter with brochure, resume, photostats, photocopies, slides, photographs and tearsheets to be kept on file. Samples not kept on file are returned by SASE if requested. Reports within one month. No originals returned to artist at job's completion. To show a portfolio, mail final reproduction/product and b&w and color tearsheets, photostats and photographs. Pays by the project, $125-450. Buys all rights.

Tips: "I look for an artist who has realistic drawing skills but who can temper everything with a decorative feeling. I look for a 'warm' quality that I think will be appealing to the consumer. We still depend a tremendous amount on freelance talent. Send samples of as many different styles as you are capable of doing well. Versatility is a key to having lots of work. Update samples sent over time as new work is developed." Sees trend toward "more sophisticated design and classical elegance in wrapping paper and some stationery items. Rich jewel-tone colors are prominent."

PAPER ART COMPANY INC., Suite 300, 7240 Shadeland Station, Indianapolis IN 46256. (317)841-9999. Creative Director: Shirley Whillhite. Estab. 1934. Produces paper-tableware products, invitations and party decor.

Close-up

Peggy Jo Ackley
Greeting Card Artist
San Anselmo, California

© Barbara Kelley 1991

Peggy Jo Ackley is in her little "cottage" studio behind her home in California working on a Mother's Day card—a year in advance. A design for Renaissance Greeting Cards, the card typifies the unique, now recognizable style of the artist—happy scenes of intricate little flowers, lace, ribbons and a heartfelt message.

Such a card might take two days to complete, Ackley says. Renaissance generally sends her a concept for a holiday or theme. She'll first discuss her ideas and the greetings with the writers (or sometimes the message is her own). She then develops these ideas in pencil sketches or overlays and sends them off. Once any changes are approved (via fax or phone), she finalizes her drawings—usually in gouache, her preferred medium.

A freelancer since 1982 and a regular with Renaissance since 1985, Ackley now has an established business in San Anselmo, working three to four days a week around her young son's schedule. Able to capitalize on her charming, whimsical card style, she has expanded her freelance design with her own giftwrap, china, houseware, juvenile bedding and a book of wallpapers.

Ackley loved to draw as a child—on everything—and her college training was in fine arts. But before settling into her art career she worked a series of jobs, not always art-related. Meanwhile she sent out her card designs and developed a portfolio, which one year she took to the New York Stationery Show. Right off she sold two designs and her career was launched.

From her own experience of getting started, she stresses the importance of developing an individual style; "paint what you enjoy, what you're good at—please your own sensibilities," she says. Most beginners are inclined to do just what they think will sell. Once you're in the business you will have to know what elements sell or don't sell. And you have to keep up with trends, especially humor. Ackley's style is less affected by change, but she keeps atop new interests with TV, magazines, and art and museum shows, which indicate what subjects might be popular.

Before you send work out, the artist continues, you should explore the market, visit lots of card shops to see what's out there, what the card companies are, the styles they produce. Then approach the companies with the kind of artwork you admire—"they'll be more in tune with your own interests." Once you see what's out there then you can develop your own images and style—and get together a good strong portfolio.

Your initial presentation should be as professional as possible. When you approach a market, Ackley says, be sure to include four or five concept sketches and at least one or two finished pieces, in transparencies or color photocopies. Art directors need to see what your finished cards will look like.

Ackley acknowledges her own early mistakes, such as submitting a series of cards which individually canceled each other out. Each card must stand on its own, she says. Also, because she was once involved in a lawsuit, she advises you to check the company's reputa-

tion—and viability. Today she admits, it may be harder to break in because there are fewer card companies; many of the little individualized companies have been bought up by bigger ones.

Success as a greeting card artist comes from good business practices, and Ackley offers these tips: If possible, get a contract; get the copyright under your own name; be sure to get your originals back; and work on an advance against royalty basis instead of a flat fee. A successful card might sell for three to four years; one of Ackley's sold for nine.

Greetings are important; and humor not only sells well but is a good entree into the market, if you have the inclination. But in general, Ackley says "the successful card has a broad base of appeal and hits home with people somewhere—in subject, style, humor or thought." Each card should hold something special to make the buyer want to give it a closer look.

—Jean Fredette

These pleasing and lighthearted cards were done by Ackley for Renaissance Greeting Cards and Family Line, Inc. Their pastel colors and quaint images remind their recipients of simple and happy times. Reprinted with permission of Peggy Jo Ackley.

Needs: Approached by 50 freelance artists/year. Buys 40% of line from freelance artists/year. Prefers flat watercolor, designer's gouache for designs. Requires 9¼ circular format for plate design. Produces general everyday patterns for birthday, weddings, casual entertaining, baby and bridal showers; St. Patrick's Day, Easter, Valentine's Day, graduation, Fall, Halloween, Thanksgiving, Christmas and New Year.

First Contact & Terms: Send query letter with photocopies of artwork, printed samples and SASE. Samples are not returned. Original artwork is not returned if purchased. Pays by the project, $250-500 or royalties.

Tips: "Color coordinating and the mixing and matching of patterns are prevalent. Need sophisticated designs. We require professional, finished art that would apply to our product."

THE PAPER COMPANY, 731 S. Fidalgo, Seattle WA 98108. (206)762-0982. Vice President: Tom Boehmer. Estab. 1979. Produces stationery. "Produces contemporary stationery (fine writing papers) whose primary market is females ages 16-60. Wide range of themes from sexy and sophisticated to fun and silly (but not juvenile)."

Needs: Approached by 20 freelance artists/year. Works with 4-6 freelance artists/year. Buys 45 designs and illustrations/year from freelance artists. Prefers artists whose work is adaptable to stationery (writing paper). Buys freelance designs and illustrations mainly for writing papers. Considers airbrush and pastel (open to whatever works). Prefers fun, silly or sophisticated, upscale themes. "We do not use cartoons." Prefers 6¼×9 proportions. Produces material for Christmas and everyday; "limitless subjects"; submit 9 months before holiday.

First Contact & Terms: Send query letter with brochure, photostats and rough sketches suitable for writing papers. Samples are filed or are returned only if requested by artist. Reports back within 1 month. To show a portfolio, mail thumbnails, roughs and photostats. Original artwork is sometimes returned to the artist after job's completion. Pays average flat fee of $400/illustration.

Tips: "Submit rough sketches of artwork in a format suitable for writing paper (i.e. there must be enough space left on sheet for writing space). We do not do greeting cards. Write a query letter with b&w photocopies for artist's file. B&w photocopies not returned. Most of our artwork is on a commissioned basis."

PAPER MAGIC GROUP INC., 347 Congress St., Boston MA 02210. Art Director: Ms. Mel Nieders. Estab. 1984. Produces greeting cards, stationery, vinyl wall decorations, 3-D paper decorations. "We are publishing seasonal cards and decorations for the mass market. Design is traditional, with emphasis on Christmas."

Needs: Works with 50 freelance artists/year. Requires artists with a minimum of 2 years experience in greeting cards. Work is by assignment only. Designs products for Christmas, Valentine's Day, Easter and Halloween.

First Contact & Terms: Send query letter with resume, slides and SASE. Color photocopies are acceptable samples. Samples are filed or are returned by SASE only if requested by artist. Reports back within 60 days. Original artwork is not returned to the artist after job's completion. Pays by the project, $300-800. Buys all rights.

Tips: "Send samples of work by mail, especially Christmas ideas. Please, make only one phone inquiry to see if it was received, no others."

PAPER MOON GRAPHICS, INC., Box 34672, Los Angeles CA 90034. (213)645-8700. Creative Director: Michael Conway or Robert Fitch. Estab. 1977. Produces greeting cards and stationery. "We publish greeting cards with a friendly, humorous approach – dealing with contemporary issues for an audience 20-35 year old, mostly female."

Needs: Works with 20 freelance artists/year. Buys 400 designs/illustrations/year. "Looking for a new cartoon style with bright, friendly color." Buys freelance illustrations mainly for greeting cards and card concepts. Prefers 10×14. Produces material for all holidays and seasons, Valentine's Day and birthdays. Submit 12 months before holiday.

First Contact & Terms: Send query letter with brochure, tearsheets, photostats, photocopies, slides and SASE. Samples are filed or are returned only if requested by artist and accompanied by SASE. Reports back within 6 weeks. To show a portfolio, mail color roughs, slides and tearsheets. Original artwork is returned to the artist after job's completion. Pays average flat fee of $350/design; $350/illustration. Negotiates rights purchased.

Tips: "We're looking for bright, fun cartoon style with contemporary look. Artwork should have a young 20's and 30's appeal." A mistake freelance artists make is that they "don't know our product. They send inappropriate submissions, not professionally presented with no SASE."

PAPERPOTAMUS PAPER PRODUCTS INC., Box 35008, Station E, Vancouver BC V6M 4G1 Canada. (604)270-4580. FAX: (604)270-1580. Director of Marketing: George Jackson. Estab. 1988. Produces greeting cards for women ages 18 to 55. "We have also added a children's line."

Needs: Works with 6-10 freelance artists/year. Buys 48-96 illustrations from freelance artists/year. Also uses artists for P-O-P displays, paste-up and inside text. Prefers watercolor, but will look at all media that is colored; no b&w except photographic. Seeks detailed humorous cartoons and detailed nature drawings i.e.

flowers, cats. "No studio card type artwork." Prefers 5⅛ × 7 finished art work. Produces material for Christmas; submit 18 months before holiday.

First Contact & Terms: Send query letter with brochure, resume, photocopies and SASE. Samples are not filed and are returned by SASE only if requested by artist. Reports back within 2 months. Call or write to schedule an appointment to show a portfolio, or mail roughs and color photographs. Original artwork is not returned to the artist after job's completion. Pays average flat fee of $100/illustration or royalties of 3-5%. Prefers to buy all rights, but will negotiate rights purchased.

Tips: "Have a good sense of what the greeting card market is about. Know what the best selling humorous card lines are and what the market is buying. Understand the time frame necessary to produce a properly done card line."

PARTHENON WEST, Box 5, Boulder CO 80306. (303)444-7662. President: Clark Ummel. Estab. 1985. Produces greeting cards. "We are a publisher of bold, contemporary greeting cards and note cards, mainly appealing to young creative urbanites."

Needs: Approached by 10-30 freelance artists/year. Works with 0-10 freelance artists/year. Buys 0-50 designs/illustrations/year from freelance artists. "We prefer artists able to create non-traditional and wild designs suitable for greeting cards with a fine art feel to them." Uses freelance artists mainly for new lines of greeting cards. Also uses freelance artists for mechanicals. Considers "any media as long as it reproduces well." Looking for "bold, contemporary, very graphic styles utilizing unique designs and/or printing techniques." Produces material for Christmas, Valentine's Day, birthdays, everyday and blank note cards. Submit 1 year before holiday.

First Contact & Terms: Send query letter with resume, SASE, photographs and slides. "No phone calls." Samples are filed for 18 months or are returned by SASE if requested by artist. Reports back within 45 days. "We will call if we are interested in reviewing a portfolio." Negotiates rights purchased. Original artwork is returned at the job's completion. Pay by the project, $75-100; royalties of 3-5%.

Tips: Sees trend toward "independent companies capturing more and more of the market."

***PIECES OF THE HEART, INC.**, P.O. Box 56163, Sherman Oaks CA 91413. (818)995-3273. FAX: (818)501-2058. President: David Wane. Estab. 1989. Produces greeting cards and puzzle cards for all ages.

Needs: Approached by 5 freelance artists/year. Works with 2 freelance artists/year. Buys 2 freelance designs and illustrations/year. Works on assignment only. Uses freelance artists mainly for cards. Also uses freelance artists for P-O-P displays. Does not want to see line art. Produces material for all holiday seasons. Submit 9 months before holiday.

First Contact & Terms: Send query letter with brochure, photographs and photocopies. Samples are filed. Reports back to the artist only if interested. Call to schedule an appointment to show a portfolio, which should include thumbnails and color samples. Rights purchased vary according to project. Originals are returned at job's completion.

PINEAPPLE PRESS, Box 461334, Los Angeles CA 90046. (818)972-9239. President: S. A. Piña. Estab. 1986. Produces posters and limited editions.

Needs: Approached by 200 freelance artists/year. Works with 8 freelance artists/year. Buys 5 designs from freelance artists/year. Buys 20 illustrations from freelance artists/year. Prefers "artists who understand a deadline." Works on assignment only. Also uses freelance artists for paste-up, mechanicals and lettering. Prefers acrylic and airbrush technique. Prefers contemporary look.

First Contact & Terms: Send query letter with resume, slides and SASE. Samples are filed or are returned by SASE. Reports back within 2 months. Original artwork is returned to artist after job's completion. Pays by the project, $200-1,000 average; royalties of 5-10%. Negotiates rights purchased.

Tips: "Be persistent and professional. New emerging artists should not be afraid to submit their work. Send a bio or a resume. Do not send black-and-white photocopies as color samples. Sees trend toward more contemporary prints/patterns."

PIONEER GIFT WRAP, 2939 Vail Ave., Los Angeles CA 90040. (213)726-2473. Vice President, Marketing: Bill Lake III. Estab. 1928. Produces giftwrap.

Needs: Approached by around 20 freelance artists/year. Works with 20-30 freelance artists/year. Buys 50-75 designs and illustrations/year. Prefers artists with experience in giftwrap and greeting cards. Considers acrylic. Seeks upscale traditional and downscale contemporary styles. Prefers 15″ cylinder circumference. Produces material for Christmas, Valentine's Day, Mother's Day, Father's Day, Easter, Hanukkah, birthdays and everyday; "all art to be finalized 2/15."

First Contact & Terms: Send query letter with brochure, tearsheets and slides. Samples are not filed and are returned only if requested by artist. Reports back within 3 weeks. To show a portfolio, mail thumbnails, roughs, original/final art, slides and photographs. Original artwork is not returned to the artist after job's completion. Pays average flat fee of $250/design. Buys all rights.

Tips: "Know the giftwrap market and be professional. Understand flexographic printing process limitations."

PLUM GRAPHICS INC., Box 136, Prince Station, New York NY 10012. (212)966-2573. Contact: Kirsten Coyne. Estab. 1983. Produces greeting cards. "They are full-color, illustrated, die-cut; fun images for young and old."

Needs: Buys 12 designs and illustrations/year from freelance artists. Prefers local artists only. Works on assignment only. Uses freelance artists for greeting cards only. Considers oil, acrylic, airbrush and watercolor (not the loose style). Looking for representational and tight-handling styles. Prefers animal themes.

First Contact & Terms: Send query letter with photocopies or tearsheets. Samples are filed or are returned by SASE if requested by artist. Reports back to the artist only if interested. "We'll call to view a portfolio." Portfolio should include original/final art and color tearsheets. Buys all rights. Original artwork is returned at the job's completion. Pays by the project, $200 minimum. Pays an additional fee if card is reprinted.

Tips: "I suggest that artists look for the cards in stores to have a better idea of the style. They are sometimes totally unaware of Plum Graphics and submit work that is inappropriate."

PLYMOUTH INC., 361 Benigno Blvd., Bellmawr NJ 08099. Art Director: Alene Sirott-Cope. Produces posters and paper products, such as 3×5 wire-bound memo books, wire-bound theme books, portfolios, scribble pads, book covers, pencil tablets, etc., all with decorative covers for school, middle grades and high school. "We use contemporary illustrations. Some of our work is licensed. We are expanding into the gift trade with various paper products aimed toward an older age group, 19 and up."

Needs: Approached by 200 freelance artists/year. Buys 300 designs and 300 illustrations from freelance artists/year. Works on assignment only. Uses artists for illustration, logo design, design, paste-up and mechanicals. Prefers full-color and airbrush. Prefers "very graphic designs and illustration." Looking for "contemporary styles and fads, colorful and fun."

First Contact & Terms: Send query letter with brochure showing art style or resume, tearsheets, photostats, photocopies, slides and photographs. Do not send original pieces that must be returned. Reports only if interested. Mail appropriate materials or write to schedule an appointment to show a portfolio, which should include final reproduction/product and color tearsheets. Pays by the project, $300-600. Considers experience of artist when establishing payment. Buys all rights or negotiates rights purchased.

Tips: "Plymouth is looking for professional illustrators and designers. The work must be top notch. It is the art that sells our products. We use many different styles of illustration and design and are open to new ideas. Portfolio should include color print samples (approximately postcard size); we do not use black-and-white illustration or cartoons." The most common mistake freelancers make in presenting samples or portfolios is "presenting everything instead of a few choice pieces."

POPSHOTS, INC., 472 Riverside Ave., Westport CT 06880. (203)454-9700. FAX: (203)454-4955. Vice President, Creative: Paul Zalon. Estab. 1978. Produces greeting cards that pop-up for customers aged 13-60.

Needs: Works with 40 freelance artists/year. Commissions 50 designs and illustrations/year from freelance artists. Works on assignment only. Uses freelance artists mainly for camera ready art and concepts. Considers all media. Looking for "very contemporary designs, as well as period reproduction styles (Victorian, 1940s and 1950s etc.)" Produces material for Christmas, graduation, birthdays, Valentine's Day, Mother's Day and get well. Submit 1 year before holiday.

First Contact & Terms: Send query letter with tearsheets, slides and transparencies. Samples are filed or are returned by SASE. Reports back within 1 month to the artist only if interested. Write to schedule an appointment to show a portfolio or mail appropriate materials." Buys all rights. Pays by the project, $100-2,500.

POTPOURRI PRESS, 6210 Swiggett Rd., Greensboro NC 27410; mailing address: Box 19566, Greensboro NC 27419. (919)852-8961. Director of New Product Development: Janet Pantuso. Estab. 1968. Produces paper products including bags, boxes, stationery and tableware; tins; stoneware items; and collectible figurines for giftshops, the gourmet shop trade and department stores. Primary target—women 25 and older.

Needs: Buys 10-20 designs from freelance artists/year; buys 10-20 illustrations from freelance artists/year. Works on assignment only. Uses artists for calligraphy, mechanicals and art of all kinds for product reproduction. Prefers watercolor, acrylic, marker and mechanical work. Content/styles include traditional, seasonal illustrations for Christmas introductions and feminine florals for everyday. Produces everyday and seasonal products; submit material 1-2 years in advance.

First Contact & Terms: Send query letter with resume and tearsheets, photostats, photocopies, slides and photographs. Samples not filed are returned by SASE. Reports back as soon as possible. Call or write to schedule an appointment to show a portfolio, which should include anything to show ability. "Artist must have good portfolio showing styles the artist is comfortable in." Pays for illustration by the project $150-2,500. Buys all rights.

Tips: "Our audience has remained the same but our products are constantly changing. We are now developing a collectible line of figurines. I often receive work from artists that is not at all applicable to our line. It's a waste of my time and theirs. I wish artists would learn more about the company before submitting work to me. Our art needs are increasing. We need artists who are flexible and willing to meet deadlines."

***PRATT & AUSTIN COMPANY, INC.**, 642 S. Summer St., Holyoke MA 01040. (413)532-1491. FAX: (413)536-2741. President: Bruce Pratt. Estab. 1931. Produces greeting cards, stationery and calendars. "Our market is the modern woman at all ages. Design must be pretty, cuddly and elicit a positive response."
Needs: Approached by 50+ freelance artists/year. Works with 20 freelance artists/year. Buys 100-150 freelance designs and illustrations/year. Uses freelance artists mainly for concept and finished art. Also uses freelance artists for calligraphy. Produces material for Christmas, birthdays, everyday, Mother's Day. Submit 12 months before holiday.
First Contact & Terms: Send query letter with tearsheets, slides and transparencies. Samples are filed or are returned by SASE if requested. Reports back within 3 weeks. To show a portfolio, mail thumbnails, roughs, color tearsheets and slides. Rights purchased vary according to project. Original artwork is returned at job's completion. Pays by the hour, $20; by the project, $200; or offers royalties of 1-5%.

THE PRINTERY HOUSE OF CONCEPTION ABBEY, Conception MO 64433. Art Director: Rev. Norbert Schappler. Estab. 1950. A publisher of religious greeting cards; religious Christmas and all-occasion themes for people interested in religious yet contemporary expressions of faith. "Our card designs are meant to touch the heart and feature strong graphics, calligraphy and other appropriate styles."
Needs: Approached by 75 freelance artists/year. Works with 25 freelance artists/year. Uses artists for product illustration. Prefers acrylic, pastel, cut paper, silk screen, oil, watercolor, line drawings; classical and contemporary calligraphy. Prefers contemporary and dignified styles and solid religious themes. Produces seasonal material for Christmas and Easter. Strongly prefers calligraphy to type style.
First Contact & Terms: Send query letter with brochure showing art style or resume, tearshects, photostats, photocopies, slides and photographs. Samples returned by SASE. Reports within 3 weeks. To show a portfolio, mail appropriate materials only after query has been answered. Portfolio should include final reproduction/product and color tearsheets and photographs. "In general, we continue to work with artists year after year once we have begun to accept work from them." Pays flat fee of $150-300 for illustration/design. Usually purchases exclusive reproduction rights for a specified format; occasionally buys complete reproduction rights.
Tips: "Abstract or semi-abstract background designs seem to fit best with religious texts. Color washes and stylized designs are often appropriate. Computerized graphics are beginning to have an impact in our field; multi-colored calligraphy is a new development. Remember our specific purpose of publishing greeting cards with a definite Christian/religious dimension but not piously religious i.e. wedded with religious dimension; it must be good quality artwork. We sell mostly via catalogs so artwork has to reduce well for catalog." Sees trend towards "more personalization and concern for texts."

***PRODUCT CENTRE-S.W. INC./THE TEXAS POSTCARD CO.**, Box 860708, Plano TX 75086. (214)423-0411. Art Director: Susan Hudson. Produces greeting cards, posters, melamine trays, coasters and postcards. Themes range from nostalgia to art deco to pop/rock for contemporary buyers.
Needs: Buys 100 designs from freelance artists/year. Uses artists for P-O-P display, paste-up and mechanicals. Considers any media; "we do use a lot of acrylic/airbrush designs." Prefers contemporary styles. Final art must not be larger than 8×10. "Certain products require specific measurements; we will provide these when assigned."
First Contact & Terms: Send resume, business card slides, photostats, photographs, photocopies and tearsheets to be kept on file. Samples not filed are returned only by request with SASE including return insurance. Reports within 4 months. No originals returned to artist at job's completion. Call or write for appointment to show portfolio. Pays by the project, $50-100. Buys all rights.
Tips: "Artist should be able to submit camera-ready work and understand printer's requirements. The majority of our designs are assigned. We do not want to see crafty items or calligraphy."

PRODUCT CONCEPT, INC, 3334 Adobe Court, Colorado Springs CO 80907. (719)632-1089. Creative Director: Cliff Sanderson. President: Susan Ross. Estab. 1986. New product development agency. "We work with a variety of companies in the gift and greeting card market in providing design, new-product development and manufacturing services."
Needs: Works with 20-25 freelance artists/year. Buys 400 designs and illustrations/year from freelance artists. Prefers artists with 3-5 years of experience in gift and greeting card design. Works on assignment only. Buys freelance designs and illustrations mainly for new product programs. Also uses freelance artists for calligraphy, P-O-P display and paste-up. Considers all media. Produces material for all holidays and seasons.
First Contact & Terms: Send query letter with resume, tearsheets, photostats, photocopies, slides and SASE. Samples are filed or are returned by SASE only if requested by artist. Reports back within 7 days. To show a portfolio, mail color and b&w roughs, original/final art, final reproduction/product, slides, tearsheets, photostats and photographs. Original artwork is not returned after job's completion. Pays by the project, $250-2,000. Buys all rights.
Tips: "Be on time with assignments." Sees trend toward "rich colors and Victorian influence."

RECYCLED PAPER PRODUCTS INC., 3636 N. Broadway, Chicago IL 60613. Art Director: Melinda Gordon. Publishes greeting cards, postcards, adhesive notes, buttons and mugs. Artist's guidelines available.
Needs: Buys 1,000-2,000 and up designs and illustrations/year from freelance artists. Considers b&w line and color—"no real restrictions." Looking for "great ideas done in your own style with messages that reflect your own slant on the world." Prefers 5 × 7 vertical format for cards, 10 × 14 maximum. "Our primary concern is greeting cards." Produces seasonal material for all major and minor holidays including Jewish holidays. Submit seasonal material 18 months in advance; everyday cards are reviewed throughout the year.
First Contact & Terms: Send SASE for artist's guidelines. "I don't want slides or tearsheets—I am only interested in work done for greeting cards." Reports in 2 months. Original work usually not returned at job's completion, but "negotiable." Buys all rights. Average flat fee is $250 for illustration/design with copy. Some royalty contracts.
Tips: "Remember that a greeting card is primarily a message sent from one person to another. The art must catch the customer's attention, and the words must deliver what the front promises. We are looking for unique points of view and manners of expression whether the themes are traditional or very contemporary. Our artists must be able to work with a minimum of direction and meet deadlines. There is a renewed interest in the use of recycled paper—we have been the industry leader in this for 20 years."

RED FARM STUDIO, 334 Pleasant St., Box 347, Pawtucket RI 02862. (401)728-9300. Executive Vice President: Steven P. Scott. Chairman of the Board: J. Parker Scott. Produces greeting cards, giftwrap, coloring books, paper dolls, story-coloring books, Christmas cards, gift enclosures, notes, invitations and paintables. Specializing in nautical and traditional themes and fine watercolors. Art guidelines available upon request if SASE is provided.
Needs: Buys approximately 200 designs and illustrations/year from freelance artists. Prefers watercolor. Submit Christmas artwork 1 year in advance.
First Contact & Terms: Send query letter with printed pieces, photographs or original art. Call for appointment to show portfolio, which should include "good examples, either printed or originals of finished product. Do not send sketches. Important—always include an SASE." Samples not filed are returned by SASE. Reports within 2 weeks. Original artwork not returned after reproduction. Pays for illustration by the project, $175-300. Buys all rights. Finds most artists through references/word-of-mouth, samples received through the mail and portfolio reviews.
Tips: "We are interested in realistic, fine art watercolors of traditional subjects like nautical scenes, flowers, birds, shells and landscapes. We do not reproduce photography."

REGENCY & CENTURY GREETINGS, 1500 W. Monroe St., Chicago IL 60607. (312)666-8686. Art Director: David Cuthbertson. Estab. 1921. Publishes Christmas cards; traditional and some religious.
Needs: Approached by 300 freelance artists/year. Buys 200 illustrations and designs/year from freelance artists. Prefers pen & ink, airbrush, watercolor, acrylic, oil, collage and calligraphy. Prefers traditional themes.
First Contact & Terms: Send query letter with samples. Submit seasonal art 8 months in advance. Reports in 6 weeks. Previously published work OK. Buys exclusive Christmas card reproduction rights. Originals can be returned to artist at job's completion. Pays $150 minimum, b&w; $200, color design. Pays on acceptance. Finds most artists through references/word-of mouth and samples received through the mail and galleries.
Tips: "Artist should visit stationery shops for ideas and request artist's guidelines to become familiar with the products. Portfolio should include published samples." Does not want to see college projects. "Traditional still sells best in more expensive lines but will review contemporary designs for new lines. Present a wide range of styles."

RENAISSANCE GREETING CARDS, Box 845, Springvale ME 04083. (207)324-4153. FAX: (207)324-9564. Art Director: Janice Keefe. Estab. 1977. Publishes greeting cards; "current approaches" to all-occasion cards, seasonal cards, Christmas cards including nostalgic themes. "Alternative card company with unique variety of cards of all captions for all ages."
Needs: Approached by 400-500 freelance artists/year. Buys 250 illustrations/year from freelance artists. Full-color illustrations only. Produces everyday occasions—birthday, get well, friendship, etc., and seasonal material for Christmas, Valentine's Day, Mother's Day, Father's Day, Easter, graduation, St. Patrick's Day, Halloween, Thanksgiving, Passover, Jewish New Year and Hanukkah; submit art 18 months in advance for

The asterisk before a listing indicates that the listing is new in this edition. New markets are often the most receptive to freelance submissions.

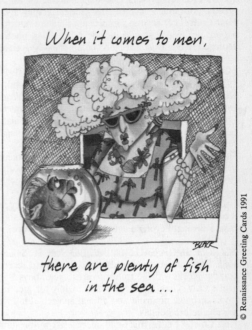

When it comes to men,

there are plenty of fish
in the sea ...

© Renaissance Greeting Cards 1991

"But unfortunately, you have to throw most of them back," reads the inside of this card illustrated by Jennifer Black Reinhardt. "This design was one of a series we did with her after finding that her work sold well in our card line," art director of Renaissance Greeting Cards, Janice Keefe, says. "We love the bright colors and brazen characters." Black Reinhardt was paid $150 against royalties for the card. Keefe says it's successful because "the image is well-suited to the copy, supports the concept and is a lighthearted approach to a common dilemma!"

fall and Christmas material; approximately 1 year for other holidays. "Currently interested in humorous concepts and illustration."

First Contact & Terms: To request artists' guidelines, include SASE. To show a portfolio, mail original/final art, color tearsheets, slides or transparencies. Packaging with sufficient postage to return materials should be included in the submission. Reports in 2 months. Originals returned to artist at job's completion. Pays for design by the project, $125-300 advance on royalties or flat fee, negotiable.

Tips: "Indicate if the work sent is available or only samples. In traditional themes, Victorian, fine art and classical styles are strong as ever; in contemporary—bright colors, textures. We're printing a much larger percentage of our cards on recycled paper and doing more nature/conservation oriented designs."

***REPRODUCTA CO. INC.,** 11 E. 26th St., New York NY 10010. Creative Director: Ira Kramer. Estab. 1948. Publishes stationery, postcards and greeting cards; religious and general.

Needs: Buys 1,000 freelance designs/year. Needs artwork for all occasions—religious, floral, wildlife and "cutesy."

First Contact & Terms: To show a portfolio, mail art and SASE. Looking for seasonal, Christmas, Mother's Day, Easter and Father's Day themes. No originals returned to artist at job's completion. Request artist's guidelines. Buys all rights. Pays $150-500; payment negotiated.

Tips: Common mistakes freelancers make in presenting portfolios include "showing weakest points, not investigating wants of prospective clients and showing work that doesn't apply. Show us greeting card art, not advertising."

***ROHNART INC.,** 20 Van Dam St., New York NY 10013. (212)255-7421 or (800)777-1235. FAX: (212)645-6009. Creative Director: Maria Desimone. Produces greeting cards. "We produce hot stamped and embossed high-quality graphic greeting cards."

Needs: Prefers artists with experience in graphic design. Works on assignment only. Uses freelance artists for calligraphy. No photography—needs graphic mediums. Prefers bold, clean designs. Prefers 5×7″ final art. Produces material for all holidays and seasons. Submit 12 months before holiday.

First Contact & Terms: Send query letter with tearsheets, photostats, SASE, photocopies and slides. Samples are filed or are returned by SASE if requested. Reports back within 4-6 weeks. Call to schedule an appointment to show a portfolio, which should include thumbnails, roughs, photostats, tearsheets, photographs, slides and dummies. Negotiates rights purchased. Originals are not returned. Pays royalties.

SCANDECOR INC., 430 Pike Rd., Southampton PA 18966. (215)355-2410. Creative Director: Lauren B. Harris. Produces posters, calendars and greeting cards.
Needs: Also uses freelance artists for calligraphy, P-O-P displays and mechanicals.
First Contact & Terms: Samples not filed are returned. Call or write to schedule an appointment to show a portfolio, which should include color slides, photostats and photographs. Original artwork sometimes returned to the artist after job's completion. Negotiates rights purchased.

SCOTT CARDS INC., Box 906, Newbury Park CA 91319. (818)998-8617. President: Larry Templeman Estab. 1985. Produces greeting cards for contemporary adults of all ages.
Needs: Approached by 100 freelance artists/year. Works with 15 freelance artists/year. Buys 75 designs from freelance artists/year. "We will double that amount this year if submissions warrant." Prefers pen & ink. Looking for "hard-edged cartoons appealing to sophisticated adults. We like humorous, sensitive and romantic messages aimed at modern adult relationships: single, married, friends, work, etc. No ryhmed verse." No seasonal material.
First Contact & Terms: Send query letter with brochure or photocopies. Samples are filed or are returned by SASE. Reports back within 3 months. To show a portfolio, mail photocopies only, no original artwork. Pays average flat fee of $50, design/illustration or royalties of 5% "after first 10 designs purchased." Buys all rights.
Tips: "New ways to say 'I love you' always sell if they aren't corny or too obvious. Humor helps, especially if it twists. We are looking for nontraditional sentiments that are sensitive, timely and sophisticated. Our cards have a distinct flavor, so before submitting your work, write for our guidelines and samples brochure."

***CAROLE SMITH GALLERY, INC.**, 363 State St., Salem OR 97301. (503)362-9185. Contact: Jennifer. Estab. 1981. Produces greeting cards. Specializes in art reproduction cards.
Needs: Works with 3-5 freelance artists/year. Buys 3-5 freelance designs and illustrations/year. Prefers local artists only. Uses freelance artists mainly for greeting cards. Considers watercolor and oil. Looking for tropical, impressionistic and animal subjects. Produces material for Christmas and everyday. Submit 12 months before holiday.
First Contact & Terms: Send query letter with resume and slides. Samples are not filed and are returned by SASE if requested. Reports back within 3 months. Do not contact for portfolio review. Negotiates rights purchased. Originals are returned at job's completion. Pays flat fee.

***STATUS PAPER PRODUCTS, INC.**, 2922 Scott Blvd., Santa Clara CA 95054. (800)346-7373. FAX: (408)727-5158. Contact: Alice Schwinn. Estab. 1987. Produces greeting cards, stationery, giftwrap and posters. Uses styles which target many age groups, from children to seniors.
Needs: "At this time we have 2 freelance artists under contract—however we need to expand our variety through new portfolios." Buys 30 freelance designs and illustrations/year. Uses freelance artists for greeting cards. "We pride ourselves in the fact that we offer many varieties of looks that change often." Produces material for Christmas, Valentine's Day and New Year. Submit 8-12 months before holiday.
First Contact & Terms: Send query letter with photocopies. Samples are filed. Reports back only if interested. Call to schedule an appointment to show a portfolio, which should include original/final art, slides and photographs. Negotiates rights purchased. Originals are returned at job's completion. Negotiable royalties.

***STRAIGHT STATUS, INC.**, 426 New York Ave., New Castle IN 47362. (317)521-4040. FAX: (317)521-3509. Catalog Production Manager: Julie Higinbotham. Estab. 1981. Produces greeting cards, bookmarkers, stickers, sportswear and mugs. "Straight Status is marketing several lines of profession-specific promotional products with a whimsical, yet professional focus. Our products are purchased by orthodontists, dentists and eye care professionals who want to promote their practices in a fun way."
Needs: Prefers artists with experience in greeting cards, sportswear and/or product development. Works on assignment only. Considers all media. Style and size of acceptable art depends on the project. Produces material for Halloween, Christmas, Easter, birthdays, Valentine's Day, Thanksgiving and everyday. Submit seasonal material 10 months in advance.
First Contact & Terms: Send query letter with resume and photocopies. Samples are returned. Reports back within 3-4 weeks. To show a portfolio, mail thumbnails and roughs and b&w and color tearsheets and photographs. Original artwork is not returned at job's completion. Pays by the project, $50-150. Buys all rights.

STUART HALL CO., INC., Box 419381, Kansas City MO 64141. Vice President of Advertising and Art: Judy Riedel. Produces stationery, school supplies and office supplies.
Needs: Approached by 30 freelance artists/year. Buys 40 designs and illustrations from freelance artists/year. Artist must be experienced—no beginners. Works on assignment only. Uses freelance artists for design, illustration, calligraphy on stationery, notes and tablets, and paste-up and mechanicals. Considers pencil sketches, rough color, layouts, tight comps or finished art; watercolor, gouache, or acrylic paints are preferred for finished art. Avoid fluorescent colors. "All art should be prepared on heavy white paper and lightly

attached to illustration board. Allow at least one inch all around the design for notations and crop marks. Avoid bleeding the design. In designing sheet stock, keep the design small enough to allow for letter writing space. If designing for an envelope, first consult us to avoid technical problems."
First Contact & Terms: Send query letter with resume, tearsheets, photostats, slides and photographs. Samples not filed returned by SASE. Reports only if interested. To show a portfolio, mail roughs, original/final art, final reproduction/product, color, tearsheets, photostats and photographs. No originals returned to artist at job completion. "Stuart Hall may choose to negotiate on price but generally accepts the artist's price." Buys all rights.

***SUNRISE PUBLICATIONS INC.**, Box 4699, Bloomington IN 47402. (812)336-9900. FAX: (812)336-8712. Administrative Assistant, Creative Services Dept.: Kim Patton. Estab. 1974. Produces greeting cards and posters.
Needs: Approached by approximately 300 freelance artists/year. Works with approximately 200 freelance artists/year. Buys 400 freelance designs and illustrations/year. Uses freelance artists mainly for greeting card illustration. Also uses freelance artists for calligraphy. Considers any medium. Looking for "highly detailed, highly rendered illustration, but will consider a range of styles." Produces material for Christmas, Valentine's Day, Mother's Day, Father's Day, Easter, Hanukkah, graduation, Thanksgiving, New Year, Halloween, birthdays, everyday and St. Patrick's Day. Reviews seasonal material year-round.
First Contact & Terms: Send query letter with SASE, tearsheets, photographs, photocopies, photostats, slides and/or transparencies. Samples are not filed and are returned by SASE. Reports back within 2 weeks for queries regarding status; submissions returned within 3 months. To show a portfolio, mail appropriate materials. Portfolio should include color tearsheets, photographs and/or slides. Negotiates rights purchased. Original artwork is returned at the job's completion. Pays $350 flat fee, minimum.

SUNSHINE ART STUDIOS, INC., 45 Warwick St., Springfield MA 01102. (413)781-5500. Assistant Art Director: Midge Stark. Estab. 1921. Produces greeting cards, stationery, calendars and giftwrap which are sold in own catalog, appealing to all age groups.
Needs: Approached by 100 freelance artists/year. Works with 100-125 freelance artists/year. Buys 100-125 designs and illustrations/year from freelance artists. Prefers artists with experience in greeting cards. Works on assignment only. Uses freelance artists mainly for greeting cards, giftwrap and stationery. Also uses freelance artists for calligraphy. Considers gouache, watercolor and acrylic. Looking for "cute animals, florals and traditional motifs." Prefers art 4½ × 6½ or 5 × 7. Produces material for Christmas, Easter, birthdays and everyday. Submit 6-8 months before holiday.
First Contact & Terms: Send query letter with brochure, resume, SASE, tearsheets and slides. Samples are filed or are returned by SASE if requested by artist. Reports back to the artist only if interested. Portfolio should include original/final art and color tearsheets and slides. Buys all rights. Original artwork is not returned at the job's completion. Pays by the project, $250-400.

***SUPER-CALLI-GRAPHICS**, 425 E. Hyde Park, Inglewood CA 90302. (213)677-4171. FAX: (213)390-4753. Owner: Marcia Miller. Estab. 1978. Produces "stationery and trendy desk accessories and gifts for children and teenagers."
Needs: Works with 12 freelance artists/year. Buys 100 freelance designs and illustrations/year. Prefers local artists only. Works on assignment only. Uses freelance artists mainly for design and paste-up. Also uses freelance artists for mechanicals. Looking for "colorful, modern, trendy artwork." Produces material for Christmas, Valentine's Day, Easter and Halloween. Submit 1 year before holiday.
First Contact & Terms: Send query letter with photocopies. Samples are filed and not returned. Reports back to the artist only if interested. Mail appropriate materials. Portfolio should include color samples. Buys all rights. Original artwork is not returned at the job's completion. Pays by the hour, $10-25; by the project, $100 minimum.

T.E.E.M., 343 Beinoris Dr., Wood Dale IL 60191. (708)860-0323. FAX: (708)860-0382. Vice President: Margot A. Fraisl. Estab. 1985. Produces ribbon, tags and enclosure cards. Is a Narrow Web Printer-Converter of highly decorative ribbons, seals, tags, enclosure cards, directed towards craft, floral, gift markets; all ages.
Needs: Approached by more than 10 freelance artists/year. Works with 3-4 freelance artists/year. Buys more than 300 designs and illustrations/year from freelance artists. Prefers local artists with some understanding of pre-press artwork. Looks for repeat pattern, such as in textile illustration. Works on assignment basis only. Uses freelance artists mainly for concept designs for seasonal events and collections, particularly for ribbon and gift tags. Also uses freelance artists for illustration. Considers pencil and marker. Looking for all styles, except airbrush. For size, contact at company will give specific directions. Produces material for all holidays and seasons and everyday. Submit 6-12 months before holiday.
First Contact & Terms: Send query letter with resume and SASE. Samples are filed or are returned by SASE if requested by artist. Reports back within 1 month. To show a portfolio, mail roughs, original/final art and b&w and color samples. Rights purchased vary according to project. Original artwork is not returned at job's completion. Pays by the project, $35-75. Payment is based on the complexity of the design.

***THESE THREE, INC.,** 120 E. 9th Ave., Homestead PA 15120. (412)461-5525. Art Coordinator: Peg Harmon. Estab. 1987. Produces greeting cards. Products have two "looks": fine art and light humor (includes cards for children).

Needs: Approached by 100 freelance artists/year. Works with 3-5 freelance artists/year. Buys 30-100 freelance designs and illustrations/year. Uses freelance artists mainly for greeting cards. Considers watercolor, colored pencil and light acrylic. Looking for soft, pastel and bright children's illustration. Prefers size 10×14 final art. Produces material for all holidays and seasons, birthdays and everyday.

First Contact & Terms: Send query letter with brochure, resume, SASE and slides. Samples are filed or returned by SASE. Reports back within 2 months. To show a portfolio, mail appropriate materials. Portfolio should include thumbnails, color photographs and slides. Rights purchased vary according to project. Original artwork is not returned to the artist at the job's completion. Pays royalties.

ARTHUR THOMPSON & COMPANY, 4700 F St., Omaha NE 68117-1482. (402)731-0411. Contact: Jeanie Sturgeon. Publishes greeting cards and letterheads; holiday (Christmas and Thanksgiving) and business-to-business cards.

Needs: Approached by 50 or so freelance artists/year. Uses freelance artists for product illustration and freelance photographers for photos. Accepts art in any media. Prefers clean, corporate-type designs or traditional work. Business-to-business line includes thank you's, congratulations, etc.

First Contact & Terms: Write and send samples if possible. Prefers transparencies or slides. Do not send original art. Reports in 6 weeks. Provide samples and tearsheets to be kept on file for possible future assignments. Negotiates payment. Pays by the project, $200-350. Considers product use and rights purchased when establishing payment. Artist guidelines available upon request.

Tips: "Remember that we are a business-to-business greeting card company. We try to keep our cards oriented toward business themes."

TLC GREETINGS, 615 McCall Rd., Manhattan KS 66502. Creative Director: Michele Johnson. Estab. 1986. Produces greeting cards for women 18-40.

Needs: Works with 9 freelance artists/year. Buys 20 designs from freelance artists/year. Works on assignment only. Open to any media. Prefers cartoon-type characters, humorous illustrations. "Our cards are 5×7; can work with larger size. We use 90% humorous illustration."

First Contact & Terms: Send query letter with brochure, photocopies and SASE. Samples are filed or are returned by SASE. Reports back within 4-6 weeks. To show a portfolio, mail slides, tearsheets and photostats. Pays average flat fee of $100-200 for illustration/design. Negotiates rights purchased.

Tips: "Keep in mind positive, humorous designs. I see a trend away from so much risqué and cutting humor—see more fun, cleaner humor."

TO COIN A PHRASE, 104 Forrest Ave., Narberth PA 19072. (215)664-3130. Owner: Gerri Rothman. Estab. 1975. Produces custom stationery, general cards, informal cards, invitations, contemporary cards and juvenile cards for 30 upwards in age and affluent.

Needs: Uses freelance artists for calligraphy and illustration. Prefers line drawings; sophisticated and cartoonish. Looks for contemporary art that is more abstract in quality.

First Contact & Terms: Send query letter with photocopies or call. Samples not filed are returned only if requested. Reports back only if interested. Call or write to schedule an appointment to show a portfolio. Pays for calligraphy, $10 per hour or by the piece.

Tips: New trends we see in greeting cards are leaning towards "artsy" cards. "Do not want to see italic, Roman or uncial calligraphy."

TRISAR, INC., 121 Old Springs Rd., Anaheim CA 92808. (714)282-2626. FAX: (714)282-1370. Creative Director: Randy Harris. Estab. 1979. Produces greeting cards, buttons, balloons, T-shirts and mugs. "There is a strong emphasis on age-related concepts, i.e. 'over the hill' etc., also on seasonal shirts, mugs, etc."

Needs: Approached by 10 freelance artists/year. Works with 5 freelance artists/year. Buys 6 designs and illustrations/year from freelance artists. Prefers local artists with experience in silk screening, shirts and hats and mug designs. Works on assingment only. Uses freelance artists mainly for specific projects. Considers torn paper, acrylic, graphic design, combination of phrase and art. Produces material for Father's Day, Halloween, Christmas, graduation, birthdays, Valentine's Day, Mother's Day and everyday. Submit 9 months before holiday.

First Contact & Terms: Send query letter with SASE, photographs, photocopies, photostats and slides. Samples are filed or are returned by SASE if requested by artist. Reports back to the artist only if interested. Call to schedule an appointment to show a portfolio, which should include roughs, original/final art and color photographs. Negotiates rights purchased. Original artwork is not returned at the job's completion. Pays by the project, $200-400.

UNIQUE INDUSTRIES, INC., 2400 S. Weccacoe Ave., Philadelphia PA 19148. (215)336-4300. Director of New Products: Martin Moshel. Estab. 1962. Manufacturer. "We produce a complete line of party supplies primarily for the children's market." Products include paper party plates, party napkins, tablecovers, giftwrap, party hats, blowouts, invitations, party games, hanging decorations, etc.
Needs: Approached by 30-50 freelance artists/year. Works with 5-10 freelance artists/year. "We purchase birthday and party graphics for our products. We do not print full-color reflective art. Art must be prepared as 'line art' to be printed in four flat colors (plus screens). Frequently after reviewing an artist's style and capabilities, Unique offers assignments utilizing the artist's specific style or technique. Unique uses freelance artists for design concepts and finished art. *New* designs created for our party supplies must be presented as it would appear on a plate (in a 9⅜″ circle). *Existing* art can be presented in any size or shape."
First Contact & Terms: Send query letter, tearsheets, photostats and/or photographs. Do not send original art. "We report back within 4-6 weeks. To show a portfolio, call to schedule an appointment." Pays $50 minimum for design sketches. Payment for finished art ranges between $75-250 depending on the complexity of the project. Buys all rights. "All art becomes the exclusive property of Unique Industries, Inc., for use on any and all products we market."
Tips: "Visit party goods stores and major chain stores or toy stores (which have large party departments). Artwork submitted to us must be colorful and upbeat. Our catalog is available upon request." Sees trend toward "licensed properties (such as Teenage Mutant Ninja Turtles) dominating the market."

VINTAGE IMAGES, Box 228, Lorton VA 22199. (703)550-1881. Art Director: Brian Smolens. Estab. 1985. Produces greeting cards, games and posters. "We produce social stationery and prints using sophisticated humor."
Needs: Approached by 10 freelance artists/year. Works with 3 freelance artists/year. Buys 36 designs and illustrations/year from freelance artists. Uses freelance artists for whole card lines. Also uses freelance artists for calligraphy and P-O-P displays. Considers "any media that can be accurately reproduced." Looking for sophisticated humor. "We will also consider a bold, elegant personal style." Produces material for Christmas, Valentine's Day and everyday.
First Contact & Terms: Send query letter with brochure, SASE and photographs. Samples are filed or are returned by SASE. Reports back within 2 months. To show a portfolio, mail photostats, photographs and slides. Buys all rights. Original artwork is returned at the job's completion. Pays by the hour, $20-50; by the project, $200-500; royalties of 5%.

ALFRED J. WALKER TOWNHOUSE PRESS, 319 Dartmouth St., Boston MA 02116. (617)262-0188. Vice President: Jim Duffy. Estab. 1978. Produces greeting cards. "We produce fine art greeting cards, notecards and Christmas cards."
Needs: Approached by 15-20 freelance artists/year. Works with 6-8 freelance artists/year. Buys 10-20 designs and illustrations/year. "We are presently looking for Christmas images." Uses freelance artists mainly for reproducing fine art as note cards and greeting cards, sometimes illustrations. Considers oil, acrylic, watercolor and pastel. Produces material for Christmas. Submit 1 year before holiday.
First Contact & Terms: Send query letter with SASE, tearsheets, photographs, photocopies, slides and transparencies. Samples are filed and returned by SASE if requested by artist. Reports back within 60 days. Call to schedule an appointment to show a portfolio, which should include original/final art, photographs and slides. Negotiates rights purchased. Original artwork is returned at job's completion. Pays royalties of 5%. "There is initial payment of $150, then royalties."

WEST GRAPHICS, 238 Capp St., San Francisco CA 94110. (415)621-4641. FAX: (415)621-8613. Art Director: Tom Drew. Estab. 1979. Produces greeting cards, calendars, satirical books and gift bags. "We publish greeting cards of a humorous and satirical nature targeting women between the ages of 30-40."
Needs: Approached by 100 freelance artists/year. Works with 40 freelance artists/year. Buys 150 designs and illustrations/year from freelance artists. Uses freelance artists mainly for illustration. "All other work is done in-house." Considers all media. Looking for outrageous contemporary illustration; images that are on the cutting edge. Prefers art proportionate to finished size of 5×7, no larger than 10×14. Produces material for Father's Day, Halloween, Christmas, Easter, graduation, birthdays, Valentine's Day, Hanukkah, Thanksgiving, Mother's Day, New Year and everyday. Submit 1 year before holiday.
First Contact & Terms: Send query letter with resume, SASE, tearsheets, photocopies, photostats, slides and transparencies. Samples should relate to greeting card market. Samples are filed or are returned by SASE if requested by artist. Reports back within 6 weeks. To show a portfolio, mail thumbnails, roughs, color photostats, tearsheets, photographs, slides, dummies and samples of printed work if available. Rights purchased vary according to project. Pays average flat fee of $200 for illustration/design; offers royalties of 5%.
Tips: "Art and concepts should be developed with an occasion in mind such as birthday, belated birthday etc. Humor sells the best. We will review published samples and roughs. Your target should be issues that women care about: relationships, safe sex, religion, aging, success, money, crime, health, weight, etc. Alternative greeting cards are on the increase." Also there is a "younger market and more cerebral humor."

***WIDGET FACTORY CARDS**, Damonmill Square, Concord MA 01742. (508)371-9866. Contact: Suzy Becker. Estab. 1987. Produces "whimsical everyday and occasion greeting cards for people 25+ who like to read."
Needs: Approached by 20 freelance artists/year. Works with 1 freelance artist/year. Buys 1 freelance design and illustration/year. Interested in colorful, whimsical art, which would be for a new line (not just 1-2 cards). Uses freelance artists mainly for design of support materials. Also uses freelance artists for P-O-P displays, paste-up, mechanicals and catalogs. Considers all media. Looking for folk art, not larger than 8½×11″. Produces material for Father's Day, Halloween, Christmas, Easter, graduation, birthdays, Valentine's Day, Hanukkah, everyday, Mother's Day and Earth Day.
First Contact & Terms: Send query letter with SASE and photocopies and 3 sample cards—1 birthday, 1 winter holiday of choice; written copy not necessary, but concept of copy required. Samples are not filed and are returned by SASE. Reports back within 1 month. To show a portfolio, mail original/final art, dummies and 3 sample cards. Rights purchased vary according to project. Originals are returned at job's completion. Pays royalties of 5%.

***WILD CARD®**, Box 3960, Berkeley CA 94703-0960. Art Director: Leal Charonnat. Estab. 1985. Publishes greeting cards and stationery, with current, avant-garde themes for 20-40 year olds—"young, upwardly mobile urbanites." Many designs die-cut. Specializes in animals (graphic), cats, zoo, dinosaurs, etc.
Needs: Looking for imaginative die-cut designs that fit the basic greeting card market themes (birthday, Christmas, Valentine's, friendship, etc.); must be very graphic as opposed to illustrated. Specializes in die-cut 3-D cards.
First Contact & Terms: Please "submit after receiving our guidelines. Cannot review submittals that have not received our guidelines." Send submittal pack and brochure/flyer or resume to be kept on file. All materials 8½×11 only. Prefers brochure of work with nonreturnable pen & ink photostats or photocopies as samples; do not send original work. "If your project is accepted, we will contact you. But we cannot always promise to contact everyone who submits." Pays for design by the project or royalties, $75-250; flat fee of $75-250/illustration. Also pays royalties for card line ideas. "We will have all publishing rights for any work published. Artist may retain ownership of copyright." Pays on publication.
Tips: "Present only commercially potential examples of your work. Prefer to see only die-cut ideas. *Do not* present work that is not of a professional nature or what one would expect to see published. Know what is already in the market and have a feeling for the subjects the market is interested in. Go out and look at *many* card stores before submitting. Ask the owner or buyer to 'review' your work prior to submitting."

WILLIAMHOUSE-REGENCY, INC., 28 West 23rd St., New York NY 10010. Executive Art Director: Nancy Boecker. Estab. 1955. Produces Christmas cards, stationery, invitations and announcements.
Needs: Approached by 20 freelance artists/year. Works with 5 freelance artists/year. Buys 20 designs and illustrations/year. "Prefers artists with experience in our products and techniques (including foil and embossing)." Buys freelance designs and illustrations mainly for Christmas cards and wedding invitations. Also uses freelance artists for calligraphy. Considers all media. "In wedding invitations, we seek a non-greeting card look. Have a look at what is out there." Produces material for personalized Christmas, Rosh Hashanah, New Year, wedding invitations and birth announcements. Submit seasonal material 12 months before holiday.
First Contact & Terms: Send query letter with SASE. Samples are not filed and are returned by SASE. Reports back within 3 weeks. Call or write to schedule an appointment to show a portfolio or mail roughs and dummies. Pays average flat fee of $150/design. Buys reprint rights or all rights.
Tips: "Send in any roughs or copies of finished ideas you have, and we'll take a look. Write for specs on size first with SASE or write to show portfolio." Sees trend toward "old-fashioned looks."

CAROL WILSON FINE ARTS, INC., Box 17394, Portland OR 97217. (503)283-2338 or 281-0780. Contact: Gary Spector. Estab. 1983. Produces greeting cards, postcards, posters and stationery that range from contemporary to nostalgic. "At the present time we are actively looking for unusual humor to expand our contemporary humor line. We want cards that will make people laugh out loud! Another category we also wish to expand is fine arts."
Needs: Approached by hundreds of freelance artists/year. Uses artists for product design and illustration of greeting cards and postcards. Considers all media. Prefers humorous cartoons and fine art. Produces seasonal material for Christmas, Valentine's Day and Mother's Day; submit art preferably 1 year in advance.
First Contact & Terms: Send query letter with resume, business card, tearsheets, photostats, photocopies, slides and photographs to be kept on file. No original artwork on initial inquiry. Write for an appointment to show portfolio or for artists' guidelines. "All approaches are considered but, if possible, we prefer to see ideas that are applicable to specific occasions, such as birthday, anniversary, wedding, new baby, etc. We look for artists with creativity and ability." Samples not filed are returned by SASE. Reports within 2 months. Negotiates return of original art after reproduction. Payment ranges from flat fee to royalties. Buys all rights.
Tips: "We have noticed an increased emphasis on humorous cards for specific occasions, specifically feminist and 'off-the-wall' humor. We are also seeing an increased interest in romantic fine-arts cards and very elegant cards featuring foil, embossing and die-cuts."

XSEND-TRIX CARDS, Box 470307, Fort Worth TX 76147. (817)737-9912. Contact: Pam Pace. Estab. 1986. Produces stationery and greeting cards for all occasions for ages 25-60.

Needs: Approached by 50 freelance artists/year. "We will work with unpublished artists and writers. We are always looking for new and different line ideas, artwork and writers." Uses freelance artists mainly for "artwork and greetings; both individual card ideas and *line* ideas." Considers "two-dimensional works only: watercolor, tempera, marker, anything! We are looking for a bright, contemporary feeling paired with brief greetings." Prefers art no larger than 11×14; not smaller than 5×5. Produces material for everyday and blank cards and stationery. Submit 1 year before holiday.

First Contact & Terms: Send query letter with resume, SASE, tearsheets and slides or mock-ups. Samples are filed if interested or returned by SASE. Reports back within 2 months. Rights purchased vary according to project. Pays royalties of 4-8% or flat rate.

Tips: The market for alternative card lines is getting tougher due to rack/buy-back programs of the 'big boys'. Small alternative lines must maintain quality and a unique look to compete. We like to buy groups of art from the same artist, which are then featured with his/her own credit line. Also, line ideas must be well roughed out."

Other Greeting Card Companies

Each year we contact all companies currently listed in *Artist's Market* requesting they give us updated information for our next edition. We also mail listing questionnaires to new and established companies which have not been included in past editions. The following greeting card and paper product companies did not respond to our request to update their listings for 1992 (if they indicated a reason, it is noted in parentheses after their name).

Albion Cards
Argus Communications, Inc.
Brilliant Enterprises
Collector's Gallery (asked to be deleted)
Dalee Book Co. (late response)
The Fiori Collection
Fraressi-Lamont Inc. (late response)
The Gift Wrap Company (late response)
The Great Northwestern Greeting Card Company
Hallmark Cards, Inc.
Harvard Fair Corporation
Lasercraft
Maine-Line Company (asked to

be deleted)
The Michigan Stationery Co.
Mimi et Cie
New Boundary Designs, Inc. (late response)
The Next Trend (unable to contact)
North East Marketing System (NEMS)
Open End Studios (overstocked)
Out of the West (late response)
Pacific Paper Greetings (late response)
Paper Peddler, Inc.
Pawprints Greeting Cards (unable to contact)

Peachtree Communications, Inc.
Pioneer Balloon Company (asked to be deleted)
Reedproductions (late response)
Son Mark, Inc.
Texan House, Inc.
U.S. Pizazz, Inc. (no longer uses freelancers)
Vagabond Creations Inc. (late response)
Wanda Wallace Associates (late response)
Western Greeting, Inc.
Wizworks

Market conditions are constantly changing! If you're still using this book and it is 1993 or later, buy the newest edition of Artist's Market *at your favorite bookstore or order directly from Writer's Digest Books.*

Magazines

According to James Brady, columnist for *Adweek* magazine, the industry is in the "worst magazine recession in recent history." Circulation has dropped off; postage costs have increased 40 percent in the last three years; production costs have gone up; and advertising is way down. Several magazines have ceased publication, and many of those still in business have become almost desperate in their appeal to advertisers, which often creates a Catch-22 situation—the more magazines try to turn on advertisers, the more they turn them off. So willing have many become to transform themselves from unique entities supported by ads into marketing tools in the service of advertisers, that advertisers are oftentimes unable to detect the individual indentity and readership of a publication. At the last American Magazine Conference, Paul Keye, chairman of Keye/Donna/Pearlstein said, "I think we [the advertisers] sometimes have a greater respect for your readers and your editorial than you [the publishers] do."

The industry's hard times are due in part, according to *The New York Times* advertising reporter Randall Rothenberg, to what happened in the 80s—when enlarged magazine profits encouraged publishers to launch a number of new titles. Now these titles are forced to compete with each other for a limited supply of advertising revenue.

On the bright side, some say the need on the part of advertisers to take a hard look at a magazine's vitality—its editorial and circulation—will spur editors and publishers to do the same, to focus again on the singularity of the magazine's content and readership.

Others say that, conscious of the visual orientation of the TV-viewing reader, editors and publishers are placing a great deal of the burden on the art director to give a magazine a facelift when it begins to fail. Hence, you may have noticed the way a magazine with which you are familiar has a look which is frequently being modified.

Still, flipping through the design annuals, one sees that magazines continue to be in design's vanguard. Many in the industry say the "yuppie clutter" and typographic frenzy of the 80s are being replaced by a new concern for simplicity, a return to the design of the 60s, a return to functionalism.

Also notable is the way technology continues to alter the industry. In a recent *Print* article, Ellen Lupton writes, "The computer is changing the institution of magazine publishing—its cost (cheaper), its bureaucracy (smaller), its subject matter (more specialized), its market (more focused)."

So before approaching any of the listed magazines, be sure to do your research. Stay abreast of how magazine design and illustration are evolving generally and more specifically, what the current style is for the particular magazine you wish to submit to. Go to the newsstand or library to familiarize yourself with the publications out there. If you can't find a magazine listed in *Artist's Market*, ask to be sent a sample copy. If you mistarget—send cartoons depicting housekeeping routines to a sophisticated women's career publication, for example, you'll most likely end up with little more than a rejection and a consequent blow to the ego.

Keep in mind that consumer magazines, in the broadest sense of the term, appeal to the public at-large. But these are often broken down into less generic categories such as women's, product information and news magazines. Illustrations here are commonly used as teasers to draw readers into an article, to supplement the editorial message or, in chil-

dren's magazines especially, for narrative clarity. Trade or business publications focus on an audience involved in a particular profession, and their busy readers require attention-grabbing, graphic images which convey an instant message; airbrush illustration, as well as conventional pen and ink and pencil, tend to be popular media. In addition, approximately 8,000 house organs or company magazines serve businesses throughout the country, heralding employee activities, company achievements and industry news. Finally, special interest magazines appeal to individualized groups. Literary publications are ideal for experimental abstract and lithographic work, while travel magazines have created a growing market for artwork with leisure and recreational themes.

Before submitting any samples, carefully read the guidelines for each magazine listed here. Some publications have special submission requirements. It is, however, fairly standard practice to mail nonreturnable samples along with a brief cover letter of introduction and a resume. Always include a self-addressed, stamped envelope large enough to accommodate your samples, but indicate that the director is welcome to keep samples on file.

Persistence pays off in this field if your work is good, your attitude professional and your target market appropriate. Several weeks after your initial submission, mail another sample package accompanied by a "reminder" letter, another copy of your resume and a SASE. Regardless of the response you receive, follow-up again in a few months to remind the art director that you are still interested in the publication and are available for assignments. Art directors and editors often offer tips if they think your work is promising, and making changes based upon these suggestions can sometimes result in sales as well as helpful tips for future ventures. Remember, however, to check the magazine's masthead before resubmitting any material. A staff change, especially in a top editing or art directing position, can mean that you are dealing with a whole new ballgame.

Payment for cartoons and illustrations varies and is determined by the assignment, your skill, experience, rights purchased and the magazine's budget. Widely circulated publications usually boast large pay scales, but small, fledgling magazines, even nonpaying ones, should not be discounted if you are starting out. These publications, which tend to be more open to experimentation, can also provide a valuable testing ground for your potential in the market.

To supplement the listings in this section, look for the following resources in your library: the *Standard Periodical Directory*, the *Internal Publications Directory*, *The Gebbie Press All-in-One Directory* and *Standard Rate and Data Service. Folio, Print, HOW, Communication Arts, Magazine Design and Production* and *MagazineWeek* are good sources for industry updates. Cartoonists can consult *Gag Recap* for trends; Writer's Digest Books publishes a market book just for cartoonists, *Humor and Cartoon Markets*.

ABORIGINAL SF, Box 2449, Woburn MA 01888-0849. Editor: Charles C. Ryan. Estab. 1986. Science fiction magazine for adult science fiction readers. 4-color. Bimonthly. Circ. 30,000. Sample copy $3.50; art guidelines for SASE with 1 first-class stamp.
Cartoons: Buys 2-8 cartoons/year from freelancers. Prefers science fiction, science and space themes. Prefers single panel or double panel with or without gagline, b&w line drawings, b&w washes and color washes. Send finished cartoons. Samples are filed or are returned by SASE. Reports back within 2 months. Buys first rights and nonexclusive reprint rights. Pays $20, b&w; $20, color.
Illustrations: Works with 10-15 illustrators/year. Buys 8-16 illustrations/issue from freelancers. Works on assignment only. Prefers science fiction, science and space themes. "Generally, we prefer art with a realistic edge, but surrealistic art will be considered." Prefers watercolor, acrylic, oil and pastel. Send query letter with photocopies and slides. Samples not kept on file are returned by SASE. Reports back within 2 months. To show a portfolio, mail photocopied samples and/or color slides. Buys first rights and nonexclusive reprint rights. Pays $300 color cover; $250 color inside; on publication.
Tips: "Show samples of color art showing a range of ability. The most common mistake freelancers make is failure to include a SASE."

ABYSS, Box 140333, Austin TX 78714. Editor: David F. Nalle. Estab. 1979. Full-sized magazine emphasizing fantasy and adventure games for adult game players with sophisticated and varied interests. B&w bimonthly. Circ. 1,800. Does not accept previously published material. Returns original artwork after publication. Sample copy for $3. Art guidelines free for SASE with first-class postage.

Cartoons: Approached by 25 cartoonists/year. Buys 8-10 cartoons/year from freelancers. Prefers humorous, game or fantasy-oriented themes. Prefers single, double or multiple panel with or without gagline and b&w line drawings. Send query letter with roughs. Write for appointment to show portfolio. Material not filed is returned by SASE. Reports in 6 weeks. Buys first rights. Pays $2-5, b&w; on publication.

Illustrations: Approached by 100 illustrators/year. Works with 3-5 illustrators/year. Buys 50-70 illustrations/year from freelancers. Need editoral and fantasy in style of H.J. Ford and John D. Batten. Uses freelance artists mainly for covers and spots. Prefers science fiction, fantasy, dark fantasy, horror or mythology themes. Send query letter with samples. Write for appointment to show portfolio. Prefers photocopies or photographs as samples. Samples not filed are returned by SASE. Reports within 1 month. Buys first rights. Pays $20-30 b&w, $50-75 color, cover; $3-8 b&w, inside; on publication.

Tips: Does not want to see "Dungeons and Dragons oriented cartoons or crudely created computer art." Notices "more integration of art and text through desktop publishing."

ACCENT ON LIVING, Box 700, Bloomington IL 61702. Editor: Betty Garee. Estab. 1956. Emphasis on success and ideas for better living for the physically handicapped. Quarterly. Original artwork returned after publication, if requested. Sample copy $2.

Cartoons: Approached by 30 cartoonists/year. Buys approximately 12 cartoons/issue, 50/year from freelancers. Receives 5-10 submissions/week from freelancers. Interested in seeing people with disabilities in different situations. Send finished cartoons and SASE. Reports in 2 weeks. Buys first-time rights (unless specified). Pays $20 b&w; $35 full page; on acceptance.

Illustrations: Approached by 20 illustrators/year. Uses 3-5 illustrations/issue from freelancers. Interested in illustrations that "depict articles/topics we run." Works on assignment only. Provide samples of style to be kept on file for future assignments. Samples not kept on file are returned by SASE. Reports in 2 weeks. To show a portfolio, mail color and b&w samples. Buys all rights on a work-for-hire basis. Pays $50 and up color cover; $20 and up b&w; on acceptance.

Tips: "Send a sample and be sure to include various styles of artwork that you can do."

***ADIRONDACK LIFE,** Box 97, Rt. 9N, Jay NY 12941. (518)946-2191. FAX: (518)946-7461. Art Director: Ann Eastman. Estab. 1970. Bimonthly regional magazine "focusing on the life-styles, environmental issues, history, recreation, traditions and wildlife of the Adirondack Park. Heavy emphasis on landscapes and scenic photos." Circ. 50,000. Accepts previously published artwork. Original artwork returned at job's completion. Sample copies available. Art guidelines available.

Cartoons: Approached by 6 or more freelance cartoonists/year. Buys 3 or more freelance cartoons/issue. Preferred themes "are generally, people and their relation to wilderness and/or wildlife." Prefers b&w and color washes and b&w line drawings. Send query letter with finished cartoons. Samples are filed or returned by SASE if requested by artist. Reports back to the artist only if interested. Buys one-time rights. Pays $150+ for b&w, $250+ for color.

Illustrations: Approached by 12 or more freelance illustrators/year. Buys 6 or more freelance illustrations/issue. Most art is assigned. Considers pen and ink, watercolor, color pencil and charcoal. Send query letter with brochure, tearsheets or other appropriate samples. Samples are filed or are returned by SASE if requested by artist. Reports back to the artist only if interested. To show portfolio, mail appropriate materials or call. Buys one-time rights. Pays $150+ for b&w, $250 + for color, inside. Pays on publication "unless it's an assignment."

AIM, Box 20554, Chicago IL 60620. (312)874-6184. Editor-in-Chief: Ruth Apilado. Managing Editor: Dr. Myron Apilado. Art Director: Bill Jackson. Estab. 1973. Readers are those "wanting to eliminate bigotry and desiring a world without inequalities in education, housing, etc." Quarterly. Circ. 16,000. Sample copy $3.50; artist's guidelines for SASE. Reports in 3 weeks. Previously published, photocopied and simultaneous submissions OK. Receives 12 cartoons and 4 illustrations/week from freelance artists. Finds most artists through references/word-of-mouth and samples received through the mail.

Cartoons: Buys 10-15 cartoons/year. Uses 1-2 cartoons/issue; all from freelancers. Interested in education, environment, family life, humor through youth, politics and retirement; single panel with gagline. Especially needs "cartoons about the stupidity of bigotry." Mail finished art. SASE. Reports in 3 weeks. Buys all rights on a work-for-hire basis. Pays $5-15 b&w line drawings; on publication.

Illustrations: Uses 4-5 illustrations/issue; half from freelancers. Prefers pen & ink. Interested in current events, education, environment, humor through youth, politics and retirement. Provide brochure to be kept on file for future assignments. No samples returned. Reports in 4 weeks. Prefers b&w for cover and inside art. Buys all rights on a work-for-hire basis. Pays $25, b&w illustrations, cover; on publication.

Tips: "For the most part, artists submit material omitting African-American characters. We would be able to use more illustrations and cartoons with people from all ethnic and racial backgrounds in them. We also use material of general interest. Artists should show a representative sampling of their work and target their sample magazine's specific needs; nothing on religion."

***ALABAMA LITERARY REVIEW**, Troy State University, Troy AL 36082. (205)566-8112, ext. 3286. Editor: Dr. Theron Montgomery. Estab. 1986. Literary magazine. "We are a literary medium that publishes poetry, fiction, drama, essays, reviews, photography and graphic art." Biannual. Circ. 880. No previously published artwork. Original artwork returned at job's completion. Sample copies available for $4.50. Art guidelines not available.

Cartoons: Approached by 3 freelance cartoonists/year. Buys 1 freelance cartoon/year. Prefers throught-provoking or intriguing graphics; single panel without gagline. Send query letter with finished cartoons. Samples are not filed and are returned by SASE if requested by artist. Reports back within 2 months. Buys first rights. Pays copies for b&w.

Illustrations: Approached by 5 freelance illustrators/year. Buys 1 freelance illustration/year. Prefers thought-provoking or intriguing graphics; charcoal. Send query letter with SASE. Samples are not filed and are returned by SASE if requested by artist. Reports back within 2 months. Mail appropriate materials. Portfolio should include b&w original/final art. Buys first rights. Pays in copies on publication.

AMATEUR RADIO TODAY, (formerly *73 Magazine*), Hancock NH 03449. Publisher: Wayne Green. For amateur radio operators and experimenters. 4-color with traditional design. Sample copy $2.50.

Cartoons: Approached by 8 cartoonists/year. Must be about electronics/radio. Pays $20, b&w.

Illustrations: Needs technical illustrations. Works on assignment only. Does not return samples. Does not report back on possible future assignments. Send query letter with resume to be kept on file. Buys all rights on a work-for-hire basis. Pays $5-20, spot art; $75/page, finished art; $400, color, cover; on acceptance.

Tips: "Most work is done inhouse."

AMELIA, 329 E St., Bakersfield CA 93304. (805)323-4064. Editor: Frederick A. Raborg, Jr. Estab. 1983. Magazine; also publishes 2 supplements—*Cicada* (haiku) and *SPSM&H* (sonnets) and illustrated postcards. Emphasizes fiction and poetry for the general review. Quarterly. Circ. 1,250. Accepts some previously published material from illustrators. Original artwork returned after publication if requested with SASE. Sample copy $7.95; art guidelines for SASE.

Cartoons: Buys 3-5 cartoons/issue from freelancers for *Amelia.* Prefers sophisticated or witty themes (see Cynthia Darrow's or Jessica Finney's work). Prefers single panel with or without gagline (will consider multipanel on related themes); b&w line drawings and washes. Send query letter with finished cartoons to be kept on file. Material not filed is returned by SASE. Reports within 1 week. Buys first rights or one-time rights; prefers first rights. Pays $5-25, b&w; on acceptance.

Illustrations: Buys 80-100 illustrations and spots annually from freelancers for *Amelia;* 24-30 spots for *Cicada;* 15-20 spots for *SPSM&H* and 50-60 spots for postcards. Considers all themes; "no taboos, except no explicit sex; nude studies in taste are welcomed, however." Prefers pen & ink, pencil, watercolor, acrylic, oil, pastel, mixed media and calligraphy. Send query letter with resume, photostats and/or photocopies to be kept on file; unaccepted material returned immediately by SASE. Reports in 1 week. Portfolio should contain "one or two possible cover pieces (either color or b&w), several b&w spots, plus several more fully realized b&w illustrations." Buys first rights or one-time rights; prefers first rights. Pays $25, b&w, $100, color, cover; $5-25, b&w, inside; on acceptance, "except spot drawings which are paid for on assignment to an issue."

Tips: "Wit and humor above all in cartoons. In illustrations, it is very difficult to get excellent nude studies (such as one we used by Carolyn G. Anderson to illustrate a short story by Judson Jerome in our Fall 1986 issue.) Everyone seems capable of drawing an ugly woman; few capture sensuality, and fewer still draw the nude male tastefully."

AMERICA WEST AIRLINES MAGAZINE, Suite 240, 7500 N. Dreamy Draw Dr., Phoenix AZ 85020. Art Director: Elizabeth Krecker. Estab. 1986. Inflight magazine for fast-growing national airline. Appeals to an upscale audience of travelers reflecting a wide variety of interests and tastes. Monthly. Circ. 125,000. Original artwork is returned after publication. Sample copy $3.

Illustrations: Approached by 100 illustrators/year. Buys illustrations mainly for spots, columns and feature spreads. Buys 5-10 illustrations/issue, 60-100 illustrations/year from freelancers. Uses freelance artwork mainly for features and columns. Works on assignment only. Prefers pen & ink, airbrush, mixed media, colored pencil, watercolor, acrylic, oil, pastel, collage and calligraphy. Send query letter with color brochure showing art style and tearsheets. Looks for the "ability to intelligently grasp idea behind story and illustrate

✱ *The asterisk before a listing indicates that the listing is new in this edition. New markets are often the most receptive to freelance submissions.*

it. Likes crisp, clean colorful styles." Samples are filed. Does not report back. Does not review portfolios. Buys one-time rights. Pays $75-250, b&w; $150-500, color, inside; on publication. "Send lots of good-looking color tearsheets that we can keep on hand for reference. If your work interests us we will contact you."
Tips: "In your portfolio show examples of editorial illustration for other magazines, good conceptual illustrations and a variety of subject matter. Often artists don't send enough of a variety of illustrations; it's much easier to determine if an illustrator is right for an assignment if I have a complete grasp of the full range of their abilities. Send high-quality illustrations and show specific interest in our publication." Does not want to see "photocopies—makes artwork and artist look sloppy and unprofessional."

AMERICAN BANKERS ASSOCIATION-BANKING JOURNAL, 345 Hudson St., New York NY 10014. (212)620-7256. Art Director: Jeff A. Menges. Estab. 1908. Emphasizes banking for middle and upper level-banking executives and managers. Monthly. Circ. 42,000. Accepts previously published material. Returns original artwork after publication.
Illustrations: Buys 2-3 illustrations/issue from freelancers. Themes relate to stories, primarily financial, from the banking industry's point of view; styles vary, realistic, cartoon, surreal. Looks for clear, clean b&w linework or halftones in style of David Lewis and John McDonald. Works on assignment only. Send query letter with brochure and samples to be kept on file. Prefers tearsheets or photographs as samples. Samples not filed are returned by SASE. Negotiates rights purchased. Pays $500, color, cover; $100, b&w or color, inside; on acceptance.

AMERICAN BIRDS National Audubon Society, 950 3rd Ave., New York NY 10022. (212)546-9190. Art Director: Victoria Leidner. Estab. 1946. A quarterly consumer magazine. "A superlative ornithology journal devoted to the recording and discovery of birds in their habitat, their behavior patterns, migratory patterns, birders' trends and sittings." Circ. 15,000. No previously published artwork. Original artwork returned at job's completion. Sample copy $5. Art guidelines available.
Illustrations: Publishes approximately 4 freelance illustrations/issue; approximately 16 freelance illustrations/year. Prefers clear factual detail line art or full illustrations of birds, b&w only; pen & ink. Send query letter with photostats. Samples are filed or returned. Reports back within 3 weeks. Write to schedule an appointment to show a portfolio, which should include original/final art, b&w tearsheets, photostats and photographs. Negotiates rights purchased. "We are nonprofit. We publish artist's work without paying fees."

AMERICAN BREWER MAGAZINE, Box 510, Hayward CA 94541. (415)538-9500 (mornings). Publisher: Bill Owens. Estab. 1985. Trade journal. Magazine. "We focus on the micro-brewing industry." Quarterly. Circ. 4,000. Accepts previously published artwork. Original artwork returned after publication. Sample copies for $5. Art guidelines available.
Cartoons: Approached by 6-8 cartoonists/year. Buys 2 cartoons/issue, 8/year from freelancers. Prefers themes "related to drinking or brewing handcrafted beer"; single panel. Send query letter with roughs. Samples not filed and are returned. Reports back within 2 weeks. Buys reprint rights. Pays $50, b&w.
Illustrations: Approached by 6-10 illustrators/year. Buys 2 illustrations/issue, 10/year from freelancers. Works on assignment only. Prefers themes relating to "beer, brewing or drinking." Considers pen & ink. Send query letter with photocopies. Samples are not filed and are returned. Reports back within 2 weeks. To show a portfolio mail appropriate materials, which should include photocopies. Buys reprint rights.

AMERICAN FITNESS, Suite 310, 15250 Ventura Blvd., Sherman Oaks CA 91403. (818)905-0040. Editor-at-Large: Peg Jordan. Managing Editor: Rhonda J. Wilson. Magazine emphasizing fitness, health and exercise for sophisticated, college-educated, active life-styles. Bimonthly. Circ. 25,000. Accepts previously published material. Original artwork returned after publication. Sample copy $1.
Cartoons: Approached by 12 cartoonists/month. Buys 1 cartoon/issue from freelancers. Material not kept on file is returned if requested. Buys one-time rights. Pays $35.
Illustrations: Approached by 12 illustrators/month. Buys 1-2 illustrations/issue from freelancers. Works on assignment only. Prefers very sophisticated 4-color line drawings. Send query letter with brochure showing art style and tearsheets. Wants to see "previously published work featuring material geared toward our magazine." Reports back within 2 months. To show a portfolio, mail thumbnails and roughs. Buys one-time rights.

AMERICAN HORTICULTURIST, 7931 E. Boulevard Dr., Alexandria VA 22308. (703)768-5700. Editor: Kathleen Fisher. Estab. 1922. Consumer magazine for advanced and amateur gardeners and horticultural professionals who are members of the American Horticultural Society. Monthly. Circ. 20,000. Accepts previously published artwork. Original artwork is returned at job's completion. Sample copies for $2.50. Art guidelines not available.
Illustrations: Buys 15-20 illustrations/year from freelancers. Works on assignment only. "Botanical accuracy is important for many assignments." Considers pen & ink, colored pencil, watercolor and charcoal. Send query letter with tearsheets, slides and photocopies. Samples are filed. "We will call artist if their style

matches our need." To show a portfolio mail b&w and color tearsheets and slides. Buys one-time rights. Pays $50-150, b&w, $100-300, color, inside; on publication.

THE AMERICAN LEGION MAGAZINE, Box 1055, Indianapolis IN 46206. Contact: Cartoon Editor. Emphasizes the development of the world at present and milestones of history; 4-color general-interest magazine for veterans and their families. Monthly. Original artwork not returned after publication.
Cartoons: Uses 2-3 cartoons/issue, all from freelancers. Receives 100 submissions/week from freelancers. Especially needs general humor in good taste. "Generally interested in cartoons with broad appeal. Prefers action in the drawing, rather than the illustrated joke-type gag. Those that attract the reader and lead us to read the caption rate the highest attention. No-caption gags purchased only occasionally. Because of tight space, we're not in the market for the spread or multipanel cartoons but use both vertical and horizontal single-panel cartoons. Themes should be home life, business, sports and everyday Americana. Cartoons that pertain only to one branch of the service may be too restricted for this magazine. Service-type gags should be recognized and appreciated by any ex-service man or woman. Cartoons that may offend the reader are not accepted. Liquor, sex, religion and racial differences are taboo. Ink roughs not necessary but desirable." Usually reports within 1 month. Buys first rights. Pays $150; on acceptance.
Tips: "Artists should submit their work as we are always seeking new slant and more timely humor. Black-and-white art is primarily what we seek. Note: Cartoons are separate from the art department."

AMERICAN LIBRARIES, 50 E. Huron St., Chicago IL 60611. (312)280-4216. FAX: (312)440-0901. Senior Editor: Edie McCormick. Estab. 1907. Professional journal; magazine "published by the American Library Association for its 50,000 members, providing independent coverage of news and major developments in and related to the library field." Monthly. Circ. 50,554. Original artwork is returned at job's completion. Sample copy $5. Art guidelines available.
Cartoons: Approached by 15 cartoonists/year. Buys 1-3 cartoons/issue, 20/year from freelancers. Prefers themes related to libraries. Send query letter with brochure and finished cartoons. Samples are filed. Does not report on submissions. Buys first rights. Pays $35-50, b&w.
Illustrations: Approached by 20 illustrators/year. Buys 2 illustrations/issue, 20/year from freelancers. Works on assignment only. Send query letter with brochure, tearsheets and resume. Samples are filed. Does not report on submissions. To show a portfolio, mail tearsheets, photostats, photographs and photocopies. Portfolio should include broad sampling of typical work with tearsheets of both b&w and color. Buys first rights. Pays $75-150 for b&w; $250-300 for color, cover; $75-150 for b&w; $150-250 for color, inside; on acceptance.
Tips: "I suggest inquirer go to a library and take a look at the magazine first." Sees trend toward "more contemporary look, simpler, more classical, returning to fewer elements."

AMERICAN MOTORCYCLIST, American Motorcyclist Association, Box 6114, Westerville OH 43081-6114. (614)891-2425. Executive Editor: Greg Harrison. Managing Editor: Bill Wood. Associate Editor: Roger T. Young. Monthly. Circ. 150,000. For "enthusiastic motorcyclists investing considerable time and money in the sport." Sample copy $1.50.
Cartoons: Buys 1-2 cartoons/issue from freelancers. Receives 5-7 submissions/week from freelancers. Interested in motorcycling; "single panel gags." Prefers to receive finished cartoons. Include SASE. Reports in 3 weeks. Buys all rights on a work-for-hire basis. Pays $15 minimum, b&w washes; on publication.
Illustrations: Buys 1-2 illustrations/issue, almost all from freelancers. Receives 1-3 submissions/week from freelancers. Interested in motorcycling themes. Send query letter with resume and tearsheets to be kept on file. Prefers to see samples of style and resume. Samples returned by SASE. Reports in 3 weeks. Buys first North American serial rights. Pays $100 minimum, color, cover; $30-100, b&w and color, inside; on publication.

AMERICAN MUSIC TEACHER, Suite 1432, 617 Vine St., Cincinnati OH 45202-2434. Art Director: Diane M. DeVillez. Estab. 1951. 4-color trade journal emphasizing music teaching. Features historical and how-to articles. "*AMT* promotes excellence in music teaching and keeps music teachers informed. It is the official journal of the Music Teachers National Association, an organization which includes concert artists, independent music teachers and faculty members of educational institutions." Bimonthly. Circ. 26,424. Accepts previously published material. Original artwork returned after publication. Sample copies available.
Illustrations: Buys 1 illustration/issue, 6/year from freelancers. Uses freelance artwork mainly for diagrams and illustrations. Prefers musical theme. "No interest in cartoon illustration." Send query letter with brochure or resume, tearsheets, slides and photographs. Samples are filed or are returned only if requested. Reports back within 3 months. To show a portfolio, mail original/final art, color and b&w tearsheets, photographs and slides. Buys one-time rights. Pays $50-150, b&w and color, cover and inside; on publication.
Tips: "In a portfolio show silhouettes and classical music subject matter."

THE AMERICAN SPECTATOR, Box 549, Arlington VA 22216-0549. (703)243-3733. Managing Editor: Wladyslaw Pleszczynski. Concerns politics and literature. Monthly. Circ. 43,000. Original artwork returned after publication.

Illustrations: Uses 2-3 illustrations/issue, all from freelancers. Interested in "caricatures of political figures (or portraits with a point of view)." Works on assignment only. Samples returned by SASE. Reports back on future assignment possibilities. Provide resume, brochure and tearsheets to be kept on file for future assignments. Prefers to see portfolio and samples of style. Reports in 2 weeks. Buys first North American serial rights. Pays $150 minimum, b&w line drawings, cover; $35 minimum, b&w line drawings, inside; pays on publication.

***AQUA-FIELD PUBLICATIONS**, 66 W. Gilbert, Shrewsbury NJ 07702. (201)842-8300. Art Director: Anita Schettino. Estab. 1974. Magazine emphasizing outdoor recreation: hunting, fishing, scuba and camping. "Geared to the active outdoors-oriented adult, mid-to-upper income area. There is some family material. Publishes annuals. Publications are 4-color, 2-color and b&w, conservative/classic design. Circ. 200,000 per magazine. Accepts previously published material. Original artwork is returned to the artist after publication. Art guidelines for SASE with first-class postage.
Illustrations: Approached by 30-40 illustrators/year. Works with 3-4 illustrators/year. Buys 4-8 illustrations/issue, approximately 100/year from freelancers. Uses freelance artists mainly for paste-up, covers and spots, and b&w magazine illustration specific to story subject matter. Works on assignment only. Send query letter with photostats and slides of color work and b&w photocopies of b&w art. Samples are filed or returned by SASE. Reports back within 1 month. Call or write to schedule an appointment to show a portfolio, which should include original/final art, tearsheets, photographs, slides, color and b&w. Buys one-time rights; negotiates rights purchased. Pays $35-75, b&w spots; negotiable for color, cover and inside. Pays on publication.
Tips: "Don't send original art. I want to see mostly realistic/painterly work. I don't want to see totally abstract work or work that doesn't apply to our outdoors theme."

ART BUSINESS NEWS, Box 3837, Stamford CT 06905. (203)356-1745. Editor: Jean Marie Angelo. Trade journal emphasizing the business of selling art and frames, trends, new art editions, limited editions, posters and framing supplies. Features general interest, interview/profile and technical articles. Monthly. Circ. 30,000. Original artwork returned after publication. Sample copy $5. Uses freelance artists mainly for big features.
Cartoons: Approached by 10 cartoonists/year. Buys some cartoons/issue from freelancers. Prefers "sophisticated, light business orientation." Prefers single panel, b&w line drawings and b&w washes. Send query letter with samples of style. Samples are filed or are returned. Reports back within weeks. Pays $35-50, b&w.
Illustrations: Approached by 5 illustrators/year. Works on assignment only. Send query letter with brochure showing art style, tearsheets and slides. Samples are filed (excluding slides) or are returned. Reports back within weeks. Write to schedule an appointment to show a portfolio or mail color and b&w tearsheets and photographs. Buys one-time rights. Pays $100, b&w, cover; $200, color, inside.

ART DIRECTION, 6th Floor, 10 E. 39th St., New York NY 10016. (212)889-6500. FAX: (212)889-6504. Editor: Dan Barron. Estab. 1949. Emphasizes advertising for art directors. Monthly. Circ. 12,000. Original work not returned after publication. Sample copy $4.50. Art guidelines available.
Illustrations: Receives 7 illustrations/week from freelancers. Uses 2-3 illustrations/issue; all from freelancers. Works on assignment only. Interested in themes that relate to advertising. Send query letter with brochure showing art styles. Samples are not filed and are returned only if requested. Reports in 3 weeks. Write to schedule an appointment to show a portfolio, which should include tearsheets. Negotiates rights purchased. Pays $350, color, cover; on publication.
Tips: "Must be about current advertising."

THE ARTIST'S MAGAZINE, 1507 Dana Ave., Cincinnati OH 45207. Editor: Mike Ward. Emphasizes the techniques of working artists for the serious beginning, amateur and professional artist. Published 12 times/year. Circ. 275,000. Occasionally accepts previously published material. Returns original artwork after publication. Sample copy $2 with SASE and 50¢ postage.
Cartoons: Contact Mike Ward, editor. Buys 2-3 "top-quality" cartoons/issue from freelancers. Most cartoons bought are single panel finished cartoons with or without gagline; b&w line drawings and washes. "We're also on the lookout for color, multipanel (4-6 panels) work with a theme to use on our 'P.S.' page. Any medium." All cartoons should be artist-oriented, appeal to the working artist and should not denigrate art or artists. Avoid cliché situations. For single panel cartoon submissions, send cover letter with 4 or more finished cartoons. For "P.S." submissions, query first with roughs and samples of your artwork. Material not filed is returned only by SASE. Reports within 1 month. Pays $65 and up, b&w single panels; $200 and up, "P.S." work. Buys first North American serial rights. Pays on acceptance.
Illustrations: Contact Carol Winters, art director. Buys 2-3 illustrations/issue from freelancers. Works on assignment only. Send query letter with brochure, resume and samples to be kept on file. Prefers photostats or tearsheets as samples. Samples not filed are returned by SASE. Buys first rights. Pays on acceptance. "We're also looking for b&w spots of art-related subjects. We will buy all rights, $15-25 per spot."

ISAAC ASIMOV'S SCIENCE FICTION MAGAZINE, 380 Lexington Ave., New York NY 10168-0035. (212)557-9100. FAX: (212)986-7313. Art Director: Terri Czeczko. Estab. 1977. Consumer magazine of science fiction and fantasy. Monthly. Circ. 100,000. Accepts previously published artwork. Original artwork returned at job's completion. Sample copies available. Art guidelines free for SASE with first-class postage.

Illustrations: Approached by 60 illustrators/year. Buys 10 illustrations/issue, 130 illustrations/year from free-lancers. Works on assignment only. Considers pen & ink, airbrush, watercolor, acrylic and oil. Send query letter with tearsheets "I view portfolios on Tuesdays of each week." Samples are sometimes filed or are returned by SASE if requested by artist. Reports back only if interested. Portfolio should include tearsheets. Buys one-time rights; rights purchased vary according to project. Pays $600, color, cover. Pays $100, b&w.

***ASPEN MAGAZINE**, Box 9-3, Aspen CO 81612. (303)920-4040. FAX: (303)920-4044. Art Director: Robert Maraziti. City consumer magazine with the emphasis on Aspen and the valley. Bimonthly. Circ. 15,000. Accepts previously published artwork. Original artwork returned at job's completion. Samples copies available. Art guidelines available.

Illustrations: Approached by 15 freelance illustrators/year. Buys 2 freelance illustrations/issue. Themes and styles should be appropriate for editorial content. Considers all media. Send query letter with tearsheets, photostats, photographs, slides, photocopies and transparencies. Samples are filed. Reports back only if interested. Call to schedule an appointment to show a portfolio, which should include thumbnails, roughs, tearsheets, slides and photographs. Buys first, one-time or reprint rights. Pays on publication.

ATLANTIC CITY MAGAZINE, P.O. Box 2100, Pleasantville NJ 08232-1324. (609)272-7907. Art Director: Michael L.B. Lacy. Estab. 1979. Emphasizes the growth, people and entertainment of Atlantic City for residents and visitors. 4-color. Monthly. Circ. 50,000.

Illustrations: Approached by 1,000 illustrators/year. Works with 20 illustrators/year. Buys 36 illustrations/year from freelancers. Uses artists for spots, department and feature illustration. Uses mainly 4-color and some b&w. Works on assignment only. Send query letter with brochure showing art style and tearsheets, slides and photographs to be kept on file. Call or write to schedule an appointment to show a portfolio, which should include original/final art, final reproduction/product, color and b&w tearsheets and photographs. Buys first rights. Pays $500, b&w and color, cover; $75, b&w, $225, color, inside; on publication.

Tips: "We are looking for intelligent, reliable artists who can work within the confines of our budget and time frame. Deliver good art and receive good tearsheets."

ATLANTIC SALMON JOURNAL, Box 429, St. Andrews, New Brunswick, EOG 2XO Canada. (506)529-8889. Managing Editor: Harry Bruce. Estab. 1952. Emphasizes conservation and angling of Atlantic salmon; travel, biology and cuisine for educated, well-travelled, affluent and informed anglers and conservationists, biologists and professionals. Quarterly. Circ. 20,000. Does not accept previously published material. Returns original artwork after publication. Sample copy free for SAE. Art guidelines available.

Cartoons: Buys 1-2/issue from freelancers. Prefers cnvironmental or political themes, specific to salmon resource management, travel and tourism—light and whimsical. Prefers single panel with or without gagline; b&w line drawings. Send query letter with samples of style to be kept on file. Material not filed is returned. Reports within 8 weeks. Buys first rights and one-time rights. Pays $25-50, b&w; on publication.

Illustrations: Buys 1-2/issue from freelancers. Prefers themes on angling, environmental scenes and biological drawings. Prefers spot pencil sketches, watercolor and acrylic. Send query letter with samples to be kept on file. Prefers photostats, tearsheets, slides or photographs as samples. Include SAE and IRC. Samples not filed are returned. Reports within 8 weeks. Buys first rights and one-time rights. Pays $150-225, b&w; and $350-500, color, cover; on publication.

***AUSTRALIAN WOMEN'S WEEKLY**, 54 Park St., Sydney Australia 2000. A.C.P. Designer-in-Chief: Phil Napper. Readers are average to highly sophisticated women. Monthly. Circ. over 1 million. Original artwork not returned after publication. Art guidelines with SASE (nonresidents include IRCs).

Cartoons: Approached by 10 cartoonists/year. Pays $50 (Australian) for b&w.

Illustrations: Uses 2 illustrations/issue; buys all from freelancers. Interested in action illustration in traditional style; good anatomy, any medium. Works on assignment only. Provide tearsheets to be filed for possible future assignments. Send samples of style. No samples returned. Reports in 2 weeks. Buys all rights. Pays $400 (Australian)/color; on acceptance.

Tips: Artists "must be good enough for national publication. I would like to see a trend toward more traditional illustration—a la Rockwell."

AUTOMOBILE MAGAZINE, 120 E. Liberty, Ann Arbor MI 48104. (313)994-3500. Art Director: Lawrence C. Crane. Estab. 1986. An "automobile magazine" for up-scale life-styles. Monthly. Circ. 450,000. Original artwork is returned after publication. Art guidelines specific for each project.

Illustrations: Buys illustrations mainly for spots and feature spreads. Works with 5-10 illustrators/year. Buys 2-5 illustrations/issue from freelancers, 20-30/year. Works on assignment only. Considers airbrush, mixed media, colored pencil, watercolor, acrylic, oil, pastel and collage. Send query letter with brochure showing

art style, resume, tearsheets, slides, photographs and transparencies. Show automobiles in various styles and media. "This is a full-color magazine, illustrations of cars and people must be accurate." Samples are returned only if requested. "I would like to keep something in my file." Reports back about queries/submissions only if interested. To show a portfolio mail appropriate materials, then call. Portfolio should include original/final art, and color tearsheets, slides and transparencies. Buys first rights and one-time rights. Pays $900, color, cover; $200 and up, color, inside.
Tips: "Send samples that show cars drawn accurately with a unique style and imaginative use of medium."

AXIOS, The Orthodox Journal, 800 S. Euclid Ave., Fullerton CA 92632. (714)526-4952. Editor: Daniel Gorham. 2-color newsletter emphasizing "challenges in ethics and theology, some questions that return to haunt one generation after another, old problems that need to be restated with new urgency. *Axios* tries to present the 'unthinkable' " from an Orthodox Catholic viewpoint. Monthly. Circ. 8,478. Accepts previously published material, simultaneous submissions. Original artwork returned after publication. Sample copy $2.
Illustrations: Buys 5-10 illustrations/issue from freelancers. Prefers bold line drawings, seeks icons, b&w; "no color *ever*; uses block prints—do not have to be religious, but must be *bold*!" Send query letter with brochure, resume, business card or samples to be kept on file. Samples not filed are returned by SASE. Reports within 5 weeks. To show a portfolio, mail final reproduction/product and b&w. Buys one-time rights. Pays $50, b&w cover and $20-50, b&w inside; on acceptance.
Tips: "Realize that the Orthodox are *not* Roman Catholics, nor Protestants. We do not write from those outlooks. Though we do accept some stories about those religions, be sure *you* know what an Orthodox Catholic is. Know the traditional art form—we prefer line work, block prints, linocuts." Recession has affected need for freelance art "so much that we are cutting back to almost none until it clears."

B.C. OUTDOORS, 202-1132 Hamilton St., Vancouver, British Columbia V6B 2S2 Canada. (604)687-1581. Editor: George Will. Emphasizes fishing, hunting, RV camping, wildlife/conservation. Published 7 times/year. Circ. 45,000. Original artwork returned after publication unless bought outright. Free sample copy.
Cartoons: Approached by more than 10 cartoonists/year. Buys 1-2 cartoons/issue; all from freelancers. Cartoons should pertain to outdoor recreation: fishing, hunting, camping and wildlife in British Columbia. Format: single panel, b&w line drawings with or without gagline. Prefers finished cartoons. Include SAE (nonresidents include IRC). Pays on acceptance. Reports in 2 weeks. Buys one-time rights.
Illustrations: Approached by more than 10 illustrators/year. Buys 12 illustrations/year from freelancers. Interested in outdoors, creatures and activities as stories require. Freelancers selected "generally because I've seen their work." Format: b&w line drawings for inside, rarely for cover; b&w washes for inside and color washes for inside and cover. Works on assignment only. Samples returned by SAE (nonresidents include IRC). Reports back on future assignment possibilities. Arrange personal appointment to show portfolio or send samples of style. When reviewing samples, especially looks at how their subject matter fits the publication and the art's quality. Reports in 2-6 weeks. Buys first North American serial rights or all rights on a work-for-hire basis. Payment negotiable, depending on nature of assignment. Pays on acceptance.

BALLOON LIFE MAGAZINE, 2145 Dale Ave., Sacramento CA 95815. (916)922-9648. Editor: Glen Moyer. Estab. 1985. Monthly magazine emphasizing the sport of ballooning. This is a "4-color magazine covering the life of sport ballooning, contains current news, feature articles, a calendar and more. Audience is sport balloon enthusiasts." Circ. 3,500. Accepts previously published material. Original artwork returned after publication. Sample copy for SASE with $2 postage.
Cartoons: Approached by 20-30 cartoonists/year. Buys 1-2 cartoons/issue, 10-15/year from freelancers. Prefers gag cartoons, editorial or political cartoons, caricatures and humorous illustrations. Prefers single panel with or without gaglines; b&w line drawings. Send query letter with samples, roughs and finished cartoons. Samples are filed or returned. Reports back within 2 weeks. Buys first rights. Pays $25, b&w; on publication.
Illustrations: Approached by 10-20 illustrators/year. Buys 1-3 illustrations/year from freelancers. Send query letter with business card and samples. Samples are filed or returned. Reports back within 2 weeks. Buys first rights. Pays $25-50, color, cover; $25-40, color, inside; on publication.
Tips: "The magazine files samples. When we identify a need, we look at our files to see whose style would best fit the project."

BALTIMORE JEWISH TIMES, 2104 North Charles St., Baltimore MD 21218. (301)752-3504. Creative Director: Kim Muller-Thym. Tabloid emphasizing special interest to the Jewish community for largely local readership. Weekly. Circ. 20,000. Returns original artwork after publication, if requested. Sample copy available.
Illustrations: Approached by 50 illustrators/year. Buys 4-6 illustrations/issue from freelancers. Works on assignment only. Prefers high-contrast, b&w illustrations. Send query letter with brochure showing art style or tearsheets and photocopies. Samples not filed are returned by SASE. Reports back if interested. To show a portfolio, mail appropriate materials or write to schedule an appointment; portfolio should include original/final art, final reproduction/product and color tearsheets and photostats. Buys first rights. Pays $200, b&w, cover and $300, color, cover; $50-100, b&w, inside; on publication.
Tips: Sees trend toward "more freedom of design integrating visual and verbal."

BARTENDER MAGAZINE, Box 158, Liberty Corner NJ 07938. (908)766-6006. FAX: (908)766-6607. Editor: Jackie Foley. Estab. 1979. Trade journal emphasizing restaurants, taverns, bars, bartenders, bar managers, owners, etc. Quarterly. Circ. 130,000.
Cartoons: Approached by 10 cartoonists/year. Buys 3 cartoons/issue from freelancers. Prefers bar themes; single panel. Send query letter with finished cartoons. Samples are filed. Buys first rights. Pays $500, color.
Illustrations: Approached by 5 illustrators/year. Buys 1 illustration/issue from freelancers. Works on assignment only. Prefers bar themes. Considers any media. Send query letter with brochure. Samples are filed. To show portfolio, mail appropriate materials. Negotiates rights purchased. Pays $500, color, cover; on publication.

BASEBALL CARDS MAGAZINE, 700 E. State St., Iola WI 54990. (715)445-2214. FAX: (715)445-4087. Editorial Assistant: Greg Ambrosius. Estab. 1981. Consumer magazine. "We publish the nation's largest magazine for collectors of sports cards and other sports memorabilia." Monthly. Circ. 305,000. Accepts previously published artwork. Original artwork returned after publication. Sample copy for 8½ × 11 envelope and $1.25 postage. Art guidlines free for SASE with first-class postage.
Cartoons: Approached by 1 cartoonist/year. Buys 6 cartoons/issue, 48 cartoons/year from freelancers. Prefers cartoons "done in the style of Topps' cartoon backs for its baseball and football cards"; single panel, b&w line drawings. Send query letter with roughs. Samples are filed. Reports back within 2 weeks. Buys one-time rights. Pays $35, b&w, $150, color.
Illustrations: Approached by 8-10 illustrators/year. Buys 2 illustrations/issue; 24 illustrations/year from freelancers. Prefers baseball themes. Considers collage, airbrush, acrylic, marker and colored pencil. Send query letter with SASE, photostats and slides. Samples are filed. Reports back within 2 weeks. Call to schedule an appointment to show a portfolio, which should include b&w, roughs, color, photostats, photocopies, original/final art and photographs. Rights purchased vary according to project. Pays $50-125, b&w, $125-400, color, inside.
Tips: The best way for a cartoonist or illustrator to break in is "by showing the ability to render usual faces and images in a slightly unusual manner."

BASSMASTER MAGAZINE, 1 Bell Rd., Montgomery AL 36117. (205)272-9530. Art Director: Scott W. Hughes. Estab. 1968. Membership only publication with 2 newsstand issues a year; magazine format. 4-color. Monthly. Circ. 550,000. Original artwork returned at job's completion. Sample copies available. Art guidelines not available.
Illustrations: Approached by 10-20 illustrators/year. Buys 5 technical or editorial illustrations/issue, 50/year from freelancers. Works on assignment only. Preferred subjects are bass fish, fishing techniques and maps, usually scenic black line, not illustrative 4-color; in the style of Chris Armstrong and Bernie Schultz. Considers pen & ink, watercolor, mixed media and Macintosh computer created diagrams such as maps. Send query letter with brochure, tearsheets and resume. Samples are not filed and are returned by SASE if requested by artist. Reports back within 1 week. Write to schedule an appointment to show a portfolio. Portfolio should include original/final art and b&w tearsheets and slides. Rights purchased vary according to project. Payment varies. "We do not use art for the cover."
Tips: "Artists should have a basic knowledge of bass fish, fishing techniques, etc." Does not want to see "illustrious oil, pastel or acrylic paintings (we just don't use them). We are now specifically looking for an artist with a basic knowledge of fishing techniques to illustrate various fishing diagrams, lake maps, etc., on Adobe Illustrator."

***THE BERKELEY MONTHLY,** 1301 59th St., Emeryville CA 94608. (415)658-9811. FAX: (415)658-9902. Art Director: Jim McCann. Estab. 1970. Consumer monthly tabloid. Editorial features are general interests (art, entertainment, business owner profiles) with an upscale audience. Circ. 75,000. Accepts previously published artwork. Originals are returned at job's completion. Sample copies and art guidelines for SASE with first-class postage.
Cartoons: Approached by 40-50 freelance cartoonists/year. Buys 3 freelance cartoons/issue; 12/year. Prefers single panel and b&w line drawings. Send query letter with finished cartoons. Samples are filed or returned by SASE if requested by artist. Reports back to the artist only if interested. Buys one-time rights. Pays $150 for b&w.
Illustrations: Approached by 100-150 freelance illustrators/year. Buys 4 freelance illustrations/issue, 100/year. Prefers pen & ink, watercolor, acrylic, color pencil, oil, charcoal, mixed media and pastel. Send query letter with resume, SASE, tearsheets, photocopies and slides. Samples are filed or returned by SASE if requested by artist. Reports back only if interested. Write to schedule an appointment to show a portfolio, which should include thumbnails, roughs, b&w tearsheets and slides. Buys one-time rights. Pays $100 for b&w, inside. Pays 30 days after publication.

BEVERAGE WORLD MAGAZINE, 150 Great Neck Rd., Great Neck NY 11021. (516)829-9210. Art Director: Ingrid Atkinson. Editor: Alan Wolf. Emphasizes beverages (beers, wines, spirits, bottled waters, soft drinks, juices) for soft drink bottlers, breweries, bottled water/juice plants, wineries and distilleries. Monthly. Circ.

Close-up

James Endicott
Illustrator
Newberg, Oregon

© Barbara Kelley 1991

James Endicott entered the fine arts program of Cal State University at Long Beach in the mid-60s with the intention of becoming a more masterful fine artist. Instead, due to curriculum requirements and the influence of one man, he left with his heart in illustration. The one man was illustration instructor Dick Oden, who is still at Cal State. With what Endicott characterizes as a European attitude, "Oden firmly believes in the marrying of fine art and illustration," a sensibility which Endicott himself adheres to but finds rare in this country.

While in school he was greatly influenced by, in addition to Oden, the collective "Rocky and Bullwinkle" mentality of his classmates and by what he was reading at the time, primarily the theater of the absurd. These influences seem to carry over into his surreal and magical illustration. In his pieces one sees insects 100 times the size of their human counterparts, reptiles slithering through the sky, birds breathing fire, creatures with gossamer wings and long slippery tongues. There is a lightness and a darkness to his work.

The function of magazine illustration, says Endicott, is "to arrest the attention of someone thumbing through a magazine and then to provide him with something he can look at again and again, like a work of art which has meaning each time it is seen in a different light." He does not consider his illustration to be secondary to the content of the article it has been commissioned for. The illustration he did on Hollywood, for example, strongly stands in its own right. One does not need to read the article to understand what Endicott is mocking and why. The piece was done for the then art director of *Penthouse*, who had commissioned a number of other satirical pieces from Endicott. Unfortunately, he says, assignments for satirical pieces are hard to come by in American magazines.

These days Endicott's editorial work is for magazines which deal with concepts and abstractions—the areas of economics, computers and health: publications such as *Businessweek, Inc., Byte, Computer World, Hippocrates* and *Longevity*. His work for these clients has not decreased with the recession. He says that while advertising executives "switch gears during a recession to harder sell," magazine art directors do not.

The restrictions imposed on an illustrator by magazines, Endicott says, are instead due to the power of the editors. "The art directors are usually simpatico," he says. "But the editors tend to want to have every point in an article illustrated and kind of operate with the attitude that the reader is not quite up to snuff, not quite bright enough to understand. The best magazines to work for," he says, "are the ones with powerful art directors, where if your work is individualistic, you're being hired to think—to offer input and interpretation—as well as to mechanically produce something."

Endicott also does children's book illustration—to satisfy his desire to convey a subject matter which is naturalistic, impressionistic and emotional. *Listen to the Rain*, published by Henry Holt, for example, is a long poem he illustrated about rain; he's done another about the ocean and is presently working on one about trees. In order to bring in a steady income, he does work for advertising. This work is similar to his editorial work, only, he says, it is

"considerably watered down—a high chrome, polished paper, full-color, whistle-tooting, horn-blowing, aren't-we-wonderful type of thing." But, he says, "my income has been consistent" as a result.

A fan of such European illustrators as Andre Francois, he feels his European counterparts are given a much greater freedom to visualize in "a more whimsical fashion and be more clever as a result." He believes the "polished technique" so rampant in American illustration is caused by the "deadly seriousness about products here."

Endicott has been freelancing since 1973 and now has five reps. But he well remembers the Catch 22 of starting out. "It's always, 'we want someone with experience, but we're not going to give you the experience.' It's tough to get the ball rolling," he says, but the key is getting a good portfolio together. "The main thing in a portfolio," says Endicott, who used to teach a portfolio class at Cal State University at Long Beach "is consistency. It's only as good as your weakest piece." He recommends showing 10-12 pieces at most. He urges one to start with small clients and to find an art director one works well with.

He says there are many more magazines now than there were when he started out and hence, greater opportunity for the editorial illustrator. When asked whether he thinks magazines are now using more photography than illustration, he says, "No, I think we're still in an age of illustration. I think it started in the 60s and is still going."

—Lauri Miller

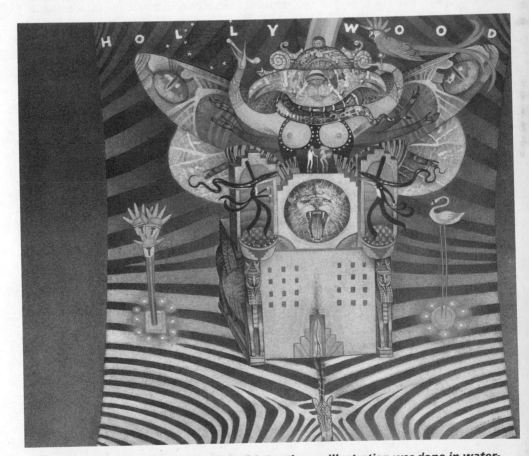

Like the majority of Endicott's work, this **Penthouse** *illustration was done in water-color. He is so fond of the medium both because of the speed with which he can use it and the "uncontrollable aspect of it. It's kind of scary,"* *he says,* *"because it's a bit unforgiving. If it stains the paper, there's not much you can do. There's sort of an underlying faith that it will come off."* Reprinted with permission of James Endicott.

33,000. Accepts simultaneous submissions. Original artwork returned after publication if requested. Sample copy $2.50.

Illustrations: Uses 5 illustrations/issue; buys 3-4 illustrations/issue from freelancers. Works on assignment only. Send query letter with photostats, slides or tearsheets to be kept on file. Write for appointment to show portfolio. Reports only if interested. Negotiates rights purchased. Pays $350 color, cover; $50-100, b&w, inside; on acceptance. Uses color illustration for cover, usually black-and-white for spot illustrations inside.

BICYCLING MAGAZINE, 33 E. Minor St., Emmaus PA 18098. Art Director: John Pepper. Magazine. 10 published/year. Original artwork is returned after publication.
Illustrations: Buys illustrations mainly for spots, feature spreads, technical and maps. Buys 8 illustrations/issue from freelancers. Works on assignment only. Send query letter with tearsheets, photocopies, slides, photographs and transparencies. Samples are filed or returned only if requested. Reports back about queries/submissions only if interested. Call to schedule an appointment to show a portfolio. Buys one-time rights.

BIRD TALK, Box 6050, Mission Viejo CA 92690. (714)855-8822. Editor: Karyn New. Estab. 1983. Consumer magazine publishing "informative material to help pet bird owners care for their birds." Monthly. Circ. 175,000. Accepts previously published artwork. Original artwork is returned after publication. Sample copies $4. Art guidelines free for SASE with first-class postage.
Cartoons: Buys about 6 cartoons/issue, about 72 cartoons/year from freelancers. Prefers clear line drawings of humorous pet bird situations. "No 'Polly want a cracker' or pirate jokes!" Prefers single panel with gagline; b&w line drawings. Send finished cartoons. Samples not filed and are returned by SASE. Reports back within 4 weeks. Buys one-time rights. Pays $35, b&w; after publication.
Illustrations: Buys illustrations mainly for spot use and feature spreads. Buys 0-3 illustrations/issue, 30/year from freelancers. Works on assignment only. Prefers line drawings. Samples are not filed and are returned by SASE. Reports back within 4 weeks. "We work only with someone who can send good original spot art." Buys one-time spot rights, when assigned all rights. Pays $20, b&w; after publication.
Tips: "We accept finished spot art as fillers. If we like the artist's style, we will contact him/her for assignments."

BLACK WARRIOR REVIEW, Box 2936, University of Alabama, Tuscaloosa AL 35487. (205)348-4518. Editor: Glenn Mott. Literary magazine; publishes contemporary poetry, fiction and nonfiction by new and established writers. 4-color. Biannual. Circ. 2,000. Accepts previously published artwork. Original artwork is returned at job's completion. Sample copy $4. Art guidelines not available.
Illustrations: Approached by 4 freelance illustrators/year. Buys 2 illustrations/issue from freelancers. Themes and styles vary. Considers pen & ink, airbrush, watercolor, acrylic, oil, collage and marker. Send query letter with photocopies. Samples are not filed and are returned. Reports back in 1 month. Pays $150 for b&w cover illustrations; on publication.
Tips: "Look at the magazine." Prefers frank, political style and content.

BLUE COMET PRESS, 1708 Magnolia Ave., Manhattan Beach CA 90266. (213)545-6887. President/Publisher: Craig Stormon. Estab. 1986. Publishes limited edition comic books in b&w with 4-color covers. Genres: adventure, fantasy, science fiction, animal parodies and social parodies. Themes: outer space, future science and social commentary. "Our *Blue Comet* comics are for everybody—for kids and grown ups. We have PG rating. We are starting an adult imprint—Black Skull Studios. BSS will package for larger publishers, and do pencils & inks, for other publishers, as well as continuing to publish." Bimonthly and quarterly. Circ. 20,000. Original artwork returned after publication. Sample copy $2.50. Art guidelines for SASE with 1 first-class stamp.
Illustrations: Cartoons appearing in magazine are realistic, clean, sharp, professional quality in style of Tim Vigil, Dave Garcia and Castonmon. Uses freelance artists for inking, lettering, pencilling, color work, posters and covers. Send query letter with resume and photocopies of work, story form 4-8 pages. Samples not filed are returned by SASE if requested. Reports back within 1 month. Call or write to schedule an appointment to show a portfolio, or mail 4-8 pages of pencil or ink drawings, 4-8 pages of action continuity, 4-8 photocopies of original pencil art or inking and 4-8 pages of lettering. Rights purchased vary. Pays $10-35/page for pencilling, $10-25/page for inking and $5-10 for lettering; on publication "or after." Also pays percentage.
Tips: "I don't need cartoony art. Need realistic art, good anatomy. Must be top quality."

THE B'NAI B'RITH INTERNATIONAL JEWISH MONTHLY, B'nai B'rith, 1640 Rhode Island Ave. NW, Washington DC 20036. (202)857-6645. Editor: Jeff Rubin. Emphasizes a variety of articles of interest to the Jewish family. Published 10 times/year. Circ. 200,000. Original artwork returned after publication. Sample copy $2. Also uses artists for "design, lettering, calligraphy on assignment. We call or write the artist, pay on publication."
Illustrations: Approached by 20 illustrators/year. Buys 2 illustrations/issue from freelancers. Theme and style vary, depending on tone of story illustrated. Works on assignment only. Write or call for appointment to show portfolio, which should include tearsheets, slides or photographs. Reports within 3 weeks. Samples

returned by SASE. Buys first rights. Rates vary according to size of illustration; on publication.

BODY, MIND AND SPIRIT MAGAZINE, Box 701, Providence RI 02901. (401)351-4320. Publisher and Editor-in-Chief: Paul Zuromski. Editor: Carol Kramer. Estab. 1982. Magazine emphasizing New Age, natural living and metaphysical topics for people looking for tools to improve body, mind and spirit. Bimonthly. Circ. 150,000. Original artwork returned after publication. Sample copy for 9x12 SASE with $1.07 postage.
Cartoons: Approached by 10 cartoonists/year. Buys 6 cartoons/year from freelancers. Prefers New Age, natural living and metaphysical themes. Prefers single panel with gagline; b&w line drawings. Send query letter with samples of style and roughs to be kept on file. Write to show a portfolio. Material not filed is returned by SASE. Reports within 3 months. Buys one-time or reprint rights. Pays $25, b&w.
Illustrations: Approached by 40 illustrators/year. Works with 3 illustrators/year. Buys 25 illustrations/year from freelancers. Works on assignment only. Prefers line art with New Age, natural living and metaphysical themes. Send query letter with resume, tearsheets, photostats, photocopies, slides and photographs. Samples not filed are returned by SASE. Reports within 3 months. To show a portfolio, mail original/final art and tearsheets. Buys one-time reprint rights. Pays $75, b&w, $250, color, inside; on publication.

BOSTONIA MAGAZINE, 10 Lenox St., Brookline MA 02146. (617)353-9711. Art Director: Douglas Parker. Estab. 1900. Magazine emphasizing "innovative ideas and excellence in writing" for graduates of the university and those interested in quality writing. 4-color. Bimonthly. Circ. 145,000. Original artwork is returned to the artist after publication. Sample copies $2.50.
Cartoons: "Would be interested in creative ideas." Send query letter with samples of style. Samples are filed. Reports back within weeks only if interested. Buys first rights.
Illustrations: Buys 25 illustrations/issue, 200/year from freelancers. Works with 150-200 illustrators/year. Works on assignment only. Send resume, tearsheets, photostats, photocopies, slides and photographs. Samples are filed. Reports back within weeks only if interested. To show a portfolio, mail color and b&w thumbnails, roughs, original/final art, tearsheets, final reproduction/product, photostats, photographs and slides. Buys first rights. "Payment depends on final use and size." Pays on acceptance.
Tips: "Portfolio should include plenty of tearsheets/photocopies as handouts. Don't phone; it disturbs flow of work in office. No sloppy presentations. Show intelligence and uniqueness of style." Prefers illustrations "meant to inform and elucidate, for example, those by Paul Davis, David Levine and Eugen Mihaesco."

BOWLING DIGEST, 990 Grove St., Evanston IL 60201. Emphasizes sports. Monthly. Circ. 525,000. Original artwork returned after publication.
Cartoons: Considers sports themes. Prefers single panel; b&w line drawings or color washes. Material not filed is returned by SASE. Pays on publication.
Illustrations: Considers sports themes. Works on assignment only. Send 4-color sample tearsheets (no original art). Prefer caricatures and conceptual pieces. Samples not filed are returned by SASE. Pays on acceptance.

BOY'S LIFE, 1325 W. Walnut Hill Lane., Irving TX 75015. (214)580-2352. Design Director: Joseph Connolly. Magazine emphasizing fiction and articles on scout-related topics such as camping, nature lore, history and science. Monthly. Circ. 1,400,000.
Cartoons: Buys 5 cartoons/issue from freelancers.
Illustrations: Buys 6 b&w and 5 color illustrations/issue from freelancers. Prefers b&w work. Send query letter with photocopies and slides. Reports back within 10 days. Buys first rights. Pays $1,250-1,500 color, cover; $175-200, b&w, $950, color, inside.
Tips: "Artwork for this magazine should not be simplistic or crude and should not be geared down to kids."

BRIDAL GUIDE, 2nd Floor, 441 Lexington Ave., New York NY 10017. (212)949-4040. Design Director: Derek Burton. Estab. 1984. "Magazine for 'Brides to Be', advice on wedding gowns, wedding ceremonies, receptions, showers and married life including finance, sex, consumer tips, decorating your first home and registering for china and tableware." Bimonthly. Circ. 500,000. Accepts previously published artwork. Original artwork is returned after publication (unless bought outright). Samples copies available. Art guidelines available.
Cartoons: Buys 1-2 cartoons/issue, 6-12/year from freelancers. Prefers single panel with or without gagline; b&w line drawings and washes and color washes. Send query letter with samples of style. Samples are filed and are not returned. Reports back within 2 weeks only if interested. Negotiates rights purchased. Pays $120-250, color; on acceptance.
Illustrations: Buys illustrations mainly for spots and feature spreads. Buys 5 illustrations/issue, 30/year from freelancers. Works on assignment only. Prefers pastel. Considers pen & ink, mixed media, colored pencil, watercolor, charcoal pencil and calligraphy. Send query letter with tearsheets, photostats and photocopies. Samples are filed or are returned only if requested. Reports back only if interested. Call to schedule an appointment to show a portfolio which should include tearsheets and transparencies. Negotiates rights purchased. Pays $120, b&w; $250, color, inside.
Tips: "Best to send promo piece and follow up with a call to send portfolio if we're interested."

BRIDE'S MAGAZINE, Condé-Nast Publications, 350 Madison Ave., New York NY 10017. (212)880-8530. Art Assistant: Ashley Thompson. Estab. 1934. Magazine. Bimonthly. Original artwork is returned after publication. Sample copies free for SASE with first-class postage.
Cartoons: "No cartoons at this time. Possibly in the future." Send query letter with samples of style.
Illustrations: Buys illustrations mainly for spots and feature spreads. Buys 10 illustrations/issue from freelancers. Works on assignment only. Considers pen & ink, airbrush, mixed media, colored pencil, watercolor, acrylic, collage and calligraphy. Send query letter with brochure, tearsheets, photocopies and slides. In samples or portfolio, look for "graphic quality, conceptual, skill, good 'people' style; lively, young, but sophisticated work." Samples are filed. Reports back only if interested. Call to schedule an appointment to show a portfolio, or mail color and b&w original/final art, tearsheets, slides, photostats, photographs and transparencies. Buys one-time rights or negotiates rights purchased. Pays $100-300, b&w; $100-500, color, inside; on publication.
Tips: Sectons most open to illustrators are "Something New" (a short subject page with 4-color art); special sections (pulp paper 2-color), travel section features (black and white)."

BRIGADE LEADER, Box 150, Wheaton IL 60189. (708)665-0630. Estab. 1960. 2-color magazine for Christian laymen and adult male leaders of boys enrolled in the Brigade man-boy program. Circ. 12,000. Published 4 times/year. Original artwork returned after publication. Sample copy for $1.50 and large SASE; artist's guidelines for SASE.
Cartoons: Contact: Cartoon Editor. Approached by 30 cartoonists/year. Buys 1 cartoon/issue, all from freelancers. Receives 3 submissions/week from freelancers. Interested in sports, nature and youth; single panel with gagline. SASE. Buys first rights only. Pays $25-35, b&w line drawings; on publication.
Illustrations: Art Director: Robert Fine. Approached by 45 illustrators/year. Buys 2 illustrations/issue from freelancers. Uses freelance artists mainly for illustrations for articles. Prefers clean line & wash. Uses pen & ink, airbrush, charcoal/pencil and watercolor. Interested in man and boy subjects, sports, camping—out of doors, family. Works on assignment only. Samples returned by SASE. Reports back on future assignment possibilities. Provide resume and flyer to be kept on file for future assignments. Prefers to see portfolio and samples of style. Pays $150 and up, b&w, cover and $100-200, for inside use of b&w line drawings and washes; on publication.
Tips: Looks for "good crisp handling of b&w line work, clean washes and skill in drawing. Portfolios should have printed samples of work. We like to see original concepts and well-executed drawings. We need more work on sports and father-son activities."

BULLETIN OF THE ATOMIC SCIENTISTS, 6042 S. Kimbark, Chicago IL 60637. (312)702-2555. Production Artist: Paula Lang. Emphasizes arms control; science and public affairs for audience of 40% scientists, 40% politicians and policy makers, and 20% interested, educated citizens. B&w magazine with 4-color cover. Monthly. Circ. 25,000. Original artwork returned after publication. Sample copy $3; free artist's guidelines for SASE.
Cartoons: Buys about 5-10 cartoons/issue, including humorous illustrations, from freelancers. Considers arms control and international relations themes. "We are looking for new ideas. Please, no mushroom clouds or death's heads." Prefers single panel without gagline; b&w line drawings. Send finished cartoons. Cartoon portfolios are not reviewed. Material returned by SASE. Reports within 1 month. Buys first rights. Pays $25, b&w; on acceptance.
Illustrations: Buys 2-8 illustrations/issue from freelancers. Prefers serious conceptual b&w art with political or other thoughtful editorial themes; pen & ink, airbrush, charcoal/pencil, acrylic, oil and collage. "Do not even consider sending work until you have viewed a few issues. The name of the magazine misleads artists who don't bother to check; they wind up wasting time and postage." Works on assignment only. Send query letter with brochure and tearsheets or photostats to be kept on file, "except for completely unsuitable work which is returned promptly by SASE." Artist may write or call for appointment to show portfolio but prefers mailed samples. Reports within 1 month. Buys first world-wide rights. Pays $300, b&w, $400, color cover; $100/¼ page, $150/½ page, $250/full page, b&w, inside; on acceptance.
Tips: "Don't show design, advertising, calligraphy samples—just editorial illustration. It helps to show printed pieces within the published text so I can see how the artist interpreted the article. Also, don't bother with nude figure studies. Come on, look at the titles of the magazines you send to! A representative sampling of work is OK. Our needs are so specific that artists usually try too hard to match them—with little success."

BUSINESS & COMMERCIAL AVIATION, (Division of McGraw-Hill), 4 International Dr., Rye Brook NY 10573. (914)939-0300. Art Director: Mildred Stone. Technical publication for corporate pilots and owners of business aircraft. 4-color. Monthly. Circ. 55,000.
Illustrations: Works with 12 illustrators/year. Buys 12 editorial and technical illustrations/year from freelancers. Uses artists mainly for editorials and some covers. Especially needs full-page and spot art of a business-aviation nature. "We generally only use artists with a fairly realistic style. This is a serious business publication—graphically conservative. We have a monthly section for the commuter industry and another for the helicopter industry. These magazines will have a more consumer-magazine look and will feature more 4-

color illustration than we've used in the past. Need artists who can work on short deadline time." Query with samples and SASE. Reports in 4 weeks. Photocopies OK. Buys all rights, but may reassign rights to artist after publication. Negotiates payment. Pays $350, inside illustration and $800-1,000, color, cover; on acceptance.
Tips: "Send or bring samples. I like to buy based more on style than whether an artist has done aircraft drawings before."

CALIFORNIA APPAREL NEWS, Suite A-777, 110 E. 9th St., Los Angeles CA 90079-1777. (213)627-3737. FAX: (213)623-5707. Art Director: Jim Yousling. Advertising Art Director: Molly Rhodes. Weekly trade tabloid in modern newspaper format and bimonthly over-sized magazines with 4-color and b&w illustrations. Weekly. Circ. 720,000. Accepts previously published material. Original artwork is returned after publication. Sample copy available.
Illustrations: Approached by 100 or more freelance artists each year. Works with 10 freelance illustrators and 3 freelance designers/year. Buys 2,000 illustrations/year from freelancers. Works on assignment only. Send query letter with brochures, resume, tearsheets and photocopies. Samples are filed or returned only if requested by artist. Reports back only if interested. Call or write to schedule an appointment to show a portfolio, which should include roughs, original/final art, tearsheets and color and b&w photostats and photographs. Negotiates rights purchased. Pays $35-175 color, cover; $35 & up/b&w, $50 & up/color, inside; on publication.

***CALIFORNIA BUSINESS**, Suite 400, 4221 Wilshire Blvd., Los Angeles CA 90010. (213)937-5820, ext. 328. FAX: (213)931-8492. Art Director: Michael Walters. Estab. 1965. Monthly consumer magazine. "Business publication for executives (age 40-55) in California. The slant is personal and analytical." Circ. 140,000. Originals are returned at job's completion. Sample copies are free for SASE with first-class postage.
Illustrations: Buys 8-10 freelance illustrations/issue; 100-120/year. Works on assignment only. Prefers pen & ink, watercolor, collage, acrylic, oil and mixed media. Send query letter with tearsheets, photocopies, slides or "whatever format is convenient." Samples are filed. Reports back to the artist only if interested. Mail appropriate materials. Portfolio should include b&w tearsheets or slides "as the artist deems appropriate." Buys first rights. Pays $850 for b&w and color cover; $275 for b&w and color inside; on acceptance.
Tips: "Be familiar with the subject and the publication. Show an ability for solid conceptual thinking."

CAMPUS LIFE, 465 Gundersen Dr., Carol Stream IL 60188. Art Director: Jeff Carnehl. For high school and college students. "Though our readership is largely Christian, *Campus Life* reflects the interests of all kids — music, activities, photography and sports." Monthly. Circ. 140,000. Original artwork returned after publication. "No phone calls, please. Show us what you can do." Uses freelance artists mainly for illustration.
Cartoons: Approached by 50 cartoonists/year. Buys 100 cartoons/year from freelancers. Uses 3-8 single-panel cartoons/issue plus cartoon features (assigned) on high school and college education, environment, family life, humor through youth and politics; applies to 13-23 age groups; both horizontal and vertical format. Prefers to receive finished cartoons. Reports in 4 weeks. Pays $50 minimum, b&w; on acceptance.
Illustrations: Approached by 100 illustrators/year. Works with 10-15 illustrators/year. Buys 2 illustrations/ issue, 50/year from freelancers. Styles vary from "literal traditional to very conceptual." Works on assignment only. "Show us what you can do, send photocopies, promos or tearsheets. Please no original art transparencies or photographs. Samples returned by SASE." Reporting time varies. Buys first North American serial rights; also considers second rights. Pays $50-300, b&w, $125-400 for color, inside; on acceptance.
Tips: "I do like to see a variety in styles, but I don't want to see work that 'says' grade school. Keep sending a reminder every couple of months."

CANADIAN FICTION MAGAZINE, Box 946, Station F, Toronto, Ontario M4Y 2N9 Canada. Editor: Geoffrey Hancock. Anthology devoted exclusively to contemporary Canadian fiction. Quarterly. Canadian artists or residents only. Sample copy $9.95.
Illustrations: Buys 16 pages of art/issue; also cover art. Include SAE (nonresidents include IRC). Reports in 4-6 weeks. Pays $10/page; $25, cover. Uses b&w line drawings and photographs.
Tips: "Portraits of contemporary Canadian writers in all genres are valuable for archival purposes."

***CANADIAN PHARMACEUTICAL JOURNAL**, 1785 Alta Vista Dr., Ottawa ON K1G 3Y6 Canada. (613)523-7877. FAX: (613)523-0445. Art Director: Dick Logan. Estab. 1861. Trade journal. Magazine. Circ. 13,000. Accepts previously published artwork. Originals are returned at job's completion. Sample copies available.
Illustrations: Approached by 20 freelance illustrators/year. Buys 6 illustrations/issue, 70-100/year. Works on assignment only. "Stories are relative to the interests of pharmacists — scientific to life-style." Considers all media. Send query letter with photostats and transparencies. Samples are filed. Reports back to the artist only if interested. Call to schedule an appointment to show a portfolio, which should include slides, photostats and photographs. Rights purchased vary according to project. Pays $600-2,000 for color, cover; $200-1,000 for color, inside; on acceptance.

CANOE MAGAZINE, Box 3146, Kirkland WA 98083. (206)827-6363. Art Director: Ray Weisgerber. Estab. 1973. Magazine dealing with all types of paddle sports. Bimonthly. Circ. 44,000. Accepts previously published artwork. Original artwork is returned after publication. Sample copies free for SASE with first-class postage. Art guidelines not available.
Illustrations: Buys illustrations mainly for spots. Buys 2-5 illustrations/issue, 14-21 illustrations/year from freelancers. Works on assignment only. Prefers pen & ink. Considers colored pencil, watercolor and acrylic. Send query letter with brochure showing art style, tearsheets and photocopies. When reviewing a portfolio looks for knowledge of paddle sports. Samples are filed. Does not report back. Write to schedule an appointment to show a portfolio. Buys one-time rights. Pays $75, b&w, $600, color, inside; on publication.

***CAREER FOCUS**, Suite 225, 3100 Broadway, Kansas City MO 64111. (816)756-3039. FAX: (816)756-3018. Contact: Editorial Department. Estab. 1985. Educational, career development magazine. "A motivational periodical designed for Black and Hispanic college graduates who need career development information." Bimonthly. Circ. 250,000. Accepts previously published artwork. Originals are returned at job's completion. Sample copies and art guidelines are free for SASE with first-class postage.
Illustrations: Approached by 5 freelance illustrators/year. Buys 1 freelance illustration/issue. Send query letter with SASE, photographs, slides and transparencies. Samples are filed. Reports back to the artist only if interested. Buys one-time rights. Pays $20 for b&w, $25 for color, cover; on publication.

***CAROLINA QUARTERLY**, Greenlaw Hall 066A, University of North Carolina, Chapel Hill NC 27514. Editor: David Kellogg. Magazine "emphasizing literature for libraries and readers all over the U.S. who are interested in contemporary poetry and fiction." Publishes 3 issues/year. Magazine is "perfect-bound, finely printed." Circ. 1,000. Returns original artwork after publication. Sample copy $5 (includes postage and handling). Art guidelines free for SASE with first-class postage.
Cartoons: Approached by 5 freelance cartoonists/year. Pays $25 per artist per issue on publication.
Illustrations: Uses freelance artists mainly for covers, sometimes inside photos. Approached by 10 freelance illustrators/year. Buys up to 5 illustrations/issue. Prefers small b&w sketches. Send query letter with samples. Portfolio should include list of previous publications. Prefers color slides, b&w prints. Prefers photographs as samples. Reports within 2 months. Buys first rights. Pays $25 and comp copies; on publication.
Tips: "Do not submit sentimental, populist, amateurish work."

CARTOONS, 8490 Sunset Blvd., Los Angeles CA 90069. Contact: Dennis Ellefson. "For young males who like cars and bikes."
Cartoons: Buys 150 pages of cartoon stories and 60 single-panel cartoons/year from freelancers. Should be well-drawn, identifiable, detailed cars. Prefers to see roughs. Include SASE. Reports in 2-4 weeks. Pays $100 minimum, page; $25, single panel; $25, spot drawings.
Tips: "Check out the automotive scene in *Hot Rod* and *Car Craft* magazines. And then look at *Cartoons*." Remember to include "return address and phone number."

CAT FANCY, Fancy Publications Inc., Box 6050, Mission Viejo CA 92690. (714)855-8822. Editor: K.E. Segnar. For cat owners, breeders and fanciers. Readers are men and women of all ages interested in all phases of cat ownership. Monthly. Circ. 317,000. Simultaneous submissions and previously published work OK. Sample copy $3; free artist's guidelines.
Cartoons: Buys 12 cartoons/year from freelancers; single, double and multipanel with gagline. "Central character should be a cat." Send query letter with photostats or photocopies as samples. Send SASE. Reports in 6 weeks. Pays $20-50, b&w line drawings; on publication. Buys first rights.
Illustrations: Buys 2-5 b&w spot illustrations per issue. Article illustrations assigned. Prefers to work with local artists. Pays $20, spots; $50-100, b&w illustrations.
Tips: "We need published cartoons with an upbeat theme and realistic illustrations of purebred and mixed-breed cats."

CATHOLIC FORESTER, Box 3012, 425 W. Shuman Blvd., Naperville IL 60566-7012. (312)983-4920. Editor: Barbara Cunningham. Estab. 1883. Magazine. "We are a fraternal insurance company but use general-interest art and photos. Audience is middle-class, many small town as well as big city readers, patriotic, somewhat conservative. We are distributed nationally." Bimonthly. Circ. 150,000. Accepts previously published material. Original artwork returned after publication if requested. Sample copy for 9 × 12 SASE with 3 first-class stamps.
Cartoons: Approached by more than 50 cartoonists/year. Buys 6-7 cartoons/issue from freelancers. Considers "anything *funny* but it must be clean." Prefers single panel with gagline; b&w line drawings. Material returned by SASE if requested. Reports within 3 months; "we try to do it sooner." Buys one-time rights or reprint rights. Pays $25, b&w; on acceptance.
Illustrations: Approached by more than 20 illustrators/year. Works with 4-5 illustrators/year. Buys 145 illustrations/year from freelancers. Prefers watercolor, pen & ink, airbrush, oil and pastel. Send query letter with photostats, tearsheets, photocopies, slides, photographs, etc. to be kept on file. Samples not filed are

returned by SASE. Reports within 3 months. Write for appointment to show portfolio. Does not want to see "weird, off-beat illustrations." Buys one-time rights or reprint rights. "Payment depends on difficulty of art." Pays $30-50, b&w cover; $30-50, simple spot; $300-400 color cover; on acceptance. "We have large and small needs, so it's impossible to say."
Tips: "A list of what artist expects to be paid would be a big help—some I've contacted after receiving their samples wanted *much* more money than I can pay."

CATS MAGAZINE, Box 290037, Port Orange FL 32129. (904)788-2770. FAX: (904)788-2710. Editor: Linda J. Walton. Estab. 1945. Consumer magazine. "*Cats* is edited for those with an active involvement with cats, whether as owners or breeders." Monthly. Circ. 149,000. Original artwork returned after publication. Sample copies free for SASE with $1.25 first-class postage. Art guidelines not available. Uses freelance artists mainly for inside art.
Cartoons: Approached by 3-5 cartoonists/year. Buys 2 cartoons/issue, 12-15/year from freelancers. Prefers "humorous cat themes. No dead-cat or cruel-to-cats themes." Prefers single panel, with gagline, b&w washes and line drawings. Send query letter with finished cartoons. Most samples are filed. Those not filed are returned by SASE if requested by artist. Reports back within 5 days. Buys one-time rights. Pays $15, b&w.
Illustrations: Approached by 5-15 illustrators/year. Buys 10-12 illustrations/year. Prefers "cats" themes. Considers pen & ink, watercolor and oil. Send query letter with SASE and transparencies. Samples are filed. Reports back within 5 days. Mail appropriate materials. Pays $150, color, cover.
Tips: "Funny, well-drawn cartoons usually hit the spot with our readers. Make sure the gaglines aren't stupid. Artwork should show cats in a realistic manner." Does not want to see "cutesy cats."

CAVALIER, 2600 Douglas Rd., Coral Gables FL 33134. (305)443-2378. Managing editor: Nye Willden. Estab. 1952. Consumer magazine. "Sophisticated adult men's magazine, sexually oriented." 4-color. Monthly. Circ. 200,000. Original artwork returned after publication on request. Sample copy $3. Art guidelines available.
Cartoons: Approached by 30-50 cartoonists/year. Buys 6-7 cartoons/issue, 70-80/year from freelancers. Prefers "traditional, funny sex cartoons." Prefers single panel, with gagline; b&w washes. Send query letter with finished cartoons. Samples are not filed and are returned by SASE. Reports back within 2 weeks. Buys first rights. Pays $75/spots; $100/page, b&w; $150, color.
Illustrations: Approached by 20-30 illustrators/year. Buys 2 illustrations/issue, 24/year from freelancers. Works on assignment only. Prefers sexual themes. Considers watercolor, airbrush, acrylic, oil and mixed media. Send query letter with SASE, tearsheets, photographs, slides and transparencies. Most samples are filed. Those not filed are returned by SASE if requested. Reports back within 10 days. Call to schedule an appointment to show a portfolio, which should include color tearsheets, photocopies, original/final art and photographs. Buys first rights. Pays $200, b&w, $300, color, inside; on publication.
Tips: "Study our magazine for our style and format."

***CD REVIEW,** Wayne Green Entertainment, Forest Rd., Hancock NH 03449. (603)525-4201. FAX: (603)525-4423. Art Director: Bob Dukette. Consumer magazine. "*CD Review* is edited for those who buy or intend to buy compact discs, compact disc players and related audio system components. The editorial content consists of reviews of compact discs, compact disc players and related hardware; the news and developments in the digital audio industry; interviews and articles about the people, events and technology. *CD Review* evaluates performance and sound quality of the CDs." Monthly. Circ. 115,000. Accepts previously published artwork. Originals are returned at job's completion. Samples copies available.
Illustrations: Approached by 40-50 freelance illustrators/year. Buys 6-12 freelance illustrations/year. Works on assignment only. Prefers clever, original and conceptual themes in pen & ink, watercolor, collage, color pencil, oil, mixed media and pastel. Send query letter with tearsheets and slides. Samples are filed or returned by SASE if requested by artist. Reports back to the artist only if interested. Write and send samples to schedule an appointment to show a portfolio, which should include original/final art, tearsheets and slides. Pays $50 for b&w, $600 for color, cover; $350 for color, inside; on acceptance.
Tips: "Be available to work quickly, meet deadlines and be able to work within a tight budget."

CHESAPEAKE BAY MAGAZINE, 1819 Bay Ridge Ave., Annapolis MD 21403. (301)263-2662. Art Director: Christine Gill. Estab. 1972. Consumer magazine. "The magazine focuses on the boating environment of the Chesapeake Bay—including its history, people, places and ecology." Monthly. Circ. 35,000. Original artwork returned after publication. Sample copies free for SASE with first-class postage. Art guidelines available. "Please call."
Cartoons: Approached by 12 cartoonists/year. Prefers boating themes; single panel, with gagline, b&w washes and line drawings. Send query letter with finished cartoons. Samples are filed. Reports back to the artist only if interested. Buys one-time rights. "Please inquire about payment."
Illustrations: Approached by 12 illustrators/year. Buys 2-3 technical and editorial illustrations/issue from freelancers. Considers pen & ink, watercolor, collage, acrylic, marker, colored pencil, oil, charcoal, mixed media and pastel. For editorial illustration, "usually prefers watercolor or oil for 4-color. Style and tone are determined by the artist after they read the story." Send query letter with resume, tearsheets and photo-

graphs. Samples are filed. Reports back only if interested. Call to schedule an appointment to show a portfolio, which should include b&w and color thumbnails, tearsheets, slides, roughs, photostats, photocopies, original/final art and photographs. "Anything they've got." Does not want to see b&w photocopies. Buys one-time rights. "Price decided when contracted."

Tips: "Our magazine design is relaxed, fun, oriented toward people having fun on the water. Style seems to be loosening up. Colors brighter. Send tearsheets or call for an interview—we're always looking."

CHESS LIFE, 186 Route 9W, New Windsor NY 12550. (914)562-8350. Art Director: Jami Anson. Estab. 1939. Official publication of the United States Chess Federation. Contains news of major chess events with special emphasis on American players, plus columns of instruction, general features, historical articles, personality profiles, cartoons, quizzes, humor and short stories. Monthly. Circ. 60,000. Accepts previously published material and simultaneous submissions. Sample copy for SASE with $1.07 postage; art guidelines for SASE with first-class postage.

Cartoons: Approached by 100-150 cartoonists/year. Buys 48 cartoons/year from freelancers. All cartoons must have a chess motif. Prefers single panel with gagline; b&w line drawings. Send query letter with brochure showing art style. Material not kept on file returned by SASE. Reports within 2-4 weeks. Negotiates rights purchased. Pays $25, b&w; $40, color; on publication.

Illustrations: Approached by 75-100 illustrators/year. Works with 4-5 illustrators/year from freelancers. Buys 8-10 illustrations/year. Uses artists mainly for covers and cartoons. All must have a chess motif; uses some humorous and occasionally cartoon-style illustrations. "We use mainly b&w." Works on assignment, but will also consider unsolicited work. Send query letter with photostats or original work for b&w; slides for color, or tearsheets to be kept on file. Reports within 4 weeks. Call to schedule an appointment to show a portfolio, which should include roughs, original/final art, final reproduction/product and tearsheets. Negotiates rights purchased. Pays $100, b&w; $200, color, cover; $25, b&w; $35-50, color, inside; on publication.

Tips: "Include a wide range in your portfolio."

CHIC, Larry Flynt Publications, Suite 300, 9171 Wilshire Blvd., Beverly Hills CA 90210. (213)858-7100. Cartoon/Humor Editor: Susan Tinsley. For affluent men, 25-30 years of age, college-educated and interested in current affairs, luxuries, investigative reporting, entertainment, sports, sex and fashion. Monthly. Returns original art.

Cartoons: Publishes 20/month; 10 full-page color, 4 color spots and 6 b&w spots. Receives 300-500 cartoons from freelancers. Especially needs "outrageous material. Mainly sexual, but politics, sports OK. Topical humor and seasonal/holiday cartoons good." Mail samples. Prefers 8½x11" size; avoid crayon, chalk or fluorescent color. Also avoid, if possible, large, heavy illustration board. Samples returned by SASE only. Place name, address and phone number on back of each cartoon. Reports in 3 weeks. Buys first rights with first right to reprint. Pays $200, full page, color; $100 spot, color; $75 spot, b&w; on acceptance.

Tips: Especially needs more cartoons, cartoon breakaways or one-subject series. "Send outrageous humor—work that other magazines would shy away from. Pertinent, political, sexual, whatever. We are constantly looking for new artists to complement our regular contributors and contract artists. An artist's best efforts stand the best chance for acceptance!"

CHICAGO, 414 N. Orleans, Chicago IL 60610. (312)222-8999. Editor: Hillel Levin. Art Director: Kathy Kelley. "For active, well-educated, high-income residents of Chicago's metropolitan area concerned with quality of life and seeking insight or guidance into diverse aspects of urban/suburban life." Monthly. Circ. 204,000. Original artwork returned after publication.

Illustrations: Buys 7-8 editorial illustrations/issue from freelancers. Interested in "subjective approach often, but depends on subject matter." Works on assignment only. Query with brochure, flyer and tearsheets, photostats, photocopies, slides and photographs to be kept on file. Accepts finished art, transparencies or tearsheets as samples. Samples not filed are returned by SASE. Reports in 4 weeks. Call to schedule an appointment to show a portfolio, which should include original/final art, tearsheets and photostats. Buys first North American serial rights. Negotiates pay for covers, color-separated and reflective art. Pays $600, color, $400 minimum, b&w ($100-200 for spot illustrations); inside. Usually pays on publication.

CHICAGO LIFE MAGAZINE, Box 11311, Chicago IL 60611-0311. Publisher: Pam Berns. Estab. 1984. Consumer magazine emphasizing life-style. Bimonthly. Circ. 60,000. Accepts previously published artwork. Original artwork returned at job's completion. Sample copy free for SASE with $1.75 postage. Art guidelines not available.

Cartoons: Approached by 25 cartoonists/year. Buys 1 cartoon/issue, 6/year from freelancers. "Prefers sophisticated humor"; b&w line drawing. Send query letter with photocopies of finished cartoons. Samples are filed or are returned by SASE if requested. Reports back only if interested. Buys one-time rights. Pays $20 for cartoons.

Illustrations: Approached by 30 freelance illustrators/year. Buys 3 freelance illustrations/issue, 18/year from freelancers. Prefers "sophisticated, avant-garde or fine art. No 'cute' art, please." Considers all media. Send SASE, slides and photocopies. Samples are filed or returned by SASE. Reports back within 3 weeks. To

show a portfolio, mail appropriate material with SASE. Portfolio should include slides and photocopies. Buys one-time rights. Pays $30 for b&w, $30 for color, inside; on acceptance.

CHILD LIFE, 1100 Waterway Blvd., Box 567, Indianapolis IN 46206. (317)636-8881. Art Director: Janet K. Moir. Estab. 1921. For children 9-11. Monthly except bimonthly January/February, April/May, July/August and October/November. 4-color. Sample copy 75¢.
Illustrations: Approached by 200 illustrators/year. Works with 30 illustrators/year. Buys approximately 50 illustrations/year from freelancers on assigned themes. Especially needs health-related (exercise, safety, nutrition, etc.) themes, and stylized and realistic styles of children 9-11 years old. Uses freelance artwork mainly for stories, recipes and poems. Send query letter with brochure showing art style or resume and tearsheets, photostats, photocopies, slides, photographs and SASE. Especially looks for an artist's ability to draw well consistently. Reports in 6 weeks. To show a portfolio, mail appropriate materials or call or write to schedule an appointment; portfolio should include original/final art, b&w and 2-color and/or 4-color pre-separated art. Buys all rights. Pays $250/illustration, color, cover. Pays for illustrations inside by the job, $70-140 (4-color), $55-110 (2-color), $30-70 1 page (b&w); 30 days after completion of work. "All work is considered work for hire."
Tips: "Artists should obtain copies of current issues to become familiar with our needs. I look for the ability to illustrate children in group situations and interacting with adults and animals, in realistic or cartoony styles. Also use unique styles for occasional assignments—cut paper, collage or woodcut art. We do not purchase cartoons at this time. I do not want to see cartoons, portraits of children or slick airbrushed advertising work. It's a good idea to send out mailings of your current work—it keeps your name in the art director's mind. Often I like someone's work but won't get an appropriate assignment for some time; be patient."

CHILDREN'S DIGEST, Box 567, Indianapolis IN 46206. (317)636-8881. Contact: Art Director. Special emphasis on health, nutrition, safety and exercise for preteen children. Monthly except bimonthly January/February, March/April, May/June and July/August. Accepts previously published material and simultaneous submissions. Sample copy 75¢; art guidelines free for SASE.
Illustrations: Approached by 200 illustrators/year. Works with 50 illustrators/year. Buys 23-35 illustrations/issue, 230 illustrations/year from freelancers. Uses freelance artwork mainly for stories, articles and recipes. Works on assignment only. Send query letter with brochure, resume, samples and tearsheets to be kept on file. Write for appointment to show portfolio. Prefers photostats, slides and good photocopies as samples. Samples returned by SASE if not kept on file. Reports within 4 weeks. Buys all rights. Pays $250, color, cover; $30-70, b&w; $55-110, 2-color; $65-140, 4-color, inside; on acceptance. "All artwork is considered work for hire."
Tips: Likes to see situation and storytelling illustrations with more than 1 figure. When reviewing samples, especially looks for artists' ability to bring a story to life with their illustrations. "We welcome the artist who can illustrate a story that will motivate a casual viewer to read. I do not want to see samples of graphic design (menus, logos, etc.). To break in, pick a story already illustrated and re-illustrate it the way you would have."

CHILDREN'S PLAYMATE, Box 567, Indianapolis IN 46206. (317)636-8881. Art Director: Steve Miller. For ages 6-8; special emphasis on sports, fitness, health and nutrition. 4-color. Published 8 times/year. Sample copy sent if artist's work might be used.
Illustrations: Uses 25-35 illustrations/issue; buys 10-20 from freelancers. Interested in "stylized, humorous or realistic themes; also nature and health." Prefers pen & ink, airbrush, charcoal/pencil, colored pencil, watercolor, acrylic, oil, pastel, collage and computer illustration. Especially needs b&w and 2-color artwork for line or halftone reproduction; text and full-color cover art. Works on assignment only. Prefers to see portfolio and samples of style; include illustrations of children, families, animals—targeted to children. Provide brochure or flyer, tearsheet, stats or good photocopies of sample art to be kept on file. Send SASE. Buys all rights on a work-for-hire basis. Will also consider b&w art, camera-ready for puzzles, such as dot-to-dot, hidden pictures, crosswords, etc. Payment will vary. "All artwork is considered work for hire." Pays $225/b&w cover; up to $140 b&w, $70 color inside.
Tips: "Look at our publication prior to coming in. Stories and activities are geared to children 5-8 yrs. Illustration should be appropriate to age group. Also, gain some experience in preparation of 2-color and 4-color overlay separations."

***THE CHRISTIAN READER**, Box 220, Wheaton IL 60187. (708)668-8300. FAX: (708)668-8905. Art Director: Rai Whitlock. Estab. 1963. A bimonthly general interest magazine. "A digest of the best in Christian reading." Circ. 200,000. Accepts previously published artwork. Originals are returned at job's completion. Sample copies and art guidelines free for SASE with first-class postage.
Cartoons: Buys 2 freelance cartoons/issue. Prefers home, family, church life and general interest. Send query letter with samples of published work. Samples are filed or returned by SASE. Reports back to the artist only if interested. Buys one-time rights. Pays $100 for b&w.

Illustrations: Buys 12 freelance illustrations/issue. Works on assignment only. Prefers family, home and church life. Considers all media. Samples are filed or returned by SASE if requested by artist. Reports back only if interested. To show a portfolio, mail appropriate materials. Buys one-time rights. Pays $150 for b&w, $250 for color, inside; on publication.

Tips: "Send samples of your best work, in your best subject, and best medium. We're interested in fresh and new approaches to traditional subjects and values."

THE CHRONICLE OF THE HORSE, Box 46, Middleburg VA 22117. Editor: John Strassburger. Estab. 1937. Emphasizes horses and English horse sports for dedicated competitors who ride, show and enjoy horses. Weekly. Circ. 23,500. Sample copy and guidelines available for $2.

Cartoons: Approached by 25 cartoonists/year. Buys 1-2 cartoons/issue, 50-75/year from freelancers. Considers anything about English riding and horses. Prefers single panel with or without gagline; b&w line drawings or washes. Send query letter with finished cartoons to be kept on file if accepted for publication. Material not filed is returned. Reports within 2-4 weeks. Buys first rights. Pays $20, b&w; on publication.

Illustrations: Approached by 25 illustrators/year. "We use a work of art on our cover every week. The work must feature horses, but the medium is unimportant. We do not pay for this art, but we always publish a short blurb on the artist and his or her equestrian involvement, if any." Send query letter with samples to be kept on file until published. If accepted, insists on high-quality, b&w 8×10 photographs of the original artwork. Samples are returned. Reports within 3 weeks.

Tips: Does not want to see "current horse show champions or current breeding stallions."

THE CHURCHMAN'S HUMAN QUEST, (formerly *The Churchman*), 1074 23rd Ave. N., St. Petersburg FL 33704. (813)894-0097. Editor: Edna Ruth Johnson. Published 6 times/year. Magazine is b&w with 2-color cover. Design is "tasteful." Circ. 10,000. Original artwork returned after publication. Sample copy available.

Cartoons: Buys 2-3 cartoons/issue from freelancers. Interested in religious, political and social themes. Prefers to see finished cartoons. SASE. Reports in 1 week. Pays $7 on acceptance.

Illustrations: Buys 2-3 illustrations/issue from freelancers. Interested in themes with "social implications." Prefers to see finished art. Provide tearsheet to be kept on file for future assignments. SASE. Reports in 1 week. Pays $5, b&w spot drawings; on acceptance.

Tips: "Read current-events news so you can apply it humorously."

CINCINNATI MAGAZINE, 409 Broadway, Cincinnati OH 45202. (513)421-4300. Art Director: Tom Hawley. Estab. 1960. Consumer magazine; emphasizing the city of Cincinnati. Monthly. Circ. 30,000. Accepts previously published artwork. Original artwork returned at job's completion. Sample copies free for SASE with first-class postage. Art guidelines not available.

Cartoons: Approached by 20 cartoonists/year. Buys 4 cartoons/issue, 48/year from freelancers. "There are no thematic or stylistic restrictions." Prefers single panel; b&w line drawings. Send query letter with finished cartoons. Samples are filed or returned by SASE. Reports back within 2 months. Buys one-time rights or reprint rights. Pays $25, b&w.

Illustrations: Approached by 20 illustrators/year. Buys 6 illustrations/issue, 72/year from freelancers. Works on assignment only. Send query letter with tearsheets and photocopies. Samples should be 8½×11. Samples are filed or returned by SASE if requested by artist. Reports back only if interested. Call to schedule an appointment to show a portfolio. Buys one-time rights or reprint rights. Pays $250, color, cover; $85, b&w; $135, color, inside; on acceptance.

CINCOM SOLUTIONS MAGAZINE, 2300 Montana Ave., Cincinnati OH 45211. (513)662-2300. Art Director: Larry Hanes. Estab. 1968. Sent out internationally to users of our products. Circ. 25,000.

Illustrations: Works with 20 freelance illustrators/year. Works on assignment only. Prefers a "large variety of illustration styles from anywhere. I do not hesitate to work with people in other cities." Prefers loose, nonconservative styles or distorted styles. "I need a wide range of illustrations in all styles."

First Contact and Terms: Send query letter with resume, samples, tearsheets, slides and photocopies of b&w art. Samples are filed. Reports back about queries/submissions within 5 days. To show a portfolio, mail appropriate materials. Pays $100-500. Buys first rights.

CIRCLE K MAGAZINE, 3636 Woodview Trace, Indianapolis IN 46268. (317)875-8755. FAX: (317)879-0204. Art Director: Dianne Bartley. Estab. 1968. Kiwanis International's youth magazine for (college age) students emphasizing service, leadership, etc. 5/year. Circ. 14,000. Original artwork is returned to the artist at the job's completion. Sample copies are available.

Illustrations: Approached by more than 30 illustrators/year. Buys 1-2 illustrations/issue, 5-10/year from freelancers. Works on assignment only. No preferred themes, styles or media. "We look for variety." Send query letter with tearsheets. Samples are filed. Reports back to the artist only if interested. Mail tearsheets and slides. Pays $100, b&w, $250, color, cover; $50, b&w, $150, color, inside; on acceptance.

***CIRCLE TRACK MAGAZINE**, 8490 Sunset Blvd., Los Angeles CA 90069. (213)854-2350. Art Director: Mike Austin. Magazine emphasizing oval-track racing for enthusiasts, ages 18-40. Monthly. Circ. 110,000. Original artwork returned after publication. Sample copy and art guidelines available.
Cartoons: Buys 1-2 cartoons/issue from freelancers. Prefers technical, automotive themes. Prefers single panel, b&w line drawings. Send samples of style to be kept on file. Call for appointment to show portfolio. Material not filed is returned. Reports only if interested. Negotiates rights purchased. Pays $75, b&w; $150, color.
Illustrations: Buys 0-1 illustrations/issue from freelancers. Works on assignment only. Prefers automotive themes. Send resume. Samples not filed are returned. Reports only if interested. Call to schedule an appointment to show a portfolio, which should include original/final art. Negotiates rights purchased. Pays $200, b&w; $400, color, inside; on publication.

CLASSIC TOY TRAINS, 2107 Crossroads Circle, Waukesha WI 53187. Art Director: Lawrence Luser. Estab. 1987. Magazine emphasizing collectible toy trains. Quarterly. Circ. 73,000. Accepts previously published material. Original artwork is sometimes returned to the artist after publication. Sample copies available.
Illustrations: Buys various illustrations/issue from freelancers. Send query letter with brochure. Samples are filed or returned only if requested. Reports back only if interested. Write to schedule an appointment to show a portfolio, or mail original/final art, final reproduction/product and color and b&w photographs. Negotiates rights purchased.

CLEARWATER NAVIGATOR, 112 Market St., Poughkeepsie NY 12603. (914)454-7673. Graphics Coordinator: Nora Porter. B&w newsletter emphasizing sailing and environmental matters for middle-upper income Easterners with a strong concern for environmental issues. Bimonthly. Circ. 8,000. Accepts previously published material. Original artwork returned after publication. Sample copy free with SASE.
Cartoons: Buys 1 cartoon/issue from freelancers. Prefers editorial lampooning–environmental themes. Prefers single panel with gaglines; b&w line drawings. Send query letter with samples of style to be kept on file. Material not filed is returned only if requested. Reports within 1 month. Buys first rights. Pays negotiable rate, b&w; on publication.
Illustrations: Buys editorial and technical illustration of nature subjects. Pays $75, b&w cover; $50 b&w inside.

CLEVELAND MAGAZINE, Suite 730, 1422 Euclid Ave., Cleveland OH 44115. (216)771-2833. Contact: Edward Walsh.City magazine emphasizing local news and information. Monthly. Circ. 50,000.
Illustrations: Approached by 100 illustrators/year. Buys 5-6 editorial illustrations/issue from freelancers on assigned themes. Sometimes uses humorous illustrations. Send query letter with brochure showing art style or samples. Call or write to schedule an appointment to show a portfolio, which should include original/final art, final reproduction/product, color tearsheets and photographs. Pays $300, b&w, $400, color, cover; $200, b&w, $350, color, inside.
Tips: "Artists used on the basis of talent. We use many talented college graduates just starting out in the field. We do not publish gag cartoons but do print editorial illustrations with a humorous twist. Full page editorial illustrations usually deal with local politics, personalities and stories of general interest. Generally, we are seeing more intelligent solutions to illustration problems and better techniques."

CLUBHOUSE, Box 15, Berrien Springs MI 49103. (616)471-9009. Editor and Art Director: Elaine Trumbo. Magazine emphasizing stories, puzzles and illustrations for children ages 9-15. 6×9 format, 2-color, amply illustrated. Published 6 times/year. Circ. 10,000. Accepts previously published material. Returns original artwork after publication if requested. Sample copy for SASE with postage for 3 oz. Finds most artists through references/word-of-mouth and mailed samples received.
Cartoons: Approached by over 100 cartoonists/year. Buys 2 cartoons/issue from freelancers. Prefers animals, kids and family situation themes; single panel with gagline, vertical format; b&w line drawings. Accepts previously published material. Pays $12 b&w, inside; on acceptance.
Illustrations: Approached by over 100 illustrators/year. Buys 19-20 illustrations/issue from freelancers on assignment only in style of Debora Weber/Victoria Twichell-Jensen. Prefers pen & ink, charcoal/pencil and all b&w media. Assignments made on basis of samples on file. Send query letter with resume and samples to be kept on file. Samples returned by SASE within 1 month. Portfolio should include b&w final reproduction/product, tearsheets and photostats. Usually buys one-time rights. Pays according to published size: $30 b&w, cover; $25 full page, $18 ½ page, $15 ⅓ page, $12 ¼ page, b&w inside; on acceptance.
Tips: Prefers "natural, well-proportioned, convincing expressions for people, particularly kids. Children's magazines must capture the attention of the readers with fresh and innovative styles–interesting forms. I continually search for new talents to illustrate the magazine and try new methods of graphically presenting stories. Samples illustrating children and pets in natural situations are very helpful. Tearsheets are also helpful. I do not want to see sketchbook doodles, adult cartoons or any artwork with an adult theme. No fantasy, dragons or mystical illustrations."

COBBLESTONE MAGAZINE, 30 Grove St., Peterborough NH 03458. (603)924-7209. Editor: Carolyn Yoder. Emphasizes American history; features nonfiction, supplemental nonfiction, fiction, biographies, plays, activities, poetry for children between 8 and 14. Monthly. Circ. 47,000. Accepts previously published material and simultaneous submissions. Sample copy $3.95. Material must relate to theme of issue; subjects and topics published in guidelines which are available for SASE.

Illustrations: Uses variable number of illustrations/issue; buys 1-2 illustrations/issue from freelancers. Prefers historical theme as it pertains to a specific feature. Works on assignment only. Send query letter with brochure, resume, business card and b&w photocopies or tearsheets to be kept on file or returned by SASE. Write for appointment to show portfolio. Buys all rights. Payment varies. Artists should request illustration guidelines. Pays on publication.

Tips: "Study issues of the magazine for style used. Send samples and update samples once or twice a year to help keep your name and work fresh in our minds."

***COLLEGE MONTHLY MAGAZINE**, 332 Main St., Worcester MA 01608. (508)753-2550. FAX: (508)752-3050. Art Director: Don Landgren. Estab. 1986. A monthly college tabloid covering college life-style, and political and social problems. Circ. 75,000. Accepts previously published artwork. Sample copies available for $3. Art guidelines available.

Cartoons: Approached by 10-15 freelance cartoonists/year. Buys 2 freelance cartoons/issue, 24/year. Prefers college life-style, political and social problems; single panel. Send query letter with brochure. Samples are filed. Reports back only if interested. Buys one-time rights. Pays $10 for b&w; $20 for color.

Illustrations: Buys 1 freelance illustration/issue, 6/year. Works on assignment only. Send query letter with tearsheets. Samples are filed. Reports back only if interested. Mail appropriate materials. Portfolio should include roughs and b&w tearsheets. Buys one-time rights. Pays $20 for b&w, $30 for color, cover; $10 for b&w, $20 for color, inside; on publication.

COLLISION® MAGAZINE, Box M, Franklin MA 02038. (508)528-6211. Editor: Jay Kruza. Has an audience of new car dealers, auto body repair shops and towing companies. Articles are directed at the managers of these small businesses. Monthly. Circ. 16,000. Prefers original material but may accept previously published material. Sample copy $4. Art guidelines free for SASE with first-class postage.

Cartoons: Cartoon Editor: Brian Sawyer. Buys 3 cartoons/issue from freelancers. Prefers themes that are positive or corrective in attitude. Prefers single panel with gagline; b&w line drawings. Send rough versions or finished cartoons. Reports back in 2 weeks or samples returned by SASE. Buys all rights and reprint rights. Pays $10/single panel b&w line cartoon.

Illustrations: Buys about 2 illustrations/issue from freelancers based upon a 2-year advance editorial schedule. Send query letter with brochure, tearsheets, photostats, photocopies, slides and photographs. Samples are returned by SASE. Reports back within 15-30 days. "Payment is for assigned artwork ranging form $25 for spot illustrations up to $200 for full-page material"; on acceptance.

Tips: "Show us your style and technique on a photocopy. Include phone number and time to call. We'll suggest material we need illustrated if your work seems appropriate. We prefer clean pen & ink work but will use color."

***COLOR WHEEL**, 4 Washington Ct., Concord NH 03301. (603)228-5723. Co-editor: Frederick Moe. Estab. 1990. Literary magazine. "The subjects we are interested in are spiritual growth, interpersonal relationships and our relationship with the natural world." Published twice a year. Circ. 200. Accepts previously published artwork. Original artwork is returned at job's completion if requested. Sample copy $5.

Illustrations: Buys 4 freelance illustrations/issue, 8-10/year. Prefers spiritual or ecological themes. Considers pen & ink and collage. Send query letter with SASE and photocopies. Samples are filed or returned by SASE if requested. Reports back within 4-6 weeks. Buys first rights. Pays $10+ for b&w, $25+ for color, if used for cover, otherwise pays in copies for b&w inside illustrations. Pays on acceptance.

Tips: "Be familiar with *Color Wheel*. We are very open to artists who have never had their work published. We know intuitively when work is right for our magazine. We hope to increase payment for artwork as funds permit."

COMMONWEAL, 15 Dutch St., New York NY 10038. (212)732-0800. Contact: Editor. Estab. 1924. Public affairs journal. "Journal of opinion edited by Catholic lay people concerning public affairs, religion, literature and all the arts." B&w with 2-color cover. Biweekly. Circ. 20,000. Original artwork is returned at the job's completion. Sample copies free for SASE with first-class postage. Guidelines free for SASE with first-class postage.

Cartoons: Approached by 20-40 cartoonists/year. Buys 3-4 cartoons/issue, 60/year from freelancers. Prefers simple lines and high-contrast styles. Prefers single panel, with or without gagline; b&w line drawings. Send query letter with finished cartoons. Samples are filed or are returned by SASE if requested by artist. Reports back within 5 days. Buys first rights. Pays $8.50, b&w.

Illustrations: Approached by 20 illustrators/year. Buys 3-4 illustrations/issue, 60/year from freelancers. Prefers high-contrast illustrations that "speak for themselves." Prefer pen & ink and marker. Send query letter with tearsheets, photographs, SASE and photocopies. Samples are filed or returned by SASE if requested by artist. Reports back within 5 days. Mail b&w tearsheets, photographs and photocopies. Buys first rights. Pays $25, b&w cover; $10, b&w inside; on publication.

COMMUNICATION WORLD, Suite 600, One Hallidie Plaza, San Francisco CA 94102. (415)433-3400. Editor: Gloria Gordon. Emphasizes communication, public relations (international) for members of International Association of Business Communicators: corporate and nonprofit businesses, hospitals, government communicators, universities, etc. who produce internal and external publications, press releases, annual reports and customer magazines. Monthly except June/July combined issue. Circ. 14,000. Accepts previously published material. Original artwork returned after publication. Art guidelines available.
Cartoons: Approached by 6-10 cartoonists/year. Buys 6 cartoons/year from freelancers. Considers public relations, entrepreneurship, teleconference, editing, writing, international communication and publication themes. Prefers single panel with gagline; b&w line drawings or washes. Send query letter with samples of style to be kept on file. Material not filed is returned by SASE only if requested. Reports within 2 months only if interested. Write or call for appointment to show portfolio. Buys first rights, one-time rights or reprint rights; negotiates rights purchased. Pays $25-50, b&w; on publication.
Illustrations: Approached by 20-30 illustrators/year. Buys 6-8 illustrations/issue from freelancers. Theme and style are compatible to individual article. Send query letter with samples to be kept on file; write or call for appointment to show portfolio. Accepts tearsheets, photocopies or photographs as samples. Samples not filed are returned only if requested. Reports back within 1 year only if interested. Buys first rights, one-time rights or reprint rights; negotiates rights purchased. Pays $100, b&w and $300, color, cover; $100 maximum, b&w and $275, color, inside; on publication.
Tips: Sees trend toward "more sophistication, better quality, less garish, glitzy – subdued, use of subtle humor."

CONSERVATORY OF AMERICAN LETTERS, Box 123, South Thomaston ME 04858. (207)354-6550. Editor: Bob Olmsted. Estab. 1986. Newsletter emphasizing literature for literate, cultured adults. Quarterly. Original artwork returned after publication. Sample copy for SASE with first-class postage.
Illustrations: Approached by 30-50 illustrators/year. "Very little illustration used. Find out what is coming up, then send something appropriate. Unsolicited 'blind' portfolios are of little help." Buys first rights, one-time rights or reprint rights. Pays $150, color, cover; on acceptance.

CONSTRUCTION EQUIPMENT OPERATION AND MAINTENANCE, Construction Publications, Inc., Box 1689, Cedar Rapids IA 52406. (319)366-1597. Editor-in-Chief: C.K. Parks. Estab. 1948. Black-and-white tabloid with 4-color cover. Concerns heavy construction and industrial equipment for contractors, machine operators, mechanics and local government officials involved with construction. Bimonthly. Circ. 67,000. Original artwork not returned after publication. Free sample copy.
Cartoons: Buys 75 cartoons/year. Buys 8-10 cartoons/issue, all from freelancers. Interested in themes "related to heavy construction industry" or "cartoons that make contractors and their employees 'look good' and feel good about themselves"; single panel. Send finished cartoons and SASE. Reports within 2 weeks. Buys all rights but may reassign rights to artist after publication. Pays $15, b&w. Reserves right to rewrite captions.
Illustrations: Buys more than 20 illustrations/issue; "very few" are from freelancers. "Most of the illustrations we buy are part of a package with editorial material." Works with 2 illustrators/year. Pays $80-125; on acceptance.

THE CONSTRUCTION SPECIFIER, 601 Madison St., Alexandria VA 22314. (703)684-0300. Editor: Kristina Kessler. Estab. 1949. Emphasizes commercial (*not* residential) design and building for architects, engineers and other A/E professionals. Monthly, 4-color. Circ. 19,000. Returns original artwork after publication if requested. Sample copy for SASE. Design is conservative, but sharp.

✳ *The asterisk before a listing indicates that the listing is new in this edition. New markets are often the most receptive to freelance submissions.*

Cartoons: Cartoons are "b&w, sketchy, somewhat tongue-in-cheek." Pays $75, b&w; $125, color.
Illustrations: Works with 2-3 illustrators/year. Buys 1-2 illustrations/issue; 10-20/year from freelancers on assignment only. Send query letter with photostats, tearsheets, photocopies, slides or photographs. Samples not filed are returned by SASE. Reports back only if interested. Buys one-time rights. Pays $200, color, cover; $50-125, b&w, inside; on publication.

***THE CONSULTANT PHARMACIST,** Suite 515, 2300 9th St. S., Arlington VA 72204. (703)920-8492. FAX: (703)486-2997. Production Manager: Catherine Burdette. Estab. 1986. Trade journal. Publishes information relevant to pharmacy practice in long-term care and other extended care facilities and settings. Monthly. Circ. 11,000. Accepts previously published artwork. Originals are returned at job's completion. Sample copies free for SASE with first-class postage.
Cartoons: Approached by 1-5 freelance cartoonists. Buys 3 freelance cartoons/year. Prefers satire and humor. Send query letter with brochure. Samples are filed or returned by SASE if requested by artist. Reports back only if interested. Buys one-time rights. Pays $100 for b&w, $200 for color.
Illustrations: Approached by 1-5 freelance illustrators/year. Buys 1-2 freelance illustrations/issue, 12/year. Works on assignment only. Prefers abstract. Will consider any media. Send query letter with brochure and resume. Samples are filed or returned by SASE if requested by artist. Reports back only if interested. Mail appropriate materials. Buys one-time rights. Pays $500 for color, cover and $200 for color, inside; on publication.

CORPORATE CLEVELAND, (formerly *Ohio Business Magazine*), 1720 Euclid, Cleveland OH 44115. (216)621-1644. FAX: (216)621-5918. Editor-in-Chief: Richard Osborne. Estab. 1977. Business magazine for northeast Ohio. Monthly, 4-color. Circ. 31,000. Accepts previously published artwork. Original artwork returned at job's completion. Sample copies available. Art guidelines available.
Illustrations: Works on assignment only. Send query letter with brochure. Samples are filed. Write to schedule an appointment to show a portfolio. Buys one-time rights. Pays $50, b&w, $800, color, cover; $50, b&w, $500, color, inside.

COUNTRY AMERICA, 1716 Locust St., Des Moines IA 50336. (515)284-3031. FAX: (515)284-2700. Art Director: Jerry J. Rank. Estab. 1989. Consumer magazine "emphasizing entertainment and lifestyle for people who enjoy country life and country music." Monthly. Circ. 700,000. Original artwork sometimes returned at job's completion. Art guidelines not available.
Illustrations: Approached by 10-20 illustrators/year. Buys 1-2 illustrations/issue, 10-15 illustrations/year from freelancers on assignment only. Contact through artist rep or send query letter with brochure, tearsheets, slides and transparencies. Samples are filed. Reports back only if interested. Call or write to schedule an appointment to show a portfolio, which should include roughs, original/final art, tearsheets and slides. Rights purchased vary according to project. Pays on acceptance.

COUNTRY JOURNAL, Box 8200, Harrisburg PA 17105. Art Director: Sheryl O'Connell. Estab. 1974. Consumer magazine "featuring the how and why of country living for people who live in rural areas or who are thinking about living there. Readership aimed to middle and upper income levels." 4-color. Bimonthly. Circ. 200,000. Original artwork is returned after publication. Sample copies $4 and SASE with first-class postage.
Illustrations: Buys illustrations mainly for departments and feature spreads. Buys 8-16 illustrations/issue, 48-96/year. Works on assignment only. Considers pen & ink, mixed media, colored pencil, oils, pastels, collage, charcoal pencil, woodcuts and scratchboard. Send query letter with brochure showing art style, tearsheets, photostats, photocopies, photographs and transparencies. Looks for "ability with human form, architectural and technical illustration (but not high-tech styles)." Samples are filed. Samples not filed are returned only if requested and accompanied by SASE. Reports back about queries/submissions only if interested. Write to schedule an appointment to show a portfolio which should include original/final art, tearsheets and transparencies. Pays $500 color cover. Pays $125,b&w; $225, color, inside ¼ page; on publication.
Tips: The best advice for an illustrator is "to examine the magazine. Present samples appropriate to our style. Artists who exemplify this style include Nancy Hull, Malcolm Wells and Frank Fretz."

CRICKET, The Magazine for Children, Box 300, Peru IL 61354. Art Director: Ron McCutchan. Estab. 1973. Emphasizes children's literature for children, ages 6-14. Design is fairly basic and illustration-driven; 2-color with 2 basic text styles. Monthly. Circ. 140,000. Accepts previously published material. Original artwork returned after publication. Sample copy $1; art guidelines free for SASE.
Illustrations: Approached by 300-400 illustrators/year. Works with 75 illustrators/year. Buys 600 illustrations/year from freelancers. Needs editorial (children's) illustration in style of Trina Schart Hyman, Charles Mikolaycak, Roy Howell, Janet Stevens and Quentin Blake. Uses artists mainly for cover and interior illustration. Prefers realistic styles (animal or human figure); occasionally accepts caricature. Works on assignment only. Send query letter with brochure, samples and tearsheets to be kept on file, "if I like it." Prefers photostats and tearsheets as samples. Samples are returned by SASE if requested or not kept on file. Reports within 6-8 weeks. Portfolio should include "several pieces that show an ability to tell a continuing story or narrative."

This gouache on black paper illustra-
tion, which accompanies a poem by
Constance Levy, was done by Bonnie
MacKain of Glendale, California for
Cricket magazine. Rights and permis-
sions coordinator Mary Ann Hocking
says, "Bonnie had a lot of free rein on
this; all I suggested was to use lots of
white space to keep it snowy." MacKain
had five weeks to complete the project
and was paid $150. Hocking raves
about the professionalism of the illus-
trator: "She's always ready to hear my
suggestions but also comes up with a
lot of her own ideas; she's always on
time, and she delivers art that amazes
me."

"Snow Feet" is reprinted with permission of Margaret K.
McElderry Books, an imprint of Macmillan Publishing
Company, from *I'm Going To Pet a Worm Today and Other
Poems,* by Constance Levy. Copyright © 1991 by Constance
Levy. Originally appeared in *Cricket* Magazine.

© Bonnie MacKain 1991

Does not want to see "overly slick, cute commercial art (i.e. licensed characters and overly sentimental greeting cards)." Buys reprint rights. Pays $500, color, cover; $85-150/b&w, inside; on publication.
Tips: Freelancers have "a tendency to throw in the kitchen sink—I notice a lack of editing, which is helpful for me actually, since I can see what they've done that doesn't work. Of course, it's usually to their detriment." Today the "emphasis seems to be moving away from realism in illustration—and there is a lack of good realists who know anatomy and how the body works in movement."

***CRYPTOLOGIA,** Rose-Hulman Institute of Technology, Terre Haute IN 47803. (812)877-1511. Managing Editor: Brian J. Winkel. Estab. 1977. Emphasizes all aspects of cryptology: data (computer) encryption, history, military, science, ancient languages, secret communications for scholars and hobbyists. Quarterly. Circ. 1,000. Accepts previously published material and simultaneous submissions. Original artwork returned after publication.
Cartoons: Buys 10 cartoons/year. Uses 1-2 cartoons/issue. Prefers plays on language, communication (secret), ancient language decipherment, computer encryption. Prefers single, double or multipanel, with or without gagline; b&w line drawings or washes. Send query letter with samples of style, roughs or finished cartoons to be kept on file. Material not kept on file is returned by SASE. Reports within 2 weeks. Negotiates rights purchased. Pays $25 on acceptance.

CURRENTS, Box 6847, 314 N. 20th St., Colorado Springs CO 80904. Editor: Eric Leaper. Estab. 1979. Magazine emphasizing whitewater river running for kayakers, rafters and canoeists; from beginner to expert; middle-class, college-educated. B&w quarterly. Circ. 10,000. Accepts previously published material. Original artwork returned after publication. Sample copy $1. Art guidelines for SASE with first-class postage.
Cartoons: Buys 0-1 cartoon/issue from freelancers. Themes *must* deal with whitewater rivers or river running. Prefers single panel with gagline; b&w line drawings. Send query letter with roughs of proposed cartoon(s) to be kept on file. Samples not kept on file are returned by SASE. Reports within 6 weeks. Buys one-time rights. Pays $10-35, b&w.
Illustrations: Buys 0-2 illustrations/issue from freelancers. Prefers pen & ink. Works on assignment only. Themes must deal with rivers or river running. Send query letter with proposed illustrations. Samples not filed returned by SASE. Reports within 6 weeks. To show a portfolio, mail "whatever artists feel is necessary." Buys one-time rights. Pays $10-35, b&w; inside; on publication.
Tips: "Make sure you have seen a sample copy of *Currents* and our guidelines. Be sure you know about rivers and whitewater river sports. Art must pertain to whitewater river running. Don't send sketches that are too rough to tell if you're any good."

***THE DAIRYMAN,** 14970 Chandler St., Box 819, Corona CA 91718. (714)735-2730. FAX: (714)735-2460. Art Director: Edward Fuentes. Estab. 1922. Trade journal; magazine format; audience comprised of "Western-based milk producers (dairymen), herd size 100+, Holstein cows (black and white), cover the 13 Western

states." Monthly. Circ. 23,000. Accepts previously published artwork. Original artwork is returned at job's completion. Samples copies available. Art guidelines available.

Illustrations: Approached by 5 freelance illustrators/year. Buys 1-4 freelance illustrations/issue. Works on assignment only. Preferred themes "depends on editorial need." Considers pen & ink, airbrush, watercolor, acrylic, collage and pastel. Send query letter with brochure, tearsheets and resume. Samples are filed or are returned by SASE if requested by artist. Reports back within 2 weeks. Write to schedule an appointment to show a portfolio. Portfolio should include thumbnails, tearsheets and photographs. Buys all rights. Pays $100 for b&w, $200, color, cover; $50, b&w, $100, color, inside; on publication.

Tips: "We have a small staff. Be patient if we don't get back immediately. A follow-up letter helps. Being familiar with dairies doesn't hurt. But keep cow puns to a minimum, we've 'herd' them all. Quick turnaround will put you on the 'A' list."

© The Dairyman 1990

Illustrator Pat Bagley has "a twisted sense of humor that is very similiar to ours," says The Dairyman art director Edward Fuentes. With watercolor and ink, Bagley illustrated this cover for an article on government and FDA drug tests for dairy cows. The finished art "perfectly met our needs," he says, "reflecting the slant of the article. Also it was humorous, which we think carries more impact." The response has been interesting: "lots of comments from readers who enjoyed the humor, a few who thought the 'specimen cup' nature was in bad taste, and the drug testing boys at one State Department of Agriculture called to ask if they could have the painting!"

DC COMICS INC., 1325 Avenue of the Americas, New York NY 10010. (212)636-5400. Executive Editor: Dick Giordano. Super-hero and adventure comic books for mostly boys 7-14, plus an older audience of high school and college age. Monthly. Circ. 6,000,000. Original artwork is returned after publication.

Illustrations: Buys 22 comic pages/year. Works on assignment only. Send query letter with resume and photocopies. Do not send original artwork. Samples not filed are returned if requested and accompanied by SASE. Reports back within 2 months. Write to schedule an appointment to show a portfolio, which should include thumbnails and original/final art. Buys all rights. Payment varies on acceptance.

Tips: "Work should show an ability to tell stories with sequential illustrations. Single illustrations are not particularly helpful, since your ability at story telling is not demonstrated."

***DECOR**, 408 Olive, St. Louis MO 63102. (314)421-5445. Assistant Editor: Shawn Candela. Estab. 1890. "Trade publication for retailers of art, picture framing and related wall decor. Subscribers include gallery owners/directors, custom and do-it-yourself picture framers, managers of related departments in department stores, art material store owners and owners of gift/accessory shops." A 4-color magazine with a "simple and straightforward" design. Monthly. Circ. 24,170. Simultaneous submissions and previously published work OK. Original artwork not returned after publication. Sample copy $5.

Cartoons: Uses 6-10 cartoons/year; buys all from freelancers. Receives 5-10 submissions/week from freelancers. Cartoons are "line drawings concerning the humorous side of selling art and framing." Interested in themes of galleries, frame shops, artists and small business problems; single panel with gagline. "We need cartoons as a way to 'lighten' our technical and retailing material. Cartoons showing gallery owners' problems with shows, artists and the buying public, inept framing employees, selling custom frames to the buying public and running a small business are most important to us." Send finished cartoons. SASE. Reports in 1 month. Buys various rights. Pays $20, b&w line drawings and washes; on acceptance.

Tips: "Most of our cartoons fill one-quarter-page spaces. Hence, cartoons that are vertical in design suit our purposes better than those that are horizontal. Send good, clean drawings with return envelopes; no more than 6 cartoons at a time."

DECORATIVE ARTIST'S WORKBOOK, 1507 Dana Ave., Cincinnati OH 45207. Art Director: Carole Winters. Estab. 1987. Magazine. "A step-by-step decorative painting workbook. The audience is primarily female; slant is how-to." Bimonthly. Circ. 120,000. Does not accept previously published artwork. Original artwork is returned at job's completion. Sample copy available for $4.65. Art guidelines not available.
Cartoons: Approached by 5-10 cartoonists/year. Buys 10-15 cartoons/year. Prefers themes and styles related to the decorative painter; single panel with and without gagline; b&w line drawings. Send query letter with finished cartoons. Samples are not filed and are returned by SASE if requested by artist. Reports back within 1 month. Buys first rights. Pays $50, b&w.
Illustrations: Approached by 100 freelance illustrators/year. Buys 1 illustration/issue; 6-7/year from freelance artists. Works on assignment only. Prefers realistic and humorous themes and styles. Prefers pen & ink, watercolor, airbrush, acrylic, colored pencil, mixed media and pastel. Send query letter with brochure, tearsheets and photocopies. Samples are filed. Reports back to the artist only if interested. To show a portfolio, mail slides. Buys first rights or one-time rights. Pays $50, b&w, $150, color, inside. Pays on publication.

DELAWARE TODAY MAGAZINE, 120A Senatorial Dr., Wilmington DE 19807. (302)656-1809. Art/Design Director: Ingrid Hansen-Lynch. Magazine emphasizing regional interest in and around Delaware. Features general interest, historical, humorous, interview/profile, personal experience and travel articles. "The stories we have are about people and happenings in and around Delaware. They are regional interest stories. Our audience is middle-aged (40-45) people with incomes around $79,000, mostly educated." 4-color. "We try to be trendy in a conservative state." Monthly. Circ. 25,000. Accepts previously published material. Original artwork returned after publication. Sample copy available.
Cartoons: "I rarely buy cartoons." Open to all styles. Works on assignment only. Prefers no gagline; b&w line drawings, b&w and color washes. Send query letter with samples of style. Do not send folders of pre-drawn cartoons. Samples are filed. Reports back only if interested. Buys first rights or one-time rights. Pays $75, small; $100, large.
Illustrations: Buys approximately 3-4 illustrations/issue from freelancers. "I'm looking for different styles of editorial illustration—different techniques!" in style of Dan Yaccarino and Coco Masuda. Works on assignment only. Open to all styles. Send query letter with resume, tearsheets ("about 1-2 dozen"), slides and whatever pertains. Samples are filed. Reports back only if interested. Call to schedule an appointment to show a portfolio, which should include original/final art and color and b&w tearsheets and final reproduction/product. Buys first rights and one-time rights. Pays $75, small b&w and color; $125, large b&w and color, inside; $300, cover; on publication.

DETROIT FREE PRESS MAGAZINE, 321 W. Lafayette, Detroit MI 48226. (313)222-6737. Art Director: A.J. Hartley. Sunday magazine of major metropolitan daily newspaper emphasizing general subjects. 4-color. Weekly. Circ. 1.3 million. Original artwork returned after publication; "the third largest newspaper magazine in the country." Sample copy available.
Illustrations: Buys 1-2 illustrations/issue from freelancers. Uses a variety of themes and styles, "but we emphasize fine art over cartoons." Works on assignment only. Send query letter with samples to be kept on file unless not considered for assignment. Send "whatever samples best show artwork and can fit into 8½×11 file folder." Samples not filed are not returned. Reports only if interested. Buys first rights. Pays $450-600, color, cover; $450-600, color and $250-350, b&w, inside; on publication.

DETROIT MONTHLY MAGAZINE, 1400 Woodbridge, Detroit MI 48207. (313)446-6000. Design Director: Michael Ban. Editor: John Barron. Emphasizes "features on political, economic, style, cultural, lifestyles, culinary subjects, etc., relating to Detroit and region" for "middle and upper-middle class, urban and suburban, mostly college-educated professionals." Monthly. Circ. approximately 100,000. "Very rarely" accepts previously published material. Sample copy for SASE.
Cartoons: Approached by 25 cartoonists/year. Pays $150, b&w; $200, color.
Illustrations: Approached by 1,300 illustrators/year. Buys 10/issue from freelancers. Works on assignment only. Send query letter with samples and tearsheets to be kept on file. Write for appointment to show portfolio. Prefers anything *but* original work as samples. Samples not kept on file are returned by SASE. Reports only if interested. Pays $1,000, color, cover, $300-400, color, full page, $200-300, b&w, full page, $100, spot illustrations; on publication.
Tips: A common mistake freelancers make in presenting their work is to "send too much material or send badly printed tearsheets." Sees trends toward Russian/European poster style illustrations, post modern "big type" designs.

© Dave Cutler 1990

"That time is powerful and fleeting," is what freelance illustrator Dave Cutler says he wanted to convey on this cover for an article about aging. The art director gave him a brief summary of the text over the phone and then faxed the article to him. Cutler's deadline was five days and he was paid $600. The New York state-based illustrator says the piece is being used for additional promotions, such as on his American Showcase page and on various mailers. "It has brought a very good response," he says, "especially from newspaper magazines."

DIR COMMUNICATIONS, Suite 135, 6198 Butler Pike, Blue Bell PA 19422. (215)653-0810. FAX: (215)653-0817. Creative Director: Scott M. Stephens. Estab. 1984. Company magazines and posters for Fortune 100 companies. Monthly, quarterly, annual. Circ. 500,000. Accepts previously published artwork. Original artwork is not returned. Sample copy free for SASE with first-class postge.

Cartoons: Approached by 3 freelance cartoonists/year. Contact only through artist rep. Samples are filed and not returned. Reports back to the artist only if interested. Buys all rights. Pays $100, b&w; $150, color.

Illustrations: Approached by 10 freelance illustrators/year. Buys 40 freelance illustrations/issue. Works on assignment only. Prefers comic book and realistic styles. Considers airbrush, acrylic, oil and color pencil. Send query letter with brochure, tearsheets and photostats. Samples are filed or returned by SASE if requested by artist. Reports back to the artist only if interested. Write to schedule an appointment to show a portfolio. Mail appropriate materials. Portfolio should include original/final art, color tearsheets, photostats, photographs, slides and photocopies. Buys all rights. Pays $500, color, cover; $75, b&w, $100, color, inside. Pays on acceptance.

Tips: "Have a universally appealing style. We deal with medical and educational publications, so abstract images and style will not be considered."

DISCOVER, 3 Park Ave., New York NY 10016. (212)779-6200. Art Director: C. Warre. Estab. 1980. A science magazine. Monthly. Circ. 1 million.
Cartoons: Buys 1 cartoon/issue. Buys 40 cartoons/year. Prefers science as a theme. Prefers single panel b&w line drawings. Send query letter with samples of style. Samples are filed or are returned. Reprts back regarding queries/submissions within 1 month. Buys first rights. Pays on acceptance.
Illustrations: Buys illustrations mainly for covers, spots and feature spreads. Buys 20 illustrations/issue, 300/year from freelancers. Prefers watercolor. Considers pen & ink, airbrush, mixed media, colored pencil, acrylic, oil, pastel, collage, marker, charcoal pencil, photo engraving, scraperboard and silkscreen. Send query letter with brochure showing art style, or nonreturnable tearsheets. Samples are filed or are returned only if requested. Reports back within 1 month. Mail appropriate materials to show a portfolio. Buys first rights. Pays on acceptance.
Tips: Would like to see technical, anatomical, science maps, schematic diagrams, astronomical, geological and archeological illustrations.

***DIVER MAGAZINE,** Suite 295, 10991 Shellbridge Way, Richmond, British Columbia V6X 3C6 Canada. (604)273-4333. Editor/Publisher: Peter Vassilopoulos. Emphasizes scuba diving, ocean science and technology (commercial and military diving) for a well-educated, outdoor-oriented readership. Published 9 times/year. Circ. 25,000. Sample copy $3; art guidelines for SAE (nonresidents include IRC).
Cartoons: Buys 1 cartoon/issue from freelancers. Interested in diving-related cartoons only. Prefers single panel b&w line drawings with gagline. Send samples of style. SAE (nonresidents include IRC). Reports in 2 weeks. Buys first North American serial rights. Pays $15 for b&w; on publication.
Illustrations: Interested in diving-related illustrations of good quality only. Prefers b&w line drawings for inside. Send samples of style. SAE (nonresidents include IRC). Reports in 2 weeks. Buys first North American serial rights. Pays $7 minimum for inside b&w; $100 minimum for color cover and $15 minimum for inside, color; 1 month after publication.

DOG FANCY, Box 6050, Mission Viejo CA 92690. (714)240-6001. Editor: Kim Thornton. Estab. 1970. 4-color magazine for dog owners and breeders of all ages, interested in all phases of dog ownership. Monthly. Circ. 150,000. Simultaneous submissions and previously published work OK. Sample copy $4; free artist's guidelines with SASE.
Cartoons: Buys 24 cartoons/year from freelancers; single, double or multiple panel. "Central character should be a dog." Mail finished art. Send SASE. Prefers photostats or photocopies as samples. Reports in 6 weeks. Buys first rights. Pays $35, b&w line drawings; on publication.
Illustrations: Buys 10 illustrations/year from freelancers, mainly for spot art and article illustration. Prefers local artists. Works on assignment only. Buys one-time rights. Pays $20, spot, $50-100, b&w illustrations; on publication.
Tips: "Spot illustrations are used in nearly every issue. I need dogs in action (doing just about anything) and puppies. Please send a selection that we can keep on file. Drawings should be scaled to reduce to column width (2¼")."

THE DOLPHIN LOG, The Cousteau Society, 8440 Santa Monica Blvd., Los Angeles CA 90069. (213)656-4422. Editor: Pamela Stacey. Educational magazine covering "all areas of science, natural history, marine biology, ecology and the environment as they relate to our global water system." For children ages 7-15. A 4-color, 20-page bimonthly, 8×10 trim size. Circ. 110,000. Sample copy for $2 and SASE with 65¢ postage; art guidelines for SAE with first-class postage.
Cartoons: Cartoons are used very rarely. Considers themes or styles related to magazine's subject matter. Prefers single panel with or without gagline; b&w line drawings. No talking animals. Send query letter with samples of style. Reports within 1 month. Buys one-time rights, reprint rights and translation rights. Pays $25-75, b&w and color; on publication.
Illustrations: Buys approximately 10 illustrations/year. Uses simple, biologically and technically accurate line drawings and scientific illustrations. Subjects should be carefully researched. Prefers pen & ink, airbrush and watercolor. Send query letter with tearsheets and photocopies or brochure showing art style. "No portfolios. We review only tearsheets and/or photocopies. No original artwork, please." Samples are returned upon request with SASE. Reports within 1 month. Buys one-time rights and worldwide translation rights. Pays $25-200 on publication.
Tips: "Artists should first request a sample copy to familiarize themselves with our style. Do not send art which is not water-oriented."

DRAGON MAGAZINE, TSR, Inc., Box 111, Lake Geneva WI 53147. (414)248-3625. Editor: Roger Moore. Art Director: Larry Smith. For readers interested in role-playing games, particularly "Dungeons & Dragons." 4-color and b&w approx. 50/50 split; "our magazines are game oriented, thus they should look fun." Circ. 90,000. Query with samples and SASE. Usually buys first rights only. Pays within 60 days after acceptance.

Cartoons: Approached by 100 cartoonists/year. Buys 80 cartoons/year from freelancers on fantasy role-playing. Pays $40, b&w only.

Illustrations: Approached by 100 illustrators/year. Buys at least 100 illustrations/year from freelancers on fantasy and science fiction subjects. Send slides, b&w or color photocopies. Wants to see "samples that show complete compositions—not spot drawings or portrait-style work, style can vary, but figure work must be first rate, historical and fantasy reference must be accurate." Style of Larry Elmore, Jeff Easley and Jim Holloway. Does not want to see "single figure drawings, morbid subjects, bad taste in general." Pays $250, b&w, $500 and up, color, inside; $900 and up, color, cover.

Tips: "The more particular the work is to the 'Dungeons & Dragons' game the better. Do not send any material larger than 8½×11. Due to the recession we are buying more ½ page illustration than full page work. Other than that it's not affecting us at all. Art is integral to our product."

ECLIPSE COMICS, Box 1099, Forestville CA 95436. Editor-in-Chief: Catherine Yronwode. Estab. 1978. Publishes comic books and graphic albums. "Most of our comics feature fictional characters in action-adventures. Genres include super-heroes, science fiction, weird horror, detective adventure, literary adaptations, etc. We also publish a line of nonfiction comics (graphic journalism) dealing with current and historic political and social subjects. The emphasis is on drawing the human figure in action. Audience is adolescent to adult." Publishes 20 comics/month on average. Some are monthlies, some bimonthly; others are one-shots or mini-series. Magazines are saddle-stitched or perfect-bound, 4-color or b&w with 4-color cover, using bright, clever colors, dramatic covers, interiors in comic book form. Circ. 30,000-100,000, depending on title. Does not accept previously published material except for reprint collections by famous comic book artists. Original artwork returned after publication. Sample copy $2; art guidelines for SASE.

Cartoons: "We buy entire illustrated stories, not individual cartoons. We buy approximately 6,250 pages of comic book art by freelancers/year—about 525/month." Interested in realistic illustrative comic book artwork—drawing the human figure in action; good, slick finishes (inking); ability to do righteous 1-, 2- and 3-point perspective required. Formats: b&w line drawings or fully painted pages with balloon lettering on overlays. Send query letter with samples of style to be kept on file. "Send minimum of 4-5 pages of full-size (10×15) photocopies of pencilled *storytelling* (and/or inked too)—no display poses, just typical action layout continuities." Material not filed is returned by SASE. Reports within 2 months by SASE only. Buys first rights and reprint rights. Pays $100-200/page, b&w; "price is for pencils plus inks; many artists do only pencil for us, or only ink." Pays $25-35/page for painted or airbrushed coloring of greylines made from line art. Pays $200-400/page, fully painted comics; on acceptance (net 30 days).

Illustrations: "We buy 12-15 cover paintings for science fiction and horror books per year." Science fiction paintings: fully rendered science fiction themes (e.g. outer space, aliens); horror paintings: fully rendered horror themes (e.g. vampires, werewolves, etc.). Send query letter with business card and samples to be kept on file. Prefers slides, color photos or tearsheets as samples. Samples not filed are returned by SASE. Reports within 2 months by SASE only. Buys first rights or reprint rights. Pays $200-500, color; on acceptance (net 30 days). "We also buy paintings for our popular political and baseball trading card sets; each set consists of 36 small painted caricatures or portraits. Trading card art pays $3,700 per set of paintings; on acceptance (net 30 days)."

EMERGENCY MEDICINE MAGAZINE, Cahners Publishing Company, 249 W. 17th St., New York NY 10011. (212)645-0067. Art Director: Lois Erlacher. Estab. 1969. Emphasizes emergency medicine for primary care physicians, emergency room personnel, medical students. Bimonthly. Circ. 129,000. Returns original artwork after publication.

Cartoons: "We rarely use cartoons."

Illustrations: Works with 70 illustrators/year. Buys 3-12 illustrations/issue, 100-200/year from freelancers. Prefers all media except marker and computer illustration. Works on assignment only. Send tearsheets, transparencies, original art or photostats to be kept on file. Samples not filed are not returned. To show a portfolio, mail appropriate materials. Reports only if interested. Buys first rights. Pays $750, color, cover; $100-500, b&w and $250-600, color, inside; on acceptance.

Tips: "Portfolios may be dropped off Tuesdays only and picked up Thursdays. All portfolios will be reviewed by art directors from other Cahners publications as well. Contact Annabell Carter. Do not show marker comps. Show a minimum of 4×5 transparencies; 8×10's are much better. In general, slides are too small to see in a review."

EMPLOYEE SERVICES MANAGEMENT MAGAZINE, NESRA, 2400 S. Downing Ave., Westchester IL 60154. (312)562-8130. Editor: Elizabeth D. Martinet. Emphasizes the field of employee services and recreation for human resource professionals, employee services and recreation managers and leaders within corporations, industries or units of government. Published 10 times/year. Circ. 5,500. Accepts previously published material. Returns original artwork after publication. Sample copy for SASE with 72¢ postage; art guidelines for SASE with first-class postage.

Art © Elman Brown 1991, Text © Richard Matheson 1991

It was "his moody, dense style" that Eclipse Enterprises editor-in-chief Catherine Yronwode says moved her to assign this project to Elman Brown of Staten Island, New York. Yronwode was introduced to Brown by the writer who adapted this graphic album from a science fiction/horror novel. The illustration communicates the "dark, terrible fate of a lone man struggling to survive in a world gone mad," says Yronwode. "The creepy repetition of the story is mirrored in the obsessively detailed crosshatching of the art."

Illustrations: Approached by 5-10 illustrators/year. "We usually use watercolors, colorful images which portray issues in the business environment (i.e., stress, travel plans, fitness/wellness, etc.)." Buys 0-1 illustration/issue from freelancers. Works on assignment only. Send query letter with resume and tearsheets or photographs to be kept on file. Samples not filed are returned only if requested. Reports within 1 month. Buys one-time rights. Pays $100-200, b&w and $300-400, color, covers; on acceptance.

Tips: Looking for "illustrations with clean lines in bright colors pertaining to human resources issues. I like to be surprised; 'typical' illustrations bore me." Sees as trend "the use of computer graphic programs to enhance, create or 'play with' an illustration."

ENDLESS VACATION MAGAZINE, 3502 Woodview Trace, Indianapolis IN 46268. (317)871-9417. FAX: (317)871-9507. Art Director: Stan Sams. Estab. 1975. Consumer magazine; 4-color; "we are a travel magazine published for people dedicated to vacationing." Monthly. Circ. 750,000. Original artwork returned at job's completion. Sample copies available. Art guidelines not available.

Cartoons: Cartoons appearing in magazine "depict travel situations, clean fun." Pays $300 for color spot.

Illustrations: Buys 2-3 illustrations/issue, 20/year from freelancers. Works on assignment only. Usually prefers "positive and fun" themes and "clean, detailed and literal" styles like Norm Bendell and Bart Forbes. Considers mixed media, watercolor, pastel and collage. Send query letter with tearsheets. Samples are filed or returned by SASE if requested by artist. Reports back only if interested. To show a portfolio, mail tearsheets and slides. "If sending slides, send SASE for their return." Buys first rights. Pays $300 and up, color, inside; on acceptance.

Tips: "Send non-returnable samples of work for our files. Be sure to send enough to give us an idea of your style. No phone calls please. The recession is not affecting our need for freelance artists very much."

ENTREPRENEUR MAGAZINE, 2392 Morse Ave., Box 19787, Irvine CA 92714-6234. Editor: Rieva Lesonsky. Design Director: Richard R. Olson. Magazine offers how-to information for starting a business, plus ongoing information and support to those already in business. 4-color. Monthly. Circ. 340,000. Original artwork returned after publication.
Illustrations: Approached by 36 illustrators/year. Uses varied number of illustrations/issue; buys varied number/issue from freelancers. Needs editorial illustration "some serious, some humorous depending on the article. Illustrations are used to grab readers' attention." Style of Shawn McKelvey, John Rowe, John McKinley, Anthony Sigala. Works on assignment only. Send query letter with resume, samples and tearsheets to be kept on file. Does not want to see photocopies. Write for appointment to show portfolio. Buys first rights. Pays $800, color, cover; $200-600, color, inside; on acceptance.
Tips: Freelancers should "have a promo piece to leave behind." A developing trend is the "use of a combination of different media—going away from airbrush to a more painterly style."

ENVIRONMENT, 4000 Albemarle St. NW, Washington DC 20016. (202)362-6445. Production Graphics Editor: Amie Freling. Estab. 1958. Emphasizes national and international environmental and scientific issues. Readers range from "high school students and college undergrads to scientists, business and government leaders and college and university professors." Black-and-white magazine with 4-color cover. Circ. 16,000. Published 10 times/year. Original artwork returned after publication if requested. Sample copy $4.50; cartoonist's guidelines available.
Cartoons: Buys 1-2 cartoon/issue; all from freelancers. Receives 5 submissions/week from freelancers. Interested in single panel line drawings or b&w washes with or without gagline. Send finished cartoons and SASE. Reports in 2 months. Buys first North American serial rights. Pays $35, b&w cartoon; on publication.
Illustrations: Buys 0-10/year from freelance artists. Uses illustrators mainly for cover design, promotional work and occasional spot illustrations. Send query letter, brochure, tearsheets and photocopies. To show a portfolio, mail original/final art or reproductions. Pays $300 color, cover; $100 b&w, $200, color, inside; on publication.
Tips: "Regarding cartoons, we prefer witty or wry comments on the impact of humankind upon the environment." For illustrations, "we are looking for an ability to communicate complex environmental issues and ideas in an unbiased way. Send samples of previously published work and samples of different styles."

EVANGEL, Box 535002, Indianapolis IN 46253-5002. (219)267-7656. Contact: Vera Bethel. Readers are 65% female, 35% male; ages 25-31, married, city-dwelling, mostly non-professional high school graduates. Circ. 35,000. 8-page 5½×8½ weekly, 2-color.
Cartoons: Approached by 20 cartoonists/year. Buys 1 cartoon/issue from freelancers on family subjects. Pays $10, b&w; on publication. Mail finished art.
Illustrations: Approached by 10 illustrators/year. Buys 1 illustration/issue from freelancers on assigned themes. Pays $50, 2-color; on acceptance. Query with samples or slides and SASE. Reports in 1 month.

EXECUTIVE FEMALE, 127 W. 24th St., New York NY 10011. (212)645-0770. Editor-in-Chief: Basia Hellwig. Estab. 1978. Association magazine NAFE. "Get ahead guide for women executives, which includes articles on managing employees, personal finance, starting and running a business." Circ. 250,000. Accepts previously published artwork. Original artwork is returned after publication.
Cartoons: Send query letter with roughs. Samples are filed. Responds only if interested. Buys first or reprint rights. Pays $25-50, b&w; $250, color (4 panels).
Illustrations: Buys illustrations mainly for spots and feature spreads. Buys 7 illustrations/issue. Works on assignment only. Send query letter with brochure, resume and tear sheets. Samples are filed. Responds only if interested. Call to schedule an appointment to show a portfolio. Buys first or reprint rights. Pays $50-200, b&w; $75-300, color, inside; on publication.

EXPECTING MAGAZINE, 685 3rd Ave., New York NY 10017. (212)878-8700. Art Director: Claudia Waters. Estab. 1967. Emphasizes pregnancy, birth and care of the newborn; for pregnant women and new mothers. Quarterly. Circ. 1.2 million, distributed through obstetrician and gynecologist offices nationwide. Original artwork returned after publication.
Illustrations: Approached by 40-50 illustrators/year. Buys approximately 6 illustrations/issue. Color only. Works on assignment. "We have a drop-off policy for looking at portfolios; I make appointments if time permits. Include a card to be kept on file. Do *not* send actual samples of work; send only *nonreturnable* copies for our files." Buys one-time rights. Pays $200 and up for color, inside; within 30 days after publication.
Tips: "I need examples of 'people' illustrations. Bright colors. Very stylized work. Almost all of the illustrations I assign are about moms, dads, babies and sometimes I need a still life."

***THE FAMILY,** 50 St. Paul's Ave., Boston MA 02130. (617)522-8911. FAX: (617)522-4081. Art Director: Sr. Mary Joseph. Estab. 1952. Religious (Catholic) family-oriented magazine. *"The Family* magazine is committed to helping families grow in the awareness of the heritage that is theirs, in reverence for the dignity of persons, in understanding of Catholic teaching, and in holiness of purpose." Monthly. Circ. 10,000. Original artwork is returned at the job's completion. Sample copies free for SASE with first-class postage.
Illustrations: Approached by 50 freelance illustrators/year. Buys 2 freelance illustrations/issue; 20/year. Works on assignment only. Prefers realistic style. Considers pen & ink, airbrush, color pencil, mixed media, watercolor, acrylic, oil, pastel, marker, charcoal. Send query letter with brochure, resume, SASE, tearsheets, photocopies, slides and transparencies. Samples are filed. Reports back within 3-4 months. Pays $200 for color cover. Pays $100 for b&w, $125 for color inside.
Tips: "Send samples of your artwork with requests for guidelines."

FAMILY CIRCLE, 110 5th Ave., New York NY 10011. (212)463-1000. Art Director: Doug Turshen. Circ. 7,000,000. Supermarket-distributed publication for women/homemakers covering areas of food, home, beauty, health, child care and careers. 17 issues/year. Does not accept previously published material. Original artwork returned after publication. Sample copy and art guidelines not available.
Cartoons: No unsolicited cartoon submissions accepted. Reviews in office first Wednesday of each month. Buys 1-2 cartoons/issue. Prefers themes related to women's interests from a feminist viewpoint. Uses limited seasonal material, primarily Christmas. Prefers single panel with gagline, b&w line drawings or washes. Buys all rights. Pays $325 on acceptance. Contact Christopher Cavanaugh, (212)463-1000, for cartoon query only.
Illustrations: Buys 20 illustrations/issue from freelancers. Works on assignment only. Reports only if interested. Provide query letter with samples to be kept on file for future assignments. Prefers slides or tearsheets as samples. Samples returned by SASE. Prefers to see finished art in portfolio. Submit portfolio on "portfolio days," every Wednesday. All art is commissioned for specific magazine articles. Reports in 1 week. Buys all rights on a work-for-hire basis. Pays on acceptance.

FANTAGRAPHIC BOOKS, 7563 Lake City Way, Seattle WA 98115. (206)524-1967. FAX: (206)524-2104. Contact: Gary Groth or Kim Thompson. Publishes comic books and graphic novels. Titles include *Love and Rockets, Amazing Heroes, Los Tejanos, Hate, Eightball, Graphic Story Monthly, Sinner, Yahoo* and *Unsupervised Existence.* All genres except superheroes. Monthly and bimonthly depending on titles. Circ. 8-30,000. Sample copy $2.50.
Cartoons: Approached by 500 cartoonists/year. Fantagraphic is looking for artists who can create an entire product or who can work as part of an established team. Most of the titles are b&w. Send query letter with photocopies which display storytelling capabilities, or submit a complete package. All artwork is creator-owned. Buys one-time rights usually. Payment terms vary. Creator receives an advance upon acceptance and then royalties after publication.
Tips: "We prefer not to see illustration work unless there is some accompanying comics work. We also do not want to see unillustrated scripts." A common mistake freelancers make is that they "sometimes fail to include basic information like name, address, phone number, etc. They also fail to include SASE. In comics, I see a trend away from 'classical' representation toward more personal styles. In illustration in general, I see more and more illustrators who got their starts in comics appearing in national magazines."

FATE MAGAZINE, Box 64383, St. Paul MN 55164. (612)291-1970. FAX: (612)291-1908. Art Director: Terry Buske. Estab. 1948. Consumer magazine; "true reports of the strange and unknown; focus on parapsychology, UFOs, the paranormal, monsters, archaeology, lost civilizations, new science, ghosts, etc." Monthly. Circ. 100,000. Accepts previously published artwork. Original artwork returned after publication. Sample copies are available. Art guidelines free for SASE with first-class postage.
Illustrations: Approached by 75-100 illustrators/year. Buys 1 illustration/issue, 12-20/year from freelancers. Works on assignment only. Prefers very professional and modern pulp styles and a knowledge of the subject. Considers airbrush, acrylic and oil. Send query letter with brochure, tearsheets, photographs, slides and SASE. Samples are filed or returned by SASE if requested. Reports back within 1-1½ months. Mail b&w and color tearsheets, photographs and slides. Negotiates rights purchased. Pays $200-400, color, cover; net 30 after acceptance.
Tips: "Have a good knowledge of the subject matter and pulp magazine style. Not all of our covers are pulp, however. We also use very nice modern paintings and a variety of styles. We want the artist to have fun."

FFA NEW HORIZONS, (formerly *National Future Farmer*), Box 15160, Alexandria VA 22309. (703)360-3600. Editor-in-Chief: Wilson W. Carnes. For members of the Future Farmers of America who are students of vocational agriculture in high school, ages 14-21. Emphasizes careers in agriculture/agribusiness and topics of general interest to youth. 4-color. Bimonthly. Circ. 396,536. Reports in 3 weeks. Buys all rights. Pays on acceptance. Sample copy available.
Cartoons: Approached by 25 cartoonists/year. Buys 30 cartoons/year from freelancers on Future Farmers of America or assigned themes. Receives 10 cartoons/week from freelance artists. Pays $20, cartoons; more for assignments.

Illustrations: Approached by 20 illustrators/year. "We buy a few illustrations for specific stories; almost always on assignment." Send query letter with tearsheets or photocopies. Write to schedule an appointment to show a portfolio, which should include final reproduction/product, tearsheets and photostats. Negotiates payment.
Tips: Wants to see "b&w line art; several pieces to show style and general tendencies; printed pieces." Does not want to see "slides of actual 4-color original art." Sees "a glut of poor computer graphics. It all looks the same."

FIELD & STREAM MAGAZINE, 2 Park Ave., New York NY 10016. (212)779-5294. Art Director: Victor J. Closi. Magazine emphasizing wildlife hunting and fishing. Monthly. Circ. 2 million. Original artwork returned after publication. Sample copy and art guidelines for SASE.
Illustrations: Approached by 200-250 illustrators/year. Buys 9-12 illustrations/issue from freelancers. Works on assignment only. Prefers "good drawing and painting ability, realistic style, some conceptual and humorous styles are also used depending on magazine article." Wants to see "emphasis on strong draftsmanship, the ability to draw wildlife and people equally well. Artists who can't, please do not apply." Send query letter with brochure showing art style or tearsheets and slides. Samples not filed are returned only if requested. Reports only if interested. Call or write to schedule an appointment to show a portfolio, which should include roughs, original/final art, final reproduction/product and tear sheets. Buys first rights. Payment varies: $75-300 simple spots; $500-1,000, single page, $1,000 and up, spreads, and $1,500 and up, covers; on acceptance.
Tips: Wants to see "more illustrators who can handle simple pen & ink and 2-color art besides 4-color illustrations, who are knowledgeable about hunting and fishing."

***FIFTY SOMETHING MAGAZINE**, 8250 Tyler Blvd., Mentor OH 44060. (216)974-9594. FAX: (216)974-1004. Editor: Linda L. Lindeman. Estab. 1990. Bimonthly consumer magazine. "We cater to the fifty-plus age group with upbeat information, feature stories, travel, romance, finance and nostalgia. Circ. 25,000. Accepts previously published artwork. Original artwork is returned at the job's completion. Sample copies free for 10×12 envelope with $1 postage.
Cartoons: Approached by 50 freelance cartoonists/year. Buys 3 freelance cartoons/issue; 18/year. Prefers funny issues on aging. Prefers single panel with gagline and b&w line drawings. Send query letter with brochure, roughs and finished cartoons. Samples are filed. Reports back only if interested. Buys one-time rights. Pays $10, b&w and color.
Illustrations: Approached by 50 freelance illustrators/year. Buys 2 freelance illustrations/issue; 12/year. Prefers old-fashioned, nostalgia. Considers all media. Send query letter with brochure, photographs, photostats, slides and transparencies. Samples are filed. Reports back only if interested. Mail appropriate materials. Portfolio should include thumbnails, original/final art, b&w photographs, slides and photocopies. Buys one-time rights. Pays $25, b&w, $100, color, cover; $25, b&w, $75, color inside; on publication.

FINESCALE MODELER, 21027 Crossroads Circle, Waukesha WI 53187. Art Director: Lawrence Luser. Estab. 1972. Magazine emphasizing plastic modeling. Circ. 73,000. Accepts previously published material. Original artwork is returned to the artist after publication. Sample copy and art guidelines available.
Illustrations: Prefers technical illustration "with a flair." Send query letter with brochure. Samples are filed or returned only if requested by artist. Reports back only if interested. Write to schedule an appointment to show portfolio or mail color and b&w tearsheets, final reproduction/product, photographs and slides. Negotiates rights purchased.
Tips: "Show b&w and color technical illustration. I want to see automotive, aircraft and tank illustrations."

FIRST HAND LTD., 310 Cedar Lane, Teaneck NJ 07666. (201)836-9177. Art Director: Laura Patricks. Emphasizes homoerotica for a male audience. Monthly. Circ. 60,000. Sample copy $3; art guidelines available for SASE.
Cartoons: Buys 5 cartoons/issue from freelancers. Prefers single panel with gagline; b&w line drawings. Send finished cartoons to be kept on file. Material not filed is returned by SASE. Reports back within 2 weeks. Buys first rights. Pays $15, b&w; on acceptance.
Illustrations: Buys 20 illustrations/issue from freelancers. Prefers "nude men in a realistic style; very basic, very simple." Send query letter with photostats or tearsheets to be kept on file or returned. Reports within 2 weeks. Call or write for appointment to show portfolio. Buys all magazine rights. Pays for design by the hour, $10. Pays $25-50, b&w, inside; on acceptance.
Tips: "I like to see current work, not work that is too old. And I prefer to see printed samples if that is possible."

FIRST PUBLISHING, 435 N. LaSalle, Chicago IL 60610. (312)670-6770. Art Director: Mike McCormick. Publishes comic books and graphic novels including *Badger, Nexus* and *Dreadstar*.
Illustrations: Prefers comic storytelling with well-realized figures. Uses freelance artists for inking, lettering, penciling, color work and covers. Send query letter with photocopies of original art, which should be proportional to 10x15; include your name, address and phone number on every sample page. Samples are sometimes

filed. Call to schedule an appointment to show a portfolio. Negotiates rights purchased and payment. All material is invoiced. Pays $200 and up, cover; $50 and up, pencil and ink, $20 and up, color, $15 and up, letters; inside. Payment is 30-60 days after acceptance.
Tips: "I'd rather see what the artist considers his strongest work, rather than his attempt to imitate the current editorial product."

***FLING**, Relim Publishing Co., 550 Miller Ave., Mill Valley CA 94941. (415)383-5464. Editor: Arv Miller. Bimonthly. Emphasizes sex, seduction, sports, underworld pieces, success stories, travel, adventure and how-to for men, 18-34. Sample copy $5.
Cartoons: Prefers sexual themes. "The female characters must be pretty, sexy and curvy, with extremely big breasts. Styles should be sophisticated and well drawn." Pays $30, b&w, $50-100, color; on acceptance.

FLORIDA LEADER MAGAZINE, Box 14081, Gainesville FL 32604-2081. (904)373-6907. Art Director: Jeffrey L. Riemersma. Estab. 1983. *"Florida Leader Magazine* is a college-oriented publication that blends trendy feature articles, news from Florida schools, plus hard-hitting investigative reporting and interviews that debate important student issues." Bimonthly, 4-color. Circ. 27,000. Accepts previously published artwork. Original artwork is not returned after publication, unless requested by artist. Sample copies free for SASE with first-class postage. Art guidelines available. Design is "contemporary, colorful, upbeat and usually satirical or humorous."We use freelancers for all inside illustrations."
Illustrations: Approached by 20-30 illustrators/year. Buys illustrations mainly for spots and feature spreads. Buys 4-5 illustrations/issue, 32/year from freelancers. Works on assignment only. Considers pen & ink, airbrush, mixed media, colored pencil, acrylic, oil, pastel and collage. Send query letter with brochure showing art style and tearsheets. Looks for originality, technique, use of color, ability to draw human figure and caricatures. Samples are filed or returned by SASE. Reports back about queries/submissions only if interested. Negotiates rights purchased. Call or write to schedule an appointment to show a portfolio, mail color and b&w original/final art or tearsheets. Pays $35, b&w; $50, color, inside; on publication.
Tips: "Two oversights freelancers make in presenting their work are not describing the project and media used in enough detail and sending only black-and-white examples—we use color far more than b&w currently."

FLORIST, Florists Transworld Delivery Association, Box 2227, Southfield MI 48037. (313)355-9300. Editor-in-Chief: William Golden. Production Manager: Margaret Baumgarten. Managing Editor: Susan Nicholas. Emphasizes information pertaining to the operation of the floral industry. For florists and floriculturists. Monthly. Circ. 24,000. Reports in 1 month. Accepts previously published material. Does not return original artwork after publication.
Cartoons: Buys 3 cartoons/issue. Interested in retail florists and floriculture themes; single panel with gagline. Mail samples or roughs. SASE. Buys one-time rights. Pays $20, b&w line drawings; on acceptance.
Illustrations: Works on assignment only. Send query letter with photostats, tearsheets, photocopies, slides or photographs. Samples not filed are returned by SASE. Reports within 3 months. To show a portfolio, mail final reproduction/product, tearsheets, photostats and photographs. Buys first rights.

FLYING MAGAZINE, 500 W. Putnam Ave., Greenwich CT 06830. FAX: (203)622-2725. Art Director: Nancy Bink. Consumer magazine emphasizing airplanes and pilots. "We use lots of 4-color photography and illustrations." Monthly. Circ. 325,000. Original artwork returned after publication. Sample copies are available. Photo guidelines are available.
Illustrations: Approached by 50-100 illustrators/year. Buys 2-3 illustrations/issue, 24-36/year from freelancers. Works on assignment only. Theme preferred is "airplanes." Any media is acceptable. Contact through artist rep or send query letter with tearsheets. Samples are filed. Reports back only if interested. Write to schedule an appointment to show portfolio which should include roughs, original/final art and tearsheets. Buys one-time rights. Pays $150, b&w, $500, color; inside "more depending on the size and complexity"; on acceptance.
Tips: "Understand and love airplanes and flying."

FOOD & SERVICE, Box 1429, Austin TX 78767. (512)444-6543. Vice President, Member Services: David W. Gibbs. Art Director: Neil Ferguson. Estab. 1940. Official trade publication of Texas Restaurant Association. Seeks illustrations (but not cartoons) dealing with business problems of restaurant owners and food-service operators, primarily in Texas, and including managers of clubs, bars and hotels. Published 11 times/year. Circ. 5,000. Simultaneous submissions OK. Sample copy for SASE.
Illustrations: Works with 15 illustrators/year. Buys 36-48 illustrations/year from freelancers. Uses artwork mainly for covers and feature articles. Seeks high-quality b&w or color artwork in variety of styles (airbrush, watercolor, pastel, pen & ink, etc.). Seeks versatile artists who can illustrate articles about food-service industry, particularly business aspects. Works on assignment only. Query with resume, samples and tearsheets. Call for appointment to show portfolio. Pays for illustration $175-250, color cover; $50-100, b&w; $125-200, color inside. Negotiates rights and payment upon assignment. Originals returned after publication.

Tips: "In a portfolio, show samples of color work and tearsheets. Common mistakes made in presenting work include sloppy presentation and typos in cover letter or resume. Request a sample of our magazine (include a 10×13 SASE), then send samples that fit the style or overall mood of our magazine."

For a **Food & Service Magazine** *article addressing the challenges of opening a second restaurant, Karen B. Stolper of New York City created this pastel and acrylic illustration, which shows, she says, "the tenuous balance one must maintain while managing more responsibility." For the assignment, art director Neil Ferguson asked that she read the manuscript, submit her ideas and then gave her a deadline of two weeks for the final art.*

***FOOD PROCESSING**, Putman Publishing Co., 301 E. Erie, Chicago IL 60611. (312)644-2020. Editor/Publisher: Roy Hlavacek. Emphasizes equipment, new developments, laboratory instruments and government regulations of the food processing industry. For executives and managers in food processing industries. 4-color. Monthly. Circ. 66,000. Photocopied submissions OK. Original artwork not returned after publication. Free sample copy and artist's guidelines.

Cartoons: Buys 1-2 cartoons/issue from freelancers. Receives 10-15 submissions/week from freelancers. Interested in "situations in and around the food plant (e.g., mixing, handling, transporting, weighing, analyzing, government inspection, etc.)"; single panel with gagline. Prefers to see finished cartoons. SASE. Reports in 1 week. Buys all rights. Pays $20 minimum, b&w line drawings.

Illustration: Uses editorial and technical illustration. Payment varies.

Tips: "Avoid most 'in-the-home' and all retailing cartoon situations. Stick to in-the-food-plant situations—meat packing, vegetable and fruit canning, candymaking, beverage processing, bakery, dairy—including any phase of processing, inspecting, handling, quality control, packaging, storage, shipping, etc."

FOOTBALL DIGEST, 990 Grove St., Evanston IL 60201. Emphasizes sports. Monthly. Circ. 525,000. Original artwork returned after publication.

Cartoons: Considers sports themes. Prefers single panel; b&w line drawings or color washes. Material not filed is returned by SASE. Pays on publication.

Illustrations: Considers sports themes. Works on assignment only. Send 4-color sample tearsheets (no original art). Prefer caricatures and conceptual pieces. Samples not filed are returned by SASE. Pays on acceptance.

***FOR GRADUATES ONLY**, 339 N. Main St., New City NY 10956. (914)638-0333. FAX: (914)634-9423. Publisher: Darryl Elberg. Consumer magazine. *For Graduates Only* is an annual guide for college students. Accepts previously published artwork. Original artwork is returned at job's completion. Sample copies for SASE with first-class postage.

Cartoons: Approached by 2 freelance cartoonists/year. Buys 1 freelance cartoon/issue; 12/year. Preferred themes are youth oriented. Send query letter with brochure, roughs and cartoons. Samples are not filed or returned. Reports back only if interested. Rights purchased vary according to project. Pays $50-100.

Illustrations: Approached by 25 freelance illustrators/year. Buys 6-12 freelance illustrations/issue; 50-100/year. Works on assignment only. Themes and style vary. Considers pen & ink, watercolor, airbrush, marker, charcoal, mixed media. Send query letter with brochure, resume, photographs, slides and transparencies. Samples are not filed or returned. Reports back to the artist only if interested. Mail appropriate materials. Portfolio should include thumbnails, roughs, color photographs and slides. Rights purchased vary according to project. Pays $50 for b&w, $100 for color, cover. Pays $50 for b&w, $100 for color, inside; on publication.

***FOR SENIORS ONLY**, 339 N. Main St., New City NY 10956. (914)638-0333. FAX: (914)634-9423. Publisher: Darryl Elberg. Consumer magazine. *For Seniors Only* is published biannually for high school students. Accepts previously published artwork. Original artwork is returned at job's completion. Sample copies for SASE with first-class postage.

Cartoons: Approached by 2 freelance cartoonists/year. Buys 1 freelance cartoon/issue; 12/year. Preferred themes are youth oriented. Send query letter with brochure, roughs and cartoons. Samples are not filed or returned. Reports back only if interested. Rights purchased vary according to project. Pays $50-100.

Illustrations: Approached by 25 freelance illustrators/year. Buys 6-12 freelance illustrations/issue; 50-100/year. Works on assignment only. Themes and style vary. Considers pen & ink, watercolor, airbrush, marker, charcoal, mixed media. Send query letter with brochure, resume, photographs, slides and transparencies. Samples are not filed or returned. Reports back only if interested. Mail appropriate materials. Portfolio should include thumbnails, roughs, color photographs and slides. Rights purchased vary according to project. Pays $50 for b&w, $100 for color, cover. Pays $50 for b&w, $100 for color, inside; on publication.

FORBES MAGAZINE, 60 5th Ave., New York NY 10011. (212)620-2200. Art Director: Everett Halvorsen. Deputy Art Director: Roger Zapke. Estab. 1917. Business magazine; 4-color; reader friendly; for adults "usually over 40; witty, intelligent illustrations, no cartoons." Biweekly. Circ. 770,000. Does not accept previously published material "except stock material." Original artwork returned after publication. Sample copies available. Art guidelines not available.

Illustrations: Approached by 100 illustrators/year. Buys 5-6 illustrations/issue, 200/year from freelancers. Works on assignment only. Prefers witty, intelligent, contemporary but understandable ideas. Style of Patrich McDonnel, Charles Slackmern and John Segal. Considers pen & ink, airbrush, watercolor, acrylic and oil; "it doesn't really matter if it's well done." Send query letter with photocopies. Samples are filed "if they're interesting; otherwise they are discarded" or returned by SASE if requested. Reports back within 2 weeks only if interested. If does not report back, "forget it or wait until we have an assignment. Generally, we don't report back unless we have an assignment." Call to schedule an appointment to show a portfolio, which should include thumbnails, original/final art, tearsheets and slides. Buys one-time rights. Pays $1,700, b&w, $2,000, color, cover; $400, b&w, $450, color, inside; on acceptance.

Tips: "Look at the masthead. There are a total of 4 associates who make the assignments. The artist should at least know the names and titles of those they wish to contact. It is preferred that a portfolio be dropped off. It gives all the associate art directors a chance to review the work. Portfolios should include a name and phone number on the outside. We recommend sending samples a few times only. Call Roger Zapke, Deputy Art Director for portfolio reviews."

***FORDHAM UNIVERSITY**, 113 W. 60th St., New York NY 10023. Art Director: Jill Ann Biondo. Quarterly alumni magazine. Circ. 100,000. Does not accept previously published artwork. Originals returned at job's completion. Sample copies free for SASE with first-class postage.

Illustrations: Approached by 25 freelance illustrators/year. Buys 2-3 freelance illustrations/issue; 12/year. Works on assignment only. Preferred themes or styles vary depending on issue. Considers pen & ink, watercolor, collage, color pencil, mixed media, pastel and computer illustrations done on Mac. Send query letter with tearsheets and photocopies. Samples are filed and are returned by SASE if requested by artist. Reports back only if interested—will set up a portfolio drop-off next. Mail appropriate materials. Portfolio should include original/final art, color tearsheets. Rights purchased vary according to project. Pays on acceptance.

Tips: "We'd like to see illustrators with sophisticated, fresh style."

FOREIGN SERVICE JOURNAL, 2101 E St. NW, Washington DC 20037. (202)338-4045. Contact: Managing Editor. Estab. 1924. Magazine emphasizing foreign policy for foreign service employees. Monthly. 4-color with design in *"Harpers* style." Circ. 11,000. Accepts previously published material. Returns original artwork after publication.

Cartoons: Buys 6 cartoons/year from freelancers. Write or call for appointment to show portfolio. Buys first rights. Pays $100 and up, b&w; on publication.

Illustrations: Works with 6-10 illustrators/year. Buys 20 illustrations/year from freelancers. Uses artists mainly for covers and article illustration. Works on assignment only. Write or call for appointment to show portfolio. Buys first rights. Pays $100 and up, b&w, cover; $100 and up, b&w, inside; on publication.

Tips: Portfolio should include "political cartoons and conceptual ideas/themes."

"I wanted to portray minorities in a positive light," says San Francisco-based illustrator Thorina Rose, of this scratchboard piece for Foundation News. For the assignment, Rose was required to read the articles on minority foundations and then develop the concepts; she was given about two weeks. Janin Design, which works closely with the magazine, discovered Rose's work in The Washington Post. The piece was used again for the American Association of University Women publication.

FOUNDATION NEWS, 1828 L St. NW, Washington DC 20036. (202)466-6512. Associate Editor: Jody Curtis. Estab. 1959. 4-color nonprofit association magazine which "covers news and trends in the nonprofit sector, with an emphasis on foundation grantmaking and grant-funded projects." Bimonthly. Circ. 12,000. Accepts previously published artwork. Original artwork returned after publication. Sample copy available. Art guidelines not available.

Cartoons: Prefers single panel; b&w line drawings. Send query letter with brochure, finished cartoons and other samples. Samples are filed "if good"; none are returned. Reports back within weeks. Buys one-time rights. Payment negotiated.

Illustrations: Approached by 50 freelance illustrators/year. Buys 3 illustrations/issue, 18/year from freelancers. Considers all formats. Send query letter with tearsheets, photostats, slides and photocopies. Samples are filed "if good"; none are returned. Reports back in weeks. Call or write to schedule an appointment to show a portfolio, which should include thumbnails, roughs and b&w and color tearsheets, photostats, photographs, slides and photocopies. Buys first rights. Pays $750, color, cover; $250, b&w; on acceptance.

Tips: The magazine is "clean, uncluttered, sophisticated, simple but attractive. It's high on concept and originality. Somwhat abstract, not literal."

FRONT PAGE DETECTIVE, RGH Publications, 20th Floor, 460 W. 34th St., New York NY 10001. Editor-in-chief: Rose Mandelsberg. For mature adults—law enforcement officials, professional investigators, criminology buffs and interested laymen. Monthly. B&w with 2-color cover.
Cartoons: Must have crime theme. Submit finished art. SASE. Reports in 10 days. Buys all rights. Pays $25; on acceptance.
Tips: "Make sure the cartoons submitted do not degrade or ridicule law enforcement officials. Omit references to supermarkets/convenience stores."

FUTURIFIC MAGAZINE, Suite 1210, 280 Madison Ave., New York NY 10016. Publisher: B. Szent-Miklosy. Emphasizes future-related subjects for highly educated, upper income leaders of the community. Monthly. Circ. 10,000. Previously published material and simultaneous submissions OK. Original artwork returned after publication. Free sample copy for SASE with $3 postage and handling.
Cartoons: Buys 5 cartoons/year from freelancers. Prefers positive, upbeat, futuristic themes; no "doom and gloom." Prefers single, double or multiple panel with or without gagline, b&w line drawings. Send finished cartoons. Samples returned by SASE. Reports within 4 weeks. Will negotiate rights and payment. Pays on publication.
Illustrations: Buys 5 illustrations/issue from freelancers. Prefers positive, upbeat, futuristic themes; no "doom and gloom." Send finished art. Samples returned by SASE. Reports within 4 weeks. Walk in to show a portfolio. Negotiates rights and payment. Pays on publication.
Tips: "Only optimists need apply. Looking for good, clean art. Interested in future development of current affairs, but not sci-fi."

THE FUTURIST, 4916 St. Elmo Ave., Bethesda MD 20814. (301)598-6414. Art Director: Cynthia Fowler. Managing Editor: Timothy H. Willard. Emphasizes all aspects of the future for a well-educated, general audience. B&w magazine with 4-color cover; "fairly conservative design with lots of text." Bimonthly. Circ. 30,000. Accepts simultaneous submissions. Return of original artwork following publication depends on individual agreement.
Cartoons: Approached by 1-2 cartoonists/year. Pays $125, b&w; $175, color.
Illustrations: Approached by 5-10 freelance illustrators/year. Buys 3-4 illustrations/issue from freelancers. Needs editorial illustration. Uses a variety of themes and styles "usually line drawings, often whimsical. We like an artist who can read an article and deal with the concepts and ideas." Works on assignment only. Send query letter with brochure, samples or tearsheets to be kept on file. Call or write for appointment to show portfolio. "Photostats are fine as samples; whatever is easy for the artist." Reports only if interested. Rights purchased negotiable. Pays $500-750, color, cover; $75-350, b&w; $200-400, color, inside; on acceptance.
Tips: "When a sample package is poorly organized, poorly presented—it says a lot about how the artists feel about their work." Sees trend toward "moving away from realism; highly stylized illustration with more color."

GALLERY MAGAZINE, 401 Park Ave., South, New York NY 10016. Creative Director: Michael Monte. Emphasizes sophisticated men's entertainment for the middle-class, collegiate male. Monthly. 4-color with flexible format. Circ. 375,000.
Cartoons: Approached by 100 cartoonists/year. Buys 3-8 cartoons/issue from freelancers. Interested in sexy humor; single, double or multiple panel with or without gagline, color and b&w washes, b&w line drawings. Send finished cartoons. Reports in 1 month. Buys first rights. Pays $75, b&w, $100, color; on publication. Enclose SASE. Contact: J. Linden.
Illustrations: Approached by 300 illustrators/year. Buys 60 illustrations/year from freelancers. Works on assignment only. Interested in the "highest creative and technical styles." Especially needs slick, high-quality, 4-color work. Send flyer, samples and tearsheets to be kept on file for possible future assignments. Send samples of style or submit portfolio. Prefers prints over transparencies. Samples returned by SASE. Reports in several weeks. Negotiates rights purchased. Pays $350, b&w, $1,000 color, inside; on publication.
Tips: A common mistake freelancers make is that "often there are too many samples of literal translations of the subject. There should also be some conceptual pieces."

GAME & FISH PUBLICATIONS, 2250 Newmarket Parkway, Marietta GA 30067. (404)953-9222. Graphic Artist: Allen Hansen. Estab. 1975. Monthly consumer magazine. 4-color. Circ. 400,000 for 30 state-specific magazines. Original artwork is returned after publication. Sample copies available. Uses freelancers mainly for spot illustrations and leads for feature articles.
Illustrations: Approached by 50 illustrators/year. Buys illustrations mainly for spots and feature spreads. Buys 1-8 illustrations/issue, 30-60/year from freelancers. Considers pen & ink, watercolor, acrylic and oil. Send query letter with photostats and photocopies. "We look for an artist's ability to realistically depict North American game animals and game fish." Samples are filed or returned only if requested. Reports back only if interested. Buys first rights. Pays $25 and up, b&w, $75-100, color, inside; 2½ months prior to publication.
Tips: Does not want to see cartoons.

***GARDEN SUPPLY RETAILER,** 1 Chilton Way, Radnor PA 19089. (215)964-4275. FAX: (215)964-4273. Estab. 1950. Trade magazine for garden center operators and power equipment dealers; covers business. Monthly. Circ. 41,000. Accepts previously published artwork. Original artwork is returned at job's completion. Sample copy free for SASE with first-class postage.

Cartoons: Approached by 4-5 freelance cartoonists/year. Buys 3-4 freelance cartoon/year. Cartoons should pertain to specialized editorial content. Prefers single panel with gagline. Send query letter with roughs. Samples are filed. Reports back within 1 month.

Illustrations: Buys 1-2 freelance illustrations/year. Works on assignment only. Themes should pertain to specialized editorial content. Considers mixed media. Samples are filed. Works on assignment only.

GENT, Dugent Publishing Corp., Suite 600, 2600 Douglas Rd., Coral Gables FL 33134-6125. Publisher: Douglas Allen. Editor: Bruce Arthur. Managing Editor: Nye Willden. For men "who like big-breasted women." 96 pages 8½×11, 4-color. Sample copy $3.

Cartoons: Buys humor and sexual themes; "major emphasis of magazine is on large D-cup-breasted women. We prefer cartoons that reflect this slant." Mail cartoons. Buys first rights. Pays $75, b&w spot drawing; $100, page.

Illustrations: Buys 3-4 illustrations/issue from freelancers on assigned themes. Submit illustration samples for files. Portfolio should include "b&w and color, with nudes/anatomy." Buys first rights. Pays $125-150, b&w; $300, color.

Tips: "Send samples designed especially for our publication. Study our magazine. Be able to draw erotic anatomy. Write for artist's guides and cartoon guides *first*, before submitting samples, since they contain some helpful suggestions."

GLASS FACTORY DIRECTORY, Box 7138, Pittsburgh PA 15213. (412)362-5136. Manager: Liz Scott. Lists glass manufacturers in U.S., Canada and Mexico. Annual.

Cartoons: Buys 5-10 cartoon/issue from freelancers. Receives an average of 1 submisson/week from freelancers. Cartoons should pertain to glass manufacturing (flat glass, fiberglass, bottles and containers; no mirrors). Prefers single and multiple panel b&w line drawings with gagline. Prefers roughs or finished cartoons. Send SASE. Reports in 1-3 months. Buys all rights. Pays $25; on acceptance.

Tips: "Learn about making glass of all kinds. We rarely buy broken glass jokes. There *are* women working in glass plants."

GOLF ILLUSTRATED, 3 Park Ave., New York NY 10016. (212)779-6200. Art Director: Irasema Rivera. Estab. 1914. "First full-service golf magazine. It helps readers improve their game and stay on top of events on the pro tour. Also additional coverage of travel, fitness and fashion." Published 10 times a year. Circ. 450,000. Original artwork is usually returned to the artist after publication. Sample copies free for SASE with first-class postage.

Cartoons: Buys 5-10 cartoons/year from freelancers. Prefers "not your typical golf cartoon." Prefers single or double b&w panel with gagline. Send query letter with finished cartoons. Samples are filed or are returned by SASE. Returns unusable cartoons within 2 weeks. Does not report back on kept cartoons until used. Buys first rights. Pays $50, b&w.

Illustrations: Buys 5-10 illustrations/issue from freelancers. Works on assignment only. Send query letter with samples. Call or write to schedule an appointment to show a portfolio, which should include color and b&w tearsheets or final reproduction/product. Buys first rights. Pays $300 and up, b&w; $400 and up, color, inside; on publication.

Tips: "Send tearsheets of current work. Color and black-and-white samples should have client's name present. Send samples that are the same size."

GOLF JOURNAL, Golf House, Far Hills NJ 07931. (908)234-2300. Managing Editor: George Earl. Readers are "literate, professional, knowledgeable on the subject of golf." Published 8 times/year. Circ. 285,000. Original artwork not returned after publication. Free sample copy.

Cartoons: Buys 1-2 cartoons/issue from freelancers. "The subject is golf. Golf must be central to the cartoon. Drawings should be professional and captions sharp, bright and literate, on a par with our generally sophisticated readership." Formats: single or multiple panel, b&w line drawings with gagline. Prefers to see finished cartoons. Send SASE. Reports in 1 month. Buys one-time rights. Pays $25-50, b&w cartoons; on acceptance.

Illustrations: Buys several illustrations/issue from freelancers. "We maintain a file of samples from illustrators. Our needs for illustrations are based almost solely on assignments, illustrations to accompany specific stories. We need talent with a light artistic touch, and we would assign a job to an illustrator who is able to capture the feel and mood of a story. A sense of humor is a useful quality in the illustrator, but this sense shouldn't lapse into absurdity." Uses color washes. Send samples of style to be kept on file for future assignments. Reports in 1 month. Buys all rights on a work-for-hire basis. Payment varies, "usually $300, page, $500, color, cover."

WOULD YOU USE THE SAME CALENDAR YEAR AFTER YEAR?

Of course not! If you scheduled your appointments using last year's calendar, you'd risk missing important meetings and deadlines, so you keep up-to-date with a new calendar each year. Just like your calendar, *Artist's Market®* changes every year, too. Many of the buyers move or get promoted, rates of pay increase, and even buyers' art needs change from the previous year. You can't afford to use an out-of-date book to plan your marketing efforts!

So save yourself the frustration of getting your work returned in the mail, stamped MOVED: ADDRESS UNKNOWN. And of NOT submitting your work to new listings because you don't know they exist. **Make sure you have the most current writing and marketing information by ordering** *1993 Artist's Market* **today.** All you have to do is complete the attached post card and return it with your payment or charge card information. Order now, and there's one thing that won't change from your *1992 Artist's Market* - the price! That's right, we'll send you the 1993 edition for just $21.95. *1993 Artist's Market* will be published and ready for shipment in September 1992.

Let an old acquaintance be forgot, and toast the new edition of *Artist's Market*. Order today!

(See other side for more books for artists and graphic designers.)

To order, drop this postpaid card in the mail.

☐ YES! I want the most current edition of *Artist's Market®*. Please send me the 1993 edition at the 1992 price – $21.95.* (NOTE: *1993 Artist's Market* will be ready for shipment in September 1992.) #10274
*Plus postage & handling: $3.00 for one book, $1.00 for each additional book. Ohio residents add 5½% sales tax. Also send me the following books:

_____ (10257) 1992 Guide to Literary Agents & Art/Photo Reps, $15.95 $13.55* (available NOW)
_____ (30155) Fine Artist's Guide to Showing & Selling Your Work, $17.95* (available NOW)
_____ (30281) Artist's Friendly Legal Guide, $18.95* (available NOW)
_____ (30200) Getting Started as a Freelance Illustrator or Designer, $16.95* (available NOW)
_____ (30353) Graphic Artist's Guide to Marketing & Self-Promotion, $19.95* (available NOW)

☐ Payment enclosed (Slip this card and your payment into an envelope)
☐ Please charge my: ☐ Visa ☐ MasterCard

Account # _____ Exp. Date _____

Signature _____ Phone (_____) _____

Name _____

Address _____

City _____ State _____ Zip _____

(This offer expires May 31, 1993)

 Writer's Digest Books / Writer's Digest Books
1507 Dana Avenue
Cincinnati, OH 45207

Credit Card Orders Call Toll-Free 1-800-289-0963

6050

MORE BOOKS FOR FINE ART/ GRAPHIC ART PROFESSIONALS

NEW! SAVE 15%
1992 Guide to Literary Agents & Art/Photo Reps
edited by Robin Gee
This new directory lists reps across North America, in addition to answering the most-often asked questions about reps. Save 15% on this new directory when you use the attached order form.
240 pages/~~$15.95~~ $13.55, hardcover

ARTIST'S MARKET BUSINESS SERIES

The Fine Artist's Guide to Showing & Selling Your Work
Learn how to create simple — yet clever — promotional pieces, approach potential buyers, protect yourself from legal problems, develop a portfolio, plus much more. 128 pages/$17.95, paper

Revised & Updated! **Artist's Friendly Legal Guide**
Complete with Q&A sections, checklists, plus samples of contracts, invoices, purchase order, and tax forms. 144 pages/$18.95, paper

Getting Started as a Freelance Illustrator or Designer
Written in an easy-to-follow Q&A format, this book will show you the ins and outs of becoming a successful freelancer. 128 pages/$16.95, paper

Revised & Updated!
The Graphic Artist's Guide to Marketing & Self-Promotion
This book is packed with creative marketing techniques used by successful artists, with 60+ sample resumes, business cards, etc. 128 pages/$19.95, paper

Use coupon on other side to order your copies today!

NO POSTAGE NECESSARY IF MAILED IN THE UNITED STATES

BUSINESS REPLY MAIL
FIRST CLASS MAIL PERMIT NO. 17 CINCINNATI, OHIO

POSTAGE PAID BY ADDRESSEE

WRITER'S DIGEST BOOKS
1507 DANA AVENUE
CINCINNATI OH 45207-9965

Tips: Wants to see "a light touch, identifiable, relevant, rather than nitwit stuff showing golfballs talking to each other." Does not want to see "willy-nilly submissions of everything from caricatures of past presidents to meaningless art. They should know their market; we're a golf publication, not an art gazette."

GOOD OLD DAYS, 306 E. Parr Rd., Berne IN 46711. (219)589-8741. Editor: Rebekah Montgomery. Estab. 1964. Literary magazine covering American oral history 1900-1949. Monthly. Circ. 140,000. Accepts previously published artwork. Original artwork is sometimes returned after publication. Sample copies available for $2. Art guidelines not available.
Cartoons: Buys 1 or more cartoons/issue, 12 or more cartoons/year from freelancers. Prefers nostalgic themes. Prefers single or double panel with or without gagline; b&w line drawings. Send finished cartoons. Samples are filed. Reports back regarding queries/submissions within 14 days. Buys first rights, one-time or all rights. Pays $15-75, b&w; on publication.
Illustrations: Buys illustrations mainly for covers, spots and feature spreads. Buys 1 illustration/issue from freelancers. Works on assignment only. Prefers pen & ink. Considers mixed media, watercolor, acrylic, oil and pastel. Send query letter with photostats, photocopies, photographs and transparencies. Looks for realism and authenticity in subject matter. Reports back about queries/submissions within 14 days. Call or write to schedule an appointment to show a portfolio which should include color and b&w original/final art, tearsheets, slides, photostats and transparencies. Buys first rights, one-time rights, reprint rights or all rights. Will negotiate rights purchased. Pays $500-800, color, cover; $35-75, b&w, inside; on publication.
Tips: "Show realistic, historically accurate portrayals. I do not want to see cartoony drawings."

GOURMET, Conde Nast Publications, Inc., 560 Lexington Ave., New York NY 10022. (212)371-1330. Art Director: Irwin Glusker. Magazine "for those interested in all aspects of good living, preparation of food, wine, dining out and travel." Monthly. Circ. 700,000. Sample copies $2.50 and SASE.
Cartoons: Buys one-time rights. Pays $300, b&w.
Illustrations: "Larger issues include work from 15 artists. We are open to new artists, especially for black-and-white work." Columns are illustrated by regular freelancers, but restaurants in other cities are sometimes featured, and those areas' local artists are generally used. Send query letter with photocopies and SASE. Samples are filed. Reports "as soon as possible." Buys one-time rights. Pays $200-400, b&w.

***GRAND RAPIDS MAGAZINE**, Gemini Publications, Suite 1040, Trust Building, 40 Pearl St. NW, Grand Rapids MI 49503. (616)459-4545. Editor: Carole Valade Smith Koehler. Managing Editor: Mary Banks. For greater Grand Rapids residents. Monthly. Circ. 13,500. Original artwork returned after publication. Local artists only.
Cartoons: Buys 2-3 cartoons/issue from freelancers. Prefers Michigan, Western Michigan, Lake Michigan, city, issue or consumer/household themes. Send query letter with samples. Samples not filed are returned by SASE. Reports within 1 month. Buys all rights. Pays $25-40 b&w.
Illustrations: Buys 2-3 illustrations/issue from freelancers. Prefers Michigan, Western Michigan, Lake Michigan, city, issue or consumer/household themes. Send query letter with samples. Samples not filed are returned by SASE. Reports within 1 month. To show a portfolio, mail original/final art and final reproduction/product or call to schedule an appointment. Buys all rights. Pays $100 color, cover; $20-30 b&w and $30-50 color, inside; on publication.
Tips: "Approach us only if you have good ideas."

GRAPHIC ARTS MONTHLY, 249 W. 17th St., New York NY 10011. (212)463-6834. Editor: Roger Ynostroza. Managing Editor: Michael Karol. For management and production personnel in commercial and specialty printing plants and allied crafts. Monthly magazine, 4-color. Design of magazine is "direct, crisp and modern." Circ. 94,000. Sample copy $10.
Cartoons: Approached by 25 cartoonists/year. Buys 15 cartoons/year from freelancers on printing, layout, paste-up, typesetting and proofreading. They should be single panel, sophisticated and illustrate story; no captions. To show portfolio, mail art and SASE. Reports in 3 weeks. Buys first rights. Pays on acceptance.
Illustrations: Approached by 120 illustrators/year. Needs editorial and technical illustration that "conveys the tone of the copy in style of Tom Bloom." Pays $125, inside; $1,200, cover. Portfolio should include "good, recent work. Also any printed cards to keep for our files."

GRAPHIC STORY MONTHLY, 7563 Lake City Way, Seattle WA 98115. (206)524-1967. FAX: (206)524-2104. Editor: Gary Groth. Art Director: Dale Yarger. A comic magazine aimed at thinking adults and devoted to "the work of the new breed of sophisticated comic artists. Any and all subjects considered (drama, humor, satire, etc.)." Stories consist of 1-10 b&w pages. Circ. 10,000. Sample copy $3.50.
Illustrations: Send query letter with samples. Buys one-time North American rights. "Creator retains copyright." Pays $30/page; on publication.

GRAY'S SPORTING JOURNAL, On The Common, Box 130, Lyme NH 03768. (603)795-4757. Editor: Ed Gray. Art Director: DeCourcy Taylor. Concerns the outdoors, hunting and fishing. Published 6 times/year. Circ. 35,000. Sample copy $6.95; artist's guidelines for SASE.

Illustrations: Buys 2-6 illustrations/issue, 10 illustrations/year from freelancers on hunting and fishing. Send query letter with tearsheets, slides and SASE. Reports in 4 weeks. To show a portfolio, mail tearsheets and photographs. Buys one-time rights. Pays $350, color art; $75-200, b&w line drawings, inside.
Tips: "Will definitely not accept unsolicited original art."

GROUP PUBLISHING, 2890 N. Monroe, Loveland CO 80538. (303)669-3836. Senior Art Director: Jean Bruns. Publishes *Group Magazine* (8 issues/year; circ. 62,000); *Group's Jr. High Ministry Magazine* (5 issues/year) for adult leaders of Christian youth groups; *Children's Ministry Magazine* (6 issues/year) for adult leaders who work with kids from birth to sixth grade; *Parents & Teenagers Magazine* (bimonthly) for families with teenagers. Also books for adults and teenagers (many with cover and interior illustration), clip-art resources, audiovisual material and printed marketing material. Previously published, photocopied and simultaneous submissions OK. Original artwork returned after publication, if requested. Sample copy $1.
Cartoons: Occasionally uses spot cartoons in publications.
Illustrations: Buys 2-5 illustrations/issue from freelancers. Prefers a loose, lighthearted pen & ink and/or color style. Send query letter with brochure showing art style or samples to be kept on file for future assignments. Reports only if interested. To show a portfolio, mail color and b&w photostats and slides. Pays $350 minimum, color cover (negotiable). Pays $25-400, b&w/spot illustrations (line drawings and washes) to full-page color illustrations, inside; on acceptance. Buys first publication rights and sometimes reprint rights.
Tips: "We seek b&w illustrations of a serious, more conceptual nature as well as humorous illustrations in styles appropriate to our Christian adult and teenage audience (mature and contemporary, not childish). We look for evidence of maturity and a well-developed style in the illustrator. We are also attracted to good, artistically sound renderings, particularly of people and the ability to conceptualize well and approach subjects in an unusual way. We do not want to see amateurish work nor work that is crude, gross, deliberately offensive or puts down any ethnic or religious group. We want to see work that shows thought, care, good technique and craftsmanship."

GTE DISCOVERY PUBLICATIONS, INC., Box 3007, Bothell WA 98118. (206)487-6172. Creative Director: Kate Thompson. Consumer magazines; "annual state tourism magazines for various areas throughout the nation including the Pacific NW, Alaska, California, Hawaii, and Massachussetts." Annual combined circ. 2 million. Accepts previously published artwork. Original artwork returned after publication. Sample copies available. Art guidelines not available.
Illustrations: Approached by 8-10 illustrators/year. Buys 10 illustrations/year from freelancers. Works on assignment only. Considers pen & ink, airbrush, acrylic, collage, color pencil and computer generated art. Send query letter with brochure, tearsheets and resume. Samples are filed. Reports back only if interested. Mail appropriate materials: original/final art, b&w tearsheets, slides and photocopies. Rights purchased vary according to project. Pays on acceptance.

***GULF COAST MEDIA AFFILIATES**, 205 S. Airport Dr., Naples FL 33942. (813)643-4232. FAX: (813)643-6253. Art Director: Linda L. Titus. Estab. 1989. Publishes *GulfCoast Magazine*, a monthly city-style regional of people and places to go on the Gulf Coast; *Business Quarterly*, a business quarterly on the Gulf Coast; and *Chambers* annuals promoting area tourism— "Made Easy Annual" and "Gulf Coast Living Annual." Also publishes chamber of commerce books. Circ. 22,000. Accepts previously published artwork. Originals are returned at job's completion. Sample copies free for SASE with first-class postage.
Illustrations: Buys 1-2 freelance illustrations/issue, 20/year. Works on assignment only. Preferred themes depend on subject; watercolor, collage, airbrush, acrylic, marker, color pencil, mixed media. Send query letter with brochure, tearsheets, photographs and photocopies. Samples are filed. Reports back only if interested. Call to schedule an appointment to show a portfolio, which should include roughs and original/final art. Buys first rights, one-time rights and reprint rights. Pays $35 for b&w, $50 spot for color, inside or $250/page; on acceptance.

GULFSHORE LIFE MAGAZINE, Suite 800, 2975 S. Horseshoe Dr., Naples FL 33942. (813)643-3933. Creative Director: Mark May. Estab. 1970. "Consumer magazine emphasizing life-style of southwest Florida for an affluent, sophisticated audience." Monthly. Circ. 20,000. Accepts previously published material. Original artwork returned after publication. Sample copy $3.95.
Illustrations: Approached by 15-20 freelance illustrators/year. Buys 1 illustration/issue from freelancers. Prefers watercolor, collage, airbrush, acrylic, colored pencil, mixed media and pastel. Send query letter with brochure, resume, tearsheets, photostats and photocopies. Samples not filed are returned by SASE. Reports back only if interested. Write to schedule appointment to show a portfolio, which should include thumbnails, original/final art, final/reproduction/product and tearsheets. Negotiates rights purchased. Buys one-time rights. Pays $50-2,000, color, inside and cover; on publication.

***HADASSAH MAGAZINE**, 50 W. 58th St., New York NY 10019. (212)303-8012. FAX: (212)303-8282. Estab. 1914. Consumer magazine. *Hadassah Magazine* is a monthly magazine chiefly of and for Jewish interests— both here and in Israel. Circ. 340,000.

This gouache on paper illustration was done by Betsy Everitt of San Francisco for **Gulfshore Life Magazine**. *It is a pastel-colored visual image for an article on saving bays in the Gulf area. Art director Mark May told her to "do something to create a feeling of sea life and our concern for it." Everitt did this with an earth-mother type image which elicits, she says, "a caring, compassionate feeling." The published piece has given her "continuous exposure to other art directors and publishers."*

© Betsy Everitt 1990

Cartoons: Buys 10 cartoons/year. Buys 1-2 freelance cartoons/issue, 8-10/year. Preferred themes include the Middle East/Israel, domestic Jewish themes and issues. Send query letter with finished cartoons. Samples are filed or returned by SASE. Reports back within 3 weeks. Buys first rights. Pays $50 for b&w; $100 for color.
Illustrations: Approached by 5 freelance illustrators/year. Works on assignment only. Prefers Jewish holidays. Samples are filed or are returned by SASE. Reports back within 3 weeks. Write to schedule an appointment to show a portfolio, which should include original/final art, tearsheets and slides. Buys first rights. Pays $125 for b&w, $300 for color, cover; on publication.

***HEALTHCARE FORUM JOURNAL,** 830 Market St., San Francisco CA 94102. (415)421-8810. FAX: (415)421-8837. Art Director: Bruce Orson. Estab. 1936. A bimonthly trade journal for healthcare executive administrators, a publication of the Healthcare Forum Association. Circ. 25,000. Accepts previously published artwork. Originals are returned at job's completion. Sample copies available.
Illustrations: Approached by 15-20 freelance illustrators/year. Buys 3-5 freelance ilustrations/issue, 25/year. Works on assignment only. Preferred styles vary, usually abstract and painterly; watercolor, collage, acrylic, oil and mixed media. Send query letter with SASE, tearsheets, photostats and photocopies. Samples are filed and returned by SASE if requested by artist. Reports back only if interested. Buys one-time rights. Pays $500-600 for color, cover; $350 for b&w, $450 for color, inside; on acceptance.

***HEARTLAND USA,** Box 925, Hailey ID 83333-0925. (208)788-4500. FAX: (208)788-5098. Picture Researcher: Judy Guryan. Estab. 1990. Magazine of US Tobacco. Audience is blue-collar men. Quarterly. Circ. 750,000. Accepts previously published artwork. Originals are returned at job's completion. Sample copies for SASE with first-class postage.
Cartoons: Approached by 20 freelance cartoonists/year. Buys 6 freelance cartoons/issue, 24/year. Preferred themes are blue-collar life-style; single panel, with or without gagline, b&w line drawings and washes. Send query letter with roughs. Samples are filed. Reports back within 2 weeks. Rights purchased vary according to project. Pays $150 for b&w.

Illustrations: Approached by 12 freelance illustrators/year. Buys 4 freelance illustrations/issue, 16/year. Preferred themes are blue-collar life-style. Prefers flexible board. Send query letter with tearsheets. Samples are filed. Reports back within 2 weeks. Call to schedule an appointment to show a portfolio, which should include original/final art, tearsheets and slides. Rights purchased vary according to project. Pays $150 for b&w; on publication.

***THE HERB COMPANION**, 201 E. 4th St., Loveland CO 80537. (303)669-7672. FAX: (303)667-8317. Managing Editor: David Merrill. Estab. 1988. Consumer magazine. "A bimonthly magazine devoted to interests of avocational herb gardeners and users. Covers horticulture, history, uses of herbs for food, fragrance, craft and pleasure." 4-color; design is colorful, nearly elegant, very readable and accessible." Circ. 32,000. Original artwork is returned at job's completion. Sample copy free for SASE with first-class postage. Art guidelines available.
Illustrations: Approached by 20 freelance illustrators/year. Buys 2-6 freelance illustrations/issue, 12-36/year. Works on assignment only. Prefers still-life, botanical/biological. Considers pen & ink, watercolor, color pencil and pastel. Send query letter with tearsheets, SASE, photographs, photocopies and transparencies. Samples are filed or returned by SASE if requested by artist. Reports back within 6 weeks. Mail appropriate materials. Portfolio should include color tearsheets, photographs, slides and photocopies. Buys first rights and one-time rights. Pays $500 for color, cover; $100/page for b&w, $150/page for color, inside; on acceptance.
Tips: "Present yourself by mail, give us samples we can keep; show everything you do. When we have a need, the samples will sell your work. Be patient."

THE HERB QUARTERLY, Box 548, Boiling Springs PA 17007. (717)245-2764. Editor and Publisher: Linda Sparrowe. Magazine emphasizing horticulture for middle to upper class men and women with an ardent enthusiasm for herbs and all their uses—gardening, culinary, crafts, etc. Most are probably home owners. Quarterly. Circ. 30,000. Accepts previously published material. Original artwork returned after publication if requested. Sample copy $5.
Illustrations: Prefers pen & ink illustrations, heavily contrasted. Illustrations of herbs, garden designs, etc. Artist should be able to create illustrations drawn from themes of manuscripts sent to them. Send query letter with brochure showing art style or resume, tearsheets, photocopies, slides and photographs. Samples not filed are returned by SASE only if requested. Reports within weeks. To show a portfolio, mail original/final art, final reproduction/product or b&w photographs. Buys reprint rights. Pays $200, full page; $100, half page; $50, quarter page and spots; on publication.

***HIGH PERFORMANCE MOPAR**, 299 Market St., Saddle Brook NJ 07662. (201)712-9300. FAX: (201)712-9899. Art Director: Michael R. Smith. A bimonthly consumer magazine. An automotive publication for Chrysler enthusiasts, from older models up to most current line of Chrysler products. Circ. 100,000. Accepts previously published artwork. Originals are returned at job's completion. Sample copies and art guidelines available.
Cartoons: Approached by 5-10 freelance cartoonists/year. Buys 2-5 freelance cartoons/year. Prefers automotive related; single panel, b&w or color washes and b&w line drawings. Send query letter with roughs, finished cartoons, published works and tearsheets. Samples are filed. Reports back to the artist only if interested. Rights purchased vary according to project. Pays $25 for b&w, $250 for color.
Illustrations: Approached by 5-10 freelance illustrators/year. Buys 10-20 freelance illustrations/year. Prefers automotive related; pen & ink, watercolor, collage, airbrush, acrylic, marker, color pencil and mixed media. Send query letter with brochure, resume, tearsheets, photographs, photocopies, photostats, slides and transparencies. Samples are filed. Reports back only if interested. Call to schedule an appointment to show a portfolio, which should include roughs, original/final art, color tearsheets and photographs. Rights purchased vary according to project. Pays $25 for b&w, $250 for color, inside.
Tips: "Send automotive-related subjects. Anything that could relate to the reader in an automotive sense: muscle cars from 60s and 70s are most appropriate; high-tech illustrations of most current automotive trends."

***HIGH PERFORMANCE PONTIAC**, 299 Market St., Saddle Brook NJ 07662. (201)712-9300. FAX: (201)712-9899. Art Director: Michael R. Smith. Estab. 1981. A bimonthly consumer magazine. "An automotive publication for the Pontiac enthusiast. All aspects of the Pontiac Motor Division, history, collecting, current happenings." Circ. 100,000. Accepts previously published artwork. Originals are returned at job's completion. Sample copies and art guidelines available.
Cartoons: Approached by 5-10 freelance cartoonists/year. Buys 2-5 freelance cartoons/year. Prefers automotive related; single panel, b&w or color washes and b&w line drawings. Send query letter with roughs, finished cartoons, published works and tearsheets. Samples are filed. Reports back to the artist only if interested. Rights purchased vary according to project. Pays $25 for b&w; $250 for color.
Illustrations: Approached by 5-10 freelance illustrators/year. Buys 10-20 freelance illustrations/year. Prefers automotive related; pen & ink, watercolor, collage, airbrush, acrylic, marker, color pencil and mixed media. Send query letter with brochure, resume, tearsheets, photographs, photocopies, photostats, slides and transparencies. Samples are filed. Reports back only if interested. Call to schedule an appointment to show a

portfolio, which should include roughs, original/final art, b&w tearsheets, photographs and slides. Rights purchased vary according to project. Pays $25 for b&w, $250 for color, inside; on publication.
Tips: "Send automotive-related subjects. Relation between reader and automotive industry. Muscle cars from 60s and 70s most appropriate, technical automotive work also a plus."

HIGHLIGHTS FOR CHILDREN, 803 Church St., Honesdale PA 18431. (717)253-1080. Art Director: Rosanne Guararra. Cartoon Editor: Kent Brown. For ages 2-12. Monthly, bimonthly in July/August. Circ. 2,300,000.
Cartoons: Buys 2-4 cartoons/issue from freelancers. Receives 20 submissions/week from freelancers. Interested in upbeat, positive cartoons involving children, family life or animals; single or multiple panel. Send roughs or finished cartoons and SASE. Reports in 4-6 weeks. Buys all rights. Pays $20-40, line drawings; on acceptance. "One flaw in many submissions is that the concept or vocabulary is too adult, or that the experience necessary for its appreciation is beyond our readers. Frequently, a wordless self-explanatory cartoon is best."
Illustrations: Uses 30 illustrations/issue; 25 from freelancers. Works with freelancers on assignment only. "We are always looking for good hidden pictures. We require a picture that is interesting in itself and has the objects well hidden. Usually an artist submits pencil sketches. In no case do we pay for any preliminaries to the final hidden pictures." Prefers "realistic and stylized work; upbeat, fun, more graphic than cartoon." Prefers pen & ink, colored pencil, watercolor, marker, cut paper and mixed media. Send samples of style and flyer to be kept on file. Send SASE. Reports in 4-6 weeks. Buys all rights on a work-for-hire basis. Pays on acceptance.
Tips: We have a wide variety of needs, so I would prefer to see a representative sample of an illustrator's style or styles."

HISTORIC PRESERVATION MAGAZINE, 1785 Massachusetts Ave. NW, Washington DC 20036. (202)673-4042. FAX: (202)673-4172. Art Director: Jeff Roth. Estab. 1952. Association magazine; "a benefit of membership in the National Trust for Historic Preservation." Bimonthly. Circ. 225,000. Original artwork returned after publication. Sample copies available for $2 plus SASE. Art guidelines not available.
Illustrations: Approached by more than 100 illustrators/year. Buys 1-3 illustrations/issue, 6-18/year from freelancers. Works on assignment only. Considers all media. Send query letter with brochure, tearsheets and photostats. Samples are filed. Reports back to the artist only if interested. To show a portfolio, mail thumbnails, tearsheets, slides, roughs and photographs. Buys one-time rights. Pays $200, b&w, $300, color, cover. Pays $100, b&w, $150, color, inside; on acceptance.
Tips: "Do not show us a variety of styles or techniques; show us the style or technique that you do best."

HOBSON'S CHOICE, (formerly *Starwind*), Box 98, Ripley OH 45167. Contact: Editor. Estab. 1974. Emphasizes science fiction, fantasy and nonfiction of scientific and technological interest. Monthly, b&w, 16-20 page newsletter format. Circ. 2,500. Sample copy $1.75; art guidelines for SASE.
Cartoons: Approached by 10-12 cartoonists/year. Buys 17-20 cartoons/year from freelancers. Interested in science fiction, science and fantasy subjects; single and multi-panel b&w line drawings. Prefers finished cartoons. SASE. Reports in 2-3 months. Buys first North American serial rights. Pays $5; on publication.
Illustrations: Approached by 20-30 illustrators/year. Buys 35 illustrations/year from freelancers. Needs editorial, technical and story illustrations. Illustrators whose work appear in the SF press exemplify the style, tone and content: Brad Foster, Gregory West, Janet Aulisio. Works with 15 illustrators/year. Sometimes uses humorous and cartoon-style illustrations depending on the type of work being published. Works on assignment only. Samples returned by SASE. Reports back on future assignment possibilities. Send resume or brochure and samples of style to be kept on file for future assignments. Illustrates stories rather extensively (normally an 8×11 and an interior illustration). Format: b&w line drawings, camera-ready artwork. Send SASE. Reports in 2-3 months. Buys first North American rights. Pays up to $50, b&w, cover; up to $25, b&w, inside; on publication.
Tips: "We first of all look for work that falls into science fiction genre; if an artist has a feel for and appreciation of science fiction he/she is more likely to be able to meet our needs. We look to see that the artist can do well what he/she tried to do—for example, draw the human figure well. We are especially attracted to work that is clean and spare, not cluttered, and that has a finished, not sketchy quality. If an artist also does technical illustrations, we are interested in seeing samples of this style too. Would specifically

The asterisk before a listing indicates that the listing is new in this edition. New markets are often the most receptive to freelance submissions.

like to see samples of work that we'd be capable of reproducing and that are compatible with our magazine's subject matter. We prefer to see photocopies rather than slides. We also like to be able to keep samples on file, rather than have to return them."

HOCKEY DIGEST, 990 Grove St., Evanston IL 60201. Emphasizes sports. Monthly. Circ. 525,000. Original artwork returned after publication.
Cartoons: Considers sports themes. Prefers single panel; b&w line drawings or color washes. Material not filed is returned by SASE. Pays on publication.
Illustrations: Considers sports themes. Works on assignment only. Send 4-color sample tearsheets (no original art). Prefer caricatures and conceptual pieces. Samples not filed are returned by SASE. Pays on acceptance.

HOME & CONDO, Suite 800, 2975 S. Horseshoe Dr., Naples FL 33942. (813)643-3933. FAX: (813)643-5017. Art Director: Susan Donolo. Estab. 1980. Consumer magazine; "a homebuyers guide to Gulf Coast living." Monthly. 4-color with "loosely formatted" design. Circ. 25,000. Accepts previously published artwork. Original artwork is returned at the job's completion. Sample copies $2.50. Art guidelines free for SASE with first-class postage.
Cartoons: Light-hearted marker renderings of topics for homebuyers, including financial topics. Pays $75 for b&w; $100 for color.
Illustrations: Buys 1 editorial illustration/issue, 10 illustrations/year from freelancers. Works on assignment only. Considers pen & ink, colored pencil, watercolor and marker. Send query letter with brochure, tearsheets, photostats, resume, photocopies and transparencies. Samples are filed. Reports back to the artist only if interested. Call to schedule an appointment to show a portfolio. Portfolio should include original/final art and tearsheets. Buys one-time rights. Pays $100, b&w; $200, color, inside; on publication.

HOME EDUCATION MAGAZINE, Box 1083, Tonasket WA 98855. (509)486-1351. Managing Editor: Helen Hegener. Estab. 1983. "We publish one of the largest magazines available for home schooling families." Desktop published in 2-color. Bimonthly. Circ. 5,500. Accepts previously published artwork. Original artwork is returned after publication upon request. Sample copy $4.50. Art guidelines free for SASE with first-class postage.
Cartoons: Approached by 20-30 cartoonists/year. Buys 1-2 cartoons/issue, 4-6/year from freelancers. Style preferred is open, but theme must relate to home schooling. Prefers single, double or multiple panel with or without gagline; b&w line drawings and washes. Send query letter with samples of style, roughs and finished cartoons, "any format is fine with us." Samples are filed or returned by SASE if requested. Reports back regarding queries/submissions within 10 days. Buys reprint rights, one-time rights or negotiates rights purchased. Pays $5-10, b&w; on acceptance.
Illustrations: Approached by 40-60 illustrators/year. Buys illustrations mainly for cover, spots and feature spreads. Buys 12-20 illustrations/issue, 150-200/year from freelancers. Works with 4-6 illustrators/year. Consider pen & ink, mixed media, markers, charcoal pencil or any good sharp b&w or color media. Send query letter with tearsheets, photocopies or photographs. "We're looking for originality, clarity, warmth, children, families and parent-child situations are what we need." Samples are filed or are returned by SASE if requested. Reports back about queries/submissions within 10 days. Call or write to schedule an appointment to show a portfolio or mail appropriate materials, which should include tearsheets. Buys one-time rights, reprint rights or negotiates rights purchased. Pays $15-40, b&w, $20-100 color, cover and $2-40, b&w; $10-50 color inside; on acceptance.
Tips: "We always need good 'filler' artwork for our publications. We're very willing to work with new artists."

***HOME OFFICE COMPUTING MAGAZINE**, 740 Broadway-12th, New York NY 10003. (212)505-3687. FAX: (212)477-0071. Art Director: Judy Kamilar. Estab. 1980. Consumer magazine. Monthly journal of small business/home office advice. Circ. 380,000. Accepts previously published artwork. Originals are returned at job's completion "when possible." Sample copies available.
Illustrations: Approached by 45 freelance illustrators/year. Buys 12 freelance illustrations/issue, 140/year. Works on assignment only. Prefers pen & ink, watercolor, collage, acrylic, color pencil and mixed media. Send query letter with tearsheets or call to set up appointment or drop off portfolio. Samples are filed. Reports back only if interested. Call to schedule an appointment to show a portfolio, which should include tearsheets and slides. Buys one-time rights. Pays $250 for b&w, $5-600 for color, cover; $250 for b&w, $250-300 for color, inside.

HONOLULU MAGAZINE, 36 Merchant St., Honolulu HI 96813. (808)524-7400. Art Director: Teresa J. Black. "City/regional magazine reporting on current affairs and issues, people profiles, lifestyle. Readership is generally upper income (based on subscription)." Monthly. Circ. 45,000. Original artwork is returned after publication. Sample copies free for SASE with first-class postage.

Cartoons: Buys 2-5 cartoons/issue from freelancers. Prefers local (Hawaii) themes. Prefers single or double panel without gagline; b&w line drawings, b&w and color washes. Send query letter with samples of style. Samples are filed or are returned if requested. Reports back only if interested. Buys first rights or one-time rights. Pays $35, b&w; $50, color; on publication.

Illustrations: Buys illustrations mainly for spots and feature spreads. Buys 1-3 illustrations/issue from free-lancers. Works on assignment only. Prefers airbrush, colored pencil and watercolor. Considers pen & ink, mixed media, acrylic, pastel, collage, charcoal pencil and calligraphy. Send query letter with brochure showing art style. Looks for local subjects, conceptual abilities for abstract subjects (editorial approach)—likes a variety of techniques. Looks for strong black-and-white work. Samples are filed or are returned only if requested. Reports back only if interested. Write to schedule an appointment to show a portfolio which should include original/final art and color and b&w tearsheets. Buys first rights or one-time rights. Pays $75, b&w; $200, color, inside; on publication.

Tips: "Needs both feature and department illustration—best way to break in is with small spot illustration."

***HOPSCOTCH, The Magazine for Girls**, Box 1292, Saratoga Springs NY 12866. (518)587-2268. Editor: Donald P. Evans. Estab. 1989. A bimonthly consumer magazine for girls between the ages of 6 and 12. Circ. 7,000. Accepts previously published artwork. Originals are returned at job's completion. Sample copies available for $3. Art guidelines free for SASE with first-class postage.

Illustrations: Approached by 75-100 freelance illustrators/year. Buys 6-7 freelance illustrations/issue, 36-42/year. Artists work mostly on assignment. Prefers traditional and humor; pen & ink. Send query letter with photocopies. Samples are filed. Reports back within 2 weeks. Mail appropriate materials. Portfolio should include b&w photocopies. Buys first rights and reprint rights. Pays $20-40 for b&w, $150 for color, cover; on acceptance.

***HORSE ILLUSTRATED**, Box 6050, Mission Viejo CA 92690. (714)855-8822. Editor: Sharon Ralls Lemon. For people of all ages who own, show and breed horses, and who are interested in all phases of horse ownership. Monthly. Circ. 110,000. Sample copy $3.50; art guidelines for SASE.

Cartoons: Buys several cartoons/issue. Prefers single or double panel. "Central character should be a horse." Send finished art. SASE. Reports within 2 months. Buys one-time rights. Pays $25-50, b&w line drawings; on publication.

Illustrations: Buys several illustrations/year of horses. Send finished art. SASE. Reports within 2 months. Buys one-time rights. Pays $20-100, b&w line drawings, inside; on publication. Rate depends on use and whether illustrator was assigned.

Tips: When reviewing an illustrator's work, "we look for realism and accurate portrayal of the horse. We don't use 'fantasy' or 'surrealistic' art. For cartoons, we look for drawing ability and humor. We will, however, accept good humor with adequate illustration over good illustration with poor humor. Generally, we use free-standing illustrations as art rather than going to the illustrator and commissioning a work, but this is impossible if the artist sends us poor reproductions. Naturally, this also lessens his chance of our seeking out his services."

HOSPITAL PRACTICE, 10 Astor Place, New York NY 10003. (212)477-2727. Design Director: Robert S. Herald. Estab. 1966. 4-color magazine emphasizing clinical medicine and research for practicing physicians throughout the U.S. 18 issues/year. Circ. 200,000. Original artwork returned after publication if requested.

Illustrations: Approached by 30 illustrators/year. Works with 5-8 illustrators/year. Buys about 200 illustrations/year from freelancers. Uses only non-symbolic medical and scientific (conceptual) illustrations in a style similar to *Scientific American*. Prefers "an elegant, if traditional, visual communication of biomedical and clinical concepts to physicians." Prefers pen & ink, airbrush, watercolor and acrylic. Works on assignment only. Send query letter with brochure showing art style, resume, photostats, photographs/slides and/or tearsheets to be kept on file. Does not report unless called. Call for appointment to show portfolio, which should include b&w and color original/final art, tearsheets and photostats. Returns material if SASE included. Negotiates rights purchased. Pays $950, color, cover; $50 and up, b&w, inside; on publication.

Tips: "Our specific editorial approach limits our interest to physician-oriented, 'just-give-us-the-facts' type of medical and scientific illustrations, though they, too, can be done with creative imagination."

HOUSE & GARDEN, 350 Madison Ave., New York NY 10017. (212)880-7976. Art Director: Dania Martinez. Readers are upper income home owners or renters. Monthly. Circ. 500,000.

Illustrations: Uses minimum number of illustrations/issue, all of which are commissioned by the magazine. Selection based on "previous work, samples on file, and from seeing work in other publications. Illustrations are almost always assigned to fit specific articles." Themes "vary with our current format and with article we want illustrated." Format: b&w line drawings or washes. Portfolios viewed on first Tuesday of every month. Send samples of style and SASE to art director. Reports "from immediately to 4 weeks." Payment on acceptance "varies depending on artist, size and type of illustration." Buys one-time rights.

HOW MAGAZINE, 1507 Dana Ave., Cincinnati OH 45207. Art Director: Carole Winters. Estab. 1985. Trade journal; magazine format; "how-to and business techniques magazine for graphic design professionals." Bimonthly. Circ. 35,000. Does not accept previously published artwork. Original artwork return at job's completion. Sample copy available for $8.50. Art guidelines not available.

Illustrations: Approached by 100 freelance illustrators/year. Buys 2 illustrations/issue, 12 illustrations/year from freelancers. Works on assignment only. Considers all media, including photography. Send query letter with brochure, teasheets, photocopies and transparencies. Samples are filed or are returned by SASE if requested by artist. Reports back only if interested. To show a portfolio, mail slides. Buys first rights, one-time rights or reprint rights. Pays $500, color, cover; $50, b&w, $150, color, cover. Pays on publication.

***HSUS NEWS,** 5430 Grosvenor Lane, Bethesda MD 20814. Art Director: Theo Tilton. Estab. 1954. Quarterly magazine focusing on Humane Society News and animal protection issues. Circ. 450,000. Accepts previously published artwork. Originals are returned at job's completion. Sample copies are available.

Illustrations: Buys 1-2 freelance illustrations/issue, many/year. Works on assignment only. Themes vary. Send query letter with samples. Samples are filed or returned. Reports back within 1 month. Mail appropriate materials. Portfolio should include original/final art, b&w and color tearsheets and slides. Buys one-time rights and reprint rights. Pays $250 for b&w, $400 for color, cover; $150 for b&w, $300 for color, inside; on acceptance.

HUDSON VALLEY, Box 429, 297 Main Mall, Poughkeepsie NY 12602. (914)485-7844. Art Director: Karen Van Campenhont. Estab. 1971. Regional magazine with a broad range of subjects-Hudson Valley from Saratoga north to Westchester south. Average income of well educated reader is $88,000. "We have national advertising and special features. The Hudson Valley area has rural charm, jet city savvy, history, environmental concern and business sense." Monthly. Circ. 26,000. Accepts previously published artwork. Original artwork is returned after publication. Sample copies free for SASE with first-class postage.

Illustrations: Approached by 200 illustrators/year. Buys humorous and serious editorial illustrations for covers, spots, and feature spreads. Buys 15 illustrations/year from freelancers. Works on assignment only. Considers pen & ink, airbrush, mixed media, colored pencil, watercolor, acrylic, oil, pastel, collage, markers, charcoal pencil and calligraphy. Send query letter with samples. Samples are filed. Reports back within 2 months only if interested. Write or call to schedule an appointment to show a portfolio. Buys one-time rights; negotiates rights purchased. Pays $300, color, cover; up to $150, b&w; up to $250, color, inside; on publication.

Tips: "We don't want to see cartoons."

***HUMPTY DUMPTY'S MAGAZINE,** Box 567, Indianapolis IN 46206. (317)636-7760. Art Director: Lawrence Simmons. A health-oriented children's magazine for ages 4-7, published 8 times a year. Circ. 300,000. Originals are not returned at job's completion. Sample copies and art guidelines available.

Illustrations: Approached by 10 freelance illustrators/year. Buys 20 illustrations/issue, 160/year. Works on assignment only. Preferred styles are mostly cartoon and some realism. Considers any media as long as finish is done on scannable (bendable) surface. Send query letter with slides, photocopies, tearsheets and SASE. Samples are filed or returned by SASE if not kept on file. Reports back only if interested. Mail appropriate materials. Portfolio should include color tearsheets, photostats, photographs and photocopies. Buys all rights. Pays $250 for color, cover; $30-70 for b&w, $65-140 for color, inside; on publication.

***ILLINOIS MEDICINE,** Suite 700, 20 N. Michigan Ave., Chicago IL 60602. (312)782-1654. FAX: (312)782-2023. Managing Editor: Carla Nolan. Estab. 1989. Company magazine for the Illinois State Medical Society. A biweekly tabloid published for the physician members of the Illinois State Medical Society featuring, nonclinical socioeconomic and legislative news. Circ. 20,000. Accepts previously published artwork. Illustrations are returned at job's completion. Sample copies available.

Cartoons: Approached by 20 freelance cartoonists/year. Buys 1 freelance cartoon/issue, 75/year. Prefers medical themes—geared to physicians; single panel, with gagline, b&w washes and line drawings. Send query letter with finished cartoons. Samples are not filed and are returned. Reports back within 2 months. Buys one-time rights. Pays $50 for b&w.

Illustrations: Approached by 10 freelance illustrators/year. Buys 1 freelance illustration/issue, 25/year. Works on assignment only. Preferred themes are medical or governmental; pen & ink, watercolor, charcoal and pastel. Send query letter with brochure, tearsheets, photostats or photographs. Samples are filed. Reports back only if interested. Call to schedule an appointment to show a portfolio, which should include roughs, original/final art, b&w and color tearsheets, photostats and photographs. Buys one-time rights. Pays $50-200 for b&w, $100-400 for color; on acceptance.

***INCENTIVE MAGAZINE,** 633 3rd Ave., New York NY 10017. (212)984-2210. FAX: (212)867-4395. Art Director: Allen Schlossman. Estab. 1904. Trade journal. Monthly business magazine emphasizing motivation and promotion. Circ. 40,000. Originals are returned at job's completion. Samples copies available.

Illustrations: Approached by 15 freelance illustrators/year. Buys 10 freelance illustrations/issue, 100/year. Works on assignment only. Considers the full range of styles from lighthearted to moody and serious. Prefers watercolor, airbrush, acrylic, color pencil, mixed media and pastel. Send query letter with tearsheets, photostats, photographs, photocopies and self promo. Samples are filed or are returned by SASE if requested by artist. Reports back only if interested. Mail appropriate materials. Portfolio should include original/final art, color tearsheets, photographs and photocopies. Buys first rights. Pays $600 for b&w, $750 for color, cover; $250 for b&w, $300 and up for color, inside.
Tips: "Send samples of work showing a consistent and unique style, in a creative and intelligent manner."

inCIDER MAGAZINE, 80 Elm St., Peterborough NH 03458. (603)924-0100. Art Director: John Sizing. Estab. 1984. Magazine. "*InCider* covers the Apple II, Apple II GS computer market. The magazine reviews new products, software, hardware and peripherals and teaches basic programs in support of those computers. Monthly. Circ. 124,000. Original artwork is returned after publication. Sample copies free for SASE with $1.25 postage.
Illustrations: Approached by over 100 illustrators/year. Buys illustrations mainly for covers, spots and feature spreads. Works with 24 illustrators/year. Buys 2-3 illustrations/issue, 24 illustrations/year from freelancers. Uses freelance artists mainly for full-page, 4-color illustration for feature articles and covers, spot art. Works on assignment only. Considers airbrush, mixed media, watercolor, acrylic, oil, collage and charcoal/pencil. Send brochure and tearsheets. "Illustrator must understand technical aspects of our computer." Samples are filed or returned only if requested. Wants to see "examples of Mac generated work for use with DTP." Reports back only if interested. Write to schedule an appointment to show a portfolio, or mail original/final art, tearsheets, slides and transparencies. Buys first rights. Pays $800-1,000, b&w; $1,000-1,200, color, cover; $400-700, b&w; $750-900, color, inside; on acceptance.
Tips: "Know our magazine. You must be creative, be able to work with our budget and hold deadlines. All illustrations must be well executed." Common mistakes freelancers make in presenting their work is "sending b&w representations of color work, not researching the type of manager they are contacting. As trend sees illustration moving closer to fine art, further blurring any distinction between the two . . . anything goes."

***INCOME PLUS**, Suite 303, 73 Spring St., New York NY 10012. (212)925-3180. FAX: (212)925-3612. Design Director: Greg Treadway. Estab. 1989. Trade journal for small business entrepreneurs. Monthly. Circ. 250,000. Originals are returned at job's completion. Sample copies available. Art guidelines free for SASE with first-class postage.
Cartoons: Approached by 20 freelance cartoonists/year. Buys 10 freelance cartoons/issue, 12/year. Preferred themes are small business situations; single panel without gagline. Send query letter with finished cartoons. Reports back within 1 month. Buys one-time rights. Pays $10 for b&w.
Illustrations: Approached by 50 freelance illustrators/year. Buys 2 freelance illustrations/issue, 24-30/year. Works on assignment only. Themes are small business; style is varied between serious and caricature. Prefers pen & ink, watercolor, collage, airbrush, color pencil and mixed media. Send query letter with tearsheets, SASE and samples. Samples are filed or returned by SASE if requested by artist. Reports back within 1 month. Call or write to schedule an appointment to show a portfolio, which should include tearsheets and photocopies. Buys one-time rights. Pays $100 for b&w, $300 for color, cover; $100 for b&w, $200 for color, inside; on publication.
Tips: "Know the publication. Contact the design director."

***INFORMATIONWEEK**, 600 Community Dr., Manhasset NY 11030. (516)562-5693. FAX: (516)562-5036. Art Director: Hector Marrero. Estab. 1985. A weekly trade magazine covering news for information management. Circ. 160,000. Accepts previously published artwork. Originals are returned at job's completion. Sample copies free.
Cartoons: Approached by 24 freelance cartoonists/year. Will consider all styles. Prefers 4-color illustrated. Send query letter with samples of work. Samples are filed or returned by SASE if requested by artist. Reports back only if interested. Buys one-time North American rights. Pays $1,500 for color covers.
Illustrations: Approached by "dozens" of freelance illustrators/year. Buys 1-2 freelance illustrations/issue. Works on assignment only. Will consider all styles. Prefers 4-color illustrations. Send query letter with tearsheets. Samples are filed or returned by SASE if requested by artist. Reports back only if interested. Call to schedule an appointment to show a portfolio, which should include tearsheets. Buys one-time North American rights. Payment is negotiable. Pays on acceptance.

INSIDE, 226 S. 16th St., Philadelphia PA 19102. (215)893-5797. Editor: Jane Biberman. Estab. 1979. Quarterly. Circ. 70,000. Original artwork returned after publication.
Illustrations: Buys several illustrations/issue from freelancers. Buys 40 illustrations/year. Prefers color and b&w drawings. Works on assignment only. Send samples and tearsheets to be kept on file; call for appointment to show portfolio. Samples not kept on file are not returned. Reports only if interested. Buys first rights. Pays from $125, b&w, and from $300, full-color; on acceptance. Prefers to see sketches.

© T. S. Jessell 1991

Tulsa, Oklahoma-based illustrator Timothy S. Jessell desired to reveal the "frustration and confusion in a corporate environment" for this Information Week cover. For the assignment, art director Hector W. Marrero instructed him to portray a "manager/executive overwhelmed by a computer network breakdown." It was done in pastel and Prismacolor and paid Jessell $1,500. The work served to "establish me further in the field of illustration," he says.

INSIDE SPORTS, 990 Grove St., Evanston IL 60201. Emphasizes sports. Monthly. Circ. 525,000. Original artwork returned after publication.
Cartoons: Considers sports themes. Prefers single panel; b&w line drawings or color washes. Material not filed is returned by SASE. Pays on publication.
Illustrations: Considers sports themes. Works on assignment only. Send 4-color sample tearsheets (no original art). Prefer caricatures and conceptual pieces. Samples not filed are returned by SASE. Pays on acceptance.

THE INSTRUMENTALIST, 200 Northfield Rd., Northfield IL 60093. (708)446-5000. Editor: Anne Driscoll. Emphasizes music education for "school band and orchestra directors and teachers of the instruments in those ensembles." Uses 4-color, 2-color and b&w art. Monthly. Circ. 20,000. Original artwork may be returned after publication. Sample copy $2.50.
Cartoons: Approached by 3-4 cartoonists each year. Buys 3 cartoons/issue, 36/year, all from freelancers. Interested in positive cartoons; no themes stating "music is a problem or making fun of the profession"; single panel with gagline, if needed; b&w line drawings. Send finished cartoons. Samples not returned. Reports in 1-2 months. Buys all rights. Pays $20, b&w; on acceptance.
Illustrations: Uses freelance artwork mainly for covers. Buys Kodachrome transparencies or slides for covers. Query about suitable subjects. Pays $50-100 on acceptance.
Tips: Looks for "realistic or abstract closeups of performers and musical instruments. Style should be modern, with clean lines and sharp focus that will reproduce well. Black-and-white glossy photos are best; color slides for covers should be Kodachrome film. Artwork that does not pertain to music can help show your style, but it is best to see what you can do within musical themes. Include music-related cartoons—instrumentalists, conductors, music teachers that do not make fun of the profession."

INTERNATIONAL DOLL WORLD, 306 E. Parr Rd., Berne IN 46711. (219)589-8740. Editor: Rebekah Montgomery. A consumer journal that provides information on doll collecting, restoration and crafting. Bimonthly. 4-color. Circ. 89,000. Accepts previously published artwork. Original artwork is sometimes returned after publication. Sample copies $2.50. Art guidelines not available.
Cartoons: Approached by 2-3 cartoonists/year. Buys 2-3 cartoons/year from freelancers. Prefers themes on doll collecting. Prefers single panel with gagline. Send finished cartoons. Samples are filed. Samples not filed are returned by SASE. Reports back regarding queries/submissions only if interested. Negotiates rights purchased. Pays $20, b&w; on publication.
Illustrations: Approached by 14-15 illustrators/year. Buys illustrations mainly for feature spreads and paper dolls. Buys 2 illustrations/issue, 12/year from freelancers. Considers mixed media, colored pencil, watercolor, acrylic, oil and pastel. Send query letter with tearsheets, slides, photographs and transparencies. Looks for realistic technique. Samples are filed or are returned by SASE if requested. Reports back about queries/

submissions within 14 days. Call or write to schedule an appointment to show a portfolio which should include color original/final art, slides, photographs and transparencies Negotiates rights purchased. Pays $35-150, color, inside; on publication.

Tips: "The best way for an illustrator to break into our publication is to send paper dolls." The most common mistake freelancers make in presenting their work is "sending it on paper that produces a blurry line."

IOWA MUNICIPALITIES, League of Iowa Municipalities, Suite 209, 100 Court Ave., Des Moines IA 50309. Editor-in-Chief: Joy M. Newcom. Executive Director: Peter B. King. Magazine for city officials. Bimonthly. B&w with 2-color cover; design is "cubical, almost clip art-like with newspaper 'feel.' " Circ. 7,500. Previously published, photocopied and simultaneous submissions OK. Sample copy $2.

Cartoons: Political orientation relating to cities or issues concerning cities. Pays $25 for b&w.

Tips: "Have a good idea? Try us. Just looking for work? Don't try us. We rarely need freelancers without ideas of their own." Noting the effects of the recession, the editor says, "We haven't heard from anyone in 1½ years. Had to make do using our clip files, because we can't really afford to go looking either."

***IOWA WOMAN**, Box 680, Iowa City IA 52244. (319)987-2879. Editor: Marianne Abel. Estab. 1979. Literary magazine. "A quarterly magazine for every woman who has a mind of her own and wants to keep it that way, with fine literature and visual art by women everywhere." Circ. 2,400. Accepts previously published artwork. Originals are returned at job's completion. Sample copies $5. Art guidelines free for SASE with first-class postage.

Cartoons: Approached by 1 freelance cartoonist/year. "Have bought none yet, but we would use 10 freelance cartoons/year." Preferred theme/style is narrative, political and feminist; single, double and multiple panel, with or without gagline, and b&w line drawings. Send query letter with roughs, finished cartoons and SASE. Samples are filed or are returned by SASE if requested by artist. Reports back within 1 month. Buys first rights. Pays subscription and 2 copies.

Illustrations: Approached by 5 freelance illustrators/year. Buys 20 freelance illustrations/issue and 80/year. Prefers images of nature, incidental sketches and scenes; pen & ink, watercolor, collage, mixed media, b&w photo reproducible photocopies. Send query letter with tearsheets or slides, letter of introduction, SASE and photocopies. Samples are filed or returned by SASE if requested by artist. Reports back within 1 month. Mail appropriate materials. Portfolio should include thumbnails, b&w tearsheets, slides and photocopies. Buys first rights. Pays subscription and 2 copies. Pays on publication.

Tips: "We consider Iowa (or former Iowa) women artists only for the cover; women artists from everywhere else for inside art. We prefer to work on assignment, except for cartoons."

ISLANDS, 3886 State St., Santa Barbara CA 93105. (805)682-7177. FAX: (805)569-0349. Art Director: Albert Chiang. Estab. 1981. Consumer magazine of "international travel with an emphasis on islands." 4-color with contemporary design. Bimonthly. Circ. 150,000. Original artwork returned after publication. Sample copies available. Art guidelines free for SASE with first-class postage.

Illustrations: Approached by 20-30 illustrators/year. Buys 1-2 illustrations/issue, 6-8/year from freelancers. Needs editorial illustration. Uses freelance artists mainly for production on computer and editorial illustration. No theme or style preferred. Considers pen & ink, watercolor, collage, colored pencil, charcoal, mixed media, and pastel. Send query letter with brochure, tearsheets, photographs and slides. "We prefer samples of previously published tearsheets." Samples are filed. Reports back only if interested. Write to schedule an appointment to show a portfolio or mail appropriate materials. Portfolio should include original/final art and color tearsheets. Buys first rights or one-time rights. Pays $50, b&w, $100, color, cover; $300, b&w, $100, color, inside; on acceptance.

Tips: A common mistake freelancers make is that "they show too much, not focused enough. Specialize!" Notices "no real stylistic trends, but desktop publishing is affecting everything in terms of how a magazine is produced."

JACK AND JILL, Box 567, 1100 Waterway Blvd., Indianapolis IN 46206. (317)636-8881. Art Director: Edward F. Cortese. Emphasizes entertaining articles written with the purpose of developing the reading skills of the reader. For ages 7-10. Monthly except bimonthly January/February, April/May, July/August and October/November. Magazine is 4-color, 2-color and b&w. The editorial content is 50% artwork. Buys all rights. Original artwork not returned after publication (except in case where artist wishes to exhibit the art. Art must be available to us on request.) Sample copy 75¢.

Illustrations: Approached by more than 100 illustrators/year. Buys 25 illustrations/issue; 10-15/issue from freelancers. Uses freelance artists mainly for cover art, story illustrations and activity pages. Interested in "stylized, realistic, humorous illustrations for mystery, adventure, science fiction, historical and also nature and health subjects." Style of Len Ebert, Les Gray, Fred Womack, Phil Smith and Clovis Martin. Prefers mixed media. Works on assignment only. Send query letter with brochure showing art style and resume, tearsheets, photostats, photocopies, slides and photographs to be kept on file; include SASE. Reports in 1 month. To show a portfolio, mail appropriate materials or call or write to schedule an appointment. Portfolio should include original/final art, color, tearsheets, b&w and 2-color pre-separated art. Buys all rights on a

work-for-hire basis. Pays $250 cover, $140 full page, $90 ½ page, $65 spot for 4-color. For 4-color pre-separation art pays $175 full page, $105 ½ page and $70 spot. Pays $110 full page, $80 ½ page, $55 spot for 2-color. Pays $70 full page, $55 ½ page, $30 spot for b&w. On publication date, each contributor is sent two copies of the issue containing his or her work.

Tips: Portfolio should include "illustrations composed in a situation or storytelling way, to enhance the text matter. I do not want to see samples showing *only* single figures, portraits or landscapes, sea or air."

JOURNAL OF ACCOUNTANCY, 1211 Avenue of the Americas, New York NY 10036. (212)575-5268. Art Director: Jeryl Costello. Magazine emphasizing accounting for certified public accountants. Monthly. Circ. 350,000. Original artwork returned after publication.

Illustrations: Approached by 200 freelance illustrators/year. Buys 2-6 illustrations/issue from freelancers. Prefers business, finance and law themes. Prefers mixed media, then pen & ink, airbrush, colored pencil, watercolor, acrylic, oil and pastel. Works on assignment only. Send query letter showing art style. Samples not filed are not returned. Reports only if interested. Call to schedule an appointment to show a portfolio, which should include original/final art, color and b&w tearsheets. Buys first rights. Pays $1,200, color, cover; $150-600, color (depending on size), inside; on publication.

Tips: "I look for indications that an artist can turn the ordinary into something extraordinary, whether it be through concept or style. In addition to illustrators, I also hire freelancers to do charts and graphs. In portfolios, I like to see tearsheets showing how the art and editorial worked together." Does not want to see "too many different styles in subject matter not relative to accounting, business or government."

JOURNAL OF HEALTH EDUCATION, (formerly *Health Education*), 1900 Association Dr., Reston VA 22091. Editor: Patricia Steffan. Estab. 1970. "For school and community health professionals, keeping them up-to-date on issues, trends, teaching methods, and curriculum developments in health." Bimonthly. Conservative inside 4-color design; any style cover. Circ. 10,000. Original artwork is returned to the artist after publication if requested. Sample copies available. Art guidelines not available.

Illustrations: Approached by 15 illustrators/year. Works with 6 illustrators/year. Buys 6 illustrations/year from freelancers. Uses artists mainly for covers. Wants health-related topics, any style. Prefers watercolor, pen & ink, airbrush, acrylic, oil and computer illustration. Works on assignment only. Send query letter with brochure showing art style or photostats, photocopies, slides or photographs. Samples are filed or are returned by SASE. Reports back within weeks only if interested. Write to schedule an appointment to show a portfolio, which should include color and b&w thumbnails, roughs, original/final art, photostats, photographs and slides. Negotiates rights purchased. Pays $45, b&w; $250-500, color, cover; on acceptance.

THE JOURNAL OF LIGHT CONSTRUCTION, RR 2, Box 146, Richmond VT 05477. (802)434-4747. Art Director: Thersa Emerson. Black-and-white tabloid with 4-color cover; trade journal emphasizing residential and light commercial building and remodeling. Emphasizes the practical aspects of building technology and small-business management. Monthly. Circ. 70,000. Accepts previously published material. Original artwork is returned to the artist after publication. Sample copy free.

Illustrations: Buys 10 illustrations/issue, 120/year from freelancers. "Lots of how-to illustrations are assigned on various construction topics." Send query letter with brochure, resume, tearsheets, photostats and photocopies. Samples are filed or are returned only if requested by artist. Reports back within 2 weeks. Call or write to schedule an appointment to show a portfolio, which should include original/final art, final reproduction/product and b&w tearsheets. Buys one-time rights. Pays $400, color, cover; $60 b&w, inside; on acceptance.

Tips: "Write for a sample copy. We are unusual in that we have drawings illustrating construction techniques. We prefer artists with construction and/or architectural experience."

JUDICATURE, Suite 1600, 25 E. Washington, Chicago IL 60602. Contact: David Richert. Estab. 1917. Journal of the American Judicature Society. Published 6 times/year. B&w magazine with 2-color cover and conservative design. Circ. 20,000. Accepts previously published material. Original artwork returned after publication. Sample copy for SASE with $1.44 postage.

Cartoons: Approached by 10 cartoonists/year. Buys 1-2 cartoons/issue from freelancers. Interested in "sophisticated humor revealing a familiarity with legal issues, the courts and the administration of justice." Send query letter with samples of style and SASE. Reports in 2 weeks. Buys one-time rights. Pays $35 for unsolicited cartoons.

Illustrations: Approached by 20 illustrators/year. Buys 2-3 illustrations/issue. Works on assignment only. Interested in styles from "realism to light cartoons." Prefers subjects related to court organization, operations and personnel. Send query letter with brochure showing art style and SASE. Reports within 2 weeks. Write to schedule an appointment to show a portfolio, which should include roughs and original/final art. Wants to see "b&w and the title and synopsis of editorial material the illustration accompanied." Buys one-time rights. Negotiates payment. Pays $250, b&w, cover; $175, b&w, inside.

Tips: "Show a variety of samples, including printed pieces and roughs."

KALEIDOSCOPE: International Magazine of Literature, Fine Arts, and Disability, 326 Locust St., Akron OH 44302. (216)762-9755. Editor-in-Chief: Darshan Perusek. Estab. 1979. Magazine. "We address the experience of disability through literature and the fine arts. Avoid the trite and sentimental. Treatment of subject should be fresh, original and imaginative." Semiannual. Circ. 1,500. Accepts previously published artwork. Original artwork is returned after publication. Sample copies $2. Art guidelines available.
Illustrations: Approached by 10 illustrators/year. Considers pen & ink, watercolor and acrylic. Send query letter with photocopies, slides and photographs. Samples are not filed and are returned by SASE. Reports back within 6 weeks. "Final acceptance or rejection can take up to six months." Buys first rights. Pays $25-100; on publication.
Tips: "Inquire about future theme of upcoming issues. Become familiar with *Kaleidoscope*. Sample copy very helpful. We are actively seeking high quality art. We continue to seek balanced, realistic portrayals of people with disabilities."

KALLIOPE, a journal of women's art, 3939 Roosevelt Blvd., Jacksonville FL 32205. (904)387-8211. Contact: Art Director. Estab. 1978. Literary magazine which publishes an average of 18 pages of art by women in each issue. (Reproductions are published in b&w). "Publishes poetry, fiction, reviews, and visual art by women and about women's concerns." Triannual. Black-and-white perfect-bound, 80 pages, 18 pages of visual art per issue. Circ. 1,200. Original artwork is returned at the job's completion. Sample copy $7. Art guidelines available.
Cartoons: Approached by 1 cartoonist/year. Uses 1 cartoon/issue from freelancers. Topics should relate to women's issues. Send query letter with roughs. Samples are not filed and are returned by SASE. Reports back within 2 months. Rights purchased vary according to project. Pays 1 year subscription or 3 complimentary copies for b&w.
Illustrations: Approached by 35 illustrators/year. Uses 18 illustrations/issue, 54/year from freelancers. Looking for "excellence in visual art by women (nothing pornographic)." Send query letter with resume, SASE, photographs and artist's statement (50-75 words). Samples are not filed and are returned by SASE. Reports back within 2 months. Mail b&w photographs, resume and artist's statement. Rights purchased vary according to project. Pays 1 year subscription or 3 complimentary copies for b&w, cover and inside.
Tips: Seeking "excellence in theme and execution and submission of materials. Previous artists have included Louise Fishman, Nancy Azara, Lorraine Bodger, Genna Watson, Betty LaDuke, Grace Graupe-Pillard, Anna Tomczak."

KASHRUS Magazine—The Periodical for the Kosher Consumer, Box 204, Brooklyn NY 11204. (718)998-3201. Editor: Rabbi Wikler. Estab. 1980. Consumer magazine which updates consumer and trade on issues involving the kosher food industry, especially mislabeling, new products and food technology. Bimonthly. Circ. 10,000. Accepts previously published artwork. Original artwork is returned after publication. Sample copy $1.
Cartoons: Buys 5 cartoons/year. Buys 1 cartoon/issue from freelancers. Pays $25-50, b&w.
Illustrations: Buys illustrations mainly for covers. Works on assignment only. Prefers pen & ink. Send query letter with photocopies. Reports back about queries/submissions within 7 days. To show a portfolio, mail appropriate materials, which should include tearsheets and photostats. Pays $150, b&w, cover; $100, b&w, inside.
Tips: "Send food- and travel-related material. Do not send off-color material."

KEYNOTER, Kiwanis International, 3636 Woodview Trace, Indianapolis IN 46268. (317)875-8755. Executive Editor: Tamara P. Burley. Art Director: Jim Patterson. Official publication of Key Club International, non-profit high school service organization. Published 7 times/year. Copyrighted. 2-color. Circ. 130,000. Previously published, photocopied and simultaneous submissions OK. Original artwork returned after publication. Free sample copy.
Illustrations: Buys 3 editorial illustrations/issue from freelancers. Works on assignment only. SASE. Reports in 2 weeks. "Freelancers should call our Production and Art Department for interview." Buys first rights. Pays $500, b&w, $700, color, cover; $200, b&w, $500, color, inside. Pays on receipt of invoice.

KID CITY MAGAZINE, 1 Lincoln Plaza, New York NY 10023. (212)595-3456. Art Director: Michele Weisman. For ages 6-10.
Illustrations: Approached by 1,000 illustrators/year. Buys 100 illustrations/year from freelancers. Query with photocopied samples. Buys one-time rights. Pays $300 minimum, page, b&w; $400, page, $600, spread, color; on acceptance.
Tips: A common mistake freelancers make in presenting their work is "sending samples of work too babyish for our acceptance."

***KIPLINGER'S PERSONAL FINANCE MAGAZINE,** (formerly *Changing Times*), 1729 H St. NW, Washington DC 20006. (202)887-6416. Contact: Senior Art Assistant. Estab. 1937. A monthly consumer magazine covering personal finance issues including investing, saving, housing, cars, health, retirement, taxes and insurance.

Circ. 1,300,000. Originals are returned at job's completion. Sample copies available.
Illustrations: Approached by 1,000 freelance illustrators/year. Buys 15 freelance illustrations/issue. Works on assignment only. Looking for original conceptual art. Interested in new styles. Send query letter with tearsheets and photocopies. Samples are filed or are returned by SASE if requested by artist. Reports back within 2 months. Call. Portfolio should include tearsheets. Buys first rights. Pays on acceptance.
Tips: "Send us high-caliber original work that shows creative solutions to common themes."

KIWANIS, 3636 Woodview Trace, Indianapolis IN 46268. (317)875-8755. Executive Editor: Chuck Jonak. Art Director: Jim Patterson. Estab. 1918. Magazine emphasizing civic and social betterment, business, education, religion and domestic affairs for business and professional persons. Uses cartoons, illustrations, and photos from freelancers. Original artwork returned after publication. Published 10 times/year. Finds artists through talent sourcebooks, references/word-of-mouth and portfolio reviews.
Cartoons: Buys 30 cartoons/year. Buys 3 cartoons/issue, all from freelancers. Interested in "daily life at home or work. Nothing off-color, no silly wife stuff, no blue-collar situations." Prefers finished cartoons. Send query letter with brochure showing art style or tearsheets, slides, photographs and SASE. Reports in 3-4 weeks. Pays $50, b&w; on acceptance.
Illustrations: Works with 20 illustrators/year. Buys 6-8 illustrations/issue, 30 illustrations/year from freelancers. Prefers pen & ink, airbrush, colored pencil, watercolor, acrylic, mixed media, calligraphy and paper sculpture. Interested in themes that correspond to themes of articles. Works on assignment only. Keeps material on file after in-person contact with artist. Include SASE. Reports in 2 weeks. To show a portfolio, mail appropriate materials (out of town/state) or call or write to schedule an appointment; portfolio should include roughs, original/final art, final reproduction/product, color and b&w tearsheets, photostats and photographs. Buys first North American serial rights or negotiates. Pays $1,000, full-color, cover; $400-800, full-color, inside; $50-75, spot drawings; on acceptance.
Tips: "We deal direct—no reps. Have plenty of samples, particularly those that can be left with us. I see too much student or unassigned illustration in many portfolios."

L.A. PARENT MAGAZINE, 443 E. Irving Dr., Burbank CA 91504. (818)846-0400. FAX: (818)841-4380. Editor: Jack Bierman. Estab. 1979. Tabloid. A monthly city magazine for parents of young children. Circ. 100,000. Accepts previously published artwork. Originals are returned at job's completion. Sample copies free for SASE with first-class postage.
Illustrations: Buys 2 freelance illustrations/issue, 24/year. Works on assignment only. Send query letter with samples. Samples are filed or returned by SASE. Reports back within 2 months. Mail appropriate materials. Portfolio should include thumbnails, tearsheets and photostats. Buys one-time rights and reprint rights. Pays $50-75 for b&w, cover; on acceptance.
Tips: "Show an understanding of our publication. Since we deal with parent/child relationships, we tend to use fairly straightforward work."

***LACMA PHYSICIAN,** Box 3465, Los Angeles CA 90051-1465. Managing Editor: Michael Villaire. Estab. 1871. Trade magazine. "We present news and features of socioeconomic and political interest to physicians, as well as information of, for and about LACMA and its members." Published 20/year. Circ. 10,700. Originals are returned at job's completion. Sample copies available.
Illustrations: Approached by 30-50 freelance illustrators/year. Buys 1-2 freelance illustrations/issue, 20-30/year. Works on assignment only. Prefers pen & ink, airbrush, marker or, "depending on assignment." Send query letter with nonreturnable samples. Samples are not filed or returned. Reports back to the artist only if interested. Mail appropriate materials. Buys first rights. Pays $200 for b&w, $400 for color, cover; $100 for b&w, $200 for color, inside; on acceptance.

LADYBUG, the Magazine for Young Children, Box 300, Peru IL 61354. Art Director: Ron McCutchan. Estab. 1990. Emphasizes children's literature and activities for children, ages 2-7. Monthly. Circ. 140,000. Accepts previously published material. Original artwork returned after publication. Sample copy $1; art guidelines free for SASE.
Illustrations: Approached by 300-400 illustrators/year. Works with 40 illustrators/year. Buys 200 illustrations/year from freelancers. Examples of artists used: Marc Brown, Cyndy Szekeres, Rosemary Wells, Tomie de Paola, Diane Groat. Uses artists mainly for cover and interior illustration. Prefers realistic styles (animal or human figure); occasionally accepts caricature. Works on assignment only. Send query letter with brochure, samples and tearsheets to be kept on file, "if I like it." Prefers photostats and tearsheets as samples. Samples are returned by SASE if requested or not kept on file. Reports within 6-8 weeks. Portfolio should show a strong personal style and include "several pieces that show an ability to tell a continuing story or narrative." Does not want to see "overly slick, cute commercial art (i.e. licensed characters and overly sentimental greeting cards)." Buys reprint rights. Pays $750, color, cover; $250/full page, color; on publication.
Tips: "Has a need for artists who can accurately and attractively illustrate the movements for finger-rhymes and songs and basic informative features on nature and "the world around you." Multiethnic portrayal is also a *very* important factor in the art for *Ladybug*."

LADY'S CIRCLE MAGAZINE, 111 E. 35th St., New York NY 10016. (212)689-3933. Editor: Mary F. Bemis. Art Director: Bart Diehl. Estab. 1963. We are a mid- to low-income homemaker's magazine that specializes in cooking, crafts, psychology and how-to articles. We have a special section devoted to an older audience entitled "The Over-50 Section" that's very popular. We publish humor and fiction, both needing illustration. Bimonthly. Circ. 250,000. Accepts previously published artwork. Original artwork is sometimes returned after publication. Sample copy $1.95. Art guidelines not available. Prefers single panel with gagline; b&w line drawings. Send query letter with samples of style. Samples are filed. Samples not filed are returned. Reports back regarding queries/submissions within 3 months. Negotiates rights purchased. Pays $10-50, b&w; on publication.
Illustrations: Buys illustrations mainly for spots and feature spreads. Buys 3 illustrations/issue, 30 illustrations/year from freelancers. Works on assignment only. Prefers pen & ink. Considers watercolor, collage, markers and calligraphy. Send query letter with brochure showing art style, tearsheets and photostats. Samples are filed. Samples not filed are returned only if requested. Reports back about queries/submissions within 3 months. Call or write to schedule an appointment to show a portfolio or mail appropriate materials which should include tearsheets, photostats, photographs and b&w. Negotiates rights purchased. Pays $50-150, b&w; on publication.

LAKELAND BOATING, Suite 500, 1600 Orrington Ave., Evanston IL 60201. (708)865-5400. FAX: (708)869-5989. Art Director: Allen Landsberger. Estab. 1945. Consumer magazine for Great Lakes boaters. Monthly. 4-color. Accepts previously published artwork. Original artwork returned after publication. Sample copies and art guidelines available.
Cartoons: Single panel, humorous with a technical boating orientation or safety, pleasure, satire. Send query letter with brochure. Samples are filed. Reports back within 1 month. Rights purchased vary according to project. Negotiates payment.
Illustrations: Approached by 5-6 illustrators/year. Prefers "boating oriented themes (i.e. safety, pleasure, skiing—Great Lake images)." Considers any media. Send query letter with samples. Samples are filed or are returned by SASE if requested. Does not report back, in which case the artist should call. Call to schedule an appointment to show portfolio. Rights purchased vary according to project. Negotiates payment. Pays $25-35/¼ page, b&w; $50-65/¼ page, color, inside.
Tips: "We are interested in first-class images pertaining to the Great Lakes region as well as illustrating 'life on the water.'"

LANDSCAPE TRADES, 1293 Matheson Blvd., Mississauga, Ontario Canada. (416)629-1184. Kevin Press. 4-color magazine for landscapers, nursery garden centers, grounds maintenance firms, wholesale growers, suppliers of goods to the landscaping industry, parks and recreation officials, horticulturists and others. Monthly. Circ. 5,086. Free sample copy.
Cartoons: Buys 1 cartoon/issue from freelancers which should relate to the industry and have appeal to readers mentioned above. Prefers single or multiple panel b&w line drawings or washes with or without gagline but will also consider color cartoons. Send finished cartoons or samples of style. Buys one-time rights. Pays $25 (Canadian), b&w; on publication. "Please include phone number when writing."
Illustrations: Buys 1 editorial illustration/issue; 0-1 from freelancers. "I'd be happy to keep samples on file and request illustrations when a particular need or idea comes up." Prefers b&w line drawings or washes for inside. Send finished art or samples of style. Pays $20 (Canadian) for inside b&w; on publication. "Please include phone number when writing."

LAW PRACTICE MANAGEMENT, Box 11418, Columbia SC 29211. (803)754-3563 or 359-9940. Managing Editor/Art Director: Delmar L. Roberts. For the practicing lawyer. Published 8 times/year. Circ. 23,113. Previously published work rarely used.
Cartoons: Primarily interested in cartoons "depicting situations inherent in the operation and management of a law office, e.g., operating word processing equipment and computers, interviewing, office meetings, lawyer/office staff situations, and client/lawyer situations. We are beginning to use 1-2 cartoons/issue. We never use material about courtroom situations." Send query letter with resume. Reports in 90 days. Usually buys all rights. Pays $50 for all rights; on acceptance.
Illustrations: Uses inside illustrations and, infrequently, cover designs. Pen & ink, charcoal/pencil, watercolor, acrylic, oil, collage and mixed media used. Send query letter with resume. Reports in 90 days. Usually buys all rights. Pays $75-125; $150-200 for 4-color; on publication.
Tips: "There's an increasing need for artwork to illustrate high-tech articles on technology in the law office. We're also interested in computer graphics for such articles."

LEISURE WORLD, 1215 Ouellette Ave., Windsor, Ontario N8X 1J3 Canada. (519)971-3209. FAX: (519)977-1197. Assistant Editor: Kate McCrindle. Estab. 1988. Consumer magazine. Reflects the leisure time activities of members of the Canadian Automobile Association. Bimonthly. 4-color with travel spreads; b&w club news is 8-page insert. Circ. 250,000. Accepts previously published artwork. Original artwork returned at the job's completion. Sample copy free for SASE with first-class stamp. Art guidelines available.

Cartoons: Auto-related. Reports back within 1 month. Pays $25, b&w; $35, color.
Illustrations: Send query letter with photographs, photocopies, photostats, slides and transparencies. Most samples are filed. Those not filed are returned. Reports back in 1 month. Call or write to schedule an appointment to show a portfolio or mail thumbnails, roughs, original/final art, b&w or color tearsheets, photostats, photographs, slides and photocopies. Pays $25, b&w, $50, color, cover; $25, b&w, $35, color inside. "Negotiable."
Tips: "We occasionally use icons to represent theme of travel piece – i.e. theatre, destination."

THE LOOKOUT, 8121 Hamilton Ave., Cincinnati OH 45231. (513)931-4050. Editor: Simon J. Dahlman. 4-color magazine for conservative Christian adults and young adults. Weekly. Circ. 125,000. Original artwork not returned after publication, unless requested. Sample copy and artists' guidelines available for 50¢.
Cartoons: Uses 1 cartoon/issue; buys 20 cartoons/year from freelancers. Interested in church, Sunday school and Christian family themes. Pays $25 for b&w. Currently overstocked.
Illustrations: Buys 3-4 illustrations/issue from freelancers. Interested in "adults, families, interpersonal relationships; also, graphic treatment of titles." Works on assignment only. Send query letter with brochure, flyer or tearsheets to be kept on file for future assignments to Richard Briggs, Art Coordinator, at above address. Reporting time varies. Buys all rights but will reassign. Pays $150, b&w, $175, full-color illustrations, inside, firm; on acceptance. "Sometimes more for cover work."
Tips: "We use a variety of styles, but mainly realistic and impressionistic. The design of magazine is conservative, in that we are not avant-garde in design – not always locked in a standard grid."

LOS ANGELES, 1888 Century Park E., Los Angeles CA 90067. (213)557-7592. Design Director: William Delorme. Emphasizes life-styles, cultural attractions, pleasures, problems and personalities of Los Angeles and the surrounding area. Monthly. 4-color magazine with a contemporary, modern design. Circ. 170,000. Especially needs very localized contributors – custom projects needing person-to-person concepting and implementation. Previously published work OK. Pays on publication. Sample copy $3.
Cartoons: Contact Lew Harris, Editor-in-Chief. Buys 5-7 cartoons/issue on current events, environment, family life, politics, social life and business; single, double or multipanel with gagline. Looks for "sophisticated *New Yorker* type." To show a portfolio, mail roughs. Pays $25-50, b&w line or tone drawings.
Illustrations: Buys 10 illustrations/issue on assigned themes. Prefers general interest/life-style illustrations with urbane and contemporary tone. Send or drop off samples showing art style (tearsheets, photostats, photocopies and dupe slides). Pays $300-500, color, cover; $150-500, b&w, $200-800, color, inside; on publication.
Tips: "Show work similar to that used in the magazine – a sophisticated style. Study a particular publication's content, style and format. Then proceed accordingly in submitting sample work. We initiate contact of new people per Showcase reference books or promo flyers sent to us. Portfolio viewing is all local."

LOUISIANA LIFE MAGAZINE, Box 308, Metairie LA 70004. (504)456-2220. Art Director: Julie Dalton Gourgues. Estab. 1981. Consumer magazine; "general interest; covering all aspects of life in Louisiana – from music and food to politics and business." Bimonthly. 4-color with a classic contemporary design. Circ. 35,000. Accepts previously published artwork. Original artwork returned after publication. Sample copy $3.50. Art guidelines not available.
Illustrations: Approached by 15-30 illustrators/year. Buys 3-5 illustrations/issue, 18-30/year from freelancers. Works on assignment only. Prefer themes and styles which are not traditional and are those of the individual artist. Prefers collage, colored pencil, oil, charcoal, mixed media, scratchboard and pencil. Send query letter with brochure, tearsheets, resume, SASE and transparencies. Samples are filed. Reports back within 2 months. Call or mail appropriate materials. Portfolio should include original/final art and b&w tearsheets and slides. Buys first rights. Pays $225, color or b&w, cover; $50-135, color or b&w, inside; on publication.
Tips: "We use illustration solely for editorial and we let the illustrator submit the concept. Style depends on the article – always sophisticated and never literal. With the addition of fiction to our publication, I'm looking for more illustrators."

THE LUTHERAN, 8765 W. Higgins Rd., Chicago IL 60631. (312)380-2540. Art Director: Jack Lund. Estab. 1988. General interest magazine of the Evangelical Lutheran Church in America. Published 17 times a year; ⅓ 4-color and ⅔ 2-color, "contemporary" design. Circ. 1.2 million. Previously published work OK. Original artwork returned after publication on request. Free sample copy.
Cartoons: Approached by 300 cartoonists/year. Buys 1 cartoon/issue from freelancers. Receives 30 submissions/week from freelancers. Interested in humorous or thought-provoking cartoons on religion or about issues of concern to Christians; single panel. Prefers finished cartoons. Send SASE. Reports usually within a week. Buys first rights. Pays $25-100, b&w line drawings and washes; on publication.
Illustrations: Buys 6 illustrations/year from freelancers. Works on assignment. Send samples of style to keep on file for future assignments. Buys all rights on a work-for-hire basis. Samples returned by SASE if requested. Pays $500, 2-color and 4-color, cover; $25-300, b&w, $400, color, inside; on publication.
Tips: "Include your phone number with submission. Send samples that can be retained for future reference."

Boshra M. Abo-Saif had a two-week deadline for this scratchboard illustration for The Lutheran. It was "one of a four-part series on Luther's theology of the cross," says Abo-Saif of Park Ridge, Illinois. The designer and illustrator was paid $400 for the piece and benefitted futher from the exposure to so many readers and the consequent request for an exhibit of his work.

© Boshra Abo-Saif 1990

MADE TO MEASURE, 600 Central Ave., Highland Park IL 60035. (312)831-6678. Publisher: William Halper. Emphasizes manufacturing, selling of uniforms, career clothes, men's tailoring and clothing. Magazine distributed to retailers, manufacturers and uniform group purchasers. Semiannual. Circ. 24,000. Art guidelines available.
Cartoons: Buys 15 cartoons/issue from freelancers. Prefers themes relating to subject matter of magazine; also general interest. Prefers single panel with or without gagline; b&w line drawings. Send query letter with samples of style or finished cartoons. Any cartoons not purchased are returned to artist. Reports back. Buys first rights. Pays $30-40 b&w; on acceptance.

THE MAINE SPORTSMAN, Box 365, Augusta ME 04332. Editor: Harry Vanderweide. Emphasizes Maine outdoors for hunters and fishermen. Monthly 4-color tabloid. Circ. 30,000. Original work returned after publication.
Cartoons: Approached by 20 cartoonists/year. Buys 1-3 cartoons/month from freelancers. Prefers to buy 10-12 at a time. Samples returned by SASE. Reports in 1 week. Pays $10 for b&w, $20 for color; on acceptance.
Illustrations: Approached by 2-4 illustrators/year. Buys 1-3 illustrations/month from freelancers. Especially wildlife scenes. Most issues feature drawing on cover. Send query letter with brochure showing art style and samples. Samples returned by SASE. Reports in 1 week. Buys first rights, pays when illustration is published. Pays $100 maximum b&w, $300 maximum color, cover; $25 maximum, b&w, $100 color, inside.
Tips: "We prefer cartoons that are actually humorous, especially if they don't require a caption line. Currently we are in need of high-quality, pen & ink wildlife drawings. We need dynamic, single image drawings with minimal background image. Subjects needed are trout, salmon, bass, bluefish, striped bass, whitetail bucks, moose, bear, coyote, bobcat."

MANAGEMENT ACCOUNTING, 10 Paragon Dr., Montvale NJ 07645. (201)573-6269. Editor: Robert F. Randall. Estab. 1919. Emphasizes management accounting for management accountants, controllers, chief accountants and treasurers. Monthly. 4-color with a 3-column design. Circ. 85,000. Accepts simultaneous submissions. Original artwork not returned after publication. Sample copy free for SASE.
Cartoons: Approached by 15 cartoonists/year. Buys 12 cartoons/year from freelancers. Prefers single panel with gagline; b&w line drawings. Topics include office, financial, business-type humor. Send finished cartoons. Material not kept on file is returned by SASE. Reports within 2 weeks. Buys one-time rights. Pays $25, b&w; on acceptance.
Illustrations: Approached by 6 illustrators/year. Buys 1 illustration/issue from freelancers.
Tips: Does not want to see sexist cartoons.

MANAGEMENT REVIEW, 135 W. 50th St., New York NY 10020. (212)903-8286. FAX: (212)903-8168. Art Director: Seval Newton. Estab. 1921. Company magazine; "a business magazine for senior managers. A general, internationally focused audience." Monthly. Circ. 150,000. Original artwork returned after publication. Tearsheets available.

Cartoons: Approached by 10-20 cartoonists/year. Buys 1-2 cartoons/issue, 10-12 cartoons/year from freelancers. Prefers "business themes and clean drawings of minority women as well as men." Prefers double panel; b&w washes and line drawings. Send query letter with finished cartoons and SASE. Samples are filed. Reports back within 2 months. Buys first rights. Pays $100, b&w, $200, color.

Illustrations: Approached by 50-100 illustrators/year. Buys 4-8 illustrations/issue, 70-80 illustrations/year from freelancers. Works on assignment only. Prefers business themes and strong colors. Considers airbrush, watercolor, collage, acrylic, and oil. Send query letter with tearsheets, photographs and slides. Samples are filed. Reports back only if interested. To show a portfolio, mail original/final art and b&w tearsheets, photographs and slides. Buys first rights. Pays $800, color, cover; $250, b&w, $350, color, inside; on acceptance.

Tips: "Send tearsheets; periodically send new printed material."

***MARRIAGE PARTNERSHIP**, Christianity Today, Inc., 465 Gundersen Dr., Carol Stream IL 60188. (708)260-6200. FAX: (708)260-0114. Art Director: Gary Gnidovic. Estab. 1988. Quarterly consumer magazine. "We seek to strengthen and encourage healthy marriages. Read by couples aged 23-55 most of them Christians with kids at home." Circ. 75,000. Accepts previously published artwork. Original artwork is returned after publication. Sample copies available upon assignment. Art guidelines available.

Cartoons: Contact Barbara Calvert, editorial coordinator. Approached by 20 freelance cartoonists/year. Buys 10 freelance cartoons/issue, 40/year. Preferred themes are marriage, home life, family relationships. Prefers single panel. Send query letter with finished cartoons. Samples are not filed and are returned by SASE. Reports back within 1 month. Buys first rights. Pays $50 for b&w.

Illustrations: Approached by 50 freelance illustrators/year. Buys 20 freelance illustrations/issue, 80/year. Works on assignment only. Themes/styles vary. Prefers pen & ink, watercolor, colored pencil, oil and pastel. Send query letter with tearsheets and photocopies. Samples are filed. Reports back only if interested. Mail appropriate materials. Portfolio should include tearsheets, photocopies and promo pieces. Buys first rights. Pays $20-550 for color and b&w; on acceptance.

MEDICAL ECONOMICS MAGAZINE, Five Paragon Dr., Montvale NJ 07645. (201)358-7200. Art Administrator: Mrs. Donna DeAngelis. Estab. 1909. Bimonthly; 4-color, "contemporary, with more of a consumer publication look than a trade publication look; magazine for those interested in the financial and legal aspects of running a medical practice." Circ. 182,000. Accepts previously published material. Original artwork returned after publication. Uses freelance artists mainly for "all editorial illustration in the magazine."

Cartoons: Approached by more than 50 cartoonists/year. Buys 10-12 cartoons/issue from freelancers. Prefers medically related themes. Prefers single panel, with gagline; b&w line drawings and washes. Send query letter with finished cartoons. Material not filed is returned by SASE. Reports within 8 weeks. Buys all rights. Pays $100, b&w.

Illustrations: Approached by more than 100 illustrators/year. Works with more than 30 illustrators/year. Buys 100 illustrations/year from freelancers. Prefers all media including 3-D illustration. Needs editorial and medical illustration that varies, "but is mostly on the conservative side." Works on assignment only. Send query letter with resume and samples. Samples not filed are returned by SASE. Reports only if interested. Call to schedule an appointment to show a portfolio, which should include original/final art (if possible) and tearsheets. Buys one-time rights. Pays $900-1,250, color, cover; $200-800, b&w and $450-1,000, color, inside; on acceptance.

Tips: "In a portfolio, include original art and tearsheets, showing conceptualization. I do not want to see work copied from another source." Would like to see "promo pieces or leave behinds—how else do we remember an illustrator's work?" A common mistake freelancers make in presenting their work is "self-deprecation—they'll show a piece, then say 'Oh that's just leftover from my old style (days, school, whatever)' if they feel it's not up to par, they should get rid of it, or at least get it out of their portfolio." As far as the recession goes, "we're ad based, so if there are not as many ads, there is not as much editorial and less illustration."

***THE MEETING MANAGER**, Suite 5018, 1950 Stemmons Freeway, Dallas TX 75207. (214)746-5222. FAX: (214)746-5248. Art Director: Robin Gailey. Estab. 1972. Association publication. A monthly magazine sent to 10,000+ members in the meeting planning industry. Circ. 13,000. Accepts previously published artwork. Originals are returned at job's completion if requested beforehand. Sample copies for $3.

Illustrations: Approached by 5 freelance illustrators/year. Buys 3 freelance illustrations/year. Works on assignment only. Prefers professional, business art; airbrush and acrylic. Send query letter with brochure, tearsheets and nonreturnable samples. Samples are filed. Reports back only if interested. Write to schedule an appointment to show a portfolio. Mail appropriate materials. Portfolio should include original/final art, tearsheets and photographs. Rights purchased vary according to project. Pays $400 for color, cover or inside; on acceptance or publication.

Tips: "Send best samples of work. They should be nonreturnable. When an artist is matched with a specific assignment, they will be contacted."

MEN'S GUIDE TO FASHION, 3 W. 18th St., New York NY 10011. Art Director: Michael Renchiwich. Magazine directed to the young man's guide to clothing, grooming and fitness. Monthly. 4-color. Original artwork is not returned after publication. Art guidelines not available.
Illustrations: Buys illustrations mainly for spots. Buys 5 illustrations/issue. Buys 50+ illustrations/year. Needs editorial illustration that is "hip and intelligent." Style of Robert De Michelle. Works on assignment only. Considers pen & ink, mixed media, colored pencil, watercolor and collage. Send query letter with photocopies. Looks for intelligence when reviewing samples. Samples are filed. Samples not filed are not returned. Does not report back. Mail appropriate materials which should be photocopies. Buys all rights. Payment varies according to assignment. Pays on publication.
Tips: "We now need very little artwork that the staff cannot do themselves."

THE MERCEDES-BENZ STAR, 1235 Pierce St., Lakewood CO 80214. (303)235-0116. Editor: Frank Barrett. Estab. 1956. Magazine emphasizing new and old Mercedes-Benz automobiles for members of the Mercedes-Benz Club of America and other automotive enthusiasts. Bimonthly. Circ. 25,000. Does not usually accept previously published material. Returns original artwork after publication. Sample copy for SASE with $2 postage.
Illustrations: Works with 3+ illustrators/year. Buys 20+ illustrations/year from freelancers. Uses freelancers mainly for technical illustration. Prefers Mercedes-Benz related themes. Looks for authenticity in subject matter. Prefers pen & ink, airbrush and oil. Send query letter with resume, slides or photographs to be kept on file except for material requested to be returned. Write for appointment to show portfolio. Samples not filed are returned by SASE. Buys first rights. Pays $100-1,500; on publication.
Tips: " In a portfolio, include subject matter similar to ours."

***METROSPORTS MAGAZINE**, 695 Washington St., New York NY 10014. (212)627-7040. FAX: (212)242-3293. Publisher: Julie Jaffe. Estab. 1986. Consumer magazine. A monthly magazine featuring multiple recreational sports coverage: New York metro and Boston markets in separate editions. Circ. 130,000. Accepts previously published artwork. Originals are returned at job's completion. Art guidelines free for SASE with first-class postage.
Cartoons: Approached by 4-5 freelance cartoonists/year. Preferred theme is sports. Send query letter with brochure and roughs. Samples are filed. Reports back only if interested. Negotiates rights purchased. Pays $25 for b&w.
Illustrations: Approached by 4 freelance illustrators/year. Prefers line drawings, pen & ink and marker. Send query letter with photographs or photocopies. Samples are filed. Mail appropriate materials. Portfolio should include photocopies. Buys one-time rights. Pays $25 for b&w cover; on publication.
Tips: "Looks for charm, wit, originality."

MILITARY LIFESTYLE MAGAZINE, Suite 710, 4800 Montgomery Lane, Bethesda MD 20814. Art Director: Judi Connelly. Estab. 1969. Emphasizes active-duty military life-styles for military families. 4-color. Published 10 times/year. Circ. 530,000. Original artwork returned after publication.
Illustrations: Approached by 30-35 illustrators/year. Buys 2-6 illustrations/issue, 60-65/year from freelancers. Uses artists mainly for features, no covers. Theme/style depends on editorial content. Works on assignment only. Send brochure and business card to be kept on file. Accepts photostats, recent tearsheets, photocopies, slides, photographs, etc., as nonreturnable samples. Samples returned only if requested. Reports only if interested. Buys first rights. Payment depends on size published, cover and inside; pays on publication.
Tips: "Request copy of magazine. Include $1.50 per issue for postage and handling."

MILITARY MARKET MAGAZINE, Springfield VA 22159-0210. (703)750-8676. Editor: Nancy M. Tucker. Emphasizes "the military's PX and commissary businesses for persons who manage and buy for the military's commissary and post exchange systems; also manufacturers, brokers and distributors." Monthly. 4-color with contemporary design. Circ. 8,000. Simultaneous submissions OK. Original artwork not returned after publication.
Cartoons: Approached by 25 cartoonists/year. Buys 3-4 cartoons/issue from freelancers. Interested in themes relating to "retailing/buying of groceries or general merchandise from the point of view of the store managers and workers"; single panel with or without gagline, b&w line drawings. Send finished cartoons. Samples returned by SASE. Reports in 6 months. Buys all rights. Pays $25, b&w; on acceptance.
Tips: "We use freelance cartoonists only—*no* other freelance artwork." Do not "send us military-oriented cartoons. We want retail situations *only*. *No* bimbo cartoons."

***MILLER FREEMAN PUBLICATIONS**, 600 Harrison St., San Francisco CA 94107. (415)905-2200. Graphics Operations Manager: Amy R. Brokering. Publishes 24 4-color business magazines on paper and pulp, computers, music and medical subjects. Monthly. Circ. 100,000+. Returns original artwork after publication.

Cartoons: Approached by 5-10 freelance cartoonists/year. Cartoons appearing in magazines are line art and people/figures—humorous slice-of-life." Payment varies.

Illustrations: Approached by 40-50 freelance illustrators/year. Uses freelance illustrators mainly for illustration of feature articles. Buys 2 illustrations/month from freelancers. Works on assignment only. Send query letter with samples to be kept on file. Portfolio should include printed samples, particularly 4-color, along with query letter. Do not send photocopies or original work. Samples not filed are returned by SASE. Reports back only if interested. Negotiates rights purchased. Payment varies; on acceptance.

Tips: Common mistakes freelancers make include "sending too many samples and/or not being self-critical or selective with the samples submitted."

MODERN DRUMMER, 870 Pompton Ave., Cedar Grove NJ 07009. (201)239-4140. Editor-in-Chief: Ronald Spagnardi. Art Director: Scott Bienstock. For drummers, all ages and levels of playing ability with varied interests within the field of drumming. Monthly. Circ. 85,000. Previously published work OK. Original artwork returned after publication. Sample copy $3.95.

Cartoons: Buys 3-5 cartoons/year. Buys 1 cartoon/every other issue from freelancers. Interested in drumming themes; single and double panel. Prefers finished cartoons or roughs. Include SASE. Reports in 3 weeks. Buys first North American serial rights. Pays $5-25; on publication.

Tips: "We want strictly drummer-oriented gags."

MODERN MATURITY, 3200 E. Carson, Lakewood CA 90712. (213)496-2277. Art Director: James H. Richardson. Estab. 1956. Emphasizes health, lifestyles, travel, sports, finance and contemporary activities for members 50 years and over. Bimonthly. Circ. 21,000,000. Previously published work OK. Original artwork returned after publication. Sample copy available.

Illustrations: Approached by 200 illustrators/year. Buys 8 illustrations/issue, 48 illustrations/year from freelancers. Works on assignment only. Considers watercolor, collage, oil, mixed media and pastel. Samples are filed "if I can use the work." Reports back to the artist only if interested. Call to schedule an appointment to show a portfolio. Portfolio should include original/final art, tearsheets, slides and photocopies. Buys first rights. Pays $1,000, b&w; $2,000, color, cover; $2,000, color, inside, full page; on acceptance.

Tips: "We generally use people with a proven publications editorial track record. I request tearsheets of published work when viewing portfolios."

***MODERN PLASTICS**, 1221 Avenue of Americas, New York NY 10020. (212)512-3491. Art Director: Bob Barravecchia. Trade journal emphasizing technical articles for manufacturers of plastic parts and machinery. Monthly. 4-color with contemporary design. Circ. 60,000. Original artwork is sometimes returned after publication.

Illustrations: Works with 4 illustrators/year. Buys 4 illustrations/year. Prefers airbrush and conceptual art. Works on assignment only. Send brochure. Samples are filed. Does not report back. Call to schedule an appointment to show a portfolio, which should include tearsheets, photographs, slides, color and b&w. Buys all rights. Pays $800-1,000, color cover; 4-color photos, inside; on acceptance.

***MOMENT**, Suite 300, 3000 Connecticut Ave. NW, Washington DC 20008. (202)387-8888. Assistant Editor: Lisa Traiger. Estab. 1973. A bimonthly consumer magazine. A Jewish publication, featuring articles on religion, politics, culture and Israel. Bimonthly. Circ. 35,000. Accepts previously published artwork. Originals are returned at job's completion. Sample copies available for $4.50.

Cartoons: Uses reprints only, "depends on issue." Prefers political, Middle East, Israel. Samples are filed. Reports back only if interested. Rights purchased vary according to project. Pays $30 for ¼ page b&w and color.

Illustrations: Buys 2-5 freelance illustrations/year. Works on assignment only. Send query letter. Samples are filed. Reports back only if interested. Rights purchased vary according to project. Pays $30 for b&w, $225 for color, cover; $30 for color, inside; ¼ page or less.

Tips: "We look for specific work or style to illustrate themes in our articles. Please know the magazine."

MONEY MAKER MAGAZINE, 5705 N. Lincoln Ave., Chicago IL 60659. (312)275-3590. Art Director: Beth Ceisel. Estab. 1980. Consumer magazine. Bimonthly. Circ. 150,000. Accepts previously published artwork. Original artwork returned after publication. Art guidelines free for SASE with first-class postage.

Illustrations: Buys 8-10 illustrations/issue, 45-60/year from freelancers. Works on assignment only. Considers pen & ink, airbrush, mixed media, acrylic, oil and collage. Editorial illustration is hired based upon specific needs of an article in each issue, therefore style, tone and content will vary. Send query letter with brochure, tearsheets, photographs, slides, SASE, photocopies and promo pieces. Samples are filed or returned by SASE. Call or write to schedule an appointment to show a portfolio or mail appropriate materials. Buys first rights and one-time rights. Payment varies.

THE MORGAN HORSE, Box 960, Shelburne VT 05482. (802)985-4944. Art Director: Dorian Scotti. Emphasizes all aspects of Morgan horse breed including educating Morgan owners, trainers and enthusiasts on breeding and training programs; the true type of the Morgan breed, techniques on promoting the breed,

© Dave Lesh 1990

This illustration by David Lesh was done for Money Maker *magazine and is delightful to an illustrator's way of thinking in the way the text is wrapped around the image, instead of vice versa. To portray goal-hitting mutual funds was the job Lesh was given. The two-page spread was also featured in Print's Regional Design Annual.*

how-to articles, as well as preserving the history of the breed. Monthly. Circ. 10,000. Accepts previously published material, simultaneous submissions. Original artwork returned after publication. Sample copy $4.

Illustrations: Approached by 10 illustrators/year. Buys 2-5 illustrations/year from freelancers. Uses freelance artists mainly for editorial illustration and mechanical production. "Line drawings are most useful for magazine work. We also purchase art for promotional projects dealing with the Morgan horse—horses must look like *Morgans.*" Send query letter with samples and tearsheets. Accepts "anything that clearly shows the artist's style and craftsmanship" as samples. Samples are returned by SASE. Reports within 6-8 weeks. Call or write for appointment to show portfolio. Buys all rights or negotiates rights purchased. Pays $25-100, b&w; $100-300, color, inside on acceptance.

Tips: As trend sees "more of an effort on the part of art directors to use a broader style. Magazines seem to be moving toward more interesting graphic design. Our magazine design is a sophisticated blend of conservative and tasteful contemporary design. While style varies the horses in our illustrations must be unmistakably Morgans."

MOTOR MAGAZINE, 645 Stewart Ave., Garden City NY 11530. (516)227-1303. Art Director: Harold A. Perry. Estab. 1903. Emphasizes automotive technology, repair and maintenance for auto mechanics and technicians. Monthly. Circ. 135,000. Accepts previously published material. Original artwork returned after publication if requested. Never send unsolicited original art.

Illustrations: Buys 5-15 illustrations/issue from freelancers. Works on assignment only. Prefers realistic, technical line renderings of automotive parts and systems. Send query letter with resume and photocopies to be kept on file. Will call for appointment to see further samples. Samples not filed are not returned. Reports only if interested. Buys one-time rights. Write to schedule an appointment to show a portfolio, which should include final reproduction/product and color tearsheets. Payment negotiable for cover, basically $300-1,500; $50-500, b&w, inside; on acceptance.

Tips: "*Motor* is an educational, technical magazine and is basically immune to illustration trends because our drawings *must* be realistic and technical. As design trends change we try to incorporate these into our magazine (within reason). Though *Motor* is a trade publication, we approach it, design-wise, as if it were a consumer magazine. We make use of white space when possible and use creative, abstract and impact photographs and illustration for our opening pages and covers. But we must always retain a 'technical look'

to reflect our editorial subject matter. Publication graphics is becoming like TV programming, more calculating and imitative and less creative."

MTL MAGAZINE, Suite 201, 8270 Mountain Sights, Montreal, Quebec H4P 2B7 Canada. (514)731-9449. FAX: (514)731-7459. Art Director: Jocelyne Fournel. Estab. 1986. Consumer magazine; "an informative and entertaining approach to the interests, activities and lifestyle of Montrealers." Monthly. Circ. 65,000. Original artwork returned after publication. Sample copies available. Art guidelines not available.
Illustrations: Approached by 15 illustrators/year. Buys 5 illustrations/issue, 55 illustrations/year from freelancers. Works on assignment only. Prefers themes appropriate to the Montreal lifestyle. Considers acrylic and mixed media. Send query letter with photocopies. Samples are filed. Reports back within 2 weeks. Call to schedule an appointment to show a portfolio, which should include tearsheets. Buys first rights. Pays $350, b&w, $450, color, cover; $200, b&w, $250, color, inside; on publication.
Tips: "We are looking for good technique and originality."

MUSCLE MAG INTERNATIONAL, Unit 2, 52 Bramsteele Rd., Brampton, Ontario L6W 3M5 Canada. (416)457-3030. Publisher: Robert Kennedy. Estab. 1974. Consumer magazine. "Bodybuilding and fitness magazine for men and women." Monthly; 4-color, glitzy, lots of pictures and artwork. Circ. 170,000. Original artwork is not returned at job's completion. Samples copy for $2.
Cartoons: Approached by 100 freelance cartoonists/year. Buys 2 freelance cartoons/issue; 40/year. Prefers caricatures; with gagline; color washes. Send query letter with finished cartoons. Samples are not filed and are not returned. Reports back within 3 weeks. Buys all rights. Pays $50, b&w; $75, color.
Illustrations: Approached by 250 freelance illustrators/year. Buys 3 freelance illustrations/issue, 50/year. Prefers "a loose style, tightened up with black ink lines." Considers any and all media. Send query letter with photographs and slides. Samples are not filed and are not returned. Reports back within 3 weeks. Mail original/final art, tearsheets, photographs and photocopies. Buys all rights. Pays $250, b&w, $1,000, color, cover; $250, b&w, $350, color, inside; on acceptance.
Tips: "So many cartoonists and illustrators are playing with their careers. They need to ask themselves before submitting work to magazines, 'Do I really expect this magazine to publish this work?' "

MUSCLE MAGAZINE, Box 6100, Rosemead CA 91770. Art Director: Michael Harding. Magazine emphasizing bodybuilding, exercise and professional fitness. Features general interest, historical, how-to, inspirational, interview/profile, personal experience, travel articles and experimental fiction (all sports-related). Monthly. Circ. 332,425. Accepts previously published material. Original artwork returned after publication.
Illustrations: Buys 5 illustrations/issue, 60 illustrations/year from freelancers. Send query letter with resume, tearsheets, slides and photographs. Samples are filed or are returned. Reports back within 1 week. To show a portfolio mail color and b&w tearsheets, final reproduction/product, photographs and slides. Buys first rights, one-time rights, reprint rights and all rights. Pays on acceptance.
Tips: "Be consistent in style and quality."

***MY FRIEND**, 50 St. Paul's Ave., Boston MA 02130. (617)522-8911. FAX: (617)522-4081. Art Director: Sr. Mary Joseph. Estab. 1979. A monthly children's magazine (except July and August). A Catholic publication for kids, containing information, entertainment and Christian formation for young people ages 6 to 12. Circ. 17,000. Originals are returned at job's completion. Sample copies and art guidelines free for SASE with first-class postage.
Illustrations: Approached by 50 freelance illustrators/year. Buys 6 freelance illustrations/issue, 60/year. Works on assignment only. Preferred themes/styles are humorous, realistic and children; pen & ink, watercolor, airbrush, acrylic, marker, colored pencil, oil, charcoal, mixed media and pastel. Send query letter with brochure, tearsheets, resume, SASE, photocopies, slides and transparencies. Samples are filed. Reports back within 3-4 months. Buys first rights. Pays $200 for color, cover; $50 for b&w, $75 for color, inside; on acceptance.

***MY WEEKLY, "THE MAGAZINE FOR WOMEN EVERYWHERE"**, 80 Kingsway E., Dundee DD4 8SL Scotland. Editor: Sandra Monks. Estab. 1910. Magazine emphasizing women's interests for family-oriented women of all ages. Weekly, 4-color. "Design is bright and open." Circ. 696,275. Accepts previously published material. Original artwork returned after publication. Art guidelines free for SASE with postage.
Illustrations: Buys approximately 250 illustrations/year from freelancers. Uses artists mainly for short story and serial illustration. Prefers romantic, family . . . "updated Rockwell" themes. Send query letter with brochure showing art style or resume, tearsheets and photographs. Samples not filed are returned only if requested. Reports within 2 months. Buys British rights. Pays $100-150 inside, color. Pays on acceptance.
Tips: "Send good samples and be willing to adapt to the 'My Weekly'-type illustration."

THE NATION, 72 5th Ave., New York NY 10011. (212)242-8400. Assistant Editor: Micah Sifry. Estab. 1865. "We are a journal of left/liberal political opinion, covering national and international affairs, literature and culture" in magazine format. Weekly. Circ. 85,000. Original artwork is returned after publication upon request. Sample copies available. Art guidelines not available.

Illustrations: Approached by 50 freelance illustrators/year. Buys illustrations mainly for spots and feature spreads. Buys 3-4 illustrations/issue. Buys 150-200 illustrations/year. Works with 25 illustrators/year. Works on assignment only. Considers pen & ink, airbrush, mixed media and charcoal pencil. No color, b&w only. Send query letter with tearsheets and photocopies. "On top of a defined style, artist must have a strong and original political sensibility." Samples are filed or are returned by SASE. Reports back about queries/submissions only if interested. Call to schedule a portfolio review or mail appropriate materials. Portfolio should include tearsheets and photostats. Buys first rights. Pays $150, b&w, cover; $75, b&w, inside.

***NATIONAL DRAGSTER**, 2035 Financial Way, Glendora CA 91740. Art Director: J.R. Martinez. Estab. 1959. Drag Racing tabloid distributed to 80,000 association (NHRA) members. "The nation's leading drag racing weekly." B&w tabloid with 4-color cover and newspaper style design. Weekly. Circ. 80,000. Accepts previously published artwork. Original artwork is not returned after publication. Sample copies available. Art guidelines not available.
Cartoons: Buys 5-10 cartoons/year. Prefers drag racing theme, b&w only. Prefers single panel with gagline; b&w line drawings and b&w washes. Send query letter with samples of style. Samples are filed. Reports back regarding queries/submissions only if interested. Negotiates rights purchased. Pays $50/up, b&w. Pays on publication.
Illustrations: Buys illustrations mainly for spots. Buys 10-20 illustrations/year. Cartoons are single panel, drag racing oriented. Style is creative image, line or wash, sometimes humorous. Computer art O.K. Style of Don Weller. Prefers drag racing oriented pen & ink. Considers airbrush, mixed media and markers. Send query letter with brochure showing art style, tear sheets, photostats and photocopies. Looks for realistic automotive renderings. Samples are filed. Reports back about queries/submissions only if interested. To show a portfolio, mail appropriate materials which should include original/final art, tear sheets, photostats and photographs. Negotiates rights purchased. Pays $100+, b&w, inside. Pays on publication.
Tips: Send "concept drawings, drag racing illustrations (actual cars, cut-aways, etc.)."

NATIONAL GARDENING, 180 Flynn Ave., Burlington VT 05401. (802)863-1308. FAX: (802)863-5962. Art Director: Linda Provost. Estab. 1980. Consumer magazine "specializing in home vegetable gardening; environmentally conscious; fun and informal but accurate; a gardener-to-gardener network." Bimonthly. 4-color. Circ. 200,000. Sometimes accepts previously published artwork. Original artwork returned after publication. Sample copies available. Art guidelines not available.
Illustrations: Approached by 50 illustrators/year. Buys 10 illustrations/issue, 220 illustrations/year from freelancers. Works on assignment only. Preferred themes or styles "range from botanically accurate how-to illustrations to less literal, more interpretive styles. See the magazine. We use all media." Style of Kim Wilson Eversz, Andrea Eberbach, Amy Bartlett Wright. Send query letter with brochure, SASE, tearsheets, photostats and slides. "I prefer something to keep on file, and SASE if I must return anything." Samples are filed or returned by SASE if requested. Reports back only if interested "and when interested, i.e. ready to assign work." Call to schedule an appointment to show a portfolio, which should include "your best work in your best form." Buys one-time rights. Pays $50-200, b&w; $125, spot; $350 (average), full page for color, inside; within 30 days of acceptance.

NATIONAL GEOGRAPHIC, 17th and M Streets NW, Washington DC 20036. (202)857-7000. Art Director: Allen Carroll. Estab. 1888. Monthly. Circ. 10,500,000. Original artwork sometimes returned after publication.
Illustrations: Works with 20 illustrators/year. Buys 50 illustrations/year from freelancers. Interested in "full-color, representational renderings of historical and scientific subjects. Nothing that can be photographed is illustrated by artwork. No decorative, design material. We want scientific geological cut-aways, maps, historical paintings." Works on assignment only. Prefers to see portfolio and samples of style. Samples are returned by SASE. "The artist should be familiar with the type of painting we use." Provide brochure, flyer or tearsheet to be kept on file for future assignments. Pays $3,500, color, $750, b&w, inside; on acceptance.
Tips: "Send historical and scientific illustrations, ones that are very informative and very accurate. I do not want to see decorative, abstract portraits."

THE NATIONAL NOTARY, 8236 Remmet Ave., Box 7184, Canoga Park CA 91304-7184. (818)713-4000. Contact: Production Editor. Emphasizes "notaries public and notarization—goal is to impart knowledge, understanding, and unity among notaries nationwide and internationally." Readers are notaries of varying primary occupations (legal, government, real estate and financial), as well as state and federal officials and foreign notaries. Bimonthly. Circ. 80,000. Original artwork not returned after publication. Sample copy $5.
Cartoons: Approached by 5-8 cartoonists/year. Cartoons "must have a notarial angle"; single or multi panel with gagline, b&w line drawings. Send samples of style. Samples not returned. Reports in 4-6 weeks. Call to schedule an appointment to show a portfolio. Buys all rights. Negotiates pay; on publication.
Illustrations: Approached by 3-4 illustrators/year. Uses about 3 illustrations/issue; buys all from local freelancers. Works on assignment only. Themes vary, depending on subjects of articles. Send business card, samples and tearsheets to be kept on file. Samples not returned. Reports in 4-6 weeks. Call for appointment. Buys all rights. Negotiates pay; on publication.

Tips: "We are very interested in experimenting with various styles of art in illustrating the magazine. We generally work with Southern California artists, as we prefer face-to-face dealings."

NATIONAL REVIEW, 150 E. 35th St., New York NY 10016. (212)679-7330. Art Director: Paul Hebert. Emphasizes world events from a conservative viewpoint. Bimonthly. B&w with 4-color cover, design is "straight forward—the creativity comes out in the illustrations used." Original artwork returned after publication. Uses freelance artists mainly for illustrations of articles and book reviews, also covers.
Cartoons: Buys 15 cartoons/issue from freelancers. Interested in "light political, social commentary on the conservative side." Prefers to receive finished cartoons. Send SASE. Reports in 2 weeks. Buys first North American serial rights. Pays $50 b&w; on publication.
Illustrations: Buys 15 illustrations/issue from freelancers. Especially needs b&w ink illustration, portraits of political figures and conceptual editorial art (b&w line plus halftone work). "I look for a strong graphic style; well-developed ideas and well-executed drawings." Style of Tim Bower, Jennifer Lawson, Janet Hamlin, Alan Nahigian. Works on assignment only. Send query letter with brochure showing art style or tearsheets and photocopies. No samples returned. Reports back on future assignment possibilities. Call to schedule an appointment to show a portfolio, which should include original/final art, final reproduction/product and b&w tearsheets. SASE. Also buys small decorative and humorous spot illustrations in advance by mail submission. Buys first North American serial rights. Pays $85-100 b&w, inside; $500 color, cover; on publication.
Tips: "Tearsheets and mailers are helpful in remembering an artist's work. Artists ought to make sure their work is professional in quality, idea and execution. Recent printed samples alongside originals help. Changes in art and design in our field include fine art influence and use of more halftone illustration." A common mistake freelancers make in presenting their work is "not having a distinct style, i.e. they have a cross sample of too many different approaches to rendering their work. This leaves me questioning what kind of artwork I am going to get from this person when I assign him/her a piece."

NATURAL HISTORY, American Museum of Natural History, Central Park W. and 79th St., New York NY 10024. (212)769-5500. Editor: Alan Ternes. Designer: Tom Page. Emphasizes social and natural sciences. For well-educated professionals interested in the natural sciences. Monthly. Circ. 500,000. Previously published work OK.
Illustrations: Buys 23-25 illustrations/year; 25-35 maps or diagrams/year. Works on assignment only. Query with samples. Samples returned by SASE. Provide "any pertinent information" to be kept on file for future assignments. Buys one-time rights. Pays $200 and up, color inside; on publication.
Tips: "Be familiar with the publication. Always looking for accurate and creative scientific illustrations, good diagrams and maps."

***THE NEIGHBORHOOD WORKS,** 2125 W. North Ave., Chicago IL 60647. Editor-in-Chief: Mary O'Connell. Estab. 1977. A bimonthly magazine. "*TNW* is a 32-page, nonprofit magazine covering community organizing in respect to housing, energy, planning and economic development and the environment." Circ. 2,000. Accepts previously artwork. Original artwork not returned at the job's completion. Sample copies for SASE with 75¢ postage. Art guidelines not available.
Illustrations: Buys 1-3 illustrations/issue. Buys 15 illustrations/year. Works on assignment only. Prefers pen and ink. Send query letter with SASE, tearsheets, photocopies—"just enough to give us an idea of your style." Samples are filed. Reports back within 3 weeks. Mail appropriate materials. Portfolio should include roughs, b&w tearsheets and photocopies. Rights purchased vary according to project. "We are nonprofit. We have minimum budget and pay about $50 per drawing."
Tips: "We are a liberal, progressive magazine and we like to work with artists concerned with our issues. We are solution/action-oriented and we like artwork to be the same."

***NEVADA,** Suite 200, 1800 Hwy. 50 E., Carson City NV 89710. (702)687-5416. FAX: (702)687-6159. Estab. 1936. Consumer magazine "founded to promote tourism in Nevada. Features on Nevada artists, history, recreation, photography, gaming." Bimonthly. Circ. 100 million. Accepts previously published artwork. Original artwork returned to the artist at job's completion. Sample copies for $1.50. Art guidelines available.
Illustrations: Approached by 25 freelance illustrators/year. Buys 4 freelance illustrations/issue. Works on assignment only. Send query letter with brochure, resume and slides. Samples are filed. Reports back within 6 weeks. To show a portfolio, mail 20 slides and bio. Buys one-time rights.

NEW AGE JOURNAL, 342 Western Ave., Brighton MA 02135. (617)787-2005. Art Director: Dan Mishkind. Emphasizes alternative lifestyles, holistic health, ecology, personal growth, human potential, planetary survival. Bimonthly. Circ. 150,000. Accepts previously published material and simultaneous submissions. Original artwork returned after publication by request. Sample copy $3.
Illustrations: Buys 60-90 illustrations/year from freelancers. Works on assignment only. Send tearsheets, slides or promo pieces. Samples returned by SASE if not kept on file. Pays $600, color, cover; $300, color, inside.
Tips: "I prefer to see tearsheets or printed samples."

NEW HOME MAGAZINE, Box 2008, Laconia NH 03247. (603)528-4285. FAX: (603)524-0643. Art Director: John Goodwin. Estab. 1986. Consumer magazine "targeted to people who have recently purchased a home. *New Home* concentrates on the issues and needs of the new homeowner with service based articles and departments." Bimonthly. Circ. 300,000. Accepts previously published artwork. Original artwork is returned at job's completion. Samples copies available. Art guidelines free for SASE with first-class postage.
Illustrations: Approached by 100-150 illustrators/year. Buys 5-10 illustrations/issue, 35-75 illustrations/year from freelancers. Works on assignment only. Considers various styles. Considers pen & ink, airbrush, colored pencil, watercolor, acrylic, oil, pastel and collage. Send query letter with tearsheets. Samples are filed. Reports back to the artist only if interested. Write to schedule an appointment to show a portfolio, which should include b&w and color tearsheets. Rights purchased vary according to project. Pays $100, color, inside; on publication.

THE NEW PHYSICIAN, 1890 Preston White Dr., Reston VA 22091. Contact: Art Director: Mary Ellen Vehlow. For physicians-in-training; concerns primary medical care, political and social issues relating to medicine. Published 9 times/year. Circ. 30,000. Original artwork returned after publication. Buys one-time rights. Pays on publication.
Cartoons: Cartoon submissions welcome. Send finished artwork.
Illustrations: Approached by 100-200 illustrators/year. Buys 3+ illustrations/issue from freelancers. Usually commissioned. Samples returned by SASE. Submit resume and samples of style. Reports in 6-8 weeks. Provide resume, letter of inquiry, brochure and flyer to be kept on file for future assignments. Buys one-time rights. Pays $600, color, cover; $100, b&w, $300, color, inside.

THE NEW REPUBLIC, 1220 19th St. NW, Washington DC 20036. (202)331-7494. Assistant Editor: Leona Hiraoka Roth. Estab. 1914. Political/literary magazine; political journalism, current events in the front section, book reviews and literary essays in the back. Weekly; b&w with 4-color cover. Circ. 100,000. Original artwork returned after publication. Sample copy $3.
Illustrations: Approached by 300 illustrators/year. Buys 1-2 illustrations/issue, 48 illustrations/year from freelancers. Uses freelance illustration mainly for cover art. Works on assignment only. Prefers caricatures, portraits, 4-color, "no cartoons." Style of Vint Lawrence. Considers airbrush, colored pencil, watercolor, acrylic and oil. Send query letter with tearsheets. Samples are filed "if we think we may work together," or returned by SASE. Reports back within 1 month. "We'll contact you after seeing tearsheets." Portfolio should include roughs, tearsheets and "whatever the artist thinks matches our style best." Rights purchased vary according to project. Pays $500 for color, cover. Pays on publication.

NEW YORK HABITAT MAGAZINE, 928 Broadway, New York NY 10010. Managing Editor: Lloyd Chrein. Estab. 1982. "We are a how-to magazine for cooperative and condominium boards of directors in New York City and Westchester." Published 8 times a year; b&w with 4-color cover. Circ. 10,000. Original artwork is returned after publication. Sample copy $5. Art guidelines free for SASE with first-class postage.
Cartoons: Cartoons appearing in magazine are "line with some wash highlights." Pays $75 for b&w.
Illustrations: Approached by 50 freelance illustrators/year. Buys illustrations mainly for spots and feature spreads. Buys 1-3 illustrations/issue from freelancers. Needs editorial and technical illustration that is "ironic, whimsical, but not silly." Works on assignment only. Prefers pen & ink. Considers marker. Send query letter with brochure showing art style, resume, tearsheets, photostats, photocopies, slides, photographs and transparencies (fee requirements). Looks for "clarity in form and content." Samples are filed or are returned by SASE. Reports back about queries/submissions only if interested. For a portfolio review, mail original/final art and b&w tearsheets. Pays $75-125, b&w.
Tips: "Read our publication, understand the topic. Look at the 'Habitat Hotline' and 'Case Notes' sections." Does not want to see "tired cartoons about Wall Street board meetings and cute street beggars."

NEW YORK MAGAZINE, 755 2nd Ave., New York NY 10017. (212)880-0700. Design Director: Robert Best. Art Director: Syndi Becker. Emphasizes New York City life; also covers all boroughs for New Yorkers with upper-middle income and business people interested in what's happening in the city. Weekly. Original artwork returned after publication.

***** *The asterisk before a listing indicates that the listing is new in this edition. New markets are often the most receptive to freelance submissions.*

Illustrations: Works on assignment only. Send query letter with tearsheets to be kept on file. Prefers photostats as samples. Samples returned if requested. Call or write for appointment to show portfolio (drop-offs). Buys first rights. Pays $1,000, b&w and color, cover; $800, 4-color, $400, b&w full page, inside; $225, 4-color, $150, b&w spot, inside; on publication.

THE NEW YORKER, 25 W. 43rd St., New York NY 10036. (212)840-3800. Contact: Art Editor. Emphasizes news analysis and lifestyle features.
Needs: Buys cartoons and cover designs. Receives 3,000 cartoons/week. Mail art or deliver sketches on Wednesdays. Include SASE. Strict standards regarding style, technique, plausibility of drawing. Especially looks for originality. Pays $500 minimum, cartoons; top rates for cover designs. "Not currently buying spots."
Tips: "Familiarize yourself with your markets."

NORTH AMERICAN HUNTER, Box 3401, Minnetonka MN 55343. (612)936-9333. FAX: (612)944-2687. Editor: Bill Miller. Estab. 1978. Publishes hunting material only, for avid hunters of both small and big game in North America. Bimonthly magazine; 4-color; design "takes advantage of modern production capabilities (wraps, silhouettes) but stays somewhat conservative because of our older reader base." Circ. 250,000. Accepts previously published material. Original artwork returned after publication unless all rights are purchased. Sample copy $5; art guidelines available.
Cartoons: Approached by 50 cartoonists/year. Buys 15-20 cartoons/year from freelancers. Considers humorous hunting situations. "Must convey ethical, responsible hunting practices; good clean fun; not too detailed, but logically accurate." Prefers single panel with gagline; b&w line drawings or washes; 8½×11 vertical or horizontal format. Send query letter with roughs or finished cartoons. Returns unpurchased material immediately. Reports within 2 weeks. Buys all rights. Pays $35, b&w; on acceptance.
Illustrations: Approached by 100 illustrators/year. Buys 2 illustrations/issue from freelancers; usually includes 1 humorous illustration. Works with 5-7 illustrators/year. Prefers line art, mostly b&w, occasionally color. "Work should be close to being photographically real in most cases." Works on assignment only. Send query letter with samples. Samples not filed are returned. Reports within 2 weeks. Buys one-time rights. Pays up to $250, color, cover; up to $100, b&w or color, inside; on acceptance.
Tips: "Send only art that deals with hunting, hunters, wildlife or hunting situations. North American big and small game only. We accept only detailed and realistic-looking pieces—no modern art." Recession is affecting our magazine "very little—not at all."

***THE NORTH AMERICAN REVIEW**, University of Northern Iowa, Cedar Falls IA 50614. (319)273-6455. Art Director: Roy R. Behrens. Estab. 1815. "General interest quarterly, especially known for fiction (twice winner of National Magazine Award for fiction)." Accepts previously published work. Original artwork returned to artist at job's completion. "Sample copies can be purchased on newsstand or examined in libraries."
Illustrations: Approached by 500 freelance artists/year. Buys 20 freelance illustrations/issue. Buys 80 freelance illustrations/year. Artists primarily work on assignment but not always. Looks for "well-designed illustrations in any style. The magazine has won many illustration awards because of its insistence on quality. We prefer to use b&w media for illustrations reproduced in b&w and color for those reproduced in color. We prefer line art (camera ready) for spot illustrations" Send query letter with SASE, tearsheets, photocopies, slides, transparencies. Samples are filed if of interest or returned by SASE if requested by artist. Reports back to the artist only if interested. No portfolio reviews. Buys one-time rights. Contributors receive 2 copies of the issue. Pays $300 for color, cover plus 50 tearsheets of cover only; $5 for b&w inside spot illustrations; $65 for b&w large illustration. No color inside. Pays on publication.
Tips: "Send black-and-white photocopies of spot illustrations (printed size about 2×2"). For the most part, our color covers and major black-and-white inside illustrations are obtained by direct assignment from illustrators with whom we are in contact, e.g. Gary Kelley, Osie Johnson, Chris Payne and others. The magazine is affiliated with the Graphic Design Program (undergraduate and graduate) in the Department of Art at the University of Northern Iowa." Write for guidelines for annual cover competition.

NORTHWEST REVIEW, 369 PLC, University of Oregon, Eugene OR 97403. (503)346-3957. Editor: John Witte. Art Editor: George Gessert. Emphasizes literature. "We publish material of general interest to those who follow American poetry and fiction." Original artwork returned after publication. Published 3 times/year. Sample copy $3.
Illustrations: Uses b&w line drawings, graphics and cover designs. Receives 20-30 portfolios/year from freelance artists. Arrange interview or mail slides. Send SASE. Reports as soon as possible. Acquires one-time rights. Pays in contributor's copies. Especially needs high-quality graphic artwork. "We run a regular art feature of the work of one artist, printed in b&w, 133-line screen on quality coated paper. A statement by the artist often accompanies the feature."
Tips: "We are currently committed to an ongoing feature on *environmental art*, publishing in each issue reviews of artists' books and reproducing one artists' book in its entirety."

NOTRE DAME MAGAZINE, 415 Main Bldg., Notre Dame IN 46556. (219)239-5336. Art Director: Don Nelson. Estab. 1971. General interest university magazine for Notre Dame alumni and friends. Quarterly. Circ. 115,000. Accepts previously published artwork. Original artwork returned after publication. Sample copies and/or art guidelines not available.

Illustrations: Approached by 40 illustrators/year. Buys 5 illustrations/issue from freelancers. Works on assignment only. *Looking for talented, accomplished, experienced editorial artists only.* Tearsheets, photostats, photographs, slides and photocopies OK for samples. Samples are filed "if they are good" or are returned by SASE if requested. "Don't send submissions—only tearsheets and samples." To show a portfolio, mail published editorial art. Buys first rights. Payment negotiated.

Tips: "We have very high standards; if you are an entry level illustrator without professional training we are not interested in seeing your work."

NUGGET, Dugent Publishing Co., Suite 608, 2600 S. Douglas Rd., Miami FL 33134-6125. Editor: Jerome Slaughter. Illustration Assignments: Nye Willden. For men and women with fetishes.

Cartoons: Buys 10 cartoons/issue, all from freelancers. Receives 50 submissions/week from freelancers. Interested in "funny fetish themes." Black-and-white only for spots, b&w and color for page. Prefers to see finished cartoons. SASE. Reports in 2 weeks. Buys first North American serial rights. Pays $75, spot drawings; $100, page.

Illustrations: Buys 4 illustrations/issue from freelancers. Interested in "erotica, cartoon style, etc." Works on assignment only. Prefers to see samples of style. No samples returned. Reports back on future assignment possibilities. Send brochure, flyer or other samples to be kept on file for future assignments. Buys first North American serial rights. Pays $100-200, b&w.

Tips: Especially interested in "the artist's anatomy skills, professionalism in rendering (whether he's published or not) and drawings which relate to our needs." Current trends include "a return to the 'classical' realistic form of illustration, which is fine with us because we prefer realistic and well-rendered illustrations."

***NUTRITION TODAY**, 428 E. Preston St., Baltimore MD 21202. (301)528-8520. Art Director: James R. Mulligan. Trade journal emphasizing nutrition in the public and private sector directed to the practicing dietitian. Features general interest and technical articles. Bimonthly; b&w with 4-color cover and "eclectic" design. Circ. 16,000. Accepts previously published material. Original artwork returned after publication. Sample copy available. Art guidelines for SASE with 50¢ postage.

Illustrations: Buys 8 illustrations/year from freelancers. Works on assignment only. Prefers technical illustrations of diverse topics. Send query letter with brochure or resume and photocopies. Samples are filed. Samples not filed are not returned. Reports back only if interested. Write to schedule an appointment to show a portfolio, which should include original/final art, final reproduction/product, slides, color and b&w. Buys all rights. Pays $200, b&w; $400, color, cover; $100, b&w; $300, color, inside; on acceptance.

Tips: "Have a strong background in technical art, such as graphs and flow charts incorporating graphics."

***THE OFFICIAL PRO RODEO SOUVENIR PROGRAM**, Suite 200, 104 Pro Rodeo Dr., Colorado Springs CO 80919. (719)531-0177. FAX: (719)593-0220. Director Publication Marketing: Mary Ellen Davis. Estab. 1973. An annual souvenir program for rodeo events. "This magazine is purchased by rodeo organizers, imprinted with rodeo name and sold to spectators at rodeo events." Circ. 350,000. Accepts previously published artwork. Original artwork returned at job's completion. Sample copies available. Art guidelines not available.

Illustrations: Buys 1 freelance illustration/year. Works on assignment only. "We assign a rodeo event— 50%-art, 50%-photos." Considers all media. Send query letter with brochure, resume, SASE, tearsheets, photographs and photocopies. Samples are filed. Reports back within 3 months. Call to schedule an appointment to show a portfolio. Buys one-time rights. Pays $200 for color, cover. Pays on publication.

Tips: "Know about rodeo and show accurate (not necessarily photo-realistic) portrayal of event. Artwork is used on the cover about 50 percent of the time."

OHIO MAGAZINE, 62 E. Broad St., Columbus OH 43215. (614)461-5083. Art Director: Brooke Wenstrup. Emphasizes feature material of Ohio for an educated, urban and urbane readership. Monthly. Circ. 110,000. Previously published work OK. Original artwork returned after publication. Sample copy $3.

Illustrations: Buys 1-3/issue from freelancers. Interested in Ohio scenes and themes. Prefers fine art versus 'trendy' styles. Prefers pen & ink, charcoal/pencil, colored pencil, watercolor, acrylic, oil, pastel, collage, marker, mixed media and calligraphy. Works on stock and assignment. Send query letter with brochure showing art style or tearsheets, dupe slides and photographs. SASE. Reports in 4 weeks. On assignment: pays $75-150, b&w; $100-250, color, inside; on publication. Buys one-time publication rights.

Tips: "It helps to see one work in all its developmental stages. It provides insight into the artist's thought process. Some published pieces as well as non-published pieces are important. A representative sampling doesn't hurt, but it's a waste of both parties' time if their work isn't even close to the styles we use."

OLD WEST, Box 2107, Stillwater OK 74076. (405)743-3370. Editor: John Joerschke. Black-and-white magazine with 4-color cover; emphasizes American western history from 1830 to 1910 for a primarily rural and suburban audience, middle-age and older, interested in Old West history, horses, cowboys, art, clothing

Close-up

Dwayne Flinchum
Art Director
Omni
New York, New York

© Barbara Kelley 1991

It's rare to find a magazine that readers will purchase for the cover alone, but art director Dwayne Flinchum and his staff have made *Omni* just that. The magazine has a scientific slant, but whether you're browsing at the newsstand or looking for markets for your art, don't let that deter you. Flinchum says he has no more science in his background than the average reader.

"It's really more of a general interest approach," he says of the magazine's editorial content. "Our material is fresh every month. It puts the future first. We've broadened our approach from the first issues and now include a little bit of everything. The school of thought is: *Omni* does have to *look* different—other worldly. Lately we've had articles on subjects like the future of money, and I tried to run really 'business-looking' illustrations, but it wasn't effective.

"The trend for really tight realism is on the way out. I judged an illustration show in Los Angeles and that was the consensus of the judges. We voted for more painterly, freer, splashier styles. The realism looked really stiff and wooden. The trend now is for more expressionism."

The art staff at *Omni* has only recently begun using Macintosh computers for layout. But not for illustration. Flinchum feels the resulting pieces are often too lifeless. "To make it interesting and fresh, you almost have to do [hand-rendered] illustration," he says.

Flinchum has developed a looser style of art directing than is found at some publications. "Artists shouldn't cater to the market," he says, "but should do what they like. We commission two or three illustrations for each issue. In the beginning I art directed heavily and had a specific concept for each illustration, but I find if I stay out of it, they do a great job."

Flinchum prefers a surrealistic style in the pieces he commissions, and he doesn't limit himself to well-known artists. "We've had René Magritte, and on the next page a full-bleed illustration by a 19-year-old college guy who did a beautiful piece of art. We try to get away from a class system. We have illustration; we have fine art."

So how should you approach *Omni*? Some artists complain art directors flip through their portfolios in three seconds and tell them their style simply isn't right. "I remember those fast reviews," Flinchum says, laughing as he recalls his own early days as an artist. "But you kind of have to be that way. Now that I'm on this end of it, I probably have 20 to 40 unsolicited pieces of mail sitting on my desk right now. An art director has the attention span of a gnat, but I honestly know if a piece is right for *Omni* within three seconds. It's too bad you have to be brash about it.

"I really respect people who present their work professionally, simply, with maybe a black matte. I get all these little gimmicky things, cute little tag lines. The most effective pieces artists can show are original art. It's not convenient, but I think all art directors were originally interested in fine art, and they love the craft side of art. Yet we accept submissions

in any form. An art director I know presents his work in a carrousel for reviews, which means everyone's in a dark room and he has to flash the work up. It has more impact.

"In this industry, people just starting out get snapshots made and blanket the whole editorial community. I'm really against that. I'm sure when I open my mail today, I'll have submissions from people who specialize in sports. They should focus on a few publications they respect. Starting out, they have to have their work shot cheaply or send out a card. But they should look at other artists' work, research the market and hit maybe three or four magazines."

Flinchum finds his schedule is generally far too busy for in-person portfolio reviews and encourages out-of-town artists to drop off their portfolios for a day. "I occasionally like to meet them, but it's really unusual. I just don't have the time," he says, then adds, "I wish I could do that all day—just meet people and talk about their work."

—*Sheila Freeman*

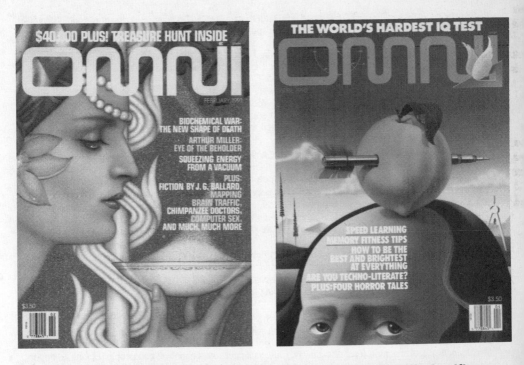

As these illustrations attest, Omni **covers are not always futuristic and scientific-looking, but they are unique, attractive, and as Flinchum says, "other-worldly." Whereas the art directors of many publications hire freelancers to produce a stylized elaboration of a thumbnail sketch, Flinchum hires artists and illustrators for their unique conceptualizations and styles. He finds that if he stays out of it, they usually do a great job.** Reprinted with permission of *Omni*.

and all things western. Quarterly. Circ. 30,000. Accepts previously published material and considers some simultaneous submissions. Original artwork returned after publication. Sample copy $2. Art guidelines for SASE.

Illustrations: Buys 5-10 illustrations/issue, including 2 or 3 humorous illustrations; buys all from freelancers. "Inside illustrations are usually, but need not always be, pen & ink line drawings; covers are western paintings." Send query letter with samples to be kept on file; "we return anything on request." Call or write for appointment to show portfolio. "For inside illustrations, we want samples of artist's line drawings. For covers, we need to see full-color transparencies." Reports within 1 month. Buys one-time rights. Pays $100-150 for color transparency for cover; $20-50, b&w, inside. "Payment on acceptance for new artists, on assignment for established contributors."

Tips: "We think the mainstream of interest in Western Americana has moved in the direction of fine art, and we're looking for more material along those lines. Our magazine has an old-fashioned pulp Western history design with a few modern touches. We use a wide variety of styles so long as they are historically accurate and have an old-time flavor."

***OMNI,** 1965 Broadway, New York NY 10023. (212)496-6100. FAX: (212)496-8613. Art Director: Dwayne Flinchum. Estab. 1978. A monthly consumer magazine. "A general interest consumer publication with scientific slant." Circ. 850,000. Accepts previously published artwork. Sample copies available. Art guidelines available.

Illustrations: Approached by 500 freelance illustrators/year. Buys 5-10 freelance illustrations/issue. Buys 50-100 freelance illustrations/year. (Estimate includes spot art.) Prefers "surreal subject matter (style is eclectic)." Prefers pen and ink, airbrush, acrylic, oil. Send query letter with SASE. Samples are filed or returned by SASE if requested by artist. Reports back within 3 weeks. Mail appropriate materials. Portfolio should include tearsheets and slides. Buys one-time rights. Pays $800 for color, cover. Pays $350/full page for b&w, $450/full page for color, inside. Pays on publication.

Tips: "We have a very open door policy for reviewing new illustrators. We have a drop-off (portfolio) day every Wednesday, and the illustrator can usually expect to get it back same day. Illustrators interested in having their work published should research their sources carefully—and market their work with greater discrimination. Most publications are only interested in a specific niche of content and style."

***ON OUR BACKS,** 526 Castro St., San Francisco CA 94114. (415)861-4723. Estab. 1984. Magazine format. A bimonthly magazine covering lesbian sexuality. "One of our specialties is lesbian erotic photography." Original artwork is returned at job's completion upon request with SASE. Submission guidelines available.

Cartoons: Needs lesbian sex humor. Pays $15 for b&w.

Illustrations: Send query letter with photocopies. Samples are filed or are returned by SASE. Reports back within 6 weeks. Call or write to schedule an appointment to show a portfolio. Rights purchased vary according to project. "We pay $15 per single photograph that we publish; $50 for pictorials." Pays 30 days after publication.

Tips: "Lesbian sex photography is a pioneer effort, and we are constantly trying to enlarge our scope and possibilties. We explore a variety of sexual styles, and nudity, per se, is not necessarily the focus. An erotic, and often emotional interpretation is. In general, we want a diversity of lesbians and intriguing themes that touch on our gay experience in a sexy and convincing manner."

***OPPORTUNITY MAGAZINE,** Suite 303, 73 Spring St., New York NY 11235. Editor: Donna Ruffini. Design Director: Greg Treadway. Features articles dealing with direct (door-to-door) selling and on ways to start small businesses. For independent salesmen, agents, jobbers, distributors, sales managers, flea market operators, franchise seekers, multi-level distributors, route salesmen, wagon jobbers and people seeking an opportunity to make money full- or part-time. Monthly b&w with 4-color cover. Uses mainly clip art and black-and-white line drawings. Circ. 250,000. Original artwork not returned after publication. Sample copy free for SASE with 50¢ postage.

Illustrations: Needs editorial illustration. Style is humorous and otherwise—very basic line drawings—"business-oriented with a relaxed style." Pays $200, color, cover.

Tips: "Get sample copy beforehand and have an idea of what is appropriate."

THE OPTIMIST MAGAZINE, 4494 Lindell Blvd., St. Louis MO 63108. (314)371-6000. Editor: Gary S. Bradley. Black-and-white magazine with 4-color cover; emphasizes activities relating to Optimist clubs in U.S. and Canada (civic-service clubs). "Magazine is mailed to all members of Optimist clubs. Average age is 42, most are management level with some college education." Circ. 170,000. Accepts previously published material. Sample copy for SASE.

Cartoons: Buys 3 cartoons/issue from freelancers. Prefers themes of general interest; family-orientation, sports, kids, civic clubs. Prefers single panel, with gagline. No washes. Send query letter with samples. Submissions returned by SASE. Reports within 1 week. Buys one-time rights. Pays $30, b&w; on acceptance.

ORANGE COAST MAGAZINE, Suite 8, 245-D Fischer Ave, Costa Mesa CA 92626. (714)545-1900. Art Director: Sarah McNeill. General interest regional magazine. Monthly. Circ. 40,000. Returns original artwork after publication. Sample copy and art guidelines available. Contact Brigid Madaris, Associate Art Director for guidelines.

Illustrations: Works with several illustrators and assigns 24-30 illustration jobs/year. Considers airbrush. Works on assignment only. Send brochure showing art style or tearsheets, slides or transparencies to be kept on file. Samples not filed are returned only if requested. Reports only if interested. To show a portfolio, mail color original/final art, final reproduction/product, tearsheets and photographs. Acquires one-time rights. Works on byline—basis only—there is no budget for monetary payment. Illustrator receives full credit and tearsheets in trade for artwork.

Tips: There is a need for "fluid free-style illustration and for more photojournalistic expression within an artists mode—i.e., the art meets needs to express a story exactly, yet in a creative manner and executed well."

ORGANIC GARDENING, 33 E. Minor St., Emmaus PA 18098. (212)967-8582. Art Director: Emilie Whitcomb. Magazine emphasizing gardening. Published 9 times/year. Circ. 1 million. Original artwork is returned to the artist after publication unless all rights are bought. Sample copies not available.

Illustrations: Buys 10 illustrations/issue, 90 illustrations/year from freelancers. Works on assignment only. Prefers botanically accurate plants and, in general, very accurate drawing and rendering. Send query letter with brochure, tearsheets, slides and photographs. Samples are filed. Samples not filed are returned by SASE only. Reports back within 1 month. Call or write to schedule an appointment to show a portfolio, which should include color or b&w final reproduction/product. Pays $50-200, b&w, $75-300, color, for spot art only. "We will pay more if size is larger than ¼ to ⅓ page." Buys first rights or onc-time rights.

Tips: "Work should be very accurate and realistic. Detailed and fine rendering quality is essential. We send sample issues to artists we publish—we do not provide tearsheets though."

THE OTHER SIDE, 300 W. Apsley St., Philadelphia PA 19144. (215)849-2178. Editor: Mark Olson. Art Director: Cathleen Benberg. "We are read by Christians with a radical commitment to social justice and a deep allegiance to Biblical faith. We try to help readers put their faith into action." Published 6 times/year. B&w with a 4-color cover. Circ. 13,000. Sample copy $4.50.

Cartoons: Approached by 20-30 cartoonists/year. Receives 3 cartoons and 1 illustration/week from freelance artists. Buys 12 cartoons/year from freelancers on current events, environment, economics, politics and religion; single and multiple panel. Pays $25, b&w line drawings; on publication. "Looking for cartoons with a radical political perspective."

Illustrations: Approached by 40-50 illustrators/year. Especially needs b&w line drawings illustrating specific articles. Send query letter with tearsheets, photocopies, slides, photographs and SASE. Reports in 6 weeks. Photocopied and simultaneous submissions OK. To show a portfolio, mail appropriate materials or call to schedule an appointment; portfolio should include roughs, original/final art, final reproduction/product and photographs. Pays within 1 month of publication. Pays $125-200, 4-color; $40-150, b&w line drawings inside; on publication.

Tips: "We're looking for illustrators who share our perspective on social, economic and political issues, and who are willing to work for us on assignment."

OTTAWA MAGAZINE, 192 Bank St., Ottawa, Ontario K2P 1W8 Canada. (613)234-7751. Art Director: Peter de Gannes. Emphasizes lifestyles for sophisticated, middle and upper income, above average education professionals; ages 25-50. Monthly. Circ. 50,000. Accepts previously published material. Sample copy available; include $2 Canadian funds to cover postage (nonresidents include 4 IRCs).

Cartoons: Approached by 10 cartoonists/year. Pays $75, b&w; $125, color.

Illustrations: Buys 6-8 illustrations/issue from freelancers. Receives 3-4 submissions/week from freelancers. "Illustrations are geared to editorial copy and run from cartoon sketches to *Esquire*, *New York* and *D* styles. Subjects range from fast-food franchising to how civil servants cope with stress. Art usually produced by local artists because of time and communication problems." Open to most styles including b&w line drawings, b&w and color washes, collage, photocopy art, oil and acrylic paintings, airbrush work and paper sculpture for inside. Also uses photographic treatments. Send query letter with resume and photocopies. "Do not send original artwork." No samples returned. Reports in 2 months. To show a portfolio, mail appropriate materials, which should include tearsheets and photostats. Buys first-time rights, or by arrangement with artist. Pays $450, b&w; $600, color, cover; $200, b&w; $400-500, color, inside; on acceptance.

Tips: Prefers "work that shows wit, confidence in style and a unique approach to the medium used. Especially in need of artists who can look at a subject from a fresh, unusual perspective. There is a trend toward more exciting illustration, use of unusual techniques like photocopy collages or collages combining photography, pen & ink and watercolor. Freedom is given to the artist to develop his treatment. Open to unusual techniques. Have as diversified a portfolio as possible."

OUTDOOR AMERICA MAGAZINE, 1401 Wilson Blvd., Level B, Arlington VA 22209. Editor: Kristin Merriman. Estab. 1922. Emphasizes conservation and outdoor recreation (fishing, hunting, etc.) for sportsmen and conservationists. Quarterly. Circ. 55,000. Accepts previously published material. Original artwork returned after publication. Sample copy $1.50.
Cartoons: Approached by 100 cartoonists/year. Payment for cartoons varies.
Illustrations: Approached by 150 illustrators/year. Buys 10+ illustrations/year from freelancers. Often commissions original work from non-local artists, and will occasionally purchase one-time or reprint rights to existing wildlife or recreation illustrations. Send query letter with resume, Xeroxed samples or tearsheets, list of where previously published, to be kept on file. Samples not filed are returned. Reports within 2 months. Buys one-time rights or reprint rights. Pays, $250, color, cover; $15-75, b&w; $35-100, color, inside. Pays on publication.
Tips: "Send samples and resume, then call us later if you don't hear from us in a month or so."

OUTDOOR CANADA MAGAZINE, Suite 202, 703 Evans Ave., Toronto, Ontario M9C 5E9 Canada. Editor: Teddi Brown. For the Canadian sportsman and his family. Stories on fishing, camping, hunting, canoeing, wildlife and outdoor adventures. Readers are 81% male. Publishes 8 regular issues a year, a fishing special in February. Circ. 140,000. Finds most artists through references/word-of-mouth.
Illustrations: Approached by 12-15 illustrators/year. Buys approximately 10 drawings/issue from freelancers. Uses freelance artists mainly for illustrating features and columns. Prefers pen & ink, airbrush, acrylic, oil and pastel. Buys first rights. Pays up to $400. Artists should show a representative sampling of their work, including fishing illustrations.

OUTSIDE MAGAZINE, 1165 N. Clark St., Chicago IL 60610. (312)951-0990. FAX: (312)951-6136. Design Director: John Askwith. Estab. 1977. Consumer magazine. "America's leading active lifestyle magazine." Monthly. Circ. 325,000. Sample copies available. Art guidelines free for SASE with first-class postage.
Illustrations: Approached by 150-200 illustrators/year. Buys 150 illustrations/year from freelancers. Works on assignment only. Prefers contemporary editorial styles. Considers watercolor, collage, airbrush, acrylic, colored pencil, oil, mixed media and pastel. Send query letter with brochure, tearsheets and slides. Most samples are filed. Those not filed are returned by SASE. Call to schedule an appointment to show a portfolio, which should include original/final art, tearsheets and slides. Buys one-time rights. Pays $750 for color, inside; on publication.
Tips: "Establish target publications. Maintain contact through update mailings until assignment is received. Always get as many tearsheets from a job that you can."

OVERSEAS!, Kolpingstr 1, 6906 Leimen, West Germany. Editorial Director: Charles L. Kaufman. Managing Editor: Greg Ballinger. Estab. 1973. "*Overseas!* is the leading lifestyle magazine for the U.S. military stationed throughout Europe. Primary focus is on European travel, with regular features on music, sports, video, audio and photo products." Sample copy for SAE and 4 IRCs; art guidelines for SAE and 1 IRC.
Cartoons: Buys 5+ cartoons/issue, 60+ cartoons/year from freelancers. Prefers single and multiple panel cartoons. "Always looking for humorous cartoons on travel, being a tourist in Europe and working in the U.S. military. Looking for more *National Lampoon* or *New Yorker*-style cartoons/humor than a *Saturday Evening Post*-type cartoon. Anything new, different or crazy is given high priority." On cartoons or cartoon features don't query, send nonreturnable photocopies. Pay is negotiable, $15-50/cartoon.
Illustrations: Works with 20+ illustrators/year. Buys 50-75 illustrations/year from freelancers. Prefers pen & ink, pencil and mixed media. Send query letter with nonreturnable photocopies. "We will assign when needed." Pays $50-100, b&w; $150, color, inside.
Tips: "We are very interested in publishing new young talent. Previous publication is not necessary."

PACIFIC NORTHWEST, Suite 101, 701 Dexter Ave. N, Seattle WA 98109. (206)284-1750. Editor: Ann Naumann. Emphasizes regional interests. Published 12 times/year. Circ. 90,000. Previously published material and simultaneous submissions OK if so indicated. Original artwork returned after publication. Free art guidelines for SASE.
Illustrations: Uses 6-10 illustrations/issue. Uses illustrations for specific articles. Send query letter, roughs and samples of style. Provide samples to be kept on file for possible future assignments. Samples returned by SASE if not kept on file. Buys one-time rights.

PALM BEACH LIFE, 265 Royal Poinciana Way, Palm Beach FL 33480. (305)820-4762. Design Director: Anne Wholf. Emphasizes culture, cuisine, travel, fashion, decorating and Palm Beach County lifestyle. Readers are affluent, educated. Monthly. Circ. 30,000. Sample copy $4.18; art guidelines for SASE.
Illustrations: Buys 3-4 illustrations/issue; all from freelancers. Only assigned work. Uses line drawings to illustrate regular columns as well as features. Format: color washes for inside and cover; b&w washes and line drawings for inside. "Any technique that can be reproduced is acceptable." Send samples or photocopies and/or arrange appointment to show portfolio. Send SASE. Reports in 4-6 weeks. Pays $300-600, color cover; $100-350, inside color; $60-150, inside b&w; on acceptance. Top price on covers only paid to established

artists; "the exception is that we are looking for super-dramatic covers." Looking for subjects related to Florida and lifestyle of the affluent. Price negotiable. Send slides or prints; do not send original work. *Palm Beach Life* cannot be responsible for unsolicited material.
Tips: "Look at magazines to see what we are like—make an appointment."

PARADE MAGAZINE, 750 3rd Ave., New York NY 10017. (212)573-7187. Director of Design: Ira Yoffe. Photo Editor: Miriam White. Emphasizes general interest subjects. Weekly. Circ. 37 million (readership is 70 million). Original artwork returned after publication. Sample copy and art guidelines available.
Illustrations: Uses varied number of illustrations/issue. Works on assignment only. Send query letter with brochure, resume, business card and tearsheets to be kept on file. Call or write for appointment to show portfolio. Reports only if interested. Buys first rights, and occasionally all rights.
Tips: "Provide a good balance of work."

***PARAPLEGIA NEWS**, Suite 111, 5201 N. 19th Ave., Phoenix AZ 85015. Art Director: Meryl Poticha. Estab. 1947. Magazine emphasizing wheelchair living for wheelchair users, rehabilitation specialists. Monthly; 4-color, "contemporary." Circ. 25,000. Accepts previously published material. Original artwork not returned after publication. Sample copy free for SASE with $1.45 postage.
Cartoons: Buys 36 cartoons/year. Buys 3 cartoons/issue from freelancers. Prefers line art with wheelchair theme. Prefers single panel with or without gagline; b&w line drawings. Send query letter with finished cartoons to be kept on file. Write for appointment to show portfolio. Material not kept on file is returned by SASE. Reports only if interested. Buys all rights. Pays $10, b&w.
Illustrations: Works with 2 illustrators/year. Buys 1 illustration/issue from freelancers. Needs editorial and medical illustration "well executed and pertinent." Prefers wheelchair living or medical and financial topics as themes. Send query letter with brochure showing art style or tearsheets, photostats, photocopies and photographs. Samples not filed are returned by SASE. Reports only if interested. To show a portfolio, include final reproduction/product, color and b&w, tearsheets, photostats, photographs. Negotiates rights purchased. Pays on acceptance.
Tips: "Show published work."

PEDIATRIC ANNALS, 6900 Grove Rd., Thorofare NJ 08086. (609)848-1000. Managing Editor: Mary L. Jerrell. Emphasizes pediatrics for practicing pediatricians. Monthly. Circ. 33,000. Original artowrk returned after publication. Sample copies available.
Illustrations: Prefers technical and conceptual medical illustration which relate to pediatrics. Prefers watercolor, acrylics, oils, pastels and mixed media. Send query letter with tear sheets, slides and photographs to be kept on file except for those specifically requested back. Reports within 2 months. Buys one-time rights or reprint rights. Pays $250-450, color, cover.
Tips: "*Pediatric Annals* continues to require that illustrators be able to treat medical subjects with a high degree of accuracy. We need people who are experienced in medical illustration, who can develop ideas from manuscripts on a variety of topics, and who can work independently (with some direction) and meet deadlines. Nonmedical illustration is also used occasionally. We deal with medical topics specifically related to children. Include color work, previous medical illustrations and cover designs in a portfolio, show a representative sampling of work."

PENNSYLVANIA MAGAZINE, Box 576, Camp Hill PA 17011. (717)761-6620. Editor-in-Chief: Albert Holliday. Estab. 1981. For college-educated readers, ages 35-60+, interested in self-improvement, history, travel and personalities. Bimonthly. Cir. 40,000. Query with samples. SASE. Reports in 3 weeks. Previously published, photocopied and simultaneous submissions OK. Buys first serial rights. Pays on publication or on acceptance for assigned articles/art. Sample copy $2.95.
Cartoons: Buys 5-10 cartoons/year from freelancers. Must be on Pennsylvania topics. Pays $25-50.
Illustrations: Buys 25 illustrations/year from freelancers on history and travel-related themes. Minimum payment for cover, $100, inside color, $25-50; inside b&w, $5-50. "I would like to see small *New Yorker*-type pen & ink sketches for spot art."

PENNWELL PUBLISHING CO., 1421 S. Sheridan, Tulsa OK 74112. (918)835-3161. Art Director: Mike Reeder. Emphasizes dental economics for practicing dentists; 24-65 years of age. Monthly. Circ. 100,000. Sample copy for SASE; art guidelines available.
Cartoons: Approached by 6-12 cartoonists/year. Buys about 1 cartoon/2 issues from freelancers. Prefers dental-related themes. Prefers single panel, with or without gagline; b&w line drawings. Send up to 12 cartoons in a batch. Material is returned by SASE only. Reports if interested. Pays $60, b&w; on acceptance.

PERSIMMON HILL, 1700 NE 63rd St., Oklahoma City OK 73111. (405)478-2250. FAX: (405)478-4714. Director of Publications: M.J. Van Deventer. Estab. 1963. "A journal of western heritage focusing on both historical and contemporary themes. It features nonfiction articles on notable persons connected with pioneering the American West; western art, rodeo, cowboys, Western flora and animal life; or other phenomena of the West

of today or yesterday. Lively articles, well written, for a popular audience." Quarterly; 4-color, "contemporary." Circ. 15,000. Accepts previously published artwork. Original artwork returned after publication. Sample copy $5. Art guidelines free for SASE with first-class postage.

Illustrations: Approached by 75-100 illustrators/year. Buys 5 illustrations/issue, 20-25 illustrations/year from freelancers. Works on assignment only. Prefers Western-related themes and pen & ink sketches. Send query letter with resume, SASE, photographs or slides and transparencies. Samples are filed or returned by SASE if requested. Reports back within 4-6 weeks. Call to schedule an appointment to show a portfolio, which should include original/final art, photographs or slides. Buys first rights. Pays $50, b&w, $200, color, cover; $150, color, inside (negotiable).

Tips: "Most illustrations are used to accompany articles. Work with our writers, or suggest illustrations to the editor that can be the basis for a freelance article on a companion story." Sees trends toward "bold colorations/magazine illustration; design borders on geometric design themes."

PHI DELTA KAPPAN, Box 789, Bloomington IN 47402. Editor-in-Chief: Pauline Gough. Contact: Editor. Emphasizes issues, policy, research findings and opinions in the field of education. For members of the educational organization Phi Delta Kappa and subscribers. Published 10 times/year. B&w with 4-color cover and conservative, classic design. Circ. 150,000. SASE. Reports in 8 weeks. "We return cartoons after publication." Sample copy $3.50 – "the journal is available in most public and college libraries." Uses freelance artists mainly for cartoons, assigned illustrations.

Cartoons: Approached by over 100 cartoonists/year. Looks for "finely drawn cartoons, with attention to the fact that we live in multi-racial, multi-ethnic world. Funny."

Illustrations: Approached by over 100 illustrators/year. Uses 1 4-color cover and spread and approximately 7 b&w illustrations per issue, all from freelancers, who have been given assignments from upcoming articles. Needs editorial illustration. Style of Kerry Gavin, Mario Noche. Most illustrations depict some aspect of the edcuation process (from pre-kindergarten to university level) often including human figures. Samples returned by SASE. To show a portfolio, mail a few slides or photocopies with SASE. Buys one-time rights. Payment varies.

Tips: "We look for artists who can create a finely crafted image that holds up when translated onto the printed page. Our journal is edited for readers with master's or doctoral degrees, so we look for illustrators who can take abstract concepts and make them visual, often through the use of metaphor."

PHYSICIAN'S MANAGEMENT, 7500 Old Oak Blvd., Cleveland OH 44130. (216)243-8100, ext. 808. Editor-in-Chief: Robert A. Feigenbaum. Art Director: David Komitau. Published 12 times/year. Circ. 120,000. Emphasizes business, practice management and legal aspects of medical practice for primary care physicians.

Cartoons: Receives 50-70 cartoons/week from freelancers. Buys 10 cartoons/issue from freelancers. Themes typically apply to medical and financial situations "although we do publish general humor cartoons." Prefers single and double panel; b&w line drawings with gagline. Uses "only clean-cut line drawings." Send cartoons with SASE. Pays $80 on acceptance.

Illustrations: Approached by 5 illustrators/year. Buys 2-4 illustrations/issue from freelancers. Accepts b&w and color illustrations. All work done on assignment. Send a query letter to editor or art director first or send examples of work. Fees negotiable. Buys first rights. No previously published and/or simultaneous submissions.

Tips: "First, become familiar with our publication. Cartoons should be geared toward the physician – not the patient. No cartoons about drug companies or medicine men. No sexist cartoons. Illustrations should be appropriate for a serious business publication. We do not use cartoonish or comic book styles to illustrate our articles. We work with artists nationwide."

***PICTURE PERFECT**, Box 15760, Stanford CT 06901. (203)978-0562. FAX: (203)323-8362. Publisher: Andres Aquino. Estab. 1989. Consumer magazine; magazine format; "a photography magazine covering fashion, travel, beauty and entertainment." Bimonthly. Circ. 50,000. Original artwork is returned at job's completion. Sample copy $4.

Illustrations: Buys 5 freelance illustrations/issue. Prefers fashion trends and lifestyle. Considers pen & ink, airbrush and mixed media. Send query letter with tearsheets, photostats and SASE. Samples are filed or returned by SASE if requested by artist. Reports back within 3 weeks. To show a portfolio, mail tearsheets and photostats. Buys first rights; rights purchased vary according to project. Pays $150 for b&w, $200 for color, cover; $75 for b&w, $125 for color, inside; on publication.

Tips: "Review the material and editorials covered in our magazine. Your work should have excellent visual impact. We are photography oriented."

PIG IRON, Box 237, Youngstown OH 44501. (216)783-1269. Editors-in-Chief: Jim Villani, Rose Sayre and Naton Leslie. Black-and-white magazine with 2-color cover; emphasizes literature/art for writers, artists and intelligent lay audience with emphasis in popular culture. Annually. Circ. 1,000. Previously published and photocopied work OK. Original artwork returned after publication. Sample copy $3.

Cartoons: Approached by 50 freelance cartoonists/year. Uses 1-15 cartoons/issue, all from freelancers. Receives 1-3 submissions/week from freelancers. Interested in "the arts, political, science fiction, fantasy, alternative lifestyles, psychology, humor"; single and multiple panel. Especially needs fine art cartoons. Prefers finished cartoons. SASE. Reports in 2 months. Buys first North American serial rights. Pays $5 minimum, b&w halftones and washes; on acceptance.

Illustrations: Approached by 100 freelance illustrators/year. Uses 15-30 illustrations/issue, all from freelancers. Receives 1-3 submissions/week from freelancers. Interested in "any media: pen & ink washes, lithographs, silk screen, charcoal, collage, line drawings; any subject matter." B&w only. Prefers finished art or velox. Reports in 2 months. Buys first North American serial rights. Minimum payment: Inside: $5; on publication.

Tips: "*Pig Iron* is a publishing opportunity for the fine artist; we publish art in its own right, not as filler or story accompaniment. The artist who is executing black-and-white work for exhibit and gallery presentations can find a publishing outlet with *Pig Iron* that will considerably increase that artist's visibility and reputation." Current themes: The Environment.

PLANNING, American Planning Association, 1313 E. 60th St., Chicago IL 60637. (312)955-9100. Editor-in-Chief: Sylvia Lewis. Art Director: Richard Sessions. For urban and regional planners interested in land use, housing, transportation and the environment. Monthly. Circ. 30,000. Previously published work OK. Original artwork returned after publication, upon request. Free sample copy and artist's guidelines available.

Cartoons: Buys 2 cartoons/year from freelancers on the environment, city/regional planning, energy, garbage, transportation, housing, power plants, agriculture and land use. Prefers single panel with gaglines ("provide outside of cartoon body if possible"). Include SASE. Reports in 2 weeks. Buys all rights. Pays $50 minimum, b&w line drawings; on publication.

Illustrations: Buys 20 illustrations/year from freelancers on the environment, city/regional planning, energy, garbage, transportation, housing, power plants, agriculture and land use. Prefers to see roughs and samples of style. Include SASE. Reports in 2 weeks. Buys all rights. Pays $250 maximum, b&w drawings, cover, $100 minimum, b&w line drawings inside; on publication.

Tips: "Don't send portfolio." Does not want to see "corny cartoons. Don't try to figure out what's funny to *Planners*. All attempts seen so far are way off base."

***PLAYGIRL**, 801 2nd Ave., New York NY 10017. (212)661-7878. FAX: (212)692-9297. Art Director: Jana Khalifa. Estab. 1973. Consumer magazine featuring entertainment for women. Monthly. Circ. 300,000. Accepts previously published artwork. Original artwork returned at job's completion. Sample copies available. Art guidelines available.

Cartoons: Approached by 10 freelance cartoonists/year. Buys 1 freelance cartoon/issue. Preferred subject is people. Prefers single panel. Send query letter with finished cartoons. Samples are filed or are returned by SASE. Reports back to the artist only if interested. Buys all rights. Pays $300, b&w, color.

Illustrations: Approached by 20 freelance illustrators/year. Buys 5 freelance illustrations/issue. Prefers romantic or humorous scenes involving people. Considers pen and ink, mixed media, watercolor, oil, pastel, collage and charcoal. Send query letter with tearsheets, photographs, slides and transparencies. Samples are filed or returned by SASE. Reports back to the artist only if interested. Call to schedule an appointment to show a portfolio, which should include original/final art, b&w and color tearsheets and slides. Buys all rights. Pays $300, b&w, color, cover. For inside, b&w or color, pays $300, ¼ page; $500, ½ page; $800, full page. Pays on publication.

POCKETS, Box 189, 1908 Grand Ave., Nashville TN 37202. (615)340-7333. Editor: Janet McNish. Devotional magazine for children 6 to 12. Monthly magazine except January/February. 4-color. Circ. 75,000. Accepts previously published material. Original artwork returned after publication. Sample copy for SASE with 73¢ postage.

Illustrations: Approached by 50-60 illustrators each year. Uses variety of styles; 4-color, 2-color, flapped art appropriate for children. Realistic fable and cartoon styles. We will accept tearsheets, photostats and slides. Samples not filed are returned by SASE. *Reports only if interested.* Buys one-time or reprint rights. Pays $50-550 depending on size; on acceptance. Decisions made in consultation with out-of-house designer.

Tips: "We forward artists' samples to our out-of-town designer. He handles all contacts with illustrators."

POPULAR ELECTRONICS, 500 B Bi-County Blvd., Farmingdale NY 11735. (516)293-3000. Editor: Carl Laron. Magazine emphasizing hobby electronics for consumer and hobby-oriented electronics buffs. Monthly b&w with 4-color cover. Circ. 87,877. Original artwork not returned after publication. Sample copy free.

Cartoons: Approached by over 20 cartoonists/year. Buys 3-5 cartoons/issue from freelancers. Prefers single panel with or without gagline; b&w line drawings and b&w washes. Considers a diversity of styles and subjects: electronics, radio, audio, video." Send finished cartoons; "we purchase and keep! Unused ones returned." Samples are returned. Reports within 2 weeks. Buys all rights. Pays $25, b&w or color.

POPULAR SCIENCE, Times Mirror Magazines, Inc., 2 Park Ave., New York NY 10016. (212)779-5000. Art Director: David Houser. For the well-educated adult male, interested in science, technology, new products. Original artwork returned after publication.

Illustrations: Uses 30-40 illustrations/issue; buys 30/issue from freelancers. Works on assignment only. Interested in technical 4-color art and 2-color line art dealing with automotive or architectural subjects. Especially needs science and technological pieces as assigned per layout. Samples returned by SASE. Reports back on future assignment possibilities. Provide tearsheet to be kept on file for future assignments. "After seeing portfolios, I photocopy or photostat those samples I feel are indicative of the art we might use." Reports whenever appropriate job is available. Buys first publishing rights.

Tips: "More and more scientific magazines have entered the field. This has provided a larger base of technical artists for us. Be sure your samples relate to our subject matter, i.e., no rose etchings, and be sure to include a tearsheet for our files."

***POTATO EYES,** Box 76, Troy ME 04987. (207)948-3427. Co-Editor: Carolyn Page. Estab. 1988. A biannual literary magazine. "A literary arts journal focusing on the Appalachian chain from the Laurentians to Alabama." Circ. 800. Original artwork returned at job's completion. Sample copies available: $5 for back issues, $6 for current issue.

Illustrations: Prefers detailed pen and ink drawings or block prints, primarily realistic. Considers pen and ink. Send query letter with photocopies. Samples are filed and are not returned. Reports back within 1-2 months. Buys one-time rights. Pays $25 and up for b&w, cover. Pays on publication.

PRACTICAL HOMEOWNER MAGAZINE, 27 Unquowa Rd., Fairfield CT 06430. (203)259-9877. FAX: (203)259-2361. Contact: Art Director. Estab. 1980. Consumer magazine emphasizing home design, building and remodeling. 9 issues/year. Circ. 740,000. Original artwork returned after publication. Sample copies and/or art guidelines not available.

Illustrations: Approached by 50 illustrators/year. Buys 8 illustrations/issue, 70 illustrations/year from freelancers. Works on assignment only. Prefers "technical and architectural/whimsical themes and styles." Style of Bartalos, Zimmerman, Hewitt, Moran, Moors. Prefers pen & ink, watercolor, airbrush and colored pencil. Send tearsheets. Samples are filed. Reports back only if interested. Mail tearsheets and slides. Buys one-time rights. Pays $150 for b&w, $300 for color, inside; $500 for color cover; on publication.

PRAIRIE SCHOONER, 201 Andrews Hall, University of Nebraska, Lincoln NE 68588-0334. (402)472-3191. Editor: Hilda Raz; Business Manager: Pam Weiner. Estab. 1927. Literary magazine. "*Prairie Schooner,* now in its sixty-fifth year of continuous publication, is called 'one of the top literary magazines in America,' by *Literary Magazine Review*. Each of the four annual issues contains short stories, poetry, book reviews, personal essays, interviews or some mix of these genres. Contributors are both established and beginning writers. Readers live in all states in the U.S. and in most countries outside the U.S." Quarterly. Circ. 2,200. Original artwork is returned after publication. "We rarely have the space or funds to reproduce artwork in the magazine but hope to do more in the future." Sample copies $2.

Illustrations: Approached by 1-5 illustrators/year. Uses freelance artists mainly for cover art. "Before submitting, artist should be familiar with our cover and format, 6×9", black and one color or b&w, vertical images work best; artist should look at previous issues of *Prairie Schooner*. We are rarely able to pay for artwork; have paid $50 to $100."

PRAYING, Box 419335, Kansas City MO 64141. (816)531-0538. Editor: Arthur N. Winter. Estab. 1984. Emphasizes spirituality for everyday living for lay Catholics and members of mainline Protestant churches; primarily Catholic, non-fundamentalist. "Starting point: The daily world of living, family, job, politics, is the stuff of religious experience and Christian living." Bimonthly 2-color magazine. Circ. 20,000. Accepts previously published material. Original artwork not returned after publication. Sample copy and art guidelines available.

Cartoons: Approached by about 24 cartoonists/year. Buys 1-2 cartoons/issue from freelancers. Especially interested in cartoons that spoof fads and jargon in contemporary spirituality, prayer and religion. Prefers single panel with gagline; b&w line drawings. Send query letter with samples of style to be kept on file. Material not filed is returned by SASE. Reports within 2 weeks. Buys one-time rights. Pays $50, b&w; on acceptance.

Illustrations: Approached by about 24 illustrators/year. Works with 6 illustrators/year. Buys 2-3 illustrations/issue, from freelancers. Prefers contemporary interpretations of traditional Christian symbols to be used as incidental art; also drawings to illustrate articles. Send query letter with samples to be kept on file. Prefers photostats, tearsheets and photocopies as samples. Samples returned if not interested or return requested by SASE. Reports within 2 weeks. Buys one-time rights. Pays $50, b&w; on acceptance.

Tips: "I do not want to see old-fashioned church cartoons centering on traditional church humor—windy sermons, altar boy jokes, etc. Know our content. We'd like cartoons making fun of contemporary Catholic spirituality."

PREMIERE MAGAZINE, 2 Park Ave., New York NY 10016. (212)725-5846. Art Director: David Walters. Estab. 1987. "Popular culture magazine about movies and the movie industry, both in the U.S. and international. Of interest to both a general audience and people involved in the film business." Monthly. Circ. 500,000. Original artwork is returned after publication.

Illustrations: Approached by 250+ illustrators/year. Works with 150 illustrators/year. Buys 15-25 illustrations/issue, 180-200+ illustrations/year from freelancers. Buys illustrations mainly for spots and feature spreads. Works on assignment only. Considers all styles depending on needs. Send query letter with tearsheets, photostats and photocopies. Samples are filed. Samples not filed are returned by SASE. Reports back about queries/submissions only if interested. Call to schedule an appointment to show a porfolio which should include tearsheets. Buys first rights or one-time rights. Pays $350, b&w; $375-1,200, color, inside.

Tips: "I do not want to see originals or too much work. Show only your best work."

THE PRESBYTERIAN RECORD, 50 Wynford Dr., Don Mills, Ontario M3C 1J7 Canada. (416)441-1111. Production and Design: Valerie Dunn. Published 11 times/year. Deals with family-oriented religious themes. Circ. 68,000. Original artwork returned after publication. Simultaneous submissions and previously published work OK. Free sample copy and artists' guidelines.

Cartoons: Approached by 12 cartoonists/year. Buys 1-2 cartoons/issue from freelancers. Interested in some theme or connection to religion. Send roughs and SAE (nonresidents include IRC). Reports in 1 month. Pays $25-50, b&w; on publication.

Illustrations: Approached by 6 illustrators/year. Buys 1 illustration/year from freelancers on religion. "We use freelance material, and we are interested in excellent color artwork for cover." Any line style acceptable — should reproduce well on newsprint. Works on assignment only. Send query letter with brochure showing art style or tearsheets, photocopies and photographs. Samples returned by SAE (nonresidents include IRC). Reports in 1 month. To show a portfolio, mail original/final art and color and b&w tearsheets. Buys all rights on a work-for-hire basis. Pays $50-100, color washes and opaque watercolors, cover; pays $30-50, b&w line drawings, inside; on publication.

Tips: "We don't want any 'cute' samples (in cartoons). Prefer some theological insight in cartoons; some comment on religious trends and practices."

PRESBYTERIAN SURVEY, 100 Witherspoon, Louisville KY 40202. (502)569-5636. FAX: (501)596-5018. Art Director: Meg Goodson. Estab. 1830. Official church magazine emphasizing religious world news and inspirational features. Monthly. Circ. 250,000. Originals are sometimes returned after publication. Sample copies free for SASE with first-class postage. Art guidelines not available.

Cartoons: Approached by 20-30 cartoonists/year. Buys 1 cartoon/issue, 20 cartoons/year from freelancers. Prefers general religious material; single panel. Send query letter with brochure, roughs and/or finished cartoons. Samples are filed or are returned. Reports back within 3 weeks. Rights purchased vary according to project. Payment depends on cover and/or size.

Illustrations: Approached by more than 50 illustrators/year. Buys 2-6 illustrations/issue, 50 illustrations/year from freelancers. Works on assignment only. Prefers ethnic, mixed groups and symbolic world unity themes. Media varies according to need. Send query letter with slides. Samples are filed or are returned by SASE. Reports back only if interested. Call or write to schedule an appointment to show a portfolio, which should include original/final art, tearsheets and photographs. Buys one-time rights. Pays $100, b&w, $350, color, cover; $150, b&w, $100, color, inside.

Tips: "The artist's work should represent the tasteful, representative style of Presbyterianism."

PREVENTION MAGAZINE, 33 E. Minor St., Emmaus PA 18098. (215)967-5171. Executive Art Director: Wendy Ronga. Estab. 1940. Emphasizes health, nutrition, fitness and cooking. Monthly. Circ. 3,200,000. Accepts previously published artwork. Returns original artwork after publication. Art guidelines available.

Cartoons: Approached by more than 50 cartoonists/year. Buys 2 cartoons/issue, 24 cartoons/year from freelancers. Prefers themes of health, pets and fitness. Considers single panel with or without gagline; b&w line drawings, b&w washes. Send finished cartoons. Samples are not filed and are returned by SASE within 4 weeks. Reports back within 2 months. Buys first rights. Pays $250, b&w; on acceptance.

Illustrations: Approached by more than 70 freelance illustrators/year. Buys about 5 illustrations/issue from freelancers. Uses freelance artwork mainly for inside editorial. Themes are assigned on editorial basis. Works on assignment only. Send samples to be kept on file. Prefers tearsheets or slides as samples. Samples not filed are returned by SASE only if requested. Reports back only if interested. Call to schedule an appointment to show a portfolio which should include b&w and color tearsheets, slides and transparencies. Buys one-time rights. Pays $100-2,000.

Tips: "Artists too often don't look at a current issue to see the kind of work I use. They think since this is a health magazine that I want just medical art, or they saw the magazine ten years ago." Looking for "health-related, stylized" work.

PROCEEDINGS, U.S. Naval Institute, Annapolis MD 21402. (301)268-6110. Art Director: LeAnn Bauer. Magazine emphasizing naval and maritime subjects. *"Proceedings* is an independent forum for the sea services." Monthly. B&w with 4-color cover. Design is clean, uncluttered layout, "sophisticated." Circ. 110,000. Accepts previously published material. Sample copies and art guidelines available.

Cartoons: Buys 1 cartoon/issue, 23 cartoons/year from freelancers. Prefers cartoons assigned to tie in with editorial topics. Send query letter with samples of style to be kept on file. Material not filed is returned if requested by artist. Reports within 1 month. Negotiates rights purchased. Payment varies.
Illustrations: Buys 1 illustration/issue. Works on assignment only. Needs editorial and technical illustration. "Like a variety of styles if possible. Do excellent illustrations and meet the requirement for military appeal." Style of Tom Freeman, R.G. Smith and Martz McCandlish. Prefers illustrations assigned to tie in with editorial topics. Send query letter with brochure, resume, tearsheets, photostats, photocopies and photographs. Samples are filed or are returned only if requested by artist. Reports within 1 month. Mail appropriate materials. Negotiates rights purchased. Pays $50, b&w, $150, color, inside. "Contact us first to see what our needs are."

PROFESSIONAL ELECTRONICS, 2708 W. Berry St., Ft. Worth TX 76109. (817)921-9062. Editor-in-Chief: Wallace S. Harrison. For professionals in electronics, especially owners, technicians and managers of consumer electronics sales and service firms. Bimonthly. 4-color. Circ. 10,000. Samples of previously published cartoons furnished on request.
Cartoons: Buys themes on electronics sales/service, association management, conventions and directors' meetings. Prefers single panel with gagline. Submit art with SASE. Reports in 2 weeks. Buys first rights. Pays $10, b&w line drawings; on acceptance.
Illustrations: Buys assigned themes. "Content should be humorous or pertinent to professionals in electronics." Submit art and SASE. Reports in 2 weeks. Buys first rights. Pays $30-60, b&w line drawings, cover. Pays $10-15, b&w line drawings, inside; on acceptance.
Tips: Currently overstocked.

PROFIT, Box 1132, Studio City CA 91604. (818)789-4980. Associate Editor: Marjorie Clapper. Magazine emphasizing business news for the business community. Circ. 10,000. Monthly. Original artwork not returned after publication. Sample copy $1.
Cartoons: Prefers single panel; b&w line drawings or b&w washes. Send query letter with samples of style to be kept on file if acceptable. Samples not filed are returned by SASE. Reports only if interested. Buys all rights. Payment varies.
Illustrations: Buys 0-5 illustrations/issue from freelancers. Works on assignment only. Send query letter with brochure showing art style or resume and samples. Samples returned by SASE. Reports only if interested. To show a portfolio, mail thumbnails, original/final art, final reproduction/product, tear sheets, b&w photographs and as much information as possible. Buys all rights. Payment varies. Pays on publication.

THE PROGRESSIVE, 409 E. Main St., Madison WI 53703. Art Director: Patrick JB Flynn. Estab. 1909. Monthly. B&w with 2-color cover and bold design. Circ. 40,000. Free sample copy and artists' guidelines.
Illustrations: Works with 50 illustrators/year. Buys 12 b&w illustrations/issue, 150 illustrations/year from freelancers. Needs editorial illustration that is "honest, bold, personal, artwork." Style of David McGinnis, Henrik Drescher, Franck Jetter, Sue Coe. Works on assignment only. Send query letter with tearsheets and/or photocopies. Samples returned by SASE. Reports in 2 months. Cover pays $250-300. Inside pays $100-200, b&w line or tone drawings/paintings. Buys first rights.
Tips: Do not send original art. Send direct mail samples, a postcard or photocopies and appropriate return postage. "The successful art direction of a magazine allows for personal interpretation of an assignment."

PUBLIC CITIZEN, Suite 610, 2000 P St., Washington DC 20036. (202)833-3000. Editor: Ann Radelat. Emphasizes consumer issues for the membership of Public Citizen, a group founded by Ralph Nader in 1971. Bimonthly. Circ. 42,000. Accepts previously published material. Returns original artwork after publication. Sample copy available with $9 × 12"$ envelope, SASE with first-class postage.
Illustrations: Buys up to 10 illustrations/issue. Prefers contemporary styles. Prefers pen & ink; uses computer illustration also. "I use computer art when it is appropriate for a particular article." Send query letter with samples to be kept on file. Samples not filed are returned by SASE. Reports only if interested. Buys first rights or one-time rights. Pays $300, 3-color, cover; $50-200, b&w or 2-color, inside; on publication.
Tips: "Frequently commissions more than one spot per artist. Also, send several keepable samples that show a range of styles and the ability to conceptualize."

PUBLIC RELATIONS JOURNAL, 33 Irving Place, New York NY 10003. (212)995-2230. Art Director: Susan Yip. Emphasizes issues and developments, both theory and practice, for public relations practitioners, educators and their managements. Monthly. Circ. 15,733. Accepts previously published material. Returns original artwork after publication.
Illustrations: Preferred themes and styles vary. Send brochure and samples to be kept on file. Samples not filed are returned only if requested. Reports back only if interested. Negotiates rights purchased. Pays $500, color, cover; $75, b&w, $100, color, inside; on publication.

PUBLISHER'S WEEKLY, 4th Floor, 249 W. 17th St., New York NY 10011. (212)645-9700. Art Director: Karen E. Jones. Magazine emphasizing book publishing for "people involved in the creative or the technical side of publishing." Weekly. 51 issues /year. Circ. 50,000. Original artwork is returned to the artist after publication. Sample copy available.
Illustrations: Buys 75 illustrations/year from freelancers. Works on assignment only. "Open to all styles." Send query letter with brochure or resume, tearsheets, photostats, photocopies, slides and photographs. Samples are not returned. Reports back only if interested. To show a portfolio, mail appropriate materials. Pays $175, b&w, $250, color, inside; on acceptance.
Tips: "Send promotional pieces and follow up with a phone call."

QUANTUM—Science Fiction & Fantasy Review, 8217 Langport Terrace, Gaithersburg MD 20877. Publisher/Editor: D. Douglas Fratz. Emphasizes science fiction and fantasy literature for highly knowledgeable science fiction professionals and well-read fans. Three issues per year Circ. 1,800. Accepts previously published material. Returns original artwork after publication. Sample copy $3. Art guidelines for SASE with first-class postage.
Cartoons: Approached by 25 cartoonists/year. Buys 1-2 cartoons/issue, 4-6 cartoons/year from freelancers. Themes must be related to science fiction or fantasy, including humor for in-group OSF professionals and fans. Prefers single panel; b&w line drawings. Send query letter with samples of style to be kept on file unless SASE included. Reports within 2 months. Buys one-time rights. Pays $2.50, b&w; on publication.
Illustrations: Approached by 40 illustrators/year. Works with 20 illustrators/year. Buys 9-10/issue from freelance artists. Prefers "sharp, bold b&w art." Science fiction or fantasy themes only. Prefers pen & ink, then airbrush and charcoal/pencil. Send query letter with tearsheets, photostats or photocopies to be kept on file unless SASE included. Accepts any style. Samples not filed are returned by SASE. Reports within 4 weeks. To show a portfolio, mail appropriate materials, which should include b&w original/final art, final reproduction/product and tearsheets. Buys one-time rights. Pays $20, b&w, cover; $15/page, b&w, inside; on publication.
Tips: "Show us only science fiction or fantasy work. Do not send color samples, slides or original art. Send black-and-white samples."

***ELLERY QUEEN'S MYSTERY MAGAZINE,** Davis Publications, 380 Lexington Ave., New York NY 10017. (212)557-9100. Editor: Eleanor Sullivan. Emphasizes mystery stories and reviews of mystery books. Reports within 1 month. Pays $25 minimum, line drawings. All other artwork is done inhouse. Pays on acceptance.

QUILT WORLD, 306 E. Parr Rd., Berne IN 46711. Editor: Sandra L. Hatch. Concerns patchwork and quilting. Bimonthly. Previously published work OK. Original artwork not returned after publication. Sample $3.
Cartoons: Approached by 10 cartoonists/year. Buys 2 cartoons/issue from freelancers. Receives 25 submissions/month from freelancers. Uses themes "poking gentle fun at quilters." Send finished cartoons. Reports in 3 weeks if not accepted. "I hold cartoons I can use until there is space." Buys all rights. Pays $15 on acceptance and/or publication.

***QUILTING TODAY/TRADITIONAL QUILTWORKS,** 301 Church St., New Milford PA 18834. (717)465-3306. FAX: (717)465-7187. Editorial Director: Patti Bachelder. Estab. 1987. Consumer magazines; both publications specialize in quilts and related stories, how-to articles and patterns. Bimonthly. Circ. 40,000 each. Original artwork is returned at job's completion. Sample copy $4.
Cartoons: Approached by 1-2 freelance cartoonists/year. Buys 2-3 freelance cartoons/year. Prefers quilt themes; single panel, with gagline, b&w line drawings. Send query letter with finished cartoons. Samples are not filed and are returned by SASE. Reports back within 4-6 weeks. Buys first rights or reprint rights. Pays $20 for b&w.
Illustrations: Buys 1-2 freelance illustrations/year. Works on assignment only. Themes should relate to article. Considers pen & ink. Send query letter with SASE and photostats. Samples are filed. Reports back within 6 weeks. To show a portfolio, mail appropriate materials. Portfolio should include original/final art, b&w and color tearsheets. Negotiates rights purchased. Pays $25 for b&w; on publication.
Tips: "Look over our magazines; suggest how your particular artwork would enhance them."

R-A-D-A-R, 8121 Hamilton Ave., Cincinnati OH 45231. Editor: Margaret Williams. For children 3rd-6th grade in Christian Sunday schools. Original artwork not returned after publication.
Cartoons: Buys 1 cartoon/month from freelancers on animals, school and sports. Prefers to see finished cartoons. Reports in 1-2 months. Pays $17.50; on acceptance.
Illustrations: Buys 5 or more illustrations/issue from freelancers. "Art that accompanies nature or handicraft articles may be purchased, but almost everything is assigned." Send tearsheets to be kept on file. Samples returned by SASE. Reports in 1-2 months. Buys all rights on a work-for-hire basis. Pays $150, full-color cover; $70, inside.

RADIO-ELECTRONICS, 500-B Bi-County Blvd., Farmingdale NY 11735. (516)293-3000. FAX: (516)293-3115. Editor: Brian Fenton. Estab. 1939. Monthly. Consumer magazine emphasizing electronic and computer construction projects and tutorial articles; practical electronics for technical people including service techni-

cians, engineers and experimenters in TV, hi-fi, computers, communications and industrial electronics. Circ. 210,000. Previously published work OK. Free sample copy.

Cartoons: Approached by 20-25 cartoonists/year. Buys 70-80 cartoons/year on electronics, computers, communications, robots, lasers, stereo, video and service; single panel. Send query letter with finished cartoons. Samples are filed or are returned by SASE. Reports in 1 week. Buys first or all rights. Pays $25 minimum, b&w washes; on acceptance.

Illustrations: Approached by 10 illustrators/year. Buys 3 illustrations/year from freelancers. Works on assignment only. Preferred themes or styles depend on the story being illustrated. Considers airbrush, watercolor, acrylic and oil. Send query letter with tearsheets and slides. Samples are filed or are returned by SASE. Reports back within 2 weeks. Mail appropriate materials: roughs, tearsheets, photographs and slides. Buys all rights. Pays $300, color, cover; $100, b&w, $300, color, inside; on acceptance.

Tips: Artists approaching *Radio-Electronics* should have an innate interest in electronics and technology that shows through in their work."

RAINBOW CITY EXPRESS, Box 8447, Berkeley CA 94707-8447. Editor/Publisher: Helen B. Harvey. Estab. 1988. "Journal/newsletter/creative forum"; magazine format emphasizing "adventures on the spiritual path, true experiences and insights of spiritual awakening, evolving consciousness, women's issues, creativity and related topics." B&w with 2-color cover. Quarterly. Circ. 500-1,000. Sometimes accepts previously published artwork. Whether originals returned to the artist at the job's completion depends on rights purchased. Back issues $6. Art guidelines for SASE with two first-class stamps.

Illustrations: "We have a commissioned artist but are branching out." Buys 1-5 illustrations/issue, 4-20 illustrations/year from freelancers. "We also purchase completed art." Needs editorial illustration — "spiritual, aesthetic." Prefers "sophisticated, delicate renderings with ethereal , spiritual, aesthetic qualities." Prefers pen & ink. Send query letter with SASE tearsheets and photocopies. Samples not filed and are returned by SASE if requested by artist. Reports back within 1-3 months, only if accompanied by SASE. Mail b&w photocopies. (Never send original — only copy art!") Rights purchased vary according to project. Pays $75-100, b&w, cover; $20-50, b&w, inside.

Tips: "Order a sample copy and read and study it. To draw or write for RCE, one must read RCE. We are very unique. We wish to convey the beauty and joy of the creative/spiritual life. Artwork reflects the contents of our essays/poetry, etc. Most issues feature a concept or theme and artwork is tailored for that theme. Example: Autumn issues feature 'Harvests in the Feminine Realm.' "

REAL PEOPLE MAGAZINE, 16th Floor, 950 3rd Ave., New York NY 10022. (212)371-4932. FAX: (212)838-8420. Editor: Alex Polner. Estab. 1988. Consumer magazine; "general interest featuring celebrities and self-help articles and profiles for men and women ages 35 and up, a middle brow audience." Bimonthly. Circ. 165,000. Original artwork returned after publication. Sample copy $3.50 plus postage. Art guidelines not available.

Illustrations: Approached by 5-10 illustrators/year. Buys 1-2 illustrations/issue, 6-12 illustrations/year from freelancers. Works on assignment only. Theme or style depends on the article. Prefers pen & ink, watercolor or acrylic. Send query letter with tearsheets. Samples are filed. Reports back only if interested. Call to schedule an appointment to show a portfolio, which should include tearsheets. Buys one-time rights. Pays $100, b&w, $200, color, inside; on publication.

Tips: "There is no secret. We select the artist that best matches the story we want illustrated."

***THE RECORD OF HAMPDEN-SYDNEY COLLEGE**, 637 College Rd., Hampden-Sydney VA 23943-0637. (804)223-2361, ext. 261. Director of Publications: R. McClintock. Estab. 1924. Alumni magazine published twice a year. Emphasizes features and news of concern to alumni — features cover all subjects, and often require illustration. Circ. 11,000. Accepts previously published artwork. Original artwork returned at job's completion. Sample copies available for $2. Art guidelines available.

Illustrations: Approached by 15 freelance illustrators/year. Buys 3-5 freelance illustrations/issue. Works on assignment only. Preferred style is representational; otherwise variable. Considers pen and ink, airbrush, color pencil, water color, acrylic, oil and collage. Send query letter with brochure, SASE, tearsheets, photographs, photocopies and slides. Samples are filed or are returned. Reports back within 2 weeks. Write to schedule an appointment to show a portfolio, which should include thumbnails, roughs, tearsheets, photographs and slides. Rights purchased vary according to project. Pays $200, b&w, color, cover. Pays $75, b&w, $100, color, inside. Pays on publication.

REDBOOK MAGAZINE, 224 W. 57th St., New York NY 10019. (212)649-3457. Art Director: Terry Koppel. Consumer magazine "geared to baby boomers with busy lives. Interests in fashion, food, beauty, health, etc." Monthly. Circ. 7 million. Accepts previously published artwork. Original artwork returned after publication with additional tearsheet if requested. Art guidelines not available.

Illustrations: Buys 3-4 illustrations/issue. "We prefer photo illustration for fiction and more serious articles, loose or humorous illustrations for lighter articles; the only thing we don't use is high realism. Illustrations can be in any medium. Book drop off any day, pick up the next day. Work samples are accepted in the mail;

should include anything that will represent the artist and should not have to be returned. This way the sample can remain on file, and the artist will be called if the appropriate job comes up." Buys reprint rights or negotiates rights. Payment for accepted work only: $150-600, b&w, $400-1,200, color.
Tips: "Look at the magazine before you send anything, we might not be right for you. Generally, illustrations should look new, of the moment, intelligent."

***THE REPORTER**, Women's American ORT, 315 Park Ave. S., New York NY 10010. (212)505-7700. FAX: (212)674-3057. Editor: Eve Jacobson. Estab. 1966. A quarterly magazine for Jewish women emphasizing issue, lifestyle, education. Circ. 110,000. Original artwork returned at job's completion. Sample copies free for SASE with first class postage.
Illustrations: Approached by 25 freelance illustrators/year. Buys 1 freelance illustration/issue. Works on assignment only. Prefers contemporary art. Considers pen and ink, mixed media, watercolor, acrylic, collage and marker. Send query letter with brochure, resume, tearsheets, photographs, photocopies, photostats and slides. Samples are filed or are returned by SASE if requested by artist. Reports back to the artist only if interested. Portfolio should include b&w tearsheets, photostats, photographs, slides and photocopies. Rights purchased vary according to project. Pays $150, color, cover. Pays $50, b&w, $75, color, inside. Pays on publication.

RESIDENT AND STAFF PHYSICIAN, 80 Shore Rd., Port Washington NY 11050. (516)883-6350. Executive Editor: Anne Mattarella. Emphasizes hospital medical practice from clinical, educational, economic and human standpoints. For hospital physicians, interns and residents. Monthly. Circ. 100,000.
Cartoons: Buys 3-4 cartoons/year from freelancers. "We occasionally publish sophisticated cartoons in good taste dealing with medical themes." Reports in 2 weeks. Buys all rights. Pays $25; on acceptance.
Illustrations: "We commission qualified freelance medical illustrators to do covers and inside material. Artists should send sample work." Send query letter with brochure showing art style or resume, tearsheets, photostats, photocopies, slides and photographs. Call or write to schedule an appointment to show a portfolio, which should include color and b&w final reproduction/product and tearsheets. Pays $700, color, cover; payment varies for inside work; on acceptance.
Tips: "We like to look at previous work to give us an idea of the artist's style. Since our publication is clinical, we require highly qualified technical artists who are very familiar with medical illustration. Sometimes we have use for nontechnical work. We like to look at everything. We need material from the *doctor's* point of view, *not* the patient's."

THE RETIRED OFFICER, 201 N. Washington St., Alexandria VA 22314. (703)549-2311. Art Director: M.L. Woychik. Estab. 1945. Four-color magazine for retired officers of the uniformed services; concerns current military/political affairs; recent military history, especially Vietnam and Korea; holiday anecdotes; travel; human interest; humor; hobbies; second-career job opportunities and military family lifestyle.
Illustrations: Works with 9-10 illustrators/year. Buys 15-20 illustrations/year from freelancers. Buys illustrations on assigned themes. (Generally uses Washington DC area artists.) Uses freelance artwork mainly for features and covers. Send query letter with resume and samples. Pays $300, b&w; $400+, color, cover; $250, full page b&w; $300, full page color, inside.
Tips: "Send pieces showing your style and concepts in a few different mediums. I do not want to see a different style for every piece of art."

RISK MANAGEMENT, 205 E. 42nd St., New York NY 10017. (212)286-9292. Graphic Design Manager: Linda Golden. Emphasizes the risk management and insurance fields. Monthly. Circ. 11,500.
Illustrations: Approached by 15-20 illustrators/year. Buys 3-5 illustrations/issue, 48 illustrations/year from freelancers. Uses artists mainly for covers, 4-color inside and spots. Prefers color illustration or stylized line; no humorous themes. Works on assignment only. Send card showing art style or tearsheets. Call for appointment to show portfolio, which should include original art and tearsheets. Prefers printed pieces as samples; original work will not be kept on file after 1 year. Samples not kept on file are returned only if requested. Buys one-time rights. Pays $385, 4-color, inside and $500, 4-color cover; on acceptance.
Tips: When reviewing an artist's work, looks for "neatness, strong concepts, realism with subtle twists and sharply-defined illustrations."

ROAD KING MAGAZINE, Box 250, Park Forest IL 60466. (312)481-9240. Editor: George Friend. Estab. 1963. Emphasizes services for truckers, news of the field, CB radio and fiction; leisure-oriented. Readers are "over-the-road truckers." Quarterly. 4-color digest-sized magazine. Circ. 224,000.
Cartoons: Approached by 10 cartoonists/year. Buys 1-2 cartoons/issue; all from freelancers. Interested in over-the-road trucking experiences. Prefers single panel b&w line drawings with gagline. Send finished cartoons and SASE. "Gag lines and cartoon must be legible and reproduceable." Reports in 2-4 months. Buys first North American serial rights. Pays $25 and up, b&w; on acceptance.

Illustrations: Approached by 10 illustrators/year. Works with 4-5 illustrators/year. Needs editorial and technical illustration. Uses artwork mainly for spots and cartoons. Pays $100-300, color, cover; $25-50 b&w, $75-100 color, inside.

Tips: "Stick to our subject matter. No matter how funny the cartoons are, we probably won't buy them unless they are about trucks and trucking."

THE ROTARIAN, 1560 Sherman Ave., Evanston IL 60201. Editor: Willmon L. White. Associate Editor: Jo Nugent. Art Director: P. Limbos. Estab. 1911. Emphasizes general interest and business and management articles. Service organization for business and professional men and women, their families, and other subscribers. Monthly. Sample copy and editorial fact sheet available.

Cartoons: Approached by 14 cartoonists/year. Buys 5-8 cartoons/issue from freelancers. Interested in general themes with emphasis on business, sports and animals. Avoid topics of sex, national origin, politics. Send query letter to Cartoon Editor, Charles Pratt, with brochure showing art style. Reports in 1-2 weeks. Buys all rights. Pays $75 on acceptance.

Illustrations: Approached by 8 illustrators/year. Buys 10-20 illustrations/year; 7 or 8 humorous illustrations year from freelancers. Uses freelance artwork mainly for covers and feature illustrations. Buys assigned themes. Most editorial illustrations are commissioned. Send query letter to Art Director with brochure showing art style. Reports within 10 working days. Buys all rights. Call to schedule an appointment to show a portfolio, which should include keyline paste-up, original/final art, final reproduction/product, color and photographs. Pays on acceptance; payment negotiable, depending on size, medium, etc, up to $900, color, cover; $500, color, inside; full page.

Tips: "Preference given to area talent." Conservative style and subject matter.

RUNNER'S WORLD, 33 E. Minor St., Emmaus PA 18098. (215)967-5171. Art Director: Ken Kleppert. Estab. 1965. Emphasizes serious, recreational running. Monthly. 4-color with a progressive design. Circ. 470,000. Returns original artwork after publication. Sample copy available.

Illustrations: Approached by hundreds of illustrators/year. Works with 25 illustrators/year. Buys average of 90 illustrations/year, 6/illustrations/issue from freelancers. Needs editorial, technical and medical illustrations. "Styles include tightly rendered human athletes, caricatures and cerebral interpretations of running themes. Also, *RW* uses medical illustration for features on biomechanics." Style of David Suter, Tomm Bloom, John Segal, Enos. Prefers pen & ink, airbrush, charcoal/pencil, colored pencil, watercolor, acrylic, oil, pastel, collage and mixed media. Works on assignment only. Send samples to be kept on file. Prefers tearsheets or slides as samples. Samples not filed are returned by SASE. Reports back only if interested. Pays $300 and up. Buys one-time rights. "No cartoons or originals larger than 11×14."

Tips: Portfolio should include "a maximum of 12 images. Show a clean presentation, lots of ideas and few samples. Don't show disorganized thinking. Portfolio samples should be uniform in size."

RUTGERS MAGAZINE, Alexander Johnston Hall, New Brunswick NJ 08903. Art Director: Joanne Dus-Zastrow. Estab. 1987. General interest magazine covering research, events, art programs, etc. that relate to Rutgers University. Readership consists of alumni, parents of students and University staff. Published 4 times/year, 4-color, "conservative design." . Circ. 137,000. Accepts previously published artwork. Original artwork is returned after publication. Sample copies available.

Illustrations: Approached by 40 illustrators/year. Buys illustrations mainly for covers and feature spreads. Buys 4 illustrations/issue, 16 illustrations/year from freelancers. Considers mixed media, watercolor, pastel and collage. Send query letter with brochure. "Show a strong conceptual approach." Editorial illustration "varies from serious to humorous, conceptual to realistic." Style of Andy Levine, Mary Power, Mike Moran, Jack Unruh and Carol Wald. Samples are filed. Does not report back. Write to schedule an appointment to show a portfolio. Buys one-time rights. Pays $800-1,000, color, cover; $100-800, color, inside; on publication.

Tips: "Open to new ideas. See a trend away from perfect realism in illustration. See a willingness to experiment with type in design."

***RV BUSINESS,** 29901 Agoura Rd., Agoura CA 91301. (818)991-4980. Art Director: Ellen Koller. A bimonthly magazine emphasizing the business end of the RV industry. Circ. 20,000. Accepts previously published artwork. Original artwork returned at job's completion. Sample copies available.

Cartoons: Approached by 3 freelance cartoonists/year. Buys 2-5 freelance cartoons/year. Prefers editorial cartoons. Prefers single panel, without gagline, b&w line drawings, b&w washes and color washes. Send query letter with brochure and printed work. Reports back to the artist only if interested. Buys first rights and reprint rights. Pays $300 for b&w, $500 for color.

Illustrations: Approached by 20 freelance illustrators/year. Buys 1-2 freelance illustrations/issue. Works on assignment only. Prefers themes related to the RV industry, varied styles. Considers all media. Send query letter with brochure and resume. Samples are filed. Reports back to the artist only if interested. Call to schedule an appointment to show a portfolio, which should include a variety of materials. Buys first rights. Pasy $300, b&w, $500, color, cover. Pays $300, b&w, $500, color, inside.

SALT LICK PRESS, 1909 Sunny Brook Dr., Austin TX 78723. Editor/Publisher: James Haining. Published irregularly. Circ. 1,500. Previously published material and simultaneous submissions OK. Original artwork returned after publication. Sample copy $6.
Illustrations: Uses 12 illustrations/issue; buys 2 from freelancers. Receives 2 illustrations/week from freelance artists. Interested in a variety of themes. Send brochure showing art style or tearsheets, photostats, photocopies, slides and photographs. Samples returned by SASE. Reports in 6 weeks. To show a portfolio, mail roughs and b&w photostats and photographs. Negotiates payment; on publication. Buys first rights.

***SAN FRANCISCO'S THE CITY MAGAZINE**, Suite 312, 1095 Market St., San Francisco CA 94103. (415)252-1391. FAX: (415)252-7460. Art Director: Scott Kambic. Estab. 1989. A consumer magazine. "A city magazine aimed at upscale San Franciscans or San Franciscans at heart. Editorial focus strictly within the city of San Francisco." Monthly. Circ. 30,000. Original artwork returned at job's completion. Sample copies free for SASE with first class postage. Art guidelines not available.
Cartoons: Approached by 10+ freelance cartoonists/year. Buys 2 freelance cartoons/issue. Preferred theme is "San Francisco, exclusive." Considers single, double and multiple panel, with or without gagline, b&w line drawings, b&w washes and color washes. Send query letter with brochure and roughs. Samples are filed. Reports back to the artist only if interested; artist should follow-up. Buys first rights. Pays $10 minimum.
Illustrations: Approached by 100 freelance illustrators/year. Buys an average of 3 illustrations/issue. Works on assignment only. Considers all media. Send query letter with brochure, tearsheets and photocopies. Samples are filed. Reports back to the artist only if interested. Call to schedule an interview to show a portfolio, which should include original/final art, tearsheets, photostats, photographs, slides, photocopies. Buys first rights. Pays $100, color, cover; $50, color inside. Pays on publication.

SAN JOSE STUDIES, San Jose State University, San Jose CA 95192. (408)277-2841. Editor: Fauneil J. Rinn. Estab. 1974. Emphasizes the arts, humanities, business, science, social science; scholarly. Published 3 times/year. B&w with 2-color cover; digest format with good quality paper, perfect-binding. Circ. 500. Original artwork returned after publication. Sample copy $5.
Cartoons: Acquires 3-4 cartoons. Interested in "anything that would appeal to the active intellect." Prefers single panel b&w line drawings. Send photocopies and SASE. Reports in 2 weeks. Acquires first North American serial rights. Pays in 2 copies of publication, plus entry in $100 annual contest.
Illustrations: Approached by 3-4 illustrators/year. Needs editorial illustration. "We have used several pieces of work in a special section and have used details of work on our covers." Prefers line drawings; "political, literary or philosophical in content, decorative and small." Style of Judy Rosenblatt.
Tips: "We are interested in cartoons and other drawings with visible detail even if reduced in size. We like art that relieves the reader faced with type-filled pages."

SANTA BARBARA MAGAZINE, 216 E. Victoria St., Santa Barbara CA 93101. (805)965-5999. Art Director: Kimberly Kavish. Estab. 1975. Magazine emphasising Santa Barbara culture and community. Bimonthly. 4-color with classic design. Circ. 11,000. Original artwork returned after publication if requested. Sample copy $2.95.
Illustrations: Approached by 20 illustrators/year. Works with 2-3 illustrators/year. Buys about 0-1 illustrations/issue, 1-3 illustrations/year from freelance artists. Needs editorial illustrations. Uses freelance artwork mainly for departments. Works on assignment only. Send query letter with brochure, resume, tearsheets and photocopies. Reports back within 6 weeks. To show a portfolio, mail b&w and color original/final art, final reproduction/product and tearsheet; will contact if interested. Buys first rights. Pays approximately $275, color, cover; $175, color, inside; on acceptance. "Payment varies."
Tips: "Be familiar with our magazine."

SATELLITE ORBIT, Suite 600, 8330 Boone Blvd., Vienna VA 22182. (703)827-0511. FAX: (703)356-6179. Contact: Art Director. Magazine emphasizing satellite television industry for home satellite dish owners and dealers. Monthly. 4-color; design is "reader friendly, with small copy blocks — large TV listing section." Circ. 350,000. Accepts previously published material. Original artwork returned after publication.
Cartoons: Satellite TV-related, witty and well drawn. Pays $75 for b&w.
Illustrations: Buys 2-5 illustrations/issue from freelancers. Needs editorial illustration "inventive clearly drawn spots that get the point across." Style of John Cimeo, Gil Eisner, Joe Murray, Seymour Chwast. Works on assignment only. Send query letter with tearsheets, photocopies, slides and photographs. Samples not filed are returned only if requested. Reports within 1 month. To show a portfolio, mail color and b&w tearsheets and photographs. Negotiates rights purchased. Negotiates payment. Pays $450, b&w; $1,500, color, cover; $150, b&w; $250, color, inside; on publication.
Tips: "I usually only use spot illustration work. Black-and-white stuff usually gets overlooked and I don't like to see uninventive poorly-drawn stuff."

THE SATURDAY EVENING POST, The Saturday Evening Post Society, 1100 Waterway Blvd., Indianapolis IN 46202. (317)636-8881. Estab. 1897. General interest, family-oriented magazine. Published 9 times/year. Circ. 600,000. Sample copy $1.

Cartoons: Cartoon Editor: Steven Pettinga. Buys about 300 cartoons/year, 35 cartoons/issue. Uses freelance artwork mainly for humorous ficiton. Prefers single panel with gaglines. Receives 100 batches of cartoons/week from freelance cartoonists. "We look for cartoons with neat line or tone art. The content should be in good taste, suitable for a general-interest, family magazine. It must not be offensive while remaining entertaining. We prefer that artists first send SASE for guidelines and then review recent issues. Political, violent or sexist cartoons are not used. Need all topics, but particularly medical, health, travel and financial." SASE. Reports in 1 month. Buys all rights. Pays $125, b&w line drawings and washes, no pre-screened art; on publication.

Illustrations: Art Director: Chris Wilhoite. Uses average of 3 illustrations/issue; buys 90% from freelancers. Send query letter with brochure showing art style or resume and samples. To show a portfolio, mail original/final art. Buys all rights, "generally. All ideas, sketchwork and illustrative art are handled through commissions only and thereby controlled by art direction. Do not send original material (drawings, paintings, etc.) or 'facsimiles of' that you wish returned." Cannot assume any responsibility for loss or damage. "If you wish to show your artistic capabilities, please send nonreturnable, expendable/sampler material (slides, tearsheets, photocopies, etc.)." Pays $1,000, color, cover; $175, b&w, $450, color, inside.

Tips: "Send samples of work published in other publications. Do not send racy or too new wave looks. Have a look at the magazine. It's clear that 50 percent of the new artists submitting material have not looked at the magazine."

***SCIENCE FICTION CHRONICLE,** Box 2730, Brooklyn NY 11202-0056. (718)643-9011. FAX: (718)643-9011. Editor/Publisher: Andrew Porter. Estab. 1979. A monthly magazine/trade journal covering science fiction, fantasy and horror; includes news, letters, reviews, market reports, etc. Monthly. Circ. 6,000. Accepts previously published work. Sample copies free for SASE with 5 oz. of first class postage.

Illustrations: Approached by 10-20 freelance illustrators/year. Prefers science fiction, fantasy and horror themes suitable for covers only. Considers airbrush and acrylic. Send query letter with transparencies or slides only. Samples are not filed and are returned by SASE. Reports back within 2-4 weeks. Mail appropriate materials. Portfolio should include slides. Buys one-time and reprint rights. Pays $100, color, cover. Pays on publication.

Tips: "It's damned hard—to break into our publication but several artists have gone on to professional careers—*SFC* is seen by all editors and art directors in the SF/fantasy field."

SCIENCE NEWS, 1719 N St. NW, Washington DC 20036. (202)785-2255. Art Director: Janice Rickerich. Emphasizes all sciences for teachers, students and scientists. Weekly. Circ. 235,000. Accepts previously published material. Original artwork returned after publication. Sample copy for SASE with 39¢ postage.

Illustrations: Buys 6 illustrations/year from freelancers. Prefers realistic style, scientific themes; uses some cartoon-style illustrations. Works on assignment only. Send query letter with photostats or photocopies to be kept on file. Samples returned by SASE. Reports only if interested. Buys one-time rights. Write to schedule an appointment to show a portfolio, which should include original/final art. Pays $50-200; on acceptance.

Tips: Uses some cartoons and cartoon-style illustrations.

***THE SCIENCE TEACHER,** 1742 Connecticut Ave. NW, Washington DC 20009. (202)328-5800. FAX: (202)328-0974. Assistant Editor; Clare Lumley. Estab. 1958. A monthly Education Association magazine. "A journal for high school science teachers, science educators and secondary school curriculum specialists." Circ. 27,000. Accepts previously published work. Original artwork returned at job's completion. Sample copies available; no artist guidelines.

Cartoons: Approached by 6+ freelance cartoonists/year. Buys 0-1 freelance cartoon/issue. Preferred theme is science humor. Prefers single panel, with or without gagline, b&w line drawings, b&w washes. Send query letter with non-returnable samples. Reports back to the artist only if interested. Buys one-time rights. Pays $35 for b&w.

Illustrations: Approached by 75+ freelance illustrators/year. Buys 2 freelance illustrations/issue. Buys 18 freelance illustrations/year. Works on assignment only. Considers pen and ink, airbrush, collage, charcoal—"black and white only." Send query letter with tearsheets and photocopies. Samples are filed. Reports back to the artist only if interested. Call to schedule an appointment to show a portfolio, which should include original/final art, b&w. Buys one-time rights. Pays $150, b&w. Pays on publication.

***SCREEN ACTOR,** 7065 Hollywood Blvd., Hollywood CA 90028. (213)856-6650. FAX: (213)856-6603. Editor: Mark Locher. Estab. 1934. Trade journal; magazine format. "*Screen Actor* is the official publication of the Screen Actors Guild; covers issues of concern to performers." Quarterly. Circ. 75,000. Accepts previously published work. Originals are returned at job's completion. Sample copies available.

Cartoons: Approached by 4 freelance cartoonists/year. Buys 2 freelance cartoons/year. Prefers entertainment, movies, TV themes. Prefers single panel, with gagline, b&w line drawings. Send query letter with finished cartoons. Samples are filed. Reports back to the artist only if interested. Rights purchased vary according to project. Pays $200 for b&w.

Illustrations: Approached by 3 freelance illustrators/year. Buys 3 freelance illustrations/issue. Works on assignment only. Prefers entertainment, movies, TV themes. Considers pen and ink, airbrush, watercolor and acrylic. Send query letter with brochure, resume and tearsheets. Samples are filed. Reports back to the artist only if interested. Call to schedule an appointment to show a portfolio, which should include b&w and color, tearsheets and photographs. Rights purchased vary according to project. Pays $200, b&w, $500, color cover. Pays $200, b&w, $500, color, inside. Pays on acceptance.
Tips: Looking for "clever use of entertainment themes."

SEA MAGAZINE, Box 17789 Cowan, Irvine CA 92714. Art Director: Jeffrey Fleming. Estab. 1908. Consumer magazine. Emphasizes recreational boating for owners or users of recreational boats, both power and sail, primarily for cruising and general recreation; some interest in boating competition; regionally oriented to 13 western states. Monthly, 4-color. Circ. 70,000. Accepts previously published artwork. Return of original artwork depends upon terms of purchase. Sample copy for SASE with first-class postage.
Illustrations: Approached by 20 illustators/year. Buys illustrations mainly for editorial. Buys 10 illustrations/year from freelancers. Prefers pen & ink. Considers airbrush, watercolor, acrylic and calligraphy. Send query letter with brochure showing art style. Samples are returned only if requested. Reports only if interested. Call to schedule an appointment to show a portfolio, which should include tearsheets and cover letter indicating price range. Negotiates rights purchased. Pays $50, b&w; $250, color, inside; on publication (negotiable).
Tips: "We will accept students for portfolio review with an eye to obtaining quality art at a reasonable price. We will help start career for illustrators and hope that they will remain loyal to our publication."

***SENIOR MAGAZINE**, 3565 S. Higuera, San Luis Obispo CA 93401. (805)544-8711. FAX: (805)544-4450. Publisher: Gary Suggs. Estab. 1981. A monthly tabloid-sized magazine for people 40 years of age. Circ. 300,000. Accepts previously published work. Original artwork returned at job's completion. Sample copies free for SASE with first class postage. Art guidelines available for SASE.
Cartoons: Buys1-2 freelance cartoons/issue. Prefers themes appropriate for mature 40+ people. Prefers single panel with gagline. Send query letter with finished cartoons. Samples are filed. Reports back within 15 days. Pays $25 for b&w.
Illustrations: Works on assignment only. "Would like cover drawings of famous people." Considers pen and ink. Send query letter with photostats. Samples are filed. Reports back within 15 days. Buys first rights and one-time rights. Pays $100 for b&w. Pays on publication.

SHAREWARE MAGAZINE, 1030-D E. Duane Ave., Sunnyvale CA 94086. (408)730-9291. FAX: (408)730-2107. Art Director: Dave Titus. Estab. 1988. Consumer magazine featuring software (called Shareware) for the IBM PC and compatible computers: reviews, new relcascs, author interviews, for beginners to programmers. Bimonthly, 4-color. Design conveys "warm, subtle humor." Circ. 65,000. Accepts previously published artwork. Original artwork is returned to the artist at the job's completion. Sample copies available. Art guidelines not available.
Illustrations: Approached by 10-20 illustrators/year. Buys 1 illustration/issue, up to 6 illustrations/year from freelancers. Work is on assignment only. Considers watercolor, collage, airbrush, acrylic, oil, computer and mixed media. Send a query letter with brochure and tearsheets to be kept on file. Reports back only if interested. mail appropriate materials: artist's best work. Buys first rights or reprint rights. Pays $500, color, cover; $150, b&w, $300, color, inside; on acceptance.
Tips: "Be able to work on a tight budget."

***SHEEP MAGAZINE**, W 2997 Markert Rd., Helenville WI 53137. (414)593-8385. FAX: (414)593-8384. Estab. 1980. A monthly tabloid consumer trade journal covering sheep, wool and woolcrafts. Circ. 15,000. Accepts previously published work. Original artwork returned at job's completion. Sample copies available.
Cartoons: Approached by 30 freelance cartoonists/year. Buys 6-8 freelance cartoons/issue. Will consider all themes and styles. Prefers single panel with gagline. Send query letter with brochure and finished cartoons. Samples are returned. Reports back within 3 weeks. Buys first rights and all rights. Pays $15-25, b&w; $50-100, color.

The asterisk before a listing indicates that the listing is new in this edition. New markets are often the most receptive to freelance submissions.

Illustrations: Approached by 10 freelance illustrators/year. Buys 5 freelance illustrations/year. Works on assignment only. Considers pen and ink, color pencil, watercolor. Send query letter with brochure, SASE and tearsheets. Samples are filed or returned. Reports back within 3 weeks. Mail appropriate materials. Portfolio should include thumbnails, b&w tearsheets. Buys first rights and all rights. Pays $45-75, b&w, $75-150, color, cover. Pays $45-75, b&w, $50-125 color, inside. Pays on acceptance.
Tips: "Demonstrate creativity and quality work. We're eager to help out beginners."

***SHOFAR**, 339 N. Main St., New City NY 10956. (914)638-0333. FAX: (914)634-9423. Publisher: Darryl Elberg. *Shofar* is a monthly children's magazine. Accepts previously published artwork. Original artwork is returned at job's completion. Sample copies free for SASE.
Cartoons: Approached by 2 freelance cartoonists/year. Buys 1 freelance cartoon/issue; 12 cartoons/year. Preferred themes are youth oriented. Send query letter with brochure, roughs and cartoons. Samples are not filed or returned. Reports back to the artist only if interested. Rights purchased vary according to project. Pays $50-100.
Illustrations: Approached by 25 freelance illustrators/year. Buys 6-12 freelance illustrations/issue. Works on assignment only. Themes and styles vary. Considers pen and ink, watercolor, airbrush, marker, charcoal, mixed media. Send query letter with brochure, resume, photographs, slides and transparencies. Samples are not filed or returned. Reports back to the artist only if interested. To show a portfolio, mail thumbnails, roughs, color photographs and slides. Rights purchased vary according to project. Pays $50, b&w, $100, color, cover; $50, b&w, $100, color, inside. Pays on publication.

SIGNS OF THE TIMES MAGAZINE, 1350 N. King's Rd., Nampa ID 83687. (208)465-2591 or 465-2500. Art Director/Designer: Ed Guthero. Magazine emphasizing Christian lifestyle. "Looks at contemporary issues, from a Christian viewpoint—news, health, self-help, etc., covers a wide variety of topics. We attempt to show that Biblical principles are relevant to all of life. Our audience is the general public." Monthly. Circ. 370,000. Accepts previously published material. Original artwork is returned to the artist after publication.
Cartoons: Buys when applicable. Prefers "any contemporary style, also,—airbrush, and "David-Levine" type of editorial style for black & white. We don't use a lot of cartooning, but we use some." Send query letter with samples. Samples are filed. Reports back only if interested. Buys one-time rights. Pays approximately $300-450, color, full page.
Illustrations: Buys 6-10 illustration/issue, 72-120/year from freelancers. Works on assignment only. Prefers contemporary editorial illustration, "conceptual in approach as well as contemporary realism." Prefers mixed media, then pen & ink, airbrush, colored pencil, watercolor, acrylic, oil, pastel, collage and calligraphy. Call or send query letter with tear sheets and slides. Samples are filed or are returned only if requested by artist. Reports back only if interested. Call or write to schedule an appointment to show a portfolio or mail final reproduction/product, color or b&w slides. Buys one-time rights. Pays approximately $500+, color, cover; $80-300, b&w, (1 page) $450+ average, color, inside. Pays on acceptance (30 days). Fees negotiable depending on needs and placement, size, etc. in magazine.
Tips: "Many young illustrators show work using popular movie stars, photos, etc, as reference-I like to see the techniques done using their own original reference; it's better to show their ability to do original work."

***SILVERFISH REVIEW**, Box 3541, Eugene OR 97403. (503)344-5060. Editor/Publisher: Rodger Moody. Estab. 1979. Literary magazine that publishes poetry, fiction, translations, essays, reviews, interviews and poetry chapbooks. Published irregularly. Circ. 750. Sample copies available for $3, regular issue, $4, chapbook, plus $1.50 for postage.
Illustrations: Buys 1 freelance illustration/issue. Prefers pen and ink and charcoal. Send query letter with photocopies. Samples are filed. Reports back within 1 month. Mail appropriate materials. Portfolio should include photocopies. Buys one-time rights. Pays $25-40, b&w, cover or inside.

THE SINGLE PARENT, 8807 Colesville Rd., Silver Spring MD 20910. (301)588-9354. Editor: Allan Glennon. Estab. 1958. Emphasizes family life in all aspects—raising children, psychology, divorce, remarriage, etc.— for all single parents and their children. 2-color with 4-color cover. Bimonthly. Circ. 120,000. Accepts simultaneous submissions and occasionally accepts previously published material. Original artwork returned after publication. Sample copy available for 10 × 12 SASE with postage for 3 oz. or for $1 without SASE.
Cartoons: Rarely uses cartoons. Prefers cartoonish figures with singles themes. Pays $25 for b&w.
Illustrations: Works with 3-6 illustrators/year. Buys 40-50 illustrations/year; buys all from freelancers, mainly article and story illustration. Needs editorial illustration. Style of Sonia Safier-Kerzner, Joan Waites, Jim Long, Kim Salinas. Works on assignment for all stories. Assignments based on artist's style. Send query letter with brochure, samples to be kept on file. Write or call for appointment to show portfolio. Prefers photostats, photographs, tearsheets as samples. Reports within 6 weeks. Purchases one-time rights. Pays $250, color, cover; $75-150, b&w; $75-150, color, inside (2-color mechanicals); on publication.
Tips: "Send line art and one- or two-color illustrations of parent-child interaction or children. Bring your portfolio by if you are in the vicinity. *The Single Parent* uses more realistic illustrations than before, though an occasional 'mood piece' or symbolic image is used."

The isolation, sadness and loss of this young boy matches the tone of the Single Parent Magazine article for which Joan C. Waites created it. It was about "the effects of death or divorce on children and the grieving process they go through," she says. The Chevy Chase, Maryland-based illustrator, who is also a staff artist with The Becker Group in Baltimore, was paid $100 for the work. She says it was "a first attempt at a looser and more emotional style that has been well-received by other markets."

© Joan Waites 1991

SKI MAGAZINE, 380 Madison Ave., New York NY 10016. (212)779-5000. Art Director: Steve Wierzbicki. Estab. 1936. Emphasizes instruction, resorts, equipment and personality profiles. For new, intermediate and expert skiers. Published 8 times/year. Circ. 600,000. Previously published work OK "if we're notified."
Cartoons: Approached by approximately 12 cartoonists/year. Buys 40-50 cartoons/year from freelancers. Especially needs cartoons of skiers with gagline. "Artist/cartoonist must remember he is reaching experienced skiers who enjoy 'subtle' humor." Mail art and SASE. Reports immediately. Buys first serial rights. Pays $50, b&w and color; on publication.
Illustrations: Approached by 30-40 freelance illustrators/yaer. Buys 40-50 illustrations/year from freelancers. Mail art and SASE. Reports immediately. Buys one-time rights. Pays $1,000, color, cover; $150, b&w and color, inside; on acceptance.
Tips: "The best way to break in is an interview and showing a consistent style portfolio. Then, keep us on your mailing list."

SOCCER DIGEST, 990 Grove St., Evanston IL 60201. Emphasizes sports. Monthly. Circ. 525,000. Original artwork returned after publication.
Cartoons: Considers sports themes. Prefers single panel; b&w line drawings or color washes. Material not filed is returned by SASE. Pays on publication.
Illustrations: Considers sports themes. Works on assignment only. Send 4-color sample tear sheets (no original art). Prefer caricatures and conceptual pieces. Samples not filed are returned by SASE. Pays on acceptance.

***SOCCER NOW**, Box 5045, Hawthorne CA 90251-5045. (213)643-6455, ext. 113. FAX: (213)643-6455. Publications Manager: Kristen Kearney. Estab. 1978. "Membership magazine of the American Youth Soccer Organization, with emphasis on soccer in general, also news and family interests. Audience consists of players and parents (volunteers)." Circ. 275,000. Sample copies available.
Cartoons: Approached by 30-50 freelance cartoonists/year. Buys 10-15 freelance cartoons/year. Prefers humorous soccer situations. Prefers single and multiple panel with gagline. Send query letter with samples of published or unpublished work. Samples are filed. Reports back to the artist only if interested. Buys all rights. Payment negotiable.

Close-up

Cynthia Carrozza
Illustrator
Boston, Massachusetts

© Barbara Kelley 1991

The term "networking"—that buzzword of the nineties—doesn't seem to have a place in illustrator Cynthia Carrozza's vocabulary. The self-described loner is not active in any artists' guilds, shies away from meeting personally with clients and thinks showing her portfolio around is a "horrifying experience."

The attitude flies in the face of most conventional wisdom. Yet it's worked for Carrozza, whose impressive client list has been garnered in the few short years since her 1985 graduation from the Art Institute of Boston. That list—which runs the gamut of newspapers, magazines, publishing companies and corporate clients—includes *The Boston Globe, The Christian Science Monitor, Connoisseur, Seventeen* and Houghton Mifflin. Her income, she's happy to report, doubled each year since she started working, until last year—when it tripled.

The energy she saves by not struggling to cultivate contacts is channeled into her finely honed talent, her dogged diligence and her keen sense of marketing. While she concedes that a beginning artist can learn valuable lessons by taking his or her portfolio around to prospective clients, her own route to success has been paved with slick self-promotional mailings and uncompromisingly positive word of mouth.

"I eventually want my name to be really well known," Carrozza says, "but it's just recently that people are beginning to know me. They know that I care about my work, that I get it done on time and that, if there are changes to be made, I'm willing to make them."

If the name "Carrozza" is finding a front spot in art directors' and editors' mental Rolodexes, it's largely due to her commitment to promote herself. Twice a year she mails out slick, expensively produced examples of work to about 300 prospective markets, and then once a year she expands the mailing to some 1,500 markets. Her lists, which are on computer, are constantly being enlarged and updated.

Her success is also rooted in her work ethic: She typically works 80-hour weeks, although not all of that time is spent in her studio. "I'm working when I'm not working," she says. "There's no real separation between my life and my work."

Carrozza firmly deplores the idea of a beginner working on spec or for free to get experience. Her suggestion is to do work for a company that will give the artist extra samples for promotion and then "send it all over the country. If the work is good, you'll get calls back."

Beyond an innate talent, perseverance is the single most important quality for someone in her line of work, she says. "People get discouraged and don't have enough self-confidence to keep going. Only two people from my class are actually doing this kind of work. But it's really important to stick with it—and also to have some sort of job to supplement you while you get established."

While Carrozza's work is not limited to any particular market—in fact she strives for a diverse client base, which she says has helped her comfortably ride out the recession—she prefers working for editorial rather than advertising clients. "It gives me more freedom to

Yours Free

Get this Professional Watercolor Brush...FREE with your paid subscription to

The Artist's® MAGAZINE

Subscribe today to America's favorite how-to magazine for artists. Get step-by-step art instruction, tips from top art professionals, inside information on where and how to show and sell your art, and more. Plus, get a FREE watercolor brush with your paid subscription! 12 issues just $18.

USE THIS CARD TO START YOUR SUBSCRIPTION TODAY!

**MAIL THIS CARD TODAY!
NO POSTAGE NEEDED.**

The Artist's Magazine
Order Form

Start my subscription immediately! Also send my FREE brush as soon as you receive my subscription payment.

☐ I've enclosed payment of $18 for 12 issues, $15.00 off the newsstand price. Send my free brush immediately!

☐ Bill me and send my free brush when you receive my payment.

Mr. Mrs. Ms.

Name

Address Apt. #

City

State Zip

*Outside U.S. add $7 (includes GST in Canada) and remit in U.S. funds.
Look for your first issue in about 6 weeks!
Basic subscription rate: $24. Newsstand rate: $33. VVAM5

Get more with...

The Artist's® MAGAZINE

- More step-by-step art instruction—see how a professional artist creates from first sketches to finished work
- More of all your favorite mediums—oils, watercolors, acrylics, pastels, colored pencil, charcoal, sculpture and others
- More monthly market reports and show listings—all the facts you need to show and sell your work throughout the United States
- More business advice—practical pointers and helpful information about the business side of art
- More monthly reports on art materials and methods—find out about the new products and techniques that can make your work more professional
- More of everything you need to be the finest artist you can be.

MAIL THE POST-PAID CARD BELOW TO START YOUR SUBSCRIPTION TODAY!

BUSINESS REPLY MAIL

FIRST CLASS MAIL PERMIT NO. 77 HARLAN, IOWA

POSTAGE WILL BE PAID BY ADDRESSEE

The Artist's® MAGAZINE

**P O BOX 2121
HARLAN IA 51593-2310**

NO POSTAGE
NECESSARY
IF MAILED
IN THE
UNITED STATES

do what I want," she says. "I think it's really important to read the whole article or book and then come up with my own ideas."

Once she generates those ideas, she translates them into sketches — at least two and no more than five, she says, depending on the job. The art director or editor will choose from among those sketches, perhaps giving comments or suggestions along the way.

Besides being known for her reliability and attention to detail, Carrozza's clients also flock to her elegant but whimsical style, which employs very bright colors and stylized anatomy. Her next goal is to illustrate more book covers, especially classic novels, which she says seem appropriate for her style. And she keeps an eye toward the international market, an arena she hasn't yet entered but for which she has definite plans.

"This might sound terrible," she says apologetically, "but I really like visibility. The more visibility, the better. When I go into a store and see a magazine or newspaper that has my illustration in it, it makes me feel like I exist in the world. . . . I really care about every piece. I put as much effort into something that nobody's ever going to see. But satisfaction for myself means my work is being seen everywhere."

— Perri Weinberg-Schenker

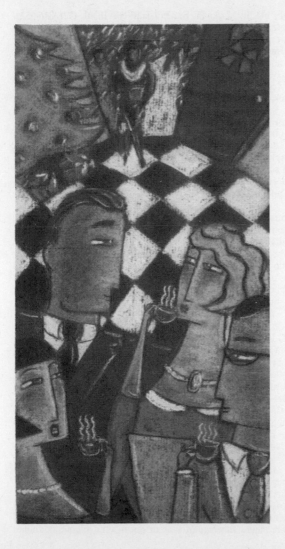

Carrozza did this full-color illustration depicting the festivities of the holiday season for **The Boston Globe's "At Home"** *section. It accompanied an article about having a* **Christmas open house.**

Reprinted with permission of Cynthia Carrozza.

Illustrations: Approached by 25 freelance illustrators/year. Buys 3-4 freelance illustrations/issue. Usually works on assignment only. Prefers illustrations of kids and parents—"theme of article usually determines illustration." Considers pen and ink, acrylic, marker, color pencil. Send query letter with tearsheets, photocopies and photostats. Samples are filed. Reports back to the artist only if interested. Mail appropriate materials. Portfolio should include tearsheets and photocopies. Buys all rights. Payment negotiable. Pays on acceptance.
Tips: "Send humorous illustrations and cartoons relating to soccer, showing children and family situations."

SOCIAL POLICY, 25 W. 43rd St., New York NY 10036. (212)642-2929. Managing Editor: Audrey Gartner. Estab. 1970. Emphasizes the human services—education, health, mental health, self-help, consumer action, voter registration, employment. For social action leaders, academics, social welfare practitioners. Quarterly magazine, b&w with 2-color cover. Circ. 5,000. Accepts simultaneous submissions. Original artwork returned after publication. Sample copy $2.50.
Illustrations: Approached by 12 illustrators/year. Works with 6+ illustrators/year. Buys 6-8 illustrations/issue from freelancers. Accepts b&w only, "with social consciousness." Prefers pen & ink and charcoal/pencil. Send query letter and tearsheets to be kept on file. Call for appointment to show portfolio, which should include b&w original/final art, final reproduction/product and tearsheets. Reports only if interested. Buys one-time rights. Pays $100, cover; $25, b&w, inside; on publication.
Tips: When reviewing an artist's work, looks for "sensitivity to the subject matter being illustrated."

SOFTWARE MAINTENANCE NEWS, Suite 5F, 141 St. Marks Pl., Staten Island NY 10301. (718)816-5522. FAX: (718)816-9038. Editor: Nicholas Zvegintzov. Estab. 1983. Magazine "that talks directly to the experience of software professionals who maintain existing software." Two-column traditional design in 4-color. Monthly. Circ. 8,000. Accepts previously published artwork. Original artwork may be returned after publication. Sample copies available. Art guidelines not available.
Cartoons: Approached by 5 cartoonists/year. Buys 1 cartoon/issue, 12 cartoons/year from freelancers. "Cartoons must be about software; prefers wild styles." Any format is acceptable. Send query letter with roughs. Samples are returned. Reports back in 1 week. Buys one-time rights. Pays $25 and up, b&w; $50 and up, color; on publication.
Illustrations: Approached by 5 illustrators/year. Buys illustrations mainly for covers. Buys 1 illustration/issue, 12 illustrations/year from freelancers. Works on assignment only. We are looking for sci-fi type, imaginative illustration. Considers pen & ink, airbrush, mixed media, colored pencil, watercolor, acrylic, oil, pastel, collage, marker, charcoal pencil and calligraphy. Send query letter with brochure showing art style and photocopies. Samples are filed; "don't send something you want back." Reports within 1 week. Call to schedule an appointment to show a portfolio. Buys one-time rights. Pays $125 and up, b&w, $125 and up, color, cover; $25, b&w, $50, color, inside; on publication.

SOLIDARITY MAGAZINE, Published by United Auto Workers, 8000 E. Jefferson, Detroit MI 48214. (313)926-5291. Editor: David Elsila. "1.5 million member trade union representing U.S. and Canadian workers in auto, aerospace, agricultural-implement and other industries."
Illustrations: Works with 10-12 artists/year for illustrations. Uses artists for posters and magazine illustrations. Interested in graphic designs of publications, topical art for magazine covers with liberal-labor political slant. Especially needs illustrations for articles on unemployment, economy. Prefers Detroit-area artists, but not essential. Looks for "ability to grasp publication's editorial slant" when reviewing artist's work. Send query letter with resume, flyer and/or tear sheet. Samples to be kept on file. Pays $75/small b&w spot illustration; up to $400 for color covers; $400+/designing small pamphlet.

SOUTH FLORIDA MAGAZINE, Suite 500, 800 Douglas Rd., Coral Gables FL 33134. (305)445-4500. FAX: (305)445-4600. Art Director: Albert Rosado. Consumer magazine. "Regional lifestyle monthly magazine. Readers are sophisticated, affluent, mobile, have taste." Monthly. 4-color with a sophisticated design. Circ. 40,000. Original artwork returned to the artist at the job's completion.
Illustrations: Approached by 25 illustrators/year. Buys 20 illustrations/year from freelancers. Needs editorial illustration with a sophisticated, abstract style. Works on assignment only. Prefers pen & ink, watercolor, collage, airbrush, colored pencil, oil, charcoal, mixed media and pastel. Send query letter with brochure, tearsheets, photographs, photocopies and photostats. Reports back to the artist only if interested. Call to schedule an appointment to show a portfolio. Portfolio should include roughs, tearsheets and slides. Buys first rights. Pays $25-500, color, inside; on acceptance.

SOUTHERN ACCENTS, 2100 Lakeshore Dr., Birmingham AL 35209. (205)877-6347. Art Director: Lane Gregory. Magazine emphasizing high-style interiors. Monthly. Circ. 800,000. Original artwork returned after publication. Sample copy for a large manila SASE.
Illustrations: Approached by 30-40 illustrators/year. Buys 2 illustrations/issue from freelancers. Uses freelance artists mainly for illustrating monthly columns. Works on assignment only. Prefers watercolor, colored pencil or pen & ink. Send query letter with brochure showing art style or resume and samples. Samples

returned only if requested. Reports only if interested. Call or write to schedule an appointment to show a portfolio, which should include b&w and color tearsheets and slides. Buys one-time rights. Pays $300, b&w; $500 color, inside; on acceptance.

Tips: In a portfolio include "four to five best pieces to show strengths and/or versatility. Smaller pieces are much easier to handle than large. Its best not to have to return samples but to keep them for reference files." Don't send "too much. It's difficult to take time to plow through mountains of examples." Notices trend toward "lighter, fresher illustration."

***SOUTHERN CALIFORNIA HOME & GARDEN,** 13315 Washington Blvd., Los Angeles CA 90066. (213)578-1088. Art Director: Emily Borden. Estab. 1988. Consumer magazine focusing on regional homes and gardens. Monthly. Circ. 75,000. Accepts previously published artwork. Original artwork returned at job's completion. Sample copies available.

Illustrations: Buys 3 freelance illustrations/issue. Usually works only assignment only. Considers pen and ink, watercolor, collage, acrylic, color pencil, charcoal, mixed media and pastel. Send query letter with brochure, photographs, photocopies, transparencies and promos. Samples are filed. Reports back to the artist only if interested. Mail appropriate materials. Portfolio should include original/final, b&w tearsheets, photostats, photocopies and photographs. Buys first or one-time rights. Pays 45 days after acceptance.

***SOUTHERN EXPOSURE,** Box 531, Durham NC 27702. (919)688-8167. Managing Editor: Eric Bates. Estab. 1972. A quarterly magazine of Southern politics and culture. Circ. 5,000. Accepts previously published artwork. Original artwork returned at job's completion. Sample copies available for $4.

Illustrations: Buys 2 freelance illustrations/issue. Send query letter with nonreturnable samples. Pays $100, color, cover. Pays $50-100, b&w, inside.

SPORTS CAR INTERNATIONAL, Suite 120, 3901 Westerly Place, Newport Beach CA 92660. (714)851-3044. Art Director: Keith May. Estab. 1986. Entertainment for the exotic and classic sports car enthusiast. Printed "four-color on glossy stock, we are America's premier sports car magazine." Monthly. Circ. 75,000. Original artwork is returned after publication. Sample copy and art guidelines available.

Illustrations: Works with 6-8 illustrators/year. Buys 48-60 illustrations/year from freelancers. Buys illustrations mainly for spots and feature spreads. Works on assignment only. Prefers pen & ink, airbrush and watercolor. Send query letter with brochure showing art style. Looks for originality, movement and color. Samples are filed. Reports back about queries/submissions only if interested. Call to schedule an appointment to show a portfolio which should include tearsheets, slides, photographs and transparencies. Buys first rights. Pays $400, b&w, $600, color, full page; $200, color, spots; on publication.

STONE SOUP, The Magazine by Children, Box 83, Santa Cruz CA 95063. (408)426-5557. Editor: Gerry Mandel. Literary magazine emphasizing writing and art by children through age 13. Features adventure, ethnic, experimental, fantasy, humorous and science fiction articles. "We publish writing and art by children through age 13. We look for artwork that reveals that the artist is closely observing his or her world." 4-color. Bimonthly. Circ. 13,000. Original artwork is returned after publication. Sample copies available. Art guidelines for SASE with first-class postage.

Illustrations: Buys 8 illustrations/issue from freelancers. Prefers complete and detailed scenes from real life. Send query letter with photostats, photocopies, slides and photographs. Samples are filed or are returned by SASE. Reports back within 1 month. Buys all rights. Pays $25, b&w, cover; $8, b&w, inside; on publication.

Tips: "We accept artwork by children only, through age 13."

STUDENT LAWYER, 750 N. Lake Shore Dr., Chicago IL 60611. (312)988-6049. Editor: Sarah Hoban. Art Director: Robert Woolley. Estab. 1972. Trade journal emphasizing legal education and social/legal issues. "*Student Lawyer* is a monthly legal affairs magazine published by the Law Student Division of the American Bar Association. It is not a legal journal. It is a features magazine, competing for a share of law students' limited spare time — so the articles we publish must be informative, lively good reads. We have no interest whatsoever in anything that resembles a footnoted, academic article. We are interested in professional and legal education issues, sociolegal phenomena, legal career features, profiles of lawyers who are making an impact on the profession and the (very) occasional piece of fiction." Monthly (September-May). 4-color. Circ. 35,000. Accepts previously published material. Original artwork is returned to the artist after publication. Samples copies $4. Art guidelines free for SASE with first-class postage.

Illustrations: Approached by 20 illustrators/year. Buys 8 illustrations/issue, 75 illustrations/year. Needs editorial illustration with "innovative, intelligent style." Uses freelance art for covers and inside art; on assignment only. Send query letter with brochure, tearsheets and photographs. Samples are filed or returned by SASE. Reports back within 3 weeks only if interested. Call to schedule an appointment to show a portfolio, which should include original/final art and tearsheets. Buys one-time rights. Pays $450, b&w; $500, color,cover; $250, b&w; $350, color, inside features; $100 for b&w department pieces on acceptance.

Tips: "In your portfolio, show a variety of color and black and white, plus editorial work."

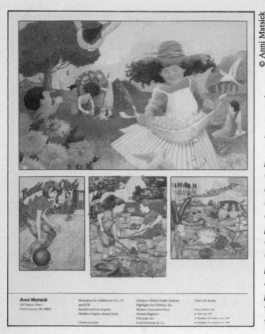

© Anni Matsick

Anni Matsick of State College, Pennsylvania highlights some of her recent work in this ad page from **The Graphic Artists Guild's Directory of Illustration.** *With it she hoped to attain "direct exposure to potential buyers in the children's illustration market." As a result Matsick received calls from major publishers, design and production houses and art directors across the country (a portion of the 18,000 illustration buyers the book is distributed to free), requesting to see her portfolio. The ad page cost her $1,895, which includes 2,000 copies of the page for use in self-promotion. All four of the pieces pictured are from markets she learned of through* Artist's Market.

THE SUN, 107 N. Roberson, Chapel Hill NC 27516. (919)942-5282. Editor: Sy Safransky. Magazine of ideas. Monthly. Circ. 15,000. Accepts previously published material. Original artwork returned after publication. Sample copy $3. Art guidelines free for SASE with first-class postage.
Cartoons: Buys various cartoons/issue from freelancers. Send finished cartoons. Material not kept on file is returned by SASE. Reports within 3 months. Buys first rights. Pays $25 and up b&w and color; plus copies and subscription.
Illustrations: Buys various illustrations/issue from freelancers. Send query letter with samples. Samples not filed are returned by SASE. Reports within 3 months. To show a portfolio, mail appropriate materials. Buys one-time rights. Pays $25 and up; plus copies and subscription. Pays on publication.

SUNSHINE MAGAZINE, 200 E. Las Olas Blvd., Ft. Lauderdale FL 33301. (305)356-4690. Art Director: Kent Barton. Estab. 1983. Consumer magazine; the Sunday Magazine for the Sun Sentinel Newspaper; featuring anything that would interest an intelligent adult reader living on South Florida's famous 'gold goast.' " Circ. 350,000. Accepts previously pubished artwork. Original artwork returned to artist at the job's completion. Sample copies and art guidelines available.
Illustrations: Approached by 12-25 illustrators/year. Buys 1 illustration/issue, 60-70 illustrations/year from freelancers. Works on assignment only. Preferred themes and styles vary. Considers all color media. Send query letter with any available samples. Samples are filed or are returned by SASE. Reports back to the artist only if interested. Mail approprite materials: original/final art and color tearsheets, photostats, slides and photocopies. Buys first rights, one-time rights. Pays $600, color, cover; $500, color, inside; on acceptance.

***SUNWORLD**, 80 Elm St., Peterborough NH 03458. (603)924-0100. Art Director: Marilyn Fletcher. Estab. 1990. An independent monthly journal of Sun and SPARC computer systems. Circ. 56,000. Original artwork returned at job's completion. Sample copies available.
Illustrations: Approached by 24 freelance illustrators/year. Buys 4 freelance illustrations/issue. Artists work on assignment only. Send query letter with tearsheets. Samples are filed or are returned by SASE if requested by artist. Reports back to the artist only if interested. Write to schedule an appointment to show a portfolio, which should include original/final art, color tearsheets. Rights purchased vary according to project. Payment varies. Pays on acceptance.

***TAMPA REVIEW**, The University of Tampa, Box 19F, Tampa FL 33606-1490. (813)253-3333, ext. 62. Editor: Richard Mathews. Estab. 1988. Literary magazine. *"Tampa Review* publishes outstanding works of poetry, fiction, nonfiction and art from the U.S. and abroad." Circ. 450. B&w wtih 4-color cover, text pages single 6" wide columns in Palatino. Art presented on single pages, usually full page. "We prefer vertical works to

fill page." Accepts previously published artwork. Original artwork is returned at job's completion. Sample copy $7.50. Art guidelines available.

Illustrations: Buys 6 freelance illustrations/issue, 6/year. Prefers contemporary work. Considers pen & ink, acrylic, oil, charcoal, mixed media. Send query letter with resume, SASE, photographs, slides or PMTs January through March. Submissions are held through April, then returned by SASE if requested by artist. Reports back within 3 months if interested. Mail appropriate materials. Portfolio should include b&w slides, glossy prints and PMTs suitable for verticle 6×8″ or 6×9″ reproduction. Buys one-time rights. Pays $10 for color, cover; $10 for b&w.

Tips: "Send us high quality work sharply reproduced. We've been working through galleries."

***TAVERN SPORTS INTERNATIONAL,** Suite 850, 101 E. Erie, Chicago IL 60611. (312)266-9499. FAX: (312)266-7215. Managing Editor: Jocelyn Hathaway. Estab. 1988. Trade journal. A bimonthly magazine covering the recreational entertainment market served by the coin-op music/amusement and hospitality industries. Circ. 20,500. Original artwork returned at job's completion if requested. Sample copies available.

Cartoons: Approached by 2-5 freelance cartoonists/year. Buys 1 freelance cartoon/issue. Prefers humor relating to player/game scenarios. Preferred format varies. Send query letter with brochure and roughs. Samples are filed or returned by SASE if requested by artist. Reports back to the artist only if interested. Buys all rights. Pays $20 for b&w; $40 for color.

Illustrations: Approached by 6-10 freelance illustrators/year. Buys 3-5 freelance illustrations/issue. Works on assignment only. Prefers concept pieces on legislative and marketing issues. Likes varied techniques. Send query letter with brochure. Samples are filed or returned by SASE if requested by artist. Reports back to the artist only if interested. Call to schedule an appointment to show a portfolio, which should include original/final art, tearsheets, photocopies. Buys all rights. Pays $125, color, cover. Pays $40, b&w, $60, color, inside. Pays on acceptance.

Tips: "Remember that *TSI* is on a tight budget; if you're willing to work for less, you'll work more. Artists are given a lot of creative independence, though they must understand the subject matter and magazines market first."

TENNIS, 5520 Park Ave., Trumbull CT 06611. (203)373-7000. Art Director: Kathleen Burke. For young, affluent tennis players. Monthly. Circ. 500,000.

Cartoons: Buys 12 cartoons/year from freelancers. Receives 6 submissions/week from freelancers on tennis. Prefers finished cartoons, single panel. Reports in 2 weeks. Pays $75, b&w.

Illustrations: Works with 15-20 illustrators/year. Buys 50 illustrations/year from freelancers. Uses artists mainly for spots and openers. Works on assignment only. Send query letter with tearsheets. Mail printed samples of work. Pays $200-800 for color; on acceptance.

Tips: "Prospective contributors should first look through an issue of the magazine to make sure their style is appropriate for us."

THE TEXAS OBSERVER, 307 W. 7th, Austin TX 78701. (512)477-0746. Contact: Editor. Estab. 1954. Emphasizes Texas political, social and literary topics. Biweekly. B&w. Circ. 12,000. Accepts previously published material. Returns original artwork after publication. Sample copy for SASE with postage for two ounces; art guidelines for SASE with first class postage.

Illustrations: Buys 2 illustrations/issue, 24-30 illustrations/year from freelancers. Needs editorial illustration with political content. "We only print black and white, so pen & ink is best; washes are fine." Send photostats, tearsheets, photocopies, slides or photographs to be kept on file. Samples not filed are returned by SASE. Reports within 1 month. Write or call for appointment to show portfolio. Buys one-time rights. Pays $35, b&w cover; $20, inside; on publication.

Tips: "I don't want to see unsolicited cartoons or color samples. We use a few pen-and-ink line drawings, mainly from local artists.

THEDAMU ARTS MAGAZINE, 13217 Livernois, Detroit MI 48238-3162. (313)931-3427. Publisher: David Rambeau. Estab. 1970. Literary magazine; tabloid format; "general adult multi-disciplinary urban arts magazine." Monthly. Circ. 4,000. Accepts previously published artwork. "Send copies only." Sample copies free for SASE with first-class postage. Art guidelines free for SASE with first-class postage.

Cartoons: Approached by 5-10 cartoonists/year. "We do special cartoon issues featuring a single artist like a comic book except with adult, urban themes. That would run 7 tab pages and a cover." Prefers b&w line drawings. Send query letter with 3-6 b&w cartoons. Samples are filed. Reports back within 2-3 months only if interested. Buys one-time rights usually, but rights purchased vary according to project. Pays $25-200 for b&w.

Illustrations: Approached by 5-10 illustrators/year. Buys 2-3 illustrations/issue, 20 illustrations/year from freelancers. Prefers urban contemporary themes and styles. Prefers pen & ink. Send query letter with resume and 3-6 photocopies. Samples are filed. Reports back within 2-3 months. "We're a small magazine so we're not interested in a full portfolio." Pays $25-200 for b&w, cover; on publication.

Tips: "We're the first or second step on the publishing ladder for artists and writers. Submit same work to others also. Be ready to negotiate."

TIKKUN MAGAZINE, 5100 Leona St., Oakland CA 94619. (415)482-0805. Publisher: Michael Lerner. Estab. 1986. "A Jewish critique of politics, culture and society. Includes articles regarding Jewish and non-Jewish issues, left of center politically." Bimonthly. Circ. 40,000. Accepts previously published material. Original artwork is returned to the artist after publication. Sample copies $5 plus $1.20 postage or "call our distributor for local availability at (800)221-3148. If unavailable in your area, free with SASE."
Illustrations: Approached by 50-100 illustrators/year. Buys 0-8 illustrations/issue from freelancers. Prefers line drawings: (filed, payment on use). Send brochure, resume, tearsheets, photostats, photocopies. Slides and photographs for color artwork only. Buys one time rights. Slides and photographs returned if not interested. Often we hold onto line drawings for last-minute use. Pays $25 b&w, inside; $250 color; on publication.
Tips: Does not want to see "computer graphics, sculpture, heavy religious content."

***TOURIST ATTRACTIONS AND PARKS,** Suite 210, 7000 Terminal Square, Upper Darby PA 19082. (215)734-2420. President: Scott Borowsky. Estab. 1972. Deals with arenas, attractions, fairgrounds, stadiums, concerts, theme and amusement parks. Published 6 times/year. Circ. 20,000. Also uses freelance artists for illustration, promotional pieces, covers, layout and paste-up (each issue). Pays $7-8/hour for paste-up.
Illustrations: Buys 6 illustrations/issue. Send query letter with resume and samples. Include SASE. Buys all rights. Cover: Pays $50 minimum, gray opaques; on publication. Buys gray opaques for inside.
Tips: "Part-time work available for paste-up and mechanicals."

TQ, Box 82808, Lincoln NE 68501. (402)474-4567. Art Director: Victoria Valentine. "Our main purpose is to help Christian teens live consistently for Christ, and to help them grow in their knowledge of the Bible and its principles for living." Monthly 4-color magazine. Circ. 50,000. Original artwork returned after publication. Free sample copy.
Cartoons: Managing Editor: Win Mumma. Buys 2-3 cartoons/issue from freelancers. Receives 4 submissions/week from freelancers. Interested in wholesome humor for teens; prefer cartoons with teens as main characters; single panel. Prefers to see finished cartoons. Reports in 4-6 weeks. Buys first rights on a work-for-hire basis. Pays $25 for b&w; $50 for color cartoons.
Illustrations: Some illustrations purchased on assignment only. Submit samples with query letter. Pays $500/page for 4-color art; $300/½ page 4-color art.

***TRAILER BOATS MAGAZINE,** Poole Publications, Inc., 20700 Belshaw Ave., Carson CA 90746-3510. (213)537-6322. FAX: (213)537-8735. Editor: Wiley Poole. Estab. 1971. A monthly consumer magazine. *"Trailer Boats* is the leading national magazine aimed at owners of boats under 30 feet (trailerable). This market segment is by far the largest in the marine industry." Circ. 81,000. Original artwork returned at job's completion. Sample copies available.
Cartoons: Approached by 6 freelance cartoonists/year. Buys 2-3 freelance cartoons/year. Prefers boating-related themes (no sailboats), single column line art. Prefers single panel with gagline. Send query letter with roughs and technique samples. Samples are not filed and are returned by SASE. Reports back to the artist only if interested. Buys one-time rights. Pays $25, b&w.
Illustrations: Approached by 6 freelance illustrators/year. Buys 2-3 freelance illustrations/year. Prefers boating-related themes (no sailboats), single column line art. Considers pen and ink. Send query letter with tearsheets, photographs, photocopies, photostats and slides. Samples are not filed and are returned by SASE. Reports back to the artist only if interested. Mail appropriate materials. Portfolio should include thumbnails, b&w tearsheets, photostats and photocopies. Buys one-time rights. Pays $25, b&w, inside.

TRAINING Magazine, The Human Side of Business, 50 S. 9th St., Minneapolis MN 55402. (612)333-0471. FAX: (612)333-6526. Art Director: Jodi Boren Scharff. Estab. 1964. Trade journal; magazine format; "covers job-related training and education in business and industry, both theory and practice." Audience: "training directors, personnel managers, sales and data processing managers, general managers, etc." Monthly; 4-color; we use a variety of styles, but it is a business-looking magazine. Circ. 51,000. Sample copies free for SASE with first-class postage. Art guidelines not available.
Cartoons: Approached by 20-25 cartoonists/year. Buys 1-2 cartoons/issue, varying number of cartoons/year from freelancers. "We buy a wide variety of styles. The themes relate directly to our editorial content, which is training in the workplace." Prefers single panel, with and without gagline; b&w line drawings; b&w washes. Send query letter with brochure and finished cartoons. Samples are filed or are returned by SASE if requested by artist. Reports back within 1 month. Buys first rights or one-time rights. Pays $25, b&w.
Illustrations: Buys 6-8 illustrations/issue, from freelancers. Works on assignment only. Prefers "themes that relate directly to editorial content. Styles are varied." Considers pen & ink, airbrush, mixed media, watercolor, acrylic, oil, pastel and collage. Send query letter with brochure, resume, tearsheets, photocopies and photostats. Samples are filed or are returned by SASE if requested by artist. Reports back to the artist only if interested. Call or write to schedule an appointment to show a portfolio, which should include original/final

art and b&w and color tearsheets, photostats, photographs, slides and photocopies. Buys first rights or one-time rights. Pays $500 and up, color, cover; $75-200, b&w, $200-250, color, inside; on acceptance.
Tips: "Show a wide variety of work in different media and with different subject matter. Good renditions of people are extremely important."

TRANSITIONS ABROAD: The Magazine of Overseas Opportunities, 18 Hulst Rd., Box 344, Amherst MA 01004. Editor: Clayton A. Hubbs. Emphasizes "educational, low-budget and special interest overseas travel for those who travel to learn and to participate." Bimonthly magazine; b&w with 2-color cover. Circ. 15,000. Original artwork returned after publication. Sample copy $3.50; art guidelines for SASE.
Illustrations: Buys 3 illustrations/issue from freelancers. Especially needs illustrations of American travelers and natives in overseas settings (work, travel and study). Send roughs to be kept on file. Samples not kept on file are returned by SASE. Reports in 4 weeks. Buys one-time rights. Pays $25-100, b&w line drawings; $30-100, b&w washes, cover; on publication.
Tips: The trend is toward "more and more interest in travel which involves interaction with people in the host country, with a formal or informal educational component. We usually commission graphics to fit specific features. Inclusion of article with graphics increases likelihood of acceptance. Artists should study the publication and determine its needs."

TRAVEL & LEISURE, 1120 6th Ave., New York NY 10036. (212)382-5600. Design/Art Director: Bob Ciano. Associate Art Directors: Joseph Paschke and Daniela Maioresco. Emphasizes travel, resorts, dining and entertainment. Monthly. Circ. 1,300,000. Original artwork returned after publication. Art guidelines for SASE.
Illustrations: Approached by 250-350 illustrators/year. Buys 1-15 illustrations/issue, all from freelancers. Interested in travel and leisure-related themes. Prefers pen & ink, airbrush, colored pencil, watercolor, acrylic, oil, pastel, collage, mixed media and calligraphy. "Illustrators are selected by excellence and relevance to the subject." Works on assignment only. Provide business card to be kept on file for future assignment; samples returned by SASE. Reports in 1 week. Buys world serial rights. Pays a minimum of $250 inside b&w and $800-1,500 maximum, inside color; on publication.

***TRIATHLETE MAGAZINE**, Suite 303, 1415 3rd St., Santa Monica CA 90046. (213)394-1321. FAX: (213)458-6248. Art Director: Tom Price. Estab. 1983. A monthly consumer magazine geared to the sport of triathlons, covering training tips, sports, medium, buyer's guide and fashions. Circ. 75,000. Original artwork returned at job's completion. Sample copies free for SASE.
Illustrations: Buys 1-4 freelance illustrations/issue. Works on assignment only. Open to all styles and media. Send query letter with brochure and tearsheets. Samples are filed. Does not report back, in which case the artist should call to follow-up. Call to schedule an appointment to show a portfolio, which should include b&w and color tearsheets. Pays $100, b&w; $200, 2-color. Pays $400-700, 4-color, inside.

TROUT, Box 6225, Bend OR 97708. (503)382-2327. Editor: Thomas R. Pero. Estab. 1959. High-calibre quarterly magazine aimed at sophisticated trout and salmon anglers. Theme is conservation of fisheries habitat and a quality outdoor environment. Quarterly. Circ. 70,000. Original artwork is returned after publication. Sample copy $4. Art guidelines free for SASE with first-class postage.
Cartoons: Buys 1 cartoon/issue, 4 cartoons/year from freelancers. Prefers single panel b&w line drawings, b&w washes and color washes. Send query letter. Samples are filed. Samples not filed are returned. Reports back regarding queries/submissions within 1 month. Buys first rights. Pays $50, b&w; on acceptance.
Illustrations: Buys illustrations mainly for spots and feature spreads. Buys 6 illustrations/issue, 24 illustrations/year from freelancers. Considers watercolor, acrylic, oil and charcoal pencil. Send query letter with brochure showing art style, tearsheets and photographs. Samples are filed. Samples not filed are returned. Reports back about queries/submissions within 1 month. For a portfolio review mail appropriate materials, which should include photographs. Buys first rights. Pays $50, b&w; $200, color, inside; on acceptance.

TRUE WEST, Box 2107, Stillwater OK 74076. (405)743-3370. Editor: John Joerschke. Black-and-white magazine with 4-color cover; emphasizes American western history from 1830 to 1910 for a primarily rural and suburban audience, middle-age and older, interested in Old West history, horses, cowboys, art, clothing and all things western. Monthly. Circ. 30,000. Accepts previously published material and considers some simultaneous submissions. Original artwork returned after publication. Sample copy $2. Art guidelines for SASE.
Illustrations: Approached by 75 illustrators/year. Buys 5-10 illustrations/issue from freelancers. "Inside illustrations are usually, but not always, pen & ink line drawings; covers are Western paintings." Send query letter with samples to be kept on file; "we return anything on request." "For inside illustrations, we want samples of artist's line drawings. For covers, we need to see full-color transparencies." Reports within 30 days. Call or write for appointment to show portfolio. Buys one-time rights. Pays $100-150, for color transparency for cover; $20-50, b&w, inside. "Payment on acceptance for new artists, on assignment for established contributors."

Tips: "Wc usc a widc varicty of stylcs so long as thcy are historically accurate and have an old-time flavor."

TURTLE MAGAZINE FOR PRESCHOOL KIDS, 1100 Waterway Blvd., Box 567, Indianapolis IN 46206. (317)636-8881. Art Director: Bart Rivers. Estab. 1979. Emphasizes health, nutrition, exercise and safety for children 2-5 years. 4-color. Monthly except bimonthly January/February, April/May, July/August and October/November. Original artwork not returned after publication. Sample copy 75¢; art guidelines for SASE. Finds most artists through samples received in mail.
Illustrations: Approached by 100 illustrators/year. Works with 20 illustrators/year. Buys 15-30 illustrations/ issue from freelancers. Interested in "stylized, humorous, realistic and cartooned themes; also nature and health." Works on assignment only. Send query letter with resume, photostats or good photocopies, slides and tearsheets to be kept on file. Samples not kept on file returned by SASE. Reports only if interested. Buys all rights. To show a portfolio, mail tearsheets or slides. Pays $250, cover; $70-175, pre-separated 4-color; $65-140, 4-color, $55-110, 2-color; $30-70, b&w; inside; on publication.
Tips: "Familiarize yourself with our magazine and other children's publications before you submit any samples. The samples you send should demonstrate your ability to support a story with illustration."

***TWINS MAGAZINE,** Suite 155, 6740 Antioch, Merriam KS 66204. (913)722-1090. FAX: (913)722-1767. Art Director: Cindy Himmelberg. Estab. 1984. A bimonthly. International magazine designed to give professional guidance to multiples, their parents and professionals who care for them. Circ. 45,000. Sample copies available. Art guidelines free for SASE with first class postage.
Illustrations: Approached by 10 freelance illustrators/year. Buys 10 freelance illustrations/issue. Works on assignment only. Prefers children (twins) in assigned situations. Considers watercolor, airbrush, acrylic, marker, color pencil and pastel. Send query letter with resume, tearsheets, photocopies, slides. Samples are filed or returned by SASE if requested by artist. Reports back to the artist only if interested. Call to schedule an appointment to show a portfolio, which should include original/final art, color tearsheets, photographs and photocopies. Buys all rights. Pays $100, color, cover. Pays $75, color, inside. Pays on publication.

***UNIXWORLD MAGAZINE,** 444 Castro St., Mountain View CA 94041. (415)940-1500. Art Director: Joe Sikoryak. Estab. 1984. Trade magazine. "*Unixworld* is a business-oriented computer magazine with many useful articles aimed at the business user as well as more technical readers." Monthly. Circ. 60,000. Original artwork returned at job's completion. Sample copies free for SASE with first class postage.
Illustrations: Buys 4-6 illustrations/issue. Works on assignment only. Prefers "less realistic, more expressive and stylistic," color work. Send query letter with tearsheets and photocopies. Samples are filed or are returned by SASE if requested by artist. Reports back to the artist only if interested. Buys first rights. Pays $750+, color, cover. Pays $250+, color, inside. Pays on publication.

UNMUZZLED OX, 105 Hudson St., New York NY 10013. (212)226-7170. Editor: Michael Andre. Emphasizes poetry, stories, some visual arts (graphics, drawings, photos) for poets, writers, artists, musicians and interested others. B&w with 2-color cover and "classy" design. Circ. 18,000. Whether original artwork is returned after publication "depends on work—artist should send SASE." Sample copy $4.95 plus $1 postage.
Cartoons: Number used/issue varies. Send query letter with copies. Reports within 10 weeks. No payment for cartoons.
Illustrations: Uses "several" illustrations/issue. Needs editorial illustration. Themes vary according to issue. Send query letter and "anything you care to send" to be kept on file for possible future assignments. Reports within 10 weeks.
Tips: Magazine readers and contributors are "highly sophisticated and educated"; artwork should be geared to this market. "Really, *Ox* is part of New York art world. We publish art not 'illustration.'"

VARBUSINESS, 600 Community Dr., Manhasset NY 11030. (516)365-4600. Art Director: David Loewy. Estab. 1985. Emphasizes computer business. For and about value added resellers. The art is in a lighter, less technical vein." 4-color with an "innovative, contemporary, very creative" design. Monthly. Circ. 75,000. Original artwork is returned to the artist after publication. Art guidelines not available.
Illustrations: Approached by 100+ illustrators/year. Works with 30-50 illustrators/year. Buys 150 illustrations/year from freelancers. Needs editorial illustrations. Prefers "pop illustrative style." Style of Lou Brooks, Robert Risko, Mark Fredrickson, Bill Mayer. Uses artists mainly for covers, full and single page spreads and spots. Works on assignment only. Prefers airbrush, then pen & ink, colored pencil, acrylic, pastel and computer illustration. Send query letter with tearsheets. Samples are filed or are returned only if requested. Reports back only if interested. Call or write to schedule an appointment to show a portfolio, which should include tearsheets, final reproduction/product and slides. Buys one-time rights. Pays $2,000, color, cover; $300-1,000, color, inside; on publication.
Tips: "Show printed pieces or suitable color reproductions, I do not want to see photocopies, stats or original art. Artists should have a pop, illustrative style. Concepts should be imaginative not literal. Sense of humor is important." Sees trend toward "more computer illustration." Emphatically says, "I do not use editorial cartoons."

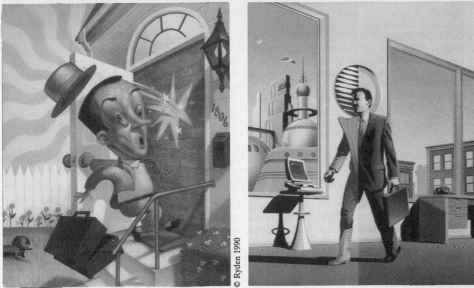

© Ryden 1990

© Dan Cosgrove 1991

"Avoiding the Road to Nowhere" is the title of the article Mark Ryden was given by Varbusiness art director David Loewy for the illustration on the left. How better to represent the text's content—salesmen running into a brick wall—then in this literal translation in acrylic? "I simply wanted to give it a humorous tone," the Monrovia, California-based illustrator says. The cover was done by Dan Cosgrove of Chicago, and unfortunately is not done complete justice in this reproduction, for one half of it is in color. Of the assignment the designer/illustrator says, "They wanted a business man leaving an office of the 50s or 60s (black and white) and entering an office of the future."

VEGETARIAN TIMES, Box 570, Oak Park IL 60303. (708)848-8120. Art Director: Gregory Chambers. Consumer food magazine with emphasis on fitness and health for readers ages 30-50, 75% women. Monthly. Circ. 100,000. Accepts previously published material. Original artwork returned after publication. Sample copy $2.
Illustrations: Buys 4 illustrations/issue from freelancers. Send query letter with samples showing art style. To show a portfolio, mail appropriate materials or call to schedule an appointment; portfolio should include roughs, original/final art, color and b&w tearsheets and photographs. Pays $30-300, inside; on publication.
Tips: "I work primarily with food/health-related topics, and look for someone who is familiar with or sympathetic to vegetarianism and whole foods cuisine."

VENTURE, Box 150, Wheaton IL 60189. (708)665-0630. Art Director: Robert Fine. Estab. 1959. For boys 10-15. "We seek to promote consciousness, acceptance of and personal commitment to Jesus Christ." Bimonthly magazine; 2-color. Circ. 20,000. Simultaneous submissions and previously published work OK. Original artwork returned after publication. Sample copy $1.85 with large SASE; artists' guidelines with SASE.
Cartoons: Send to attention of cartoon editor. Approached by 20 cartoonists/year. Buys 1-3 cartoons/issue; all from freelancers. Receives 2 submissions/week from freelancers, on nature, sports, school, camping, hiking; single panel with gagline. "Keep it clean." Prefers finished cartoons. SASE. Reports in 2-4 weeks. Buys first-time rights. Pays $30 minimum, b&w line drawings.
Illustrations: Approached by 35 illustrators/year. Contact art director. Works with 3-4 illustrators/issue. Buys 2 illustrations/issue, 15-20 illustrations/year from freelancers, on education, family life and camping; b&w only. Works on assignment only. Send business card, tearsheets and photocopies of samples to be kept on file for future assignments. Samples returned by SASE. Reports back on future assignment possibilities. SASE. Reports in 2 weeks. Buys first time rights. Pays $100+ for b&w, cover; $85+ for b&w; inside; on publication.
Tips: Due to the recession "we're cutting back slightly."

VETTE MAGAZINE, 299 Market St., Saddle Brook NJ 07662. (201)488-7171. Editor-in-Chief: D. Randy Riggs. Estab. 1976. Magazine "devoted exclusively to the Corvette automobile and the hobby of Corvetting." Monthly. 4-color. Circ. 60,000. Original artwork is returned after publication. Sample copies $2.50. Art guidelines not available.
Cartoons: Approached by 5 cartoonists/year. Pays $50-75 b&w.
Illustrations: Buys illustrations mainly for spots and feature spreads. Buys 1-2 illustrations/issue, 20 illustrations/year from freelancers. Needs editoria and technical illustration. Works on assignment only. Consider pen & ink, airbrush, colored pencil, watercolor, acrylic, oil, pastel, marker and charcoal/pencil. Send query letter with brochure, tearsheets, photostats and photocopies. Samples not filed are returned only if requested. Reports back within 2 weeks. Call to schedule an appointment to show a portfolio, or mail tearsheets and photostats. Buys first rights. Pays $35-150, b&w; $50-800, color, inside; on acceptance.
Tips: The best way to break in is to send "spot illustrations for fillers. Major art is assigned according to articles. Label back of art with name and address."

VIDEOMAKER MAGAZINE, Box 4591, Chico CA 95927. (916)891-8410. FAX: (916)891-8443. Art Director: Sarah Ellis. Consumer magazine for video camera users. Monthly. Circ. 50,000. Accepts previously published artwork. Original artwork returned at job's completion. Sample copies are available. Art guidelines not available.
Cartoons: Approached by 30 cartoonists/year. Buys 3 cartoons/issue, 32 cartoons/year from freelancers. "We will assign themes or styles." Prefers b&w line drawings, color washes. Send query letter with photocopies. Samples are filed. Reports back to the artist only if interested. Rights purchased vary according to project. Pays $35-100, b&w, $50, color.
Illustrations: Approached by 30 illustrators/year. Buys 3 illustrations/issue, 36 illustrations/year from freelancers. Works on assignment only. Preferred themes are camcorders. Considers pen & ink, airbrush, colored pencil, mixed media, watercolor, acrylic, oil, pastel, collage, marker and charcoal. Send query letter with photocopies. Samples are filed. Reports back to the artist only if interested. Call to schedule an appointment to show a portfolio, which should include thumbnails, tearsheets and photographs. Negotiates rights purchased. Pays $30, b&w, $125, color, inside; on publication.
Tips: "Come up with ideas (cartoons) drawn out (something to do with camcorder) then write or call. Send a sample of previous work."

VOLKSWAGEN WORLD, Volkswagen of America, Inc., Troy MI 48007. (313)362-6770. Editor: Marlene Goldsmith. For Volkswagen owners. Quarterly. Circ. 300,000.
Illustrations: Approached by 10 illustrators/year. Send query letter with samples. SASE. Reports in 6 weeks. Buys First North American rights. Pays $500 minimum, color, cover; $150 minimum, per printed page, color, cover; on acceptance.
Tips: "We're happy to send sample issues to prospective contributors. It's the best way of seeing what our needs are. I'm looking for contemporary illustration."

WASHINGTON FLYER MAGAZINE, Suite 111, 11 Canal Center Plaza, Alexandria VA 22314. (703)739-9292. FAX: (703)683-2848. Assistant Editor: Laurie McLaughlin. Estab. 1989. Consumer magazine. "In-airport publication focusing on travel, transportation, trade and communications for frequent business and pleasure travelers." Bimonthly. 4-color. Circ. 160,000. Accepts previously published artwork. Original artwork is returned to the artist at the job's completion. Sample copies available. Art guidelines available.
Illustrations: Buys 2 illustrations/issue, 12 illustrations/year from freelancers. Needs editorial illustration—"clear, upbeat, sometimes serious, positive, bright." Works on assignment only. Considers all media. Send query letter with brochure, tearsheets, photostats, photographs, slides, SASE, photocopies and transparencies. Samples are filed. Reports back to the artist only if interested. Call or write to schedule an appointment to show a portfolio. Portfolio should include color tearsheets, photostats, photographs, slides and photocopies. Buys reprint rights or all rights.
Tips: "We are very interested in reprint rights."

***THE WASHINGTON MONTHLY**, 1611 Connecticut Ave., NW, Washington DC 20009. (202)462-0128. Production Manager: Donne Masaki. Estab. 1969. Monthly national political magazine.
Illustrations: Caricatures, illustrations and spot drawings. Send cover letter, resume and photocopies. Include 3 samples. Samples are filed. Reports back to the artist only if interested. Mail appropriate materials. Rights purchased vary according to project. Pays a flat fee $200. Pays on publication.
Tips: "We are a low budget, high visibility magazine. Artists must be willing to work on spec, with short notice."

***WASHINGTON PHARMACIST**, Suite 101, 1420 Maple Ave. S.W., Renton WA 98055-3196. (206)228-7171. Publications Director: Sheri Ray. Estab. 1959. Association trade magazine emphasizing pharmaceuticals, professional issues, management for pharmacists. Bimonthly. Circ. 1,700. Accepts previously published artwork. Sample copies available.

Cartoons: Approached by less than 2 cartoonists/year. Buys less than 5 freelance cartoons/year. Preferred themes vary. Send query letter with brochure and roughs. Samples are filed. Reports back to the artist only if interested. Rights purchased vary according to project. Pays $50 for b&w; $100 for color.

Illustrations: Approached by less than 2 freelance illustrators/year. Buys 2-5 freelance illustrations/year. Considers pen and ink. Send query letter with brochure and photocopies. Reports back to the artist only if interested. Rights purchased vary according to project. Pays on acceptance.

THE WASHINGTON POST MAGAZINE, 1150 15th St. NW, Washington DC 20071. (202)334-6185. FAX: (202)334-5693. Art Director: Mark Danzig. Estab. 1986. Consumer magazine; general interest. Weekly. Circ. 1,200,000. Original artwork returned after publication. Art guidelines not available.

Illustrations: Approached by 500 illustrators/year. Buys 3 illustrations/issue, 200 illustrations/year from freelancers. Works on assignment only. Prefers any media. Send query letter with tearsheets. Samples are filed. Reports back only if interested. Mail appropriate materials: tearsheets and slides. Buys one-time rights. Pays $1,500, color, cover; $350, color, inside; on acceptance.

WEEKLY READER/SECONDARY/U.S. KIDS MAGAZINE C/C Field Publications, 245 Long Hill Rd., Middletown CT 06457. (203)638-2757. FAX: (203)638-2787. Graphics Director: Vickey Bolling. Estab. 1928. Educational newspaper, magazine, posters and books. U.S. Kids has a magazine format *Weekly Reader* and *Secondary* periodicals have a newspaper format. The *Weekly Reader* emphasizes news and education for children 4-14. The philosophy is to connect students to the world. *U.S. Kids* magazine features stories, puzzles and games in an educational fun format. Publications are 4-color or 2-color; b&w with 4-color or 2-color cover. Design is "clean, straight-forward." Accepts previously published artwork. Original artwork is returned the artist at the job's completion. Sample copies are available.

Cartoons: Approached by 10 cartoonists/year. Prefers contempory, humorous line work. Preferred themes and styles vary according to the needs of the story/articles; single panel. Send query letter with printed samples. Samples filed or are returned by SASE if requested by artist. Reports back within 3-4 weeks. Rights purchased vary according to project. Pays $75, b&w; $250-300, color (full page).

Illustrations: Needs editorial, technical and medical illustration. Style should be "contemporary and age level appropriate for the juvenile audience. Style of Janet Hamlin, Janet Street, Joe Locco, Joe Klein and Mas Mianot. Approached by 60-70 illustrators/year. Buys more than 50/week, 2,600 illustrations/year from freelancers. Works on assignment only. Prefers pen & ink, airbrush, colored pencil, mixed media, watercolor, acrylic, pastel, collage and charcoal. Send query letter with brochure, tearsheets, slides, SASE and photocopies. Samples are filed or are returned by SASE if requested by artist. Reports back within 3-4 weeks. Pays $250, b&w, $300, color, cover; $250, b&w, $300, color, inside. Payment is usually made within 2-3 weeks of receiving the invoice.

Tips: "Our primary focus is the children's marketplace; figures must be drawn well if style is realistic. Art should reflect creativity and knowledge of audience's sophistication needs." Our budgets are tight and we have very little flexibility in our rates—We need artists who can work with our budgets—still seeking out artists of all styles—professionals!"

WESTERN SPORTSMAN, Box 737, Regina, Saskatchewan S4P 3A8 Canada. (306)352-2773. Editor-in-Chief: Roger Francis. For fishermen, hunters, campers and outdoorsmen. Bimonthly. 4-color; design is "open and free. Light enough that it doesn't force someone to read." Circ. 29,000 ABC audited. Original artwork returned after publication. Sample copy $4; artist's guidelines for SASE (nonresidents include IRC).

Cartoons: Approached by 20 cartoonists/year. Buys 40 cartoons/year on the outdoors; single panel with gaglines. Send art or query with samples. SASE (nonresidents include IRC). Reports in 3-8 weeks. Buys first North American serial rights. Pays $20 per cartoon, b&w line drawings; on acceptance.

Illustrations: Approached by 15 illustrators/year. Buys 8 illustrations/year from freelancers on the outdoors. Needs editorial illustration, with a "down to earth look, local—not artsy, overly colorful or any 'retro' look. Good simple truthfulness in art." Style of Don Brestler. Mail art or query with samples. SASE (nonresidents include IRC). Reports in 3-8 weeks. Buys first North American serial rights. Pays $50-250, b&w line drawings, inside; $325, color, cover on acceptance.

Tips: "Send animal samples to judge for accurate depiction."

WESTWAYS, 2601 S. Figueroa, Los Angeles CA 90007. (213)741-4850. FAX: (213)741-3033. Art Director: Don Letta. Estab. 1918. A monthly magazine covering travel and people; reaches an upscale audience through AAA membership as well as newstand and subscription sales. Circ. 450,000. Original artwork returned at job's completion. Sample copies available. Art guidelines available.

Illustrations: Approached by 20 freelance illustrators/year. Buys 2-6 freelance illustrations/issue. Works on assignment only. Preferred style arty-tasteful, colorful. Considers pen and ink, watercolor, collage, airbrush, acrylic, color pencil, oil, mixed media and pastel. Send query letter with brochure, tearsheets and samples. Samples are filed. Reports back within 1-2 weeks only if interested. Mail appropriate materials. Portfolio should include thumbnails, original/final art, b&w and color tearsheets. Buys first rights. Pays $250 minimum for color, inside. Pays on publication.

Tips: "Send samples of work that would be appropriate for *Westways*."

WHERE VICTORIA, 1001 Wharf St., Victoria, BC V8V 4V6 Canada. (604)388-4324. FAX: (604)388-6166. Art Director: Leigh Lundgren. Estab. 1977. Tourist magazine featuring general information on shopping and attractions for the tourist market. Monthly. 4-color. Circ. 30,000. Accepts previously published artwork. Original artwork returned to artist at the job's completion. Sample copies available. Art guidelines available.
Illustrations: Approached by 10 illustrators/year. Buys 20 illustrations/year from freelancers. Needs editorial illustration. Prefers lifestyle and scenic themes and realistic styles; usually used in shopping or dining listings section. Considers watercolor and acrylic. Send query letter with tearsheets, photographs, slides and transparencies. Samples are filed. Reports back to the artist only if interested. Call to schedule an appointment to show a portfolio. Portfolio should include tearsheets, photographs and slides. Buys first, one-time or reprint rights. Payment negotiable. Pays on publication.

WILDLIFE ART NEWS, 3455 Dakota Ave. S., St. Louis Park MN 55416-0246. (612)927-9056. FAX: (612)927-9353. Publisher: Robert Koenke. Estab. 1982. Trade journal; magazine format; "the largest magazine in wildlife art originals, prints, duck stamps, artist interviews and industry information." Bimonthly. 4-color with "award-winning, design. Many two-page color art spreads." Circ. 45,000. Accepts previously published artwork. Original artwork returned to artist at job's completion. Sample copy $5. Art guidelines free for SASE with first class postage.
Cartoons: Buys 12 cartoons/year from freelancers. Prefers nature, wildlife and environmental themes; single panel. Send query letter with roughs. Sample are not filed and are returned by SASE. Reports back within 1 month. Buys first rights. Pays $50, b&w.
Illustrations: Approached by 50 illustrators/year. Needs editorial illustration. Works on assignment only. Prefers nature and animal themes. Considers pen & ink and charcoal. Send query letter with brochure, resume, SASE, photocopies and transparencies. Samples are not filed and are returned by SASE if requested by artist. Reports back within 3 weeks. Mail appropriate materials: color tearsheets, slides and photocopies. Buys first rights. "We do not pay for artists for illustration in publication material."
Tips: "Interested wildlife artists should send SASE, 3-7 slides or transparencies, short biography and be patient!" Also publishes *International Artist Yearbook*, the largest source book of wildlife artists' biographies, color reproductions, print prices and calendar of events for wildlie art shows. Carvers, photographers, flat artists, and three-dimensional artists are invited in the international volume."

***WILLOW SPRINGS**, MS-1, Cheney WA 99004. (509)458-6429. Editor: Nance Van Winckel. Estab. 1977. Literary magazine. "We are looking for high quality poetry, fiction, non-fiction, translations and artwork." Biannual. Circ. 1,000. Original artwork returned at job's completion. Sample copies available for $4.
Illustrations: Buys first rights. Pays $25,color, cover. Pays $25, b&w, inside. Pays on publication.

WILSON LIBRARY BULLETIN, 950 University Ave., Bronx NY 10452. (212)588-8400. Editor: Mary Jo Godwin. Emphasizes the issues and the practice of library science. 4-color with a "lively" design. Published 10 times/year. Circ. 13,500. Free sample copy. Uses freelance artists mainly for cartoons and logos.
Cartoons: Approached by 25-30 cartoonists/year. Buys 2-3 cartoons/issue from freelancers on education, publishing, reading, technology and libraries; single panel with gagline. Mail finished art and SASE. Reports back only if interested. Buys first rights. Pays $100, b&w line drawings and washes; on publication.
Illustrations: Approached by 20-30 illustrators/year. Buys 1-2 illustrations/issue from freelancers. Works on assignment only. Send query letter, business card and samples to be kept on file. Do not send original work that must be returned. Reports back only if interested. Call for appointment to show portfolio. Buys first rights. Pays $400, color washes; $100-200, b&w line drawings and washes, inside; $25, spot drawings; on publication.
Tips: Artist should have "knowledge of our publication and its needs."

***WIN**, Suite 213, 16760 Stagg St., Van Nuys CA 91406. (818)781-9355. FAX: (818)781-3125. Art Director: K. Blackmun. A monthly consumer magazine. "The only magazine in the country devoted to all aspects of gambling." Accepts previously published artwork. Original artwork returned at job's completion. Samples copies available.
Cartoons: Buys 2 freelance cartoons/issue. Buys 20 freelance cartoons/year. Must be gambling related. Prefers single panel, with gagline, b&w line drawings, color washes. Send query letter with finished cartoons. Samples are filed or returned by SASE if requested by artist. Reports back to the artist only if interested. Buys first rights. Pays $25/cartoon.
Illustrations: Buys 2-5 freelance illustraitons/issue. Works on assignment only. Prefers a contemporary look. Considers pen and ink, watercolor, collage, airbrush, acrylic, color pencil and mixed media. "Send query letter with promotional materials that we can keep on file; we can't guarantee return of originals or slides." Samples are filed. Reports back to the artist only if interested. Call (local artists). Portfolio should include b&w and color, tearsheets and slides. Buys first rights. Pays $150 color, cover. Pays $75, b&w, $100, color, inside.

WINES & VINES, 1800 Lincoln Ave., San Rafael CA 94901. (415)453-9700. Editor: Philip E. Hiaring. Emphasizes the grape and wine industry in North America for the trade—growers, winemakers, merchants. 4-color. Monthly. Circ. 4,200. Accepts previously published material. Original artwork not returned after publication. **Illustrations:** Send query letter to be kept on file. Reports within 1 month. Buys first rights. Pays $50-100, color, cover; $15, b&w, inside; on acceptance.

***WINGS WEST MAGAZINE**, 89 Sherman St., Denver CO 80203-4001. (303)778-7145. FAX: (303)837-0256. Editor/Publisher: Babette André. Estab. 1985. A quarterly magazine covering aviation and flying safety. Circ. 20,000. Accepts previously published artwork. Original artwork returned at job's completion. Samples copies free for SASE with first class postage.
Cartoons: Approached by 10 freelance cartoonists/year. Buys 2 freelance cartoons/issue. Prefers aviation themes. Prefers single and double pannel, with or without gagline, b&w and color washes. Send query letter with roughs. Samples are not filed and are returned by SASE if requested by artist. Reports back within 3-5 days. Rights purchased vary according to project. Payment negotiated.
Illustrations: Approached by 12 freelance illustrators/year. Buys 3-5 freelance illustration/issue. Works on assignment only. Prefers aviation theme or style. Considers pen and ink. Send query letter with SASE. Samples are not filed and are returned by SASE if requested by artist. Reports back within 3-5 days. Write to schedule an appointment to show a portfolio or mail appropriate materials. Portfolio should include roughs, b&w photostats and photocopies. Rights purchased vary according to project. Pays on publication.

WINNING!, 15115 S. 76th E. Ave., Bixby OK 74008. (918)366-4441. FAX: (918)366-6250. Managing Editor: Simon P. McCaffery. Estab. 1976. Consumer magazine; emphasizing all aspects of legal gaming, especially state and foreign lotteries, sweepstakes and Las Vegas style casino gaming. We also include travel articles. Monthly. Circ. 150,000. Accepts previously published artwork. Original artwork returned after publication. Sample copy $1 plus SASE with $1 postage (first class). Art guidelines available.
Cartoons: Approached by 20-30 cartoonists/year. Buys 1-2 cartoons/issue, 12-15 cartoons/year from freelancers. Prefers "anything related directly to gaming"; with gagline, b&w line drawings. Send query letter with samples of published or unpublished work. Samples are filed or returned by SASE if requested by artist. Reports back within 2 weeks. Buys first North American rights or reprint rights. Pays $50, b&w.
Illustrations: Approached by more than 50 illustrators/year. Buys 1-2 illustrations/issue, 10-12 illustrations/year from freelancers. Works on assignment only. Prefers themes and how-to illustrations. Prefers pen & ink. Send query letter with brochure, tearsheets, slides and SASE. Samples are filed or returned by SASE if requested by artist. Reports back within 2 weeks. Write to schedule an appointment to show a portfolio or mail appropriate materials: thumbnails and b&w tearsheets, slides and photocopies. Buys first North American rights. Pays $100, b&w, inside. Pays within 30 days of acceptance.

***WOMAN BOWLER**, 5301 S. 76th St., Greendale WI 53129-1191. (414)421-9000. FAX: (414)421-3013. Editor: Karen Sytsma. Estab. 1936. Membership magazine providing bowlers, association leaders, proprietors and industry leaders information on WIBC and woman's bowling. Published 8 times per year. Circ. 150,000. Sample copies are available.
Cartoons: Approached by 30-50 freelance cartoonists/year. Reports back within 3 weeks. Buys first rights. Payment negotiable.
Illustrations: Approached by 20-100 freelance illustrators. Buys 2-5 freelance illustrations/issue. Prefers bowling themes that work with copy. Considers watercolor, collage, airbrush, marker, color pencil, mixed media. Send query letter with tearsheets. Samples are filed. Reports back within 3 weeks. Call to schedule an appointment to show a portfolio, which should include original/final art, b&w and color tearsheets. Buys first rights. Payment negotiable. Pays on acceptance.

WOMEN'S SPORTS & FITNESS, Suite 421, 1919 14th St., Boulder CO 80302. (303)440-5111. FAX: (303)440-3313. Art Director: Mark Tuchman. Estab. 1974. Consumer magazine. "Women's sports publication targeting women 20-40 years old." Monthly. Circ. 250,000. Accepts previously pubished artwork. Original artwork returned to artist at job's completion. Sample copies not available. Art guidelines not available.
Illustrations: Approached by 100 illustrators/year. Buys 3-4 illustrations/issue. Works on assignment only. Prefers non-technical styles—lively, both real and expressionistic, sometimes humorous. Considers all media and styles. Send query letter with promotion pieces. Samples are filed. Reports back to the artist only if interested. Rights purchsed vary according to project. Pays $50-300, color, inside; on acceptance.

WONDER TIME, 6401 The Paseo, Kansas City MO 64131. (816)333-7000. Editor: Evelyn Beals. Estab. 1969. "Story paper" emphasizing inspiration and character-building material for first and second graders, 6-8 years old. Weekly. Circ. 40,000. Does not accept previously published material. Original artwork not returned to the artist after publication. Sample copies for SASE with 50¢ postage.
Illustrations: Approached by 6-10 illustrators/year. Buys 1 illustration/issue from freelancers. Works on assignment only. Send query letter with tear sheets or photocopies to be kept on file. Reports only if interested. Buys all rights. Pays $40, b&w; $75, color cover. Pays $40, b&w; $75, color inside; on acceptance.

Tips: "Include illustrations of children in your portfolio. I do not want to see fantasy art."

WOODENBOAT, Box 78, Brooklin ME 04616. (207)359-4651. Editor: Jonathan A. Wilson. Executive Editor: Jennifer Elliott. Art Director: Lindy Gifford. Concerns designing, building, repairing, using and maintaining wooden boats. Bimonthly. Circ. 106,000. Previously published work OK. Sample copy $4.
Illustrations: Buys 48 illustrations/year on wooden boats or related items. Send query letter with samples and SASE. Reports in 1-2 months. "We are always in need of high quality technical drawings. Rates vary, but usually $25-350. Buys first North American serial rights. Pays on publication.

WOODMEN OF THE WORLD, 1700 Farnam St., Omaha NE 68102. (402)342-1890. Editor: George M. Herriott. For members of the Woodmen of the World Life Insurance Society and their families. Emphasizes Society and member activities, insurance and health issues, American history, general interest topics and humor. Monthly; b&w with 4-color cover, conservative design. Circ. 480,000. Previously published material acceptable. Original artwork returned after publication, if arrangements are made. Free sample copy.
Cartoons: Approached by 25 cartoonists/year. Buys 10 cartoons/year from freelancers. Interested in general interest family-oriented subjects; single panel. Send finished cartoons. SASE. Pays $15, b&w; $25, color. Reports in 2 weeks. Buys various rights. Pays $10, b&w line drawings, washes and halftones; on acceptance.
Illustrations: Approached by 10 illustrators/year. Works with 3-4 illustrators/year. Buys 5 illustrations/year; buys 3-4/year from freelancers. Interested in general topics, including seasonal, humorous, historical and human interest. Prefers mixed media. Works on assignment only. Send samples of art style, prices and references for files. Prefers to see finished art. SASE. Reports in two weeks. Buys one-time rights. Payment varies according to job.
Tips: Especially looks for creative material that takes a different approach to a story. "Vary the media used and techniques." Only uses local freelancers.

WORDPERFECT, THE MAGAZINE, 270 W. Center St., Orem UT 84057. (801)226-5555. FAX: (801)226-8804. Art Director: Nickie Egan. Four-color consumer magazine "for WordPerfect users. It's an upbeat, colorful, conceptual magazine; hence, no computers are illustrated—since everyone knows what they look like." Monthly. Circ. 200,000. Accepts previously published artwork. Samples copies and art guidelines available.
Illustrations: Approached by 25 illustrators/year. Buys 10 illustrations/issue, 120 illustrations/year from freelancers. Works on assignment only. Prefers anything conceptual—no computers. Considers pen & ink, airbrush, colored pencil, mixed media, watercolor, acrylic, oil, pastel, collage, marker and charcoal. Send query letter with resume, tearsheets, photographs, photocopies and slides. Samples are filed or are returned upon request. Reports back to the artist only if interested. Call or write to schedule an appointment to show a portfolio or mail appropriate materials. Portfolio should include color tearsheets, slides and photocopies. Buys one-time rights. Pays $700-1,000, color, cover; $300-500, color, inside.

WORKBENCH, K.C. Publishing, Inc., 4251 Pennsylvania, Kansas City MO 64111. Executive Editor: Robert N. Hoffman. Estab. 1957. For woodworkers and do-it-yourself persons. Bimonthly magazine; b&w with 4-color cover. Circ. 870,000.
Cartoons: Buys 15 cartoons/year from freelancers. Interested in woodworking and do-it-yourself themes; single panel with gagline. Submit art. SASE. Reports in 1 month. Buys all rights, but may reassign rights to artist after publication. Pays $40 minimum, b&w line drawings; on acceptance.
Illustrations: Works with 10 illustrators/year. Buys 100 illustrations/year from freelancers. Artists with experience in the area of technical drawings, especially house plans, exploded views of furniture construction, power tool and appliance cutaways, should write for free sample copy with SASE and artists' guidelines. Style of Eugene Thompson, Don Mannes and Mario Ferro. Pays $50-1,200, b&w; $100-1,500, color, inside.

WRITER'S YEARBOOK, 1507 Dana Ave., Cincinnati OH 45207. Submissions Editor: Peter Blocksom. Emphasizes writing and marketing techniques, business topics for writers and writing opportunities for freelance writers and people trying to get started in writing. Annually. Original artwork returned with one copy of the issue in which it appears. Sample copy $3.95. Affiliated with *Writer's Digest.* Cartoons submitted to either publication are considered for both.
Cartoons: Uses 3-6 freelance cartoons/issue. "All cartoons must pertain to writing—its joys, agonies, quirks. All styles accepted, but high-quality art is a must." Prefers single panel, with or without gagline, b&w line drawings or washes. "Verticals are always considered, but horizontals—especially severe horizontals—are hard to come by." Send finished cartoons. Samples returned by SASE. Reports in 1-2 months. Buys first North American serial rights, one-time use. Pays $50 minimum, b&w; on acceptance.

YELLOW SILK: Journal of Erotic Arts, Box 6374, Albany CA 94706. (415)644-4188. Publisher: Lily Pond. Estab. 1981. Emphasizes erotic literature and arts for well educated, highly literate readership, generally personally involved in arts field. Quarterly. Circ. 15,000. Does not accept previously published material. Returns original artwork after publication. Sample copy $7.

Cartoons: Buys 12 cartoons/year. Acquires 0-3/issue from freelancers. Prefers themes involving human relationships and/or sexuality " 'All persuasions; no brutality' is editoral policy. Nothing tasteless." Accepts any cartoon format. Send query letter with finished cartoons or photocopies to be kept on file. Include phone number, name and address on each sample. Material not filed is returned by SASE with correct stamps, no meters. Reports only if SASE included. Buys first or reprint rights. Negotiates payments. Minimum payment plus 3 copies; on publication.

Illustrations: Acquires 10-20/issue by one artist if possible. Considers "anything in the widest definitions of eroticism except brutality, bondage or S&M. Nothing tasteless. We're looking for work that is beautiful, artistically. Considers this category somewhat misnamed. We really fine arts as opposed to illustration. No pornography. All sexual persuasions represented." Prefers acrylic, then pen & ink, watercolor, oil, pastel, collage and mixed media. Send originals, photocopies, slides, photostats, good quality photographs. Color and b&w examples in each submission are preferred. Include name, address and telephone number on all samples. Samples not filed returned by SASE. Reports back within 8 weeks. To show portfolio, mail original/final art, b&w and color, photostats, photographs, photocopies and slides. Buys first rights or reprint rights. Negotiates payment plus copies; on publication.

***YM,** 28th Floor, 685 3rd Ave., New York NY 10017. (212)878-8602. FAX: (212)286-0935. Senior Designer: Dana Smith. A fashion magazine for teen girls between the ages of 14-21. Ten issues (monthly and 2 joint issues—June-July and December-January.) Original artwork returned at job's completion. Sample copies available.

Cartoons: Buys 1-3 freelance cartoons/issue. Prefers funny, whimsical illustrations related to girl/guy problems. Prefers single and double panel, color washes. Send query letter with finished cartoons as samples of work (promo copies). Samples are filed or not filed (it depends on how good). Samples are not returned. Reports back to the artist only if interested. Buys one-time rights. Pays $350 and up, color.

Illustrations: Buys 1-2 freelance illustrations/issue. Buys 12-36 freelance illustrations/year. Preferred themes include horoscope and dreams. Considers watercolor, collage, acrylic, color pencil, oil, charcoal, mixed media, pastel. Samples are filed or not filed (depending on quality). Samples are not returned. Reports back to the artist only if interested. Call to schedule an appointment to show a portfolio, which should include roughs and original/final art, color tearsheets and photocopies. Buys one-time rights. Pays $350 and up, color, inside. Pays on acceptance or publication. Offers one half of original fee as kill fee.

Other Magazines

Each year we contact all publishers currently listed in *Artist's Market* requesting they give us updated information for our next edition. We also mail listing questionnaires to new and established firms which have not been included in past editions. The following advertising, audiovisual and public relations firms either did not respond to our request to update their listings for 1992 (if they indicated a reason, it is noted in parentheses after their name), or they are firms which did not return our questionnaire for a new listing.

Amazing Heroes (late response)
The American Atheist
The American Baptist Magazine
American Squaredance (late response)
Anemone (unable to contact)
Animals
Appalachian Trailway News
Ararat
Archie Comic Publications Inc. (no longer uses freelancers)
Architectural Digest (asked to be deleted)
The Atlantic Monthly
The Autograph Collector's Magazine
Baja Times (late response)
Bend of the River Magazine (late response)
Bird Watcher's Digest (late response)
Black Bear Publications (late

response)
Boat Journal (no longer uses outside freelancers)
Boston Globe Magazine
Boundary Magazine
Bow & Arrow Magazine
Brum Beat
Butter Fat Magazine
The California Fire Service (late response)
Car Craft (unable to contact)
Cartoon World (late response)
Catholic Singles Magazine
Central Florida Magazine
Channels Magazine
Charleston Magazine
Chattanooga Life & Leisure (out of business)
Christian Herald
Christian Home & School (late response)
Chronicles, a Magazine of American Culture
Church Management-The

Clergy Journal (late response)
City Guide Magazine
Clavier
Cleaning Business (late response)
Clifton Magazine
Columbia
Columbus Single Scene (late response)
Comico the Comic Company (unable to contact)
Common Lives/Lesbian Lives (late response)
Confident Living
Dakota Country (late response)
David C. Cook Publishing Co.
The Covenant Companion
Crosscurrents
CWC/Peterborough
Cycle World (no longer carries illustration)
D Magazine
Denver Magazine/Denver

Business Magazine (asked to be deleted)
Discoveries
Dog Fancy
Eidos Magazine (late response)
Electrical Apparatus (late response)
Electrical Contractor (overstocked)
Event
The Exceptional Parent (late response)
Exclusively Yours Magazine
The Eye Magazine
Family Motor Coaching (late response)
Fiction International
The Final Edition (late response)
Fly Fisherman Magazine
Games (unable to contact)
GBH, the Members' Magazine (asked to be deleted)
General Learning Corporation
Glenfed Today
Good Reading Magazine (late response)
Green Feather Magazine (unable to contact)
Gun World
Harvard Magazine (overstocked)
Hawaii—Gateway to the Pacific
Health Education
Health World
Heartland Journal (out of business)
Heaven Bone (late response)
Hibiscus Magazine
Maclean Hunter Publishing Company (no longer uses freelancers)
Hustler
Hustler Humor Magazine
Ideals Magazine
Impulse Magazine
Indianapolis 500 Yearbook (late response)
Inside International (no longer uses freelancers)
Inside Texas Running
Insight Magazine (asked to be deleted)
Japanophile (late response)
Journal of the West (late response)
Kentucky Living
Kids! Magazine
Kidsports Magazine
Kite Lines
L.A. Style
Legion (asked to be deleted)
Longevity
Lost Treasure
Luna Ventures (late response)
The Lutheran Journal
Macworld
Mademoiselle
Magic Changes (late response)
Medical Times (asked to be deleted)

Memco News (late response)
Michigan Woman Magazine
Mid Atlantic Country Magazine
Middle Eastern Dancer
Mirabella
Moody Monthly Magazine
The Mother Earth News (suspended publication)
Mother Jones
National Rural Letter Carrier
New Blood Magazine (late response)
New England Monthly
New Letters (late response)
New Mexico Magazine (overstocked)
New Orleans Review (late response)
the new renaissance (late response)
New Woman Magazine (no longer uses freelancers)
New Writer's Magazine (late response)
New York Times Magazine
Northern California Home & Garden, Western Media
The Northern Logger & Timber Processor (late response)
Nuclear Times Magazine (unable to contact)
Oceanus (no longer uses outside freelancers)
Ophthalmology Management
Optometric Management
Oregon River Watch (late response)
Paint Horse Journal (late response)
Pandora (late response)
Parenting Magazine (overstocked)
Parent's Choice
Paris Passion
PC Resource (ceased publication)
Peninsula Magazine
Pensions and Investments (overstocked)
Penthouse
Perinatology-Neonatology (unable to contact)
Petersen's Fishing (ceased publication)
Phoenix Home & Garden Magazine (asked to be deleted)
Pittsburgh Magazine
Plainswoman
Playboy
Popular Electronics (late response)
Prelude Magazine
Preservation News
Prism International
Private Pilot
Private Practice (no longer uses freelancers)
Quarry Magazine
Rag Mag (late response)
Read Me (ceased publication)

Real Estate Center Journal
Regardie's
Restaurant Business Magazine (asked to be deleted)
Restaurant Hospitality (late response)
Rolling Stone
Rip Off Press, Inc.
Rough Notes (late response)
Safe & Vault Technology (late response)
Safety & Health
The St. Louis Journalism Review
San Francisco Focus
School Shop/Tech Directions
Scream Magazine
Seacoast Life Magazine
Seek (late response)
Sesame Street (asked to be deleted)
Sierra Magazine
Sign of the Times—A Chronicle of Decadence in the Atomic Age (late response)
Sky and Telescope
Skylander Magazine
The Small Pond Magazine of Literature (late response)
Soap Opera Digest
Soldiers Magazine
Sonoma Business Magazine and 101 North Magazine
South Coast Poetry Journal (late response)
Spy
Sterling Magazine (no longer carries illustration or cartoons)
Stock Car Racing Magazine (unable to contact)
The Strain (late response)
Suds n' Stuff
Sun Dog: The Southeast Review (late response)
Texas Monthly
The Sunday Oregonian's Northwest Magazine (ceased publication)
Third World
Today's Fireman (late response)
Today's Policeman (late response)
Tradition (late response)
Utne Reader
Vanity Fair
Visions-International, the World of Illustrated Poetry (late response)
The War Cry, Magazine of the Salvation Army
Weddings West
West Coast Review of Books
The Western Producer
Wildfire
Wire Journal International (late response)
The Workboat (late response)
World Trade
Yankee Magazine
Zillions

Performing Arts

Music theater, dance, opera—each of these performing arts categories seeks originality, dynamic design and strong imagery, but always with the goal of passing along information. Not only do artists literally set the stage for these groups, but they also provide visual exposure through promotional materials such as programs, brochures, flyers and invitations.

The needs of these groups vary according to their particular medium. Musical groups such as symphonies require artwork mainly for posters, programs and brochures. Similarly, ballet, opera and theater companies require the talents of artists for promotional materials, but they also need scene designers and painters, costume designers and lighting specialists for their productions. Public relations director Michael Sande of A Contemporary Theatre in Seattle says he looks for freelance artists with "originality, creativity and the ability to grasp concepts from the written word—plays and discussions with theater artists (directors, playwrights and the marketing department)." Performing arts companies also more than ever, look for affordability.

The nation's performing arts companies are confronted with such a barrage of problems that the question of how to stay afloat is foremost in their collective mind. Not only is the concept of publicly funded art in question, but so is the financial need on the part of opera companies, for example, when weighed against the underfunded areas of education and welfare. And as production costs are rising, attendance is going down.

Oakland and Denver and a host of other cities are now without orchestras. Theater companies are finding themselves in precariously unstable situations. Dance companies are cutting back on their number of performances. Exemplary of the desperation felt is the action taken by the Buffalo Philharmonic. With a 2.2 million dollar deficit and the management's demands of a wage freeze, it ran an ad in *USA Today* which read, "Major symphony orchestra, illustrious history, will consider relocation."

It's best to work with a local performing arts group first to become acquainted with the demands of the field. If you find that you have an empathy for one category over another, perhaps a preference for dance rather than theater, then focus your efforts in your area of preference.

As with any market area, research performing arts groups as much as possible before approaching them with your work. Some groups have only seasonal needs, such as summer theaters, so check to see if this information is listed and when the group's needs are heaviest. Residencies are also available, perfect for the artist seeking summer employment and a weekly salary. For additional information, look to this section's Close-up of Paul Davis.

For further names and information regarding performing arts, consult the *American Dance Directory*, *Dance Magazine*, the *Summer Theatre Directory*, *American Theatre Association Directory*, *Theatre Profiles*, the *Music Industry Directory*, *Musical America* and the Central Theatre's *Opera/Musical Theatre Companies and Workshops in the United States and Canada*.

ALBERTA BALLET, 141 18th Ave. SW, Calgary, Alberta T25 0B8 Canada. (403)245-4222. FAX: (403)245-6573. Marketing Manager: Dorothy Evaskevich. Production Manager: Harry Patterson. Estab. 1966. 18 member dance ensemble.

Needs: Approached by 10 freelance artists/year. Works with 2-3 freelance artists/year. Freelance art needs are heaviest in spring. Artists work on assignment only. Uses freelance artists for advertising design, illustration and layout; brochure design and layout; poster design and illustration.

First Contact & Terms: Send query letter with photographs, photocopies and photostats. Samples are not filed and are returned. Reports back within 5 days. Call to schedule an appointment to show a portfolio, which should include slides and samples of previous work. Pays for design by the project, $600 minimum. Pays for illustration by the project, $600-1,500. Payment depends on budget and artist's experience. Buys one-time rights or all rights.

Tips: "Know something about the company before coming in."

***REYNALDO ALEJANDRO DANCE THEATER,** Suite 5-G W., 160 Bleecker St., New York NY 10012. (212)674-0673. Artistic Director: Ron Alejandro. Modern dance troupe inspired by Philippine traditions.
Needs: Works with 10 illustrators/year. Uses artists for advertising, costumes, direct mail brochures, flyers, posters and programs.
First Contact & Terms: Query with samples and SASE. Reports in 1 month. Works on assignment only. No samples returned. Reports back on future assignment possibilities. Provide business card and/or brochure to be kept on file for future assignments. Pays $30-50/job for illustration, design and lettering.

AMERICAN BALLET, 86 Main St., Pascoag RI 02859. (401)568-0015 or 568-1680. Administrator: Paul Christiansen. Estab. 1983. "The American Ballet offers the best in ballet—fairy tale classics to contemporary."
Needs: Approached by 100 freelance artists/year. Works with 15 freelance designers/year, 10 freelance illustrators/year. Needs "scenic artists and ballet guest artists." Prefers artists with experience in costuming, scenic design and ballet. Uses freelance artists for costume design, lighting, set design, scenery and guest ballet artists. With lighting tries to achieve enhancement of the dancers.
First Contact & Terms: Send query letter with resume. Samples are filed or are returned. Reports back within 30 days. Write to schedule an appointment to show a portfolio, which should include b&w photographs. Pays for design and illustration by the hour, $10 minimum; design by the project, $100-500. Rights vary according to project.
Tips: "Be business-like in approach. Reliable and responsible artists are given first preference."

***AMERICAN PLACE THEATER,** 111 W. 46th St., New York NY 10036. (212)840-2960. FAX: (212)391-4019. General Manager: Dara Hershman. Estab. 1963. Off-Broadway theater producing new American work.
Needs: Approached by 6-20 freelance artists/year. Works with 3 freelance artists/year. Needs heaviest in fall. Artists work on assignment only. Uses freelance artists for brochure design and layout and flyers.
First Contact & Terms: Send query letter with brochure. Samples are not filed and are returned by SASE if requested by artist. Reports back only if interested. Mail appropriate materials. Portfolio should include photostats. Pays for design by the project, $150 minimum. Pays for illustration by the project, $50 minimum. Rights purchased vary according to project.

AMERICAN THEATRE DANCE CO., INC., Box 861, Coconut Grove FL 33233. (305)856-8825. Director: Diane Pariser. Promotion and management of dancers and musicians (bands, companies and other arts groups).
Needs: Works with 3 freelance designers and 3 illustrators/year. Freelance art needed through the year. Works on assignment only. Uses artists for advertising and brochure design, illustration and layout and poster design and illustration. Promotional materials include ethnic artwork, line drawings, and photos.
First Contact & Terms: Send query letter with brochure. Samples are filed. Reports back only if interested. Call to schedule an appointment to show a portfolio. Pays for design and illustration by the project, $150-500. Considers complexity of project and available budget when establishing payment. Buys one-time rights, reprint rights or all rights.
Tips: Artists should have "some experience doing artwork for performers."

ARDEN THEATRE COMPANY, 923 Ludlow St., Philadelphia PA 19107 (street address). Box 801, Philadelphia PA 19105 (mail address). (215)829-8900. General Manager: Amy L. Murphy. Estab. 1988. "Brings to life the greatest stories of all time by the greatest storytellers of all time; ultimate theater, ranges from literary adaptation to drama to musicals."

The asterisk before a listing indicates that the listing is new in this edition. New markets are often the most receptive to freelance submissions.

Needs: Works with 10-20 freelance artists/year. Freelance art needs are heaviest in August-May. Artists work on assignment only. Prefers local artists only. Uses freelance artists for advertising design, illustration and layout; brochure design, illustration and layout; poster design and illustration; set design; costume design; lighting and scenery.

First Contact & Terms: Send query letter with brochure, resume, tearsheets, photographs, photocopies or "any representative work." Samples are filed. Reports back to the artist only if interested. "If artist would like information returned—please request." Call to schedule an appointment to show a portfolio or mail "any and all samples." Pays for design by the project, $100-1,000. Pays for illustration by the project, $100-300. Rights purchased vary according to project.

Tips: "Brochure/graphic design work needed now. Most hiring is done from April through October—but we are always interested in local artists' work."

***ATLANTA OPERA,** Suite 620, 1800 Peachtree St. NW, Atlanta GA 30309. (404)355-3311. FAX: (404)355-3259. Director of Marketing and Public Relations: Todd R. Schultz. Estab. 1979. Company has $1.4 million annual budget, 11-member staff and produces 3 fully staged operas each year.

Needs: Approached by 24 freelance artists/year. Works with 2-3 freelance artists/year. Needs heaviest in Dec.-Jan. (art) and May-Oct. (photos). Artists work on assignment only. Uses freelance artists for advertising design and illustration; brochure design, illustration and layout; and poster design and illustration.

First Contact & Terms: Send query letter with examples or copies of work. Samples are filed and are returned by SASE if requested by artist. Reports back within 3 weeks. Call to schedule an appointment to show a portfolio, which should include original/final art, photographs, and printed examples of jobs done. Pays for design and illustration by the project—"much of our work is done pro bono." Buys all rights.

Tips: "Although many projects are done for us pro bono, we do offer benefits and heavy exposure in Atlanta and surrounding areas."

ATLANTA SYMPHONY ORCHESTRA, 1293 Peachtree St. NE, Atlanta GA 30309. (404)898-1197. FAX: (404)898-9297. Director of Publications: Kevin Moore. Estab. 1950. Nonprofit. "Largest arts organization in the Southeast. Some projects are more fun and exciting while others are more upscale and conservative."

Needs: Approached by 15 freelance artists/year. Works with 5 freelance designers and 2 freelance illustrators/year. Freelance art is needed throughout the year. Artists work on assignment only. Prefers local artists only. Uses freelance artists for advertising design, illustration and layout; brochure design, illustration and layout; and poster design and illustration. Various looks "but all must exemplify class and dignity."

First Contact & Terms: Send query letter. Samples are filed or are returned by SASE if requested by artist. Reports back to the artist only if interested. Write to schedule an appointment to show a portfolio or mail appropriate materials. Portfolio should include thumbnails, original/final art and b&w tearsheets and photographs. Payment to freelance artists for design and illustration depends on complexity of project, available budget and turnaround time. Rights purchased vary according to project.

Tips: "We have high-visibility work that is excellent for an artist portfolio. We need artists who are *very* conscious of budget (type, printing and design). Creativity with low-budget is a *must.*"

***BAILIWICK REPERTORY,** 3212 N. Broadway, Chicago IL 60657-3515. (312)883-1090/1091. Executive Director: David Zak. Estab. 1982.

Needs: Approached by 20 freelance artists/year. Works with 5 freelance artists/year. Has a contest in spring. Write for submission rules by January. Uses freelance artists for advertising, brochure, and poster design. Style should be bold and daring and reproduce well in b&w ads.

First Contact & Terms: Send query letter with brochure, tearsheets, photographs and SASE. Samples are filed. Reports back within 3 months. Mail appropriate materials. Portfolio should include tearsheets and photographs. Pays for design by the project. Buys one-time rights.

Tips: "Bailiwick generally produces five main stage shows between August and April. Generally, three shows are large and two shows are small. Shows are often politically intriguing, or theatrically inventive. Adaptations of classics (generally lesser known works) and musicals are appropriate."

***BALLET CONCERTO, INC.,** 3803 Camp Bowie, Fort Worth TX 76135. (817)738-7915. Artistic Director: Margo Dean. Nonprofit ballet company.

Needs: Works with 2 freelance artists/year. Freelance art needs are seasonal. Needs heaviest in January. Works on assignment only.

First Contact & Terms: Send resume. Samples are filed. Samples not filed are returned only if requested by artist. Reports back only if interested. Considers skill and experience of artist when establishing payment.

***BALLET IOWA,** 2020 Grand Ave., West Des Monies IA 50265. (515)222-0698. FAX: (515)222-0927. Marketing Coordinator: Jennifer Morris. Estab. 1966. Ballet Iowa is a 12-member professional dance company. There is also an affiliated School of Ballet Iowa.

Needs: Works with 2-3 freelance artists/year. Freelance art needed throughout the year. Artists work on assignment only. "Interested in beginning artists or artists who are willing to sometimes donate their work as we are an arts organization with very limited funds." Uses freelance artists for brochure and poster design and illustration. "We like a variety of styles that reflect the programs we are presenting."
First Contact & Terms: Send query letter with brochure, resume and photocopies. Samples are filed. Reports back within 2 months. Mail appropriate materials. Payment negotiated. Negotiates rights purchased.

***BEL CANTO CHORUS OF MILWAUKEE,** Suite 510, 828 N. Broadway, Milwaukee WI 53202-3611. (414)272-7950. General Manager: Kathleen Asta. Estab. 1946. Season consists of 3 large choral/orchestral and 2 chamber choral/orchestral works.
Needs: Works with 1-2 freelance artists/year. Freelance art is needed throughout the year. Prefers local artists only. Uses freelance artists for advertising design and layout, brochure design and layout and posters. Preferred style is "unique, catchy, like use of puns in copy."
First Contact & Terms: Send query letter with tearsheets, SASE and photocopies. Samples are filed and are returned by SASE if requested by artist. Reports back within 2 weeks. Call to schedule an appointment to show a portfolio, which should include roughs and original/final art. Pays for design and illustration by the project, $100-200. Rights purchased vary according to project.

BETHUNE THEATREDANSE, Suite 221, 8033 Sunset Blvd., Los Angeles CA 90046. (213)874-0481. Artistic Director: Zina Bethune. Twelve member multimedia ballet company "incorporating visual technology (film, video, laser, animation and special effects) to enhance and expand the traditional theater of dance."
Needs: Works on assignment only. Uses artists for advertising, brochure, poster, program, set and costume design; lighting; scenery; film and video; special effects, i.e., lasers, image transference, etc. Promotional materials are "informative, contemporary and interesting. We are a multi-media threatredanse company—our goal is to achieve a New Age look to our work with video, lighting and sound."
First Contact & Terms: Send query letter with brochure, resume, business card and samples to be kept on file. Write for appointment to show portfolio. Prefers good representation of artist's work as samples. Samples not returned. Reports only if interested. Pays by the project, $50 minimum. Negotiates pay considering complexity of project, available budget and skill and experience of artist.
Tips: Artists should use "the movement and sweep of dance to express a variety of concepts and images. As a dance company, whose concept is a futuristic one, this helps us capture who and what we are. Research the company's needs before submitting to them and "do not send material that needs to be returned."

BOARSHEAD: MICHIGAN PUBLIC THEATER, 425 S. Grand Ave., Lansing MI 48933. (517)484-7800. Managing Director: Judith Gentry. Nonprofit equity regional theater with a season running from September-May. Seating capacity 250.
Needs: Needs heaviest in late summer or early winter. Uses artists for brochure design, illustration and layout; and poster design.
First Contact & Terms: Send query letter with brochure showing art style or resume. Samples are filed or are returned by SASE if requested. Reports back within 1-2 weeks. Write to schedule an appointment to show a portfolio or mail roughs and final reproduction/product. Pays for design by the project, $50 minimum. Pays for illustration by the project. Considers how work will be used when establishing payment. Negotiates rights purchased.
Tips: "Prefer single designs for theater productions—advertising, programs, posters and brochures."

CENTER THEATER, 1346 W. Devon Ave., Chicago IL 60660. (312)508-0200. Production Manager: R.J. Coleman. Estab. 1981. "We are a professional not-for-profit theater with a training program for actors."
Needs: Approached by 2 freelance artists/year. Works with 12 designers and 2 illustrators/year. Freelance art needs are seasonal. Needs heaviest in the fall and spring. Artists work on assignment only. Uses freelance artists for advertising, brochure, poster and costume design; lighting; advertising layout; set design and scenery. Promotional materials are "clean but fun, classy, but eye grabbing."
First Contact & Terms: Send query letter with brochure, resume, SASE, photographs and photocopies. Samples are filed or are returned by SASE if requested by artist. Reports back within 3 months. Write to schedule an appointment to show a portfolio, which should include photostats and slides. Pays for design by the project, $100-350. Pays for illustration by the project, $50-500. Rights purchased vary according to project.
Tips: "As a nonprofit, most of our design work is done gratis. After the initial gratis project, there is usually an opportunity for paying work if there is mutual satisfaction. Because of the recession we are definitely looking for ways to save money, relying on in kind exchanges, simpler designs."

CENTER THEATRE GROUP, (formerly Mark Taper Forum), 135 N. Grand Ave., Los Angeles CA 90012. (213)972-7259. FAX: (213)972-0746. Art Director: Christopher Komuro. Inhouse agency for the Ahmanson Theatre and the Mark Taper Forum of the Los Angeles Music Center. Recent productions have been musicals, comedies, dramas. Provides advertising and posters for live theater.

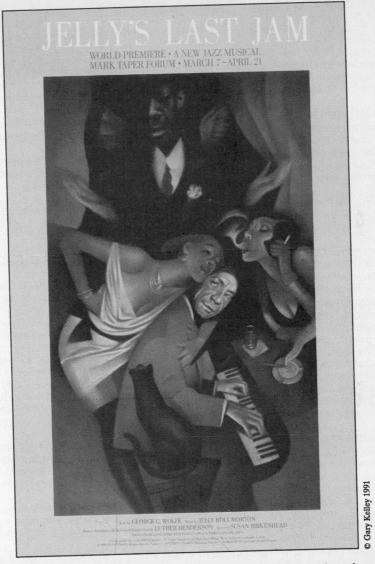

© Gary Kelley 1991

Illustrator Gary Kelley of Cedar Falls, Iowa created this dreamy and somber poster for the Mark Taper Forum's (see Center Theatre Group) production of Jelly's Last Jam, a musical play about Jelly Roll Morton and his meeting with Satan the night before he died. Kelley says he had three weeks with which to interpret the storyline and create the final art. It was done in pastel on paper and summons, Kelley says, "a dark mood but with the energy evident in the production itself." The assignment gave Kelley "good exposure to the Los Angeles-area theater audiences and association with a critically-acclaimed musical."

Needs: Works with 2 freelance designers/year. Works with 10 freelance illustrators/year. Uses artists for advertising design and illustration. Promotional materials include heavy use of illustration and photography.
First Contact & Terms: Send brochure showing art style or tearsheets, photostats and slides. Samples not filed are returned by SASE. Reports only if interested. Call or write to schedule an appointment to show a portfolio, which should include color and b&w original/final art, final reproduction/product and tearsheets.

Pays for design by the hour, $15-20. Pays for illustration by the project, $300-1,500.

CHARLESTON BALLET, 822 Virginia St. E., Charleston WV 25301. (304)342-6541. Director/Choreographer: K. R. Pauley.
Needs: Works with 2-4 freelance artists/year. Works on assignment only. Uses artists for advertising, brochure, poster, set and costume design and scenery.
First Contact & Terms: Send a resume, tearsheets, photographs and slides. Samples are filed or are returned if requested. Reports back only if interested. Write to schedule an appointment to show a portfolio, which should include color and b&w final reproduction/product. Pays for design and illustration by the project, $100 maximum. Considers how work will be used when establishing payment. Buys reprint rights.

CHEYENNE SYMPHONY ORCHESTRA, Suite 203, Box 851, Cheyenne WY 82003. (307)778-8561. Executive Director: Betty Flood. Estab. 1954. Symphony association with 1760 members; 6 subscription concerts, youth concert, chamber concert series.
Needs: Approached by 5 freelance artists/year. Works with 2 freelance designers and illustrators/year. Freelance art needs are heaviest in the fall and spring. Artists work on assignment only. Prefers local artists only. Uses freelance artists for advertising design, illustration and layout and brochure design, illustration and layout.
First Contact & Terms: Send query letter with SASE and appropriate samples. Samples are filed or are returned by SASE if requested by artist. Reports back to the artist only if interested. To show a portfolio, write an appropriate letter. Pays for design or illustration by the project, $50-500.

CIRCLE REPERTORY COMPANY, 161 Avenue of the Americas, New York NY 10013. (212)691-3210. FAX: (212)675-8098. Director of Communications: Gary W. Murphy.
Needs: Works with several freelance artists/year. Freelance art needs are seasonal. Needs heaviest in May and September. Works on assignment only. Uses artists for advertising and brochure design, illustration and layout; poster design and illustration.
First Contact & Terms: Send query letter with brochure showing art style or resume and samples. Samples are sometimes filed or are returned by SASE. Reports only if interested. Write to schedule an appointment to show a portfolio, which should include color and b&w thumbnails, original/final art and final reproduction/product. Negotiates payment for design and illustration. Considers complexity of project, skill and experience of artist, client's budget, how work will be used, turnaround time and rights purchased when establishing payment. Negotiates rights purchased.
Tips: "Every season brings a new look to Circle Rep. The 'look' lasts for the entire season. Artists applying to Circle Rep should take into account all elements of a theater season including subscription brochures, newsletters, single ticket ads and benefit invitations."

CITIARTS/THEATRE CONCORD, 1950 Parkside Dr., Concord CA 94519. (415)671-3065. FAX: (415)671-3375. Contact: Richard Elliott. Produces musicals, comedy and drama. Assigns 30-50 freelance jobs/year.
Needs: Works with up to 10 freelance illustrators and 28 freelance designers/year. Works on assignment only. Uses artists for costume design; flyers; graphic/set design; posters; programs; theatrical lighting; advertising and brochure design, illustration and layout.
First Contact & Terms: Query, then mail slides or photos. Samples returned by SASE. Reports back on future assignment possibilities. Call or write to schedule an appointment to show a portfolio, which should include thumbnails, roughs, original/final art and b&w photographs. Pays for design by the project, $500-3,000. Pays for illustration by the project, $100-1,000.
Tips: In a portfolio, artists should "specifically include items relating to live theater productions in any way."

CIVIC BALLET CENTER AND DANCE ARTS, 25 S. Sierra Madre Blvd., Pasadena CA 91107. (818)792-0873. Director: Elly Van Dijk. Home of the Pasadena Civic Ballet, Inc., a pre-professional ballet company, a nonprofit organization. Offers classes in classical ballet, modern, jazz, creative dance for all ages and levels.
Needs: Works with about 15 freelance artists/year.
First Contact & Terms: Los Angeles-area artists preferred; performing experience a plus. Send query letter with resume to be kept on file. Reports only if interested and needed. Pays by the hour, $10-30. Considers skill and experience of artist when establishing payment.

***CIVIC LIGHT OPERA**, The Benedum Center, 719 Liberty Ave., Pittsburgh PA 15222. (412)281-3973. Director of Marketing/Promotions: Cindy Opatick. "We produce six full-scale Broadway musicals each summer. Recent productions have been upbeat with lots of color. Attendance is over 165,000."
Needs: Works with 2 freelance designers/year; and 2 freelance illustrators/year. Freelance art needs are seasonal. Works on assignment only. Uses artists for advertising and brochure design, illustration and layout. Prefers pen & ink and desktop publishing.

First Contact & Terms: Send query letter with brochure and photostats. Samples are filed. Samples not filed are not returned. Reports back only if interested. Call to set an appointment to show a portfolio. Pays for design and illustration by the project, $20-1,000. Considers complexity of project and turnaround time when establishing payment. Buys all rights.

***CLEVELAND OPERA**, 1438 Euclid Ave., Cleveland OH 44115. Production Manager: Keith Nagy. Regional professional opera company.
Needs: Freelance art needs are seasonal. Needs heaviest in October-May. Works on assignment only. Uses artists for set design, costume design, lighting and scenery.
First Contact & Terms: Send a resume. Most samples are not filed. Samples not filed are returned. Reports back within 3 weeks. Write to schedule an appointment to show a portfolio. Pays for design by the project, $2,500-3,800. Considers complexity of project, skill and experience of artist, show budget and turnaround time when establishing payment. Negotiates rights purchased.
Tips: "Keep resumes brief and up-to-date."

***CLEVELAND PUBLIC THEATRE**, 6415 Detroit Ave., Cleveland OH 44113. (216)631-2727. Artistic Director: James Levin. Estab. 1982. Focuses on "new work, sound and performance festivals and original plays."
Needs: Approached by 10-12 freelance artists/year. Works with 4-5 freelance artists/year. Freelance art needed throughout the year. Artists work on assignment only. Prefers local artists only. Uses freelance artists for advertising design and layout, brochure design and layout, poster design and illustration, set design and scenery.
First Contact & Terms: Send query letter with resume. Samples are not filed and are returned. Reports back only if interested. Call or write to schedule an appointment to show a portfolio, which should include thumbnails, roughs, original/final art or b&w or color photostats, tearsheets, photographs, slides and transparencies. Pays for design by the hour, $50-100, or by the project. Pays for illustration by the project, $50-100. Rights purchased vary according to project.

***CONCORD PAVILION**, Box 6166, Concord CA 94524. (415)676-8742. Assistant General Manager: Doug Warrick. Performing arts center; presents dance, rock, pop music, jazz, symphonies, sports and boat shows. Assigns 3-5 jobs/year.
Needs: Works with 1-2 illustrators and 1-2 designers/year; spring and summer only. Uses artists for advertising design/layout, billboards, bumper stickers, direct mail brochures, flyers, graphic design, posters, programs, set design, set/stage design painters, technical charts/illustrations and theatrical lighting design.
First Contact & Terms: Prefers local artists. Send photos, tearsheets or portfolio and SASE. Reports in 1 month. Works on assignment only. Samples returned by SASE. Provide resume, brochure and flyer to be kept on file for future assignments.

A CONTEMPORARY THEATRE (ACT), 100 W. Roy St., Seattle WA 98119. (206)285-3220. Public Relations Director: Michael Sande. Estab. 1965. "The mission of A Contemporary Theatre is to produce plays that challenge and test contemporary mores and societal perceptions and to be willing to set a theatrical tone which opens society to penetrating inquiries and examinations."
Needs: Approached by 10 freelance artists/year. Works with 2-3 freelance artists/year. Freelance art needs are seasonal. Needs heaviest from November-May. Works on assignment only. Prefers artists with experience in designing for performing arts organizations. Uses freelance artists for advertising, brochure and poster design; advertising, brochure and poster illustration; advertising and brochure layout. Prefers contemporary styles.
First Contact & Terms: Send query letter with brochure, resume and samples of promotional work. Samples are filed. Reports back to the artist only if interested. Write to schedule an appointment to show a portfolio which should include original/final art and b&w photostats and tearsheets. Pays for design by the project, $200-1,000. Pays for illustration by the project, $50-300. Rights purchased vary according to project.

THE CRICKET CONTEMPORARY THEATRE, 1407 Nicollett St. S., Minneapolis MN 55403. (612)871-3763 or 871-2244. Marketing Director: Glenn Morehouse. Production Manager: John Paul. Estab. 1971. "We are a contemporary theater producing 5 shows/season with additional special 'concerts.' We have a 213 seat house and 1,000 subscribers."
Needs: Approached by 20 freelance artists/year. Works with 25 freelance artists/year. Freelance art needs are seasonal. Needs heaviest from September-June. Artists work on assignment only. Prefers artists with experience in theater. Uses freelance artists for advertising, brochure and poster design; advertising, brochure and poster illustration; lighting and brochure layout. Style preferred depends on the play.
First Contact & Terms: Send query letter with resume. Samples are filed. Reports back to the artist only if interested. Write to schedule an appointment to show a portfolio, which should include original/final art and b&w slides. Pays for design by the project, $600 minimum. Pays for illustration by the project. "So far, all of our illustration has been donated."

Tips: "Our season runs September-June. I would suggest contacting the theater in July or August to find out what the next season's plays will be and if there are opportunities for design. We also display fine art in our lobby for each show. The Cricket's Commission on art sold is 21½%. So far, we have sold 2 pieces out of our lobby this season and around 10 pieces last season."

***CROSSROADS THEATRE CO.**, 320 Memorial Pkwy., New Brunswick NJ 07746. (908)249-5581. FAX: (908)249-1861. General Manager: André Robinson. Estab. 1978. LORT theater company, 6 mainstage productions, a benefit gala and tours.
Needs: Approached by 5-6 freelance artists/year. Works with 1-2 freelance artists/year. Freelance art needed throughout the year. "Prefers artist with expanded conceptual ideas, non-traditional." Uses freelance artists for advertising design illustration and layout; brochure design, illustration and layout; catalog layout; poster design and illustration; set design; costume design; lighting; and scenery. Looks for art on the "cutting edge."
First Contact & Terms: Send query letter with brochure, tearsheets, photographs, slides and transparencies. Samples are filed or are returned by SASE if requested by artist. Reports back only if interested. Mail appropriate materials. Call to schedule an appointment to show a portfolio, which should include tearsheets, photographs, and slides. Pays for design by the project, $500-10,000. Pays for illustration by the project, $500-2,000. Rights purchased vary according to project.

***CSC REPERTORY**, 136 E. 13th St., New York NY 10003. (212)677-4210. Managing Director: Patricia Tayler. Estab. 1969. "Off-Broadway theater doing innovative productions of international classics."
Needs: Works with 9 designers (set and lights) and 3 graphic designer (set painters, etc)/year. Freelance art needed throughout the year. Artists work on assignment only. Prefers local artists with experience in theatre design. Uses freelance artists for advertising design, illustration and layout; brochure design, illustration and layout; poster design and illustration; set and costume design; lighting; and scenery.
First Contact & Terms: Send query letter with resume then call to schedule an appointment to show a portfolio. Material in artist's portfolio "depends on previous work." Pays for design by the project, $200-5,000. Rights purchased vary according to project.

***DE LA CROIX PRODUCTIONS INTERNATIONAL INC.**, P.O. Box 9751 NW, Washington DC 20016. (301)921-0047. Executive Producer: Maximilien De Lafayette. Produces shows, plays, music, and various artistic projects; recruits, trains, promotes and manages artists, actors, actresses, choreographers, designers, dancers, singers and stage directors as well as freelance painters and illustrators.
Needs: Works with 110 freelance artists/year. Uses artists for advertising, brochure, catalog, and magazine/newspaper design, illustration and layout; AV presentations; exhibits; displays; signage; posters and design for plays and artistic productions.
First Contact & Terms: Send resume, at least 2 letters of reference and samples to be kept on file; write for appointment to show portfolio. Prefers photostats as samples. Reports within 2 weeks. Works on assignment only. Pays by the project. Considers skill and experience of artist when establishing payment.
Tips: Looks for "originality, new style, creativity, ability to meet work schedule, precision and flexibility when considering freelance artists."

***DECIDEDLY JAZZ DANCEWORKS**, Box 4626, Station C, Calgary Alberta T2N 2G7 Canada. (403)270-3533. Contact: Damon Johnston or Dan Evans. Estab. 1984. "Professional jazz dance performance; also runs a community dance school."
Needs: Approached by 4-5 freelance artists/year. Works with 1 freelance artist/year. Needs heaviest in spring and fall. Artists work on assignment only. Prefers local artists only. Uses freelance artists for advertising, poster and brochure design and illustration; set design; and lighting.
First Contact & Terms: Send query letter with resume, photographs, slides or transparencies. Samples are not filed and are returned. Reports back only if interested. Call to schedule an appointment to show a portfolio, which should include thumbnails, roughs, original/final art, b&w and color photographs. Pays for design by the project, $50-300. Pays for illustration by the project, $50-500. Rights purchased vary according to project.

MARK DeGARMO AND DANCERS, Suite 24, 179 E. 3rd St., New York NY 10009. (212)353-1351. Artistic Director: Mark DeGarmo. "Mark DeGarmo and Dancers is an ensemble of six professional dancers dedicated to the development and performance of original modern dance. The variety of programs ranges from an informal lecture-demonstration to a full-evening concert with costumes, music, sets, and technical personnel. Also available are individual classes, teaching/choreographing residencies, solo or duet performances, and special children's performances."
Needs: Works with 4 freelance artists/year. Freelance art needed throughout the year. Works on assignment only. Uses artists for advertising and brochure design, illustration and layout; poster design and illustration; set and costume design; lighting.

First Contact & Terms: Send query letter with cover letter, resume and photocopies. Samples are filed or are returned by SASE. Reports back only if interested. Write to schedule an appointment to show a portfolio, which should include photostats and photographs. Pays for design and illustration by the job, $150-2,200. Considers complexity of project, skill and experience of artist, available budget, how work will be used, turnaround time and rights purchased when establishing payment. Negotiates rights purchased.

DULUTH BALLET, The Depot, 506 W. Michigan St., Duluth MN 55802. (218)722-2314. Office Staff: Willy McManus. Artistic Director: Nancy Gibson. Managing Director: Scarlett Antonia. Ballet company of 8 dancers with a repertoire ranging from modern/contemporary to classical dance styles.
Needs: Works with 3-4 freelance artists/year; needs heaviest approximately one month before summer, fall and winter concerts. Uses artists for advertising design, illustration and layout.
First Contact & Terms: Send query letter with brochure, resume and samples to be kept on file. Prefers photostats and photography as samples. Samples returned by SASE if not kept on file. Call or write for appointment to show portfolio. Pays for design by the project, $50-100 average. Pays for illustration by the project, $50-200 average. Considers complexity of project, available budget, skill and experience of artist, how work will be used, turnaround time and rights purchased when establishing payment.
Tips: "Make sure work is appropriate to our situation. Sometimes we receive material that has no application to what we are doing."

***ENSEMBLE THEATRE OF CINCINNATI,** 1127 Vine St., Cincinnati OH 45210. (513)421-3555. Artistic Director: David White. Estab. 1985. Focuses on collaborative productions with medium size costs and many new works.
Needs: Works with 6-8 freelance artists/year. Needs heaviest in Sept.-June. Works on assignment only. Prefers local artists only. Uses freelance artists for brochure design and layout, set design, costume design, lighting and scenery.
First Contact & Terms: Send query letter with brochure, resume, SASE, photographs and photocopies. Samples are filed. Reports back only if interested. Write to schedule an appointment to show a portfolio. Pays for design by the project. Pays for illustration by the project. Negotiates rights purchased.

FLORIDA PHILHARMONIC, (formerly Philharmonic Orchestra of Florida), 1430 N. Federal Hwy., Ft. Lauderdale FL 33304. (305)561-2997. Director of Marketing: David Carane.
Needs: Works with 2 freelance artists/year; needs heaviest in October-May. Uses freelance artists for brochure design, illustration and layout; poster design and illustration.
First Contact & Terms: Send query letter with resume, tearsheets, photostats, photocopies or brochure showing art style. Samples are filed and are not returned. Reports back only if interested. Write to schedule an appointment to show a portfolio. Pays for design and illustration by the hour, $50 minimum. Considers complexity of project, available budget and rights purchased when establishing payment.

FLORIDA STUDIO THEATRE, 1241 North Palm Ave., Sarasota FL 34236. (813)366-9017. Artistic Director: Richard Hopkins. Estab. 1973. "We are an intimate theater seating 165-4,000 subscribers; the season runs from January-June."
Needs: Works with 4-10 freelance artists/year. Freelance art needs are seasonal. Needs heaviest in January-May. Artists work on assignment only. Uses freelance artists for costume design, advertising illustration and set design. The look preferred "depends on the assignment."
First Contact & Terms: Send query letter with resume, photographs and slides. Samples are filed. Reports back to the artist only if interested. Write to schedule an appointment to show a portfolio, which should include original/final art, slides and photographs. Payment for design is based on assignment and experience. Pays for design by the project, $50-1,200. Rights purchased vary according to project.

***FOOLS COMPANY, INC.,** 358 W. 44th St., New York NY 10036. (212)307-6000. Artistic Director: Martin Russell. "Fools Company produces works and workshops in the performing, video, and literary arts for the stimulation and development of an aware public." Recent productions have been experimental.
Needs: Works with 5 freelance designers/year and 4 freelance illustrators/year. Freelance art needs are seasonal. Needs heaviest in January-March. Uses artists for advertising and brochure design, illustration and layout, poster design and illustration.
First Contact & Terms: Send query letter with brochure, resume, tearsheets, photostats, photocopies and slides. Samples are not filed. Samples not filed are returned by SASE. Reports back only if interested. Write to schedule an appointment to show a portfolio, which should include final reproduction/product. Pays for design by the project, $200. Considers available budget when establishing payment. Negotiates rights purchased.

***GEORGE STREET PLAYHOUSE,** 9 Livingston Ave., New Brunswick NJ 08901. (908)846-2895. FAX: (908)247-9151. Publications Director: Rick Engler. Estab. 1974. 367 seat theater; produces 7 plays each season, including premiers and contemporary classics.

Needs: Approached by 5-10 freelance artists/year. Works with 3-5 freelance artists/year. Freelance art needed throughout the year. Artists work on assignment only. Prefers artists with experience in designing for theatre. Uses freelance artists for advertising and brochure design, illustration and layout. Style should be "bold, professional, innovative, theatrical and fun."

First Contact & Terms: Send query letter with resume, tearsheets and samples. Samples are filed. Reports back only if interested. Write to schedule an appointment to show a portfolio, which should include original/final art, b&w and color tearsheets. Pays for design by the project, $100-2,000. Pays for illustration by the project, $100-200. Rights purchased vary according to project.

Tips: "Budgets are a consideration. We're a nonprofit theater searching for the best way to utilize limited resources."

***GEVA THEATRE**, 75 Woodbury Blvd., Rochester NY 14607. (716)232-1366. FAX: (716)232-4031. Marketing Director: Ann Marie Sanders. Estab. 1972. "6-play season of American plays, concluding with a New Play Festival. 13,500 subscribers. Special events."

Needs: Approached by 8-10 freelance artists/year. Works with 6-10 freelance artists/year. Needs heaviest in September-May. Artists work on assignment only. Prefers local artists only. Uses freelance artists for advertising and brochure design, illustration and layout; poster design and illustration.

First Contact & Terms: Send query letter with slides and transparencies. Samples are filed or are returned. Reports back within 2 weeks. Call to schedule an appointment to show a portfolio, which should include original/final art, b&w photographs, slides and transparencies. Pays for design and illustration by the project, $200-500. Rights purchased vary according to project.

***THE GOODMAN THEATRE**, 200 S. Columbus Dr., Chicago IL 60603. (312)443-7269. FAX: (312)266-6004. Graphic Design Director: Leslie Bodenstein. Estab. 1925. Regional theater (2 theaters) with strong subscription base.

Needs: Approached by 15 freelance artists/year. Works with 5 freelance artists/year. Freelance art needed throughout the year. Artists work on assignment only. Prefers artists with experience in photography, illustration and calligraphy. Uses freelance artists for advertising, brochure and poster design and illustration. Preferred style is "contemporary, exciting, innovative, fresh and risky."

First Contact & Terms: Send query letter with any type of samples. Samples are filed. Reports back within 2 weeks. Write to schedule an appointment to show a portfolio, or mail appropriate materials. Portfolio should include original/final art, slides, tearsheets, photographs and transparencies. Pays for illustration by the project, $200-1,000. Buys first and reprint rights. Rights purchased vary according to project.

Tips: "We are an inhouse design department and always appreciate new, fresh ideas."

***HANGAR THEATRE**, Box 205, Ithaca NY 14851. (607)273-8588. PR/Marketing Director: Katie Johnson. Estab. 1978. "An Equity, 380-seat summer regional theater, providing 5 shows (including one musical) of high professional quality to 18,000 people from the Finger Lakes Area."

Needs: Approached by 10 freelance artists/year. Works with 3-5 freelance artists/year. Needs heaviest in late spring, but freelance art needed throughout year. Artists work on assignment only. Prefers artists with experience in graphic design and some theatrical knowledge. Uses freelance artists for advertising and brochure design, illustration and layout; poster design and illustration; annual reports; and gala invitations. Style should be dramatic, engaging ("but look changes, according to our season").

First Contact & Terms: Send query letter with resume, SASE, photocopies and photostats. Samples are not filed. Reports back only if interested. Write to schedule an appointment to show a portfolio, which should include roughs, original/final art, color photostats and photographs. Mail appropriate materials. Pays for design by the project, $100-800. Pays for illustration by the hour; by the project, $75-1,500. Buys all rights.

Tips: "The artist must be able to translate the 'essence' of each play and the ideas and vision of our artistic director into metaphorical imagery. Excellent communication skills and creativeness are essential."

HARTFORD BALLET, 226 Farmington Ave., Hartford CT 06105. (203)525-9396. FAX: (203)249-8116. Executive Director: John Simone. Nationally recognized company under the artistic direction of Michael Uthoff, with a repertory in classical and contemporary ballet; mainstage performances include 15 local performances of the annual holiday "Nutcracker" and other productions featuring full-length and repertory world premieres and revivals.

Needs: Freelance artists needed for brochure and advertising design, particularly in the spring and fall. Designers also needed for costume, poster and scenic design; depending upon the needs of the current production.

First Contact & Terms: Send query letter and samples of work to be kept on file. Write for an appointment to show portfolio, which should include "good photos, designs of costumes (if applicable); good examples of previous b&w and four color graphic design work; examples of copywriting for advertising/graphic work." If return of samples is requested, send SASE. Terms discussed before any work is contracted. Fees based upon project needs.

© Mark Stearney, Derived from "Exactitude," by Pierre Fix-Masseau

The above design/illustration by Chicago-based Mark Stearney was derived from a 1932 travel poster by Pierre Fix-Masseau and closely art directed by Goodman graphic design director Leslie Bodenstein. The airbrushed image was used for all promotional material for Chicago's Goodman Theatre's production of The Visit. The piece is both "true to the play and commercially successful, in that it is a strong, clean image that really sticks out," says marketing director Joanna Lohmiller. "The train was to symbolize the play's central character, Claire; it conveyed a power and strength that is cold as steel and rather menacing. It was also very sexy in its slickness," Lohmiller says.

Tips: "We need a contemporary style with strong sales emphasis." Looks for "consistency, reliability; good, accurate estimates of job costs."

***HONOLULU THEATRE FOR YOUTH,** 2846 Ualena St., Honolulu HI 96819. (808)839-9885. FAX: (808)839-7018. Director: Gina Gutierrez. Estab. 1955. "Hawaii's regional professional theater providing the island state with quality theater for all ages."
Needs: Approached by 25 freelance artists/year. Works with 10 freelance artists/year. Needs heaviest in August-December. Artists work on assignment only. Uses freelance artists for brochure, poster, costume, and set design, and lighting.
First Contact & Terms: Send query letter with resume. Samples are filed. Reports back only if interested. Call or write to schedule an appointment to show a portfolio, which should include original/final art, photographs and slides. Mail appropriate materials. Pays for design by the project. Rights purchased vary according to project.

***INDIANA REPERTORY THEATRE,** 140 W. Washington St., Indianapolis IN 46204. (317)635-5277. FAX: (317)236-0767. Marketing Director: Michael O'Rand. Estab. 1971. A regional theater that produces a 6-play season along with various special productions.

Needs: Approached by 6 freelance artists/year. Works with 2 freelance artists/year. Needs heaviest in August-April. Artists work on assignment only. Prefers artists with experience in performing arts. Uses freelance artists for advertising illustration, brochure design and illustration, poster design and illustration.
First Contact & Terms: Contact only through artist agent. Samples are filed. Portfolio should include thumbnails, original/final art and b&w and color tearsheets. Pays for design and illustration by the project, $250-1,000. Buys all rights.

***INTIMAN THEATRE COMPANY**, Box 19760, Seattle WA 98109. (206)626-0775. PR Manager: Gary D. Tucker. Estab. 1972. A professional theater company presenting a six-play season June-December.
Needs: Approached by 15 freelance artists/year. Works with 4 freelance artists/year. Needs heaviest in May-December. Artists work on assignment only. Prefers local artists only. Uses freelance artists for brochure design, illustration and layout; poster design and illustration; and program cover art.
First Contact & Terms: Send query letter with any applicable samples. Samples are not filed and are returned by SASE if requested by artist. Reports back within 1 month. Write to schedule an appointment to show a portfolio, which should include original/final art. Payment negotiable. Rights purchased vary according to project.

***ROBERT IVEY BALLET COMPANY**, 1910 Savannah Highway, Charleston SC 29407. (803)556-1343. Artistic Director: Robert C. Ivey. "Consists of two companies: the Senior Company—classically trained men and women chosen in open auditions providing educational outreach in schools, lecture-demonstrations for community organizations and joint performances with area arts groups; and the Robert Ivey Youth Ballet, offering training to dancers age 9-13."
Needs: Works with 12 freelance artists/year; needs heaviest in spring and fall. Uses artists for advertising, brochure, program, set and costume design; posters, lighting and scenery.
First Contact & Terms: Send query letter with brochure showing art style. To show a portfolio, mail appropriate materials, which should include roughs, final reproduction/product, photostats and photographs. Pays for design by the project, $300-800 average. Pays for illustration by the project, $300-500 average. "Poster illustrations and ad layouts change with each performance. Costume and set design pays considerably more." Considers complexity of project and available budget when establishing payment.
Tips: Artists fail to consider "the budget of the organization when presenting specs. Also that total budget must cover many phases. Artwork should be able to be recycled for several ventures."

***KENTUCKY OPERA**, 631 S. 5th St., Louisville KY 40202-2201. (502)584-4500. FAX: (502)584-7484. Director of Public Relations: Gerald E. Farrar. Estab. 1952. Opera company with staff of 20 producing 4 operas per season with 18 performances.
Needs: Approached by 5 freelance artists/year. Works with 2 freelance artists/year. Needs heaviest in spring and summer. Artists work on assignment only. Prefers local artists only. Uses freelance artists for advertising and brochure design, illustration and layout; poster design and illustration.
First Contact & Terms: Send query letter with resume and tearsheets. Samples are filed. Reports back within 6 months only if interested. Call or write to schedule an appointment to show a portfolio, which should include roughs, color tearsheets and slides. Pays for design and illustration by the project. Buys all rights.

***L.A. SOLO REPERTORY ORCHESTRA**, 7242 Louise Ave., Van Nuys CA 91406. (818)342-8400. Music Director: James Swift. Estab. 1973. Performs symphony concerts, oratorio, classic pops.
Needs: Approached by 50 freelance artists/year. Works with 10 freelance artists/year. Needs heaviest in spring and fall. Artists work on assignment only. Uses freelance artists for brochure design and illustration. Style is "conservative, yet eye-catching."
First Contact & Terms: Send query letter with photocopies. Samples are filed or returned by SASE if requested by artist. Reports back to the artist only if interested. Mail appropriate materials. Portfolio should include sample brochures (photocopies OK). Pays for design by the project. Pays for illustration by the hour, $20 minimum. Buys reprint rights.
Tips: "Contact in June, any year."

LINCOLN SYMPHONY ORCHESTRA ASSOCIATION, Suite 211, 1200 N. Lincoln NE 68508. (402)474-5610. Executive Director: Richard Frevert. Estab. 1926. Symphony orchestra presenting 20-25 concerts annually.
Needs: Approached by 4-5 freelance artists/year. Works with 1-2 freelance designers and illustrators/year. Freelance art is needed throughout the year. Artists work on assignment only. Prefers artists with experience in performing arts promotion. Uses freelance artists for advertising design, illustration and layout; brochure design, illustration and layout; poster design and illustration. Recent promotional materials included a 4-color booklet.
First Contact & Terms: Send query letter with brochure, resume and tearsheets. Samples are filed. Reports back to the artist only if interested. Call to schedule an appointment to show a portfolio, which should include thumbnails, roughs, original/final art and b&w and color samples. Design and illustration "currently donated." Negotiates rights purchased.

Tips: Recent productions have been "sales-oriented, emphasizing quality and history."

LOS ANGELES CHAMBER ORCHESTRA, Suite 801, 315 W. 9th St., Los Angeles CA 90015. (213)622-7001. FAX: (213)955-2071. Director of Marketing and Public Relations: George Sebastian. Estab. 1968. Classical music company.
Needs: Approached by 25-50 freelance artists/year. Works with 4-6 freelance artists/year. Freelance art is needed throughout the year. Artists work on assignment only. Prefers local artists only with experience in brochure production and advertising. Uses freelance artists for advertising design, illustration and layout; brochure design, illustration and layout; poster design and illustration. Prefers "a young, fresh look."
First Contact & Terms: Send query letter with brochure. Samples are filed. Does not report back, in which case the artist should "contact this office." Call to schedule an appointment to show a portfolio, which should include original/final art. Pays for design and illustration by the project. "Each project differs significantly." Rights purchased vary according to project.
Tips: "Forget that we are a classical music organization."

***MANHATTAN CLASS COMPANY THEATRE,** 442 W. 42nd St., New York NY 10036. (212)239-9033. FAX: (212)643-0119. General Manager: Will Cantler. Estab. 1983. "We are a nonprofit theater of over 150 core actors, directors and playwrights producing a wide variety of work."
Needs: Approached by 3-4 freelance artists/year. Works with 4-8 freelance artists/year. Freelance art needed throughout the year. Artists work on assignment only. Prefers local artists only. Uses freelance artists for advertising and brochure design, illustration and layout; costume and set design; lighting; scenery; and newsletter design. No preferred style—every show and event is different.
First Contact & Terms: Send query letter with resume, SASE, tearsheets, photographs, photocopies and photostats. Samples are filed. Reports back only if interested. Write to schedule an appointment to show a portfolio, which should include original/final art, photostats, tearsheets and photographs. Pays for design and illustration by the project, $100 maximum. Rights purchased vary according to project.
Tips: "We produce a huge variety of plays, readings, studio and experimental work, and handicapped and minority outreach, all to high professional standards on impossible deadlines and with lots more love than money."

***THE MASTERWORK MUSIC & ART FOUNDATION,** Morristown NJ 07962-1436. (201)887-1732. Editorial Director: Shirley S. May. Concert presenters and school.
Needs: Works with 1-2 freelance artists/year. Needs heaviest in summer. Artists work on assignment only. Uses freelance artists for advertising and brochure design and layout; poster design. Prefers a "dignified, refined look."
First Contact & Terms: Send query letter with photocopies. Samples are filed if interested and are not returned. Mail appropriate materials. Portfolio should include photocopies only. Pays for design by the project.

***MESA SYMPHONY ORCHESTRA,** Suite 102, 136 W. Main St., Mesa AZ 85201. (602)969-1226. FAX: (602)969-0012. General Manager: Lynda Collum. Estab. 1956. Symphony orchestra that presents approximately 25-30 concerts each season.
Needs: Approached by 4 freelance artists/year. Works with 2 freelance artists/year. Freelance art needed throughout the year. Artists work on assignment only. Prefers local artists only. Uses freelance artists for brochure design, illustration and layout; poster design and illustration. Style varies with project.
First Contact & Terms: Send query letter with resume. Reports back only if interested. Mail appropriate materials. Portfolio should include roughs. Pays for design by the hour, $20-45, or pays negotiable rates—"always on a tight budget." Pays for illustration by the project, $400-800. Rights purchased vary according to project.
Tips: "Deadlines are sometimes nearly impossible to meet. We like to offer artists lots of flexibility to express their ideas within a broad concept agreed upon by both parties."

MILWAUKEE CHAMBER THEATRE, 152 W. Wisconsin Ave., Milwaukee WI 53203. (414)276-8842. Artistic Director: Montgomery Davis. Estab. 1980. "We are a professional equity theater company that offers classical and contemporary productions in a 200-seat theater with 1,200 subscribers."
Needs: Approached by 25 freelance artists/year. Works with 6 freelance artists/year. Freelance art needs are seasonal. Needs heaviest September-June. Artists work on assignment only. Uses freelance artists for costume design, lighting, set design and scenery.
First Contact & Terms: Send query letter with brochure, resume and color photographs. Samples are filed. Reports back to the artist only if interested. Call or write to schedule an appointment to show a portfolio or mail appropriate materials. Pays for design by the project, $500-1,200.
Tips: "Call for appointment in the spring or summer for the following year. Then make a follow-up call."

MILWAUKEE PUBLIC THEATRE, (formerly FMT), Box 07147, Milwaukee WI 53207. Co-Director: Mike Moynihan. Theatre company.
Needs: Works with 2-4 freelance artists/year. Uses artists for advertising and brochure design, illustration and layout; product, costume and textile design; calligraphy; paste-up; posters and direct mail.
First Contact & Terms: Send query letter with brochure showing art style or resume and tearsheets, photostats, photocopies, slides and photographs. Samples not filed are returned if accompanied by SASE. Reports only if interested. To show a portfolio, mail appropriate materials or write to schedule an appointment; portfolio should include original/final art, final reproduction/product and color tearsheets, photostats and photographs. Pays for design by the project, $25-500. Pays for illustrations by the project, $25-75. Considers complexity of project, available budget and turnaround time when establishing payment.

THE MINNESOTA OPERA, 620 N. First St., Minneapolis MN 55401. (612)333-2700. FAX: (612)333-0869. Marketing Director: Kathy Graves. Opera/musical theater production company, presenting 4 operas (21 performances total) an annual American musical, and a national tour of an opera. Recent productions have been "innovative, freshly-conceived and stylized."
Needs: Works with 2-4 freelance artists/year. Freelance art needed throughout the year. Works on assignment only. Uses artists for advertising and brochure design, illustration and layout; poster design and illustration. "Direct, bold and dramatic."
First Contact & Terms: Send query letter with brochure, resume, tearsheets, photocopies and slides. Samples are filed or are returned only if requested by artist. Reports back only if interested. Write to schedule an appointment to show a portfolio or mail roughs and final reproduction/product. Pays for design by the hour, $25-40 and by the project. Pays for illustration by the project, $100-750. Considers complexity of project, skill and experience of artist and available budget when establishing payment. Buys reprint rights.
Tips: Looks for freelancers with the "ability to work with diverse needs, creativity with limited budgets."

***THE MISSISSAUGA SYMPHONY ORCHESTRA,** 161 Lakeshore Rd. W, Mississauga, Ontario L5H 1G3 Canada. (416)274-1571. Executive Director: Richard Solomon. An 80-member community orchestra, a non-profit organization.
Needs: Works with 1 freelance artist/year. Needs heaviest June-January. Uses artists for brochure design, illustration and layout; and poster and program design and illustration. Prefers "a classy, bold, yet not overpowering look that follows similar prior guidelines (i.e. more conservative than modern)."
First Contact & Terms: "Artist should have examples of fine workmanship, helpful and flexible personality, and be willing to *negotiate* and work closely with executive director." Works on assignment only. Send query letter with business card and samples to be kept on file. Prefers photostats and photocopies as samples. Samples not filed returned only if requested. Reports only if interested. "Design and illustration have previously been donated. If not possible, a minimum payment would be arranged due to lack of funds." Would consider complexity of project, project's budget (due to nonprofit status) and turnaround time when establishing payment.

MISSISSIPPI SYMPHONY ORCHESTRA, Box 2052, Jackson MS 39225. (601)960-1565. Director of Marketing: Jane Clover. Estab. 1944. "Largest performing arts organization in Mississippi. Over 1,000 subscribers."
Needs: Approached by 5 freelance artists/year. Works with 5-6 freelance designers/year. Needs are heaviest from September-April. Artists work on assignment only. Prefers local artists only. Uses freelance artists for advertising design, illustration and layout; brochure design, illustration and layout; and poster design and illustration. Style should be "classy but 'user-friendly' and accessible. Promotional materials are slick, but not pretentious."
First Contact & Terms: Send query letter with brochure and resume. Samples are filed. Reports back to the artist only if interested. Write to schedule an appointment to show a portfolio, which should include original/ final art and b&w samples. Pays for design by the hour, $20-30, by the project, $100-1,000. Rights purchased vary according to project.
Tips: "As we're a nonprofit group, we desperately need artists who will offer their time as a tax-deductible contribution."

***MJT DANCE CO.,** Box 180587, Boston MA 02118. (617)482-0351. Director: Margie J. Topf. Modern dance troupe. Recent productions have been modern dance concerts by professionals and children's dance programs in schools.
Needs: Assigns 2-10 jobs/year. Works with 2-4 freelance designers/year and 1-2 freelance illustrators/year. Local artists only. Uses artists for advertising, direct mail brochures, flyers, graphics, posters, programs, tickets, exhibits and lighting. Especially needs brochure design, layout, paste-up. Promotional materials are "2-color, unusual on interesting paper with strong copy. Low budget." With lighting tries to achieve professional standards of the industry.
First Contact & Terms: Send query letter with resume and SASE or arrange interview. Reports within 2 weeks. Pays $5-20/hour depending on project, or offers in-kind or class exchange..
Tips: "Video is becoming a major consideration in the performing arts. Be well-versed in many different art forms."

ELISA MONTE DANCE CO., 39 Great Jones St., New York NY 10012. (212)533-2226. Manager: Bernard Schmidt. Modern dance company "with strong international flavor."
Needs: Works with 1-2 freelance artists/year. Prefers local artists. Works on assignment only. Uses artists for advertising, brochure and catalog design, illustration and layout; mechanicals; posters; and direct mail. Prefers collage.
First Contact & Terms: Send query letter with brochure showing art style or resume, photocopies or photographs. Samples not filed are returned by SASE only if requested by artist. Reports only if interested. Call or write to schedule an appointment to show a portfolio, which should include roughs, final reproduction/product and color photographs. Pays for design by the project, $400-1,000. Pays for illustration by the project, $100-400. Considers complexity of project, skill and experience of artist and how work will be used when establishing payment.

THE NEW CONSERVATORY CHILDREN'S THEATRE AND SCHOOL, 25 Van Ness, San Francisco CA 94102. (415)861-4914. Executive Director: Ed Decker. Estab. 1981. A performing arts school for ages 4-19.
Needs: Approached by 20 freelance artists/year. Work with 5-7 freelance designers/year. Freelance art needed throughout the year. Artists work on assignment only. Prefers local artists only. Uses freelance artists for brochure design, lighting, advertising layout, set design and scenery.
First Contact & Terms: Send query letter with brochure, resume, SASE and tearsheets. Samples are filed. Reports back to the artist only if interested. Write to schedule an appointment to show a portfolio or mail appropriate materials. Pays for design by the project, $200-500. Rights purchased vary according to project.

NEW JERSEY SHAKESPEARE FESTIVAL, Drew University, Madison NJ 07940. (201)408-3278. Artistic Director: Bonnie J. Monte. Contemporary and classical theatrical troupe.
Needs: Works with 1-2 freelance illustrators and 3 freelance designers/year. Assigns 3-6 freelance jobs/year. Design work for costumes, sets, props and lighting is seasonal, June to mid-December. Uses artists for advertising, costumes, designer-in-residence, direct mail brochures, exhibits, flyers, graphics, posters, programs, sets and theatrical lighting.
First Contact & Terms: Query with resume or arrange interview to show portfolio. Include SASE. Reports within 1 week. Interviews for designers are held in March and April. Provide resume to be kept on file for future assignments. Pays $1,200-1,400/show for set and costume design (large shows).
Tips: "Our season has expanded to 27 playing weeks." An artist's work should display an "understanding of historical period, good use of color, practicality and fit of costumes. Sets should show an ease to build, and to change from one show to another."

***NEW REPERTORY THEATRE**, 54 Lincoln St., Box 418, Newton Highlands MA 02161-0002. (617)332-1646. Director of Marketing: Carolyn C. Howe. "We are a small, professional theater producing a five play season."
Needs: Approached by 5 freelance artists/year. Works with 1-2 freelance artists/year. Freelance art needed throughout the year. Artists work on assignment only. Prefers local artists only. Uses freelance artists for brochure design, illustration and layout; poster design and illustration.
First Contact & Terms: Send query letter with resume and samples of work. Samples are filed. Reports back only if interested. Call or write to schedule an appointment to show a portfolio, which should include original/final art, b&w and color photographs and slides. "Fee depends on project. As a small theatre, our resources are limited." Negotiates rights purchased.
Tips: "Our design needs are specific and always under tight deadlines. The artist/designer should be able to show a broad sample of work. Artist's ability to work with client's suggestions and ideas is of utmost concern."

NEW YORK CITY OPERA NATIONAL COMPANY, NY State Theater, Lincoln Center, New York NY 10023. (212)870-5635. Administrative Director: Nancy Kelly. "Opera company founded in 1979 by Beverly Sills as a national touring company with the purpose of bringing opera to areas of the country without resident opera associations. Its primary function is to provide young singers with an opportunity to gain performing experience; veteran singers use the tours to try new roles before singing them in New York."
Needs: Needs for freelance artists heaviest prior to tours in winter. Uses artists for set and costume design. Style should be "relatively simple and representational. It must capture the essential character of the opera." Prefers pen & ink, airbrush and collage. "Scenic and costume designers should be aware of the rigors of traveling productions and should think about portability and economics." Artists also used for graphics for marketing the current production.
First Contact & Terms: Previous experience is advisable; union memberships are required for set and costume design. Send query letter with resume to be kept on file. Reports only if interested. Pays for design and illustration by the project, $500-800; "varies according to design; follows union rates." Considers complexity of project and available budget when establishing payment.
Tips: "The use of artists is tied specifically to whatever opera we may be performing in a given year. We generally tour in the January-April time period and hire artists one year ahead of each tour. Send us examples of work of a similar nature to what we need, such as posters promoting plays, operas, etc. Elaborate colored

Close-up

Paul Davis
Designer/Illustrator
New York, New York

© Barbara Kelley 1991

Paul Davis' poster of Lawrence Olivier in the role of King Lear is powerful—simple and emotional. As with most of his theater posters, it is a single, bold image which conveys the essence of the leading role, and as with all of his theater posters, it evokes the energy and magic of live performance. In this work Olivier's aged face, framed with white hair and beard, fills half the piece. His brow is furrowed and his eyes are knowing; they convey quiet and dignified suffering. It is a complex expression that seems to say, "I am not alone in this tragedy." At the time, this poster made one not want to miss the event, which is characteristic of all the theater posters Davis creates.

"It seems to me," says Davis, "that the most interesting posters are some sort of call to action. They suggest you should do something. In the case of the theater, it calls you to go to that performance." But first and foremost, he says, they must be attention grabbing. "I think that's where most of them fail. There are many who use very delicate type or subtle imagery, and they fade into the background." A poster, he says, needs to be a bold, dramatic and provocative statement, calling on an innovative use of photography or illustration, as well as decisive design work.

"There are lots of very self-conscious posters designed with an idea that may be graphically clever, but that does not have much relationship to the play," he says. He emphasizes the importance of going to theater rehearsals, which is where he takes the photographs he usually works from. For a theater poster, he says, "you should show something that is either connected in a very symbolic way to the play or something that happens on the stage. So if there's a particular actor or personality in the play, I will often focus on him because I think that's what [the audience] goes to see, people alive on the stage. I don't ever get tired of it because it really seems to be a genuine response to what's going on in the theater."

When Davis left Tulsa, Oklahoma at the age of 17 and came to New York, it was to attend the School of Visual Arts and become an illustrator. At the age of 22 he joined Push Pin Studios; three years later he embarked on his independent illustration and design career. His distinctive style has appeared on the covers and interiors of countless American and foreign publications, as well as book jackets, record album covers and packaging. Until it recently ceased publication, he was the art director of *Wigwag* magazine.

The majority of his poster work has been for the New York Shakespeare Festival, headed by Joseph Papp, currently his largest client. With Papp, Davis seems to have the ideal collaborative relationship, one that many artists dream of. "Most of my important work has been done for him," Davis says. "I had done lots of things for the theater before, but almost none of them had ever been published. It was always an aggravating process. I guess Joe understood what my work was doing, and he pushed it in the direction that it should have been pushed—toward experimentation and newness. What he does really," he says thoughtfully, "is create spaces in which people are able to create—he does this for directors, actors, writers, and he's done this for me."

Upon reflection, he says, "What is wonderful is when you feel you can move forward

together and know there is new territory out there ahead of you. What's difficult for designers and illustrators is that they're often asked to repeat a past success. A lot of what passes for creative," he says, "is [art directors] looking through your portfolio and saying, 'give me something like this.' It may be something you did last year or ten years ago; it's really not creating."

Overall, Davis feels posters have gotten blander and less interesting. Instead of being created for the streets, where he feels they belong, he says they have only become larger versions of magazine ads. "I think what's wrong is that the people who commission posters and who are using that media don't really understand it very well. I walk down the street and I see posters everywhere, but they're not very good and they're not very memorable.

"I think people are just sort of blinded," he says, "All [art directors] are really looking at is the little sketch they see in their office. They're not looking at the posters in the real world where they exist." As an exercise for his students at the School of Visual Arts, he had them make signs and photograph them in different places to see what happened. "I think it's really important," says Davis, "to look at the work in the place where it's going to be. There's all this printed stuff everywhere. To me, it's just creating more pollution, but it's nothing that's really doing a job and being effective."

— Lauri Miller

The acrylic on board poster of King Lear *was done for Mobil Showcase Network's television production of the play and displays Davis' talent for portraiture. The poster on the right is a creative conceptualization of the New York Shakespeare Festival's production of* Miracolo d' Amore. Reprinted with permission of Paul Davis.

illustrations are useless to us, since our advertising is limited to two-color posters and flyers."

***NEW YORK STATE THEATRE INSTITUTE,** (formerly Empire State Institute for the Performing Arts), 1400 Washington Ave., PAC 266, Albany NY 12222. (518)442-5399. Acting Artistic Director: Ed Lange. Professional resident theater; usually 5 productions requiring designers each season.
Needs: Works with 20-25 artists/year. Works on assignment only. Uses artists for poster design and illustration, set and costume design, lighting and scenery. Prefers acrylics and oils.
First Contact & Terms: Send query letter and resume to be kept on file; do not send samples with first contact. Reports back only if interested. Write to schedule an appointment to show a portfolio. Pays for design usually by the project. Pays for illustration usually by the project, $500-1,000. Considers complexity of project, project's budget, skill and experience of the artist, and rights purchased when establishing payment.

OAKLAND ENSEMBLE THEATRE, Suite 800, 1615 Broadway, Oakland CA 94612. (415)763-7774. Public Relations Director: Victoria Kirby. "Committed to producing insightful, engaging and substantive works of theater particularly as they relate to pluralism in America's national life. Our frame of reference is Black."
Needs: Works with 2-3 freelance artists/year. Freelance art needs are seasonal. Needs heaviest from July-March. Works on assignment only. Uses artists for advertising and brochure design, illustration and layout; poster design and illustration; set design; costume design; lighting and scenery.
First Contact & Terms: Send query letter with brochure showing art style or resume and samples. Samples are filed or are returned by SASE only if requested. Reports back within 3 weeks. Write to schedule an appointment to show a portfolio. Pays for illustration/design by the hour, $35-50. Considers complexity of project, skill and experience of artist and available budget when establishing payment.

***O'KEEFE CENTRE FOR THE PERFORMING ARTS,** 1 Front St. E., Toronto ON M5E 1B2 Canada. (416)393-7474. FAX: (416)393-7459. Marketing and Sales Manager: Susan Minns. Estab. 1960. "Canada's premier entertainment center; 3,167 seats. Home to national ballet and opera company, also presents Broadway musicals, comedians, family entertainment."
Needs: Approached by 25 freelance artists/year. Works with 2 freelance artists/year. Freelance art needed throughout the year. Artists work on assignment only. Uses freelance artists for advertising design and layout, brochure design and layout, and poster design. Prefer "elegant yet interesting and innovative design."
First Contact & Terms: Send query letter with brochure, resume and samples. Samples are filed. Reports back only if interested. Mail appropriate materials. Pays for design by the project.

OLYMPIC BALLET THEATRE, Anderson Cultural Center, 700 Main St., Edmonds WA 98020. (206)774-7570. Artistic Directors: John and Helen Wilkins. Ballet company with 20 dancers, approximately 100 members and a Board of Trustees of 20, which does a full-length "Nutcracker" Spring Showcase and tour, lecture-demo's and mini-performances.
Needs: Works with 2 freelance artists/year. Needs heaviest in fall, winter and spring. Uses freelance artists for advertising, brochure, catalog, poster and program design and illustration; set and costume design.
First Contact & Terms: Works on assignment only. Call or write for appointment to show portfolio. Pays by the project, $25-1,000 for design; $25-400 for illustration. Considers complexity of project and project's budget when establishing payment.
Tips: Looks for "imagination, attention to detail; someone who is a clear thinker about the project and related business matters."

OMAHA MAGIC THEATRE, 1417 Farnam St., Omaha NE 68102. (402)346-1227. Artistic Director: JoAnn Schmidman. Estab. 1968. "Our company and audience are a cross-cultural, inter-generational mix. Our audience is a true cross-section of the community."
Needs: Works with 3-8 freelance artists/year. Freelance art needed throughout the year. Uses freelance artists for set and costume design, lighting, scenery and " 'images'—visuals often projected on overheads throughout the play into performance space." Prefers non-naturalist, non-realistic styles.
First Contact & Terms: Send query letter with resume and slides. Samples are returned by SASE. Reports back within 3 months. Pays for design by the project, $1,000-2,500. Negotiates rights purchased.
Tips: "The plays we produce are the most avant of the avant-garde. The plays we produce must in some way push form and/or content to new directions."

PENNSYLVANIA STAGE COMPANY, 837 Linden St., Allentown PA 18101. (215)434-6110. Producing Director: Peter Wrenn-Meleck. "We are a LORTD theater, located 2 hours from New York City devoted to a diverse repertory of new and classic works presented on a proscenium stage. Our house seats 274 people, and we currently have 6,000 subscribers."
Needs: Works with 15 freelance artists/year; "We need freelance designers for our season which runs from October-July." "Artists must be able to come to Allentown for design consultation and construction." Works on assignment only. Uses artists for set, costume, and lighting design. "As a growing professional regional theater, we have increased needs for graphic artists, photography and illustration for print materials (bro-

chures, flyers) and particularly for our program magazine, *Callboard*, which is published seven times a year.
First Contact & Terms: Send query letter with resume. Prefers photostats, slides, b&w photos, color washes, roughs, as samples. Samples returned by SASE. Reports back whether to expect possible future assignments. Provide resume to be kept on file for possible future assignments. Pays by the project, $500-1,500 average, for design; $25-125 for print material. Considers complexity of project, available budget, and skill and experience of artist when establishing payment.
Tips: "We prefer that designers have extensive experience designing for professional theater."

RUDY PEREZ PERFORMANCE ENSEMBLE, Box 36614, Los Angeles CA 90036. (213)931-3604. Artistic Director: Rudy Perez. Performance art and experimental dance company, also known as the Rudy Perez Dance Theater, a nonprofit organization dependent on funding from National Endowment for the Arts and the California Arts Council, corporate and private fundings; box office and bookings currently in the LA area.
Needs: "The work is mainly collaborations with visual artists and composers." Uses artists for publicity before performances and updating press kits, brochures, etc.
First Contact & Terms: Send query letter with brochure and resume to be kept on file. Reports within 1 week. "Since we are a nonprofit organization we depend on in-kind services and/or negotiable fees."
Tips: Artists should have "an interest in dance and theater."

PHILADELPHIA DANCE CO. (Philadanco), 9 N. Preston St., Philadelphia PA 19104-2210. (215)387-8200. Executive Director: Joan Myers Brown. 14 member dance company performing contemporary, neoclassic, jazz and modern works.
Needs: Works with 3 freelance designers/year and 2 freelance illustrators/year. Freelance art needed throughout the year. Works on assignment only. Uses artists for advertising design and layout; brochure, poster and costume design; lighting and scenery.
First Contact & Terms: Send query letter with brochure showing art style. Samples are filed or are returned only if requested. Reports back within 25 days. Write to schedule an appointment to show a portfolio, which should include previous work samples. Pays for design and illustration by the project. Considers complexity of project and client's budget when establishing payment. Negotiates rights purchased.
Tips: "Philadanco is becoming more sophisticated in its printed matter and requires designs to reflect the maturity of the company. We look at past work with dancers/dance companies and at contemporary styles in photography and pen and ink."

***THE PHILADELPHIA ORCHESTRA,** 1420 Locust St., Philadelphia PA 19102. (215)893-1909. FAX: (215)893-1948. Director of Marketing: Jean Brubaker. Estab. 1900.
Needs: Approached by 15 freelance artists/year. Works with 2 freelance artists/year. Needs heaviest in fall. Artists works on assignment only. Prefers local artists only with experience in "performing art and anything other than corporate annual reports. Have a lot of imagination with paper and 2-color work." Uses freelance artists for advertising design and layout, and brochure design and layout. Looks for artists who are very creative with photography and have excellent 2-color pieces.
First Contact & Terms: Send query letter with brochure and resume. Do not call. Samples are filed or are returned by SASE if requested by artist. Reports back only if interested. Write to schedule an appointment to show a portfolio, which should include samples of printed work. Mail appropriate materials. Pays for design by the project. Buys all rights.
Tips: "Do not call—send samples."

PICCOLO OPERA COMPANY, Lee Jon Associates, 18662 Fairfield Ave., Detroit MI 48221. (313)861-6930. Contact: Lee Jon Associates. Opera company, performs in English; productions staged and in costume. Travels around the country. Performs for adults and for youngsters, with piano or orchestra.
Needs: Works with 1-2 freelance illustrators/year. Works on assignment only. Prefers artists with layout experience. Uses artists for advertising design, brochure illustration and layout, poster design and set design. Promotional materials vary in style from "modern" to "old fashion."
First Contact & Terms: Send query letter with resume, samples and SASE. Reports in 3-4 weeks. Pays by the project, $50-300; negotiable. Considers available budget, skill and experience of artist and creative talent of artist when establishing payment.

 The asterisk before a listing indicates that the listing is new in this edition. New markets are often the most receptive to freelance submissions.

Tips: When reviewing work, especially looks for "the impact of subject matter. Artists shouldn't overemphasize the design at the expense of the information; consider color in relation to legibility. We deal in emotions and the nostalgia aroused by music, so look for more 'romantic' design." Also interested in cartoon-style illustrations.

***PLAYWRIGHTS HORIZONS INC.,** 416 W. 42nd St., New York NY 10036. (212)564-1235. FAX: (212)594-0296. Director Audience Services: Mike Lynch. Estab. 1971. "A nonprofit producer of New American plays and musicals for a subscription audience of 5,500."
Needs: Approached by 5-12 freelance artists/year. Works with 2-5 freelance artists/year. Needs heaviest in February-May. Artists work on assignment only. Prefers local, experienced artists only. "Need to fine good inexpensive logo designs for plays." Uses freelance artists for advertising illustration; brochure design, illustration and layout; play logos. "We try to emphasize the audience and their participation in our brochures."
First Contact & Terms: Send query letter with brochure, resume, representative selection of work, if possible. Samples are filed. Reports back only if interested. Write to schedule an appointment to show a portfolio, which should include thumbnails, original/final art and color finished product. Pays for design by the project, $500-2,500. Rights purchased vary according to project.
Tips: "We are looking for young artists willing to work at low fees for the experience and visibility gained by working for one for the most prestigious theaters in the country."

POSEY SCHOOL OF DANCE, INC., Box 254, Northport NY 11768. (516)757-2700. President: Elsa Posey. Private school/professional training in performing arts.
Needs: Works with 4 or more freelance artists/year; needs heaviest in spring and fall. Prefers regional artists willing to work within nonprofit performing arts budget. Works on assignment only. Uses artists for advertising and brochure design, illustration and layout; poster and program design and illustration; set and costume design; lighting and scenery. Also uses artists for a newsletter and for advertising copy. Interested in *appropriate* cartoons.
First Contact & Terms: Send query letter with resume, tearsheets, photostats and photocopies. Samples returned by SASE. Reports within 4 weeks. To show a portfolio, mail tearsheets and photostats. Pays for design and illustration by the project, $25-250. Negotiates payment. Considers complexity of project, available budget, skill and experience of artist, how work will be used and rights purchased when establishing payment.
Tips: Artist must have "illustrative ability with understanding of dance, dancer's body and movement. Looking for honesty and a more personal approach."

***PRINCE GEORGE SYMPHONY ORCHESTRA,** 2880 15th Ave., Prince George, BC V2M 1T1 Canada. (604)562-0800. General Manager: Irene Heese. Estab. 1971. Performs a minimum of 26 classical and popular orchestral concerts per year with 55-60 musicians. 800+ subscribers plus many single ticket holders.
Needs: Approached by 2-3 freelance artists/year. Works with 2-3 freelance artists/year. Needs heaviest Sept.-May. Artists work on assignment only. Prefers local artists. Uses freelance artists for advertising design and layout; brochure design and layout; and poster design. Looks for an unusual or unique style.
First Contact & Terms: Send query letter with brochure, resume, samples of previous work. Samples are filed or returned by SASE if requested by artist. Reports back only if interested. Call to schedule an appointment to show a portfolio, which should include photostats, tearsheets and photographs. "We are just moving now to payment. Until now we have depended on volunteer labour." Pays for design by the project, $1200 maximum. Pays for illustration by the project, $50 minimum. Buys first rights.

PURDUE CONVOCATIONS AND LECTURES, CA-3, Rm. 9, Purdue University, West Lafayette IN 47907. (317)494-9412. FAX: (317)494-0540. Director of Publicity: Paula Titus. Estab. 1950s. "We present the performing arts. We have 1,200 friends and a mailing list of 17,000."
Needs: Approached by 2 freelance artists/year. Works with 2 freelance designers and illustrators/year. Needs are heaviest in October-November. Artists work on assignment only. Prefers artists with experience in the performing arts. Uses freelance artists for brochure design and illustration. "Prefers cutting-edge styles, yet work should be welcoming, moving away from highbrow."
First Contact & Terms: Send query letter with brochure, resume, tearsheets and photostats. Samples are filed. Reports back to the artist only if interested. Call to schedule an appointment to show a portfolio. Portfolio should include thumbnails, photostats and slides. Pays for illustration/ design by the project, $75-1,500. Buys all rights.
Tips: "We like to have a lot of input and will often ask for changes. Promotional materials have a whimsical style."

SALT LAKE SYMPHONIC CHOIR, Box 45, Salt Lake City UT 84110. (801)466-8701. FAX: (801)466-8780. General Manager: R. Taggart. Estab. 1949. Concert touring choir (professional circuit) with 80 members.
Needs: Approached by 20 freelance artists/year. Works with 2 freelancers/year. Needs are heaviest in the fall. Uses freelancers for brochure, poster and costume design; brochure and poster illustration; and brochure layout. Prefers a sophisticated style.

First Contact & Terms: Contact only through artist agent. Reports back only if interested. To schedule and appointment to show a portfolio mail roughs. Pays for design and illustration by the project. Buys all rights.

SAN DIEGO REPERTORY THEATRE, 79 Horton Plaza, San Diego CA 92101-6144. (619)231-3586. FAX: (619)235-0939. Marketing Director: Keith Davis. Estab. 1976. "We are located downtown and are San Diego's largest professional theater with nearly 7,000 subscribers and more than 100,000 annually attendance. We specialize in contemporary drama and musicals, new plays and the unique interpretation of classics."
Needs: Approached by 3-4 freelance artists/year. Works with 2-3 freelance artists/year. Freelance art needs are seasonal. Needs heaviest from November-March. Artists work on assignment only. Prefers local artists with experience in title illustration and non-traditional corporate marketing. Uses freelance artists for advertising design and layout; brochure design, illustration and layout; costume, lighting and set design. Prefers "a contemporary and bold look with a heavy use of photos and bold headlines."
First Contact & Terms: Send query letter with brochure and client listing. Samples are not filed and are returned by SASE if requested by artist. Reports back to the artist only if interested. To show a portfolio, mail thumbnails, roughs and original/final art. Pays for design by the project, $150-750. Pays for illustration by the project, $75-150. Rights purchased vary according to project.
Tips: "We are particularly interested in artists with expertise in combining illustration and design to completion. We prefer viewing 2-3 thumbnails to start. Some research is needed for illustration (reading plays first). Biggest annual project is the season brochure, usually 3-4 PMS or 4-color process."

SAN FRANCISCO OPERA CENTER, War Memorial Opera House, San Francisco Opera, San Francisco CA 94102. (415)565-6491. FAX: (415)255-6774. Director: Christine Bullin. Special Projects Coordinator: Joan Juster. SFOC is the umbrella organization for the educational and training programs of the San Francisco Opera.
Needs: Works with 3-4 freelance artists/year; needs heaviest in summer preparing for fall and spring seasons. Uses artists for advertising, brochure and program design, illustration and layout; set and costume design; posters; lighting; scenery; PR and educational packets.
First Contact & Terms: Send query letter with brochure, resume, business card, photostats, slides and photographs to be kept on file. Write for appointment to show portfolio. Reports only if interested. Pays for design and illustration by the project, $50-300 average. Considers available budget, how work will be used and rights purchased when establishing payment.

***SAN JOSE REPERTORY THEATRE**, Box 2399, San Jose CA 95109. (408)291-2266. FAX: (408)995-0737. PR Manager: Jayne Cravens. Estab. 1980. Fully professional LORT C theater producing a 5 play season for the South Bay area.
Needs: Approached by 4-10 freelance artists/year. Works with 4 freelancers/year. Freelance art needed throughout the year. Artists work on assignment only. Prefers local artists only. Uses freelance artists for advertising and brochure design and layout; program design, newsletter design. Style should be "professional, unique, daring, fun and lively."
First Contact & Terms: Send query letter with brochure, resume, tearsheets. Samples are filed. Reports back within 2 weeks. Call to schedule an appointment to show a portfolio, which should include original/final art, photostats and tearsheets. Pays for design by the project, $200-1,500; plus promotional listing in newsletters and programs; tickets to productions. Pays for illustration by the project, $200-500. Negotiates rights purchased.
Tips: "We are a young, up-and-coming theater presenting outstanding productions to an extremely diverse population somewhat intimidated about going to theater for the first time. But once we get them in the door, they keep coming back. We work under tight deadlines."

***SANTA BARBARA SYMPHONY**, 214 E. Victoria St., Santa Barbara CA 93101. (805)965-6596. Contact: Marketing Director. Professional symphony orchestra, 78 members. Presents 7 matinee and 7 evening performances, October-May. Periodic run-out concerts; regular subscription concerts at the Arlington Theatre; internationally-renowned guest artists.
Needs: Works with 1-2 freelance artists/year; needs heaviest in early spring. Local artists only. Uses artists for advertising and brochure design, layout and illustration.
First Contact & Terms: Send query letter with brochure, resume and samples to be kept on file. Reports only if interested. Call for appointment to show portfolio, which should include final reproduction/product. Artists submit fee schedule. Considers complexity of project, available budget, how work will be used and personality — "willingness to listen to our needs and comply with them" — when establishing payment.

***SEACOAST REPERTORY THEATRE COMPANY**, Portsmouth Academy of Performing Arts, 125 Bow St., Portsmouth NH 03801. (603)433-7272. Director: Judith Lyons. Estab. 1987. 250-seat metropolitan theater, presenting musicals, classics, comedy.

Needs: Approached by 20 freelance artists/year. Works with 10+ freelance artists/year. Freelance art needed throughout the year. Prefers artists with experience in graphics, scenic design, posters, brochures, lighting, costumes. Uses freelance artists for advertising and brochure design, illustration and layout; catalog design and illustration; poster design and illustration; set and costume design; lighting; and scenery.

First Contact & Terms: Send query letter with brochure, resume, SASE, tearsheets, photographs and photocopies. Samples are filed or returned by SASE if requested by artist. Reports back within 1 month. Call or write to schedule an appointment to show a portfolio, which should include tearsheets and photographs. Mail appropriate materials. Pays for design and illustration by the project. Payment is negotiable.

Tips: "We are actively looking for set, costume and lighting designers."

SEATTLE CHILDREN'S THEATRE, 305 Harrison Ave. N., Seattle WA 98109. (206)443-0807. Public Relations Director: Cyndi Pock. "Provides professional theatre for young audiences and offers classes year-round for grades K-12. The mainstage serves approximately 80,000 patrons each year and the education programs enroll over 500 students each calendar year."

Needs: Works with 10 freelance designers and 5 freelance illustrators/year. Freelance art needed throughout the year. Works on assignment only. Uses artists for advertising and brochure design, illustration and layout; poster design and illustration; set design; costume design; lighting and scenery. Promotional materials are upbeat, contemporary.

First Contact & Terms: Send query letter with brochure showing art style or resume, tear sheets, photostats, photocopies or slides. Samples are filed. Samples not filed are returned by SASE. Reports back only if interested. Write to schedule an appointment to show a portfolio, which should include final reproduction/product, color, b&w, tear sheets, photostats, photographs or slides. Pays for design and illustration by the project, $50-1,000. Considers complexity of project, client's budget, turnaround time, skill and experience of artist and how work will be used when establishing payment. Negotiates rights purchased.

Tips: "SCT is a nonprofit arts organization and does not have a large budget for contracted work. We do, however, use artists regularly once they begin working for SCT so the workload can become overwhelming but consistent. March is the best time to approach SCT as this is when we are looking for and solidifying work. Write, don't call."

SEATTLE GROUP THEATRE COMPANY, (formerly The Group Theatre Company), 3940 Brooklyn Ave. NE, Seattle WA 98105. (206)685-4969. Marketing Director: Laura Newton. Professional theater promoting a full theatrical season using flyers, brochures and posters. Other events generate invitations, etc.

Needs: Works with 6 freelance artists/year. Prefers local artists only. Uses artists for advertising illustration; brochure design, illustration and layout; posters and annual reports.

First Contact & Terms: Send query letter with brochure showing art style or resume, tearsheets and photocopies. Samples not filed are returned by SASE. Reports only if interested. Call or write to schedule an appointment to show a portfolio, which should include thumbnails, roughs, final reproduction/product and color tearsheets. Payment is negotiable.

Tips: "We really negotiate each project. We are a nonprofit organization. If you rigidly demand a top-of-the-market fee, we're probably not for you."

SINGING BOYS OF PENNSYLVANIA, Box 206, Wind Gap PA 18091. (215)759-6002. Director: K. Bernard Schade. "Touring boy choir." Needs heaviest in fall and winter.

Needs: Local artists only. Works on assignment only. Uses artists for direct mail brochures, flyers, posters and record jackets; design, illustration and layout of advertising and brochures; poster, set and costume design; lighting and scenery.

First Contact & Terms: Query. Pays for design by the project, $100-250.

***SOHO REP**, 524 W. 57th St., Bldg. 533/1, New York NY 10019. Artistic Directors: Julian Webber and Marlene Swartz. "We are an established off-off-Broadway theater company, seating 100. We do original plays and revivals of theatrical, physically dynamic plays."

Needs: Freelance art needs are seasonal. Uses artists for poster, flyer and program design, set design, costume design and scenery. Prefers pen & ink, computer illustration and typography.

First Contact & Terms: Send query letter with resume. Samples not filed are returned by SASE. Reports back only if interested. Write to schedule an appointment to show a portfolio. Pays for design by the project, $100 minimum.

Tips: "In your portfolio, include examples of advertising you have designed or illustrated — brochures, mailing pieces and posters."

***THE SOLOMONS COMPANY/DANCE**, 889 Broadway, New York NY 10003. (212)477-1321. Art Director: Gus Solomons. Estab. 1972. Post modern/experimental concert dance and performance.

Needs: Approached by 6-10 freelance artists/year. Works with 3-4 freelance artists/year. Freelance art needed throughout the year. Artists work on assignment only. Prefers local artists only. Uses freelance artists for poster and costume design.

First Contact & Terms: Send query letter with tearsheets, photographs and photocopies. Samples are filed. Reports back within 1 week. Call to schedule an appointment to show a portfolio, which should include thumbnails, b&w photostats and tearsheets. Pays for design by the project, $100-300. Pays for illustration by the project, $100 minimum. Buys all rights.

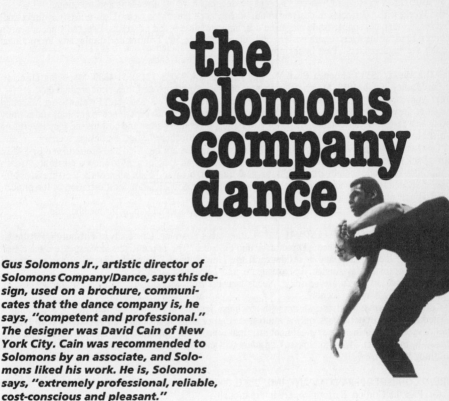

the solomons company dance

Gus Solomons Jr., artistic director of Solomons Company/Dance, says this design, used on a brochure, communicates that the dance company is, he says, "competent and professional." The designer was David Cain of New York City. Cain was recommended to Solomons by an associate, and Solomons liked his work. He is, Solomons says, "extremely professional, reliable, cost-conscious and pleasant."

© David Cain

SOUTHWEST JAZZ BALLET COMPANY, Box 38233, Houston TX 77238. (713)694-6114. Contact: President or Artistic Director. Professional touring ballet company; producers of "America in Concert."
Needs: Works with 5 freelance artists/year. Works on assignment only. Uses artists for advertising illustration, brochure illustration and layout, poster illustration, costume design and scenery.
First Contact & Terms: Send query letter with resume and "end product" to be kept on file. Reports within 1 month. Call or write to schedule an appointment to show a portfolio, which should include final reproduction/product. Pays by the project. Considers complexity of project when establishing payment.
Tips: Looking for 1920s through 1960s Americana style.

STEPPENWOLF THEATRE COMPANY, 1650 N. Halsted St., Chicago IL 60614. (312)335-1888. FAX: (312)335-0440. Marketing Manager: Denise Rosen. Estab. 1976. "We are a theatrical ensemble of 23 actors producing a 5 play subscription season."
Needs: Approached by 8-10 freelance artists/year. Works with 2-3 freelance artists/year. Freelance art is needed throughout the year. Artists work on assignment only. Prefers local artists only. Uses freelance artists for advertising, brochure, catalog and poster design; advertising, brochure, catalog and poster illustration; advertising, brochure and catalog layout. Prefers a bold and professional, but fun and unique look.
First Contact & Terms: Send query letter with brochure, resume, SASE, tearsheets or a sampling of work in any convenient format. Samples are filed or are returned by SASE if requested by artist. Reports back within 2 weeks. Call to schedule an appointment to show a portfolio, which should include original/final art, tearsheets and photographs. Pays for design by the project, $250 maximum. "Our usual designer receives a promotional listing for donating the majority of her work." Pays for illustration by the project, $200 maximum.

"Sometimes we offer an in-kind payment; i.e. tickets to Steppenwolf." Rights purchased vary according to project.

Tips: "Our design needs are sporadic and always under impossible deadlines. A broad sample of work which shows capabilities is best for our impromptu design decisions. We choose by the style we need represented. Artists' ability to work with client's suggestions and ideas is of utmost concern."

***SYRACUSE OPERA COMPANY, INC.**, Box 6904, Syracuse NY 13217-6904. Managing/Director: Julie Richard. Artistic Director: Richard McKee. "Recent productions have been realistic and traditional."
Needs: Works with 1-3 freelance designers and 1-2 freelance illustrators/year. Uses artists for direct mail brochures, posters, newspaper/trade magazine ads, bumper stickers and programs. Especially needs season brochures; fund raising flyers; opera posters, 500 bumper stickers, 500 T-shirts, and display ads. Promotional materials are "understated." Pays by the project.

***THEATRE WEST**, 3333 Cahuenga Blvd. W., Los Angeles CA 90068. (213)851-4839. Managing Director: Douglas Marney. Estab. 1962. Membership theater offering workshops and theatrical productions.
Needs: Approached by 3 freelance artists/year. Works with 6 freelance artists/year. Freelance art is needed throughout the year. Artists work on assignment only. Prefers artists with experience in graphics and scenery painting and design. Uses freelance artists for advertising, brochure, poster and costume design; advertising and brochure and poster illustration; lighting; advertising and brochure layout; set design; scenery.
First Contact & Terms: Send query letter with resume. Samples are not filed and are returned by SASE. Reports back to the artist only if interested. Write to schedule an appointment to show a portfolio. Artist's portfolio should include thumbnails, roughs, original/final art, b&w and color photostats, tearsheets, photographs, slides and transparencies. Pays for design by the project, $50-250. Pays for illustration by the project, $50-250. Rights purchased vary according to project.
Tips: "As we are a membership company of theater artists, artists should apply for membership."

THREE RIVERS SHAKESPEARE FESTIVAL, 1617 Cathedral of Learning, University of Pittsburgh, Pittsburgh PA 15260. (412)624-6467. Producing Director: Attilio Favorini. "The Three Rivers Shakespeare is the classical professional theatre company in residence at the University of Pittsburgh. Five plays are performed through the months of May-August: 3 Shakespeare, and 2 Shakespeare offshoots."
Needs: Freelance art needs are seasonal. Needs heaviest from May-August. Uses artists for set design, costume design, lighting and scenery.
First Contact & Terms: Send query letter with brochure. Samples are filed or are returned by SASE only if requested by artist. Reports back only if interested. Call or write to schedule an appointment to show a portfolio, which should include original/final art, final reproduction/product, photographs and slides. Pays for design by the project, $1,750 minimum. Considers skill and experience of artist and available budget when establishing payment.

TOURING CONCERT OPERA COMPANY, INC., 228 E. 80th St., New York NY 10021. (212)988-2542. Artistic Director: Priscilla Gordon. Performs opera internationally.
Needs: Works with many freelance artists/year. Freelance art needed throughout the year. Uses artists for advertising and brochure design, illustration and layout; poster design and illustration; set and costume design; lighting and scenery.
First Contact & Terms: Send resume and samples. Samples are filed. Reports back only if interested. To show a portfolio, mail photostats. Payment is negotiated.

***UTAH SHAKESPEAREAN FESTIVAL**, 351 W. Center, Cedar City UT 84720. (801)586-7880. FAX: (801)586-1944. Art Director: Michelle Livermore. Estab. 1962. A summer Shakespearean festival.
Needs: Works with 3 freelance artists/year. Needs are heaviest in summer/early fall. Works on assignment only. Uses freelance artists for brochure and poster illustration. Prefers dramatic and theatrical style.
First Contact & Terms: Send query letter with brochure, resume, tearsheets, photographs, photocopies and photostats. Samples are filed. Reports back to the artist only if interested. Mail appropriate materials. Portfolio should include b&w and color photostats, tearsheets and photographs. Pays for illustration by the project, $1,000 minimum. Buys all rights.

VALOIS COMPANY OF DANCERS, CPA 1028, University of Toledo, Toledo OH 43606. (419)537-4922. Art Director: Elaine Valois. Resident modern dance company active in public schools, workshops and mini-concerts and full performance. Consists of 5-9 upperclassmen/graduates in dance. Recent productions have been abstract, contemporary, multi media.
Needs: Works with 6 freelance artist/year. Needs heaviest in spring. Prefers local artists. Uses artists for advertising and brochure design, illustration and layout; poster design and illustration; costume design and lighting. "Student artists often help us, and we continue to support them and purchase from them when they go professional."

© Utah Shakespeare Festival 1991

The above illustrations by Bruce Waldman of Kew Gardens, New York were used by the Utah Shakespeare Festival to promote its performances of Hamlet *(on the left) and* Death of a Salesman. *Director of marketing Roger Bean says he saw the right-hand piece in the illustrator's portfolio and asked him to use the same style and medium for Hamlet. The artist was given a 30-day turnaround which he met and "made the necessary changes easily," says Bean. "The audience and patrons have loved them. We made them into posters because they were so popular."*

First Contact & Terms: Send query letter with brochure, business card and photostats to be kept on file. Samples not kept on file are returned only if requested. Reports within 2 weeks. To show a portfolio, mail appropriate materials or call to schedule an appointment; portfolio should include final reproduction, "any representation." Pays for design by the project, $20-500; pays for illustration by the project, $15-200. "Photos should be included. Financial history should not." Considers complexity of project, available budget and how work will be used when establishing payment.

Tips: "We have noticed more inventive use of photographic material blended in with graphics."

VICTORY GARDENS THEATER, 2257 N. Lincoln Ave., Chicago IL 60614. (312)549-5788. Managing Director: John Walker. "Subscriber-based not-for-profit professional theater, dedicated to the development of new works and using Chicago talent."

Needs: Works with 10-20 freelance artists/year. Works with developing or experienced, local artists on assignment only. Uses artists for advertising, brochure, catalog and poster design and illustration; set, lighting and costume design. Prefers marker and calligraphy, then collage and computer illustration.

First Contact & Terms: Send query letter with resume and tearsheets to be kept on file. Samples not filed are returned by SASE. Reports back only if interested. Pays for poster design by the project, $100-300 average; pays set, lighting and costume design according to U.S.A.A. Considers complexity of project, project's budget, skill and experience of the artist and turnaround time when establishing payment.

Tips: "Send examples of all types of brochures, posters, etc. I would like to see work done for other theater arts organizations." Desiring non-corporate look, but slick. The ability to encapsulate dramatic themes in striking, retentive, attention-getting visual images working within constraints of time, budget, and copy."

VIRGINIA OPERA, 160 Virginia Beach Blvd., Norfolk VA 23510. (804)627-9545. FAX: (804)622-0058. Marketing Director: Lisa Jardanhazy.

Needs: Works with 1-3 freelance designers and illustrators/year; needs heaviest in spring and summer. Works on assignment only. Uses freelance artists for advertising and brochure design, illustration and layout; poster design and illustration. Prefers collage, colored pencil, watercolor, acrylic, oil and pastel.

First Contact & Terms: Send resume and tearsheets, photostats, slides or portfolio of work. Samples are filed or are returned only if requested. Reports back only if interested. Call to schedule an appointment to show a portfolio, which should include original/final art, final reproduction/product, tearsheets, photostats and photographs. Pays for design and illustration by the project, $100 minimum. Considers complexity of project, skill and experience of artist, available budget and how work will be used when establishing payment. Negotiates rights purchased.

Tips: "Virginia Opera symbolizes excellence and always projects an image of quality. We are respected in our field as one of the leading regional opera companies in the country, and our image should reflect such. Opera is a very beautiful art form—lavish sets and costumes—and our artwork should convey that image."

WEST COAST ENSEMBLE, 6240 Hollywood Blvd., Hollywood CA 90028. (213)871-8673. Artistic Director: Les Hanson. Estab. 1982. "The West Coast Ensemble is a nonprofit theater company with two intimate theaters." Recent productions include "one set that was comfortable, middle class, mid-America 1930's; another was stark minimalism."

Needs: Approached by 25 freelance artists/year. Works with 6-9 freelance designers and 1-2 freelance illustrators/year. Freelance art needed throughout the year; assignment only. Prefers local artists with experience in set lighting and costume design. Promotional materials are eye catching but conservative.

First Contact & Terms: Send query letter with resume. Samples are filed. Reports back to the artist only if interested. To show a portfolio, mail original/final art and photographs. "Payment depends on the budget of the production." Pays for design by the project $50-300. Pays for illustration by project, $25-100. Buys all rights.

***MAIDA WITHERS DANCE CONSTRUCTION CO.**, 800 21st St. NW, Washington DC 20052. (703)522-7060. Director: Maida Withers. Estab. 1974. Produces contemporary work for site and stage and video.

Needs: Approached by 2 freelance artists/year. Works with 8 freelance artists/year. Freelance art is needed throughout the year. Prefers artists with experience in music, visual arts and video.

First Contact & Terms: Send query letter with resume. Does not report back. Mail appropriate materials. Pays for design by the project. Negotiates rights purchased.

Other Performing Arts Companies

Each year we contact all companies currently listed in *Artist's Market* requesting they give us updated information for our next edition. We also mail listing questionnaires to new and established companies which have not been included in past editions. The following performing arts companies either did not respond to our request to update their listings for 1992 (if they indicated a reason, it is noted in parentheses after their name), or they are firms which did not return our questionnaire for a new listing.

Alley Theatre
The Arkansas Arts Center Children's Theatre (late response)
Austin Lyric Opera
Berkshire Public Theatre, Inc.
Capital Repertory Company
Chicago Symphony Orchestra
Commonwealth Opera, Inc.
Contemporary Dance Theater, Inc.
Dance Kaleidoscope
Dancellington Inc.
Dimensions Dance Theater
Scott Evans Productions (late response)
Footpath Dance Company (unable to contact)
Gus Giordano Jazz Dance Chicago (unable to contact)
Hartford Stage Co.

Hartford Symphony Orchestra
Houston Ballet
Matti Lascoe Dance Theatre Co. (late response)
Martinsville Henry County Festival of Opera (late response)
Michigan Opera Theatre
Mid-Willamette Ballet Ensemble (late response)
Minnesota Orchestra
Missouri Repertory Theatre
New Mexico Symphony Orchestra
New York Harp Ensemble (late response)
Paradise Area Arts Council
Pennsylvania Opera Theater
Pioneer Playhouse of Kentucky
Queens Opera Association Inc. (late response)

Renaissance Dance Co. of Detroit (late response)
The Repertory Dance Theatre (RDT)
Rites and Reason
Roosevelt Park Amphitheatre
Beth Soll & Company/Dance Projects, Inc.
The Theatre Ballet of San Francisco
Theatre Project Company
Theatre-by-the-Sea
Theatre-in-the-Schools, Inc.
Theatreworks
Tulsa Philharmonic Orchestra
Utah Symphony Orchestra
Wolf Trap Farm Park for the Performing Arts
Anna Wyman Dance Theatre
Yale Repertory Theatre

Record Companies

If a record company decides to record and release the work of a musical artist or group, it is because they feel certain the recording will fit in with and enhance the company's image and vision—and be profitable. The company will thus undertake the costly responsiblities of providing recording facilities, securing producers and musicians and overseeing the manufacture, distribution and promotion of the new release. It is a serious and expensive business, and it is important that freelance illustrators and designers understand it as such.

Before sending samples or submitting a portfolio for review to a record company art director, the freelance artist should be very familiar with the particulars of record, cassette and CD design, as well as the company's overall image. If the company produces CDs and cassettes and very few LPs (as is often the case these days), you should know this. And if their recordings are classical, of course you should not send the art director samples appropriate for rap.

In addition to conveying the record company's image, art directors call upon freelance artists to help them create a look that is distinctive, provocative and appropriate to the performer and music. Many art directors rely on photography to convey a band's image when it is first being launched. Once the public has identified with the group, the cover images may become more conceptual and abstract.

With the demise of the LP and an environmental consciousness which is causing many companies to reevaluate the CD's long box, the vision of many art directors has been scaled down to the size of the CD jewel case. And perhaps yours should be too.

Creative directors at record companies are looking for a distinctive style that has a strong visual impact. Your sample package should include examples that reflect a strong graphic image that literally beckons a viewer. You don't have to live in one of the recording capitals to land the job, since most work is on assignment only. When negotiating a contract, remember to ask for a credit line on the album jacket and then later, a number of samples for your portfolio. Skills such as layout and paste-up are useful to fill many production jobs at record companies.

The names and addresses of hundreds of record companies and affiliated services, such as design, artwork and promotions, are listed in the *Songwriter's Market 1992*, *Billboard International Buyer's Guide*, the *California Music Directory* and the *Music Industry Directory*.

***ACE RECORDS**, 103 Fairmont Lane, Pearl MS 39208. (601)939-6868. Owner: Johnny Vincent. Estab. 1946. Produces CDs, tapes and albums; rock and roll, rap, group artists, rhythm and blues. Recent releases: "Greatest Performance," by Johnny Adams; "The Fratzs," by The Fratzs; and "Happy and Blue," by Jimmy Clanton.
Needs: Produces 11 soloists and 2 groups/year. Works with 2 visual artists/year. Prefers artists with experience in laying out album covers. Works on assignment only. Uses artists for CD cover design and illustration, album/tape cover design and illustration, brochure design and illustration, catalog design, illustration and layout, direct mail packages, and advertising design and illustration.
First Contact & Terms: Send query letter with brochure, photostats and resume. Samples are filed. Reports back only if interested. To show a portfolio, mail original/final art and photostats. Pays by the project. Rights purchased vary according to project.
Tips: "Begin working small projects with record companies and learn from someone who's been in the business a long time."

***AIRWAX RECORDS**, Box 288291, Chicago IL 60628. (312)779-2384. President: Casey Jones. Estab. 1983. Produces CDs, tapes and albums; rhythm and blues, soul, and blues. Recent releases: "The Chi-Town Boogieman," by Casey Jones.

Needs: Produces 2 soloists and 2 groups/year. Works with 5 visual artists/year. Prefers artists with experience in the performing circuit. Works on assignment only. Uses artists for posters.

First Contact & Terms: Send query letter with brochure. Samples are not filed and are returned. Reports back only if interested. To show a portfolio, mail b&w material. Pays by the project. Rights purchased vary according to project.

ALEAR RECORDS, Route 2, Box 114, Berkeley Springs WV 25411. (304)258-2175. Owner: Jim McCoy. Estab. 1973. Produces tapes and albums: country/western. Recent releases: "The Taking Kind," by J.B. Miller; "If I Throw away My Pride," R.L. Gray; and "Portrait of a Fool," by Kevin Wray.

Needs: Produces 12 soloists and 6 groups/year. Works with 3 visual artists/year. Works on assignment only. Uses artists for CD cover design and album/tape cover illustration.

First Contact & Terms: Send query letter with resume and SASE. Samples are filed. Reports back within 30 days. To show a portfolio, mail roughs and b&w samples. Pays by the project, $50-250.

© R. Cavolina 1990

Fine artist and art director Robert Cavolina created this album art for Alias Records using photography, photocopies and colored pencils. The Los Angeles-based artist had a two-week deadline for this "quiet and solitary" image. He was sought out by art director Lorry Fleming and says he has benefitted from the exposure.

***ALIAS RECORDS,** 374 Brannan St., San Francisco CA 94107. (415)546-1863. FAX: (415)546-1433. Production Manager: Lorry Fleming. Estab. 1985. Produces CDs, tapes and albums; rock and roll and folk. Recent releases: "Space Mountain," by Hypnolovewheel; "Slow," by The Sneetches; and "Milo Binder," by Milo Binder.

Needs: Produces an average of 6 groups/year. Works with 2-6 visual artists/year. Prefers local artists only with experience in LP/CD/CS layout. works on assignment only. Uses artists for CD cover design, album/tape cover design and illustration, brochure design, catalog design and layout, advertising design and illustration, posters, post cards, promotional items.

First Contact & Terms: Send query letter with resume, tearsheets and photocopies. Samples are filed. Reports back within 1 month. To show a portfolio, mail roughs, original/final art and tearsheets. Pays by the hour, $12-20. Rights purchased vary according to project.

Tips: The best way for a freelance artist to break into CD/Album/Tape design and illustration is to "work out layouts for 'mock' projects and work for little pay on first projects."

***ALPHA INTERNATIONAL RECORD CO.,** 1080 N. Delaware Ave., Philadelphia PA 19125. (215)425-8682. FAX: (215)425-4376. Production Manager: Arthur Stoppe. Estab. 1989. Produces CDs, tapes and albums; rock and roll, rap, black/urban, soul, pop, college/alternative and dance. Recent releases: "Imagination," by Exotic Birds; *Robbie Mychals*, by Robbie Mychaals, and *Leave Me Alone*, by the Hunger.

Needs: Produces 3-4 soloists and 3-4 groups/year. Works with 5-6 visual artists/year. Prefers artists with experience in music—records and tapes, etc. Works on assignment only. Uses artists for CD cover design and illustration, album/tape cover design and illustration, advertising design and illustration and posters.

First Contract & Terms: Send query letter with tearsheets, photostats, resume and photocopies. Samples are filed. Reports back only if interested. To show a portfolio, mail thumbnails, roughs, originals/final art, tearsheets and photographs. Pays by the project. Buys all rights.

AMERICAN MUSIC CO./CUCA RECORD & CASSETTE MFG. CO., Box 8604, Madison WI 53708. Vice President, Marketing: Daniel W. Miller. Produces polka, rock and roll, soul, country/western and folk. Recent releases: "Mule Skinner Blues," by The Fendermen; and "Listen to Me," by Legend.
Needs: Produces 1-5 records/year. Uses artists for album cover design and illustration; primarily uses caricatures and line drawings.
First Contact & Terms: Send query letter with business card and samples; may be kept on file. Prefers color slides as samples. Samples not filed are returned by SASE. Reports to the artist only if interested. Pays by the project, $25-100 average. Considers available budget when establishing payment. Purchases all rights.
Tips: Uses mostly "artists who are beginners."

APON RECORD COMPANY, INC., Steinway Station, Box 3082, Long Island City NY 11103. (212)721-8599. President: Andre M. Poncic. Produces classical, folk and pop.
Needs: Produces 20 records/year. Works with 10 visual artists/year. Uses artists for album cover design and illustration, catalog illustration and layout, posters.
First Contact & Terms: Works on assignment only. Send brochure and samples to be kept on file. Write for art guidelines. Samples not filed are returned by SASE. Reports to the artist within 60 days only if interested. Considers available budget when establishing payment. Purchases all rights.

ART ATTACK RECORDINGS, Box 31475, Fort Lowell Station, Tucson AZ 85751. (602)881-1212. President: William Cashman. Produces rock and roll, country/western, jazz, pop, rhythm and blues; solo artists.
Needs: Produces 4 records/year; works with 4 recording artists/year. Works with 5 visual artists/year. Uses artists for album cover design and illustration; catalog design and layout; advertising design, illustration and layout, posters.
First Contact & Terms: Works on assignment only. Send query letter with brochure, business card, tearsheets or photographs to be kept on file. Samples not filed are returned by SASE only if requested. Reports only if interested. Write for appointment to show portfolio. Original artwork not returned to artist. Pays by the hour, $10-25 average. Considers complexity of project and available budget when establishing payment. Purchases all rights.

ARZEE RECORD COMPANY and ARCADE RECORD COMPANY, 3010 N. Front St., Philadelphia PA 19133. (215)426-5682. President: Rex Zario. Produces rock and roll, country/western, rhythm and blues. Recent releases: "Rock Around the Clock," by James E. Myers; "Worlds Apart," by Ray Whitley; "Why Do I Cry Over You," by Bill Haley.
Needs: Produces 25 records/year. Works with 150 visual artists/year. Uses artists for brochure and catalog design, posters.
First Contact & Terms: Send query letter with brochure and tearsheets to be kept on file. Samples not filed are returned by SASE if requested. Reports within 6 weeks. Originals not returned after job's completion. Call for appointment to show portfolio. Buys all rights.

***BAL RECORDS**, Box 369, LaCanada CA 91012. (818)548-1116. President: Adrian P. Bal. Estab. 1965. Produces 4-6 rpm (singles); rock and roll, jazz, rhythm and blues, pop and country/western. Recent releases: "Right to Know," by James Jackson; "Dance to the Beat of My Heart," by Dan Gertz; and "You're Part of Me," by Paul Richards.
Needs: Produces 2-4 soloists and 1 or 2 groups/year. Works with 1-3 visual artists/year. Uses artists for direct mail packages.
First Contact & Terms: Send cassette with SASE. Samples are not filed and are returned by SASE. Reports back ASAP.

 The asterisk before a listing indicates that the listing is new in this edition. New markets are often the most receptive to freelance submissions.

***B-ATLAS & JODY RECORDS**, 2557 E. 1st St., Brooklyn NY 11223. (718)339-8047. Vice President/ A&R Director: Vincent Vallis. Estab. 1979. Produces CDs, tapes and albums; rock and roll, jazz, rap, rhythm and blues, soul, pop, country/western and dance. Recent releases: "Where Did Our Love Go," by Demetrius Dollar Bill; "Alone," by Alan Whitfield, and "People," by Alan Whitfield.
Needs: Produces 10 soloists and 10 groups/year. Works with 5 visual artists/year. Works on assignment only. Uses artists for CD cover design and illustration and brochure illustration.
First Contact & Terms: Send query letter with SASE and photocopies. Samples are filed. Reports back within 2 weeks. To show a portfolio, mail photographs. Pays by the project, $50-100. Buys one-time rights.

BOUQUET-ORCHID ENTERPRISES, Box 11686, Atlanta GA 30355. (404)355-7635. President: Bill Bohannon. Produces country, pop and contemporary gospel.
Needs: Produces 10 records/year; 5 of which have cover/jackets designed and illustrated by freelance artists. Uses artists for record album and brochure design.
First Contact & Terms: Send query letter with resume and samples. "I prefer a brief but concise overview of an artist's background and works showing the range of his talents." Include SASE. Reports within 2 weeks. Negotiates payment.

***BSW RECORDS**, Box 2297, Universal City TX 78148. (512)653-3989. President: Frank Willson. Estab. 1987. Produces CDs, tapes and albums; rock and roll, country/western and solo artists.
Needs: Produces 25 soloists and 5 groups/year. Works with 3-4 visual artists/year. Uses artists for CD cover design, album/tape cover design and illustration, brochure design and illustration, direct mail packages, advertising design and illustration, and posters.
First Contact & Terms: Send query letter with SASE. Samples are filed. Reports back within 1 month. To show a portfolio, mail photographs. Pays by the project. Buys all rights.

***BUSINESS DEVELOPMENT CONSULTANTS**, Box 16540, Plantation FL 33318. (305)741-7766. President: Phyllis Finney Loconto. Estab. 1980. Produces CDs, tapes and albums; rock and roll, jazz, rap, group and solo artists, rhythm and blues, soul, pop, classical, folk, educational, country/western, dance. Recent releases: "Come Follow Me," Frank X. Loconto, inspirational; "Back in Bimini," by The Calypsonians; and "Out of the Darkness," by June and Jr. Battiest.
Needs: Produces 50 soloists and 20 groups/year. Works with 10 visual artists/year. Prefers local artists. Works on assignment only. Uses artists for CD cover design and illustration, album/tape cover design and illustration, brochure design and illustration, catalog design, illustration and layout, direct mail packages, advertising design and illustration and posters.
First Contact & Terms: Send query letter with samples. Samples are filed and returned by SASE if requested by aritst. Reports back only if interested. To show a portfolio, mail thumbnails and other samples. Pays by the project. Rights purchased vary according to project.
Tips: "Freelance artists need to be able to communicate/negotiate."

***CAPITOL MANAGEMENT**, 1300 Division St., Nashville TN 37203. (615)242-4722. FAX: (615)242-1177. Owner: Robert Metzgar. Estab. 1979. Produces CDs, tapes and albums; rock and roll, jazz, group and solo artists, rhythm and blues, pop, country/western. Recent releases: Carl Butler (Sony/CBS Records), Mickey Jones (Capitol Records), and Warner Mack (MCA Records).
Needs: Produces 25 soloists and 5 groups/year. Works with 15 visual artists/year. Prefers artists with experience in music field. Works on assignment only. Uses artists for CD cover design and illustration, album/tape cover design and illustration, brochure design and illustration, catalog design, illustration and layout. direct mail packages, advertising design and illustration and posters.
First Contact & Terms: Send query letter with samples of work. Samples are filed. Reports back within 1 month. Call or write to schedule an appointment to show a portfolio, which should include thumbnails, b&w and color tearsheets and photographs. Pays by the project, $300-5,000. Buys all rights. Negotiates rights purchased. Rights purchased vary according to project.

***CAPRICE INT'RECORDS**, Postal Suite 808, Lititz PA 17543. President: Joey Welz. Produces CDs, tapes and albums. Recent releases "Gypsy Dawn," by Nan Beeson and Beeson's Gypsys; "Precious Oil," by Joel Curtis (top 40); and "Headin' for Armageddon," by Joey Welz (country).
Needs: Produces 6 soloists and 3 groups/year. Works with 2 visual artists/year. Prefers artists with experience in album, cassette and disc covers. Works on assignment only. Uses artists for CD cover design and illustration, album/tape cover design and illustration.
First Contact & Terms: Send query letter with tearsheets, photostats, photographs and photocopies. Samples are filed and not returned. Reports back only if interested. To show a portfolio, mail b&w and color photostats, tearsheets, photographs and slides. Offers 1-5% royalty. Buys one-time rights. Rights purchased vary according to project.

***CAROLINE RECORDS**, 114 W. 26th St., New York NY 10001. (212)989-2929. FAX: (212)989-9791. Director: Janet Billig. Estab. 1983. Produces CDs and tapes; rock and roll, and metal; group and solo artists. Recent releases: "Rock for Light," by Bad Brains; "Land Falls," by Springhouse; and "Frazzle Fry," by Primus.
Needs: Produces 1 soloist and 15 groups/year. Works with 2 visual artists/year. Works on assignment only. Uses artists for CD cover design and illustration, album/tape cover design and illustration; brochure design and illustration; catalog design, illustration and layout; advertising design and illustration; and posters.
First Contact & Terms: Send query letter with brochure, photostats, resume, photographs, SASE. Samples are filed. Reports back only if interested. Call to schedule an appointment to show a portfolio, which should include b&w and color tearsheets, photographs and slides. Pays by the project, $10-1,000. Rights purchased vary according to project.

CDE, Box 310551, Atlanta GA 30331-0551. President: Charles Edwards. Produces dance, soul, jazz, rhythm and blues.
Needs: Produces 6-10 records/year; 100% of the album covers assigned to freelance designers, 100% to freelance illustrators. Assigns varying number of freelance jobs/year. Works on assignment only. Uses artists for album cover, poster, brochure and advertising design and illustration and direct mail packages. No set style, "we are open-minded to any style."
First Contact & Terms: Send query letter with brochure showing art style, photostats and original work. Samples not returned. Reports within 2 months. Original work returned after job's completion "by request." Negotiates payment. Buys first rights or negotiates rights purchased.
Tips: "The business needs new and creative people."

***CELESTIAL SOUND PRODUCTIONS**, 23 Selby Rd. E. 11, London NW1 England. 081503-1687. Managing Director: Ron Warren Ganderton. Produces rock and roll, classical, soul, country/western, jazz, pop, educational, rhythm and blues; group and solo artists. Recent releases: "Sound Ceremony," "Do It for Money," and "Once Bitten."
Needs: Works with "many" visual artists/year. Uses artists for album cover design and illustration; advertising and brochure design and illustration, posters.
First Contact & Terms: Send query letter with brochure showing art style or send resume, business card and photographs to be kept on file "for a reasonable time." Samples not filed are returned by SASE only if requested. Reports within 5 days. Call to schedule an appointment to show a portfolio, which should include roughs, color and b&w photographs. Original artwork returned after job's completion. Pays by the project. Considers available budget, how work will be used and rights purchased when establishing payment. Buys all rights, reprint rights or negotiates rights purchased.
Tips: "We are searching for revolutionary developments and those who have ideas and inspirations to express in creative progress."

CHAPMAN RECORDING STUDIOS, 228 W. 5th St., Kansas City MO 64105. (816)842-6854. Office Manager: Gary Sutton. Estab. 1973. Produces CDs, tapes and albums; rock and roll, soul, country/western, jazz, folk, pop, rhythm and blues, rap, educational; solo artists. Recent releases: "Rumor Has It," by Freddie Hart; and "Cold As Ashes," by Montgomery Lee.
Needs: Produces 12 soloists and 12 groups/year. Works with 2 visual artists/year. Prefers artists with experience in CD, cassette and albums art/layout. Works on assignment only. Uses artists for CD cover design and illustration, album/tape cover design and illustration, brochure design, direct mail packages, advertising design and illustration.
First Contact & Terms: Send query letter with brochure and tearsheets. Samples are filed. Reports back only if interested. Mail appropriate materials. Portfolio should include b&w photostats, tearsheets and photographs. Pays by the project, $250-2,500. Buys first, one-time and all rights.

CREOLE RECORDS LTD., The Chilterns France Hill Drive, Camberley Surrey GU15 3QA England. 0276-686077. FAX: 0276-686055. Manager: Steve Tantum. Produces dance, soul and pop; group and solo artists. Recent releases: "I Want to Wake Up with You" by Borris Gardiner.
Needs: Produces 45 records/year. Produces 5 soloists and 4 groups/year. Works with 6 visual artists/year. Uses artists for album cover design and illustration; advertising design, illustration and layout and posters.
First Contact & Terms: Send resume and samples to be kept on file. Accepts any samples. Samples not filed are returned by SAE (nonresidents include IRC). Reports within 3 weeks. Original art sometimes returned to artist if SAE. Payment varies. Considers complexity of project, available budget, skill and experience of commercial artist, how work will be used and rights purchased when establishing payment. Buys all rights.

CURTISS RECORDS, Box 1622, Hendersonville TN 37077. President: W. Curtiss. Estab. 1970. Produces CDs, tapes and albums: rock and roll, rhythm and blues, country/western, jazz, soul, folk, dance, rap, pop and gospel; solo and group artists. Recent releases: "Big Heavy" and "Real Cool," by Rhythm Rockers.

Needs: Produces 8-10 soloists and 5-10 groups/year. Works with 3-12 visual artists/year. Works on assignment only. Uses artists for CD cover design and illustration, album/tape cover design and illustration, brochure design and illustration, catalog design, illustration and layout, direct mail packages, advertising design and illustration and posters.

First Contact & Terms: Send query letter with brochure, photographs and SASE. Samples are sometimes filed or are returned by SASE. Reports within 3-4 weeks. Write to schedule an appointment to show a portfolio, which should include original/final art and b&w and color photographs and SASE. Pay varies. Negotiates rights purchased.

CURTISS UNIVERSAL RECORD MASTERS, Box 1622, Hendersonville TN 37077. (615)822-1044. Manager: S.D. Neal. Produces soul, country, jazz, folk, pop, rock and roll, and rhythm and blues. Recent releases by Dixie Dee & The Rhythm Rockers, and Ben Williams.

Needs: Produces 6 records/year; some of which have cover/jackets designed and illustrated by freelance artists. Works on assignment only. Uses artists for album cover and poster design.

First Contact & Terms: Send business card and samples to be kept on file. Submit portfolio for review. Include SASE. Reports within 3 weeks. Originals returned to artist after job's completion. Negotiates pay based on artist involved. Negotiates rights purchased.

***DIRECT FORCE PRODUCTIONS**, Box 255, Roosevelt NY 11575. (212)713-5779. President: Ronald Amedee. Estab. 1989. Produces CDs and tapes; rock and roll, jazz, rap, rhythm and blues, soul, pop, country/western; group and solo artists. Recen releases: *Love Attack*, by Jason Taylor, *You're the One*, by Paco Aniedee; and *I Want You*, by Deana Caroll.

Needs: Produces 20 soloists and 10 groups/year. Works with 15 visual artists/year. Prefers artists with experience in the music field. Uses artists for CD cover design, album/tape cover design and illustration, advertising design, posters.

First Contact & Terms: Send query letter with resume and photographs. Samples are filed or returned. Reports back within 15 days. Call to schedule an appointment to show a portfolio or mail appropriate materials: original/final art and b&w and color samples. Pays by the project. Rights purchased vary according to project.

FARR MUSIC AND RECORDS, Box 1098, Somerville NJ 08876. Contact: (201)722-2304. Candace Campbell. Produces CDs, tapes and albums; rock and roll, dance, soul, country/western, folk and pop; group and solo artists.

Needs: Produces 12 records/year by 8 groups and 4 soloists. Works with 12+ freelance designers and 20+ freelance illustrators/year. Uses artists for album cover design and illustration, brochure and catalog design, advertising design and illustration and posters.

First Contact & Terms: Send query letter with resume, tearsheets, photostats, photocopies, slides and photographs to be kept on file. Samples not filed are returned by SASE. Reports within 3 weeks. To show a portfolio, mail roughs, final reproduction/product and color photographs. Original art returned to the artist. Pays for design and illustration by the hour, $30-150. Buys first rights or all rights.

FINER ARTS RECORDS/TRANSWORLD RECORDS, Suite 115, 2170 S. Parker Rd., Denver CO 80231. (303)755-2546. FAX: (303)755-2617. President: R. Bernstein. Produces rock and roll, dance, soul, country/western, jazz, pop and rhythm and blues records by group and solo artists. Recent releases: "Israel Oh Israel" (a new Broadway musical), "Bonnie Delaney," "Kaylen Wells" and "Leeona Miracle." New recording artists ready for release.

Needs: Produces 2-3 soloists and 2-3 groups/year. Uses artists for album cover design and illustration and posters.

First Contact & Terms: Send query letter with brochure showing art style or resume and tearsheets, photostats and photocopies. Samples are filed or returned only if requested. Reports back only if interested. Write to schedule an appointment to show a portfolio. Pays by the project, $500 minimum. Considers complexity of project, available budget and turnaround time when establishing payment. Buys all rights and negotiates rights purchased.

FINKELSTEIN MANAGEMENT CO. LTD./TRUE NORTH RECORDS, Suite 301, 151 John St., Toronto Ontario M5V 2T2 Canada. (416)596-8696. FAX: (416)596-6861. Director: Jehanne Languedoc. A&R Director: Steven Ehrlick. Estab. 1969. Produces CDs, tapes and albums: rock and roll, folk and pop; solo and group artists. Recent releases: "Big Circumstance" and "Stealing Fire," by Bruce Cockburn, and "Barney Bentall & The Legendary Hearts," by Barney Bentall.

Needs: Produces 1 soloist and 2 groups/year. Works with 4 or 5 visual artists/year. Prefers artists with experience in album cover design. Uses artists for CD cover design and illustration, album/tape cover design and illustration, posters and photography.

INTRODUCTORY SUBSCRIPTION OFFER
SAVE 30%!

Learn the techniques of superior graphic design...
top professional designers show you HOW it's done

HOW

HOW introduces you to the biggest names in the graphic art profession. Look over the shoulders of design greats like Milton Glaser and Seymour Chwast, and follow as they develop jobs for clients like Bloomingdale's, MTV, Generra and BMW.

HOW presents new techniques for designing a variety of media forms: annual reports • signage • book covers • magazine layout • exhibits • animation • print and TV ads • photography...whatever your client needs to express an image or identity.

HOW helps you understand the latest in computer graphics, desktop publishing systems, and creative techniques used by today's design experts.

USE THE ORDER CARD BELOW TO TAKE ADVANTAGE OF A SPECIAL INTRODUCTORY OFFER!

SUBSCRIBE TO HOW at special introductory savings!

☐ Start my introductory subscription to HOW, and send me the next 6 issues (including the valuable Self-Promotion Issue) for just $33*...a savings of 30% off the newsstand price!

Send HOW to: VHAM 9

NAME (please print)

ADDRESS

CITY STATE ZIP

☐ Check or money order for $33 enclosed ☐ Charge my ___Visa___MasterCard

Card No. _____ Exp. Date _____

Signature _____

My job title/occupation is (choose one): 10 ☐ Photographer 11 ☐ Librarian 12 ☐ Art director/graphic design staff 13 ☐ Advertising/marketing staff 14 ☐ Production staff 15 ☐ Sales staff 16 ☐ Owner/mgmt. 17 ☐ Editorial 18 ☐ PR staff 19 ☐ Student 20 ☐ Corp. design dept. 21 ☐ Illustrator/artist 22 ☐ Creative director 23 ☐ Art supervisor 24 ☐ Printing buyer 25 ☐ Instructor 63 ☐ Other (please specify):

Type of company is (choose one): 1 ☐ Advertising agency 2 ☐ Company 3 ☐ Design studio 4 ☐ Graphic arts firm 5 ☐ Publishing firm 6 ☐ Gov't agency/bureau 7 ☐ Educational institution ☐ Other (please specify):

*For surface mail to Canada, add $15 (includes GST); overseas, add $22; airmail, add $65. Remit in U.S. funds. Make checks payable to HOW. Newsstand rate $47.

INCLUDED IN YOUR SUBSCRIPTION... HOW'S ANNUAL SELF-PROMOTION ISSUE!

Exciting • Informative • Inspiring

Your subscription to HOW includes the valuable Self-Promotion Issue, a slick showcase of the year's hottest self-promotion campaigns by designers across the country, PLUS exclusive profiles on the winners of HOW's Self-Promotion Competition.

The Self-Promotion Issue also brings you the latest how-to's from world-class designers: promotional design tips, how to put together an impressive portfolio, advice for marketing yourself, finding new clients, pricing your work and more.

RESERVE YOUR COPY BY STARTING YOUR SUBSCRIPTION TODAY!

NO POSTAGE
NECESSARY
IF MAILED
IN THE
UNITED STATES

BUSINESS REPLY MAIL
FIRST CLASS MAIL PERMIT NO. 17 CINCINNATI, OH

POSTAGE WILL BE PAID BY ADDRESSEE

P O BOX 12575
CINCINNATI OH 45212-9927

First Contact & Terms: Send query letter with SASE. Samples are filed or are returned by SASE if requested by artist. Reports only if interested. Call to schedule an appointment to show a portfolio which should contain "whatever you feel is an accurate representation of your work." Pays by the project. Buys all rights.

***FLIPSIDE DESIGN**, Suite 800, 1809 7th Ave., Seattle WA 98101. (206)292-8772. FAX: (206)292-8727. Art Director: Peter Morada. Estab. 1990. Produces CDs, tapes and albums; jazz, rap, soul, pop, metal and dance. Recent releases: "Love & Peace," by 4-Way; "Releases the Pressure," by Criminal Nation; and "Strong Emotion," by Blu Max.
Needs: Produces 3 soloists and 5 groups/year. Works with 3-10 visual artists/year. Works on assignment only. Uses artists for CD cover design and illustration, album/tape cover design and illustration and posters.
First Contact & Terms: Contact only through artist rep. Send query letter with tearsheets, resume, photographs, slides and transparencies. Samples are filed. Reports back only if interested. Call or write to schedule an appointment to show a portfolio, which should include original/final art, photostats, tearsheets, photographs, slides and transparencies. Pays by the project, $500. Rights purchased vary according to project.
Tips: Artist needs "unique style, conducive to application/concept. Must have professional work and attention to detail."

***GRASS ROOTS PRODUCTIONS**, Box 532, Malibu CA 90265. (213)858-7282. President: Lee Magid. Produces jazz, rock, country, blues, instrumental, gospel, classical, folk, educational, pop and reggae; group and solo artists. Assigns 15 jobs/year. Recent releases: "On The Streets Again," and "Live," by Rags Waldorf; and "Have Horns, Will Travel," by Russ Gary Big Band Express; "The Joy That Floods My Soul," by Tramaine Hawkins.
Needs: Produces 15-20 records/year; works with 6 soloists and 6 groups/year. Local artists only. Works on assignment only. Uses artists for album cover design and illustration; brochure design, illustration and layout; catalog design, direct mail packages, posters and advertising illustration. Sometimes uses cartoons and humorous and cartoon-style illustrations depending on project.
First Contact & Terms: Send query letter with brochure, resume, and slides to be kept on file. SASE. Samples not filed are returned by SASE. Reports only if interested. Write for appointment to show a portfolio. Pays by the project. Considers available budget when establishing paymnet. Buys all rights.
Tips: "It's important for the artist to work closely with the producer, to coincide the feeling of the album, rather than throwing a piece of art against the wrong sound." Artists shouldn't "get overly progressive. 'Commercial' is the name of the game."

***GRP RECORDS**, 555 W. 57th St., New York NY 10019. (212)245-7033. FAX: (212)245-0765. Vice President Creative Services: Andy Baltimore. Estab. 1976. Produces CDs, tapes and albums: jazz. Recent releases: *Welcome to the St. James Club*, by the Rippingtons; *Extremities*, by Tom Schuman; *Now You See It . . . Now You Don't*, by Michael Brecker.
Needs: Produces a varying number of soloists and groups each year. Works on assignment only. Uses artists for CD and album/tape cover illustration and design.
First Contact & Terms: Send query letter with brochure, photocopies and photostats; don't submit original materials. Samples are filed or are returned by SASE. Reports back to the artist only if interested. Call or write to schedule an appointment to show a portfolio. Portfolio should include b&w or color photostats and photographs. Rights purchased vary according to project.
Tips: "Try to land a freelance assignment within an art or creative service department of a record company—even if the assignment is only to do mechanicals. Opportunities to show your work always present themselves."

***HEADS UP INTERNATIONAL LTD.**, Box 976, Lynnwood WA 98046. (206)787-1037. FAX: (206)787-1031. President: Dave Love. Estab. 1982. Produces CDs and tapes; rock and roll, jazz, folk and international music. Recent releases: "Interior Design," by Kenny Blake; "Churun Meru," by Carlos Guedes; and "Carcas," by Bochinche.
Needs: Produces 6 groups/year. Works with 2 visual artists/year. Prefers local artists only. Works on assignment only. Uses artists for CD cover design and illustration, album/tape cover design, brochure illustration, catalog design, illustration and layout, posters.
First Contact & Terms: Send query letter with brochure and tearsheets. Samples are filed. Reports back within 1 month only if interested. Call to schedule an appointment to show a portfolio, which should include tearsheets. Pays by the project. Rights purchased vary according to project.

***HIT CITY RECORDS**, 4708 Bawell St., Baton Rouge LA 70808. (504)925-0288. Owner: Henry Turner. Estab. 1984. Produces CDs, tapes and albums; rock and roll, jazz, rap, rhythm and blues, soul, pop, folk, country/western; group and solo artists. Recent releases: "Little Heart," by Valarie Jo Brock; "I Need You," by Henry Turner Jr. and Flavor; and "Hey Bartender," by Eldon Ray and Kross Kountry.
Needs: Produces 2-5 soloists and 3-7 groups/year. Works with 80-100 visual artists/year. Uses artists for CD cover design and illustration; album/tape cover design and illustration; brochure design and illustration; catalog design, illustration and layout; direct mail packages; advertising design and illustration; and posters.

Close-up

Andy Baltimore
Vice President/Creative Director
GRP Records
New York, New York

© Barbara Kelley 1991

"Everyone's pretty excited around here," says Andy Baltimore, Vice President and Creative Director of GRP Records in New York. "Glenn Miller went gold," he says, referring to *In the Digital Mood*, a 1983 recorded session starring the latter-day Miller band, which sold more than 500,000 units. To celebrate this success, GRP rereleased a special limited gold edition, for which Andy Baltimore and his six-person staff created a special package: a gold framed jewelcase and 44-page booklet containing text and black-and-white photos covering Miller's career. It all fits nicely into a gold framed slipcase with window. "It must be my day today," Baltimore says, for he'd just received notice of *Billboard*'s response to the rerelease: "The packaging will make it a boon for collectors," the magazine said.

GRP Records, recently acquired by MCA, was formed in 1983 by studio engineer Larry Rosen and film composer, arranger and conductor Dave Grusin (the composer for such films as "On Golden Pond," "Tootsie," and "The Fabulous Baker Boys" and Oscar winner for "The Milagro Beanfield War"). Along with introducing the musical artistry of such bands as Spyro Gyra, Chick Corea and Michael Brecker, the jazz company utilizes the most advanced state-of-the-art technology and was among the first to introduce compact discs, digital audio tapes, and enter the field of music videos. "Because the artistic quality of the music and the engineering were always so well respected," Baltimore says, "I really had to work twice as hard to keep that image on the package."

This was a particularly daunting task for Baltimore, whose background was not in art direction but rather documentary filmmaking. In 1982 while he was writing a screenplay for his first motion picture, (a New York comedy) and still $70,000 short for preproduction, he received a call from Grusin and Rosen, friends of his, requesting help with televising a jazz concert in Japan. "When I got back from Japan, they said, 'Andy, we need an album cover.' I asked, 'How do I do a cover?' " They told him he'd find out, he did and has been with them ever since. Reflecting on the chaos of those initial days, he says, "I took a door that wasn't being used, painted it black, and that was my first art table," he laughs. "A couple of years ago, the president of the company paid me a nice compliment. 'You know Andy,' he said, 'they used to talk about the music and the quality; now they're talking about the music, the quality and the packaging.' "

Really, Baltimore has done more than hold his own. He has received numerous awards: the Art Directors Creativity Award (twice), Art Directors Club Merit Award and the American Institute of Graphic Arts Award, among others.

Baltimore says his job as creative director is "fast and furious," with administrative duties oftentimes requiring that he talk to four people simultaneously. In the evening, when most have gone home, he does the conceptualizing and creating that comprises the other estimated 50 percent of his job, music playing all the while.

From GRP's first year, when they put out three to four albums to this year when they

put out 43, Baltimore has seen a lot of changes in music packaging. Because the LP is fast becoming extinct (GRP produces only a very small amount for Europe), Baltimore's visual concern now is primarily how an image will look on a compact disc jewelcase. CDs account for 65 percent of their sales, while cassettes account for the other 35 percent. "My feeling," about the demise of the LP, he says, "is there's no sense in complaining about the fact that we have to work with something smaller; this is the reality, so we have to adjust." To Baltimore, who says he can be creatively challenged by just about anything (from redecorating a house to building a stone sculpture on the beach), this seems to offer yet another such challenge. Even poster size, he notes, has gotten smaller, due to the lack of wall space at music retail stores. He does notice more special packaging, such as their Glenn Miller reissue, and feels this will allow for more creative possibilities.

When it comes time for choosing the appropriate image for a cover, Baltimore relies on his and his staff's creative taste and intuition. He says, "I usually don't go out to see what other companies are doing; I just do what I feel I have to do, what captures the mood of the music, what I feel our audience is going to relate to."

Because Baltimore feels they are "putting the wrapping on a band's music," he thinks it important to involve the band. Often before he has hired a photographer or illustrator, he talks to the musical artist, asking such questions as what images he saw as he was writing the music, what he feels as he performs it. He shares these ideas with the photographer or illustrator and then often says, "Listen to this and we'll see what you come up with."

Baltimore doesn't believe cover illustration is being replaced with photography but says if a new band is being launched, he'll use photography in order to better convey their personality to the public. Once the band's identity has been formed, Baltimore says, "there's no end to the type of art we might use."

Unfortunately, he says, he sees many samples and portfolios inappropriate for GRP's needs, usually because the quality is not up to par with the company's work. He looks for freelancers with talent and familiarity with GRP's music and image. They should get along with his "very up, enthusiastic and proud" staff, and he says jovially, enjoy jazz and like Chinese food.

—Lauri Miller

These two GRP Records CD covers show the range of illustration Baltimore employs to match the sounds within. "What really counts," he says, "is that the package we've created works with the music and the artist—and helps sell records."

Reprinted with permission of GRP Records

First Contact & Terms: Send query letter with brochure, resume, SASE. Samples arc not filed and are returned by SASE if requested by artist. Reports back within 2 weeks. Call to schedule an appointment to show a portfolio, which should include b&w and color photographs. Pays by the hour, $5-7. Negotiates rights purchased.

Tips: The best way for freelance artists to break into CD/album/tape design and illustration is to "make their services available to projects with little or no budget to cash in on the promotion."

***IMAGINARY ENTERTAINMENT CORP.**, 332 N. Dean Rd., Auburn AL 36830. (205)821-5277. Proprietor: Lloyd Townsend. Estab. 1982. Produces CDs, tapes and albums; rock and roll, jazz, classical, folk and spoken word. Recent releases: "Electronic Syncopations," by Patrick Mahoney; "Sonic Defense Initiative Vol. 2," by various artists; and "Auburn Knights Orchestra's 60th Anniversary," by Auburn Knights Orchestra.

Needs: Produces 1-2 soloists and 1-2 groups/year. Works with 1-2 visual artists/year. Works on assignment only. Uses artists for CD cover design and illustration, album/tape cover design and illustration and catalog design.

First Contact & Terms: Send query letter with brochure, tearsheets, photographs and SASE. Samples are filed or returned by SASE if requested by artist. Reports back within 2-3 months. To show a portfolio, mail thumbnails, roughs and photographs. Pays by the project, $25-500. Buys one-time rights; negotiates rights purchased.

JAY JAY, NE 35 62nd St., Miami FL 33138. (305)758-0000. President: Walter Jagiello. Produces country/western, jazz and polkas. Recent releases: "Happiness To You," and "All Night with Li'l Wally," by Li'l Wally (CDs, tapes).

Needs: Produces 6 albums/year. Works with 2 freelance designers/year. Works on assignment only. Uses artists for album cover design and illustration, brochure design, catalog layout; advertising design, illustration and layout and posters. Sometimes uses artists for newspaper ads.

First Contact & Terms: Send brochure and tearsheets to be kept on file. Call or write for appointment to show portfolio. Samples not filed are returned by SASE. Reports within 2 months. Pays by the project, $20-50. Considers skill and experience of artist when establishing payment. Purchases all rights.

***KENNING PRODUCTIONS**, Box 1084, Newark DE 19715-1084. (302)292-1445. President: Kenny Mullins. Estab. 1982. Produces CDs and tapes; rock and roll, jazz, rhythm and blues, pop, folk and country/western; solo artists. Recent releases: "The Lates Single," by Dover Conley; "Fight," by Kenny Mullins; and "M.U.K.," by Mullins, Unruh and Kirk.

Needs: Produces 5-6 soloists and 3-4 groups/year. Works with 12-15 visual artists/year. Works on assignment only. Uses artists for CD cover design and illustration, album/tape cover design and illustration, and posters.

First Contact & Terms: Send query letter with brochure, resume and SASE. Samples are filed and are not returned. Reports back in 1 month. To show a portfolio, mail b&w and color photographs. Pays by the project. Negotiates rights purchased.

KIMBO EDUCATIONAL, 10 N. 3rd Ave., Long Branch NJ 07740. Production Coordinators: Amy Laufer and James Kimble. Educational record/cassette company. Produces 8 records and cassettes/year for schools, teacher supply stores and parents. Contents primarily early childhood physical fitness, although other materials are produced for all ages.

Needs: Works with 3 freelance artists/year. Local artists only. Works on assignment only. Uses artists for ads, catalog design, album covers and flyer designs. Artist must have experience in the preparation of album jackets or cassette inserts.

First Contact & Terms: "It is very hard to do this type of material via mail." Write or call for appointment to show portfolio. Prefers photographs or actual samples of past work. Reports only if interested. Pays for design and illustration by the project, $200-500. Considers complexity of project and budget when establishing payment. Buys all rights.

Tips: "The jobs at Kimbo vary tremendously. We are an educational record company that produces material from infant level to senior citizen level. Sometimes we need cute 'kid-like' illustrations and sometimes graphic design will suffice. A person experienced in preparing an album cover would certainly have an edge. Prefer working with local talent. We are an educational firm so we cannot pay commercial record/cassette art prices."

KOTTAGE RECORDS, Box 121626, Nashville TN 37212. (615)726-3556. President: Neal James. Estab. 1972. Produces CDs and tapes: rock and roll, rhythm and blues, country/western, soul, pop; solo and group artists. Recent releases: "Love Don't Lie," by Ted Yost and "Jeremiah Hedge," by Jeremiah Hedge (tapes).

Needs: Produces 6 soloists and 2 groups/year. Works with 2 freelance designers/illustrators/year. Works on assignment only. Uses artists for CD cover and album/tape cover design and illustration, brochure and advertising design, posters and video covers. Promotional materials include musicians' bio and show mini-posters.

First Contact & Terms: Send query letter with resume and SASE. Samples are not filed and are returned by SASE if requested by artist. Reports within 3 weeks. Write to schedule an appointment to show a portfolio, which should include b&w and color tearsheets and photographs. Pays by the project, $50 and up. Rights purchased vary according to project.

James Magnant of Underhill, Vermont designed this cassette cover for Lambsbread International after president/ owner Bobby Hackney had seen some of his previous work and liked it. Hackney is impressed with "his ability to convey an idea from a vision that was described to him and the fact that he made deadlines and was willing to quickly change anything that was unsatisfactory." The response, says Hackney, has been "quick and favorable."

© LBI Records 1990

***LAMBSBREAD INTERNATIONAL RECORD COMPANY/LBI,** Box 328, Jericho VT 05465. (802)899-3787. President: Bobby Hackney. Estab. 1983. Produces CDs, tapes and albums; rhythm and blues, reggae. Recent releases: "Sign of the Times (A Reggae Statement)," by Lambsbread; "International Love," by Lambsbread; and "This Love," by The Hackneys.
Needs: Produces 2 soloists and 2 groups/year. Works with 3 visual artists/year. Works on assignment only. Uses artists for CD cover design, album/tape cover design and illustration, catalog design, direct mail packages, advertising design and posters.
First Contact & Terms: Send query letter with brochure, tearsheets, resume, photographs, SASE and photocopies. Samples are filed. Reports back only if interested. To show a portfolio, mail thumbnails, roughs, photostats and tearsheets. Payment negotiated. Buys all rights or negotiates rights purchased according to project.
Tips: "Become more familiar with the way music companies deal with artists. Also check for the small labels which may be doing activity in your area."

LANA RECORDS/TOP SECRET RECORDS, Box 12444, Fresno CA 93777-2444. (209)266-8067. Director: Robby Roberson. Produces rock and roll, classical, dance, soul, country/western, jazz, folk, pop, educational, rhythm and blues; group and solo artists. Recent releases: *Mival Masters,* by Master's Touch and *Maria Elena,* by Maria Elena (CDs and tapes).
Needs: Produces 5 soloists and 5 groups/year. Works with 1+ freelance designers/year. Prefers at least 2 years of experience or past credits. Uses artists for album cover, brochure and catalog design and illustration; catalog layout; direct mail packages; advertising design and illustration; and posters.
First Contact & Terms: Send query letter with resume and photocopies. Samples are filed or are returned by SASE. Reports back within 2 weeks. Write to schedule an appointment to show a portfolio or mail photostats. Pays for design by the project, $250-1,000. Pays for illustration by the hour, $25-50. Considers complexity of project and rights purchased when establishing payment. Buys all rights.

LANDMARK COMMUNICATIONS GROUP, Box 148296, Nashville TN 37214. President: Bill Anderson Jr. Estab. 1980. Produces CDs and tapes: country/western and gospel. Recent releases: *You Were Made for Me,* by Skeeter Davis and *Millions of Miles,* by Teddy Nelson. (CDs, tapes and albums).

Needs: Produces 6 soloists and 2 groups/year. Works with 2-3 freelance designers and illustrators/year. Works on assignment only. Uses artists for CD cover design and album/tape cover illustration.
First Contact & Terms: Send query letter with brochure. Samples are filed. Reports back within 1 month. Portfolio should include tearsheets and photographs. Rights purchased vary according to project.

LEMATT MUSIC LTD./Pogo Records Ltd./Swoop Records/Grenouille Records/Zarg/R.T.F.M. Records-Check Records/Lee Music Ltd., % Stewart House, Hill Bottom Rd., Sands, IND, EST, Highwycombe, Buckinghamshire England. 063081374. FAX: 063081612. Manager, Director: Ron Lee. Produces rock and roll, dance, country/western, pop, and rhythm and blues; group and solo artists. Recent releases "American Girl," by Hush; "Children of The Night," by Nightmare; and "Phobias," by Orphan.
Needs: Produces 25 records/year; works with 12 groups and 6 soloists/year. Works with 1-2 visual artists/year. Works on assignment only. Uses a few cartoons and humorous and cartoon-style illustrations where applicable. Uses artists for album cover design and illustration; advertising design, illustration and layout; and posters.
First Contact & Terms: Send query letter with brochure, resume, business card, slides, photographs and videos to be kept on file. Samples not filed are returned by SASE (nonresidents send IRCs). Reports within 3 weeks. To show a portfolio mail original/final art, final reproduction/product and photographs. Original artwork sometimes returned to artist. Considers complexity of project, available budget, skill and experience of artist, how work will be used and turnaround time when establishing payment. Payment negotiated.

JOHN LENNON RECORDING MUSIC LINE INTERNATIONAL (CEPAC), Box 597, Station P, Toronto, Ontario M5S 2T1 1R8 Canada. (416)658-3726/966-0983. FAX: (416)961-0124. Music producers and arrangers: Oliver Moore, Don Don. Agent: Joseph Sudano. Estab. 1979. Produces CDs, tapes and albums: rhythm and blues, rap and pop; group and solo artists. Recent releases: "Fantasy Love," by Blysse; "You're Changing," and "Summer Nights," by Carl Ellison and the Mixx.
Needs: Produces 5 soloists and 2 groups/year. Works with 1-3 visual artists/year. Works on assignment only. Uses artists for brochure design and illustration.
First Contact & Terms: Send query letter with resume and SASE (IRC). Samples are not filed and are returned by SASE (IRC). Reports back within months. To show a portfolio, mail b&w samples. Pays by the hour, $25-35. Pays by the project or by the day, $200-280. Rights purchased vary according to project.

LITTLE RICHIE JOHNSON AGENCY, Box 3, Belen NM 87002. (505)864-7442. FAX: (505)864-7442. General Manager: Tony Palmer. Produces country/western records. Recent releases: "Step Aside," and "I Don't Want to See You Cry," by Jerry Jaramillo (tapes and albums).
Needs: Produces 5 soloists and 2 groups/year. Works on assignment only. Prefers local artists only. Uses artists for album/tape cover design and advertising design.
First Contact & Terms: Send query letter with brochure showing art style or photographs. Samples are filed or are returned by SASE only if requested. Reports back only if interested. To show a portfolio, mail photographs. Pays for design and illustration by the project. Considers complexity of project and available budget when establishing payment. Rights purchased vary according to project.

LUCIFER RECORDS, INC., Box 263, Brigantine NJ 08203. (609)266-2623. President: Ron Luciano. Produces pop, dance and rock and roll.
Needs: Produces 2-12 records/year. Experienced artists only. Works on assignment only. Uses artists for album cover design; brochure design, illustration and layout; catalog design; direct mail packages; advertising layout, design and illustration; and posters.
First Contact & Terms: Send query letter with resume, business card, tearsheets, photostats or photocopies. Reports only if interested. Original art sometimes returned to artist. Write to show a portfolio, or mail tearsheets and photostats. Pays by the project. Considers budget, how work will be used, rights purchased and the assignment when establishing payment. Negotiates pay and rights purchased.

JACK LYNCH MUSIC GROUP/NASHVILLE COUNTRY PRODUCTIONS, 306 Millwood Dr., Nashville TN 37217-1609. (615)366-9999. CEO: Col. Jack Lynch. Estab. 1963. Produces CDs, cassettes and tapes: country/western, MOR, bluegrass and gospel. Recent releases: "Easy This Time," by Paul Woods and "Don't Let the Fire Go Out," by Glenda Rider (CDs, tapes).
Needs: Produces 1-12 soloists and 1-12 groups/year. Works with 1-12 designers and illustrators/year. Prefers local artists only with experience in the music industry. Works on assignment only. Uses artists for CD cover design and album/tape cover design.
First Contact & Terms: Send query letter with brochure, resume and SASE. Samples are filed or are returned by SASE if requested by artist. Reports back to the artist only if interested. To show a portfolio, call or mail appropriate materials, which should include b&w and color samples. Pays by the project $100-500. Buys all rights or rights purchased vary according to project.

***M.O.R. RECORDS**, 17596 Corbel Court, San Diego Ca 92128. (619)485-1550. FAX: (619)485-1883. President/Owner: Stuart L. Glassman. Estab. 1980. Produces CDs and tapes; jazz and pop. Recent releases: *Colors of My Life*, by Frank Sinatra Jr.; *As Time Goes By*, by Al Rosa; and *Shifting Whispering Sands*, by Wally Flaherty.
Needs: Produces 2 soloists/year. Prefers artists with experience in pop/M.O.R. music. Uses artists for CD cover design and tape cover illustration.
First Contact & Terms: Send query letter with resume. Samples are filed. Reports back within 2 months. Portfolio should include thumbnails. Pays by the project. Rights purchased vary according to project.

Baltimore, Maryland-based Ben Crenshaw has a knowledge of "the history of Celtic art and has been drawing in the Celtic style for many years," states Maggie Sansone of Maggie's Music. These qualities made him the right person to design the cover for an album of instrumental Celtic music. Done in mixed media, Sansone feels it to be "a dramatic, strong visual image that reproduces well for [their] advertising needs." She appreciated the way Crenshaw "explained the various techniques and printing options [that could be used] to save money. He also considered how the image would look when reduced for print advertising."

© Maggie Sansone 1987

***MAGGIE'S MUSIC, INC.**, Box 4144, Annapolis MD 21403. (301)268-3394. President: Maggie Sansone. Estab. 1984. Produces folk music of British Isles and Ireland, American instrumental folk. Recent releases: "Sounds of the Season," by Maggi Sansone, "Mist & Stone," by Maggi Sansone, and "Grey Eyed Morn," by Sue Richards.
Needs: Produces 1-2 soloists and 1-2 groups/year. Works with 2 visual artists/year. Prefers artists with experience in album covers and folk art. Works on assignment only. Uses artists for CD cover design and illustration; album/tape cover design and illustration; brochure design and illustration; catalog design, illustration and layout.
First Contact & Terms: Send query letter with brochure. Samples are filed. Reports back only if interested. To show a portfolio, mail appropriate materials; call after sending materials. Portfolio should include roughs and samples of finished work. Payment negotiated. Buys all rights; vary according to project.
Tips: "Send samples of work, color and b&w."

***MECHANIC RECORDS, INC.**, 2nd Floor, 6 Greene St., New York NY 10013. (212)226-7272. FAX: (212)941-9401. Vice-President: Holly Lane. Estab. 1988. Produces CDs, tapes and albums; pop and rock and roll. Recent releases: "Trixter," by Trixter; "Nothingface," by Voivod; and "Dancin' on Coals," by Bang Tango.
Needs: Produces 5-7 groups/year. Works with 3 visual artists/year. Uses artists for CD cover design and illustration, album/tape cover design and illustration, brochure design and illustration, direct mail packages, advertising design and illustration, posters.
First Contact & Terms: Send query letter with brochure, resume, tearsheets, photostats, photocopies. Samples are filed and not returned. Reports back only if interested. To show a portfolio, mail appropriate materials. Payment varies. Rights purchased vary according to project.

MODERN MUSIC VENTURES, INC., 5626 Brock St., Houston TX 77023. (713)926-4431. FAX: (713)926-2253. Vice President Operations: David Lummis. Estab. 1986. Produces CDs, tapes and albums: rock and roll, classical, country/western, jazz, dance, rap, Latin (especially Tejano); solo and group artists. Recent releases: "La Primeva Vez," by Rick Gonzales and the Choice; "Fantasy," by Dizzy Gillespie and Arnett Cobb.
Needs: Produces 6 soloists and 6 groups/year. Works with 3 visual artists/year. Prefers artists with experience in cover art, artist photographs, etc. Works on assignment only. Uses artists for CD and album/tape cover design and illustration, posters, banners, logos, etc.

First Contact & Terms: Send query letter with samples. Samples are filed. Pays by the project, $100-2,500. Rights purchased vary according to project.
Tips: "Work 'on spec' with a small independent in order to obtain a final product as demo, in support of other materials."

***NARADA PRODUCTIONS, INC.**, 1835 N. Farwell Ave., Milwaukee WI 53202. (414)272-6700. FAX: (414)272-6131. Image Research: Kathy Lanser. Estab. 1980. Produces CDs and tapes; New Age. Recent releases: "Wilderness Collection," by various; "Skyline Firedance," by David Lanz; and "In Wake of the Wind," by David Arkenstone.
Needs: Works with 10-20 visual artists/year. Prefers to purchase rights to existing work. Uses artists for CD cover illustration, tape cover design and illustration.
First Contact & Terms: Send query letter with brochure, tearsheets, slides, SASE, photocopies, and transparencies. Samples are filed or returned by SASE. Reports back only if interested. To show a portfolio, mail tearsheets and photographs. Pays by the project. Rights purchased vary according to project.

NERVOUS RECORDS, 4/36 Dabbs Hill Lane, Northolt, Middlesex England. (01)963-0352. FAX: (01)961-8110. Contact: R. Williams. Produces rock and roll and rockabilly. Recent releases: "Boppin in Canada," by various artists and "Mayday," by the Scamps. (CDs).
Needs: Produces 7 albums/year; works with 7 groups and soloists/year. Works with 3 freelance designers/year; 2 freelance illustrators/year. Uses artists for album cover, brochure, catalog and advertising design.
First Contact & Terms: Send query letter with samples; material may be kept on file. Write for appointment to show portfolio. Prefers tearsheets as samples. Samples not filed are returned by SAE (nonresidents include IRC). Reports only if interested. Original art returned to the artist. Pays for design and illustration by the project, $50-200 average. Considers available budget and how work will be used when establishing payment. Purchases first rights.
Tips: "We have noticed more use of imagery and caricatures in our field so fewer actual photographs are used." Wants to see "examples of previous album sleeves, in keeping with the style of our music."

***NESAK INTERNATIONAL**, Box 588, Florham Park NJ 07932. (201)808-9776. FAX: (201)808-9664. General Manager: Doris Chodorcoff. Estab. 1989. Produces CDs and tapes; jazz, classical and reggae; group and solo artists. Recent releases: "Life Out On The Road," by Jay Leonhart; "Sister Rosetta Tharpe in Concert," by Sister Rosetta Tharpe; and "Reggae Fever," by Ronnie Benjamin.
Needs: Produces 6 soloists and 4 groups/year. Works with 15 visual artists/year. Works on assignment only. Uses artists for CD cover design and illustration, album/tape cover design and illustration and catalog design.
First Contact & Terms: Send query letter with brochure, resume, photographs. Samples are not filed and are returned by SAE if requested by artist. Reports back within 2 weeks. To show a portfolio, call or mail appropriate materials. Portfolio should include thumbnails. Negotiates rights purchased.

***NEXT STEP RECORDS**, 912 E. 3rd St., Studio 104, Los Angeles CA 90013. (213)617-3362. FAX: (213)617-1544. President: Barbara Wright. Estab. 1990. Produces CDs and tapes; ballroom, Latin and swing dance music. Recent releases: "Neon Ballroom," by Tango Nomads and "Mean Maxine," by Nobody's Baby.
Needs: Produces 2 or 3 groups/year. Works with 2 or 3 visual artists/year. Prefers local artists only. Uses artists for album/tape cover illustration and CD cover illustration.
First Contact & Terms: Send query letter with tearsheets, photographs, photocopies and SASE. Samples are filed or returned by SASE if requested by artist. Reports back only if interested. Call to schedule an appointment to show a portfolio, which should include original/final art, tearsheets and photographs. Pays by the project, $200-1,000. Buys all rights.
Tips: "We are always looking for contemporary art which shows dancing couples in dramatic and/or romantic poses."

***NICOLETTI PRODUCTIONS INC./GLOBAL VILLAGE RECORDS**, Box 2818, Newport Beach CA 92663. (714)494-0181. FAX: (714)494-0982. President: J. Nicoletti. Estab. 1976. Produces CDs, tapes and albums; rock and roll, jazz, rap, group artists, rhythm and blues, soul, pop, folk, country/western and dance; group and solo artists. Recent releases: *Soldiers Eyes*, by Joseph Nicoletti; *Lets Put the Fun Back in Rock'n'Roll*, by Fabian, Frankie Avalon, Bobby Rydell; and *Do It Again*, by Cheryl.
Needs: Produces 3 soloists/year. Works with 10 visual artists/year. Uses artists for all design, illustration and layout work.
First Contact & Terms: Send query letter with tearsheets, photostats, resume, SASE, photographs, slides, photocopies and transparencies—Present "a clean package of your best work." Samples are filed. Reports back within 3 weeks. Call to schedule an appiontment to show a portfolio, which should include "whatever you need to show." To show a portfolio, mail appropriate materials. Payment negotiated. Negotiates rights purchased.

***NORTHEASTERN RECORDS**, Box 3589, Saxonville MA 01701-0605. (508)820-4440. FAX: (508)820-7769. General Manager: Lynn Joiner. Estab. 1980. Produces CDs and tapes; rock and roll, jazz, classical, folk and country/western. Recent releases: "Andanzas: Songs of South America," by Andanzas; "Return of the Neanderthal Man," by the Fringe; and "Brahms, Op. 114,115," by the Boston Chamber Music Soc.
Needs: Produces 8-10 titles/year. Works with 4-5 graphic artists/year. Prefers Boston area artists only with experience in design. Works on assignment only. Uses artists for CD cover design and illustration.
First Contact & Terms: Send query letter with brochure. Samples are filed or returned by SASE if requested by artist. Does not report back, in which case the artist should call. Call to schedule an appointment to show a portfolio, which should include examples of color design work. Pays by the CD/cassette project, $400-500. Buys all rights to design. Negotiates rights purchased for original art.
Tips: "Get to know people at labels and be willing to work cheap."

NORTHWEST INTERNATIONAL ENTERTAINMENT, INC., 5503 Roosevelt Way NE, Seattle WA 98105. (206)524-1020. FAX: (206)524-1102. Art Director: David Sterling. Produces rock and roll, soul, jazz, pop, rhythm and blues; group and solo artists. Recent releases: "Recuerdos demi Pueblo Cuautla," by Nicolas (tape).
Needs: Produces 2-3 soloists and 2-3 groups/year. Works with 2-3 freelance desingers and illustrators/year. Works on assignment only. Uses artists for album cover design and illustration and posters. Style of promotional materials and cover depends on the project.
First Contact & Terms: Send query letter with brochure or resume and tearsheets, photostats and photocopies. Samples are filed or are returned by SASE. Reports back within 1 month. Write to schedule an appointment to show a portfolio. Pays by the project, $50 minimum. Considers complexity of project, available budget, skill and experience of artist, how work will be used, turnaround time and rights purchased when establishing payment. "We buy whatever rights are applicable to our needs."
Tips: "Send resume and samples — if we are interested, we will contact you." Looking for "creativity and orginality."

NUCLEUS RECORDS, Box 111, Sea Bright NJ 07760. President: Robert Bowden. Produces country/western, folk and pop. Recent release: "Herry C," and "Selfish Heart," by Robert Bowden (tapes).
Needs: Produces 2 records/year. Artists with 3 years' experience only. Works with 2-3 freelance designers and illustrators/year. Works on assignment only. Uses artists for album cover design.
First Contact & Terms: Send query letter with resumes, original work and photographs. Write for appointment to show a portfolio, which should include photographs. Samples are returned. Pays for design by the project, $125-150. Pays for illustration by the project, $150-200. Reports within 1 month. Originals returned to artist after job's completion. Considers skill and experience of artist when establishing payment. Buys all rights.

OUR GANG ENTERTAINMENT, INC., 33227 Lake Shore Blvd., Eastlake OH 44095. (216)951-9787. FAX: (216)974-1004. Art Director: Linda L. Lindeman. Produces rock and roll, jazz, pop, educational, rhythm and blues, exercise albums and promotional advertising discs. Recent releases: "All For You," by Link; "Dancersize," by Carol Hensel and "Vintage Gold," collections of masters.
Needs: Produces 10 records/year. Works with 10-15 freelance designers and illustrators/year. Assigns 50-75 freelance jobs/year. Uses artists for album cover, poster, brochure and advertising design and illustration; brochure and advertising layout; and direct mail packages. Theme depends on nature of the job; "we often use airbrush illustrations, line drawings of exercise positions and routines." Especially needs illustration of human features and positions. Promotional materials have a nostaligic look.
First Contact & Terms: Artist must show ability to produce. Send query letter with resume and samples; call or write for appointment to submit portfolio for review. Prefers photostats, slides or originals as samples. Samples returned with SASE. Reports in 2 weeks. Works on assignment only. Original work not returned to artist after job's completion. Pays for design and illustration by the project, $150-500. Considers available budget and turnaround time when establishing payment. Buys all rights.
Tips: "We have a need for logo design; abstract and old fashioned designs are becoming a trend."

 The asterisk before a listing indicates that the listing is new in this edition. New markets are often the most receptive to freelance submissions.

***PAN-TRAX RECORDS/USA MANAGEMENT,** 112 South Main St., Dickson TN 37055. (516)446-5431. FAX: (615)446-5493. Manager: Nikolai P. Estab. 1987. Produces CDs, tapes and albums; rock and roll, jazz, rap, rhythm and blues, soul, pop, classical, books, printed music, etc.; group and solo artists. Recent releases include the following recording artists: Ruscha, Shawn C. and Scott Anderson.
Needs: Works with 10 visual artists/year. Prefers artists with experience in T-shirts and graphics. Uses artists for all types of illustration and design, including T-shirt and books.
First Contact & Terms: Send query letter with brochure, resume, photographs. Samples are filed. Reports back only if interested. To show a portfolio, mail photographs. Pays royalties of sales. Buys all rights.
Tips: Looking for "excellent, creative, original and affordable work."

PARC RECORDS, INC., Box 547877, Orlando FL 32854-7877. (407)292-0021. FAX: (407)896-4597. Contact: Art Director. Produces rock and roll and pop records; group and solo artists. Recent releases: "Lightning Strikes Twice," by Molly Hatchet; and "Body Language," by Ana.
Needs: Produces 3 soloists and 3 groups/year. Uses artists for album cover design and illustration, brochure and direct mail package design and advertising design and illustration.
First Contact & Terms: Contact only through artist's agent. Reports back only if interested. Pays for design and illustration by the project, $150-10,000. Considers available budget when establishing payment.

PLANKTON RECORDS, 236 Sebert Rd., Forest Gate, London E7 ONP England. (081)534-8500. Senior Partner: Simon Law. Produces rock and roll, rhythm and blues, funk and gospel; solo and group artists. Recent releases: *Light Factory*, by Light Factory Muscians and *Pride and Pain*, by Solid Air. (Tapes).
Needs: Produces 2 soloists and 2 groups/year. Works with 1 freelance designer and illustrator/year. "We usually work with a freelance visual artist if he or she is connected to and sympathetic with the recording artist." Works on assignment only. Uses artists for album cover design and illustration.
First Contact & Terms: Send query letter with brochure. Samples not filed are returned by SASE and IRC. Reports back within 2 months. Pays for design and illustration by the project, $150-250. Considers available budget when establishing payment. Buys reprint rights.
Tips: "All the products that we release have a Christian bias, regardless of musical style. This should be borne in mind before making an approach."

PPI ENTERTAINMENT GROUP, (formerly Peter Pan Industries), 88 St. Francis St., Newark NJ 07105. (201)344-4214. Creative Director: Dave Hummer. Estab. 1923. Produces rock and roll, dance, soul, pop, educational, rhythm and blues, aerobics and self-help videos; group and solo artists. Recent releases: "Happy Birthday Baby" and "James Dean: A Tribute," by various artists.
Needs: Produces 15 records and videos/year. Works with 8 freelance designers/year and 10 freelance illustrators/year. Uses artists for album cover design and illustration; brochure, catalog and advertising design, illustration and layout; direct mail packages; posters; and packaging.
First Contact & Terms: Works on assignment only. Send query letter with samples to be kept on file; call or write for appointment to show portfolio. Prefers photocopies or tearsheets as samples. Samples not filed are returned only if requested. Reports only if interested. Original artwork returned to artist. Pays by the project. Considers complexity of project and turnaround time when establishing payment. Purchases all rights.

R.E.F. RECORDING CO./FRICK MUSIC PUBLISHING CO., 404 Bluegrass Ave., Madison TN 37115. (615)865-6380. Contact: Bob Frick. Produces country/western and gospel. Recent releases: "My Little Girl," by Scott Frick; "She's Gone Forever," by Craig Steele and "Time Tricks and Politics," by Eddie Isaacs.
Needs: Produces 30 records/year; works with 10 groups artists/year. Works on assignment only.
First Contact & Terms: Send resume and photocopies to be kept on file. Write for appointment to show portfolio. Samples not filed are returned by SASE. Reports within 10 days only if interested.

RECORD COMPANY OF THE SOUTH, 5220 Essen Lane, Baton Rouge LA 70807. (504)766-3233. Art Director: Ed Lakin. Produces rock and roll and rhythm and blues. Recent releases: "Don't Take It Out on the Dog," by Butch Hornsby; "World Class," by Luther Ken; and "Off My Leg," by Terry Burhans.
Needs: Produces 5 records/year; 20% of the album covers are assigned to freelance illustrators. Assigns 1 job/year. Uses artists for album cover and poster illustration and direct mail packages.
First Contact & Terms: Prefers artists from the South. Make contact through agent; send query letter with brochure/flyer and samples. Prefers photostats and slides as samples. Samples returned by SASE. Reports within 3 weeks. Works on assignment only; reports back on whether to expect possible future assignments. Provide brochure/flyer to be kept on file for possible future assignments. Original work returned to artist after job's completion. Pays by the project, $500-1,000 average; by the hour, $40-70 average; or a flat fee of $1,000 for covers. Considers complexity of project and available budget when establishing payment. "We generally buy first rights and reprint rights."
Tips: "Illustrators need to stay on the cutting edge of design." Make personal contact before sending samples. "Look at Dave Bathel's work out of St. Louis—hottest graphic designer in the country."

RELATIVITY RECORDS, 187-07 Henderson Ave., Hollis NY 11423. (718)464-9510. Art Director: David Bett. Estab. 1979. Produces CDs, tapes: rock and roll, jazz, rap, pop and heavy metal; solo artists. Recent releases: "Passion and Warfare," by Steve Vai and"Here Comes Trouble," by Scatterbrain (CDs and tapes).
Needs: Produces 5-10 solo and 20-25 groups/year. Works with 10-20 freelance illustrators/year. Prefers artists with experience in "anything from underground comic-book art to mainstream commercial illustration." Works on assignment only. Uses artists for CD and album cover, brochure and catalog illustration; posters; logo art; and lettering. Style and tone for design includes "the full spectrum of styles."
First Contact & Terms: Send slides, tearsheets or photostats. Samples are filed or returned with SASE. Reports back only if interested. Call or write to show a portfolio, which should include color and b&w slides or transparencies or printed samples. Pays by the project, $500-2,500. Considers complexity of project, available budget and rights purchased when establishing payment. Rights purchased vary according to project.
Tips: "We seek creative people with imagination. Avoid the obvious"

RHYTHMS PRODUCTIONS, Whitney Bldg., Box 34485, Los Angeles CA 90034. President: R.S. White. Estab. 1955. Produces albums, tapes and books: educational children's. Recent titles include "Adventures of Professor Whatzit and Carmine Cat," by Dan Brown and Bruce Crook.
Needs: Works on assignment only. Prefers California artists. Produces varying number of cassettes/year, all of which have covers/jackets designed and illustrated by freelance artists. Works with 1-2 visual artists/year. Prefers artists with experience in cartooning. Uses freelance artists for album/tape cover design and illustration and children's books.
First Contact & Terms: Send query letter photocopies and SASE. Samples are filed or are returned by SASE if requested by the artists. Reports within 1 month. "We do not review portfolios unless we have seen photocopies we like." Pays by the project. Buys all right.
Tips: "We like illustration that is suitable for children. We find that cartoonists have the look that we prefer. However, we also like art that is finer and that reflects a quality look for some of our more classical publications."

***ROB-LEE MUSIC**, Box 37612, Sarasota FL 34237. (813)377-1877. FAX: (813)377-1877. President: Rob Russen. Estab. 1966. Produces CDs, tapes and albums; rock and roll, jazz, rhythm and blues, soul, pop, country/western; group and solo artists. Recent releases: "Paradise," by Adrienne West; "DDT," by Preston Steele; "I Came to Dance," by Phoenix.
Needs: Produces 3-6 soloists and 6-10 groups/year. Works with 10-12 visual artists/year. Works on assignment only. Uses artists for CD cover design and illustration, album/tape cover illustration, direct mail packages, posters and logos.
First Contact & Terms: Send query letter with brochure, resume, SASE, and photographs. Samples are filed. Reports back only if interested. To show a portfolio, mail thumbnails, b&w photostats and photographs. Payment negotiated. Buys all rights.

ROWENA RECORDS & TAPES, 195 S. 26th St., San Jose CA 95116. (408)286-9840. Owner: Jeannine O'Neal. Estab. 1967. Produces CDs, tapes and albums: rock and roll, rhythm and blues, country/western, soul, rap, pop and new age; group artists. Recent releases: "Lady's Choice," "Catfish On A Stick," by Jeannine O'Neal; "Up On The Edge," by Jaque Lynn; and "Can You Feel It," by Charlie (albums).
Needs: Produces 20 soloists and 5 groups/year. Uses artists for CD cover design and illustration, album/tape cover design and illustration and posters.
First Contact & Terms: Send query letter with brochure, resume, SASE, tearsheets, photographs, photocopies and photostats. Samples are filed or are returned by SASE. Reports back within 1 month. To show a portfolio, mail original/final art. "Artist should submit prices."

***SADDLESTONE PUBLISHING AND RECORDING**, 264 'H' St., Box 8110-21, Blaine WA 98230. (604)535-3129. A&R and Marketing: Harold Wainwright. Estab. 1986. Produces CDs, tapes and albums; rock and roll, rhythm and blues, pop, country/western; solo artists. Recent releases: "Fragile," by Razzy Bailey; "No More on the Outside," by Ray St. Germain; and "Wild One," by Randy Friskie.
Needs: Produces 26 soloists and 4 groups/year. Works with 5 visual artists/year. Works only with artists reps. Uses artists for CD cover design and illustration, album/tape cover design and illustration, brochure design and illustration, advertising design and illustration, posters.
First Contact & Terms: Send query letter with resume and photographs. Samples are filed. Reports back within 6 months. To show a portfolio, mail original/final art, b&w and color materials. Pays by the project, $150-1,100. Rights purchased vary according to project.

***SAM RECORDS, INC.**, 76-05 51st Ave., Elmhurst NY 11373. (718)335-2112. FAX: (718)335-2184. Promotions Director: Tina Bennet. Estab. 1976. Produces CDs, tapes and albums; rap, rhythm and blues and dance. Recent releases: "Spread a Little Love," by Richard Rogers; "This Dub is Mine," by Desire; and "Let's Do It in the Dancehall," by Jamal-Ski.

Needs: Produces 6 soloists and 6 groups/year. Works with 3 visual artists/year. Prefers local artists only. Works on assignment only. Uses artists for CD cover design and illustration, album/tape cover design and illustration, advertising design and illustration, posters.
First Contact & Terms: Send query letter with brochure, tearsheets and resume. Samples are filed. Reports back only if interested. Call to schedule an appointment to show a portfolio. Pays by the project. Buys all rights.

SAN-SUE RECORDING STUDIO, Box 773, Mt. Juilet TN 37122. (615)754-5412. Owner: Buddy Powell. Estab. 1970. Produces tapes and albums: rock and roll, country/western and pop. Recent releases: "Little People," by Sue Powell; "My Way," by Jerry Baird; and "Which Way You Going Billy," by Sandi Powell.
Needs: Produces 20 soloists and 5 groups/year. Works with 3-4 visual artists/year. Works on assignment only. Uses artists for CD cover design, album/tape cover design and illustration, advertising design and posters.
First Contact & Terms: Send query letter with brochure, resume and SASE. Samples are filed or are returned by SASE. Reports back within 10 days. Write to schedule an appointment to show a portfolio, which should include photostats.

SEASIDE RECORDS, 100 Labon, Tabor City NC 28463. (919)653-2546. President: Elson H. Stevens. Produces rock and roll, country/western, pop, rhythm and blues, beach music and gospel. Recent releases: "Here I Go Again," by Angela; and "On the Down Side," by T.J. Gibson.
Needs: Work with various visual artists/year. Works on assignment only. Uses artists for album cover design and illustration, direct mail packages, posters and sleeves.
First Contact & Terms: Send query letter with brochure. Samples are filed. Reports back within 60 days. Call to schedule an appointment to show a portfolio, which should include color and b&w final reproduction/product. Pays by the project, $200 minimum. Considers complexity of project and available budget when establishing payment. Buys all rights.
Tips: Wants to see "finished project. Do not send draft works."

***SHAPRICE PRODUCTIONS INC.**, 832 S. 2nd St., Philadelphia PA 19147. (215)467-3900. President of Operations: Terry Price. Estab. 1990. Produces CDs, tapes and albums; rap, rhythm and blues, and pop. Recent releases: "Let Freedom Ring," by John Whitehead.
Needs: Produces 2 soloists and 2 groups/year. Prefers artists with experience in graphics, layout and design. Works on assignment only. Uses artists for CD cover design and illustration, album/tape cover design and illustration and posters.
First Contact & Terms: Send query letter with photographs. Samples are filed. Reports back only if interested. Call to schedule an appointment to show a portfolio, which should include roughs, original/final art and photographs. Pays by the project. Buys all rights.

SIRR RODD RECORD & PUBLISHING COMPANY, Box 58116, Philadelphia PA 19102-8116. President: Rodney J. Keitt. Estab. 1985. Produces dance, soul, jazz, pop, rhythm and blues; group and solo artists. Recent releases: "Fashion & West Oak Lane Jam," by Klassy K; and "The Essence of Love/Ghetto Jazz," by Rodney Jerome Keitt.
Needs: Produces 2 soloists and 3 groups/year. Works with 1 visual artist/year. Works on assignment only. Uses artists for album cover design and illustration, direct mail packages, advertising design and illustration and posters.
First Contact & Terms: Send query letter with resume, photostats, photocopies and slides. Samples are filed and are not returned. Reports back within 2 months. Write to show a portfolio, which should include color thumbnails, roughs, final reproduction/product, photostats and photographs. Pays by the project, $100-3,500. Considers available budget, skills and experience of artist, how work will be used and rights purchased when establishing payment. Buys reprint rights or negotiates rights purchased.
Tips: "Treat every project as though it was a major project. Always request comments and criticism of your work."

SLAMDEK/SCRAMDOWN, Box 43551, Louisville KY 40253. (502)244-8694. Submissions Analyst: Matilda Pfenstemeyer. Estab. 1986. Produces CDs, tapes and DATs: rock and roll, alternative rock, hardcore, punk rock cover bands, acoustic thrash, etc. Recent releases: "Blurry," by Hopscotch Army; "If the Spirits are Willing," by Endpoint; and "Memphis Sessions," by Slambang Vanilla Featuring Jesus Rosebud.
Needs: Produces 5-10 groups/year. Works with 1-3 freelance designers and illustrators/year. Prefers artists with experience in color and photograph integration. Works on assignment only. Uses artists for CD cover design and illustration; album/tape cover design and illustration; brochure design and illustration; catalog design, illustration and layout; advertising design and illustration; posters and promotional holographs.
First Contact & Terms: Send query letter with SASE, tearsheets and photographs. Samples are filed. To show a portfolio, mail color tearsheets and photographs. Payment varies. Rights purchased vary according to project.

Tips: "What is garbage to you may be a goldmine to someone else. Expect nothing and you won't be disappointed." Cover art is "dayglow neon post-renaissance pornography."

SPHEMUSATIONS, 12 Northfield Rd., One House, Stowmarket Suffolk IP14 3HE England. 0449-613388. General Manager: James Butt. Produces classical, country/western, jazz and educational records. Recent releases: "Little Boy Dances," by G. Sudbury; "The Magic of Voice & Harp," by P. Scholomowitz and Andre Back; and "P. Mendel: Route 56," by Paul Mendel.
Needs: Produces 6 soloists and 6 groups/year. Works with 1 visual artist/year. Works on assignment only. Uses artist for album cover design and illustration, brochure design and illustration, catalog design and layout, direct mail packages, advertising design and illustration and posters.
First Contact & Terms: Contact through artist's agent or send query letter with resume, tearsheets, photostats and photocopies. Samples are filed or are returned only if requested. Reports back within 6 weeks. Write to show a portfolio, which should include final reproduction/product and color and b&w photostats and photographs. Pays for illustration by the project, $500-2,000. Considers complexity of project, available budget, skills and experience of artist, how work will be used, turnaround time and rights purchased when establishing payment. Buys reprint rights, all rights or negotiates rights purchased.
Tips: Looks for "economy, simplicity and directness" in artwork for album covers.

SRSF RECORDINGS/ENTERTAINMENTS ENTERPRISES, Box 14131, Denver CO 80214. President: Sharon Smith-Fliesher. Estab. 1980. "Our company produces and distributes musical works in the form of cassettes, 45's, LP's and CD's;" members are musicians. In-conjunction with *Lambda Performing Arts Guild* Performing Arts Consulting Firm.
Needs: Works with 6 freelance artists/year. Looks for a contemporary tone and style. Uses freelance artists mainly for album design/artwork. Also uses freelance artists for advertising layout, brochure design, illustration and layout. Prefers line art.
First Contact & Terms: Send query letter with brochure, resume, tearsheets, photostats and photocopies. Samples are filed or are returned by SASE only if requested. Reports back within 6 weeks. Mail appropriate materials: roughs, original/final art, b&w photostats, tearsheets, final reproduction/product. Pays for design/illustration by the hour, $10-15. Buys all rights. "Our company caters to the gay and lesbian community. All others also welcome."

***STARDUST RECORDS/WIZARD RECORDS**, Drawer 40, Estill Springs TN 37330. Contact: Col. Buster Doss, Box 13, Estill Springs TN 37330. (615)649-2577. Produces CDs, tapes and albums; rock and roll, folk, country/western. Recent releases: "I'll Never Find Another You," by R.B. Stone; "The Man I Love," by Linda Wonder; and "I'll Come Back," by Cliff Archer.
Needs: Produces 12 soloists and 4 groups/year. Works with 3 or 4 visual artists/year. Works on assignment only. Uses artists for CD cover design and illustration, album/tape cover design and illustration, brochure design, and posters.
First Contact & Terms: Send query letter with brochure, tearsheets, resume and SASE. Samples are filed. Reports back within 1 week. Call to schedule an appointment to show a portfolio, which should include thumbnails, b&w photostats. Pays by the project, $300. Buys all rights.

SUSAN RECORDS, Box 4740, Nashville TN 37216. (615)865-4740. Manager: Susan Neal. Produces rock and roll, dance, soul, country/western, rock-a-billy, jazz, pop and rhythm and blues; group and solo artists. Recent release: "That's It Baby," by Dixie Dee.
Needs: Produces 15 records/year. Uses artists for album cover design and illustration; brochure design, illustration and layout; catalog design, illustration and layout; advertising design and layout.
First Contact & Terms: Send brochure, business card, SASE and photographs to be kept on file unless return requested. Samples not filed are returned by SASE. Reports within 15 days. Original art returned to the artist. Write for appointment to show a portfolio. Considers available budget and rights purchased when establishing payment. Negotiates rights purchased.

***MICK TAYLOR MUSIC**, % Jacobson & Colfin, P.C., 156 5th Ave., New York NY 10010. (212)691-5630. FAX: (212)645-5038. Attorney: Bruce E. Colfin. Estab. 1985. Produces CDs, tapes and albums; rock and roll, rhythm and blues; group and solo artists. Recent releases: "Stranger in This Town," by Mick Taylor (MAZE Records).
Needs: Produces 1- soloists and 1-2 groups/year. Works with 2-3 visual artists/year. Works on assignment only. Uses artists for CD cover design and illustration, and album/tape cover design and illustration.
First Contact & Terms: Send query letter with brochure, resume, SASE. Samples are filed or returned by SASE if requested by artist. Reports back within 6-8 weeks. Call or write to schedule an appointment to show a portfolio, which should include tearsheets. Pays by the project. Rights purchased vary according to project.

TEROCK RECORDS, Box 4740, Nashville TN 37216. Manager: S.D. Neal. Estab. 1959. Produces CDs, tapes and albums: rock and roll, jazz, rap, rhythm and blues, soul, pop, rock-a-billy, country/western, dance; solo and group artists. Recent releases: "Changes," by Ritchie Derwald; "Bright Lights," by Dixie Dee & the Rhythm Rockers; and "Wild Rock," by Mickey Finn.
Needs: Produces 6 soloists and 4-8 groups/year. Works with various visual artists/year. Works on assignment only. Uses artists for CD cover design and illustration, album/tape cover design and illustration, direct mail packages, posters, brochure design and illustration, advertising design and illustration, and catalog layout.
First Contact & Terms: Send query letter with brochure, SASE, photographs and photocopies. Samples are filed or are returned by SASE if requested by artist. Reports back within 3 weeks. Write to schedule an appointment to show a portfolio or mail appropriate materials. Portfolio should include roughs, original/final art and b&w and color photostats and photographs. Payment varies. Negotiates rights purchased.

***TEXAS STAR INTERNATIONAL**, Box 460086, Garland TX 75046. (214)497-1616. President: Lonny Schonfeld. Estab. 1988. Produces CDs and tapes; rock and roll, pop, educational and country/westerns; group artists. Recent releases: "Jingle Bell Rock," by Bobby Priestley; "Man Overboard," by Heartland; "Let it Snow, Let it Snow, Let it Snow," by Donna Priestley.
Needs: Produces 2 soloists and 2 groups/year. Works with 4 visual artists/year. Prefers artists with experience in logos, advertising and children's art. Uses artists for CD cover design, album/tape cover design and illustration, brochure design, direct mail packages, advertising design and posters.
First Contact & Terms: Send query letter with SASE, photographs and other samples of work. Samples are filed or are returned by SASE if requested by artist. Reports back within 10 days. To show a portfolio, mail original/final art and photographs. Pays by the project, $100 minimum. Buys all rights. Rights purchased vary according to project.
Tips: "Be original—if we wanted someone else's style, we would hire them."

TOP RECORDS, 4, Galleria del Corso, Milano Italia. (02)76021141. FAX: 0039/2/76021141. Estab. 1975. Produces CDs, tapes, albums: rock and roll, rap, rhythm and blues, soul, pop, folk, country/western, dance; solo and group artists. Recent releases "You Set My Heart on Fire," by Tina Charles; "Contrabbandieri Di Musica," by Goran Kuzmicac; and "Space Vampires," by Henry Mancini.
Needs: Produces 5 soloists and 5 groups/year. Works with 2 visual artists/year. Works on assignment only.
First Contact & Terms: Send query letter with brochure. Samples are filed or are returned. Reports back within 2 weeks. Call to schedule an appointment to show a portfolio or mail appropriate materials. Portfolio should include original/final art and photographs. Buys all rights.

***UNDERGROUND RELEASE RECORDS**, Suite 245, 1724 Sacramento St., San Francisco CA 94109. (415)474-0662. Estab. 1984. Produces CDs, tapes and albums: ethnic and alternative. Recent releases: *D' Cuckoo*, by D'Cuckoo; *Taiko Dojo Live*, by San Francisco Taiko Dojo.
Needs: Produces 3-4 soloists/year. Works on assignment only. Uses artists for CD cover album/tape cover design, album/tape cover illustration.
First Contact & Terms: Send query letter with tearsheets and resume. Samples are filed. Reports back to the artist only if interested. Call. Pays by the project. Rights purchased vary according to project.

VELVET PRODUCTION CO., 517 W. 57th St., Los Angeles CA 90037. (213)753-7893. Manager: Aaron Johnson. Produces soul and rhythm and blues. Recent releases: "There are Two Sides to Every Coin," by Arlene Bell; and "I Ain't Jiving, Baby," by Chick Willis.
Needs: Produces 6 records/year. Works with 6 freelance artists/year. Experienced artists only. Works on assignment only. Uses artists for posters, album cover illustration, brochure design and catalog layout.
First Contact & Terms: Send query letter with brochure showing art style or resume, photostats and photocopies to be kept on file. Samples not kept on file are returned by SASE. Reports only if interested. Original artwork is returned after job's completion. Write for appointment to show a portfolio. Pays by the project, $50-200 average. Negotiates rights purchased.

WARNER BROS. RECORDS, 3300 Warner Blvd., Burbank CA 91505. (818)953-3361. FAX: (818)953-3232. Art Dept. Assistant: Michelle Barish. Produces CDs, tapes and sometimes albums: rock and roll, jazz, rap, rhythm and blues, soul, pop, folk, country/western; solo and group artists. Recent releases: *Out of Time*, by R.E.M. and *Rhythm of the Saints*, by Paul Simon. (CDs, tapes, albums). Releases approximately 150 total packages/year.
Needs: No restrictions regarding freelance artists. Works on assignment only. Uses freelance artists for CD cover design and illustration; album tape cover design and illustration; brochure design and illustration; catalog design, illustration and layout; advertising design and illustration; and posters.
First Contact & Terms: Send query letter with brochure, tearsheets, resume, slides and photographs. Samples are filed or are returned by SASE if requested by artist. Reports back to the artist only if interested. Submissions should include roughs, original/final art and b&w and color tearsheets, photographs, slides and transparencies. "Any of these are acceptable." Pays $12-35; by the project. Buys all rights.

Tips: "Send a portfolio—we tend to use artists or illustrators with distinct/stylized work—rarely do we call on the illustrators to render likenesses; more often we are looking for someone with a conceptual or humorous approach."

***WELK MUSIC GROUP**, Suite 800, 1299 Ocean Ave., Santa Monica CA 90401. (213)451-5727. FAX: (213)394-4148. Preproduction Coordinator: Georgett Cartwright. Estab. 1987. Produces CDs, tapes and albums; rhythm and blues, jazz, soul, folk, country/western; solo artists. Recent releases: "Let It Fly," by The Dillards; "Memphis Boys," by The Memphis Boys, and "Swingin' Blues," by Pete Fountain.

Needs: Produces 2 soloists and 6 groups/year. Prefers artists with experience in the music industry. Uses artists for CD cover design and illustration, album/tape cover design and illustration; catalog design, illustration and layout; direct mail packages; advertising design.

First Contact & Terms: Send query letter with brochure, resume, photographs and printed samples. Samples are filed. Reports back only if interested. To show a portfolio, mail tearsheets and printed samples. Pays by the project. Buys all rights.

***WORLD ARTIST RECORDS**, Box 405, Alamo CA 94507. (415)254-4600. Vice President: Randal Larsen. Estab. 1953. Produces CDs, tapes and albums: rock and roll, jazz; group and solo artists.

Needs: Prefers professional talent only. Uses artists for all types of design and illustration.

First Contact & Terms: Send query letter with brochure, SASE, photocopies. Samples are filed or returned by SASE. Reports back to the artist only if interested. To show a portfolio, mail photostats and tearsheets. Pay by the project. Rights purchased vary according to project.

Other Record Companies

Each year we contact all companies currently listed in *Artist's Market* requesting they give us updated information for our next edition. We also mail listing questionnaires to new and established companies which have not been included in past editions. The following record companies either did not respond to our request to update their listings for 1992 (if they indicated a reason, it is noted in parentheses after their name), or they are firms which did not return our questionnaire for a new listing.

A & M Records
Alphabeat (late response)
The Amethyst Group Ltd. (late response)
Arista Records
Atlantic Records
AVM Corporation
Azra International
Big Bear Records (late response)
Billy Baker & Associates
Bernadol Music Limited
B.G.S. Productions Ltd.
Bovine Record Company (late response)
Capitol Records
Chrysalis Records
Comma Records & Tapes (late response)
Cosmotone Records (late response)
Cowboy Junction Flea Market & Publishing Co. (late response)
Current Records/Management
Demi Monde Records and Publishing Ltd. (late response)
Digimix International Records Ltd.
DKP Productions, Inc.
Dynacom Communications
Elektra/Asylum Records
EMI
Epic Records
Executive Records

Freckle Records
Frontline Music Group
Galactic Graphica
Geffen Records
Global Records (late response)
Grass Roots Records
Hard Hat Records & Cassette Tapes (late response)
I.R.S. Records
Island Records
K.A.M. Executive Records
Kicking Mules Records
King Klassic Records
Howard Knight Entertainment Group (asked to be deleted)
Lamon Records, Inc.
Larrco Industries of Texas, Inc.
Klarrco Satellite Radio and T.V. Division (late response)
Link Records
Majega Records/Productions
MCA Records
Meda Records Inc.
Mirror Records Inc.
Monticana Records (unable to contact)
Motown Records
Musica Schallplatten Vertrieb Ges. M.B.H.
Nise Productions Inc.
Ohio Records
Orbit Records
Original Cast Records
Orinda Records (late response)

Pink Street Records, Inc.
Play Records, Inc.
Polygram
Prairie Music Ltd. (late response)
Rapp Production Inc./Do it Now Productions Inc.
RCA Records
Rhino Records
Robbins Records, Inc. (late response)
Rockland Music, Inc.
Rik Tinory Productions
Shaolin Film & Records (late response)
Sony Music Entertainment, Inc.
Starcrest Productions (late response)
Tom Thumb Music (late response)
Trend Recording and Distributing Co. (late response)
Turf Handler Records, Inc.
Ugly Dog Records (unable to contact)
Virgin Records
Watchesgro Music BMI—Interstate 40 Records (late response)
Windham Hill Records
Zanzibar Records
Z-Zone Records (unable to contact)

Syndicates & Clip Art Firms

Syndicates are basically agents for cartoonists, selling comic strips, panels and editorial cartoons to newspapers and magazines. They also handle merchandising of licensed products. Features can be daily, daily and Sunday, Sunday only, weekly (no day specified) or, in the case of magazines, monthly or bimonthly. Strips usually originate with the syndicate, while editorial cartoons usually appear first in the editorial cartoonist's base newspaper, then in other papers that subscribe through the syndicate.

Syndicates are facing a shrinking market. There are fewer daily newspapers today than there were ten years ago, and with the recession the survivors are confronting cutbacks in feature budgets. Therefore, syndicate salespeople have fewer and less eager markets for new material. Also, editors hesitate to drop a long-established strip for a newcomer, because such moves always result in a deluge of reader complaints. This was the case when *The Washington Post* recently tried to drop the strips "Mark Trail," "Gasoline Alley," and "Steve Roper and Mike Nomad." Many of the strips' fans wrote to demand that the person responsible for the cuts be fired.

Comics are used in virtually every daily newspaper, with the exception of *The New York Times* and *The Wall Street Journal*, as one of the most effective vehicles for building circulation. What *The Post*'s cartoon reshuffler was trying to do was add five comics tailored for children and young adults to win and keep young readers.

This is the good news. Newspapers realize that without comics they would be in even deeper trouble; thus, the search for new and relevant strips has become more pressing. The slow but steady growth in the number of women cartoonists continues; there are now about 12 women among the 200 syndicated cartoonists. "Teenage Mutant Ninja Turtles" from Creators Syndicate and "Talk to Us" from Universal Press Syndicate are a couple of strips recently introduced for youth. There were also strips presented for the burgeoning older population, and the environment as a subject continues to be popular. The number of minority cartoonists continues to grow, an example of which is Stephen Bentley, creator of "Herb and Jamaal" and this year's Close-up.

Selling to syndicates is not an easy task, but it is achievable. Facing a shrinking market, syndicates are generally looking for a "sure thing," a feature they feel will be worth investing the $25,000 needed to promote and sell a new strip to newspapers. In general, syndicates look for originality, quality, salability and timeliness. Characters must have universal appeal in order to attract a diversity of readers.

The best approach to selling your work to syndicates is to submit work that has already been published regularly in a paper. This proves to the syndicate that you have established a loyal following and have produced a strip on a regular basis. Send a package to the syndicate's cartoon editor that contains a brief cover letter summarizing your idea, short biographical sketches of each character you show, and two dozen cartoon samples (never originals) on 8½ × 11 white paper. Unpublished cartoonists should build up their portfolios by cartooning for local papers before submitting work to a syndicate.

An alternative to syndication is self-syndication. Nicole Hollander proved it can be done with her strip "Sylvia." In this situation, cartoonists act as their own salespeople, sending

packets to newspapers and other likely outlets. This requires developing a mailing list, promoting the strip periodically and developing a pricing, billing and collections structure. If you're a good businessperson, this might be the route for you.

Before signing a contract with a syndicate, consult an attorney to review its terms. A checklist of favorable terms includes: (1) creator ownership of the strip and its characters; (2) periodic evaluation of the syndicate's performance; (3) a five-year contract without automatic renewal; and (4) a percentage of gross, instead of net, receipts.

Clip art firms provide their clients—individuals, associations and businesses—with camera-ready illustrations, cartoons, spot drawings and decorative art for use in newsletters, brochures, advertisements and more. Generally clip art is rendered in black and white in a realistic manner to adapt to any use. Clip art falls into certain subject areas, such as animals, food, clothing or medicine. Though all rights are generally purchased, try to receive name credit alongside your work. Computer software now supplies clip art, so clip art firms must provide more unique material than in the past.

For regular updates on syndicates and clip art firms, read *Editor & Publisher*'s weekly column on the subject. Also, the weekly trade magazine publishes an annual directory, which includes syndicates. Writer's Digest Books publishes a market book just for cartoonists, *Humor and Cartoon Markets*.

ALLIED FEATURE SYNDICATE, Drawer 48, Joplin MD 64802-0048. (417)673-4743. FAX: (417)673-4743. Editor: Robert Blanset. Estab. 1940. Syndicate serving 50 outlets: newspapers, magazines, etc.
Needs: Approached by 100 freelance artists/year. Buys from 10 or more freelance artists/year. Introduces 25-50 new strips/year. Considers comic strips, gag cartoons, caricatures, editorial/political cartoons, illustrations and spot drawings. Prefers single panel, double panel, multiple panel with or without gagline; b&w line drawings, b&w washes and color washes.
First Contact & Terms: Sample package should include cover letter, photocopies and finished cartoons. One sample of each should be included. Samples are filed or are returned by SASE if requested by artist. Does not report back. "On some occasions we do contact the artist." Call to schedule an appointment to show a portfolio. Portfolio should include b&w samples. Pays 50% of net proceeds; on publication. Buys first rights. Offers automatic renewal. Syndicate owns original art and the characters. "This is negotiable with artist. We always negotiate."

***AMERICAN INTERNATIONAL SYNDICATE**, 1324½ N. 3rd St., St. Joseph MO 64501. (816)279-9315. FAX: (816)279-9315. Vice President: Robert Brown. Estab. 1987. Syndicate serving 14 daily-weekly newspapers. Art guidelines available for SASE with appropriate postage.
Needs: Approached by 500 freelance artists/year. Buys from 15 freelance artists/year. Introduces 15 new strips/year. Considers comic strips, gag cartoons and spot drawings. Prefers single and multiple panel, with gagline, b&w line drawings and washes. Prefers sports, family, business and environment-education themes. Also uses freelance artists for puzzles and games, science features or nature type features. Maximum size of artwork 2½×7″ (strip); 5×5″ (panel).
First Contact & Terms: Sample package should include cover letter, roughs, tearsheets, finished cartoons (2) and SASE. 8-12 samples should be included. Samples are filed or returned by SASE if requested by artist. Reports back within 1 month. Portfolio should include b&w roughs, tearsheets and color slides. Pays 50% of gross income. Pays on "receipt of money." Buys all rights. Minimum length of contract 2 years. Offers automatic renewal. Artist owns original art and characters.

AMERICAN NEWSPAPER SYNDICATE, 9 Woodrush Dr., Irvine CA 92714. (714) 559-8047. Executive Editor: Susan Smith. Estab. 1987. Syndicates to U.S. and Canadian medium and large-sized general interest and special interest newspapers.
Needs: Wants to syndicate 5 new cartoonists this year. Looking for b&w and color comic strips, comic panels, editorial cartoons, illustrations and spot drawings. "We are particularly looking for humorous features that are fresh, contemporary and genuinely funny. We also will consider dramatic serial strip concepts that are unique and that have strong characters. We need features that can run daily and Sunday. Material should appeal to all ages and can be on any subject."
First Contact & Terms: Send query letter with copies of 6 weeks of dailies and character sketches. Samples not kept on file are returned by SASE. Please do *not* send original art. Reports within 3 weeks. Buys U.S. newspaper rights. Wants to sign contracts with cartoonists to produce material on a regular basis. Also looking for merchandising and licensing possibilities.

Tips: "We are willing to take on material that may be considered too unconventional by the other syndicates. Because of our understanding of the newspaper syndication market, we feel we can find a place for the previously unpublished cartoonists. We urge you to be fresh and original. Be yourself. Don't try to imitate other, well-known cartoonists. Develop three-dimensional characters in open-ended situations that will provide ample opportunities for comic possibilities. Ask yourself: do I *really like* these characters? Is this feature *really* funny? Would I want to read it every day? When you can honestly answer yes to these questions, you may have a feature that is a potential hit."

ART PLUS REPRO RESOURCE, Box 1149, Orange Park FL 32067-1149. (904)269-5139. Publisher: Wayne Hepburn. Estab. 1983. Clip art firm serving about 12,000 outlets, including churches, schools, associations and ministries.
Needs: Buys 40-60 cartoons and 200-1,000 illustrations/year from freelance artists. Prefers illustrations and single panel cartoons with gagline and b&w line art. Maximum size is 7x10 and must be reducible to 20% of size without losing detail. "We need very graphic material." Prefers religious or educational themes.
First Contact & Terms: Send photocopies. Samples not filed are returned by SASE. Guidelines and catalog available for 9x12 SASE with 2 first-class stamps. Reports back within 2 months. To show a portfolio, mail roughs and photostats. Pays $5-50; on acceptance. Buys all rights.
Tips: "All our images are published as clip art to be reproduced by readers in their bulletins and newsletters for churches, schools, associations, etc. We need art for holidays, seasons and activities; new material every 3 months. We want singlepanel cartoons, not continuity strips."

BLACK CONSCIENCE SYNDICATION, INC., 21 Bedford St., Wyandanch NY 11798. (516)491-7774. President: Clyde R. Davis. Estab. 1987. Syndicate serving regional magazines, schools, daily newspapers and television.
Needs: Considers comic strips, gag cartoons, caricatures, editorial or political cartoons, illustrations and spot drawings. Prefers single, double or multipanel cartoons. "All material must be of an importance to the Black community in America and the world." Especially needs material on gospel music and its history. "In September 1991 our new format was a video magazine project. Merited by-monthly, this half hour program will highlight our clients' material. We are accepting ½" tapes, 2 minutes maximum. Tape must describe the artist's work and provide brief bio of the artist. Mailed to 25 different Afrocentric publications every other month."
First Contact & Terms: Send query letter with resume, tearsheets and photocopies. Samples are filed or are returned by SASE only if requested by artist. Reports back within 2 months. Call to show a portfolio, which should include tearsheets. Pays 50% of gross income; on publication. Considers client's preferences when establishing payment. Buys first rights.
Tips: "All material must be inspiring as well as informative. Our main search is for the truth."

ASHLEIGH BRILLIANT ENTERPRISES, 117 W. Valerio St., Santa Barbara CA 93101. (805)682-0531. Art Director: Ashleigh Brilliant. Estab. 1967. Syndicate and publisher. Outlets vary. "We supply a catalog and samples for $2 plus SASE."
Needs: Considers illustrations and complete word and picture designs. Prefers single panel. "Our product is so unusual that freelancers will be wasting their time and ours unless they first carefully study our catalog." Maximum size of artwork 5½×3½" horizontal only.
First Contact & Terms: Samples are returned by SASE if requested by artist. Reports back within 2 weeks. Pays flat fee of $40 minimum. Pays on acceptance. Buys all rights. Syndicate owns original art.

CAROL BRYAN IMAGINES, THE LIBRARY IMAGINATION PAPER, 1000 Byus Dr., Charleston WV 25311. Editor: Carol Bryan. Estab. 1978. Syndicates clip art for 3,000 public and school libraries. Sample issue $1.
Needs: Buys 6-15 freelance illustrations/issue. Considers gag cartoons, illustrations and spot drawings. Prefers single panel; b&w line drawings. Prefers library themes—"not negative towards library or stereotyped (example: showing a spinster librarian with glasses and bun). Prefers subjects dealing with 'today's' libraries— fax mediums, computers, equipment—good-looking librarians—upbeat ideas. It's a more-than-books-world now—it's the complete information place. Need more focus on school library items."

***** ***The asterisk before a listing indicates that the listing is new in this edition. New markets are often the most receptive to freelance submissions.***

First Contact & Terms: Send query letter with tearsheets, photocopies and finished cartoons. Send no more than 6 samples. Samples are filed or are returned by SASE. Reports back within 3 weeks. Pays flat fee, $10-25; on publication. Buys one-time or reprint rights.

Tips: "Seeing a sample issue is mandatory—we have a specific style and have been very successful with it. Your style may blend with our philosophy. Need great cartoons that libraries can publish in their newsletters."

***CELEBRATION: A CREATIVE WORSHIP SERVICE**, Box 419293, Kansas City MO 64141. (816)531-0538. Editorial Office: 11211 Monticello Ave., Silver Spring MD 20902. (301)649-4937. Editor: Bill Freburger. Clients: Churches, clergy and worship committees.

Needs: Assigns 60/year. Uses artists for spot and line drawings on religious themes.

First Contact & Terms: Query; out-of-town artists only. Reports within 1 week. No originals returned to artist at job's completion. Pays $40/illustration.

CITY NEWS SERVICE, Box 39, Willow Springs MO 65793. (417)469-2423. President: Richard Weatherington. Estab. 1969. Editorial service providing editorial and graphic packages for magazines.

Needs: Buys from 12 or more freelance artists/year. Considers caricature, editorial cartoons and tax and business subjects as themes; considers b&w line drawings and shading film.

First Contact & Terms: Send query letter with resume, tearsheets or photocopies. Samples should contain business subjects. "Send five or more black and white line drawings, color drawings, shading film or good line drawing editorial cartoons." Does not want to see comic strips. Samples not filed are returned by SASE. Reports within 4-6 weeks. To show a portfolio, mail tearsheets or photostats. Pays 50% of net proceeds; pays flat fee, $25 minimum. "We may buy art outright or split percentage of sales." Considers complexity of project, skill and experience of artist and how work will be used and rights purchased when establishing payment.

Tips: "We have the markets for multiple sales of editorial support art. We need talented artists to supply specific projects. We will work with beginning artists. Be honest about talent and artistic ability. If it isn't there then don't beat your head against the wall."

***COMMUNITY & SUBURBAN PRESS SERVICE**, Box 639, Frankfort KY 40602. (502)223-1736. Editor: Eugene Combs. Syndicate serving 300 weekly newspapers.

Needs: Approached by 20 freelance artists/year. Buys from 8-10 freelance artists/year. Considers comic strips and gag cartoons. Prefers single panel with gagline. Maximum size of artwork 10 × 12″, usually reduced to 40-50%.

First Contact & Terms: Sample package should include cover letter and photostats. 6-7 samples should be included. Samples are filed or returned by SASE if requested by artist. Reports back within 1 month. Mail appropriate materials. Portfolio should include final reproduction/product, b&w. Pays a flat fee $15 minimum. Buys all rights. Offers automatic renewal. Syndicate owns original art.

COMMUNITY FEATURES, Dept. C, Box 75, Berkeley CA 94701-0075. Art Editor: B. Miller. Syndicates to 200 daily and weekly newspapers. Mails brochure of new syndicated offerings to over 500 newspapers. Guidelines $1 and #10 SASE. Specify "artists' guidelines."

Needs: Interested in professional quality b&w illustrations, line art and spot drawings. Does not seek color.

First Contact & Terms: Send tearsheets, veloxes, PMTs or excellent photocopies (published and unpublished) that can be kept on file. Include #10 SASE for reply. Do not send artboards or original art. Reports within 3-6 weeks. Buys various rights. Will consider line-art on all topics listed in guidelines. Pays $20-200 flat rate for one-shot and occasional work; 50% commission for regularly appearing features. Pays on acceptance.

Tips: "We look for a clean modern look. Submit very clear copies. Include SASE for reply. Don't sent elaborate packages with detailed cover letters. Your work speaks for itself. Keep samples on file with us, and we will contact you as the need arises. No artwork is ever distributed for publications without artist's prior written approval."

CONTINENTAL FEATURES/CONTINENTAL NEWS SERVICE, Suite 265, 341 W. Broadway, San Diego CA 92101. (619)492-8696. Director: Gary P. Salamone. Parent firm established August, 1981. Syndicate serving 3 outlets: house publication, publishing business and the general public through the *Continental Newstime* magazine. Guidelines available to the artist for SASE.

Needs: Approached by 100+ freelance artists/year. Number of new strips introduced each year varies. Considers comic strips and gag cartoons. Recent introductions include *"Portfolio,"* (1991) by William F. Pike. Prefers single panel with gagline. Maximum size of artwork 8 × 10, must be reducible to 65% of original size.

First Contact & Terms: Sample package should include cover letter and photocopies. 10-15 samples should be included. Samples are filed or are returned by SASE if requested by artist. Reports back within 1 month with receipt of SASE only if interested. To show a portfolio, mail photocopies and cover letter. Pays 70% of gross income on publication. Rights purchased vary according to project. The minimum length of the contract is one year. The artist owns the original art and the characters.

Close-up

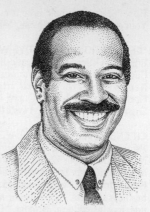

Stephen Bentley
Cartoonist
Monrovia, California

© Barbara Kelley 1991

On April 1, 1988, Stephen Bentley received a phone call from Tribune Media Services. The syndicate, the caller announced, was interested in carrying the comic strip Bentley had submitted. "I thought it was an April Fool's joke," quips the creator of the now-syndicated cartoon "Herb & Jamaal."

Like most "undiscovered" cartoonists, Bentley had been rejected by all the major syndicates before striking success with this cast of characters, whose two stars are business partners, best friends, and an occasional voice for black cultural awareness.

"This is not an easy route," Bentley says of his career choice. "Herb & Jamaal" is the fifth strip he's developed over the last 13 years and the first to approach lucrativeness, although one of his others, called "Squirt," was carried by a small syndicate for five months. That strip, based on characters in a fire department, featured current humor and a progressive cast, including black, Hispanic and women firefighters. It held its own for a while, Bentley says, but the syndicate was too small to effectively promote the strip, and it failed to collect enough papers.

About 50 papers carry "Herb & Jamaal," which began as a daily strip but now includes Sundays. The strip originally featured Herb as the main character, and Jamaal played a background role. But Tribune wanted the two to share the spotlight, so Bentley brought Jamaal forward—a process of refinement that took about a year to achieve. Although the initial contact between cartoonist and syndicate was in April 1988, the strip didn't make it onto the page until August 7, 1989.

The friendship that has evolved between the two main characters is Bentley's star achievement, the prime quality that endears the creation to its creator. The fact that the characters are black is secondary to that friendship, he says; in fact, labeling them as "black friends" rather than just "friends" can hurt the strip's exposure.

"I'm not sure cartoons featuring black characters are recognized as humorous cartoons rather than black cartoons," he says. "If a paper is presented with three excellent black cartoons, and they have space for all three, they won't take them all. I think that's a failure of the editors."

Bentley's criticism doesn't mean he shies away from incorporating his characters' cultural background into the strip. There is often talk of historical black figures or human rights issues—but it's always presented in a humorous light.

Through Bentley's years of receiving rejection letters, he learned some valuable lessons about trying to work with a large syndicate. He suggests submitting about six weeks' worth of daily strips and making certain the packaging is attractive. "I kept thinking my cartoons should speak for themselves, but you should provide a background explanation for your characters," he says.

The most important factor, he says, is to have a clear concept: develop well-rounded characters, characters whose backgrounds you know as intimately as your own.

Yet, regardless of how well-developed the characters are, a reader is likely to skip over a strip if the art isn't appealing, Bentley says. "There have to be crisp lines, the writing has to be articulate, but I think the art has to be able to carry the writing through. The eye focuses on what's visually appealing first. Then it wants to see what the characters are talking about."

Bentley's diverse background, as well as his talent and sense of humor, have prepared him well for his chosen field. He studied both art and English in college, spent years working as a freelance artist, and dabbled in a wide range of other occupations—many of which have found their way into his cartoons. For example, "Squirt" arose from Bentley's training in fire science. "Hey, Coach," which appeared monthly in *Swimming World* magazine, was spawned from his years of work as a summer camp instructor. The idea, he says, is to draw what you know and to involve the human psyche.

"I'm both a writer and an artist," he says, "but now I see myself more as a sociologist. My characters have to be social in their environment and in how they relate to other people. I'd like to get a degree in sociology," he continues. "If I do, I'll use these characters as my dissertation."

— Perri Weinberg-Schenker

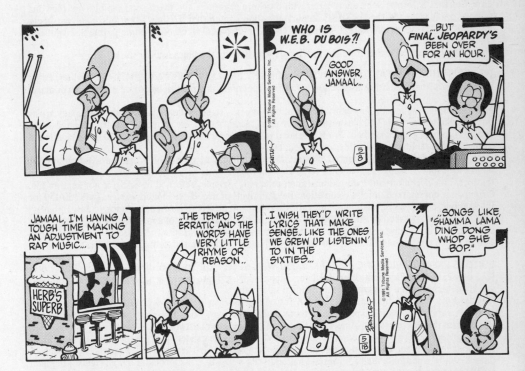

Herb and Jamaal go way back, Bentley explains, to high school. "Herb's naturally devious and crafty intelligence could have made him a world-class con man were it not balanced by a strong set of values." Jamaal's militant youth "has been replaced by a mellower outlook. Although he was for a time a pro basketball player (not, as some will think, because he's black but because he's over 7' tall). Jamaal looks up (actually down) to Herb as someone who really has his life together."

Reprinted with permission of Tribune Media Services.

Tips: "Continental Features/Continental News Service does not consider highly abstract or stick-figure art and certainly, no more worm characters. We state our anticipated cartoon needs, and we receive only submissions outside the given parameters. If cartoonists exhibit a bit more flexibility, they can improve their chances for sales."

CREATORS SYNDICATE, INC., 5777 W. Century Blvd., Los Angeles CA 90045. (213)337-7003. President: Richard S. Newcombe. Vice President, General Manager: Anita Medeiros. Estab. 1987. Serves 1,700 daily newspapers, weekly and monthly magazines.
Needs: Buys from 100 freelance writers and artists/year. Considers comic strips, gag cartoons, caricatures, editorial or political cartoons and "all types of newspaper columns."
First Contact & Terms: Send query letter with brochure showing art style or resume and "anything but originals." Samples are not filed and are returned by SASE. Reports back within 2 months. Write to show a portfolio, which should include tearsheets and photostats. Pays 50% of net proceeds. Considers saleability of art work and client's preferences when establishing payment. Negotiates rights purchased.

DEAR NEWSPAPERS, (formerly *McLean Providence Journal* and *Arlington Courier*), Box 580, McLean VA 22101. (703)356-3320. Editor: David Dear. Estab. 1986. Publishes weekly newspapers covering Arlington, Great Falls, Falls Church, McLean and Tysons Corner, Virginia. Syndicates to weekly newspapers and local guide books.
Needs: Buys from 2 freelance artists/year. Prefers local or Virginia artists. Considers comic strips, gag cartoons, caricatures, editorial or political cartoons, illustrations and spot drawings. Prefers pen & ink with washes.
First Contact & Terms: Send query letter with brochure or resume and tearsheets. Samples are filed and samples not filed are returned by SASE. Reports back only if interested. To show a portfolio, mail tearsheets. Pays flat fee, $5-90; on publication. Considers clients' preferences when establishing payment. Negotiates rights purchased.
Tips: "We prefer local artists from North Virginia who have local themes in their work."

EDITOR'S CHOICE CLIP ART, 6th Floor, 500 S. Salina St., Syracuse NY 13202. (315)472-4555. Editor: Peggy Ries. Clip art firm. Bimonthly distribution to major corporations that publish employee newsletters or magazines.
Needs: Serious and humorous editorial illustration, graphics, standing heads, etc. Works with many artists on a regular basis. Prefers line illustrations in pen & ink, scratchboard, etc., or pencil illustration on textured board. Also buys graphic symbols. Work is related to business and industry, employee relations, health and wellness, physical fitness, family life, recreation, etc.
First Contact & Terms: Experienced illustrators and graphic designers only. Works on assignment only. Send query letter, resume and samples to be kept on file. Reports within 60 days. Prefers photocopies as samples. "Include information on remuneration required." Samples returned by SASE if not kept on file. Original art not returned at job's completion. Buys all rights or negotiates limited use fee. Pays $20-150 for illustrations; negotiates payment amount, varies according to project. Pays on acceptance.
Tips: "Only accomplished illustrators will be considered. Amateurs need not apply. Send 10-12 samples that show an individual's diversity of styles and techniques. We need illustrations that are easily reproducible. Pen or pencil illustrations must be clear and of good quality. We have no use for color illustrations."

EDITORS PRESS SERVICE, INC., 15th Floor, 330 W. 42nd St., New York NY 10036. (212)563-2252. FAX: (212)563-2517. Vice President: John P. Klem. Estab. 1933. Syndicate servicing 1,700 publications: daily and weekly newspapers and magazines. International sales only.
Needs: Buys from 3-5 freelance artists/year. Introduces 1-2 new strips/year. Considers comic strips, gag cartoons, caricatures, editorial/political cartoons and illustrations. Considers single, double or multipanel. Prefers pen & ink. Prefers non-American themes. Maximum size of artwork: 11×17.
First Contact & Terms: Send cover letter, finished cartoons, tearsheets and photocopies. Include 24-48 strips/panels. Does not want to see original artwork. Samples not filed are returned. Reports back within 14 days. To show a portfolio, mail appropriate materials. Pays 50% of gross income. Buys all rights. Minimum length of contract: two years. Artist owns original art and characters.
Tips: Last year there were "fewer new strip launches. Look for niches. Do not copy existing successful features. Study the existing competition. Read newspaper!" Looking for "well written gags and strong character development."

RICHARD R. FALK ASSOCIATES, 1472 Broadway, New York NY 10036. (212)221-0043. President: R. Falk. Estab. 1940. Syndicates to regional magazines and daily newspapers.
Needs: Buys from 3-4 freelance artists/year. Works on assignment only. Considers caricatures, editorial or political cartoons and spot drawings. Prefers line drawings. Prefers theatrical and entertainment themes.
First Contact & Terms: "Only send simple flyers, throwaway illustrations, photocopies." Reports back only if interested. Pays flat fee or $100-500 on acceptance. Considers clients' preferences when establishing payment. Buys one-time rights.

FILLERS FOR PUBLICATIONS, 7015 Prospect Place NE, Albuquerque NM 87110. (505)884-7636. President: Lucie Dubovik. Distributes to magazines and newspapers.
Needs: Buys 72 pieces/year from freelancers. Considers single panel, 4 × 6 or 5 × 7 cartoons on current events, education, family life, retirement, factory and office themes; clip art and crossword puzzles. Inquire for subject matter and format.
First Contact & Terms: Send query letter with samples of style and SASE. Samples are returned. Reports in 3 weeks. Previously published and simultaneous submissions OK. Buys first rights. Pays $7, cartoons, line drawings; $25/page of clip art; on acceptance.
Tips: Does not want to see comic strips.

FOTO EXPRESSION INTERNATIONAL, Box 1268, Station "Q"., Toronto Ontario M4T 2P4 Canada. (416)841-9788. FAX: (416)841-2283. Director: M.J. Kubik. Serving 35 outlets.
Needs: Buys from 80 freelance artists/year. Considers b&w and color single, double and multiple panel cartoons, illustrations and spot drawings.
First Contact & Terms: Send query letter with brochure showing art style or resume, tearsheets, slides and photographs. Samples not filed returned by SASE. Reports within one month. To show a portfolio, mail final reproduction/product and color and b&w photographs. Artist receives percentage; on publication. Considers skill and experience of artist and rights purchased when establishing payment. Negotiates rights purchased.
Tips: "Quality and content are essential. Resume and samples must be accompanied by a SASE or, out of Canada, International Reply Coupon is required."

PAULA ROYCE GRAHAM, Suite 20 G, 2770 W. 5th St., Brooklyn NY 11224. (718)372-1920. Contact: Paula Royce Graham. Syndicates to newspapers and magazines.
Needs: Considers b&w illustrations. Uses artists for advertising and graphics.
First Contact & Terms: Send business card and tearsheets to be kept on file. Samples returned by SASE only if requested. Reports within days. Write for appointment to show a portfolio. Pay is negotiable; on publication. Considers skill of artist, client's preferences and rights purchased when establishing payment. Buys all rights.
Tips: "Keep it simple."

GRAPHIC NEWS BUREAU, gabriel graphics, Box 38, Madison Square Station, New York NY 10010. (212)254-8863. Cable: NOLNOEL. Director: J.G. Bumberg. Custom syndications and promotions to customized lists, small dailies, suburbans and selected weeklies.
Needs: Represents 4-6 freelance artists/year, preferably within easy access. No dogmatic, regional or pornographic themes. Uses single panel cartoons, illustrations, halftones in line conversions and line drawings.
First Contact & Terms: Send query letter only. Reports within 4-6 weeks. Returns original art after reproduction on request with SASE. Provide 3x5 card to be kept on file for possible future assignments. Negotiates rights purchased; on publication.
Tips: A new, added service provides for counseling and conceptualizing in graphics/management/communications ". . . when and where printing is an integral part of the promotion, product, service."

HEALTH CARE PR GRAPHICS (formerly Hospital PR Graphics), 6th Floor, 500 S. Salina St, Syracuse NY 13202. (315)472-4555. FAX: (315)472-5258. Editor: Peggy Ries. Estab. 1981. Clip art firm. Distributes monthly to hospitals and other health care organizations.
Needs: Uses illustration, drawings, spot drawings and graphic symbols related to health care for use in brochures, folders, newsletters, etc. Prefers sensitive line illustrations, spot drawings and graphics related to hospitals, nurses, doctors, patients, technicians and medical apparatus. Also buys cartoons.
First Contact & Terms: Experienced illustrators only, preferably having hospital exposure or access to resource material. Works on assignment only. Send query letter, resume, photostats or photocopies to be kept on file. "Send 10 to 20 different drawings which are interesting and show sensitive, caring people." Does not want to see "color illustration or styles that cannot be reproduced easily." Samples returned by SASE if not kept on file. Reports within 1 month. Original art not returned at job's completion. Buys all rights. Pays flat rate of $30-150 for illustrations; negotiates payment, which varies according to project. Pays on acceptance.
Tips: "We are looking to establish a continuing relationship with freelance graphic designers and illustrators. Illustration style should be serious, sensitive and somewhat idealized. Send enough samples to show the variety (if any) of styles you're capable of handling. Indicate the length of time it took to complete each illustration or graphic, and/or remuneration required. Practice drawing people's faces. Many illustrators fall short when drawing people."

***IMPACT VISUALS PHOTO & GRAPHICS, INC.**, Suite 901, 28 W. 27th St., New York NY 10001. (212)683-9688. Co-Editor: Michael Kaufman. Estab. 1986. Syndicate serving 600 outlets, mainly for photos. Usual outlets include magazines, newspapers, book publishers and progressive organizations; mainly weeklies and monthlies. Art guidelines available for #10 SASE.

Needs: Approached by 20 freelance artists/year (excluding photographers). Buys from 12-15 freelance artists/year. Considers caricatures, editorial/political cartoons and illustrations. Prefers single and double panel and b&w line drawings. Theme/style must be progressive in orientation. Maximum size of artwork 8½ × 11″.

First Contact & Terms: Sample package should include cover letter (must explain politics, experience, plans), resume and finished cartoons. 20 samples should be included. Samples are filed or are returned by SASE if requested by artist. Reports back within 1 month. Mail appropriate materials. Portfolio should include photocopies. Pays 60% of gross income to full members; 50% to nonmembers. Pays on publication. Buys one-time rights or rights purchased vary according to project. Minimum length of contract is 2 years. Offers automatic renewal. The artist owns the original and characters.

Tips: "Send for submission guidelines first with SASE. Do not call. Must be politically left."

INTERPRESS OF LONDON AND NEW YORK, 400 Madison Ave., New York NY 10017. (212)832-2839. Editor/Publisher: Jeffrey Blyth. Syndicates to several dozen European magazines and newspapers.

Needs: Buys from 4-5 freelance artists/year. Prefers material which is universal in appeal; no "American only" material.

First Contact & Terms: Send query letter and photographs; write for artists' guidelines. Samples not kept on file returned by SASE. Reports within 3 weeks. Purchases European rights. Pays 60% of net proceeds on publication.

***JODI JILL FEATURES,** Suite 143, 2888 Bluff St., Boulder CO 80301. Art Editor/President: Jodi Jill. Estab. 1983. Syndicate serving "hundreds" of newspapers, magazines, publications. Art guidelines not available.

Needs: Approached by 250 freelance artists/year. "Tries to average 10 new strips per year." Considers comic strips, editorial/political cartoons and gag cartoons. Prefers single, double or multiple panel and b&w line drawings. Needs art, photos and columns that are visual puzzles. Maximum size of artwork 8½ × 11″.

First Contact & Terms: Sample package should include cover letter, resume, tearsheets, finished cartoons and photocopies. 6 samples should be included. Samples are not filed and are returned by SASE if requested by artist. Reports back within 1 month. Mail appropriate materials. Portfolio should include b&w roughs and tearsheets. Pays 40% of net proceeds. Pays on acceptance. Negotiates rights purchased. Minimum length of contract is 1 year. The artist owns original art and characters.

Tips: "We like to deal in columns. If you have a visual puzzle column we would like to look it over. Some of the best work is unsolicited."

JSA PUBLICATIONS, INC., Box 37175, Oak Park MI 48237. (313)546-9123. Director: Joe Ajlouny. Estab. 1982. Serves 18 outlets, mainly magazines and books.

Needs: Buys from 24 freelance artists/year. Considers greeting cards, comic strips, map art, caricatures, editorial or political cartoons. Prefers pen & ink and airbrush. Prefers panels to strips.

First Contact & Terms: Send query letter with resume and samples. Include enough to accurately express artist's talent and styles. Samples are filed or are returned by SASE only if requested. Reports back within 4 weeks only if interested. Call to schedule an appointment to show a portfolio. Pays flat fee of $50-900; on publication. Considers client's preferences and rights purchased when establishing payment. Negotiates rights purchased.

Tips: All submissions "must be of professional quality. Have a superior method of expression. By this we mean it must distinguish the artist from all others, especially true of comic strips or panels, except they must be funny or telling too!" Develop a theme and title concept and stick to it. We prefer educational, informational, contemporary submissions."

***A.D. KAHN, INC.,** Suite 100, 24133 Northeastern, Southfield MI 48075-2568. (313)355-4100. FAX: (313)356-4344. President/Editor: David Kahn. Estab. 1960. Syndicate serving daily and weekly newspapers, monthly magazines. Art guidelines not available.

Needs: Approached by 6-12 freelance artists/year. Represents from 1-2 freelance artists/year. Introduces 1-2 new strips/year. Considers comic strips, editorial/political cartoons, gag cartoons, puzzles/games.

First Contact & Terms: Sample package should include material that best represents artist's work. Samples are filed if interested; those not filed are returned by SASE if requested by artist. Does not report back, in which case the artist should call for results. Call to schedule an appointment to show a portfolio. Pays 50% of net proceeds or gross income. Negotiates rights purchased. Rights purchased vary according to project. The artist owns original art and characters.

LEOLEEN-DURCK CREATIONS/LEONARD BRUCE DESIGNS, Suite 226, Box 2767, Jackson TN 38302. (901)668-1205. Syndicator: Leonard Bruce. Estab. 1981. Syndicate and consulting firm for beginning cartoonists. Syndicate serving 5 outlets that include newspapers and magazines.

Needs: Approached by 50 freelance artists/year. Buys from 4 freelance artists/year. Introduces 2 new strips/year. Considers comic strips and gag cartoons. Prefers single and multiple panel with gagline. Prefers "off-the-wall" themes. Maximum size of artwork 9 × 12″ reducible to 75% of original size.

First Contact & Terms: Sample package should include cover letter, resume, character descriptions, tearsheets, photocopies and SASE. Reports back within 10 days. To show portfolio mail color photostats and tearsheets. Pays 50% of net proceeds. Pays on publication. Buys first rights. Minimum length of contract is 6 months. The artist owns original and the characters.
Tips: "I want to see camera-ready artwork reduced down. I do not want to see sloppy borders or bad printing by the artist."

LOS ANGELES TIMES SYNDICATE, 218 S. Spring St., Los Angeles CA 90012. (213)237-7987. Executive Editor: Steven Christensen. (213)237-3213.
Needs: Comic strips, panel cartoons and editorial cartoons. "We prefer humor to dramatic continuity. We consider only cartoons that run 6 or 7 days/week. Cartoons may be of any size, as long as they're to scale with cartoons running in newspapers." (Strips usually run approximately 6⁷⁄₁₆ × 2, panel cartoons 3⅛ × 4; editorial cartoons vary.) Recent introductions include Phoebe's Place, Southpaw.
First Contact & Terms: Submit photocopies or photostats of 24 dailies. Submitting Sunday cartoons is optional; if you choose to submit them, send at least four. Reports within 2 months. Include SASE. Syndicate buys all rights.
Tips: "Don't imitate cartoons that are already in the paper. Avoid linework or details that might bleed together, fade out or reproduce too small to see clearly. We hardly ever match artists with writers or vice versa. We prefer people or teams who can do the entire job of creating a feature."

METRO CREATIVE GRAPHICS, INC., 33 W. 34th St., New York NY 10001. (212)967-4602. FAX: (212)714-9139. Contact: Andrew Shapiro. Estab. 1910. Clip art firm. Distributes to 6,000 daily and weekly paid and free circulation newspapers, schools, graphics and ad agencies and retail chains.
Needs: Buys from 100 freelance artists/year. Considers single panel illustrations and line and spot drawings; b&w and color. Special emphasis on computer generated art for Macintosh for desktop publishing. Send floppy disk samples using Adobe Illustrator or visual evidence of computer skills. Prefers all categories of themes associated with retail, classified, promotion and advertising. Also needs covers for special-interest tabloid section.
First Contact & Terms: Send query letter with brochure showing style or photostats, photocopies, slides, photographs and tearsheets to be kept on file. Samples not kept on file returned by SASE. Reports only if interested. Works on assignment only. Pays flat fee of $25-800; on acceptance. Considers skill and experience of artist, saleability of artwork and clients' preferences when establishing payment.
Tips: "Don't rely on 1-2 samples to create interest. Show a variety of styles and special ability to draw people in realistic situations. If specialty is graphic design, think how you would use samples in advertising. Clip art has become extremely important in advertising and the art has become more modern and exciting covering subjects that were previously not covered. We're not interested in seeing cartoons for syndication most editorial art, or oil paintings."

NATIONAL NEWS BUREAU, Box 5628, Philadelphia PA 19129. (215)546-8088. Editor: Harry Jay Katz. Syndicates to 300 outlets and publishes entertainment newspapers on a contract basis.
Needs: Buys from 500 freelance artists/year. Prefers entertainment themes. Uses single, double and multiple panel cartoons, illustrations; line and spot drawings.
First Contact & Terms: To show a portfolio, send samples and resume. Samples returned by SASE. Reports within 2 weeks. Returns original art after reproduction. Send resume and samples to be kept on file for future assignments. Negotiates rights purchased. Pays flat rate, $5-100 for each piece; on publication.

***NEW ENGLAND MOTORSPORTS/INTERNATIONAL MOTORSPORTS SYNDICATES**, 84 Smith Ave., Stoughton MA 02072. (617)344-3827. Estab. 1988. Syndicate serving 15 daily newspapers, motorsports trade weeklies. Art guidelines not available.
Needs: Considers sports pages material. Prefers single panel with motorsports motif. Maximum size 1 column.
First Contact & Terms: Sample package should include cover letter. Include 1 sample. Samples are filed. Reports back within 1 week. Mail appropriate materials. Portfolio should include original/final art. Pays a flat $5 fee. Pays on acceptance. The syndicate owns original art and characters.

OCEANIC PRESS SERVICE, Box 6538, Buena Park CA 90622-6538. (714)527-5650. FAX: (714)527-0268. Manager: J. West. Estab. 1957. Syndicates to 300 magazines, newspapers and subscribers in 30 countries.
Needs: Buys several hundred pieces/year from freelancers. Considers cartoon strips (single, double and multiple panel) and illustrations. Recent introductions include "ABC of Home Repair." Prefers camera-ready material (tearsheets or clippings). Cartoonist who exemplifies tone and style we want is "Booth, Adam Lasalvy (French). Themes include published sex cartoons, family, inflation, juvenile activity cartoons, and covers for paperbacks (color transparencies). "No graphic sex or violence. Poke fun at established TV shows. Bad economy means people must do their own home, car and other repairs. How-to articles with b&w line drawings are needed. Magazines will buy less and have more features staff-written. Quality is needed. People

like to read more about celebrities, but it has to have a special angle, not the usual biographic run-of-the-mill profile. Much will be TV related. I'd like to see a good cartoon book on Sherlock Holmes, on Hollywood, on leading TV shows."

First Contact & Terms: Send query letter with photostats and samples of previously published work. Accepts tearsheets and clippings. Send SASE. Reports within 1 month. Pays 50% of gross income. Originals returned to artist, or put on auction. Guidelines $1 with SASE.

Tips: "The trend is definitely toward the women's market: money saving topics, service features—how to do home repair—anything to fight inflation; also unusual cartoons about unusual happenings; unusual sports; and cartoons with sophisticated international settings, credit cards, air travel. Color cartoons will have an edge. We would like to receive more clippings for foreign reprints. Competition is keen—artists should strive for better quality submissions."

PROFESSIONAL ADVISORY COUNSEL, INC., Suite 230, 5909 N.W. Expressway, Oklahoma City OK 73132-5102. (405)728-8000. President: Larry W. Beavers. Estab. 1952. Syndicate serving approximately 1,700 international outlets.

Needs: Buys from freelance artists/year. Considers illustrations and spot drawings; b&w and color. Prefers camera-ready artwork. Also uses artists for advertising. Considers any media.

First Contact & Terms: Send query letter and roughs with 3-5 samples to file. Samples returned by SASE only if requested. Especially looks for "simplicity and fast-relating/assimilating potential." Reports only if interested. Write for appointment to show portfolio and for artists' guidelines. Pays flat fee, $200-475 average; on acceptance. Buys all rights.

Tips: "Make your contact quick, concise and to-the-point. We still must keep producing new material although the economic slow down does slow sales."

REPORTER, YOUR EDITORIAL ASSISTANT, 7015 Prospect Place NE, Albuquerque NM 87110. (505)884-7636. Editor: George Dubow. Syndicates to newspapers and magazines from secondary level schools and colleges.

Needs: Considers single panel cartoons on teenage themes.

First Contact & Terms: Mail art and SASE. Reports in 3 weeks. Buys first rights. Originals returned to artist only upon request. Pays $5-10.

Tips: Does not want to see comic strips.

***SALMON SYNDICATION**, P.O. Box 712, Vallejo CA 94590. (707)552-1699. Syndicated comics serving 42 newspapers. Guidelines not available.

Needs: Approached by 25-50 freelance artists/year. Prefers single panel. Prefers subtle, mature material.

First Contact & Terms: Sample package should include cover letter and photocopies. 6-18 samples should be included. Samples are filed or are returned by SASE if requested. Reports back to the artist only if interested. Mail appropriate materials. Portfolio should include photostats. Artist owns original art and characters.

Tips: "We're not looking for material at this time, but will consult with SASE."

SINGER MEDIA CORP., 3164 Tyler Ave., Anaheim CA 92801. (714)527-5650. Executive Vice President: Katherine Haw. Syndicates to 300 worldwide magazines, newspapers, book publishers and poster firms; strips include "Famous Women In History," "Baseball Intelect," and "Verizontal" (math puzzle). Artists' guidelines $1.

Needs: Buys several thousand freelance pieces/year. Considers single, double and multiple panel cartoon strips; family, children, sex, juvenile activities and games themes. Especially needs business, outer space and credit card cartoons of 3-4 panels. Cartoonists who exemplifies tone and style we want is Shirvanian, Steiner, Day. Prefers to buy reprints or clips of previously published material.

First Contact & Terms: To show a portfolio, send query letter with tearsheets. Show 10-12 samples. "Prefer to see tearsheets or camera ready copy or clippings." Include SASE. Reports within 2-3 weeks. Returns originals to artist at job's completion if requested at time of submission with SASE. Licenses reprint or all rights; prefers foreign reprint rights. Pays 50% gross income. Pays a flat fee; $5-200/per catoon.

Tips: "Send us cartoons on subjects like inflation, taxes, sports or Christmas; we get thousands on sex. Everyone wants new ideas—not the same old characters, same old humor at the doctor or psychiatrist or at the bar. More sophisticated people are needed. Study *The New Yorker*'s cartoons. Background is also needed—not just two people talking."

TEENAGE CORNER INC., 70-540 Gardenia Court, Rancho Mirage CA 92270. President: Mrs. David J. Lavin. Syndicates rights.

Needs: Prefers spot drawings and illustrations.

First Contact & Terms: Send query letter and SASE. Reports within 1 week. Buys one-time and reprint rights. Negotiates commission. Pays on publication.

TRIBUNE MEDIA SERVICES, INC., 64 E. Concord St., Orlando FL 32801. (305)839-5650. Editor: Mike Argirion. Syndicate serving daily and Sunday newspapers.
Needs: Seeks comic strips and newspaper panels.
First Contact & Terms: Send query letter with resume and photocopies. Sample package should include "2-3 weeks of daily and Sunday strips or panels." Samples not filed are returned. Reports within 4-6 weeks. Pays 50% of net proceeds.

UNITED MEDIA, 200 Park Ave., New York NY 10166. Director of Comic Art: Sarah Gillespie. Estab. 1978. Syndicate servicing U.S. and international newspapers. Guidelines available for SASE. "United Media consists of United Feature Syndicate and Newspaper Enterprise Association. Submissions are considered for both syndicates. Duplicate submissions are not needed."
Needs: Introduces 2-4 new strips/year. Considers comic strips and comic panels single, double and multiple panels. Recent introductions include "Big Name" and "Dr. Z." Prefers pen & ink. Maximum size of artwork: 8½×11.
First Contact & Terms: Send cover letter, finished cartoons and photocopies. Include 36 dailies, "Sundays not needed in first submissions." Do not send "oversize submissions, concepts but no strip." Samples are not filed and are returned by SASE. Reports back within 3 months. "Does not view portfolios." UFS pays 50% of net proceeds. NEA pays flat fee, $400 and up a week. Buys all rights. Minimum length of contract 5 years and 5 year renewal. Automatic renewal. 50/50 ownership of art; syndicate owns characters.
Tips: "Send copies, but not originals. Dailies only are needed on first submissions. Send a cover letter and resume. Do not send mocked-up licensing concepts." Looks for "originality, art and humor writing. Be aware of long odds; don't quit your day job; work on developing your own style and humor writing. Worry less about 'marketability'—that's our job."

UNIVERSAL PRESS SYNDICATE, 4900 Main St., Kansas City MO 64112. Editorial Director: Lee Salem. Syndicate serving 2750 daily and weekly newspapers.
Needs: Considers single, double or multiple panel cartoons and strips; b&w and color. Prefers photocopies of b&w, pen & ink, line drawings.
First Contact & Terms: Reports within 4 weeks. To show a portfolio, mail photostats. Buys syndication rights. Send query letter with resume and photocopies.
Tips: "A well-conceived comic strip with strong characters, good humor and a contemporary feel will almost always get a good response. Be original. Don't be afraid to try some new idea or technique. Don't be discouraged by rejection letters. Universal Press receives 100-150 comic submissions a week, and only takes on two or three a year, so keep plugging away. Talent has a way of rising to the top."

***WADE'S CARTOON SERVICE**, Suite 3, 1924 N. Talbott Ave., Indianapolis IN 46202. (317)925-6517. Contact: Harlan Wade. Syndicate serving 200 weekly newspapers. Art guidelines available.
Needs: Approached by 200 freelance artists/year. Buys from 50 freelance artists/year. Introduces 4-5 new strips/year. Considers comic strips, editorial/political cartoons, gag cartoons. Perfers single and multiple panel, with gagline, b&w line drawings and washes. Other needs include short stories with cartoons. Maximum size of artwork 8½×11" reducible to 3×3" or 4×4".
First Contact & Terms: Sample package should include cover letter, finished cartoons and photocopies. 10 samples should be included. Samples are filed or returned by SASE. Reports back within 2 weeks. Call or mail appropriate materials. Portfolio should include b&w photostats. Pays 50% of gross income. Pays on publication. Buys one-time rights. Minimum length of contract is 6 months. Artist owns original art and characters.
Tips: "I'd like to see about 10 very good drawings in the sample package."

***WASHINGTON POST WRITERS GROUP**, 1150 15th St., NW, Washington DC 20071-9200. (202)334-6375. Editorial Director: Alan Shearer. Estab. 1973. Syndicate serving over 1,000 daily, Sunday and weekly newspapers in U.S. and abroad. Art guidelines available for SASE and necessary postage.
Needs: Approached by 1,000+ prospective cartoonists and columnists/year. Introduces 1 new strip/year. Recent introductions include "Pickles," by Brian Crane. Prefers single and multiple panel and b&w line drawings. Does not handle one-time material.
First Contact & Terms: Sample package should include cover letter, resume, tearsheets, photostats and photocopies. 15-20 samples should be included. Samples are not filed and are returned by SASE if requested. Reports back within 3 weeks. To show a portfolio, mail photostats and tearsheets. Payment is contract negotiated. Buys all rights. Minimum lenghth of contract varies.
Tips: Submissions should be "sophisticated and well-drawn, but we are open-minded. The Writers Group has always been a small syndicate, and plans to remain so."

WHITEGATE FEATURES SYNDICATE, 71 Faunce Dr., Providence RI 02906. (401)274-2149. Talent Manager: Eve Green. Estab. 1988. Syndicate serving daily newspapers and magazines. Recently introduced Dane Berg's "Citizen Senior."

Needs: "We're planning on 6 or more strips next year. Do one now." Considers comic strips, gag cartoons, editorial/political cartoons, illustrations and spot drawings; single, double and multi panels. Also needs artists for advertising and publicity. Work must be reducible to strip size.

First Contact & Terms: Send cover letter, resume, tearsheets, photostats and photocopies. Include about 12 strips. Samples are filed or are returned by SASE. Reports back within 1½ months if SASE included. To show a portfolio, mail tearsheets, photostats, photographs and slides; include b&w. Pays 50% of net proceeds upon syndication. Negotiates rights purchased. Minimum length of contract 5 years (flexible). Artists owns original art; syndicate owns characters (negotiable).

Tips: Include in a sample package "info about youself, tearsheets of previous work, notes about the strip and enough samples to tell what it is. Please don't write asking if we want to see; just send samples." Looks for "good writing, strong characters, good taste in humor. No hostile comics. We like people who have been cartooning for a while and have been printed. Try to get published in local newspapers."

Other Syndicates

Each year we contact all companies currently listed in *Artist's Market* requesting they give us updated information for our next edition. We also mail listing questionnaires to new and established companies which have not been included in past editions. The following syndicates either did not respond to our request to update their listings for 1992 (if they indicated a reason, it is noted in parentheses after their name), or they are firms which did not return our questionnaire for a new listing.

Adventure Feature Syndicate
B M Enterprises
Cartoonews International
Chronicle Features
Dynamic Graphics Inc.
Future Features Syndicate
 (moved; no forwarding ad-
dress)
Graphic Arts Communications
Hispanic Link News Service
Intercontinental Media Ser-
 vices (unable to contact)
King Features Syndicate, Inc.
Minority Features Syndicate
Religious News Service
Syndicated Writers & Artists,
 Inc.
The Washington Post Writers
 Group

Market conditions are constantly changing! If you're still using this book and it is 1993 or later, buy the newest edition of Artist's Market *at your favorite bookstore or order directly from Writer's Digest Books.*

Glossary

Adobe Illustrator® Macintosh drawing and painting software.

Airbrush. Small pencil-shaped pressure gun used to spray ink, paint or dyes to obtain graduated tonal effects.

Ben-day. An artificial process of shading line illustrations, named after its inventor.

Bleed. Area of a plate or print that extends (bleeds off) beyond the edge of a trimmed sheet.

Book. Another term for a portfolio.

Buy-out. The sale of all reproduction rights (and sometimes the original work) by the artist; also subcontracted portions of a job resold at a cost or profit to the end client by the artist.

Camera-ready. Art that is completely prepared for copy camera platemaking.

Collaterals. Accompanying or auxiliary pieces, such as brochures, especially used in advertising.

Color separation. Photographic process of separating any multi-color image into its primary component parts (cyan, magenta, yellow and black) for printing.

Comprehensive. Complete sketch of layout showing how a finished illustration will look when printed; also called a comp.

Edition. The total number of prints published of one piece of art.

Gagline. The words printed, usually directly beneath a cartoon; also called a caption.

Gouache. Opaque watercolor with definite, appreciable film thickness and an actual paint layer.

Halftone. Reproduction of a continuous tone illustration with the image formed by dots produced by a camera lens screen.

Keyline. Indentification, through signs and symbols, of the postions of illustrations and copy for the printer.

Kill fee. Portion of the agreed-upon price the artist receives for a job that was assigned, started, but then canceled.

Lithography. Printing process based on a design made with a greasy substance on a limestone slab or metal plate and chemically treated so image areas take ink and non-image areas repel ink; during printing, non-image areas are kept wet with water.

Logotype. Name or design of a company or product used as a trademark on letterheads, direct mail packages, in advertising, etc., to establish visual identity; also called a logo.

Mechanicals. Paste-up or preparation of work for printing.

Overlay. Transparent cover over copy, giving instruction, corrections or color location directions.

Paste-up. Procedure involving coating the backside of art, type, Photostats, etc., with rubber cement or wax and adhering them in their proper positions to the mechanical board. The boards are then used as finished art by the printer.

Photostat. Black-and-white copies produced by an inexpensive photographic process using paper negatives; only line values are held with accuracy. Also called stat.

P-O-P. Point-of-purchase; a display device or structure located with the production or at the retail outlet to advertise or hold the product to increase sales.

Quark XPress®. Computer page layout program—the electronic equivalent of both a phototypesetter and a drawing board, allowing the artist to design pages with all type and images in place and output them as single page mechanicals. Other such programs are PageMaker®, Ventura Publisher® and Ready Set Go®.

Query. Inquiry to an editor or buyer eliciting his interest in a work you want to illustrate or sell.

Roughs. Preliminary sketches or drawings.

Serigraph. Silkscreen; stencil method of printing involving a stencil adhered to a fine mesh cloth and stretched tightly over a wooden frame. Paint is forced through the holes of the screen not blocked by the stencil.

Speculation. Creating artwork with no assurance that the buyer will purchase it or reimburse expenses in any way, as opposed to creating artwork on assignment.

Spot drawing. Small illustration used to decorate or enhance a page of type, or to serve as a column ending.

Storyboard. Series of panels which illustrates a progressive sequence or graphics and story copy for a TV commercial, film or filmstrip. Serves as a guide for the eventual finished product.

Tearsheet. Published page containing an artist's illustration, cartoon, design or photograph.

Thumbnail. A rough layout in miniature.

Transparency. A photographic positive film such as a color slide.

Type spec. Type specification; determination of the size and style of type to be used in a layout.

Velox. Photoprint of a continuous tone subject that has been transformed into line art by means of a halftone screen.

Index

Improve your skills, learn a new technique, with these additional books from North Light

Graphics/Business of Art
Artist's Friendly Legal Guide, by Conner, Karlan, Perwin & Spatt $18.95 (paper)
Business & Legal Forms for Graphic Designers, by Tad Crawford $15.95 (paper)
CLICK: The Brightest in Computer-Generated Design and Illustration, $39.95 (cloth)
COLORWORKS: The Designer's Ultimate Guide to Working with Color, by Dale Russell (5 in series) $24.95 ea.
The Complete Book of Caricature, by Bob Staake $18.95
The Complete Guide to Greeting Card Design & Illustration, by Eva Szela $27.95 (cloth)
The Designer's Commonsense Business Book, by Barbara Ganim $22.95 (paper)
Designing with Color, by Roy Osborne $26.95 (cloth)
59 More Studio Secrets, by Susan Davis $29.95 (cloth)
47 Printing Headaches (and How to Avoid Them), by Linda S. Sanders $24.95 (paper)
Getting Started as a Freelance Illustrator or Designer, by Michael Fleischman $16.95 (paper)
Getting Started in Computer Graphics, by Gary Olsen $27.95 (paper)
Getting the Max from Your Graphics Computer, by Lisa Walker & Steve Blount $27.95 (paper)
The Graphic Artist's Guide to Marketing & Self Promotion, by Sally Prince Davis $19.95 (paper)
Handbook of Pricing & Ethical Guidelines, 7th edition, by The Graphic Artist's Guild $22.95 (paper)
Homage to the Alphabet: Typeface Sourcebook, $39.95 (cloth)
HOT AIR: An Explosive Collection of Top Airbursh Illustration $39.95 (cloth)
How to Check and Correct Color Proofs, by David Bann $27.95 (cloth)
How to Draw & Sell Comic Strips, by Alan McKenzie $18.95 (cloth)
How to Understand & Use Design & Layout, by Alan Swann $19.95 (paper)
Label Design 2, by Walker and Blount $49.95 (cloth)
Legal Guide for the Visual Artist, Revised Edition by Tad Crawford $18.95 (paper)
Letterhead & Logo Designs: Creating the Corporate Image, $49.95 (cloth)
Licensing Art & Design, by Caryn Leland $12.95 (paper)
Presentation Techniques for the Graphic Artist, by Jenny Mulherin $24.95 (cloth)
Print's Best Corporate Publications $34.95 (cloth)
The Professional Designer's Guide to Marketing Your Work, by Mary Yeung $29.95
Type & Color: A Handbook of Creative Combinations, by Cook and Fleury $34.95 (cloth)
Type Recipes, by Gregory Wolfe $19.95 (paper)
Typewise, written & designed by Kit Hinrichs with Delphine Hirasuna $39.95
The Ultimate Portfolio, by Martha Metzdorf $32.95

Watercolor
Buildings in Watercolor, by Richard S. Taylor $24.95 (paper)
How To Make Watercolor Work for You, by Frank Nofer $27.95 (cloth)
Watercolor Painter's Pocket Palette, edited by Moira Clinch $15.95 (cloth)
The Wilcox Guide to the Best Watercolor Paints, by Michael Wilcox $24.95 (paper)

Mixed Media
Business & Legal Forms for Fine Artists, by Tad Crawford $12.95 (paper)
Capturing Light & Color with Pastel, by Doug Dawson $27.95 (cloth)
Festive Folding, by Paul Jackson $22.95 (cloth)
Fine Artist's Guide to Showing & Selling Your Work, by Sally Price Davis $17.95 (paper)
How to Succeed As An Artist In Your Hometown, by Stewart P. Biehl $24.95 (paper)
Master Strokes, by Jennifer Bennell $24.95 (cloth)
Painting Landscapes in Oils, by Mary Anna Goetz $27.95 (cloth)
Painting the Beauty of Flowers with Oils, by Pat Moran $27.95 (cloth)

To order directly from the publisher, include $3.00 postage and handling for one book, $1.00 for each additional book. Allow 30 days for delivery.

North Light Books
1507 Dana Avenue, Cincinnati, Ohio 45207
Credit card orders call TOLL-FREE
1-800-289-0963
Prices subject to change without notice.

1992 Close-up Personalities

Illustrator: Barbara Kelley

*Polly Cianciolo
Program Director
Page 270*

*Dwayne Flinchum
Art Director
Page 552*

*Carol Donner
Medical Illustrator
Page 82*